THE
HISTORY
OF ART
A GLOBAL
VIEW

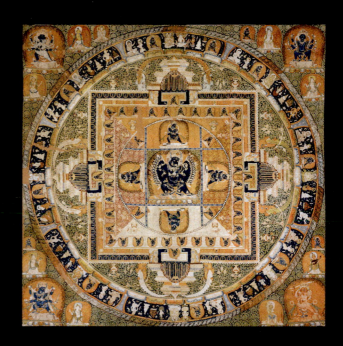

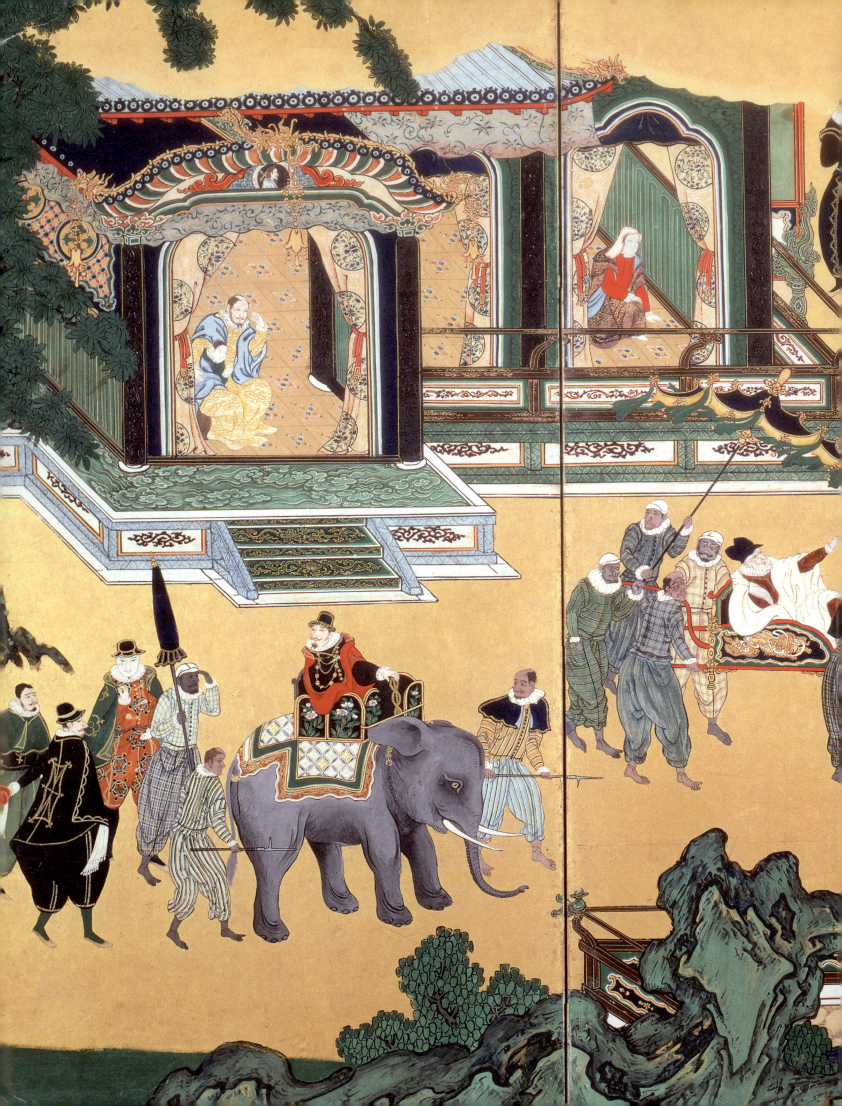

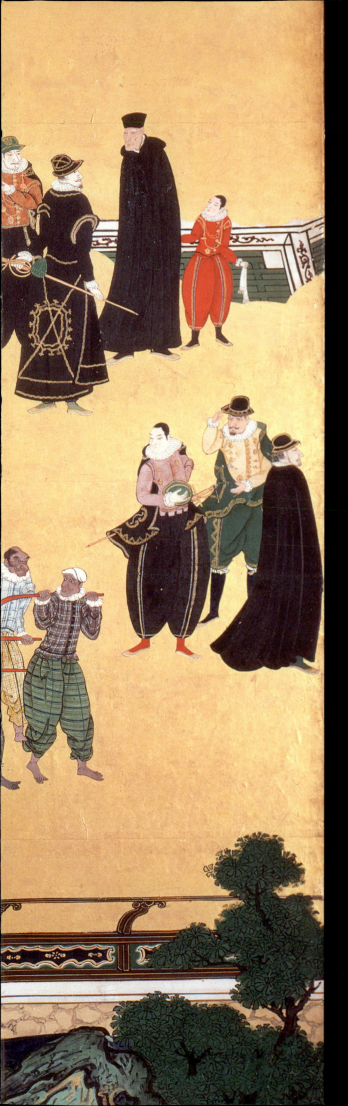

THE HISTORY OF ART

A GLOBAL VIEW

VOLUME ONE

PREHISTORY TO 1500

JEAN ROBERTSON · DEBORAH HUTTON

CYNTHIA S. COLBURN

ÖMÜR HARMANŞAH

ERIC KJELLGREN

REX KOONTZ

DE-NIN D. LEE

HENRY LUTTIKHUIZEN

ALLISON LEE PALMER

STACEY SLOBODA

MONICA BLACKMUN VISONÀ

FRONT COVER
Combined volume: Head from Wunmonije Compound, Ife,
Nigeria, Ancestral Yoruba, 1250–1350. National Museum of Ife,
Nigeria. Photo Scala, Florence.

Volume 1: Ear ornament from Sipán tombs, Moche, Peru,
c. 300 CE. Museo Tumbas Reales de Sipán, Peru. Photo Frans
Lemmens/Alamy Stock Photo.

Volume 2: Yinka Shonibare, CBE, *Cake Man*, 2013. Image courtesy
Stephen Friedman Gallery and Pearl Lam Galleries. Photo
Stephen White & Co. © Yinka Shonibare CBE. All Rights Reserved,
DACS/Artimage 2021.

Frontispiece: *Mandala of Vajrabhairava*, Yuan dynasty,
c. 1330–32. Metropolitan Museum of Art, New York. Lila Acheson
Wallace Gift, 1992, 1992.54. Photo Metropolitan Museum of Art/
Art Resource/Scala, Florence.

Title page: Kanō Naizen, *Namban Byōbu* (detail), Momoyama
period, 1593. Kobe City Museum, Japan. Photo Kobe City Museum/
DNPartcom.

The History of Art: A Global View © 2021 Thames & Hudson Ltd,
London

Designed by Christopher Perkins

First published in 2021 in the United States of America by
Thames & Hudson Inc., 500 Fifth Avenue, New York,
New York 10110

Library of Congress Control Number 2020952139

Combined volume: ISBN 978-0-500-02237-5
Volume 1: ISBN 978-0-500-29355-3
Volume 2: ISBN 978-0-500-29356-0
Combined volume Not for Sale: ISBN 978-0-500-84365-9
Volume 1 Looseleaf/3-Hole-Punch: ISBN 978-0-500-84421-2
Volume 2 Looseleaf/3-Hole-Punch: ISBN 978-0-500-84422-9

Printed and bound in Slovenia by DZS-Grafik d.o.o.

Be the first to know about our new releases, exclusive content
and author events by visiting
thamesandhudson.com
thamesandhudsonusa.com
thamesandhudson.com.au

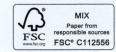

Brief Contents

Table of Contents

Preface

Thames & Hudson's *The History of Art: A Global View* grew out of the need for a more global, inclusive way to teach the history of the world's art. The author team of eleven specialists had already devised ways to meet the challenge of teaching globally in their own classrooms. Headed by lead authors Jean Robertson and Deborah Hutton, this community of scholars cohered around the shared goal of bringing multiple perspectives to a worldwide narrative. The resulting survey represents every global region as an important part of a chronological, interwoven history that emphasizes cross-cultural connections, contrasts, and comparisons. Because we recognize that every course is unique in coverage and emphases, the book was designed to be flexible, so users could devise their syllabi to be as global or as regionally focused– as they need. Over 1,600 images, maps, and diagrams ensure that every major region is abundantly illustrated and described.

As the first major art history survey textbook written in the twenty-first century, *The History of Art: A Global View* is also the only survey that intentionally reflects the diversity of today's students, and equips them to study and understand the history of art in new and revealing ways. By responding to these changes in how the course is taught, *The History of Art: A Global View* offers many benefits existing art history survey books are missing.

Our Unique Approach

Careful research into how art history is taught today guided the editors at Thames & Hudson when planning the book and choosing the author team, with a number of key outcomes that make *The History of Art: A Global View* unique.

CROSS-CULTURAL CONNECTIONS Teaching an inclusive, global, comparative course is a crucial goal for many instructors. Interspersed among the chapters of *The History of Art: A Global View* are two-page "Seeing Connections" features that compare how different parts of the world approached similar problems; exchanged objects, materials, techniques, styles, and ideas; or developed and used styles and media. These interchapters choose key moments (for example, the Silk Road), developments (such as ancient writing) or phenomena (such as diaspora) to demonstrate how art has always been global.

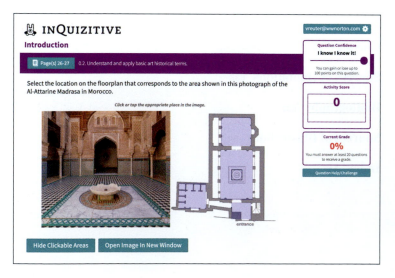

Instructors who have time to teach art from only some geographical regions can assign Seeing Connections features to show students that, since the earliest times, art has been made throughout the world.

The overarching organizational structure of six thematic parts ("The Earliest Art," "Early Cities and Empires," "The Spread of Religions," "Looking Inward, Exploring Outward," "Imperialism, Revolution, and Innovation," and "Art in a Connected World") helps students think about commonalities and differences. Timelines open each part to show what was happening around the world during the period covered. A global map shows where a selection of representative objects discussed in that part were created.

BRIEF CHAPTERS, CHRONOLOGICAL ORGANIZATION Chronology was our primary organizing principle. With seventy-five brief chapters (on average just sixteen pages each) instead of thirty or thirty-five longer ones, the history of art from different cultures can be more tightly interwoven. Major global regions are represented by multiple chapters in each volume, giving readers a sense of how art was developing contemporaneously on every continent. Because they are brief, chapters can be read in about an hour, so instructors can assign more than one chapter a week.

Instructors who want to integrate global content closely in their classes can assign chapters in chronological order—but even if they skip chapters or assign them out of order, our chapters are designed so that students don't miss critical information. On-page glossary definitions give readers instant access to new terms, or a refresher if they don't remember an unfamiliar word. (The glossary in the back of the book compiles all the terms in one place.) That way, instructors can skip chapters if they want to de-emphasize an era, region, or stylistic movement, without fearing that students will have missed a critical piece of information.

A Cohesive Package of Digital Resources

A richly illustrated suite of resources meets the challenge of teaching a global course, and reinforces visual literacy. Instructor and student support resources include the following:

INQUIZITIVE AND EBOOK The adaptive assessment tool InQuizitive* is fully integrated with an interactive ebook, which features zoomable images, an audio pronunciation guide, architectural panoramas, animations, and videos focusing on historical eras and themes, media and processes, and practice in visual analysis. After completing their InQuizitive assignments, students come to class prepared, leading to more engaging discussions.

The book's authors contributed a major share of the InQuizitive questions, which were reviewed and class-tested. Efficacy studies designed by a research scientist have shown that assigning InQuizitive improves average student grades by nearly a full point, boosting a C grade to a B, and a B to an A. InQuizitive's unique confidence slider gives students extra incentive to understand and retain what they have read.

INSTRUCTOR RESOURCES For instructors, media resources are available at your fingertips for easy integration with your Learning Management

*InQuizitive is currently available to North American adopters only.

System (LMS), with links that can readily be incorporated into a syllabus or lecture, and resources that can be searched and browsed according to a number of criteria. Our resources were written by the authors and a team of experienced instructors, thoroughly reviewed and checked.

The Instructor's Manual includes resources such as chapter outlines and summaries; lecture ideas and teaching tips; discussion questions; recommended readings; and suggested videos and websites. Sample syllabi show how the book's flexibility provides a variety of ways to teach the course, and demonstrate how to incorporate the many brief chapters into a typical two-term art history survey course.

A chapter-by-chapter Test Bank makes it easier to transition to this new book and features over 2,250 test questions, available in Norton Testmaker. In Testmaker, you can create assessments online, search and filter test bank questions by chapter, type, difficulty, learning objectives, and other criteria. You can also customize questions to fit your course and easily export your tests to Microsoft Word or Common Cartridge files for import into your LMS.

All the images in the book are available as both jpgs and Power Points—or use our prepared lecture slides as a basis for your lecture: they are fully ADA compliant.

Finally, the Thames & Hudson Global View Gallery includes thousands of images, searchable by key word, for instructors to download to supplement your lecture slides.

The media resources are available to qualified adopters in North America. If you are outside North America, please contact Education@ThamesHudson.co.uk.

Additional Features

A variety of features provide different ways to approach the material, and give readers a chance to experience and practice the work art historians do.

INTRODUCTION TO VISUAL ANALYSIS Connecting the formal components of objects to the histories and cultures that created them requires a complex set of skills. The book's global Introduction gives readers an understanding of formal and visual analysis, and presents the basics of contextual analysis, showing how the two work hand in hand. It shows readers what art history is, why it matters, and how it is practiced by art historians regardless of the work or culture they are studying. A simple comparative example invites students to practice using their visual analysis skills – skills they can use in their art history class and beyond.

MORE CONTEXT To boost students' understanding of how art's creation and content are influenced by cultural context, *The History of Art: A Global View* provides more and better context alongside the visual examples. In addition to matching the historical, political, religious, economic, literary, cultural, and philosophical context found in other books, Chapter Introductions provide a historical overview to guide readers through each chapter.

VISUAL CULTURE There is a growing interest in the discipline about including not just so-called "high art" but also material and visual culture in various media, to help understand how different forms of visual communication shape our understanding of the world. Our book looks beyond painting, sculpture, and monumental architecture to consider other types of art, such as portable religious objects; vessels and ceramics; textiles and fashion; books, posters, and documentary photographs; manufactured consumer products; and masquerades and performances.

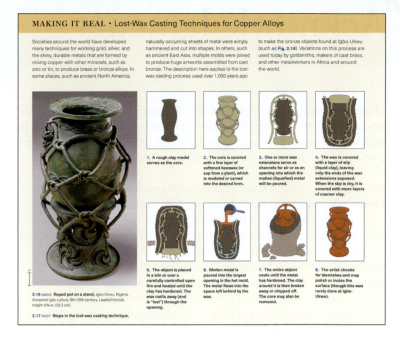

MAKING IT REAL • Lost-Wax Casting Techniques for Copper Alloys

2.16 ABOVE **Roped pot on a stand,** Igbo-Ukwu, Nigeria, Ancestral Igbo culture, 9th–10th century. Leaded bronze, height 12¾ in. (32.3 cm).

2.17 RIGHT Steps in the lost-wax casting technique.

ART HISTORICAL THINKING Another key goal of the course is to introduce students to art historical thinking—basic methods and concepts. "Art Historical Thinking" boxes throughout the book introduce students to the issues, concepts, and controversies art historians consider.

LOOKING MORE CLOSELY An objective of almost all courses is teaching students to carry out a visual analysis. Frequent "Looking More Closely" boxes show the reader how specific artworks are analyzed, with details to highlight important aspects of the works under consideration.

MAKING IT REAL To understand much of art and art history, students need to understand the materials and techniques involved. Many students in art history classes are practicing artists themselves, and they are especially attentive to how art was made. "Making it Real" boxes give this important background, with detailed diagrams and illustrations.

GOING TO THE SOURCE Primary-source excerpts within the chapters give students a chance to consider historical perspectives, and gain familiarity with how to use primary sources.

MAPS To give readers a better geographical appreciation, a map opens nearly every chapter, focusing in on the part of the world and the time-frame covered in that chapter. More than one hundred maps are found throughout the book.

DIAGRAMS AND RECONSTRUCTIONS Descriptions of ancient sites and buildings are accompanied by detailed drawings, plans, and reconstructions to help students visualize structures that no longer exist. Diagrams show how objects were made or functioned, or focus on details that are hard to see.

EXPERT AUTHORS The author team of eleven specialists represents expertise in all the important chronological eras as well as all major global areas, and ensures accuracy and up-to-date coverage of every period and region. See page 15 to meet our author team.

Acknowledgments

Thames & Hudson would like to thank the many reviewers and specialists who offered their expert advice by commenting on the chapters in manuscript form, class-testing preliminary versions of the book, and writing or reviewing the instructor and student resources.

The following specialists provided expertise in specific areas and time periods:

Prehistoric Art – John Robb, University of Cambridge; Paul Bahn; Bruno David, Monash University

Africa – Peri Klemm, California State University, Northridge; Amanda Maples, North Carolina Museum of Art

The Americas – Leah McCurdy, University of Texas at Arlington

Oceania – Jerome Feldman, Hawai'i Pacific University

Korea – Sooa Im McCormick, The Cleveland Museum of Art; Charlotte Horlyck, SOAS University of London; Seojeong Shin, American University

Japan – Claire Cuccio; Akiko Walley, University of Oregon; Chelsea Foxwell, University of Chicago

Early and Medieval China – Kate A. Lingley, University of Hawai'i at Mānoa

Twentieth-century China – Christine Ho, University of Massachusetts Amherst

Buddhist art – Denise Leidy, Yale University Art Gallery

Southeast Asia – Melody Rod-ari, Loyola Marymount University; Paul Lavy, University of Hawai'i at Mānoa

South Asia – Kerry Lucinda Brown, Savannah College of Art & Design; Rebecca M. Brown, Johns Hopkins University

Hindu art – Emma Natalya Stein, Smithsonian's National Museum of Asian Art

Mesopotamia and West Asia – Zainab Bahrani, Columbia University

Egypt – Christina Riggs, University of Durham; Ian Shaw, University of Liverpool; Amy Calvert

Islamic art – Alisa Eimen, Minnesota State University Mankato; Jennifer Roberson, Sonoma State University

Middle Ages in Europe – Camille Serchuk, Southern Connecticut State University; Roger Stalley, Trinity College Dublin

Renaissance in Europe – Julia DeLancey, University of Mary Washington; Renzo Baldasso

Dutch Republic – Julie Hochstrasser, University of Iowa

Mannerism in Europe – Felicia Else, Gettysburg College

The following reviewers commented on chapters in manuscript form, and offered excellent advice on revisions that would make the final book a better fit for use in their classrooms:

Karen Abbondanza, University of Massachusetts Dartmouth; Kirk Ambrose, University of Colorado, Boulder; Jennifer Armstrong, Seneca College; Matthew Backer, Lone Star College–CyFair; C. Cody Barteet, University of Western Ontario; Rozmeri Basic, University of Oklahoma–Norman; Rachael Bower, Northwest Vista College; Karen Brown, College of Western Idaho; Kerry Lucinda Brown, Savannah College of Art & Design; Laura Bruck, Rocky Mountain College of Art & Design; Denise Budd, Bergen Community College; Tyrus Clutter, College of Central Florida–Ocala; Logan Cowé, Houston Community College; Julia DeLancey, University of Mary Washington; Joyce de Vries, Auburn University; Alisa Eimen, Minnesota State University, Mankato; Jill Foltz, El Centro College; Amy Gansell, St. John's University; Marie Gasper-Hulvat, Kent State University–Stark; Parme Giuntini, Otis College of Art and Design; Amy Golahny, Lycoming College; Benjamin Harvey, Mississippi State University; Deana Hight, Mt. San Antonio College; Heather Horton, Pratt Institute; Menno Hubregste, University of Victoria; Joanna Inglot, Macalester College; Alice Jackson, University of Alabama at Birmingham; Elizabeth Kim, Texas Woman's University; Lara Kuykendall, Ball State University; Thomas Larose, Virginia State University; Karen Leader, Florida Atlantic University; Ann Marie Leimer, Midwestern State University; Lisa MacBride, Tunxis Community College; Heather Madar, Humboldt State University; Marguerite Mayhall, Kean University; Jennifer McLerran, Northern Arizona University; Gustav Medicus, Kent State University; Melissa Mednicov, Sam Houston State University; Marina Mellado Corriente, Virginia Commonwealth University; Maria Modlin, Pitt Community College; Elizabeth Moran, Christopher Newport University; Johanna Movassat, San Jose State University; Vandana Nadkarni, Raritan Valley Community College; Emily Newman, Texas A&M University–Commerce; Micheline Nilsen, Indiana University South Bend; Marjorie Och, University of Mary Washington; Sara Orel, Truman State University; Natalie Phillips, Ball State University; Shannon Pritchard, University of Southern Indiana; Madeline Rislow, Missouri Western State University; Miles David Samson, Worcester Polytechnic Institute; Camille Serchuk, Southern Connecticut State University; Lindsay Shannon, North Central College; Karen Shelby, Baruch College–The City University of New York; Amy Sluis, Lone Star College–University Park; Tamara Smithers, Austin Peay State University; Susana Sosa, Fresno City College; Kaylee Spencer, University of Wisconsin–River Falls; Jessica Stewart, James Madison University; Joe Thomas, Kennesaw State University; John D. Turner, Indiana Tech; Buffy Walters, Marion Military Institute; Carolyn West Pace, Mohawk Valley Community College; Emily Winthrop, Virginia Commonwealth University; Michele Wirt, College of Central Florida–Lecanto; Ronald Wrest, Bakersfield College.

Instructor and Student Resource Contributors

These dedicated contributors used their classroom experience to write and review instructor and student resource materials, augmenting the authors' original material, to ensure we provided the high-quality resources our adopters depend on:

Magdalene Breidenthal, Queens College, CUNY; Deirdre Carter, Indiana University, Herron School of Art and Design, IUPUI; Clarissa Chevalier, University of California San Diego; Colin Edgington; Arthur DiFuria, Savannah College of Art and Design; Alisa Eimen, Minnesota State University; Andy Findley, Indiana University, Herron School of Art and Design, IUPUI; Jill Foltz, Dallas College; Evan Freeman, Queens College, CUNY; Hannah Fritschner; Pierette Kulpa, Kutztown University; Anne McClanan, Portland State University; Alysha Meloche, Drexel University; Kurt Norlin, Bittner Development Group; Erika Pazian, Central Washington University; Rachel Sailor, University of Wyoming; Sarahh Scher, Emerson College; Camille Serchuk, Southern Connecticut State University; Surana Singh, East Los Angeles College; Amy Sluis, Lone Star College–University Park; Andrea Snow, The University of North Carolina at Chapel Hill; Tiffany Thurman, Plano East Senior High School and Green Stripe Consulting, LLC.

The Authors

The History of Art: A Global View was possible only due to the spirit and hard work, both independently and in collaboration with others, of its talented and dedicated author team, which includes:

CYNTHIA S. COLBURN is Professor of Art History at Pepperdine University, where she has received two awards for excellence in teaching. Her research focuses on the art and archaeology of the ancient Mediterranean, especially the role of bodily adornment and performance in identity construction. Her publications include *Reading a Dynamic Canvas: Adornment in the Ancient Mediterranean World* (co-edited with Maura K. Heyn), as well as articles on global art history. She has also conducted archaeological fieldwork in Italy, Greece, and Turkey.

Dr. Colburn authored chapters on Cycladic and Minoan art; Mycenaean art and Greek art from the Mycenaean period through the Late Classical and Hellenistic; Villanovan and Etruscan art; and Roman art from the Republic through the late Roman Empire.

ÖMÜR HARMANŞAH is Associate Professor of Art History at the University of Illinois at Chicago. As an archaeologist and an architectural historian, Dr. Harmanşah specializes in the art, architecture, and material culture of ancient West Asia. He is the author of *Cities and the Shaping of Memory in the Ancient Near East* and *Place, Memory, and Healing: An Archaeology of Anatolian Rock Monuments*.

Dr. Harmanşah authored chapters on the art of Mesopotamia, ancient West Asia and West Asian Empires, and ancient Egypt from the Predynastic Nile Valley through the Late Period. He was primary author on Chapter 1, "The Beginnings of Art," and coordinated contributions from co-authors who are experts on other regions.

DEBORAH HUTTON is Professor of Art History in the Department of Art and Art History at The College of New Jersey. Her research explores art made for the Muslim courts of South Asia between the sixteenth and early twentieth centuries. Her book *Art of the Court of Bijapur* won the American Institute of Indian Studies Edward Cameron Dimock Jr. Prize in the Indian Humanities. She co-authored (with Deepali Dewan) *Raja Deen Dayal: Artist-Photographer in 19th-century India* and co-edited (with Rebecca Brown) *Asian Art: An Anthology*; *Blackwell Companion to Asian Art*; and *Rethinking Place in South Asian and Islamic Art, 1500–Present*.

Dr. Hutton wrote chapters on the art of South and Southeast Asia from the earliest periods to the present, and on Islamic art in North Africa, West Asia, and Central Asia from the seventh century to the present. In collaboration with De-nin Lee, she co-authored the Introduction. Along with Jean Robertson, she also served as the textbook's co-lead author: assisting with the editing of all the chapters, co-authoring the Part Openers, and coordinating vocabulary throughout the volumes.

ERIC KJELLGREN is a leading scholar of the arts of Oceania. Formerly curator of Oceanic Art at The Metropolitan Museum of Art and director of the American Museum of Asmat Art (AMAA) and Clinical Faculty in Art History at the University of St. Thomas in Minnesota, he has worked extensively with contemporary Indigenous Australian artists and done field research in Vanuatu. Dr. Kjellgren is the author of two books, *How To Read Oceanic Art* and *Oceania: Art of the Pacific Islands in The Metropolitan Museum of Art*. He has curated numerous exhibitions at The Metropolitan and the AMAA and had curatorial responsibility for the redesign and reinstallation of The Metropolitan's permanent galleries for Oceanic Art.

Dr. Kjellgren wrote chapters on the arts of Oceania from the earliest period to the present, including the section on Oceanic art in Chapter 7.

REX KOONTZ is Professor of Art History at the University of Houston and Consulting Curator of Ancient American Art at the Museum of Fine Arts, Houston. He has studied the public sculpture of Ancient Mexico for more than two decades, and published articles, book chapters, and the books *Lightning Gods and Feathered Serpents*; *Blood and Beauty: Organized Violence in the Art and Architecture of Mesoamerica* (with Heather Orr); *Landscape and Power in Ancient Mesoamerica*, edited with Kathryn Reese-Taylor and Annabeth Headrick; and *Mexico*, with Michael Coe and Javier Urcid.

Dr. Koontz wrote chapters on the art of the Americas, from early South America and Mesoamerica and North America, to the art of North, South, and Mesoamerica from 1300 onward.

DE-NIN D. LEE is Associate Professor of Art History in the department of Visual & Media Arts at Emerson College. Her research in Chinese painting currently focuses on the intersection of landscape and environment. She is author of *The Night Banquet: A Chinese Scroll through Time* and editor of *Eco-Art History in East and Southeast Asia*.

Dr. Lee wrote chapters on East Asia—the areas of present-day China, Japan, and Korea—from prehistorical times to the modern period. In collaboration with Deborah Hutton, she co-authored the Introduction.

HENRY LUTTIKHUIZEN is Professor of Art History Emeritus at Calvin University. He has served as the president of the Midwest Art History Society and the American Association of Netherlandic Studies. With Dorothy Verkerk, he co-authored the second edition of *Snyder's Medieval Art* and with Larry Silver, he co-authored the second edition of *Snyder's Northern Renaissance Art*. Most recently, he is co-editor of *The Primacy of the Image in Northern European Art, 1400–1700*. Dr. Luttikhuizen has curated numerous exhibitions, including *The Humor and Wit of Pieter Bruegel the Elder* and *Stirring the World: German Printmaking in the Age of Luther*.

Dr. Luttikhuizen wrote the chapters on Jewish and Christian art in late antiquity; art of the Byzantine Empire and the Mediterranean world from 500–1500; and European art from the early medieval period to the late Middle Ages, including Romanesque and Gothic art and architecture.

ALLISON LEE PALMER is Professor of Art History in the School of Visual Arts at the University of Oklahoma, where she has won numerous teaching awards. Her publications include *Leonardo da Vinci:* *A Reference Guide to His Life and Works*; *Historical Dictionary of Architecture*; *Historical Dictionary of Romantic Art and Architecture*; and the *Historical Dictionary of Neoclassical Art and Architecture*.

Dr. Palmer authored chapters on the art of Renaissance Europe, including Italy, Spain, France, northern Europe, and England, from the fifteenth through the sixteenth centuries.

JEAN ROBERTSON is Chancellor's Professor of Art History Emerita at Indiana University, Herron School of Art and Design, IUPUI, where she received three Indiana University awards for excellence in teaching. She specializes in art history and theory after 1980, viewed in a global context. She served as founding co-director of the Southern Ohio Museum and associate curator of the Columbus (Ohio) Museum of Art. Among her publications are *Themes of Contemporary Art: Visual Art after 1980*; *Spellbound: Rethinking the Alphabet*; and *Painting as a Language: Material, Technique, Form, Content*, all co-authored with Craig McDaniel.

Dr. Robertson wrote chapters on European and North American art from the Romantic period to the present. She was primary author on Chapter 74, "Art of the Global Contemporary," and coordinated contributions from co-authors who are experts on other regions. Along with Deborah Hutton, she also served as the textbook's co-lead author: assisting with the editing of all the chapters, co-authoring the Part Openers, and coordinating vocabulary throughout the volumes.

STACEY SLOBODA is the Paul H. Tucker Professor of Art at the University of Massachusetts Boston. Her research focuses particularly on eighteenth-century art, design, and material culture in Britain, with a special interest in cross-cultural exchange and global networks. She is the author of *Chinoiserie: Commerce and Critical Ornament in Eighteenth-Century Britain*; co-editor of *Eighteenth-Century Art Worlds: Global and Local Geographies of Art*; and editor of *A Cultural History of the Interior in the Age of Enlightenment, 1650–1800*.

Dr. Sloboda authored chapters on European art in the Baroque period, in the Dutch Republic, during the Enlightenment, and the Rococo and Neoclassical periods. She also played a pivotal role in conceiving the "Seeing Connections" features, and in coordinating the efforts of her co-authors as they collaborated on the features.

MONICA BLACKMUN VISONÀ is Professor of Art History and Visual Studies and affiliate faculty in African American and Africana Studies at the University of Kentucky. She was principal author of *A History of Art in Africa*, and co-edited (with Gitti Salami) *A Companion to Modern African Art*; both of these publications won awards from ACASA, the Arts Council of the African Studies Association. Her other publications include *Constructing African Art Histories for the Lagoons of Côte d'Ivoire*.

Dr. Visonà authored chapters on the art of Africa from the earliest times up to and including the modern and postcolonial period, and contributed to conceptualizing and writing the Part Openers.

Introduction

You Are Invited

Come have a closer look at the sculpture illustrated here (**Fig. 0.1**). What do you see? Has a brightly dressed performer just tossed yet another cake on the stack of frosted delights teetering atop his back? Skillfully thrown, it has landed, but the stack leans dangerously. The outcome of this trick is uncertain.

intensity the saturation or brilliance of a given color.

linear perspective a system of representing three-dimensional space and objects on a two-dimensional surface by means of geometry and one or more vanishing points.

style characteristics that distinguish the artwork of individuals, schools, periods, and/or cultures from that of others.

point of view the implied position of the observer generated within the artwork.

anamorphic a distorted image that is stretched out and must be viewed at an angle or with a mirror to see the image in its correct shape.

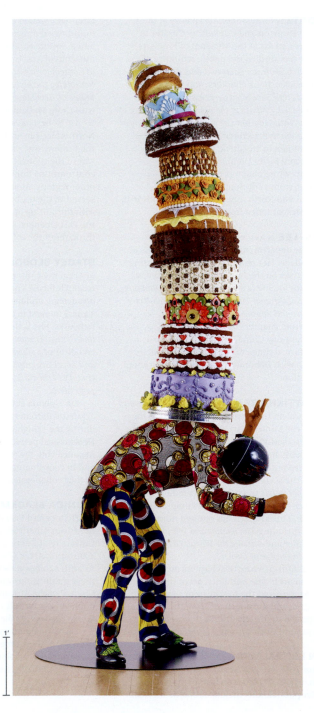

0.1 Yinka Shonibare, CBE, *Cake Man*, 2013. Unique life-size mannequin, Dutch-wax printed African textile, leather, gold, polyester, and plaster, 10 ft. 4 in. × 34⅝ in. × 47¼ in. (3.15 m × 88 cm × 120 cm).

The Nigerian-British artist Yinka Shonibare, CBE (b. 1962), commands our attention in *Cake Man* (2013) using a comical mixture of colorful African patterns, theatrical gesture, and a leaning tower of cakes. Once he has captured our interest, though, he suspends the narrative. *Cake Man* encourages us to wonder: How long before the cakes come tumbling down? This question (and any others we might ask) opens up the possibility of engaging more deeply with the sculpture. Shonibare uses humor and drama to make a statement about the human condition. Note that the figure's head takes the form of a globe tracing Hong Kong's stock-market activity from 2013. The more he acquires, the greater his burden, suggesting that human greed leads to impossible balancing acts.

Whereas Shonibare makes visible the consequences of unchecked greed, the contemporary American artist Kerry James Marshall (b. 1955) considers an idea that often arises in the study of art: beauty. Marshall's *School of Beauty, School of Culture* takes us into the world of a Black American hair salon (**Fig. 0.2**). Amid the expected primping and posing in front of heart-shaped mirrors—reminding us of the supposed connection between physical attractiveness and romantic possibility—an oddity in the foreground draws the curiosity of two toddlers. The boy squats to get a better look; the girl points in an attempt to show it to the adults, who pay no attention, despite the **intensity** of the object's yellow color. What is this strange thing?

To see the yellow image better, we must take another perspective. Bring your eyes parallel with the bottom edge of the page, and rotate the book so that the bottom right corner is closest to you, and look again. Closing one eye may help to bring it into focus. Marshall has manipulated the techniques of **linear perspective** to create an illusion: a deliberately cartoon-like image of a blonde woman appears in a space belonging to the Black community. Conforming to a different **style** and **point of view**, this distorted image (an **anamorphic** projection) belongs to a different cultural and spatial realm, yet it casts a shadow here in the salon, both literally and figuratively.

Even as Marshall's painting explores ideas of race and beauty, it also expresses awareness of art history. Nearly five hundred years ago, Hans Holbein the Younger painted into *The Ambassadors* (1533) an anamorphic skull as a reminder of the inevitability of death and the fleeting quality of life (see Fig. 48.12). Take a moment to look at Holbein's painting so you can see the specter that looms in front of the wealthy, powerful men. In *School of Beauty, School of Culture*, Marshall consciously makes reference to *The Ambassadors* not only to deepen the haunting effect of racial stereotypes but also to encourage us to

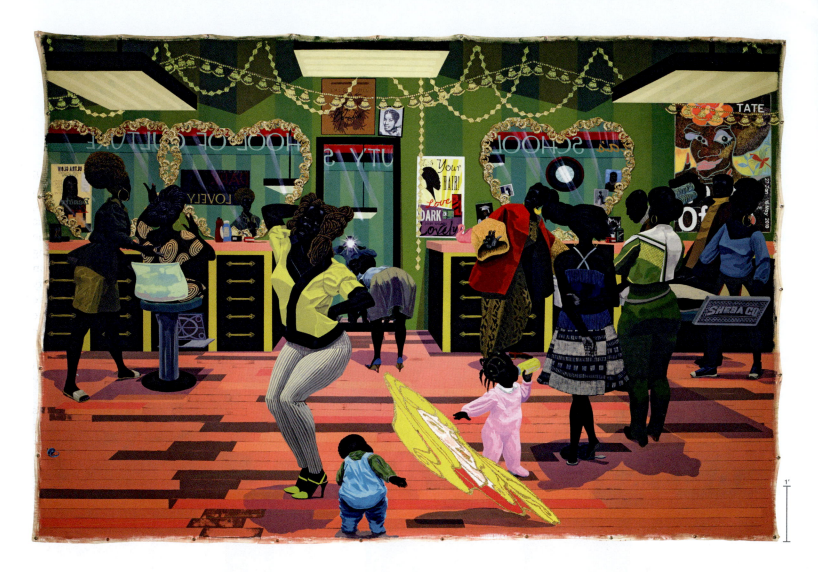

think critically about the relationship between beauty and cultural biases in art history's **canon**. With its own history rooted in European imperialism, art history has long idealized the art of western Europe and white North America at the expense of art of other cultures.

By contrast, *The History of Art: A Global View* examines the meaning and significance of art from all six inhabited continents and their many cultures. To learn about so much art is a tall order, requiring a balancing act. As much as we want to include every excellent artwork in this book, we have to combine a broad selection with the right number to maintain balance. Thus, this book strives for as much breadth and variety as possible while maintaining a substantive and coherent narrative. At times, the content may be unfamiliar and daunting. But, if *Cake Man* sparks your curiosity and if you can see how the anamorphic projections work in *School of Beauty, School of Culture* and *The Ambassadors*, you have everything you need to start learning art history. So, put your eyes, mind, and hands to work. You are invited to study the history of art from its earliest days to the present.

Art Matters

Artworks from all around the world make up our shared human inheritance. They leave a material record of human creativity, resourcefulness, yearning, and experience.

By studying that record, we deepen our understanding of ourselves and our world. In other words, art matters. Consequently, art history delves into the matter, or materials, that make up art, as well as the many ways that art makes an impact on human lives.

To demonstrate this point more concretely, let us look briefly at five examples. Made from a variety of materials, these artworks together suggest how studying art is a form of time travel, allowing us to peer into the past and helping us to reconstruct vanished cultures. They also reveal how art conveys power, shapes memory, and spreads ideas, thus making visible crucial aspects of societies. Art has been, and continues to be, an important component of the global economy, and as artworks circulate across great distances, they trace a web of human relationships. Artworks can also be instrumental in forging a shared identity, whether for a family, a village, a region, or a nation. A great work of art, whatever its **form** and material, can help us to see in new ways and call us to action.

To learn what happened yesterday or a century ago, we can turn to written records. But what about cases without surviving records, or those places—technically, prehistoric cultures—where forms of writing had not yet reached? In the absence of writing, we can look to extant images, such as the Bangudae **petroglyphs**. One

0.2 **Kerry James Marshall,** ***School of Beauty, School of Culture,*** 2012. Acrylic and glitter on unstretched canvas, 8 ft. 11⅞ in. × 13 ft. 1⅞ in. (2.74 × 4 m). Birmingham Museum of Art, Alabama.

canon a set of what are regarded as especially significant artworks.

form (1) an object that can be defined in three dimensions. (2) the physical, visual, and other relevant aesthetic characteristics of an artwork.

petroglyph an image created on a rock surface through incision, picking, carving, or abrading.

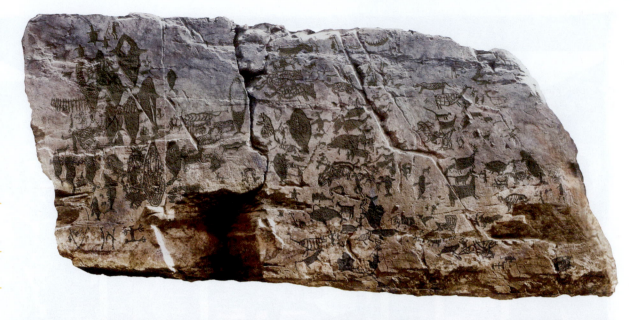

0.3 Bangudae Petroglyphs, Ulsan City, South Korea, *c.* 6000–500 BCE.

composition the organization of elements in a work of art, distinct from its subject matter.

schematic depicted in a simplified, graphic form.

monumental having massive or impressive size or extent.

rock-cut carved from solid stone where it naturally occurs.

facade any exterior vertical face of a building, usually the front.

column in architecture, an upright, weight-bearing pillar, usually cylindrical.

pediment in architecture, the triangular component that sits atop a columned porch, doorway, or window.

patron a person or institution that commissions artwork or funds an enterprise.

motif a distinctive subject or visual element appearing in an artwork, such as a figure, an object, or a pattern.

chintz a type of multicolored, cotton fabric with a shiny finish.

pattern recurring arrangements in an artwork.

mass especially in sculpture and architecture, three-dimensional volumes or dense aggregations of matter or material.

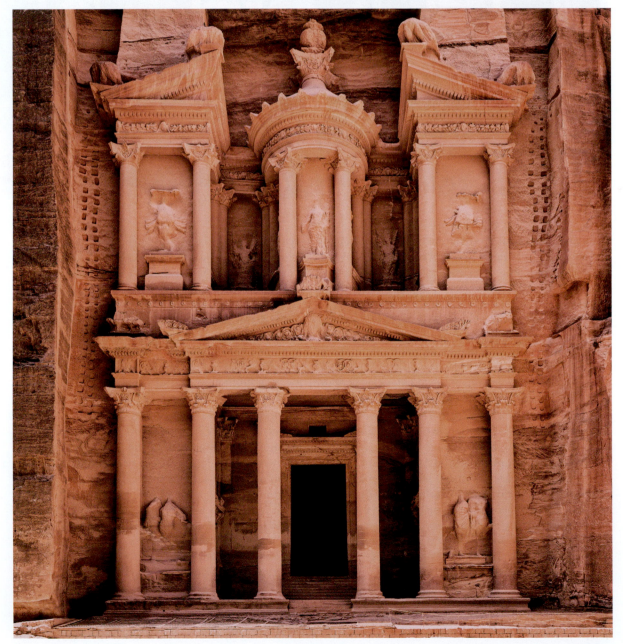

0.4 Treasury facade, Petra, Jordan, *c.* 200 BCE–*c.* 200 CE.

section features a pod of whales—including a juvenile riding the back of an adult—swimming up the rock face (**Fig. 0.3**). Look closely: do you see them on the left side? Their sea is alive with turtles, seals, and fish. Deer, pigs, wolves, and tigers thrive on the land (right side). Amid this zoological richness we find another creature, the human. Humans may be few, small, and not central to the **composition**, but their ingenuity is depicted through the presence of **schematic** boats (for example, the slight arc shape at the top right). Weapons, such as the harpoon already lodged in a whale, demonstrate human power too.

Power and memory are recurring themes in art, particularly in **monumental** architecture. At the ancient Mediterranean metropolis of Petra in modern-day Jordan, an enormous tomb (today commonly called the "Treasury") was made for a ruler of the ancient Nabatean kingdom (**Fig. 0.4**). Sculptors carved the tomb directly into a sandstone cliff, making it an early example of **rock-cut** architecture. Its **facade** contains elements—such as **columns** and **pediments**—that generally appear on free-standing buildings, where they are structurally necessary. Columns, for example, help support a roof. At Petra such laboriously carved architectural elements are unnecessary to the integrity of the structure, so why were they used? The answer: to demonstrate the prestige of the royal **patron**.

Specific architectural details of the Treasury were associated with other Mediterranean centers of power from the same time period. Look at the top of the pediment, where two sides of the triangle do not meet; this feature is known as a broken pediment. The combination of a broken pediment with a circular room, visible above the door opening at the center of the Treasury's facade, originates in the esteemed city of Alexandria (Egypt). By incorporating this arrangement at Petra, patron and builders connected themselves to the sophisticated Alexandrians, attempting to prove their cosmopolitan attitude. Their choices demonstrate that visual **motifs** can travel from one locale to another, creating a network of shared visual culture.

When visual forms and motifs travel, they usually acquire new associations, which may deepen existing meanings or completely transform them. In some cases, artwork is physically transformed, too. This eighteenth-century jacket, for example, was stitched and worn in northern Europe, but the cotton **chintz** from which it is made began its life as a flat piece of cloth made by artisans on the Indian subcontinent (**Fig. 0.5**). Between 1500 and 1800 CE, people from Indonesia to North America prized South Asian cotton cloth for its fine weave and bright, colorful **patterns**. Here, a Dutch designer further transformed the Indian fabric by carefully cutting and piecing it so that the floral pattern precisely fit the jacket's tailored design. Notice how the large flower, with its petals fanning out above, would have sat at the base of the wearer's back, emphasizing the slenderness of her waist. In its original flat form, that floral motif would have lacked that visual effect. The cloth's travel and its transformation into a jacket remind us how objects connect people from across the world.

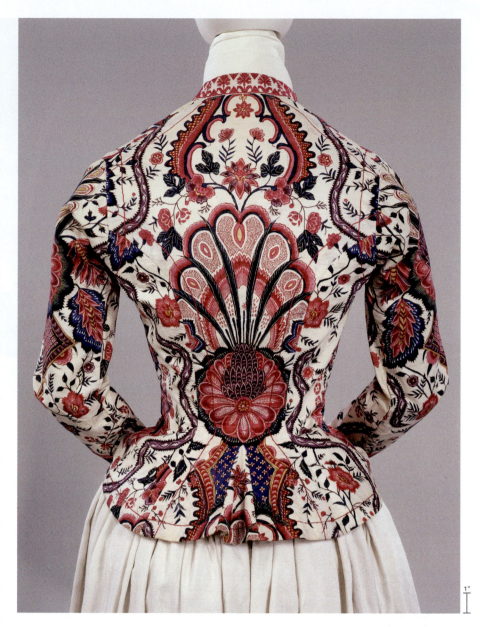

0.5 Woman's jacket, 1750. Cotton chintz; jacket made in the Netherlands, fabric from the Coromandel coast of India, 22½ × 12⅝ in. (57 × 32 cm). Rijksmuseum, Amsterdam, the Netherlands.

Through close analysis, we discover how art reveals much about cultures around the world. But art does not merely reflect society; it also has the power to shape it. For example, distinctive monuments can raise the profile of cities. The Iraqi-British architect Zaha Hadid (1950–2016) had this ambition in mind when designing the Heydar Aliyev Center in Baku, Azerbaijan, in the early twenty-first century (**Fig. 0.6**, p. 20). Planners envisioned for Baku a one-of-a-kind building that would draw people together and showcase the capital city's redevelopment and cultural achievements. Hadid, an award-winning female architect in a field dominated by men, transformed the vision into reality with the Heydar Aliyev Center, which houses a conference hall, auditorium, and museum.

Hadid's distinctive design rejects straight lines and sharp corners. The building, which appears both organic and futuristic, is integrated with its environment through walls that curve to become part of the surrounding terrace. Its exterior **mass** is broken up into a series of interlocking forms conveying movement. In the interior, the dissolving of boundaries continues with light-drenched, fluid

0.6 Zaha Hadid Architects, Heydar Aliyev Center, Baku, Azerbaijan, 2007–12.

spaces. The center's striking profile—different from every angle—is photogenic and inviting. Not surprisingly, the building has become a symbol of the city.

Art has the power to shape our actions, visualize what is otherwise unseen, and make permanent something that is transitory. But art itself can also be transitory, changing either through the actions of the artist, the audience, the environment, or all three. In recent years, using the Internet and other advanced digital technologies, artists have created interactive artworks that pose an alternative to the idea of the artist having complete control of the finished product. An artwork may respond in real time to changes in weather or traffic patterns, for example. Alternatively, artists may invite audience participation to shape the form that the artwork takes. For example, Maya Lin (b. 1959), best known for designing the Vietnam Veterans Memorial in Washington, D.C. (see Fig. 73.16), uses the Internet as a platform for a new memorial—this time to the planet. Alarmed by the rapid decrease in biodiversity due to human activity, Lin uses a website to bring together audio clips, photographs, videos, information, and maps—all relating to the loss of species and habitats—in *What Is Missing?* (2009–present). She encourages viewers to add their own memories and observations to this multilayered digital memorial, thus allowing us all to bear witness to these losses. Like the

natural world, the artwork itself is in a constant state of flux, and therefore cannot be captured in a static textbook illustration. Pause here and visit **whatismissing.net** to explore the website. Note how it is not merely a collection of information. How do Lin's aesthetic choices affect your perception of the memorial? How does the experience of moving through the website compare to the experience of looking at a painting or photograph? If you are so inclined, contribute to the artwork yourself.

Getting Started

As the preceding examples demonstrate, our goal in art history is to understand the meaning and significance of art. If you are new to art history, you may be uncertain about how to start. The best way to begin is with "close looking," a process of carefully and intentionally examining an artwork. Take a moment to look again, closely, at the opening two artworks of this chapter.

Close looking will generate observations about the artwork's notable characteristics and take us to the next step: posing questions. Some questions, such as "What is the strange, yellow thing pictured in *School of Beauty, School of Culture*?" (**Fig. 0.2**), direct us to look again at the artwork, paying special attention to particular forms. Other questions, such as "What happened in 2013 in the Hong Kong stock market that drew Shonibare's interest?"

(**Fig. 0.1**), take us beyond the artwork into surrounding contexts. Pursuing answers to these two different types of questions will generate either a **formal analysis** or a **contextual analysis**, respectively.

A formal analysis explores the visual, material characteristics—or "forms"—of the artwork, leading to an interpretation of the artwork's message or meaning. For example, the distorted image of the blonde woman in Marshall's *School of Beauty, School of Culture* can be said to represent the intrusion of a standard of beauty that only the children seem to notice, suggesting that the adults in the painting have different and more complicated relationships to that standard. By contrast, a contextual analysis considers the circumstances in which the artwork is created, how and by whom it is used, and how and where it is viewed. When exhibited in Hong Kong, Shonibare's *Cake Man* directed special attention to Hong Kong's history as a hub of global finance. To reveal an artwork's meaning and significance, contextual analyses often use analytical frameworks from other disciplines, such as economics, sociology, religious studies, gender studies, and environmental studies.

In the preceding paragraphs, we discussed formal analysis and contextual analysis separately. But in practice the two are intertwined. On the one hand, formal analysis serves as the basis for contextual analysis, and on the other hand, awareness of context strengthens formal analysis. Here we examine four artworks, going step by step through strategies of analysis.

Take a look at this picture (**Fig. 0.7**). While you are looking at it, perhaps some questions will arise. Some of these questions—*who* made it, *what* is its title, *when* was it made, *what* is the **medium**—are questions of identification. We can answer these questions using the information in the caption: In 1903, Käthe Kollwitz (1867–1945) made this **print**, *Woman with Dead Child*. Other questions may probe the picture's **subject matter**, form, and meaning: Who are these figures and why do they appear as they do, in black and white, unclothed, without a **background**, one tightly embracing the other? Generally speaking, these types of questions focus on *how* an artwork looks and why it looks that way. These questions spur formal analysis and interpretation.

A formal analysis of *Woman with Dead Child* must consider its main **formal elements**. These elements may include line and **shape**. Here, Kollwitz uses dark lines as **outlines** to create a silhouette of human bodies against a background, and finer lines to trace the bodies' supple **contours**, such as those of the knees and feet. As for shape, the two bodies intertwine to form a tight, irregularly shaped knot. Other formal elements include color, which is used sparingly (as in the greenish triangle of

formal analysis the method of examining and understanding an artwork's form, including its medium and materials, formal elements, and principles of design.

contextual analysis the method of examining and understanding an artwork by considering it in relation to its relevant context, whether historical, religious, social, and so forth.

medium the generalized type of an artwork, primarily based on the materials used.

print an image or artwork resulting from the mechanical transfer of a design, generally used to produce multiple copies.

subject matter the subject of an artwork.

background the portions of an artwork around and behind the central subject(s).

formal elements the characteristics of line, shape, color, light/shadow, texture/pattern, space/point of view, and (when relevant) time and sound.

shape the external form of an object or figure.

outline a line that marks the boundary of a shape.

contour line the outline that defines a form.

1"

0.7 Käthe Kollwitz, *Woman with Dead Child*, 1903. Seventh state: soft-ground etching with engraving, printed in black and overworked in green and gold wash on thick white wove paper. 16⅜ in. × 18⅞ in. (42 × 48 cm). British Museum, London.

1'

negative space formed between the figure's left foot and right knee at bottom left) and light, which picks out the child's forehead and casts a deep shadow beneath the mother's hand. Lines created through the **techniques** of **hatching** and **cross-hatching** create additional shadows that **model** the contours of faces and limbs.

Patterns and **textures** are formal elements, too. The smooth texture of the child's forehead contrasts with the knobby quality of the mother's bony hand. Finally, Kollwitz uses space and point of view to impart both monumentality and intimacy, respectively. By nearly filling the entirety of the space, the two bodies seem massive, or monumental. By bringing the pair close to the **picture plane** (note the **foreshortening** of the mother's left thigh) and at eye level, Kollwitz draws viewers into this intimate human drama.

After making note of formal elements in isolation, we can bring together our observations to formulate a sense of the artwork's overarching style. Kollwitz has marshalled line and shape, color and light (and shadow), and texture in the service of **naturalism**. Rather than seeing in *Woman with Dead Child* an accumulation of lines and marks, we are likely to see a mother clinging in unspeakable grief to her dead child. Kollwitz's use of naturalism works in tension with **expressionism**, which permits a degree of exaggeration or simplification in the service of expression, as in the areas where the mother's face essentially dissolves or where marks and smudges attest more to the actions of the artist's hand than to the forms of the things represented.

Kollwitz's depiction of raw emotion is further enhanced through strategies of **design**, which refer both to the manner in which motifs within an artwork are arranged, or composed, and to the overall composition. Kollwitz limits her motifs to the two bodies of the mother and child, and she does not depict clothing, background, and other ornamentation. The two bodies are consistent in style, generating a sense of **unity**. Variety in **tone**—from the highlight on the child's head to the mother's dark hair—creates visual interest without compromising that unity. Kollwitz's composition is asymmetrical but balanced, and the intertwined bodies are rotated slightly as in a three-quarter view (neither frontal, nor profile). Thus, the effect is somewhere between the total stillness of perfect symmetry and the dynamic energy or sense of potential that is present in unbalanced compositions.

Having looked closely at and undertaken this formal analysis of *Mother with Dead Child*, we can begin to shape an interpretation as to how this particular artwork expresses its subject matter. Kollwitz's representation of maternal grief is raw (naked bodies and unembellished postures), immediate (figures placed close to the picture plane, and seemingly spontaneous fresh marks of the artist's hand), and without respite (no background or excess space surrounding the bodies).

0.8 Ceremonial board (*malu*), Sawos people, Middle Sepik River region, Papua New Guinea, nineteenth century. Wood, traces of paint, 6 ft. 3 in. × 24 in. × 6½ in. (190 × 61 × 16.5 cm). Metropolitan Museum of Art, New York.

Let us now bring close looking and formal analysis to a second artwork: a ceremonial wooden board called a *malu*, made by an artist of the Sawos of Papua New Guinea, an island nation just north of Australia (**Fig. 0.8**). As we look at the *malu*, we might ask the same questions about form that we asked about *Woman with Dead Child*, but because the medium is different, we need to adjust our formal analysis. Here, line, shape, and pattern take precedence over color, light, and texture. The wood would originally have been brightly painted, but it now has a uniform color and texture, and while light is necessary to see the *malu*, it is not a key element of its design. The artist focused primarily on setting lines, shapes, and patterns into a long, roughly rectangular composition in a manner that is elaborate, dynamic, and nearly symmetrical. The meandering lines and the curved shapes of the negative spaces work together to create a pattern that keeps our eyes moving. This pattern functions as a background from which several creatures emerge. These creatures make references to both humans and animals, but few are straightforward. The sizable anthropomorphic (human-like) face at the top of the *malu* represents a sago beetle, identified by its long nose or snout down the center, which is topped by a fully three-dimensional human head. The beetle's face has **stylized** human features: eyes, nostrils, and a mouth. Just above the middle of the *malu*, images of two birds, perhaps eagles, project outward; just below the middle, two hornbills arrange their long, curving beaks into a spiral shape. At the bottom center, the projecting form of a pig faces downward.

On the basis of formal analysis alone, we can see that different artistic styles have been used for the **openwork** areas of the board and the more three-dimensional shapes of the creatures that project from it. But this observation is not yet an interpretation. To understand why the board looks the way it does, we need more information, which raises questions of context: Who used this *malu* and why? Although the Sawos made *malu*, they intended them for trade with the Iatmul, a neighboring group who lived along the nearby Sepik River and customarily exchanged goods with the Sawos. Reportedly, the Iatmul used *malu* to commemorate the death of an adolescent boy or initiator during all-male initiation ceremonies into manhood, which involved physical ordeals that, occasionally, resulted in actual fatalities. Initiates were expected to be warriors. The depiction of hornbills and eagles, species symbolically associated with warfare in many New Guinea societies, may reference this. Likewise, initiates were expected to play an active role in ritual life, and the image of the pig, the most sacred and important sacrificial animal for ceremonies across much of New Guinea and the Pacific, may symbolize this religious obligation. Unlike many Iatmul ceremonial objects, which were kept in the men's ceremonial house, *malu* were displayed in ordinary Iatmul households. As in the case of all artwork, further research into relevant contexts—economic, ritual, and social—may shed more light on the meaning of this and other *malu*.

Whereas we are uncertain about the precise meaning of the motifs in the *malu*, we are more confident of the identification of this artwork, a statue from Sri Lanka

0.9 *Bodhisattva* **Tara,** Sri Lanka, eighth century CE, Anuradhapura Period. Gilded bronze, height 56 in. (142.2 cm). British Museum, London.

negative space areas of a composition not occupied by objects or figures.

technique the method used to make an aspect of an artwork.

hatching short, parallel lines used in drawing or engraving to represent light and shadow.

cross-hatching a shading technique in which close parallel lines are drawn across one another to darken an area.

model the representation of a three-dimensional form.

texture the surface quality of an artwork that can be physically felt or perceived.

picture plane the surface of a picture or the vertical plane in the extreme foreground of a picture, parallel to the surface.

foreshortening in two-dimensional artworks, the illusion of a form receding into space: the parts of an object or figure closest to the viewer are depicted as largest, those furthest as smallest.

naturalism representing people or nature in a detailed and accurate manner; the realistic depiction of objects in a natural setting.

expressionism in any era, art that is highly emotional in character, with colors, shapes, or space being distorted and non-naturalistic as a means to convey vivid extremes of subjective experience and feeling.

design the deliberate arrangement of formal elements into a composition.

unity a principle of design that strives for coherence and/or focus in the composition.

tone the comparative lightness or darkness of a hue.

stylized treated in a mannered or non-naturalistic fashion.

openwork decoration created by holes that pierce through an object.

iconography images or symbols used to convey specific meanings in an artwork.

(an island off the southern tip of India), as the *bodhisattva* Tara (**Fig. 0.9**). Our basis for this identification is **iconography**. Buddhist iconography informs us that *bodhisattvas*—enlightened beings who vow to help all living beings reach the Buddhist goal of enlightenment—share some traits with the Buddha, such as elongated earlobes and symbolic hand gestures (*mudra*). Other traits differ from the Buddha's. For example, *bodhisattvas* often wear jewelry. In this case, Tara's high crown with a cavity intended to hold an image of the Buddha not only identifies her as a *bodhisattva*, but also, more specifically

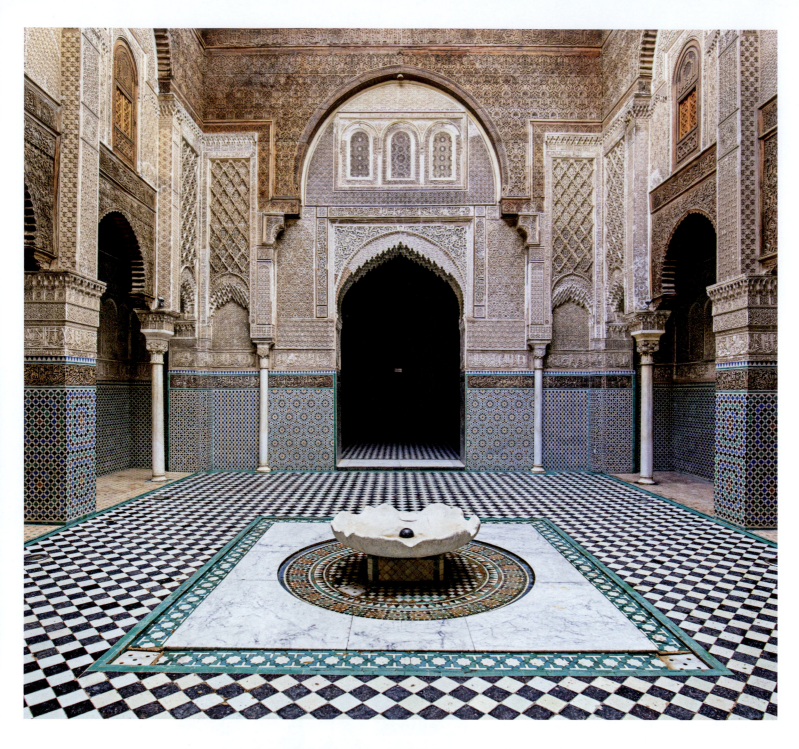

0.10 Courtyard of Al-Attarine Madrasa, Fez, Morocco, fourteenth century.

as Tara. She is the female counterpart to Avalokiteshvara, the *bodhisattva* of compassion, who likewise wears a crown bearing an image of the Buddha. Having used iconography to identify this artwork's subject, we may proceed to formal and contextual analyses.

Significant formal qualities of the sculpture include its shape, size, proportions, color, and texture. Because it approximates a human body, we should consider posture, gesture, and facial expression as part of the composition. At 4 feet 8 inches, Tara is nearly life-size. Although the figure faces front, it has three-dimensional **volume**. Additionally, the curving hips, slight *contrapposto*, and delicate *mudra* imply movement and animate the form. The body and face are smooth, complete, and **idealized**; drapery wrapped around the lower body falls in

an elegant and regular pattern that would be unlikely—indeed, impossible—in life. Cast of solid bronze and then **gilded**, the figure has a rich, regal appearance that was originally augmented with small gems inlaid in the eyes, though these gems are now lost. The artistic style here is not naturalistic (as in Kollwitz's *Mother and Dead Child*); instead, an idealized body makes visible Tara's enlightened state.

A contextual analysis would see Tara as a religious icon, rather than as a secular (non-religious) sculpture or artwork, such as Shonibare's *Cake Man*. The sculpture may have been commissioned by a wealthy patron as an act of religious piety. Alternatively, it may represent the monetary contributions of a community of believers seeking religious merit. Either way, the figure's

curvaceous and therefore **auspicious** form is a response to religious motives and expectations. Most likely originally enshrined in a temple alongside a male *bodhisattva* counterpart, Tara would have been placed on an altar so that all viewers would gaze up at her. In the shimmering light of candles and surrounded by smoky incense, she would bestow her blessing and compassion.

We can extend close looking, formal analysis, and contextual analysis to architecture, too. Just as images, objects, and sculpture are all around us, so too is architecture, which plays a vital role in how we perceive the world. Because architecture is meant to be occupied, the questions we ask about buildings are slightly different than the questions we ask about other artworks. To begin, we might inquire about a building's function and intended occupants. Building designs should address such issues as temperature control, traffic flow, security, privacy, and other practical concerns. When analyzing a building, in addition to considering who built it and why, we examine its formal qualities—such as space, materials, ornament, color, light, sightlines (views), and acoustics—and how these are used to respond to the needs specified by a building's function and intended occupants.

As an example, consider the Al-Attarine Madrasa (**Fig. 0.10**). A madrasa is a Muslim religious school, and this one was built in the heart of the bustling Moroccan city of Fez in the fourteenth century. The area immediately around the building would have been hot, crowded, and noisy: unsuitable conditions for quiet study and contemplation. To counteract these circumstances, the madrasa is oriented inward around a central courtyard that is open to the sky, as is evident in the building's **floorplan** (**Fig 0.11**). The courtyard, as a space that is neither entirely indoors nor outdoors, allows in light and air while keeping out noise and prying eyes.

The madrasa's materials enhance the soothing environment. Following a **regional style** particular to Morocco and southern Spain, cut tilework covers the floor and lower portion of the walls, carved **stucco** appears above the tilework, and carved woodwork adorns the very top of the walls and the ceiling. Tile and stucco are cool to the touch and provide visual interest through their intricate,

geometric patterns. Look closely at the courtyard in **Fig. 0.10** and notice the different ornamentation on the walls and floor. The tiles are of many **hues**, but they share a cool color **palette**; as a result, the rich ornamentation does not distract from the courtyard's overall sense of harmony. Finally, in the center of the courtyard is a fountain; standing in that space, one would be able to hear the low gurgle of water, further augmenting the sense of cool contemplation that the courtyard has created.

Give It a Try

The best way to learn how to perform a visual analysis is to try it yourself. This section presents two examples. We walk you through the first one. In the second example, we pose several questions that provide a useful starting point for a visual analysis. To begin, take a few minutes to look closely at **Fig. 0.12**, p. 26, and jot down your observations. Be sure to read the caption, which includes important identification information.

Did you notice that the image is a photographic **self-portrait**? Photography is a medium, like printmaking, that produces multiple copies. Unlike printmaking, however, photography, which literally means "writing with light," uses chemicals to affix what is captured through the camera lens to a **negative** that is in turn printed on paper. This process gives the final work a direct physical relationship to its subject (for more on photography, see Chapter 61). This technology for image-making particularly lends itself to documenting actual events, but it is equally a vehicle for creativity and self-expression, as we see in *Experiment with double exposure, III: self-portrait* by the Indian photographer Umrao Singh Sher-Gil (1870–1954) (**Fig. 0.12**).

Self-portraits, whether in the medium of photography or another medium, provide artists such as Albrecht Dürer (1471–1528), Martín Chambi (1891–1973) and Cindy Sherman (b. 1945) with the opportunity to depict themselves as they choose. How does Sher-Gil present himself here? He wears a thick woolen tunic, fashioned after one of his cultural heroes, the Russian writer Leo Tolstoy. In his lap, Sher-Gil holds a pair of eye-glasses resting on an open book. The doors to a cabinet of books have been opened, thereby creating a private, literary world. What do these facts tell us about the aspects of his identity he wants to emphasize?

Because the artwork is a black-and-white photograph, the formal elements of color and volume generally do not apply, but light and shadow, texture and pattern, and composition all play important roles. Let's focus on light and shadow, which Sher-Gil uses dramatically. Notice how light picks out Sher-Gil's prominent forehead, silvery hair, and thick beard. Light reflects brightly off the gold-lettered titles and convex spines of many books in the cabinet. Finally, light lands on Sher-Gil's hands—the one clearly grasping the glasses, the other curiously out of focus—and the opened book. These areas of light are complemented by darker tones, such as the grey of his costume and the shadows cast by his nose onto the left half of his face or in the deep folds of his tunic. Strangely, in places where we might expect a shadow or a grey pant leg, books appear faintly. Are Sher-Gil's left

volume mass or three-dimensional shape.

contrapposto from the Italian for "counterpoise," a posture of the human body that shifts most weight onto one leg, suggesting ease and potential for movement.

idealized a depiction that is more beautiful and perfect than the actual subject.

gilded covered or foiled in gold.

auspicious signaling prosperity, good fortune, and a favorable future.

floorplan in architecture, a diagram showing the arrangement of a building's spaces, walls, and passages on a given floor.

regional style shared aesthetic qualities in a geographic area.

stucco fine plaster that can be easily carved; used to cover walls or decorate a surface.

hue color, regardless of saturation or modulation.

palette an artist's choice of colors; also refers to the tray, board or other surface on which an artist mixes colors of paint.

self-portrait an artist's depiction of herself or himself.

negative in photography, a reverse image created when light strikes a light-sensitive surface; a negative can then be used to print positives.

prayer chamber

courtyard

fountain

entrance

0.11 FAR LEFT **Plan of Al-Attarine Madrasa,** Fez, Morocco, fourteenth century.

1"

non-representational art that contains no visual representations of figures or objects.

landscape a genre that depicts natural environments as well as such human environments as cityscapes.

abstracted altered through simplification, exaggeration, or otherwise deviating from natural appearance.

warp and **weft** in textile weaving, warp threads are the stationary vertical threads held taut to the loom and weft refers to the yarn that is woven horizontally over and under the warp threads to make cloth.

leg, his left elbow, the left side of his forehead on the verge of disappearing? As with the artist's blurred right hand, the crisp, documentary quality of the photograph has given way to ambiguity. The "double exposure" in the photograph's title hints at Sher-Gil's artistic experiment. Sher-Gil has exposed the light-sensitive photographic plate twice, resulting in two superimposed images. How does this specific use of the camera's capacity to capture light enhance Sher-Gil's self-representation? One interpretation might be that Sher-Gil has played with light and shadow, suggesting that photography is an art that mixes fact and fiction. Another interpretation may be that Sher-Gil, who was a scholar as well as a photographer, deliberately blurred the boundary between his body and the books as a way of representing his inner sense of self.

If you carry out a contextual analysis of this image, what areas might you investigate? Would you choose to learn about early photographic processes to better understand how the manipulation of exposure times affect the resulting photographs? Would you want to consider Sher-Gil's biography and other photographs he produced? Would you look into the tradition of artistic self-portraits in painting so that you might compare Sher-Gil's self-representation to those in another medium? All of these areas—and more—would provide fruitful avenues of inquiry.

Let's conduct another visual analysis with an artwork in a different medium. Consider **Fig. 0.13** and its caption. Take time to look closely and jot down your observations. Did the green color, highlighted with pops of ocher, black, and white, grab your attention? Did you notice the texture of the cotton weave and the seemingly random pattern of blocks and lines? At first, this artwork by Anni Albers (1899–1994) may appear to be entirely **non-representational**; however, after reading the title, *Pasture,* did you begin to see it as a **landscape** that has been **abstracted**? What questions arise when you consider this work? Are you curious to learn more about weaving and the ways in which construction elements, such as the **warp** and **weft**, shape the final form? Do you want to study more about Anni Albers and perhaps consider the ways in which her gender affected her artistic practices? During the mid-twentieth century, many artists, including Albers, deliberately experimented with abstraction, exploring the expressive capacities of their medium. However, many abstract artists of the period (the most frequently discussed of whom were men) tended to work in painting and sculpture, which were considered fine art. Albers consciously chose to work in a medium traditionally diminished as craft. (Note that the distinction between art and craft so prominent in much of the history of European and American art does

not apply in the history of art from most other regions of the world.) What might you learn by comparing this woven work to, say, an abstract painting from the same period? Again, there are many ways to approach studying an artwork—you will encounter a vast variety in the chapters that follow—but note that they all begin with close looking.

Close looking forms the foundation of what art historians do, whether they are working as educators, appraisers, restorers, critics, or curators. An art appraiser, for example, studies an artwork to determine where, when, and by whom it was made. Comparing the artwork to similar ones that have been recently sold, the appraiser establishes a monetary value. An educator, by contrast, might study an artwork to understand how it was used in religious rituals, on diplomatic missions, or within local communities to teach others. No matter the professional field they work in, art historians use close looking to propel research and analysis, and their conclusions must be clearly articulated. Together, these art historical skills are valuable—whatever one's occupation. Exercises in close looking sharpen the abilities of the future attorney; research and analysis in foreign cultures enhance the capacities of the scientist and politician alike; drawing conclusions on the basis of disparate information is what managers, social workers, and informed citizens do daily. Art-historical knowledge is valuable, too, most directly but not exclusively for artists and designers. But regardless of your career path, art history aids in knowing yourself and navigating your world.

0.13 Anni Albers, *Pasture*, 1958. Mercerized cotton, 14 × 15½ in. (35.5 × 39.3 cm). Metropolitan Museum of Art, New York.

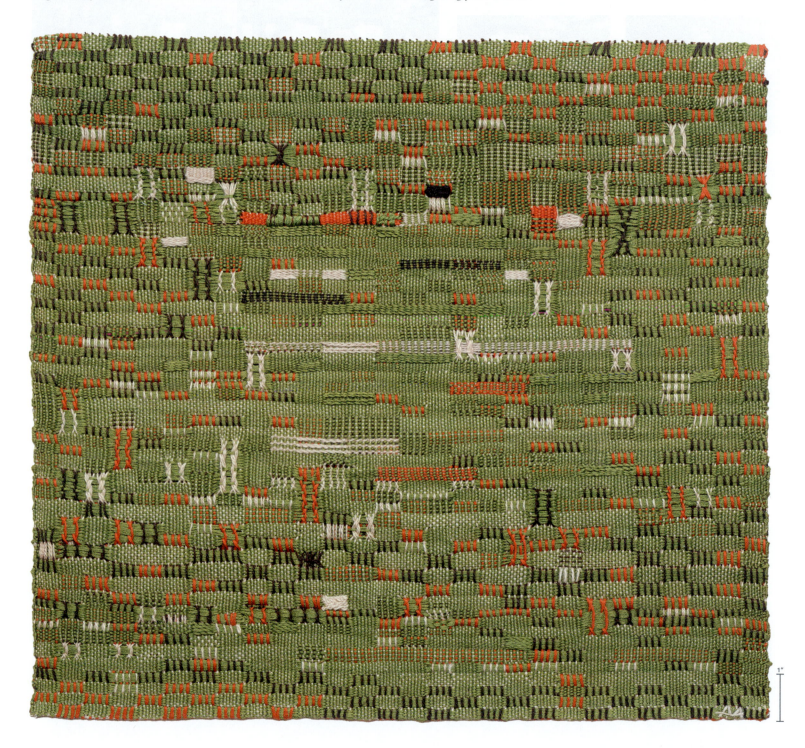

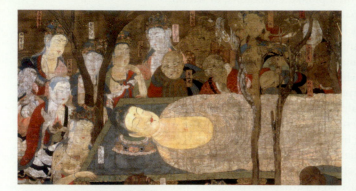

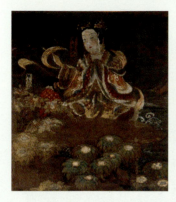

A Smaller figures facing the Buddha

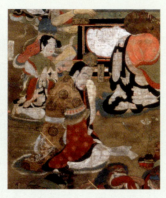

B Queen Maya descending from the heavenly realm

C The monks' patterned robes

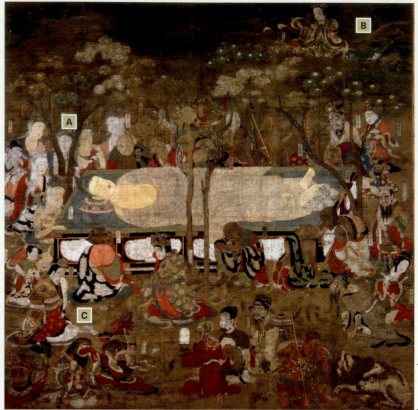

0.14 (A–C) **Parinirvana of the Buddha,** Kongōbuji, Kōyasan, Wakayama Prefecture, Japan, *c.* 1086. Ink and colors on silk, 8 ft. 9 in. × 8 ft. 10 in. (2.67 × 2.69 m). Koyasan Reihokan Museum, Koya, Japan.

"If you want to see something," the poet Howard Nemerov advised, "look at something else." In art history, comparing one artwork to another often leads to insights that could not be generated by looking at one artwork alone. As an example, here are notes from a student who was asked to compare an eleventh-century Japanese painting of the *Parinirvana of the Buddha* (hereafter *Parinirvana*) to a twelfth-century stained-glass window from France, *Crucifixion* (**Figs. 0.14** and **0.15**).

A meaningful comparison requires a common basis, such as the same subject matter. When asked to consider potential similarities in this area, the student wrote these notes:

Subject matter: Based on the iconography, *Parinirvana* depicts the end of the Buddha's life when he experiences a complete liberation from embodied being, or transformation into nothingness. *Crucifixion* represents Jesus being put to death on a cross, or crucified, thereby bearing the sins of the world. Both artworks portray as their subject matter the extraordinary death of a major religious figure.

Having determined a common basis for comparison, this student made notes on particular aspects of form:

Composition: Both *Parinirvana* and *Crucifixion* place the major religious figure at the center, a privileged place, and at a larger scale to other figures, thereby emphasizing the central roles of the Buddha and Jesus, respectively. Smaller figures surround, turn, and face the Buddha, further underscoring his centrality (**Fig. 0.14, A**). So, too, do the individuals on either side of the cross (**Fig. 0.15, B**).

Setting and Background: In *Parinirvana*, monks, laymen, *bodhisattvas*, and the Buddha's mother Queen Maya (upper right, descending from the heavenly realm; **Fig. 0.14, B**) gather in a grove of flowering trees. By contrast, *Crucifixion* dispenses with setting. Figures flanking the cross stand against a plain, red background framed in blue.

These observations about composition, setting, and background led the student to a realization about subject matter, captured in these notes:

Narrative: *Crucifixion* depicts more than one moment. Below, an empty tomb signifies Jesus having risen from the dead, while above, he stands triumphantly between two angels in the scene of Christ in Majesty,

when he was said to have departed from Earth and entered into the presence of God in heaven (**Fig. 0.15, B and C**). The scenes together create a sequence of actions, or a story. By contrast, the *Parinirvana* focuses on a single event and its setting.

The analysis of form, however, is not yet complete. The two artworks' respective media—ink and colors on silk, and stained glass—differ markedly; still, they share some formal elements. The student continued, adding notes as follows:

Medium and Color: When strong light strikes the stained glass from behind, *Crucifixion* presents vivid hues to viewers. By contrast, *Parinirvana* is a painting of ink and colors on silk, and the palette of colors is more modulated [its colors are created by mixing more than one hue]. In both artworks, many colors are distributed all throughout the composition, generating visual excitement, or splendor, which enhances the importance of the central figure. When writing the paper, I plan on describing the placement and impact of the color red in greater detail as my example.

Line and Shape: In *Parinirvana*, lines represent the rough contours of the trees,

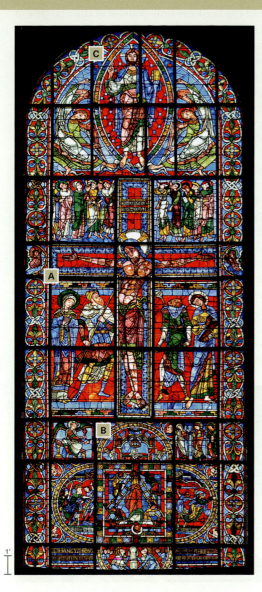

0.15 (A–C) Crucifixion, St. Peter's Cathedral, Poitiers, France, *c.* 1150. Stained glass, 27 ft. 9⅛ in. × 9 ft. 10⅝ in. (8.46 × 3.01 m).

and an important implied line [not actually drawn, but suggested] is the sightline of Queen Maya, who gazes at the Buddha (**Fig. 0.14, B**). Curved and diagonal lines create the illusion of movement, thereby infusing the image with visual energy. The gently leaning tree and Queen Maya's gaze alleviate the static quality of the Buddha's horizontal body. In *Crucifixion*, outlines demarcate the figures and their shapes. The shape of Mary's still body [the Virgin Mary, shown at far left] contrasts dramatically with the shape made by the aggressive stance of the Roman soldier Longinus [at center left], who is said to have pierced Jesus' body with his lance (**Fig. 0.15, A**).

Pattern: In *Parinirvana*, the flowering trees are made to form attractive patterns. Queen Maya and the *bodhisattvas* wear elaborately

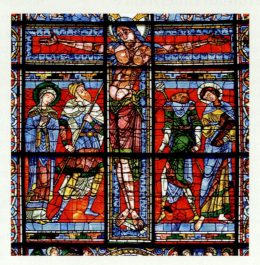

A Christ on the cross

patterned textiles (possibly embroidered or woven), necklaces formed of beads that alternate regularly in color and shape, and delicately designed gold crowns. The monks' robes are patterned like pieced quilts (**Fig. 0.14, C**). In the stained glass, sumptuous patterns in the oval frame around Christ enhance the celebratory aspect of "Christ in Majesty" (**Fig. 0.15, C**). Elaborate, patterns of knots, plants, and abstract shapes fill the borders between scenes, too, in *Crucifixion*.

Light and Shadow: Neither composition demonstrates significant interest in illusions of light and shadow. But, in *Cruxifición*, light itself plays a role in illuminating the stained glass. Moreover, in the Christian context, colored light signifies divine light.

Space and Perspective: Both artworks depict figures in three-quarter view [halfway between frontal and profile], and both use isometric perspective [in which the lines have no vanishing points] to represent, respectively, the empty tomb (**Fig. 0.15, B**) and the platform bed on which the Buddha lies. Additionally, in *Parinirvana* figures overlap one another, suggesting that some are behind and others in front.

Posture, Gesture, and Facial Expression: Both *Parinirvana* and *Crucifixion* depict dramatic religious events, and unsurprisingly, they treat the human body in expressive ways. In both, the grief of the bereaved is rendered visible through posture, gestures, and facial expression. When I start writing the paper, I'll describe in greater detail the most expressive figures in each artwork— perhaps that lion rolling on the ground at the lower right of *Parinirvana* or that weeping

B The empty tomb

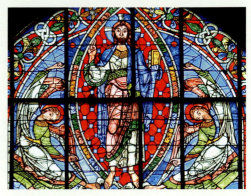

C Christ in Majesty

man who brings his sleeve to his face at left—as my examples. For *Crucifixion*, the contrast between Mary and Longinus (described under Line and Shape) may work well here.

In addition to conveying the artwork's subject matter, the way the body is represented may also indicate period style, regional style, or an artist's personal style. The student demonstrated awareness of style in these notes:

Style: During the twelfth century in areas of western Europe, bodies were typically elongated, as is the case here (**Fig. 0.15, A**). By contrast, in eleventh-century Japan, idealized faces are fleshy, arms tubular, and gestures elegant; the facial features and bodies of foreigners and guardian figures, however, obeyed a different set of standards.

When asked to write a comparison essay, the student referred to these notes to develop a thesis about the visual representation of religious stories. Not every note made it into the final essay; rather, relevant observations that supported the analysis and interpretation were judiciously selected and synthesized. The student also followed up on describing how the color red functions in the artworks, as well as on selecting expressive figures. For additional assistance in writing art history essays, see Further Reading (p. 31).

history painting a genre of painting that takes significant historical, mythological, and literary events as its subject matter.

calligraphy the art of expressive, decorative, or carefully descriptive hand lettering or handwriting.

order in Mediterranean Classical architecture, categories of columns and their corresponding capitals: Doric, Ionic, and Corinthian.

Our Shared Human Inheritance

This book takes the view that art—whatever its origin—is our shared human inheritance. Seeing art as our common inheritance both expands our individual horizons and removes impediments to learning by acknowledging the possibility of connecting personally to art from all times and places. Past students of art history have attested to the value of adopting this viewpoint, and they have offered these additional study tips:

1. *Form study groups with one or more classmates.* Get together regularly to discuss artworks and ideas. Use these sessions to quiz one another. Often the most effective way to learn something is to teach it to someone else.
2. *Make flashcards.* Draw the artwork on one side; on the other side, list such information as artist, title, period, or date. Adapt flashcards for learning pronunciation and the meaning of terms, too.
3. *Read.* Read in advance of lectures, then re-read afterward. Take notes and mark ideas that were confusing; raise these questions during class discussion or study-group meetings.
4. *Use the discussion questions at the end of each chapter.* Use these questions to test your growing knowledge, reflect on big themes, initiate conversation and debate, and prompt independent research.

These are just a few suggestions to get you started. As you study, develop strategies that work for you. For example, you might use sticky notes to mark key reference material, such as the **orders** of Classical architecture (see box: Looking More Closely: The Greek Orders, p. 225).

To enhance learning, this book puts key terms, such as **history painting**, in boldface and provides definitions in the margin and in the glossary at the end of the book (although some general art terms that are used throughout the book are only defined in the margins in this Introduction.) It also includes boxed features that explain techniques, translate primary sources, discuss art-historical concepts, and serve as models for close looking. Between chapters, it presents short essays in the category "Seeing Connections." These essays use a common theme, whether the allure of gold or the spread of photography, to examine several artworks from around the world. The purposes of "Seeing Connections" are to highlight the interconnectedness of human experiences of art and to present the variety of perspectives for analyzing artworks.

As an example, consider *Guernica* (1937), the painting Pablo Picasso (1881–1973) made in response to the Nazis' unprovoked, devastating bombing of the Spanish town of Guernica during the Spanish Civil War (**Fig. 0.16**). Were *Guernica* to feature in a "Seeing Connections" essay, it might be joined with Kollwitz's print (**Fig. 0.7**) and the *bodhisattva* Tara (**Fig. 0.9**) to discuss stylistic variations in the representation of the body in art. Alternatively, the essay might compare *Guernica* to two or three other artworks from around the world to discuss history painting, the relationship between modern art and war, and

0.16 BELOW **Pablo Picasso,** *Guernica*, 1937. Oil on canvas, 11 ft. 6 in. × 26 ft. 6 in. (3.51 × 8.08 m). Museo Nacional Centro de Arte Reina Sofia, Madrid.

0.16a FAR RIGHT **Pablo Picasso,** *Guernica* **(detail).**

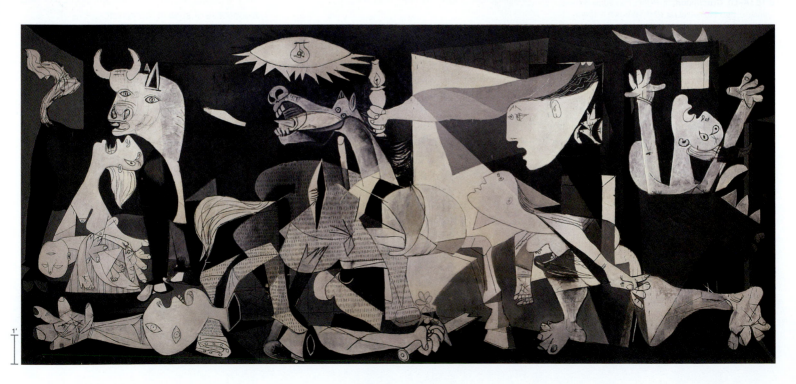

other illuminating themes. This book includes a "Seeing Connections" feature on "The Universal Impulse Toward Abstraction" (see p. 1078) and another on "Modern Art and War," (see p. 1110) but *Guernica* is not included in either one. If you added it to these discussions, how would you articulate the connections between Picasso's painting and the other artworks? By the time you've read those parts of the book, you may be ready to answer that question. The "Seeing Connections" feature underscores this book's commitment to a global perspective, and it invites you to find your own connections.

A few final thoughts: Although this is a book about art, including some of the most beautiful art in the world, its chief concern is not beauty. Instead, it selects visually compelling examples to develop visual literacy on the one hand, and to discuss art and architecture in relevant historical contexts on the other hand. Some artworks give magnificent form to unseen deities; others demonstrate unsurpassed technological achievement. Some images give voice to anguish and longing; others celebrate love and transcendence. Art can be used to normalize racism and prop up dictatorships, but it can also speak truth to power and encourage more just ways of seeing our world.

Recognizing these conditions, let us make a careful study of art and in so doing remind ourselves of our common humanity and of our potential for human excellence. The last artwork in this introduction is a work of **calligraphy** (Fig. 0.17). When Chinese artist Xu Bing (b. 1955) first spent time in the United States, he spoke limited English. More intrigued than frustrated, he turned his experience into art, creating an amalgamated form of writing called Square Word Calligraphy. If you can read this sentence, then you can read Xu's message in the artwork. Take a moment to puzzle it out (and look at the caption if you need a hint). Drawing inspiration from Xu and indeed from art the world over, this book takes the same hopeful attitude that art is for the people.

Discussion Questions

1. Undertake your own comparative analysis. Choose two sculptures, such as *Cake Man* and the *bodhisattva* Tara, or two paintings, such as *School of Beauty, School of Culture* and *Guernica*.

2. Compare two buildings or sites that you know and have experienced, such as your childhood home and that of one of your friends, two public monuments, or two buildings you regularly encounter.

Further Reading

- Barnet, Sylvan. *A Short Guide to Writing about Art.* 9th edn. Upper Saddle River, NJ: Pearson, 2008.
- D'Alleva, Anne. *Look! The Fundamentals of Art History,* Upper Saddle River, NJ: Prentice Hall, 2006.
- Gocsik, Karen, and Adan, Elizabeth. *Writing about Art.* New York: Thames & Hudson, 2019.

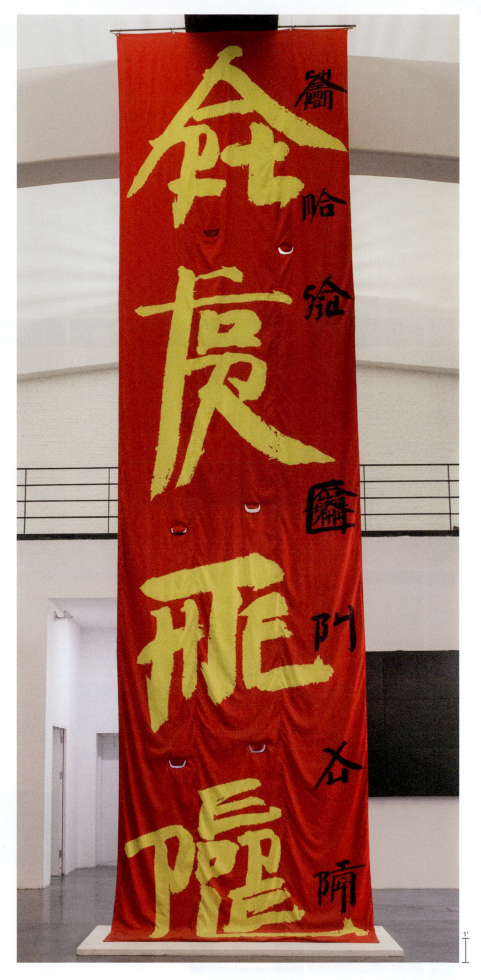

0.17 **Xu Bing, *Art for the People,*** 1999. Mixed media installation, 36 × 9 ft. (10.97 × 2.74 m). Ullens Center for Contemporary Art, Beijing.

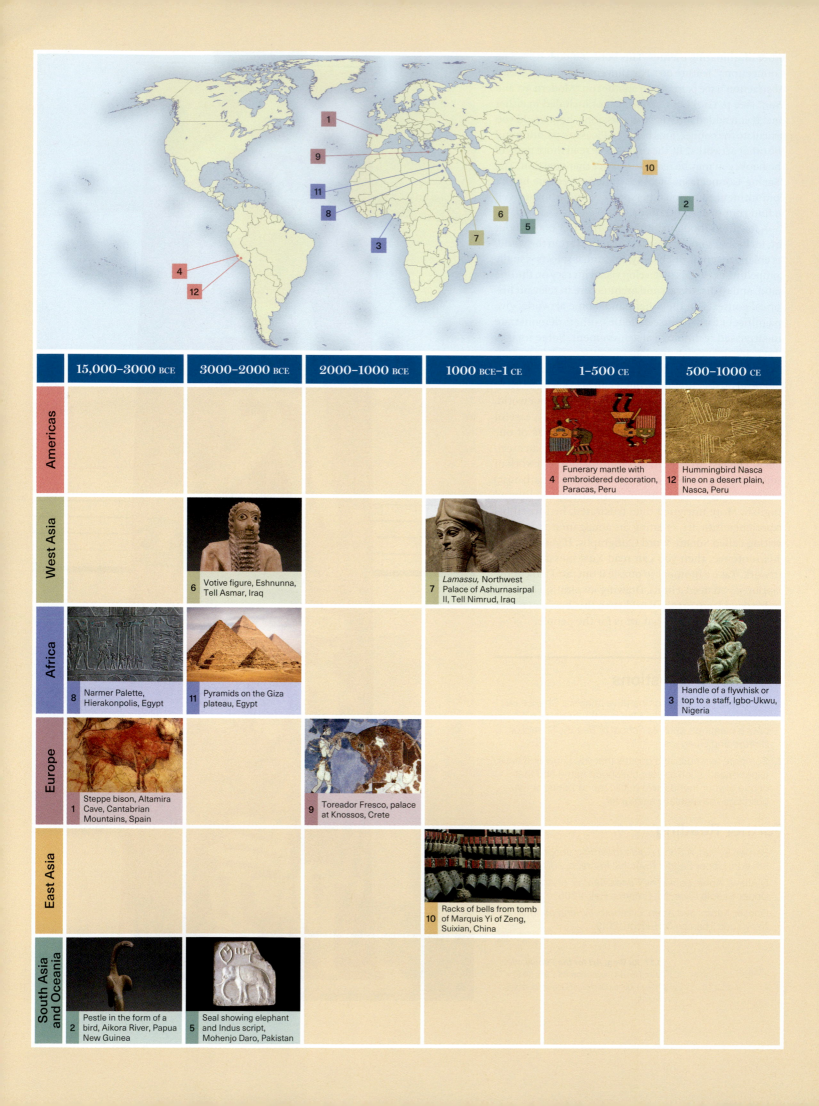

	15,000–3000 BCE	3000–2000 BCE	2000–1000 BCE	1000 BCE–1 CE	1–500 CE	500–1000 CE
Americas					4 Funerary mantle with embroidered decoration, Paracas, Peru	12 Hummingbird Nasca line on a desert plain, Nasca, Peru
West Asia		6 Votive figure, Eshnunna, Tell Asmar, Iraq		7 *Lamassu*, Northwest Palace of Ashurnasirpal II, Tell Nimrud, Iraq		
Africa	8 Narmer Palette, Hierakonpolis, Egypt	11 Pyramids on the Giza plateau, Egypt				3 Handle of a flywhisk or top to a staff, Igbo-Ukwu, Nigeria
Europe	1 Steppe bison, Altamira Cave, Cantabrian Mountains, Spain		9 Toreador Fresco, palace at Knossos, Crete			
East Asia				10 Racks of bells from tomb of Marquis Yi of Zeng, Suixian, China		
South Asia and Oceania	2 Pestle in the form of a bird, Aikora River, Papua New Guinea	5 Seal showing elephant and Indus script, Mohenjo Daro, Pakistan				

The Earliest Art

The creation of art has been part of the human experience for at least 65,000 years. Small stone carvings, as well as [1] paintings on cave walls from Europe to Southeast Asia, provide traces of our earliest ancestors' lives, although their meanings remain obscure. The development of agriculture and cooking transformed the way humans related to their environment over the ensuing millennia, and these changes were echoed in the embellishment [2] of objects, such as a gracefully carved stone pestle from New Guinea. Metallurgy was invented independently in several regions—Mesopotamia, South and East Asia, and [3] along the Niger River in Africa—allowing artists to cast objects from brass and bronze. Likewise, many cultures developed complex methods of textile production, fulfilling practical needs as well as providing new modes for visual expression, as exemplified by woven and embroidered [4] cloth from South America. As societies cultivated writing systems, writing began to appear on objects, whether to record a transaction, express a belief, or mark ownership— for example, in the lines of characters found on small seals [5] from the Indus culture.

Early art and architecture connected new social, political, and economic structures with religious beliefs. In West Asian city-states, between roughly the fourth and first [6] [7] millennium BCE, the twin institutions of temple and palace emerged, leading to artistic patronage. Similar institutions arose in other societies, with royal and divine power frequently intertwined. For instance, the ancient Egyptian [8] Narmer Palette records the ruler's victory and its blessing by the gods. Art became vital to rites of passage for both the living and the dead, with precious items created for use in both this world and the next. Surviving artworks provide insights into everything from the athleticism of [9] young Minoans who lived on the Greek island of Crete to [10] the role of music in ancient Chinese elite culture. Early humans occasionally built structures or created images so monumental that they dominated their environments. [11] These include the gigantic pyramids of the Third and Fourth Dynasty kings of Egypt and the forms scraped by the [12] Nasca into the desert soil of southern Peru, which are so large that they are fully visible only from the air.

1

—

The Beginnings of Art

65,000–3200 BCE

Frieze of horses, rhinoceros, and aurochs in Chauvet Cave, France (detail).

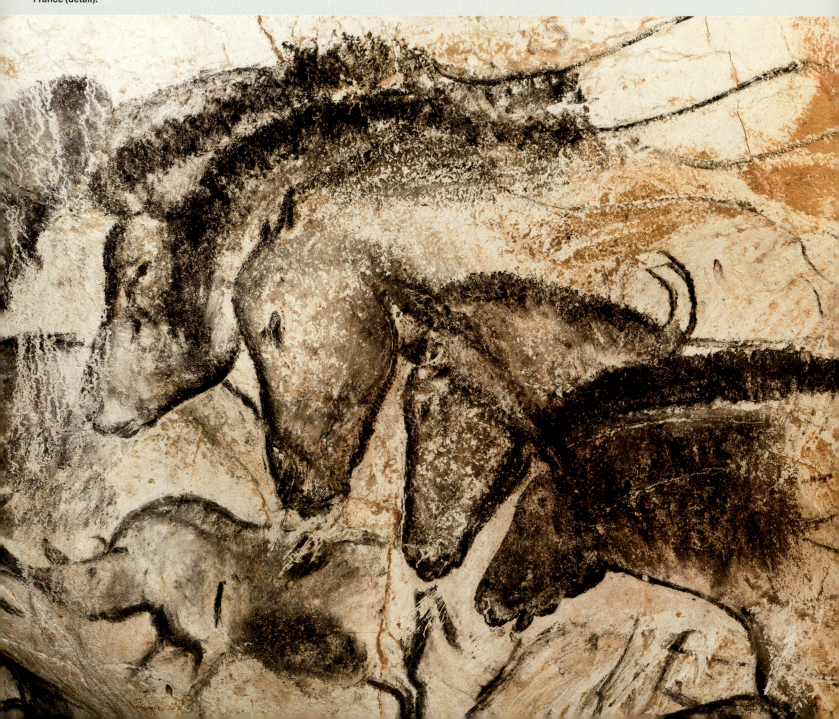

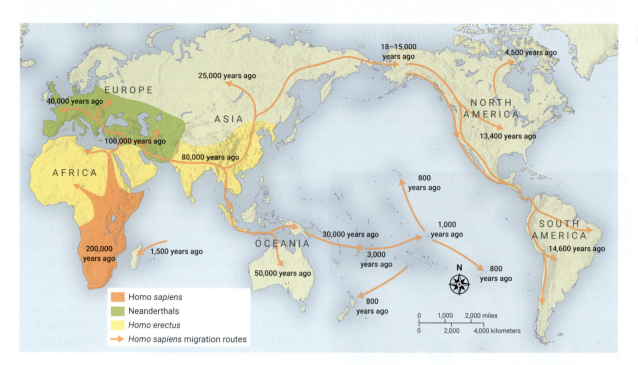

Map 1.1 Early human migration.

Introduction

The earliest human evidence for activity that would develop into what we now perceive as tool-making dates back to more than two million years ago, with the creation of stone tools such as hand axes. The ancestors of the modern human species, *Homo sapiens*, originated in Africa, where these early stone tools were found. Such artifacts, and what they reveal about changes in tool manufacture, have long been used by archaeologists to trace the evolution of early humans. By 500,000 years ago, human communities had begun to develop a technological process known as flint-knapping, in which humans chose a specific kind of stone, such as flint or obsidian, and used it to shape durable rocks into stone tools of gradually increasing sophistication, such as symmetrically made hand axes. The tools that these communities left behind, and the places they were found, also provide evidence of how early humans moved across the land, and researchers now believe that the original communities from Africa migrated throughout the world beginning about 200,000 years ago (**Map 1.1**). When they arrived in Europe, they coexisted for some time with Neanderthals (the human species *Homo sapiens neandertalensis*), who then disappeared about 40,000 years ago. Early humans were hunter-gatherers who lived during the last Ice Age, when large parts of northern Europe, Asia, and North America were covered with glaciers. During this last Ice Age, human communities began to give shape to materials, making stone tools, and, in some areas, building structures out of mammoth bones or tusks.

Early examples such as these challenge our definition of what art is, and whether it is a useful term outside a modern context. Some people prefer to focus instead on the images humans made. An image is a representation of a physical reality encountered in life, or simply an abstract visual expression that can take the form of a drawing, a painting, a statue or even a built structure. Art historians have pointed out the difficulty in differentiating what is a work of art and what is a functional tool among ancient peoples, because

that distinction is a modern concept. Recent research has also shown that what we now consider to be prehistoric art (such as cave paintings and figurines) most probably had vital functional roles in the lives of early humans. Such items were made to accomplish particular goals. However, these works suggest that their creators made deliberate aesthetic choices, and were aware of the visual power of images.

Current evidence for image-making on cave walls and rock shelters shows that it began about 65,000 years ago, and includes abstract shapes, patterns, and depictions of animals and humans. Beyond representing exactly what was visible around them, these images may have had vital functions for the human community. Images painted and carved onto the walls of caves and exposed rock surfaces might have been created not because they were simply decorative or representational, but because they were believed to *accomplish* something. So why did ancient artists choose to make images in deep, dark caves? Contrary to the common assumption, hunter-gatherer groups of the Ice Age rarely lived deep inside caves; they mostly lived in rock shelters, the mouths of caves, or open-air sites. However, caves preserve archaeological evidence particularly well, so that is where we are most likely to discover the traces of early art these groups left behind. Humans probably visited deep caves only for special occasions, possibly for rituals, to make new images, or to view older images, and caves often seem to have constituted sacred spaces.

After the Ice Age ended around 9,600 BCE and the global climate began to warm substantially, humans in West Asia (a region including present-day Turkey, Israel, Jordan, Syria, Iran, Iraq, and the countries on the Arabian peninsula) began living in settled communities, thanks to the domestication of cereals and animals. Many art historians have proposed that the beginning of settled life was revolutionary in terms of the creative abilities of early humans and their art, which can be seen as the most powerful expression of those abilities.

What Is an Image? Thinking about Cave Paintings

Recent research has shown that the paintings applied to the walls of dark, deep caves may have been the work of specialized individuals, using a variety of mineral and vegetal pigments, and experimenting with different tools and techniques—especially the use of the body.

Techniques included printing with the palm, tracing with fingers, drawing with sticks or blocks of **ocher**, scraping the rock surface, shading with charcoal, and using a paintbrush made of hair or moss. Sometimes, ancient artists and their descendants created this art over several thousand years, repainting over existing images at the same sites.

The durability of the stone surfaces and the protection provided by caves and rock shelters have preserved significant sites of early art around the world. One of the earliest examples of cave art was discovered by scientists in the La Pasiega Cave in Monte Castillo in northern Spain (**Fig. 1.1**). Here, walls of this cave are richly painted in red and black with dots and lines, club-shaped forms, groups of animals, and possibly even human-formed figures. A dating technique based on the age of calcium deposits that formed over some of these paintings tells us that at least one ladder-like form was likely created by Neanderthal artists, long before the arrival of *Homo sapiens* in Europe. It was once thought that Neanderthals lacked the cognitive capacity to create art, but La Pasiega, along with cave paintings at other sites, challenges that thinking.

MAROS-PANGKEP CAVE PAINTINGS In the Maros-Pangkep Caves on the Indonesian island of Sulawesi, artists created **hand stencils** by placing their hands on the wall and then blowing pigment over them to create negative images, or imprints (**Fig 1.2**). This method is seen in many caves across the world and over time. In Argentina's Cueva de las Manos (Cave of the Hands) (**Fig. 1.3**) similar hand-stencil images were applied to the walls of a rock

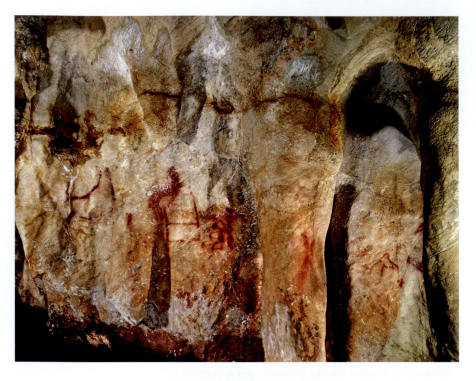

1.1 ABOVE **Paintings in the La Pasiega Cave of Monte Castillo,** Puente Viesgo, Cantabria, Spain, *c.* 65,000 BCE.

1.2 RIGHT **Painting in the Maros-Pangkep Caves,** Sulawesi, Indonesia, *c.* 37,000–34,000 BCE.

ocher a naturally occurring clay pigment that ranges in color from yellow to red, brown or white.

hand stencil an image created by placing a hand on the wall of a rock shelter or other surface and blowing paint over it to create a silhouetted image of the hand.

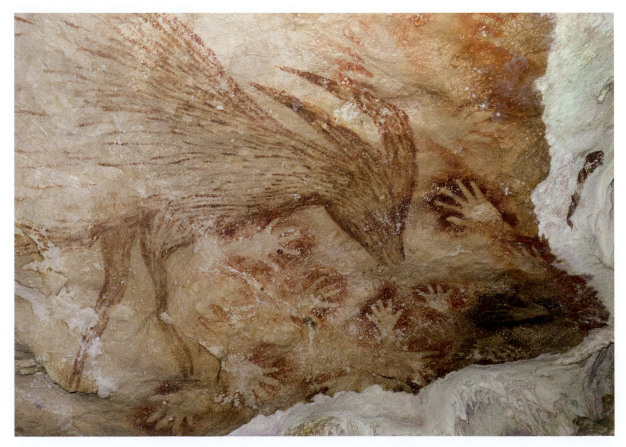

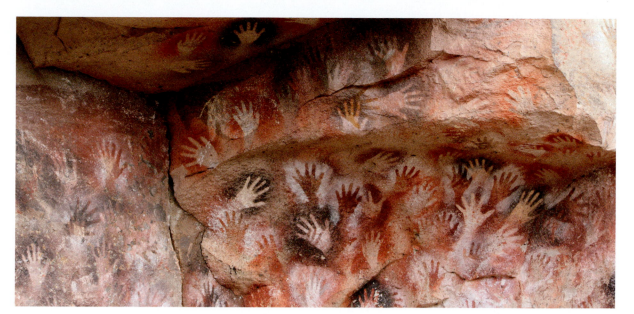

1.3 Hand prints and stencils, Cueva de las Manos, Santa Cruz, Argentina, c. 11,000–7000 BCE.

ART HISTORICAL THINKING • Timescales

Art historians use timescales and temporal categories to divide history into periods that share characteristics or mark significant cultural or technological changes. Scholars commonly use pairs of terms for periods, such as prehistoric (before writing was invented) and historic; Paleolithic and Neolithic (separated by the beginning of agriculture and settled life); Bronze Age and Iron Age (defined by changing metallurgical technologies); and preindustrial and industrial (separated by the Industrial Revolution, the rapid development of industry and industrial processes that began in the late eighteenth and early nineteenth centuries). Scholars also define periods based on cultural, political, technological, or ecological characteristics. For example, the Early Dynastic period in Egypt is a political designation that takes into account the dynastic rulership within the Egyptian state. That period overlaps with the Early Bronze Age in Egypt, during which bronze-making technologies flourished. Such labels help us contextualize works of art in history, but they sometimes reflect older, biased ways of thinking and become problematic when applied broadly or generally.

The Upper Paleolithic and Neolithic periods are typically assigned absolute dates (40,000–9600 BCE for the Upper Paleolithic and 9600–6000 BCE for the Neolithic). But these divisions and dates are based on cultural or technological developments and human lifestyle changes that took place at different times in different parts of the world. For example, the Neolithic spans 9600 BCE–6000 BCE in Europe, northern Africa, and West Asia, but in the British Isles the Neolithic does not start until 4000 BCE and it ends around

2500 BCE, since that is when agriculture began to emerge there. Similarly, the word "prehistoric" usually describes a period before the invention of writing, or before writing that we have not yet been able to decipher. Because writing developed independently at different times in different global regions, however, the dates for the definitions of "prehistoric" and "historical" are not universal. The continued use of these terms reflects how a majority of art historians have, in the past, mainly studied works from Europe and North America, thought about art from that point of view, and privileged certain cultures and art forms in their discussions.

Today, the most common division of time is the year according to the Gregorian calendar, which is based on the solar cycle, or the time that it takes Earth to revolve around the sun. The Common Era (CE), according to the Gregorian calendar, begins in the year 1 CE, designated in the Christian tradition as the approximate year of the birth of Jesus, and previously indicated as AD (*anno domini*, or "in the year of the lord" in Latin). Dates before the year 1 CE are designated as BCE (Before the Common Era) and are counted backward from year 1. Various regions and cultures use non-solar calendars and set their beginning at different significant events. For instance, the migration of the Prophet Muhammad and his companions from Mecca to Medina (the Hijra) in April of 622 CE begins year 1 in the Islamic lunar calendar. Thus, part of the years 2018–2019 CE in the Gregorian calendar corresponds to the year AH 1440 in the Islamic calendar (AH stands for *anno hegirae*, "in the year of the Hijra").

Another factor to consider is that some scholars, particularly geologists, paleontologists, and archaeologists, use BP, or "before present," where the "present" is set at 1950, when radiocarbon dating began to be used. When studying or writing about an artwork, it is important to consider these different timescales as part of its context.

Recently, the scientific study of the environment and global climate change has led some scholars to propose that we are living in a new geological epoch called the Anthropocene, defined by humans' increased impact on the planet's ecosystems. (*Anthropos* is Greek for "man.") The onset of the Anthropocene—variously argued to be during the Industrial Revolution or the mid-twentieth century—would mark the end of the Holocene, which started at the end of the last Ice Age, roughly 12,000 years ago. Climate-related issues have renewed both scholars' and artists' interest in studying our ancient ancestors and the long history of the human–environment relationship, and artists, art historians, and architectural historians have been deeply influenced by this newly found ecological consciousness.

Discussion Questions

1. How do the different ways that we divide up time reveal societal priorities and ways of viewing the world?
2. What are the advantages and disadvantages of placing art objects into historical periods? In what ways do art objects transcend these categories?

figurative art that portrays human or animal forms.

radiocarbon dating a scientific method of determining the age of an object, based on the presence of carbon-14 in organic material.

shelter between 11,000 and 7000 BCE. The paintings in the Maros-Pangkep Caves, which also include images of animals moving across the surfaces of the cave walls, may date to between 37,000 and 34,000 BCE.

When humans began to create **figurative** forms like those at Maros-Pangkep, they typically depicted the animals they saw around them—for example, aurochs (an extinct species of wild cattle) and bison in Europe, and kangaroos and flightless birds in Australia. Human figures were much less commonly and often less naturalistically depicted than animals. In some locations, artists combined animal and human features to depict hybrid figures. They also drew imaginary figures that feature some human and animal parts, perhaps to represent supernatural spirits or forces. Plant life and landscape features are almost never shown.

Paintings from a series of deep caves that cluster in the mountainous region of southern France and northern Spain tell extraordinary stories about ancient peoples. Similar to the Maros-Pangkep Caves, the cave sites of Chauvet and Lascaux (in France) and Altamira (in Spain) served for thousands of years as sacred sites of ritual and image-making for the hunting-gathering communities of Europe during the Upper Paleolithic. They each demonstrate the Paleolithic artists' interest in creating scenes of wild, powerful animals moving across the uneven surfaces, nooks and crevices of limestone cave walls.

CHAUVET CAVE Some of the best-preserved and most complex figurative paintings from Europe are contained in Chauvet Cave. These may date to 30,000 to 28,000 BCE, although these dates are debated by specialists. Located on the Ardèche River in south-central France, this buried and sealed limestone cave was discovered in 1994 and is now closed to the general public to preserve its interior and paintings. The 1,300-foot-long (nearly 400 m) cave features about 950 images, including both engravings and paintings, most with scenes of animals (at least thirteen

different species) depicted in groups and individually, along with hand imprints and stencils, geometric shapes and patterns, and a few partial human figures. There are also other images at Chauvet that are engraved, formed by lines carved with flakes of flint (a hard, gray rock) into the surface of the cave wall.

One scene in the End Chamber of the Chauvet Cave's Megaloceros Gallery (named for an extinct species of large deer) features an extraordinary continuum of moving animals, sometimes overlapping and in some cases seeming to emerge from cracks in the wall (**Fig. 1.4**). Drawings of horses, rhinoceroses, aurochs, a panther, cave lions, and bears stretch across a large wall. The figures were created with charcoal and are shown in profile. They are mostly outlined, though some are partially created by areas of solid color, and shading appears to give dimension to portions of the animals. While the ground they stand on is not depicted or implied, the animals do appear to have a spatial relationship with one another. Within some of the various animal groups, the activities seem to tell a story, showing creatures fighting, mating, and moving as a herd. New images were added to the existing images over time. In fact, **radiocarbon dating** suggests that some of the overlapping images were created up to 5,000 years apart.

Until radiocarbon dating was invented, scholars attempted to date cave paintings by analyzing their style and technique, hypothesizing that the oldest paintings in Europe were those created using simpler techniques and less skilled workmanship, while the more recent paintings were those that featured more naturalistic representation of animals and the most complex painting technologies. The majority of radiocarbon dates have upheld this hypothesis, although some results from Chauvet Cave (which many scholars dispute) suggest much earlier dates for some of the more naturalistic figures.

The interest of early human communities in depicting wild animals may be linked to the idea of these

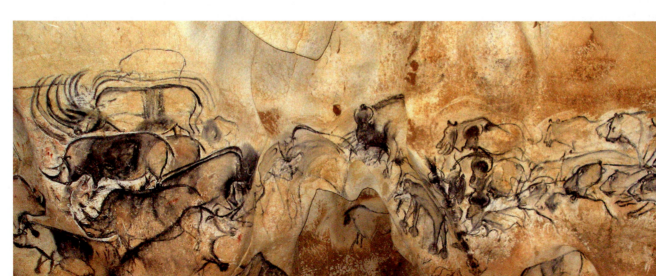

1.4 Megaloceros Gallery cave paintings, Chauvet Cave, France, 30,000 BCE.

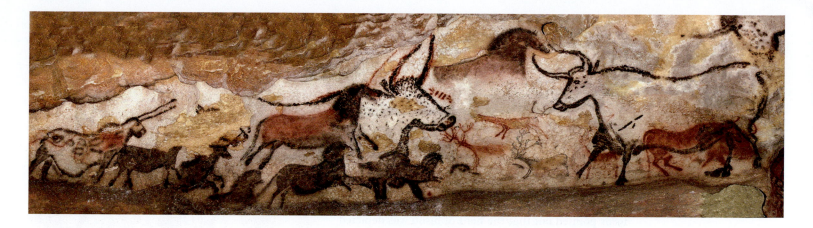

animals as potentially dangerous and therefore powerful. Making images would have thus transformed caves into efficacious, potent, and divine places. Art historians have offered various interpretations by analyzing the paintings, studying their context, and borrowing insights from other scientific fields. For example, one early interpretation of European cave art argued that early humans were depicting the animals they hunted and ate. By drawing animals in a particular situation, the artists were compelling them to be there during the hunt—a form of magic that may have been believed to give humans control of the outcome. However, while lions, leopards, aurochs, bulls, snakes, foxes, scorpions, and birds are frequently found in Paleolithic and Neolithic art, very few of these animals were hunted and consumed by ancient peoples. Analysis of bone residue found in caves has revealed that the animals depicted were often not the principal ones eaten. The visual evidence of the paintings and the evidence of bone residues both challenge the earlier assumption that early artists portrayed only the animals that they hunted, as well as the popular idea that cave paintings served as a hunting magic to capture the spirit of the animal.

LASCAUX CAVE Discovered in 1940, the paintings in Lascaux Cave may date to the height of the Ice Age, around 15,000 BCE. Lascaux features approximately 2,000 individual engraved and painted figures. One of the most spectacular spaces in the Lascaux Cave is the gallery known as the Hall of Bulls, named for the extensive depiction of aurochs (wild cattle) and other wild animals on the walls and ceiling (**Fig. 1.5**). Based on the organization of space and on the accumulation of these paintings over thousands of years, scholars suggest that this gallery was the site of rituals in which multiple individuals participated. As in the Chauvet Cave, the scenes are dominated by superimposed images of wild animals including aurochs, horses (equines), and stags. Some of the auroch figures are 15 feet long (4.57 m), making the representations in the gallery feel monumental.

The uneven surfaces of the rock are used by the artists deploying **painterly** techniques in such a way that the paintings do not flatten or ignore the existing geological texture but enhance and empower it. In this scene, for example, the artists appear to have used horizontal bands on the wall as the ground on which several

of the animals move. Most of the figures are drawn in profile, but with certain elements, such as the eyes and the horns, as if viewed from the front. The artists used lines (outline), solid blocks of color (silhouette), or a combination of these techniques, and they mixed manganese with yellow and red ocher pigments in some of the figures. The flickering light of the torches in the darkness of the cave would have animated the figures. With the effect of light and shadow, the aurochs and other creatures would have appeared to be swiftly moving. While the Lascaux painters may have used techniques similar to modern artists, however, they probably made the images for reasons far distant from ours; rather than simply representing animals, people may have believed that the images enabled encounters with animals on a spiritual plane.

ALTAMIRA CAVE Located in the Cantabrian Mountains in northern Spain, the Altamira Cave was the first major ancient cave-art site to be recognized in Europe. The amateur archaeologist Marcelino Sanz de Sautuola and his young daughter Maria discovered it in 1879. The authenticity of the cave was challenged in a long-held

1.5 Hall of Bulls, Lascaux Cave, Dordogne, southwestern France, c. 15,000 BCE.

painterly characterized by color and texture, rather than line.

1.6 Steppe bison, Altamira Cave, detail from the ceiling of the main hall, Cantabrian Mountains, northern Spain, c. 12,500 BCE.

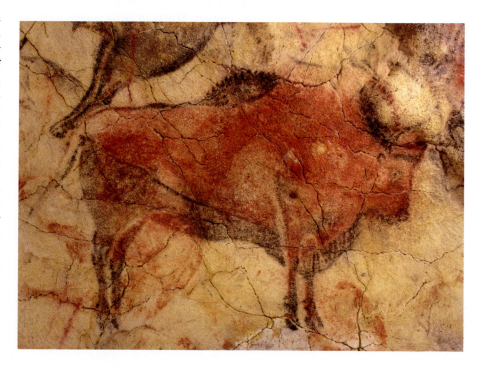

1.7 BELOW **Painted rock fragments from Apollo 11 Cave,** Namibia, southwest Africa, 25,500–23,500 BCE. National Museum of Namibia, Windhoek.

1.8 FAR RIGHT **A group of Gwion Gwion figures,** near the King Edward River, Kimberley region, Western Australia, c. 20,000 BCE.

controversy that lasted until 1902. Scholars simply could not believe that such highly skilled representations of animals could be the work of ancient communities. The walls and ceilings of the cave are populated with colorful drawings of a herd of now-extinct steppe bison (**Fig. 1.6**, p. 39). After the bison figures were engraved in the rock, they were painted in rich red and brown iron-based ocher, with black and brown for the outlines of their bodies and other details, showing that the artists had highly developed their control of pigment mixing. The use of shading and different pigments to give dimension to the forms, as well as the careful attention to detail, bring a certain degree of vibrancy to the animals. Anthropologists in the 1980s pointed out that the herd of bison was depicted during its mating season, confirming that the animal representations on cave walls may have portrayed specific, symbolically charged events rather than serving as generic representations of wild animals.

APOLLO 11 CAVE Unlike their counterparts in Europe, ancient artists in Africa do not appear to have painted the walls of deep caves. Rather, throughout the continent, they painted and engraved images in rock shelters and on stone outcrops, thousands of which have been preserved by the dry climate. They also painted on smaller, portable stones, which might have been carried by individuals or communities for purposes that remain unclear. Several small slabs of painted rock in a well-protected rock shelter known as the Apollo 11 Cave in the mountains of Namibia, in southwest Africa, date to around 24,000 BCE. Created with a charcoal pigment, the animal on this slab is the oldest figurative image found in Africa to date. Two fragments of one slab show the profile view of a four-legged hybrid animal, possibly a supernatural figure (**Fig. 1.7**).

GWION GWION FIGURES During the same era, hunter-gatherers in Australia met periodically for ceremonial activities and trade at rock shelters, where they may have believed supernatural beings dwelt or crossed over from this realm to another. Artists in areas known today as Arnhem Land, the Kimberley, and Queensland created paintings on these shelter walls over many years, layering and repainting images of animals, supernatural beings,

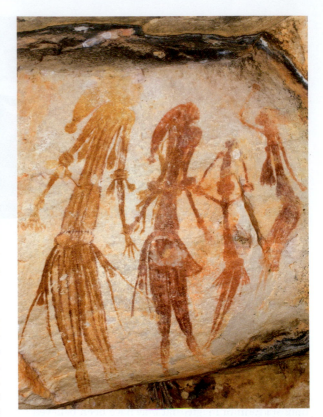

and—more than in rock paintings in other parts of the world—humans. The Gwion Gwion figures (so-called after their local name among one group in the area where the ancient people who created them lived) of the Kimberley region of Western Australia have been dated to as early as 20,000 BCE (**Fig. 1.8**). This dating is controversial, however, because experts do not have a direct method for dating the pigments in the paintings. (Indirect methods include dating the mud-wasp nests on top of the painted areas.)

Frequently painted in groups, Gwion Gwion figures often have their long hair drawn back in ornate hairstyles, or possibly ornamental headdresses. They wear complex skirt-like garments and what appear to be tassels suspended from their shoulders, waists, and elbows. Some carry boomerangs or other implements. Their elaborate attire and the presence of boomerangs, which, in contemporary Indigenous Australian ceremonies, are clapped together in pairs as percussion instruments, suggest that some Gwion Gwion images depict people engaged in rituals. In the neighboring region of Arnhem Land, similar lithe human images may date to at least 12,000 BCE. As in the Gwion Gwion paintings, these figures also have long hair or wear headgear, but they are shown as if they are running or otherwise in motion. They appear both as solitary figures and in scenes that may portray hunting, warfare, and other activities.

Figurines: Human, Animal, and Hybrid

In addition to painting and engraving caves and stones, ancient artists also made figurines out of soft clay or carved stone, ivory, and bone—the same materials that they used to create the tools for cutting, shaping, polishing, and **incising** the sculptures. Figurines may also have been carved from wood and other perishable materials,

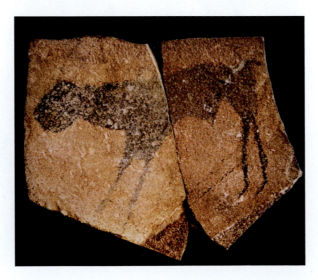

incised cut or engraved.

but no such works are known to have survived. The earliest known portable figurines were found in Europe and West Asia.

While depictions of humans are extremely rare in cave imagery, figurine art seems to be a medium in which humans are more frequently depicted. In many places, female figurines are far more common than male ones, suggesting that artists and communities wanted to capture some idea of womanhood in objects that could travel with them and be handed down across generations.

Several sculpted figurines represent animals or human–animal hybrid figures. The creation of hybrid figures—images of creatures that did not exist in observable nature—indicates that the simple division between "human" and "animal" that we take for granted today may not have applied to these ancient communities. The artists may have exaggerated specific characteristics of the figures or used hybrids to express ideas beyond what they saw.

LION–HUMAN FIGURINE A very early example of a hybrid figurine is the lion–human figurine (**Fig. 1.9**) found in a cave in Hohlenstein-Stadel in southwest Germany, along with beads, jewelry, and worked-bone tools. This 12-inch-tall figurine was carved, using stone tools, from the ivory tusk of a mammoth. The hybrid creature has a carefully carved head of a lion but borrows the bodily posture of a human being with elaborately articulated arms and legs. Lines on the arms, as well as features such as the mouth and eyes, have been incised into the ivory. Commonly dated to approximately 40,000–35,000 BCE, this may be one of the oldest known sculptures in human history.

Most of the early human figurines discovered in Europe and West Asia are naked, although humans at this time are believed to have worn clothing of some kind. While some of these small figurines do not indicate the figure's biological sex, others have bodies with distinct or exaggerated sexual characteristics. Some are abstracted rather than naturalistic, with features missing, minimized, or suggested. It is possible that the figurines represented women and men in general, rather than specific individuals, and therefore they may reveal how early humans conceived of gender.

WOMAN OF WILLENDORF The artist focused considerable attention on certain aspects of female anatomy in this figurine (**Fig. 1.10**) when it was created around 24,000 BCE. Found in 1908 near the village of Willendorf, Austria, it is now called the Woman of Willendorf. Less than 5 inches high, the figurine has a substantial belly and a deep and pronounced navel. The thighs are solid, the hips are wide, and the vulva is clearly defined. The arms, slender compared to the rest of the body, wrap around full breasts. The slightly forward-leaning head has no facial features, but it is decorated with a highly textured pattern that is sometimes interpreted as a textile—perhaps a knitted cap—or braided hair. Given its posture and tiny feet, the figurine, like many others from this period, was probably meant to be handled or carried rather than to stand upright. The limestone from which the Woman of Willendorf was carved is not native to the region, meaning that either the raw stone or the finished figure was transported from one place to another. Originally, it was colored red with ocher pigment.

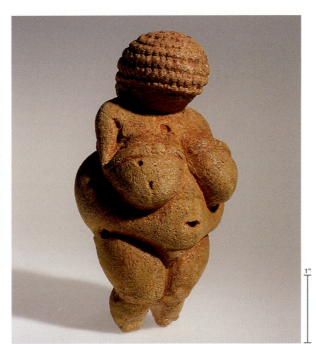

1.9 FAR LEFT **Lion–human figurine,** statuette from Hohlenstein-Stadel, southwest Germany, *c.* 40,000–35,000 BCE. Mammoth ivory, height 11⅝ in. (29.5 cm). Museum Ulm, Germany.

1.10 LEFT **Woman of Willendorf,** Austria, 24,000–22,000 BCE. Oolitic limestone, height 4⅜ in. (11.1 cm). Naturhistorisches Museum, Vienna.

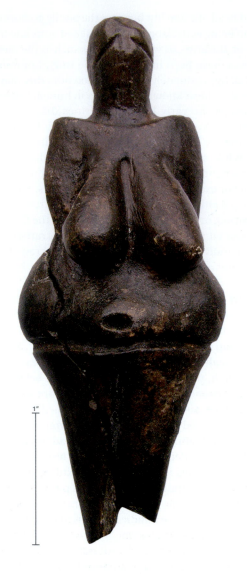

1"

megalith a large stone used as, or part of, a prehistoric monument.

low relief (also called bas-relief) raised forms that project only slightly from a flat background.

Cyclopean masonry a stone-building technique in which large boulders are roughly shaped and fitted together to create well-knit, structurally sound walls.

CERAMIC FEMALE FIGURINE Other figurines from roughly the same period were made of clay rather than carved from rock. In 1925, archaeologists found more than 2,300 human and animal clay figurines, many with abstract or abbreviated bodily forms, at the site of Dolní Věstonice in the Czech Republic. This temporary settlement, under a shelter constructed of mammoth bones and tusks around 25,000 BCE, included a kiln for firing clay objects. Archaeological evidence points to the unusual technique of intentionally firing wet clay at high temperatures, which would have caused many figurines to explode during the firing process. It seems, then, that these were intended as short-lived spectacles rather than lasting sculptures. A well-preserved and rare example of a nearly intact, well-fired female figurine (**Fig. 1.11**) was found in a layer of ash, broken into just two pieces. It shares numerous features with the Willendorf figurine, such as its height (4¼ inches), small feet, absence of facial features, and wide hips, sizable breasts, and deeply incised navel. The sculpture's small size allowed individuals to carry it—along with its associated meanings—wherever they might move.

Some art historians have suggested that the Dolní Věstonice figurines, and others like them, are not naturalistic representations of ancient human bodies, but rather attempts to portray bodily ideals in a specific culture. Recent art-historical scholarship refutes earlier interpretations of the voluptuous female figurines as erotic objects. Indeed, many of the female figurines from this period have slimmer shapes, lacking the exaggerated features that led to earlier interpretations of the full-figured sculptures as mother goddesses or as evidence for matriarchal or woman-led societies. Instead, recent archaeological research suggests that such amply proportioned female figurines denoted accumulated knowledge, experience, and continuity across generations, given the fact that the objects represent older rather than younger women, as suggested by their drooping skin (see also **Fig. 1.20**, p. 47).

Megalithic Structures

Following the end of the glacial period around 9600 BCE, global temperatures began to rise. These slow shifts in the global environment coincided with changes in the ways humans lived and their relationship to the land. In regions where humans had gathered vegetables, fruits, and wild grains (wheat, rice, flax) for several thousand years, such as New Guinea, East Asia, West Asia, northeast Africa, and South America, humans began cultivating fields, producing harvests, and storing the surplus. The climate and vegetation of the Middle East and the Eastern Mediterranean created a hospitable environment for the domestication of plants and animals and the transition of human communities to settled life. This dramatic transition from a hunting-gathering lifestyle in small groups to a settled life in relatively large communities in year-round villages seems to have happened at different times in different parts of the world, but the earliest archaeologically known transition was in the zone known as the Fertile Crescent in West Asia. In other regions, including northwest Africa and North America, pastoral communities migrated seasonally with animal herds, living in semi-permanent or portable dwellings. These circumstances led to changes in the lives of humans, including their customs of burial and ritual, their economic relationships, their art, and their architectural technologies.

As part of their transition to settled life, people in various parts of the world began to create both simple and complex **megalithic** structures, erecting massive stones (known as menhirs)— sometimes moving them great distances—to mark a spot in the landscape. In some regions, including South Asia, East Asia, West Asia, and Europe, megaliths were often associated with burials. A common type of megalith is the dolmen, which is composed of one large flat stone laid as a roof across two or more upright ones. The construction of megalithic structures required coordinated labor and the mobilization of large groups of people. Archaeologists have suggested that these sites probably had ritual functions. Some megalithic structures and arrangements of stones appear to have a calendrical or astronomical purpose, such as the large circle of stones created by pastoral people in Nabta Playa in northeast Africa (present-day Egypt), beginning around 6000 BCE. The site also contains a number of human and cattle burials.

GÖBEKLI TEPE The recently excavated site of Göbekli Tepe in southeastern Turkey is located on a flat limestone plateau on the lower slopes of the Taurus Mountains (see **Map 1.2**). Around 9600 BCE at this site with an abundance of stone, half-nomadic hunter-gatherers constructed a series of semi-underground, curved, and rectangular stone structures (**Fig. 1.12**). Benches built alongside the interior walls, and significant quantities of wild animal remains, suggest that rituals and communal feasts took place inside the structures. The non-domesticated plant species recovered by archaeologists suggest that Göbekli Tepe's builders were probably nomadic hunter-gatherers, rather than engaged in agriculture.

Locally quarried megalithic limestone pillars, some as tall as 15 feet (4.57 m), supported the roofs of those Göbekli Tepe structures that had carved interior walls and pillars. The T-shaped pillars (**Fig. 1.13**) were carved in **low relief** with representations of a wide variety of animals—snakes, boars, foxes, cranes, scorpions, aurochs, gazelles, birds of prey, wild asses, boars, lions, leopards, and other unidentified wild species—in various combinations. Some of the pillars depict human arms wrapping around the sides of the pillars, and thus may have symbolized human bodies. Each ritual feasting structure had a lifespan of one hundred to one hundred and fifty years, after which it was ritually demolished and buried, and replaced with a new ritual structure next door.

Building Göbekli Tepe would have been labor intensive and would have required communal activity on an immense scale to haul and position the large stones needed for construction. Because Göbekli Tepe was built by hunter-gatherer groups and was not part of a settled community, its architectural and iconographic complexity provide a wealth of archaeological evidence for ritual life that has revolutionized our understanding of the beginnings of the Neolithic period in the Eastern Mediterranean world. Recent archaeological field research in the close vicinity has located several other sites similar to Göbekli Tepe, suggesting that the mountain sanctuary of Göbekli Tepe was neither unique nor isolated in a complex landscape of hunter-gatherers.

MNAJDRA COMPLEX, MALTA Even though they date considerably later than the sites in Turkey, the closest analogies to the monuments of Göbekli Tepe are found on the Mediterranean island of Malta and in southern England. In Malta, starting around 4000 BCE (5,000 years after Göbekli Tepe), architectural complexes were built using a combination of megalithic and **Cyclopean** stonemasonry in which the massive blocks are roughly fitted together without mortar. The complexes, such as that

Map 1.2 Eastern Mediterranean and Anatolia in the Neolithic period.

1.12 BELOW LEFT **Göbekli Tepe semi-subterranean structure,** Southeastern Turkey, c. 9000 BCE.

1.13 BELOW **T-shaped pillar with a roaring lion.** Göbekli Tepe, Southeastern Turkey, c. 9000 BCE.

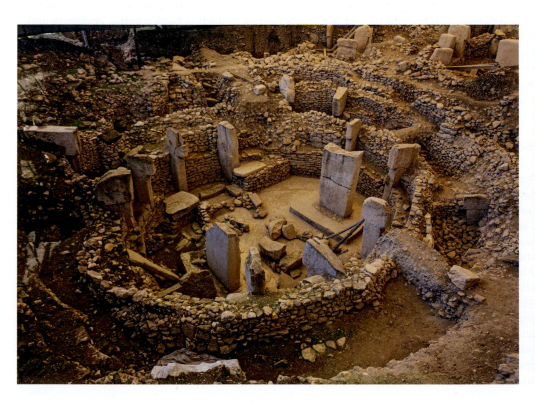

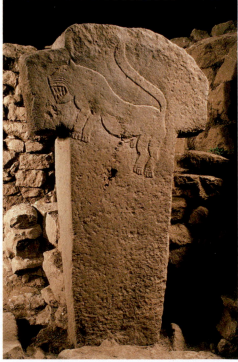

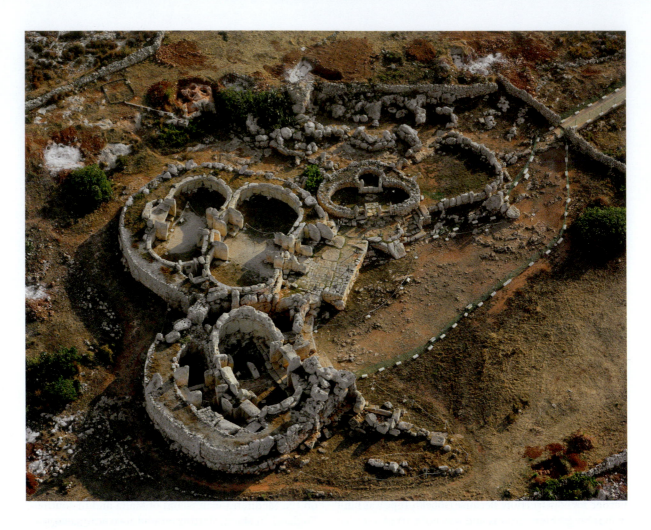

apsidal relating to an apse: a semicircular recess.

corbeling an overlapping arrangement of wood, stone, or brick wall projections arranged so that each course extends farther from the wall than the course below.

henge an ancient monument with an outer circular ditch and inner bank.

post-and-lintel a form of construction in which two upright posts support a horizontal beam (lintel).

trilithons two upright megaliths topped with a third horizontal stone, the lintel.

at Mnajdra (**Fig. 1.14**), are designed in a clover-leaf plan with multiple large, **apsidal** rooms. Mnajdra was built of a relatively hard variety of locally quarried coralline limestone with slightly **corbeled** walls, suggesting that the apse spaces (semicircular recesses projecting from an external wall) may have been at least partially covered by a stone roof. Upright monoliths or pillars mark entrances and transitional areas between spaces.

Although these complexes are believed to have served as ceremonial sites, they also provided protection from enemies and served as storehouses for food. In addition, their design and their relationship to the surrounding landscape suggest that social activities, such as feasts and religious celebrations, took place there.

STONEHENGE From its earliest history, Stonehenge, on the Salisbury Plain of Wiltshire in southern England (**Fig. 1.15**), seems to have been associated with cremated human burials, some of which have been excavated. This megalithic stone circle was built and rebuilt repeatedly over more than a thousand years (2900–1500 BCE), at the end of an episode of megalithic building practices in Neolithic Europe. Farmers in Britain had earlier constructed several concentric-circle earth-works (constructed banks of soil) known as causewayed enclosures. Communal feasting took place within these enclosures, and animal bones were dumped in the ditches. Stonehenge emerged in this landscape of communal gatherings and rituals of the Neolithic British Isles, which

were home to more than nine hundred stone circles. Stonehenge maintains its prominent position in the public imagination because of its architectural complexity, the care its builders took in selecting and transporting specific stones, and its expressive monumentality.

Stonehenge itself is both a **henge** enclosure and a concentric stone circle, built of huge pieces of gray sandstone in a **post-and-lintel** system. It probably underwent four main stages of construction and several phases of adjustment and rebuilding between 2900 and 1500 BCE. In the earliest stage of construction, a circular ditched enclosure measuring 320 feet (97.54 m) in diameter was built, and this feature was retained in later stages.

In the second stage, which took place during the third millennium BCE (2500–2000 BCE), a double ring of standing bluestones (so named for their bluish color, and weighing 5 tons each) was erected in the center of the ditched enclosure. These heavy bluestones were transported from the Preseli Hills of Wales, a distance of at least 240 miles (386 km). The builders of Stonehenge also used bluestones to make axes, traces of which were discovered on the site.

In the third stage of construction, the builders used sandstone monoliths, much more massive than the bluestones, to form a new ringed enclosure consisting of five **trilithons**. The tallest of these trilithons are 24 feet (7.32 m) high. The five trilithons were arranged in a horseshoe layout facing a break in the circular ditch leading to a 35-foot-long (10.67 m) path. In the fourth and final state of

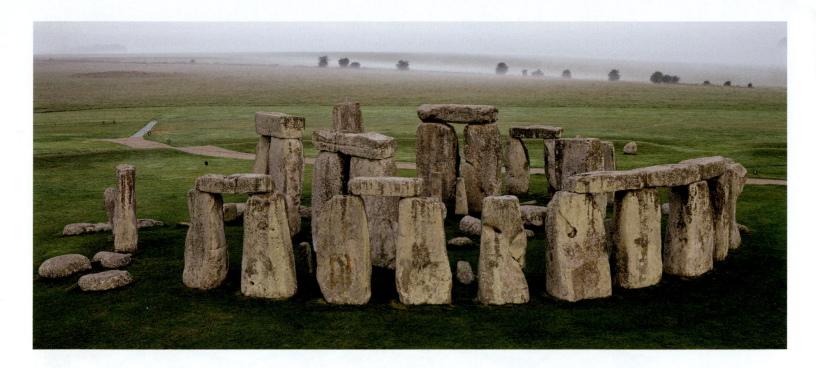

construction in the mid-second millennium BCE (around 1500 BCE), the complex gained its contemporary layout when the builders reorganized the bluestones between the trilithons and the sandstone circle. The alignment of the trilithon horseshoe and other stones with the sun during the winter and summer solstices led to theories that Stonehenge functioned as a calendar and served astronomical purposes. Stonehenge's purpose continues to inspire debate among scholars.

Early Settled Communities

Changes in the climate did not always alter where people lived and how they acquired or produced food. In areas rich in game and naturally growing foodstuffs, communities may still have gathered food and hunted animals, and they may have continued to move around, and to develop artistic technologies, such as textile and ceramic production. When the early agricultural communities of West Asia transitioned into a settled lifestyle and started living in much larger-scale sedentary communities, however, many things changed in their lives: their diet and ways of processing food, their relationship with the environment and animals, their customs of burial and ritual, their economic relationships, their architectural technologies, and perhaps most strikingly, their art. These changes in everyday life took place slowly from roughly 9600–6000 BCE, during which time humans domesticated plants, such as wheat, barley, and legumes (including lentils), and animals, such as sheep, goats, and (later) cattle. This long process of selective breeding and experimentation finally allowed communities to survive long, harsh winters by processing and storing food.

With this settled life, Neolithic communities developed houses, using architectural innovations such as building with mudbrick. These **adobe** dwellings became the location of artisanal practices, such as textile and figurine production and wall painting. The need for long-term food storage also opened the way to specialized pottery production. Though much of the discovery and excavation of these early settlements has occurred in West Asia, research is advancing at other sites around the world. For example, the Yangshao settlement (at Jiangzhai in modern China) dates to *c.* 5000 BCE and consists of individual dwellings organized around a central point. Each house was made of a round pit dug into the earth, walls lined with sticks plastered with mud, and a thatched roof. In some other cultures, sites for ceremonial gathering or burial were constructed to be more durable than dwellings, which means that the art and objects that remain today come from a different context than those found in early houses.

ANCESTOR SKULL Some inhabitants of early agricultural communities in West Asia seem to have adopted the practice of burying their dead family members under the floors of their houses, under specially designated

1.15 Stonehenge, Salisbury Plain, southern England, 2900–1500 BCE.

adobe made of sun-dried clay, usually combined with organic materials.

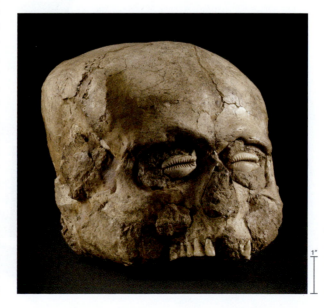

1.16 Ancestor skull, Jericho, Jordan Valley, *c.* 7000–6500 BCE. Plaster, human skull, cowrie-shell inlay, 6 × 6⅝ × 8¾ in. (15.2 × 16.7 × 22 cm). Ashmolean Museum, Oxford.

platforms. People in these communities often revisited and commemorated their buried ancestors by reopening their graves and removing their skulls. Ancestor skulls were modeled or "re-fleshed" with lime plaster; their eyes were inlaid with shells; and pigments were used to add details such as hair (**Fig. 1.16**, p. 45). The relatives then returned the plastered and augmented skulls to their graves, suggesting an intimate engagement with dead ancestors.

ÇATALHÖYÜK One well-known settlement on the Central Anatolian plateau associated with increased land cultivation and animal domestication was Çatalhöyük ("The Fork Mound") in south-central Turkey. Built near a marshy landscape with access to water and good agricultural land, this extensive settlement was inhabited for over 1,100 years (7100 to 6000 BCE). Its population of between 3,000 and 8,000 people occupied mostly single-room houses, built of mudbrick (**Fig. 1.17**). Each house had an entrance in the roof, accessed by a ladder. The densely clustered houses had abutting walls, and the rooftops allowed movement about the complex, in the absence of any streets. This layout strengthened the settlement's defenses, with the edges essentially serving as a town wall.

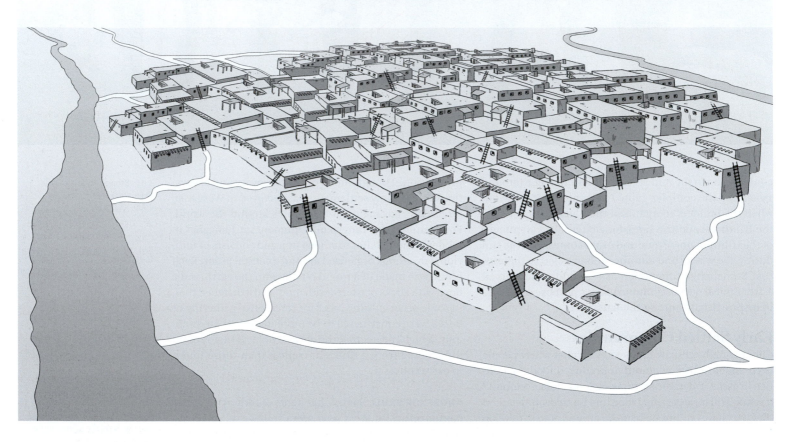

1.17 Çatalhöyük settlement
(reconstruction drawing), Konya plain, Turkey.

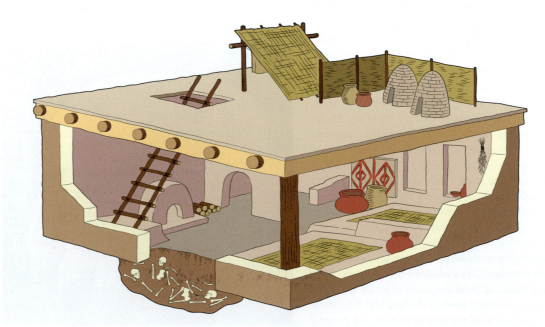

1.18 House in Çatalhöyük
(cross-sectional diagram), Konya plain, Turkey.

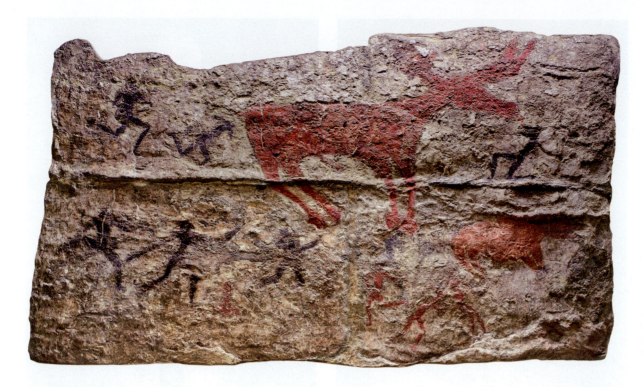

1.19 **Wall painting from Çatalhöyük,** Konya plain, Turkey. 6400–6200 BCE. Anatolian Civilizations Museum, Ankara, Turkey.

The household space was used for everyday functions, such as sleeping, eating, processing and storing food, making clay and stone figurines, producing pottery, and performing rituals. The houses were organized around an oven, and different functions were carried out on diverse rectangular platforms of varying heights (**Fig. 1.18**). In addition to the main room, many houses featured smaller subsidiary rooms for storage, food processing, and other domestic activities. Houses were used continuously over long periods of time and across generations, and their inhabitants maintained their dwellings by periodically replastering the wall and floor surfaces and repainting the walls. The dead were buried beneath the floors of the houses.

ÇATALHÖYÜK WALL PAINTING The depiction of powerful animals seen in cave paintings continued on the interior walls of some houses in Anatolia, in West Asia. The houses of Çatalhöyük feature wall paintings, many consisting of geometric and repeating patterns. One of the more figurative paintings depicts massive wild animals, such as bulls, stags, and wild boar (**Fig. 1.19**). Lively human figures, wearing leopard-skin skirts, are positioned around the main creature, as if baiting or teasing it. In some of the Çatalhöyük houses, a variety of animal body parts (including bull horns, cattle or vulture skulls, fox and weasel teeth, bear claws, and wild boar tusks) were used as construction materials or as decorations, either embedded in the walls or on the edges of platforms.

ÇATALHÖYÜK FEMALE FIGURINE Excavators also found small figurines of animals and humans at Çatalhöyük. One relatively large figurine (**Fig. 1.20**) of finely polished marble (a recrystallized limestone) was found under the floor of a platform usually associated with ceremonial

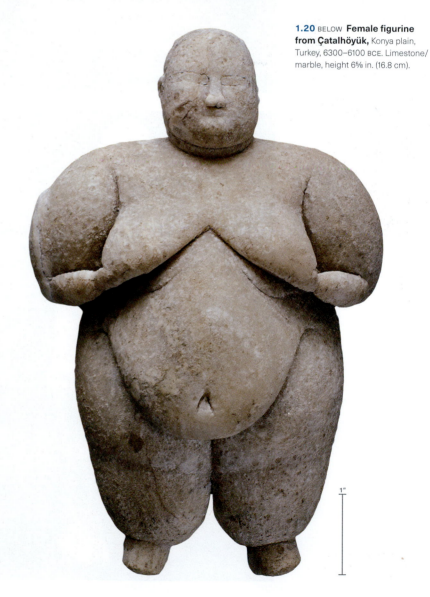

1.20 BELOW **Female figurine from Çatalhöyük,** Konya plain, Turkey, 6300–6100 BCE. Limestone/marble, height 6⅝ in. (16.8 cm).

1"

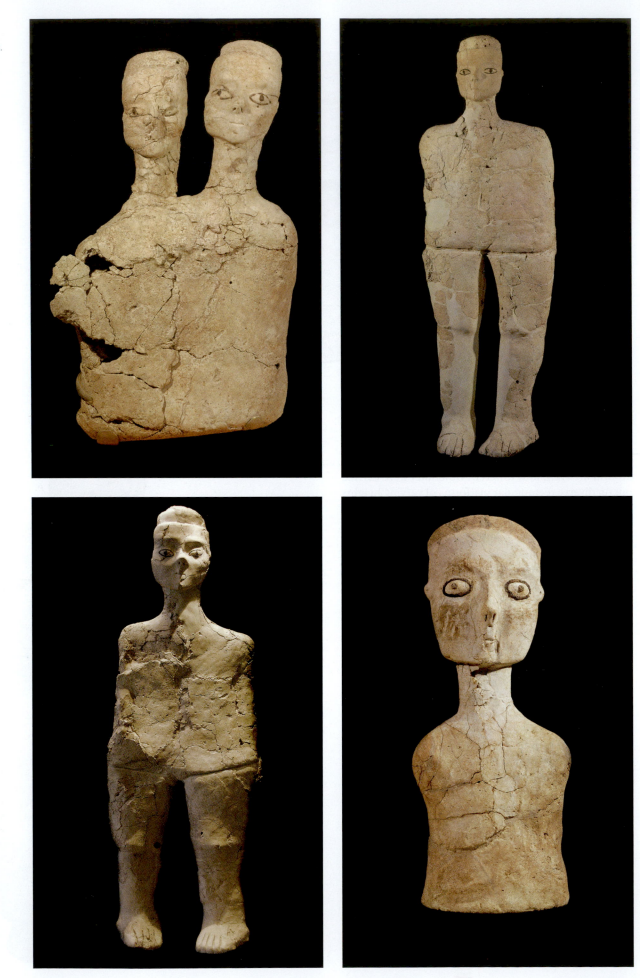

1.21 Ain Ghazal statues, Jordan, c. 6750–6500 BCE. Lime plaster, cowrie shell, and bitumen. Approximate height 3 ft. (91 cm). Jordan Archaeological Museum, Amman.

functions. Carefully buried in a similar manner to family members, it depicts the body of a naked woman with distinctly carved facial features. The breasts lie flat and to the side, as they would if the woman pictured were lying down. The sagging belly may indicate an older woman who has given birth multiple times. Because the hands and feet are proportionally small, the figurine cannot stand upright.

Many of the Çatalhöyük figurines appear to have had their heads broken off, either when they were discarded or abandoned in a house that was left behind. Some of them even have detachable heads. The heads were believed to constitute the figure's concentrated location of power or potency, and this suggests that their identities may have been considered changeable.

AIN GHAZAL STATUES At the Neolithic settlement of Ain Ghazal ("Spring of the Gazelles") near Amman in Jordan, archaeologists unearthed thirty human-like statues and **busts** made of reed-bundle-and-twine cores modeled with lime plaster (**Fig. 1.21**). The faces and other parts of the statues were decorated with red and tawny ochers and white clay. Although the torsos and the legs have a trunk-like roughness, the faces are elaborately shaped, with the eyes carefully formed and painted. Two separate heads emerge from some of the busts, suggesting twins. None of the figures is marked with a clear biological sex. At some point the statues were deliberately damaged and buried together in a pit. The meaning of this burial and the statues' function are unclear, but they may have played a role in funerary rituals or ancestor worship.

Human groups lived in relatively isolated communities during these earliest periods. As groups and societies became more stable and formed tighter connections, they began to develop regional identities with distinct languages, social structures, cultures, and art, which the next several chapters will explore. Although this book examines cultures geographically, it is also clear that human groups were not shut off from one another. Rather, they engaged in economic and cultural exchange both regionally and across long distances, even in very early times. These exchanges affected the materials, styles, and content of art throughout all cultures.

bust a sculpture of a person's head, shoulders, and chest.

Discussion Questions

1. The rich collection of images on cave walls, produced over thousands of years, includes extensive animal imagery, while many figurines of the prehistoric period depict humans, animals, or hybrid creatures. Discuss the different theories concerning the functions and roles of such images among prehistoric communities.

2. Compare Stonehenge to the other megalithic examples discussed in this chapter. What common traits do they share? What is distinctive about each one?

3. Choose three examples of material evidence found in West Asian settlements. How do they illustrate changes in the lifestyles and relationships to the environment?

Further Reading

- Bailey, Douglass. *Prehistoric Figurines: Representation and Corporeality in the Neolithic.* London: Routledge, Taylor & Francis, 2005.
- Hodder, Ian. *The Leopard's Tale: Revealing the Mysteries of Çatalhöyük.* London: Thames & Hudson, 2006.
- Lorblanchet, Michel and Bahn, Paul. *The First Artists.* London: Thames & Hudson, 2017.
- Miracle, Preston and Borić, Dušan. "Bodily Beliefs and Agricultural Beginnings in Western Asia: Animal–Human Hybridity Re-examined." In Dušan Borić and John Robb (eds.) *Past Bodies: Body-Centered Research in Archaeology.* Oxford: Oxbow Books, 2008, pp. 101–13.
- Thurman, Judith. "First Impressions: What Does the World's Oldest Art Say About Us?" *The New Yorker*, June 23, 2008.

Chronology

c. 200,000 BCE onward	Modern humans (*Homo sapiens*) begin migrating out of Africa	*c.* 11,000–7000 BCE	Cueva de las Manos paintings are made
c. 65,000 BCE	The earliest known cave painting is made: La Pasiega Cave in Spain	*c.* 9600 BCE	The end of the Last Glacial Period (or Ice Age)
c. 40,000 BCE	The earliest securely dated European figurines are made	*c.* 9600–6000 BCE	Grains and animals are domesticated in West Asia, North Africa, southern China, and New Guinea; the Sahara Desert becomes a grassland
c. 37,000–34,000 BCE	The earliest rock paintings are made in the Maros-Pangkep Caves, Sulawesi, Indonesia		
c. 30,000–28,000 BCE	The earliest cave art is made in Northern Spain and Southern France	*c.* 9600 BCE	Göbekli Tepe megalithic monuments are made
c. 24,000 BCE	Paintings are made on stone, later found in the Apollo 11 Cave, Namibia, Africa	*c.* 7400–6000 BCE	Çatalhöyük is settled
c. 24,000–22,000 BCE	The Woman of Willendorf figurine is made	*c.* 6750–6500 BCE	Ain Ghazal human statues are made
c. 20,000 BCE(?)	Gwion Gwion figure paintings are made	*c.* 4000–3000 BCE	The Mnajdra complex is built in Malta
c. 15,000–12,500 BCE	Lascaux Cave and Altamira Cave engravings and paintings are made	*c.* 2900–1500 BCE	Stonehenge is constructed, in several phases

2

Art of Early Africa

8000 BCE–1000 CE

Dying eland with human
figures (detail), San.
Drakensberg, South Africa.

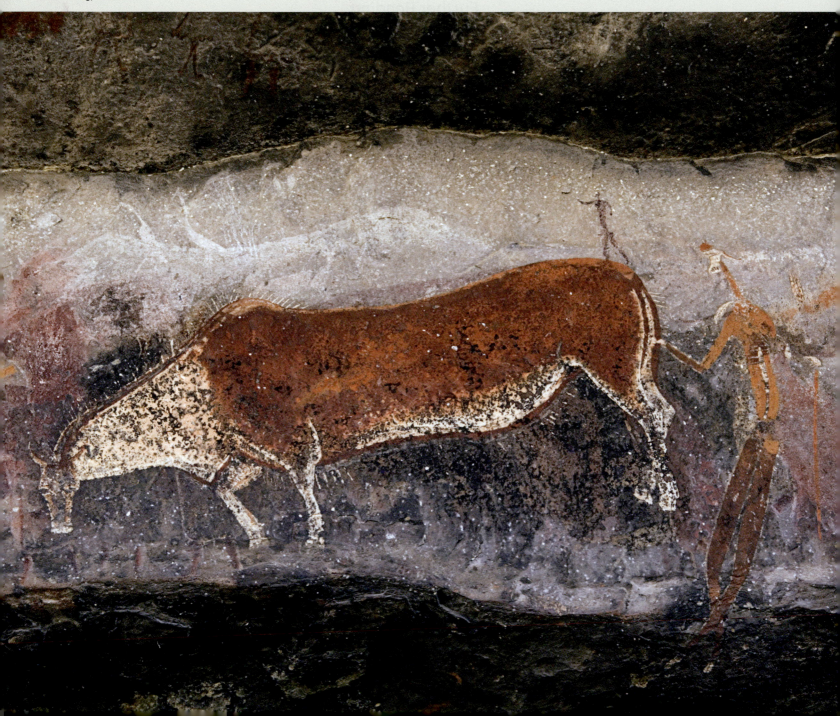

Introduction

All human beings alive today trace their ancestry to the African continent. Home to the world's oldest populations, Africa also yielded some of the world's earliest artworks (see Chapter 1) and hosted the world's most diverse mix of cultures, whose varied belief systems were reflected in their art. Unfortunately, archaeological research into early African cultures has been sporadic and incomplete. For both political and economic reasons, Egypt is the only African region to have been extensively excavated by archaeologists. While abundant examples of ancient Egyptian art were preserved due to to its arid climate and its burial practices, virtually no objects made of organic materials such as wood or leather have survived in other African regions. As a result, the ancient African artworks featured in this chapter cannot be placed within a comparable archaeological record. Instead, archaeologists rely on fragmentary physical evidence from ancient sites hundreds of miles apart, many of which have been looted—meaning that items have been taken illegally from archaeological sites without recording their location or context. Scholars have attempted to interpret early art by linking ancient populations to much later groups with similar languages, religious beliefs or lifestyles, but such connections are speculative.

Despite the wide gaps in our understanding of the African past, archaeologists have been able to gather much useful information on art and innovation in ancient Africa. Symbolic images were engraved and painted on rock surfaces as early as 26,000 years ago in southern Africa, and as early as 10,000 years ago in northern Africa. In the center of this region, populations domesticated wild cattle and wild grains, and created new forms of rock art. Further south, in the hills southwest of Lake Chad, in present-day Nigeria, Chad, and Cameroon, blacksmiths invented ironworking around 1000 CE, and North Africans began to import iron objects from other Mediterranean cultures at about the same time. West Africans then developed ways to cast other metals, such as brass, bronze, and other copper alloys. All these forms of art and technology spread across the continent as populations migrated to new lands or exchanged goods with their neighbors, and the first long-distance trade routes across the continent were established by 500 CE. Works of art created before 1000 CE thus provide glimpses of expanding and experimental African cultures.

The Highlands of the Sahara, c. 8000–c. 2000 BCE

While the last Ice Age covered the Northern Hemisphere with glaciers, the northern half of the African continent was quite arid. As that period came to an end, beginning about 12,000 years ago, rains came to north Africa, transforming the arid landscape into a grassland with rivers and trees. Small animals—foxes, anteaters, antelopes, jackals, and donkeys—gradually moved into the newly green area, followed by crocodiles, hippopotamuses, lions, giraffes, and elephants. The region's buffalo, with their huge curved horns, were dwarfed by aurochs, a species of enormous wild cattle that is now extinct.

2.1 Satellite composite view of the African continent, showing deserts and forests, 2005.

Humans followed the migrating animals into the green Sahara. From about 8000 BCE, varied populations lived in the mountainous regions that now are encircled by desert sands, and their artists left images of animals, humans, and supernatural beings on the walls of rock shelters, canyons, and cliffs. About 4,000 years ago, the climate changed again, and most of these early populations left the region. As the rains disappeared, the Sahara became, once again, the world's largest desert (**Fig. 2.1**).

LARGE WILD FAUNA STYLE RELIEFS Early hunters carved, scraped, and polished thousands of **petroglyphs** into rock surfaces across the Sahara. Unlike European cave paintings of the Paleolithic period (Figs. 1.1–1.6), which are deep in underground caves, the rock art found in North Africa and elsewhere on the continent appears in shallow rock shelters and on stone outcrops above ground. The ancient rock art of the Sahara that depicts in **low relief** the large animals then roaming the landscape is described as the Large Wild Fauna Style, or as the Bubalus Style after a now-extinct species that lived in the region.

Images in the Large Wild Fauna Style were **incised** during the long period of time beginning with the human resettlement of the Sahara, and ending when these animals became scarce in the region, roughly 9000–4000 BCE. Most scholars date them between 7500 and 5000 BCE, but some specialists assign them to a shorter time span, or give them later dates. The artists

petroglyph an image created on a rock surface through incision, picking, carving, or abrading.

low relief (also called bas-relief) raised forms that project only slightly from a flat background.

incised cut or engraved.

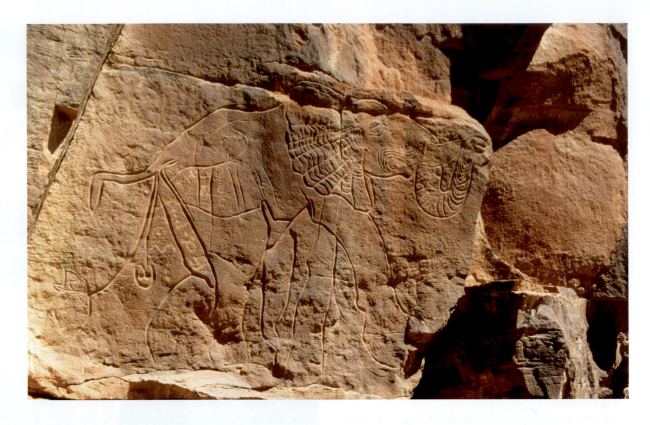

2.2 Elephant relief, Messak Settafet, Libya, Large Wild Fauna Style, with later inscriptions, 7500–5000 BCE. Abrasives and stone tools on rock surface.

rubbed deep grooves into the rock surface with abrasives or stone tools to define the contours of the animals. The technique is well illustrated in one relief of an elephant, which is almost half the size of the actual animal (**Fig. 2.2**); additional lines provide textures for the elephant's ears, trunk, and eyes. Cutting into and sanding down the surfaces of the rock to create these long, continuous grooves must have been an arduous, time-consuming process, suggesting that these animals were profoundly important to the artists.

Many of the wild animals shown in the Large Wild Fauna Style rock art are naturalistic, and closely resemble the actual appearance of an elephant, buffalo, or giraffe. However, some of their features have yet to be sufficiently explained. For example, a round, pitted object appears to hang suspended from the elephant's anus. Some observers have suggested that the object indicates that the elephant is defecating, because elephant dung helped hunters to track the animals. They believe that such images were created to master the animal's spirit before a hunt or to celebrate a successful kill. However, most rock art specialists believe that the round object is a symbol of some kind, rather than a depiction of a physical object.

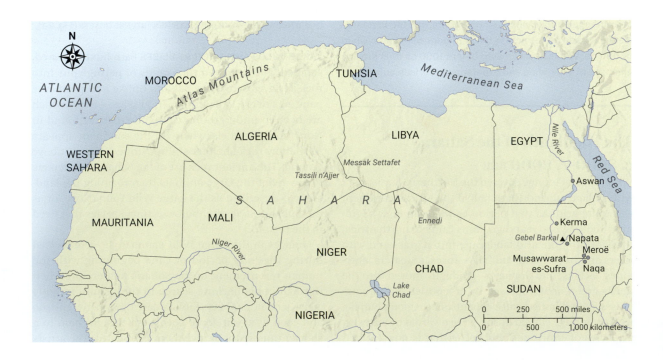

Map 2.1 Ancient sites in northern Africa

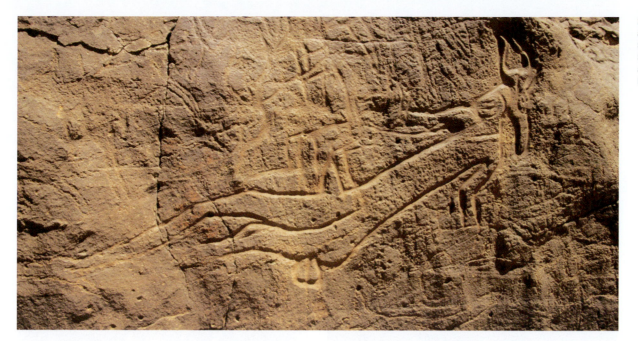

2.3 Falling human figure with animal head or mask, Messak Settafet, Libya. Large Wild Fauna Style, 7500–5000 BCE. Abrasives and stone tools on rock surface, length 21½ in. (54.6 cm).

Rock carvings, especially those found in the canyons of a huge rocky plateau in southern Libya named the Messak Settafet (see **Map 2.1**), combine animal and human features. On one rock wall an elongated, reclining man appears to be falling, and has turned to catch himself (**Fig. 2.3**). He has an animal head that might be that of a wild African donkey or an anteater or an antelope, but with features that are stretched to the point that its identity remains a mystery. There are a few Large Wild Fauna Style images where shallow lines at the base of an animal head hint at a human face beneath the animal features, suggesting that the artist wished to show a human wearing a mask. However, these are rare, and composite animal-headed figures such as this hybrid being are much more typical of the Large Wild Fauna Style.

Other Large Wild Fauna Style figures have the heads of felines, or even giraffes or elephants. The most numerous hybrids in the Messak Settafet, however, merge human figures with canids (wild dogs or jackals). Hundreds of them hunt, run, dance, fight, and tumble across the canyon walls. One of the most detailed depictions uses an unusual technique, outlining the shapes with a double contour and polishing the interior surfaces. This jackal–man hybrid wears a broad belt and a tail-like extension at the back (**Fig. 2.4**). The sharp teeth in the open jaws give the figure a threatening aspect missing from many other examples, which have closed mouths or even a dog-like grin.

Although most hybrid figures are found in the central Sahara, incised images of animals in the Large Wild Fauna Style are scattered across the entire desert, from the foothills of the Atlas Mountains in Algeria to the Ennedi highlands of Chad (see **Map 2.1**). An elephant in a modified Large Wild Fauna Style was even found on a rock that rolled into the Nile River near Aswan, at the southern border of ancient Egypt. Such similarities of style and subject matter in art that was spread across enormous distances, over thousands of years, suggest that early African populations were linked through migration patterns, and that they may have shared religious practices.

ARCHAIC STYLE ROCK ART IN TASSILI N'AJJER While the Messak Settafet of Libya was a particularly important site for Large Wild Fauna Style images, the mountain range to its southwest, known as Tassili n'Ajjer, is the home of Africa's most diverse rock art. Rock shelters in this region of southern Algeria are protected by overhangs, and display huge paintings that are not seen elsewhere. Their figures have circular heads with no discernible

2.4 Jackal-headed or masked figure, Messak Settafet, Libya. Large Wild Fauna Style, 7500–5000 BCE. Abrasives and stone tools on rock surface, height 45 in. (114.3 cm).

2.5 RIGHT **Horned female
figure,** Tassili n'Ajjer, Algeria.
Archaic Style, *c.* 6500–6000 BCE.
Pigment on rock, dimensions
unknown.

2.6 FAR RIGHT **Masked figure
or supernatural being,** Tassili
n'Ajjer, Algeria. Archaic Style,
c. 6500–6000 BCE. Pigment on rock,
approximate height 12 in. (30.5 cm).

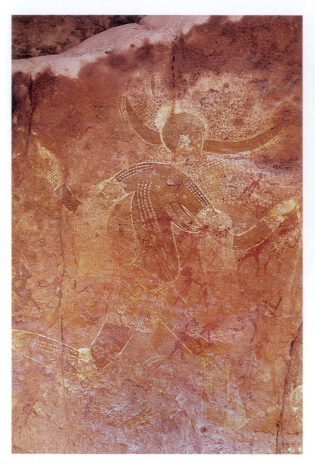

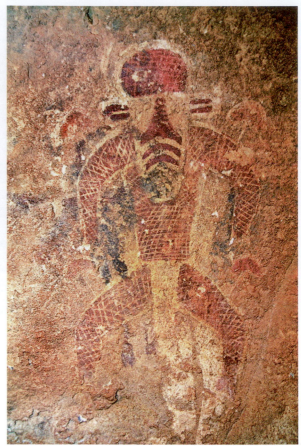

polychrome displaying several
different colors.

masquerade the masks,
choreography, music,
costumes, lyrics, and staging
of performances involving
transformations of the human
body.

ocher a naturally occurring
clay pigment that ranges
in color from yellow to red,
brown, or white.

bound (of a dry pigment)
mixed with a wet substance
(a binder) that helps the
pigment adhere to a surface.

facial features, and they have thus been described as
the Round Head Style or the Archaic Style. In the 1980s,
archaeological research in a cave near Tassili n'Ajjer dated
small versions of these faceless figures to approximately
6000 BCE. The Archaic Style thus appears to overlap in
time with some Large Wild Fauna Style images.

An intriguing Archaic Style painting shows an
apparently female figure with a curved breast, rounded
stomach, upraised arms, and long bovine horns, similar
to the horns on the wild cattle in Large Wild Fauna Style
engravings (**Fig. 2.5**). White dots cascade over her body,
and rows of white lines hang from her waist and from
bands on her upper arms, suggestive of strands of fiber.
The position of the figure's upraised arms and bent legs
implies that she is dancing or running. It was painted
over the top of several smaller, darker figures, some in
similar poses. As is the case for almost any rock art in
unprotected, remote locations, these ancient paintings
have been vulnerable to damage and even destruction
during the modern era. The first French visitors to publish
reproductions of this painting moistened it to bring out
its delicate colors before photographing it, and some later
travelers followed this destructive practice. Repeated
wetting has also damaged other Archaic Style images
and made them difficult to see.

The head and hands of another **polychrome** figure
from Tassili n'Ajjer are composed of abstract shapes that
recall human features but distort them, as if the drawing
represents a person wearing a mask (**Fig. 2.6**). Assuming
that this image depicts a **masquerade**, art historians
have searched for West African and even Central African

masks that resemble its face. Although they have located
modern masks and fiber costumes that seem similar to
the Archaic image, no masquerade recorded in recent
years is likely to have endured in unchanging form for
over eight thousand years. The painting may also repre-
sent a supernatural being, rather than a masked person.

PASTORALIST STYLE ROCK ART Tassili n'Ajjer is also the
site where the greatest number of paintings in the strik-
ingly naturalistic Pastoralist Style (also called the Cattle
Style) have been found. Archaeologists have tied these
paintings to the population that began to fire ceramic
vessels and to domesticate wild grains and cattle in the
central Sahara from 5000 to 2000 BCE. Most of their living
sites have been dated to about 3500 BCE, and were aban-
doned about 2000 BCE. In fact, the Pastoralist Style is
named for the practice of cattle herding, which they had
recently developed. The paintings show not only domes-
ticated cattle, with the specific patterns of their hides
and the shapes of horns, but also humans interacting in
relaxed poses and using natural gestures in what appear
to be scenes of daily life. People are depicted with con-
siderable variation, but most are shown with dark skin
tones. The different sizes and proportions of the people
in this detail from a much larger painting from Tassili
n'Ajjer indicate that they are women, men, and children
(**Fig. 2.7**). While children appear in the art of some later
Egyptian tombs and Mesopotamian monuments, lifelike
images of children were relatively rare in art around the
world until about 2000 years ago. Pastoralist Style rock art,
therefore, includes some of the world's earliest depictions

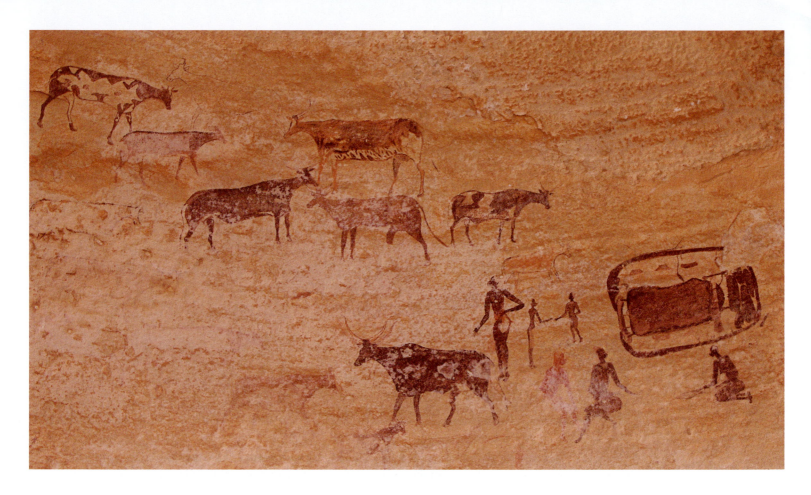

of children interacting with their families and friends. Analysis of the paints has revealed that they contain the same **ochers**, chalks, and charcoal as the much earlier Archaic Style paintings. In Pastoralist Style paintings, however, the pigments are **bound** with cow's milk so that the food the animals produce—along with their portraits—fill the compositions. The use of cow's milk emphasizes cattle's importance to these communities.

Later painted and engraved images found across the Sahara are even more varied in style as well as in subject matter. Generally, as the Sahara became more arid after 2000 BCE, naturalistic paintings were replaced by figures that were more abstract. Over time, the scenes began to include men riding horses and wheeled chariots, and, later on, camels and camel-riding nomads.

The Mountains of Southern Africa, *c.* 2000 BCE–1880 CE

Hunter-gatherers have lived in southern Africa for as long as the human species has existed, and archaeologists have dated some of their early paintings to 24,000 BCE (see **Fig. 1.7**). Beginning about 3,000 years ago, these ancient populations were joined in southern Africa by people speaking a group of languages known as Bantu, who had migrated southward from the center of the African continent, bringing with them new technologies such as ironmaking, and new economies centered on herding and agriculture. The small groups of hunter-gatherers who continued to live alongside these farmers and pastoralists spoke diverse languages known as

Khoisan, or simply San. Archaeologists trace the most recent southern African rock art to San artists who lived in the Drakensberg, or uKhahlamba mountains of South Africa until the late nineteenth century (see **Fig. 2.9**, p. 56).

TSISAB GORGE FRIEZE One of the oldest painted rock shelters in southern Africa is found in the Daureb (or Brandberg) mountain range in present-day Namibia in a high mountain pass called the Tsisab Gorge (**Map 2.2**).

2.7 Scene of cattle with men, women, and children, Tassili n'Ajjer, Algeria, Pastoralist Style, *c.* 5000–2000 BCE. Pigment bound with milk, dimensions unknown.

Map 2.2 Ancient sites in southern Africa.

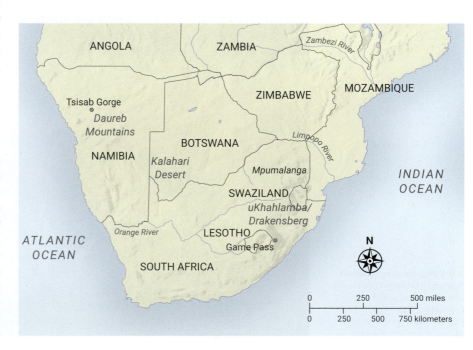

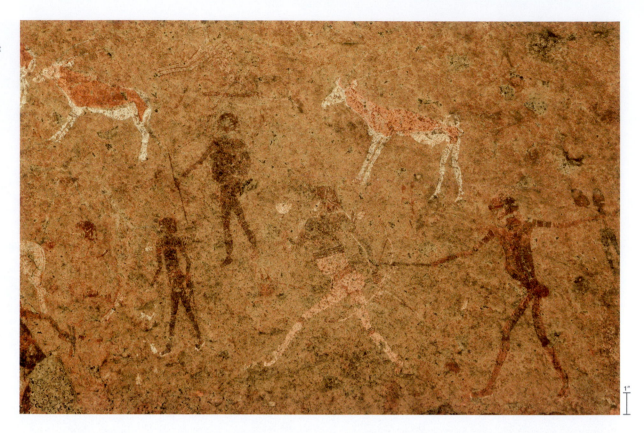

2.8 Dancers and antelopes,
Tsisab Gorge, Daureb, Namibia.
Ancestral San, *c.* 2000 BCE. Pigment
on rock, figure height 6 to 9 in. (15.2
to 22.9 cm).

frieze any sculpture or painting
in a long, horizontal format.

This scene (**Fig. 2.8**), painted *c.* 2000 BCE, is a lively **frieze** of more than a dozen small human figures between about 6 to 9 inches high, interspersed with even smaller antelopes. All of them face to the viewer's left, and some appear to be leaping or running. The composition spans the concave back wall of the rock shelter. One of the figures, visible in the lower center of this detail, seems to be richly painted and adorned, possibly for a religious event or ritual. While this striding figure and the delicate animals are all quite lifelike, some of the other human figures are more abstracted. All are formed of solid shapes that create silhouettes on the rough rock surface.

UKHAHLAMBA/DRAKENSBERG ROCK PAINTINGS Many more paintings attributed to the San and their ancestors can be found in the uKhahlamba, or the Drakensberg, the mountain range that runs parallel to the eastern shoreline of present-day South Africa, through Swaziland and Lesotho (see **Map 2.2**, p. 55). Some of the magnificent panels painted in the sheltered overhangs of the uKhahlamba cliffs might be thousands of years old, but most can be reliably assigned only to a broad period of time before the late nineteenth century, when Dutch-speaking settlers, or Afrikaners, killed virtually the entire San population of the region. Although the paintings of

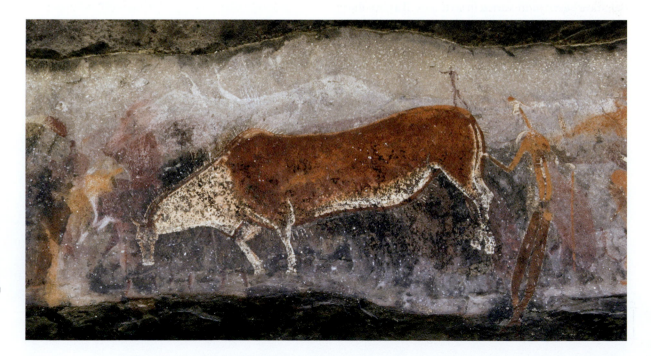

2.9 Dying eland with human figures, uKhalamba/Drakensberg (Game Pass Shelter, Kamberg), South Africa. San, before 1900. Pigment bound with eland blood on rock, dimensions unknown.

this mountain range include small human figures and a variety of humanoid forms, the focus of many scenes is an eland, a huge horned antelope that can weigh as much as 2,000 pounds. A detail from an undated rock shelter in the Drakensberg (**Fig. 2.9** and p. 50) shows the carefully drawn hoofs and horns and the soft, colorful shaded shapes used to define this impressive animal. The hair along the neck of the eland is shown in great detail, as are its lowered head and faltering limbs, and it appears to be falling or dying.

LYDENBURG TERRA-COTTA HEADS Several archaeological sites in present-day South Africa are identified as evidence for the arrival of Bantu-speaking populations, who brought with them ceramic and iron-making technologies. A buried cache of seven hollow **terra-cotta** heads was discovered near Lydenburg in the Mpumalanga Valley (see **Map 2.2**). Two were large enough to be placed over a human head and might have served as helmet masks. When one was restored (**Fig. 2.10**), conservators found traces of white **slip**. They also found a sparkly, mica-like mineral rubbed into some facial features, including the ridged eyebrows, as well as bands around the neck incised with parallel strokes. One head seems to have the shape of an animal, but the others have human features. Dated between 500 and 800 CE, the Lydenburg heads are among the earliest art objects of fired clay found in southern Africa.

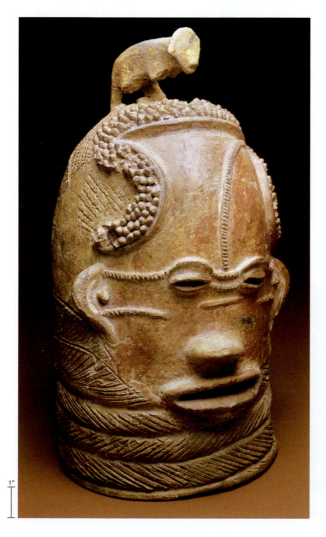

Ancient Nubia and the Nile Valley, c. 2500 BCE–350 CE

In contrast to Africa's ancient rock art, artworks from Nubia, in the southern portion of the Nile River valley, can often be dated fairly precisely. The varied cultures of Nubia may be documented in an archaeological record that is more complete than for any other African region—with the exception of its northern neighbor, Egypt. As in Egypt, artworks in Nubia were preserved by an arid climate and by the funerary practices of the local cultures. For some periods, archaeologists can even refer to inscriptions written in the local language or to documents written by foreigners, which allow them to place artworks in a chronological sequence.

Nubia was probably named for the gold deposits of its deserts, as *nbw* is an Egyptian word for gold. Located approximately midway between the sources of the Nile in modern Ethiopia and Uganda, and the delta through which the Nile flows on its way to the Mediterranean, most of Nubia was in the modern nation of Sudan (see **Map 2.1**, p. 52). Distances in this portion of the Nile Valley are measured by a series of six cataracts, or stony rapids, that impede boat traffic. The First Cataract, near the archaeological site of Aswan, marked the division between Egypt and Nubia. Nubian kingdoms built their capitals near the Second, Third and Fifth Cataracts, (see Map 6.1). Periodically, Egypt sent its traders, diplomats, and armies south, sometimes conquering and occupying Nubian territory for centuries, while the kingdoms of Nubia sent rulers, queens, administrators, soldiers, and entertainers to Egyptian courts in the north. Given these many interchanges, it is not surprising that Nubian and Egyptian art influenced each other greatly. From about 4000 BCE, early fishing and farming communities along the southern Nile were joined by separate groups of herders from the Sahara. Immigrants continued to bring new cultural practices to the region over a period of several thousand years. Beginning around 3000 BCE, ancient Egypt became a unified state whose history continued through dynastic changes, while a series of societies arose at different sites in Nubia. One of the most powerful was Kerma, which flourished from about 2100–1500 BCE (see **Map 2.1**). Several centuries later, it was succeeded by the Nubian kingdom of Kush. Kushite kings ruled Egypt as the Twenty-Fifth Dynasty for several generations during the eighth century BCE, fighting to protect both Egypt and Nubia from foreign invaders. When Egypt was conquered by Greek, and then by Roman rulers, Nubia remained independent, enduring for almost another thousand years.

PENDANT WITH HEAD OF A GODDESS A tiny pendant from the tomb of a Nubian queen of Kush (**Fig. 2.11**, p. 58) was created using two precious minerals mined in Nubia: gold and rock crystal (quartz). The small translucent sphere of polished quartz catches and reflects sunlight. A female head made of gold sits atop the rock crystal sphere. The shape of her hairstyle indicates that she is wearing a wig. At the top of the head is a solar disk framed by two horns, and a loop at the back of the head allowed the queen to hang the object at her neck, on her forehead, or in her hair.

terra-cotta baked clay or ceramic; also known as earthenware.

slip a layer of fine clay or glaze applied to ceramics before firing.

2.10 FAR LEFT **Lydenburg head,** Lydenburg, Mpumalanga region, South Africa, 500–800 CE. Fired clay, height 15 in. (38.1 cm).

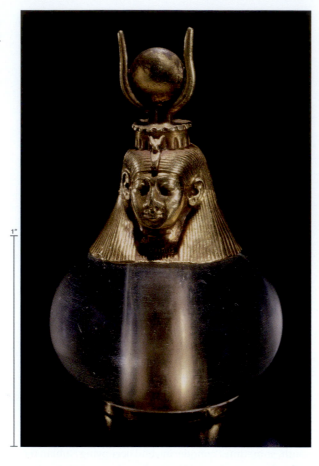

2.11 Pendant with the head of a goddess, El-Kurru, Sudan. Nubian, Napata period, 743–712 BCE. Rock crystal and gold, height 2 in. (5.1 cm).

1"

Nubians may have identified gold with divine beings, just as other African cultures did. For example, in some West African cultures, gold is regarded as a conduit to the ancestors (see Fig. 49.14), and the ancient Egyptians considered gold to be imbued with the sun's powers, which assist the soul in its journey to the afterlife. The head probably represents Hathor, a goddess worshipped in both Nubia and Egypt. Shown as a cow, or as a female figure wearing a wig or cattle horns, Hathor's image appears very early in the art of Egypt as "mistress of the Western Desert." Throughout the history of ancient Egypt, Hathor was the goddess of music and dance, and she was paired with solar deities such as Ra and Horus. The slender horns seen here were also attributes of Isis, a

2.12 Elephant binding captives, Temple of Apedemak, Musawwarat es-Sufra, Sudan. Nubian, Meroitic period, c. 320 BCE. Stone relief.

benevolent Egyptian goddess who, like Hathor, protected divine kings, but Hathor was more frequently featured in the artworks Nubians left in the tombs of their queens. While this tiny representation of Hathor may relate to the ancient Egyptian goddess who first appears as the "celestial cow," perhaps it ultimately descends from the horned figure painted thousands of years earlier in the central Sahara (see **Fig. 2.5**).

Because the grave in which this pendant was found had been quite damaged, the excavators could not determine the queen's name, but inscriptions tell us that she lived around 725 BCE, during the period when the Kings of Kush also ruled Egypt. Queens, along with other members of the Kushite royal families, were buried in pyramids close to the capital city of Napata, near the Fourth Cataract of the Nile. Napata's main temple, dedicated to Amun (a deity revered by Egyptians and Nubians alike), was placed in the shadow of a dramatic rock formation now called Gebel Barkal, the "holy mountain." Amun's temple was built of stone and shared features with Egyptian temples (see Fig. 6.6), including open courtyards and cliff-like entrances. The halls were guarded by colossal statues of kings, flanked by columns sculpted to resemble aquatic plants (see Fig. 4.10).

TEMPLES OF APEDEMAK By 300 BCE, the Kushite capital had moved much farther south, to Meroë, near the Fifth Cataract of the Nile. The kings and queens of Meroë continued to use the walls of temples and tombs to show that they were serving the gods of their land. Some of these deities were revered in Egypt as well as in Nubia, but Apedemak, a war god who took the form of a lion, was purely a Nubian deity. The rulers of Meroë erected temples to Apedemak at the crossroads of the desert routes that linked their cities on the banks of the Nile. On the interior walls of a temple dedicated to Apedemak in the large enclosed temple complex at Musawwarat es-Sufra (**Map 2.1**), dated to around 320 BCE, low reliefs depict the rulers' defeated enemies tethered by ropes (**Fig. 2.12**). A triumphant elephant holds one end of the rope in its trunk. Both the animal and its captives are shown in profile, as in much earlier rock art. Stone statues of elephants also appear among the columns of the large enclosure, which may have housed live trained elephants.

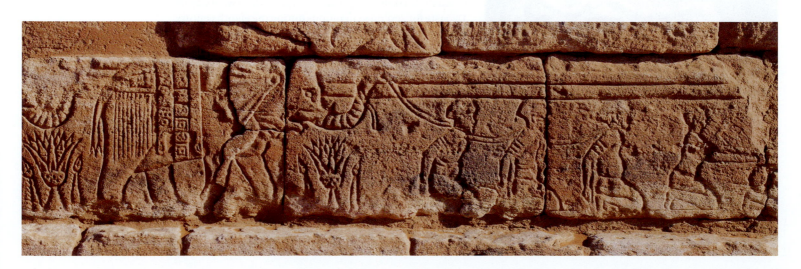

Carved more than 5,000 years after elephants in the Large Wild Fauna Style (**Fig. 2.2**, p. 52), this relief reveals the enduring importance of these powerful animals in the daily lives and collective imagination of northern Africans.

The exterior walls of another temple to Apedemak (**Fig. 2.13**), constructed around 50 CE at Naqa, a site south of Musawwarat es-Sufra, were carved with images of deities and rulers in low relief. The monumental figure of Queen Amanitore (ruled Meroë *c.* 1 BCE–20 CE) is on the viewer's right and her co-ruler Natakamani on the left as they flank the entrance to the temple. Both gather their enemies into a cluster in one hand, raising a weapon in the other to beat them into submission. Egyptian kings had portrayed themselves in this triumphant pose for thousands of years, but Egyptian temples feature no comparable image of a conquering female ruler. The depiction of Queen Amanitore corresponds to historical accounts that stress the authority of the powerful royal women of Nubia. Although the temple built for these rulers of Meroë is tiny compared to those built in Egypt during this period for Egypt's Roman overlords, it projects an image of supernatural might and protection.

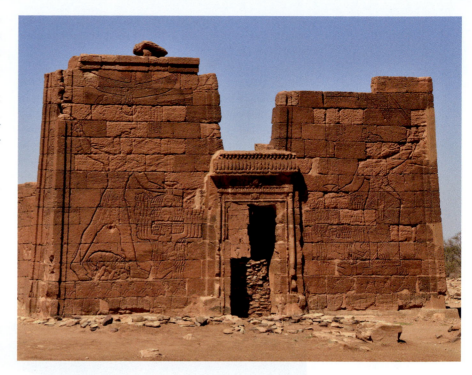

2.13 **Amanitore and Natakamani,** on the entrance to the Temple of Apedemak, Naqa, Sudan. Nubian, Meroitic period, *c.* 50 BCE. Stone relief.

West Africa and the Niger River, *c.* 1000 BCE–1000 CE

Just as the Nile River valley received waves of immigrant communities leaving the increasingly arid Sahara, the grasslands south of the desert attracted migrating pastoralists and early farmers. The western half of this semi-arid landscape, the southern "shore" (Arabic "Sahel") of the Sahara, is dominated by another great river, the Niger. The Niger River waters a broad range of climatic zones as it curves north from its headwaters into the Sahel, and then bends south through the savannah (**Map 2.3**). After merging with the Benue River, the Lower Niger enters dense forests and forms a swampy coastal delta almost 2,600 miles from its source before entering the Atlantic Ocean. All along its banks, it nurtures herders, farmers, and fishermen with varied origins and histories. As early as 3,000 years ago, some of these communities were using iron-making technologies that appear to have been invented in the hills northeast of the Niger River and south of Lake Chad. By 1,000 years ago, metalsmiths of the Lower Niger region were casting copper alloys to create intricate and complex artworks. Archaeologists have just begun to explore some of the

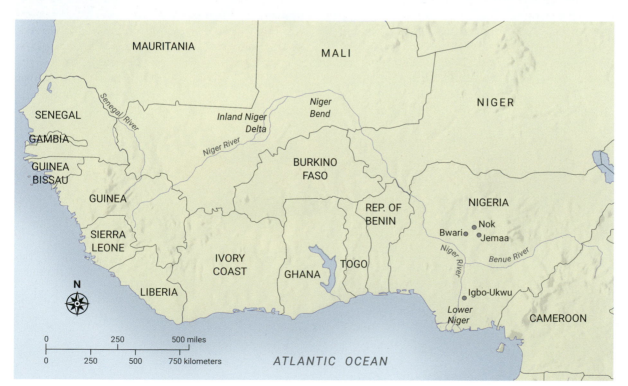

Map 2.3 **Ancient sites on the Niger and Benue Rivers.**

ancient sites in the watershed of the Niger River, and ongoing excavations are in the process of changing our view of its art history.

The earliest African sculptures found south of the Sahara Desert come from the hilly plateau north of the confluence where the Niger joins the Benue River, in what is now central Nigeria. These are figures (or partial figures) made around 2,500 years ago by an iron-making population that had mastered the firing of both ceramics and iron ores by about 1000 BCE. The figures are made of terra-cotta, which is a particularly durable material. Their distinctive style is named for Nok, the village closest to the place where the first example was discovered in the early twentieth century, when Nigeria was a British colony.

NOK STYLE TERRA-COTTAS A particularly fine near-life-size ceramic head in the Nok Style (**Fig. 2.14**) was discovered in the Nigerian village of Jemaa and shown to an archaeologist in the colonial era. He compared it to fired clay figures unearthed in tin-mining operations, which had sometimes been swept away from their original locations by floodwaters and buried some 25 feet underground. The stylized facial features include triangular eyes (with each iris dramatically rendered as a circular hole), an open mouth with full lips, and a regular, almost spherical head. All of these qualities are typical of the Nok Style. The neck is broken where the head was once attached to a full figure. The even surface and crisp details of the face suggest that the artist must have used a sharp tool to carve the clay after the surface had partially dried, since if the clay had been modeled instead of carved, the edges would appear much softer. Nok artists might also have applied these techniques to wooden sculpture that did not survive. In recent excavations, archaeologists have found that all the organic materials buried with the

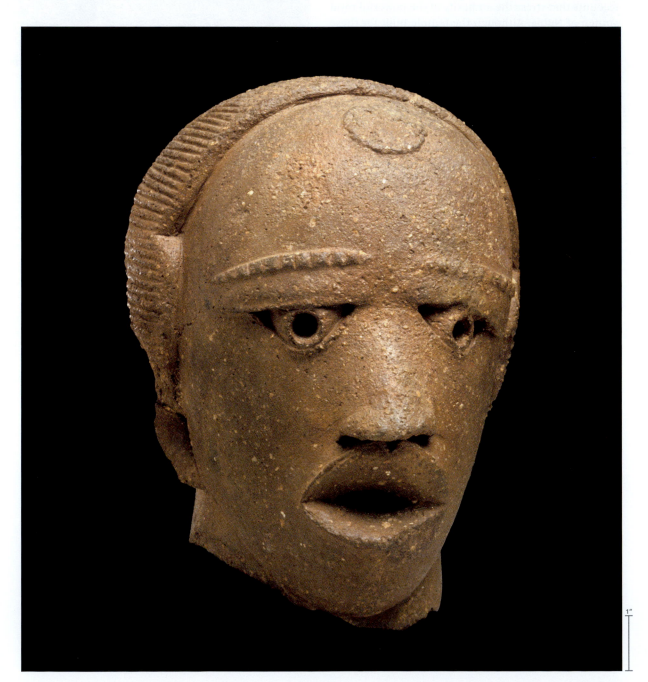

2.14 Head broken from a figure, Jemaa, Nigeria, Nok Style, 700–400 BCE. Fired clay, height 9⅞ in. (25.1 cm).

1"

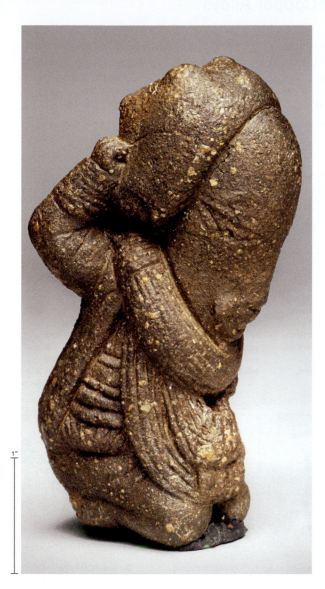

composed of pieces of ancient terra-cottas unearthed by Nigerian farmers and then shipped to Europe, in violation of international law. European forgers glued unrelated fragments together to form a core and then coated them with a mixture made from ground pieces of ancient terra-cotta and modern binders. New imaging technologies have since revealed that they are fakes rather than (as their buyers had hoped) exceptionally well-preserved antiquities obtained by illicit means (see Seeing Connections: Stolen Things: Looting and Repatriation of Ancient Objects, p. 219). The forgeries went undetected for several decades because so few Nok works had come from archaeological excavations. In the twenty-first century, a German–Nigerian archaeological team surveying hundreds of looted sites determined that both the production of Nok terra-cottas and local iron-smelting operations were at their peak between 700 and 400 BCE. While some terra-cottas were made before and after this period, all are more than 2,000 years old. Figures from intact sites were not found in dwellings or in burials (some of which had stone grave markers) but were unearthed in shallow deposits scattered across the landscape. For an unknown reason, almost all had been deliberately broken. Researchers thus know that complete Nok figures are probably fakes.

Comparing ancient Nok terra-cottas with the ceramics of twentieth-century populations living in central and eastern Nigeria allows us to speculate on how the Nok figures were used. In these modern small communities, ceramic vessels were used for different purposes. The peaks of thatched, cone-shaped roofs were protected by ceramic objects that often looked like overturned hemispherical pots. Terra-cotta sculpture, and ceramic pots topped with heads or figures, were left in sacred spots in the landscape as offerings to invisible supernatural beings. Similar vessels, dedicated to deceased family members, were placed on graves or smashed during funerals. Pots and terra-cotta figures were also used in private homes during procedures intended to cure various illnesses. The ancient Nok works may have had a similarly complex set of functions.

IGBO-UKWU AND THE LOWER NIGER RIVER

For many centuries following the end of the Nok Style—about 200 BCE to 1000 CE—a variety of sculpture in fired clay was produced throughout the savannahs north and south of the Niger River. This was also the period of time when the ancestors of Bantu-speaking populations migrated south and southeast; the Lydenburg heads found in the Mpumalanga Valley testify to the arrival of these groups in southern Africa. Other populations who used iron tools were penetrating deeper into the dense forests of West Africa, entering regions formerly occupied by hunting and gathering populations. Although relatively little archaeological work has been done in these forest regions, terra-cottas, stone sculptures, and a variety of intricate metal objects have been found in the Lower Niger River and its broad delta. After being unearthed by locals in the twentieth century, some ancient works in brass or bronze were often reinserted into the religious life of a local community. Therefore they now possess both ancient and modern layers of meaning and use.

2.15 FAR LEFT **Kneeling figure,** Bwari, Nigeria, Nok Style, *c.* 700–400 BCE. Fired clay, height 4¼ in. (10.8 cm).

fired clay statues had decayed and been absorbed into the surrounding soil.

Another Nok terra-cotta was found in a tin mine near the town of Bwari. This tiny (4¼ inches high) kneeling or seated figure is a solid piece of fired clay (**Fig. 2.15**). Although the surfaces are worn, the Nok style of the delicately modeled facial features is still clear. Of particular interest is the size of the head in relationship to the rest of the body, as similar proportions were used in much more recent figures from this part of West Africa. For example, twentieth-century Yoruba artists in Nigeria and the Republic of Benin exaggerated the size of the heads of statues to indicate the head's importance as the center of a person's destiny and character. This Nok terra-cotta suggests that such ideas about human anatomy may have their origin in the distant past. Furthermore, the heavy loops of beads that hang over the chest of the Nok figure reveal an interest in beadwork, and later cultures have adorned their rulers with beads.

The Bwari figure's raised left fist and kneeling pose, whose meanings are uncertain, aroused such interest in European collectors that they were copied in some of the many Nok forgeries that flooded the art market during the late twentieth century. Many of these forgeries were

Societies around the world have developed many techniques for working gold, silver, and the shiny, durable metals that are formed by mixing copper with other minerals, such as zinc or tin, to produce brass or bronze alloys. In some places, such as ancient North America, naturally occurring sheets of metal were simply hammered and cut into shapes. In others, such as ancient East Asia, multiple molds were joined to produce huge artworks assembled from cast bronze. The description here applies to the lost-wax casting process used over 1,000 years ago to make the bronze objects found at Igbo-Ukwu (such as **Fig. 2.16**). Variations on this process are used today by goldsmiths, makers of cast brass, and other metalworkers in Africa and around the world.

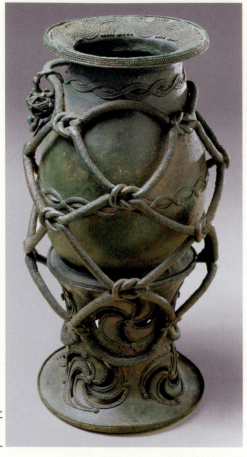

2.16 ABOVE **Roped pot on a stand**, Igbo-Ukwu, Nigeria, Ancestral Igbo culture, ninth–tenth century. Leaded bronze, height 12¾ in. (32.3 cm).

2.17 RIGHT **Steps in the lost-wax casting technique.**

1. **A rough clay model serves as the core.**

2. **The core is covered with a fine layer of softened beeswax (or sap from a plant), which is modeled or carved into the desired form.**

3. **One or more wax extensions serve as channels for air or as an opening into which the molten (liquefied) metal will be poured.**

4. **The wax is covered with a layer of slip (liquid clay), leaving only the ends of the wax extensions exposed. When the slip is dry, it is covered with more layers of coarser clay.**

5. **The object is placed in a kiln or over a carefully controlled open fire and heated until the clay has hardened. The wax melts away (and is "lost") through the opening.**

6. **Molten metal is poured into the largest opening in the hot mold. The metal flows into the space left behind by the wax.**

7. **The entire object cools until the metal has hardened. The clay around it is then broken away or chipped off. The core may also be removed.**

8. **The artist checks for blemishes and may polish or incise the surface (though this was rarely done at Igbo-Ukwu).**

finial an ornament at the top, end, or corner of an object or building.

radiocarbon dating a scientific method of determining the age of an object, based on the presence of carbon-14 in organic material.

lost-wax casting a method of creating metal sculpture in which a clay mold surrounds a wax model and is then fired. When the wax melts away, molten metal is poured in to fill the space.

IGBO-UKWU BRONZES A pair of archaeological excavations, however, unearthed a spectacular assemblage of ancient bronzes in its original context at the Lower Niger site of Igbo-Ukwu, in the homeland of the Nigerian people now identified as Igbo (or Ibo). The bronzes accompanied the burial of a man of high status, whose body was seated on a throne. His limbs were wrapped in strings of thousands of tiny glass beads that had been imported across trans-Saharan trade routes established several centuries earlier. Fixed into the ground before him were wooden staffs topped by bronze **finials**, which were also decorated with trade beads.

Radiocarbon dating and the form of the beads, which date them to a specific period of manufacture, established that the bronzes in the burial were cast between 800 and 1000 CE. Their unique blend of copper, tin, lead, and silver reveals that they were made from ores mined to the northeast in the Benue River watershed, and created by the process of **lost-wax casting**. While the Igbo-Ukwu bronzes are the oldest items made using the lost-wax process that have been found thus far in the Lower Niger region, their elaborate forms and intricate surface detail make it very unlikely that they were the first to be made. This level of skill would have taken a long time to master, so there must have been earlier works in bronze or brass that have not yet been discovered, or which are now in locations where they cannot be dated.

According to oral accounts recorded at the very beginning of the pre-colonial era, high-ranking Igbo elders in this region of Nigeria were appointed to care for the sacred emblems of a divine king known as the Eze Nri, objects that were stored in a secret location. It is possible

that two other deposits found at Igbo-Ukwu—one a display that may have been a shrine, and one a cache of ceramic vessels and bronze objects—were the treasures guarded by such elders for an early Eze Nri or a comparable leader. Some of the bronzes (of which there were almost a thousand) were metal reproductions of things that exist in other materials, such as leopard skulls, conch shells, carved gourds, and pots of fired clay. One masterpiece was a reproduction, completely cast of bronze, of a ceremonial ceramic vessel attached to a pierced ceramic base with a net of knotted ropes (see box: Making it Real: Lost-Wax Casting Techniques for Copper Alloys).

PENDANT FROM IGBO-UKWU A copper-alloy pendant from this treasury displays the technical skill of the ancient Igbo artists (**Fig. 2.18**), while raising intriguing questions about the ideological context for which it was made. It would have been worn or suspended so that the small metal bells hung below it on wires strung with beads. The two large ovoid (egg-shaped) forms are joined at the top by a bird with its wings curved back. Raised patterns on the ovoid objects appear to be stylized flies. Are these objects two eggs, possibly offered as a sacrifice, or is the ensemble a symbol of male genitalia or female breasts? Any answer remains guesswork.

FLYWHISK HANDLE FROM IGBO-UKWU Among the many other objects buried with the deceased at Igbo-Ukwu was a small equestrian (a rider on a horse), which was either the top of a staff or the handle of a flywhisk (**Fig. 2.19**, p. 64). Today, flywhisks are made from the tails of cattle or horses set into holders, and they are still an effective way to brush off flying insects. Across Africa, these whisks have long been associated with leadership and wealth, possibly because the animals used for their tails were so valuable. The top (or end) of this copper-alloy handle is adorned by a small figure who blows on an instrument and rides a horse.

Why is the horse so small? Perhaps the artist had never seen a real horse, or perhaps the scale was deliberate: The animal is less important than its rider, just as the rider's head is more important than his (much smaller) body. The rider's face is marked with parallel lines, similar to the permanent **scarification** (or *ichi*) incised into the faces of high-achieving Igbo men in the twentieth century. Each set of *ichi* marks proclaimed that a man had attained a new title and a new set of community responsibilities. The rider is perhaps an early Eze Nri, who would have distributed titles, ensuring that elders served their people with justice, truth, and wisdom. The authority of the last Eze Nri was destroyed by the British when Nigeria became their colony in the early twentieth

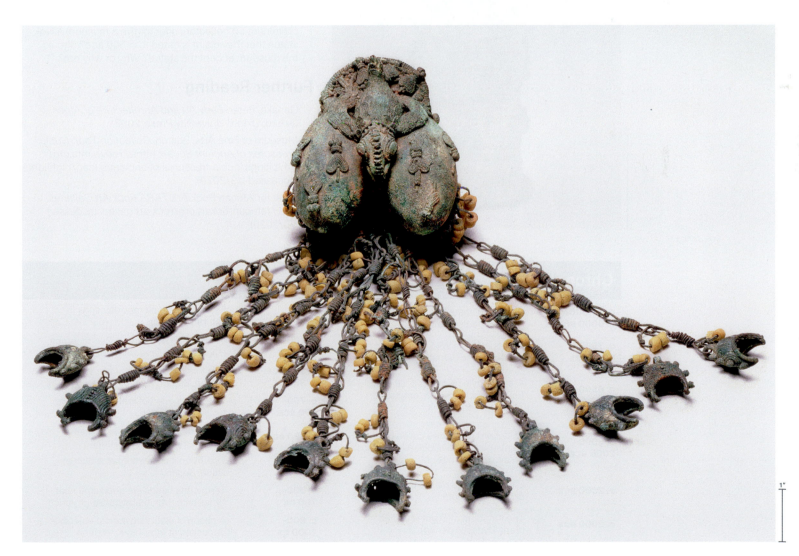

2.18 Pendant, Igbo-Ukwu, Nigeria, Ancestral Igbo culture, *c.* 800–900 CE. Copper alloy, glass beads, height 8½ in. (21.6 cm).

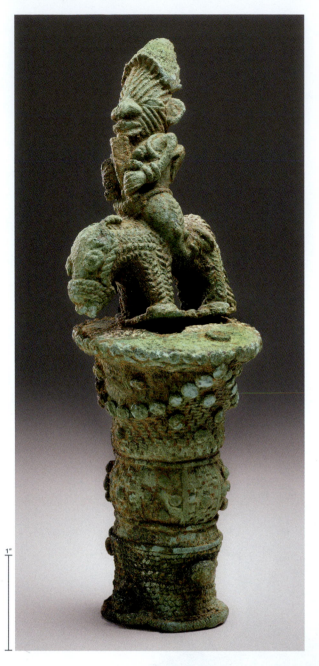

2.19 Handle of a flywhisk, or top to a staff, Igbo-Ukwu, Nigeria, Ancestral Igbo culture, c. 800–900 CE. Copper alloy, height 6¼ in. (15.9 cm).

1″

century, bringing an end to a position of leadership that was at least one thousand years old.

Archaeologists attempt to use art objects such as the bronzes from Igbo-Ukwu to reconstruct Africa's hidden past. Given the preliminary nature of their research, the vast distances they must cover, the diversity of African populations, and the complexity of ancient religious beliefs and cultural practices on the continent, many of their fundamental questions have yet to be answered.

Discussion Questions

1. Because the artists who painted rock surfaces in the uKhahlamba had all been killed or dispersed by the end of the nineteenth century, researchers usually consult accounts of the beliefs and practices of other San populations in South Africa and Botswana. Other San groups, however, were not producing rock art in the nineteenth or twentieth centuries. What might be the advantages and disadvantages of comparing undated paintings, such as Fig. 2.9, to the religious lives of San populations in the twentieth century?

2. Several of the artworks in this chapter (Figs. 2.11, 2.15, and 2.19) are small enough to fit in the human hand. Imagine that you could hold one of these objects. How would the sense of touch provide you with an experience that might be quite different from that of looking at the object or its reproduction?

3. What moral and practical issues might arise if prominent art collectors offer to give a museum a Nok statue that they claim is dated to c. 500 BCE? Should the museum accept the statue? Why or why not?

Further Reading

- Garlake, Peter. *Early Art and Architecture of Africa*. Oxford: Oxford University Press, 2002.
- Museum of Fine Arts, Boston. *Collection Tour: Nubia: Treasures of Ancient Sudan*: https://www.mfa.org/exhibitions/nubia-treasures-of-ancient-sudan/highlights (accessed 1/3/2020).
- Trust for African Rock Art. *TARA Rock Art Galleries*, http://africanrockart.org/rock-art-gallery (accessed 1/3/2020).

Chronology

c. 11,000–c. 9000 BCE	A wetter climate allows humans to resettle the Sahara		c. 2000 BCE	San artists create rock paintings in Daureb, Namibia
c. 7500–5000 BCE	Reliefs in Large Wild Fauna Style are created in the Sahara		c. 1000–500 BCE	Ironworking develops in Central Africa (Nigeria, Chad and Cameroon)
c. 6500–6000 BCE	Archaic Style paintings (also called Round Head Style) are created at Tassili n'Ajjer, Algeria		c. 795 BCE–c. 350 CE	The Kingdom of Kush at Napata and Meroë, Sudan
			c. 700–400 BCE	The peak period of making Nok Style terra-cottas, Nigeria
c. 5000–2000 BCE	Pastoralist Style (also called Cattle Style) paintings are created in Algeria; most date to c. 3500 BCE		c. 320 BCE	The Temple of Apedemak is built at Musawwarat es-Sufra, Sudan
			c. 50 CE	The Temple of Apedemak is built at Naqa, Sudan
c. 2000 BCE	Climate change makes the Sahara a desert once more		c. 500–700 CE	Terra-cotta heads are deposited near Lydenburg, Mpumalanga, South Africa
c. 3000 BCE	The Kingdom of Egypt is unified (Early Dynastic period)		c. 800–1000 CE	A cache of elaborate bronze objects is deposited at Igbo-Ukwu, Nigeria

3

Art of Mesopotamia and West Asia

5000–2000 BCE

Votive figure (detail), Eshnunna (Tell Asmar), Iraq.

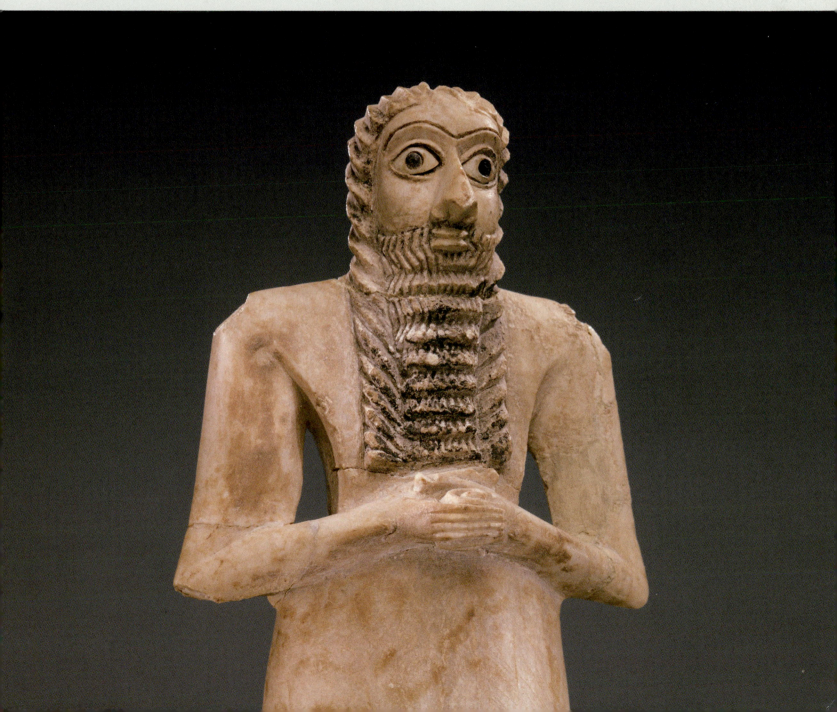

Map 3.1 Mesopotamia and the Fertile Crescent, 3300–2000 BCE.

Introduction

The earliest West Asian cultures prospered in a region sometimes called the Fertile Crescent: an arc-shaped area that stretches from the foothills of the Zagros Mountains across the Tigris and Euphrates Rivers, along the borderlands between present-day northern Iraq and Syria and southeastern Turkey, and all the way to the eastern coast of the Mediterranean Sea (Map 3.1). (West Asia has also been called the Near East in the past.) The abundance of wild wheat, barley, sheep, and goats in the Fertile Crescent made it ideal for agriculture and the domestication of animals, and the advancement of agriculture and irrigation techniques enabled people to settle in one location rather than follow the seasonal migrations of wild animals. Living in stable communities allowed people to engage in activities other than farming. They built permanent houses in small settlements and began to trade with other communities and regions.

The alluvial plain of Mesopotamia (Greek for "between the rivers"), the region between the Tigris and Euphrates Rivers, is a southern extension of the Fertile Crescent. Several powerful and influential city-states and empires developed in Mesopotamia between the Tigris and Euphrates Rivers from roughly 5000 to 2900 BCE. Following the first development of cities, long-distance trade and complex state bureaucracies also developed in the region. In the course of these three thousand years of history, 5000–2000 BCE, two major urban economic institutions (the temple and the palace) were formed, writing was invented, and an urban elite class flourished, contributing to a highly developed lineage of craftsmanship and the arts, and new ways to use art in support of political and religious power and systems of belief. Specialists emerged, including engineers, architects, and artists, who contributed to the flourishing of complex, innovative, and technically skilled art.

This stability allowed for the accumulation of surplus of food and wealth not only in cities but also in the hands of an elite class. Much of the monumental art produced in West Asia during this period, sponsored by rulers and temples, was designed to emphasize the city-state's power and belief systems. Devotion to the gods was paramount in art of all sizes, from small votive sculptures to massive temple complexes. Modest works by ancient artisans in households are also of interest to the history of art, because they provide crucial information about the life of ordinary people. These objects allow us to study the material culture of different communities, their technologies of production, their identities, and belief systems. The images that appeared in public monuments and private objects also reflected shifts in the perception of rulers. These shifts appeared dramatically when the Akkadian Empire—the world's first empire—rose to power, overthrowing the Sumerian-speaking states that preceded them. The innovations during this time have led many modern and contemporary scholars to see the achievements of Mesopotamia as representing a turning point in the long development of human history. Mesopotamian and wider Western Asian cultures are therefore often considered ancestors to the later Mediterranean and European societies in broader historical narratives.

Regional Cultures in Early Mesopotamia

Several farming communities developed in Mesopotamia during the sixth and fifth millennia BCE. While these communities shared cultural elements and languages, they also developed distinct regional identities, expressed through their art and **material culture**. The most common objects were ceramic pots, which stored the food that

material culture the materials, objects, and technologies that accompany everyday life.

people used daily. These pots provide not only vital information about the identities, daily lives, and belief systems of the people who lived during this period, but also evidence of their creativity and inventiveness. The people of these communities built their houses from bricks molded from mud and dried in the sun. Because sun-dried bricks deteriorate fast when not maintained, the houses were worn down over time by rain and wind, creating a mound (called a *tell* or a *hoyuk* in present-day Middle East). New houses were then constructed on the ruins of earlier ones. These houses were often complex structures for extended families, with specific spaces for hospitality, food production and storage, pottery production, and weaving.

In general, Mesopotamian ceramics of the sixth millennium BCE were formed by hand, rather than on a wheel. Some potters of the period constructed large containers by using a coiling technique in which they stacked clay coils one on top of another to build the form, and then smoothed the surfaces. Potters of the later Ubaid cultures, who lived in the fertile southern plains of the Tigris and the Euphrates Rivers between roughly 5500 and 3800 BCE, introduced an innovation in ceramic technologies: the **tournette**, an early form of potter's wheel that speeded production by allowing ceramics to be shaped more easily.

UBAID BEAKER Early ceramics were often adorned with painted animals, architecture, and elements of the landscape. Artists frequently lengthened, exaggerated, or otherwise refined the shapes, and these designs often created slightly abstract forms. See, for example, the carefully crafted decoration on this wide-mouthed beaker found in Susa, a region in western Iran in contact with Ubaid culture (**Fig. 3.1**). The brown-painted decoration, applied to the vessel's highly burnished, buff-colored surface, consists of designs framing geometrically abstracted representations of animals, including aquatic birds with long necks, running dogs, and ibexes. The horns of the ibex—a type of mountain goat—are exaggerated to curve around an abstract circular design at the center, and they end precisely at the slenderest part of the goat's waist. The elongated dogs, depicted above the frame, are clearly running.

Urbanization in the Uruk Period, *c.* 3800–3100 BCE

The first West Asian cities emerged in the silt-rich plains of southern Mesopotamia, in the area that stretches roughly from present-day Baghdad to the Persian Gulf. Over the course of the Uruk period (*c.* 3800–3100 BCE), once-dispersed small communities gradually gathered around a series of economic, ceremonial, and ritual centers, forming two of the earliest-known cities, both in modern Iraq: Uruk (on the site of modern Warka) and Nippur. Food for the residents of these cities was produced in adjoining fields and farms, which freed some of the community to specialize in crafts, to work in administrative capacities for the temples and elite class, and to engage in trade and mercantilism.

The material culture of Uruk tells the story of early urban development. For example, the highly specialized and individually decorated ceramics of earlier cultures were replaced by mass-produced, utilitarian **coarseware** known as beveled rim bowls, suggesting that production had to keep up with a significant surge in the population. By the late fourth millennium BCE (the last few centuries before 3000 BCE), Uruk encompassed over three-quarters of a square mile, and its legendary city wall was constructed. The rulers and the wall of Uruk are mentioned in later Mesopotamian epic poetry, such as the *Gilgamesh Epic*, which celebrates the feats of Gilgamesh, legendary king of Uruk.

Both the invention of writing and the first monumental arts of this period emerged in the temple, the space of religious and ceremonial practice. In the early Mesopotamian city, temples were the first urban institutions. Dedicated to both female and male gods, temples housed daily rituals, worship of multiple deities, and occasional festivals. The gods were believed to dwell above the heights of mountains or deep in the underworld, but they also resided in the temples that people made for them, and thus served as the patrons of those cities. The temple priests and priestesses made sure that daily rituals were maintained with appropriate sacrifices and offerings so that the divinities were pleased and the order of the city was maintained. This role in appeasing the gods gave temples enormous power, but they were more than religious places: they organized agricultural production, owned large flocks, and employed craftspeople and

tournette a pivoted work surface that makes the shaping and decorating of pots easier and quicker.

coarseware a type of thick, gritty pottery used for everyday purposes.

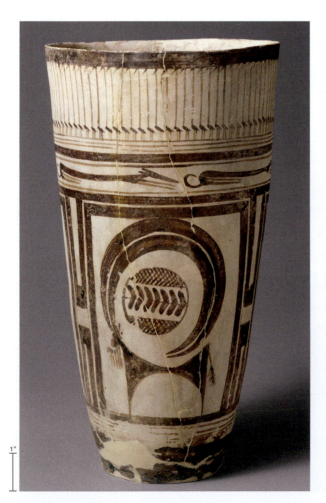

1"

3.1 FAR LEFT **Beaker with decoration of animals,** Susa, Iran, 4200–3800 BCE. Painted ceramic, height 11⅜ in. (28.9 cm), diameter 6½ in. (16.5 cm). Musée du Louvre, Paris.

merchants. Because of their economic power, temples were also sites of politics and royal sponsorship. Uruk had two such urban institutions: Kullaba (the Temple Precinct of Anu) and Eanna (the Temple Precinct of Innana). They were dedicated to the two chief deities of the city at the time: Anu, the god of heavens, and Inanna, the goddess of agricultural prosperity, abundance, and sexuality.

The development of writing in southern Mesopotamia coincides with the emergence of cities, and therefore was part and parcel of a highly innovative time. Since the earliest texts we have from Uruk are lists of commodities, archaeologists and historians have pointed out the economic role of writing as primarily a technology of exchange. Such long-distance trade was important to the economy and social organization of these early cities, since the region lacked some of the most crucial natural resources, such as building stone or quality timber for construction, precious stones for seals, jewelry, or statuary, or any metals for tools and weaponry. Approximately six thousand tablets were excavated from the Eanna Precinct at Uruk, which suggests that once invented, writing was widely adopted in Mesopotamia (see box: Making It Real: Writing in Mesopotamia, p. 70).

THE TEMPLE OF ANU AT URUK Around 3300 BCE, the Temple of Anu (**Fig. 3.2**) in the Kullaba precinct was built on a tall earthen platform, allowing the temple to rise high above Uruk's urban center, and, impressively, be visible for miles. The platform was built over previous levels of temple construction and was elaborately decorated with

niches all around. It hints at an early example of a **ziggurat**, a type of temple built during the later periods of Mesopotamian architecture (see **Fig. 3.19**, p. 79).

Constructed of mud bricks, the exterior walls of the Temple of Anu were plastered with white gypsum, giving it its modern name: the White Temple. It had a deeply niched **facade**, which created alternating light and shadow under the intense sun of southern Iraq, as well as niched surfaces in its central ritual space. The building consisted of a central, oblong ceremonial space with smaller rooms on either side. By adapting the three-room design of domestic houses for the dwellings of gods and goddesses, the builders of the Temple of Anu monumentalized house design by elevating it to the realm of the gods.

THE EANNA TEMPLE PRECINCT The architecture of the group of buildings in the Eanna ("House of Heaven") precinct was even more complex and extensive than the Temple of Anu in the Kullaba precinct. The overlapping buildings on the site's architectural plan (**Fig. 3.3**) indicate that the Eanna precinct underwent a series of construction projects in the last few centuries of the fourth millennium BCE (roughly 3300–3000 BCE).

The precinct consisted of multiple structures, including temples dedicated to the goddess Inanna, storerooms, and administrative buildings. Many of the buildings shared the deeply niched facade design of the Temple of Anu. The Riemchen Building, a rectangular building excavated in the Eanna Complex, yielded a particularly rich trove of artifacts, probably dedicated

3.2 **Temple of Anu (White Temple) at Uruk (Warka, Iraq),** c. 3300 BCE. Reconstruction proposal, 2012. Whitewashed temple, with niches, approximate area 57½ × 73 ft. (17.53 × 22.25 m).

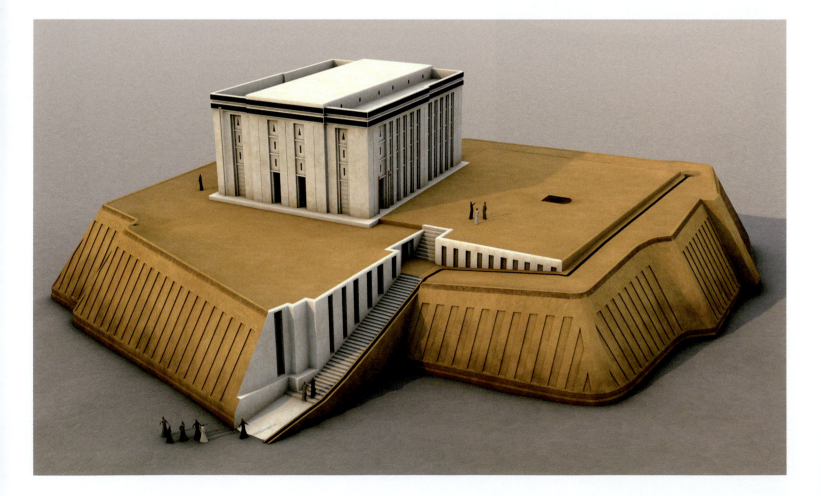

Limestone Temple

Red Temple

Ubaid Temple

cone mosaic courtyard

round pillar hall

Great Hall

Eanna precinct

City of Uruk

N

0 75 150 feet
0 25 50 meters

pillar hall

Riemchen Building

stone-cone building

Great Court

course a layer of bricks or other building units arranged horizontally along a wall.

ashlar a stone wall masonry technique using finely cut square blocks laid in precise rows, with or without mortar.

terra-cotta baked clay; also known as earthenware.

mosaic a picture or pattern made from the arrangement of small colored pieces of hard materials, such as stone, tile, or glass.

to Inanna's temple. The Limestone Temple (top right in **Fig. 3.3**) was a massive structure, measuring 250 × 98 feet (76.2 × 29.87 m)—larger than the Parthenon in Athens (see Fig. 14.3), which would not be built until more than 2,500 years later. Its foundations were built of finely cut blocks of limestone, transported from a long distance and laid in precise rows or **courses**. This **ashlar** technique was later abandoned, probably because the southern Mesopotamian plain did not have enough stone to build many such structures, making the technique unsustainable in the long term. Nevertheless, this period of innovative design is significant because it questioned older traditions and sought new forms and methods.

CONE MOSAICS Another innovation at the Eanna precinct was the use of cone mosaics to consolidate and decorate the mudbrick walls (**Fig. 3.4**). Cone-shaped pieces with a tapered, peg-like form were either fashioned from **terra-cotta** or carved from stone. The cones were then embedded into plaster to create a surface covering for walls and columns. This protected the mudbrick from the physical effects of rain, wind, and human use, giving it a longer life. Additionally, the painted tops or natural colors of these cones (usually red and black) allowed artists to create a **mosaic**-like surface decoration, bringing a playful vividness to the architecture. The designs, typically geometric, might have imitated the patterns found on reed mats and textiles used in houses. While the cone mosaics were an important innovative design in architectural technology in south-

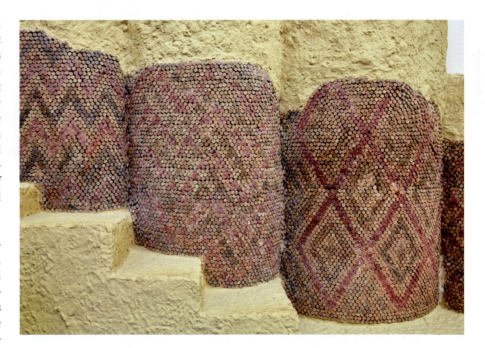

ern Mesopotamia in the Uruk period, they were later abandoned—proof that not all newly invented technologies or art forms become incorporated into long-term traditions.

URUK VASE Serving as the center stage of urban economic activity, the temple and its divinities both produced and received food and livestock, fine art objects, and the first

3.4 Cone mosaics at Uruk, (Warka, Iraq), late Uruk period, 3300–3100 BCE. Excavated at the Eanna complex. Pergamon Museum, Berlin.

Mesopotamians used a reed stylus with a triangular tip to inscribe or impress symbols into moist clay tablets (**Fig. 3.5**). This form of writing is called cuneiform, which means "wedge-shaped" in Latin. After being inscribed, tablets were either dried in the sun or—if they were particularly important—fired in a kiln. They are perhaps the most durable written documents ever created.

Cuneiform script was not invented overnight. Long before tablets, Mesopotamian merchants and administrators used small lumps of clay, known as tokens, which they incised with marks to record a numerical value for specific commodities for sale or transfer. They then deposited the tokens inside hollow clay spheres and sealed them by rolling a small cylinder across the clay, making an impression (see **Fig. 3.10**, p. 72) to prevent tampering. The impressions on the seals served as the signatures of administrative offices or individuals. The sealed hollow clay spheres, filled with tokens, served as stable, precisely detailed records of economic transactions.

3.5 Using a stylus to create cuneiform inscriptions on wet clay.

The earliest tablets from Uruk used a complex system of around nine hundred signs (see **Fig 3.6**). These signs include numbers or units of measurement, and pictograms or logograms (signs that represent and stand in for a whole word or a phrase). The pictograms drew heavily from representational elements found on seals and other media. Early in its development, therefore, writing derived substantially from pictures.

For example, as the chart shows (**Fig. 3.7**), when the ancient Sumerian language of southern Mesopotamia was first written down, a drawing of a human head stood for the word "head" (Sumerian *sag*), while a drawing of a bowl stood for "ration" (Sumerian *ninda*). As writing became more widespread and complex, pictograms gradually transformed into abstract glyphs, which were easier to write with a stylus. A glyph is a conventionalized representation that consistently stands for a word, syllable, or sound. In the most developed cuneiform writing systems, some glyphs stood for a complete word or a phrase, while others stood for syllables. That is, the latter were phonetic, or sound-based, signs.

Over the centuries, many different languages of West Asia used cuneiform script. Mesopotamian texts were written in Sumerian, and later Akkadian, Hittite, and Hurrian.

Late Uruk c. 3100 BCE	ED III c. 2400 BCE	Ur III c. 2000 BCE	Old Babylonian c. 1700 BCE	Middle Assyrian c. 1200 BCE	Neo-Babylonian c. 600 BCE	meaning of archaic sign
						sag "head"
						ninda "ration"

3.6 TOP **Early tablets from Uruk**, from the Eanna precinct. Leftmost tablet: 4 × 3⅛ × 2 in. (9.9 × 7.8 × 5 cm). Vorderasiatisches Museum, Berlin.

3.7 ABOVE **Development of the cuneiform signs for "head" and "ration"** from the earliest pictograms of the late Uruk period to the Neo-Babylonian glyphs of c. 600 BCE.

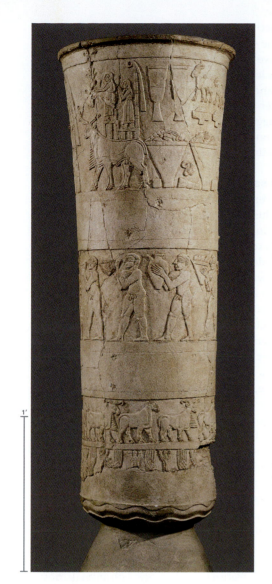

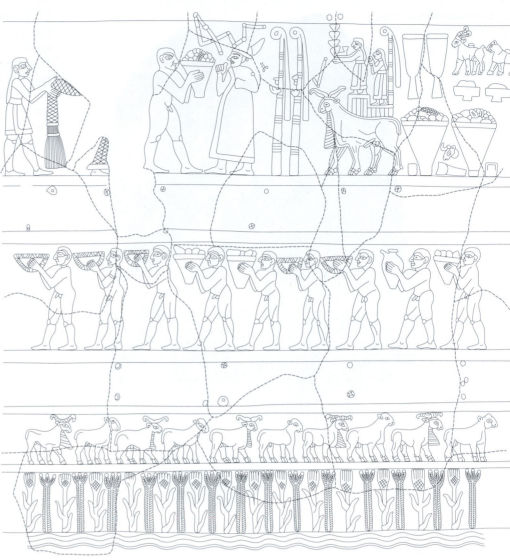

public monuments with political imagery in West Asia. Archaeologists working at Uruk's temple precincts have discovered storerooms packed full not only of small precious artifacts but also of large monuments. This carved alabaster vase (**Fig. 3.8**), over 3 feet high, was found in a storeroom in the Eanna precinct. The vase appears to have been broken and repaired in antiquity, suggesting its significance and long life in the temple. It was further damaged when it was looted from the Iraq Museum in 2003 during the U.S. invasion, but it was returned and repaired a few months later.

The vase is one of the earliest examples of **pictorial narrative**, which represents a radical innovation within Mesopotamian art, toward storytelling in pictures. The carving on the surface of the vase is divided into several horizontal **registers** (**Fig 3.8a**). In the lowest register, wavy lines define the base of the composition as water, topped with an alternating row of flax plants and date palms, although the identification of these plants is debated. Just above the vegetation, alternating rams and ewes walk to the right. This three-level base shows an ordered ecology of water, plants, and animals, most likely associated with the worship of Inanna throughout Uruk's marshy southern landscape. The vase's middle register depicts a row

of naked and clean-shaven males with defined genitalia. The men move to the left, carrying foodstuffs in baskets and vessels, perhaps a visual representation of the ritual offerings of food and drink to the gods and goddesses performed at this and other temples.

The alternating direction of movement on the vase from both left and right connects the moving bodies in the separate registers into a single procession that culminates in the top register with the presentation of offerings to a female figure, most probably the temple priestess, who wears a long robe and a headdress. A figure who seems to be overseeing the ceremony is unfortunately not preserved because of an ancient repair, but many scholars believe he was a king or similar person of importance. Just in front of where he stood, a naked male figure delivers an offering to the priestess. Behind her stands a pair of reed posts, which are a symbol of Inanna. Behind the posts, the temple compound is represented by various offerings, including the animals shown in the procession below and alabaster vases similar to the Uruk Vase itself.

LION-HUNT STELE The urban complex of Uruk does not appear to have the type of buildings that could be called a palace—the residential and administrative buildings

3.8 ABOVE LEFT **Uruk Vase,** carved with low relief representations in registers, *c.* 3200 BCE. Alabaster, height 41⅜ in. (105.1 cm). Iraq Museum, Baghdad.

3.8a ABOVE **Relief carving on the Uruk Vase (reconstruction drawing)**

pictorial narrative storytelling in pictures that presents a connected sequence of events.

register a horizontal section of a work, usually a clearly defined band or line.

3.9 Lion-Hunt Stele from Uruk, (Warka, Iraq), Eanna precinct, 3200 BCE. Basalt, height 31½ in. (80 cm). Iraq Museum, Baghdad.

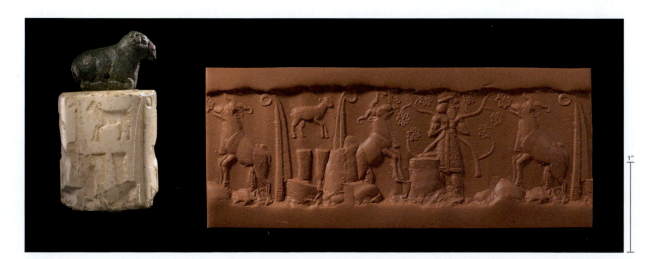

this distinctive human figure hunting lions. He appears twice in the scene, at two different scales: first with his spear (above) and then with his bow and arrow (below). He wears a long kilt and has a long beard and a bun-like hairstyle and headdress. The uneven, natural form of the boulder and the floating images on the smoothed surface suggest that this **stele** is an early example of a public monument, a medium for the expression of state ideologies in Mesopotamia.

CYLINDER SEAL The priest-king is also depicted on many Uruk seals, including this cylinder seal found in the Eanna precinct, illustrated with its modern impression (**Fig. 3.10**). Seals functioned as bureaucratic tools for administering trade and exchange. Using metal tools, artisans carved distinctive designs, typically figures, into hard precious stones. When pressed against wet clay, the stamp seal left a raised impression that acted as the signature of a merchant, official, or other important person. Storeroom doors, vessels containing foodstuffs, and even clay envelopes for letters or contracts were sealed in this way. The cylinder seal was an innovation of the Uruk period. Instead of a flat surface, the design was carved onto a round stone, which could then be rolled across the wet clay. Because of the round design, the impression could be rolled over longer spaces, creating one continuous image.

Many cylinder seals were carved from imported semiprecious stones, such as agate, hematite, or lapis lazuli—which was one of the most widely used precious stones in early Mesopotamian prestige objects. Lapis lazuli was mined in the Badakhshan Mountains of Afghanistan, indicating the Mesopotamians' involvement in long-distance trade. These stones were believed to have symbolic meaning, adding an extra layer of importance to the seals. The seal shown here was carved from marble. Its impression features a rocky scene with animals, posts, and a male figure. The man appears to be the same Uruk priest-king seen on the Lion-Hunt Stele (**Fig. 3.9**). A similar figure is found on a knife carved in Egypt, known as the Gebel el-Arak knife (see Fig. 4.2). This shared **iconography** and the discovery in Egypt of cylinder seals that were clearly made in Mesopotamia demonstrate the existence of direct or indirect contact between these ancient cultures even at this early date.

stele (plural **steles**) a carved stone slab that is placed upright and often includes commemorative imagery and/or inscriptions.

iconography images or symbols used to convey specific meanings in an artwork.

associated with a king. However, images of a bearded man wearing a kilt do appear in carvings and objects, and scholars believe this figure represents an individual with both religious and worldly power. In archaeological studies of Uruk, this figure is called a priest-king (known as *En* in later Sumerian texts) because he is often depicted as a dominating individual associated with acts related to the worship of Inanna. The Lion-Hunt Stele (**Fig. 3.9**), a roughly shaped, carved basalt boulder discovered in the Eanna precinct, includes carved representations of

3.10 Cylinder seal and its (modern) impression from Uruk, (Warka, Iraq), 3300–3100 BCE. Marble, height 2 in. (5.1 cm). Vorderasiatisches Museum, Berlin.

The Early Dynastic Period, 2950–2350 BCE

In what is now called the Early Dynastic period in Southern Mesopotamia (2950–2350 BCE), several prosperous cities, with a new urban elite, emerged. The cities of Khafajah, Eshnunna, and Ur were the capitals of relatively small regional kingdoms that controlled farming and herding territories and their networks of irrigation. These autonomous urban communities depended on agricultural production and animal husbandry, and they continued long-distance trade with Anatolia, the Persian Gulf, and beyond. They also shared religious beliefs and practices involving the worship of Mesopotamian gods and celebration of their festivals. The artifacts found in graves show an increase in precious materials and prestige goods, indicating the growth of the urban elite class. These changes in social structure, and the growing centralization of power and wealth, created conditions for major architectural projects, as well as remarkable changes in the visual arts and burial practices under the sponsorship of the temple institutions and the new elite class.

VOTIVE FIGURES During the Early Dynastic period, temples remained the most important urban institution, and individuals and families continued to make offerings to the deities enshrined in them. Such gifts often took the form of carved stone plaques, metal objects, and votive statues. Placed in a cult room where rituals were held, **votive** statues allowed their donors to be in the presence of the divine. In return for these gifts, the donors expected the god or goddess to protect them from harm and bring them good fortune.

A remarkable treasure trove of votive statues comes from the Temple of Abu in Eshnunna (present-day Tell Asmar, Iraq). They were excavated in a cult room, where they had been buried in antiquity under the floor behind the altar. The statues were carved from veined gypsum—a soft stone—at a variety of scales, using **abstract formalism**: several of the bodies have conical shapes, cylindrical legs, and square sections (**Fig. 3.11**). The legs, many of which were shaped to be viewed only from the front, serve as pillars that carry the whole body. Each statue has a rectangular base to keep the figure standing upright.

Most of the male votives have long beards and hair, elaborately detailed with horizontal wave-like patterns, and most of the females have braided hair. The majority of the figures wear skirts that end with a row of tassels, while a few wear ceremonial sheepskin skirts delicately carved into the gypsum. Some of the women have one shoulder exposed. All of the votives share two distinctive features. First, their hands are clasped on their breasts in a pose of veneration, ready to hold **libation** cups for their ritual liquid offerings. Second, they have large **inlaid** eyes made of bright materials: shell for the cornea and

votive an image or object created as a devotional offering to a deity.

abstract formalism an approach to art in which forms are made abstract by simplifying their shapes and structures.

libation the ritual pouring of a liquid, often alcohol, to a spirit or deity as an offering while prayers are said.

inlay decoration embedded into the surface of a base material.

3.11 Votive figures from the Temple of Abu, Eshnunna (Tell Asmar, Iraq), 2750–2600 BCE. Gypsum, limestone, and alabaster with eyes inlaid with shell, black limestone, and lapis lazuli, largest figure height 29⅞ in. (75.9 cm). The Oriental Institute Museum, University of Chicago.

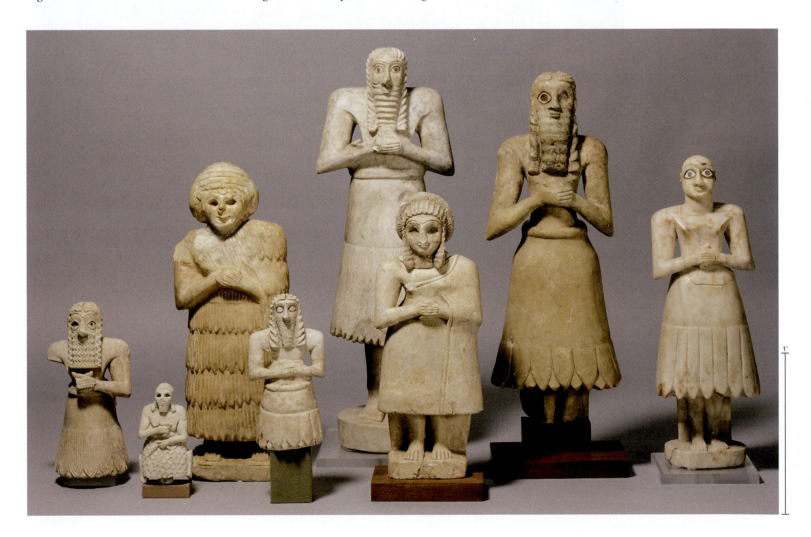

black limestone or lapis lazuli for the iris. These eyes give the votives an intense gaze, which would have been fixed on the image of the deity in the temple. We do not know the social status of the individuals represented, but because the statues are not inscribed, we do know that they were not royal. The form of these votive statues was borrowed by later Mesopotamian kings who had similar statues carved from more precious and durable stones, such as diorite.

ROYAL TOMBS OF UR One of the most prominent cities of the late third millennium BCE (the last few centuries before 2000 BCE) was Ur, the modern site of Tell el-Muqayyar in southern Iraq, home to an important sanctuary complex dedicated to the moon god, Nanna. Royal tombs excavated at Ur by archaeologists between 1922 and 1934 present evidence of elite power, long-distance trade, and artistic production.

While digging at the southwestern corner of Nanna's temple, archaeologists found and excavated nearly two thousand burials in a massive and very deep burial ground that dated to long before the construction of Ur Namma's temple complex, and, based on the architecture of the finds and the goods buried with the deceased, they identified sixteen royal tombs. In a few cases, including the tomb of Queen Puabi (Tomb 800), a retinue of individuals was ritually buried with the elite individual. Up to seventy-five people were buried simultaneously, wearing ritual garments and holding musical instruments or ceremonial objects. All members of the entourage held a small cup from which they may have drunk poison at the height of the ceremony, and some skulls show evidence that they died of blows to the head, suggesting human sacrifice. The wealth of artifacts within the royal tombs provide a rare window into urban life in the third millennium BCE, and demonstrate the complexity of technologies of production, the artistic skills, and the extent of long distance trade in Mesopotamia at the time.

ROYAL STANDARD OF UR One of the most intriguing finds in the burial ground is the Royal Standard of Ur, which was discovered in a man's tomb, Tomb PG 779. The Royal

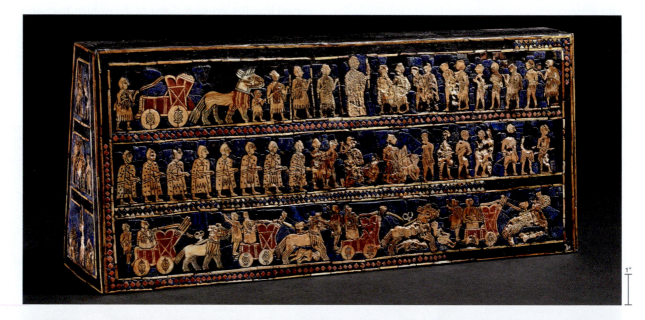

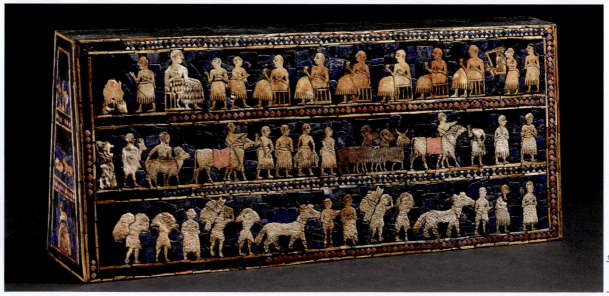

3.12a ABOVE RIGHT **Royal Standard of Ur, battle side.** From Tomb 779, Royal Tombs of Ur (Tell el-Muqayyar, Iraq), Early Dynastic IIIA period, 2550–2400 BCE. Wood inlaid with shell, lapis lazuli, red limestone, and bitumen, 7⅞ in. × 18½ in. (20 × 47 cm). British Museum, London.

3.12b RIGHT **Royal Standard of Ur, feast side.**

Standard is a hollow wooden trapezoidal box, decorated on four sides with inlaid mosaic scenes made from shell, red limestone, and lapis lazuli, and set in bitumen (a naturally occurring black viscous mixture that acts as a sort of glue or binder). Leonard Woolley, a British archaeologist who excavated at Ur, called this mysterious object a standard (a ceremonial banner) because he assumed that it would have been raised on a pole and perhaps used in funerary or other ritual processions, similar to the standards depicted on the Egyptian palette of Narmer (see Fig. 4.3). Scholars are now skeptical of Woolley's interpretation, but other theories of the object's original use have not been verified.

Whatever its function, the standard provides an early example of a pictorial narrative in which political conflict, war, and feasting are linked in a cause-and-effect relationship. Each of its two main faces depicts different episodes in a narrative divided into three horizontal registers, with concluding scenes on the top register. One face depicts a battle and the subsequent capture of prisoners of war, who are then presented to a person of high status (**Fig. 3.12a**). In the bottom register, chariots, each drawn by four onagers (a species of wild ass or horse), trample over the naked bodies of defeated enemies. The scene continues in the middle register with a group of armed soldiers taking their naked enemies prisoner. In the top register, the captives are presented to the centrally placed ruler. The use of **hierarchical scale** depicts him as slightly taller than the others, and his dominant position in the scene suggests his status as a leader. Accompanying him are courtiers holding instruments. The chariot at the far left is perhaps reserved for the ruler.

The standard's other main face also depicts people moving across the three registers. On the top register, the narrative involves a celebration in the form of a banquet (**Fig. 3.12b**). One figure, slightly larger than the others, dominates the scene. He is seated, holding a cup and wearing the ceremonial flounced skirt that is common in representations of elite people in early Mesopotamian art (see **Fig. 3.11**, p. 73, for example). He is facing the other banqueters, who are entertained by what appear to be a lyre player and a singer on the far right. The lower two registers illustrate long processions of people bringing animals and various goods, perhaps as tribute to their ruler. Interestingly, the lyre's front is decorated with a bull's head similar to that from the Great Lyre of Ur (**Fig 3.13**.)

GREAT LYRE OF UR Another spectacular find from the Royal Tombs of Ur is the Great Lyre (**Fig. 3.13**), found within a king's tomb (Tomb 789) that was looted in antiquity. Lyres must have been popular musical instruments for the funeral ceremonies at Ur, because the Royal Tombs contained several of them. The wooden core of the lyre's eleven-stringed soundbox has disintegrated, but the delicately inlaid and constructed front of the lyre was preserved. It was found adjacent to the bodies of elaborately dressed women who took part in the burial ceremony.

The front of the lyre has an inlaid base and is topped with a bearded bull's head sheathed in gold. Below the bull's head, four registers of narrative scenes are inlaid

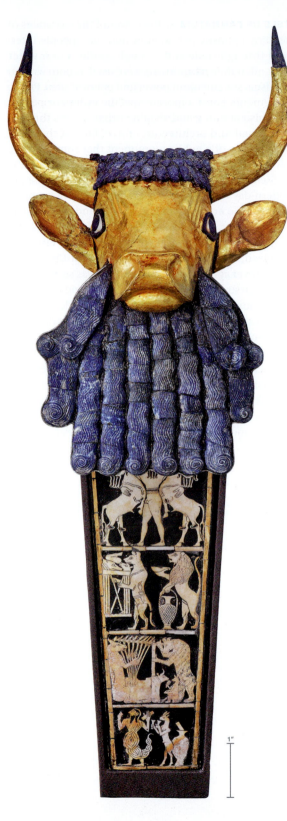

3.13 **Great Lyre with bearded bull's head,** from Tomb 789, Royal Tombs of Ur (Tell el-Muqayyar, Iraq), Early Dynastic IIIA period, 2550–2400 BCE. Wood, gold, silver, lapis lazuli, shell, and bitumen, length 15¾ in. (40 cm), width 9⅞ in. (25 cm), depth 7½ in. (19 cm). University of Pennsylvania Museum of Archaeology and Anthropology, Philadelphia.

1"

with shell on bitumen. These scenes depict animals engaged in activities normally associated with humans, such as butchering meat, carrying and pouring liquid from vessels, and playing musical instruments. In the top scene, a naked hero uses his arms to control two human-headed bulls who stare at the viewer. Taken together, the scenes seem to present either funerary rites or the afterlife in the underworld, but with animals taking on human roles.

hierarchical scale the use of size to denote the relative importance of subjects in an artwork.

STELE OF EANNATUM As the power of the city-states of the Early Dynastic period grew and their people interacted through trade and through conflicts over water and land, public monuments were used as both written and visual statements of power and political sites. Public monuments commemorate specific events or people while also defining and shaping urban spaces through their visual and architectural force. One of the earliest examples of a public monument that combines the power of inscription with the force of visual narratives is the Stele of Eannatum from the kingdom of Lagash, in modern-day Iraq (**Fig. 3.14**). This limestone monument, dated to 2460 BCE, was an imposing round-topped stele of nearly 6 feet. Preserved only in several fragments, it is primarily a victory monument erected by the city-state of Lagash, which defeated the city-state of Umma in a dispute over agricultural territory that was sacred to the god Ningirsu, the storm god and patron god of Lagash. The monument was a legal contract that settled the land dispute and formalized the agreement by marking the agreed-upon border.

The visual composition tells the story of this important victory for Lagash from two different perspectives, one historical and the other mythological. On one side (the left in **Fig. 3.14**), the story of the battle is arranged in four registers. Art historians have suggested a bottom-to-top sequential reading of this narrative, culminating in the military victory of Lagash's king, Eannatum, who appears in the top two registers and is recognizable by the ceremonial sheepskin he wears. In the second register from the top, he leads his army in a chariot. In the top register, he leads them on foot. The right side of the top register shows the violent and gruesome consequences of the war with a heap of naked and dead Umma soldiers, whose heads are picked up and carried away by vultures.

The reverse side depicts the mythological gathering considered to be the main agents of Lagash's victory. The god Ningirsu holds the Umma soldiers in his mythical battle net (upper right) and keeps them in order with his ceremonial mace. He is accompanied by his mother, the Lady of the Mountain, and by the lion-headed eagle Anzu (upper left). The two sides of the Stele of Eannatum therefore commemorate Lagash's defeat of Umma both as a historical event and as a mythologically inevitable outcome. The Sumerian text (not shown in the reconstructed drawing) is inscribed in the highly pictographic cuneiform script of the time and fills in the negative spaces of the images. This text tells the same story in a different way: King Eannatum decides to battle Umma and goes to the temple to receive divine instruction. There, in a dream, he is told that the corpses of his enemies will form a mound reaching the base of heaven. A section of the text is missing, but the last section of the inscription summarizes how Eannatum took up arms against Umma.

3.14 Stele of Eannatum (reconstruction drawing), from Girsu (Tello, Iraq), *c.* 2460 BCE. Sections in white are drawings of the actual fragments while the yellow parts are conjectural. 5 ft. 10⅞ in. × 51⅛ in. × 4⅜ in. (1.8 × 1.3 × 0.11 m). Musée du Louvre, Paris.

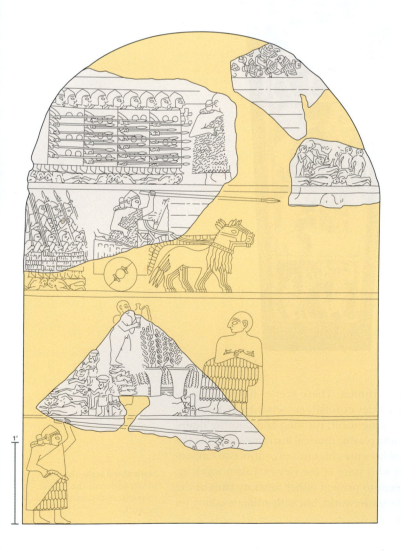

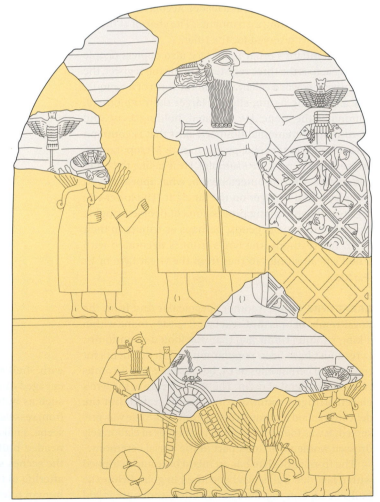

The Akkadian Empire, 2334–2193 BCE

Mesopotamia saw a number of dramatic transformations in the last few centuries of the third millennium BCE (roughly from 2350 BCE onward). Around 2350 BCE, the kings of Agade, a territorially ambitious state also known as the Akkadian Kingdom, attempted to unify politically the vast cultural and physical landscape of northern and southern Mesopotamia. Starting with the long transformational reign of Sargon (ruled 2334–2279 BCE), the first ruler of the empire, kings of the dynasty governed from the capital city of Agade, the site of which has yet to be discovered. While temples were the dominant economic institutions in urban centers earlier in the third millennium BCE, with the Akkadian rule, another competing institution began to play a vital role: the palace. As the king became a more powerful, idealized, and charismatic ruler in a very centralized political administration, representations of the king were altered to reflect this new ideology. Toward the end of the Akkadian period, the king even achieved a divine character.

HEAD OF AKKADIAN RULER This copper alloy head of an Akkadian ruler (**Fig. 3.15**) illustrates the new perception of Mesopotamian rulers in art. Found in the Temple of Ishtar in the ancient city of Nineveh in present-day Iraq, the oversized head depicts a ruler (possibly Naram-Sin, Sargon's grandson) with balanced, serene, powerful, and confident features. His long hair is braided and wrapped around his head, as in earlier images of kings (see **Fig. 3.9**, p. 72), and the curls of his long, full beard flow down from his face. His eyes would have been made from precious stones, but they were gouged out (along with his ears) at a later date, perhaps in protest against the Akkadians. The naturalism of the nose and texture of the face are blended with the abstraction used for other features, such as the arched eyebrows and heavily textured beard. This head is the earliest example of the **lost-wax** technique for casting bronze and other alloys (see box: Making It Real: Lost-Wax Casting Techniques for Copper Alloys, p. 62). The production of this Akkadian statue marks an important turning point in metallurgical arts, and its highly detailed portraiture points to the increased interest of Mesopotamian craftsmen of the late third millennium BCE in representing the human body accurately.

STELE OF NARAM-SIN This same type of confident and powerful king is seen striding up the mountain in the Stele of Naram-Sin (**Fig. 3.16**, p. 78), originally displayed in a public space in the city of Sippar. Sargon and other Akkadian kings continued the much earlier practice of carving public monuments on stone steles (see **Figs. 3.9**, p. 72 and **3.13**, p. 75), but these newer monuments depicted fewer divine actors and acts of devotion. Instead, they focused on military conflict and victories at the frontiers of the Akkadian kingdom. The primary figures are no longer gods and goddesses in human form, but the fully empowered Akkadian rulers themselves. This large (6 ft. 6 in.) monument commemorates the military victory of the Akkadian ruler Naram-Sin (ruled 2254–2218 BCE) over the Lullubi, who occupied the eastern Zagros Mountains (in the present-day Kurdish regions of Iraq and Iran).

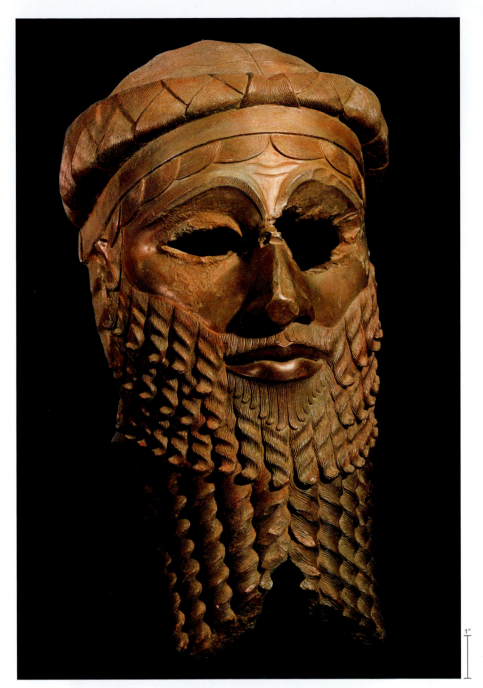

The stele represents a stunning break from the visual conventions of previous Mesopotamian stele monuments, as it eliminates the horizontal registers that were known from earlier monuments. The entire victory narrative is unified into a single scene, framed in the form of the mountain landscape itself, mimicking the great mountain represented on it. In this landscape scene, the figure of Naram-Sin immediately commands attention. He is semi-nude, muscular, bearded, and larger than all the other figures. He stands victorious, holding a bow and arrow and facing the mountain. On the left he is flanked by ordered rows of Akkadian soldiers, in contrast to the disarray of the Lullubi, who beg for mercy on the right. His broad, frontally depicted torso and his upward step emphasize his power. The deities of earlier Mesopotamian monuments, who played a major role in the visual storytelling, are now relegated to the sky at

3.15 Head of an Akkadian ruler, temple of Ishtar, Nineveh (Mosul, Iraq), Akkadian period, c. 2250–2220 BCE. Copper alloy, height 14⅜ in. (36.5 cm). Iraq Museum, Baghdad.

lost-wax casting a method of creating metal sculpture in which a clay mold surrounds a wax model and is then fired. When the wax melts away, molten metal is poured in to fill the space.

3.16 RIGHT **Stele of Naram-Sin,** found in Susa, Iran, Akkadian period, 2254–2218 BCE. Limestone, height 6 ft. 6¾ in. (2 m). Musée du Louvre, Paris.

3.17 FAR RIGHT **Disk of Enheduanna,** found in Ur (Tel el-Muqayyar, Iraq), c. 2300–2275 BCE. Alabaster, diameter 10 in. (25.4 cm). University of Pennsylvania Museum of Archaeology and Anthropology, Philadelphia.

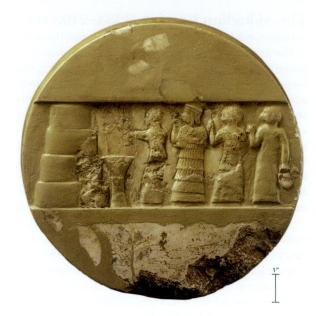

as attested by the women's seals and seal impressions found in the cities. Enheduanna, daughter of Sargon, is the first known author in human history with a recorded name. The high priestess of the moon god Nanna in Ur, she was also the author of a series of temple hymns and devotions to the goddess Inanna.

A cuneiform inscription on the back of an alabaster disk (**Fig. 3.17**) found in Ur identifies the main figure as Enheduanna, "wife" of Nanna and daughter of Sargon. The procession, carved in low relief, shows four people approaching a ziggurat or series of temple platforms, before which stands an altar. A naked man, perhaps a priest, pours a libation to dedicate the altar. Enheduanna is carved slightly larger than the other figures. She wears the ceremonial headdress of a high priestess and a flounced woolen garment. Together with the two female attendants behind her, Enheduanna raises her hand in a ritual greeting to the god.

Caring for the Cattle Pen and the Sheepfold, *c.* 2200–2000 BCE

After the collapse of the Akkadian empire around 2200 BCE, the city-states of southern Mesopotamia reasserted their regional power. These rulers in the south—such as the Second Dynasty of Lagash and the Third Dynasty of Ur—were much more closely tied to the long traditions of Mesopotamian sociopolitical life and culture and were eager to claim the heritage of long-term artistic and literary traditions. Whereas Akkadian rulers had based their reign on military power, territorial expansion, and violence, the rulers in the south built their notion of kingship on caring for their subjects. They called themselves "shepherds" and thought of their cities and temples as cattle pens and sheepfolds where their residents were protected. They were relatively peaceful statesmen who were devoted builders of temples and sponsors of the arts and literature. From the time of the kings of Ur and Lagash in the late third millennium BCE, we have an abundance of literary texts, exquisitely made and inscribed statues, and magnificently built temple complexes.

the top of the stele where they dwell above the mountain, and they are reduced to geometric symbols: two stars. Naram-Sin wears the double-horned crown that is usually associated with divine figures, announcing the ruler's claim to divine status. The narrative is unified in a single scene carved in **low relief**, framed in the shape of the mountainous landscape and resembling the mountain that it represents. The plants depicted on the stele correspond to very specific and identifiable species of trees. This and other details on the stele reinforce the idea that it depicts an actual event.

low relief (also called bas-relief) raised forms that project only slightly from a flat background.

DISK OF ENHEDUANNA Women of the Akkadian royal and elite families held important positions across the empire,

STATUES OF GUDEA Perhaps the best-known ruler of the period is Gudea (ruled 2144–2124 BCE), the *ensi* (ruler, or "lord of the plowland" in Sumerian) of Lagash. Carving votive statues of rulers from hard, dark, exotic stones, such as diorite, chlorite, or steatite, and dedicating them to a specific deity, was widely practiced by both Egyptian and Mesopotamian rulers in the third millennium BCE as a sign of royalty. Gudea commissioned many statues of himself during his lifetime, including this seated statue dedicated to Ningishzida, god of vegetation and the underworld (**Fig. 3.18**). The stone's hard surface is finely finished, well polished, and shiny, creating a dramatic sense of permanence.

There are twenty-seven statues of Gudea in various museums around the world. Some of these were excavated archaeologically between 1909 and 1929 at the site of Girsu (Tello, Iraq), while others have been looted from the site and illegally circulated. In these statues, Gudea is depicted standing in various gestures and poses of veneration and devotion, or seated, as he is here (**Fig. 3.18**). His prominent hands are clasped, his heavy-rimmed eyes seem attentive, and his body is expressive. Artfully composed and carved texts in Sumerian cuneiform cover the lower parts of his robe. His clean-shaven face and royal woolen cap with stylized curls suggest his religious dedication. Although far more pious in appearance than Naram-Sin, his cloak leaves one of his arms exposed, allowing him to display his well-shaped musculature; his rippling arms are actually discussed in the inscriptions. The stone for these statues was acquired from the Land of Magan (probably somewhere near the present-day United Arab Emirates and Oman), which was a known source of diorite. It seems likely that, although these statues were first and foremost religious and ritual objects that were not for public viewing, Gudea had them created in diorite to announce his control of the stone's sources.

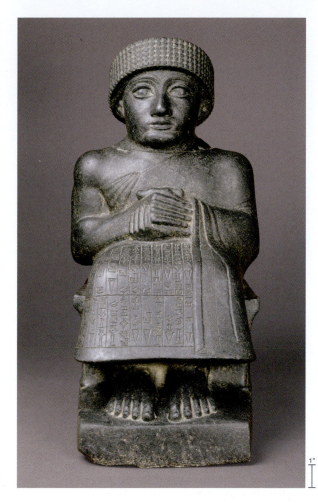

3.18 Seated statue of Gudea, ruler of Lagash, dedicated to the god Ningishzida, Girsu (Tello, Iraq), *c.* 2120 BCE. Diorite, 18⅛ × 13 in. × 8⅞ in. (46 × 33 × 22.5 cm). Musée du Louvre, Paris.

THE ZIGGURAT AT UR The major sanctuaries at the cities of Ur and Nippur were venerated across all Mesopotamia and thus transcended the political control of any particular ruler. The kings of the Third Dynasty of Ur played

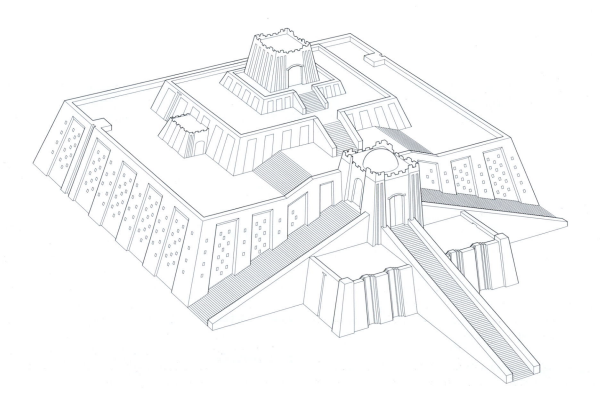

3.19 Ziggurat at the Sanctuary of the Moon God Nanna (reconstruction drawing), Third Dynasty of Ur (Tell el-Muqayyar, Iraq). Built at the time of Ur Namma (ruled 2112–2095 BCE).

orthogonal plan an architectural or urban plan in which streets or passages intersect at right angles, forming a grid pattern.

a particularly important role by sponsoring temple building (of which the ziggurat, **Fig. 3.19**, p. 79, formed a part), and formalized the architecture of the Mesopotamian temple through several major building projects. By the third millennium BCE, major sanctuary complexes had become collective sites of pilgrimage for the entire Syro-Mesopotamian world, and therefore the sponsorship of building projects at such sites was a matter of competition among Mesopotamian kings. Massive sanctuary compounds were designed with carefully planned courtyards and palace-like structures. The key monument in these expansive temple compounds, and the primary site of religious rituals, was the ziggurat, which raised the holy shrine of the gods and goddesses closer to the heavens. Staircases and gates gave access to the shrine, but the highest spaces were reserved for only the priestesses and priests.

A prime example of **orthogonally planned** architecture, the Sanctuary of the moon god Nanna underwent an extensive construction project during the reign of Ur Namma of Sumer (ruled 2112–2095 BCE), accommodating and encasing earlier buildings while far exceeding them in scale. The ziggurat at Ur, built around 2100 BCE, has three large sets of stairs and is encased in baked bricks. Each brick is individually inscribed with the name of Ur Namma as the pious patron who paid for the ziggurat's construction. Covering the massive structure (210 × 148 feet (64.01 × 45.11 m) at the base, and possibly 100 feet (30.48 m) high) were bricks that protected it against weathering by wind or rain. Little remains of most ziggurats in Mesopotamia, but the one at Ur has been partially restored after its brick structure deteriorated over the millennia.

Around 2000 BCE, the Mesopotamian states and their production of art paused after the collapse of the Third Dynasty of Ur. For the next few centuries, no stable power unified the city-states of Mesopotamia. Conflicts among competing empires caused shifting allegiances and disrupted agriculture and trade. The epic poems, known as the city laments, written after this period speak of the destruction of the cities and their eventual restoration (see Chapter 5).

Discussion Questions

1. Compare the architectural technologies of Uruk-period buildings and the Early Dynastic structures, including techniques of wall decoration, building materials, and monumentality.

2. Many of the artworks discussed in this chapter include vivid images of animals. How are they represented, and what do these representations tell us about the significance of animals in ancient Mesopotamia?

3. Compare and contrast the Stele of Eannatum and the Stele of Naram-Sin in terms of their visual and iconographic aspects, how the ruler's body is represented, how a historical event is depicted, and the way space and landscape are used.

Further Reading

- Bahrani, Zainab. "Performativity and the Image: Narrative, Representation, and the Uruk Vase." In E. Ehrenberg (ed.) *Leaving No Stones Unturned: Essays on the Ancient Near East and Egypt in Honor of Donald P. Hansen*. Winona Lake, IN: Eisenbrauns, 2002, pp. 15–22.

- Pollock, Susan. "The Royal Cemetery of Ur: Ritual, Tradition, and the Creation of Subjects." In M. Heinz and M. H. Feldman (eds.) *Representations of Political Power: Case Histories from Times of Change and Dissolving Order in the Ancient Near East*. Winona Lake, IN: Eisenbrauns, 2007, pp. 89–110.

- Winter, Irene J. "After the Battle Is Over: 'The Stele of the Vultures' and the Beginning of Historical Narrative in the Art of the Ancient Near East." *Studies in the History of Art* 16 (1985): 11–32.

Chronology

Before c. 5500 BCE	The first farming communities develop in the Fertile Crescent of Mesopotamia	**c. 2460 BCE**	The Stele of Eannatum is set up
c. 5500–3800 BCE	The Ubaid period in southern Mesopotamia	**2334–2193 BCE**	The Akkadian dynasty, founded by Sargon, comes to rule an empire including Mesopotamia and extending into Iran and the Anatolian foothills
c. 3800–3100 BCE	The Uruk period; urbanization begins; cuneiform writing develops; public monuments and great temple precincts are built		
		2254–2218 BCE	The Rule of Akkadian king Naram-Sin, who sets up a victory stele in the city of Sippar
c. 3300 BCE	The Temple of Anu is constructed at Uruk	**c. 2200 BCE**	The city-states of southern Mesopotamia reassert their power after the collapse of the Akkadian empire
c. 3300–3000 BCE	The Eanna complex undergoes major new construction and architectural experimentation at Uruk		
2950–2350 BCE	The Early Dynastic period; prosperous cities with a new urban elite rise in the small kingdoms of southern Mesopotamia	**2144–2124 BCE**	King Gudea of Lagash sets up numerous hard stone statues of himself
2600–2350 BCE	The Royal Tombs are constructed at Ur	**2112–2095 BCE**	King Ur Namma, of Third dynasty of Ur, builds a ziggurat and expands the Sanctuary of Nanna, God of the Moon

4

Egyptian Art from the Predynastic Nile Valley through the Old Kingdom

4000–2000 BCE

Fourth Dynasty Ruler Khafre
(detail), Egypt, Old Kingdom.

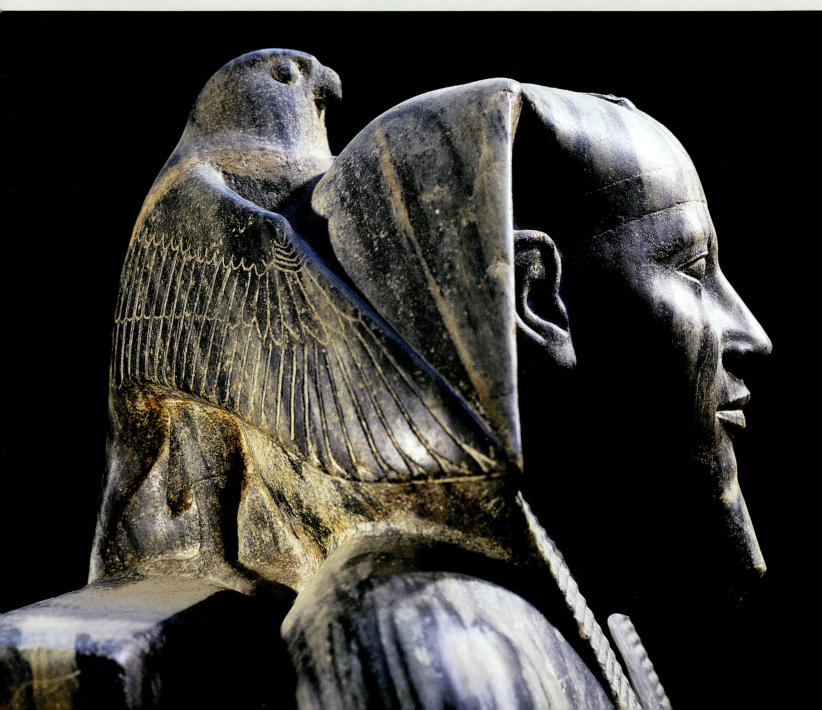

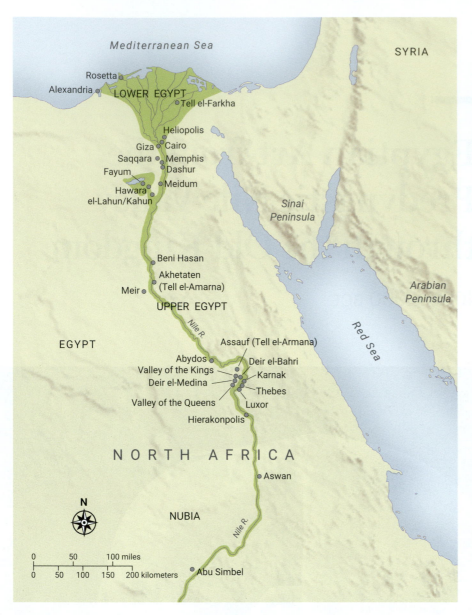

Beginning in the fourth millennium BCE, during the Predynastic period, two culturally distinct zones emerged in Egypt's political landscape: Lower Egypt in the north and Upper Egypt in the south (see Map 4.1). While these two areas sometimes co-existed peacefully, and at other times competed for power, the idea of a unified Lower and Upper Egypt held considerable political and social significance for Egyptians.

Much later, during the early part of the Old Kingdom, Egyptian kings used the concept of *ma'at* to legitimize their power. *Ma'at* was associated with earthly order and social cohesion, which were linked to the regular seasonal cycle of planting and flooding. *Ma'at* is sometimes characterized as a protective goddess, but since earthly order was a fragile state, other Egyptian gods, particularly Horus, were responsible for fighting any chaotic forces that threatened it. The kings of the Old Kingdom associated themselves with Horus as the preservers of *ma'at*, thus intimately linking themselves to the struggle between chaos and social order. Much of the ancient Egyptian art that survives today relates to this conception of the world. The significant resources Egyptians dedicated to the construction and adornment of royal tombs during the Old Kingdom show the importance of the ruler's death and rebirth as the god Osiris in the ongoing preservation of *ma'at* in the Egyptian state. The objects, sculpture, and paintings in these elaborate tombs and pyramids were believed to constitute the objects and people needed to provide for the ruler in the afterlife. In addition, the durable materials and depictions of rulers as idealized, powerful, serious people reinforced Egyptian ideas of permanence, stability, and eternal order.

While the ancient Egyptians' art often reflected this orderly, cyclical view of the world and the afterlife, it also included vibrant episodes of innovation and significant change. Over the roughly 2,000 years from the beginning of the Predynastic period to the end of the Old Kingdom, Egyptians unified Upper and Lower Egypt, invented a form of writing, built urban centers and large burial sites, and developed some of the most enduring and recognizable imagery of any ancient culture.

Map 4.1 The ancient Nile Valley: Upper and Lower Egypt.

Introduction

Ancient Egypt left a lasting imprint on the history of art, with funerary monuments such as the pyramids of Giza and the Great Sphinx, intricate rituals and objects designed to enhance life after death, and a remarkable legacy of visual representation. The history of ancient Egypt is intertwined with its most important water source, the Nile River, which runs northward from the middle of present-day Sudan, through Egypt, and into the broad, fertile delta feeding into the Mediterranean Sea. The Nile's annual flood season (*akhet*) delivered mineral-rich soils to Egypt's fields and continually improved the agricultural land. This natural cycle created a regular calendar for cultivating and harvesting crops; it also influenced Egyptians' conception of cosmic order and time. For Egyptian communities, the Nile was both the source of their livelihood and the center of life. Ancient Egyptians referred to the area along the Nile as *Kemet*, meaning "black land" —referring to the highly fertile alluvial soils of the Nile valley—and the arid desert as "red land" (*Deshret*).

material culture the materials, objects and technologies that accompany everyday life.

The Predynastic Nile Valley, before *c.* 3000 BCE

After about 3400 BCE onward in Upper Egypt, before the unification of Egypt under a single ruler, urban centers such as Hierakonpolis and Abydos developed alongside ritual sites in the southern part of the Nile Valley. These centers had rich, diverse traditions of funerary and ritual architecture, and would later be associated with the origins of Egyptian kingship and divinely ordained political power. Recent excavations in their cemeteries reveal grave goods that reflected the wealth of an emerging urban elite class. Many men and women were buried with precious jewelry, beads, cosmetic palettes, and figurines carved in stone and ivory (and presumably also wood, which has not survived over time). These urban communities shared a unified **material culture**, including the style and techniques used to make these objects and to build the structures to commemorate the burials. The art and architecture of these burial practices would

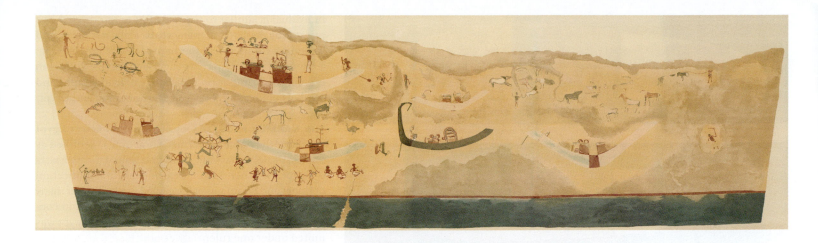

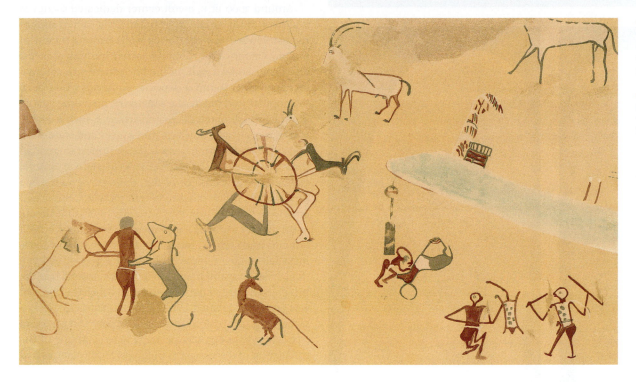

4.1 Copy of a wall painting from Tomb 100, Hierakonpolis, Egypt. Predynastic period, *c.* 3500 BCE. Watercolor painting by Joel Paulson.

4.1a Detail of watercolor copy of wall painting from Tomb 100, showing people fighting and hunting, and domesticated animals.

later form the basis for the iconic Egyptian pyramid complexes that are well known today.

TOMB PAINTING AT HIERAKONPOLIS The ancient city of Nekhen, now Hierakonpolis, was associated with the cult of Horus (usually depicted as a falcon-headed man), later known as the god of kingship. Several elite cemeteries in the city contained elaborate burials of humans and animals together, indicating close relationships between the species. A wall painting in a tomb at Hierakonpolis, dating to the mid-fourth millennium BCE, (*c.* 3500) was reproduced in this late nineteenth-century facsimile before the condition of the original wall deteriorated (**Fig. 4.1**). Ancient artists had applied red, white and black pigment to the plastered mudbrick to depict a variety of everyday human activity along the Nile River, including fighting, hunting, and herding, in a seemingly unstructured way (**Fig. 4.1a**). Boats travel on the river, including white U-shaped open galleys carrying food and other cargo, and one large black boat with a high prow, used for seafaring in the Mediterranean. Though the figures are grouped into different activities and interact with one another, they are not organized in **registers** or any other strict spatial composition. The artist does not distinguish water from land, and people and animals stand in areas in which the boats are presumably floating. The people, animals, and boats are seen as if from ground level, but the river appears to be seen from above. This informal representation of space later gave way to a more rigid, organized, and **hierarchical** use of space that would persist into the New Kingdom and the end of the Bronze Age (*c.* 1200 BCE).

GEBEL EL-ARAK KNIFE Although people in Upper Egypt independently developed cities, writing, and an early state organization at about the same time that these also arose in southern Mesopotamia, there were many instances of cultural exchange between those regions. An example of cultural interaction between Egypt and West Asia is the Gebel el-Arak knife (**Fig. 4.2**, p. 84), from the village of Gebel el-Arak near Abydos, made around the same time as the Hierakonpolis tomb painting.

register a horizontal section of a work, usually a clearly defined band or line.

hierarchical scale the use of size to denote the relative importance of subjects in an artwork.

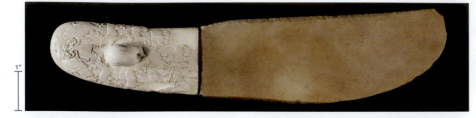

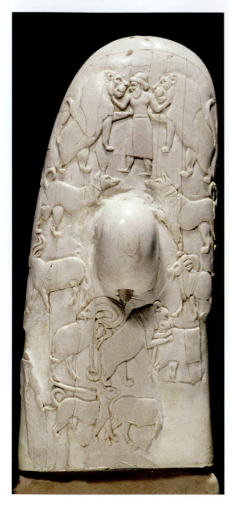
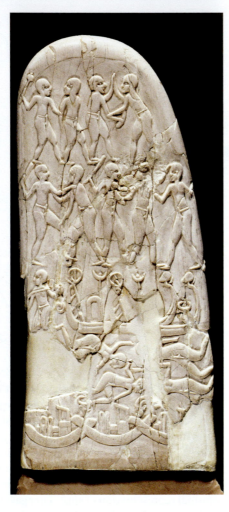

4.2 TOP AND CENTER **Gebel el-Arak knife (both sides),** Gebel el-Arak, Egypt, 3450–3300 BCE. Flint knife and hippopotamus (?) ivory handle, length 10 in. (25.4 cm). Musée du Louvre, Paris.

4.2a ABOVE LEFT and RIGHT
Details of the ivory handle of the Gebel el-Arak knife.

individual is similar to the male figure interpreted as a priest-king depicted in many **seals**, alabaster vases, and sculptures from Uruk in southern Mesopotamia (see Fig. 3.10), and art historians have suggested that the knife is an example of an intentional exchange of **iconography** and symbols of kingship between Mesopotamia and Egypt.

THE NARMER PALETTE Objects found at Lower Egypt sites bear the name of Narmer, sometimes identified as Menes, the legendary king who first united the two parts of Egypt. Whether the political and cultural unification of Upper and Lower Egypt happened gradually over many years, or more quickly through military force and conquests is uncertain, but by *c.* 3050 BCE, all of Egypt was united under one ruler.

Around 3000 BCE, a cult center dedicated to Horus had been built at Hierakonpolis. This sacred monument included low mudbrick walls around a central mound. On top of the mound was a shrine built of reeds, also enclosed by a wall. In the late nineteenth century, archaeologists found a deposit of offerings in a deep rectangular well inside the sanctuary, including a large number of elaborately decorated artifacts, such as stone-carved maceheads, palettes, flint knives and statuettes, and stone and ceramic vessels. Most important among these artifacts was the Narmer Palette (**Fig. 4.3**), a large, elaborately carved piece of flat, dark gray-green stone (graywacke), which dates to before 3000 BCE. Stone palettes were used for grinding minerals such as malachite (a bright green stone) and preparing eye paint for both humans and statues, but the Narmer Palette was likely intended to be a temple offering for a god—it is more than 2 feet long and much too heavy for normal use. On this palette, the circular depression in which the pigment was ground is created by the intertwined necks of two serpopards, a mythical hybrid of a serpent and a leopard (see left side of **Fig. 4.3**), perhaps here symbolic of the unification of the two parts of Egypt. Many palettes had a plain side, but on some, including the Narmer Palette, both surfaces are covered with **low relief**.

The Narmer Palette features some of the earliest representations of kingship in Egypt and also an early example of **hieroglyphic** writing: the king's name is written in the top center on both sides of the palette as a rectangular image of a palace entrance enclosing a catfish (the word for which was *n'r*) above a chisel (the word *mr*), which together can be read as "Narmer." In scenes separated by register lines, the king is represented multiple times and at various scales. On one side (the right side of **Fig. 4.3**), Narmer occupies the center. He is represented at hierarchical scale, striking a kneeling enemy with his ceremonial mace. He is observed by a falcon representing the god Horus, the divine protector of the king, who is believed to be his human manifestation. The falcon perches on a papyrus plant (later a symbol of Lower Egypt) and holds a leash attached to the nose of a captive's severed head that was likely intended to represent Lower Egypt. Narmer wears the white crown of Upper Egypt (recognizable by its shape) and is followed by his sandal-bearer, a high-ranking official who is depicted at a smaller scale. The king is barefoot, signifying that he

The knife has a curved flint blade and a carved ivory handle that may be made from a hippopotamus tooth. The artist created edges and the pattern on one side of the blade by flaking away parts of the stone; the back of the blade is smooth and polished. One side of the ivory handle (**Fig. 4.2a**, right) depicts a battle scene with two registers of individuals in hand-to-hand combat. Below them, two different types of boats, similar to those in the Hierakonpolis wall painting, move near the battle. On the other side of the handle (**Fig. 4.2a**, left), a bearded man in a long robe grasps the throats of two lions that have reared up on their hind feet. This robed and bearded

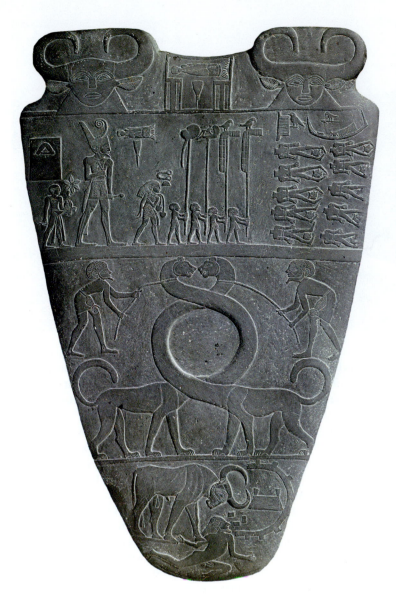
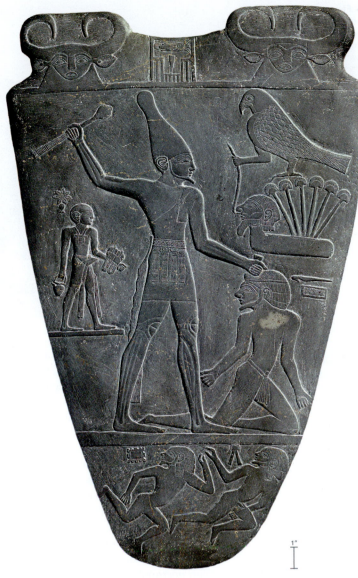

is walking on sacred ground. Two defeated enemies pose in subjugation at the bottom of the palette on the lowest register. A pair of frontally depicted human faces with cows' ears and horns is carved on the topmost register, flanking the ruler's name. These faces, which match the pair in the top register on the other side of the palette (the left side of **Fig. 4.3**), refer to an early version of the goddess Hathor, who was a protector of the king and who was also associated with cattle, the heavens, and the four corners of the world. In the register directly above the circular depression, Narmer again dominates the scene. This time he wears the red crown of Lower Egypt. He is depicted in a solemn procession to the left of standard-bearers and walks toward the headless corpses of enemies lined up across the field with their severed heads tucked between their own feet. This spectacle of violence would have been designed to instill fear and awe in Narmer's adversaries. In the bottom register, a mighty bull attacks a fortress.

Taken together, the palette's images convey the ruler's power and show how it was depicted as early states developed in Egypt. The Narmer Palette is also one of the earliest examples of Egyptian artists' desire to represent the human body in an identifiable, harmonious way. Some parts, such as the head, feet, and legs, are depicted in profile, while the torso and one eye are depicted frontally, a convention that remained in use for several centuries in two-dimensional media, such as low relief and painting.

The Early Dynastic Period, 3000–2686 BCE

Manetho, an Egyptian high priest who lived in the third century BCE, divided the history of the Egyptian state into thirty-one dynasties, or hereditary lines of rulership. Today, historians use not only Manetho's classification but also the broader period categories of Predynastic and Early Dynastic, and the Old, Middle, and New Kingdoms. The concept of kingship was already central to the unified Egyptian state that was formed during the Early Dynastic period (3000–2686 BCE), when urban institutions housed full-time specialists, artisans, and craftsmen, radically changing the production of art and architecture, including those related to funerary practices. During the so-called "intermediate" periods occurring in between the dynastic sequences of the Old, Middle,

4.3 Narmer Palette (both sides). Excavated at the sacred enclosure of Horus, Hierakonpolis, Egypt, end of Dynasty 0, *c.* 3000 BCE. Graywacke, length 25¼ in. (64.1 cm). Egyptian Museum, Cairo.

seal a small piece of hard material (stone) with an incised design; it is rolled or stamped on clay to leave an imprint.

iconography images or symbols used to convey specific meanings in an artwork.

low relief (also called bas-relief) raised forms that project only slightly from a flat background.

hieroglyph type of written script that uses conventionalized signs to represent concepts, sounds, or words.

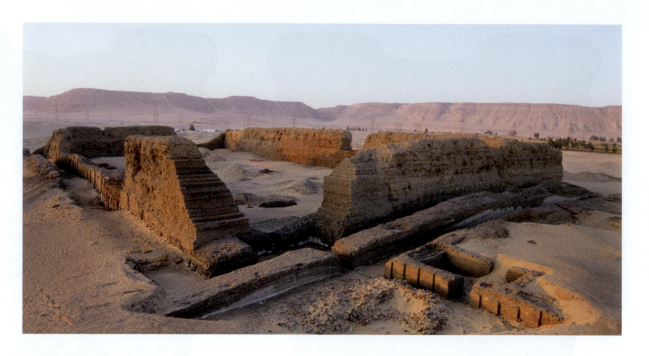

4.4 Funerary enclosure of King Khasekhemwy, Abydos, Egypt, Early Dynastic period, Second Dynasty, 2890–2686 BCE. Known in the present-day as the Shunet el-Zebib monument.

stele a carved stone slab that is placed upright and often features commemorative imagery and/or inscriptions.

necropolis a large cemetery; from the Greek for "city of the dead."

facade any exterior vertical face of a building, usually the front.

4.5 Mastaba tomb (sectional drawing), Saqqara, Egypt, Second or Third Dynasty. The *ka* statue of the deceased is visible in its small chamber (*serdab*). A vertical shaft links the mastaba superstructure to the underground burial chamber.

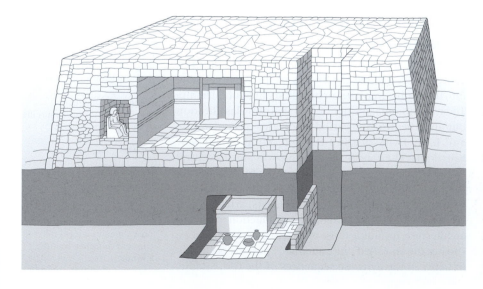

and New Kingdoms, when centralized governments lost full territorial control in Egypt, visual and architectural programs were directed by regional rulers rather than unified under a single king.

Early architectural evidence for how rulers were buried is found in Abydos, a city associated with the cult of Osiris, the god of the afterlife and the underworld. Built at the edge of agricultural land, Abydos's royal tombs featured two types of funerary architecture. Beginning around 4000 BCE, in one type of tomb, people were buried in single-chamber or multi-chamber tombs (which sometimes contained entire households) lined with mudbricks, roofed with wood, and mounded over with soil, and marked with funerary **steles** above ground. Their **necropolis**, or city of the dead, was located in the western desert, close to the cliff faces and away from cultivated areas, and their tombs included offerings such as pottery and carved stone containers. Beginning with the First Dynasty (*c.* 3000–2890 BCE), a second type of tomb, made of large rectangular ritual enclosures with niched and decorated mudbrick walls, was built closer to the agricultural fields. These enclosures consisted of massive walls surrounding an open space that may have held other structures and served ritual functions.

THE FUNERARY ENCLOSURE OF KHASEKHEMWY An example of the second type of tomb is the open-air enclosure (**Fig. 4.4**) of the last ruler of the Second Dynasty, Khasekhemwy (ruled *c.* 2704–2686 BCE). It covered a large area (approximately 407 × 184 feet, or 124 × 56 m) and was surrounded by a 16-foot-thick (4.88 m) mudbrick wall that was approximately 35 feet (10.67 m) high. The elaborate niched **facade** was plastered smooth with mud, painted white, and decorated with a pattern similar to the Egyptian reed mats used as wall or floor coverings. Inside the entrance was a structure that held offerings to the deceased king. This and other enclosures do not appear to contain burials, although retainers of the kings were buried in pits outside the enclosure walls, in a human-sacrifice ritual that was later discontinued. Also buried outside the walls were large animals and a fleet of fourteen substantial wooden boats, each within its own boat-shaped tomb made of mudbrick.

The enclosures, excluding Khasekhemwy's, seem to have been intentionally destroyed after only a short period of use, perhaps as part of a ritual burial or to give prominence to the next ruler's enclosure. The burials of early Egyptian kings at Abydos and the conception of the deceased rulers as incarnations of Osiris help explain why Abydos later became a major center for the worship of that god in the Middle Kingdom.

MASTABA TOMBS AT SAQQARA During the first half of the Second Dynasty, the rulers established their capital at the Lower Egyptian city of Memphis, which they had founded earlier as an administrative center. Memphis was the urban settlement on the eastern bank of the Nile River that flourished as a regional center and port of trade and ceremonial religious activity, while Saqqara, on the plateau on the western bank, was its necropolis. This

division marked the separation of the city of the living from the city of the dead. Placing the cemeteries in the west was a common practice, since death was associated with the west and the setting sun.

The early royal tombs at Saqqara consisted of multi-room underground chambers covered by a flat-topped rectangular structure, partly above ground, with slanted side walls built of either mudbrick or cut stone, known today as a **mastaba** (Arabic for bench, which it resembles). A vertical shaft accessible through the mastaba led to the underground burial chambers (**Fig. 4.5**). Some of the early mastaba tombs in Saqqara also had niched and painted facades, similar to the funerary enclosures at Abydos. The recesses in the niched walls were painted yellow to imitate wood and reed mats, and a low pedestal surrounding the mastaba was decorated with clay skulls of oxen, embedded with real ox horns. Mastabas were initially reserved for the burial of rulers and their families, but were later used by elite officials as well. The architectural traditions of both Abydos and Saqqara contributed to the innovations of later pyramid complexes, which combined the architectural forms and technologies of burial practices from the Early Dynastic period.

The Old Kingdom, *c.* 2686–2160 BCE

Instead of the urban temple complexes of Mesopotamian cities such as Uruk and Nippur (see Fig. 3.3), Egyptian rulers of the Third and Fourth Dynasties, who were contemporaries of those Mesopotamian cultures, built lavish funerary complexes on the Saqqara, Giza, Meidum, and Dahshur plateaus. With the political unification of Upper and Lower Egypt, architecture and visual culture from these regions also began to merge into a new, unified style. The architectural and funerary practices of the Old Kingdom (*c.* 2686–2160 BCE) make clear that the Egyptian belief system emphasized the divine king as the preserver of *ma'at*.

Egyptians believed that every ruler was Horus while he lived and Osiris after he died, and that it was their duty to contribute to the ruler's transformation from one to the other so that the order of the cosmos would continue unbroken. Tombs, body preservation, grave goods, offerings, rituals, and spells were all necessary to help rulers transition to the next world. The funerary complexes of the Third Dynasty (2686–2613 BCE) and the Fourth Dynasty (2613–2494 BCE) elevated these practices to a monumental scale. The centrality of this divine cycle to the Egyptian state and religion can be seen in the resources and labor (both hired and enslaved) needed to build these complexes, the wealth of goods included in the tombs, the amount of sculpture and building in valuable stone, and the number of priests and officials who maintained the completed complexes.

THE FUNERARY COMPLEX OF DJOSER Netjerikhet, the first king of the Third Dynasty, was known to later generations as Djoser (ruled 2667–2648 BCE). The funerary complex he commissioned at Saqqara (**Fig. 4.6**) adapted not only elements from the mastaba royal tombs there but also the complex of burials and funerary enclosures with niched and decorated walls used at Abydos and Hierakonpolis. Plant-like vegetal forms elaborately carved in stone imitated the reeds and timbers used in the walls of older structures. This use of more permanent and stable material established a new architectural aesthetic, while remaining faithful to earlier building traditions.

Djoser's complex was later said to have been conceived and designed by Imhotep, an important official in Djoser's government who came to be celebrated as a mathematician, philosopher, healer, and astronomer. Imhotep's name was inscribed on the base of one of the seated statues of Djoser, making him the first known architect in history whose name was recorded with his design. Indeed, he was so revered that the Egyptians of later dynasties made him into a god.

The funerary complex covered 37 acres (548.64 × 274.32 m) and was enclosed by a 34-foot-high (10.36 m) wall with repeating niches (see **Fig. 4.6**). The wall had fourteen false doors but only one functioning entrance that led into a grand, long hall consisting of twenty pairs of 22-foot-tall (6.71 m) stone columns carved to look like bundled reeds and capped with a limestone roof. The interior of the open-air enclosure included buildings, courtyards, temples, burial chambers for members of the royal family, and Egypt's first known **step pyramid**. Djoser's funerary complex included two royal burial structures: the

mastaba a massive, flat-topped rectangular tomb building with slanted side walls; built of either mud brick or cut stone.

step pyramid a monumental stone pyramid built using stacked platforms or steps.

4.6 Djoser's funerary complex, with the Step Pyramid (schematic drawing), Saqqara, Egypt, Old Kingdom, Third Dynasty, 2667–2648 BCE.

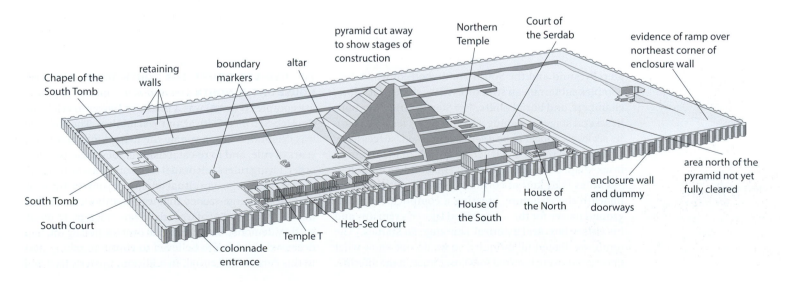

Chapel of the South Tomb — retaining walls — boundary markers — altar — pyramid cut away to show stages of construction — Northern Temple — Court of the Serdab — evidence of ramp over northeast corner of enclosure wall — South Tomb — South Court — colonnade entrance — Temple T — Heb-Sed Court — House of the South — House of the North — House of the North — enclosure wall and dummy doorways — area north of the pyramid not yet fully cleared

To understand an object, art historians consider the context in which it was made, including prevailing cultural beliefs and the object's purpose. For example, understanding the *ka* statue of Djoser requires knowledge of Egyptian ideas about death, the soul, and the afterlife.

Much of ancient Egyptian art, rituals, and monumental building activity was associated with death. A person's transition to the afterlife was a major concern and therefore the subject matter of art and building. A small square building next to Djoser's step pyramid, known as the Court of the Serdab, held an almost-life-sized statue of the seated king that was visible through a hole in the otherwise solid wall (**Fig. 4.7**).

Ancient Egyptians believed that humans are composed of the physical body and a number of distinct spiritual parts (the number varied over time as these ideas developed). The two most important parts of the spirit are the *ka* (translated here as "life force") and the *ba* (a person's or object's unique identity), which become separated from the body at death. The *ka* was represented by two upraised, disembodied arms. According to the beliefs of the Old Kingdom, the *ka* moved about the world but returned to rest in the preserved body or in statues designed to serve as eternal repositories for it. Through the false doors of Egyptian tombs, the *ka* traveled between the subterranean burial and the *serdab*, leaving to visit other places and people, or it could watch the world from the seated *ka* statue, hear the prayers said for it, and consume the essence of food and drink offerings (both real and representational) left by visitors and priests.

The *ba*, often depicted as a bird with a human head, also traveled freely but returned to the body. Perhaps because the *ba* was believed to be unable to live in a decaying body, Egyptians developed mummification to preserve the body after death. Indeed, a primary purpose

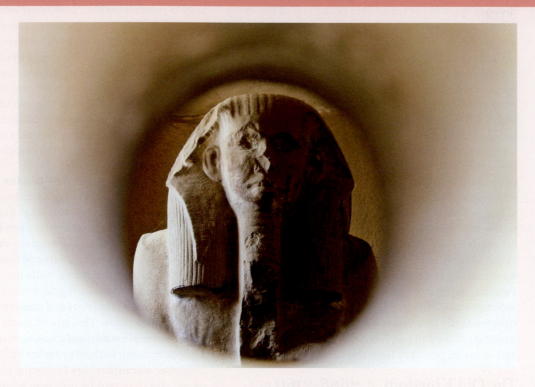

4.7 *Ka* **statue of Djoser, visible through a hole in the** *serdab* **wall, Djoser's funerary complex.** Saqqara, Egypt. Old Kingdom, Third Dynasty, 2667–2648 BCE.

of mummification, funerary rituals, and tombs was to reunite the components of a person to ensure a prosperous afterlife.

All Egyptians were believed to have a *ka*, but the king's *ka* was divine. Upon his death, the king's *ka* and *ba* were united so that the king became an *akh*, a glorified being of light like the sun god, who journeyed each night through the underworld and was reborn each day to travel through the sky. As an *akh*, the king shared in this daily cycle and in the gods' other eternal activities. Egyptians were able to believe the seemingly conflicting ideas that the deceased king could simultaneously inhabit his *ka* statue and travel through the sky as an akh.

Not surprisingly, *ka* statues became a feature of Egyptian royal funerary complexes. Although Djoser's example did not include them, a pair of upraised arms, the hieroglyph for *ka*, was sometimes placed atop the head of these statues. Later, in the Old Kingdom, the mastaba tombs of non-royal men and women adopted the same structure of a *serdab* housing a *ka* statue with a small opening that allowed the deceased to receive offerings from the living.

Discussion Question

1. How does the Egyptian conceptualization of the body (*ka, ba* and the physical body) compare to your own understanding of the body in the world, and how does that difference relate to contemporary burial practices from your own community?

Step Pyramid and the South Tomb, both of which had complex subterranean structures with shafts, corridors, chambers, and burial vaults. The Step Pyramid was built in several stages, reaching a height of 205 feet (62.48 m). Its six levels appear to be a series of stacked, successively smaller mastaba-like structures, each made of small brick-shaped limestone blocks. The builders excavated 3½ miles (5.63 km) of corridors, shafts, and chambers beneath the structure, creating a complicated underground palace for the mummified Djoser's remains and his *ka* (see box: Art Historical Thinking: *Ka* Statues.) The tomb was looted in antiquity, so we do not know what grave goods were interred for Djoser's use in the afterlife.

THE HEB-SED COURT, THE SOUTH TOMB, AND THE HOUSE OF THE NORTH The Heb-Sed Court in the funerary complex (**Fig. 4.8**) was a place for Djoser to celebrate the Heb-Sed (Sed festival, or royal jubilee). The Heb-Sed was celebrated to rejuvenate the living king after many years of rule, and to re-establish the social and political order. Living rulers celebrated this festival in the thirtieth year of their reign as a ritual of rejuvenation by running around two large stones that were symbolic boundary markers (see **Fig. 4.6**) of Upper and Lower Egypt. In doing so, they demonstrated dominion over unified Egypt, and deceased rulers were believed to continue taking part in this ceremonial ritual. In addition, Djoser's Heb-Sed

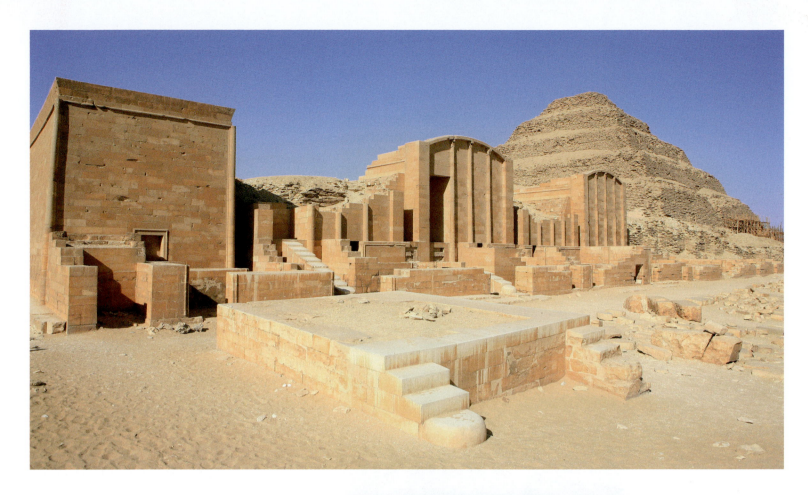

Court housed two rows of stone-built shrines of various sizes and regional architectural styles for the various deities, whose statues were carried by boat to Saqqara to observe the festival. Because these shrines were stone reproductions of ceremonial structures, some of them were solid, impenetrable forms rather than hollow buildings that could be entered. Simply by creating spaces for the statues, Djoser was inviting and anticipating an eternal audience for his eternal renewal ritual.

The funerary complex also included a second royal burial structure: the South Tomb. Its purpose is unknown, but it may have functioned along with the step pyramid in a manner similar to the tomb and royal enclosure used at Abydos (see **Fig. 4.4**). Like the step pyramid, the South Tomb had an underground maze of shafts, corridors, chambers, false doors, and burial vaults carved into the bedrock and decorated with blue-green Egyptian **faience** tiles imitating reed mats.

As we have seen, false doors were a common architectural feature in the interiors of Egyptian tombs, carved and decorated with colourful geometric designs in stone or wood to imitate the form of a door, but not leading into another physical space. In Old Kingdom Egypt and later, Egyptians understood false doors as a threshold between the world of the living and the world of the dead. Since offerings to the deceased were placed in front of these doors, they were important features of the private funerary chapels.

Some of the false doors contained carved reliefs of Djoser. In one of the carved reliefs (**Fig. 4.9**), Djoser is depicted in low relief as a rejuvenated king running

4.8 ABOVE **Djoser's funerary complex,** looking toward the Step Pyramid from the Heb-Sed Court, with limestone ashlar buildings for the king's funerary cult. Saqqara, Egypt. Old Kingdom, Third Dynasty, 2667–2648 BCE.

4.9 LEFT **The king running during the Heb-Sed festival,** in the underground tomb at Djoser's funerary complex. Saqqara, Egypt. Old Kingdom, Third Dynasty, 2667–2648 BCE. Stone relief. Ministry of Antiquities, Cairo.

faience a glassy substance that is formed and fired like ceramic, made by combining crushed quartz, sandstone, or sand with natron or plant ash.

engaged column a column attached to, or seemingly half-buried in, a wall.

capital the distinct top section, usually decorative, of a column or pillar.

corbeling an overlapping arrangement of wood, stone, or brick wall projections arranged so that each course extends farther from the wall than the course below.

4.11 Pyramids on the Giza plateau, Egypt. The pyramid of Khufu is in the foreground; the Great Pyramid of Khafre is in the center; Menkaure's is on the right, in the background. Old Kingdom, Fourth Dynasty, 2589–2503 BCE.

between the territorial markers of Upper and Lower Egypt, thus eternally performing this essential component of the Heb-Sed festival. The bearded Djoser has an idealized and athletic body, and he wears the white crown of Upper Egypt. As on the Narmer Palette, Horus as a falcon guards the king. Here, Horus extends a talon holding the sign for life-force (*ankh*) toward Djoser.

Stones carved in the shape of plants throughout Djoser's complex made references to specific Egyptian landscapes. For example, the House of the North had **engaged columns** with **capitals** shaped like the papyrus stalks and blossoms of the delta landscapes of Lower Egypt. Egyptians believed that these plants filled the marsh along the journey to the afterlife. Here, the columns are in the form of single-stemmed papyri with an open flower (**Fig. 4.10**). Examples of papyrus columns with open and closed buds are also seen in later Egyptian architecture (see Fig. 6.14). Beyond evoking the source of life and the afterlife, the papyrus plant was a precious commodity of Lower Egypt. It was used not only to produce the papyrus rolls used for writing but also to create many everyday items, including mats, baskets, ropes, sandals, and even small boats.

THE PYRAMIDS OF GIZA In the Fourth Dynasty (2575–2465 BCE), monumental pyramids became central to the ideology of the Egyptian state and expressions of state power. The complexes required an enormous investment of labor, bringing together numerous architects, craftsmen, and administrators. Orthogonally planned towns (with streets laid out in a grid pattern) were developed to

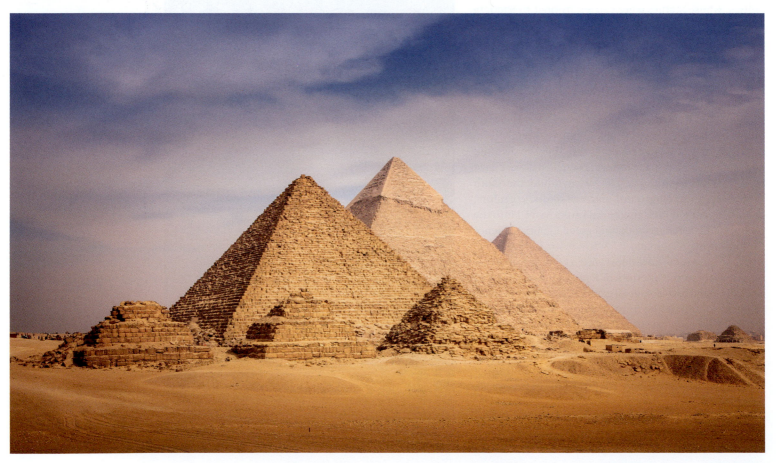

house the pyramid laborers, who worked primarily during the months of the Nile floods, when no agricultural work could be done. The three very different pyramids built at Meidum and Dahshur by Sneferu (ruled 2613–2589 BCE), the first king of the Fourth Dynasty, show how architects and artists perfected structural principles, geometric precision, and masonry and roofing techniques such as **corbeling**. Sneferu's Red Pyramid in Dahshur is the first known smooth-sided pyramid.

After Sneferu, three Fourth Dynasty rulers—Khufu (ruled 2589–2566 BCE), Khafre (ruled 2558–2532 BCE), and Menkaure (ruled 2532–2503 BCE)—built their complexes on the bedrock of the Giza plateau, which was able to support the massive weight of their pyramids (**Fig. 4.11**). These pyramids, which have captured people's imaginations for millennia, combine architecture, art, religion, and political messaging. They are the most visible remains of funerary complexes built and endowed by rulers to enact their rebirth to assure the order of Egypt and the cosmos. Contrary to popular pseudo-scientific speculation about the cosmic alignment of pyramids to the four cardinal directions and their supposed significance to religious beliefs, the Giza pyramids were instead aligned very practically with an underlying geological formation that provided a sound natural substructure to each massive pyramid, indicating a keen awareness of the engineering challenges involved in its construction.

Valley temples built on the Nile's west bank received the boat of the royal funerary procession, which carried the deceased ruler from the palace on the east bank (**Fig. 4.12**). Long, walled causeways connected the ruler's valley temple to the main mortuary temple on the east side of his pyramid, where, over several weeks, his body underwent a process of mummification, wrapping, prayers, and incantations to prepare him for his journey and transformation. The pyramid, containing the tomb chambers for the ruler, was the western end of this axis. Smaller cut-stone pyramids and mastaba tombs for queens and other members of the royal family surround the pyramids and include stone statues, furniture, and goods for their afterlife. Two carefully disassembled cedarwood boats were found in rectangular pits near Khufu's pyramid. These royal barges were intended for the deceased king and his family to use on their journey to the afterlife and may also have carried the king's body across the Nile to his funerary complex. Boat pits also appear next to Khafre's pyramid.

Khufu's pyramid complex (**Fig. 4.13**), built over a ten- to twenty-year period ending around 2566 BCE, was the largest at Giza. Sometimes called the Great Pyramid, Khufu's pyramid was constructed of approximately 2,300,000 blocks of stone, each weighing an average of 2½ tons. It reached a height of 481 feet (146.61 m) and covered more than 13 acres. The stones were moved to the site through human labor, perhaps using wooden sleds or log rollers, or over sand wetted and coated in silt from the Nile to make it slick. How the blocks were lifted into place on the rising pyramids is still debated, but workers likely built a ramp out of sand around the structure as it went up and then dismantled the ramp when the pyramid was complete. Inside the pyramid are

passageways that ascend from the entrance to separate burial chambers for the king and queen, and descend to an unfinished chamber carved into the bedrock beneath the pyramid. Some scholars believe this subterranean chamber was originally planned as Khufu's tomb, but that as the pyramid was being built, he chose to have his tomb placed higher inside it.

The pyramid's outer surface was covered with fine white limestone, which had been quarried and transported from Tura, at least 15 miles (24 km) away. Over the last four thousand years, most of the limestone was removed and re-used by other builders.

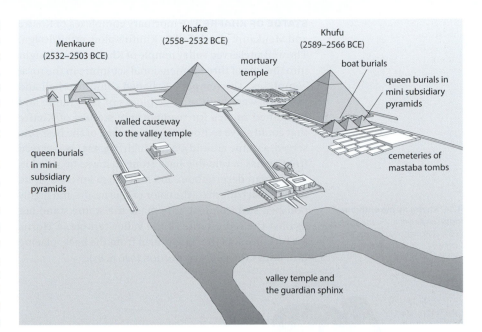

4.12 TOP **Pyramids and funerary complexes on the Giza plateau,** Egypt, belonging to the Fourth Dynasty kings Khufu, Khafre, and Menkaure. (Plan drawing.) Old Kingdom, 2589–2503 BCE.

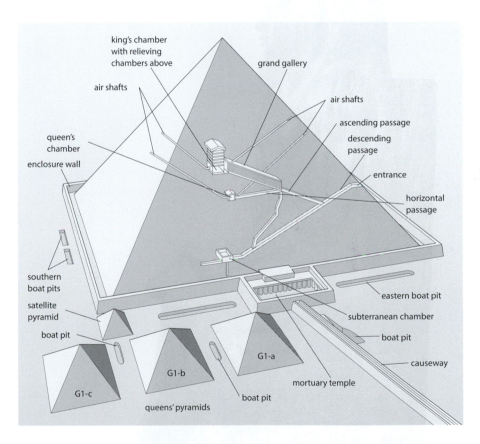

4.13 ABOVE **The Great Pyramid of Khufu,** Giza, Egypt. Schematic drawing of the pyramid and its subsidiary tombs. Old Kingdom, Fourth Dynasty, 2589–2566 BCE.

STATUE OF KHAFRE The mortuary complexes of Khafre and Menkaure largely follow Khufu's pioneering design. The well-preserved valley temple of Khafre offers insight into the role of three-dimensional sculpture in the royal complexes. The temple's T-shaped columned hall and vestibule were built of large blocks of red granite and contained niches for twenty-three statues of Khafre that could serve to house his spirit. One of the best-preserved, a statue around 5½ feet high (**Fig. 4.14**), was carved from gneiss, a valuable hard stone that was quarried in the Nubian desert about 400 miles (640 km) south. Its dark-bluish patterns—the color of Nile mud—and highly polished surface must have made the statue stand out against the red granite of the valley temple. A Horus falcon embraces the king's head from the back, placing him under the god's protection (see p. 81).

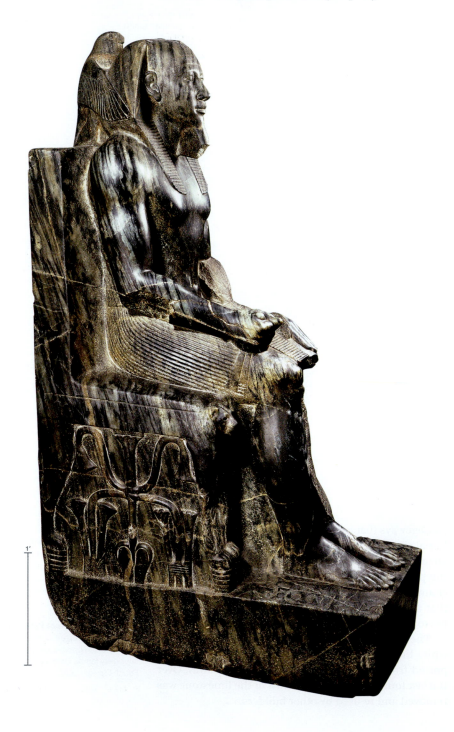

4.14 Khafre as the enthroned king, Old Kingdom, Fourth Dynasty, 2558–2532 BCE. Anorthosite gneiss, height 5 ft. 6⅛ in. (1.68 m). Egyptian Museum, Cairo.

Seated on an elaborately carved throne, Khafre wears not only a ceremonial pleated kilt but also the linen head cover and false beard reserved for royalty. The king's posture and solemn gaze into the distance create a sense of permanence and eternity. His youthful and muscular body and smooth face convey ideal strength. Each side of his throne is carved with the *sema tawy* ("Uniter of the Two Lands") motif featuring the intertwined lotus and papyrus, the plants symbolic of Upper and Lower Egypt. Like the Narmer Palette, the statue identifies Khafre's kingship with territorial unity.

THE GREAT SPHINX OF GIZA The Great Sphinx (**Fig. 4.15**) and an unfinished temple that was likely dedicated to the Sphinx sit next to Khafre's valley temple. In Egyptian religion, the sphinx is a hybrid, protective creature with the head of a human male and the body of a resting lion. Partially carved out of the local bedrock and partially built with stonework, the Great Sphinx was likely a guardian of Khafre's causeway. It measures 240 feet (73.15 m) from its tail to its paws and more than 60 feet high (over 18 m) from the ground to the top of its head, making it roughly twenty-two times larger than the lions that were thought to prowl the western hills at the entrance to the afterlife. Like the Khafre statue (see **Fig. 4.14**), the Sphinx wears the royal *nemes* headdress, making it a portrait of an Egyptian ruler, perhaps Khafre himself, whom it resembles.

We know relatively little about the Great Sphinx of Giza due to the lack of written evidence, despite its colossal size and the extraordinary amount of labor that went into its construction. For centuries, it remained a visible and haunting element of the landscape. Efforts were made to restore and conserve it, especially from the Eighteenth Dynasty onward (*c.* 1400 BCE). One of the famous kings of that dynasty, Thutmose IV, dedicated a granite stele to the Sphinx in 1401 BCE, with scenes of ritual offerings to the Sphinx and a hieroglyphic inscription that named Khafre as the original builder of the monument. Set in the center of the Sphinx's extended arms, this so-called "Dream Stele" gave a detailed account of a miraculous dream Thutmose had when he fell asleep in the shadow of the Sphinx.

STATUE OF MENKAURE AND QUEEN A statue of a couple found in the valley temple of Menkaure's funerary complex at Giza presents a solemn and dignified double portrait of the king and his principal queen, often identified as Khamerernebty II, who—in the occasional Egyptian practice of rulers marrying their siblings—was both his wife and half-sister (**Fig. 4.16**). Their close relationship is shown in their similar appearance and in her protective gesture as she holds the king close to her body. The sculpture, which is nearly life-sized, is carved out of graywacke. Both king and queen exhibit an ideal calm, youth, and strength. They are depicted in the act of striding, with both knees locked but their left feet forward, a pose that is used throughout Egypt's history for both hieroglyphs and statues. The queen wears a close-fitting sheath garment revealing the curvature of her body, emphasizing her femininity, compared to the

1'

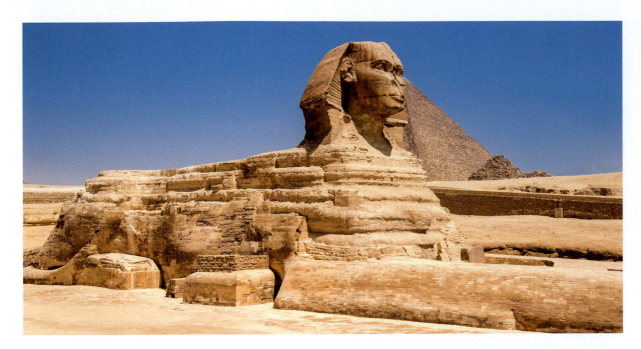

4.15 **The Great Sphinx,** Giza, Egypt, 2558–2532 BCE. 60 × 240 ft. (18.29 × 73.15 m).

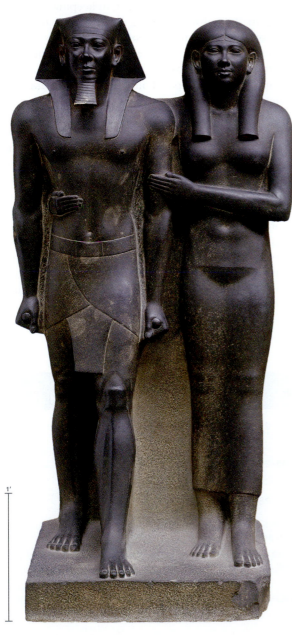

idealized musculature of Menkaure. Experts have found traces of red paint on Menkaure's face and black paint on the queen's wig, suggesting that the statue, like most Egyptian sculpture, was originally painted.

Egyptian rulers continued to build funerary complexes with pyramids throughout the rest of the Old Kingdom and through the Middle Kingdom (see Chapter 6); approximately 118 pyramids or their remains have been found in Egypt. Many of the later complexes are similar to those of the Giza complexes, but they vary in size and complexity depending on each ruler's time and resources. Innovations were introduced in these later complexes. For example, the practice of inscribing onto tomb walls a series of ritual prayers and spells for the ruler's transformation (Pyramid Texts) appears to have begun at the end of the Fifth Dynasty in the pyramid of the king Unas.

Private Tombs in Old Kingdom Egypt

Like royal art, much of the known non-royal art comes from tombs. During the period from 2500 to 2000 BCE, elite families and individuals associated with the Egyptian state continued to build elaborate mastaba tombs, especially in the cemeteries of Saqqara, Giza, and Abusir. Primarily used for high-ranking male officials in the state administration, the mastaba tombs often also housed their spouses or other family members.

Beginning in the Fourth Dynasty, the interior walls of these mastaba tombs were decorated with detailed scenes of everyday life in carved relief and painting, illustrating various crafts, agricultural activities, hunting, animal husbandry, and food preparation. The deceased appear often in these scenes, which form a visual biography by depicting their professions and life activities. Some of the displays reflect loving memories of the deceased official's life and accomplishments, and may also be hopeful images of a future prosperous life after death. Their style and iconography represented to visitors the cultural and social status of the deceased in their lifetimes, thus blending the past, present, and future in a single scene.

4.16 FAR LEFT **King Menkaure and queen, probably Khamerernebty II.** Giza, Egypt, Old Kingdom, Fourth Dynasty, (2532–2503 BCE). Graywacke with traces of red and black pigment, height 4 ft. 8 in. (1.42 m). Museum of Fine Arts, Boston.

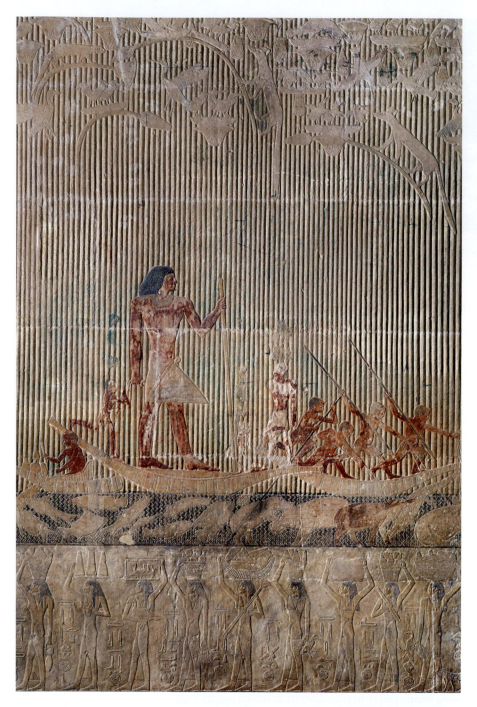

4.17 Ti watching a hippopotamus hunt (detail), Tomb of Ti, Saqqara, Egypt, Old Kingdom, Fifth Dynasty, c. 2494–2345 BCE. Painted limestone relief, height 4 ft. (1.22 m).

THE MASTABA TOMB OF TI The interior walls of the mastaba tomb of Ti, a high-ranking official in Egypt's Fifth Dynasty, were pictorially vibrant, with reliefs and paintings intended to nourish his *ka* and assist him in engaging in the activities depicted. Like the images in many non-royal tombs, the images in Ti's mastaba were personalized to reflect his honors, accomplishments, professional responsibilities, and goals. In addition to serving as chief barber of the royal household (a high-status position, as care of the king's body was a matter of religious importance), Ti was the overseer of the pyramids and temples of several Fifth Dynasty kings. His tomb at Saqqara is more complex and larger than many other mastabas, and its colorful relief sculptures are fairly well preserved.

The northern wall of Ti's chapel featured a carved and painted low-relief composition showing Ti standing on a papyrus boat. He oversees a group of men on another boat who are engaged in a hippopotamus hunt with harpoons (**Fig. 4.17**). Ti is shown in hierarchical scale to indicate his importance. His legs, arms, and face are in profile, and his torso is frontal, in keeping with the Egyptian style of representing each element from its most recognizable angle. In contrast, the other figures are smaller and more animated. Papyrus stalks provide a texture in the background of the hunting scene, while the upper part of the panel offers a vividly represented animal habitat in a papyrus swamp.

Crocodile, fish, and hippopotami swim in the river below the boats, again from their most recognizable angles, rather than what contemporary viewers might consider a more realistic viewpoint. Hippopotami were potentially dangerous to humans living and working near the river, and they were hunted in Egypt not only for their tusk-like canines (for ivory) but also for their meat, skin, and fat. Later, in the New Kingdom (1550–1069 BCE), hippopotami were linked to the god Seth, who represented evil and chaos, so hunting them allowed humans to identify with Seth's rival Osiris, and to merge his victories in the distant past with their own attempts to overcome evil in this life and the next.

Chronology

up to 3000 BCE	The Predynastic period in Egypt	**2686–2160 BCE**	The Old Kingdom: Third–Sixth Dynasties
3450–3300 BCE	The Gebel el-Arak knife is made	**2686–2648 BCE**	The reign of Djoser; he builds his funerary complex, including a step pyramid, at Saqqara
c. 3500–3000 BCE	The Narmer Palette and the Hierakonpolis Tomb 100 wall painting are created	**2613–2589 BCE**	King Sneferu builds experimental pyramids at Meidum and Dahshur
3000–2686 BCE	The Early Dynastic period, First–Second Dynasties: the development of the Egyptian state, the invention of writing, and the emergence of cities	**c. 2589–2566 BCE**	Khufu builds his Great Pyramid on the Giza plateau
		c. 2494–2345 BCE	The Fifth Dynasty tomb of Ti at Saqqara is built; the Seated Scribe statue is made
2890–2686 BCE	The funerary enclosure of Khasekhemwy at Abydos is built; mastaba tombs at Saqqara are constructed	**2160–2055 BCE**	The First Intermediate Period: Egypt is not united; the Ninth and Tenth Dynasties rule in different areas

SEATED SCRIBE The works of art in private tombs also included sculptures in stone, wood, and metal. Many of these sculptures were more lifelike depictions of the deceased, or generic depictions of workers and servants engaged in specific occupations. One example of the latter is a painted, 21-inch-high limestone statue of a seated scribe that, based on its style, can be dated to the Fifth Dynasty (**Fig. 4.18**). Scribes were high-ranking professionals who could manipulate hieroglyphs, which the ancient Egyptians called *medu netjer* or "the words of the gods." Scribes were thus artists who interacted with divine forces in addition to serving as officials in palaces and temples.

The scribe is depicted in the act of performing his duties, sitting cross-legged and holding a half-rolled piece of papyrus on his lap, his hands poised and ready to write. He wears a white kilt. Following the conventions for statues of men, his skin is painted reddish-brown and his hair is black. He looks straight ahead and far into the distance (similar to the profound stare of the valley temple statue of Menkaure and his queen in **Fig. 4.16**). His alert gaze is further intensified by his inlaid eyes of rock crystal and magnesite. Unlike the idealized sculptural portraits of Khafre and Menkaure, the scribe's body is more relaxed and natural, and he is shown with what were considered the highly desirable folds of stomach fat that distinguish a wealthy man.

After the collapse of the Old Kingdom (possibly due partly to the results of climate change), control of Egypt was decentralized among a handful of regional leaders throughout the north and south during the roughly one hundred years known as the First Intermediate Period (2160–2055 BCE). In the absence of a unified vision, regional variations in art and architecture arose from the competing power centers, but few large-scale artworks survive from this period, perhaps because the divided kingdoms could not muster the same level of resources as the Old Kingdom rulers. This political and artistic decentralization would last until Upper and Lower Egypt were unified again under Mentuhotep II and the beginning of the Middle Kingdom (*c.* 2055–1985 BCE).

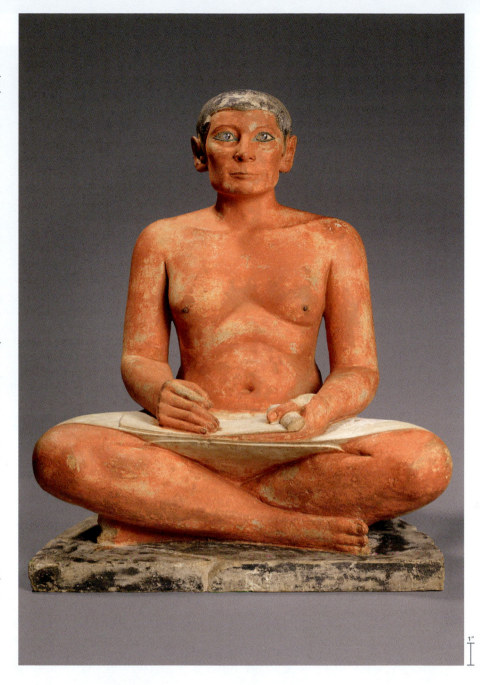

4.18 Seated statue of scribe.
Found out of context in Saqqara, Egypt. Old Kingdom, Fifth Dynasty, 2494–2345 BCE. Painted limestone, with inlaid eyes of rock crystal, and magnesite mounted in copper, height 21⅛ in. (53.6 cm). Musée du Louvre, Paris.

Discussion Questions

1. Egyptian artists often combined human and supernatural subjects in their pictorial narratives. Discuss at least one example from Upper Egypt and one from Lower Egypt. Why did the artists represent both human and divine characters?

2. The transition to large-scale architectural structures and the use of high-quality, finely cut stone in funerary monuments coincided with the formation of a unified state in Egypt. How might the construction of these structures have affected Egyptian society?

3. The pyramids of Giza are iconic monuments of ancient Egypt. What was a pyramid used for in the Old Kingdom, and what were the religious and political functions of royal funerary complexes in early Egypt?

4. During the Old Kingdom, the interior walls of mastaba tombs were covered with reliefs and paintings that sometimes included images of the deceased hunting in lush, idealized environments. What were some of the roles and functions of these images?

Further Reading

- Baines, John. *Visual and Written Culture in Ancient Egypt.* Oxford, Oxford University Press, 2007.
- Linzey, M. P. T. "The Duplicity of Imhotep Stone". *Journal of Architectural Education* 48, no. 4 (1995): 260–67.
- Hartwig, Melinda K. (ed.) *A Companion to Ancient Egyptian Art.* West Sussex: Wiley Blackwell, 2014.
- Summers, David. "Kingship in Egypt." In *Real Spaces: World Art History and the Rise of Western Modernism.* London and New York: Phaidon, 2003, pp. 205–20.

The Art of Trade and Diplomacy in the Bronze Age

Societies have long used art as an instrument of diplomacy. Trade and diplomatic gift-giving between cultures created political alliances and negotiated differences across long distances. Objects from the Mediterranean Bronze Age (c. 3000–1200 BCE) provide ample evidence that artistic exchange was used to further diplomatic and economic relations. From the Indus Valley to southern Europe, transcultural contact expanded during the Bronze Age, with many exchanges of luxury items and artworks among West Asian, Egyptian, and Aegean centers and rulers during this period. Political gift exchanges and commercial trade also resulted in the development of artistic styles that combined references from several cultures.

The ceremonial artifacts discovered in the Royal Tombs at the ancient city of Ur provide a window into ancient Mesopotamian notions of death and the afterlife. They also demonstrate the reach of Mesopotamian trade

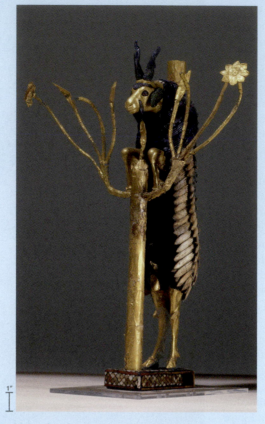

1 ABOVE **Goat and a Flowering Plant,** from Tomb PG 1237, Royal Tombs of Ur (Tell el-Muqayyer, Iraq). Early Dynastic IIIA period of Mesopotamia, c. 2550–2400 BCE. Gold, silver, lapis lazuli, copper alloy, shell, red limestone and bitumen, height 18 in. (45.7 cm). British Museum, London.

during the Early Bronze Age (c. 3000–2000 BCE). One striking example is the Goat and a Flowering Plant (**Fig. 1**; also known as "Ram in the Thicket"). The statue is one of a pair that may have served as a base for a low table. It is a composite work that depicts a male goat standing on his hind legs against an imaginary plant or shrub with rosettes. The anthropomorphized body of the goat is made of precious gold, silver, and lapis lazuli, and it stands on a silver-covered base topped with a checkered mosaic of red limestone, lapis lazuli, and shell. The goat's fleece is made of shell, and the sheath for his testicles and penis is covered in gold. These precious materials came from far away: lapis lazuli from the mountains of Afghanistan; silver and gold from the river valleys of western Anatolia; and copper (the main alloy used to make bronze) from the islands of the Persian Gulf. The artifact therefore connects Mesopotamia directly to the distant lands that supplied these resources.

Artistic and diplomatic exchange was pronounced during the Mediterranean Late Bronze Age (c. 1600–1200 BCE), evident in the depictions of foreigners bearing gifts in Egyptian tombs. This wall painting (**Fig. 2**)

2 BELOW **Wall painting with foreign emissaries bearing gifts (detail),** from tomb of Rekhmire (TT 100), Thebes, Egypt, Eighteenth Dynasty, 1479–1400 BCE. Metropolitan Museum of Art, New York.

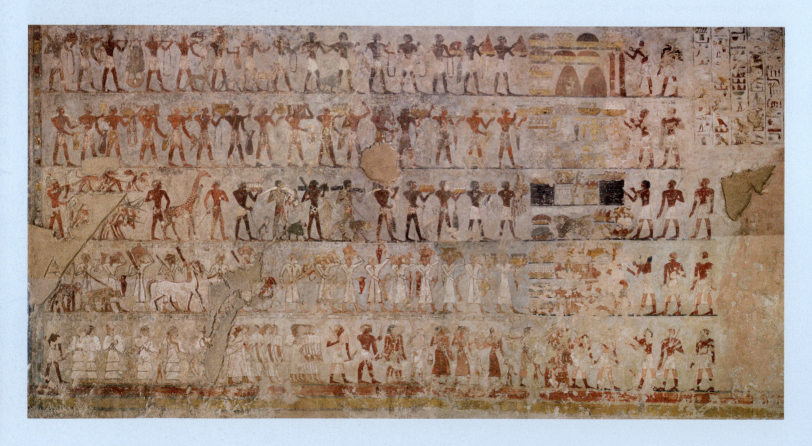

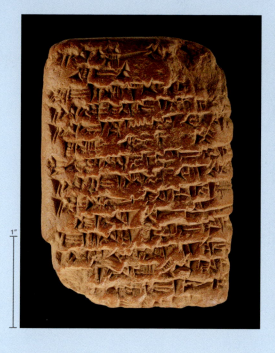

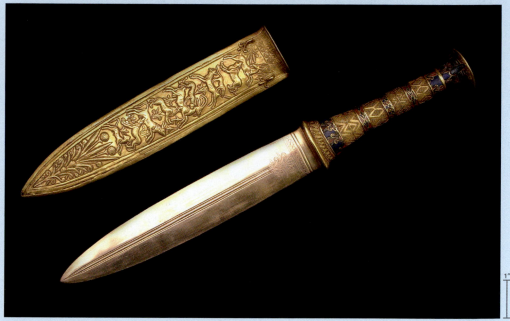

3 **Letter from Ashur-uballit, the king of Assyria, to the king of Egypt,** written in cuneiform on a clay tablet, probably from Akhetaten (Tell-el Amarna, Egypt)). New Kingdom, Eighteenth dynasty, reign of Akhenaten, *c.* 1353–1336 BCE. Clay, 3 × 2¼ in. (7.6 × 5.7 cm). Metropolitan Museum of Art, New York.

4 **Dagger and sheath from the tomb of Tutankhamun,** Valley of the Kings, Thebes, Egypt, Eighteenth Dynasty, *c.* 1333–1327 BCE. Gold, dagger length 12⅝ in. (31.9 cm); sheath length 8⅜ in. (21 cm). Egyptian Museum, Cairo.

depicts delegations of foreigners bringing tribute to Rekhmire, a high official under the rulers Thutmose III and Amenhotep II. Each group is distinguished by physical appearance, dress, and the offerings they bring. For example, Aegeans (second register, or horizontal level) carry vessels and metal ingots; Nubians (third register) bring animals including a giraffe, a leopard, and monkeys, as well as elephant tusks and ebony; and Syrians (fourth register) carry more vessels. This impressive line-up of foreigners and offerings certainly shows the power of Egypt to command tribute, but it also speaks to the strong diplomatic connections of the age.

How do modern scholars know that these distant cultures were in contact in early periods of history? The existence of foreign materials, as seen in **Fig. 1**, and images depicting tributary gifts, as seen in **Fig. 2**, provide one type of evidence. Another is preserved in texts, such as the clay tablets known today as the Amarna Letters (**Fig. 3**). Written during the reign of the Egyptian ruler Akhenaten (ruled *c.* 1353–1336 BCE), the Amarna Letters discuss the exchange of gifts among rulers. They mention not only prestigious raw materials, such as lapis lazuli and ivory, but also finished luxury products, such as jewelry and chariots. In the letter shown here, the Assyrian king Ashur-uballit (ruled 1365–1330 BCE) states that he is sending a splendid chariot, two horses, and lapis lazuli as a greeting gift to

Akhenaten. These tablets arrived at the Egyptian court with foreign couriers bearing tribute or gifts, bolstering the connections between Egypt and its allies.

Diplomacy facilitated through luxury objects brought about an artistic style that blended multiple cultural styles and iconographies. These objects played a role in elite diplomatic exchange among Egypt, Babylonia, and the Hittite Empire, and smaller regional states in Syria, Lebanon, Palestine, and Israel, and the Aegean from 1400 to 1200 BCE. This period is recognized today as an age of

great internationalism. One work demonstrating this international style is the gold dagger and sheath found suspended from the waist of the Egyptian ruler Tutankhamun, underneath his mummy wrapping (**Fig. 4**). The scenes of animal attacks and the highly decorative volute (in the form of a coiled scroll) palmettes on the sheath are typical of works that use a shared visual language to facilitate diplomatic exchange. A register of running spirals, a frequent motif in Aegean art, runs along the bottom of the sheath, while the characteristically Egyptian cartouche (an oval in which royal names are written in hieroglyphics) of Tutankhamun appears directly below. Integrating motifs, symbols, and styles from a range of Mediterranean cultures, the dagger and sheath were designed to appeal to elite audiences.

Discussion Questions

1. What role did artistic styles and iconography play in diplomatic exchange during the Bronze Age? Does this role surprise you? Why or why not?

2. What role did prestigious raw materials and technologies play in diplomatic exchange during the Bronze Age? What symbolic significance might have been accorded to materials and finished products from distant lands? Can you think of any parallels today?

3. How does the archaeological context of a work of art help art historians and archaeologists determine the nature of the contact that occurred? Compare, for example, the context of the gold dagger of Tutankhamun with that of the Mistress of Animals *pyxis* lid (see Fig. 10.13).

Further Reading

- Aruz, Joan, Benzel, Kim and Evans, Jean (eds.). *Beyond Babylon: Art, Trade, and Diplomacy in the Second Millennium BC.* New York: The Metropolitan Museum of Art; New Haven, CT: Yale University Press, 2008.

- Feldman, Marian H. *Diplomacy by Design: Luxury Arts and an "International Style" in the Ancient Near East, 1400–1200 BCE.* Chicago: University of Chicago Press, 2006.

- Pollock, Susan. "The Royal Cemetery of Ur: Ritual, Tradition and the Creation of Subjects." In M. Heinz and M. H. Feldman (eds.) *Representations of Political Power: Case Histories from Times of Change and Dissolving Order in the Ancient Near East.* Winona Lake, IN: Eisenbrauns, 2007, pp. 89–110.

Ancestor King sculpture
(detail), King's Gate, Hattusha
(Turkey).

5

Art of West Asian Empires

2000–330 BCE

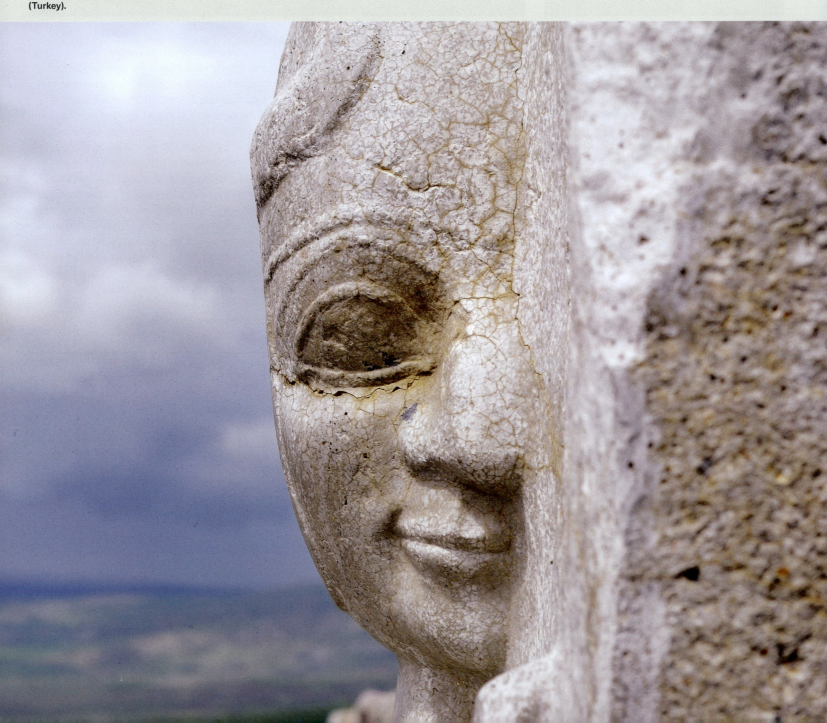

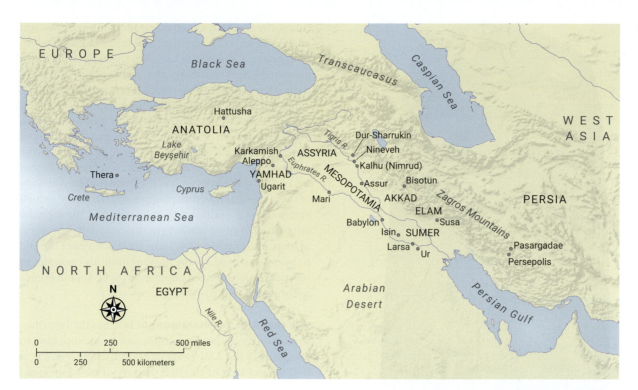

Map 5.1 West Asia, 2000–300 BCE.

Introduction

By 2000 BCE, people in Mesopotamia and other parts of West Asia were farming productive land, raising livestock, and living in populous cities, where an urban literate culture was well connected to neighboring regions through trade and exchange over land and water. The Mesopotamian cities housed prosperous sanctuaries with monumental temples served by priests, while the rulers and governors safeguarded the people and maintained state administration, collecting taxes and tribute. This prosperity helps explain why, after the collapse of the Akkadian Empire and the Third Dynasty of Ur (see Chapter 3), the regional states in Mesopotamia shared political control of the region. Throughout the centuries, institutions with long histories, such as temples and palaces, continued to be important cornerstones and stabilizers of society, while trade and agriculture remained the backbone of the economy. Despite the ebb and flow of their fortunes, cities such as Babylon and Assur remained important cultural and political centers for over 2,000 years, leaving significant legacies.

Over the course of roughly two millennia (2000–330 BCE), the urban, literate cultures of Mesopotamia expanded to a much broader geography referred to here as West Asia, which included present-day Syria, Turkey (the Anatolian Peninsula), the eastern Mediterranean coast, and the Iranian plateau, reaching all the way to the Transcaucasus and the Arabian peninsula (Map 5.1). This expansion led to both an intriguing diversification of art and greater contact and social interaction with the rest of the world. Rulers during this period commissioned artworks and the construction of monuments to inspire awe among their subjects, and to demonstrate that they were the source of laws and justice. Like rulers in the third millennium BCE, they built cities, temples, and palaces, and they commissioned monuments with inscriptions and pictorial programs – an ordered sequence of images carved on

a monument or a building that were designed to tell a story or impart a message to the viewers. In doing so, they emphasized their connection to the gods, their dominion over the physical world, and their ability to provide stability, prosperity, and continuity. During the Middle and Late Bronze Ages (2000–1200 BCE) in particular, West Asian cultures were increasingly connected to the wider world of the Mediterranean through seafaring trade, introducing artists, styles, and materials from other cultures, leading Mesopotamian art to adapt and combine styles in new ways.

From the archives and libraries that survive from this time period, we know that West Asian cultures also advanced scientific scholarship, invented new technologies of production, and developed new forms of literature and visual imagery. The discovery of iron, which was available in large supply, especially in Anatolia, and the invention of iron-working technology ultimately led to a shift away from expensive bronze technologies toward more accessible iron technologies during the Iron Ages. There was an upsurge in metalwork for tools, including new iron tools for sculptors, artisans, and builders, the latter enabling much more finely and intricately produced sculpture, relief, and architecture.

Kingship and Justice in Babylon and Mari, 2000–1600 BCE

During the Middle Bronze age, in the first half of the second millennium BCE (2000–1600 BCE), a new political order was established in Mesopotamia as new regional city-states replaced the territorial order of the Akkadian kingdom and the Third dynasty of Ur. Regional states, such as Babylon, Isin, and Larsa in the south, and Mari and Yamhad in the north, shared a dialect and are often called Old Babylonian states. In the tradition of Mesopotamian

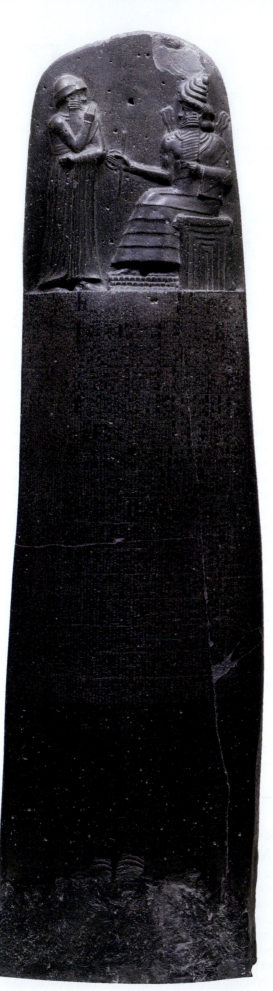

5.1 Law stele of Hammurabi.
c. 1760 BCE. Originally installed in Babylon but excavated at Susa (Iran). Black basalt, height 7 ft. 4⅝ in. (2.25 m). Musée du Louvre, Paris.

stele a carved stone slab that is placed upright and often features commemorative imagery and/or inscriptions.

ziggurat a stepped pyramid or tower-like structure in a Mesopotamian temple complex.

terra-cotta baked clay; also known as earthenware.

archaizing the use of forms dating to the past and associated with a golden age.

rulers, the Old Babylonian rulers built large palaces and created **steles**, rock carvings, and other monuments to portray a new concept of kingship that was both benevolent and just. They also built temples and **ziggurats** to their city gods that were modeled on earlier traditions, while the arts diversified in technology, materials, and visual vocabulary as compared to the third millennium BCE. In this period of shifting allegiances, rulers invoked the gods' approval to assert a divine right to rule. At the same time, the visual arts were increasingly incorporated into everyday life as a result of the flourishing technology of mold-made **terra-cotta** plaques and figurines, (which easily allowed multiples to be made) and through the circulation of ritual artifacts in the ever-widening world of mercantile activity. The terra-cotta plaques of the Old Babylonian period are the most ubiquitous examples of inexpensively produced popular art, to be kept in homes for private worship or to avert evil.

THE LAW STELE OF HAMMURABI Perhaps the best illustration of the importance of justice to Mesopotamian kingship is the Law Stele of Hammurabi (**Fig. 5.1**), a well-known king of the first dynasty of Babylon (ruled c. 1792–1750 BCE). While portions of these laws have been found on clay tablets, Hammurabi also had them inscribed for the public on a roughly seven-and-a-half-foot tall, pillar-shaped stele carved out of black basalt and polished to a high sheen. It is one of the oldest surviving legal records. The rounded top portion of the stele was carved with a figurative composition in relief, representing the face-to-face encounter between Hammurabi and the sun god Shamash, god of justice. The long-bearded Shamash, who has solar rays rising from his shoulders, is seated on a throne on the right. He wears a multi-tiered horned crown, a Mesopotamian marker of godhood, and rests his feet on mountains. The god presents to Hammurabi the rod and ring, the insignia of royal power (sometimes interpreted as a rod and a string, symbolic tools of fair measurement). Hammurabi's sharing of the same pictorial space with Shamash unites the sacred realm of the divinities with the worldly realm of the state, legitimizing Hammurabi's authority as the ruler and dispenser of justice through the support of Shamash.

The laws are inscribed in horizontal bands in cuneiform using the Akkadian language (see box: Making It Real: Writing in Mesopotamia, p. 70.) Just as the image justifies the laws by linking them to divine authority, the **archaizing** characters of the calligraphic inscriptions link them to a golden age of the past. The inscription, which is a list of legal situations and their resolutions (usually in the form of a punishment), provides insight into the nature of justice under Hammurabi's rule. For instance, it lists severe punishments for a builder whose construction fails, collapses unexpectedly, damages the owner's property or hurts his family, highlighting the notion of accountability. The monument made the ruler's power visible to his people and promised that they would be treated justly, but justice still depended on a person's social rank: the text provides a window into the social ranking of the Mesopotamian society, consisting of land-owning free men of the upper class), commoners

and free people of the lower class, and slaves. A rival to Hammurabi's kingdom in Babylonia, the kingdom of Mari flourished further north in the region of the Middle Euphrates valley, in today's eastern Syria. Mari (the present-day archaeological site of Tell Hariri in Syria), became the capital of a formidable, prosperous city-state, connected to the southern Mesopotamian cultural sphere through travel and trade along the Euphrates River and to northern Syria and the Mediterranean coast. At the height of its power, Mari was ruled by Zimri-Lim (1775–1762 BCE), who had allied with Hammurabi in earlier military campaigns.

THE PALACE OF MARI Zimri-Lim's royal palace in Mari was a vast complex of 260 rooms organized around a series of ceremonial courtyards (**Fig. 5.2**). Separate areas were used for storing food, working metal, cooking, ritual feasting, archiving cuneiform clay tablets, and housing guests. The central and largest courtyard (numbered 131 by excavators) was paved around the edges and is believed to have had tall palm trees planted in the middle. At the southern end of this Court of the Palms, jutting out into the courtyard, was a raised throne room with a semicircular podium upon which the ruler sat. The royal podium was flanked by carved limestone statues of water goddesses holding jars out of which water flowed into basins.

FRESCO OF INVESTITURE OF ZIMRI-LIM The palace provides some of the earliest evidence of cultural exchanges between the Mediterranean world and Mesopotamia, particularly in its **iconography** and use of **fresco** technique. One court (number 106) contained an extensive and complex fresco rendered in a wide range of colors, especially green and blue (**Fig. 5.3**). The scene depicts the

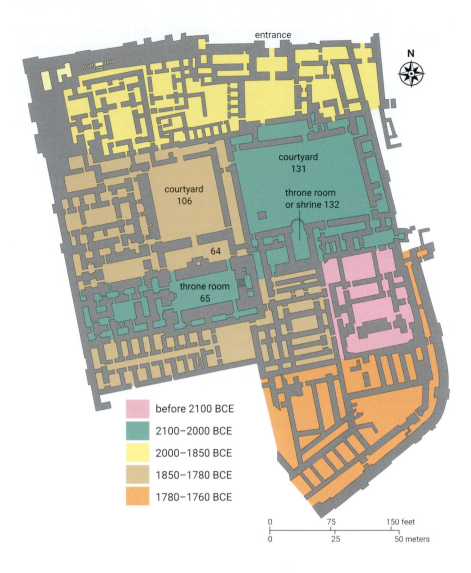

entrance

N

courtyard 131

courtyard 106

throne room or shrine 132

64

throne room 65

before 2100 BCE
2100–2000 BCE
2000–1850 BCE
1850–1780 BCE
1780–1760 BCE

0 — 75 — 150 feet
0 — 25 — 50 meters

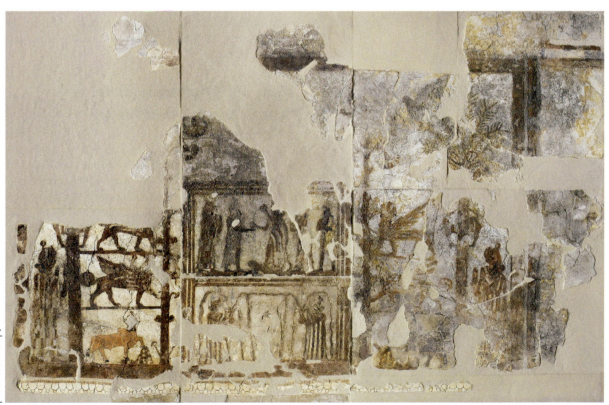

5.2 ABOVE **Palace of Mari (architectural plan),** Tell Hariri, Syria. Middle Bronze Age, *c.* 2100–1760 BCE.

iconography images or symbols used to convey specific meanings in an artwork.

fresco wall or ceiling painting on wet plaster (also called true or buon fresco). Wet pigment merges with the plaster, and once hardened the painting becomes an integral part of the wall. Painting on dry plaster is called *fresco secco*.

5.3 LEFT **The Investiture of Zimri-Lim, wall painting from Court 106 of the Palace of Mari,** (Tell Hariri, Syria), *c.* 1760 BCE. Fresco, 5 ft 9 in. × 8 ft 2½ in. (1.8 × 2.5 m). Musée du Louvre, Paris.

investiture of Zimri-Lim as king by the goddess Ishtar (the Akkadian counterpart of Inanna and the goddess of love and war), who gives him the rod and ring as symbols of rule, as Shamash had given them to Hammurabi on his law stele (**Fig. 5.1**). Zimri-Lim (on the left of the central scene) wears a ceremonial fringed garment and a round-topped headdress. Ishtar is armed with battle gear and rests her foot on a lion.

The scene is depicted in the upper half of a two-**register** composition and includes divine figures behind Zimri-Lim and Ishtar. In the lower register, symmetrically placed water goddesses hold pots, out of which water pours. Significantly, the painting replicates the space in which it is displayed; the ceremony in the fresco appears to be taking place within the Mari palace's large ceremonial courtyard, where the sculptural versions of the spring goddesses discussed above served as actual fountains. The two-register fresco composition is set within a wider landscape of palm trees and mythological creatures, including brightly colored **griffins** and sphinxes, mythological creatures with a lion's body and a human head. The technique, style, and iconography of this vivid mural connect Mari to the Greek islands, especially the roughly contemporary Minoan wall paintings known from the islands of Crete and Thera, where similar representations of exotic landscapes and fantastical creatures are found.

THE BURNEY RELIEF Throughout Babylonia (the term used to describe this cultural region of southern Mesopotamia after the fall of the First Babylonian dynasty), people made offerings to gods in the form of foodstuffs and objects such as **votive** figurines. The terra-cotta plaques of Babylonia are the most ubiquitous and inexpensively

produced popular devotional objects, similar to holy souvenirs acquired at a religious pilgrimage site today, and were kept in homes for private worship and to avert evil. Furthermore, visual arts were increasingly incorporated into everyday life through the increased use of molds to make multiples of objects in terra-cotta, which enabled mass production and the circulation of ritual items in the ever-widening world of mercantile activity.

An important recurring image in these plaques and figurines is a frontally depicted naked goddess. The Burney Relief (a name given to the artwork in 1936 for its owner at the time), sometimes also known as "The Queen of the Night," depicts one such figure in **high relief** (**Fig. 5.4**). Although her specific identity remains a mystery, some scholars identify her as Ereshkigal ("Queen of the Great Earth" or goddess of the underworld) because she has wings pointing downward to the ground, bird-of-prey talons, and a horned crown. Others believe she is Ishtar (Inanna). Her frontal pose reveals her sexual allure, a concept known from Akkadian texts as *kuzbu*, a form of bodily power. She stands on two lions sitting back to back, and she is flanked symmetrically by two owls that also gaze intensely at the viewer. Analysis of the pigment residues revealed extensive original use of red **ocher** to paint the woman and owls; the lions were painted white with black manes.

The scale pattern at the bottom of the plaque indicates that the setting is a mountainous landscape, a stylization that also appears in other images (see **Fig. 5.1**). The figure holds in her hands the rod and the ring: the insignia of the power of justice associated with Mesopotamian rulers. The plaque appears to have been partially molded, with some details modeled and **incised** in the clay. Because scholars do not know the exact site where this object was found, many questions about its origins remain. However, its large size and detail suggest it was made for a wealthy patron. The same figure also appears in smaller, cruder Babylonian mold-made plaques, indicating the popularity of the motif.

Trade and Diplomacy in the Late Bronze Age, 1600–1200 BCE

Seafaring trade and cultural interaction flourished in the Eastern Mediterranean during the Late Bronze Age (1600–1200 BCE) (**Map 5.2**). After advances in ship building and navigation, both state sponsored and independent merchant ships traveled around the Eastern Mediterranean coasts, stopping at major ports of trade and exchanging agricultural products, finished goods, and raw materials. Copper from Cyprus was shipped in bulk as ingots; olives, olive oil, and wine from the Aegean and Syria travelled in Canaanite and Mycenaean **amphorae**; and thousands of other exotic goods were transported across the seas. Diplomatic relations developed among kingdoms in the areas encompassed by present-day Egypt, western Turkey, northern Syria, and Cyprus.

Participating in the Eastern Mediterranean trade and diplomacy, Hittites—the earliest political unifiers of the Central Anatolian plateau—saw themselves as inheritors of Mesopotamian culture. They built their

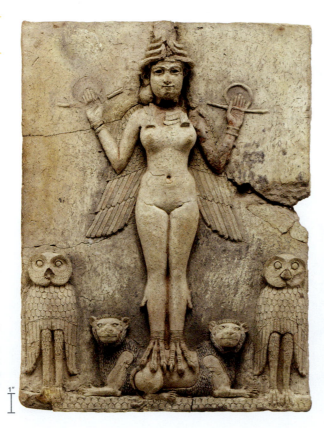

5.4 The Burney Relief ("Queen of the Night"), possibly from Larsa, Iraq (provenance unknown; acquired in the 1920s in southern Iraq). Old Babylonian, *c.* 1900–1700 BCE. Straw-tempered clay pressed onto a mold, 19½ × 14⅝ in. (49.5 × 37.1 cm). British Museum, London.

empire (1600–1175 BCE) on the existing local networks of mining, craft production, and exchange that had developed in Anatolia, and expanded into Northern Syria to control that region's resources and urban centers of craft production, such as Karkamish and Aleppo. During the same period in Mesopotamia, after the Old Babylonian dynasty ended, the Kassites (contemporaries to Hittites in Anatolia) ruled a much-reduced Babylonian empire for about five hundred years, and were often at odds with their Elamite neighbors to the east and an Assyrian regional state to the north.

THE CITY OF HATTUSHA Unlike Mesopotamia, Anatolia's highland geology is rich in sources of stone, allowing the Hittites to build more extensively. Using both **Cyclopean** and **ashlar masonry**, they built their cities and fortresses with a defensive architecture of double walls and fortified gateways. Their capital city of Hattusha (modern Boğazköy) transformed a dramatic rocky landscape filled with springs into a ceremonial state capital, with its sacred gates and streets, sacred ponds, **rock-cut** shrines, stone temples, and other structures. Its layout was designed to accommodate Hittite urban festivals that are known from Hittite texts found in Hattusha. The northern part of the city featured not only a large temple complex, probably dedicated to the Storm God, but also a palace complex on a high ridge. Three symmetrically located ceremonial gates, flanked by **monolithic** carved pillars, pierced the city walls. The massive stones of these gates were carved in high relief with guardian figures of lions, sphinxes, deities, and ancestor kings; the easternmost King's Gate (**Fig. 5.5**), for example, featured an unidentified ancestor king (see p. 98). This style of Cyclopean masonry combined with carved, monolithic figures framing a gate is comparable to the contemporaneous Lion Gate at

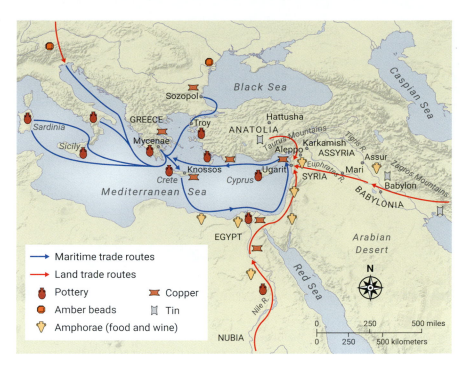

Mycenae (see Fig. 10.7) suggesting an extensive exchange of architectural knowledge and craftsmanship between the Hittites and the Mycenaeans.

YAZILIKAYA OPEN-AIR ROCK SANCTUARY The diverse communities of the Hittite empire were increasingly united by the festival calendar and state religion of Hattusha. The so-called thousand gods of Hatti, many borrowed by the Hittites from other cultures, were believed to come together during major urban festivals in a Great Assembly. The open-air sanctuary known as

Map 5.2 Maritime trade in the Eastern Mediterranean during the Late Bronze Age, *c.* **1600–1200 BCE.**

5.5 King's Gate at the Upper City of Hattusha, capital city of the Hittite empire. Boğazköy, Turkey, last third of sixteenth century BCE.

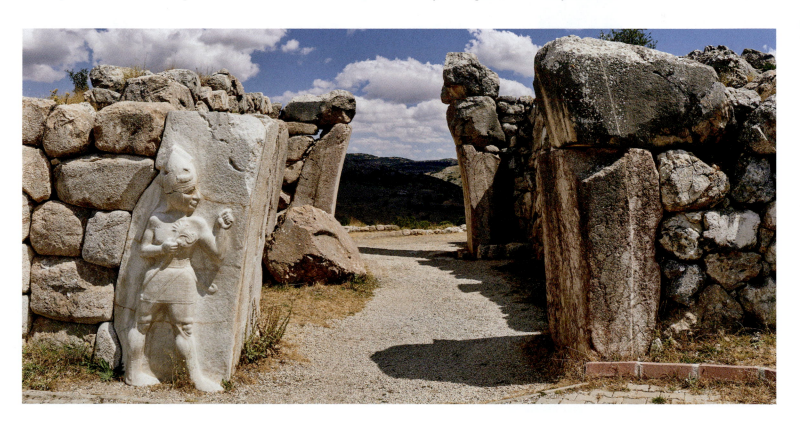

5.6 Deities in procession, from the Yazılıkaya open-air rock sanctuary, Boğazköy, Turkey, 1400–1200 BCE. Stone relief.

burial chamber for dead Hittite kings. In one carving (**Fig. 5.6**), the Storm God and the Sun Goddess stand facing each other in the center. Behind the Sun Goddess, to the viewer's right, stand their offspring. All the figures, carved in **low relief**, stand on either literal or figurative mountains: the Storm God stands atop two mountains depicted as men, and the Sun Goddess and her son stand upon feline animals who in turn stand on mountains.

EFLATUN PINAR The Hittites built water monuments near springs and rivers, which they considered to be sites of communication with their ancestors and with the gods of the underworld. A well-preserved example is the Eflatun Pınar, a sacred pool complex built close to a freshwater lake at the site of a natural spring where cold, fresh waters gushed out of the bedrock (**Fig. 5.7**). The monument was built in the southwestern borderlands of the Hittite Empire, and its Turkish name literally means "Plato's Spring." Although the Greek philosopher Plato did not live until one thousand years later, the site's significance endured, and was an important location in the medieval period and beyond, giving rise to new stories about its origin. It consists of a large, stone-built pool with a stone structure at its northeastern side. The carefully fitted blocks of the structure include a series of deities and fabulous creatures carved in relief, facing the pool in a symmetrical design. Centrally placed, although extensively eroded, are two seated deities (probably the Storm God and the Sun Goddess of the Earth) topped by winged disks, a West Asian symbol of royal power. The lowest course, standing in the water, consists of

Yazılıkaya (literally "Inscribed Rock" in Turkish), located approximately a mile (1.6 km) east of Hattusha, was used as a ritual site during those festivals, acting as a visual manifestation of that divine assembly. Representations of the various deities walking in procession are carved in profile into long rows in the sides of two rock cliffs that converge. While the larger chamber was reserved for this assembly, the narrower chamber housed representations of the gods of the underworld, where dead ancestors lived, according to Hittite belief. Archaeologists have suggested that this chamber may have served as a

low relief (also called bas-relief) raised forms that project only slightly from a flat background.

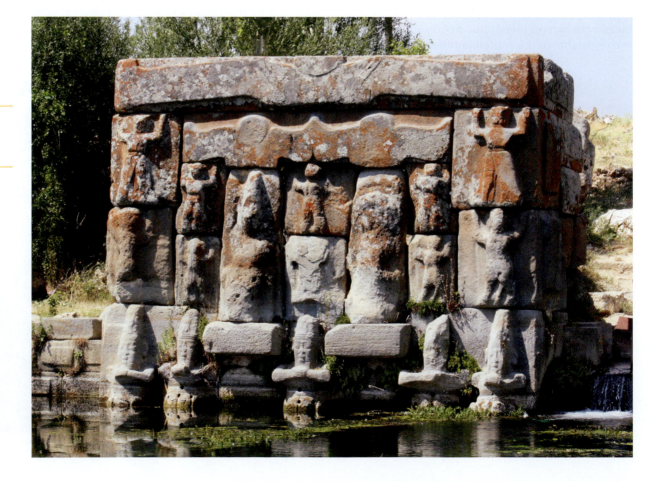

5.7 Eflatun Pınar sacred pool complex, near Beyşehir Lake, Konya province, Turkey, late fourteenth–early thirteenth century BCE.

mountain-spring deities with tall headdresses, crossed arms, mountain-shaped skirts, and holes in their bellies through which water once spurted.

GOLD BOWL FROM UGARIT Hittite political activity reached south into the Canaanite territories of the Eastern Mediterranean, putting it in conflict with Egypt, which had political and economic interests in the same region. In an area tightly connected by trade and diplomacy, the style and iconography of works of art spoke to an international, cross-cultural taste, rather than to a limited specific local meaning or significance. Such objects, therefore, often mixed various iconographic characters or styles of representation.

A small, hemispherical bowl from the ancient port city of Ugarit (in present-day northwestern Syria), made by beating red-gold foil onto a bitumen core, provides an example of mixed cultural features (**Fig. 5.8**). The intricate composition of images was created on the bowl's surface through the **repoussé** technique, while details were incised on the exterior. The composition is arranged in the form of bands showing wild and mythological animals, idealized and natural vegetation, and hunters tracking wild beasts. The widest band, running around the top of the bowl, presents a fantastical landscape, including sphinxes, griffins, and stags, interspersed with designs of **voluted** palmettes (fan-shaped palm leaves). Rows of pomegranates, along with a variety of symmetrically placed wild animals, including lions and bulls, dominate the interior band. Close examination of the motifs used to create this lively design with its pattern of interlaced bands suggests a careful mixing of Egyptian, Aegean, Mesopotamian, and Eastern Mediterranean iconographic elements and stylistic features. The visual language of exotic animals, plants and landscapes depicted, along with the guilloche pattern (formed from interlaced bands), are features that would be at home in all of those cultures. The non-political subject matter of the bowl's design may have made this precious item appropriate for a variety of diplomatic exchanges or transactions.

Iron Age: Syro-Hittite States, Neo-Assyrian Empire, and Neo-Babylonian Empire, 1200–539 BCE

Around 1200 BCE, the Mediterranean network of international diplomacy, entrepreneurial trade, and cultural connectivity came to an abrupt end, for reasons that are still much debated. Around 1175 BCE, Hattusha was abandoned and the Hittite empire collapsed, never to recover. Most of the wealthy Eastern Mediterranean ports of trade, such as Ugarit, seem to have dwindled, and the sharp economic and political decline also affected Egypt and Greece. Mesopotamia was less subject to such economic collapse compared to Anatolia and the Eastern Mediterranean region, but economies and trade throughout West Asia were nonetheless disrupted for a long time.

The end of the Bronze Age in the eastern Mediterranean marked the demise of wealthy palace economies that supported bronze-making workshops dependent on suppliers of copper and tin. Bronze workshops were replaced by

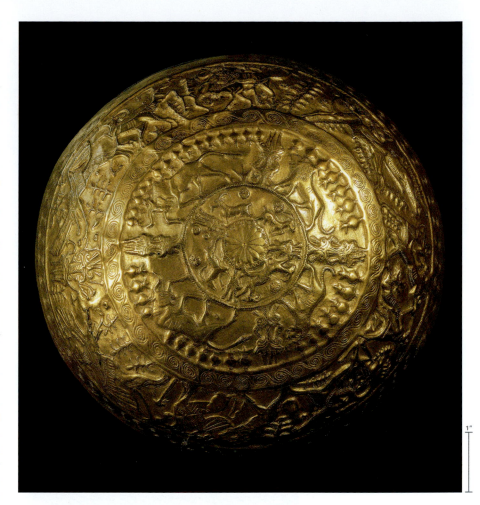

5.8 Gold bowl from Ugarit (Ras Shambra, Syria), fifteenth–fourteenth century BCE. Gold, diameter 6¾ in. (17.2 cm). Aleppo National Museum, Syria.

the more easily run iron-working workshops, supplied by more prevalent iron ores. The introduction of iron tools influenced stone carving technologies, because iron chisels replaced stone hammers in the creation of architecture and sculpture and allowed much more refined and precise ways of working stone. The Iron Ages in West Asia are usually divided into Early, Middle, and Late Iron Age, defined by political developments. During the Early Iron Age in the areas around northern Syria and southeastern Anatolia (1200–900 BCE), a series of small regional states arose, known as Syro-Hittite states because of their shared claim on the heritage of Hittite empire—for example, through using Hittite imperial styles of representation and continuing to use the Luwian hieroglyphic writing system. Also shared among these states was the extensive use of stone in the construction of urban spaces.

KARKAMISH The city of Karkamish, built at a major river crossing and port of trade on the Euphrates River, had been an important urban center under the influence of the Hittite empire and the Mitannian kingdom, which controlled northern Syria and southeastern Anatolia during the Late Bronze Age. In the eleventh and tenth centuries BCE, the rulers of this Syro-Hittite state of Karkamish engaged in a reconstruction of the city's public spaces and commissioned a series of **orthostat** programs, which were inscribed in hieroglyphic Luwian and alphabetic Phoenician. Here, urban designs were carefully planned

repoussé a relief design created by hammering malleable metal from the reverse side (not the side to be viewed).

volute a decorative element in the form of a coiled scroll.

orthostat an upright, standing stone slab, often protecting the lower part of a wall.

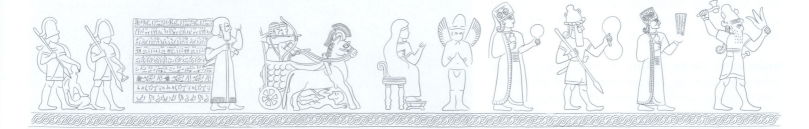

5.9a ABOVE **The Long Wall of Sculpture,** Karkamish on the Euphrates (reconstruction drawing), tenth century BCE. (originals now in Museum of Anatolian Civilizations, Ankara, Turkey).

5.9b RIGHT **Chariot scene from the Long Wall of Sculpture,** Karkamish on the Euphrates, tenth century BCE. Carved basalt orthostat, 6 ft 6¾ in. × 4 ft 10⅜ in. (2 × 1.5 m). Museum of Anatolian Civilizations, Ankara, Turkey.

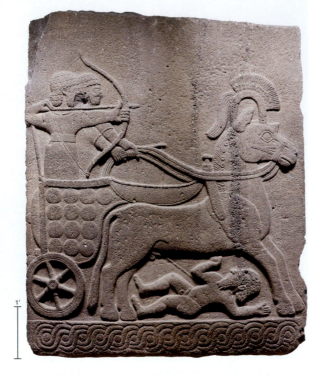

hieroglyphic a type of written script that uses conventionalized signs to represent concepts, sounds, or words.

pictorial program the complete set of imagery in a monument or on a building that is designed in a holistic and calculated manner.

libation ritual pouring of a liquid, often alcohol, to a spirit or deity as an offering while prayers are said.

and by about 1400 BCE, it rivaled Kassite Babylonia in the south and the Hittite states to its west as one of the prominent regional powers of West Asia. After 1000 BCE, the Assyrians gradually expanded their economic and political power toward the eastern coast of the Mediterranean, Syria, southeastern Anatolia, Elam (in present-day Iran), Babylonia, and eventually Egypt, and established the Neo-Assyrian empire (*c.* 911–612 BCE).

As such, Assyrians were constantly in direct contact with the ethnically and linguistically mixed world around them, and the **pictorial programs** in the Assyrian public spaces tended to focus on their military expeditions and building projects, often linked in a cause and effect relationship. The Assyrians carried out yearly military campaigns to the frontiers of their empire, consolidating their political power and increasing the empire's wealth through taxes and tribute. Much of the income was then channeled into imperial building projects in Assyrian capital cities such as Kalhu, Dur-Sharrukin, and Nineveh. Because of their expeditions, Assyrians were in direct contact with the diverse cultures around them; Assyrian palaces, temples, city walls, gates, and urban infrastructure were often built using the laborers, skilled artisans, and exotic materials brought back from foreign lands.

ART IN THE ASSYRIAN NORTHWEST PALACE Ashurnasirpal II (ruled 883–859 BCE) moved the Assyrian capital from Assur to the city of Nimrud (ancient Kalhu) further north on the Tigris River in 879 BCE, re-establishing the city through major building projects. He encircled it with a five-mile-long (around 8 km) wall and built his massive Northwest Palace on a raised terrace constructed over an ancient mound, alongside several temples, monumental gates, and a canal to bring fresh water to the city and its orchards.

The design of the Northwest Palace, with its complex architectural, pictorial and textual content, is considered a major innovation in Assyrian art. The pictorial programs in Assyrian public spaces provided detailed histories of military campaigns, glorifying the image of the king, who was depicted as victorious in battle, benevolent in his generosity, and semi-divine. The king's image was further strengthened through depictions of him participating in ceremonial lion hunts and the ritual **libations** that followed them; these scenes served as metaphors for the royal courage and strength of the kingship. Even in the more personal and private areas of the Assyrian court, the art was similar: the king commissioned imagery to project the divinely sanctioned character of the monarchy, with himself portrayed in the midst of divine and semi-divine creatures that acted as

to make use of space, as well as complex decoration, while the orthostats lined the walls of monumental buildings and formed storytelling sequences.

ORTHOSTATS On a wall and along a monumental staircase that led up to the Temple of the Storm God in Karkamish, artists carved basalt and limestone orthostats in low relief depicting the combined military, royal, and divine force of the city in a proud and festive procession (**Fig. 5.9a**). On the viewer's left, the sequence starts with a depiction of the king's infantry soldiers marching and capturing naked enemy soldiers. The king's image and a **hieroglyphic** inscription that he wrote interrupt this sequence, while a series of orthostats depicting military chariots trampling on enemy soldiers appears on the right (**Fig. 5.9b**). This military parade is then led by an image of the seated queen and a variety of Karkamishean gods and goddesses, including the principal deity of the city, the Storm God.

ASSYRIA The city of Assur, named for its patron god Ashur, in the middle Tigris River valley in Upper Mesopotamia, was the capital of a regional state since the third millennium BCE. While its influence expanded and contracted with the shifting power structures of the first half of the second millennium BCE, the city-state itself endured,

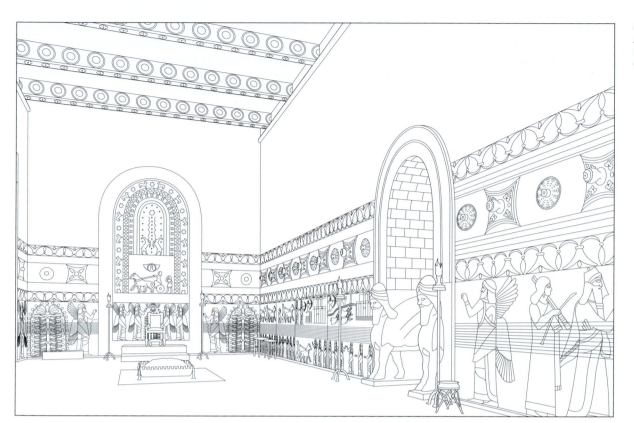

wise, strong protectors of the Assyrian state. Panels of gypsum more than seven feet high (more than 2 m) and carved with inscriptions and pictorial scenes covered the brick walls of the courtyards, throne rooms, and other spaces of the Northwest Palace. This form of decoration became a defining feature of Assyrian palaces. The regionally available gypsum that was used for the orthostats as well as for free-standing sculptures hardens as it is exposed to air, but it is relatively soft when quarried, allowing sculptors to incorporate great amounts of detail, especially when using iron tools.

THRONE ROOM OF ASHURNASIRPAL II The enormous throne room of Ashurnasirpal II (Fig. 5.10), one of several in the Northwest Palace, was entirely decorated with painted tiles and orthostats (such as Fig. 5.11), carved and inscribed in low relief and running around the whole room. A central strip of inscriptions commemorated the construction of the palace and enumerated the king's achievements; the strip divided the majority of the reliefs horizontally into two pictorial registers, below and above. These registers provided a continuous visual narrative showing sequential episodes in the military successes

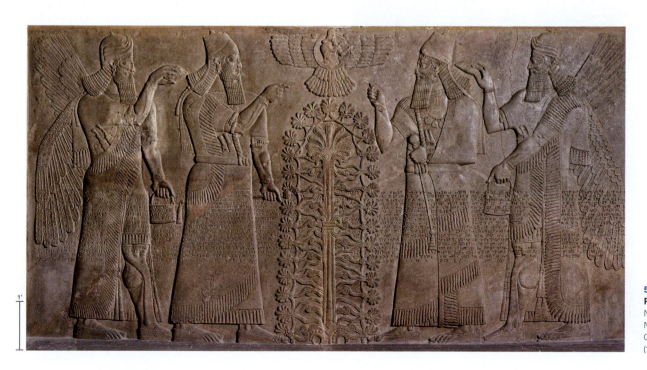

5.11 Orthostat from Throne Room (B) of Ashurnasirpal II, Northwest Palace at Kalhu (Tell Nimrud, Iraq). 883–859 BCE. Gypsum, height 76¾ inches (195 cm). British Museum, London.

of the king and his army, as well as his ceremonial lion hunts and related rituals.

Directly behind the king's throne was a carved orthostat with a symmetrical composition, on a much larger scale than the other orthostats in the room (**Fig. 5.11**). In this carefully designed scene, a geometrically stylized palm tree stands in the center, topped by the winged disk bearing an image of a god. The disk was an official emblem of the Assyrian state, adapted from similar emblems seen in Hittite monuments, such as Eflatun Pınar (see **Fig. 5.8**). Unlike earlier images from both ancient Egypt and Mesopotamia (see, for example, Figs. 4.3 and 3.13b), the figures in this orthostat are of the same size as one another, rather than being shown at different sizes to indicate their relative rank. The Assyrian king, identified by his conical head cap, seems to be depicted twice, in profile and carrying a scepter. He approaches the tree from either side with two different devotional gestures. Flanking the scene are two winged spirits that carry buckets of holy water and pine cones to purify or pollinate the tree.

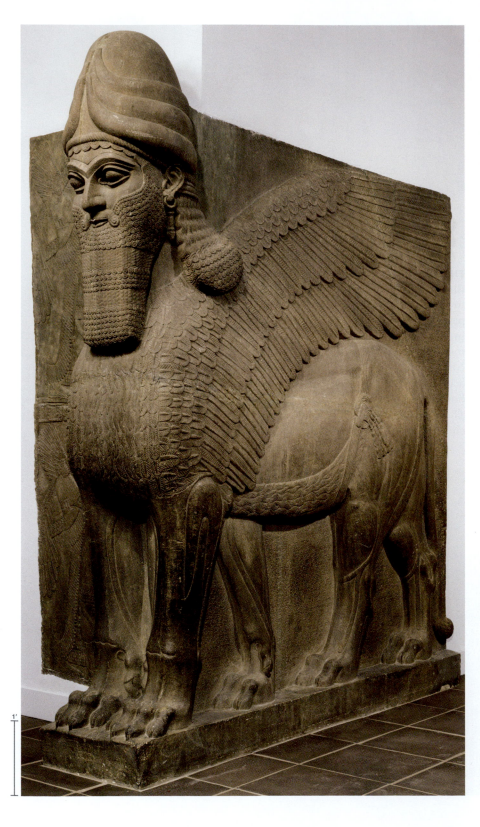

5.12 Colossus winged lion (lamassu) that guarded a portal in the Northwest Palace of Ashurnasirpal II at Kalhu (Tell Nimrud, Iraq), *c.* 879 BCE. Gypsum, 122½ × 24½ in. (3.11 × 0.62 m). Metropolitan Museum of Art, New York.

LAMASSU GUARDIAN FIGURES The arched portals that connected the main ceremonial courtyard to the major throne room of the Northwest Palace were flanked by huge sculptures of hybrid mythological creatures called *lamassu* (**Fig. 5.12**). These human-headed, eagle-winged lions (or sometimes bulls) were considered wise and cunning magical beasts, and they guarded the important doorways in Assyrian palaces, the administrative center of the empire. The carver's skill is noticeable in the intricate detailing of the curls of the *lamassu*'s beard and body hair, and the feathers of the wings. This type of gate sculpture may be the most monumental feature of an Assyrian palace, comparable to the lions and sphinxes that guarded the city gates of the Hittite capital Hattusha.

The legs of the *lamassu* are carved in such a way that, when seen frontally, the body is symmetrical and appears to be standing still, while from the side view, it appears to be striding forward. This visual effect was achieved by giving the *lamassu* five legs; when seen in profile, the closer front leg concealed the farther. The sculpture's immense size (over 10 feet, or 3 m, tall) and its animal–human hybrid nature made it a dominating and perhaps even intimidating figure to visitors. On the creature's long-bearded, human head is a tall cap, a symbol of its divine character. Royal inscriptions in Assyrian cuneiform are carved on the flat background of the stone gate, between the legs of the *lamassu*. The inscription links the narrative to the *lamassu* image directly: "Beasts of the mountains and the seas, which I had fashioned out of white limestone and alabaster, I had set up in its gates. I made [the palace] fittingly imposing."

LION HUNT IN THE NORTH PALACE OF NINEVEH The Assyrian king Sennacherib (ruled 705–681 BCE) moved the capital to the city of Nineveh, which he almost completely rebuilt and surrounded with a double fortification wall and moat. As at Nimrud, large stone *lamassu* flanked and guarded important doorways of his massive palace, which had around eighty rooms, many covered in carved orthostats. During the reigns of Sennacherib and Ashurbanipal (ruled 668–627 BCE), orthostat narratives became so detailed and comprehensive that entire courtyards or rooms were dedicated to covering the events of a single battle or hunt, with multiple episodes shown in a continuous narrative.

Scenes in the North Palace of Nineveh depicting Ashurbanipal's lion hunts show a shift toward representing dramatic moments of action rather than static scenes (**Fig. 5.13**). The king is accompanied by armed

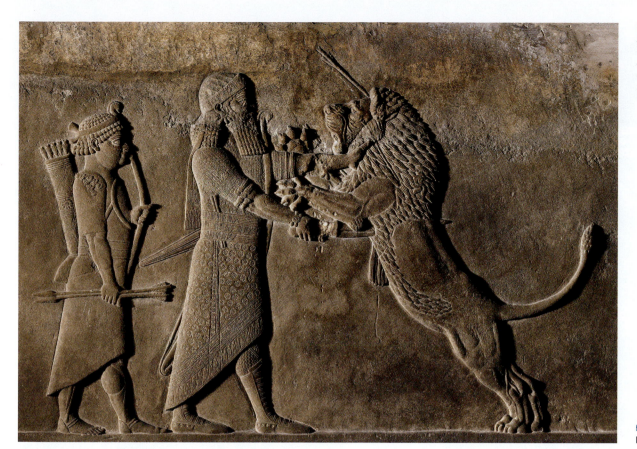

5.13 Lion hunt of King Ashurbanipal, from the North Palace, Nineveh (Mosul, Iraq), c. 645–635 BCE. Scene from gypsum relief orthostat; entire relief 24 × 46 in. (61 × 116.8 cm). British Museum, London.

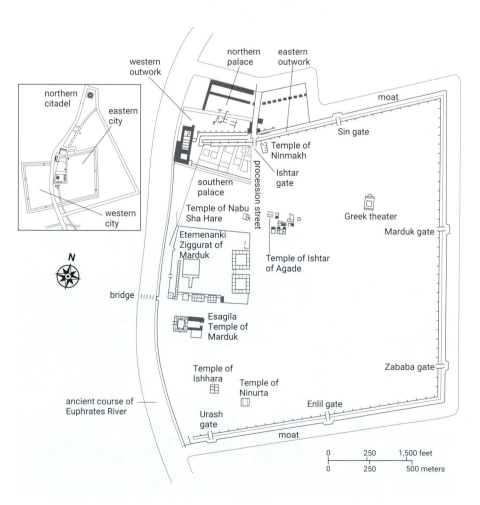

5.14 BELOW **Plan of the city of Babylon,** Neo-Babylonian dynasty.

soldiers and seen in his elaborate royal attire, including his metal armbands, cuffs, and earrings. The lions, pierced by arrows, are vividly depicted suffering and in pain, with a remarkable degree of anatomical naturalism, which would have been intensified when, as is almost certain, the reliefs still featured their original painted colors. In this illustrated scene, Ashurbanipal is on foot, and he holds a wounded but still aggressive, snarling lion by the throat with his left hand as he stabs the lion with a sword held in his right. Although the degree of relief is shallow, the artist conveys a believable impression of the animal's weight and musculature, rendering sharply observed details such as the texture of the mane. One goal undoubtedly was to highlight the lion's physical size and strength, thus demonstrating the king's prowess and bravery.

BABYLON An alliance led by Babylon revolted against the Assyrians after Ashurbanipal's death in 627 BCE and captured the Assyrian capital, Nineveh, in 612 BCE. The center of power in Mesopotamia shifted back to Babylon, although this Neo-Babylonian empire lasted for only about ninety years (626–539 BCE). Babylon became a center of scholarship, science, literature, and technological innovations, and indeed a map drawn on a clay tablet from Sippar and dating to the sixth century BCE places Babylon at the precise center of the world (see box: Looking More Closely: Babylonian Map of the World, p. 111).

During their long reigns, Nebuchadnezzar II (ruled 604–562 BCE) and Nabonidus (ruled 555–539 BCE) expanded and renewed the city through a series of monumental construction projects and visual programs (**5.14**). These

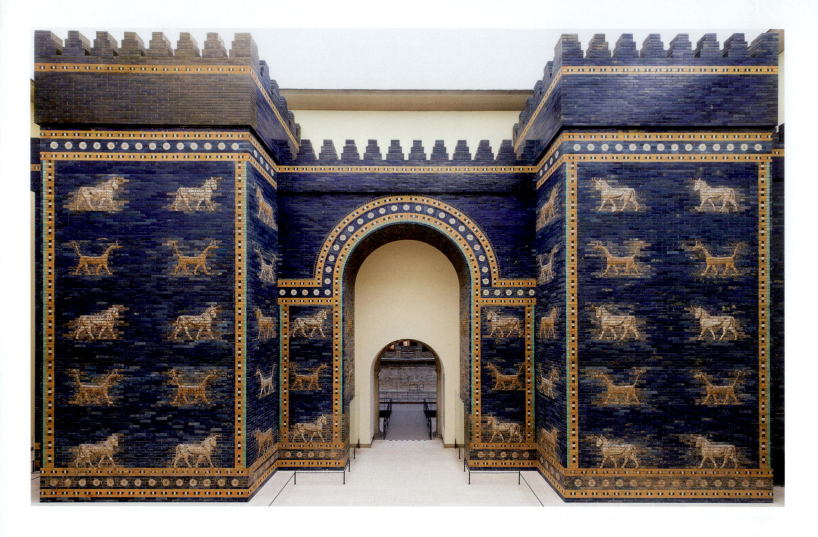

projects included a 40-foot-wide moat (12.19 m); double walls (one 12 feet thick (3.66 m), the other 21 feet thick (6.4 m) surmounted by towers; the sanctuary complex and ziggurat of Marduk, the patron god of the city; and eight great fortified gateways.

THE ISHTAR GATE OF BABYLON The ceremonial entrance to Babylon, a city of 100,000 inhabitants, was through the Ishtar Gate (**Fig. 5.15**). The gate opened onto a walled street, over 60 feet (18 m) wide at some points, that ran through the city to Marduk's ziggurat. The surfaces of the gate's walls, which were 23 feet (7 m) thick, were clad in glazed bricks. The street level was decorated with 120 almost-life-size striding lions, bulls, and dragons, creating an impressive spectacle for visitors to the city.

Dedicated to Ishtar (Inanna) and flanked by monumental towers, the 50-foot-high (15.24 m) gate bridged the whole span of the fortifications (the inner wall, the moat, and the outer wall of the city). Babylonian architects developed glazed molded bricks to clad the structure, which allowed high-relief representations of mythological animals on a deep blue background. Hundreds of other bricks glazed in a lively mix of yellow, red, brown, and other colors were molded to create low-relief representations of mythological animals and deities. Arranged symmetrically in alternating rows, striding bulls and snake dragons (*mušhuššu*) float across the vast, blue surface, which gleam in the sun. Associated with Marduk, the *mušhuššu* ("furious snake") is a hybrid mythological creature with a horned head, the body of a snake, the forelegs of a lion, and the hind legs of a bird of prey (**Fig. 5.16**).

This Ishtar Gate played a major role in the Babylonian festival *akitu*, which was celebrated for twelve days in the spring and was the city's most important religious festival. In the first days of the festival, a procession took

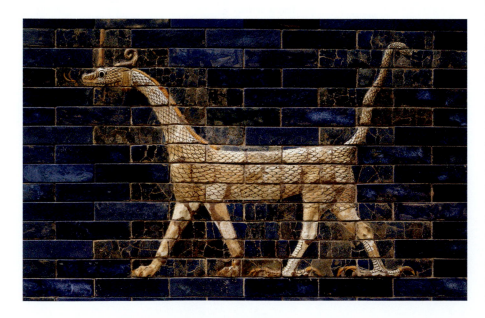

One of the earliest attempts to picture the entire known world appears on an unusual clay tablet (**Fig. 5.17**) that was excavated in the nineteenth century by Hormuzd Rassam in southern Iraq.

This extraordinary map represents the world as Mesopotamians understood it in the first half of the first millennium BCE (roughly 1000–500 BCE). The accompanying explanatory cuneiform inscription is only partially preserved. At the end of the tablet, the author indicates that this text was copied from an earlier document, and the place names on the map suggest that the text dates to earlier than the ninth century BCE. The map splits the world into known regions

and unexplored places. Within the known world, diagrammed as a perfect circle, Babylon is placed prominently at the center, with the Euphrates River flowing through it. Other place names, including Assyria, Bit-Yakin, Habban, and Urartu, are inscribed in cuneiform on smaller circles, which are placed with respect to Babylon. The known world is surrounded by an outer circle that represents the mythical ocean labeled *marrutu*, literally "the Bitter River." Eight mythical regions, each indicated by a triangle, are evenly distributed beyond the Bitter River, creating an overall star-like form. The preserved part of the text explains that the so-called

"creatures of Marduk" live in the mythical islands beyond the Bitter River, and lists these creatures, which include a scorpion-man, a mountain goat, gazelle, zebu (humped cattle), leopard, bison, lion, wolf, stag, and hyena. Some of these creatures are depicted on the walls of the Ishtar Gate of Babylon (see **Fig. 5.15**).

The map and its text give us an extraordinary glimpse into the geographical imagination of the world in Mesopotamian thought. Noteworthy is this ancient map's similarity to considerably later medieval Arab and European maps of the world (*mappa mundi*), many of which also use a circle to diagram the world.

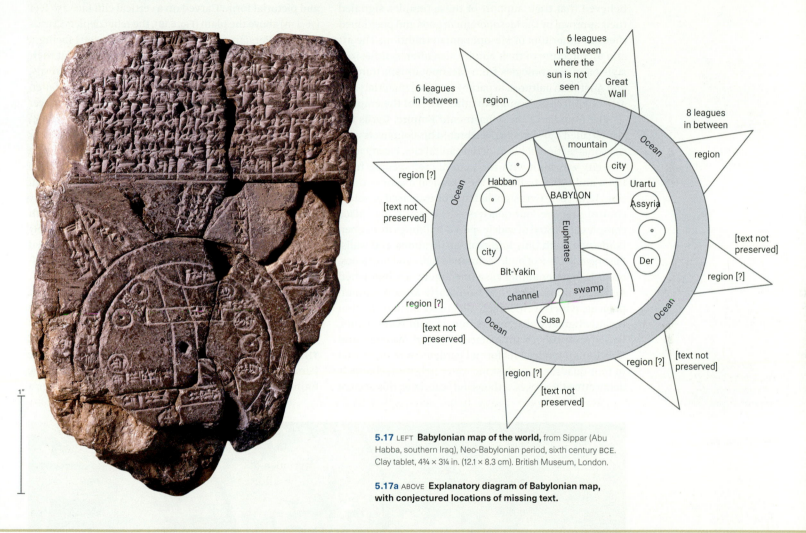

5.17 LEFT **Babylonian map of the world,** from Sippar (Abu Habba, southern Iraq), Neo-Babylonian period, sixth century BCE. Clay tablet, 4¾ × 3¼ in. (12.1 × 8.3 cm). British Museum, London.

5.17a ABOVE **Explanatory diagram of Babylonian map, with conjectured locations of missing text.**

the statue of Marduk to a small, rural temple—the *akitu* house, outside the city. While Marduk was believed to be away from the city, social order was in limbo and the city was under threat. At the end of the festival, he returns and restores the political and social order. An 82-foot (25 m) wide ceremonial street extending from Marduk's ziggurat and sanctuary formed the backbone of the public celebrations, which left the city through the Ishtar Gate and reached the *akitu* house outside of Babylon.

The Achaemenid Empire, 550–330 BCE

The Achaemenid Empire was the final empire in ancient West Asian history, and it brought prosperity for approximately 200 years to a vast territory spanning all the way from Central Asia to the Ionian Sea and Egypt, and from southern Mesopotamia to the Transcaucasus. The Persian Achaemenid dynasty transformed their kingdom into a vast empire (550–330 BCE) stretching from the Indus River and in South Asia to the Ionian Sea and Egypt, and from southern Mesopotamia to the Transcaucasus

(see **Map 5.1**). The Persians also attempted to extend their empire to mainland Greece, but were ultimately defeated (see Chapter 13).

The Achaemenids employed a unique system of provincial governments called satrapies in different regions of the Empire. This allowed local elite people to govern without much direct intervention by the king, granting political autonomy to those diverse lands. Persian kings, like other ancient West Asian rulers, asserted a divine right to their monarchy, claiming that they derived their authority to rule directly from the gods and not from the people. The Persian religion (which later developed into Zoroastrianism) held Ahura Mazda as the supreme being, but the Achaemenids also tolerated the religions of the regions they conquered. The Achaemenid kings believed that their support of these temples signaled their approval by the Mesopotamian gods and positioned them as inheritors of Mesopotamian tradition. The art and architecture of their empire also often synthesized styles and technologies from Mesopotamian, Iranian, and Anatolian cultures, in part by bringing materials and artists from those regions to other parts of the empire.

The founder of the Achaemenid Empire, Cyrus the Great (ruled 559–530 BCE), celebrated his conquests with the construction of his imperial capital city, Pasargadae. The city was built with the help of craftspeople from Ionia and Lydia, trained in the Classical masonry tradition. Reflecting Cyrus's belief that he exercised absolute control over the four quarters of the world, his palace complex consisted of widely spaced buildings in an open landscape, with only minimal fortifications and walls. Pasargadae's use of multi-columned halls and **porticoes**, open layouts enabling easy movement distinguished Achaemenid architecture from early Mesopotamian palaces, which were largely defensive structures that included great walls, towers, moats, and battlements. Relief sculpture in the palace followed Assyrian and Babylonian models. Its formal gardens were organized in four quadrants, with stone water irrigation channels delineating the spaces. A thousand years later, this ancient Iranian four-part garden plan, known as *paradeisos* in Greek, and *charbagh* (or *chahar bagh*) in Persian, became a central component in Islamic garden design because it was seen as symbolic of Paradise.

BISOTUN (BEHISTUN) ROCK RELIEF The Persians continued the Mesopotamian tradition of carving relief monuments on rock surfaces, but with changes that reflected the multilingual empire, their Zoroastrian religion, and their conception of royal power. The rock relief of Darius I (ruled 521–486 BCE) at the sacred mountain site of Bisotun (or Behistun, "Bagastana" in Old Persian, literally "place of the gods") records Darius's defeat of several forces rebelling against the empire, articulating the state ideology of imperial domination in both verbal and pictorial form. Carved on a vertical cliff face 250 feet (76.2 m) above the plain (**Fig. 5.18**), the relief depicts Darius and two Persian guards (on the viewer's left) facing a row of nine bound kings chained to each other at their necks. Darius is taller than both his guards and his rivals, at **hierarchical scale**, stepping over or on top of a fallen enemy. With his right hand, he offers a gesture of prayer to the god Ahura Mazda, who hovers above the scene, supported by a winged disk. Darius and his guards wear long robes with symmetrical folds, similar to drapery seen on Classical Greek statues (see Chapter 13). The nine rebellious rulers are identifiable by the regional clothing of their countries, but they are also labeled by name and country. The Scythian ruler at the far right with a conical hat was added later than the others, possibly after he was defeated in 519 BCE. The relief is surrounded by text recording Darius' victories inscribed in three different languages: Old Persian, Elamite, and Babylonian. Because of its use of multiple languages, the monument was key in the decipherment of cuneiform script in the nineteenth century.

THE APADANA AT PERSEPOLIS The new imperial city Persepolis ("City of the Persians" in Greek, **Fig. 5.19**), founded by Darius I and completed by Artaxerxes I

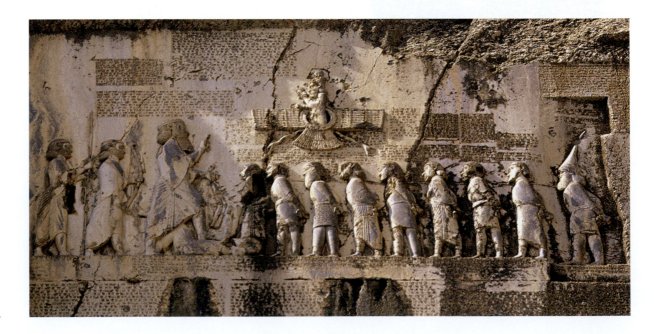

5.18 Bisotun (Behistun) **rock relief,** Zagros Mountains, Kermanshah province, Iran, 520 BCE. 10 × 18 ft. (3.05 × 5.49 m).

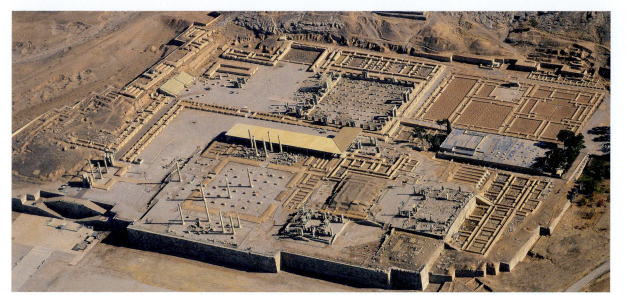

5.19 Aerial view of the remains of Persepolis, capital city of the Achaemenid Persian empire. Fars province, Iran.

(ruled 464–423 BCE), established a powerful visual vocabulary for the imperial splendor of the Persian state. Persepolis was built as a ceremonial city, like the Hittite capital Hattusha. The city was built on a huge 40-foot-high (12.19 m) platform built up against a hillside. The top of the platform was reached from the plain below by a pair of massive staircases that horses could walk up. The platform, which led to a monumental gatehouse, also held palaces, a treasury, a throne room, the Apadana, and other administrative buildings.

The Apadana, the largest building, was an audience hall in which the emperor received gifts from dignitaries and representatives from across the empire. It was also where state ceremonies, coronations, and new year's festivals were held. This **hypostyle hall**, which held thousands of people, originally had a wooden roof supported by a dense array of 72 stone columns, each reaching the extraordinary height of nearly 65 feet (19.81 m). The column **capitals** supporting the roof beams were carved from large blocks of stone into the shapes of bulls and lions. The architecture and sculptural decoration brought together the styles and artisans of West Asia, Egypt, Greece (Ionia), and Central Asia. Many of the intricate carvings were painted with bright colors.

CARVED RELIEFS AT PERSEPOLIS Throughout Persepolis, artists carved substantial narrative relief panels in stone, in the long tradition of Mesopotamian royal architecture.

hypostyle hall large room with rows of columns or pillars supporting the roof.

capital the distinct top section, usually decorative, of a column or pillar.

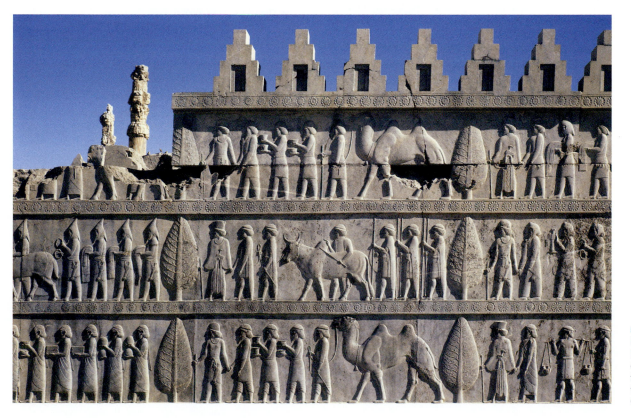

5.20 The Apadana building at Persepolis, stone reliefs on the Eastern Staircase depicting the delegations of different peoples from the empire bringing gifts; from top: Bactrians, Lydians and Gandharans. Fars province, Iran.

The narratives on the walls and stairs extended single scenes over much greater lengths than earlier panel carvings, which used separate panels to depict different moments in sequence. For example, the staircases leading into the Apadana were carved in relief with registers of long processions of officials and dignitaries of subject territories bringing gifts and tribute to the Persian emperor, an appropriate subject for the building (**Fig. 5.20**, p. 113). The emissaries, all shown in repeated patterns in profile or with their torsos twisted to the front, have their feet on the same ground plane, as in earlier depictions by the Mesopotamians and Egyptians.

The origin of the groups can be discerned from their animals and their distinctive regional clothing: Bactrians from Central Asia walk with their camels; Lydians wear their traditional headdresses and carry elegant metal vessels (open containers); Gandharans lead oxen. Stylized cypress trees separate each of the various groups. These depictions not only reflected the diverse populations of the empire but also implied their subjugation to the Persian state. The approximately life-size reliefs, originally painted, also replicate the actual experience of gift-giving delegates coming to the Apadana, turning the architecture into imperial theater.

The Achaemenid empire came to an end when Alexander III of Macedon, also known as Alexander the Great, defeated the Persian army a number of times in his expedition to the East, which started in 334 BCE. Alexander's conquests took him all the way to Central Asia after his looting and burning of Persepolis. His conquests mark the beginning of Hellenization (the influence of ancient Greece) in West Asia, leading to the foundation of the Hellenistic kingdoms and the widespread use of the Greek language. For these reasons, Alexander the Great's expedition is sometimes considered to mark the "end of Mesopotamia." However, well beyond the Hellenistic period (see Chapter 15), aspects of West Asian cultures survived in the cultural and artistic traditions of the region.

Discussion Questions

1. What were the technological, artistic, and architectural aspects of the transition from the Bronze Age to the Iron Age in the Eastern Mediterranean world including Mesopotamia, Egypt, and the Aegean? Support your discussion with examples.

2. What was the role of state monuments in ancient West Asia? Discuss with examples and compare at least two different empires that were covered in the chapter.

3. Compare examples of art from this chapter that seems more narrative (active storytelling) with others that look more static. What visual qualities led you to make these different selections? What different purposes do narrative and static art serve, and how does context affect the purpose?

Further Reading

- Feldman, Marian H. "Luxurious Forms: Refining a Mediterranean 'International Style,' 1400–1200 B.C.E.". *Art Bulletin* 84 (2002): 6–29.

- Gunter, Ann (ed.) *A Companion to Ancient Near Eastern Art (Blackwell Companions to the Ancient World)*. Malden, MA: Wiley Blackwell, 2019.

- Harmanşah, Ömür, "Monuments and Memory: Architecture and Visual Culture in Ancient Anatolian History." In Sharon R. Steadman and Gregory McMahon (eds.) *Oxford Handbook of Anatolian Studies (8000–323 BCE)*. Oxford University Press, Oxford (2011): pp. 623-651.

- Winter, Irene J. "Royal Rhetoric and the Development of Historical Narrative in Neo-Assyrian Reliefs." *Studies in Visual Communication* 7, no. 2 (1981): 2–38.

Chronology

2000–1600 BCE	The Middle Bronze Age		1200–900 BCE	Syro-Hittite states rise in northern Syria, the Levantine coast, and southeastern Anatolia
1894–1595 BCE	The first Babylonian dynasty		1200–1175 BCE	Period of collapse; the Hittite empire falls and Hattusha is abandoned
c. 1760 BCE	The Investiture of Zimri-Lim fresco is painted at Palace of Mari		11th–10th centuries BCE	The Syro-Hittite city of Karkamish is reconstructed
c. 1760 BCE	The Law Stele of Hammurabi is installed		c. 911–612 BCE	The Neo-Assyrian empire
			883–859 BCE	Orthostats at Kalhu, Nineveh are made
1600–1200 BCE	The Late Bronze Age		626–539 BCE	The Neo-Babylonian dynasty
15th–14th centuries BCE	The gold bowl from Ugarit is made		550–330 BCE	The Achaemenid Persian empire
1550–1175 BCE	The Hittite empire flourishes with capital city at Hattusha		520 BCE	Darius I constructs rock relief at Bisotun
14th–13th century BCE	The Yazılıkaya open-air rock-cut sanctuary made		334 BCE	Alexander the Great conquers the Persian empire (often defined as the "end of Mesopotamia")

6

Egyptian Art from the Middle Kingdom through the Late Period

2000–525 BCE

Colossal seated statues at
the Great Temple (detail),
Abu Simbel, Egypt.

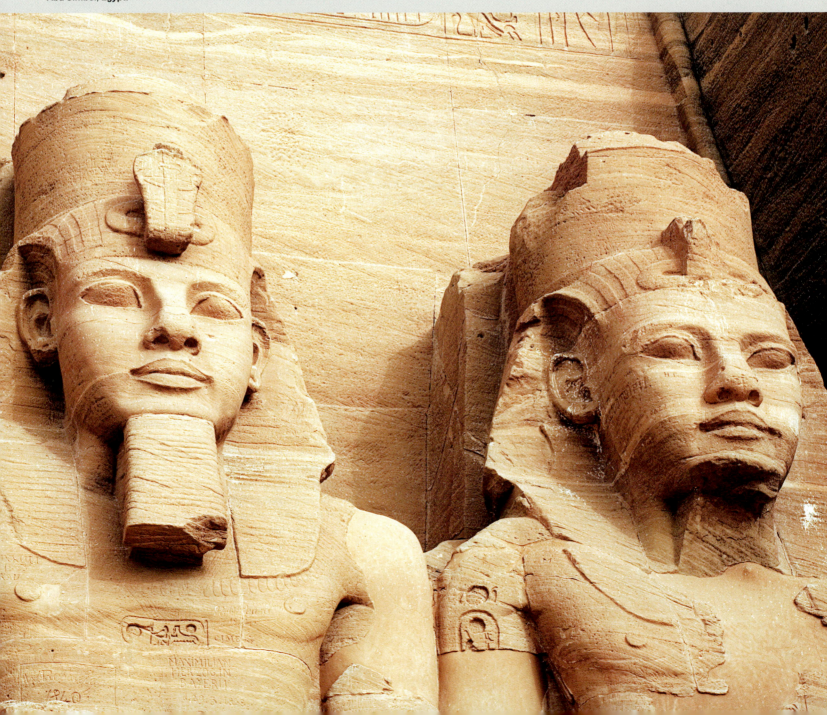

Introduction

The end of the third millennium BCE was marked by economic crisis and political dissolution in Egypt. The Egyptian society that emerged after the First Intermediate Period (2160–2055 BCE) and reunification in the Middle Kingdom (2055–1650 BCE) was significantly different from that of the Old Kingdom. When powerful states re-established their territorial control and reunited their subjects and lands in the second millennium BCE, the eastern Mediterranean had entered a new era of cultural interaction, seafaring mobility, prosperous trade, and unprecedented connectivity. Egyptian art was created in a time of cross-cultural exchange of technological knowledge, linking Egypt to Nubia and other lands to the south, to the eastern shores of the Mediterranean, to Mesopotamia and the Persian Gulf, and to the islands of the Aegean Sea. The 1922 discovery of the well-preserved tomb of Tutankhamun in the Valley of the Kings in Thebes is one of the most sensational discoveries in the history of archaeology. Touring exhibitions of this tomb and its extraordinary wealth of objects have dramatically shaped the understanding of Ancient Egypt in the public mind.

During the Middle Kingdom, political and military power no longer resided exclusively in the royal dynasties, but also with regional governors who seized power and governed with considerable authority. These newly powerful non-royal individuals built elaborate tombs for themselves and commissioned artwork for both life and the afterlife. Beliefs about the afterlife changed, too. Privileges once reserved for kings became accessible to other elite men and women, and eventually to everyone, through the proper rituals and offerings.

After a period of disunity known as the Second Intermediate Period (1650–1550 BCE), the dynasties of the New Kingdom (1550–1069 BCE) expanded the borders of Egypt to its largest geographic extent, inspiring its rulers to build monuments to proclaim their military victories and accomplishments. During this time, architectural and artistic practices shifted dramatically, representing the height of Egypt's political authority as an imperial power on a much greater scale than before. More modest stone temples and sumptuous funerary complexes of earlier dynasties gave way to enormous temple complexes with new structures in cities such as Thebes, added to over centuries by various rulers. The prosperity of the New Kingdom period lasted until about 1200–1175 BCE, when the entrepreneurial trade that had powered the urban centers and ports in the Mediterranean collapsed. This major event marked the end of the Bronze Age, the breakdown of empires, and the move of many urban dwellers to the countryside. The fragmentation during the Third Intermediate Period and subsequent rule by foreign empires during the Late Period led to greater diversification in the culture and visual culture, but also efforts to connect to Egypt's ancient past.

The Middle Kingdom, 2055–1650 BCE

Upper Egypt and Lower Egypt were reunited by Nebhepetre Mentuhotep (ruled 2055–2004 BCE) of the Eleventh Dynasty, during the First Intermediate Period. Mentuhotep ruled the unified kingdom from his dynasty's capital at Thebes (present-day Luxor), in Upper Egypt, an urban center and the seat of the cult of Amun, rather than from the Old Kingdom cultural and administrative capital at Memphis in Lower Egypt, with its vast cemeteries and pyramid complexes at Saqqara and Giza. Abydos also emerged as a major urban cult center for Osiris, the god of the dead and the Underworld. The Eleventh and Twelfth Dynasties were prosperous periods, and military victories over Nubia moved the southern borders of Egypt into what is today Sudan. At the same time, cultural and political changes as a result of the Intermediate Period's disruption of divine order and harmony led to shifts in religious beliefs, art, and architectural practices.

FUNERARY COMPLEX OF NEBHEPETRE MENTUHOTEP

The new cultural and political momentum at the time of Mentuhotep brought about innovations in monumental architecture, particularly rock-cut structures, which used the hollowed-out edges of rocky cliffs to house royal and non-royal burials. Carving into the rock and embedding tombs in the earth was a major departure from the pyramid complexes of the Old Kingdom, and required a new understanding of the natural landscape. Mentuhopet built his funerary complex on the west side of the Nile River, just as his ancestors from the Old Kingdom had. His complex (**Fig. 6.1**) was built against the high rocky limestone cliffs of Deir el-Bahri across the river from Thebes. A causeway, three-quarters of a mile long, was lined with seated statues of Mentuhotep. These statues, carved to depict him wrapped in a mummy's shroud, connected him visually with Osiris, god of the afterlife, judge of the dead, and preserver of *ma'at*. In contrast, in Old Kingdom funerary complexes, kings had been depicted with Horus motifs. This depiction of kings wrapped as mummies continued and became prominent during the New Kingdom.

The causeway led from the valley temple on the Nile to a large courtyard containing a formal garden with

6.1 The funerary complex of Nebhepetre Mentuhotep (reconstruction drawing), Deir el-Bahri, Egypt, 2055–2004 BCE.

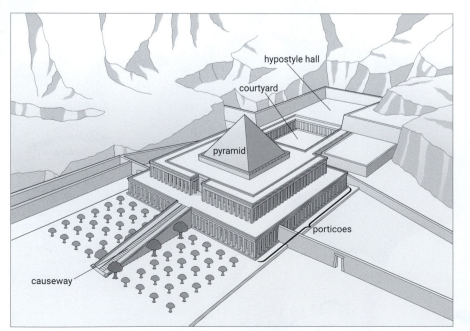

causeway
hypostyle hall
courtyard
pyramid
porticoes

tamarisk and sycamore fig trees planted in pits in front of the temple complex. A ramp at the back of the court-yard led up to the topmost terrace of two **porticoed** levels built of stone, at the center of which there seems to have been a solid mound, perhaps representing a pyramid or a **mastaba**. Behind the main structure was a small courtyard, open to the sky and surrounded with further porticoes. In the floor of the courtyard was the sealed entrance to a tunnel carved through the bedrock into the area under the cliffs, culminating in Mentuhotep's tomb chamber. In the Old Kingdom, large structures had been built over the ruler's tomb. Here, the courtyard above the passageway was used for ritual offerings to the king and Amun, a patron god of Thebes. The courtyard led into a **hypostyle hall** carved into the cliff face. This linear sequence of architectural spaces along an east–west axis culminated in a niche that held a larger-than-life-sized statue of the king.

WOODEN TOMB MODEL Many Intermediate Period and Middle Kingdom tombs of royal and elite people, including that of Mentuhotep, contained wooden models of people engaged in a range of activities to supply the needs of the dead in the afterlife. Wooden tomb models served to embody supplies for the dead, but they became less common by the end of the Middle Kingdom.

Such models were found in the tomb of Meketre (died *c.* 1990 BCE), a high-ranking official of Mentuhotep II, in the Theban Necropolis. They depict activities in the daily life of Meketre's estate, thus making them available to him in the afterlife. The models include scenes of a brewery, a granary, a slaughterhouse, and a bakery, as well as activities such as spinning, weaving, carpentry and fishing. Even leisure activities are depicted, so that Meketre could enjoy those in the afterlife as well. Over half of the models in Meketre's tomb are boats, evidence of their importance as funerary vehicles to transport the dead through the marshy world of the afterlife.

The people, animals, and objects in the models were individually carved from wood and painted following the conventions used for painted relief sculpture, then positioned in their similarly created contexts—boat, workshop, bakery. This model from Meketre's tomb (**Fig. 6.2**) shows carpenters at their tasks. In the center, a standing carpenter uses a saw to cut planks from a beam tied upright to a post with rope. To the viewer's right, a carpenter uses a chisel and a mallet to carve a beam. At the left, seated carpenters shape a beam using hand-held chopping tools.

ROCK-CUT TOMB OF AMENEMHAT Important officials during the Middle Kingdom sometimes built tombs carved into the stone hills, a practice begun in the Intermediate Period, when they rose to power. On the east bank of the Nile River midway between Thebes and Memphis, regional governors and other elite individuals commissioned thirty-nine carved tombs at Beni Hasan. These rocky formations allowed construction of a kind of tomb that was not possible in necropolises with different geology.

The **facade** of the tomb of Amenemhat, an official and priest during the reign of Senusret I (ruled 1956–1911 BCE),

portico a projecting structure with a roof supported by columns; typically functions as a porch or entrance.

mastaba a massive, flat-topped rectangular tomb building with slanted side walls; built of either mud brick or cut stone.

hypostyle hall a large room with rows of columns or pillars supporting the roof.

facade any exterior vertical face of a building, usually the front.

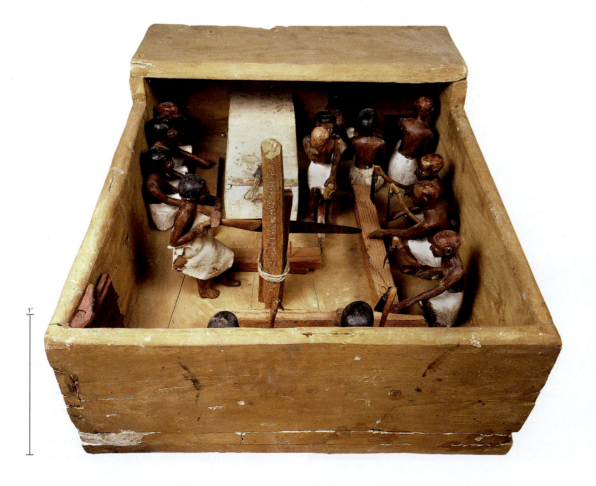

6.2 Model of a carpenter's workshop, Tomb of Meketre (TT280), Sheikh Abd el-Qurna, Theban Necropolis. Middle Kingdom, Eleventh Dynasty, *c.* 1990 BCE. Painted wood, 10 × 36 × 20 in. (25.4 × 91.4 × 50.8 cm) Egyptian Museum, Cairo.

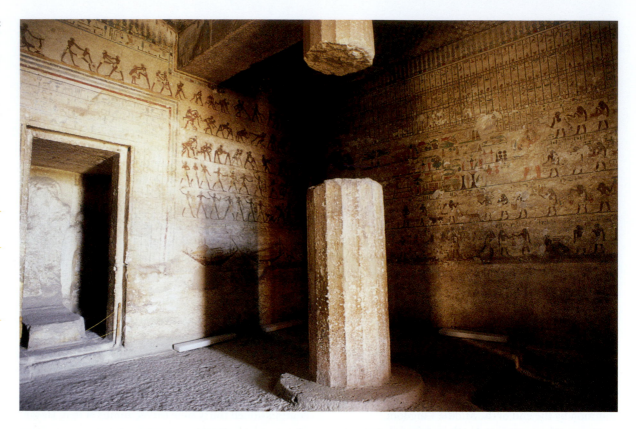

6.3 Interior hall of the rock-cut tomb of Amenemhat, Tomb 2 (BH2), Beni Hasan, Abu Qurqas, Egypt, Twelfth Dynasty, *c.* 1900 BCE.

lintel a horizontal support above a door or other opening.

hieroglyphic a type of written script that uses conventionalized signs to represent concepts, sounds, or words.

6.4 Coffin text in the coffin of **Gua,** Deir el-Bersha, Egypt, Twelfth Dynasty, *c.* 1850 BCE. Painted wood, length 7 ft. 5 in. (2.26 m). British Museum, London.

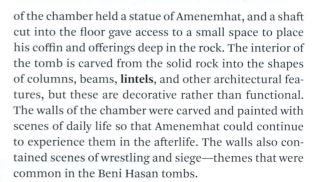

consists of a portico with two octagonal, tapered columns carved from the rock face, creating three openings giving access to the central portal, which would have been covered by a door, now lost. Four fluted columns divide the interior chamber into three areas, each with an arched ceiling (**Fig 6.3**). A niche carved into the wall at the back of the chamber held a statue of Amenemhat, and a shaft cut into the floor gave access to a small space to place his coffin and offerings deep in the rock. The interior of the tomb is carved from the solid rock into the shapes of columns, beams, **lintels**, and other architectural features, but these are decorative rather than functional. The walls of the chamber were carved and painted with scenes of daily life so that Amenemhat could continue to experience them in the afterlife. The walls also contained scenes of wrestling and siege—themes that were common in the Beni Hasan tombs.

COFFIN TEXTS Coffin adornment during the First Intermediate Period and Middle Kingdom reflects Egyptians' changing beliefs about the afterlife. The wooden coffin of Gua (**Fig. 6.4**), an official in the service of a regional ruler in central Egypt during the reign of Senusret III (ruled 1870–1831 BCE), is decorated with large sections of **hieroglyphic** texts on all sides of the interior. These Coffin Texts, deriving from the Pyramid Texts used in royal tombs during the Old Kingdom, are spells and rituals that were believed to help an elite person transform into a powerful being of eternal light (*akh*), be resurrected daily alongside Osiris, and dwell among the gods. These painted coffins also depicted objects and activities of daily life, for use by the deceased in the afterlife.

GRANODIORITE STATUE OF SENUSRET III The Twelfth Dynasty also marked a shift in the sculptural style of images of kings. Unlike Old Kingdom portraits, in which rulers were portrayed primarily with youthful faces and idealized bodies, some royal images from the Twelfth Dynasty, particularly those of Senusret III, appear expressive and individualistic. Many of these statues show

statues of royals and non-royals of the Twelfth Dynasty. The facial features are expressively carved, with deep-set eyes and protruding brows.

The New Kingdom, 1550–1069 BCE

The unity, economic prosperity, and political stability of Egypt were disrupted again during the Fifteenth to Seventeenth Dynasties, usually called the Second Intermediate Period (*c.* 1650–1550 BCE). Historical records suggest that immigrant groups from the east or the north settled in the Egyptian Delta around the middle of the seventeenth century BCE, perhaps during a time of problems within the Egyptian state (**Map 6.1**). These foreigners, whom the Egyptians called "rulers of foreign lands," are known as the Hyksos. The Hyksos established the Fifteenth Dynasty, with a capital at Avaris in the Delta, while Egyptian kings continued to rule Upper Egypt from Thebes as the Sixteenth and Seventeenth Dynasties.

Egypt was again united by Theban rulers under a centralized state in the Eighteenth Dynasty (1550–1295 BCE), initiating the New Kingdom period (1550–1069 BCE). Thebes had already seen major urban developments during the Middle Kingdom, including monumental temple complexes and residential neighborhoods at Karnak and Luxor, and funerary complexes at Deir el-Bahri. The art and archaeology of the New Kingdom is concentrated at the city of Thebes, a flourishing center of state ceremonies, religious festivals, and state-sponsored building activity. The triad of Theban gods,

6.5 FAR LEFT **Senusret III,** excavated from the funerary complex of Mentuhotep, Lower South Court, Deir el-Bahri, Twelfth Dynasty, 1870–1831 BCE. Granodiorite, height 4 ft. (1.22 m). British Museum, London.

amulet an object that is worn or carried in the belief that it will protect its owner.

Map 6.1 The Egyptian empire in the New Kingdom, (1550–1069 BCE).

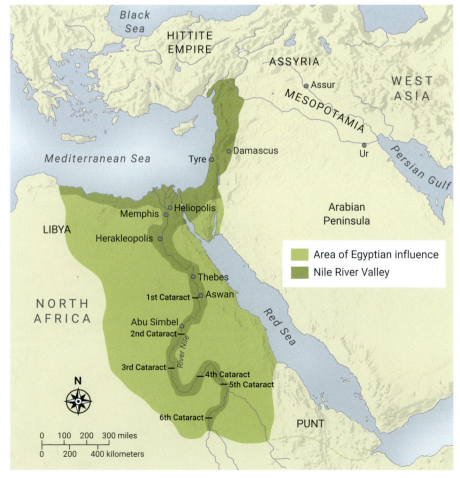

the king with a young body but with a haggard, almost anguished, face. These facial features may not necessarily have corresponded to the precise physical features of the living king. Rather, they may have been used to communicate a specific message to his subjects and to the gods. The meaning of this form of portraiture is uncertain, but many scholars believe it conveys a sense of the burden and heavy responsibilities of kingship, a sentiment also expressed in royal texts during this period.

Although it was excavated from the funerary complex of Nebhepetre Mentuhotep at Deir el-Bahri, this statue (**Fig. 6.5**) had been placed there long after his death and burial, allowing Senusret III to portray himself honoring his Eleventh-Dynasty predecessor and founder of the Middle Kingdom. Carved from granodiorite (a granite-like rock), it depicts the king wearing a royal *nemes* headdress, with an **amulet** suspended around his neck. The position of his hands, seemingly thrust in front of his body, indicates that he is praying. His throne name is carved into his sash. His expression is solemn, even severe, and his ears are very prominent, as they are on most surviving

pylon a monumental stone gateway to an ancient Egyptian temple composed of two wide, tapered towers.

obelisk a tapering, four-sided stone pillar, usually with a small pyramid as the capstone.

capital the distinct top section, usually decorative, of a column or pillar.

Amun, Mut, and their child Khonsu were elevated to become the state's chief deities, and linked the creator god Amun with the sun god Ra as the hybrid deity Amun-Ra, for whom Thebes served as an urban center. During this time, Egypt prospered as an empire. The economic vitality, trade, and military expeditions of Eighteenth-Dynasty rulers expanded its boundaries southward into Nubia and further into West Asia, thus connecting Egyptians with Minoans and other Mediterranean cultures. The visual language and building programs of New Kingdom rulers in Thebes and throughout the large state reflect not only their accomplishments but also changes in the conception of divine kingship.

TEMPLE COMPLEXES AT KARNAK AND LUXOR During the New Kingdom, temples and their extensive program of celebrations and intercessions became central to expressing the vital role of kings as powerful, living gods. During their lifetime, rulers built large funerary temples for themselves and expanded the existing temples dedicated to specific gods. Both types of temples played a public, visible role in festivals and processions for the gods as well as for the living and eternally reborn rulers.

The largest temple complexes in Thebes, now known as Karnak and Luxor, were located on the east bank of the Nile. They were connected by a six-mile-long processional avenue lined with sphinxes, which often had the body of a lion and the face or head of a ruler, or sometimes the head of a different animal. The Karnak complex consisted of separate enclosed precincts for Amun-Ra, Mut, and Khonsu, each with its own statues, temples, halls, and other buildings. Each precinct was managed by different groups of priests dedicated to the required daily rituals for those gods. Although priests had held a range of important offices in the divine structures and royal mortuary complexes of earlier periods, the establishment of dedicated formal bodies (particularly of the temple of Amun-Ra at Karnak) as part of the

administrative structure by rulers of the early Eighteenth Dynasty granted greater wealth and power to the temple institutions.

In the Amun-Ra precinct (**Fig. 6.6**), a series of entrances, halls, and enclosed structures on an east–west axis led to a temple with a statue of Amun-Ra. Along the north–south axis, a series of monumental **pylons** served as gateways that led to the precinct of Mut and then on southward to the Luxor temple. The buildings of the Amun-Ra precinct were built and expanded over several centuries, as several kings in succession commissioned architectural components to replace earlier Middle Kingdom structures, starting with Amenhotep I's (ruled 1525–1504 BCE) double gate into the precinct and a series of stone chapels. His successor Thutmose I replaced Amenhotep I's structures with a massive pylon, red granite **obelisks** (which were intended to look like huge polished sunbeams), colossal mummy statues, and a hall with columns with **capitals** in the shape of papyrus plants. Hatshepsut (ruled 1473–1458 BCE), the only woman in the New Kingdom to bear all the powers and titles of king (previously an exclusively male role), commissioned a shrine in which Amun-Ra's sacred model boat could rest during festival processions. Both she and her nephew Thutmose III (ruled 1479–1425 BCE) added obelisks to the precinct (see box: Art Historical Thinking: Obelisks, Mobility, and Meaning, p. 128).

The temple complexes at Karnak and Luxor, their avenues and commemorative monuments, were used for ritual processions during festivals, such as Opet and the Beautiful Festival of the Valley. The procession at the Opet Festival traveled from Karnak to the temples of the kings across the Nile in the Theban Necropolis, and allowed rulers to demonstrate their perceived divinity to the public and engage the whole state in their worship and preservation. The annual Opet festival, celebrated each year at the beginning of the flood season, transferred the divine powers of Amun-Ra to the king and reaffirmed the king's right to rule. During the festival, the the major deities of

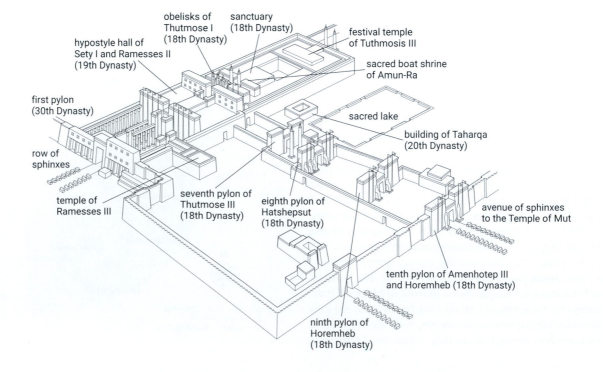

6.6 The temple precinct of Amun-Ra at Karnak, (reconstruction drawing), built and added to during the Eighteenth–Thirtieth Dynasties (1504–343 BCE).

obelisks of Thutmose I (18th Dynasty)

sanctuary (18th Dynasty)

festival temple of Tuthmosis III

hypostyle hall of Sety I and Ramesses II (19th Dynasty)

sacred boat shrine of Amun-Ra

first pylon (30th Dynasty)

sacred lake

building of Taharqa (20th Dynasty)

row of sphinxes

temple of Ramesses III

seventh pylon of Thutmose III (18th Dynasty)

eighth pylon of Hatshepsut (18th Dynasty)

avenue of sphinxes to the Temple of Mut

tenth pylon of Amenhotep III and Horemheb (18th Dynasty)

ninth pylon of Horemheb (18th Dynasty)

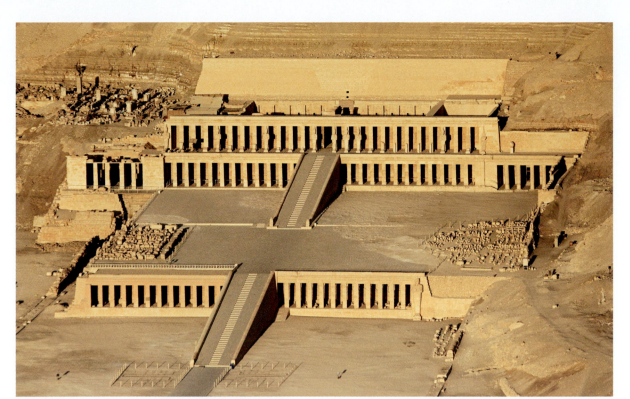

6.7 Funerary complex of Hatshepsut, with ruins of Mentuhotep's mortuary complex to the left. Deir el-Bahari, Egypt, Eighteenth Dynasty, *c.* 1473–1458 BCE.

the Egyptian state—Amun, Mut, and Khonsu—travelled from their shrines at Karnak to the temple complex at Luxor, dedicated to the cult of the royal *ka* (see box: Art Historical Thinking: Death and Dying in Egypt, p. 88). Statues of the deities were carried on sacred boats through the ceremonial street of the sphinxes. Shrines were also dedicated to the boats, as sacred agents of the cult. The statues remained in Luxor for the twenty-four days of the festival until they were returned to Karnak in another procession.

DEIR EL-BAHRI: HATSHEPSUT'S FUNERARY COMPLEX

The rulers of the New Kingdom were buried in the Theban necropolis on the Nile's west bank, continuing the practice from the Eleventh Dynasty Theban rulers. They also built large funerary temples, which were sites of ongoing worship and offerings and destinations for festival processions. However, beginning with the Eighteenth Dynasty, their tombs were separated from the funerary complexes and dug instead in the Valley of the Kings further into the desert, then sealed and left unmarked.

Hatshepsut made her connection to the long line of Theban kings more emphatic by building her funerary complex (**Fig. 6.7**) at Deir el-Bahri, directly next to the funerary complex of the Middle Kingdom ruler Mentuhotep,

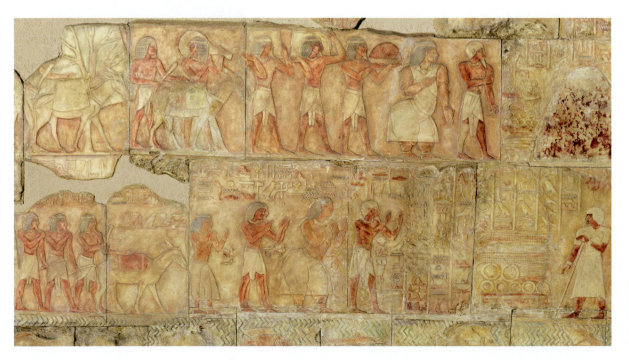

6.8 Expedition to Punt relief (plaster cast). Excavated at Deir el-Bahri, Egypt. Reign of Hatshepsut, Eighteenth Dynasty, New Kingdom 1473–1457 BCE. Royal Ontario Museum, Toronto, Canada.

built more than five hundred years earlier (see **Fig. 6.1**). As in Mentuhotep's temple, a causeway connected the funerary complex to the Nile. This sphinx-lined causeway led to the first court, which was planted with myrrh and frankincense trees. Axially organized pillars on the two upper levels supported colossal statues of Hatshepsut as a mummy wrapped in cloth, linking her to Osiris and rebirth. She wore not only the composite crown of Upper and Lower Egypt but also the ceremonial beard of Egyptian kings.

Hatshepsut reigned in a period of stability and prosperity, and she followed the earlier practice of depicting, in funerary contexts, the ruler's military conquests and other efforts on behalf of the Egyptian people. A series of reliefs in the middle level of her terraced temple depicts her support of a successful expedition via boat to the Land of Punt (**Fig. 6.8**, p. 121), a region that may have been on the Horn of Africa (present-day Eritrea, Djibouti, Ethiopia, or Somalia). Hatshepsut's emissaries gather cattle, giraffes, monkeys, baboons, and elephant tusks, as well as gold, spices, incense, and living trees. Distinctive in the brightly painted processions is the representation of the Queen of Punt as a corpulent woman (shown top right). Her body is not shown according to standard Egyptian proportions, which may have been abandoned here to make the queen appear more exotic, or to indicate the bounty of her lands. Given the conventions of representation applied to Egyptian gods, royals, and elite people, it is also possible that her different proportions result from the artist taking greater liberty in her depiction, because she did not fall into those conventional categories.

After Hatshepsut died, one of her successors systematically had her name polished off monuments and sculpture. Perhaps her stepson, Thutmose III (the first Egyptian ruler to call himself pharaoh, meaning "great house"), was angry that Hatshepsut had kept him from the throne for so many years. Whatever the cause, the later animosity toward Hatshepsut was such that considerable effort went into erasing her memory. One large obelisk erected for Hatshepsut at Karnak was evidently too large or too deeply carved for a later king to erase or alter, so he simply encased it within a wall, where neither humans nor deities could see the reliefs carved for her.

Rulers during the century following Hatshepsut continued visual and architectural programs similar to hers, and greatly expanded Egypt's borders, ushering in a period of affluence and prosperity that peaked during the long reign of Amenhotep III (1390–1352 BCE). The continuity in the art and religion, dynasty and geneaology of the New Kingdom was disrupted during the Eighteenth Dynasty by the seventeen-year reign of Amenhotep IV (ruled 1352–1336 BCE), who took the name Akhenaten ("Beneficial to Aten") in the fifth year of his reign. Akhenaten established artistic and religious practices that, while carrying on many traditional conventions, introduced markedly new ones. These changes corresponded with a shift from a close association between the state and the god Amun-Ra to a focus on the god Aten, whose name means "sun-disk," and who had originally been seen as the visual manifestation of the god Ra. Aten was mentioned in the *Book of the Dead*, an important

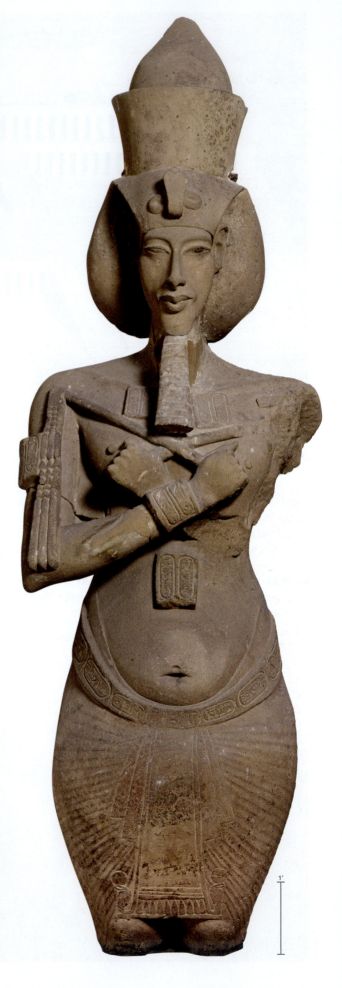

funerary text that was used from the early years of the New Kingdom. Almost overnight, Akhenaten thus replaced the multiplicity of deities in the Egyptian pantheon with one official, benevolent state deity, and himself as the sole intermediary—a revolutionary change in a society whose tradition of worshiping many deities extended back thousands of years.

COLOSSAL STATUE OF AKHENATEN The earliest and most striking expressions of Akhenaten's new ideas appeared in the reliefs and statues he commissioned for his temple to Aten at Karnak, evidently supervised by a sculptor named Bak or Bek. A row of statues of the king (**Fig. 6.9**) faced the open court of the temple. The standing statues resemble the Osiris mummy statues, with crossed arms, royal insignia (a shepherd's crook and herdsman's flail), and ceremonial headwear and beard, but Akhenaten is shown wearing his kilt, not clothed as a mummy. His narrow face with its long nose, full and fleshy lips, and elongated chin is set on a long neck and broad shoulders. The shape of his torso, so different from that of other rulers, continues to be the focus of scholarly debates. Why does he have rounded breasts, a narrow waist, a full abdomen that bulges over his waistband, and wide hips? One theory proposes that the king was displaying himself as both male and female, the human version of the androgynous creator Aten.

Akhenaten's religious and artistic reforms were further pronounced with the foundation of his new capital city Akhetaten ("Horizon of Aten"), giving him a new stage on which to transform Egyptian art, politics, and religion. His new city, at the modern site of Tell el-Amarna, about 170 miles (273 km) northwest of Thebes, made a distinct break from that historic religious and political center. Akhenaten's reign is thus known as the Amarna Period after this archaeological site.

Akhetaten occupied an orthogonally planned (with streets on a grid pattern) urban space of more than 1,000 acres, and the dead were buried in the hills east of the city rather than across the Nile in the western desert, the location of the earlier cemeteries at Memphis and Thebes. In addition to the king's various large palace complexes and administrative structures, several temples were built for Aten. They were composed of open courtyards with decorated altars and **steles**, suggesting that the deity's home in the center of the temple was in full sunlight rather than in the enclosed, dark spaces of other temples.

LIMESTONE ALTAR STELE SHOWING AKHENATEN The radical changes in the visual culture of state religion in Akhenaten's reign are exemplified in this limestone stele (**Fig. 6.10**). In this balanced composition, Akhenaten and his queen Nefertiti are shown in **sunken relief**, seated on a platform facing each other, holding their three eldest daughters. Akhenaten leans forward to kiss a child in his arms. The daughter sitting on Nefertiti's lap reaches out to Akhenaten; the daughter sitting on Nefertiti's shoulder

stele a carved stone slab that is placed upright and often features commemorative imagery and/or inscriptions.

sunken relief relief that is carved into a sunken area and does not project above the surface.

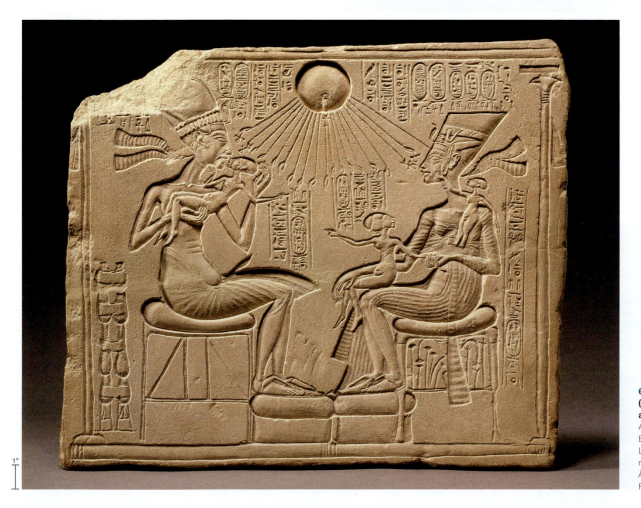

1"

6.10 Stele of Akhenaten (Amenhotep IV), Nefertiti, and their children, from Akhetaten (Tell el-Amarna, Egypt), Eighteenth Dynasty, 1352–1336 BCE. Limestone with painted sunken relief, 17⅛ × 15⅜ in. (43.5 × 39.1 cm). Ägyptisches Museum und Papyrussammlung, Berlin.

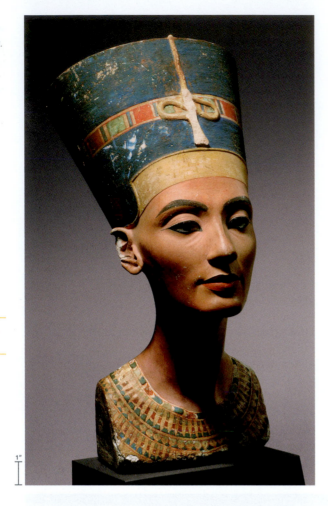

6.11 Bust of Nefertiti, from Akhetaten (Tell el-Amarna, Egypt), Eighteenth Dynasty, 1352–1336 BCE. Painted limestone with gypsum plaster layers, height 18 in. (45.7 cm). Ägyptisches Museum und Papyrussammlung, Berlin.

bust a sculpture of a person's head, shoulders, and chest.

6.12 Inner coffin of Tutankhamun, from his tomb in the Valley of the Kings, Eighteenth Dynasty, c. 1327 BCE. Solid gold with inlaid colored ceramics and semi-precious stones, 20 × 74 × 20 in. (50.8 × 188 × 50.8 cm). Egyptian Museum, Cairo.

of non-royals. In contrast, before and after the Amarna Period, royal images were confined to royal tombs and temples. One possible interpretation of this stele is that the dissemination of such artworks in elite households was meant to spread a new form of religious devotion throughout the population of Akhetaten.

BUST OF NEFERTITI A sculptural representation of Akhenaten's wife Nefertiti was found during the excavations at Tell el-Amarna in the workshop of Thutmose, whose title was "Chief of Works, the Sculptor." Many pieces of finished and unfinished sculpture were discovered in his studios, including numerous representations of the royal family. The best-known example is the so-called portrait **bust** of Nefertiti, carved out of limestone with gypsum-plaster layers to smooth the details of her face (**Fig. 6.11**).

Unlike the unfinished heads in the sculptor's workshop, this bust is finely finished with a smoothed and burnished surface. Queen Nefertiti's face was painted in a brownish tone of pink and her eyes have been outlined in black. The rock crystal inlay of only one eye—her right—is preserved. In addition to eye makeup, she wears a version of the tall, flat-topped blue crown decorated with the Egyptian cobra, a symbol of sovereignty, and a jeweled necklace with a vivid design in red, blue, green, and gold. A striped band around the queen's headdress carefully echoes the hues of her necklace. The vibrant colors and expressive detailing of the queen's portrait testify to the artist's level of care for the image's lifelike qualities, and the careful proportioning of facial features seem to aim for a work that exceeded reality.

The Amarna period was a fascinating but brief phase in the development of art and religious practice in the New Kingdom. The last five years of Akhenaten's reign seem to have been a time of turmoil, and shortly after his death in 1336 BCE, the city of Akhetaten and the worship of Aten as a single deity were abandoned. The rulers who followed Akhenaten dismantled Aten's temples and largely returned to the earlier traditions. Nevertheless, Egyptian religion and art were inescapably changed by the interlude.

reaches up to her mother's face. Aten is represented at the center top as a sun disk, from which deeply carved linear rays emanate, terminating in small hands that reach out to touch the royal family or extend life to them in the form of the *ankh* hieroglyph. The bodies of the king and queen have elongated proportions and a slender, sinuous elegance. What is truly unusual about this square stone carving is the context in which archaeologists found it. It was set into a niche in a private home, documenting the new role that the king's image played in the daily life

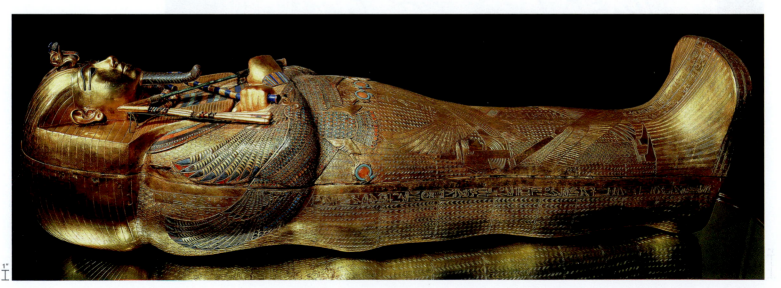

TOMB OF TUTANKHAMUN Akhenaten's successor, Tutankhamun (ruled 1336–1327 BCE), is well known in modern times not because of his accomplishments as Egyptian king, but because of the dramatic archaeological discovery of his intact, opulent tomb in the Valley of the Kings in the Theban necropolis in 1922. An intact burial, still filled with grave goods and inscriptions, is extremely rare; ancient or modern looters have disturbed almost all royal tombs in Egypt.

Tutankhamun's tomb is a relatively modest size, with four small rooms accessed through a long corridor, but it held over five thousand artifacts whose material and technological richness demonstrate the spectacular royal wealth of New Kingdom Egypt. One of the tomb artifacts was a quartzite **sarcophagus**, which the Egyptians called a "chest of life." It contained three nested coffins in the shape of the king's body. The outer two coffins were built of wood and covered with gold, but the innermost coffin was created out of thick sheets of beaten gold and inlaid with precious stones and shiny Egyptian **faience**. The king is shown with a beard and the *nemes* headcloth, and he holds the crossed flail and crook on his chest (**Fig. 6.12**). The protective feathered wings of a goddess are folded around his arms, and the cobra of an underworld goddess rests on his forehead. Inside the innermost coffin, the head and shoulders of the king's body were protected by a covering of solid gold and encircled by necklaces of real flowers. As was often the case with mummies of the elite, amulets made from gold and precious stones were found wrapped among the linen bandages covering the king's mummified body. Scientific analysis of the body revealed that Tutankhamun died at the age of nineteen, and suffered a great deal from bone-related diseases and malaria.

WOODEN CHEST OF TUTANKHAMUN Another treasure from Tutankhamun's tomb is an elaborately painted, plastered, and inlaid wooden chest featuring several images of the king as victorious in hunt and in battle. On two sides of the chest, Tutankhamun is depicted in the conventional youthful warrior pose, charging against the enemy on a chariot and shooting an arrow at the same time. One side shows his victory over the south (**Fig. 6.13**). Tutankhamun's Nubian enemies are on the left of the scene, piled up in a messy state of death, suffering, and destruction, while the Egyptian soldiers and dogs appear among them, finalizing their defeat. Behind the king, in three **registers**, charioteers and infantry follow him. The hieroglyphs name the king's enemy as the kingdom of Kush, in Nubia. On the other side of the chest, the scene is repeated, but there Tutankhamun is victorious over the peoples of the east. On the top of the chest, the king hunts and slaughters wild animals, while on each of its ends, he takes the form of a sphinx and tramples his enemies.

GREAT HYPOSTYLE HALL OF KARNAK TEMPLE The Nineteenth Dynasty (1295–1186 BCE) in Egypt brought renewed prosperity and diplomatic power to the kingdom.

sarcophagus a container for human remains.

faience a glassy substance that is formed and fired like ceramic, made by combining crushed quartz, sandstone, or sand with natron or plant ash.

register a horizontal section of a work, usually a clearly defined band or line.

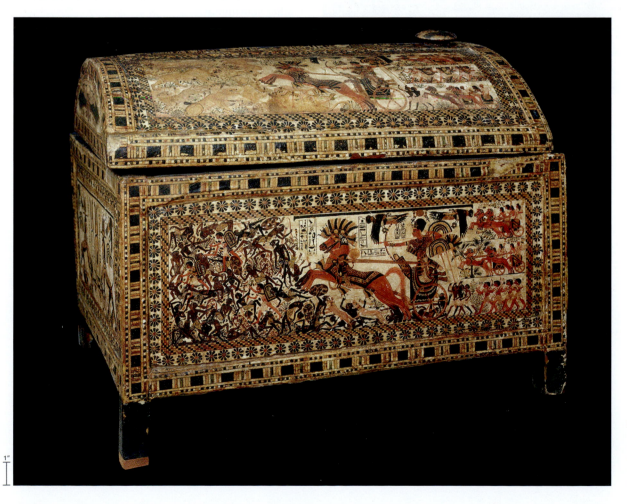

1"

6.13 Wooden chest of Tutankhamun, from his tomb in the Valley of the Kings, Egypt, Eighteenth Dynasty, 1336–1327 BCE. Wood inlaid with ivory, height 17⅜ in. (44.13 cm). Egyptian Museum, Cairo.

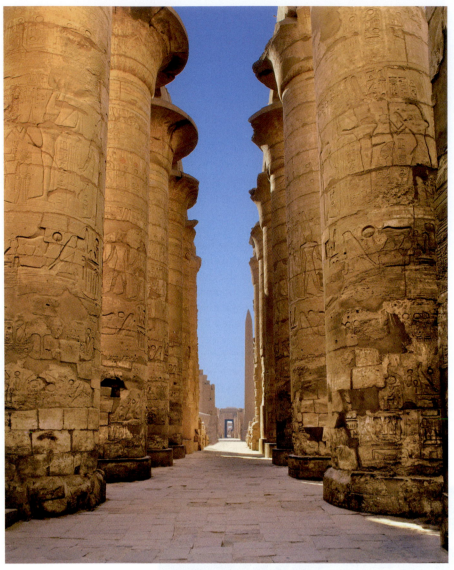

Sety I (ruled 1294–1279 BCE) and his son Ramesses II (ruled 1279–1213 BCE) both undertook many new military expeditions, not only north to the region that is now Lebanon, Syria, Israel, and Jordan, but also south to Nubia, in pursuit of resources to support the Egyptian economy. Both also sponsored projects throughout Egypt, building temples, halls, palaces, and monuments to proclaim their victories and accomplishments.

The so-called Great Hypostyle Hall (**Fig. 6.14**) at the Amun-Ra precinct at Karnak was begun by Sety I and completed by Ramesses II between the second and third pylons that had been built by two Eighteenth-Dynasty rulers. The pillars of the Great Hypostyle Hall were shaped to represent the aquatic plants thought to have grown in the sacred primordial marsh, which the entire hall evokes. This type of hall was used later in Hittite and Persian palatial complexes, and occasionally in Classical Greek temple architecture.

At 335 × 174 feet (102.1 × 53.03 m) long, the Karnak hypostyle hall had at least 134 pillars. Of these, the 12 columns in the central, and taller, row are 69 feet (21 m) high, with open papyrus-shaped capitals, while the other 122 columns are 49 feet (1.22 m) tall and topped with carved stone lintels. Additionally carved with sunken reliefs and inscriptions, the columns were originally painted to depict more clearly the open sprays of papyrus or closed buds of water lilies on their capitals. Toward the top right of **Fig. 6.14**, halfway up on one column, Ramesses II makes an offering to the gods Amun and Mut. The central figure of Amun wears the *shuti*, his typical crown with tall, two-feather adornment.

The entire hall was originally roofed, and the interior was illuminated only by a series of windows at the very top of the enclosing walls. Light sources throughout the temple were carefully designed to imitate the dark, swampy landscape of the mythical period before

6.14 Great Hypostyle Hall of Sety I and Ramesses II, precinct of Amun-Ra at Karnak, Luxor, Egypt, Nineteenth Dynasty.

colonnade a long series of columns at regular intervals that supports a roof or other structure.

hierarchical scale the use of size to denote the relative importance of subjects in an artwork.

6.15 RIGHT **Entrance of the Luxor temple complex,** with monumental pylon, obelisk, and colossal statues of Ramesses II, Egypt, Nineteenth Dynasty, 1279–1212 BCE. 79 × 213 ft. (24.08 × 64.92 m).

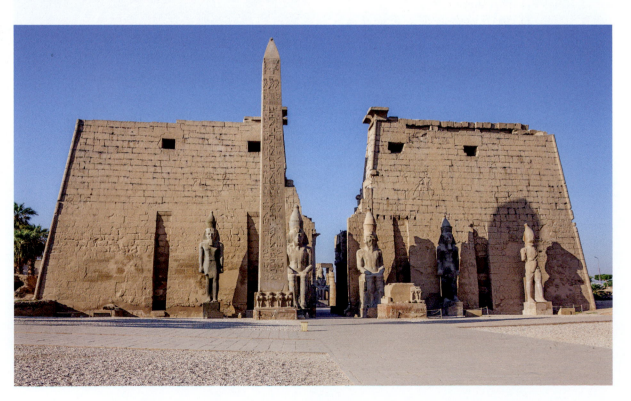

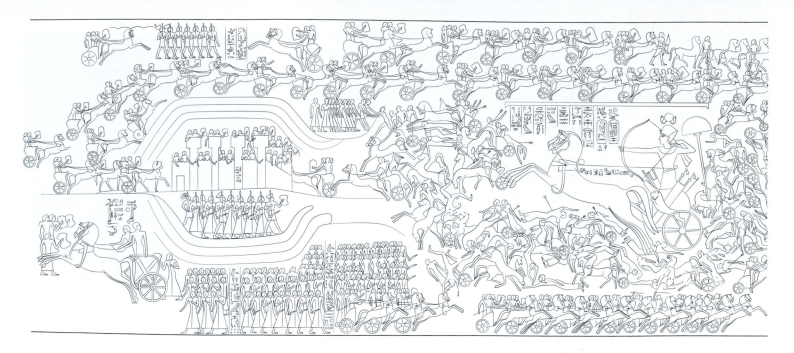

the arrival of the sun's life-giving rays. In antiquity, the space was probably filled with statues of various kings and divinities.

LUXOR PYLON Ramesses II used the grand scale of his monuments, their placement throughout Egypt, and the images and text carved into them to promote his accomplishments. In the temple complex at Luxor, site of the renewal of the king during the Opet festival and possibly the site where kings were crowned, Ramesses II commissioned a massive pylon (79 × 213 feet) and a large **colonnaded** court for the entrance to the complex. Obelisks and colossal statues of Ramesses II were erected in front of the pylon to protect the temple, and as divine equivalents of the king himself (**Fig. 6.15**).

The scene carved on the pylon's outer facade (**Fig. 6.16**) presents a battle that took place at Kadesh, in 1274 BCE, between Ramesses II's army and that of the Hittite king, Muwatalli II. Kadesh, an ancient town thought to have been located at Tell Nebi Mend in present-day Syria, was the site of a major conflict based on a border dispute between the Hittites and the Egyptians. In this composition, Ramesses II is depicted, at an enormous **hierarchical scale**, as victorious, charging forward on his colossal chariot while he shoots an arrow at the enemy. The king and his chariot and horses are carved deeper into the surface of the stone, creating a bolder image when viewed under the intense Egyptian sun. The orderly Egyptian army and the visibly disintegrating Hittite forces surround the fortress of Kadesh, as Muwatalli flees the scene in his chariot at the lower left. The hieroglyphics that accompany the painted images amplify the message conveyed by this panoramic image of battle. Since public monuments in the Middle and New Kingdoms often blended the religious with the political, this temple display may have exaggerated Ramesses's success in battle.

ABU SIMBEL Ramesses II used images of his Kadesh battle and monumental construction to spread his message of

the king's supreme power to the borderlands, particularly in the distant south. In addition to his architectural projects in the capital cities, Ramesses II built at least seven temples in Lower Nubia, past the southern frontier of the Egyptian kingdom. The most impressive examples are the two rock-cut temples at the site of Abu Simbel, just north of the Second Cataract on the Nile—a gateway to Nubia and its gold mines.

The larger of these two temples (**Fig. 6.17**, see also p. 115) was completed around 1260–1255 BCE and was dedicated to the deified Ramesses himself. The smaller one, just a short distance from the larger temple but not visible in the photograph, was dedicated to his principal queen, Nefertari. Both temples were cut into

6.16 The Battle of Kadesh on the east pylon of Ramesses II at Luxor Temple, line drawing of the pylon relief composition. 1279–1224 BCE.

6.17 Great Temple of Ramesses II with colossal seated statues, Abu Simbel, Egypt, Nineteenth Dynasty, completed 1260–1255 BCE. Sandstone, statue height 69 ft. (29.03 m).

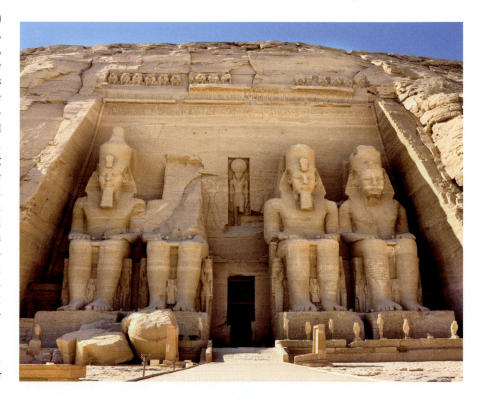

An ancient Egyptian obelisk, with its distinctive appearance—a tall, tapering pillar inscribed with hieroglyphics and topped by a small pyramid—stands in the middle of the Place de la Concorde in Paris (**Fig. 6.18**). Originally one of a pair of 75-foot-high stone pillars raised by Ramesses II at Luxor, it was taken down and transported roughly 3,000 miles (around 4,800 km) to Paris in 1833 when Muhammad Ali Pasha, the Ottoman governor of Egypt, gifted it to the French state. It is not the only obelisk to be taken from Egypt and re-erected in a distant capital city. The first Roman emperor, Augustus, removed a Late Period obelisk, now known as the Montecitorio Obelisk, from a temple at Heliopolis in 10 BCE and incorporated it into his sundial in Rome. That public monument commemorated Augustus's victory at Actium, off the Egyptian coast, against his rival Marcus Antonius and the Ptolemaic Egyptian ruler Cleopatra VII. Likewise, in the fourth century CE, the Roman emperor Theodosius I brought an obelisk of Thutmose III from Karnak to Constantinople (present-day Istanbul), the capital of the newly created eastern half of the Roman empire, where he re-erected it at the city hippodrome (racetrack).

What made obelisks so appealing that these rulers decided to transport the massive monuments over long distances? How much of the obelisks' original significance remained in their new locations? By asking such questions, art historians explore the relationship between an object's appearance, meaning, and context.

"Obelisk" is the ancient Greek term for these Egyptian monuments; the original Egyptian name for them was *tekhenu*, a word derived from the verb "to pierce," referencing their shape. Obelisks are monolithic, formed from a single block of stone. Each stone was quarried in one piece, most commonly from granite (**Fig. 6.11**). An obelisk's tall shaft is square in cross-section and tapers toward the top, ending

in a pyramidion, or small pyramid, which was often originally sheathed in metals, such as bronze, gold, or electrum, to capture the rays of the sun. In New Kingdom Egypt, obelisks were raised in pairs, in front of the gateways of major temple complexes, including those at Karnak and Luxor. The names and images of the ruler who commissioned them were prominently displayed on all four sides. As major offerings to solar deities, they linked the king and the gods for eternity.

Since the obelisks were unmistakably associated with the religious practices and architectural technologies of ancient Egypt, they were frequently taken away by foreign powers to be raised elsewhere in order to celebrate not the Egyptian king or the sun god but the later empire's colonial authority over the exotic heritage of Egypt. Because the stolen monuments carried this association even when the specific historical circumstances of their creation were forgotten and they were removed from their original context, they were useful objects for appropriation. Thus, the obelisks' connection to the achievements of ancient Egypt remained even as the obelisks were repurposed to express other kinds of cultural and political power.

Discussion Questions

1. In what ways did the significance of obelisks change when they were moved, and in what ways did it stay the same?

2. Think of an example of another type of monument or artwork with a distinctive appearance that carries certain associations. What are those associations, and how are they linked to the object's original meaning or form?

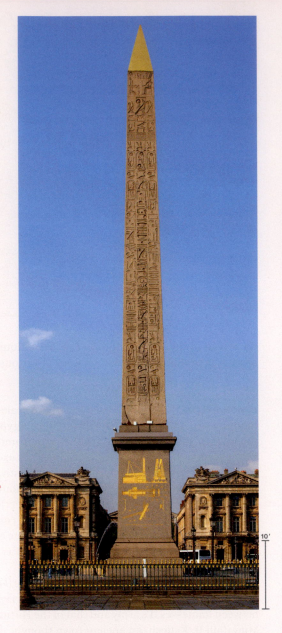

6.18 **Obelisk taken from the temple complex at Thebes,** Luxor, Egypt. Granite, height 75 ft. (22.86 m). Now standing in the Place de la Concorde, Paris.

the sandstone cliff, and the rock-cut facade took on the function of the pylons seen at Karnak and Luxor temples. Four 69-foot-tall (21.03 m) statues of the deified king were carved at the front of the facade, with small figures of the king's family members, including Nefertari and other queens and princesses, placed in front of them.

Inside the temple, two rows of statues of the mummified king extended down a hallway. The north wall of this hall presented another relief program about the Battle of Kadesh. At the very back of the temple were seated statues of some of Egypt's most important gods—the creator god Ptah of Memphis, the Theban Amun-Ra, the falcon-headed sun god Ra-Horakhty of Heliopolis, and the image of the deified king.

In the 1960s, the planned construction of the Aswan Dam meant that all the archaeological sites of southern Egypt and northern Sudan would be covered by the resulting lake. After international debates and campaigns, including funding from the United Nations Educational, Scientific, and Cultural Organization (UNESCO), the temples of Ramesses II and Nefertari at Abu Simbel (and the surrounding portions of the cliff) were cut into pieces and moved 656 feet (200 m) to the top of the bluffs. The fragments were then reassembled and set into an artificial backdrop that is now a museum and visitor center. Smaller temples that would have been submerged were reconstructed at museums, using their original stone blocks. The Temple of Dendur at the Metropolitan Museum of Art in New York City is one example.

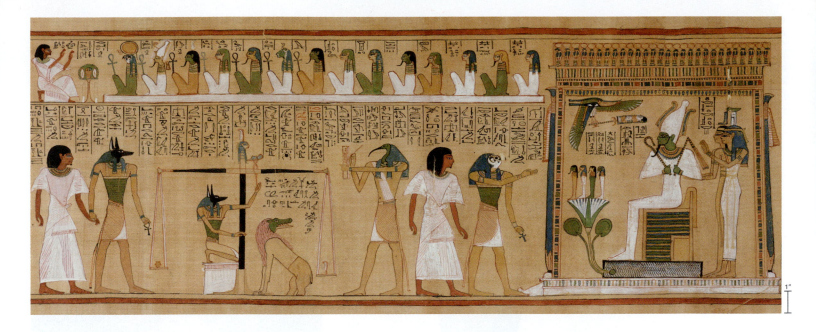

6.19 Last Judgment before Osiris, *Book of the Dead, c.* 1275 BCE. Painted papyrus, height 15⅜ in. (39.1 cm). British Museum, London.

THE *BOOK OF THE DEAD* The development and use of the *Book of the Dead* (a more accurate translation of the title is *Spells for Going Forth by Day*) reflects changing beliefs about the afterlife in the New Kingdom. This collection of spells and rituals derived in part from the earlier Pyramid Texts and Coffin Texts (**Fig. 6.4**) that were believed to help the deceased make the perilous journey through the underworld to the afterlife. During the New Kingdom, spells and rituals alone were no longer sufficient for becoming a being of pure light (*akh*) and living with the gods. People also had to be judged by the gods to determine if they had lived an ethical life. Placed in a tomb, the *Book of the Dead*, which combines hieroglyphs with illustrations on papyrus scrolls, served as a kind of manual to help the deceased successfully navigate the stages of the journey. Many copies of the book were made, and no two versions are identical.

The *Book of the Dead* created for Hunefer (died *c.* 1275 BCE), a royal scribe for Sety I, depicts the Weighing of the Heart ritual at the final stage of his journey (**Fig. 6.19**). The small top register shows him listing his good deeds to a row of seated gods. Below on the left, Anubis, the jackal-headed god who watched over death and mummification, leads Hunefer by the hand. Continuing the narrative in the next scene to the viewer's right, Anubis kneels and weighs Hunefer's heart against a feather to judge whether he has lived an ethical life, and the god Thoth records the results. The feather is the hieroglyph of Ma'at, the goddess of order and truth, who is depicted at the top of the scales. If the heart is too heavy, it is given to the waiting crocodile-hippopotamus-lion hybrid, Ammit, to devour. Instead, because Hunefer's heart weighs less than the feather, Horus leads Hunefer to Osiris, the ruler of the afterlife, who sits enthroned at right with his sisters Isis and Nephthys behind him. Standing on the large open lotus blossom are Horus's four sons, each protecting one of Hunefer's vital organs.

The decline of the New Kingdom coincided with the collapse of the seafaring trade network in the Eastern Mediterranean in the early twelfth century BCE,

exacerbated by the arrival of the so-called Sea Peoples, a migrating group of seafarers who attacked Egypt and other regions of the Eastern Mediterranean. These critical years were recorded in Egyptian state documents as a time of civil conflict and economic decline.

The Third Intermediate Period and the Late Period, 1069–525 BCE

In the new political landscape of the Third Intermediate Period (1069–664 BCE), many groups competed for political power in Egypt, including regional native dynasties and dynasties with links to power centers to the west in Libya, to the south in Nubia, and to the north in areas of the Neo-Assyrian Empire. The city of Tanis in the Eastern Delta emerged as an important political center and seat of government. Variations in Egypt's conventional visual culture reflected this decentralization of the country and the influence of other cultures. Unfortunately, only limited evidence survives of the diverse cultural mingling that the art and architecture of the time displayed.

BRONZE STATUE OF KAROMAMA Many objects made during these later dynasties were cast in bronze, and metal production included statues of royal individuals, dedicated to temples. Copper vessels (hollow containers) and artworks of beaten copper were made in the Old Kingdom, but bronze and brass were not given the same attention as gold (or valuable types of clay, wood, or stone) throughout most of Egyptian history.

Perhaps the best example of the sophisticated metalwork of the Third Intermediate Period is a bronze statue (**Fig. 6.20**, p. 130) that depicts the princess Karomama, who was a daughter of the king at Tanis and held the position of "Divine Adoratrice," or chief priestess, of Amun. Priestesses served as vital links between Amun, whose powerful religious establishment was entrenched in Thebes, and the king, who often resided elsewhere. The identification of Karomama comes from an inscription

6.20 The priestess Karomama, attributed to Ah-tefnakht. Twenty-Second Dynasty, *c.* 870–850 BCE. Bronze, inlaid with gold, silver, electrum, glass, and copper, height 23¼ in. (59.1 cm). Musée du Louvre, Paris.

lost-wax casting a method of creating metal sculpture in which a clay mold surrounds a wax model and is then fired. When the wax melts away, molten metal is poured in to fill the space.

archaism the use of forms dating to the past and associated with a golden age.

6.21 FAR RIGHT **Statue of Mentuemhat,** from Karnak, Egypt, Twenty-Fifth to Twenty-Sixth Dynasty, *c.* 700–640 BCE. Granite, height 52¾ in. (134 cm). Egyptian Museum, Cairo.

GRANITE STATUE OF MENTUEMHAT The kings of Kush, based at Napata in Nubia (in what is now Sudan), took control of Upper Egypt, initiating the Twenty-Fifth Dynasty (747–656 BCE), and then conquered Lower Egypt in 712 BCE, uniting the country. Nubians and Egyptians had been trade partners, antagonists, and allies throughout their history, and Egyptian kings, including Ramesses II, had controlled long stretches of the Nubian Nile. To legitimize their rule of the traditional Egyptian territories, Kush rulers deliberately employed **archaism** in royal art, drawing on conventions, styles, and forms from the Old Kingdom and Middle Kingdom to link their reign to Egypt's glorious past. For example, Twenty-Fifth Dynasty rulers built pyramids for their funerary complexes, mostly in present-day Sudan, in the first widespread use of the practice since the Middle Kingdom. As defenders of Egypt

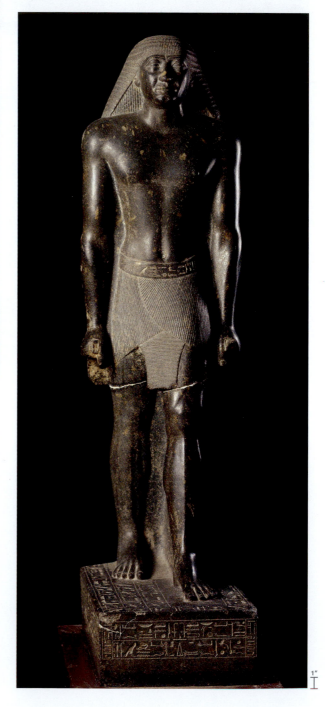

at the base of the statue. Its creation has been attributed to Ah-tefnakht, her male counterpart who oversaw the production of the most sacred of the temple's treasures.

The statue, about two feet tall, would have been placed within the ceremonial boat that carried the statue of Amun in processions. Cast in bronze using the **lost-wax** method, the figure is inlaid with tiny bits of varied alloys of copper, silver, and gold that highlight details of her dress in different colors. The feathered wings of a goddess wrap around her body, and she once held a pair of *sistra* (ritual percussion instruments), which are now lost. Because she is barefoot, she must be in the presence of the deity, fulfilling her role as a priestess. Her slim proportions, her gently rounded breasts and stomach, and the indentation in her abdomen around the region of her navel are all stylistic markers of sculpture coming from the Delta in the Twenty-First through the Twenty-Sixth Dynasties.

who upheld *ma'at* and worshipped Amun, Kushite kings also enlarged the temples at Karnak, reaffirming ancient Egyptian traditions while making their own unique cultural contributions.

An important example of this archaism in art is the gray granite statue of Mentuemhat from Karnak (**Fig. 6.21**). Mentuemhat (*c.* 700–640 BCE) was a significant official in Thebes who had worked for the Kushite kings, lived through the Assyrian invasion, and governed the city during the transition to the Twenty-Sixth Dynasty. He placed statues of himself throughout Thebes and a life-sized one in his sizable tomb on the western bank of the Nile opposite Thebes. The sculptor of this standing statue of Mentuemhat looked to Old Kingdom statues for models and adopted their idealized, upright, and youthful representations of the male body. Mentuemhat's left leg steps forward, with his right leg unbent and his arms straight at his side in a stance conventional in the Old Kingdom (see Fig. 4.16). He wears a kilt and a belt with an inscription, while his wig recalls New Kingdom art. His interest in looking back at historical styles underscores his stated adherence to the age-old values of Egypt, including justice, unity, and service to its kings and its gods.

The Twenty-Sixth Dynasty was the last native dynasty to rule Egypt. The conquest of Egypt by the Achaemenid Persians in 525 BCE and the end of the Twenty-Sixth Dynasty is usually taken as a crucial turning point in the development of a new visual vocabulary in Egyptian art and architectural practice. In 332 BCE, Alexander the Great seized the country, and his Macedonian descendants and the Ptolemaic Dynasty held power in Egypt for three centuries. They adopted the standard iconography of Egyptian kingship for their own representations. This Ptolemaic Period (332–30 BCE), an era of revival of the deep cultural traditions of the Nile Valley, lasted until the incorporation of Egypt into the Roman Empire.

Discussion Questions

1. The pharaoh in the Old Kingdom had been viewed almost as a living god. How did the perception of the king change during the Middle and New Kingdoms? How did this change affect art and architecture? Provide at least two examples.

2. Consider the development of funerary customs in the New Kingdom. How do these various rituals help provide insight into the society of the time?

3. Queen Hatshepsut built her own funerary complex at Deir el-Bahri next to that of Nebhepetre Mentuhotep, who had lived and ruled approximately 600 years earlier. What are the similarities between these two complexes? Discuss why Hatshepsut may have chosen this site for her tomb.

Further Reading

- Habachi, Labib. *The Obelisks of Egypt.* London: J. M. Dent & Sons, 1978.
- Hartwig, Melinda K. (ed.). *A Companion to Ancient Egyptian Art,* Oxford: Blackwell, 2014. [See especially pages 191 to 268 which deal with painting, reliefs and sculpture.]
- Manley, Bill. *Egyptian Art.* London: Thames & Hudson, 2017.
- Robins, Gay. *The Art of Ancient Egypt.* London: British Museum Press, 1997.

Chronology

2055–1650 BCE	**THE MIDDLE KINGDOM** The Eleventh–Thirteenth Dynasties	1274 BCE	The Battle of Kadesh between Ramesses II and Hittite Empire
2055–2004 BCE	Nebhepetre Mentuhotep builds his funerary complex at Deir el-Bahri	1260–1255 BCE	Abu Simbel Great Temple is completed by Ramesses II
c. 2000–1800 BCE	Elite rock-cut tombs are created at Beni Hasan	1200–1175 BCE	Period of political and economic collapse in the Eastern Mediterranean
1870–1831 BCE	The reign of Senusret III	1069–715 BCE	**THE THIRD INTERMEDIATE PERIOD** Decentralized rule of Egypt; the Twenty-First to Twenty-Fifth Dynasties
c. 1650–1550 BCE	**THE SECOND INTERMEDIATE PERIOD** Egypt is not united; the Fourteenth to Seventeenth Dynasties rule in different regions	*c.* 870–850 BCE	The bronze statue of Karomama is made by Ah-tefnakht
1550–1069 BCE	**THE NEW KINGDOM** The Eighteenth–Twentieth Dynasties	770–640 BCE	Kushites (Nubians) rule Egypt as the Twenty-Fifth Dynasty
1504–323 BCE	The Temple of Amun-Ra at Karnak is built and developed by many kings	*c.* 700–640 BCE	The granite statue of Mentuemhat is made
1473–1458 BCE	The reign of Hatshepsut, who builds her mortuary complex at Deir el-Bahri	664–525 BCE	**THE LATE PERIOD** The Twenty-Sixth Dynasty
1352–1336 BCE	The reign of Akhenaten; the Amarna period brings in the worship of Aten and a radically new art style	525 BCE	The Achaemenid Persian Empire conquers Egypt
1336–1327 BCE	The reign of Tutankhamun	332–30 BCE	Alexander of Macedon takes Egypt from the Achaemenid Empire; the Ptolemy Dynasty rules Egypt

Ancient Writing Systems

Three significant early writing systems were invented separately by the Mesopotamian (in ancient West Asia), the Shang dynasty (ancient China), and the Olmec/Maya (in the area of present-day Mexico) cultures. Writing developed from images, and the earliest writing systems maintained a close relationship to each culture's image-making system. Thus, some of the earliest written signs were pictograms, depicting their meaning in pictorial form. For example, a simplified profile of a seated figure could refer to the accession, or seating, of a ruler (who was "seated" in power). Writing allowed these early societies to permanently record important events, prophecies, and resources.

Cuneiform script was invented in southern Mesopotamia during the last few centuries of the fourth millennium BCE (*c.* 3300–3100 BCE). "Cuneiform" means wedge-shaped, referring to the triangular impressions left by the stylus. The earliest written documents that survive are lists composed of pictographic and numerical signs. They appear to be economic documents, testifying to the fact that writing first appeared as an administrative tool in emerging urban bureaucracies. These archaic texts draw heavily on the pictorial repertoire of seals and other visual media.

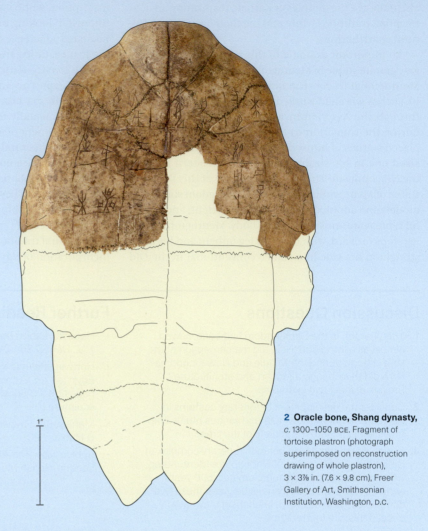

2 Oracle bone, Shang dynasty, *c.* 1300–1050 BCE. Fragment of tortoise plastron (photograph superimposed on reconstruction drawing of whole plastron), 3 × 3⅞ in. (7.6 × 9.8 cm), Freer Gallery of Art, Smithsonian Institution, Washington, D.C.

1 Mesopotamian inscribed tablet or amulet, from Sin Temple, Level VIII, Tutub (Khafajah, Iraq), *c.* 2900–2700 BCE. Slate, length 9⅞ in. (22.8 cm). Iraq Museum, Baghdad.

This inscribed figurative object (**Fig. 1**) may be either a tablet or an amulet. It takes the shape of a mythical hybrid creature, a lion-headed eagle. In Mesopotamian myth, the gigantic bird Imdugud stole the tablet of destinies from the Mesopotamian gods. The tablet is covered with archaic writing that is only partially readable. It gives a series of proper names and associated numbers, including the expression "silver not taken," suggesting that it may be a sales contract. Because this archaic text was recorded before the standardization of written language, scholars are able to identify only certain pictograms that also appear in later texts written in Sumerian, an ancient Mesopotamian language.

In China, early traces of writing are preserved on bronze vessels and oracle bones (**Fig. 2**). Early Chinese writing served the practical functions of recordkeeping and identifying ownership, but it also bound the written word to power and authority. Oracle bones—made of tortoise plastrons or ox scapulae—were a means of divination in the Shang state (*c.* 1500–1050 BCE). After stating a proposition such as "In the next ten days there will be no disaster" or "Ancestor Yi is harming the king," ritual specialists applied a hot poker to the oracle bone to generate a crack. They then "read" the crack as an affirmation or refutation to the proposition and determined a course of action, which often included offerings to deceased royal ancestors. Divinations—both the proposition and the response—were

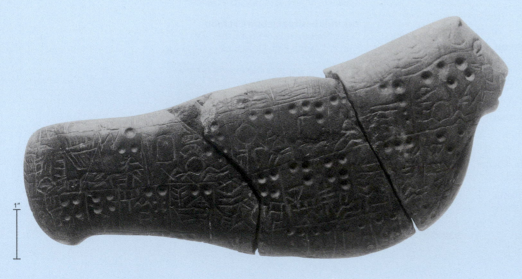

inscribed on the bone. Some divinations related to bountiful harvests or successful battles, while others attempted to determine the cause of natural calamities or even the ruler's toothache.

On oracle bones, writing may be either horizontal or vertical. In this early form of the Chinese writing system, each character or word is a separate semantic unit consisting of one or more strokes arranged within an invisible box. Chinese script is not alphabetical, and in the absence of the punctuation and grammar common to alphabetic languages, word order plays a significant role in expressing meaning. Additionally, written Chinese does not prioritize sound, as alphabetic languages do. Thus, the meaning of written Chinese persists even when pronunciation changes across time and space. In later centuries this character system formed the basis for writing other East Asian languages and became a medium of artistic expression (see Seeing Connections: The Art of Writing, p. 560).

Writing also emerged in royal contexts in ancient Mexico. This small piece in greenstone (valuable, green-hued minerals, including nephrite and jadeite) was made between about 1000 and 600 BCE (**Fig. 3**). It was worn as a pectoral (chest ornament) as a sign of royalty. The front was carved with the image of an important deity associated with agricultural fecundity and rulership, denoted by the upturned lip. The back of the pectoral was incised many centuries later with text describing the accession of an early ruler in southeastern Mexico (**Fig. 3a**, left). The seating glyph (a single symbolic figure or character in a hieroglyphic writing system) appears in the leftmost column, fifth row down from the top. It depicts a simplified profile view of a person seated with legs crossed. The Maya ruler who wore it must have valued the ancestral power embodied in the image of the deity, and wanted to associate himself with it at the moment of his accession.

The entire text consists of twenty-four glyph blocks to be read in columns of two, from top to bottom, in a stricter spatial arrangement than is found in most such images. Many of the glyphs are similar to pictorial symbols found in images from the region, and the text is directly related to the adjacent image of the ruler at the moment of accession, wearing his royal costume (**Fig. 3a**, right). Image and text together tell the complete story of a royal event.

Early writing systems show us how images and symbols developed into text, and the fact that writing was invented independently in several places around the world underlines the momentous importance of writing to the development of early urbanized cultures and societies.

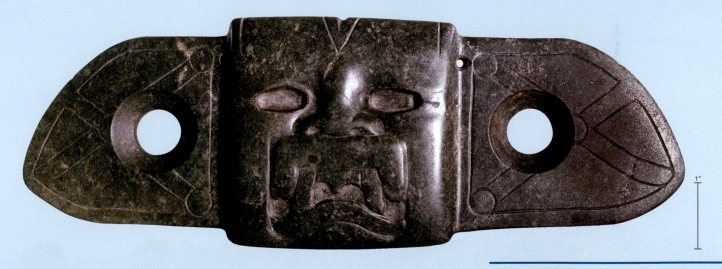

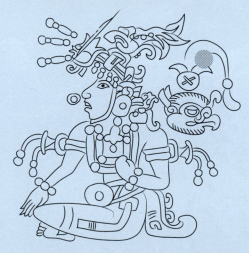

3 TOP **Pectoral from southeastern Mexico,** 900–400 BCE, Greenstone, 3½ × 10½ in. (8.9 × 26.7 cm). Dumbarton Oaks Research Library and Collection, Washington, D.C.

3a ABOVE LEFT AND RIGHT **Inscriptions on the back of pectoral (line drawing), added 100 BCE–100 CE.**

Discussion Questions

1. Describe the relationship of early writing systems to the societies in which they developed. What purposes did writing serve for those cultures? Choose one example discussed above to explain your answer.

2. Identify the fundamental differences between image systems and writing systems.

Further Reading

- Schmandt-Besserat, Denise. *When Writing Met Art: From Symbol to Story*. Austin, TX: The University of Texas Press, 2007.

- Stuart, David and Houston, Stephen D. "Maya Writing," *Scientific American*, 261, no. 2 (1989), 82–89.

- Mattos, Gilbert L., "Shang Dynasty Oracle-Bone Inscriptions" in Victor H. Mair et al. (eds.) *Hawai'i Reader in Traditional Chinese Culture*. Honolulu, HI: University of Hawai'i Press, 2005.

7

Early Art from South Asia, Southeast Asia, and Oceania

2600 BCE–300 CE

Plain of Jars, Laos.

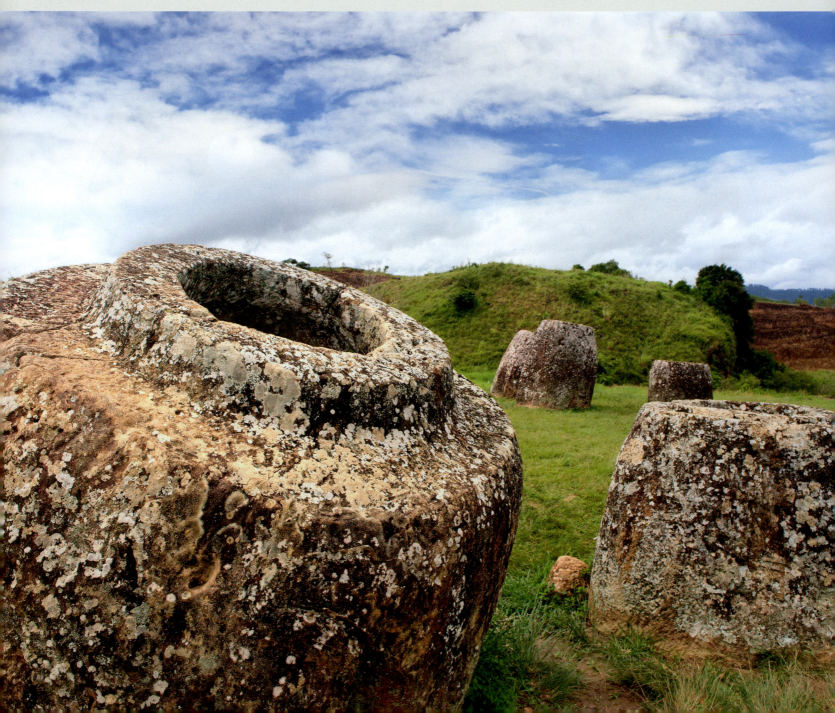

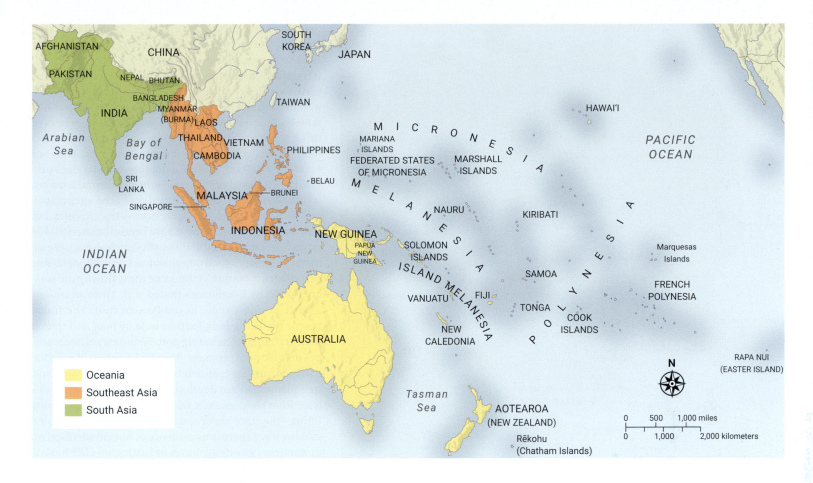

Introduction

Although we commonly conceive of the world as divided into seven continents, that configuration understates the wide range of diversity in the planet's many distinctive cultural regions. This chapter considers three such regions—South Asia, Southeast Asia, and Oceania (Map 7.1). Each matches Europe in terms of its size and diversity. For example, South Asia consists of India, Pakistan, Bangladesh, Nepal, Bhutan, and Sri Lanka (and sometimes Afghanistan). In this region, home to 20 percent of the world's population, 30 different languages are each spoken by one million or more people.

Southeast Asia can be divided into two subregions: mainland Southeast Asia (Myanmar, Thailand, Laos, Cambodia, and Vietnam) and maritime or Island Southeast Asia (Malaysia, Brunei, the Philippines, Singapore, and Indonesia). Indonesia comprises more than 17,000 islands with over 600 ethnic groups. In many respects, Indonesia's national motto, "Unity in Diversity," provides an apt theme for the three regions' artistic traditions, which are as varied as their cultures and geographies.

Although its population is much smaller, Oceania, which encompasses Australia and the Pacific Islands, is an immensely diverse region with nearly 1,400 distinct cultures. The Pacific Ocean includes more than 20,000 islands generally divided into three broad geographic areas— Melanesia, Micronesia, and Polynesia—that stretch across about one-third of the globe. Melanesia is typically subdivided into New Guinea and Island Melanesia.

Of all the regions encompassed in this chapter, the Indian subcontinent—birthplace of Hinduism and Buddhism, and home to many important sculptural and architectural monuments—has perhaps received the most attention from art historians. However, new approaches to art history that focus on cultures and the human experience, and that challenge traditional ways of viewing and analyzing art, are broadening the conversation in exciting ways. At the same time, ongoing archaeological research is deepening our understanding of these three regions' earliest visual cultures, including South Asia's Indus culture (c. 2600–1900 BCE), Southeast Asia's Bronze and Iron Ages (c. 1500 BCE–300 CE), and Oceania's New Guinea Prehistoric Stone Sculpture (c. 6000–1000 BCE) and Lapita traditions (c. 1500–300 BCE). The art and well-planned cities of the Indus people reflect the growth of a centralized authority, the development of religious practices, the existence of a writing system, and the importance of water to the culture. Water was also central to the art and cultures of Southeast Asia, the people of which engaged in trade and imbued their artworks with spiritual power. In Oceania, artists in New Guinea and some neighboring islands created stone objects used in preparing food and in religious rituals, while the seafaring Lapita culture created art that combines geometric shapes with human and animal images.

Early South Asian Art: The Indus Period, *c.* 2600–1900 BCE

The Indian subcontinent is comprised of several main geographic regions: the northern mountain ranges, including the high peaks of the Himalayas; the river plains

Map 7.1 **South Asia, Southeast Asia, and Oceania.**

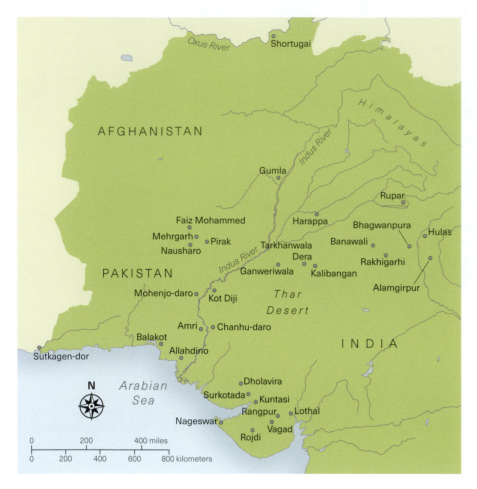

Map 7.2 Sites associated with the Indus culture, *c.* 2600–1900 BCE.

7.1 View of Mohenjo Daro, showing the walls and main streets of the ancient city (Sindh province, Pakistan), Indus period, *c.* 2600–1900 BCE.

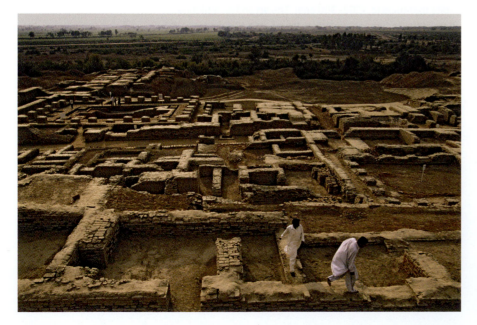

in the mid-north; the rocky, often arid Deccan plateau in the middle; and the lush, tropical, rice-growing areas of the far south. The large mid-northern Indo-Gangetic plain encompasses the mighty Indus and Ganges Rivers, both originating in the Himalayas and flowing southward to the seas.

Centered on the Indus River basin and spanning from present-day Afghanistan to the western Indian state of Gujarat, one of the world's oldest complex societies flourished between *c.* 2600 and 1900 BCE (**Map 7.2**). Some scholars refer to this society as Indus because it grew from settlements located in that river's valley. Others call it Harappan, after Harappa, the first site excavated in the early twentieth century. The ancient Mesopotamians, who lived in the region around present-day Iraq, called it Meluhha. Nobody today knows what the members of this ancient society called themselves, because scholars have not yet deciphered their written language. Thus our knowledge of Indus culture comes from visual clues provided by excavated artifacts and urban structural remains.

Archaeologists have identified over 1,000 sites associated with Indus culture, ranging from villages to cities, but less than 10 percent of them have been excavated. Based on evidence uncovered at those sites, archaeologists estimate the society's total population at one million, double that of Mesopotamia at the same time. During the society's peak, its inhabitants traded with Mesopotamians as well as with people in the Persian Gulf. The Indus people made the long journey west by boat and traded their craft items, including pottery and carnelian beads, possibly for wool products. They had a system of weights, a written language, an established social structure, and well-planned urban development, but Indus society differed from Mesopotamia, Old Kingdom Egypt, and Shang China—the other major early complex societies—in some striking ways: there is no evidence of human sacrifice, no monuments glorifying kings or battles, no elite burials with precious objects, and no grand religious structures. Small **terra-cotta** sculptures of voluptuous women that seem to relate to fertility or goddess worship provide evidence of religious practice. Whether or not such practices were precursors to Hinduism, the dominant religion of South Asia today, is a key topic of scholarly debate.

MOHENJO DARO The architecture of Indus cities offers insights into the lives of their inhabitants. The two largest cities, both located in present-day Pakistan, were Harappa and Mohenjo Daro. Harappa, which began to be settled around 3500 BCE, is in the northeast portion of the Indus river valley. Mohenjo Daro, located roughly 350 miles (560 km) south along the river, had a population estimated at 35,000 to 40,000. The city, like the other major Indus sites, featured a separate raised area, often called the citadel, which held the important public buildings. Its main urban area, often called the lower city, featured wide streets oriented to the cardinal directions of north, south, east, and west: an orderliness that indicates centralized urban planning. The lower city sat on a series of platforms constructed of mudbrick; the platforms' outer walls were made of more durable baked brick. The construction of such platforms, which protected the city from the periodic flooding of the Indus River, must have involved an immense amount of labor.

The lower city contained both public structures and private houses (**Fig. 7.1**). Many of the houses, which were made of baked brick, had two stories; many also had wells. The city had a remarkably advanced sanitation system as well. Houses had indoor latrines with pipes that emptied into drains on side streets. These drains fed into larger covered sewers on the main streets that

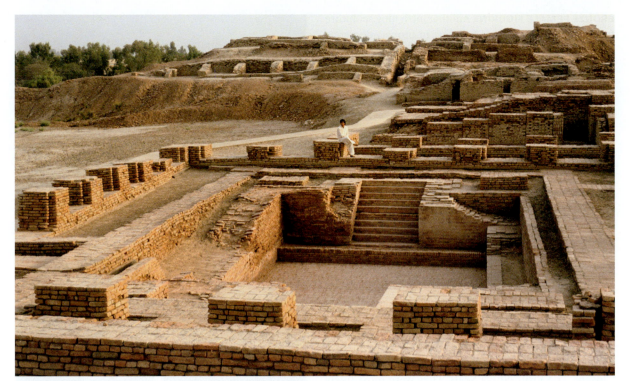

carried the waste to the city's outskirts. This degree of urban planning suggests that the culture had a centralized authority responsible for overseeing the construction and financing of such work.

THE GREAT BATH, MOHENJO DARO One of the city's largest surviving structures is the so-called Great Bath, located in the citadel area (**Fig 7.2**). Measuring 39 × 23 feet (11.8 × 7 m), it features two staircases leading down to a smooth brick floor that was covered with a layer of bitumen, a thick, sticky, asphalt-like substance that would have made it watertight. Many scholars believe that the structure had a religious or ceremonial function, and perhaps a connection with later Hindu traditions of bathing in sacred water. While such theories are based on assumptions that cannot be proven—indeed, we do not even know if it was used for bathing or for storing water—it is clear that the control of water was a vital part of Indus society. At another ancient Indus site, Lothal in Gujarat, big reservoirs surrounding the city collected river water and rainwater as part of a well-planned hydraulic system.

PRIEST-KING BUST SCULPTURE A variety of small objects have been found at Indus sites: jewelry, pottery, carved stone weights, children's toys, dice, and sculptures ranging from rustic terra-cotta forms to sophisticated bronze figures. One puzzle is the absence of any monumental sculpture. Perhaps large sculptures were made of organic materials that no longer survive, such as wood, or perhaps people took the more substantial sculptures with them when they abandoned their cities around 1900–1700 BCE. It is also possible that no large sculptures were made at all. Of the sculptures found at Mohenjo Daro, one of the most famous is the so-called priest-king, a 7-inch-tall **bust** of a man (**Fig. 7.3**). The contrast between

his elongated, half-closed eyes and his full lips and **striated** beard gives the work a refined, stylized appearance. Made from steatite, a soft stone, the bust would have been carved, fired to harden it, painted, and finally adorned with jewelry. That jewelry, along with the figure's groomed beard, armband, **diadem**, and robe with **trefoil** pattern, indicate that he represents someone of high status. Despite his common identification as a priest-king, whether the Mohenjo Daro figure depicts a deity, priest, ruler, wealthy trader, revered ancestor, or some other type of individual is unknown.

terra-cotta baked clay; also known as earthenware.

bust sculpture of a person's head, shoulders, and chest.

striated marked by lines or grooves.

diadem a crown or ornamented headband worn as a sign of status.

trefoil a decorative shape, consisting of three lobes, like a clover with three leaves.

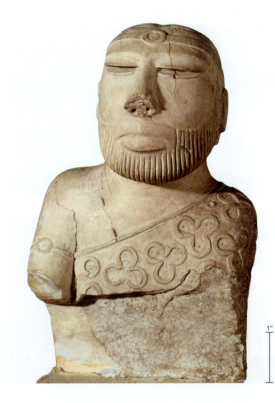

7.3 Priest-king bust, found at Mohenjo Daro (Sindh province, Pakistan), Indus period, *c.* 2600–1900 BCE. Steatite, height 7 in. (17.8 cm). National Museum of Pakistan, Karachi.

7.4 FAR RIGHT **Female figurine,** found at Mohenjo Daro (Sindh province, Pakistan), Indus period, *c.* 2600–1900 BCE. Bronze, height 4 in. (10.2 cm). National Museum, New Delhi.

7.5 BELOW **Seals showing one-horned animals, an elephant, and Indus script.** BOTTOM **Seal showing a bull, paired with its impression,** Indus period, *c.* 2600–1900 BCE. Steatite, approximate width of single seal ¾ to 1⅛ in. (1.8 to 2.8 cm). British Museum, London.

BRONZE FEMALE FIGURINE Another intriguing sculpture from Mohenjo Daro, this one cast in bronze, depicts a naked young woman, head tilted back, with one hand on her hip and the other hand resting on her slightly bent left leg (**Fig. 7.4**). Based on her pose, some scholars have suggested that it represents a dancer. Others attribute her appearance to her age; the figurine may represent an adolescent girl still growing into her long, slender limbs. Her wide, full mouth is similar to the mouth of the priest-king bust (**Fig. 7.3**), while the naturalism of her curly, plaited hair and subtly curved back differentiate her from it—a reminder that artistic styles often coexist at any given time or place. Her figure is adorned with jewelry: a pendant necklace and an array of bangles on her wrists. Similar thick bangles, made from a wide variety of materials from clay to conch shells, stoneware, and hammered sheets of gold, have been found at various Indus sites. They seem to have been commonly worn by members of every level of society.

INDUS SEALS The most numerous objects found at Indus sites are seals, or stamps, that functioned as identifying markers (**Fig. 7.5** and **Fig 7.6**; see also box: Looking More Closely: The Proto-Shiva Seal). They were most likely

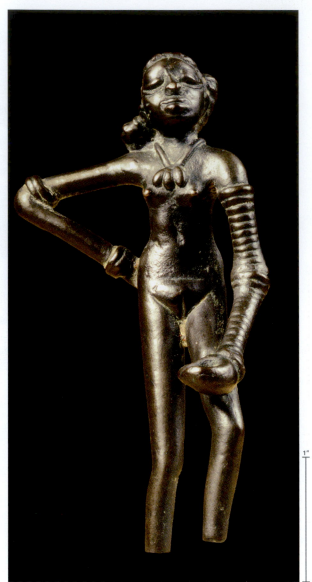

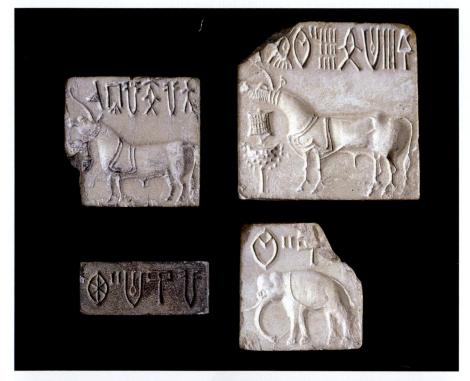

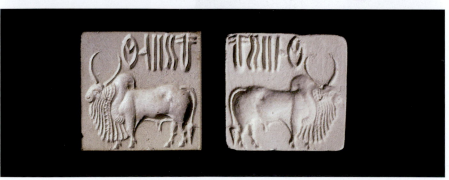

related to trade in some way, suggesting the importance of trade to Indus society. Most of the seals are small, averaging just ¾ to 1⅛ inches wide. They are made from steatite (like **Fig. 7.3**), with writing and/or images carved into a rectangular or square flat front. The seals originally had knobs on the back, for gripping as they were pressed down to leave an imprint in wet clay or a similar material. In the imprint, the writing and images would appear raised and in reverse. The knob had a single hole, presumably for a cord to pass through, so that the seal could be worn around the owner's neck. Similar holes have been found on Mesopotamian cylinder seals.

Many of the thousands of Indus seals display a row of writing above an image of an animal, often a bull, water buffalo, or Indian bison. Rhinos, tigers, elephants, and other animals are also depicted, suggesting that animals played a role in symbolic communication. The carvers skillfully planned their designs to show the curves of the animals' muscles. Intriguingly, 60 percent of the seals found at Mohenjo Daro bear images of what appears to be a one-horned horse or bull-like animal, which some scholars have called a unicorn. This depiction could

An important part of studying art history is distinguishing what we actually see from what we think we see based on the connections we make. This task can be challenging not only for new art history students but also for seasoned scholars, who are trained to apply what they know about other traditions or time periods to the object at hand.

One of the most celebrated artifacts from the Indus culture is called the Proto-Shiva seal

(**Fig. 7.6**) because some early scholars interpreted its main figure as an early or "proto" version of the Hindu god Shiva, who was depicted in art from roughly the first century CE onward (2,000 years after this seal was made). They saw a figure seated in a yoga pose (hands resting on knees, legs folded under body, feet pointed downward) on a low throne surrounded by animals, and they associated it with Shiva's titles of Master Yogi and Lord of the Animals. While this is a

compelling interpretation, it is worth looking closely at what the images on the seal actually depict (see details **A, B,** and **C**, as indicated on the line drawing of the seal's impression). The large size of the central figure compared to the surrounding animals, and the way in which most of those animals look toward him, suggest that the figure is probably connected to religious beliefs, but those beliefs are less clear than the object's modern name suggests.

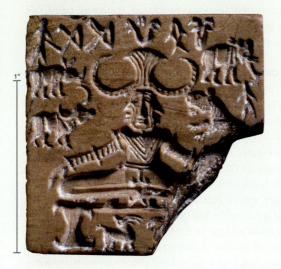

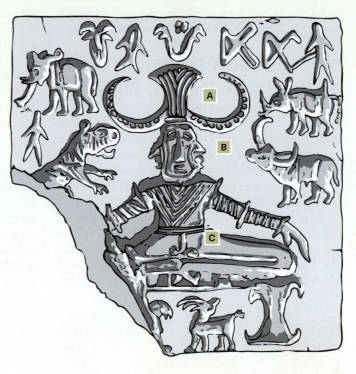

A Scholars saw a headdress with buffalo horns and related it to Shiva's sacred mount, a bull. Are bull and buffalo horns in fact the same?

B Some early scholars deduced that the figure has three faces, an attribute of Shiva. Does the figure truly have three faces, or is he wearing a mask? Perhaps he is meant to have a fourth face in the back, in which case we might associate him with the four-faced Hindu god Brahma.

C Scholars observed an erect phallus and connected it to Shiva's generative energy. Are the markings below the figure's waist phallic, or are they part of his belt buckle? Fertility and reproduction were common aspects of many early religious traditions around the world. So, even if the markings are phallic, do they necessarily link the figure to Shiva?

7.6 Proto-Shiva seal, with drawing of seal impression, from Mohenjo Daro (Sindh province, Pakistan), Indus period, c. 2600–1900 BCE. Steatite, 1⅜ × 1⅜ in. (3.5 × 3.5 cm) National Museum, New Delhi.

be an artistic convention—a way of showing an animal with two horns from the side, in profile—but terra-cotta figurines of one-horned animals have also been found. Did a one-horned animal actually exist, or do these seals depict a mythical creature?

Another intriguing aspect of the seals is their writing, which has yet to be deciphered. The seals typically feature between three and ten characters. The longest piece of Indus writing found includes only twenty-seven characters, making it difficult to study the language. However, scholars have determined that the writing was read from right to left, and the script seems to be logosyllabic, meaning that each symbol is a syllable or part of a word. In a classic conundrum, deciphering the script is probably the key to solving many of the puzzles presented by the archaeological evidence, but more archaeological evidence is needed to decipher the script.

By around 1900 BCE Indus society was in decline, with its major sites abandoned by about 1700 BCE. The reasons are unclear, but most scholars believe that the decline happened gradually and resulted from a combination of factors, including environmental changes such as shifts

in the courses of rivers. The old theory that invasions by Central Asian Indo-Aryan tribes ended Indus society has been disproven. People did migrate from Central Asia to the Indo-Gangetic plain, but that migration seems to have begun centuries later, around 1500 BCE.

These new people from Central Asia called themselves Aryans, meaning "Noble Ones." We know about them through the *Vedas*, sacred literature composed between around 1500 and 800 BCE and transmitted orally for about one thousand years before being written down. Because the people who composed and transmitted the literature spoke an early version of Sanskrit, an Indo-European language, modern scholars can read the *Vedas*. These philosophical and religious texts provide information on both society and religion at the time. For example, the Aryans kept horses. Their society seemed to be primarily agricultural and rural, unlike the Indus culture, which had no horses and the inhabitants of which lived in cities and traded over long distances. The Aryans' religion, Vedism, provided the basis for many aspects of Hinduism. It centered on reincarnation as well as cosmic and social hierarchy.

megalith a large stone used as, or as part of, a monument or other structure.

Aryan society was divided into distinct groups, and this hierarchy became more and more rigid over time. By the sixth century BCE, spiritual leaders reacting against what they saw as the injustices of the social system began to emerge. The two most important of these figures were Siddhartha Gautama (lived *c.* fifth century BCE) and Mahavira (*c.* 540–468 BCE), the founders of Buddhism and Jainism respectively (see Chapter 16). Curiously, archaeological remains from this period are relatively minimal. What has been found consists chiefly of simple pottery and copper and iron implements. Thus, from the fall of the Indus culture until around 250 BCE—a period of about 1,500 years—there is no surviving evidence of a writing system, sculpture, or urban structures in this region.

Early Southeast Asian Art: The Bronze and Iron Ages, *c.* 1500 BCE–300 CE

Although Southeast Asia (**Map 7.3**) is home to some of the oldest human fossil remains (Java's Solo Man, who lived 1.8–1.9 million years ago) and some of the earliest cave paintings found anywhere in the world (see Fig. 1.2), material evidence of writing systems or urban centers, comparable to those found in China, the Mediterranean, and the Indus region, dates to much later, around 500 CE. Up until that point, societies in Southeast Asia seem to have been localized and village based, with evidence of trade networks and social hierarchies by around 1000 BCE. In contrast to Indus culture (but in common with other early cultures), most found objects are grave goods.

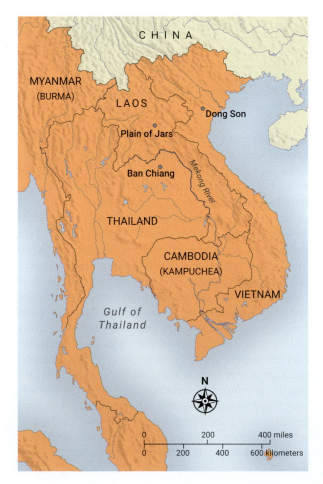

Map 7.3 Southeast Asia, showing Plain of Jars region, Ban Chiang, and Dong Son.

Based on the archaeological record uncovered thus far, scholars have pieced together a general chronology suggesting that people migrated from China to Southeast Asia, moving southward from the mainland to the islands, during the Neolithic period from 4000 BCE onward. Rice cultivation began around 3000 BCE, and bronze technology became widespread around 1500 BCE. Whether bronze casting came from China or was developed locally is still debated, but this significant technological development had spread throughout all of Southeast Asia by 500 BCE, when iron technology also appeared. During the Bronze and Iron Ages in Southeast Asia (*c.* 1500 BCE–300 CE), a wide variety of objects was produced, from wall paintings to glass beads. The three main types of objects that still exist are **megaliths**, ceramics, and bronzes.

PLAIN OF JARS Perhaps the most mysterious and visually striking of the megalith sites is the Plain of Jars in Xieng Khouang province, central Laos (**Fig. 7.7** and p. 134). It is not actually a plain, nor is it a single site. Rather, approximately 2,500 to 3,000 large stone jars lie scattered over 386 square miles (621 km) in the northern foothills and plateau of the Annamese Mountain range that runs through Laos into Vietnam and Cambodia. The solid stone jars, which can be up to 9 feet (2.74 m) high and 3 feet (91.4 cm) wide, are clustered together in groupings ranging from 1 to 350 jars. Most are sandstone, but some are made of granite or limestone. They were fashioned with iron tools, which dates their construction to between about 500 BCE and 200 or 300 CE. Some jars have rims; stone lids, which the rims would have supported, have been found nearby. A few vessels contain bones and cremated human remains, indicating that they had some relationship to burial practices. But what exactly was that relationship? And what society constructed these impressive megaliths, which can weigh up to 15 tons (13,600 kg) each? Even if the stone was sourced from the closest available deposits, making and moving such jars would have taken a vast amount of human labor and power, suggesting a social structure that organized the work.

The mid-to-late twentieth century was not kind to Laos. Between 1964 and 1973, during the Vietnam War, the United States Air Force dropped 260 million cluster bombs there, making it the most heavily bombed country in history. It is estimated that some 78 to 80 million bombs failed to detonate upon landing; they still litter the countryside, making it dangerous to live or work in the region. The bombing destroyed or damaged many of the jars and hampered the study of those that remain.

In recent years, following careful clearance and marking of unexploded bombs, archaeologists have been able to study several of the jar sites. Of these, Phonsavan is the most impressive and complete. There, the vessels are scattered around a hill containing the remnants of an ancient crematorium. Archaeologists have found cremated remains inside some of the jars, but they also uncovered burial pits in the adjacent ground. Thus, it is unclear whether the jars were burial sites themselves, grave markers, or something else. Some archaeologists think that they were used as distilling vessels, meaning that a body was placed inside the jar to decompose before

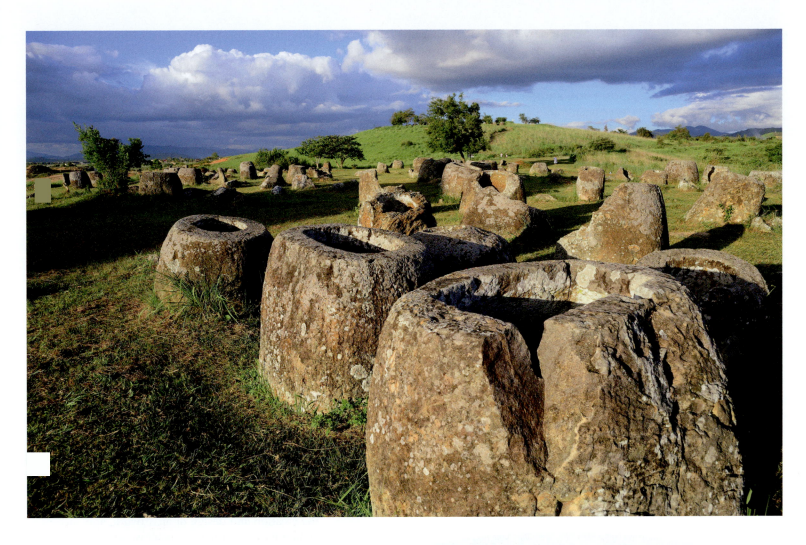

7.7 A cluster of stone burial jars on the Plain of Jars, Iron Age, *c.* 500 BCE–300 CE. Xieng Khouang province, Laos.

being moved to the crematorium for the next phase of the funeral rites. Excavations have also unearthed burial offerings, including glass and carnelian beads, bronze bells and bracelets, iron spearheads, and cowrie shells that must have come from the coast. This evidence suggests that the area was part of an ancient overland trade route connecting the Mekong River and the Gulf of Tonkin.

BAN CHIANG PAINTED CERAMIC VESSELS The best-known and most important site for early pottery production in Southeast Asia is Ban Chiang in northeast Thailand. Discovered by accident in 1966 and excavated in the 1970s, it changed people's perceptions of early Thai culture, which was relatively unknown before that time. The site has a long history of occupation, from as early as 3000 BCE, and objects from the Neolithic, Bronze, and Iron Ages have been found there. As with other early Southeast Asian finds, the surviving objects are primarily grave goods.

The most visually distinctive of these goods are buff-colored ceramic vessels featuring rust-colored designs. The earliest Ban Chiang pottery, datable to *c.* 1000–300 BCE, featured impressed or **incised** designs. These early examples of pottery were often broken intentionally before they were added to the grave. In contrast, pots made between *c.* 300 BCE and 200 CE (**Fig. 7.8**) bear painted designs and were buried intact, though the reason for this change remains unclear. The pots were placed on top of the body, along with iron and bronze objects and glass beads.

Ban Chiang ceramics display a huge range of decoration, and some scholars speculate that designs varied from village to village. In general, however, they rarely depict people or animals. The artists seem to have preferred abstract decorations, particularly spiral patterns, which cover the entire surface area. Especially notable is the skill of the painting's execution and the way it corresponds to the vessel's form. The makers applied the lines freehand, creating spirals that follow the jar's contours, with their centers at the widest part of its body.

incised cut or engraved.

1"

7.8 FAR LEFT **Clay jar,** Ban Chiang, northeastern Thailand, 300 BCE–200 CE. Painted pottery, height 15 in. (38.1 cm). British Museum, London.

Different patterns were used for the narrow point of the neck. Overall, the subtlety of the design highlights the elegance of the jar's shape.

DONG SON BRONZE DRUMS While small bronze items have been found at both Ban Chiang and the Plain of Jars, the most impressive—and largest—bronze specimens from early Southeast Asia come from Dong Son in northern Vietnam. The Dong Son culture, which seems to have been concentrated around the Red River valley, had extensive agricultural settlements with some fortified sites. There, roughly between 600 BCE and 200 CE, bronze drums were made, including the Song Da drum shown here (**Fig 7.9**). It is 2 feet (61 cm) high; the largest that have so far been found are over 3 feet (91 cm) high and weigh up to 220 pounds (100 kg). Roughly 200 have been discovered over a substantial geographic area from Cambodia to Indonesia, with still more currently being found. This spread demonstrates the extent of the trade network at the time, as well as the appeal of the drums. Most were discovered in the tombs of high-ranking figures, but they also seem to have been objects of prestige in leaders' day-to-day lives.

All Dong Son drums share a similar design: a flat face, sides that taper inward, a flared foot, and handles on the sides. The top bears a concentric design in **low relief**. Cast using either the **piece-mold** or **lost-wax** technique, these drums display considerable metal-casting skill. Hollow and without a bottom, they may have operated more like gongs: Players perhaps tilted them, placed them on their sides, or suspended them with ropes through the handles, so that when they were hit, the sound could reverberate.

The surface designs offer intriguing clues about cultural practices and the drums' significance. Rings of geometric patterns alternate with rings featuring humans and animals. Birds, particularly water birds, play a prominent role, and frogs appear on many of the drums, suggesting a water theme. The images also include men wearing feathered headdresses and performing rituals, some using drums; scenes of rice cultivation and war; and houses and boats. Notably, the houses are depicted raised on piles with large boat-shaped roofs, very similar to the distinctive houses that the Toraja, an Indigenous ethnic group, still construct on the island of Sulawesi in Indonesia. The very center of the surface, where the drum would have been hit, is typically marked with what might be a star or sun shape. Some scholars have suggested that the shape is a splash, related to the water imagery found on the drum. The prevalence of the water theme on the Dong Son drums has led some art historians to speculate that they were used in rituals to summon the monsoon rain. Others have suggested the drums were used during death rituals or war.

These drums encapsulate three broad themes found throughout much of Southeast Asian visual culture: the centrality of water, the extensiveness of trade, and the significance of the invisible to an object's potency. Art historians often think about the visible as the most important aspect of art. But in Southeast Asia, in certain contexts, the invisible—the unseen world believed to be inhabited by spirits—was a big part of the motivation for the creation and design of an artwork, and success in communicating with the invisible world was the measure of its value. The creators of the Dong Son drums may have believed that the instruments' reverberations connected the physical tangible world with the power of the unseen realm.

Early Oceanic Art: The New Guinea Prehistoric Stone Sculpture, *c.* 6000–1000 BCE, and Lapita Traditions, *c.* 1500–300 BCE

The original populations of Oceania, the vast region that includes Australia and the Pacific Islands, migrated from Southeast Asia in different waves. Moving south and east through what are today primarily the islands of Indonesia, humans first settled Australia and New Guinea some 50,000 to 65,000 years ago. Around 5,000 years ago, a second phase of settlement began when people again migrated out of mainland Southeast Asia, through Island Southeast Asia, and into the western Pacific (**Map 7.4**). Over the millennia, the descendants of all these original settlers gradually spread out across the Pacific and developed an enormous diversity of distinctive cultures, languages, and artistic traditions that deviated greatly from those of the original Southeast Asian settlers. As a result, there is little evidence of a direct influence of the ancestral Southeast Asian artistic traditions on the archaeologically and historically known arts of Oceania.

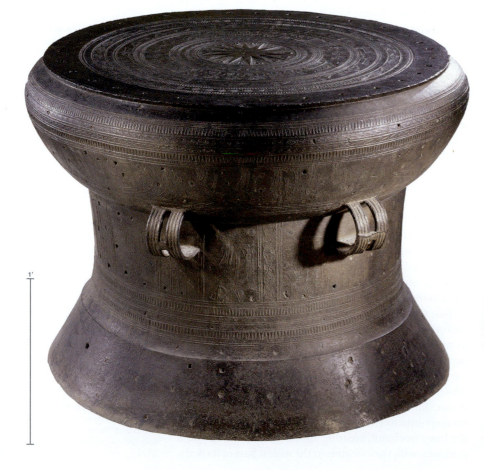

7.9 Song Da drum (also known as the Moulié Drum), from northern Vietnam, Dong Son culture, 600 BCE–200 CE. Bronze, height 24 in. (61 cm), diameter 30 in. (76.2 cm). Former Moulié collection, Musée National des Arts Asiatiques Guimet, Paris.

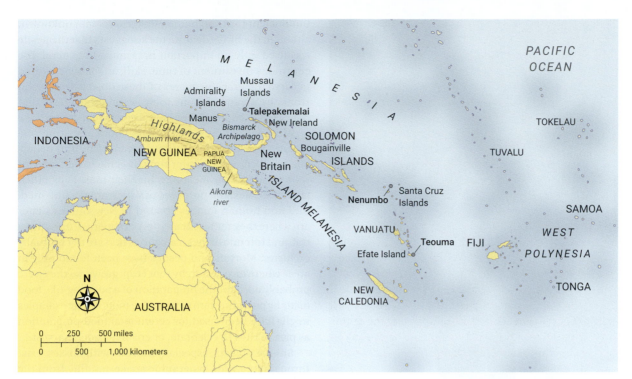

mortar a bowl-shaped object used to hold food or other substances for crushing.

pestle a club-shaped implement used to crush materials in a mortar.

boss a round, knob-like projection.

finial an ornament at the top, end, or corner of an object or building.

Paleolithic rock art in Australia (see Chapter 1) and parts of Island Southeast Asia attests to the fact that people in these regions have made art for tens of thousands of years. However, apart from the rock art, very little of this artistic heritage survives. Most likely, in the past, this region's cultures, as they did in historic times, worked primarily in wood, fiber, and other organic materials that typically do not survive in the moist tropical climate. Moreover, much of the region's prehistory remains sparsely documented or wholly unknown owing to a lack of systematic, or even preliminary, archaeological research. Only tantalizing vestiges of Oceania's ancient artistic traditions remain. These include the New Guinea prehistoric stone sculpture tradition (*c.* 6000–1000 BCE) found across much of New Guinea and the western portion of Island Melanesia, and the abundant ceramics and rare sculptural works of the Lapita culture (*c.* 1500–300 BCE), who were the first humans to settle many parts of Island Melanesia and who continued eastward to colonize the islands of West Polynesia.

NEW GUINEA PREHISTORIC STONE SCULPTURE, *c.* 6000–1000 BCE

Archaeological finds of New Guinea's prehistoric stone sculptures have been concentrated in the eastern portion of the island, extending from the mountainous Highlands of the interior down to coastal areas and outward to the islands of New Britain, New Ireland, and Manus in the Bismarck Archipelago and as far as Bougainville in the northern Solomon Islands (**Map 7.4**). Almost all examples were unearthed by chance during road building, gold mining, and tilling agricultural fields. To date none have been found in a controlled, securely dated archaeological context, but many archaeologists believe the tradition flourished between roughly 6000 and 1000 BCE. Finds cluster along the ancient coastline of a former inland sea, which was at its most extensive from about 5500 to 4500 BCE and had silted up by around 2000 BCE. Organic material associated with an important work called the Ambum Stone (see **Fig. 7.12**, p. 144) has been dated to approximately 1500 BCE.

MORTARS AND PESTLES The people who created New Guinea's prehistoric stone objects were agriculturalists. The majority of their surviving works are **mortars** and **pestles** used for pounding or crushing food or other substances. While many mortars are unadorned, some are decorated with rows of raised **bosses** around the rim or, more rarely, with sculpted human or bird images (**Fig. 7.10**). Similarly, most pestles are plain, but some examples have elaborately carved **finials** in the form of stylized birds (**Fig. 7.11**, p. 144) or other figures. The meanings of

7.10 Mortar with anthropomorphic face, Enga Province, lower Lagaip River, Paiela area, Takopa, Papua New Guinea, *c.* 6000–1000 BCE. Andesite stone, 4¾ × 8¾ × 13¾ in. (12.1 × 22.2 × 34.9 cm). The Fine Arts Museums of San Francisco, California.

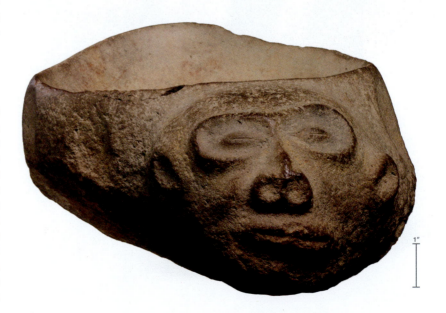

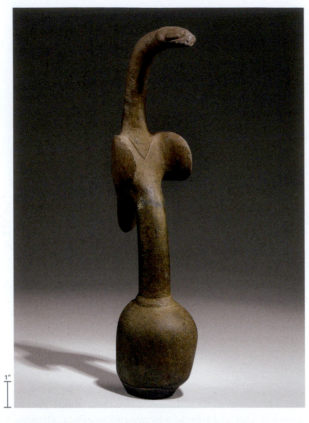

7.11 Pestle in the form of a bird, from Aikora River, Papua New Guinea, *c.* 6000–1000 BCE. Stone, height 14⅛ in. (35.9 cm). British Museum, London.

totem an animal, plant, or geometric design that is the identifying symbol of a family, clan, or other group of related individuals.

7.12 BELOW **The Ambum Stone,** found near the Ambum River, Enga region, Western Highlands Province, Papua New Guinea, *c.* 1500 BCE. Graywacke, height 7⅞ in. (20 cm). National Gallery of Australia, Canberra.

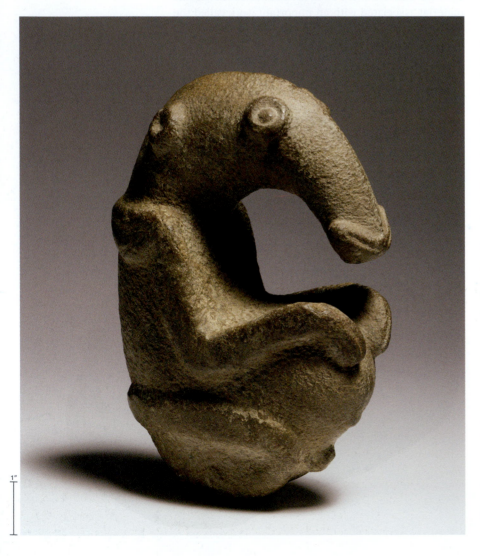

this ancient bird and human imagery remain unknown, although the bird's delicate neck suggests that the pestle was used only on important occasions. In general, the enormous investment of time, skill, and labor required to carve the graceful curves of these objects from solid stone, by means of stone tools, strongly suggests that they were used in religious and ceremonial contexts.

Although we must be careful about comparing prehistoric and historic cultures, because cultural beliefs and practices change over time, it is likely that ancient works had similar meanings for their makers as much later examples, the purposes of which are documented. Bird and human images abound in New Guinea's later art, where they represent a variety of supernatural, ancestral, and **totemic** beings, categories that are not mutually exclusive. Mortars and pestles have been found only in areas where taro, a starchy root crop, grows, so they were probably used for the preparation of a pudding-like food made by pounding taro or nuts. The more ornate examples might have been used for ceremonial food preparation as part of rites to celebrate, or ensure, a good harvest.

Similar objects, especially mortars with bosses, exist throughout a wide geographic area extending from the New Guinea Highlands to the coast to offshore islands. It seems reasonable to suggest that they had similar meanings and functions across a broad number of local cultures that were linked by complex trade networks, allowing for the exchange of objects and ideas.

THE AMBUM STONE In addition to mortars and pestles, the earliest known human-made objects from New Guinea include stone club heads, disks, and freestanding figures of humans, birds, and animals. The latter category includes a series of unusual figures found in or near the Ambum River valley in the New Guinea Highlands. They represent long-nosed animals, seated upright with their knees and elbows flexed and their forearms and hands resting on prominent, protruding bellies. The best-known and most intricately rendered is the figure known as the Ambum Stone, dated to around 1500 BCE (**Fig. 7.12**).

The precise significance of the Ambum Stone is unknown. The long, curving snout and V-shaped mouth, together with the body's somewhat embryo-like shape, have led some scholars to suggest that the figure represents a juvenile echidna: a long-nosed, egg-laying mammal related to the platypus of Australia. It is also possible that the figure represents a supernatural being rather than a real animal. Like most historic Oceanic sculpture, it was probably used in religious ceremonies.

Contemporary Highland cultures consider natural stone objects, such as unusually shaped rocks, crystals, or fossils—as well as prehistoric stone sculptures, when they are unearthed—to be of supernatural rather than human origin. Believed to be magically powerful, prehistoric stone objects were, and in some cases still are, widely used in agricultural rites designed to assure abundant harvests and large herds of pigs, an important form of wealth in most traditional New Guinea societies.

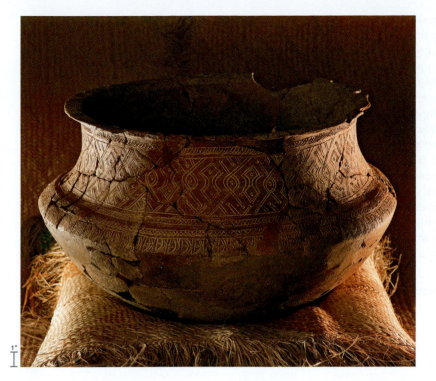

7.13 LEFT **Vessel, Lapita culture,** from the Teouma site, Efate Island, Vanuatu, *c.* 1000 BCE. Earthenware, height 12½ in. (31.8 cm). Vanuatu National Museum, Port Vila.

7.14 ABOVE **Fragment of a vessel with a human face, Lapita culture,** from the Nenumbo site, Santa Cruz Islands, Solomon Islands, *c.* 1000–900 BCE. Earthenware, height 3 in. (7.6 cm). Auckland Museum, New Zealand.

THE LAPITA CULTURE, *c.* 1500–300 BCE

Beginning around 1500 BCE, a new culture began to appear in the islands of the southwest Pacific. Today the culture is known as Lapita, after a site where some of its first artifacts were discovered. Whether the first Lapita settlers migrated by long-distance voyages from mainland or Island Southeast Asia and spread eastward, or developed locally in the islands of the Bismarck Archipelago north of New Guinea, is the subject of ongoing research and debate. Whatever their origins, by 1500 BCE Lapita groups had settled coastal areas of northern New Guinea, the Bismarck Archipelago, and much of the Solomon Islands, suggesting that they were primarily seafarers who traded with other peoples in the region. Rapidly migrating eastward, by 1200 BCE the Lapita had begun to extend their influence into previously uninhabited areas of the southwest Pacific, settling the Santa Cruz Islands, Vanuatu, and New Caledonia in Island Melanesia, and later settled most of Micronesia. By around 950 to 900 BCE, Lapita groups had reached the islands of Fiji, Tonga, and Samoa in West Polynesia where, starting around 650 BCE, their descendants began to develop the first recognizably Polynesian cultures.

LAPITA CERAMICS The known arts of the Lapita are primarily ornate earthenware pottery decorated with intricate geometric patterns (**Fig. 7.13**). Most of the designs were made by repeatedly pressing the tips of the fine teeth of what were probably comb-like implements or other stamping tools into the wet clay, a technique known as dentate (toothed) stamping. Lapita artists used dentate stamping and, occasionally, direct incising to produce dense, orderly compositions that combined curving and linear elements to create distinct design zones separated by decorated borders or bands. Most surviving Lapita ceramic works are in fragments. Where reconstruction is possible, evidence indicates that artists created a wide variety of different forms, from ridged, cauldron-shaped pots to cylinders and plate-like forms that probably served as lids for larger vessels. While some Lapita vessels may have been used to store or serve food, others were possibly used as burial jars in funerary contexts.

Most Lapita motifs are purely geometric, featuring circular, zigzagging, triangular, and other forms applied in bands. However, the ornamentation on a sizable number of Lapita vessels incorporates simplified, stylized representations of human faces with oval or lozenge-shaped eyes and prominent elongated noses (**Fig. 7.14**). The faces form part of the overall geometric patterns. In rare instances, designs depict animals, such as birds and sea turtles. Though the significance of these images is unknown, we do know that anthropomorphic beings and animals perceived as supernatural play prominent roles in the historic religious traditions of the Island Melanesian, Polynesian, and Micronesian cultures descended from the Lapita culture, so it is possible that these Lapita images held sacred significance.

The fundamental design scheme and layout of Lapita art, with its bordered zones of complex geometric designs occasionally incorporating human and animal imagery, is clearly reflected in the historic Polynesian artistic traditions that developed from it. For example, the ancestral influence of Lapita imagery is evident in the design schemes of barkcloth (see Fig. 59.16), tattooing, and other Polynesian art forms.

LAPITA FIGURE While Lapita ceramics are relatively abundant in the archaeological record, surviving examples of three-dimensional sculpture are extremely rare. The most significant is a unique human figure (**Fig. 7.15**, p. 146) carved from porpoise bone recovered from the site of Talepakemalai in the Mussau Islands of Papua

1"

7.15 Figure, Lapita culture, from the Talepakemalai site, Mussau Islands, Papua New Guinea, *c.* 1500 BCE. Porpoise bone, height 3¼ in. (8.3 cm).

New Guinea. This small carving from around 1500 BCE is the only known freestanding human sculpture from the Lapita culture. It depicts a highly stylized human image with a greatly enlarged head that occupies well over half the figure's total height. The facial features consist of a pointed chin, two slit-like grooves representing the eyes or brow ridge on either side of a long descending nose carved in low relief, and a short, shallow groove, possibly representing the mouth. The arms and hands are narrow, roughly defined forms on either side of the torso, which is an inverted triangular form whose corners are formed by the shoulders and genital region, creating a shape that echoes that of the chin. The hands end at a groove demarcating the boundary with the hips and the short, stocky legs below. In most historic Polynesian sculpture, the head, considered to be the seat of a person or divine

being's *mana*, is greatly enlarged; thus the enlarged head of the Lapita figure suggests that this belief extends far back into prehistory. The strictly frontal stance of the figure, with its arms extended down the sides and the relatively prominent belly, are also typical of some historic West Polynesian sculptural traditions.

Artworks from cultures that did not use writing or from which no decipherable writing survives, as in the case of South Asia's Indus culture, serve two functions for the art historians studying them. The surviving objects, whether Lapita ceramics, Dong Son bronze drums, or Indus seals, not only provide compelling examples of the early artistic traditions of Oceania, Southeast Asia, and South Asia, but also serve as the principal evidence for what we know about the societies and cultures that created them.

Discussion Questions

1. One of the major themes of this chapter is how much remains unknown about these early cultures of South Asia, Southeast Asia, and Oceania. What are some of the questions that arise about these art forms, and what would we have to discover to be able to answer them?

2. Choose two or three works from this chapter and analyze the role that water plays in them. Thinking about our culture today, does water play an equally important role? Why or why not?

3. Compare the materials, imagery, and possible meanings of the prehistoric stone figure tradition of New Guinea and the arts of the Lapita culture. What are some of the similarities and differences between the two? Why are the meanings of these art forms and their imagery so poorly understood?

Further Reading

- Bolton, Lissant. "Aesthetic Traces: The Settlement of Western Oceania." In P. Brunt et al. (ed.) *Art in Oceania: A New History*. New Haven and London: Yale University Press, 2012, pp. 27–49.
- Coates, Karen J. "Plain of Jars." *Archaeology* 58, no. 4 (2005): 30–35.
- Robinson, Andrew. *The Indus: Lost Civilizations*. London: Reaktion Books, 2015.
- Swadling, Pamela. "Prehistoric Stone Mortars." In Lissant Bolton, Nicholas Thomas, Elizabeth Bonshek, Julie Adams and Ben Burt (eds.) *Melanesia: Art and Encounter*. Honolulu, HI: University of Hawai'i Press, 2013, pp. 78–82.

mana supernatural power; *mana* can be manifest in many forms including humans, divine beings, animals, places and natural or human-made objects.

Chronology

	SOUTH ASIA			
		c. 500 BCE–300 CE	Iron technology develops in Southeast Asia	
c. 3500 BCE	The Indus city of Harappa begins to be inhabited	*c.* 500 BCE–300 CE	The Plain of Jars is created in Laos	
c. 2600–1900 BCE	The mature period of Indus society	*c.* 300 BCE–200 CE	Late period Ban Chiang painted pottery is produced in Thailand	
c. 1900–1700 BCE	The decline of Indus society		OCEANIA	
c. 1500–1000 BCE	Indo-Aryan groups migrate into northwest India from Central Asia	*c.* 6000–1000 BCE	Prehistoric sculpture tradition flourishes in New Guinea and parts of Island Melanesia	
c. 1500–800 BCE	The *Vedas* are composed in northern India	*c.* 1500–900 BCE	Lapita groups emerge and migrate into Island Melanesia, West Polynesia, and Micronesia	
c. 540–468 BCE	The life of Mahavira, founder of Jainism			
c. fifth century BCE	The life of Siddhartha Gautama, founder of Buddhism	*c.* 1500–300 BCE	Lapita cultures create sculpture and ceramics	
	SOUTHEAST ASIA	*c.* 1000–50 BCE	The first settlers arrive in the Mariana Islands and western Caroline Islands in Micronesia from Southeast Asia, possibly the Philippines	
c. 1500–500 BCE	Bronze technology spreads throughout communities in Southeast Asia			
c. 1000–200 BCE	Ban Chiang ceramics are produced in Thailand	*c.* 650–300 BCE	The descendants of Lapita settlers in West Polynesia develop the first recognizably Polynesian cultures	
c. 600 BCE–200 CE	Dong Son culture in Vietnam produces and distributes bronze drums	*c.* 100 CE	The first settlers arrive in the eastern Caroline Islands in Micronesia	

8

Art of Early East Asia

4000–200 BCE

Cavalryman and horse, from
tomb complex of the First Emperor
of Qin, China.

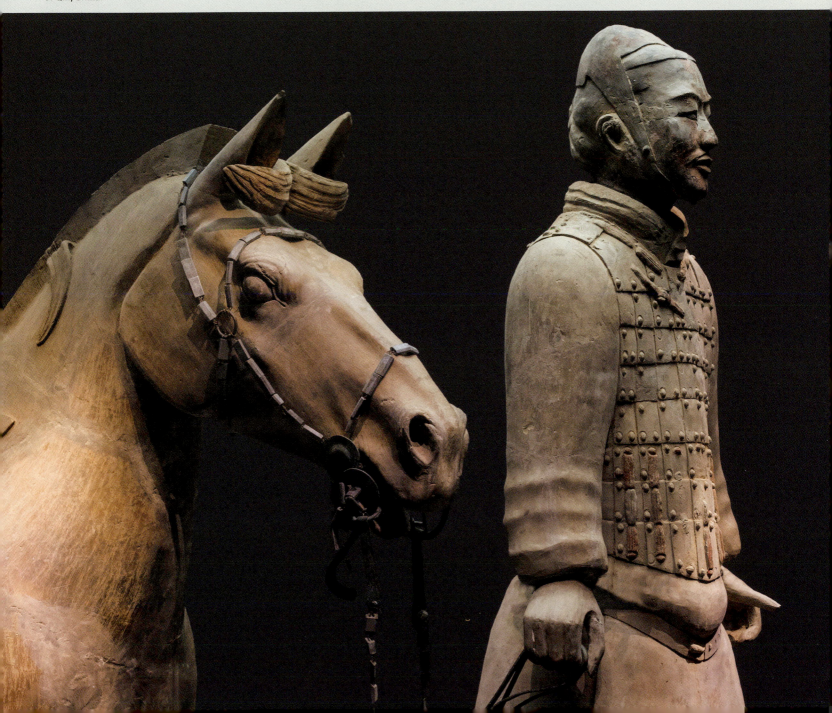

Map 8.1 Some East Asian Neolithic Cultures, c. 4000– c. 2000 BCE.

Introduction

The story of early art in East Asia encompasses not only dynamic encounters across land and seas but also growing populations and the concentration of wealth in cities. Powerful leaders designated certain cities as the capitals of kingdoms and empires, commissioning art to reflect their authority and ambition. The leaders' monumental tombs and their contents reveal the accomplishments of scores of unnamed artists.

East Asia is the name used for the lands that stretch from the Taklamakan and Gobi deserts eastward to the mountain ranges and coastlines of a substantial peninsula and many islands; it includes the high-altitude plateau formed by the Himalayas, fertile river valleys, and tropical forests (Map 8.1). Present-day China occupies the largest portion of East Asia. To the northeast, the Korean peninsula is divided into the independent nations of North and South Korea. Further east, four islands of a more extensive archipelago account for most of Japan's territory.

Long before the cultures that now identify as Chinese, Korean, and Japanese came into being, many more localized groups coexisted, flourishing in the temperate and ecologically rich East Asian regions. In recent years, it has become clear that Neolithic (beginning before c. 10,000 BCE) and Bronze Age (beginning c. 1700 BCE) communities in East Asia were not isolated, but rather that migration and trade brought people into contact with one another. In the absence of written records, such contact is visible in the material record, which reveals, for example, the spread of ceramic forms and the diffusion of bronze technology. Beginning about 1200 BCE, written records provide additional evidence for Bronze Age cultures in East Asia.

Clustered along the region's seacoasts and rivers, early East Asian communities produced durable objects of clay, jade, and bronze. Plain, ornamented, and painted ceramics served both for daily use as well as for ritual feasting and display. Objects made of jade and bronze often served as status symbols and were taken with their owners to their graves. Sculptures and other artworks were created to worship ancestors or delivered as offerings in religious rituals that sought to connect this world with the next. As people and political power became more concentrated in cities and empires, rulers used art to support their authority.

Ceramics and Jades in East Asia, *c.* 4000–*c.* 400 BCE

During the Neolithic period, beginning not later than 10,000 BCE, humans began farming and using polished stone tools. **Terra-cotta** and **jade** objects excavated throughout East Asia attest to the **material cultures** of Neolithic communities spread across a vast geographical range. In the northeast, richly textured ceramics from the Korean peninsula and the islands of Japan demonstrate the sculptural possibilities of the potter's art. In the Majiayao culture located in the early Chinese heartland, clay vessels were embellished with painting. The Liangzhu culture, which flourished along China's southeast coast, also made ceramics, but its most distinctive artifacts were fashioned from jade.

Terra-cotta vessels found in the Korean peninsula date to *c.* 7000 BCE or earlier and are primary evidence of human presence there. They share certain characteristics

terra-cotta baked clay; also known as earthenware.

jade a general term for hard, typically green minerals, including nephrite and jadeite.

material culture the materials, objects, and technologies that accompany everyday life.

with other vessels from around the world; they were shaped from clay, unglazed, and baked at a temperature below 1200 degrees Celsius (2200° F), producing hard but not entirely watertight objects. Many rounded vessels were created by rolling the clay into long cylinders and stacking them in coils. When the coils reached the desired height, the walls could be smoothed and ornamentation added.

JEULMUN VESSELS Some of the earliest vessels on the Korean peninsula have flat bottoms and raised decoration, but around 5000 BCE, a distinctive comb pattern appeared on ceramics in the western region and spread to the rest of the peninsula. The period from *c.* 7000–*c.* 1500 BCE is named after this comb pattern, Jeulmun.

Excavated from the Amsa-dong site in present-day Seoul, this particular example (**Fig. 8.1**) has a pointed base and a wide mouth. The vessel's silhouette has a gentle parabolic curve, giving it a graceful quality. Its symmetry is approximate rather than perfect, as a result of the clay coil-stacking technique. Its overall form is simple, and its walls were smoothed before it was decorated. The decoration has the effect of dividing the vessel into three horizontal **registers**. Close to the base, **incised** parallel lines create angles that point left and right. The middle register is the widest, and the lines here form a **chevron** pattern, which echoes and reverses the vessel's overall shape. At the mouth, the pattern changes once more to narrow bands of hash marks. The variation of repeated lines produces a coherent and balanced composition.

For potters, the size of a vessel poses a challenge in terms of ensuring the strength of the self-supporting walls. In this regard, building an inverted cone shape proved an effective solution. The pointed base was slightly awkward, but it required only a slight depression in the ground to maintain an upright position. Its size and decoration may indicate the owner's prestige, but relatively large vessels, such as this one, were also useful for storing food. This vessel was excavated near other terra-cotta bowls and stone tools, suggesting daily use for food storage and cooking.

MIDDLE JŌMON FLAME VESSELS Similarly to the early cultures of the Korean Peninsula, the Jōmon culture in Japan produced remarkable vessels. Jōmon culture, which spread and flourished throughout the Japanese archipelago from about 13,000 to 400 BCE, is named for its cord-marked terra-cotta vessels. When rolled against a clay surface, woven cords produce a variety of patterns

8.1 **Comb-pattern Jeulmun vessel,** excavated from Amsa-dong, Kangdong-gu, Seoul, *c.* 4000–3000 BCE. Terra-cotta with incised decoration, height 15 in. (38.1 cm). Kyonghui University, Seoul.

register a horizontal section of work; usually a defined band or line.

incised cut or engraved.

chevron pattern in the shape of a V or upside-down V.

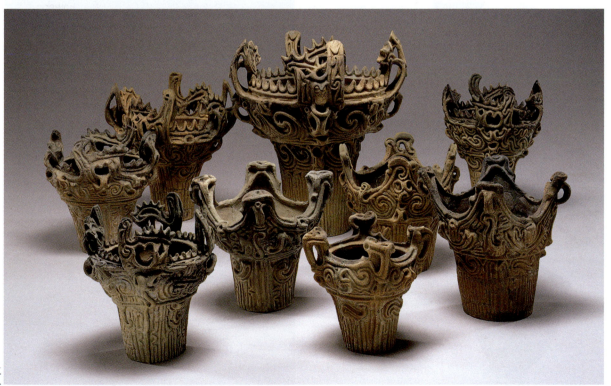

8.2 **Flame vessels,** from Sasayama, Niigata prefecture, Japan, Middle Jōmon period, *c.* 2500 BCE. Terra-cotta, largest vessel height 8⅜ in. (46.5 cm); diameter 17¼ in. (43.8 cm). Tōkamachi Museum, Japan.

and textures. By combining this technique with three-dimensional sculptural adornments, artists created especially exuberant vessels (**Fig. 8.2**, p. 149)

These Middle Jōmon (*c.* 3500–*c.* 2500 BCE) artifacts have wide mouths and surface decorations that organize the body into horizontal registers, similarly to the Jeulmun vessel. Vertical lines divide portions of the lower registers into panels, which are filled with patterns occasionally interrupted by wavy lines or curlicues. This bounded visual energy expands considerably as the vessels' silhouettes broaden at their shoulders. Clay coils swirl in sinuous bands that rise and sometimes transform into looped handles. Form and decoration also merge at the mouth. The curved forms lead the viewer's eyes around and around, while the play of textures appeals to the sense of touch. Cockscomb or flame-like embellishments are distinctive to Middle Jōmon vessels from the western coast. This assemblage was excavated from a single site in Sasayama.

The elaborate and fragile characteristics of these "flame" vessels suggest long-term settlement and surplus time for artistic experimentation. They also suggest that the vessels were luxury objects, used for ceremonial display and ritual feasting. Soot and residue inside most of the vessels likely resulted from cooking food.

FINAL JŌMON *DOGŪ* The archaeological record of later Jōmon periods shows a sharp uptick in the production of terra-cotta figures, or **dogū**. Unlike the lively Middle Jōmon flame vessels, some *dogū*, including this one from the Final Jōmon period (*c.* 1000–*c.* 400 BCE), take static forms (**Fig. 8.3**). The frozen, timeless quality results from the symmetrical composition of the head facing forward,

arms at the side, and legs vertically aligned, although one leg is missing. The swirling surface patterns of the costume generate some sense of movement across the abstracted body, but the oversized eyes command the most attention and inspired the modern description of the figurine as "goggle-eyed."

The figurine's breasts and wide hips led to an early theory that it is a symbol of fertility or motherhood. Like the vast majority of *dogū*, this one was intentionally broken, possibly as part of a ritual, and the missing limb suggests its use as an offering in ceremonial activities, perhaps asking for safe childbirth or a successful hunt. The hollow body has led some scholars to suggest that it provided a residence for a soul. In the absence of specific evidence, however, the precise meaning of this *dogū* remains unknown. Moreover, the roughly 18,000 *dogū* that have been recovered present a range of forms and probably fulfilled a variety of functions.

MAJIAYAO *GUAN* (JAR) Several other Neolithic cultures on the East Asian continent also made terra-cotta vessels and objects. Instead of using incised lines, textures, or sculptural elaborations (compare **Figs. 8.1** and **8.2**), some of these cultures used painting for ornamentation. Creating a single object thus required an additional set of skills, the painter's knowledge of pigments and ability to fix them onto a surface. This painted terra-cotta jar (**Fig. 8.4**), from the Machang phase (*c.* 2350–*c.* 2050 BCE) of the Majiayao culture in the upper reaches of the Yellow River, uses two pigments: black for outlines and emphasis, and a lighter, reddish hue for fill. It has a broad body between its relatively small base and narrow neck. Three lug handles (two can be seen in this view) break the contour, but the

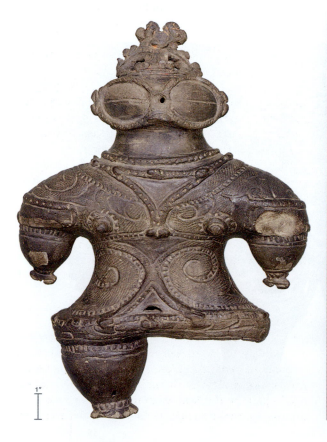

8.3 RIGHT **Goggle-eyed *dogū*,** Final Jōmon period, *c.* 1000–400 BCE. Terra-cotta, height 15 in. (38.1 cm). Tokyo National Museum, Tokyo.

8.4 FAR RIGHT **Guan (jar),** Neolithic period, Machang phase of the Majiayao culture, *c.* 2350–2050 BCE. Terra-cotta with pigments, 12⅜ in. × 9¼ in. (31.4 × 23.5 cm). Metropolitan Museum of Art, New York.

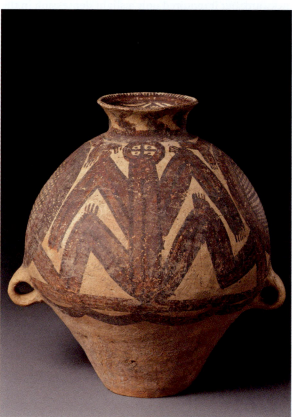

body is otherwise smooth. As in the Jeulmun and Jōmon examples, the vessel's body is divided into registers. The neck and lower register feature abstract patterns, functioning like a frame.

In the wide upper register, geometric shapes resolve into **zoomorphic** designs. Between two large medallions filled with a cross-hatch pattern (in this image, the edges of the medallions are visible on the right and left sides, just above the lug handles), four bent limbs and a head emerge from a central vertical body. Additional markings emphasize knees, elbows, feet, and hands—alternatively, these may be fur or claws. Instead of a recognizable face, the head is quartered into sectors, each bearing a single dot. Clearly, the artist shifted back and forth between abstract patterns and **representational** forms.

The most typical designs of the Majiayao culture during this time period are abstract, spiral patterns that appear on such objects as children's rattles and large **amphorae**. Artifacts bearing representational forms are less common and this one, like the goggle-eyed *dōgu* (**Fig. 8.3**), has provoked speculation. Is the figure a frog? Or is it a human being, perhaps a spiritual leader whose dress evokes the transformative capacities of ritual? Archaeologists and art historians continue to grapple with the relationship between ornament and shape, to consider manufacturing processes and exchange networks, and to analyze the specific evidence of excavation sites in order to better understand the meaning and significance of these and other early East Asian ceramics.

LIANGZHU *BI* Intentional forms with elusive meanings are also characteristic of the early artworks of the Liangzhu culture, which was located in the Yangtze River delta region of mainland East Asia and flourished around 3500–2000 BCE. Roughly contemporary with the Majiayao culture, the Liangzhu culture also made pottery, but it is better known for its distinctive jade artifacts (**Figs. 8.5** and **8.6**). Whereas clay is soft and malleable before firing, **nephrite** (commonly called jade) ranks among the hardest materials. Because nephrite has a fibrous rather than crystalline structure, it cannot be cut or chipped with a hammer and chisel. Instead, nephrite is worked by grinding. Artists must use drills and abrasives, such as sand with water, to grind jade into desired shapes, just as Mesoamerican cultures in the first millennium CE would do (see for example Fig. 12.3). Nephrite is translucent, and when polished, it produces the effect of depth. Finally, unlike metals, nephrite stays cool to the touch, and the constancy of the material means it does not tarnish over time.

Compared to shaping clay, working jade is a time-consuming and laborious process, and while jade objects are undeniably hard, they are also quite brittle. Archaeological analysis suggests that Liangzhu jades were major status symbols because they accompanied elite burials. The value of this jade disk, called a *bi*, derives in part from the amount of skilled labor required to make it, but also from its visual and physical properties (**Fig. 8.5**). The object takes the form of a perfect circle with a hole in the center. Its rich colors, from deep green and reddish-brown to white, do not correspond to its shape

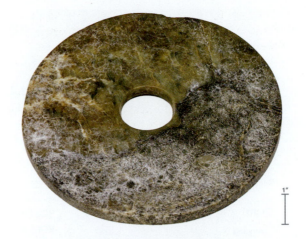

8.5 LEFT *Bi* (disk) (oblique view), Neolithic period, Liangzhu culture, c. 3500–2000 BCE. Jade (nephrite), diameter 8⅜ in. (21.3 cm). Metropolitan Museum of Art, New York.

8.6 BELOW *Cong* (tube), Neolithic period, Liangzhu culture, c. 3500–2000 BCE. Jade (nephrite), height 3½ in. (8.9 cm). Zhejiang Provincial Institute of Cultural Relics and Archaeology, Hangzhou, China.

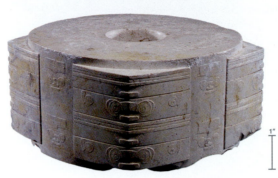

but rather form patterns of their own, according to the varied concentrations of iron in the stone.

LIANGZHU *CONG* Along with *bi*, hollow jade tubes called *cong* have been found in Liangzhu burials. While all *cong* have a square cross-section, their height differs. This example (**Fig. 8.6**) is quite short and at the corners, features a repeated pattern in two primary registers that are each further sub-divided. On the sides of the *cong*, the artist has incised detailed linear images that portray a human-like figure wearing a sizable feathered headdress and seated on a wide-eyed creature. The large eyes also appear on the corners of the *cong*, but in a more simplified form. The meaning of these motifs is not known, but one hypothesis suggests that the figure wearing the headdress may be a spiritual leader or priest.

The names *bi* and *cong* were given to these objects centuries later, when the Zhou cultures (c. 1050–256 BCE) encountered the jade disks and tubes. In written documents, the Zhou associated the perfect circular form of the *bi* with *Tian*, the celestial aspect of the cosmos, or heaven, and they related the squared *cong* to the earth. Their associations may seem plausible, but assumptions made during a later time should be carefully weighed against archaeological evidence.

Shang Culture, c. 1500–c. 1050 BCE

Significant social changes, including population growth, city building, and the development of more hierarchical societies—along with the knowledge of how to mine and smelt copper and tin into bronze—ushered in the Bronze Age in parts of the East Asian mainland by 1700 BCE. Bronze represents a major technological achievement.

zoomorphic having an animal-like form.

representational art that depicts a recognizable subject, such as a person, place, or object.

amphora an ancient pottery vessel with a narrow neck, large oval body, and two handles, used for bulk transportation of foodstuffs, such as wine, olive oil, or olives.

nephrite a hard, fibrous mineral used in the Liangzhu culture for making ritual objects; often called jade.

bi flat, perforated disks made of nephrite created by the Liangzhu culture.

cong hollow, squared tubes made of nephrite found in the Liangzhu region.

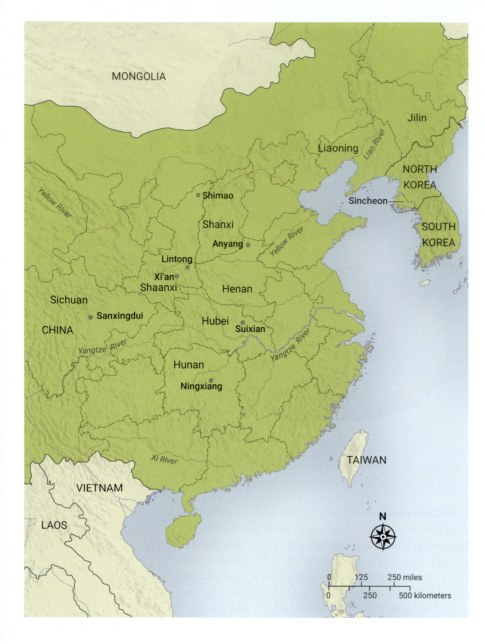

Map 8.2 East Asia archaeological sites, *c.* 1500–206 BCE.

oracle bones turtle plastrons and ox shoulder bones used for divination in the Shang state.

necropolis a large cemetery; from the Greek for "city of the dead."

8.7 FAR RIGHT **Figure of an elephant,** from the tomb of Fu Hao, Anyang, Henan, China, Shang dynasty, *c.* 1200 BCE or slightly earlier. Jade, length 2⅜ in. (6 cm). Institute of Archaeology, Beijing.

Previously, Neolithic cultures developed the knowledge and resources to transform soft clay into useful objects of hard terra-cotta. The Shang state further developed the ability to transform raw copper and tin into bronze objects that were not only hard but also strong. In this regard, bronze was superior to terra-cotta, stone, and copper. Often the term "Shang dynasty" is used interchangeably with "Bronze Age" in China, but equating the two terms suggests an abrupt change at the start of the dynasty (*c.* 1500 BCE) when, in truth, the transition from the Neolithic to the Bronze Age was more gradual.

A recently discovered archaeological site in Shaanxi province, Shimao, provides evidence of the gradual transition from Neolithic to Bronze Age settlements. Dated to about 2000 BCE, the walled site includes such defensive structures as watchtowers and gates, areas of ritual importance, craft workshops, residential zones, and cemeteries. A later and especially important Bronze Age center was located beside the Yellow River in Anyang, capital of the Shang state (*c.* 1500–*c.* 1050 BCE). The Shang people were not alone in mastering bronze technology, however.

As in the case of ceramics, distinctive stylistic traits in Shang period bronze objects suggest the presence of, and contact among, several Bronze Age cultures, including those located to the south in present-day Hunan province and to the west in present-day Sichuan province (**Map 8.2**).

A distinguishing characteristic of Shang culture was the use of bronze for casting ritual vessels: ritual offerings to ancestors were essential for maintaining power and authority (see box: Making It Real: Piece-Mold Bronze Casting, p. 154). Compared to Neolithic cultures, the Shang state commanded significantly more resources. A hierarchical, centralized bureaucracy organized human labor and specialized knowledge to transform raw minerals into gleaming bronze vessels. Whereas making an object from clay or jade required only a few artists, creating a bronze object required dozens, perhaps hundreds of artists and workers. The Shang king's ability to devote so much labor to bronze manufacture came from his political authority, and the resulting vessels were used in rituals that further legitimized his power. His authority was also supported through the use of **oracle bones** consisting of turtle plastrons (the underside of the turtle's shell) and ox shoulder bones, which were used for divination in the Shang state. These bones preserve some of the earliest examples of Chinese writing (see Seeing Connections: Ancient Writing Systems, p. 132). They are evidence of royal attempts to communicate with ancestors in the spiritual realm. Following these communications, the king would offer the appropriate sacrifices to ancestors, who would ensure the dynasty's prosperity by interceding with the gods.

FU HAO'S TOMB

An archaeological discovery that has proven immensely valuable for understanding Shang culture is the tomb of Lady Fu Hao (died *c.* 1200 BCE), consort to the king Wu Ding. Excavated in 1976 in Henan province, near the royal **necropolis** of the Shang, the tomb is much smaller than the king's final resting place, but Fu Hao's tomb had not been disturbed or looted, as other royal Shang tombs had been.

JADE ELEPHANT Over one thousand objects made of bronze, jade, stone, ivory, bone, and ceramics were buried with Fu Hao. Many of these objects had ritual functions, but some were luxury items. Among the latter is an exquisitely made small jade elephant (**Fig. 8.7**). Parts of it have been simplified, including the legs, but sensitive

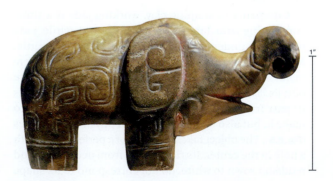

modeling is evident in the contours of the body, mouth, and trunk. Fine lines define the eyes and ears, and a pattern of hooked spirals covers the body. The curl at the end of the trunk cleverly provides a hole that allowed the elephant to be worn as a pendant. The less stylized form, compared to other Shang jade objects, connects it with jade-working traditions from areas outside of Shang culture with which they traded or had other connections. Whether the object was made in those other regions or by Shang artists in the foreign style is unknown.

BRONZE CEREMONIAL AX BLADE In addition to jewelry and luxury goods, Fu Hao had 130 bronze weapons buried with her, including this ceremonial ax blade (**Fig. 8.8**). To be fully operational, Fu Hao's ceremonial blade would have been tied through the rectangular openings to a wood handle. The wood has long since disintegrated, but the blade remains, evidence of the advanced state of bronze technology in the Shang dynasty.

Even though functionality was a major consideration for Fu Hao's ax blade, its visual qualities were not neglected. The ax's symmetry is underscored by the design of two identical mirror-image tigers whose open jaws surround a human head. Although simplified, the head has a naturalistic quality as it emerges from the background. By contrast, the stylized tigers are composed of squared spirals and curlicues locked into a two-dimensional plane. The powerful image of the tigers about to make a meal of the human head aptly captures the ax's potential function as the instrument of ritual decapitation. Besides possibly relating to the ax's use, the design also provides evidence of the circulation of images and ideas around 1200 BCE. As with the jade elephant, visual precedents for the tigers-and-human-face motif are found in artworks from regions south of the Shang state.

Another important feature on this ax is Fu Hao's name, which is cast below the human and animal decoration and attests to her ownership of the weapon (**Fig. 8.8a**). In addition to bronze casting, the Shang dynasty is characterized by another major invention: written language. Writing was closely associated with divination, ritual, and power, and like bronze, it appears to have been reserved for royal use.

BRONZE *FANG DING* There is evidence of both human and animal sacrifice in Shang royal burials, so Fu Hao's ax may have been used in such rituals. But the central ritual of the Shang state involved food offerings to ancestors who, it was believed, could communicate with the gods to benefit the dynasty. The Shang manufactured thousands of bronze vessels in a variety of shapes and sizes for this purpose. This rectangular vessel, or *fang ding*, is one of a pair bearing Fu Hao's name (**Fig. 8.9**). Such ornamented, shiny bronze vessels for food and drink allowed for communion with what the Shang believed to be the spiritual, unseen realm. Moreover, when a single *fang ding*, such as Fu Hao's, was assembled along with dozens, and sometimes hundreds, of other vessel types into a complete set, its visual power would have been substantially magnified.

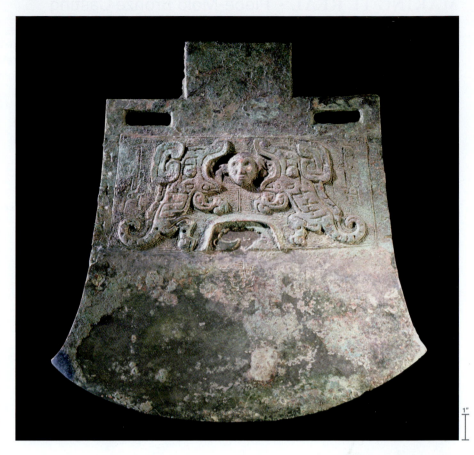

8.8 ABOVE ***Yue* (ceremonial ax),** from the tomb of Fu Hao, Anyang, Henan, China, Shang dynasty, *c.* 1200 BCE. Bronze, 15½ × 15⅛ in. (39.4 × 38.4 cm) Institute of Archaeology, Beijing.

8.8a RIGHT **Drawing of the inscription of Fu Hao's name, cast into the ceremonial ax** (modern drawing).

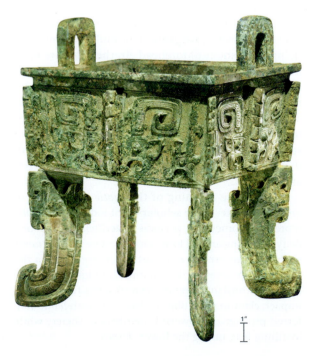

8.9 ***Fang ding* with *taotie* design,** from the tomb of Fu Hao, Anyang, Henan, China, Shang dynasty, *c.* 1200 BCE or slightly earlier. Bronze, height 16⅝ in. (42.2 cm). Institute of Archaeology, Beijing.

One way to make a single bronze object is the lost-wax technique used in ancient Africa (see box: Making It Real: Lost-Wax Casting Techniques for Copper Alloys, p. 62). Shang and Zhou bronzes resulted from a different technique: the piece-mold casting method.

Rituals for feeding the ancestors required many identical vessels organized into sets. For example, Fu Hao's tomb included forty *jue*, spouted vessels for offering drinks. Piece molds allowed for the division of creative labor, and thus they presented

the most efficient means of making not one, but many identical bronze vessels. To make a piece mold for a *fang ding*, a ceramic artist first presses slabs of damp, pliable clay around the exterior of a model (**Fig. 8.10**). Two additional clay mold pieces form the interior cavity and the space within the legs.

Next, the clay mold pieces are baked and fitted together with spacers that allow molten bronze to be poured into the mold. After the metal has cooled, the mold pieces must be broken (and effectively destroyed) in order to release the newly cast bronze object.

The final steps involve finishing and polishing. In the early development of bronze technology, seams in the mold may have allowed extraneous metal to seep out at the corners. In many cases this seepage was cut away, but in other cases the excess bronze inspired further elaboration of protruding flanges (see **Figs. 8.9** and **8.11**).

The flanges extend the vessel beyond its own frame. This dynamic effect would have been heightened by the vessel's reflective surface, but as a result of oxidation many bronzes now have a greenish color and mottled texture called a patina.

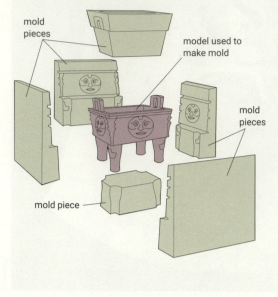

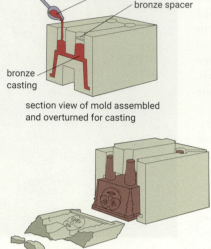

8.10 The piece-mold casting technique.

The *fang ding* and Fu Hao's ceremonial ax share a common visual vocabulary of stylized animals, spirals and hooks, and a preference for symmetry. Similarly to the ax, this vessel shows a penchant for southern styles, evident in the use of flat, zoomorphic legs rather than columnar ones. The composite animal mask on all four sides of the vessel's body, however, is typical of the Shang. The symmetrical mask, called a **taotie** by later conquerors, is organized around a central ridge rising from snout to forehead. To the sides are large horns, eyes like **bosses**, ears, and a curved tooth, or tusk. Sometimes the creature's body is splayed, with right and left halves placed to the sides of the mask, but in this example, smaller animals occupy the spaces toward the corners. Fine, squared spirals crowd the spaces around the *taotie*, creating a dense visual pattern that contrasts with the plain, sturdy quality of the rim and handles.

The precise meaning of the *taotie* is a matter of ongoing debate. Some scholars contend that the *taotie* represents something, perhaps a sacrificial animal or a deity assuming animal form. Others argue that the *taotie* evolved as an ornamental pattern emerging from the relationship between design and technique in bronze casting. A third interpretation emphasizes function and impact, claiming that objects decorated with *taotie* conferred prestige on powerful members of society while instilling fear among the lower classes.

Bronzes from Regions outside the Shang Center, *c.* 1300–*c.* 1050 BCE

Impressive as it was, the Shang was not the only Bronze Age culture on the East Asian mainland. Just as the zoomorphic legs of Fu Hao's rectangular vessel may have drawn inspiration from southern styles typical of bronzes excavated in Hunan province, likewise, southern cultures may have imitated the Shang.

SOUTHERN *FANG DING* The form of this southern *fang ding* (**Fig. 8.11**) is based on Shang precedent, but a human face replaces the *taotie*. The style of the face also rejects the Shang vocabulary of hooks and spirals in favor of a more naturalistic modeling of deep-set eyes, broad nose, curved cheekbones, and fleshy lips. The face, gazing steadily outward from all four sides of the *fang ding*, invites speculation but offers no firm answers as to its identity and purpose. The abstract patterns surrounding the faces, and the flanges projecting from the corners, follow Shang conventions. These features, along with the *fang ding* form, suggest that this southern culture, for which we have no name, may have adopted the same types of ritual food offerings that were central to the Shang.

SANXINGDUI STANDING FIGURE The southern *fang ding* suggests that the Shang shared many cultural elements with other areas, but archaeologists have also

taotie the name given to the composite animal mask frequently found on Shang bronzes.

boss a round, knob-like projection.

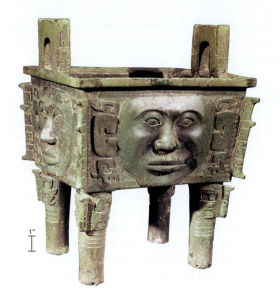

to a previously unknown culture quite unlike the Shang. The most startling discovery was a life-size figure cast in bronze (**Figs. 8.12** and **8.12a**).

Elevated on a base of stylized elephant heads, this figure appears to belong to an otherworldly realm. Its long, arrow-like silhouette draws attention to a face dominated by oversized eyes that suggest acute vision. Enlarged ears and hands also imply superhuman powers. The hat or headdress adds both height and stature, and the figure's dress is finely ornamented, as if it were embroidered. The enormous hands have been abstracted as if stretched in order to form cylinders. Given their slight angle, perhaps they once held one of the many elephant tusks found in the excavated pits. We do not know the figure's identity, but the visual evidence suggests a person of authority. Additional bronze objects from the Sanxingdui site include oversized masks and sculpted human heads with **gilding**.

The pits at Sanxingdui also contained ritual vessels comparable to those of the Shang and the southern regions. Careful archaeological and art-historical analysis suggests that this culture was contemporaneous with the Shang and developed equally advanced bronze technology. Although it certainly had indirect and possibly

uncovered evidence of early cultures in East Asia that made some strikingly different artifacts. In 1986, at a site at Sanxingdui in Sichuan province, some 800 miles west of the Shang realm, archaeologists found sacrificial pits filled with elephant tusks, jades, and bronzes belonging

8.11 FAR LEFT *Fang ding* **with human face,** from Ningxiang, Hunan. *c.* 1200–*c.* 1050 BCE. Bronze, height 15⅛ in. Hunan Museum, Changsha, China.

gilded covered or foiled in gold.

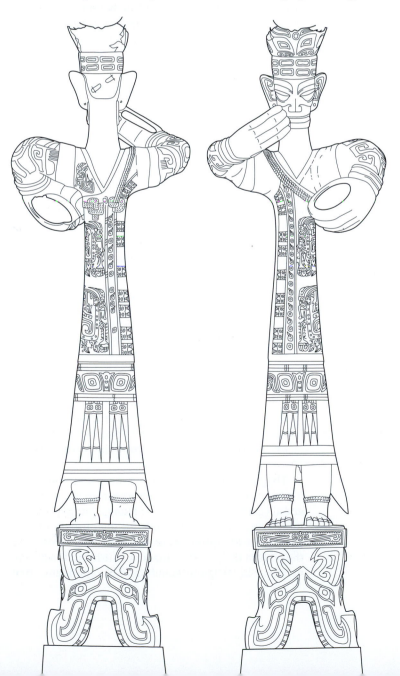

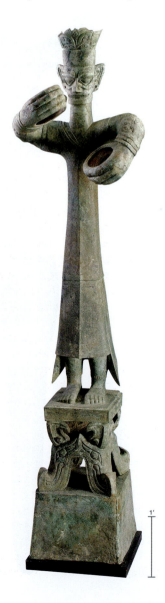

8.12 LEFT **Standing figure,** from Pit 2, Sanxingdui, *c.* 1300–*c.* 1100 BCE. Bronze, height 8 ft. 7 in. (2.62 m). Sanxingdui Museum, Guanghan, Sichuan province, China.

8.12a FAR LEFT **Standing figure, drawing of front and back views,** showing detailed ornamentation.

direct contact with the Shang, its bronze artifacts indicate a markedly different set of religious beliefs and practices.

Variation and Variety in Later Bronzes, c. 1050–256 BCE

The bronzes from Hunan and Sichuan provinces defy the narrative of a single Bronze Age culture in East Asia during the time of the Shang dynasty. Similarly, bronze daggers excavated in Liaoning and Jilin provinces, and the Korean peninsula (see **Map 8.2**) remind us that it is important to recognize the co-existence of diverse cultures and artistic styles in later periods.

LIAONING-TYPE DAGGER This slender bronze dagger (c. 1000–c. 400 BCE) from the Mumun period features a blade with the typical lute-shaped profile of the type known as Liaoning (**Fig. 8.13**). Excavated in Sincheon province in present-day North Korea, the dagger functioned as an object of social prestige in a culture that practiced intensive farming and **megalithic** burials. Bronze objects were comparatively rare, and this dagger is further distinguished by the fine decoration on its

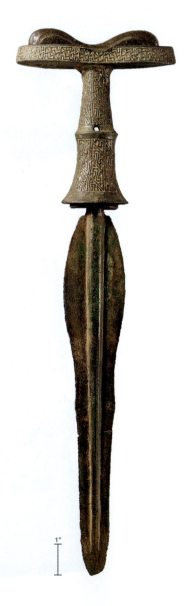

8.13 Liaoning-type dagger,
Mumun period, c. 1000–c. 400 BCE.
Bronze, length 17 in. (43.2 cm).
National Museum of Korea, Seoul.

handle. Close inspection reveals intricate saw-toothed patterns, triangles, and lozenges (diamond shapes) cast in **low relief**.

ZHOU DYNASTY BRONZES

Whereas bronze artifacts were fairly uncommon on the Korean peninsula in these early centuries, they proliferated in regions associated with the Zhou dynasty (c. 1050–256 BCE), established by invaders from the west who conquered the Shang. The Zhou adopted aspects of Shang culture, including writing, ancestor worship, and bronze manufacture. To these, the Zhou added a particular belief concerning political legitimacy, called the mandate of Heaven, which could be won or lost according to the ruler's behavior. Accusing the last Shang king of wickedness, the Zhou conqueror claimed for himself the mandate of Heaven, establishing a new dynasty and putting blood relatives in positions of power throughout Zhou territories in a manner that would now be described as feudal.

XING HOU *GUI* A fairly orderly operation of the feudal system characterized the time when this round food vessel (**Fig. 8.14**), called a *gui*, was cast around 1050–771 BCE. The *gui* has four zoomorphic handles that divide its belly into quadrants. The four large panels of the *gui* feature a fantastic animal with an elephantine head, a body in the form of a spiral, and intimidating quills projecting above the spiral shape. Cicadas fill the narrow spaces underneath the handles. Because the cicada's life cycle includes a period of underground dormancy before re-emergence, this insect suggested to Zhou peoples an extraordinary power: rebirth.

In addition to these zoomorphic designs, this vessel includes a long inscription cast into the bottom of its interior. The inscription gives it a name: the Xing Hou *Gui*, or the *gui* of the Marquis of Xing ("marquis" being a high-ranking position held by descendants of the Duke of Zhou). Further, it provides a great deal of information about its context and function, especially compared to Fu Hao's *fang ding*, which bears only her name (see **Fig. 8.9**). The inscription reads in part (**Fig. 8.14a**):

> ... the king issued his decree to Rong and the Inner Court Scribe announcing, "Assist the Marquis of Xing in his [ritual] observances! I give you three kinds of servants: Zhou people, Dong people, and Yong people." We [Rong and the scribe] cross our hands and lower our heads to praise the Son of Heaven for effecting this favor and blessing.... May Di, the High Ancestor, not end the mandate for the existence of the Zhou. We honor our deceased ancestors ... Using a record of the king's decree we made this vessel for the Duke of Zhou.

The *gui* is a food container, but the inscription makes it a historical document, too. It attests to the gratitude and allegiance of a person named Rong. The king granted Rong several groups of people for the purpose of supporting the Marquis of Xing. In casting this record into the body of the *gui*, Rong made visible his political connections, his religious beliefs, and his confidence that

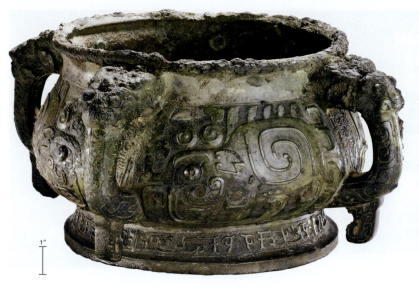

the Zhou continued to possess the mandate of Heaven. For Rong and his contemporaries, the value of this vessel derived from the combination of the symbolic and material properties of bronze, its use in sacrificial rituals to the ancestors, the imagery of powerful creatures that adorn its exterior, and the declaration cast in its interior.

HU WITH PICTORIAL DECORATION Ideally, the dukes, marquises, and other lords would have cooperated with the Zhou king. In reality, however, they competed with him at times such as the later centuries of the Zhou dynasty. In that tumultuous period, political philosophers such as Master Kong (also known by the Latinized name Confucius, 551–479 BCE) sought advisory positions at various courts. By Master Kong's time, the Zhou capital had shifted east, giving rise to the historical divisions now called the Western Zhou (_c._ 1050–771 BCE) and Eastern Zhou (770–256 BCE) periods.

During the increasing political instability of the Eastern Zhou period, a variety of new techniques and forms emerged in bronze manufacture. Lengthy inscriptions offered one means of making a vessel distinctive. Other strategies included unusual shapes and bird-like patterns; the application of elaborate, lost-wax **filigree**; and contrasting **inlays** of semi-precious stones or metal. This wine vessel, called a _hu_, uses inlaid metal to depict human activity (**Fig. 8.15**).

Separated by bands of abstract designs, three wider registers show scenes of women and men. The top register features women in flaring skirts gathering mulberry leaves. These leaves would have fed silkworms, the cocoons of which are the raw material of silk. (Some pieces of silk survive from the Warring States period (_c._ 450–221 BCE), which includes the last portion of the Eastern Zhou dynasty and the decades before the first unification of China under the Qin state.) In lower

filigree a type of decoration, typically on gold or silver, characterized by ornate tracery.

inlay decoration embedded into the surface of a base material.

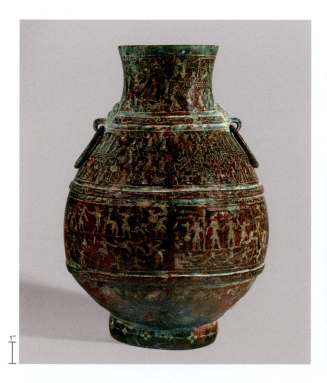

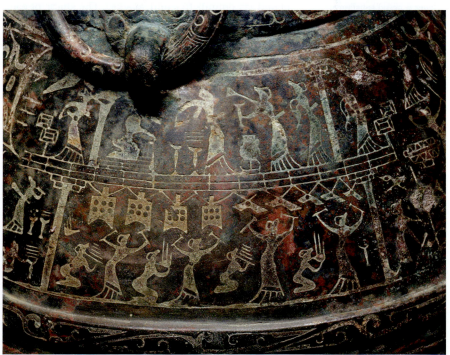

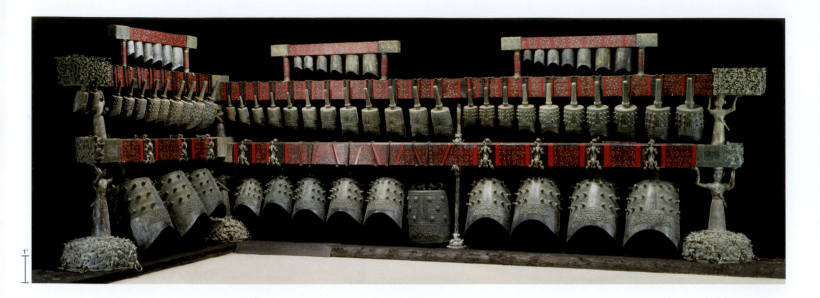

registers, archers take aim at passing birds, men paddle watercraft, and soldiers engage in combat. Like in ancient Egyptian images, human figures are represented in profile, and scenes are stacked atop one another with little attempt to render depth or atmosphere. Instead, the emphasis is on conveying the activities with clarity. For example, in a scene set between columns in the *hu*'s middle register, robed figures extend both arms up toward stone chimes and bronze bells hanging from above (**Fig. 8.15a**, p. 157).

RACKS OF BELLS A complete set of such bells survives in the excavated tomb of the Marquis Yi of Zeng (**Fig. 8.16**). This brightly **lacquered** wood rack, with uprights in the form of sculpted soldiers (see the left and right ends of the racks), supports an array of sixty-five bells. The bells are decorated with multitudes of snake-like forms and prominent **bosses**. To achieve a wide tonal range, the bells come in a variety of sizes weighing between 14 and 175 pounds (6.4 and 79.4 kg). The shape of each bell permits it to sound two different tones, depending on where it is struck. What prompted such expert engineering and prodigious use of bronze for objects other than weapons and ritual vessels? The answer lies in the important role of music. Sacred music, as Master Kong maintained in his writings, was essential for the proper conduct of rituals. Such performances, like the singing of national anthems in public ceremonies today, were intended to create unity and harmony (quite literally) and may have been especially affecting in the Warring States period.

Conquest and the Terra-cotta Army of the First Emperor of Qin

Few places reveal concern for power and immortality more than the tomb of the First Emperor of Qin (**Figs. 8.17** and **8.18**). Sometimes this formidable person is called Qin Shihuangdi, which is not a name, but a title. "Shi" means "first"; "huangdi" means "emperor"; and "Qin" is the name of his dynasty. From their homeland in the western regions, Qin armies conquered rivals eastward

to the sea until they had united all of the warring states in 221 BCE. The resulting Qin empire gives us the source of the name "China."

Along with military might and technological knowhow, the Qin overwhelmed their enemies with superior organization. Rules and standards were established centrally, and lower-level administrators carried them out across the empire. In this way, the Qin standardized writing, weights and measures, and axle widths and roads, making the Qin state far more efficient than its neighbors in communications, trade, and transportation.

TERRA-COTTA ARMY Even while building his empire and standardizing measurements, the First Emperor of Qin began work on his tomb and its extraordinary terra-cotta army. Measuring 1.2 miles (2 km) north–south by 0.6 miles (1 km) east–west, the vast, walled site in present-day Xi'an contains only a single tomb (**Fig. 8.17**). Beneath the burial mound, the tomb has yet to be excavated, owing

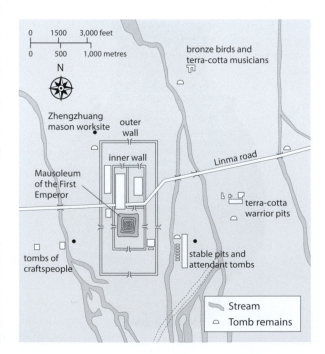

lacquer a liquid substance derived from the sap of the lacquer tree, used to varnish wood and other materials, and producing a shiny, water-resistant coating.

boss a round, knob-like projection.

8.17 FAR RIGHT **Tomb complex of the First Emperor of Qin (plan drawing).**

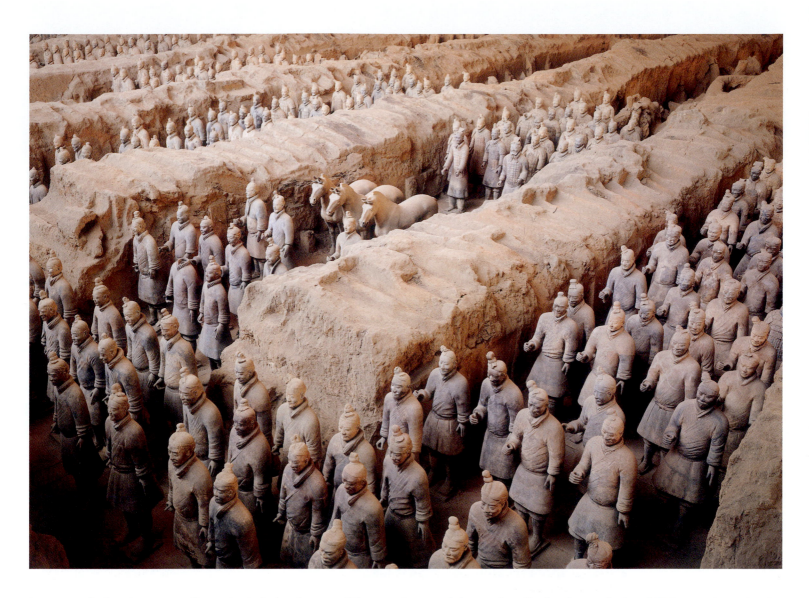

to concern for how to preserve the contents, but archaeologists have opened the underground pits east of the emperor's final resting place. Here, thousands of terra-cotta warriors stand in rank and file, forever facing enemy lines and suggesting how the First Emperor succeeded in uniting so immense a realm (**Fig. 8.18**). Although the terra-cotta army was intended to serve him in the afterlife, it provides evidence of the military power, technology, and bureaucracy that propelled the Qin state to victory during his lifetime.

The manufacture of these life-size sculptures of soldiers and horses, along with the three-quarter-sized, gilt-bronze four-horse chariots, metal weapons, and exquisite bronze birds found elsewhere in the pits, depended on a high level of technology. Qin craftspeople demonstrated mastery of clay and control of kiln conditions well beyond Neolithic capability, but they did not need a deep understanding of human physiology or advanced skills in portraiture. Each terra-cotta soldier looks different from the others, but this does not mean that each was individually conceived. Rather, the soldiers reflect the standardization and division of labor that the First Emperor imposed on his empire, taking the form of limited variations of terra-cotta legs, torsos, arms, hands, heads, hair, and headgear. Some

of these parts or modules, such as the heads, required more artistic skill. Other modules, including the legs, could have been made by low-skilled workers, such as sewer-pipe makers.

The key to assembly and quality control was a system of work units and managers, whose names are marked on the sculptures. These are not signatures that memorialize the artist; rather, they function as signs of accountability. The modular approach to manufacturing made possible the sheer quantity of soldiers, which number over seven thousand. Just as importantly, modular manufacturing generates both efficiency and variation. On the basis of just a few different body parts, the terra-cotta army mimics the individuality within conformity that characterizes real armies.

Wearing armor over a short-skirted robe, the life-sized cavalryman at the beginning of this chapter stands at complete attention (see p. 147). His hair is neatly gathered beneath a cap that is tied under his chin. His facial expression is alert and serious. His eyebrows and eyes are simplified. Showing none of the exaggeration of the standing figure from Sanxingdui (see **Fig. 8.12**), the style here may be described as naturalistic, and had the original paint been preserved, this terra-cotta cavalryman's resemblance to a real soldier would have been even more

8.18 Army, tomb complex of the First Emperor of Qin, Pit 2, c. 210 BCE. Terra-cotta, life-size. Lintong, Shaanxi province, China.

pronounced. The cavalryman leads a fit and well-groomed horse that is saddled and ready for battle. The attention given to replicating such military gear as the cavalryman's uniform is also visible in other terra-cotta army soldiers, who brandished real weapons of war.

The First Emperor's tomb and his terra-cotta army offer direct insight into the Qin dynasty, but we can also see them as artifacts emerging from early East Asian cultures. Recall, for example, the different uses of clay in Jeulmun, Jōmon, and Majiayao cultures for making terra-cotta vessels and figural sculptures. Early ceramic technology also undergirds the manufacture of bronzes. From Neolithic times through the Qin dynasty, finely crafted objects continuously conferred prestige on persons with high status, and belief in the afterlife drove the living to bury their dead with grave goods. Writing played a role, if not always prominently, in artifacts as a means of communicating with gods, of binding sociopolitical relationships, or of ensuring quality in manufacture.

In other ways, however, the Qin dynasty repudiated earlier cultures. Even as the Qin state standardized writing as a means to promote effective communication, it destroyed masses of written knowledge as a way to limit and control thinking. The First Emperor decreed that private copies of certain books and histories of defeated rivals be handed over for destruction. *The Records of the Grand Historian*, dated to the Han dynasty, described the destruction as "burning of the books."

The philosophy of Master Kong, with its interest in promoting harmony in human relationships, was of little use to Qin empire-building. Rejecting Confucianism, the First Emperor turned to a system of rewards and punishments known as Legalism in order to complete his conquests, but his brutality was met—unsurprisingly—with rebellion. The Qin dynasty lasted only four years beyond the First Emperor's death. The Han dynasty that followed would establish a more stable empire, but even more enduring was its promotion of Confucianism, which would sweep through East Asia and beyond.

Discussion Questions

1. Select one work from this chapter that depicts a human body either accurately or purposefully distorted. Which features of the body are emphasized? What artistic strategies are used, and why?

2. Choose an artwork made of clay, jade, or bronze and explain how the physical and visual properties of the medium are related to the resulting artwork.

3. How does context (such as a work excavated from a tomb) help us understand the meaning and significance of artworks? Draw on examples from this chapter in your answer.

4. Select an artwork or two from this chapter to explain the artistic strategies used to communicate power.

Further Reading

- Barnes, Gina L. *Archaeology of East Asia: The Rise of Civilization in China, Korea and Japan.* Havertown, PA: Oxbow Books, 2015.
- Ledderose, Lothar. *Ten Thousand Things: Module and Mass Production in Chinese Art.* Washington, D.C.: Trustees of the National Gallery of Art, 2000.
- Nelson, Sarah M. *The Archaeology of Korea.* Cambridge: Cambridge University Press, 1993.
- Underhill, Anne P. (ed.) *A Companion to Chinese Archaeology.* Chichester, UK: Wiley Blackwell, 2013.

Chronology

	CHINA		
		221 BCE	The first Emperor in Qin unifies China
c. 3500–*c.* 2000 BCE	The Liangzhu culture makes jade artifacts	**221–206 BCE**	The Qin dynasty; the tomb of the First Emperor and his terra-cotta army are built
c. 3300–*c.* 2000 BCE	The Majiayao culture makes painted ceramics		
c. 1500–*c.* 1050 BCE	Shang royalty cast ritual bronzes		**KOREA**
c. 1200 BCE	The earliest known writing in East Asia is made on bronze vessels and oracle bones	*c.* 7000–*c.* 1500 BCE	The Jeulmun culture makes comb-patterned ceramics
		c. 1500–*c.* 300 BCE	The Mumun culture
c. 1200 BCE	The Tomb of Lady Fu Hao of the Shang dynasty is filled with objects of bronze, jade, ivory, stone, bone, and ceramic	*c.* 1000–*c.* 400 BCE	Liaoning-type daggers are cast
			JAPAN
c. 1100–*c.* 1000 BCE	The Sanxingdui culture casts the standing figure and other bronzes	*c.* 13,000–*c.* 400 BCE	Jōmon cultures make cord-marked terra-cotta vessels
c. 1050–*c.* 771 BCE	The Western Zhou period; the Xing Hou *Gui* and other bronze vessels are cast	*c.* 3500–*c.* 2500 BCE	The Middle Jōmon period; "flame" vessels are made
c. 770–256 BCE	The Eastern Zhou period, including the Warring States period, *c.* 450–221 BCE	*c.* 1200–*c.* 400 BCE	The Final Jōmon period; many *dogū* date to this period

9

Cycladic and Minoan Art

3000–1200 BCE

Toreador fresco (detail), from palace at Knossos, Crete.

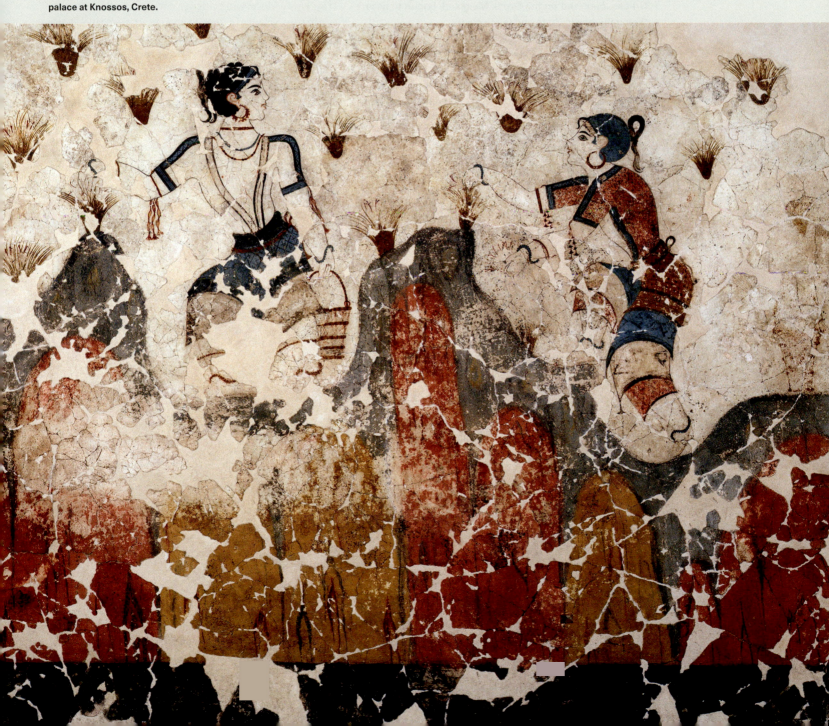

Introduction

The Aegean Sea is a region of the Mediterranean that lies between Greece and Turkey. During the third millennium BCE, this region gave rise to the Cycladic and Minoan cultures, centered on the Cycladic Islands and Crete respectively. This period is called the Early Bronze Age, reflecting the fact that stone and copper tools were replaced by those made from bronze, which is a mixture of copper and tin. While the Cycladic and Minoan people developed distinct cultures, art, and architecture, from an early date they also interacted with one another, as well as with other cultures of the Eastern Mediterranean, for example, through trade in raw materials and finished products. This highlights the importance of seafaring in these island communities. During the Middle and Late Bronze Ages (c. 2000–1180 BCE), monumental court-centered buildings, often called palaces, developed as economic and ritual centers on the island of Crete. Minoan culture began to exert a strong influence on Cycladic towns, such as the harbor town of Akrotiri on Santorini (ancient Thera)—at least until c. 1450 BCE, when the Mycenaean Greeks, centered on the Greek Mainland, began to assert their influence in Crete and the Cyclades.

Cycladic art and archaeological remains provide evidence for the importance of seafaring, ritual practices, and the human body in these island communities, as well as for a widespread prestige culture. The best-known Cycladic artifacts are abstract marble statuettes of humans; however, an overall lack of information regarding the find spots of most statuettes currently located in museums and private collections often makes their interpretation quite speculative. Likewise, in Crete we see the development of social distinctions that culminate in the Minoan palaces, but early archaeological studies that described the Minoans as the "first European civilization" affected some of the subsequent interpretations—and misinterpretations—of their art and architecture.

The Cyclades in the Early Bronze Age, c. 3000–2000 BCE

The Cycladic culture is named after a group of islands that form a rough circle, or *kyklos* in Greek, around the island of Delos (**Map 9.1**). However, the influence of Cycladic culture extended beyond the Cycladic Islands, or Cyclades. Objects that share features with Cycladic **material culture** have been recorded in the Dodecanese, in the Sporades, on Crete, on the Greek mainland, and even at sites in Anatolia (present-day Turkey), such as Troy. This widespread evidence dates to the Early Bronze Age in the Cyclades (*c.* 3000 to 2000 BCE), also called Early Cycladic when referring to this culture.

The geography of the Cyclades facilitated seafaring and connections among those living in regions across the Aegean Sea. Before the advent of sails, the use of oared boats limited the distance seafarers could travel. The Cyclades acted as stepping-stones, providing resting

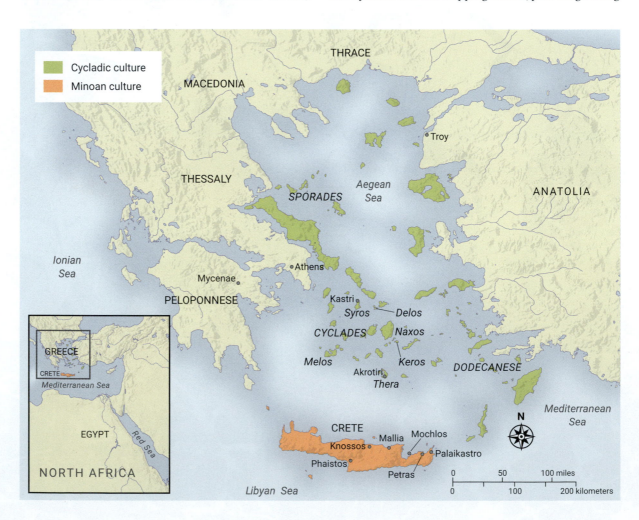

Map 9.1 Minoan and Cycladic cultures in the Bronze Age.

points across the sea and enabling travel and trade over longer distances. Though the land was not very fertile for farming, the islands provided other important resources, such as obsidian, lead, silver, copper, and marble. Most of our knowledge of Cycladic society comes from its art, architecture, and other material remains, because it left behind no writing.

EARLY CYCLADIC SETTLEMENTS Fortifications with towers are a fairly common feature of settlements in the Early Cycladic period, suggesting that enemy raids were a real concern in these small island communities. Most settlements were small hamlets or farmsteads that were home either to a single family or to several families living close together. The fortified settlement of Kastri on the island of Syros (**Fig. 9.1**), along with the cemetery of Chalandriani, forms part of a relatively large complex. A thick, double fortification wall with rounded towers protected the seemingly haphazardly arranged houses of the village. Early Cycladic cemeteries were usually located close to settlements and included groups of shallow, stone-lined pits (cist graves). This kind of burial pit was usually topped with stone slabs, but those at Chalandriani have **corbeled roofs**.

Cycladic graves and the objects found inside them seem to emphasize individual identity and personal achievements. These objects indicate the wealth and status of the people buried there. The simplest graves included ceramic vessels made of **coarseware**, millstones for grinding food, and other tools, such as simple obsidian blades. Wealthier burials included marble vessels and figurines, as well as tools, weapons, vessels, or jewelry made of copper, bronze, silver, or gold. Cycladic culture's emphasis on seafaring is apparent in finds such as the so-called "frying pans" from the cemetery of Chalandriani.

CYCLADIC TERRA-COTTA "FRYING PAN" Called frying pans because of their distinctive shape, these oval **terra-cotta** objects feature intricate **incised** designs on one side and a raised edge on the other. This example (**Fig. 9.2**) is incised on the flat side with an oared longboat that has a fish on the prow. Set in a sea of running spirals, probably representing the Aegean Sea, the longboat is placed above a triangular area. Unlike simpler canoes, longboats could hold large crews of about twenty-five people, and may have been used either for war or for ceremonies. Thus, representations of longboats could symbolize social power while underscoring the importance of seafaring to Cycladic society.

As is the case with many artifacts from the Early Cycladic period, the functions of the "frying pans" are unknown. Despite their modern name, they were probably not used as pans: There is no evidence of burning, and their elaborate incised or stamped decoration would have been completely obscured if they were laid flat for cooking. Some scholars have interpreted the oval shape, with its incised spiral design above a triangular area resembling female genitalia, as a schematic rendering of a woman's pubic area and therefore a symbol of fertility. More practically, given its raised edges, it may have been

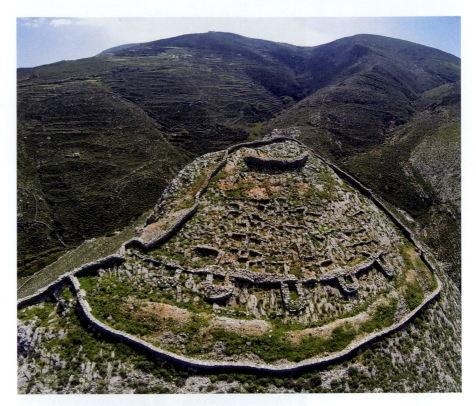

9.1 ABOVE **Aerial view of the Early Cycladic settlement of Kastri,** Syros, Greece, c. 2500 BCE.

9.2 LEFT **"Frying pan"** from Chalandriani, Syros, Greece, Early Cycladic, c. 2500–2200 BCE. Terra-cotta, diameter 11 in. (27.9 cm). National Archaeological Museum, Athens.

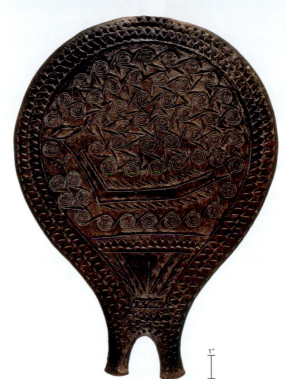

1"

used as a makeup palette (see the Narmer Palette from Egypt, Fig. 4.3) or, if polished or filled with water, as an early type of mirror.

CYCLADIC MARBLE FIGURES The most famous artifacts from the Early Cycladic period are marble sculptures of human figures carved using tools of flint, obsidian, copper, or bone. Emery, a dark granular rock available locally on the island of Naxos, was used to polish the marble and aid in cutting it. Because the majority of

material culture the materials, objects, and technologies that accompany everyday life.

corbeled roof a roof made of stone slabs that progressively overlap to create a dome, topped with a capstone.

coarseware a type of thick, gritty pottery used for everyday purposes.

terra-cotta baked clay; also known as earthenware.

incised cut or engraved.

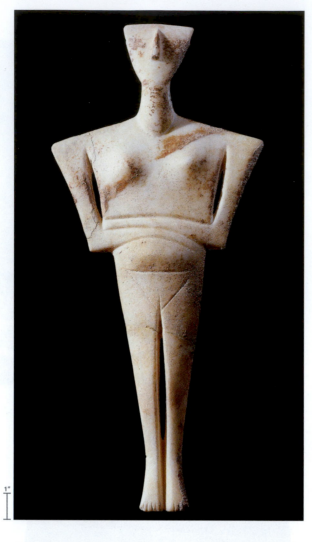

9.3 Figure of a woman, from a grave on Syros, Greece, Early Cycladic, *c.* 2600–2300 BCE. Marble, height 18 in. (45.7 cm). National Archaeological Museum, Athens.

diadem a crown or ornamented headband worn as a sign of status.

iconography images or symbols used to convey specific meanings in an artwork.

9.4 FAR RIGHT **Harp player,** Keros, Greece, Early Cycladic, *c.* 2600–2300 BCE. Marble, height 9 in. (22.9 cm). National Archaeological Museum, Athens.

to be displayed lying down or carried. Their function may have changed over time, as suggested by the fact that although most were discovered in burials, some were found in settlement or ritual contexts. The sculptures range in size from a few inches to approximately five feet high, but most are around 12 inches.

HARP-PLAYER FIGURE Some Early Cycladic marble figures are statues of men wearing belts and daggers or playing musical instruments. The harpist shown here (**Fig. 9.4**) is from the island of Keros. Though his hands and the lower portions of his arms are missing, it appears that he is playing the duck- or swan-bill harp resting on his lap. His head is raised, perhaps to suggest singing. Unlike the abstract marble figures of women discussed above, the form of the musician's body shows much more movement, with open space between the legs and arms. Approximately a dozen harpist statues exist, though not all were discovered during controlled excavations (that is, official excavations that are systematically conducted and carefully documented), leading to heated debate regarding their authenticity. The authenticity of numerous folded-arm figurines is also questioned (see box: Art Historical Thinking: Forgeries and the Art Market).

In the absence of written texts, additional excavated examples, or **iconography** representing the use of these statues, the meanings of Cycladic figures remain open to interpretation. However, enough Cycladic statues have been carefully excavated to allow scholars to speculate

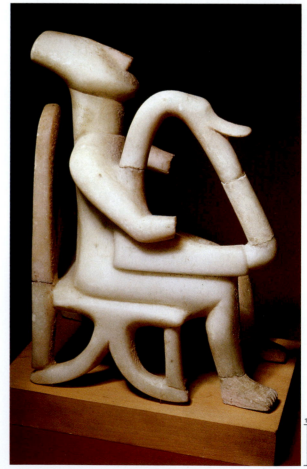

these figures have their arms folded across the body, they are sometimes called folded-arm figurines (**Fig. 9.3**). They are naked, and most appear to be women, with an incised pubic area and in some cases with breasts and/or a swollen abdomen, perhaps indicating pregnancy. The most commonly carved facial feature is the nose, but some sculptures bear remnants of paint suggesting eyes, eyebrows, and hair. Paint was also used to create decorative patterns, such as red stripes or dots, on the cheeks, chin, and forehead. One scholar has interpreted these decorations as representing lacerations from scratching oneself in mourning—though whether Cycladic people actually scratched themselves or performed a symbolic gesture is not known. Painted zigzags and eye-like shapes appear on the body of certain figures. Other painted adornments include necklaces, bracelets, and **diadems**.

The marble sculptures are fairly abstract and often emphasize geometric forms. This is particularly obvious in the lower part of the body and the head, which can be triangular or oval, and is often tilted back. Some art historians have argued that several of these figures employ a system of proportion, as in contemporaneous Egyptian art or in later Greek art. The knees are usually bent and the toes point downward, making it impossible for the figures to stand on their own, although museums often display them in a standing position. This could indicate the function of the sculptures, which were likely intended

The simple, formal qualities of the Cycladic statues in their current state, with most painted ornamentation erased by time, appealed greatly to early twentieth-century European artists, museums, and collectors. As the statues became more popular, demand skyrocketed. Unfortunately, much of this demand was filled by forgeries or illicit excavations that destroyed the finds' contexts, which could have provided invaluable information about their dates and meanings. Because there is no reliable technique for dating the production of these statues, which are relatively easy to carve, museums and private collections are now filled with so-called Cycladic figures that lack a sound archaeological provenience (the find spot or context of an archaeological artifact). It has been suggested that approximately 90 percent of known sculptures identified as Cycladic lack archaeological provenience, making it difficult to specify the meanings of these intriguing Bronze Age artifacts. They have been variously identified as representations of the deceased or of their consorts, mourners, fertility figures, or cult statues (statues of a deity that served as focal points for worship) such as a mother goddess.

The discovery of the so-called Minoan Snake Goddesses at Knossos on Crete (see **Fig. 9.11**, p. 169) also stimulated enough demand in the art world to lead to the production of forgeries. Numerous works in major museums and private collections have been revealed as fakes based on their production techniques (the forgeries are made of a single piece of ivory rather than smaller pieces connected together) and their style and iconography (including mistakes in the figures' garments). More possible forgeries exist. The Museum of Fine Arts, Boston identifies this snake goddess (**Fig. 9.5**) in its collection as either from the Minoan Bronze Age or the early twentieth century, and discusses its lack of provenance (ownership history) on its website.

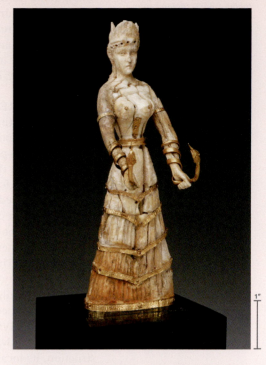

9.5 **Snake goddess statuette**, c. 1600–1500 BCE or early twentieth century forgery of a Minoan Bronze Age type of statuette. Gold and ivory, height 6 in. (15.2 cm). Museum of Fine Arts, Boston.

Discussion Questions

1. What role has the art market played in encouraging the production of forgeries? How have forgeries placed limits on our understanding of ancient societies?
2. How do you think museums, like the Museum of Fine Arts, Boston, should handle questionable objects in their collections?

on their possible uses. For example, though most come from tombs, others have been found in settlements, so their function was likely not exclusively funerary. This argument is strengthened by the fact that some statues show evidence of repair before being deposited in tombs, suggesting that they were used and valued in everyday life. The Keros Hoard, discovered at the Kavos site on the island of Keros, contained hundreds that appear to have been intentionally broken, suggesting ritual use. Some scholars have focused on the paint remnants on these figures, suggesting that paint may have been removed and reapplied numerous times during the life of a sculpture, perhaps indicating that they played a role during rites of passage, such as birth, puberty or coming of age, marriage, and death. The remains of paint on Cycladic statues, as well as the presence of other grave goods, such as vessels that once contained pigment and copper pins or needles, suggest traditions of painting or tattooing the body during life.

Given that statues from controlled excavations were found in only one-tenth of Cycladic tombs, it is clear that they, along with other rare objects, such as frying pans, marble and metal vessels, and gold or silver jewelry, were limited to men and women of a higher status. Drinking and pouring vessels, some of which have parallels beyond the Cyclades, suggest that social or ritual consumption also played a role in negotiating social positioning within Early Cycladic communities. All of this taken together suggests the existence of clear social distinctions and a geographically widespread prestige culture at the time.

Crete in the Bronze Age: Myth and Reality, c. 3000–1180 BCE

Located almost equidistant from the continents of Europe, Asia, and Africa, the island of Crete has functioned as a crossroads throughout history. Its strategic location and abundant agricultural land were probably responsible for its importance in the prehistoric Bronze Age. The British archaeologist Sir Arthur Evans (1851–1941) named the population that flourished on Crete during the Bronze Age "Minoan" after Minos, a legendary king believed to have ruled at Knossos, the largest and perhaps most powerful city of Minoan Crete. According to later Greek mythology, Knossos contained a labyrinth in which the Minotaur was imprisoned. The Minotaur—half bull, half man—was the son of Minos's wife and a white bull sent by the sea god Poseidon. Each year King Minos ordered Athens to send a tribute of fourteen young men and women to be devoured by the Minotaur, which was finally killed by the Greek hero Theseus with the help of Minos's daughter Ariadne. According to the myth, she provided him with thread that allowed him to find his way out of the labyrinth after slaying the monster.

The earliest known figural depictions in Crete, and in fact in all of Greece, which are petroglyphs of an extinct dwarf deer on a cave wall, have now been dated to over 11,000 years ago, during the Upper Paleolithic period in Crete. However, it was not until the Neolithic period, around 7000–3000 BCE, that more permanent settlement occurred on the island, probably as a result of a wave of

tholos (plural **tholoi**) a round, vaulted building, often a tomb, shaped like a beehive.

vault an arched structure, usually made of stone, concrete, or brick, that often forms a ceiling.

faience a glassy substance that is formed and fired like ceramic, made by combining crushed quartz, sandstone, or sand with natron or plant ash.

repoussé a relief design created by hammering malleable metal from the reverse side (not the side to be viewed).

ashlar a stone wall masonry technique using finely cut square blocks laid in precise rows, with or without mortar.

lintel a horizontal support above a door or other opening.

immigration from Anatolia. The number of settlements then increased dramatically in the Early Bronze Age. Evidence that Crete came into contact with West Asia (see Chapter 3) and Egypt (see Chapter 4) during the Early Bronze Age includes imported raw materials, such as gold and ivory, in Minoan tombs.

CRETE BEFORE THE PALACES

The Minoan culture of around 3000–2000 BCE is sometimes called Prepalatial because it preceded the period when the famous palaces of Crete were built. In the fertile Mesara plain in the south–central part of the island, tombs took the form of **tholoi**, some with impressive stone **vaults**. Used over several generations, they were large enough for communal burials. At the Prepalatial cemetery at Mochlos, located on a small island off the coast of northeastern Crete, communal rectangular tombs were the norm. These were known as house tombs due to their similarity to house architecture, and probably belonged to family groups. During the Bronze Age, the island was attached to Crete by a narrow strip of land, or isthmus. Tomb IV/V/VI is one of those perhaps reserved for an elite family, owing to its size and elaborate construction, its location on a promontory with views of Crete, and its paved court and open-air altar in front of the tomb.

GOLD DIADEM FROM A MINOAN TOMB The vast number of prestige items—including exotic imports, such as gold, ivory, silver, and **faience**—found in Tomb IV/V/VI suggests that the tomb belonged to high-ranking individuals whose status may have been based on political power, religious authority, or both. Along with new kinds of ceramic vessels probably used for feasting, the prestige items suggest social distinctions in Crete in the period leading up to the construction of the court-centered palaces in the early Middle Bronze Age.

Some of the prestige items from Mochlos show clear signs of wear and even repair during their owners' lifetimes before being deposited in the tombs. This gold diadem (**Fig. 9.6**), discovered among a hoard of jewelry found in a silver vessel associated with Tomb IV/V/VI, would have been made by hammering gold into a flat sheet, cutting the gold to the desired shape, and then decorating it with dot **repoussé**. However, the diadem found in the tomb has had a piece cut away at the bottom. According to one archaeologist, this may suggest that the family thought it excessively wasteful to deposit so much gold in the tomb. The antennae attachments, although reattached in the image here, were removed and then buried with the rest of the object. These acts would make no sense if the diadem had been made exclusively for funerary use.

PALATIAL PERIOD CRETE

The early Middle Bronze Age in Crete (c. 1900–1700 BCE) is also known as the Protopalatial or Old Palace period. At this time, those in authority began to communicate their status and power through permanent, monumental, court-centered buildings, such as at Knossos, Phaistos, Mallia, and Petras. Although these structures are commonly called palaces, the term is somewhat misleading because there is no proof that rulers or leaders lived in them. Rather, they appear to have functioned as important economic, political, religious, or ideological bases that formed the center of rule. By the Protopalatial period, Crete was involved in long-distance trade throughout the Aegean and Eastern Mediterranean. For example, Middle Bronze Age Cretan Kamares pottery has been discovered as far away as Egypt and Syria.

KAMARES EGGSHELL WARE CUP Kamares ware, named for the cave sanctuary on Mount Ida where it was first discovered, is a type of painted pottery often associated with Crete's palace culture that flourished during the Protopalatial period. The pots are made of fine clay turned on a potter's wheel, and many have very thin, eggshell-like walls (**Fig. 9.7**). The geometric and floral decorations are painted either in white or in shades of red, yellow, or orange on a black background.

THE PALACE OF KNOSSOS Most of what is left of the Cretan palaces dates to the Neopalatial, or New Palace, period (c. 1700–1450 BCE), after a terrible earthquake destroyed much of the earlier structures. The largest, oldest, and most famous of the palaces was at Knossos (**Figs. 9.8** and **9.9**), located near the north-central coast of Crete. This large palace includes a wide central courtyard,

9.6 BELOW **Diadem with antennae**, from Tomb IV/V/VI, Mochlos, Crete, Greece, Prepalatial period, c. 2300 BCE. Gold, height 6 in. Agios Nikolaos Museum, Crete.

9.7 BELOW RIGHT **Kamares eggshell ware cup**, from Phaistos, Crete, Greece, Middle Bronze Age, c. 1800 BCE. Terra-cotta. Heraklion Archaeological Museum, Crete.

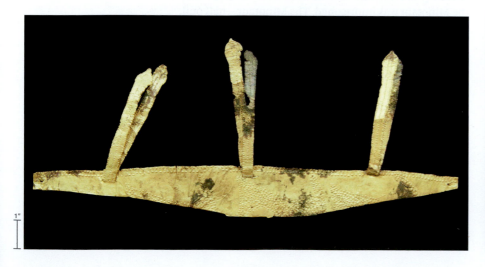

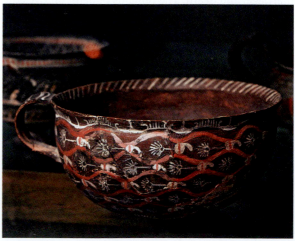

ample storage facilities, innovative architectural features, and an extensive decorative program. Knossos was first settled in the Neolithic period, and the earliest court-centered building at the site probably dates to the late Early Bronze Age. The antiquity of the site, and perhaps its early identification as an important cosmological center, may have contributed to its later position of power in the Neopalatial period. The palace's clear orientation toward Mount Juktas, with its major peak sanctuary (mountain-top shrine), speaks to the religious relevance of Knossos. Other Cretan palaces were also oriented toward mountains with religious sanctuaries.

What remains today of the palace of Knossos represents only the lower levels of the Neopalatial structure, though with heavy reconstruction in concrete dating to the early twentieth century CE. To view or walk through the remains is to experience the building's imposing scale and its great importance to Minoan society.

The monumental west facade was constructed with **ashlar** blocks. In front of the facade was the West Court, a large paved courtyard, where crowds gathered. Raised walkways led to the palace's west entrance, a wide door with a column supporting a substantial **lintel**. This entrance led to the Procession Corridor, a long hallway painted with a procession of life-size individuals moving south into the palace, and then turning east toward the Monumental Doorway that led to a stairway to the upstairs rooms on the west side of the palace. There was another entrance on the palace's north side. In front of the north entrance was a small, paved court, called the theatral area, with rising stone steps or seats, perhaps to hold spectators. Near the north entrance was a pillared hall that probably served both as a kitchen and as support for a large room upstairs, possibly a dining room. After entering, visitors could walk up a ramp to

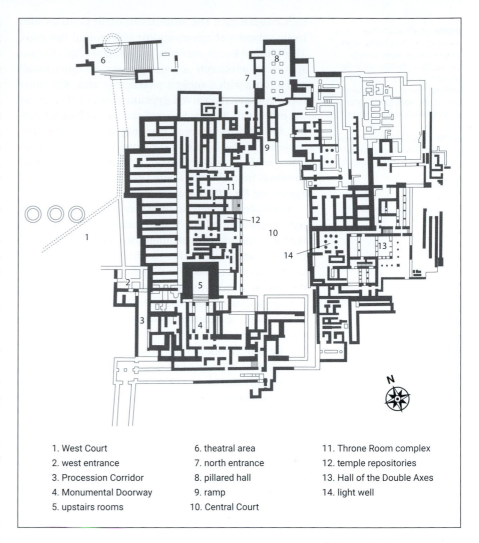

1. West Court
2. west entrance
3. Procession Corridor
4. Monumental Doorway
5. upstairs rooms
6. theatral area
7. north entrance
8. pillared hall
9. ramp
10. Central Court
11. Throne Room complex
12. temple repositories
13. Hall of the Double Axes
14. light well

9.8 ABOVE **The palace at Knossos, Crete (plan drawing).**

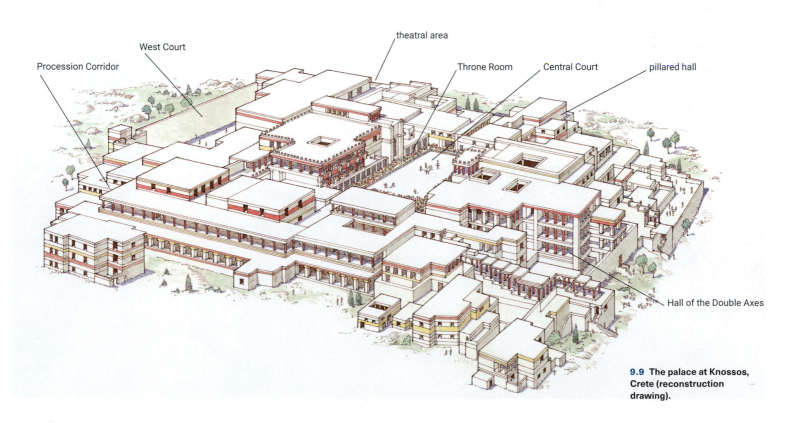

9.9 The palace at Knossos, Crete (reconstruction drawing).

the Central Court. The western side of the Central Court likely served a religious and/or ceremonial function. The Throne Room complex included several distinct spaces: an anteroom or waiting room, an inner room, and a room with a sunken rectangular area. The inner room contained a carved gypsum chair, or throne, on the north wall. That wall shows remains of **fresco** painting, including evidence of what might be a **griffin**. The presence of this fantastical creature indicated the high status of the person seated on the throne, as in the wall paintings from Akrotiri, where a griffin attends the seated figure (see **Fig. 9.18**, p. 174).

Connected by steps to the Throne Room is a sunken rectangular area called a lustral basin. A variety of potential functions have been attributed to these sunken spaces, ranging from secular bathing to ritual activity. Contextual analysis of these spaces and their associated finds and decoration suggests that they did indeed have some ritual use. Regardless of who sat on the throne, the small size of the rooms indicates that whatever rituals took place there were limited to a few high-status individuals.

The eastern side of the Knossos palace featured a set of halls, which Sir Arthur Evans thought were domestic quarters divided by sex. There is no evidence to support Evans's theory, however, and archaeologists do not know exactly how these halls were used. On the east side are

pier-and-door partitions, a signature feature of Minoan halls, that allow the space to be opened up or closed off in order to control movement, vision, light, and air. The larger Hall of the Double Axes, named for the incised mason's marks found on some of the hall's stone blocks, consists of three rooms arranged east to west. A **colonnaded** terrace runs along the hall's east and south sides. The interior's center room has two columns on the west side that lead to a light well, which is a small rectangular room open to the sky to let in light and air. Light wells often were built near staircases, as in **Fig. 9.10**. The original columns were made of wood and did not survive; the columns shown in the photograph are reconstructed. Minoan columns tapered at the bottom, so the reconstruction is accurate in this regard.

SNAKE GODDESS In a small room not far from the Throne Room on the western side of the palace, rectangular boxes were cut into the floor. These repositories were carefully and ceremonially filled with offerings, including broken and incomplete figurines, plaques, pottery, and seashells, some of which were painted. It is unclear whether the figurines were broken in a ritual ceremony or by accident, perhaps during an earthquake.

Among the offerings are the remains of two faience figurines known popularly as snake goddesses. Both are

9.10 Light well in the palace at Knossos, Crete, Greece.

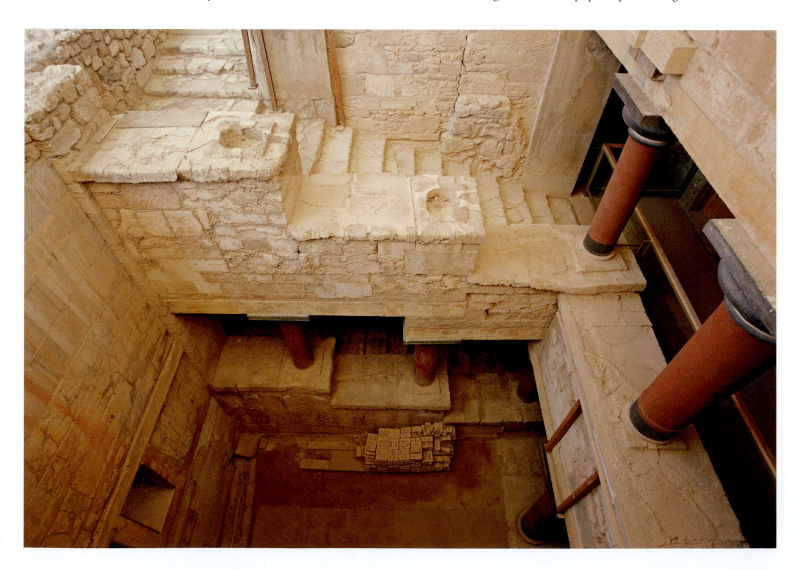

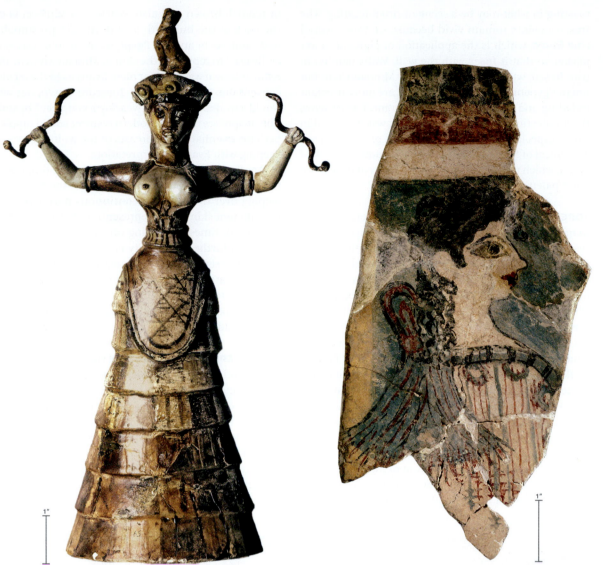

9.11 FAR LEFT **Snake goddess**, from the palace at Knossos, Crete, Greece, *c.* 1600 BCE. Faience, height approx. 11½ in. (30 cm). Heraklion Archaeological Museum, Crete, Greece.

9.12 LEFT **Woman or priestess (known as "*La Parisienne*")** from the Camp Stool fresco in the palace at Knossos, Crete, Greece, *c.* 1350 BCE. Fresco, height approx. 8 in. (20.3 cm). Heraklion Archaeological Museum, Crete, Greece.

about a foot tall and wear an elaborate floor-length skirt with an apron and an open bodice. The woman in **Fig. 9.11** has outstretched arms and a snake in each hand. The head is a modern restoration to which the headdress is joined, but it is unclear why a seated cat was restored on top of her head. She wears a flounced skirt, which some have associated with parts of West Asia, such as Syria and Mesopotamia. This connection is not surprising, given Crete's interactions with West Asia at this time. Such elaborate costumes were common among high-status people in the Neopalatial period, as seen in its frescoes. Though the two faience figures' exact meaning and function are unknown, some scholars have suggested that they represent either goddesses or priestesses. Their elaborate costumes, their association with snakes—perhaps protectors of the domestic realm—their imported medium taken up by Cretan artists, and their careful ceremonial placement in an area of the palace associated with ritual, certainly support this interpretation.

FRESCO OF WOMAN FROM KNOSSOS ("*LA PARISIENNE*")

Sir Arthur Evans, who began excavations at Knossos around the turn of the twentieth century, saw Minoan Crete as the first European civilization. This view colored some interpretations of art and artifacts from the site, such as this fresco representing a red-lipped woman with an elaborate hairstyle, who was nicknamed *La Parisienne* (**Fig. 9.12**) because of her similar appearance to cultured Parisian women in the early twentieth century. Such titles captured the imagination and made the Minoans more relatable to the Europeans of Evans's time. The woman represented is perhaps a priestess or a goddess who wears the sacred knot tied to the back of her dress. The knot is a loop of cloth at the back of the neck with another piece of cloth tied around it, leaving fabric running down the back. Representations of women wearing the sacred knot are rare, but examples of the knots themselves are found painted in frescoes and on pottery, carved in seals and from ivory, and made in faience.

La Parisienne is part of a larger work, the Camp Stool fresco, that fell from an upper story of the western part of the palace of Knossos. This fresco, which dates to the later period of the palace, around 1350 BCE, depicts two **registers** of pairs of men and women (*La Parisienne* is one of the women). Some figures sit on seats resembling camping stools. Others stand, holding vessels and

register a horizontal section of a work, usually in a clearly defined band or line.

continuous narrative multiple events combined within a single pictorial frame.

toasting in what may be a scene of ritual feasting. The fresco's colors remain vivid because Cretans favored true fresco, which is the application of pigment to wet plaster so that it fuses with the wall. Walls painted in true fresco, which were common in Minoan Crete but not in Egypt or West Asia at this time, are more resistant to fading and are therefore more vibrant. Fresco *secco*, the application of paint to dry plaster, was also used in Crete, especially for details. The colors of *La Parisienne* are typical of Minoan wall painting, including its lack of green, which makes only rare appearances in the Cretan paint palette.

TOREADOR FRESCO, KNOSSOS Frescoes were found on many walls throughout the palace: in hallways, possible residential areas, and rooms associated with ritual or administration. The fragments of the famed Toreador or Bull-leaping fresco (**Fig. 9.13**) were found in the north half of the east wing, having fallen from an upper story. The extant pieces suggest that several panels made up the original work, but only this scene could be restored with any level of detail, and there are still questions concerning its restoration. While it is the most famous work of art from Knossos, and perhaps even from all of Crete, it is generally believed to date to the period after the Mycenaean Greeks arrived in Crete around 1450 BCE (see Chapter 10). There are, however, earlier depictions of bull sports in other media.

The fresco shows two white figures wearing protective codpieces. One figure is in front of the bull, holding onto its horns, and the other at its rear, with arms outstretched toward the animal. A third figure, painted in reddish-brown and also wearing a codpiece, is on the back of the bull with legs in the air, presumably mid-vault. As in ancient Egypt, a cream color was generally used to represent the skin of Minoan women, and reddish-brown was used for men. Evans used these color conventions to interpret the Toreador fresco, but why would a woman have been wearing a codpiece? In addition, it appears that the modern restorer added nipples, perhaps to enhance the breasts of the white figures, in keeping with Evans's interpretation.

Another interpretation suggests that the differences in skin color indicate a single figure in the process of leaping over the bull in a **continuous narrative**, with the different skin colors representing that single figure at different times: beginning vault, mid-vault, and dismount. A further possibility is that the different skin colors represent different life stages of males, the lighter color indicating those who have not yet undergone rites of passage to become adults. In this interpretation, bull sports are part of the initiation process, and so the darker figure would be successfully undergoing a rite of passage.

CHRYSELEPHANTINE STATUETTE OF A MAN Discoveries made in other parts of the island continue to expand our understanding of Minoan society, including religion. A truly exceptional work of art—for its materials, naturalism, fine detail, and likely function—is the almost 20-inch-tall statuette of a male figure from the Minoan town of Palaikastro in eastern Crete (**Fig. 9.14**). Its body is made from eight sections of hippopotamus ivory, which was imported from Egypt or Syria, joined together with dowels made of olive wood. Gold foil covers part of the

9.13 Toreador fresco from the palace at Knossos, Crete, Greece, *c.* 1400 BCE. Heraklion Archaeological Museum, Crete.

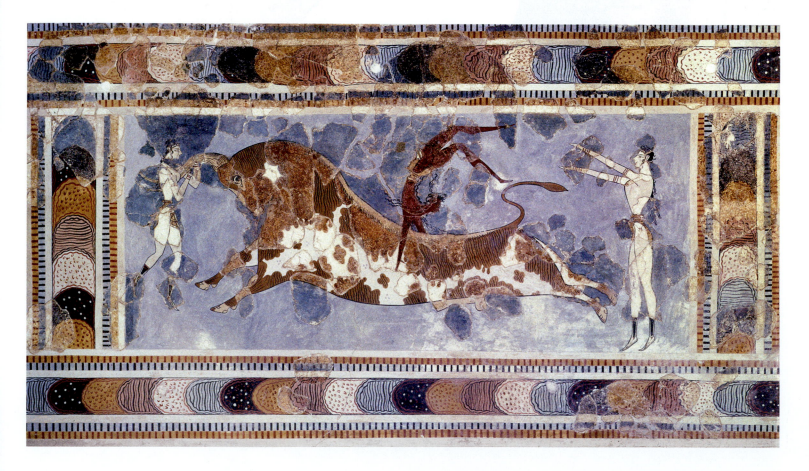

statuette's feet, arms, and the now mostly missing kilt. The hair is skillfully carved in a bluish-black serpentine stone to represent what appears to be a shaved scalp with a mohawk hairstyle. The eyes are made of rock crystal. The figure stands with his arms to his chest, a gesture also found in terra-cotta statuettes from a nearby peak sanctuary. His left foot is striding forward, as in Egyptian sculptures (such as Fig. 4.16) and later Greek sculptures of *kouroi* (male youths) from the Archaic period (see Fig. 13.11). Though the sculpture was badly damaged by fire, we can still see the fine naturalistic carving in the figure's hands and feet, where the tendons and veins are clearly visible and convincingly rendered.

This Minoan statuette is an early example of a **chryselephantine** sculpture. This technique was used later in Greece for cult statues (see Fig. 13.8), such as the monumental figures of two major Greek gods, Athena Parthenos in the Parthenon and Zeus in his temple at Olympia. The statuette appears to have been intentionally defaced and broken into pieces that were then scattered over a wide area before the building was intentionally set on fire in *c.* 1450 BCE. This idealized figure may have been a god, perhaps a predecessor to Zeus, who was later worshiped in a nearby sanctuary. The building in which some parts of the statuette were found may have served as a shrine for the god. The circumstances of the statuette's destruction may also indicate its symbolic value. Throughout time, works of art with religious meaning have fallen victim to destruction by enemies, generally on ideological grounds, indicating such objects' symbolic power.

MARINE-STYLE OCTOPUS FLASK Also discovered at Palaikastro was a Marine-Style octopus flask (**Fig. 9.15**). It represents one of the new forms of pottery introduced during the Neopalatial period: the stirrup jar, so called because of the small handles that look like stirrups. The Marine Style reversed the color scheme of the earlier Kamares ware by applying dark colors on a light background. The most popular decorative features in the Marine Style are based on the sea, which is not surprising

kouros (plural *kouroi*) a freestanding Archaic Greek sculpture of a naked young man.

chryselephantine made of gold and ivory; from the Greek words for "gold" and "elephant."

9.14 FAR LEFT **Statuette of a male figure**, from Palaikastro, Crete, Greece, *c.* 1500–1475 BCE. Ivory, gold, serpentine, rock crystal, and wood, height 19½ in. (24.1 cm). Siteia Archaeological Museum, Crete, Greece.

9.15 BELOW **Marine Style octopus flask** from Palaikastro, Crete, Greece, Neopalatial period, *c.* 1500–1450 BCE. Ceramic, height 11 in. (28 cm). Heraklion Archaeological Museum, Crete, Greece.

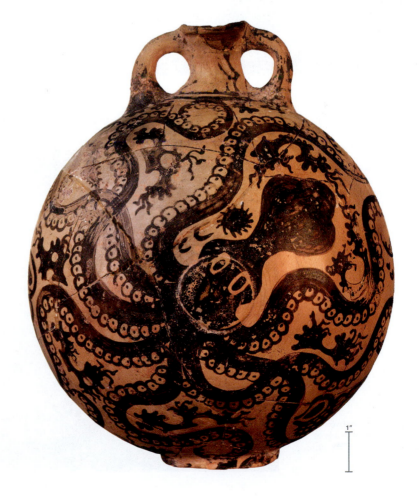

given the importance of seafaring in the region. In this case, nearly the whole surface of the pot is covered by a painted octopus. The octopus is well suited to the form of the jar, which bulges in the center and then narrows at the upper and lower ends, toward which the tentacles reach. It gives the impression that the octopus is moving on the jar, as though it really were swimming in the Aegean Sea.

Minoan Influence beyond Crete

One of the most extraordinary archaeological discoveries from the Bronze Age period in the Aegean took place on the island of Thera (present-day Santorini), the southernmost island in the Cyclades, approximately 60 miles (96.5 km) north of Crete. Shortly after excavations began in 1967, the site of Akrotiri—whose ancient name is unknown—was found under several meters of pumice and ash, the result of a cataclysmic volcanic eruption that occurred around 1600–1550 BCE. The inhabitants of this harbor town appear to have escaped the eruption, and much of their settlement was so well preserved under the ash that Akrotiri is sometimes called a "Bronze Age Pompeii," after the ancient Roman city that was similarly preserved (see Chapter 18). Walking along the streets of

Akrotiri today is almost like stepping back 3,500 years in time. Houses preserved up to, and sometimes even beyond, two stories line paved streets enhanced by a drainage system. The wall paintings inside the buildings are also remarkably well preserved, though painstaking restoration and conservation work is ongoing.

Early in its history, Akrotiri appears to have been within the Cycladic cultural sphere. In the later Bronze Age, however, Minoan Crete began to exert influence over Akrotiri's material culture, including pottery, dress, and architecture that includes pier-and-door partitions and lustral basins. The style, subject matter, technique, and palette of Akrotiri's frescoes are also reminiscent of those from Crete. While the exact nature of the contact between Crete and Akrotiri may never be known, including whether Crete's influence was also political, it is clear that they were closely connected.

FLOTILLA FRESCO FROM AKROTIRI Subjects highlighted in Akrotiri's frescoes include scenes of ritual and social ceremony, often set in vibrant local land- and seascapes. They feature the type of movement that is typical of Minoan painting (see the Toreador fresco, **Fig. 9.13**). The Flotilla fresco (**Fig. 9.16**), found at the top of the south wall

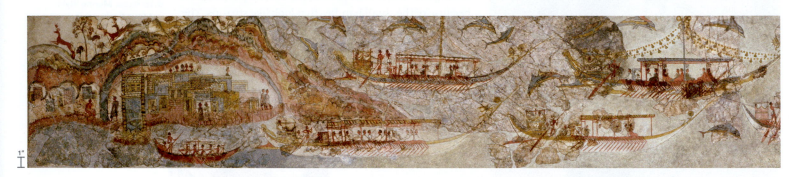

9.16 ABOVE **Flotilla fresco,** Room 5, West House, Akrotiri, Thera (Santorini, Greece), New Palace period, c. 1600 BCE. Fresco, approx. height 14 in. (35.5 cm). National Archaeological Museum, Athens.

9.16a RIGHT **Flotilla fresco (detail),** showing the town's residents watching the ships.

granulation a decorative technique in which beads of precious metal are fused onto a metal surface.

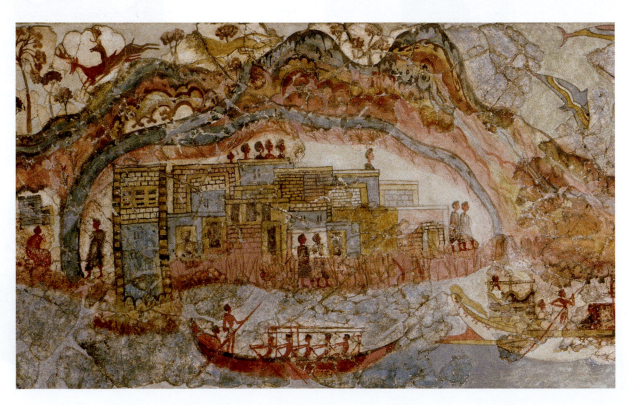

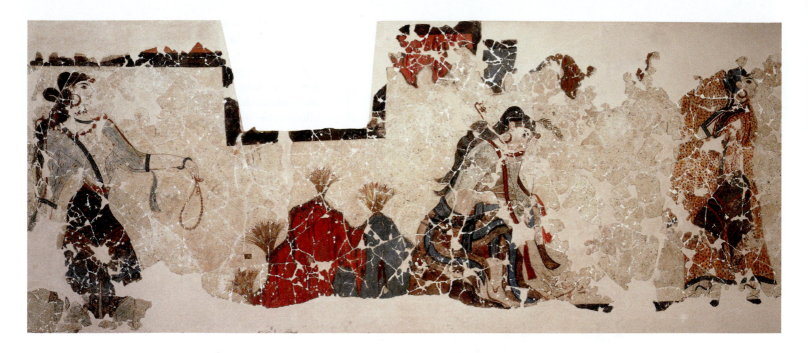

of the West House, probably depicts a town on Thera, and its subject matter makes clear the importance of seafaring to this island community. The registers of colors that encircle the seaside town in the fresco are not unlike the layers of rock left visible by an earlier volcanic eruption, which visitors can see when entering the port of Thera today. The town's residents, many in Minoan-style dress, watch festivities on the sea that feature frolicking dolphins and several oared ships with sails lowered, perhaps participating in an annual festival to kick off the sailing season. Outside of the town, animals are depicted, both predators and prey. The animals run at full gallop in a manner typical of Cretan art. The landscape also depicts a variety of vegetation, making the absence of green in the artist's palette notable, and further linking this fresco to those from Crete. One scholar has suggested that green was avoided by Cretan artists because of an association with the decay of bronze, which is interesting given that in other societies, such as in Egypt, green is associated with fertility and life.

FRESCO OF THREE WOMEN FROM AKROTIRI Frescoes highlighting ritual activity are also found in House Xeste 3 (as it was named by archaeologists) in Akrotiri. The house was divided into two parts: one area for service activities and the other for rituals, perhaps female initiation or puberty rituals. The ground floor includes spaces divided by pier-and-door partitions, one with a sunken lustral basin. As in Crete, the pier-and-door partitions allowed manipulation of movement and views into the rooms. If the partitions were opened to the area with the lustral basin, the viewer or participant would see a fresco of three women at different life stages on the back wall above it (**Fig. 9.17**).

In the center is a young girl seated on a rock, holding a bleeding foot with one hand and her head with the other, apparently in pain. She wears an elaborate skirt and a hoop earring, which appears to be **granulated**. She has a full head of hair, into which a blue scarf is entwined.

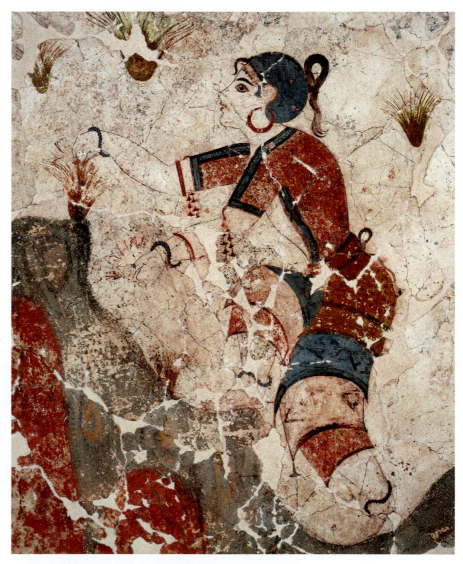

9.17 TOP **Fresco from House Xeste 3**, Akrotiri, Thera (Santorini, Greece), *c.* 1600 BCE.

9.17a ABOVE **Fresco detail,** from House Xeste 3 showing a woman gathering saffron.

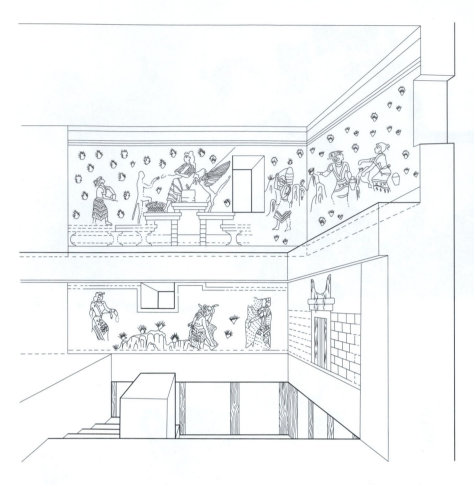

9.18 Frescoes from House Xeste 3 (reconstruction drawing), Akrotiri, Thera (Santorini, Greece), c. 1600 BCE.

alludes to their religious nature—dripping blood, on the next wall (**Fig. 9.18**). The scene can be interpreted as illustrating stages in a rite of passage. The figure on the far right may be a prepubescent girl, who is learning for the first time about the blood associated with menstruation and childbirth. The bleeding foot of the seated girl may allude to her first menstruation. Crocuses are depicted in the landscape; these may have been used as a painkiller for menstrual cramps. On the upper floor of the same house is a scene of girls picking saffron from the crocus flowers (see **Fig. 9.17a**) and bringing them to a goddess or priestess who is heavily adorned with jewelry and seated on a throne, with a winged griffin standing behind her and a blue monkey in front of her.

MINOAN-STYLE WALL PAINTINGS IN AVARIS, EGYPT

Some see Crete's influence in the Cyclades as evidence of what the fifth-century BCE Greek historian Thucydides called a Minoan thalassocracy, or a supremacy based on maritime power:

> Minos, according to tradition, was the first person to organize a navy. He controlled the greater part of what is now called the Hellenic Sea; he ruled over the Cyclades, in most of which he founded the first colonies, putting his sons in as governors after having driven out the Carians. And it is reasonable to suppose that he did his best to put down piracy in order to secure his own revenues.

There is no evidence of a shaved scalp (which would indicate youth, and is usually represented by blue paint). An olive branch placed in her hair hangs over her forehead, and an iris pin adorns the back of her hair. Behind her, an adult woman in a flounced skirt with an open bodice carries a necklace, presumably as an offering to the young girl, or to be placed in the lustral basin.

To the far right of this wall is an even younger girl. Her youth is indicated by the fact that her head is almost fully shaved, with the exception of a forelock and a ponytail. She is covered by a translucent veil and looks away from the girl on the rock toward an altar, with horns of consecration—a term coined by archaeologists that

The naval empire described by Thucydides seems more like that of his native Athens, but Crete certainly had great cultural influence in the Aegean Islands, beyond Thera, during the Neopalatial period. Frescoes in Minoan style and with similar iconography have been discovered, mostly in palatial contexts, at Miletus on the coast of modern Turkey, at Alalakh in Syria, at Tel Kabri in Israel, and at Avaris in the Nile Delta in Egypt. Avaris was the former capital of the Hyksos, an Eastern Mediterranean people who settled in the Egyptian Delta. The Hyksos ruled part of Egypt as the Fifteenth Dynasty between 1650 and 1550 BCE.

Chronology

c. 3000–2000 BCE	The Early Bronze Age in the Aegean (Early Cycladic; Early Minoan)	*c.* 1600 BCE	The flotilla fresco is painted at Akrotiri, Thera
c. 3000–2000 BCE	Cycladic figures are sculpted from marble	*c.* 1600–1550 BCE	The volcanic eruption of Thera
c. 3000–1900 BCE	The Prepalatial period on Crete	*c.* 1600–1180 BCE	The Late Bronze Age in the Aegean (Late Cycladic/Late Minoan)
c. 2000–1600 BCE	The Middle Bronze Age in the Aegean (Middle Cycladic; Middle Minoan)	*c.* 1500–1450 BCE	The Marine-Style octopus flask is made at Palaikastro, Crete
c. 1900–1700 BCE	The Protopalatial or Old Palace period on Crete	*c.* 1450 BCE	The destruction of Minoan sites; Mycenaean presence on Crete
c. 1700 BCE	Old palaces are destroyed by earthquake	*c.* 1400 BCE	The Toreador fresco is painted at Knossos
c. 1700–1450 BCE	The Minoan Neopalatial or New Palace period	*c.* 1350 BCE	The Camp Stool fresco is painted at Knossos

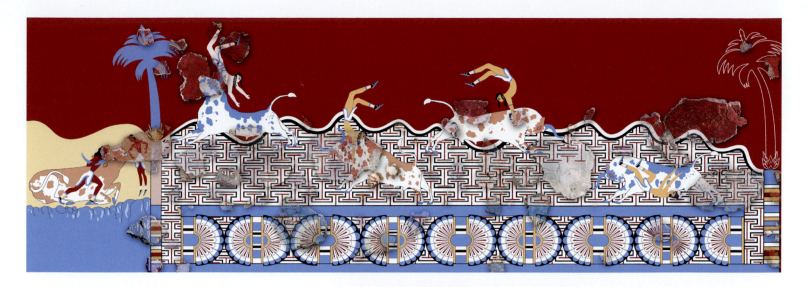

BULL-LEAPING FRESCO FROM AVARIS Fresco fragments portraying bull-leaping scenes on a labyrinthine background (**Fig. 9.19**), reminiscent of Knossos, were found in Avaris, but not in their original location, having been removed from the palace walls. In addition to the subject matter, clear parallels with Minoan art include the use of the true fresco technique, the color palette (which, unlike most Egyptian wall paintings of the era, excludes green), and the overall style. The most romantic idea about how these frescoes came to Egypt suggests that a Minoan princess was married off to an Egyptian king to form a diplomatic or political alliance. It may be, however, that Minoan artists were sent to decorate the Avaris palace walls as a gift once the style became well known and desirable at the courts of many rulers at the time (see: Seeing Connections: The Art of Trade and Diplomacy in the Bronze Age, p. 96). Such diplomatic and mercantile connections across the Mediterranean and beyond continue into the subsequent Mycenaean period, as seen in the next chapter.

9.19 TOP **Bull-leaping fresco, (reconstruction)** from Late Minoan IA, *c.* 1550 BCE. Avaris (Tell el-Dab'a, Egypt).

9.19a RIGHT **Detail of bull-leaping fresco.**

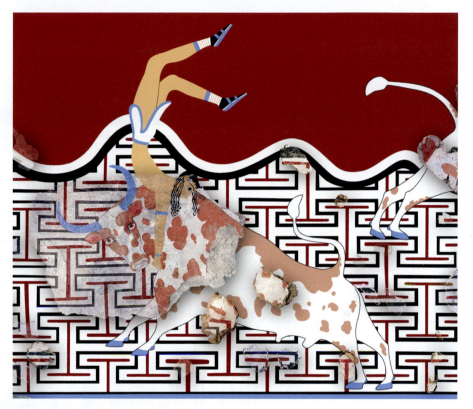

Discussion Questions

1. Choose three examples of art from Crete and/or Thera and discuss the social and ritual activities they may illustrate. What do their content and context tell us about Minoan society?

2. Compare and contrast the Toreador fresco from Knossos on Crete with the Bull-leaping fresco discovered at Avaris in terms of style, subject matter, technique, and context. What are some possible explanations for the similarities?

3. In 1970 the United Nations Educational, Scientific, and Cultural Organization (UNESCO) adopted the Convention on the Means of Prohibiting and Preventing the Illicit Import, Export, and Transfer of Ownership of Cultural Property. What impact do you think this had on the market in antiquities for both private collectors and museums?

4. Describe three examples of evidence for contacts between Crete and West Asia and/or Egypt during the Bronze Age. What is the potential significance of these contacts?

Further Reading

- Betancourt, Philip P. *Introduction to Aegean Art*. Philadelphia, PA: INSTAP Academic Press, 2007.

- Doumas, Christos. *The Wall-Paintings of Thera*. Athens: Thera Foundation, 1992.

- Hoffman, Gail L. "Painted Ladies: Early Cycladic II Mourning Figures?" *American Journal of Archaeology* 106, no. 4 (October 2002): 525–50.

- Knappett, Carl. *Aegean Bronze Age Art: Meaning in the Making*. Cambridge: Cambridge University Press (2020).

10

Mycenaean and Iron Age Greek Art

1700–600 BCE

Geometric krater (detail),
Athens, Greece.

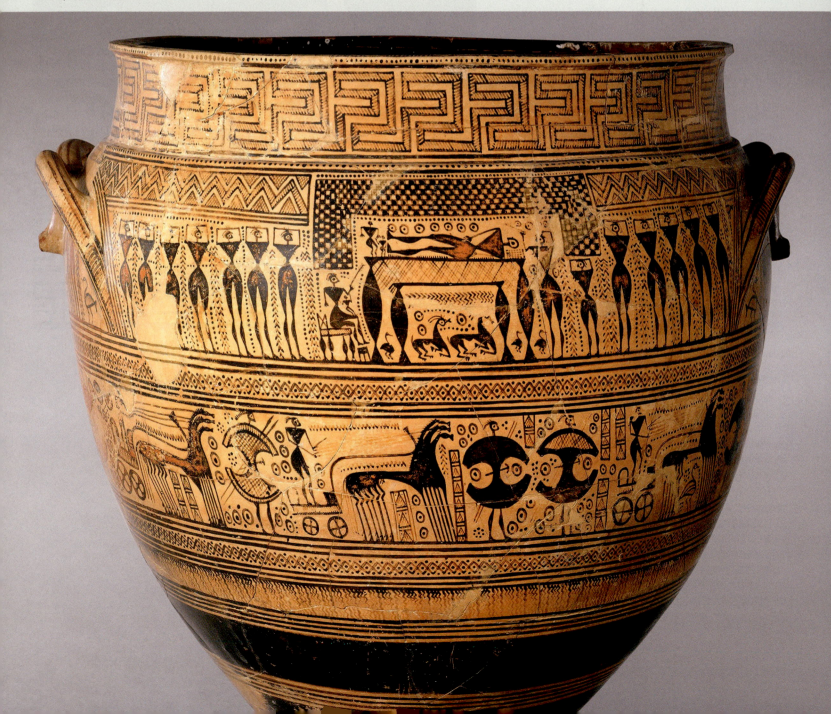

Introduction

The Mycenaean Greeks, whose society was based on the Greek mainland, wielded increasing cultural and political influence throughout the Aegean and Eastern Mediterranean region in the Late Bronze Age (Map 10.1). The poet Homer memorialized Mycenaean culture (c. 1700–1180 BCE) in two epic poems, *The Iliad* and *The Odyssey*. *The Iliad* describes the legendary Trojan War and may in fact be based on a real historical conflict between Greece and Troy, a city in Anatolia (present-day Turkey). *The Odyssey* focuses on the adventures of Odysseus, king of the Greek island of Ithaca, as he journeys home after the fall of Troy.

The evolution of Mycenaean society can be seen at the sites of Mycenae and Pylos. Virtually intact graves from the early Mycenaean period provide evidence for the emergence of an elite warrior class and a society that was in close contact not only with Minoan Crete (see Chapter 9), but also with Egypt, Mesopotamia, Asia Minor (Anatolia), Italy, and the eastern Mediterranean. Funerary rituals, including elaborate grave goods and feasts, demonstrate Mycenaean social hierarchies, wealth, and access to art, culture, and other resources from distant lands. The developmental stages of Mycenae's defensive walls, along with the architecture and art of the Mycenaean palaces, provide evidence of increasing power among the elite and the rising tensions in the region.

The Early Iron Age (c. 1100–900 BCE), which followed the collapse of the Bronze Age, is often called a Dark Age.

While it is true that literacy temporarily disappeared around 1000 BCE, archaeological explorations have revealed monumental architecture and evidence of long-distance trade and economic prosperity in some communities. The subsequent Geometric period (c. 900–700 BCE) saw an explosion of activity, including the establishment of the city-state, or *polis*; the evolution of panhellenic sanctuaries (panhellenic means "of all the Greeks"); the development of the Greek alphabet; the founding of colonies abroad; and the recording of Homer's epic poems in written form. Some scholars see the Geometric style of art as resulting from a desire for order after the collapse of Bronze Age society. The following Protoarchaic period (c. 700–600 BCE) gave rise to an artistic style influenced by West Asia. This influence resulted from the establishment of Greek colonies abroad and the arrival of traveling artists from West Asia during its period of Assyrian rule (see Chapter 5).

Mycenaean Art, *c.* 1700–1180 BCE

Mycenaean culture was named by modern scholars for Mycenae, the palatial citadel of the legendary king Agamemnon who, according to Homer, commanded the Greek army in the battle against Troy. The citadel is strategically located on a rocky outcrop in the Peloponnese peninsula (see Map 10.1) above the fertile plain of the Argolid. It is protected by steep slopes on the south and

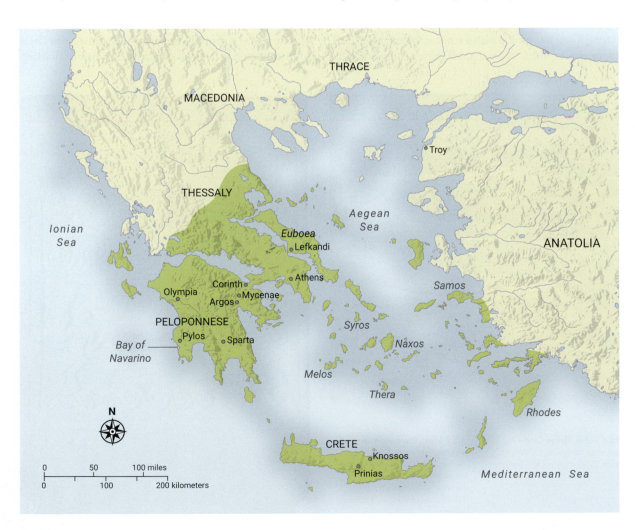

Map 10.1 Mycenaean Greece, 1700–1180 BCE.

north sides, and it commands views over the plain and toward the nearby Aegean Sea.

In 1876, Heinrich Schliemann, a businessman and avid reader of the Greek epics who had previously excavated at Troy, came to Mycenae in search of Agamemnon's palace and tomb. He was attempting to prove the truth of the Homeric epics. The excavations by him and later archaeologists have brought to light some art and artifacts that intriguingly parallel Homer's later description of this world, such as actual military helmets made of boars' tusks. Much of the picture painted by the Homeric epics, however, also reflects the post-Mycenaean world of Homer. The Mycenaean language—the earliest form of Greek recorded, *c.* 1450 BCE—was written in a script called Linear B by archaeologists because it developed from Linear A, which was used to write the decidedly non-Greek Minoan language (see Chapter 9). A great deal of our knowledge about Mycenaean society comes from clay tablets inscribed with Linear B. Though these tablets are mainly administrative documents, they also shed light on religion and politics. Study of the Linear B documents, in tandem with artistic and archaeological remains, provides an intriguing picture of the Mycenaean world.

THE SHAFT GRAVES AND EARLY MYCENEAN ART

Early Mycenaean settlements were not well preserved, because they were often built over during later periods. However, we can learn a great deal about the early Mycenaean period from its burials, specifically cist tombs (stone-lined pits roofed with a stone slab) and more elaborate shaft graves. Typical shaft graves include a deep rectangular shaft leading down to a burial enclosure lined with stone or wood. Each shaft grave received more than one burial over time, including men, women, and children, suggesting that family groups were buried together.

GRAVE CIRCLE A AT MYCENAE Two important early burial sites from Mycenae, predating the city's impressive fortification walls, are Grave Circles A and B. Although Grave Circle B is older, they do overlap in time and therefore could represent two families conspicuously and competitively displaying their wealth. The larger and more richly appointed tombs were found in Grave Circle A (around the sixteenth century BCE), which consisted of six shaft graves (**Fig. 10.1**). After the deceased was placed in one of the tombs, along with elaborate offerings, the burial enclosure was roofed with wood or stone, and the shaft was filled in with earth. Evidence of feasting was found in the soil used to fill the shaft, suggesting that elaborate funerary rituals probably served religious and, perhaps, political functions by establishing or reinforcing social distinctions.

GRAVE STELE Steles carved in **low relief** stood above some of the shaft graves in Grave Circles A and B. These are the earliest large-scale relief sculptures on the Greek mainland. Some of the steles associated with Grave Circle A include depictions of chariots and animals. In this example (**Fig. 10.2**), the upper **register** is carved with running spirals, which are typical of Minoan, Cycladic, and Mycenean art. The bottom register has similar spirals, but the action surrounds a chariot and a driver, one hand on his spear, rushing toward another figure holding

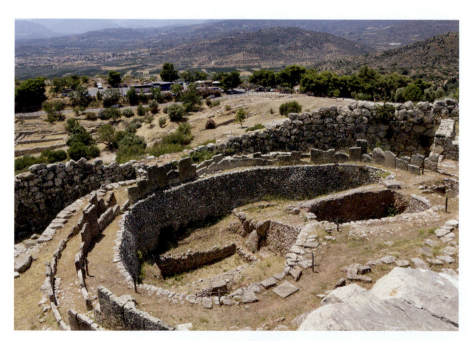

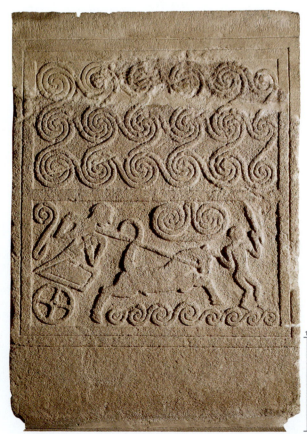

10.1 ABOVE **Grave Circle A,** sixteenth century BCE. Diameter 90 ft. (27.43 m). Mycenae, Greece.

10.2 RIGHT **Stele with chariot scene,** from Shaft Grave V, Grave Circle A, Mycenae, Greece, sixteenth century BCE. Limestone, height 4 ft. 4½ inches (1.33 m). National Archaeological Museum, Athens.

something in his hand, perhaps a weapon. While this image could be interpreted as a hunting scene or as a chariot race at funerary games (such races are mentioned in the *Iliad*), a battle scene would also be very appropriate for the warriors buried in the shaft graves below.

GOLD DEATH MASK ("THE MASK OF AGAMEMNON")

The wealth, variety, and **iconography** of the offerings in Grave Circles A and B provide evidence of an elite warrior class with access to distant lands and resources. Homer described Mycenae as "rich in gold," and when visitors enter the first hall of the National Archaeological Museum in Athens—where most of the offerings from the shaft graves are held—they may be struck by the accuracy of Homer's description. Gold jewelry, **diadems**, vessels, sword handles, and ornaments that would have been sewn onto garments or burial shrouds demonstrate the great wealth of the people buried in these graves.

Particularly intriguing are the gold death masks found over the faces of six men. Each has distinct features, suggesting an interest in preserving the identity of the deceased. The most famous of these was dubbed the Mask of Agamemnon (**Fig. 10.3**) after Homer's legendary leader of the Greeks against the Trojans. However, this mask was created about 300 years before the events related to the life of Agamemnon, if he was indeed a real person. Similar to the other masks found at the site, this one consists of a rounded face, bald head, and prominent ears. To make it, the artist hammered a single thin sheet of gold over a mold and then added the fine details with a sharp tool. Some scholars have called its authenticity into question, or suggested that Schliemann over-restored it to make it more appealing to a nineteenth-century audience, but others have strongly refuted these claims.

LION HUNT DAGGER BLADE

Many weapons were also found in the shaft graves, including spears, arrows, and daggers. Some of the daggers are elaborately decorated with inlaid gold, silver, and **niello**, a technique that was used earlier in West Asia. This dagger blade (**Fig. 10.4**) from Grave Circle A depicts five men involved in a lion hunt, but only four are left standing. The fifth hunter is on the ground, partially below his shield and under the paw of an attacking lion. The dagger blade is a reminder of the severe dangers of the hunt, which the Mycenaeans (like the people of West Asia) viewed not only as a sport but also as a symbol of power. Brandishing a spear or a bow, the other men push forward, perhaps attempting to retrieve the body of the fallen hunter.

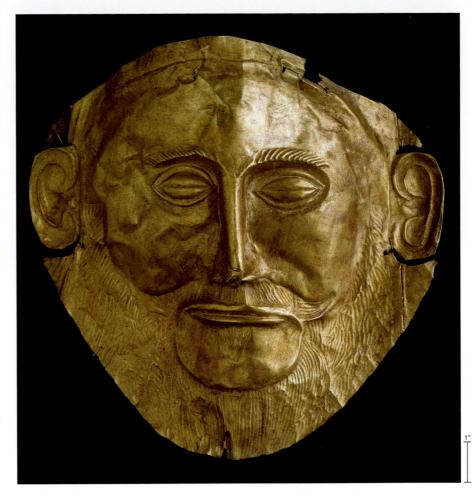

The style of this dagger blade, like other works found in the shaft graves at Mycenae, suggests strong Minoan influence. The blade depicts figures with narrow waists and animals with all four legs in the air in what is known as a flying gallop (see Fig. 9.13), giving the impression of intense speed. Art historians often use such hunting scenes as evidence to support the idea that the Mycenaeans were a violent people, unlike the more peace-loving Minoans. Violent scenes are also occasionally seen in Crete, however: a *rhyton* from Hagia Triada (an ancient Minoan site on Crete) carries an image of a bull-leaper being gored by a bull. Numerous other prestige items from the Mycenaean shaft graves, including the earliest Baltic amber found in the Aegean, a silver vessel in the shape of a stag from Anatolia, and objects made of ivory imported from Egypt, demonstrate the Mycenaeans' far-reaching connections, even in this early period.

10.3 Gold death mask ("Mask of Agamemnon"), from Grave Circle A, Mycenae, Greece, c. 1550–1500 BCE. Gold, height 10¼ in. (26 cm). National Archaeological Museum, Athens.

iconography images or symbols used to convey specific meanings in an artwork.

diadem a crown or ornamented headband worn as a sign of status.

niello a black alloy of sulfur and other metals, often used for inlay.

rhyton a conical container with a hole at the bottom, thought to hold drinks or offerings.

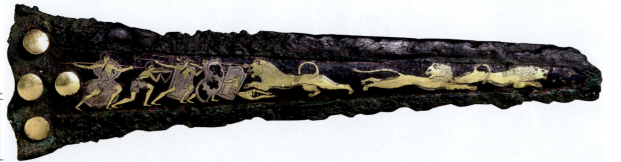

10.4 Lion hunt dagger blade, from Shaft Grave IV, Grave Circle A, Mycenae, Greece, sixteenth century BCE. Gold and silver inlaid with bands of niello, length approx. 9½ in. (24 cm). National Archaeological Museum, Athens.

MYCENAEAN PALATIAL SOCIETY AND EXPANSION

By the fourteenth century BCE, Mycenaean kingdoms on the mainland asserted economic, and to a lesser extent political, control in the region around the Aegean Sea.

Ultimately, through trade and settlement, Mycenaean reach extended to West Asia in the east and to present-day Italy and Spain in the west. Homer's description of Agamemnon as having authority over other regions finds some support in documents from Hattusha, the Hittite

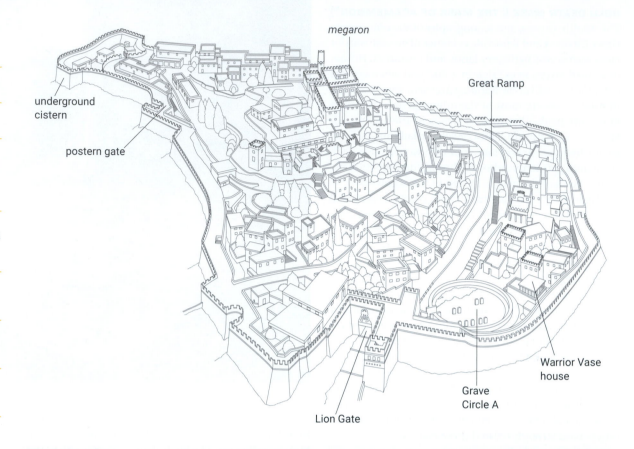

10.5 ABOVE RIGHT **Citadel of Mycenae (reconstruction drawing)**, Greece, 1600–1100 BCE.

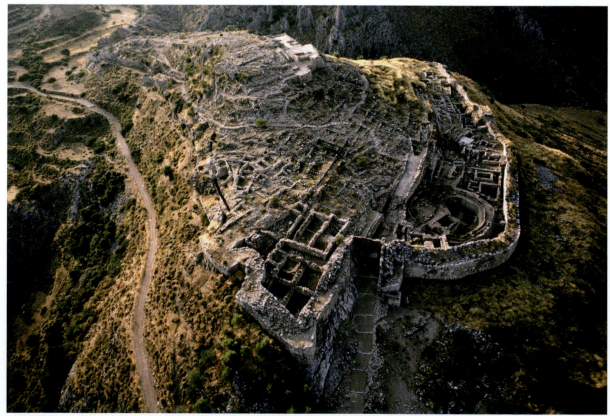

10.6 RIGHT **Aerial view of citadel of Mycenae**, Greece.

capital (in present-day Turkey); the Hittites were contemporary with the Mycenaeans. The Linear B tablets and archaeological remains suggest that Mycenaean kingdoms on the Greek mainland, such as Mycenae and Pylos, were probably independent of one another. Each kingdom had its own citadel and administrative complex, including a palace and rooms for religious activity.

MYCENAE CITADEL Around 1340 BCE, the construction of the first fortification walls at Mycenae began, probably a response to increased tensions at the time. The walls are made of massive limestone blocks roughly fitted together using no mortar, a technique known as **Cyclopean masonry**, alluding to the notion that it would take the mythological one-eyed giants known as the Cyclopes to move the stones. Around 1250 BCE the citadel was nearly doubled in size and incorporated Grave Circle A inside its city walls (**Figs. 10.5** and **10.6**). The ground level of Grave Circle A was raised, the steles were re-erected at the higher level, and a more impressive circular wall was built to enclose the graves. The protection of Grave Circle A as well as its elaboration suggests that the ruling Mycenaean elite was interested in strengthening its ancestral ties to those buried here.

LION GATE, MYCENAE The Lion Gate (**Fig. 10.7**) was also constructed at this time, as was the Great Ramp, which leads from the gate up to the citadel, passing Grave Circle A on the right. The Lion Gate is important for its protective function, both real and symbolic.

The approach to the gate includes a **bastion** on the right side that strategically narrowed the entryway, allowing defenders on the bastion to attack the more vulnerable unshielded side of any enemy trying to breach the enormous walls and gateway. The gate itself consists of two upright **monoliths** topped by a massive **lintel**. The walls on either side of the monoliths are **corbeled**, leaving space for a **relieving triangle**. Here, carved in **high relief** in limestone, is a rare example of monumental sculpture from Mycenaean times: two creatures, variously identified as lions, lionesses, griffins (mythical bird-headed lions), or sphinxes (winged creatures with a human head and a lion's body). Their front legs rest on small altars and their bodies face a Minoan-style column that tapers at the bottom. The heads, now missing, were sculpted separately, perhaps of a different material. They would have been turned outward, confronting individuals approaching the gate, as indicated by the dowel holes used to attach the heads to the bodies with pegs.

The bodies of the leonine creatures show a high level of naturalism for this period, with muscles and other aspects of the anatomy clearly indicated. Throughout ancient West Asia and Egypt, these creatures frequently functioned as **apotropaic** guardians placed at gateways to palaces or tombs (see Fig. 5.5). The central column that they protect may symbolize the palace, a religious structure, the city, an **aniconic** deity, or some combination of these; it may also connect the political power of the ruler, or *wanax* as he is called in the Linear B texts, with the divine, a practice that was common throughout the Eastern Mediterranean in the Bronze Age.

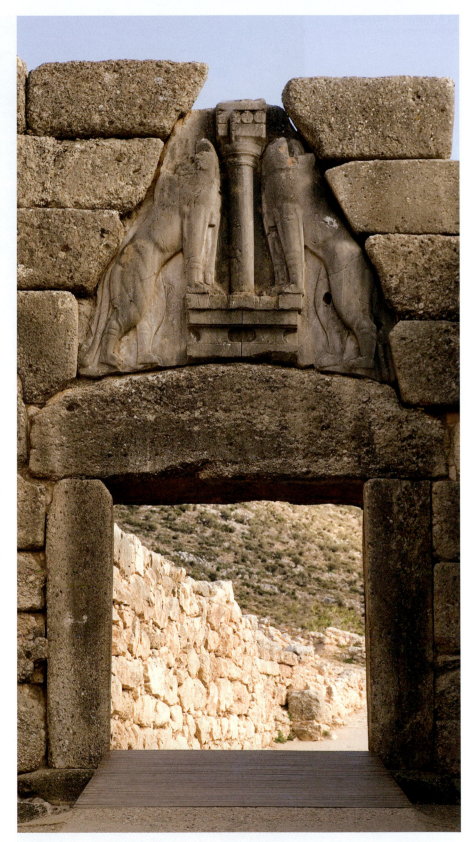

***THOLOS* TOMB (TREASURY OF ATREUS)** The burial practices of the Mycenaean elite eventually shifted from shaft graves to impressive *tholoi*, covered by a **tumulus** and located outside the fortification walls. Such conspicuous tombs could be easily re-entered for subsequent burials. Nine *tholoi* have been discovered at Mycenae. The biggest of these tombs is known as the Treasury of Atreus

10.7 Lion Gate, Mycenae, Greece, thirteenth century BCE. Limestone relief and Cyclopean masonry.

10.8 Interior of Treasury of Atreus *tholos* tomb, Mycenae, Greece, *c.* 1300–1250 BCE.

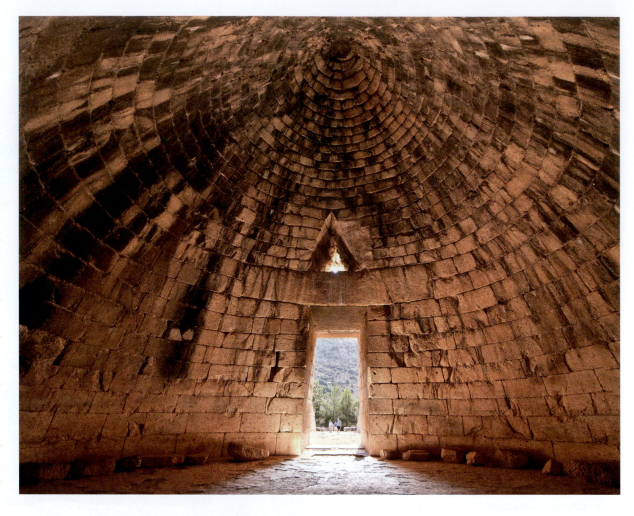

keystone a central stone, wider at the top than the bottom, placed at the summit of an arch to transfer the weight downward.

dromos an entrance passage to a subterranean tomb.

ashlar a stone wall masonry technique using finely cut square blocks laid in precise rows, with or without mortar.

figurative art that portrays human or animal forms.

engaged column a column attached to, or seemingly partially buried in, a wall.

megaron an architectural form used in Mycenaean palatial complexes; it includes a porch and a main hall.

vestibule the small lobby or hall directly before a doorway.

fluting shallow ridges running vertically along a column, or other surface.

kylix (plural ***kylikes***) an ancient Greek drinking cup with a stem.

10.9 Exterior of Treasury of Atreus *tholos* tomb, Mycenae, Greece, *c.* 1300–1250 BCE.

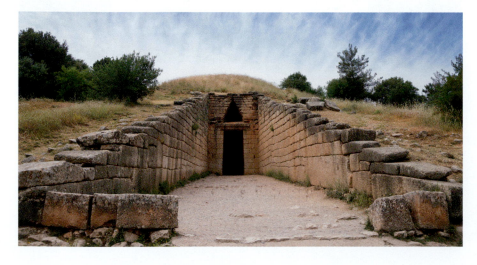

(**Fig. 10.8**), because in antiquity it was mistakenly believed to hold the riches of Atreus, the father of the Greek kings Agamemnon and Menelaus. The beehive-shaped vaulted tomb was created by digging a wide, cylindrical pit into a hillside and lining it with layers of progressively smaller stones until they met at the top, where the **keystone** was placed. At 43 feet (13.11 m) high, this corbeled vault or dome was a major feat of engineering at the time.

A ***dromos*** (**Fig. 10.9**), about 114 feet (34.75 m) long, cut into the rock and lined with **ashlar** blocks, leads to the tomb's doorway, which would have been closed off.

A relieving triangle similar to that of the Lion Gate sits above the lintel. The tomb's facade was decorated with patterns of colored stones rather than **figurative** imagery, and **engaged columns** were placed on either side of the door and relieving triangle. Given the monumentality and impressive engineering of the tomb, as well as the fact that it could continue to receive burials over long periods due to its size and the ease of re-entry, it probably once held a great wealth of offerings, but all of the *tholos* tombs at Mycenae were looted in antiquity.

PALACE OF NESTOR, PYLOS The best-preserved Mycenaean palatial complex excavated so far is the Palace of Nestor at Pylos (**Fig. 10.10**). The palatial complex is located in the southwest Peloponnese on a hilltop overlooking the bay of Navarino (see **Map 10.1**). In the *Iliad*, Nestor, "king of sandy Pylos," leads a large squadron that is surpassed in size only by that of Agamemnon. The prosperity of Pylos is also indicated by the presence of three *tholos* tombs, as well as the recent and fascinating discovery of an early warrior's shaft grave filled with opulent offerings (see box: Art Historical Thinking: The Griffin Warrior of Pylos, p. 184). More than one thousand clay tablets inscribed with Linear B script were discovered in the palace complex, some of which mention Pylos, thus confirming the identification of this site. Unlike most other Mycenaean palatial centers, Pylos was not fortified, perhaps owing to its more isolated location in the southwest Peloponnese and on

a strategic hilltop. However, its lack of fortifications is perhaps why it succumbed early to the destructions that caused the collapse of Mycenaean palatial culture and the end of the Bronze Age (see p. 185).

Visitors gained access to the main building through a simple outer entryway, called a *propylon*, with a single column. To the left of the entrance are two small rooms that functioned as archives, where Linear B tablets were discovered on the very first morning of excavations in 1939. Passing through a porch, visitors arrived at a court-yard. A room with benches to the left of the court may have functioned as a waiting room. Past the court, the **megaron** would have been entered through a porch with two columns, and beyond that is a **vestibule** leading directly into the room known as the Throne Room, which contains an enormous circular hearth more than 13 feet (around 4 m) in diameter, surrounded by four columns. Though the wooden columns at the site are long gone, the plaster collars that would have surrounded them and the base remain and show that the columns were **fluted**. No throne was discovered, but there is a base on the side of the room that may have held a throne. A Linear B tablet found at Pylos makes reference to ebony thrones, one with a golden back, and one with an ivory back. Next to the base are two hollows in the floor connected by a channel, perhaps for the pouring of libations (liquid offerings to the gods) by the *wanax*, or king. Another Linear B tablet documents a feast in which sacrifices were made to Poseidon, the god of the sea, calling to mind a scene in the *Odyssey* in which Odysseus's son Telemachos visits Pylos during a feast in the god's honor.

An attempt at capturing the grandeur of the *megaron* can be seen in a watercolor by the artist Piet de Jong (**Fig. 10.11**). De Jong painted reconstructions of prominent archaeological sites in the Mediterranean between the 1920s and 1950s, a period when much excavation and reconstruction work took place. This watercolor is based for the most part on the remains of the palace that De Jong saw, including the large circular hearth with an opening above to release smoke, impressive floors with a variety of designs, and column bases. Wall paintings discovered in the throne room include a depiction of a lyre player, perhaps entertaining guests during a feast. Numerous jars that once held olive oil were discovered in rooms behind the throne room, and the Linear B tablets speak of rose- or sage-scented oil. Perfumed oil was a highly valued commodity in the ancient world. Thousands of vessels, mainly cups such as **kylikes**, were discovered in the rooms on the western side of the main building, suggesting that the consumption of wine played an important role in ritual and social feasts in the palace; scenes of drinking appear in the wall paintings discovered there. Linear B inscriptions from the site have also led to the identification of a wine storage room.

Cultural contact between the Mycenaean world and other parts of the Eastern Mediterranean expanded in the later Mycenaean period, from the fourteenth to the thirteenth centuries BCE, a so-called international age. The Uluburun shipwreck off the coast of southern Turkey provides notable evidence of such contact. The ship itself was made from cedar from Lebanon and believed to have

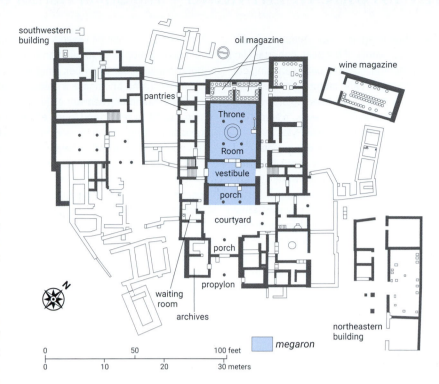

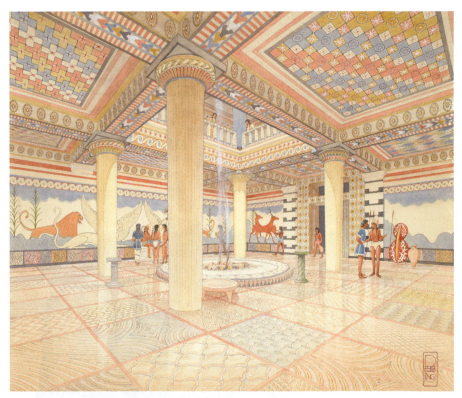

been operated by a Syro-Canaanite crew with passengers from the Greek mainland. The international cargo included copper (sourced from Cyprus), tin (sourced from present-day Turkey and Afghanistan), ivory (worked and unworked), and jewelry made of amber (from the Baltic), gold, silver, glass, faience, carnelian, and agate. A scarab inscribed with the cartouche of the Egyptian queen, Nefertiti (see Fig. 6.11), the wife of Akhenaten, was also discovered in the wreck, which was excavated over eleven archaeological seasons between 1984 and 1994 with over 22,000 dives. There is also additional artistic and even

10.10 TOP **The Palace of Nestor (architectural plan),** Pylos, Greece, c. 1400–1200 BCE.

10.11 ABOVE **Reconstruction of the *megaron* (great hall) in the Palace of Nestor,** Pylos, Greece. Watercolour by Piet de Jong, c. 1960, digitally restored by Craig Mauzy.

While we often imagine major archaeological discoveries as events of the past, important finds are still happening, continuously reshaping our understanding of art and culture. For example, in the summer of 2015, archaeologists from the University of Cincinnati discovered a Mycenaean shaft grave at the ancient site of Pylos that had remained mostly intact and completely unlooted for 3,500 years, since about 1450 BCE. After a long period of meticulous excavation that also included on-site conservation efforts, archaeologists unearthed the remains of a male warrior who was approximately thirty to thirty-five years old at the time of his death, along with hundreds of extravagant objects deposited as part of his funerary ritual. Because this burial took place long before the construction of Pylos, the warrior's remains are too old to be those of the legendary King Nestor. However, the excavation of a very high-ranking person's burial from this early date provides important information about the foundations of Mycenaean society.

The man buried here is called the Griffin Warrior after a carved ivory plaque depicting a griffin found in the grave, as well as several objects that identify this man as a warrior. For example, a 3-foot-long (91.4 cm) sword with a gold-covered hilt was found near his head and chest, with a similarly styled dagger as well. Several perforated boars' teeth were used to make the warrior's helmet; and bands of bronze, probably from his armor, were also discovered.

Other offerings include vessels of bronze, silver, and gold; a bronze mirror with an ivory handle; hundreds of beads of amber, amethyst, gold, carnelian, glass, and agate; a gold chain and pendant; numerous sealstones (engraved gems used as seals); and four well-preserved gold signet rings. Such rings were used to stamp a seal into a soft substance such as clay as a sort of signature. The abundant quantity of jewelry in the grave of a man challenges the common misconception that jewelry indicates a woman's burial.

The cleaning and conservation of what was thought to be a simple agate bead, just under 1½ inches long, literally brought to light a sealstone (**Fig. 10.12**) with a sophisticated miniature relief of a warrior in hand-to-hand combat on top of another fallen warrior below. The pyramid-shaped composition is striking, calling to mind much later works (see for example Figs. 45.2 or 45.6). The winning warrior signals his dominance both by his higher position and the fact that he is thrusting the sword into the chest of his adversary, forming one side of a triangle, while the spear of his foe forms the opposite side. He wears a codpiece while the others wear matching kilts, clearly indicating that they are opposing groups. The attention given to the depiction of movement and of the human form is also notable, given the difficulty of the medium in terms of its hardness and small size. Overlapping forms and tensed muscles are depicted in great detail. Although it is tempting to see a great

battle scene from the *Iliad* in this sealstone, it is important to remember that Homer's epics were not written down until some 700 years after the Griffin Warrior's burial, and so the stories certainly transformed over time, according to their contemporary audiences, as they were handed down through oral tradition.

10.12 Sealstone with scene of combat, from grave of the Griffin Warrior, Pylos, Greece, *c.* 1500 BCE. Agate, height 1½ in.

Discussion Questions

1. Archaeological excavations bring to light new evidence regarding ancient people and societies. What do the grave goods discovered with the individual buried in this tomb teach us about the society in which he lived?

2. Look closely at the relief sculpture of the agate sealstone and describe how the artist created a balanced pyramidal composition.

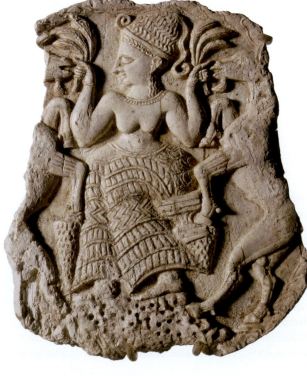

10.13 Lid of a pyxis with "Mistress of Animals" figure, from Minet el-Beidha, port of Ugarit, Tomb 3, *c.* 1250 BCE. Elephant ivory, 5⅜ in. (13.7 cm) diameter. Louvre Museum, Paris.

textual evidence for diplomatic exchange throughout the Eastern Mediterranean during this period (see: Seeing Connections: The Art of Trade and Diplomacy in the Bronze Age, p. 96).

PYXIS IN ECLECTIC STYLE A compelling example of Mycenaean influence abroad is the thirteenth-century BCE lid of a round ivory container known as a *pyxis* discovered in a private tomb at Minet el-Beidha, a harbour town on the Syrian coast (**Fig. 10.13**). The tomb itself had a stone anchor built into it, which suggests that the tomb owner was involved in sea trade. The cross-cultural influences visible in the relief carving on the lid, therefore, probably resulted from commercial exchange.

The relief carved into the lid depicts a female figure seated on a Minoan/Mycenaean-style altar, similar to the altars from the Lion Gate sculpture at Mycenae. She offers palm fronds to goats that flank her, similarly to a goddess figure in a wall painting at Mycenae. This type of composition—two animals flanking a central figure—is known as the Master (or in this case, Mistress) of Animals, and it has a long history in West Asia (see Fig. 4.2a). Here, the Mistress of Animals wears a

flounced skirt typical of Minoan and Mycenaean dress. Her completely bare top, however, is different from the open bodices of Aegean elite dress (see Fig. 9.17) and is instead reminiscent of portrayals of divinity from West Asia. She occupies a mountainous landscape, as indicated by the rocky formation below her feet. Mountains were frequently the domains of divinity in Near Eastern religions. Stylistically, the figure incorporates features that are typical of Aegean art.

Some scholars have argued that the variety of artistic styles and iconography in the relief carving was perhaps intentional, as this would have broadened its appeal in Aegean and eastern Mediterranean markets. Another suggestion is that the mixed style would have appealed to the tomb owner, who might have traveled extensively throughout the eastern Mediterranean. Certainly, the carving on the *pyxis* lid reflects the cultural contacts of the Late Bronze Age world of the Aegean and Eastern Mediterranean, as this artwork spoke across political, cultural, and religious boundaries, as did many of the prestige items found in Mycenaean contexts.

MYCENAEAN COLLAPSE AND THE END OF THE BRONZE AGE

Toward the end of the thirteenth century BCE, the fortification walls at Mycenae were expanded yet again, this time to enclose a secret underground cistern—a crucial water source. The expansion of the walls suggests that the inhabitants were fearful of enduring a lengthy siege, as the Trojans did. (If the famous Greek siege of Troy described in the *Iliad* was a historical event, it would have occurred around this time.) There are indications that this was a tense time across the Mycenaean world. Several other Mycenaean centers dug cisterns, and a wall was constructed across the Isthmus of Corinth, probably to keep invaders from entering the Peloponnese from the north—and yet, these efforts were not enough. Even though Mycenae's citadel, with its 25-foot-thick (7.62 m) walls, might have seemed impregnable, it was destroyed, along with most other Mycenaean centers, resulting in the collapse of the palace culture.

We must view the Mycenaean collapse in the context of widespread devastation throughout the Eastern Mediterranean that led to the fall of many Bronze Age cultures, including Babylon, the Hittite empire, and the kingdoms of what is often called the Levant, which includes present-day Syria, Israel/Palestine, and Lebanon. Egypt survived, but it never regained the great power it had in the New Kingdom. Scholars have debated the causes of this collapse for decades. Some argue that the causes lay in climatic events or natural disasters, such as drought or earthquakes. Others suggest a change in warfare tactics from chariot battles to foot soldiers, as a result of new weapons and the emergence of iron technology. Still others suggest internal revolts or external attacks by a group of Greeks known as the Dorians, or by diverse marauding groups that the Egyptians called the Sea Peoples. Most probably a combination of factors brought about the end of the Bronze Age. It has also been suggested that Mycenaeans, themselves reeling from the decline of their prosperity, were among the Sea Peoples.

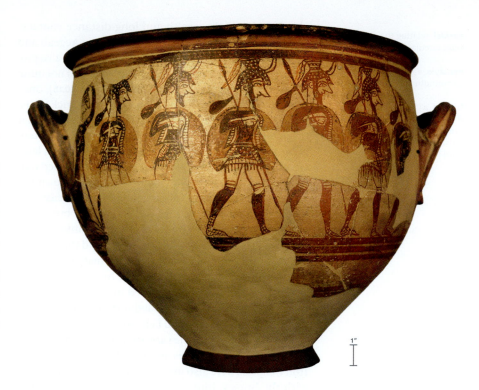

WARRIOR VASE A *krater* called the Warrior Vase (**Fig. 10.14**), evokes the Mycenaean reaction to these changes. It depicts a line of foot soldiers, holding spears and shields and wearing horned helmets, marching solemnly to battle while a woman (just visible at the far left) looks on, her hand to her head. This gesture may be one of mourning; perhaps she is tearing out her hair in grief. The soldiers are depicted using a **composite viewpoint**. For example, the eye is frontal while the face is in profile. The composition is very organized, and there is no indication of any landscape. The soldiers are evenly spaced, with spears held at the same angle, giving the entire composition a sense of military order. New weapons, technology, and warfare tactics, which seem to be represented here, could have given the loosely affiliated warriors known as the Sea Peoples an edge over the seasoned armies of the Bronze Age's great powers, opening the door to the Iron Age.

Early Iron Age/Protogeometric Art, *c.* 1100–900 BCE

The period after the collapse of Mycenaean culture is often considered a dark age, and a steep decline is certainly indicated by the destruction of palaces, the temporary disappearance of writing, a dramatic reduction in sites and population, more limited contact between cultures, and much less monumental art or architecture. Mycenaean culture did not disappear completely, however, and the Greeks of the Early Iron Age, also known as the Protogeometric period because it precedes the Geometric, looked back on the Bronze Age as a heroic time, one to be emulated rather than forgotten.

***HEROON* (HERO'S GRAVE) AT LEFKANDI** The remains of a monumental structure—one of the few constructed in the period—discovered in 1981 at Lefkandi in Euboia, Greece,

10.14 Warrior Vase (*krater*), from Mycenae, Greece, *c.* 1300 BCE. Terra-cotta, height 16 in. (40.6 cm). National Archeological Museum, Athens.

krater large vessel usually used for diluting wine with water.

composite viewpoint depicting a figure simultaneously from several viewpoints, such as both from the front and in profile.

apsidal relating to an apse: a semi-circular recess.

peristyle a line of columns surrounding an enclosed space.

faience a glassy substance that is formed and fired like ceramic, made by combining crushed quartz, sandstone, or sand with natron or plant ash.

clearly indicate the wealth and long-distance contacts of some Early Iron Age communities in the Aegean and their reverence for the Bronze Age. The structure also provides evidence that the so-called Dark Age was not quite so dark. This **apsidal** hall-like building (**Fig. 10.15**), once complete with stone foundations and mudbrick walls, was 147 feet long by 30 feet wide (44.81 × 9.14 m), and it originally included a colonnade or **peristyle** of rectangular posts, reminiscent of those that surrounded later Greek temples, such as the Parthenon. The thatched roof was supported by a row of columns that ran down the center of the building. Visitors entered on the east side through a shallow porch. In the floor of the building's central room were two burial shafts; one contained the remains of four horses, while the other held the remains of a man and a woman. The man was cremated, a practice that developed in the Iron Age, and his ashen remains were wrapped in cloth and placed inside a bronze vase made in Cyprus (an eastern Mediterranean island near mainland Turkey, Syria, and Lebanon) during the twelfth century BCE. Perhaps the vase was an heirloom that celebrated the age of heroes at the end of the Bronze Age. Iron weapons were also included in the burial and, along with the horses, indicate that the man was a warrior. Next to the cremation urn were the buried remains of a woman, very richly adorned not only with pins of bronze and iron but also with jewelry made of gold and electrum (a mixture of gold and silver). Notable among the jewelry is a Babylonian neckpiece that dates back to the early second millennium BCE—another indication of interest in the Bronze Age past.

The pottery discovered in the building may have been used for ritual meals for a short period of time after the burials were completed, reminiscent of the feasting in the Mycenaean palace at Pylos. The building was later filled in, sealed on the east end, and buried to form a tumulus. Whether the building was the home, in life, of the important individuals buried there is the subject of debate. The later burials at the east end of the mound strongly suggest that the structure came to function as a *heroon*, a site for the worship of a hero, perhaps the ancestor of an important lineage. Offerings discovered in these later burials included valuable imports from Egypt and the Levant, such as bronze and **faience** bowls and objects made of gold.

Geometric Art, *c.* 900–700 BCE

The Geometric period from around 900 to 700 BCE witnessed a surge in population and activity that led to the establishment of many institutions for which ancient Greece is now well known: the city-state, or *polis*; the Greek alphabet; colonies along the coast of present-day Turkey, southern Italy, and the island of Sicily (alongside Phoenician colonies) (**Map 10.2**); and the rise of Greek temples and panhellenic sanctuaries, such as at Olympia, where the first Olympic games were held in 776 BCE. The period takes its name from its focus on two-dimensional geometric forms in art, with a lack of interest in naturalism. Monumental sculpture is mostly absent during this period, except for ceramic grave markers decorated with geometric shapes and abstract figures.

GEOMETRIC *KRATER* This substantial ceramic *krater* (**Fig. 10.16**) from the eighth century BCE was used as a burial marker in the Dipylon cemetery just outside the walls of Athens. The bottom of the *krater* is open, perhaps to allow libations to be poured onto the earth. Although much of the surface is decorated with geometric forms, figurative representations also appear (these became more common later in the Geometric period, when this *krater* was made). However, even these figures are represented using geometric forms, such as triangles for the torsos and cut-out circles for the shields. They look more like silhouettes than actual figures. The work features neither naturalism nor the illusion of depth: several horses are indicated by legs and heads, but they appear to share one body.

Because *kraters* were used to mix wine with water, they were often associated in ancient Greece with the male domain of the symposium (a kind of discussion and drinking party), from which most women were excluded. Therefore, we can assume that this burial marker belongs to the grave of a man. In the upper register, the deceased is depicted laid upon a bier (a stand used to carry a body to the grave). He is surrounded by members of his family, whose ages are indicated by their different sizes. The checkered pattern above him represents the burial shroud that would normally be laid over the deceased, but here it is lifted to show the scene more clearly. To the side are groups of mourners with their hands to their heads in a gesture that refers to tearing out one's hair in grief (see **Fig. 10.14**). The mourners would probably have been singing laments during the ritual display of the corpse.

10.15 *Heroon* **(hero's grave)** (reconstruction drawing and cross-section), Lefkandi, Euboia, Greece, *c.* 950 BCE.

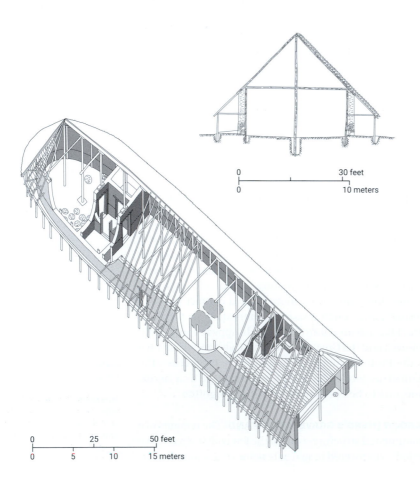

0 25 50 feet
0 5 10 15 meters

0 30 feet
0 10 meters

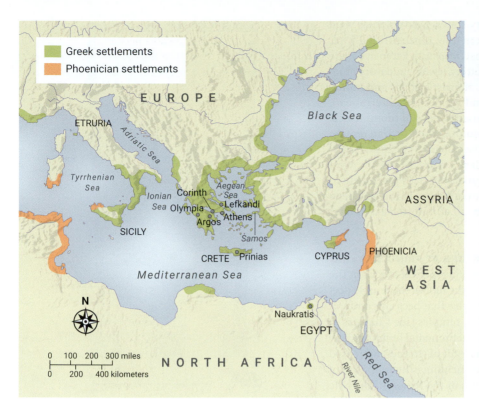

Map 10.2 ABOVE LEFT
Geometric and Protoarchaic Greece, *c.* 900–600 BCE.

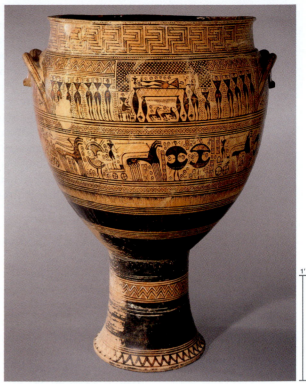

10.16 ABOVE **Geometric *krater*,** from the Dipylon cemetery, Athens, *c.* 740 BCE. Terra-cotta, height 40½ in. (102.9 cm). Metropolitan Museum of Art, New York.

The register below depicts a procession of chariots and infantry soldiers with shields, which may suggest that the man buried here was a warrior. This *krater* likely looks back to the heroic Bronze Age, as this image on the lower register calls to mind the chariot races at the funeral games of the warrior Patroklos described in *The Iliad*. Notable is the lack of focus on an afterlife. In contrast to the Egyptian belief that the deceased could continue to engage in activities from life even after death, the Greek underworld was a place of mystery and solemnity. Much Greek funerary art therefore depicts the emotions of those left behind and the status of the individual in life.

EARLY GREEK TEMPLE ARCHITECTURE Geometric designs were also common in Mycenaean temples of the Geometric period. Early Greeks worshiped their gods in open-air sanctuaries, often demarcated by a surrounding wall and sometimes containing an altar. During the Geometric period, the Greeks began to build houses, or temples, for their gods. In addition to protecting a statue of the god or goddess, temples were a gift to the deity and served to receive and protect offerings. Temples also played an important role in the emergence of the Greek city-state or *polis*, as the worship of a patron deity was an important part of civic life that brought the community together, cementing the people's communal civic identity.

Little remains of these early temples because they were made mainly of wood and mudbrick, and later temples of stone were often constructed over them. Nonetheless, it is possible to reconstruct their general form based on surviving models of early temples and archaeological remains that indicate the temple plan. One eighth-century BCE temple model (**Fig. 10.17**) was found in the sanctuary of Hera at Argos, where this great goddess and wife of the supreme god Zeus was worshiped. The **terra-cotta** model

has a rectangular plan, a shallow porch with two columns flanking the entrance, and an inner chamber, or *cella*, that could have housed a statue of the god or goddess. A flat roof covers the porch, while a **pitched roof** covers the chamber. An opening in the front part of the roof may indicate the presence of a hearth inside; the opening would have allowed smoke to escape. Some scholars have suggested that this model represents the earliest temple dedicated to Hera in her sanctuary.

Protoarchaic Art, *c.* 700–600 BCE

Following the Geometric period, the seventh century BCE witnessed an increase in trade and colonization, both east

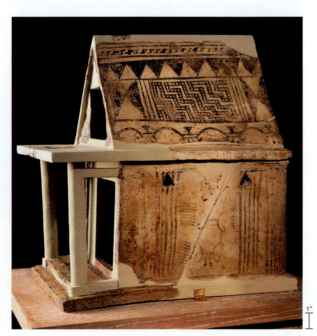

terra-cotta baked clay; also known as earthenware.

cella (also called *naos*) the inner chamber of a temple, usually houses a statue of a deity.

pitched roof a roof that slopes downward, usually in two parts, from a central ridge.

10.17 Temple model, from the sanctuary of Hera near Argos, Greece, late eighth century BCE. Terra-cotta, length 14 in. (35.6 cm). National Archaeological Museum, Athens.

and west, for the Greek city-states. New colonies were established in Sicily, southern Italy, North Africa, Egypt, and along the Black Sea coast (**Map 10.2**). Extensive trade in portable items, such as pottery, jewelry, and ivory products, led to the circulation of artistic styles and motifs throughout the Eastern and Western Mediterranean, while colonies abroad exposed Greeks to monumental stone architecture and sculpture. The Assyrian empire was at its height at this time (see Chapter 5), causing many to flee domination and settle in Greece. As a result, West Asian styles and motifs became especially prominent in Greek art. The Protoarchaic period has in the past been called "Orientalizing" (from a Latin word used to refer to "the east").

STONE TEMPLE ARCHITECTURE AT PRINIAS An early stone temple of the Protoarchaic period stood on the site of Prinias in Crete. It was the first Greek temple decorated with sculpture, a practice that became common in later Archaic and Classical temples (see Chapters 13 and 14). The use of stone for monumental buildings may have come from Egypt as a result of Greece's increased commercial contacts there, including the founding of a trading colony at Naukratis in the region of the Nile Delta (c. 620 BCE). The plan (**Fig. 10.18**) consists of a porch with **piers** and a single room with a central hearth, much like the model from the sanctuary of Hera (see **Fig. 10.17**). There is evidence of feasting in the building, an activity that was also common in the earlier Mycenaean palaces.

In contrast to the simple plan is the fairly elaborate relief sculpture. The lintel over the entrance to the temple (**Fig. 10.19**) is decorated with Protoarchaic relief sculptures of three panthers on each side walking in single file toward the center, but looking outward. The motifs are reminiscent of art from Assyria and Babylon. Above the lintel is a relieving space with two sculptures of seated goddesses facing one another. They are in the Daedalic style (named for the legendary artist Daedalus,

who was associated with Crete), with triangular faces, almond-shaped eyes, and wig-like, triangular hair. Both wear a long skirt and a cape, along with a cylindrical headdress that relates them to West Asian goddesses. Similar style standing figures are depicted on the underside of the lintel. Probably at the base of the building was a large **frieze** of relief sculptures of panthers, deer, sphinxes, and horsemen—motifs that demonstrate West Asian influence.

DAEDALIC IVORY The Daedalic style can also be seen in an impressive work of ivory from this period: a component

central hearth

lintel

porch

piers

N 0 15 feet
0 5 meters

pier an upright post that supports horizontal elements, such as a ceiling or arches.

frieze any sculpture or painting in a long, horizontal format.

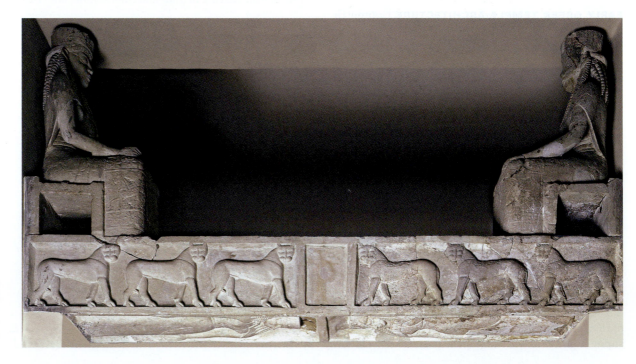

10.19 Reconstruction of lintel with sculptures, from Temple A at Prinias, Crete, Greece, 625 BCE. Heraklion Archaeological Museum, Crete.

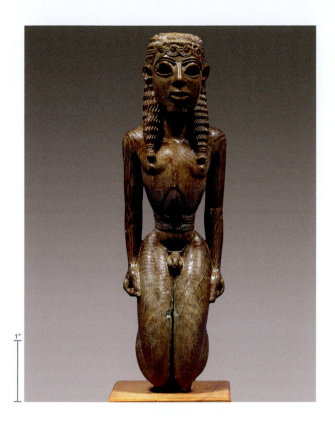

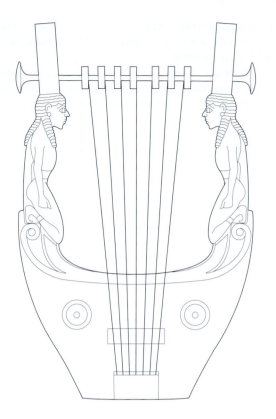

10.20 FAR LEFT **Lyre component in the form of a kneeling youth,** from the sanctuary of Hera, Samos, Greece, *c.* 650–625 BCE. Ivory, height 5⅞ in. (14.9 cm). National Archaeological Museum, Athens.

10.21 LEFT **Lyre (reconstruction drawing).**

10.22 BELOW **Corinthian olpe (pitcher),** produced in Corinth, Greece, 650–625 BCE. Terra-cotta, height 12⅞ in. (32.7 cm), diameter 6⅝ in. (16.8 cm). J. Paul Getty Museum, Los Angeles, California.

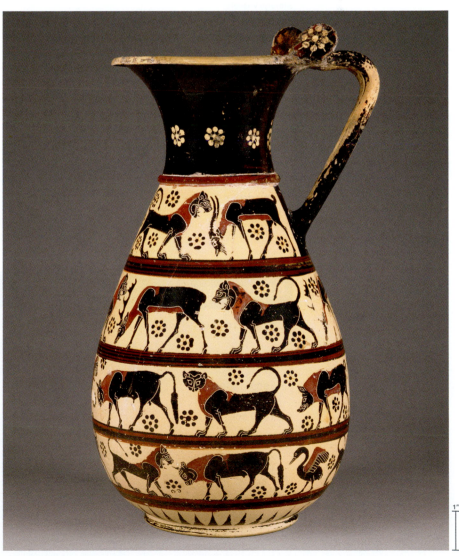

from a stringed musical instrument, called a lyre, in the form of a kneeling youth (**Fig. 10.20**). This object was dedicated to Hera at her sanctuary on the island of Samos, which also saw the development of early Greek temple architecture. Ivory continued to be a highly valued imported material during this period. Cuttings in the head, back, and bottom of the figure indicate that the youth functioned as one arm of a lyre (**Fig. 10.21**). Inventories of offerings from the temples on the Athenian Acropolis include similar gilded ivory lyres, of which this is an early example. Amber inlays still adorn the circles of the headband, but it requires an effort of imagination to reconstruct the full effect of the eyes, eyebrows, earlobes, and pubic hair, which were also once inlaid with other materials. The kneeling pose may be influenced by West Asian art, but the male nudity and the dynamism of the pose are characteristic of Greek art. The increase of Greece's trade with West Asia during the Protoarchaic period certainly exposed artists to portable ivory carvings from Syria and the eastern Mediterranean region, and some of that influence may be seen here.

CORINTHIAN PROTOARCHAIC POTTERY West Asian motifs are also evident in Corinthian pottery (**Fig. 10.22**). The city of Corinth, which is located on an isthmus (a narrow strip of land with sea on either side), commanded two harbors. On the east side of the isthmus is the Saronic Gulf, which gave access to the Aegean Sea and the Eastern Mediterranean beyond. On the west is the Gulf of Corinth, which opens to the Ionian Sea, the Adriatic Sea, and the Western Mediterranean. As a result of its enviable location, Corinth played an important role in trade throughout the Mediterranean. Its location also gave it an edge in overland trade from the

Peloponnese to the north. It is therefore not surprising that Corinth was early to adopt and adapt West Asian motifs in its pottery.

Corinthian artists developed a new kind of pottery style, now referred to as **black-figure**. Figures were drawn in black against the cream color of the clay, but details were often incised into the vessel or added in red to make them stand out. This Corinthian *olpe*, or pitcher (**Fig. 10.22**; see also **Fig. 10.23**), depicts four registers of lions, panthers, goats, deer, bulls, boars, and swans moving around the vessel's body and separated by rose-shaped decorations called rosettes. The animals, most of which derive from West Asian motifs, move in space and look in different directions, sometimes menacingly.

Corinthian pottery became quite sought after and was widely exported; it has been found in many excavations in the Mediterranean. Pottery's important role in the spread of artistic motifs, styles, and mythological subjects would continue during the subsequent Archaic and Classical periods.

10.23 Archaic Greek pottery: shapes and functions of some of the most commonly used vessels.

Pouring vessels

sieve jug *oinochoe* *olpe*

Oil containers

lekythos *aryballos* alabastron

Storage vessels

amphora *loutrophoros* *hydria*

Mixing vessels

bell *krater* *calyx krater* *volute krater*

Discussion Questions

1. To what extent did Mycenaean Greeks participate in long distance trade? Provide at least two artistic examples that demonstrate long distance exchange during this period.

2. How do the art and architecture of the time help us understand how and why the great Bronze Age societies of the Aegean and West Asia collapsed? Are there lessons to be learned from the fall of these societies?

3. How did the people living during the Protogeometric and Geometric periods view Bronze Age society? Choose two to three examples, at least one architectural, and explain how these works support your response.

4. Describe how two works of art from the Protoarchaic period were influenced by West Asian contacts. What was the historical context in which this exchange occurred?

Further Reading

- Cline, Eric H. *1177 b.c.: The Year Civilization Collapsed*. Princeton, NJ: Princeton University, 2014.
- Davis, Jack L. and Stocker, Sharon R. "The Lord of the Gold Rings: The Griffin Warrior of Pylos." *Hesperia* 85 (2016): 627–55.

Chronology

c. 1700–1180 BCE	Mycenaean culture	*c.* 1100–900 BCE	The Early Iron Age, with Protogeometric art style; *Heroon* of Lefkandi is built
c. 1600–1180 BCE	The Late Bronze Age in mainland Greece	*c.* 900–700 BCE	The Geometric period, with Geometric style of art; monumental *kraters* are used as grave markers
c. 1600–1450 BCE	Shaft graves are constructed at Mycenae		
c. 1450 BCE	Mycenaean presence on Crete; the earliest evidence of Linear B writing	800–700 BCE	Greek colonies are established in Italy, Asia Minor, and the Eastern Mediterranean; the Greek alphabet is developed; the Homeric epics are written down
c. 1400 BCE	The beginning of Mycenaean expansion beyond the Aegean, east and west		
c. 1300–1250 BCE	The Treasury of Atreus is constructed	776 BCE	The first Olympic Games take place
c. 1250 BCE	Possible period of the Trojan War	*c.* 700–600 BCE	The Protoarchaic period; black-figure pottery is developed in Corinth
c. 1200–1180 BCE	The collapse of the Bronze Age, including the Mycenaean palaces		

11

Art of Early South America

before 600 CE

Funerary mantle with embroidered
decoration (detail), Paracas.

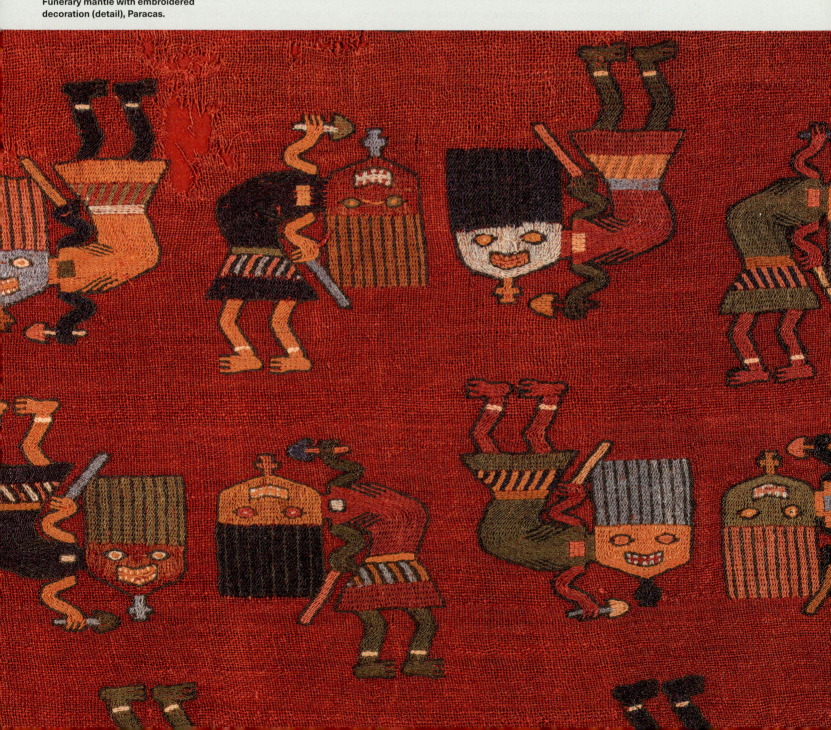

Introduction

Early humans first entered the Americas by crossing between what is now Siberia (Russia) and Alaska (United States) sometime before 12,500 BCE. At the time, this was a continuous landmass with no water separating the two, as the Bering Sea does today. These early explorers would have had no idea that they had crossed into another continent or a "New World," although they likely would have noticed that as they advanced, they met no other humans, and they would soon become even further isolated from those they had left behind. Rising waters covered the land passage between Siberia and Alaska about 10,000 years ago, when the climate became warmer. After the separation of the Americas from Siberia, very few people joined these first explorers.

This isolation allowed those who originally crossed into the Americas to develop their own artistic and social traditions without the input of other cultures. In this way, the ancient Americas may be considered a laboratory of social and artistic development, unaffected by the histories or art traditions of the rest of the world until the arrival of Europeans in the late fifteenth century. It is important to note that, while we use the word to refer to the first people that lived on the continents, these ancient cultures did not use the term Americas.

Humans spread throughout North America and soon covered the entire South American continent, from the Isthmus of Panama to the southern tips of Chile and Argentina. The Andean region (Map 11.1), encompassing the Andes Mountains and the adjacent coast and jungle regions of present-day Peru, Ecuador, and parts of Bolivia, Chile, and Argentina, produced many of South America's most complex societies and art styles. As early Andean communities developed more hierarchical societies with elite warriors and rulers, they began to produce luxury objects in textiles, ceramic, and gold, blending elements of style and iconography from a widely shared religious tradition with local cultures and styles. Major artistic themes were military power, warfare, and sacrifice. Common motifs were birds and animals, and the combination of human and animal features in visual representations of what were believed to be supernatural beings.

In addition, the Andean cultures left behind large pyramids, temple complexes, and lavish burials. Andean artists worked precious metals into jewelry earlier than anywhere else in the Americas, eventually trading gold objects and metalworking techniques north to Central America and Mesoamerica. In addition, Andean weaving traditions are some of the finest produced in the ancient Americas, with examples of woven and dyed cloth preserved in the dry deserts of the Andean coast.

The diversity of climates in the Andean region, from the high grounds of the cold Andes Mountains to the torrid heat of the Pacific coast and Amazonian jungle, gave Andeans access to a huge variety of foods and animals. Native animals found at the higher altitudes, such as llamas and alpacas, were important as beasts of burden, as well as for their fleece. The warm coastal lowlands produced cotton, coca, and tropical fruits, and the waters provided fish, whales, and sharks. The more temperate slopes of the Andes, sandwiched between the cool mountains and the hot coast, produced fruits and vegetables. Many of these resources found their way into the materials and subject matter of ancient Andean art, and trade carried art styles and symbolism across the region.

Map 11.1 The Andean region, with key archaeological sites.

The Earliest Americans

The very first Americans left little evidence of their lives: a stone-and-bone toolkit, some indications of the structures they lived in, and some remains of the plants and animals they ate. If these early Americans lived so lightly on the land and left so few signs of their presence, then what proof do we have of their existence? Using modern techniques and technologies, archaeologists uncovered the existence of a society at Monte Verde, Chile, that was more than 14,500 years old. The evidence includes the traces of plants used there and the faint outlines of wooden poles that supported human-made structures. Like all Americans of the time and for a long period thereafter, the people of Monte Verde lived by hunting animals and gathering wild plants. This way of life flourished for thousands of years, until advances in fishing and the domestication of corn and potatoes made settled life more effective.

Hunting and gathering food requires certain tools. The technology of the earliest American hunter-gatherers

eventually evolved into one of the world's most refined stone-tool traditions. Stone tools were everywhere in the ancient Americas, from what is now Canada to the tip of South America. Metalworking was not unknown, especially in the Andean region and Central America, but most artists' tools were made from stone. Using these stone tools, highly skilled ancient artists created a range of intricate, labor-intensive artistic effects and techniques.

Although human groups in the Americas were isolated from human communities in Europe and Africa, the American groups maintained strong contacts among themselves, often passing on technologies and knowledge about the domestication of key food plants. Two areas were especially important in this regard: the ancient Andes, centered on present-day Peru, and Mesoamerica, covering much of today's Mexico and all of Guatemala and Belize. Over the 3,000 years immediately before the arrival of the Spanish (from about 1,500 BCE onward until Spanish colonial forces landed in the early 1500s: see Chapters 41 and 42), both the Andean area and Mesoamerica were home to urban societies with hierarchical social structures, city living, and specialized artists and craftspeople.

Chavín, 900–200 BCE: A Widely Shared Andean Religious Tradition

Andean cultures created some of the earliest monumental buildings and complex artworks in the Americas. By the third millennium BCE (3000–2000 BCE), they were building substantial, solid platforms of **rammed earth** for use in ceremonies, and they were weaving precise designs in cloth. Very few other monumental works are known in the Americas from this early date, and no other culture built them in such concentration in the third millennium BCE.

Many early Andean ceremonial buildings contained either a sunken patio or a U-shaped building, both of which may have defined a space for religious ritual. The plans of these buildings were consistent across vastly different climatic zones, including the Pacific coastal plain, the Andes mountains, and the tropical forest of the eastern Andean slopes. This consistency suggests a broadly shared religious tradition connecting the diverse Andean groups. This shared tradition had been developing for more than a thousand years when, beginning about 900 BCE, a temple site high in the Andes now called Chavín de Huántar—built by the Chavín people—began attracting religious pilgrims from across much of the Andean region. The religion practiced at Chavín used a set of symbols that traveled throughout the Andean region on portable ceramics, jewelry, and textiles. These works were created in a unique artistic style also called Chavín, which served as one basis for later Andean artistic traditions.

TEMPLE COMPLEX OF CHAVÍN DE HUÁNTAR At the center of the pilgrimage site of Chavín de Huántar stood a religious complex consisting of two interconnected temples built at separate times (**Fig. 11.1**). The older section of the main temple was reached through a sunken circular

11.1 Chavín de Huántar temple complex (reconstruction drawing), c. 900–200 BCE.

plaza. **Low-relief** sculptures of finely worked supernatural figures stood guard outside the entrance to the temple. The U-shaped temple plan was typical of earlier buildings in this and other Andean regions; thus the layout would have been familiar to many pilgrims. In other respects, though, Chavín de Huántar was nothing like other sites they had experienced. Here, the temples were constructed of stone using **ashlar** masonry, not the rammed earth or more roughly cut stone of earlier buildings, and they were decorated with elaborately carved stone sculpture. Further, the stone architecture served as an impressive backdrop to public displays such as dances, in which the performers wore goldwork items and other luxurious costume elements.

The temple **facade** in the newer section (**Fig. 11.2**, p. 194) was built to awe visitors. Stone pillars and walls were constructed using a **post-and-lintel** system, fronting a series of steps built from large, solid blocks of stone. Building materials were chosen for their colors: the dark limestone columns contrasted with the (once) gleaming white granite pillars. The importance of stone color in the overall effect was amplified by the Chavín stonemasons' skilled cutting and fitting. This front must have created an impressive setting for the processions and rites held in and around the new temple.

Throughout the history of the Chavín temple complex, the use of stone allowed the builders to create small chambers and passageways inside the temples—unlike the earlier solid pyramids of rammed earth, which did not allow for such interior spaces. The interior of the main temple, which was the center of the most sacred religious activity, had several elements that created theatrical effects. For example, an elaborate duct system

rammed earth a building technique in which damp earth is compressed, usually within a frame or mold, to form a solid structure.

low relief (also called bas-relief) raised forms that project only slightly from a flat background.

ashlar a stone wall masonry technique using finely cut square blocks laid in precise rows, with or without mortar.

facade any exterior vertical face of a building, usually the front.

post-and-lintel a form of construction in which two upright posts support a horizontal beam (lintel).

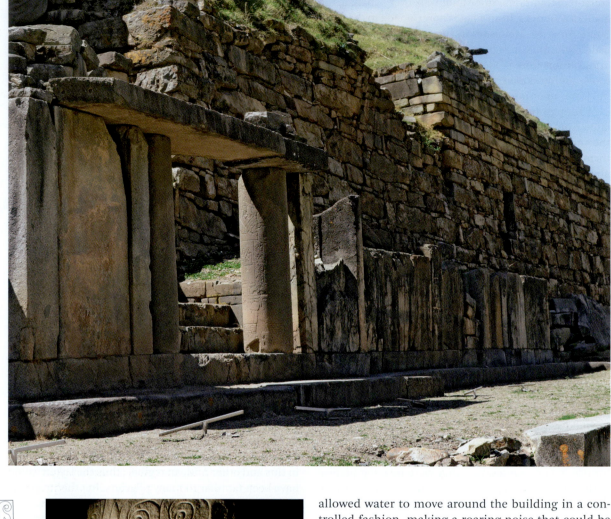

11.2 Entry facade to the newer section of the temple, Chavín de Huántar, Peru, *c.* 400–200 BCE. Granite and limestone, width approx. 30 ft. (90 m).

iconography images or symbols used to convey specific meanings in an artwork.

11.3 BELOW RIGHT **Lanzón sculpture,** Chavín de Huántar, Peru, *c.* 900–200 BCE. Stone, height 15 ft. (4.57 m). Shown within the underground galleries of the main temple.

11.3a BELOW **Relief carving on the Lanzón (roll-out drawing).**

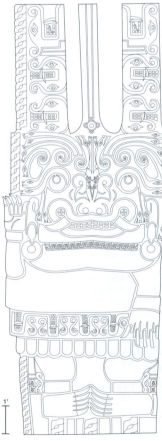

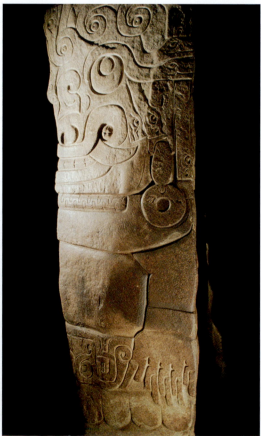

allowed water to move around the building in a controlled fashion, making a roaring noise that could be heard throughout the temple.

TEMPLE SCULPTURE (*LANZÓN*) Most pilgrims who visited the Chavín temple complex probably remained outside and witnessed public rituals taking place in the sunken plaza areas. A small number of worshipers were allowed into the building to deposit ceramic offerings in some of the chambers, where archaeologists later found them. Even fewer were allowed entry to the underground center of the complex. There, after moving through dark, twisting passageways—only about 3 feet (1 m) wide but more than 30 feet (9.14 m) long—the worshipers encountered an enormous stone sculpture with an **iconography** that merges snakes, jaguars, and humans (**Fig. 11.3**).

The sculpture was placed in the central room when the original part of the temple was built (see **Fig. 11.1**), indicating that it had been fundamental to the temple's meaning and purpose from the very beginning. Early Spanish explorers called this sculpture *Lanzón*, and the name has stuck, although it refers simply to the stone's vague resemblance to a lance blade and may have nothing to do with the object's original meaning. Its position tells us this stone was an essential part of the Chavín religion, although we do not truly understand its function and message because more than 2,000 years have elapsed between the making of the sculpture and

modern scholars' examination of it. Further, the makers left no written documentation about the meaning of the piece. What does remain is the imagery on the sculpture and the relation of that imagery to other Chavín works. Scholars have tried to interpret the iconography from these visual clues.

Close observation of the *Lanzón* reveals a wealth of carved detail on its surface. The relief carving wraps around the piece, forming the image of a fanged supernatural being that combines human and animal attributes. The figure wears earflares (big ear ornaments), an elaborate collar, and a skirt, all of which are elements of human dress. The figure has no features that clearly indicate human biological sex. Many of its other attributes relate to animals. In addition to the decidedly non-human teeth, serpents circle the eyes and form the hair. The menacing paws are reminiscent of those of the jaguar, the great jungle predator, although the representation is far from naturalistic. Other aspects of the face recall the caiman, a river predator related to the alligator. Like the jaguar, the caiman is found in the Amazon River Basin in the tropical lowlands to the east of Chavín. Although neither of these animals lived in the highland region of Chavín or on the Pacific coast of Peru to the west, the *Lanzón* focuses on these fearsome Andean and Amazonian predators, whose power was probably associated with gods and leaders (as was the case in later Andean societies). The human/animal combinations seen here and throughout Chavín art may be interpreted as images of supernatural power merging the forces of water and earth with humanity.

CHAVÍN PECTORAL Goldworking in ancient America began in the Andes during the Chavín period, and the earliest examples exhibit the Chavín symbol system. This **pectoral** in Chavín style (**Fig. 11.4**) began as a sheet of gold that had been hammered flat. The relief design was then created by **repoussé**. The relief consists of four bird heads with long down-curving beaks: two heads on each side of the pectoral. The repetition of motifs such as bird heads, representative of the sky in the same way that the caiman was representative of the watery world of rivers and the sea, is a hallmark of Chavín-style art and related later traditions. Further, Chavín artists often played visual games with the repeating elements. For example, when this object is rotated by 90 degrees, each half of the image turns into two supernatural beings without lower jaws. This visual play is difficult for the modern viewer to see, but it would have been immediately recognizable to people living in the Chavín period, who would have been familiar with the conventional forms used for such beings.

Much gold jewelry in the ancient Andes is fairly small and was made to be worn on the wrist or hung around the neck. This pectoral, at 9 inches (22.9 cm) wide, is larger than most Chavín pieces. It would have covered much of the wearer's upper chest area, and it must have been very striking when seen from afar during a sacred performance. Similar objects are often found in elite graves, and they served to distinguish the wearer as a powerful religious figure. While few such burials have been found in and

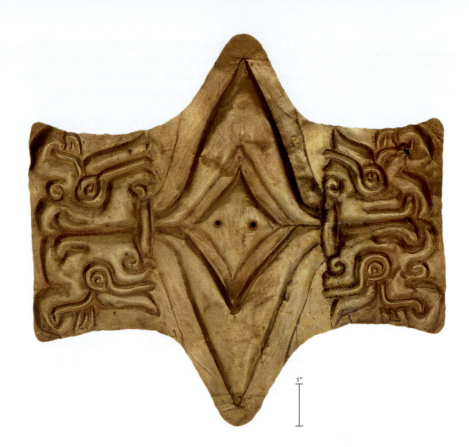

around Chavín de Huántar, there are many burials with rich goldwork in the coastal river valleys just to the west of Chavín. Many of the pilgrims who journeyed to and left offerings at Chavín came from this same coastal region.

Although the Chavín symbol system and elements of the art style traveled throughout much of the ancient Andes, there is little evidence that the people of the region of Chavín de Huántar conquered other Andean cultures or established the city as the capital of a military empire. Instead, it seems that the city's prestige came from its importance as a religious pilgrimage site, as indicated by the large number of ceramic offerings that are clearly identified with other areas of the ancient Andes. These pilgrims were not conquered, but seem to have come of their own accord with their offerings. As these pilgrims returned to their homes across the Andes, they brought Chavín style and symbols into local traditions. Aspects of the artistic influence of Chavín de Huántar lived on even after it was no longer the center of Andean religion. By 200 CE, Chavín de Huántar's importance had waned and pilgrims no longer came in large numbers to its temples.

Paracas Weaving, *c.* 200 BCE–200 CE

Farther south and toward the end of the Chavín period, an artistic style developed that used some Chavín motifs. This unique style is called Paracas after the people who created it. From around 200 BCE to 200 CE, the Paracas people lived in small villages in the southern coastal desert of Peru. They did not build in the grand architectural style of highland Chavín de Huántar, and their villages were not the sites of great pilgrimages. Instead they excelled in weaving copious amounts of fine cloth (see box: Making It Real: Andean Weaving, p. 197). Paracas is also the name of an important burial ground south

11.4 Pectoral, Chavín de Huántar, *c.* 900–500 BCE. Gold, 9¼ × 9 in. (23.5 × 22.9 cm). Metropolitan Museum of Art, New York.

pectoral a piece of jewelry or armor worn on the chest.

repoussé relief design created by hammering malleable metal from the reverse side (not the side to be viewed).

of Lima (Peru) that contains extensive remains of this culture, including well-preserved cloth that is more than 2,000 years old. This burial ground seems to have been used exclusively by the people who lived nearby.

PARACAS FUNERARY MANTLE Moisture is a great enemy of the preservation of textiles. The south coast of Peru, where the Paracas culture flourished from around 200 BCE to 200 CE, contains some of the driest deserts in the world, and its lack of moisture has preserved cloth and other perishable items, such as feathers, for thousands of years, allowing us to study such items when these same types of objects elsewhere have decayed long ago. The ancient people of this area wrapped their dead in layer upon layer of cloth before burying them in the dry desert, where both bodies and textiles were preserved.

The basic composition of this Paracas funerary mantle shows repeating figures in a grid over the entire expanse of the cloth (**Fig. 11.5**). The figures all share common traits, including a pose with the head emphatically thrown back, giving the design a sense of movement that transcends the restrictions of the grid. Other examples and later depictions on ceramics indicate that these figures were supposed to be viewed as oriented horizontally, as if they are flying through space, stomach down. In this cloth, the figures are primarily **embroidered**, a type of needlework decoration that makes it possible to use many colors in a relatively small space. Embroidery also allows for organic, curved lines, for example the arched backs of several figures (see p. 191).

11.5 Funerary mantle with embroidered decoration, Paracas, Peru, first century CE. Woven cloth, 55⅞ in. × 7 ft. 10⅞ in. (1.42 × 2.41 m) Museum of Fine Arts, Boston, Massachusetts.

The Nasca Culture, *c.* 200 BCE–500 CE

Nasca culture grew directly out of the earlier Paracas culture of the south coast of Peru, flourishing between around 200 BCE and 600 CE. The decline of Chavín de Huántar by around 200 BCE did not profoundly affect the populations of the south coast, who were less closely tied to the great pilgrimage center far to the north. Thus the Paracas culture, which overlapped in time with Chavín, gradually evolved into Nasca without a clear break and with many continuities. Unlike the earlier Paracas villages, however, the Nasca organized themselves into larger, hierarchical groups that scholars believe were ruled by chiefs. The Nasca chiefs competed against one another for political and military power and to obtain the finest jewelry and cloth. The subject matter of Nasca art embodies these chiefs' desire to be seen as powerful leaders.

NASCA "FLYING FIGURE" VESSEL Nasca art is well known for its development of polychrome (multicolored) ceramic decoration, showing elaborately dressed figures. Nasca ceramic art includes many examples of a figure gripping in one hand a human trophy head or heads, a subject seen in earlier Paracas textiles from the same region (**Fig. 11.5**). The figure's body is often horizontal, with its stomach facing the ground as if it is flying, as in this painted ceramic vessel (**Fig. 11.7**). The hand below can be seen holding two decapitated heads by their hair. These figures sometimes carry weapons as well, suggesting that warfare, with its attendant decapitation of enemy warriors, was a key theme in Nasca art. If the representations

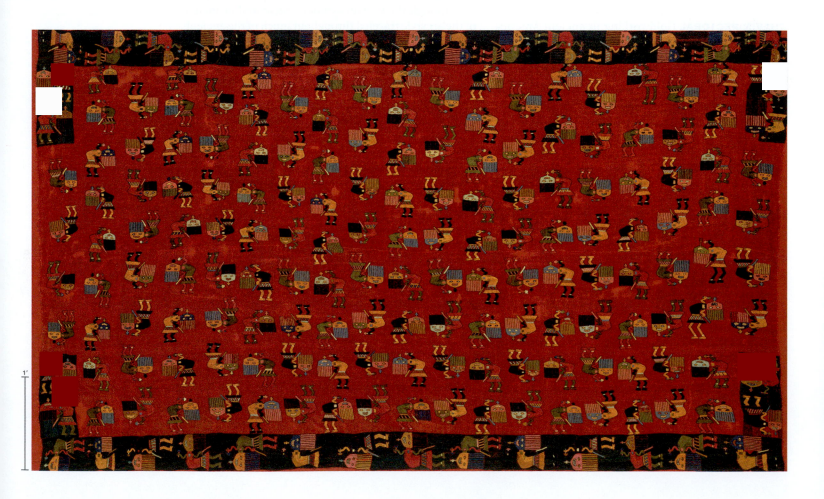

While many world cultures value fine woven cloth, in the ancient Andes, weaving was especially important. Cloth served as a kind of currency for the later Inka people (see Chapter 42), and its value depended as much on the quality as the quantity of the cloth. Inka rulers would isolate the best weavers in the royal residence, where they would spend the rest of their lives making cloth exclusively for elite men and women. Esteemed weavers could be either female or male, although female weavers were more common. The weavers had enormous technical ability, as their final products show. The weaving process was labor intensive. Making fine cloth took a long time even when the weaver was highly skilled. The Inka ruler would use some of the cloth, but he would give much of it to the members of his court. The ruler's ability to control the production of such well-made cloth affirmed his status.

Ancient Andean weaving technology appears simple at first glance. The threads used in the loom were spun by hand, using a method called drop spinning, which required only a stick to spin the raw cotton or wool and a weight to maintain tension so that the thread was tight. To weave the thread into cloth, Andean weavers (like many ancient American weavers) used a backstrap loom (**Fig. 11.6**). A traditional backstrap loom consists of two beams positioned horizontally that hold the warp (vertical) threads in place, with a strap at one end (attached to one of the beams) that passes around the weaver's back. The other end of the loom is affixed to an immobile object by a rope. When the weaver,

who is seated, leans back into the backstrap, his or her weight creates the necessary tension in the loom's warp threads. Even though it is a simple machine, a backstrap loom allows weavers to create intricate patterns, such as the tapestry weave that was so highly valued by both Inka rulers and later Spanish colonizers. In tapestry weaving, patterns are woven directly into the textile, not sewn on or otherwise added later in the process.

The act of weaving creates a tendency toward hard-edged geometric forms, because the warp (vertical) and weft (horizontal) threads are laid out at right angles to one another. The earliest Andean weaving displays strict geometric designs that were later counterbalanced by embroidering or painting more organic, curved designs on the woven cloth. However, many later Andean textiles continue to show a preference for geometric patterning that highlights the weaving technique. In fact, weaving was so central to the ancient Andean artistic ideal that other art forms used the same geometric motifs, even though these motifs were more difficult to execute in other media. For example, Andean painting on ceramic often echoes woven geometric decoration, despite the difficulty of achieving such regular, straight forms on the curved exterior of a painted vessel.

11.6 Diagram of a backstrap loom and weaver.

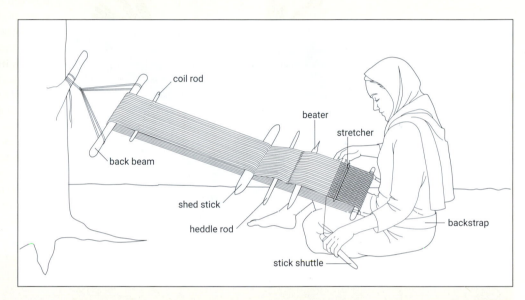

of trophy heads in Paracas art signal the practice of ritual decapitation, it is likely that such practices began in the villages of Paracas and then continued to be important for the Nasca chiefs.

The stylized figures on the Nasca ceramics display a sense of movement that is strengthened by the horizontal orientation, the emphatic hand gestures, and the head thrown back. Such lively depictions may indicate an ecstatic religious state that was made possible by the taking of a trophy head and its associated rituals. Because no evidence has been found that the Nasca people used writing, there are no contemporary texts that provide specific insight into the meaning of these images. However, several later Andean and Amazonian groups valued trance states in which a person displayed ecstasies of violent movement. The ability to enter trance

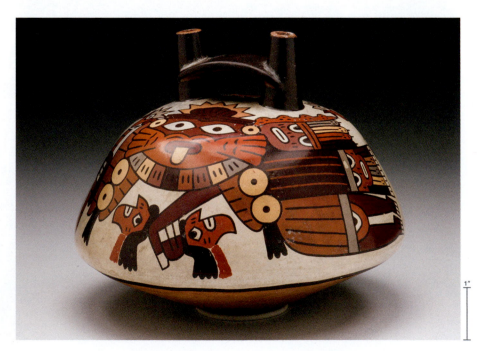

11.7 "Flying figure" vessel, Nasca, Peru, c. 50–200 CE. Ceramic with slip, height 5½ in. (14 cm). Art Institute of Chicago, Illinois.

states, using hallucinogenic substances, was often a route to social prestige and political power. Such people were important to many Andean and Amazonian societies. Several scholars have suggested that the combination of military expertise and religious power, as depicted in the trophy-head imagery, was a key foundation of a Nasca chief's power.

GOLD MOUTH MASK Nasca artists also worked in gold, which was fashioned into jewelry that chiefs and other elite persons wore. This mouth mask of finely hammered

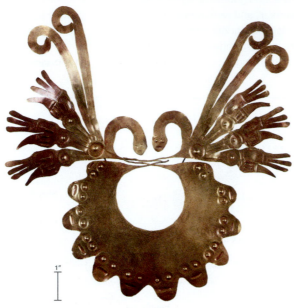

11.8 RIGHT **Mouth mask,** Peru, Early Nasca style, first century BCE. Gold, 10 × 10 in. (25.4 × 25.4 cm). Textile Museum, George Washington University, Washington, D.C.

11.9 BELOW **Hummingbird, Nasca line on a desert plain,** Nasca, Peru. *c.* 500 CE. Approx. length 320 ft. (98 m).

gold with details in repoussé (**Fig. 11.8**) is similar in design to the one shown on the flying-figure vessel (**Fig. 11.7**): On the vessel, the mask is indicated by the red-colored form around the figure's mouth that ends in whisker-like projections on either side. Today, many museum collections include several such gold mouth masks. Although we do not know where they were originally found (see Seeing Connections: Stolen Things, p. 219), many scholars assume that the masks are costume elements that were placed in elite tombs, as they were in other Andean traditions. The red color used for the mouth mask on the ceramic suggests that these gold masks may have originally been painted red, though this is often lost to the ravages of time and/or restoration.

NASCA LINES In addition to items in cloth, ceramics, and gold, Nasca artists created enormous works, now known as the Nasca lines, in the dry desert landscape of the south coast. Nasca people removed rocks to reveal the lighter ground underneath. They then piled these same rocks on either side of the line, framing and high-lighting the line formed by the pale color of the desert floor. While some of the lines are straight or form geometric shapes, the best known are those that represent animals, such as the hummingbird seen here (**Fig. 11.9**). Other lines depict different types of birds, monkeys, and even a killer whale.

The lines, which the Nasca made throughout their history, were certainly not the work of extraterrestrial visitors, as some sensationalized accounts claim. The Nasca lines follow a style much like that seen on Nasca ceramics and textiles, emphasizing bold, dynamic, and

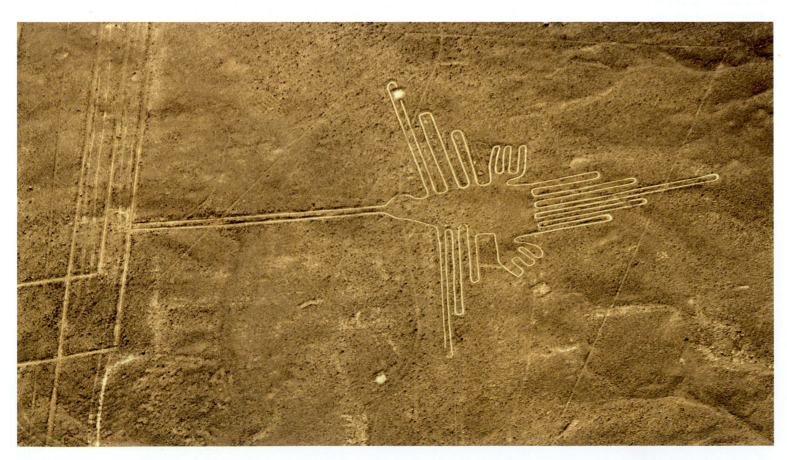

stylized forms. Ceramics were often carefully positioned near the lines, suggesting that the latter served a religious purpose and that the ceramics were offerings, much like those placed inside the earlier Chavín temple. Other ancient Andean people made similar desert markings, probably also for religious purposes, but none did so in these numbers and on this scale; some of the Nasca straight lines are 6 miles (9.6 km) long. Many of them converge at the most sacred Nasca site (Cahuachi), implying that one purpose of the lines was to mark sacred paths, much like the pilgrimage paths that led to the early site of Chavín de Huántar. They may also have marked astronomical phenomena, such as the movement of celestial bodies.

The Moche Culture, *c.* 150–700 CE

As the Nasca artistic culture grew and flourished from around 100 CE to 500 CE, several regional cultures developed across the Andean landscape. On the northern coast of the old Chavín region, populations were developing the distinctive Moche culture. Of all the ancient Andean ceramic traditions, the Moche, a culture that flourished between 100 and 700 CE, has received the most attention by Western scholars. It is easy to see why: many Moche ceramic sculptures exhibit a careful, detailed naturalism that is rare in ancient Andean art history but highly prized in Western art markets and museums. Even when the ceramics were not sculpted into portraits, they were often painted with detailed, informative narrative scenes.

MOCHE PORTRAIT VESSEL While the Nasca tradition flourished in the south, Moche was the most distinctive tradition in northern Peru. There are at least two key differences between Moche and Nasca ceramics. First, while Nasca artists used up to thirteen colors on a single vessel (see **Fig. 11.7**), Moche ceramics, such as this example (**Fig. 11.10**), usually exhibit no more than two colors, typically red on cream. Second, the upper portion of Nasca vessels often contains two spouts connected by a bridge (the handle), unlike the stirrup-like curved shape with a single spout preferred by the Moche. The stirrup-spout was a high-status ceramic form in this same north Andean region inhabited by the earlier Chavín-related cultures.

While Moche is not the direct inheritor of Chavín forms and symbols—the Moche culture arose approximately three centuries after the Chavín period—the key role of Chavín artistry in the Moche region is apparent in the similarity of the stirrup-spout. A substantial number of Moche ceramic heads represent very different facial types, which suggests that the figures are portraits. Here we see the Moche preference for a more naturalistic treatment than that preferred by their ancient Andean neighbors or ancestors. This ceramic artist does not focus solely on the face (compare **Fig 11.7**), instead investing energy in creating a headdress, with multiple birds sprouting from the headband. The birds' wings are painted in the red and brown used on many other Moche ceramics. The attention given to each individual, as well as to specific status symbols such as the headdress, suggests

11.10 Portrait vessel, Moche, Peru, *c.* 400–600 CE. Ceramic with slip, height 13½ in. (34.3 cm). Museo Larco, Lima.

that many of these portraits may represent rulers who were believed to be semi-divine.

Though aspects of the Moche style of ceramics remain consistent through time, the tradition did undergo some changes over the centuries. The earliest Moche ceramics were completely shaped by hand, while some later examples were created using molds that allowed for the reproduction of the same pot forms several times over. Thus the later vessels no longer captured a unique portrait of a specific individual, representing instead a generic elite person, made from the same mold.

MOCHE EAR ORNAMENT Many ancient Americans believed that decoration around the ear was very important; such adornment may have indicated social standing. Often the desire for more elaborate decoration led to the

11.11 Ear ornament, from Sipán tombs, Moche, Peru, *c.* 300 CE. Gold and turquoise, diameter 4¾ in. (12.1 cm). Museo Tumbas Reales de Sipán, Peru.

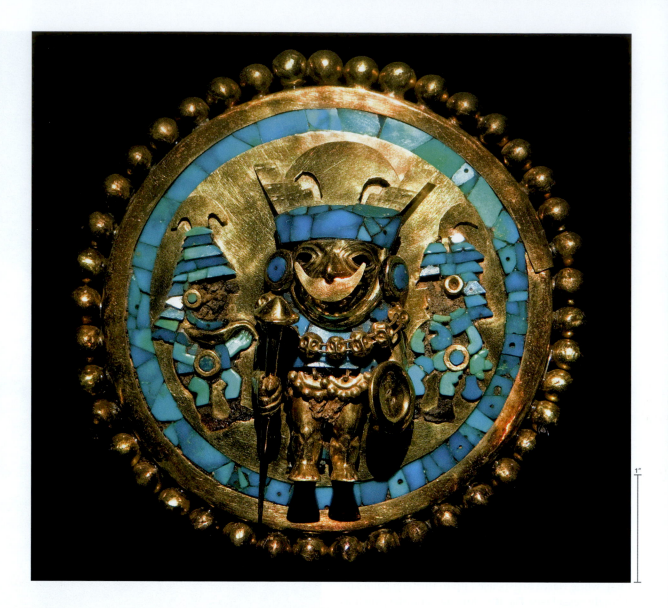

development of ear ornaments that were attached in various different ways to the earlobe. The Moche created particularly complex ear ornaments in metal (**Fig. 11.11**). For example, the figure in the center of this composition wears striking gold-and-turquoise ear ornaments that immediately draw the viewer's attention.

The back of the central figure is attached to the surface of the piece, but its front and sides project away from the surface in **high relief**. The figure wears numerous costume items that also appear in illustrated scenes on Moche ceramics, including a sacrificial knife emerging from the top-middle of the headdress, a gold nose ring in the form of an upturned crescent shape, and a ceremonial mace (heavy club) and shield. Buried skeletal remains dressed in similar costumes have been found in the graves at the site of Sipán, where this ear ornament was found.

TOMB OF MOCHE LORD, SIPÁN The tomb (**Fig. 11.12**) that contained the ear ornament was one of the richest and most important finds in Moche archaeology. In the tomb, a man of high status, known as the Lord of Sipán, was buried with a gold crescent headdress identical to that worn by the figure on the ear ornament. The Sipán tomb

also contained a mace, and belt decorations that are similar to those worn by the ear-ornament figure (seen toward the bottom of the person in the burial). The Sipán lord's body was flanked on each side by a servant or follower, just as the ornament shows assistants on either side of the main figure. A less prestigious burial was laid at the lord's head. The ornament may be an example of the exalted regalia of the person who wore it and was eventually buried with it.

The fantastic riches that were buried with the Sipán lord, and with other important people, suggest a complex society divided into a ruling class and a working class. Rulers and other important officials received these lavish burials, while most Moche did not. Furthermore, the items in the burials differed according to the particular political or religious office held by the deceased. Thus, even the wealthy were divided into specific social offices, again suggesting a hierarchical society of a type that differed from that of the earlier Andean period dominated by the pilgrimage site of Chavín. The Nasca of this same period were also interested in using grave goods to differentiate their powerful figures, but thus far no Nasca burials have been found that rival the richness and social complexity of the Moche burials.

high relief raised forms that project far from a flat background.

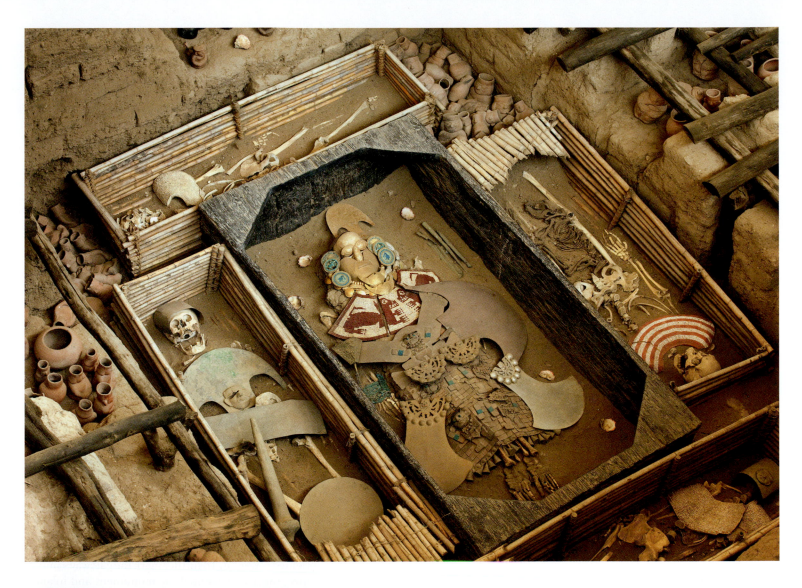

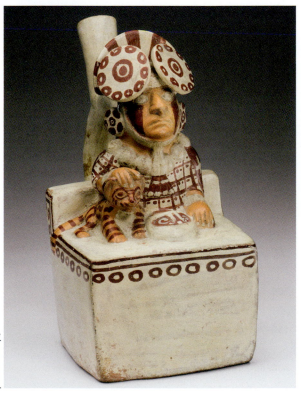

MOCHE CERAMIC WITH HUMAN AND FELINE More detailed descriptions of elite Moche people are found on sculpted and painted narrative ceramics. These ceramics exhibit the same red-on-cream painting style and the same stirrup-spout handle seen in the portrait vases (see **Fig. 11.10**), but instead of focusing on a single figure, they include multiple interacting figures. Scholars believe that these vases depict the rituals performed by the richly dressed officeholders seen throughout Moche art, including the one on the ear ornament (see **Fig. 11.11**). The vase in **Fig. 11.13** shows a seated man with ear ornaments and disks attached to his headdress, as well as a cape and other garments. Next to the man sits a pampas cat, a type of feline indigenous to the Moche area. The whole scene takes place in an area defined by red lines and repeated circles that forms the top part of the vase. The bottom half is rectangular, giving stability to the vessel, which was intended to hold liquid. The vessel's design thus perfectly integrates its subject (the seated man and cat) with its function (as a container).

MOCHE STIRRUP-SPOUT VESSEL In addition to three-dimensional ceramic sculpture, the Moche developed a fine-line drawing style that allowed them to represent detailed ritual scenes on their ceramic vessels.

11.12 ABOVE **Tomb of Moche Lord (Tomb 1),** Sipán, Peru, *c.* 300 CE.

11.13 FAR LEFT **Vessel in the form of a seated ruler with a pampas cat,** Moche, Peru, *c.* 250–550 CE. Ceramic, 7⅝ × 7½ in. (19.4 × 19.1 cm). Art Institute of Chicago, Illinois.

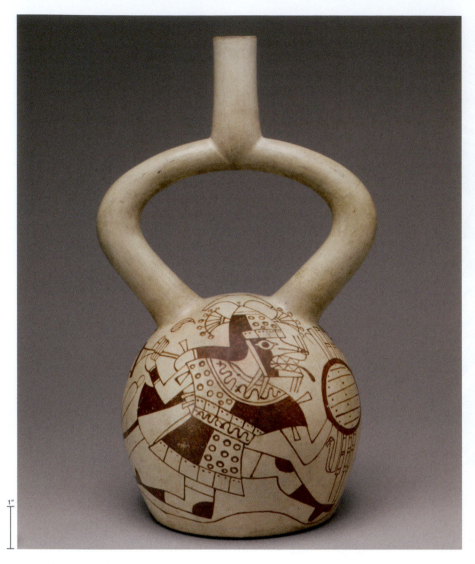

11.14 Stirrup-spout vessel depicting fox-headed (or fox-masked) warrior, Moche, Peru, c. 600–750 CE. Ceramic, height 11⅝ in. (29.5 cm). Metropolitan Museum of Art, New York.

Tiwanaku art is clearly Andean in its depiction of repeating figures and specific deities that mix human and animal characteristics, but it differs from Nasca and Moche art in its emphasis on stonework.

GATEWAY OF THE SUN, TIAHUANACO The Tiwanaku stone-carving tradition drew on the earlier Chavín tradition, which had mastered stone carving and ashlar masonry. One of the most impressive works of Tiwanaku carving is the Gateway of the Sun at Tiahuanaco (**Fig. 11.15**). Although the image reproduced here suggests that the piece is an isolated doorway, it originally served as a ceremonial entrance into a sacred precinct in Tiahuanaco. The principal imagery consists of a central figure at the very apex of the monument, posed frontally in high relief and holding a spear thrower in one hand and darts in the other. The face is sculpted in the highest relief, while the rest of the body does not project so far from the background. The frontal pose and stiff, geometric approach to the body are typical of Tiwanaku art, and the same treatment can be seen on Tiwanaku ceramics and in textiles. The central deity, commonly called the Staff God, is related to earlier Chavín deities who were also depicted frontally and held staffs or other objects of power in each hand. Several winged figures in low relief flank the god on the gateway. The Staff God and accompanying winged creatures are found throughout Tiwanaku art and appear to be the most important deities of that culture.

A carefully constructed grid orders the placement of the subsidiary figures on the Gateway of the Sun. We can compare the grid pattern to the way figures are arranged in many Andean textiles (see the Paracas textile from the adjacent south coast, **Fig. 11.5**). The winged creatures are considerably smaller than the main deity and are all oriented toward it. To further mark the gateway's importance, the artists painted the monument and inlaid it with turquoise and gold, though these embellishments have been lost over time. The addition of color created even more similarities with woven garments; as noted earlier, the importance of weaving in Andean art cannot be overstated. Here in the highlands, this textile aesthetic has been transferred to a monumental stone artwork.

As in other Moche ceramics, the artists limited their color palette, usually to two colors; this vase's red decorations on a cream background are typical (**Fig. 11.14**). **Contour line** is a simple style of drawing, but here it describes an intricate scene. A figure is running along a landscape indicated by wavy lines toward the bottom of the piece. This figure holds a shield in one hand and a mace in the other, and he wears a decorated tunic cinched with a belt, both of which bear a serpent motif. He has the face of a fox, or perhaps he is wearing a fox mask. What appears to be a tail is attached to the back of his headdress, which has the crescent-shaped sacrificial knife as its crowning motif (similar to the one from the Sipán tomb in **Fig. 11.12**). The actual costumes found in the Sipán burials suggest that the stories told on Moche ceramics illustrate real rituals conducted by humans dressed in costumes such as this one.

The Tiwanaku Culture, c. 200–500 CE

In the mountains high above the Nasca plains, the Tiwanaku artistic culture arose at about the same time as the Moche in the north and the Nasca in the south. The capital of this culture is known as Tiahuanaco ("Tiwanaku" is based on the English pronunciation of Tiahuanaco), an extensive site near Lake Titicaca in present-day Bolivia.

contour line the outline that defines a form.

Chronology

12,500 BCE	Important early evidence for humans in the Americas (Monte Verde, Chile)
900–200 BCE	Chavín de Huántar and its temples are a major religious center; the Chavín art style is highly influential
200 BCE–200 CE	The Paracas culture in southern Peru makes decorative fine cloth
200–500 CE	The Nasca culture in southern Peru creates multicolored ceramics, goldwork, and the Nasca Lines
150–700 CE	The Moche culture in northern Peru makes sculpted and painted ceramics
200–500 CE	The Tiwanaku culture builds its capital (Tiahuanaco) with a monumental gateway

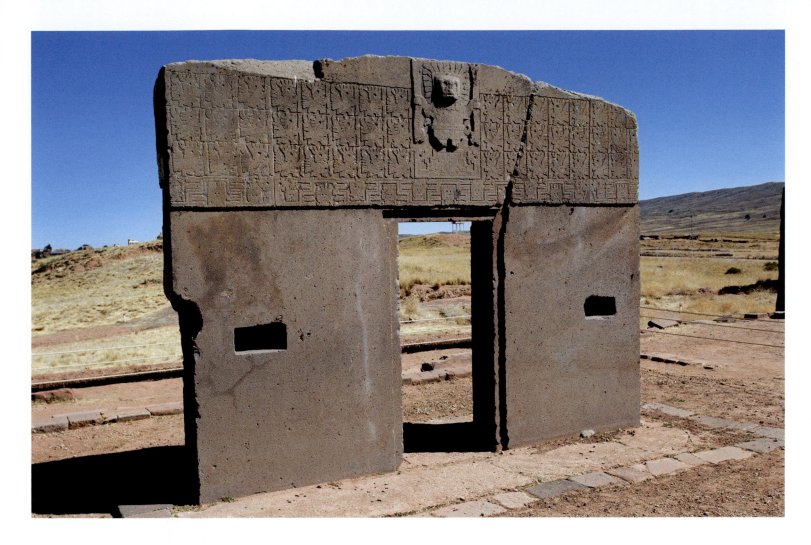

With the rise of another highland capital in the region called Wari, Tiwanaku culture experienced a transformation after 500 CE. Together the twin capitals of Wari and Tiahuanaco developed a shared artistic vocabulary that is described in Chapter 30. These capitals are just two in a long line of cultural developments in the Andean region. Beginning with the Chavín art style in 900 BCE and continuing through the artistic cultures described in this chapter, the population of the Andean region practiced a series of art styles built around the ancient practices of weaving textiles and making ceramics combined with the new technology of goldwork. Monumental buildings, finely painted ceramics, stone sculpture, and metalwork were all developed during this period, 900 BCE through 500 CE. A pan-Andean set of religious concepts emerged and circulated throughout the Andes, with significant transformations in each regional context. Parallel developments took place in Mesoamerica, the other hub of complex society in ancient America (see Chapter 12).

11.15 Gateway of the Sun, Tiwanaku culture, *c.* 375–500 CE. Stone, 9 ft. 10 in. × 13 ft (3 × 3.96 m). Tiahuanaco, Bolivia.

Discussion Questions

1. Ancient societies in the Americas established their artistic traditions without the input of traditions from outside the continents. How does this differ from the development of art in other world regions (Europe, Africa, Asia)?

2. Why did early people in the Andes build monumental structures? How did building practices, and the ideas that they embodied, change with the creation of Chavín de Huántar? What artistic ideas and conventions remained unchanged after the Chavín period?

3. Andean art as a whole has often been characterized as geometric and abstract. What do scholars suggest is the basis for this shared quality? Identify some exceptions (such as more naturalistic treatments), and explain why they are different.

Further Reading

- Atwood, Robert. "Connecting Two Realms: Archaeologists Rethink the Early Civilizations of the Amazon." *Archaeology* (July/August 2017).
- Bernier, Hélène. "Birds of the Andes." In *Heilbrunn Timeline of Art History*, New York: The Metropolitan Museum of Art, (June 2009) http://www.metmuseum.org/toah/hd/bird/hd_bird.htm
- My Peru Guide. "Andean Textile Process in Cusco – My Peru Guide." (2018) https://www.youtube.com/watch?v=pQTiNn7a2MU
- Quilter, Jeffrey. *The Ancient Central Andes* (Routledge World Archaeology Series). London: Routledge, 2013.
- Stone, Rebecca R. *Art of the Andes: From Chavín to Inca* (3rd edn.). London: Thames & Hudson, 2012.

	1000–500 BCE	500–100 BCE	100 BCE–1 CE	1–100 CE	100–300 CE	300–800 CE
Americas					1 Pyramid of the Moon, Teotihuacan, Mexico	
Africa					6 Arch of Septimius Severus, Leptis Magna, Libya	
Europe	9 Amphora with Ajax and Achilles, Athens, Greece	2 Parthenon, Athens, Greece	4 Augustus as *imperator*, Prima Porta, Italy	8 Pont-du-Gard, Nîmes, France		11 Apse mosaic, church of Santa Pudenziana, Rome, Italy
South and Central Asia		7 Lion capital from Ashokan pillar, Sarnath, India		3 Plaque with women under gateways, Begram, Afghanistan		12 Buddha from Gupta period, Sarnath, India
East Asia		10 Prince Liu Sheng's jade burial suit, Mancheng, China				5 Daisen Tomb, Kofun period, Osaka, Japan

Early Cities and Empires

Over the course of two millennia, beginning around 1,000 BCE, human populations increased, cities became bigger and more complex, clusters of city-states operated as loose confederations, and powerful new empires emerged. Although most people lived in rural communities, several important urban centers—from Teotihuacan in present-day Mexico to Athens in Greece—also developed during this period. Trade routes, including the famed Silk Road (actually a series of routes spanning Eurasia), connected cities all the way from East Asia to the center of the Roman Empire, bringing a wide variety of objects, styles, and forms to local contexts, such as the Indian-style ivory carvings found as far apart as Begram in present-day Afghanistan and Pompeii in present-day Italy.

The people who traveled along trade routes also carried with them new ideas and religious beliefs. In addition, wars and territorial conquests affected economic, social, cultural, religious, and political conditions. In various regions of Asia, in South and Central America, near the Niger River in Africa, and in the lands encircling the Mediterranean Sea, independent cities and small population centers were absorbed into expansive empires, including the Chinese Han dynasty, the Maya in Mesoamerica, and the Persian and Roman empires in Eurasia. Rulers used art and architecture, including portrait sculpture and elaborate graves, to display their prestige. They constructed new types of monuments, such as Roman triumphal arches to celebrate military victories and freestanding pillars in South Asia carved with edicts to communicate laws.

Some empires harnessed the expertise of engineers and stonemasons to build public works, among them aqueducts and baths. Alongside these developments, social stratification increased as power and wealth accumulated in fewer hands. Elite men and women acquired luxury items made of prized materials in the latest styles—for example, ceramics for Greek homes. Concern with the afterlife likewise led rulers to fill their tombs with precious objects, such as the jade items found in Chinese royal burials. New iconographies, styles, and forms of religious art also emerged alongside the birth of several new religions, including Christianity and Buddhism.

12

Art of Early Mesoamerica

before 600 CE

Offering 4 (detail),
La Venta, Mexico.

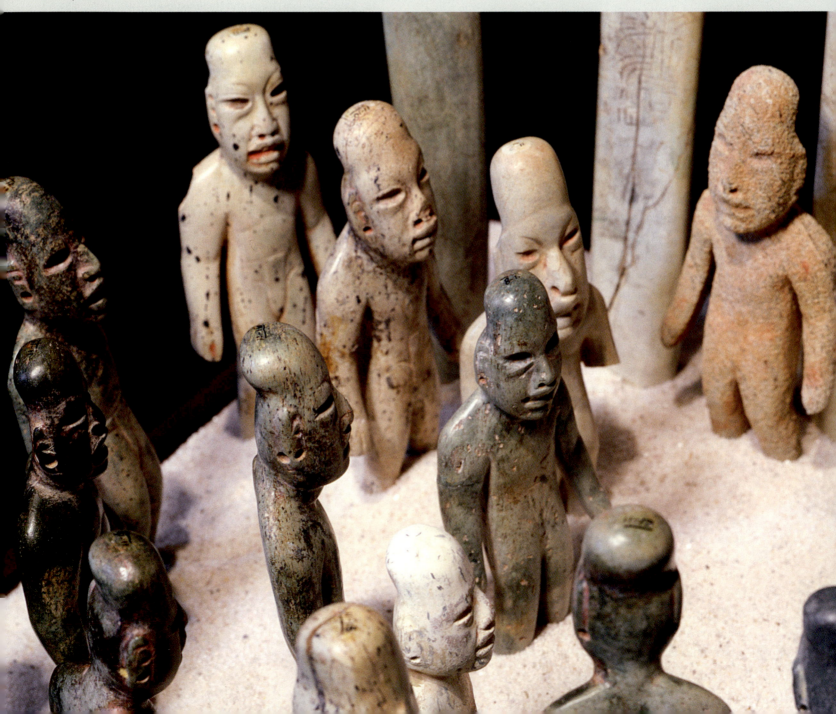

Introduction

At about the same time that Andean culture was developing in what is now Peru, a complex culture was emerging in the region known as Mesoamerica. This area stretches from central Mexico in the north through Guatemala and Belize to parts of El Salvador and Honduras in the south (Map 12.1). To the south stretches Central America, which merges into South America farther south and where the other center of ancient American culture, Peru, is located (see Map 11.1). Peru's first widespread artistic culture (Chavín, see Chapter 11, p. 192) began about 900 BCE; Mesoamerica's may be dated only a little earlier, at 1200 BCE.

Ancient Mesoamerican societies shared specific cultural elements that are unique to this region, including a 260-day ritual calendar, hieroglyphic writing in books and other media, and the love of a ritualized game played with a rubber ball. The ballgame was seen as a battle between supernatural forces, and the rituals performed during and after the game were meant to channel those forces.

Mesoamerica, like the Andes, encompassed a rich variety of climates and landscapes, from cold, high-altitude areas through the milder mountainous regions and down to the tropical jungle nearer the Atlantic and Pacific coasts. The great variety of climates and physical features of the land allowed for a range of resources and crops in a rather small area, leading to specialization in, and trade between, communities at different altitudes. Traders and other travellers could count on certain shared beliefs and practices at all altitudes, including the specific ritual calendar of 260 days. Yet, despite their cultural similarities, Mesoamerican groups saw themselves as different societies with distinct identities, clothing styles, and languages, many of which are still spoken today.

More than 3,000 years ago—by 1200 BCE—Mesoamericans developed the first cities in the Americas. Societies became more hierarchical, with an elite class that governed each city and its surrounding region until the arrival of the Spanish some 2,000 years later. An increasingly productive agricultural system allowed some city-dwellers to specialize in the making of art, resulting in the first monumental stone sculptures, as well as finely carved small objects of jade, the blue-green stone that Mesoamerican artists polished until it glistened. To build monumental architecture, which was often used for religious ceremonies, and to bring prestige and symbolic importance to their cities, the elite classes mobilized large groups of local people and often traded for or transported resources from afar.

Most of the traits that defined Mesoamerica throughout its history have their beginnings in Olmec culture (c. 1200–400 BCE), such as the art of jade carving. The complex cities of the Olmec and other early Mesoamerican cultures reflect the rise of warrior rulers who used monumental sculptures, temples, pyramids, and burial objects to associate themselves with powerful deities or natural forces, to legitimize and celebrate their rule and power, and to serve as historical reminders for future generations. Later Mesoamerican cities displayed a powerful emphasis on regularity and geometry, in a similar way that modern cities are laid out on a street grid system.

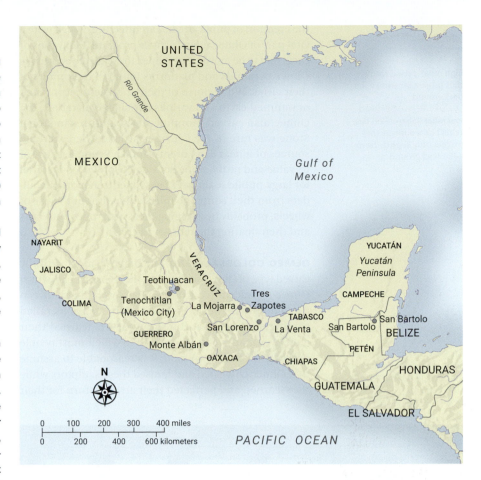

Map 12.1 Major sites in Mesoamerica before 600 CE.

Olmec Sculpture, 1200–400 BCE

When archaeologists began to find traces of an ancient culture on the Mexican Gulf Coast, they dubbed the culture Olmec, a name given to later cultures of the same region, a land characterized by rich river valleys in a hot, humid, tropical environment. These cultures are collectively known as the Olmeca, or the people of the Land of Rubber. Rubber trees, which are native to the Gulf Coast, served as the source for the rubber balls used in the ancient, ritualized Olmec ballgame.

By 1200 BCE, the area around the first Olmec city, called San Lorenzo by archaeologists, supported a complex society composed of high-status individuals living in palaces in the city center, specialists in stone-carving who created monumental sculptures for the city center, and farmers and fishers living and working in the surrounding areas. Their diet consisted of foraged foods, fish, local game, tropical tubers (foods that grow underground, such as potatoes), and maize (corn), the staple crop of the Olmec and all later Mesoamericans. By 900 BCE, the people of the Olmec city of La Venta were building monumental **rammed-earth** architecture and beginning to carve public monuments in stone, further developing many aspects of San Lorenzo stone and jade sculpture. San Lorenzo was abandoned around the time that La Venta gained prominence, approximately 900 BCE. La Venta flourished for at least 500 years, diminishing around 400 BCE when the site of Tres Zapotes rose to prominence.

The creation of Olmec cities, such as San Lorenzo and later La Venta, suggests the presence of leaders who were capable of organizing sizable workforces to aid in

rammed earth a building technique in which damp earth is compressed, usually within a frame or mold, to form a solid structure.

relief raised forms that project from a flat background.

high relief raised forms that project far from a flat background.

low relief (also called bas-relief) raised forms that project only slightly from a flat background.

12.1 Colossal Head, (Head 8), San Lorenzo, Mexico, Olmec, c. 1200–900 BCE. Basalt, 7 ft. 2 in. × 5 ft. 5 in. (2.18 × 1.65 m), weight approx. 13 tons. Museo de Antropología, Xalapa, Veracruz, Mexico.

the creation of public art and architecture, which were a vital part of Olmec rulers' artistic program. Many tons of earth had to be moved and shaped to create the enormous Olmec pyramids and platforms found in the centers of their cities. While much of their architecture consisted of rammed earth and various perishable materials, the Olmec also carved monumental sculptures in stone. Stone was rare in the Olmec heartland; there were no sources of it near San Lorenzo and La Venta. Because of its value and rarity, stone became the preferred material for large public sculpture. The Olmec transported boulders from their source 50 miles away without the use of wheels, probably by dragging them with ropes onto rafts and then floating them down the river.

OLMEC COLOSSAL HEAD The biggest, most skilfully carved type of Olmec sculpture is the colossal head, which Olmec artists crafted from boulders weighing between 5 and 20 tons. The skill shown in the heads' detailed carving suggests that the stone carvers learned their craft over many years. In a world in which most people had to grow their own food, it is reasonable to assume that Olmec chiefs fed and housed these sculptors while they learned and perfected their art. In return for their

royal patrons' support, they created monumental portrait heads of those patrons, which expressed the rulers' serious and awe-inspiring character.

Colossal heads were first discovered at Tres Zapotes in 1869. Many are more than 5 feet (1.52 m) high, and a total of seventeen have been found across all three major Olmec sites. They are superbly carved, with eyelids, nose, and mouth carefully modeled to create a sense of compelling naturalism. While many Olmec artworks contain naturalistic elements, few carry as much detail as the portrait heads do. Each includes individualized motifs in the upper portion, such as the flanking feathers on the band around the forehead of the San Lorenzo colossal head shown here (**Fig. 12.1**). The same configuration of elements is not repeated on another head. In addition, certain facial features, such as the shape and depth of the eyes and the cheeks, are specific to each. Together, the unique headdress motifs and the individualized facial features suggest that Olmec artists were representing particular people. The detailed naturalism found in these works is more remarkable when one realizes that the Olmec did all their work with tools made of stone: they had no metal tools. Artworks with such fine carving, on such a massive scale, had not been created in Mesoamerica before.

LA VENTA THRONE (ALTAR 4) In addition to a portrait head, many Olmec rulers commissioned an elaborate royal seat, or throne. Like the colossal heads, the monumental thrones were carved out of single blocks of stone. While thrones vary in size and detail, most take the form of a table, or altar, with the tabletop serving as the ruler's seat and the inset lower sides of the monument carved with figures and scenes in **relief** (**Fig. 12.2**). For example, the lower side of the La Venta altar depicted here contains a human figure carved in **high relief**, seated in a central niche. In his right hand the figure holds a thick strand of rope, of the sort that would have been required to drag huge stones such as this throne across the swampy Olmec landscape. The rope continues around the sides of the monument and ends attached to another human figure. The central niche is decorated on either side with symmetrically placed **low-relief** flower motifs. Because these motifs are also found at the entries to actual caves in the art of the period, it is likely that they express the idea of a cave or other entrance to the Underworld. The Underworld encompassed everything that was under the earth's surface, and was one of the three great divisions of the Olmec cosmos, along with the earth's surface and the sky. Above this cave motif is a highly simplified low-relief representation of a jaguar (also associated with caves and the Underworld), above which is a seat for the ruler. The throne's artistic program illustrated the power of the Olmec leader seated on it by associating him with valuable stone, passages to the Underworld, and the fierce power of the jaguar.

The scarcity of stone led the Olmec to reuse the precious material. A sculpture workshop in San Lorenzo includes evidence of stone sculptures that were in the process of being reworked into other figures when they were abandoned, probably during the city's decline.

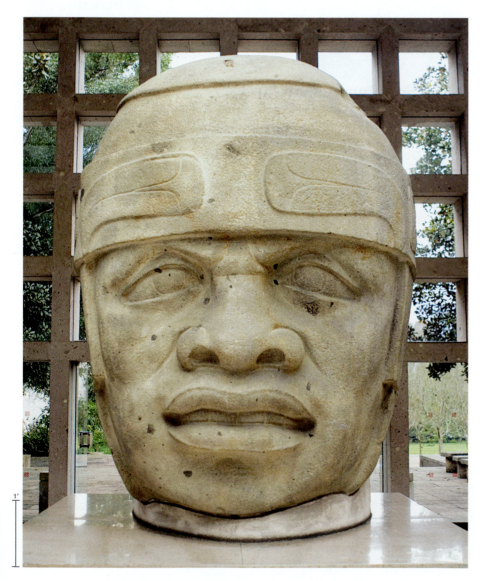

1'

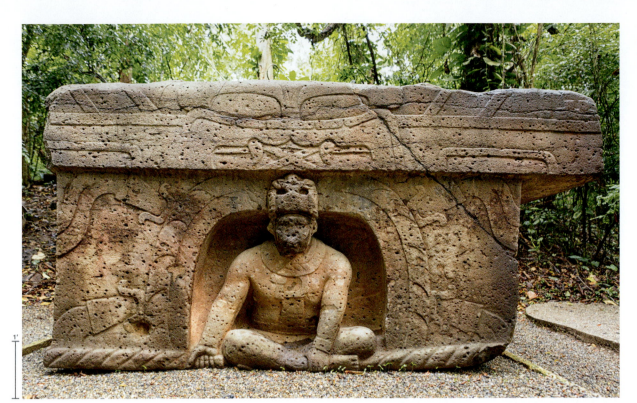

12.2 **La Venta throne (Altar 4),** Olmec, *c.* 900–400 BCE. Stone, height 5 ft. (1.52 m). Parque Museo La Venta, Villahermosa, Tabasco, Mexico.

Some of the most interesting cases of reuse are the conversions of Olmec thrones into colossal heads. Evidence on two colossal heads, including traces of the original niche, suggests that they were recarved out of thrones. It seems likely that artists memorialized at least some Olmec rulers by transforming their throne into a colossal portrait.

OLMEC JADE AX Olmec artists also created works out of **jade**, an especially valuable type of greenstone. Jade is an extremely hard stone that required a professional carver to spend many hours wearing away the rock with a mixture of sand and water, using a manual drill and abrasives to carve out the form (see Fig. 8.6). Because there were no fine jade deposits in the Gulf Coast Olmec area, they developed trade networks with the Maya, who controlled the most highly valued jade source in what is today Guatemala. The Maya and Olmec exchanged not only jade itself but also ideas about the value and symbolism of this stone. The jade-carving tradition begun by the Olmec continued throughout Mesoamerican history until the region's conquest by the Spanish, who found little value in the stone when compared to gold and silver.

The San Lorenzo Olmec had made beautifully finished jade objects without **incision** or other decoration. With the advent of La Venta, however, a range of small pieces of finely worked jade appeared, with incised symbols that often represent a deity who personifies maize or a ruler who impersonates the maize deity. The importance of this deity reflects Olmec farmers' increased cultivation of maize, a plant with leaves of the same deep green color found in the finest jade (see box: Art Historical Thinking: The Place of Maize in Mesoamerican Culture, p. 212).

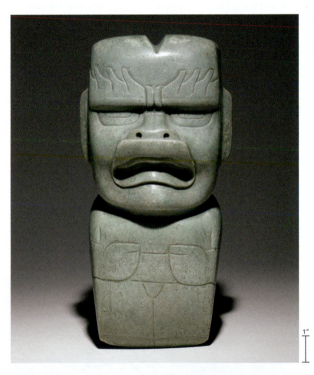

12.3 **Ceremonial ax (celt) in the form of a deity,** *c.* 900–400 BCE. Jade, height 11½ in. (29.2 cm). British Museum, London.

One type of object that Olmec artists created from jade was the **celt**, or ceremonial ax head. These celts echo the shape of the head on the farmer's ax, used to clear the jungle in preparation for planting, but the jade examples show no evidence of such use. The major elements of this celt (**Fig. 12.3**) include the downturned mouth with projecting upper lip and an indentation at the top of the head, which is oversized compared with the rest of the body. The artist has incised only the basic outlines of the lower body: a pair of hands hides a belt, below which is a vertical line that indicates two legs. Clearly,

jade general term for green minerals including nephrite and jadeite.

incised cut or engraved.

celt an ax head that is typically only used ceremonially.

the focus is on the facial features. Even here, however, the artist concentrated on the larger forms rather than small details, such as skin texture, wrinkles, or other individual characteristics. This treatment, which focuses on clean, massed forms, is common in Olmec figural sculpture.

Unlike the individualized features and headdresses of the colossal heads, the deity represented in this particular celt strongly follows traditional forms that vary little throughout San Lorenzo and La Venta sculpture. Some early scholars identified the face of this deity as a were-jaguar, a supernatural entity with jaguar-like characteristics including a snarling mouth and a vaguely feline nose that often appeared infantile. More importantly, the maize stalk that is often carved growing from the cleft in the center of the head (but not in **Fig. 12.3**) associates the celt with that plant and suggests that the deity is the Olmec maize god.

Olmec Cities: La Venta, *c.* 900–400 BCE

The civic and ceremonial focal point of La Venta was a monumental pyramid made of rammed earth rising to almost 100 feet (300 m) high. The earlier Olmec center of San Lorenzo did not contain a pyramid, although it did have central rammed-earth platforms, as La Venta later did. La Venta's pyramid is therefore the first in a long line of Mesoamerican monumental pyramidal buildings, whose construction stopped with the Spanish invasion in the sixteenth century CE. The pyramid is framed by an enclosed plaza to the north and an open, more public plaza to the south (**Fig. 12.4**). Both these plazas are defined by great rammed-earth platforms along their east and west sides. At some point in La Venta's history, four colossal heads were placed at the north entrance to the north plaza (see **Fig. 12.4**, top), and the area just to the south, in Complex A, was consecrated with some of the most spectacular greenstone and jade deposits known from the Mesoamerican world, left undisturbed until their recent discovery.

LA VENTA GREENSTONE OFFERING One **cache** in this northern area consisted of large rectangular blocks of

cache a deposit of materials or objects that does not include a burial.

tableau a stationary scene of people or objects, arranged for artistic impact.

sarcophagus a container for human remains.

stele a carved stone slab that is placed upright and often contains commemorative imagery and/or inscriptions.

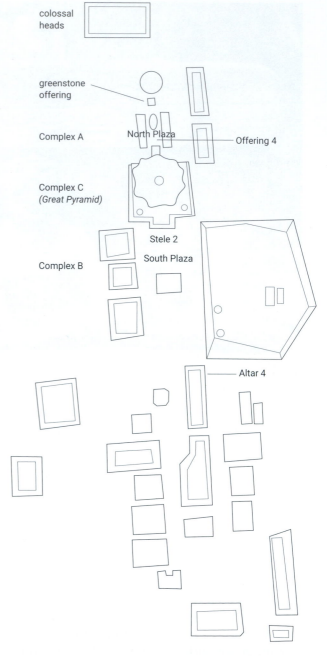

colossal heads

greenstone offering

Complex A North Plaza Offering 4

Complex C *(Great Pyramid)*

Stele 2

Complex B South Plaza

Altar 4

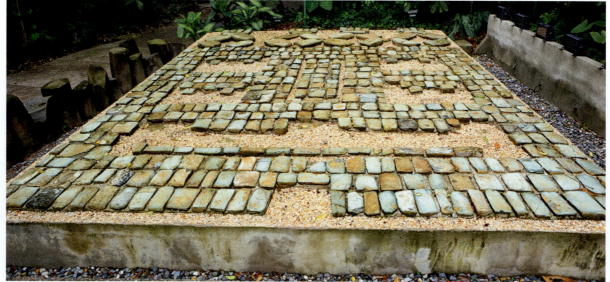

12.5 Greenstone offering, originally buried at north plaza, La Venta, *c.* 900–400 BCE. Approx. 15 × 15 ft. (4.57 × 4.57 m) La Venta, Mexico.

greenstone, laid deep into the earth (**Fig. 12.5**). The consecration event in which the blocks were offered to a deity must have occurred amid considerable pomp and ceremony: colored sands were brought in from several different spots along this part of the coast and then layered over the greenstone. This sacrifice would have been significant for the Olmec, who had to procure the greenstone from great distances before burying it deep below one of La Venta's central plazas. Other finely worked stone and jade objects were placed over these sand layers, including one of the most spectacular and enigmatic deposits known from Mesoamerica, La Venta Offering 4.

LA VENTA OFFERING 4 A complex ensemble of sixteen figures (**Fig. 12.6**) was buried deep underground La Venta's north plaza. The scene, as arranged by the Olmec, presents a **tableau** in which the figures seem to interact with one another. Behind the figures, six upright rectangular greenstone celts serve as a backdrop or frame. The La Venta Offering 4 figures and celts were probably not originally made to be part of this tableau; rather, they were made from a variety of stone types by different artists. The celts are made from the same type of stone as the large blocks buried in the cache (as in **Fig. 12.5**). The tableau's central figure, who is the object of attention for every other figure in the composition, is made of granite and has a much rougher finish than the other figures.

Earlier Olmec artists often set stone sculptures into such tableaux. For example, at San Lorenzo, large sculptures of two human figures were placed in direct relation to a jaguar, as if they were interacting. However, beyond sensing that something is unfolding in the La Venta Offering 4 tableau, scholars have yet to identify definitively the theme or action of the scene. The Olmec did not see the La Venta Offering again after its burial. In fact, the offering was just one part of a much bigger set of deposits in this spot that included the large blocks of greenstone (see **Fig 12.5**), layers of colored sands, and a decorated stone **sarcophagus**. These items must have been intended to make the space sacred, given the commonly accepted meaning of similar deposits in the later capital of the Aztec and elsewhere in Mesoamerica. These dedications were crucial to the ritual process that sacralized the space.

LA VENTA STELE 2 The plaza to the south of the great pyramid contained public monuments, including one shaped into a tall, relatively flat, **stele** (**Fig. 12.7**). Although the monument is heavily damaged, a human figure can clearly be seen at its center. The figure is carved in low relief, yet more deeply than the smaller figures that seem to float and fly around him. He holds a curved baton

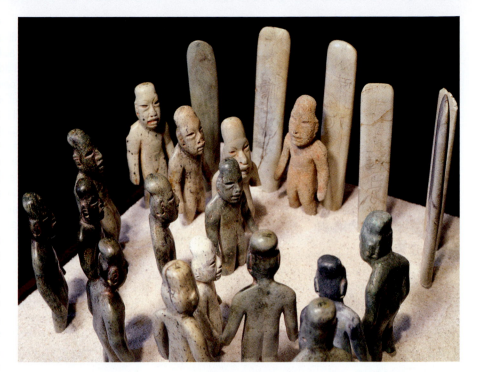

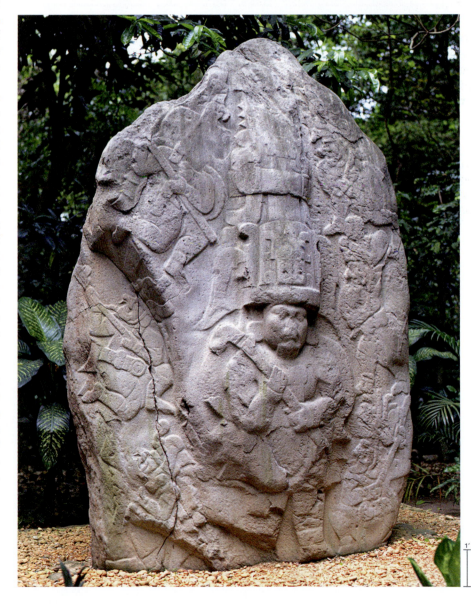

12.6 ABOVE RIGHT **Offering 4, from north plaza,** La Venta, *c.* 900–400 BCE. Jade and other precious stones, approx. height 7 to 10 in. (17.8 to 25.4 cm). Museo Nacional de Antropología e Historia, Mexico City.

12.7 RIGHT **Stele 2, south plaza,** La Venta, *c.* 900–400 BCE. Stone, approx. height 14 ft. (4.3 m). La Venta, Mexico.

When art historians consider cultural context, they must consider not just religion and history but also each constituent part of a society, including the food that was consumed. All early urban cultures developed ways of feeding themselves that made city life possible. For example, Mesopotamia depended on wheat and related grains, while early China cultivated a rice-based diet. Mesoamerican cultures relied on maize, or corn, as their basic foodstuff. This is not simply an economic matter: looking at key plants and their importance for early art traditions often gives us insight into why certain motifs are more popular than others.

Modern maize does not occur in the wild. Rather, it was domesticated into something like its current form by Mesoamericans over several thousand years. As maize became more central to the diet of many Mesoamericans during the period of Olmec culture (1200–400 BCE), it also became a major focus of art, literature, and religion.

Mesoamericans prepared, and continue to prepare, maize in a number of ways: as a flatbread (tortilla), as a stuffed, steamed dough dish (tamale), and as a drink (atole and corn beer). The key to the Mesoamerican diet was the mixing of corn with lime (the mineral related to limestone, rather than the citrus fruit) to unleash important nutrients that would otherwise not be available in a roasted ear of corn. By the collapse of Olmec society around 400 BCE, maize was the central crop of all sizable Mesoamerican groups. Because it could be grown in quantities great enough to feed urban populations, it made possible the rise of cities throughout the region.

Maize was critical not only to the Meso-american diet but also to its thought and art. The maize god (see **Fig. 12.8**) was a key deity throughout the region and was the most important early supernatural being for the Olmec and the adjacent Maya, discussed later in this chapter. Throughout Mesoamerican history, this deity was often represented as male but was sometimes shown as female or of indeterminate gender. For many Mesoamericans, the central epic of the maize god involved the god's death, often by decapitation, and rebirth; they saw the events of this epic as similar to the life cycle of the maize plant. Its cob (head) is plucked away at harvest time, and the entire plant then withers and dies (its sacrificial death). Maize is reborn in the next planting season when farmers drop grains from the cob into the soil, from which the plant then sprouts and grows, much as the maize god is resurrected in Mesoamerican sacred stories.

Discussion Question

1. How does the observation of nature, and especially important food plants, relate to other aspects of culture in Mesoamerican art?

in both hands and wears an enormous headdress. The smaller figures are depicted with symbols related to super-natural beings, suggesting the whole scene may represent a religious ritual. Such rituals were probably held in the plaza where this stele was found, and it is likely that the stele commemorates one of these occasions, much like later Maya monuments (see Fig. 30.7). The scale of such Olmec monuments as carved steles communicates the importance of the events or people they depict. These stone monuments last for many generations and therefore communicate the history of places like La Venta beyond the lifespan of those who participated.

Regional Developments and the Early Maya in Mesoamerica, c. 400 BCE–150 CE

While the Olmec were developing their distinctive culture on the Gulf Coast, the surrounding Mesoamerican cultures interacted with them, adopting and transforming many of their ideas and artistic traditions. Prior to the fall of La Venta, around 400 BCE, several complex societies elsewhere in Mesoamerica were building pyramids and platforms, and sculpting monumental works in the centers of their own growing cities. Regional cultures with such early developments include the people of Monte Albán, in Oaxaca, Mexico; the people of the Central Valley of Mexico; and the Maya of eastern Mexico, Guatemala, and Belize.

The Maya were separate culturally from the Olmec just to their west, but they drew on the Olmec experience to create their own Mesoamerican culture. The Maya inhabited many different regions, including lowland tropical jungles, highland mountain lake regions, and the Caribbean coasts. They grew maize and a variety of

iconography the visual images or symbols used by artists within their work to convey specific meanings.

other staple crops, such as beans and squash, and they valued many precious materials, such as jade, seashells, and the feathers of tropical birds. While the Maya were not creating great cities during the time of San Lorenzo, by the time of La Venta they had a distinct art style that continued to develop long after the last Olmec city declined. However, some aspects of the **iconography** at the early Maya site of San Bartolo demonstrate the importance of the pan-Mesoamerican cosmology, and deities such as the Maize God, to the early Maya artists. To examine some components of this iconography, we can analyze Maya murals featuring the maize god.

MAYA FRESCOES OF THE MAIZE GOD With the exception of ceramics, on which pigments are fired into the clay, paint does not survive well in a tropical jungle environment, and it fares only a little better in the temperate highlands. Archaeologists were surprised, therefore, to discover relatively well-preserved murals in the rooms of an ancient temple, more than 2,000 years old, in the tropical lowlands of what is now Guatemala, at the site of San Bartolo (**Fig. 12.8**). They date to around 100 BCE, about 300 years after the fall of La Venta. The red-bodied, central figure of this detail of a Maya fresco can be identified as a later version of the maize deity seen in Olmec art, with a similar upturned upper lip in what could be a snarl, almond-shaped eyes, and idealized facial structure (compare **Fig. 12.3**). This maize god's face is turned to the right in the direction of a kneeling female, who gestures in his direction. The gift appears to be a flowering squash or gourd, relating to the maize god's importance to agricultural fertility and production.

The Maya murals tell their story in a manner more complex than anything that survives in earlier Olmec art. A viewer in the room would have been surrounded

by murals with dozens of figures similar to those in the scene shown here, and they would have taken in several scenes at once, using such cues as the appearance of a repeating figure (the maize god seen for the second time, for instance) to identify the start of a new scene. While the Olmec grouped figures together in art (compare **Fig. 12.6**), the multiple scenes found in Maya art, running into one another across the length of the wall in a **continuous narrative**, require another level of reading and interpretation, suggesting an audience highly trained in comprehending complex visual art.

It could be that the Maya had already developed **screenfold books** by 100 BCE. Painted in similar styles and using similar tools, they produced these books in great numbers in later periods, but precious few examples survive from the time before the Europeans' arrival. Pages of these books were unfolded to show a series of scenes of continuous narration, all taken in at once and "read" just as the audience would read the walls here. Some central aspects of the later Classic Maya style (see Chapter 30) are already in evidence in the murals: the sinuous, organic contour that boldly defines the human bodies, and the increased interest in small details inside the human form and in the clothing. In contrast, the earlier Olmec artists were more interested in the massing of large forms than in these small details.

LA MOJARRA STELE The Maya culture was not the only one with connections to the Olmec culture. In the region where the colossal heads were carved, a stele was discovered in 1986 near the Gulf Coast city of La Mojarra, not far from the site of Tres Zapotes. Dredged from a river, the piece was dated to *c.* 156 CE, five centuries after the last Olmec city fell. Scholars designate the culture that descended from the Olmec in this region as Classic Veracruz. The Olmec were erecting stone steles to commemorate leaders by 900 BCE (see **Fig. 12.7**), establishing a tradition that the people of Classic Veracruz seem to have followed. The La Mojarra stele (**Fig. 12.9**, p. 214) is unique, though, in its use of elaborate **hieroglyphic** text and its striking portrayal of a ruler. It is so unusual and shows such technical skill that it was thought for some time to be a fake.

The stone sculpture is carved on one side. On the left portion of the incised surface is a near-life-size portrait of a ruler, complete with an extravagant headdress that includes a small, stuffed shark. The man appears in profile and wears elaborate feathered clothing on his upper torso. The lower torso and the rest of the body are now lost, sheared away at some time in the past. To the right of the figure are two large incised hieroglyphs: one in front of his face and the other held in his hand. As with the Olmec colossal heads and the La Venta steles before

continuous narrative multiple events combined within a single pictorial frame.

screenfold book a method of book-binding in which pages are attached to one another by their sides and folded into an accordion shape.

hieroglyphic a type of written script that uses conventionalized signs to represent concepts, sounds, or words.

12.8 Maize God, north wall fresco (detail), Las Pinturas, San Bartolo, Guatemala, Early Maya, *c.* 100 BCE.

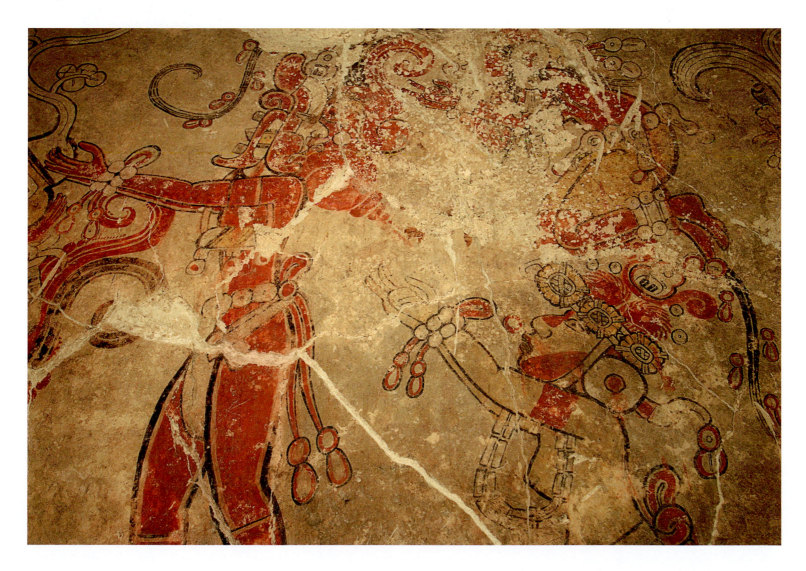

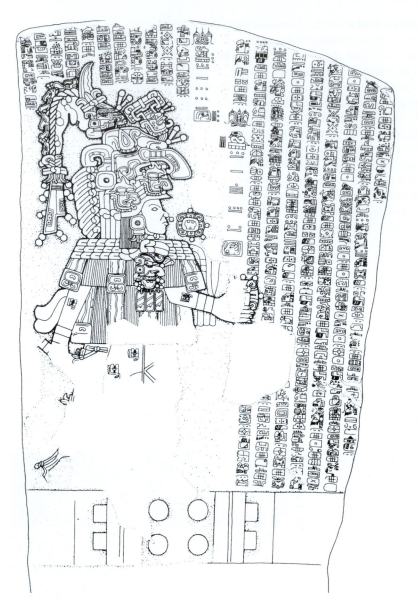

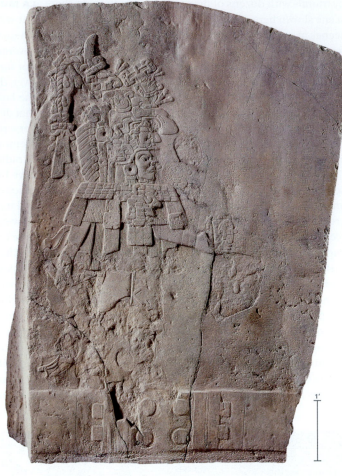

it, the La Mojarra stele commemorates a specific ruler, with clues to his identity in the visual depiction of his headdress. However, the commemoration of a leader here differs greatly from the Olmec colossal heads of almost one thousand years earlier. In the La Mojarra stele, the ruler is depicted in immense detail and in closer to two dimensions in low relief, a halfway marker between a two-dimensional image and the full three-dimensional depiction of the colossal heads.

Above and to the far right of the figure are several hundred small, delicately incised hieroglyphs that probably provided much more specific information about the ruler's identity. This text is of unprecedented length for this period. Because of the lack of comparable texts, scholars have not been able to decipher the hieroglyphs fully. One part that has been satisfactorily decoded is the beginning of the text—comprising two dates—placed not far from the subject's head. These, corresponding to 143 CE and 156 CE, probably refer to events close to the date of the actual carving, if later Mesoamerican practices are any guide. Because hieroglyphs associated with earlier Maya San Bartolo murals have been found, scholars believe that writing must have begun

in Mesoamerica sometime late in the Olmec tradition if these later complex texts were being produced by 100 BCE–150 CE. This system of glyphs remained in use for hundreds of years in the Classic Veracruz region, but no other monuments have been found with a quantity of **glyphs** comparable to that of the La Mojarra stele.

WEST MEXICO CERAMIC FIGURE Far west, on the Pacific shore of present-day Mexico, another Mesoamerican culture, unimaginatively named West Mexico by scholars, emerged at the same time as the early Maya and Classic Veracruz traditions. Instead of stone steles, these artists focused mainly on creating hollow ceramic representations of humans, deities, and animals. This ceramic tradition used rich red and orange colors with incised detail that revealed lighter, fine lines.

During a span of almost 800 years (300 BCE–500 CE), West Mexicans placed hollow ceramic figures in shaft tombs, arranged around the burial of an important person. Whatever their other functions, in this context the ceramic figures served to accompany the dead on their journey to the afterlife. In this example (**Fig. 12.10**), a figure is shown in movement, holding a shallow cup in one hand while gesturing with the other. It is sometimes described as a "drinker" figure for this reason. The precise meaning of the gesture is unclear, but the figure's importance is suggested by the horned cap tied to its head; scholars believe that the cap indicates a high

political or religious office. A wrapped protector, probably of some dense but perishable fabric or leather, is fastened around one side of the body and further suggests the figure's elevated status.

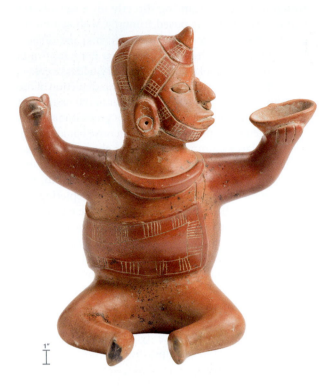

12.10 FAR LEFT **Drinker (seated figure with raised arms),** from Colima, Mexico, *c.* 300 BCE–500 CE. Ceramic with slip, height 23 in. (58.4 cm). Los Angeles County Museum of Art, California.

Teotihuacan: An Early American Metropolis, *c.* 150-650 CE

After 400 BCE, a host of cities emerged across Mesoamerica, from the old Olmec heartland to more mountainous regions in Oaxaca and central Mexico. The city of Teotihuacan, near modern Mexico City in central Mexico, became by far the largest of these emerging regional centers by 150 CE.

Teotihuacan's clear urban plan (**Fig. 12.11**) demonstrates the inhabitants' love of geometry and order. The long north–south avenue that is so prevalent in the aerial view was bisected by another avenue running east–west. Two huge pyramids straddle the north–south central street. At the city's peak, around 400 CE, multi-family residential apartment buildings surrounded these pyramids, for Teotihuacan was a substantial settlement with a population of around 250,000, making it one of the largest cities in the world. Every residential building, palace, and temple was oriented to match the plan of the two major avenues. The geometry of the great

12.11 **Aerial view of Teotihuacan,** Mexico, with the Pyramid of the Moon in the foreground, the Pyramid of the Sun at upper left, and the Street of the Dead in the center. Main pyramids *c.* 150–250 CE.

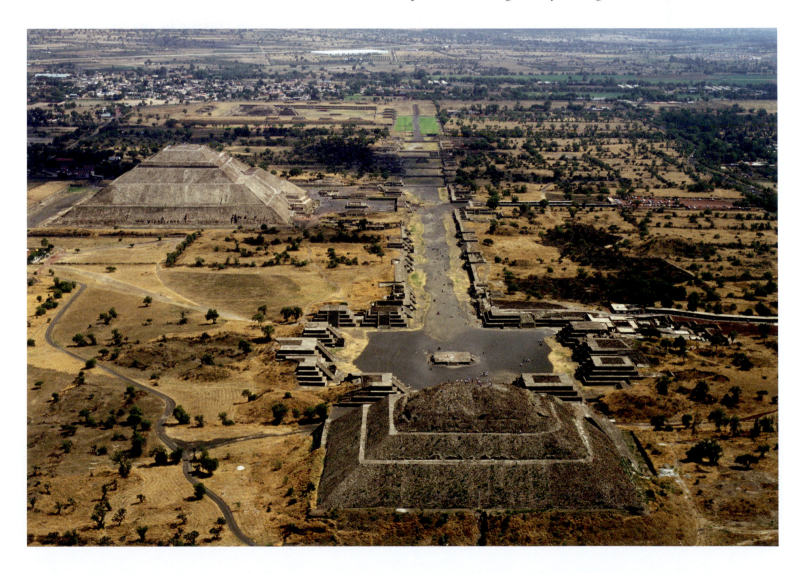

true fresco applying paint directly to wet plaster so that it fuses with the wall. Also called *buon fresco*.

earflare a large ear ornament, often passed through an extended earlobe.

central street and the major pyramids created four separate areas of the city. This four-part urban division was also found in the later Aztec capital of Tenochtitlán (see Fig. 41.1), which is only 30 miles southwest of Teotihuacan. Tenochtitlán was constructed more than one thousand years after the great pyramids of Teotihuacan and was highly influenced by them.

Many Mesoamericans considered Teotihuacan a sacred metropolis, as indicated by the ways in which Teotihuacan symbols and style were copied far from it. In addition, the city attracted many Mesoamerican emigrants, who brought their funerary customs and pottery styles with them. Much of this immigration came from what is now Oaxaca and the Gulf Coast of Mexico, as well as from north and west of Teotihuacan. All of these groups seemed to have settled in the apartment buildings in the heart of the city.

TEOTIHUACAN GODDESS MURAL The public art of Teotihuacan remained mostly unaffected by this immigration. Both pyramids and many of the apartments were heavily decorated, although much of that decoration is now gone. From the evidence that remains, however, it is clear that the artists tasked with creating public art developed a more geometric, conventionalized style than was seen in much of Mesoamerica.

The mural known as the Goddess (**Fig. 12.12**), found in the remains of an ancient apartment, is a good example

12.12 **Female figure (the Goddess)**, fresco, Tetitla apartments, *c.* 550–650 CE. Teotihuacan, Mexico.

of Teotihuacan painting style. The artist worked in **true fresco** technique, painting directly on a wet plaster surface. The figure is posed frontally, with symmetrical streams of water motifs (scroll forms) and objects issuing from both hands. The frontal pose confronts the viewer—who looks directly into the Goddess's eyes—while allowing for an exceptionally clear depiction of the clothing. The face is in the very center of the image, but instead of human features there is a greenstone mask, with fanged teeth protruding from a nose bar and huge green **earflares** framing the face. Just above the masked face is an enormous feathered headdress centered on a frontal bird head with a spinal bone in its mouth. The artist seems to have had no interest in depicting the body beneath the dress. Instead, geometric motifs that may indicate a broad collar and other aspects of costume dominate the area. The symmetry, clear outline, strong color, and firm drawing indicate an interest in order and clarity, in contrast to the tradition of Maya painting found at San Bartolo a few centuries earlier (see **Fig. 12.8**), in which sinuous lines define more naturalistic representations and figures in profile engage each other in complex narratives. These stylistic differences played out during a period of important cultural exchanges between Teotihuacan and the Maya, with each culture experimenting with imitating the style of the other.

TEOTIHUACAN PYRAMID OF THE SUN The Goddess appears to stand on, or derive from, a pyramidal structure of Teotihuacan architectural style. Nobody today knows what the Teotihuacanos called their great pyramids, so they are referred to by their much later Aztec designations: the Pyramid of the Sun and the Pyramid of the Moon. The former (**Fig. 12.13**) was the largest pyramid at Teotihuacan and indeed one of the largest in Mesoamerica. It is over 200 feet (60 m) tall and 700 feet (213 m) wide, with a base of approximately 12 acres (around 48,600 square meters). In ancient times the building was surrounded by a substantial human-made canal, giving the impression that it emerged out of a surrounding body of water. Sculptural works once decorated it, and a now-lost structure that likely served as a temple or shrine stood at the very top, although little of these remain today. It is still possible to make the trek to the top of the pyramid and from there see the entire valley, as the ancient priests certainly did.

Although much of the original decoration has been destroyed, evidence from inside the building gives some idea of what the pyramid meant to the people of Teotihuacan. More than forty years ago, archaeologists found a hidden entrance and a set of passageways to a group of four chambers at its heart. These chambers seem to have been built underground prior to the construction of the pyramid, suggesting that the Pyramid of the Sun may have been constructed to mark the location of these sacred underground rooms that may have symbolized caves. The Pyramid of the Moon also marked a sacred place in the landscape: when a person views it from the central street in the city, the building is directly in line with and echoes the shape of the most sacred mountain in the Teotihuacan Valley. Mesoamericans often equated their pyramids with mountains of particular importance

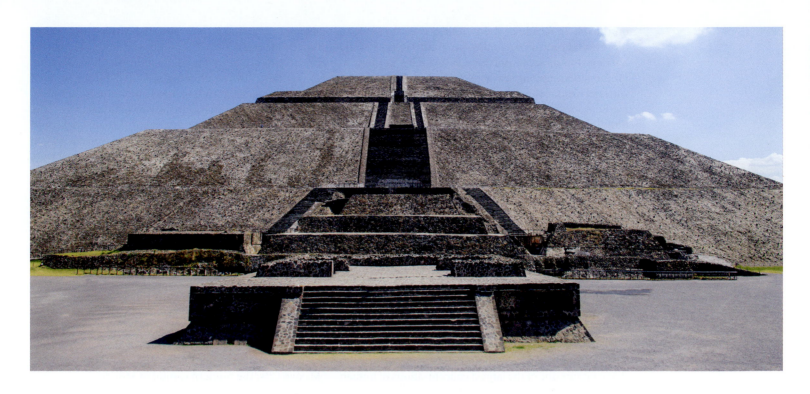

in their landscape. As a triad, mountains, caves, and water hold special significance in Mesoamerican cosmologies, as seen in La Venta Altar 4, the frescoes of San Bartolo, and here at Teotihuacan.

TEMPLE OF THE FEATHERED SERPENT The last monumental public building constructed at Teotihuacan, completed around 225 CE, is significantly smaller than the two older pyramids. It makes up for its smaller scale with much more elaborate surviving sculptural decoration on its **facade**. The Temple of the Feathered Serpent, as the building is now known, is also a pyramid, like the older buildings, but its sides are more highly decorated (**Fig 12.14**). Its architectural profile is known by its Spanish name **talud-tablero**.

Most noteworthy about this temple is the enormous amount of detailed sculpture that survives on both the *taluds* and *tableros* around all four sides of the building. Only a small portion of one side is shown here (in a reconstruction), but because the same motifs were repeated

12.13 Pyramid of the Sun, *c.* 150 CE. Teotihuacan, Mexico.

facade any exterior vertical face of a building, usually the front.

talud-tablero an architectural configuration consisting of a rectangular element set perpendicular to the ground (the *tablero*) sitting on a sloping element (the *talud*).

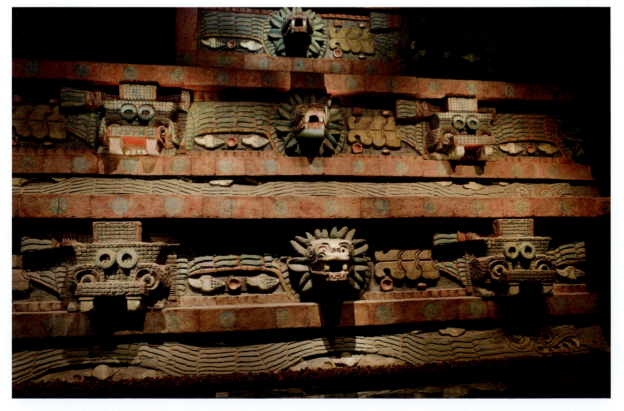

12.14 Facade of the Temple of the Feathered Serpent (detail; reconstruction), with *talud-tablero* profile, *c.* 225 CE. Teotihuacan, Mexico.

on the whole facade of the building, this can serve to represent the entire decorative program. On each of the narrow sloping *talud* portions, a low-relief serpent in profile slithers among seashells. Its entire body is stacked with horizontal elements that have been interpreted as feathers, creating the "feathered serpents" that give this building its name. This creature, named Quetzalcoatl by the Aztec, is another important supernatural figure shared among many Mesoamerican groups, symbolizing the merging of snake and bird to signify land, water, and sky. The feathered serpent body featured on the *taluds* is repeated on the rectangular *tablero* portions. Each *tablero* snake ends in a fully three-dimensional front-facing head with fangs and a forked tongue resting on the lower jaw. Feathers fan out in a mane around the neck of each to indicate that these heads connect to the feathered bodies. Between each snake head is a rectangular-shaped face decorated with prominent eyes and without a lower jaw, which scholars believe to be a headdress worn by Teotihuacan warriors. Thus the full *tablero* image is of a feathered serpent associated with a military headdress.

The Temple of the Feathered Serpent houses a tomb that contains one of the largest concentrations of human remains yet found to be associated with a single structure in Mesoamerica. The tomb was looted in ancient times. Around the inside edges of the building, oriented to the four cardinal directions, were carefully ordered deposits that seem to be large-scale human sacrifices, divided by gender. In the areas with male sacrifices, the victims had their hands tied behind their backs and were placed in an orderly row. How they were sacrificed is not known, but before the sacrificial rite they were dressed as warriors in military costume. Spear points of sharp volcanic glass (obsidian) found in the graves also stress the symbolism of warfare. This archaeological evidence connects the tombs to the military theme on the pyramid's facade.

During this period, the people of Mesoamerica created a template for urban life and introduced many new artistic practices and ideas that were to serve as a foundation for Mesoamerican artists until the Spanish arrived in the sixteenth century CE. Eventually the template for the Mesoamerican city produced at Teotihuacan flourished, making it the first of a line of great cities in the region that includes the Aztec capital of Tenochtitlán and Mexico City, the modern capital of Mexico.

Discussion Questions

1. The materials of early Mesoamerican art, such as ceramic, stone, and jade, tell us a great deal about the societies that valued them. What does the availability of a material teach us about the place of art in a society?
2. Working with difficult materials requires specialized artistic skills. What does the existence of such skills in early Mesoamerican societies tell us about them?
3. Art objects often tell stories. Discuss the artistic strategies used by early Mesoamerican artists to tell stories.
4. Scholars believe that much of the public art created by early Mesoamericans involved the commemoration of rulers and their deeds. Discuss the evidence for this claim, and if true, what it may say about the function of early monumental art in Mesoamerica.

Further Reading

- Coe, Michael. D. and Koontz, Rex. *Mexico: From the Olmecs to the Aztecs* (8th edn). London: Thames & Hudson, 2019.
- "Jade in Mesoamerica." In *Heilbrunn Timeline of Art History*. New York: The Metropolitan Museum of Art (October 2001), http://www.metmuseum.org/toah/hd/jade2/hd_jade2.htm.
- Miller, Mary E. and Taube, Karl. *The Gods and Symbols of Ancient Mexico and the Maya: An Illustrated Dictionary of Mesoamerican Religion*. London: Thames & Hudson, 1993.
- Archaeological Institute of America. "San Bartolo, Guatemala" (2013), https://www.archaeological.org/project/san-bartolo-guatemala/
- Romey, Kristin. "This Hairless Mexican Dog Has a Storied, Ancient Past." *National Geographic*, (2017), https://www.nationalgeographic.com/news/2017/11/hairless-dog-mexico-xolo-xoloitzcuintli-Aztec/

Chronology

1200–900 BCE	San Lorenzo, the first Olmec city in Mesoamerica, supports a complex society; its rulers have colossal stone heads and thrones carved	c. 300 BCE–500 CE	In the West Mexico area, hollow ceramic figures are placed in shaft tombs
		c. 100 BCE	Early Maya murals are painted at San Bartolo
900–400 BCE	La Venta becomes the main Olmec city, maintaining the tradition of colossal stone heads and carving of jade artifacts	150–600 CE	Teotihuacan becomes the largest city in Mesoamerica, with the monumental Pyramids of the Sun and Moon
900 BCE	The first monumental pyramid is built at La Venta	156 CE	Classic Veracruz group on the Gulf Coast erects the La Mojarra stele, with extensive hieroglyphic text
400 BCE	Olmec culture collapses	c. 225 CE	The Temple of the Feathered Serpent is erected at Teotihuacan

Stolen Things: Looting and Repatriation of Ancient Objects

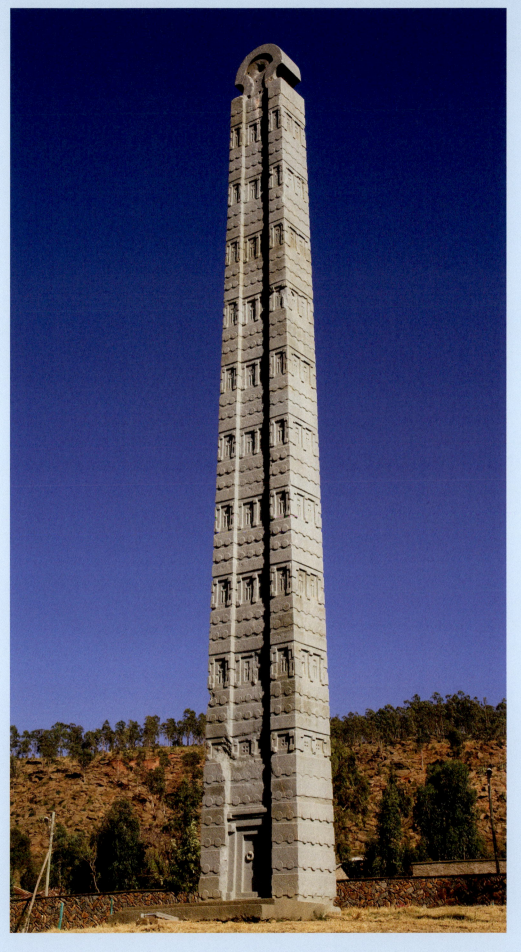

1 **Monolith**, 350 CE, Aksum, Ethiopia, height 79 ft. (24.08 m).

In many ways, the history of ancient art is a history of displaced objects. Many artifacts in European and North American collections have been collected under circumstances today viewed as theft: pillaged in military conflict or stolen by looters to be sold in the lucrative market for ancient art. Looting and illicit trade in antiquities lead to substantial loss of contextual information for the artifacts and continued destruction of archaeological sites. Recently, some governments have demanded the return of antiquities to their countries of origin, raising the question: Who owns the past? This question has philosophical, ethical, and legal dimensions, so there are no easy answers. The three examples discussed here have been returned to their countries of origin, yet many others remain disputed (see the Parthenon Marbles, Figs. 14.8, 14.9, and 14.10).

One of the many grave markers in a cemetery in Aksum (also spelled Axum), the capital of a powerful empire in the highlands of Ethiopia, is this monolith (**Fig. 1**). The huge monument, made from a single block of stone, is one of several that may be linked to King Ezana, who ruled around 350 CE (see Chapter 25). Their crisply carved surfaces replicate the walls of Aksumite palaces, reimagining those ancient buildings as multi-storied towers. During the Italian invasion of Ethiopia in the 1930s, this fallen grave marker was taken as war loot and shipped to Rome. There it was repaired and erected in a public square, emulating the obelisks (a stone pillar, usually with a pyramid as the capstone) that ancient Roman emperors brought back to their capital after conquering Egypt. After Italy's defeat in World War II, Ethiopia demanded repatriation of the monolith, but it was not returned until 2005. Today the monolith stands once more in the center of the burial ground, next to the other (newly stabilized) monuments of ancient Aksum.

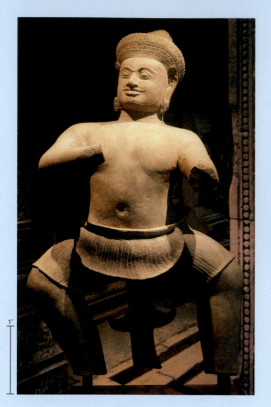

2 Bhima, Prasat Chen shrine, Koh Ker, Cambodia, *c.* 925–50 CE. Sandstone, height 5 ft. 1¾ in. (1.57 m). National Museum, Cambodia. (Pictured as displayed at the Norton Simon Museum, California).

Civil war in Cambodia from 1967 to 1975, followed by a brutal period of genocide, and years of residual conflict, resulted in extensive loss of the country's artistic heritage. The murder of intellectuals, including historians, by the Khmer Rouge regime and the widespread destruction of official records make it difficult to prove which Cambodian artworks around the world were illegally obtained and should be returned. There are success stories, however: Two sandstone sculptures from the tenth century, depicting the Hindu warriors Bhima (**Fig. 2**) and Duryodhana engaged in combat were recently repatriated. The pair originally formed the focal point of the northern Cambodian shrine, Prasat Chen. In 1972, thieves hacked off the figures at their ankles; the feet remained in place at the site. *Bhima* ended up in the Norton Simon Museum in California in 1976, while a private collector owned *Duryodhana* until putting it up for sale at auction in 2011. Before the sculpture could be sold, scholars pieced together the pair's history and even identified several other probably looted sculptures owned by U.S. museums. It took years of negotiation and threats of legal action, but in 2014, *Bhima* and *Duryodhana* were finally returned. Since then, other Prasat Chen sculptures have also been repatriated.

The group of metal objects known as the Lydian Treasure has an important place in the history of repatriation in West Asia. These objects were looted in 1965–66 from multiple Iron Age burial mounds in the provinces of Uşak and Manisa in western Turkey, and smuggled out of the country. They eventually reached New York dealers and finally entered the collections of the Metropolitan Museum of Art. The group included this elegant silver alabastron (**Fig. 3**), made as an elite East Lydian burial gift. (An alabastron is a vessel with a narrow body and neck, used to store perfume or body oils). The vessel is decorated with registers of engraved roosters, lions, bulls, deer, and a battle of hoplites (heavily armed Greek foot soldiers). This type of silver vessel was a specialty of local Lydian artisans, and this fact was influential in the success of the repatriation process. When an artifact is made in a center of craft production distinctive in its style, iconography, and technology, the provenience (find-spot) is harder to dispute. Following a long legal process between the Turkish government and the Metropolitan Museum of Art in New York, the Lydian Treasure was returned to Turkey in 1993.

Antiquities from every region have been stolen during periods of colonialism, armed conflict, and peace. In the examples discussed here, owners of stolen works returned the missing art to its place of origin without compensation. However, no amount of money can retrieve the valuable historical information and cultural legacies that are lost when an object is illegally or carelessly removed from its original context.

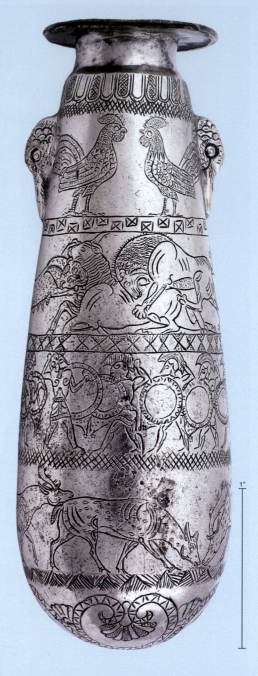

3 RIGHT **Alabastron,** East Lydia, Western Turkey. Silver, height 4 in. (10.3 cm), diameter 1⅜ in. (3.6 cm). Uşak Museum of Archaeology, Turkey.

Discussion Questions

1. The artworks discussed here were all ultimately repatriated, yet most stolen objects are not returned to the country of origin. What might be some of the issues that make it difficult for such objects to be returned?

2. Trafficking Culture is one of the organizations researching the global trade in looted artifacts. Visit their website, and explain what types of evidence they use to track objects' movements and better understand how the illegal trade in objects operates? What are the backgrounds of the researchers involved in the project, and how do their various types of expertise work together?

Further Reading

- Davis, Tess. "Returning Duryodhana," *Bostonia* (Summer 2014), http://www.bu.edu/articles/2014/returning-duryodhana/

- Harmanşah, Ömür and Witmore, Christopher. "The Endangered Future of the Past," *The New York Times* (December 21, 2007), https://www.academia.edu/343317/The_endangered_future_of_the_past

- Kersel, Morag. "Illicit Antiquities Trade." In N. Silberman (ed.) *The Oxford Companion to Archaeology*, 2nd edn. vol. 3. Oxford: Oxford University Press, 2013, pp. 67–69.

- UNESCO World Heritage Centre, "Aksum" https://whc.unesco.org/en/list/15/ (last accessed April 9, 2020).

13

Archaic and Early Classical Greek Art

600–460 BCE

Seer, east pediment of Temple
of Zeus, Olympia, Greece.

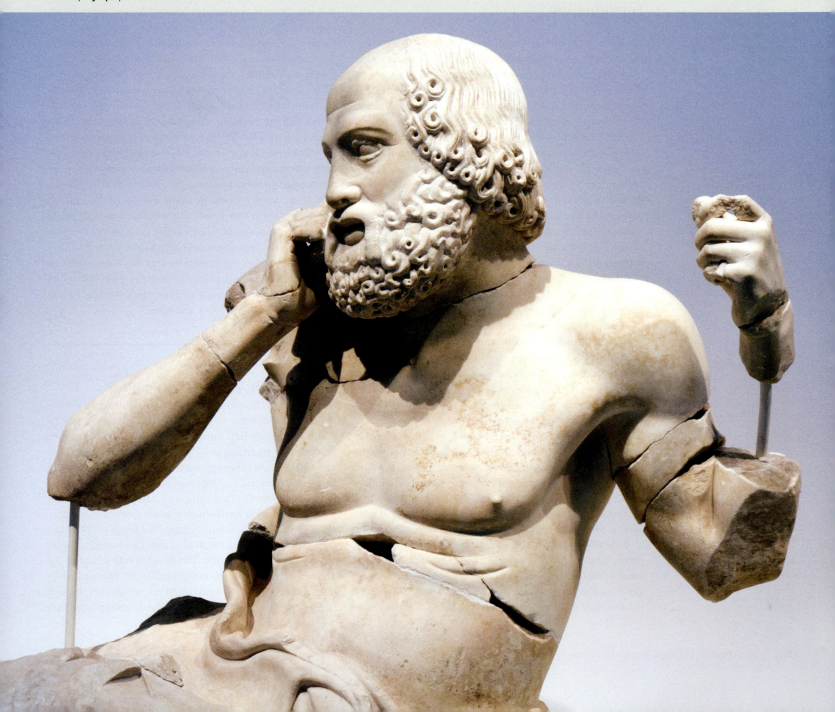

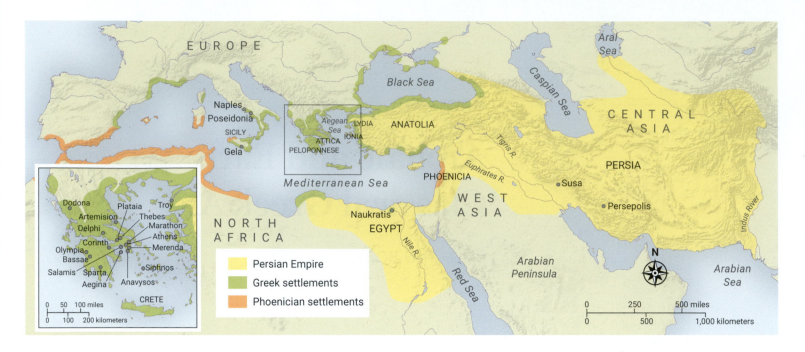

Map 13.1 Greek and Phoenician settlements, and the Persian empire during the Archaic period.

Introduction

The term "archaic" might conjure up antiquated images, but in fact the Greek Archaic period (*c.* 600–480 BCE) was a time of revolutionary change in the Greek *polis*, or city-state, in terms of both politics and art. Some *poleis* remained under the control of kings, while others, such as Athens, witnessed the development of democracy (but see Chapter 14 for a discussion of Athenian imperialism). In 508 BCE, Kleisthenes reformed the Athenian constitution; this is often considered the beginning of democracy. The modern term "democracy" comes from the Greek word *demos*, which referred both to a political subdivision that included the capital Athens and its surrounding area, and to the common people. Democracy was rule by the people—but not by all of them. Only male Athenian citizens over the age of eighteen could vote for laws and leaders; women, enslaved people, and foreigners could not.

Competition among the Greek city-states and their inhabitants is evident in the art and architecture of the time. The popularity of monumental sculptures of people increased during the Archaic period, thanks partly to affluent people's desire to flaunt their wealth and status by offering such sculptures at sanctuaries or using them as grave markers. Sculptures also became increasingly naturalistic, with more emphasis on the human form. Smaller, less costly, and less visible offerings from less wealthy people—for example, terracotta and bronze figurines—are reminders of the religious and ritual importance of dedications, regardless of the offerings' size or expense. Meanwhile, competition among the *poleis* fueled advances in architecture that led to huge, highly decorated temples constructed completely of stone—frequently marble, which was readily available in Greece.

The Early Classical period, beginning around 480 BCE, was a time of transition between the Archaic period (*c.* 600–480 BCE) and the Classical period (*c.* 460 BCE). Many scholars believe that the Early Classical style developed as a result of the Greeks' increased confidence after their decisive victories over the Persians (see **Map 13.1**). Greeks defeated the armies of the Persian empire at the Battle of Marathon in 490 BCE. Though the Persians invaded Greece again, briefly capturing Athens in 480 BCE and wreaking great destruction there, the Greeks were finally victorious at the Battles of Salamis and Plataia in 480 BCE and 479 BCE respectively. To defeat the Persians, the Greek city-states banded together for the first time, ostensibly forging a common Greek identity.

The development of a limited democracy during the Archaic period and the sense of shared Greek identity in the Early Classical period were both informed by humanism, a philosophy that stresses human abilities, independent of the divine. Early Classical artists considered the viewer's experience and represented idealized (meaning youthful and fit, to the Greeks) naturalistic human forms. However, the rise of this philosophy did not mean that Greek artists of these periods chose to depict mortal human beings to the exclusion of the gods and goddesses, who were central to Greek life and society. Rather, these artists' work celebrates not only human subjects and patrons, but also a pantheon of Greek gods, demigods, and legendary heroes, such as Zeus, Hera, Athena, Apollo, Poseidon, Herakles, Achilles, and Ajax.

Archaic Art, *c.* 600–480 BCE

Each *polis* was associated with a particular deity, who—the citizens believed—protected them and their city. The result was a growing centralization of power in religious institutions, resulting in increased construction of monumental temples throughout the Greek world. Formerly, in the Geometric (*c.* 900–700 BCE) and Protoarchaic (*c.* 700–600 BCE) eras, religious **sanctuaries**, usually demarcated by a surrounding wall, were either open-air or contained a small temple, whereas the Archaic period saw the construction of massive stone temples within the precinct walls. The new temple plans of the Archaic period exhibited many similarities in form, partly due to the influence of earlier Greek structures, including the palatial *megarons* of the Mycenaean period (see

sanctuary in ancient Greece, a sacred space reserved for the worship of a deity (or deities); it was often enclosed by a wall and could include open-air altars, temples, and other structures and monuments.

megaron an architectural form used in Mycenaean palatial complexes; it includes a porch and a main hall.

Fig. 10.11). The basic plan of the *megaron* was similar to that of early Greek temples.

STONE TEMPLE ARCHITECTURE AND SCULPTURE

Greek temples functioned as the house of the god or goddess, in which a statue of the worshiped deity was kept. Greeks believed that the divine being literally resided in the temple and was present in the sculpture, which scholars commonly refer to as a cult statue. Temples therefore gave the *polis* a visible connection to its patron deity. The buildings played a key role in religious and ritual activities, including processions and sacrifices, and some even housed an oracle, a person who acted as a medium to transmit prophecies from the gods (see **Fig. 13.3**, p. 224). Although some rituals took place inside the temple, most public worship occurred outside in the sanctuary, especially at open-air altars where sacrifices and offerings in liquid form, called libations, were presented. The interior of the temple stored the abundant—and often valuable—offerings to the deity. These gifts were recorded, so the temple served an administrative function as well.

Some of the best-preserved Greek temples were built in wealthy Greek colonies in the region known as Magna Graecia, or Greater Greece (present-day southern Italy and Sicily). The Greeks, some of whom were suffering from overcrowding and famine, in part due to climate change, were drawn to this area by natural resources such as fertile land and good ports. They established their colonies along the coasts, often pushing the local inhabitants inland. One example of a well-preserved Greek temple is the Temple of Hera I at Poseidonia, a Greek colony named after the sea god Poseidon, located about 50 miles south of present-day Naples.

TEMPLE OF HERA I, POSEIDONIA Built entirely of stone in the mid-sixth century BCE, the early Archaic Temple of Hera I at Poseidonia (**Figs. 13.1** and **13.2**, p. 224) stood in the southern part of the city in a large sacred area, where a second temple was also dedicated to Hera (queen of the Olympian gods, wife and sister of Zeus, and goddess of marriage and childbirth) about one hundred years later. Marble, the preferred building material for temples in Greece, was not readily available in Poseidonia. Thus Hera's first temple was made of limestone covered in plaster to give it the look of marble.

The Temple of Hera I combines massive proportions (at around 80 × 170 feet, or 24 × 52 m) with an awareness of the viewer's experience of the building. Built in the Doric style (see box: Looking More Closely: The Greek Orders, p. 225), the structure has a **peristyle** of nine columns on the shorter sides and eighteen columns on the longer sides that surrounds the temple's almost completely missing inner area, called the **cella** (or *naos*), which housed the statue of the goddess. The peristyle served to highlight the **post-and-lintel** structure of Greek architecture (**Fig. 13.2**, p. 224). The bulky and tightly spaced columns display a somewhat exaggerated **entasis** typical of early Archaic temples. The optical refinements of the Temple of Hera provide some of the first examples of an architecture newly geared toward human proportions and the human eye. Even as the temple's builders focused on constructing an edifice worthy of a deity, they accounted for the limitations of the human eye. This emphasis on symmetry and the human experience of architecture is also seen in the Parthenon a century later (see Fig. 14.3).

Steps run around the temple, and the columns of the peristyle rest directly on the top step, the **stylobate**. The porch features three columns between projecting wall piers (**antae**), so the temple can be referred to as **in antis**. Two entrances from the temple's front porch, or **pronaos**, lead into the *cella*, and a line of columns runs down its center, terminating in a small wall that projects from the rear, behind which is an **adyton**. The entrances and columns effectively divide the space in half. While

peristyle a line of columns enclosing a space.

cella (also called *naos*) the inner chamber of a temple; usually houses a cult statue.

post-and-lintel a form of construction in which two upright posts support a horizontal beam (lintel).

entasis the bulging center of a column, constructed to correct the optical illusion that may otherwise make the shaft appear to curve inward.

stylobate the uppermost step leading to a temple, which creates the platform on which the columns rest.

anta (plural **antae**) slightly projecting piers on either side of the entrance to a Greek or Roman temple that terminate the *cella* and porch wall. Temples of this type are referred to as *in antis*.

in antis arranging columns so that the end piers project further than those in the middle.

pronaos the porch or vestibule at the front of a temple.

adyton a rear room behind the *cella* of a temple, presumably used for rituals; often called an *opisthodomos* when used as storage.

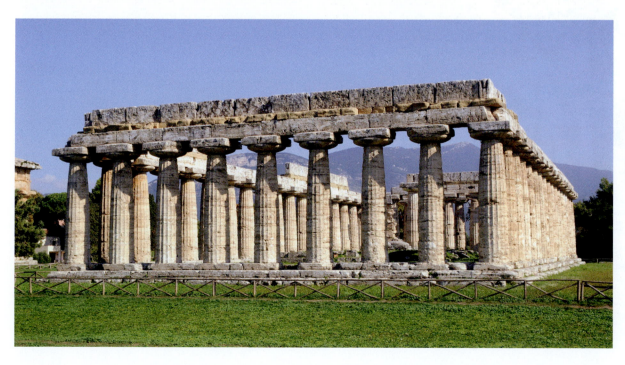

13.1 **Temple of Hera I,** Poseidonia (Paestum), Italy. *c.* 550 BCE. Limestone covered in plaster.

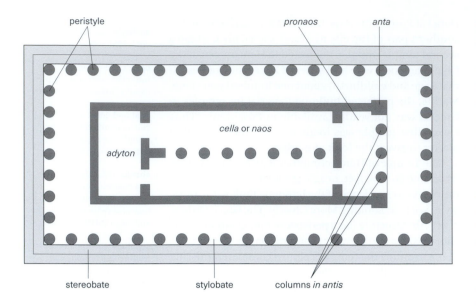

peristyle · pronaos · anta

cella or naos

adyton

stereobate · stylobate · columns *in antis*

13.2 Temple of Hera I, plan drawing, Poseidonia (Paestum), Italy.

terra-cotta baked clay; also known as earthenware.

treasury in ancient Greece, buildings paid for by individual Greek city-states to house their offerings at the sanctuaries to the gods.

13.3 Sanctuary of Apollo, Delphi, Greece, sixth–third century BCE.

the central columns served the important structural function of supporting the roof, some scholars have also suggested that the division of the *cella* could indicate the worship of two deities, perhaps represented by two cult statues in the temple. Inscriptions and **terra-cotta** figurines discovered in the sanctuary indicate that the principal deity was Hera, but her consort/husband Zeus may have been worshiped here as well.

THE TEMPLE OF APOLLO AT DELPHI Panhellenic means "of all the Greeks," and panhellenic sanctuaries were complexes outside the control of any specific *polis*, in neutral territory sacred to all members of Greek society. Such sites played a prominent role in Greek religion and contributed to a common Greek identity beyond each person's allegiance to his or her individual *polis*. This

shared identity was invaluable in helping the Greek city-states defeat their common enemy, Persia, in 480–479 BCE.

The panhellenic Sanctuary of Apollo at Delphi (**Fig. 13.3**) was in use by the eighth century BCE. It is spectacularly sited on the steep slopes of Mount Parnassos, and although the climb was grueling, the views from this mountainside surely made the ancient Greeks feel closer to the gods. Every four years Delphi hosted the Pythian Games in honor of Apollo, attracting participants from many different parts of Greece. Apollo was the god of music, the arts, and divination, and the games included athletic, music, dance, and poetry competitions. To accommodate these, in the sixth century BCE a theater was built overlooking the Temple of Apollo. A sports stadium with a racetrack was added in the fifth century BCE at the site's highest point.

Delphi held vast social and political importance. Greek citizens visited the oracle at the Temple of Apollo there to ask for guidance on religious, judicial, and personal problems. Greek rulers also consulted the Delphic oracle to receive what they believed to be direction from Apollo, allowing them to legitimize their political decisions and deflect responsibility for their actions, should they have negative results. Rulers of Persia, Lydia in Asia Minor, and later the Roman Empire also consulted the Delphic oracle known as the Pythia. After paying a tax and offering sacrifices, they were brought before the Pythia, a priestess who wore a laurel wreath and sat on a three-legged seat (a tripod), over a crack in the rock in the Temple of Apollo. According to ancient sources, a vapor coming out of the rock would intoxicate the Pythia, who would utter often cryptic prophecies that were then interpreted. For many years scholars rejected the idea of intoxicating vapors, but a more recent study of the geological evidence, ancient texts, and properties

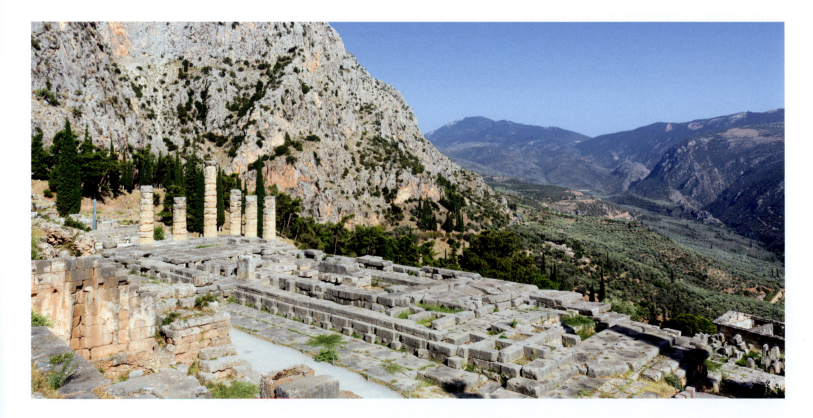

Greek temples used post-and-lintel construction, with two vertical posts, usually columns, supporting a horizontal lintel. Early stone temples featured thick columns spaced close together, but as Greek engineering advanced and architects became more confident, the columns became narrower and were placed farther apart. Most temple floor plans shared certain features, including a *pronaos*, *cella*, *adyton*, and peristyle. While variations on this plan certainly existed, a temple's facade arguably appeared more distinct.

During the Archaic period, two main architectural orders, or standard forms for temple elevations, developed: Doric and Ionic. The names derive from two Greek dialects. Doric was spoken mostly on mainland Greece, while Ionic was spoken mainly in the eastern part of Greece, primarily on the coast of Asia Minor and the Aegean islands, as well as in Athens.

In a standard Doric temple, which developed in the seventh century BCE, there are three steps, the top of which is the stylobate, or platform, on which the fluted (grooved) columns of the peristyle directly rest. Atop each column is a capital with two parts: a circular portion called the echinus and a square one called the abacus. The capital joins the column to the entablature, a horizontal lintel, which includes the architrave (the beam that actually lies on the columns), a cornice (the uppermost strip of molding on the entablature), and a frieze consisting of alternating grooved triglyphs, and metopes, which are often carved in relief (**Fig. 13.4**). Above, on the temple's short front and back ends, are

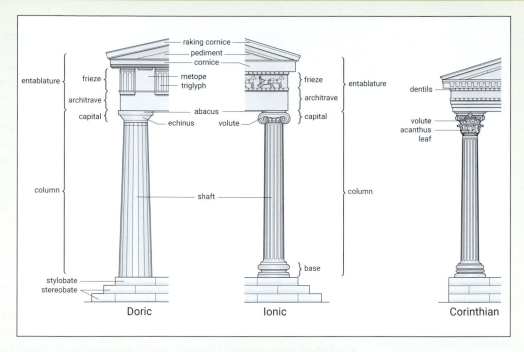

13.4 **The Classical architectural orders: (left to right) Doric, Ionic, and Corinthian.**

the pediments, triangular spaces for additional relief decoration.

Characteristic of the Ionic order, which developed in the sixth century BCE, are column bases, flat sections between the columns' flutes, a capital with volutes resembling a partially unrolled scroll between the abacus and echinus, and a continuous frieze above the architrave instead of the Doric triglyphs and metopes. The frieze often includes painting or relief sculpture. The proportions are also more elongated.

The earliest known use of a third order, the Corinthian, is a single Corinthian column found in the *cella* of the Temple of Apollo at Bassae, c. 450–400 BCE. Later used on the exteriors of temples, it was especially favored by the Romans. Similar to the Ionic order, its fluted columns include a base. Its defining feature is the Corinthian capital, which incorporates decorative and often stylized spiny leaves of the acanthus, a plant common in the Mediterranean.

of anesthetic gases suggests that accounts of the Pythia's ecstatic trance may very well be accurate.

After entering the sanctuary (see **Fig. 13.5**) by way of a ceremonial gate, visitors continued their processional climb via the Sacred Way toward the Temple of Apollo, which was rebuilt more than once during the life of the sanctuary. On the way, visitors passed several **treasuries** that housed their offerings to Apollo to attract his favor. They also drew visitors' attention to the wealth and prestige of the city-states that built them. The offerings in Delphi's treasuries ranged from small terra-cotta or bronze statuettes to monumental sculptures in a variety of materials, including marble, bronze, gold, and ivory.

TREASURY OF THE SIPHNIANS One of the most elaborate treasuries at Delphi was the Treasury of the Siphnians (**Fig. 13.6**, p. 226), built and dedicated by the residents of

13.5 Sanctuary of Apollo, plan drawing, sixth–third century BCE. Delphi, Greece.

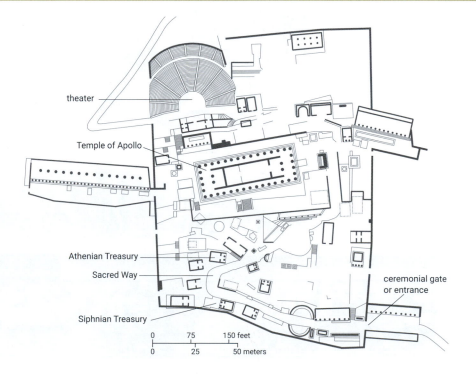

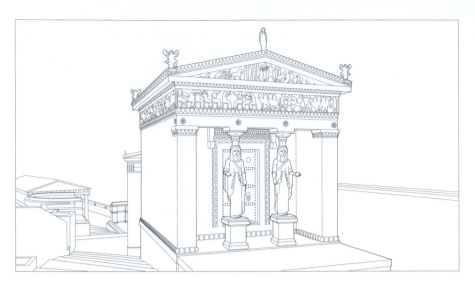

13.6 The Treasury of the Siphnians (reconstruction drawing).

akroteria sculptures that adorn the roof of a temple.

karyatid stone statue of a young woman, can be used like a column to support the entablature of a temple.

capital the distinct top section of a column or pillar, usually decorative.

pediment in architecture, the triangular component that sits atop a columned porch, doorway, or window.

frieze any sculpture or painting in a long, horizontal format.

13.7 BELOW **The Treasury of the Siphnians, east pediment and frieze,** Marble with paint remnants. Archaeological Museum, Delphi, Greece, *c.* 530–525 BCE.

13.7a RIGHT **Herakles stealing the tripod from Apollo.**

13.7b FAR RIGHT **Battle between Greeks and Trojans.**

the small island of Siphnos in the Cyclades, which gained wealth from its gold and silver mines. This treasury, which is the effort of multiple artists working in dissimilar styles, is a study in contrasts. Some of its sculptures, all of which were originally painted, show a strong interest in natural human forms and emotions, while others seem static and lifeless.

Dating from 525 BCE, the small, rectangular treasury was constructed in marble in the Ionic style, with **akroteria** on the roof. In front of the *cella* was a shallow porch with columns in the form of figures of young women, later known as **karyatids**, that stand atop

pedestals bearing intricate **capitals** on their heads. These call to mind the Archaic sculptures of elite women making offerings that were found in Greek sanctuaries. The surviving carved east **pediment** depicts the king of the gods, Zeus, acting as arbiter between Apollo and the Greek hero Herakles (later called Hercules by the Romans), son of Zeus and a human woman. They are fighting over the Delphic tripod (visible at center of **Fig. 13.7** and in **Fig. 13.7a**), which Herakles stole after the priestess refused to let him consult the oracle. Despite representing what would have been a vigorous battle between hero and god, the carving captures little movement or intensity, in the manner typical of the Archaic period.

The carved **frieze** that runs around the whole building includes the work of two different artists employing distinct styles at the same time. The sculptures on the west and south friezes are carved in **low relief** and show little interest in **perspective**, while the east and north sides are carved in higher relief, depicting depth and movement through **foreshortened**, overlapped, and twisting figures. These stylistic and technical differences might seem to suggest that the north and east friezes were completed later than the other friezes, but all of the friezes were actually carved around the same time—a fact that reminds us to be cautious about trying to date works of art based on style alone.

The frieze shows legendary battle scenes between gods and giants, and between Greeks and Trojans (the residents of Troy, in present-day Turkey), subjects that later became common in Greek art. The east frieze depicts

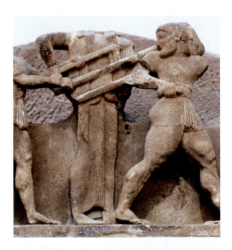

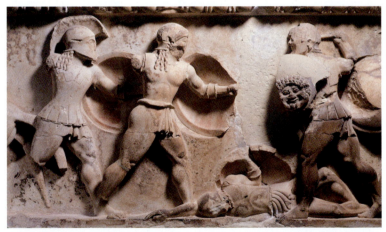

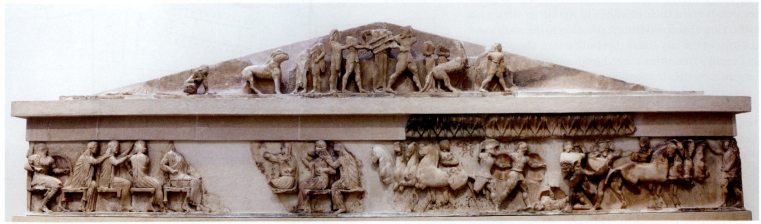

two interconnected battles that occur simultaneously: the clash between the gods on Mount Olympos over the outcome of the Trojan War, and the combat between the Greeks and Trojans at Troy (**Fig. 13.7b**). The Trojan War was a legendary drawn-out war between the Greeks and the Trojans fought primarily outside the great citadel of Troy around 1200 BCE, and in which the Greeks were ultimately victorious in sacking Troy. Many of the figures are labeled, and some of the gods are identifiable by their attributes. Ares, the god of war (seated far left), holds his shield, and the goddess Athena (third seated goddess from the right) wears her *aegis*, or protective animal skin garment. Most notable is the convincing display of depth and active motion in the frieze—a stark contrast to the stiff depiction of Herakles and Zeus on the pediment above. For example, the gods and goddesses are very animated, throwing their hands up and leaning into one another as they argue, while the horses to their right overlap four deep, and their turning torsos appear to emerge from the picture plane toward the viewer. The horses in the background are carved in low relief, while those in the foreground are in **high relief**, giving the illusion of three-dimensionality. The heavily foreshortened soldiers (to the right) are shown twisting and turning, demonstrating the artist's interest in human anatomy, as more naturalistically depicted. The fallen warrior, over whose body the others fight, evokes an emotional response in the viewer. Meanwhile, the gods sit together nearby, bickering over the soldier's fate, which they control.

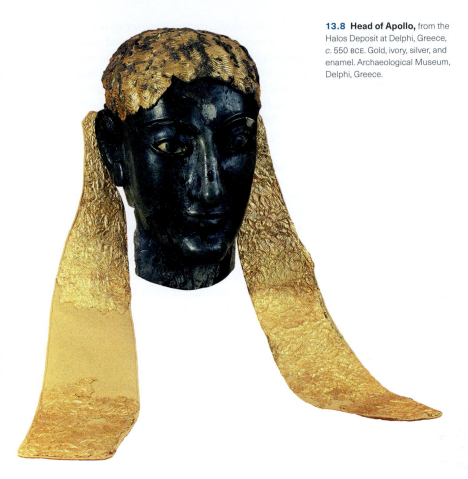

13.8 **Head of Apollo,** from the Halos Deposit at Delphi, Greece, *c.* 550 BCE. Gold, ivory, silver, and enamel. Archaeological Museum, Delphi, Greece.

CHRYSELEPHANTINE STATUE OF APOLLO, DELPHI The 1939 discovery of an important **cache** of objects buried beneath the Sacred Way at Delphi reminds us that accidents of preservation often dictate our histories of art. Many precious artworks are lost to us, owing to the value of their materials. Bronze artworks, for example, were often melted down for reuse. Similarly, few **chryselephantine** cult statues, made of ivory and gold, survive. The chryselephantine medium was ideal for displaying the importance and radiance of the divine. The materials were rare—in the case of ivory, imported from a distant land—and gold was considered to have divine properties because it does not tarnish or corrode (see: Seeing Connections: The Cultural Power of Gold Across the World, p. 362).

The cache preserved parts of several chryselephantine statues, three of which represent Apollo, his sister Artemis, and their mother Leto. The sculptures were intentionally buried with other offerings (including a life-size silver bull with silver-gilt horns) after a fire had badly damaged them, completely destroying the parts made of such flammable materials as wood. Illustrated here is the head of Apollo (**Fig. 13.8**), found at Delphi. The face, carved from elephant tusk, has been heavily restored. The eyes are inlaid and surrounded by golden lashes, and the eyebrows were originally inlaid as well, giving the face a lifelike appearance. The hair is made of gold and silver-gilt sheets with embossed wavy patterns. Gold sheet decorated with goats, lions, bulls, stags, sphinxes, winged horses, and other creatures reminiscent of the earlier Protoarchaic style with its influences from West Asia (see Chapter 10) formed the god's clothing. Together, the hair and clothing emphasize that Apollo is no mere mortal, but rather a powerful and radiant deity, deserving of a panhellenic sanctuary. Notably, the works found in the cache were already about 150 years old when they were burned and buried around 400 BCE, demonstrating the great value of votive objects—especially chryselephantine cult statues—in ancient Greece. They are part of an important sculptural tradition that began in Minoan Crete (see Fig. 9.14) and continued to the now-lost later Classical cult statues of Athena from the Parthenon (see Fig. 14.14) in Athens and of Zeus at Olympia.

KORAI AND *KOUROI*

Like many ancient societies, those of early Greece were home to both the powerful and the powerless, the rich and the poor. Individuals and families seeking to display their wealth or increase their public recognition often commissioned a *kore* (as seen in the Treasury of the Siphnians in **Fig. 13.6**) or a *kouros* as votive offerings in sanctuaries and as funerary markers. These same types of sculpture could also be used as cult statues, representing a god—usually the youthful god Apollo—or a goddess in a temple. Against this backdrop, freestanding monumental figural sculpture flourished in Greece in the sixth century BCE. The influence of Egypt, where similar stone figural sculpture had been a part of the artistic tradition for over 2,000 years, certainly played a role in popularizing such sculpture.

Artists created thousands of *korai* and *kouroi* during the Archaic period. It is often assumed that these sculptures

low relief (also called bas-relief) raised forms that project only slightly from a flat background.

perspective the two-dimensional representation of a three-dimensional object or a volume of space.

foreshortening in two-dimensional artworks, the illusion of a form receding into space: the parts of an object or figure closest to the viewer are depicted as largest, those furthest as smallest.

high relief raised forms that project far from a flat background.

cache a deposit of materials or objects that does not include a burial.

chryselephantine made of gold and ivory; from the Greek words for "gold" and "elephant."

kore (plural *korai*) a freestanding Archaic Greek statue of a clothed young woman.

kouros (plural *kouroi*) a freestanding Archaic Greek sculpture of a naked young man.

13.9 BELOW LEFT *Peplos Kore* Akropolis, Athens, *c.* 530 BCE. Marble with traces of original paint, height 47 in. (120 cm). Akropolis Museum, Athens.

13.9a BELOW RIGHT **Color reconstruction of the *Peplos Kore*** (Variant C, 2008). Ceramite, natural pigments, height 47 in. (120 cm) Created by Vincenz Brinkmann and Ulrike Koch-Brinkmann, Polychromy Research Project. Liebieghaus Skulpturensammlung, Frankfurt, Germany.

13.10 FAR RIGHT **Ariston of Paros, funerary *Kore* of Phrasikleia,** Merenda in Attica, Greece, *c.* 540 BCE. Marble, height 5 ft. 9 in. National Archaeological Museum, Athens.

gradually evolved from an abstract style to a more naturalistic one. We do see this broad trend in ancient Greek sculpture as Greek society embraced humanism, but the progression was not completely linear, and there were some situations in ancient Greece in which an older style would have been desired. Analysis of a work's context is therefore crucial when trying to date it and understand its original function.

PEPLOS KORE Several *korai* were discovered among a deposit of burned **votive** and cult statues buried on the Akropolis (Greek for high-city, the religious center) in Athens after the short-lived Persian conquest of the city in 480 BCE. Perhaps the most famous *kore* from the deposit is the *Peplos Kore* (**Fig. 13.9**). The statue is named incorrectly for the Doric sculpted **peplos** it was thought to be wearing. This is a body-length garment made from a rectangular piece of woolen cloth, often folded over at the top, with the folded flap draping down to the waist or beyond. The *peplos* was suspended from the shoulders by pins, and belted either under or over the fold of cloth.

Analysis of the preserved paint on the sculpture under a microscope has now revealed that the *kore* actually wore several garments (**Fig. 13.9a**), including a cape and a mantle that is open at the front to expose an inner garment elaborately decorated on the skirt portion with real and mythical beasts. Because such adornment was common in the depiction of goddesses, it suggests the *Peplos Kore*

is an image of Artemis, goddess of the hunt and wild animals, who actually had a shrine on the Akropolis. The hole in the *kore*'s right hand may have once held an arrow, and the now-missing left arm perhaps a bow, both attributes of Artemis.

KORE OF PHRASIKLEIA The *Peplos Kore* may be the statue of a goddess, but there is little doubt that the *Kore* of Phrasikleia (**Fig. 13.10**) depicts a mortal girl. Used as a funerary marker, the *kore* comes from a pit of the ancient cemetery of Merenda in central Attica, where it was probably buried to protect it from a threat. It was inscribed with the following epitaph: "Marker of Phrasikleia. Forever shall I be called *kore* [girl or maiden], the gods having granted me this name instead of marriage. Ariston of Paros made me." Phrasikleia holds a budding lotus in her left hand, and her wreath is adorned with lotus buds and flowers in different stages of development, alluding

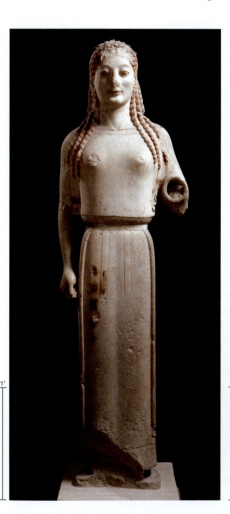

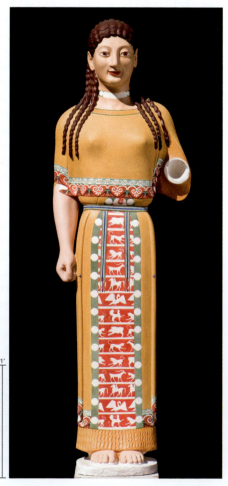

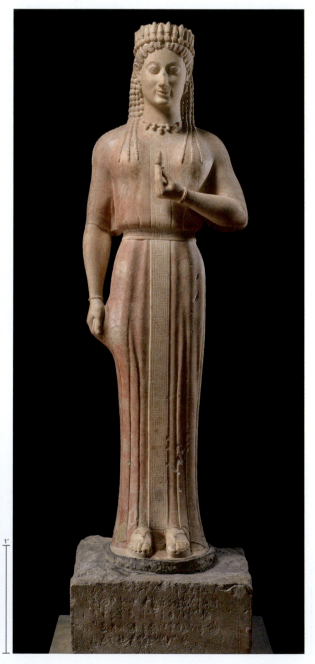

to her premature death before blooming into womanhood and marrying. Her garment is decorated with a running pattern down the center and along the arms, with delicate rosettes along the sides. Her right hand grips her skirt, though this movement does nothing to reveal more of the shape of the body underneath. Still, the subtle carving of the drapery suggests a supple body: breasts, hips, legs, and even biceps. A *kouros* found with the *Kore* of Phrasikleia in all probability represents a member of the same prominent family.

Particularly noteworthy is the fact that the artist inscribed his own name on Phrasikleia's epitaph. The artist's elevated status coincides with the rise of the *polis* and the move toward humanism in the Archaic period.

ANAVYSOS *KOUROS* A statue now popularly known as the Anavysos *Kouros* (**Fig. 13.11**) is highly likely to be a heroic nude sculpture set up by the family of a youth fallen in battle. Nudity had several meanings in ancient Greece, from heroism to vulnerability and defeat. As with all *kouroi*, this male youth is naked, and reveals the sculptor's interest in modeling naturalistic and supple forms from the stone. Slightly larger than life-sized, the figure wears braids and a headband, as many such statues do, and stands in the typical *kouros* pose borrowed from Egyptian sculpture: the left leg is forward, but without any shift in body weight to accommodate the stride. To achieve this stance, the sculptor carved the left leg as longer than the right, preventing a truly naturalistic representation. Similar to many Egyptian male sculptures (see Fig. 6.21), the Anavysos *Kouros* stands rigid, with arms held down at the sides. The figure also sports a smile, with the corners of his lips upturned. Known as the **Archaic smile**, which is present even on sculptures of wounded figures (see **Fig. 13.15**, p. 231), it is not intended to show happiness, but perhaps to animate the sculpture, making it appear more lifelike.

WOMEN IN ARCHAIC GREECE

While only male citizens in Athens could hold civic office and enjoy full political rights, the prominence of powerful goddesses, such as Athena, reminds us not to underestimate women's roles in ancient Greece. Artistic and literary remains indicate that women were extremely active in ritual. They held positions of power as priestesses, such as the Pythia at Delphi, that were often on par with the power wielded by men in public office, and the numerous sculptures depicting young women giving offerings in sanctuaries, as well as inscriptions naming specific women as dedicants (someone who dedicates or makes offerings), speak to the power of women in the public religious sphere.

We must remember, however, that the roles and rights of women in ancient Greece differed from one *polis* to another. In Sparta, for example, women had far more freedom and greater rights than they did in other *poleis*; they could own land and inherit property in their own name. Spartan women could also participate in sports and compete in the Heraia, the women's footraces at Olympia in honor of the goddess Hera. These competitions were held every four years, but not in the same year as the Olympic Games. Women were not allowed to compete at the Olympic Games or even attend them as spectators.

SCULPTURE OF A SPARTAN GIRL RUNNING A small bronze sculpture (**Fig. 13.12**, p. 230) discovered at the Sanctuary of Zeus at Dodona probably represents a participant in the Heraia. These athletes, who were unmarried young women, took part in a race over a distance of 500 feet. After the races, the winners were crowned with a wreath of wild olive and shared in eating the sacred cow sacrificed to Hera. An image of the victor was also placed in the Temple of Hera, bestowing great prestige on her and her family. In contrast to the *kore* sculptures discussed above, the girls represented in these bronze statuettes are shown in far more active poses, such as this one, lifting her short tunic as she runs. Athletic competitions may have been associated with rites of passage

Archaic smile the upturned lips of a Greek Archaic sculpture.

13.11 FAR LEFT ***Kouros*** **from Anavysos,** Attica, Greece, *c.* 530 BCE. Marble, height 6 ft. 5 in. (1.96 m). National Archaeological Museum, Athens.

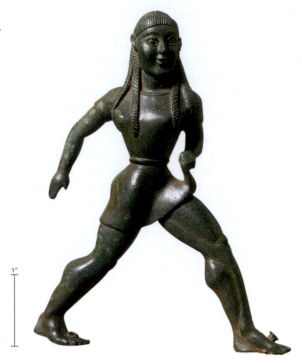

amphora an ancient pottery vessel with a narrow neck, large oval body, and two handles, used for storage or bulk transportation of foodstuffs, such as wine, olive oil, and olives.

incised cut or engraved.

for girls. Indeed, such sculptures may have been given as offerings when a girl matured into a young woman who was ready for marriage and, therefore, prepared to accept social norms for women.

ATHENIAN BLACK-FIGURE POTTERY

Expertly painted ceramics provide a hint about the high quality of lost monumental Greek painting, otherwise known almost exclusively from descriptions in ancient texts. By the sixth century BCE, Athens eclipsed the city-state of Corinth in terms of ceramic production and export. Corinth had produced pottery that was extremely popular throughout the Mediterranean in the Protoarchaic period (see Chapter 10). Athens borrowed the black-figure pottery style from Corinth, but craftspeople in the region of Attica, centered on Athens, also developed their own distinct decorative and narrative style. During the Archaic period, talented artists made Attic pottery in various shapes and for different functions, decorating it with scenes from daily life and a variety of mythological, and often psychologically complex, subjects. The popularity of Athenian pottery is clear from the number of painted Athenian vases exported to cities far from Athens, including the numerous examples found in Etruscan tombs in present-day Italy, where they were valued as high-status objects (see Chapter 17).

EXEKIAS, AMPHORA WITH AJAX AND ACHILLES One of the most famous Attic potters and painters was Exekias, who is known for his skill in conveying scenes of great human pathos in a subtle but powerful way. This elegant **amphora** signed by Exekias (**Fig. 13.13**) depicts the great Bronze Age heroes Ajax (on the right) and Achilles (on the left) quietly playing a board game. A straightforward formal analysis of the vessel demonstrates Exekias' artistic skill. The composition is well balanced. On either side of the game are the two warriors, whose names are clearly

labeled. Achilles' helmet rests on the top of his head, but Ajax has removed his; it sits behind him, by his shield. Their positions, with rounded backs leaning over the game board, mirror the curves of the amphora's body and direct the viewer's eye to the game itself. The angled spears, which continue the line of the handles downward into the vases's body, combined with the intense gazes of both heroes, also draw the viewer's eyes to the central game. Ajax holds his spears tightly, while Achilles' grip is relaxed, allowing the two weapons to separate. The **incised** detail of the hair and decorative features on the figures is exceptionally fine and speaks to the artist's skill, as do the intricate palmettes above (decorative ornaments consisting of radiating petals, like a palm leaf).

Without knowledge of the full story, viewers might get the impression that these are simply two warriors taking a break from the chaos of battle to engage in peaceful entertainment. Ancient Greeks, however, would know the horrific fates of the two heroes. Achilles and Ajax are at Troy, which the Greeks have been besieging for many years. Achilles will die in battle, despite the efforts of his mother, the sea nymph Thetis, to make her son immortal by dipping him in the river Styx by his heel. (The phrase "Achilles' heel," referring to a weak spot despite overall strength, has its origin in this story.) Still, Achilles appears to sit a little higher than Ajax in this composition, showing his elevated status as the greatest of the Greek heroes, and perhaps suggesting that Ajax, a powerful warrior, will also meet a tragic end. Indeed, after losing a speech contest against Odysseus for the prized armor of Achilles, Ajax will slay some fellow Greeks in a fit of rage and

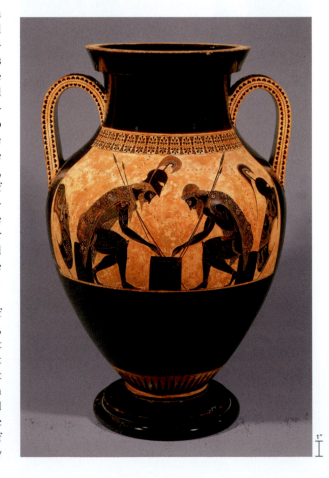

ultimately take his own life by throwing himself on his sword. Ancient Greeks would therefore have viewed this scene as ominous, foreshadowing these two mortals' violent deaths.

Early Classical Art, *c.* 480–460 BCE

The transition from the Archaic to the Early Classical period and its artistic style coincided with, and may have resulted from, the confidence that the Greeks gained in their victories over the Persians. After the Achaemenid Persian emperor Cyrus the Great conquered the Greek areas of Ionia (western Anatolia) in 547 BCE, he appointed rulers to govern them (see Chapter 5). Following the Ionians' (unsuccessful) revolution in 499–493 BCE with the assistance of other Greek *poleis*, the Achaemenid Persian kings Darius I and his son Xerxes I embarked on campaigns to conquer further Greek territories, briefly capturing Athens and wreaking destruction there in 480 BCE. To wage war with the powerful Achaemenid Empire, the Greek city-states formed a coalition and a common Greek identity, though the citizens of each *polis* also continued to see themselves as Athenians, Spartans, Thebans, and so on. Fighting for a shared cause, the Greeks decisively defeated the Persians at sea at Salamis in 480 BCE and on land at Plataia in 479 BCE.

The artistic style of the Early Classical period, often called the Severe style, introduced more movement into the human form. Inspired by the continued influence of humanism, artists sculpted figures whose weight was placed more naturalistically on one leg, with the head turning or bending. In other words, the stiff, schematic figures of the Archaic period increasingly gave way to more dynamic figures with serious expressions, hence the term "severe."

DYING GREEK WARRIORS AT THE TEMPLE OF APHAIA

Nowhere is the transition between the Archaic and Early Classical styles more evident in a single monument than in the temple dedicated to the nymph Aphaia—particularly the depiction of two wounded Greek warriors on the pediments (**Figs. 13.14** and **13.15**). The Aeginetans, having fought against the Persians at the recent naval Battle of

13.14 BELOW **Dying Greek Warrior,** sculpture from the corner of the west pediment of the Temple of Aphaia, Aegina, Greece, Archaic to Early Classical period, *c.* 480–470 BCE. Marble, length 5 ft. 6 in. (1.68 m) Glyptothek, Munich, Germany.

13.15 BOTTOM **Dying Greek Warrior,** sculpture from corner of the east pediment of the Temple of Aphaia, Aegina, Greece, Archaic to Early Classical period, *c.* 480–470 BCE. Marble, length 6 ft. (1.83 m). Glyptothek, Munich, Germany.

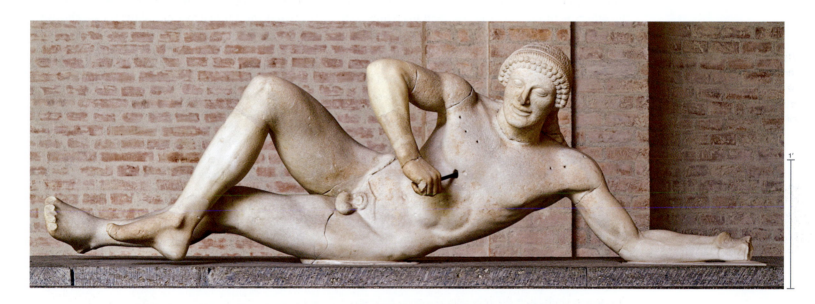

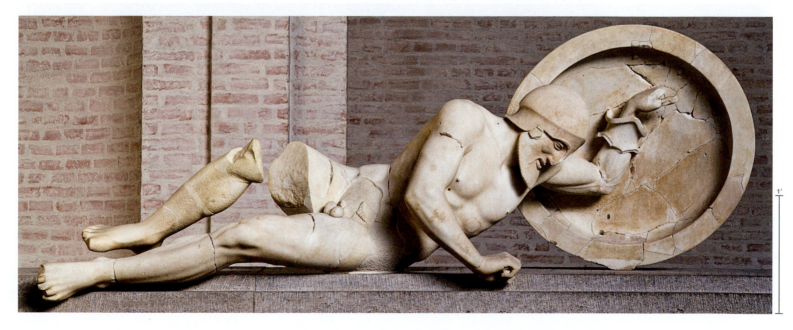

Salamis, chose to illustrate the pediments with two distinct legendary sacks of Troy, including one in which an Aeginetan hero was prominent. The sculptors worked with the triangular shape of the pediment, with soldiers standing, archers on bended knee, and fallen soldiers in the corners. Notably, the Trojan soldiers, shown elsewhere on the pediment, are dressed as fifth-century BCE Persians, in trousers and shirts, connecting the legendary heroic past to the island of Aegina's present success and announcing the Greeks' notion of their superiority over all others.

Although the subjects of the two pediments are strikingly similar, they represent completely different styles: the west pediment in the Archaic style, and the east pediment in the Early Classical/Severe style. This distinction is clear in the depiction of two wounded Greek warriors in the corners of the pediments. The pose of the west warrior (**Fig. 13.14**) is awkward for someone who has just taken an arrow to the heart; dowel holes confirm that a metal arrow was once present. The soldier's Archaic smile seems out of place as he tries to wrench the arrow from his torso. One of his legs is casually crossed over the other, as though he is at rest, and his dying body does not seem to be sinking to the ground with any convincing force.

In contrast, the east warrior (**Fig. 13.15**) exemplifies the innovative and more naturalistic Early Classical style. His muscles flex in response as his wounded body sinks in a more realistic manner, his collapse tugging his arm down from his shield-grip and his head bowing under the weight of the helmet. The warrior's form breaks out of the pedimental frame, his leg and arm hanging over the edge, drawing in the viewer below to witness his last breaths. For years, scholars believed the west pediment was carved earlier than the east pediment. More recent analysis, however, suggests that they were carved around the same time, but in different styles, with one artist looking forward and the other looking back, the two styles co-existing among

the Greek city-states as they celebrated their triumph over the Persian empire.

MONUMENTAL SEVERE STYLE SCULPTURE AT OLYMPIA

The most famous athletic competitions in ancient Greece were held every four years at the panhellenic sanctuary at Olympia, where the Early Classical sculptural style was used to superb effect on the pediments of the Temple of Zeus. As at Delphi, the sanctuary at Olympia included several structures, including treasuries, temples, and altars dedicated to Zeus, Hera, and Pelops, from whom the Peloponnese—the large Greek peninsula on which Olympia is located—received its name. The Temple of Hera, first built in the Late Geometric period and rebuilt in the Archaic, was perhaps originally dedicated to both Hera and Zeus. Then, in the fifth century BCE, during the Early Classical period, Zeus received his own temple. It is now in ruins, but the museum in present-day Olympia displays much of its massive sculptural program.

While the external **metopes** of the Temple of Zeus were not carved, the internal metopes above the porches were sculpted with reliefs of the Twelve Labors of Herakles, whom some legends identify as the founder of the Olympic Games. The west pediment was filled with freestanding sculptures illustrating the legendary battle of the Lapiths and centaurs (creatures from ancient Greek mythology with the head, arms, and torso of a human joined to the body and legs of a horse), which, according to myth, started after the centaurs got drunk and assaulted the Lapith women at a wedding feast. The east pediment (see **Fig. 13.16**) depicts the moments leading up to the fateful chariot race between Pelops and Oinomaos. According to Greek myth, it was prophesied that King Oinomaos would die if his daughter, Hippodomeia, were to marry, so Oinomaos challenged all of her suitors to a chariot race. If the suitors lost, they were put to death, and they always lost because Oinomaos's horses were divine—a

13.16 Chariot race of Pelops and Oinomaos, sculpture from the east pediment of the Temple of Zeus at Olympia, Greece, *c.* 470–456 BCE. Marble, approx. length of pediment 85 ft. (25.91 m), height at highest point 11 ft. (3.35 m). Archaeological Museum, Olympia, Greece.

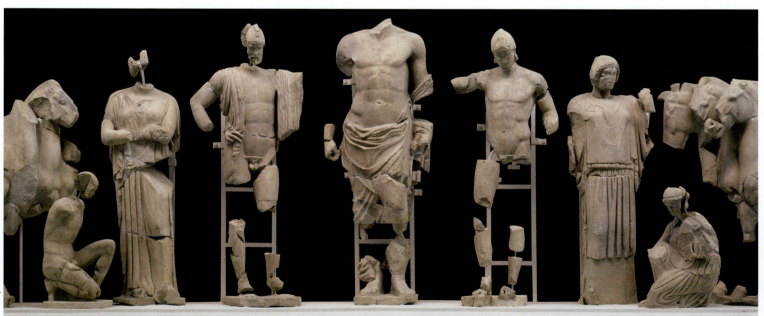

gift from his father, Ares, god of war. Eighteen suitors died before Pelops, in one version of the myth, bribed the king's groom, Myrtilos, to replace the linchpins of the king's chariot wheels with beeswax. During the race, the beeswax gave way, causing the chariot to fall apart, killing Oinomaos. Pelops then killed Myrtilos, but not before Myrtilos cursed Pelops and his descendants. These ill-fated people included Pelops's son Atreus, grandson Agamemnon, great-granddaughters Iphigenia and Elektra, and great-grandson Orestes, who all figure prominently in the *Oresteia*, a tragic trilogy by the Classical Greek playwright Aeschylus in which many of these characters are murdered. The subject of this pediment is location-driven, as Pelops was worshiped at Olympia from early times, and Zeus was believed to preside over all races. Perhaps the dire punishments for the players' treacherous actions in this theatrical composition on the east pediment served as a warning to all Olympic contestants against cheating.

SCULPTURE FROM THE EAST PEDIMENT OF THE TEMPLE OF ZEUS, OLYMPIA
At approximately 10 feet tall as preserved, Zeus stands at the center of this re-creation of the sculpture on the east pediment (**Fig. 13.16**), again illustrating the perceived role of the gods in human lives. Reconstructions vary due to the great scholarly controversy over the positions of the pediment's other figures. Oinomaos (to the left) and Pelops (to the right) are on either side of Zeus, with Hippodameia next to Pelops and Oinomaos' wife next to him. The figures, carved naturalistically in the Early Classical style, twist and turn, taking on different positions to accommodate the shape of the pediment. Zeus stands, while charioteers kneel in front of their chariots and personifications of rivers recline in the far corners.

Although the spectators and athletes of ancient Olympia were well aware of the tragic events that, in the story, would unfold just moments after the scene depicted here, the figures' facial expressions do not provide any hint of what is to come, with one exception. A seer, who is located to the right of the main group of figures (see p. 221), leans on a now-missing staff and watches the scene before him with an expression of foreboding. He alone grasps the gravity of the situation and its impact on future generations of heroic Greeks. The artist carved the seer as a realistic rather than idealized figure, communicating his advanced age and wisdom through wrinkles on his balding head, slightly sagging pectorals, and rolls on his abdomen.

KRITIOS BOY
The Early Classical movement toward naturalism is apparent in the somewhat smaller-than-life-size marble statue known as the *Kritios Boy* (**Fig. 13.17**). It is sculpted in the tradition of the Archaic *kouroi*, but in keeping with the increased focus on humanism, the body is more softly modeled and its movement is more realistic. The sculpture was named for the artist Kritios, whose workshop produced sculpture in a similar style, and who, with Nesiotes, was responsible for the second version of *The Tyrant Slayers* (see **Fig. 13.20**, p. 236). It is impossible to know the full stance of the original *Kritios Boy* because both lower arms are missing, but struts on the thighs, which would have strengthened the stability of the sculpture's arms, aid in its reconstruction.

The *Kritios Boy* is an early example of the ***contrapposto*** for which Classical period sculpture (see Chapter 14) is known. The straight left leg bears the figure's weight, while the right leg is slightly bent and more relaxed, causing the right hip and left shoulder to drop a little. The visible turn of the head gives the impression that the figure is

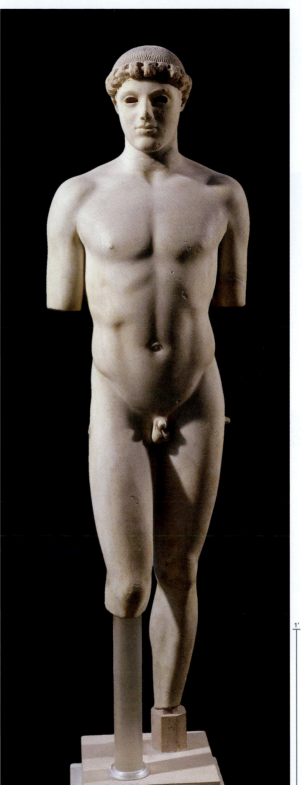

13.17 *Kritios Boy,* from the Akropolis, Athens, *c.* 480 BCE. Marble, height 48 in. (122 cm). Akropolis Museum, Athens.

contrapposto Italian for "counterpoise," a posture of the human body that shifts most weight onto one leg, suggesting ease and potential for movement.

about to move—a sharp contrast to the static stance of the Archaic *kouroi*. As in bronze sculpture, but rarely in marble, the eyes were originally inlaid, probably with glass paste. Together, the supple naturalism of the body, the more dynamic stance, and the dignified expression characterize the Early Classical style, as does the hairstyle with locks rolled up over a headband. Its clear move toward humanism is most probably a result of the confidence gained in the 480 BCE defeat of the Persian army.

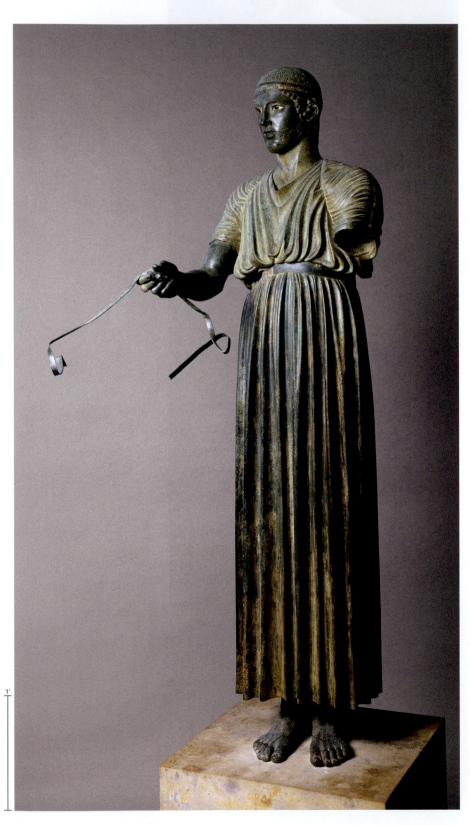

13.18 Charioteer of Delphi, from a group dedicated by Polyzalos of Gela in the Sanctuary of Apollo, Delphi, Greece, *c.* 478–474 BCE. Bronze with silver, glass, and copper inlay, height 6 ft. (1.83 m). Archaeological Museum, Delphi, Greece.

THE CHARIOTEER OF DELPHI The *Kritios Boy* was sculpted in marble, but during the Early Classical period bronze started to become the favored medium for sculpture. Bronze allowed for more dynamic poses and greater naturalism, with less risk of the breakages that were common in stone sculpture. As we saw earlier in this chapter, however, the intrinsic value of bronze meant that statues were often melted down and the bronze reused. As a result, few Classical bronze works survive.

One sculpture that does survive is the male Charioteer of Delphi (**Fig. 13.18**), which was originally part of a larger sculptural group of a horse-drawn chariot with a groom. At almost 6 feet tall, the charioteer is a striking work in its own right. This extravagant monument was a votive offering to Apollo to commemorate a victory in chariot racing at the Pythian Games at Delphi, and was buried by a powerful earthquake in 373 BCE. Uncovered in 1896 near the Temple of Apollo at Delphi, the charioteer was the first sizable bronze of the Classical period to be discovered. It is crucial to our knowledge of Early Classical sculpture, as most surviving works are Roman copies rather than Greek originals.

The charioteer was cast in eight pieces—two for the head, two for the body, and four for the limbs—using the **lost-wax casting** technique (see box: Making It Real: Lost-Wax Casting Techniques for Copper Alloys, p. 62). The figure wears a long tunic, the lower portion of which falls into systematic folds typical of the Severe style and resembles the **flutes** of a marble column, revealing no evidence of a body underneath. Even though *contrapposto* is completely lacking, perhaps because the legs would not have been seen, the feet are exceptionally naturalistic, with veins that look as though blood could be pulsing through them. The head is extremely striking, with eyes inlaid in glass and stone, intricate silver lashes, copper lips, silver teeth, and a headband inlaid with silver. As in many Severe-style works, the statue's expression is reserved and confident. The artist's use of bronze, which has more tensile strength than marble, sustains the charioteer's dynamic pose, with its remaining outstretched arm holding the reins. Although there is no great movement of the body, the slight turn of the head, open mouth, and facial features bring the work to life, distinguishing this sculpture from the more symbolic Archaic statuary. The dedication of such an extravagant votive offering at Delphi by Polyzalos of Gela, a Greek ruler from Sicily who wanted to compete with rulers from the mainland, certainly brought him great glory.

ARTEMISION ZEUS The bronze medium afforded almost limitless possibilities of poses. We see this freedom in the monumental sculpture of Zeus (**Fig. 13.19**), which was produced in Attica, as indicated by analysis of its clay core, but discovered off the coast of Cape Artemision in Euboia, Greece. At nearly 7 feet tall, Zeus assumes a modified "warrior pose," with legs apart and arms outstretched. Viewers can visualize the great god gripping his thunderbolt, about to hurl it at his enemy. Similar to the *Kritios Boy* (see **Fig. 13.17**), Zeus appears firmly planted and strong while hinting at the intense movement to follow.

13.19 Zeus in Warrior Pose, found off Cape Artemision, Greece, *c.* 460–450 BCE. Bronze, height 7 ft. (2.13 m). National Archaeological Museum, Athens.

1′

This pause before violent action represents a moment of great psychological intensity for both the subject and the viewer. By moving around the sculpture, the observer witnesses the dynamism, subtle *contrapposto*, and naturalistic modeling that help to animate it.

Details of the work are rendered with exquisite skill: note the use of copper for the lips and nipples, the originally inlaid eyes and eyebrows, and the intricate carving of the beard and hair. The facial expression helps to identify this as a Severe-style work. Some scholars have identified this sculpture as the sea god Poseidon, in part because it was discovered in the sea, in a shipwreck that sank around the time that Greece came under Roman rule. The sculpture that went down with this ship could be either of Zeus or Poseidon. Arguments against its identification as Poseidon include the stance, which is common in other

lost-wax casting a method of creating metal sculpture in which a clay mold surrounds a wax model and is then fired. When the wax melts away, molten metal is poured in to fill the space.

flutes shallow ridges running vertically along a column or other surface.

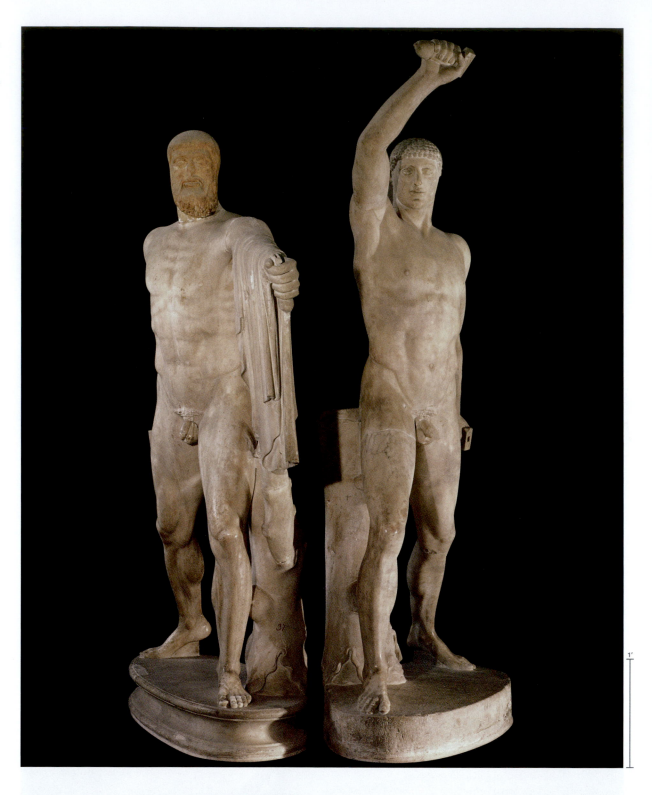

13.20 *The Tyrant Slayers,* **Roman copy,** showing Aristogiton and Harmodius. Marble, after a bronze original by Kritios and Nesiotes of 477 BCE, height 6 ft. 2 in. (1.88 m). National Archaeological Museum, Naples, Italy.

representations of Zeus; and the probable placement of Poseidon's trident, which would have obscured the figure's face, whereas Zeus's thunderbold would not. The discovery of two similarly dated Greek bronze sculptures of warriors off the coast of Riace (see Fig. 14.21) in Italy reminds us that Greek sculptures were highly valued by the Romans, who imported them by ships.

THE TYRANT SLAYERS While both the *Kritios Boy* and the Artemision Zeus reveal the humanism of the period, neither reveals to us a political statement. To consider the relationship between art and democracy in Archaic

and Early Classical Athens, we can turn to a sculptural group known as *The Tyrant Slayers*, which was the earliest known state-sponsored sculptural group commemorating people in a perceived attempt to protect the fledgling Athenian democracy. According to the historian Thucydides, in 514 BCE two aristocrats, Aristogiton and Harmodius, killed the tyrant Hippias's brother Hipparchos, presumably over a love quarrel, and were executed. Hippias later fled to Persia. To honor the martyrs for liberating Athens from tyrannical rule, around 500 BCE some Athenians commissioned the artist Antenor to create *The Tyrant Slayers.*

Because Antenor's bronze sculpture, erected in the Athenian *agora*, was so politically charged—representing the sacrifice that Athenians were willing to make for democratic freedom and sending a message to potential future tyrants—it is not surprising that the Persian king Xerxes removed the sculptural group when he sacked Athens in 480 BCE, the same year as the decisive victory of the Greeks over the Persians at Salamis. The Athenians replaced this powerful symbol just three years later in 477 BCE, with a group cast in bronze by Kritios and Nesiotes. The Early Classical second version, too, no longer survives, but the sculptural group was replicated numerous times in the Roman period. Thus, illustrated here (**Fig. 13.20**) is a marble copy of the bronze re-creation of the first sculpture. Such re-creations pose problems for art historians, who are left analyzing a copy of a copy.

Antenor's original bronze was created in the Archaic period, but the Roman copy shown here is based on Kritios and Nesiotes' later version from the Early Classical period, and as a result is more dynamic. The bearded and therefore older (according to Greek conventions) aristocrat Aristogiton thrusts forward, shielding himself with his left hand, as he prepares to plunge the sword he holds in his right hand into Hipparchos. The younger aristocrat Harmodius, his body unprotected, raises his weapon above his head, also preparing to strike (only the hilt of the sword remains in **Fig. 13.20**). This is a moment of great action and psychological drama, in complete contrast to the staid archaic *kouroi*, but the faces remain stoic, a typical Early Classical trait.

Although most Greeks united in order to defeat the Achaemenid Persians—a victory that, as we have seen, helped to define the art of the Early Classical period and the beginning of the Classical period—peace among the Greeks was not to last, as ultimately Athens's political experiment with democracy was rivaled by its desire to expand its power. And yet, humanism continues to inform artistic styles in the subsquent Classical period, as seen in art in the idealized naturalistic form, and architecture influenced by the balance, symmetry, and perception of the human body.

agora in ancient Greek towns, a public open space that functioned as a marketplace and center for political and other assemblies.

Discussion Questions

1. Art and architecture can both influence and be influenced by historical and political realities. Explain how two works of art and/or architecture from this chapter reveal these influences. Be sure to consider form and subject where relevant.

2. The Archaic and Early Classical periods witnessed a gradual transition toward a more humanistic ideology in the Greek world. What is humanism, and how does the art and architecture of the time show the transition to it? Provide specific examples.

3. When did bronze eclipse marble as the favored medium for monumental sculpture in ancient Greece, and why? Think in terms of the possibilities and limitations of these materials, using specific works of art to illustrate your points.

4. Look again at the sculptural group known as *The Tyrant Slayers* (**Fig. 13.20**). How did this sculptural group come to reflect the young Athenian democracy? What problems of interpretation arise in analyzing a copy of a copy?

Further Reading

- Eaverly, Mary Ann. *Tan Men/Pale Women: Color and Gender in Archaic Greece and Egypt, a Comparative Approach.* University of Michigan Press, 2013.
- Connelly, Joan Breton. *Portrait of a Priestess: Women and Ritual in Ancient Greece.* Princeton, NJ: Princeton University Press, 2009.
- Hurwit, Jeffrey M. "The Problem with Dexileos: Heroic and Other Nudities in Greek Art." *American Journal of Archaeology* 111, no. 1 (January 2007): 35–60.
- Barletta, Barbara A. *The Origins of the Greek Architectural Orders.* Cambridge: Cambridge University Press, 2001.

Chronology

c. 600–480 BCE	The Archaic period in Greece; early Greek stone temples and monumental freestanding sculpture develop
c. 550 BCE	Chryselephantine statue of Apollo is erected at Delphi; The Temple of Hera I is built at Poseidonia
547–546 BCE	The Persian conquest of Ionia
527 BCE	Hippias rules despotically in Athens
before 525 BCE	The Treasury of the Siphnians is built at Delphi
508 BCE	Kleisthenes reforms the Athenian constitution to institute democracy
499–493 BCE	The Ionians revolt against the Persians
499–479 BCE	The Persian Wars
490 BCE	The Greeks defeat the Persians at the Battle of Marathon
480–479 BCE	The Persian conquest of Athens; the Greeks defeat the Persians at the Battles of Salamis and Plataia
c. 480 BCE	The Early Classical period begins in Greece
c. 480–470 BCE	The Temple of Aphaia is built on Aegina
c. 470–456 BCE	The Temple of Zeus is constructed at Olympia

14

Art of Classical Greece

450–400 BCE

Riace Warrior A (detail), Italy.

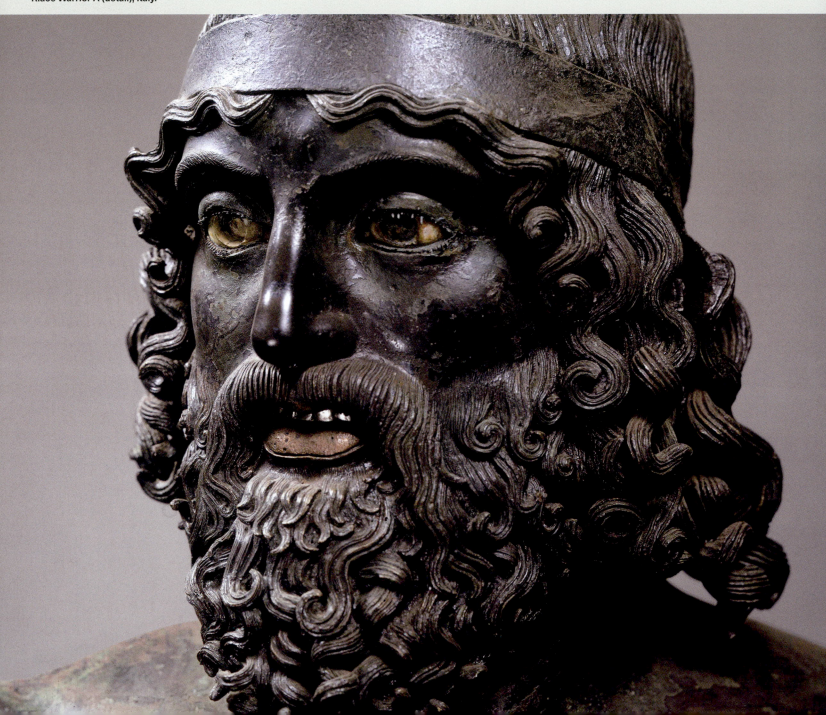

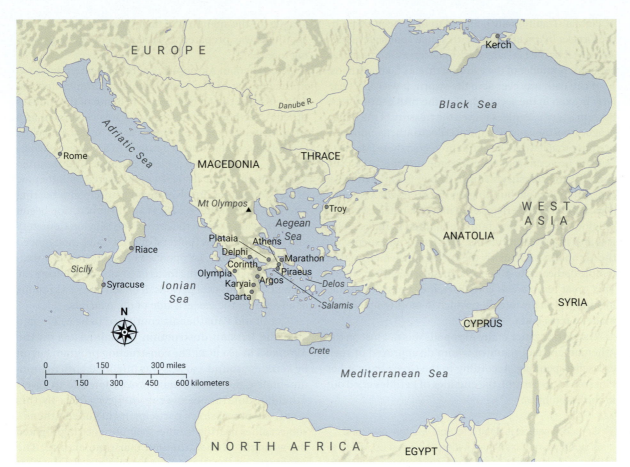

Map 14.1 Greece in the Classical period, *c.* 450–400 BCE.

Introduction

After the decisive victories of the combined Greek forces over the invading Persian Achaemenid Empire at Salamis in 480 BCE and Plataia in 479 BCE, the Delian League was established. This was an alliance of Greek city-states, led by Athens, with member states contributing either men and ships or money in order to defend Greek lands from further attack. Under the general and statesman, Perikles, who dominated Athenian politics from 461 BCE until his death in 429 BCE, Athens built a powerful navy, and its now subject allies paid tribute under the guise of the cost of defense. This is part of a great contradiction about Classical Athens. It supported democracy for its own citizens; males were encouraged to take part in politics and had the chance to serve as magistrates for a set time, but women, slaves, and resident foreigners were excluded. Elsewhere in the Aegean, furthermore, Athens engaged in imperial dominance. The threat posed by Athens under Perikles brought the city into direct conflict with Sparta, the other military superpower in Greece, which was still ruled by an aristocracy. Increased tensions between Sparta and Athens, as well as their respective allies, resulted in the lengthy Peloponnesian Wars, which began in 431 BCE and ended with the defeat of Athens in 404 BCE.

Invading Persians had briefly captured Athens in 480 BCE and destroyed many important buildings. The rebuilding of the city after the Greek victory over the Persians in 479 BCE matched Athens's imperial ambitions. At the same time, the influence of democratic ideals within Athens is evident in the humanistic elements of balance, symmetry, and order that are typical of Classical art and architecture. Humanism was a philosophical concept important in Classical times; it stressed the abilities of humans, apart from the divine, and inspired artists and architects to consider the viewer's experience and to represent idealized forms. Artists during the Classical period used naturalism, mathematical proportions, and idealized figures to convey harmony and their idea of perfection. They also depicted Greeks, and their divine allies, overcoming what they perceived as barbaric or uncivilized forces, which not only represented the Greeks' recent defeat of the Persians, but also served as a warning to potential enemies. Much of their art, like that of their forebears, was simultaneously political and religious.

The identification "High Classical" often refers to the art and culture of the second half of the fifth century BCE in Athens, especially in the age of Perikles. Some have even used the term "Golden Age" to refer to this period, seeing the art and architecture that came before as leading up to this high point, and the art that followed as descending into the superfluous. In this book, we avoid such qualitative terminology, which ranks artistic styles in a subjective order of merit, in favor of exploring these works in their historical and social contexts.

Perikles and the Athenian Akropolis

The ritual center of Athens was the Athenian Akropolis devoted to the city's patron goddess, Athena. Following its destruction by Persian forces, the Akropolis was not rebuilt until several decades after the Greeks' final victory over the Persians. The reason may have been the Oath

terra-cotta baked clay; also known as earthenware.

agora in ancient Greek towns, a public open space that functioned as a marketplace and center for politics and other assemblies.

temenos a sacred enclosure surrounding a temple or sanctuary.

of Plataia. Traditionally believed to have been taken by the Greeks in 479 BCE, the Oath stated that sanctuaries destroyed by the Persians were to be left as memorials, a constant reminder of the external threats facing Athens.

If the oath was ever actually sworn, it was spectacularly broken in the second half of the fifth century BCE. First, in 454 BCE, Perikles moved the treasury of the Delian League from the neutral island of Delos to Athens, under the pretense that it would be better protected there (**Map 14.1**). Despite protests from other League members, he used some of the treasury's funds to pay for an extensive program of temple-building on the Athenian Akropolis (**Figs. 14.1** and **14.2**). Perhaps even more than displaying his religious piety, the program highlighted Perikles' political and imperial ambitions. He spared no expense on the Akropolis, particularly the Parthenon, which was the temple dedicated to Athena Parthenos, meaning 'virgin'. This great temple was constructed entirely of marble, including even the roof tiles, which in most temples were made of **terra-cotta**.

The extravagance of the Akropolis was not lost on the Athenian citizens, many of whom disapproved of such excessive spending. According to the Greek biographer Plutarch (*c.* 46–120 CE), the enemies of Perikles cried out in the assemblies:

> Greece, it seems, is dealt a terrible wanton insult and is openly tyrannized over, when she sees us using money contributed under necessity to the war effort for gilding our city and embellishing it …

According to Plutarch, Perikles replied that Athens was not obligated to account to the members of the Delian League for the spending of their tribute money, as long as Athens was prepared to protect them against invading forces.

The Athenian Akropolis is perhaps best understood in the context of the Panathenaia, an annual festival dating back to the Archaic period in honor of the goddess Athena's birthday. From 566 BCE it was celebrated as a Grand Panathenaia every four years. The festival lasted several days and included a variety of activities, such as musical competitions, athletic contests, and feasting. The highlight of the festival was the sacred Panathenaic procession, which involved many participants bearing offerings and tribute (see **Fig. 14.2**). The procession began at the Dipylon Gate in the area of the Dipylon Cemetery and the Kerameikos (potters' quarter), and then moved through the *agora*, an open area that started as a marketplace and became the focus of government during the Archaic and Classical periods. It ended on the Akropolis at an altar on the eastern side of the *temenos*.

The Grand Panathenaia continued to be celebrated after the Persian destruction of major sites on the Akropolis in 480 BCE. The construction program begun by Perikles around 450 BCE was intended both to monumentalize the Panathenaic procession and to assert Athenian dominance over its subject allies. By this point, the procession's participants included Athens's subject allies bearing tribute; their presence highlighted the strength of the Athenian maritime empire. The structures on the Akropolis were not all completed at the same time, but each was created to play a role in this ancient procession. Thus the architecture of the Akropolis represents the marriage of Greek religion and politics.

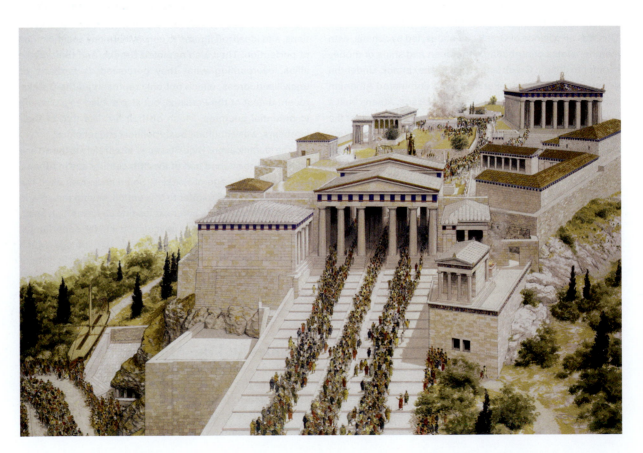

14.1 The Panathenaic procession passing through the Propylaia, Akropolis, Athens, *c.* late fifth century BCE. (Reconstruction drawing.)

old Temple of Athena

Erechtheion

Parthenon

precinct or terrace walls

statue of Athena Promakhos

Chalkotheke

Sanctuary of Artemis Brauronia

Mycenaean fortification

Propylaia

Temple of Athena Nike

```
0        100      200      300 feet
0    20   40   60   80 metres
```

14.2 FAR LEFT The Akropolis, Athens (plan drawing).

bronze statue, approximately 30 feet (9 m) tall, of Athena Promakhos (Athena as a warrior who fights in the front line). The statue no longer exists, but Pausanias and others wrote about it. The Athena Promakhos was made by the well-known sculptor Pheidias (*c.* 480–430 BCE) and erected in 456 BCE, before the Parthenon and the Propylaia were built. Pausanias said that sailors could see the tip of Athena's spear and the crest of her helmet from a great distance away on the sea, so whether entering the sanctuary on the Akropolis or sailing toward the port of Athens, visitors would be reminded of the great power of the city, always under the protection of the goddess Athena.

THE PARTHENON

As the Panathenaic procession moved beyond and to the right of the statue of Athena Promakhos, participants saw the back of the Parthenon (**Fig. 14.3**) before proceeding along its north side toward the east end of the Akropolis. Dominating the skyline from the city below, the Parthenon has captured the imaginations of visitors for over two millennia.

The Parthenon was erected fairly quickly, given the scale of the project, from 447 to 438 BCE, with additional sculptural work continuing until 432 BCE. Its architects were Iktinos and Kallikrates, who combined balance, proportion, and architectural refinements governed by the human eye to create a powerful visual perfection that embodied the democratic ideals and imperial achievements of Athens. The Roman architect Vitruvius said that Iktinos recorded these accomplishments in a treatise he

14.3 BELOW **Iktinos and Kallikrates, Parthenon (Temple of Athena Parthenos),** Akropolis, Athens, 447–432 BCE.

PROPYLAIA The Akropolis was positioned on a rocky hill above the early Theater of Dionysos, at which the plays of the great Classical playwrights, including Sophocles and Euripides, were performed. In the substantial climb to the Akropolis, the procession arrived first at the Propylaia, a monumental gateway that included five entrances side by side (**Figs. 14.1** and **14.2**). Construction of the Propylaia, designed by Mnesikles, began around 437 BCE, shortly after the completion of the Parthenon building (see **Fig 14.3**). The Propylaia displays Doric facades upon entry to and exit from the Akropolis, but Ionic columns in the interior (for more information on the Doric and Ionic orders, see box: Looking More Closely: The Greek Orders, p. 225). It provided an impressive transition from the secular world to the physically higher sacred sanctuary beyond.

The north side of the Propylaia included a room used for feasting by officials. The second-century CE Greek geographer and travel writer Pausanias refers to the room as a picture gallery, perhaps even an early museum, listing some of the famous paintings once located there. Unfortunately, no examples of large-scale paintings from this period survive to this day, so any attempt to reconstruct this tradition must rely on smaller-scale painted ceramics and literary sources.

Emerging from the Propylaia into the sanctuary, participants in the procession would first see a colossal

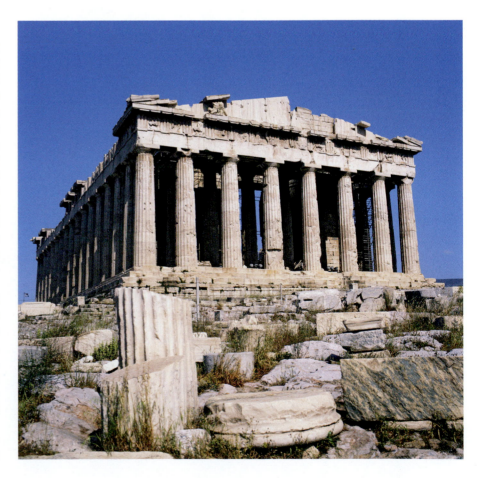

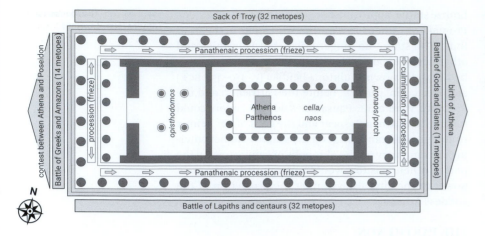

- **Sack of Troy (32 metopes)**
- contest between Athena and Poseidon
- Battle of Greeks and Amazons (14 metopes)
- procession (frieze)
- Panathenaic procession (frieze)
- opisthodomos
- Athena Parthenos
- cella/ naos
- pronaos/porch
- culmination of procession
- Battle of Gods and Giants (14 metopes)
- birth of Athena
- Panathenaic procession (frieze)
- **Battle of Lapiths and centaurs (32 metopes)**

N

14.4 ABOVE **Plan of the Parthenon,** indicating the various elements of sculptural design.

14.5 BELOW **Elevation of the Parthenon,** showing location of pediment, metopes, and frieze.

14.6 BELOW RIGHT **Optical refinements of the Parthenon,** showing curvature of the stylobate and incline of the columns (exaggerated for effect).

wrote on the refinements of Greek temple architecture, which reached their height in the Parthenon.

The plan of the temple (**Fig. 14.4**) includes a large *cella* and an *opisthodomos*. A **peristyle** surrounds the *cella*, and an additional row of six columns lines the front and rear porches. Like the Propylaia, the temple is predominantly Doric, but it also has Ionic features, such as the **frieze** that runs all the way around the exterior of the *cella* walls (**Fig. 14.5**) and the columns inside the *opisthodomos*. The addition of Ionic features reminds us that the Athenians spoke the Ionian dialect common to the western coast of present-day Turkey rather than the Doric dialect spoken

elsewhere on mainland Greece. The Ionic elements may also allude to Athens' allies or subjects in both Doric and Ionic lands.

PROPORTIONS AND REFINEMENTS OF THE PARTHENON

We see the Classical emphasis on balance in the proportions of the Parthenon, which are strictly governed by the formula $Y = 2X + 1$, in other words, a ratio of 9:4. For example, the relationship between the columns along the facade ($X = 8$) and the columns along the flank ($Y = 17$) satisfies the formula because $17 = (2 \times 8) + 1$. The relationship of the distance between the columns and the diameter of the bottom of each column was also governed by this formula, as were other measurements in the building.

Equally intriguing are the many refinements in the building, such that there is barely a straight line, or any ninety-degree angles, in the entire structure. For example, the columns incline slightly inward (lines extending up from the side columns would converge at 7,220 feet (2,200 m) up in the sky, and those from the front and back columns would converge at 16,240 (4,950 m) up) and exhibit **entasis** of the **shafts**. The walls of the building have the same inclination, and the **stylobate** and **entablature** curve slightly (**Fig. 14.6**). This person-centered, humanist architecture gives the viewer the impression that the building is rising up in a dynamic way rather than appearing static or, worse yet, sagging.

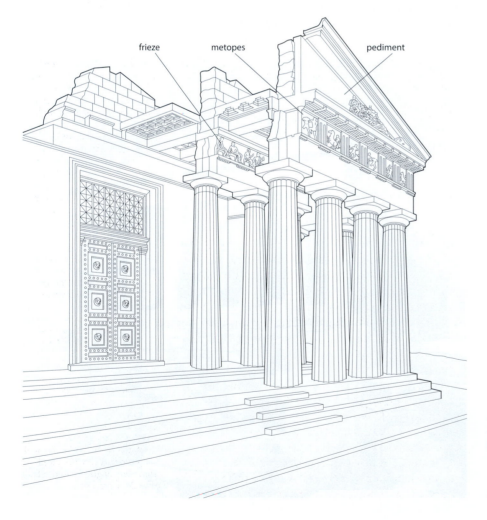

frieze metopes pediment

128 ft / 39 m

16,240 ft
4,950 m

7,220 ft
2,200 m

128 ft / 39 m

237 ft / 72.31 m

110.5 ft / 33.68 m

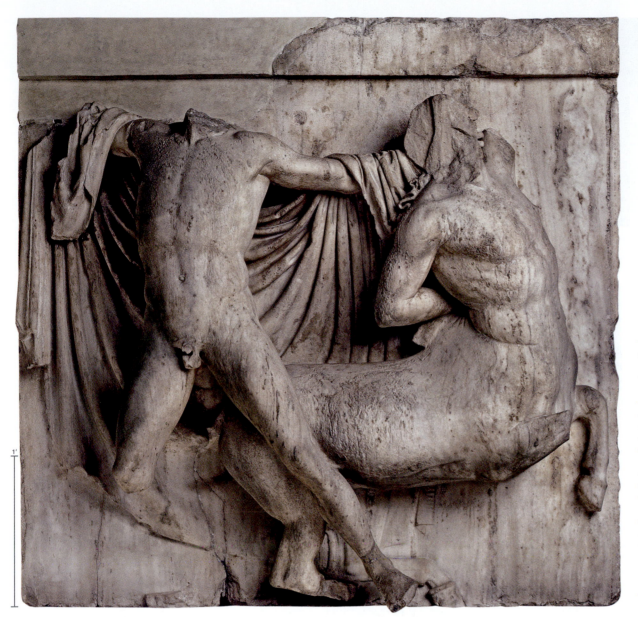

14.7 Lapith Fighting a Centaur, Parthenon metope, south flank, 447–432 BCE, from the Akropolis, Athens. Marble, 47 × 49 in. (1.19 × 1.25 m). British Museum, London.

cella (also called *naos*) the inner chamber of a temple, which usually houses a cult statue.

opisthodomos the back porch or rear room of an ancient Greek temple.

peristyle a line of columns enclosing a space.

frieze any sculpture or painting in a long, horizontal format.

entasis the bulging center of a column, constructed to correct the optical illusion that may otherwise make the column's shaft appear to curve inward.

shaft the vertical cylinder part of a column, topped by a capital; sometimes rests on a base.

stylobate the uppermost step leading to a temple that creates the platform on which the columns are situated.

entablature a horizontal lintel on a building that consists of different bands of molding; might include an architrave, frieze, or cornice.

metope a plain or decorated slab on a Doric frieze, between triglyphs.

pediment the triangular component that sits atop a columned porch, doorway, or window.

sculpture in the round freestanding three-dimensional sculpture that can be viewed from every angle; for example, by walking around it.

PARTHENON METOPES As the procession continued moving toward the front of the Parthenon along the temple's east side, participants took in the sculptural program. Pheidias, who had designed the Athena Promakhos and later the Athena Parthenos (see **Fig. 14.14**, p. 246), was also responsible for the Parthenon's sculptural program. The sculptures are very high off the ground, about 40 feet (12 m), and they were at one point brightly painted, some with metal details attached.

Each side of the Parthenon had sculpted **metopes** depicting scenes from Greek mythology. The south metopes represented the Battle of the Lapiths (Greeks) and centaurs, which, according to legend, took place after the centaurs got drunk at a wedding and assaulted the bride. One fragment shows a Greek and a centaur, recognizable by his composite horse/human form, engaged in combat (**Fig. 14.7**). The north metopes depicted the Trojan War; the west the Battle of Greeks and Amazons (mythical female warriors); and the east, or the front of the Parthenon, the Battle of the Gods and Giants. The theme is consistent: Greeks, or their divine allies, overcome what they perceived to be barbaric or uncivilized forces, symbolizing their defeat of the Persians some thirty to forty years previous.

PARTHENON PEDIMENTS The **pediments** of the Parthenon included **sculptures in the round** that were attached to the wall behind with metal pins. Much of the pedimental and other sculpture is currently missing or damaged, but we know about its subject matter from the writings of Pausanias. Most of the extant sculptures are located in either the Akropolis Museum in Athens or the British Museum in London, with a few pieces held in other collections (see box: Art Historical Thinking: The Parthenon Marbles and Cultural Heritage, p. 246). The pediment on the back (west side) of the Parthenon, which faced the Propylaia, depicted the mythological contest between Athena and Poseidon, the sea god, over which of the two would become the patron deity of Athens. Athena, with her offering of a sacred olive tree, was victorious. The contest was said to have taken place on the Akropolis, and the figures in the corners of

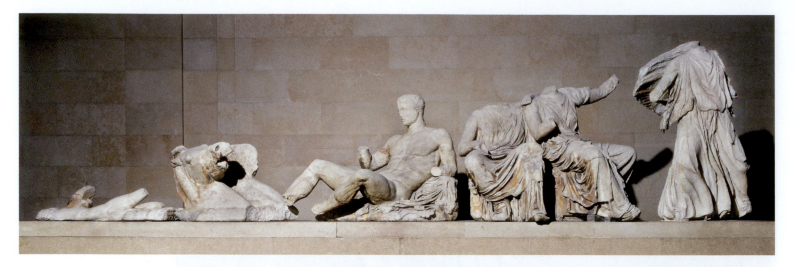

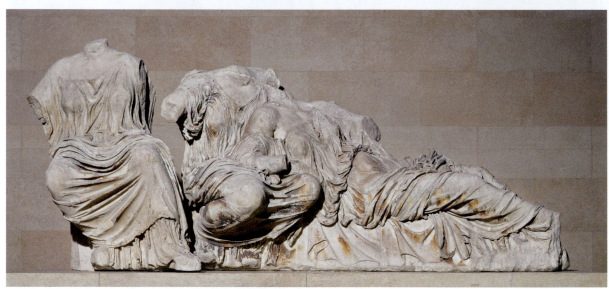

14.8 ABOVE **Sculptures from the Parthenon east pediment,** from the Akropolis, Athens, 447–432 BCE. Marble, pediment length: 93 ft 6 in. (28.45 m), height 10 to 11 feet (3.01 to 3.35 m). British Museum, London.

14.9 RIGHT **Hestia, Dione, and Aphrodite,** from the Parthenon east pediment, Akropolis, Athens, 447–432 BCE. Marble, length 10 ft. 4⅛ in. (3.06 m). British Museum, London.

14.10 BELOW **Reconstruction drawing of the Parthenon east pediment.** (a) see Fig. 14.8; (b) possible arrangement of Zeus, Hera and Athena; (c) see Fig. 14.9.

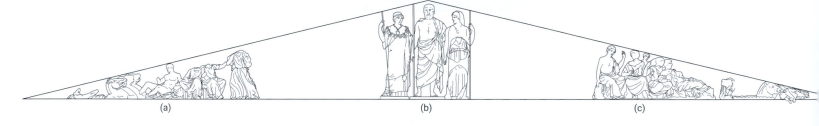

(a)　　　　　(b)　　　　　(c)

the pediment were quite possibly personifications of the actual rivers of Athens.

Much of the east pediment, originally located over the entrance to the temple, no longer survives. The fragments that do still exist are now housed primarily in the British Museum, London (**Fig. 14.8**). According to literary sources, the pediment showed the birth of Athena as a fully armed adult emerging from the head of her father, Zeus, the king of the gods. This was the legendary event that the Panathenaic festival celebrated. Most likely, Zeus was depicted at the pediment's center, with Hephaistos, the god of fire and blacksmiths who aided in Athena's birth, nearby. Hera (queen of the Olympian gods and Zeus's wife and sister) also flanked Zeus (**Fig. 14.10b**). The scene took place at dawn, as indicated by the presence of Helios (the personification of the sun) in his horse-drawn

chariot rising in the left corner and by the moon goddess Selene descending in her chariot in the right corner. The rest of the gods seemed to react to the birth of Athena, which set in motion a scene of great dynamism. On the right-hand side of this pediment were three goddesses (**Fig. 14.9**). The reclining figure is generally identified as Aphrodite, the goddess of love and beauty, because of her position, the skillfully rendered accentuation of her body by her drapery, and the garment slipping off her right shoulder. She may have been leaning on the lap of her mother, Dione. Next to Dione sat a figure that may be Hestia, goddess of the hearth and family.

PARTHENON FRIEZE The extensive 525-foot-long (160 m) continuous and sculpted Ionic frieze that ran around the entire exterior wall of the *cella* further enhanced the

role of the Akropolis and the Parthenon as processional architecture. Although about 40 feet above the ground, the 3½-foot-tall frieze could be viewed, with some difficulty, from the outer **colonnade** of the Parthenon, and its subject would have been familiar to Athenians. The greatest depth of the frieze is no more than 2½ (6.4 cm) inches, but the upper part is sculpted in **higher relief** to adjust to the position of the viewer, looking up from below. The frieze was brightly painted, and the holes visible today indicate where metal details, such as horse bridles and reins, were attached. The frieze is often interpreted as representing the Panathenaic procession, in part because of the imagery, and in part because the figures in the frieze move in the same directions as the procession. However, the subject matter is open to debate because mere mortals were not traditionally depicted on temples.

Sculpted on the west, or back, end of the temple, facing the Propylaia, are thirteen men with their horses preparing for a cavalcade (formal procession), which appears on parts of the north (**Fig. 14.11**) and south friezes moving toward the east, or front, end of the Parthenon on the far side of the sanctuary. The horses are animated and the riders are reserved, with serious faces carved naturalistically. Although their high-up position meant that the sculptures could be viewed only from a distance, the artist still took great care to depict details, such as veins underneath the skin. Using fairly shallow relief, the sculptor overlapped forms to give the illusion of depth in a very crowded and complex, yet orderly, composition, once again demonstrating the Classical emphasis on balance and order. In front of the riders and horses in the procession are chariots with a charioteer and

warrior. Continuing toward the east end of the temple are elders, musicians, and sacrificial animals, including sheep and heifers. In the frieze on the east side of the Parthenon, women are shown moving toward the area over the front entrance to the temple. They are met by a group of male officials. Over the doorway at the front of the Parthenon, the twelve seated Olympian gods flank the central scene of five standing figures (**Fig. 14.12**). (They were called "Olympian" because ancient Greeks believed that Mount Olympus, the highest peak in Greece, was the home of the major gods). The seated figures' divinity is demonstrated by their larger scale. To the left of the central scene, Zeus sits next to Hera, who is raising her veil. To the right of the central scene are Athena and Hephaistos, also seated.

The meaning of the central scene of the east frieze, which appears to be the culmination of the sculptured procession, is debated. Two young women with bundles on their heads are positioned to the left of another woman, perhaps the priestess of Athena who held an important position in Athens. A man stands at her back (on the right) and appears to be receiving a large piece of fabric from a young boy or girl. This textile is often identified as the Panathenaic *peplos*, a garment in which a statue of Athena was ritually dressed at the end of the procession. If this interpretation of the frieze is correct, then it would have been quite shocking in its day owing to the presence of mortals on a temple—in company with the gods, no less. An alternative interpretation suggests that the frieze references a mythological story in which Erechtheus, a legendary king of Athens, sacrifices one of his daughters to save Athens from an invading army.

colonnade a long series of columns at regular intervals that support a roof or other structure.

high relief raised forms that project far from a flat background.

14.11 BELOW **Cavalcade, frieze from the Parthenon west end,** Akropolis, Athens, 447–432 BCE. Marble, height approx. 3 feet (90 cm). British Museum, London.

14.12 BOTTOM **Central scene (*peplos* scene), frieze from the Parthenon east end,** Akropolis, Athens, 447–432 BCE. Marble, height approx. 3 feet (90 cm). British Museum, London.

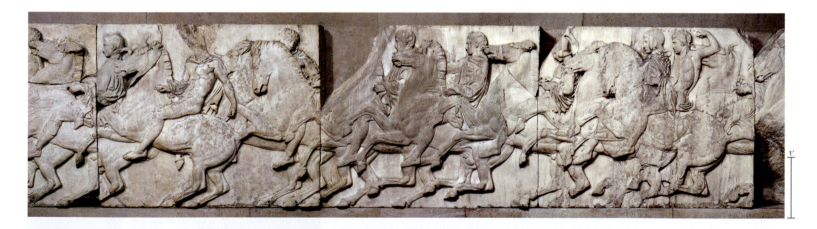

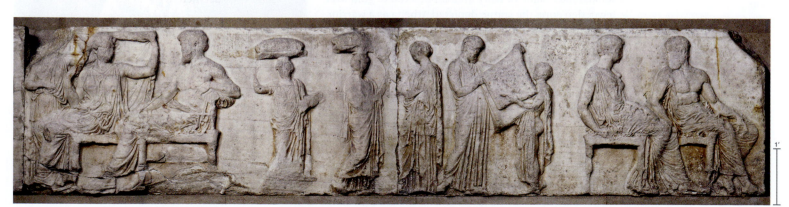

Countless ancient artworks have been removed from their land of origin to museums in Europe and the United States. Between 1801 and 1805, Lord Elgin, British Ambassador to the Ottoman Empire, shipped about half of the then-remaining Parthenon marble sculptures, sometimes called the Elgin marbles, to London, where they now reside in the British Museum. The fact that these sculptures are in the UK rather than in Greece is a contentious issue; the Greek government has repeatedly asked the British Museum to return the marbles to Athens, without success. How should we think about this controversy over cultural heritage?

The actual building of the Parthenon had a long and complex history. In the sixth century CE, the temple was converted into a church dedicated to the Virgin Mary, at which time many of the sculptures were defaced. It remained a church for nearly one thousand years, but following the Ottoman conquest of Greece it was turned into a mosque in the early 1460s. It was being used to store Ottoman ammunition when, in 1687, the Parthenon exploded under Venetian bombardment.

In the eighteenth century, Enlightenment thinker and art historian Johann Winckelmann connected the rise of democracy to the development of the so-called High Classical style of the second half of the fifth century BCE in Athens. Since then, the Parthenon has been

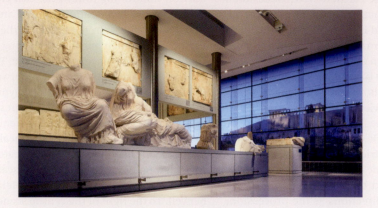

14.13 Plaster casts of the **Parthenon Marbles,** in the Akropolis Museum, Athens. The Akropolis can be seen through the window in the background.

touted as an icon of Western democratic ideals. Thus the Parthenon style has been adopted for cultural and governmental buildings from the British Museum (1823–52) to the United States Supreme Court Building (1935).

The narrative that identifies Greece as the origin of such Western ideals has fueled the heated debate. The Parthenon marbles are of great importance to Greeks, who see them as a symbol of national pride in the Greek past. The new Akropolis Museum in Athens, built in direct sight of the Parthenon (**Fig. 14.13**), has made the Greeks' plea for the marbles' return tangible by creating an impressive space for the missing sculptures. It is currently filled with bright white plaster casts as stand-ins, waiting for the original marbles to take their place. Yet some see the arguments of the Greeks—that the marbles, sculpted more than two millennia ago, belong to the country as a part of its cultural heritage—as nationalistic. The British Museum sees the Parthenon sculptures "as part of the world's shared heritage," arguing that they "transcend national boundaries." Impassioned and informed arguments are made on both sides. The questions remain: Can culture be owned, and who has the right to make such decisions?

Discussion Question

1. Why is the debate regarding the proper home of the Parthenon marbles so heated? Can culture be owned? Why or why not?

chryselephantine made of gold and ivory; from the Greek words for "gold" and "elephant."

iconography images or symbols used to convey specific meanings in an artwork.

tumulus a mound of earth raised over a burial or grave.

sphinx a winged monster with a human head and a lion's body.

14.14 FAR RIGHT **Athena Parthenos,** contemporary model of the original chryselephantine cult statue from the Akropolis, Athens. Gypsum, fiberglass, steel, aluminium, polychrome and gilding 1990–92, height 37 ft. 8½ in. (11.29 m). Parthenon, Nashville, Tennessee.

If this interpretation is correct, then the scene would depict Erechtheus receiving the burial shroud from one of his other daughters.

STATUE OF ATHENA PARTHENOS Inside the *cella* of the Parthenon was a colossal 40-foot **chryselephantine** statue of the goddess Athena Parthenos (meaning "virgin", and which gives the Parthenon its name), designed by Pheidias and dedicated in 438 BCE. Although the statue has not survived, ancient descriptions and reproductions, albeit on a much smaller scale, give some idea of what it looked like. Made of ivory and about a ton of gold over a wooden core, the statue depicted Athena as a warrior, wearing a helmet and her *aegis* (a goatskin breastplate) decorated with a Gorgon head (the gorgons were three sisters who had snakes for hair and could turn those who looked at them to stone). Her spear, shield, and a snake were nearby, and she held a figurine of the goddess of victory, Nike, a clear symbol of Athens' victory over the Persians. The **iconography** on Pheidias's statue mirrored, in large part, the subjects of the metopes on the exterior of the temple: Greeks versus centaurs on her sandals, Greeks versus Amazons on the outside of her shield, and gods versus giants on the inner part of her shield. These subjects all spoke of the power of an ordered Athenian

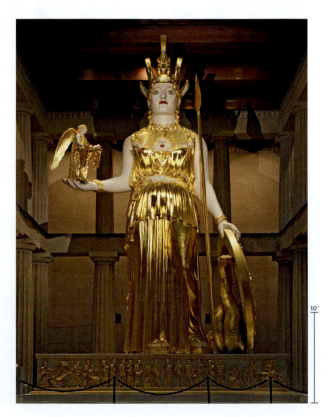

society over what the Athenians perceived as barbarism, alluding to Persia and any other external threat to Athens at the time. Small Roman sculptures imitating Pheidias's great work also exist, but to get an idea of the scale of the original it is necessary to visit the replica Parthenon built in Nashville, Tennessee, which houses its own version of Pheidias's statue of Athena, albeit not made from real ivory, but impressively gilded (Fig. 14.14).

PENDANT DISK WITH HEAD OF ATHENA PARTHENOS

One of the earliest known representations of the head of the gold-and-ivory statue of Athena is found on a gold pendant disk dating from the early to mid-fourth century BCE (Fig. 14.15). It was discovered in a **tumulus** near Kerch, an early Greek settlement in eastern Crimea on the Black Sea. Ancient literary descriptions of the goddess's helmet as having three crests—a central **sphinx** flanked by **griffins**, with the wings of Pegasus (a mythical winged horse, offspring of the god Poseidon) on either side—are paralleled here in **repoussé**. The craftsmanship of this piece is extravagant, utilizing the techniques of repoussé and **chasing** for the head of Athena, **filigree** for the ivy tendrils, and gold *cloisonné* filled with green and blue enamel. There are also complex loop-in-loop chains, as well as filigree and **granulation** on the urn-like pendants.

THE ERECHTHEION

Continuing their procession toward the altar past the ruins of the old Temple of Athena Polias, ("protector of the city), with the Parthenon on their right, ancient Athenians would have seen on their left a much smaller Ionic temple, known since antiquity as the Erechtheion (see Fig. 14.2, p. 241) after the legendary first king of Athens, Erechtheus; however, some scholars believe it is the Classical replacement of the earlier Temple of Athena Polias. Construction of the Erechtheion began around 421 BCE, after Perikles' death, but did not conclude until around 404 BCE, when the Athenians lost their war against Sparta.

The Erechtheion is extremely complex, both in terms of its architectural layout and the cults worshiped within. The intricate layout (Fig. 14.16) is due in part to the steep slope on which it was built, and in part to the preexistence in this location of a number of early shrines important to the foundation mythology of Athens, such as that of Erechtheus. The temple included four rooms and an underground chamber. Beyond the Ionic east porch, the largest room housed the ancient Archaic olivewood statue (*xoanon*) of Athena. Although it paled in comparison to the more extravagant and imperialistic chryselephantine statue of Athena in the Parthenon, this simple sculpture was the most sacred object in Athens, and it was clothed in the *peplos* during the Panathenaic procession.

NORTH PORCH OF ERECHTHEION

On the north side of the Erechtheion, at a much lower ground-level, an Ionic porch (see Fig. 14.16) housed the rock that, according to legend, Poseidon struck with his trident during his competition with Athena over who would become the patron deity of Athens, as illustrated on the west pediment of the Parthenon. The temple also included the pool of

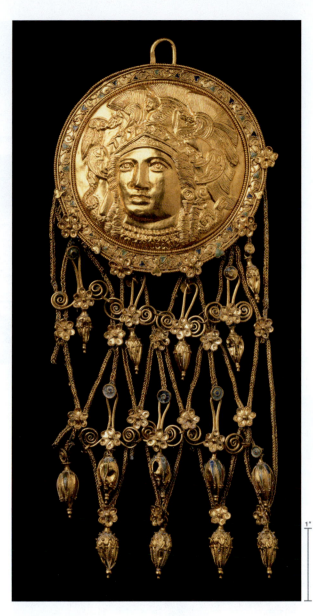

14.15 **Pendant disk with head of Athena Parthenos,** found in Kerch, eastern Crimea, *c.* 400–350 BCE. Gold and enamel, length 7⅜ in. (18.7 cm), diameter 2⅞ in. (7.3 cm). State Hermitage Museum, St. Petersburg, Russia

griffin a mythological creature with the body of a lion and the head of a bird; often winged.

repoussé relief design created by hammering malleable metal from the reverse side (not the side to be viewed).

chasing a metalwork technique in which designs are worked into the front surface of the object.

filigree a type of decoration, typically on gold or silver, characterized by ornate tracery.

cloisonné decorative enamelwork technique in which cut gemstones, glass, or colored enamel pastes are separated into compartmented designs by flattened strips of wire.

granulation a decorative technique in which beads of precious metal are fused onto a metal surface.

14.16 BELOW **The Erechtheion (architectural plan),** Akropolis, Athens, 421–404 BCE.

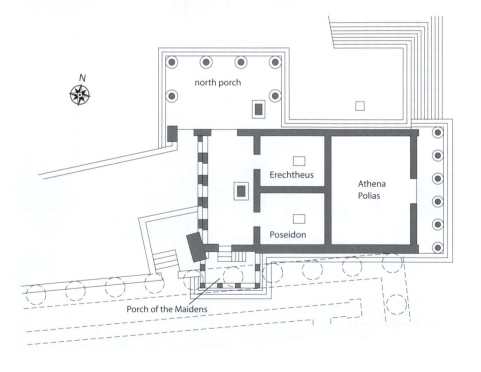

N

north porch

Erechtheus

Athena Polias

Poseidon

Porch of the Maidens

14.17 Porch of the Maidens, south side of Erechtheion, Akropolis, Athens, 421–404 BCE.

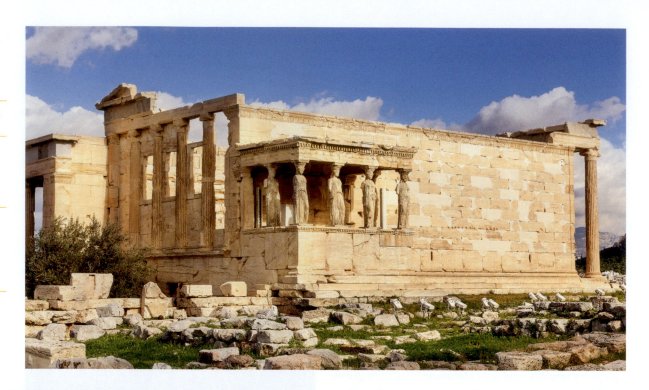

volute a decorative element in the form of a coiled scroll.

karyatid stone statue of a young woman, or *kore*, used like a column to support the entablature of a Greek or Greek-style building.

contrapposto Italian for "counterpoise," a posture of the human body that shifts most weight onto one leg, suggesting ease and potential for movement.

14.18 BELOW **Temple of Athena Nike,** Akropolis, Athens, *c.* 421–415 BCE.

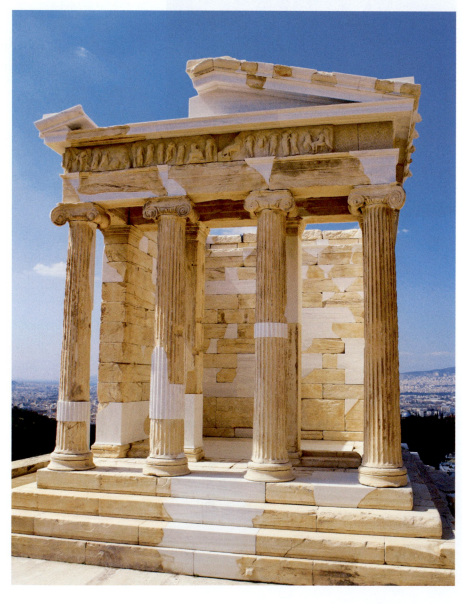

salt water that this act was believed to have formed. The olive tree gifted by Athena to the citizens of Athens won her the competition against Poseidon, perhaps due to its many practical functions, such as for nutrition, hygiene, and health, and its larger symbolic value as a symbol for peace. It, too, was accommodated within the temple. The east and north porches display an exceptionally elegant version of the Ionic style, with columns resting on bases and highly elaborate **volute** capitals. In addition to ornate carved-marble bands that ran around the building, the frieze that wrapped around the temple was made of blue limestone with marble figures set against it. Those figures are now almost completely lost.

PORCH OF THE MAIDENS On the south side of the Erechtheion, facing the Parthenon, is the well-known Porch of the Maidens (**Fig. 14.17**), where six sculpted *kore* (figures of young women) are shown on top of a high parapet supporting the entablature above. The figures are often called **karyatids**, because it was once thought that they represented the women of Karyai, a Greek *polis* (city-state) that sided with the Persians during the Persian Wars. Each one is shown in a ***contrapposto*** stance, with one weight-bearing straight leg, and one relaxed bent leg. The bent leg of each figure is revealed under the drapery. The folds over the straight leg are reminiscent of the flutes of traditional columns, which here the karyatids replace. The karyatids now standing on the Athenian Akropolis are copies. Five of the originals are housed in the Akropolis Museum, and one is in the British Museum, having been taken to the United Kingdom by Lord Elgin.

TEMPLE OF ATHENA NIKE Atop an old Mycenaean tower overlooking the approach to the Propylaia is the small Ionic Temple of Athena Nike (**Fig. 14.18**), or Victory, referring to victory in battle. The bastion on which it stands was mostly encased in limestone during the Classical

era, but Classical Athenians left part of the original tower exposed so that one could catch a glimpse of the Bronze Age **Cyclopean** masonry. Although this elegant temple may have been planned with the rest of the Periklean building program (it incorporates some of the optical refinements that are typical of the Parthenon), construction did not begin until 421 BCE. It consists of a small *cella* that is wider than it is deep, with a porch that includes four columns set in front and four columns on the back, giving it a sense of balance. Unlike other temples on the Akropolis, there is no entrance into the *cella* from the back porch on the west side of the temple.

True to its namesake, the building's decorative program focused on the theme of victory. The roof of the temple was adorned on the east and west sides with bronze **akroteria** representing Athena Nike. Depicted on the east pediment was most likely the Battle of the Gods and Giants; on the west the Battle of the Greeks and Amazons. A one-and-a-half-foot-high (45.7 cm) frieze ran all the way around the temple; pieces of the north and west friezes survive, but it is unclear whether the scenes are mythological or historical, perhaps representing Athenians battling other Greeks, or fighting in the Peloponnesian Wars. Historical narrative is quite unusual on Greek temples, which rarely feature mortals in their sculpture, and yet their presence would be in keeping with humanist ideals. The south frieze probably represents the Battle of Marathon of 490 BCE, which had already become the stuff of legend thanks to the embellished account of the Greek historian Herodotus. The east frieze, located on the front of the temple, represents a divine assembly of the Olympian gods.

NIKE ADJUSTING HER SANDAL Around the north, south, and west edges of the bastion runs a three-foot-high balustrade (railing) with a parade of sculpted and winged figures of Nike, the personification of victory, leading bulls to sacrifice in honor of Athena. In one detail, a Nike figure pauses to adjust her sandal (**Fig. 14.19**). Although the position of the figure is somewhat awkward, the artist gives the work a sense of balance by countering the elevated leg with the opposite shoulder. The heavy wings also provide a counterbalance to Nike's almost teetering body. This finely carved figure is eroticized; the diaphanous, wet-looking drapery slips from one shoulder while clinging tightly to other parts of Nike's body.

One scholar has associated the winged Nike removing her sandal with the last act of a bride before losing her virginity, interpreting it as alluding to the acts of sexual violence so common in warfare. Others suggest that Nike is removing her sandal because she is approaching sacred ground. Or perhaps this Nike, engaged in the very human activity of lingering to adjust her sandal, represents the perceptions of Athenians who felt that Nike had not hurried to their rescue in the long-drawn-out Peloponnesian Wars. Regardless of the interpretation, this humanized Nike, engaged in a very worldly activity, paves the way for the Late Classical style with its greater individualism and focus on the everyday.

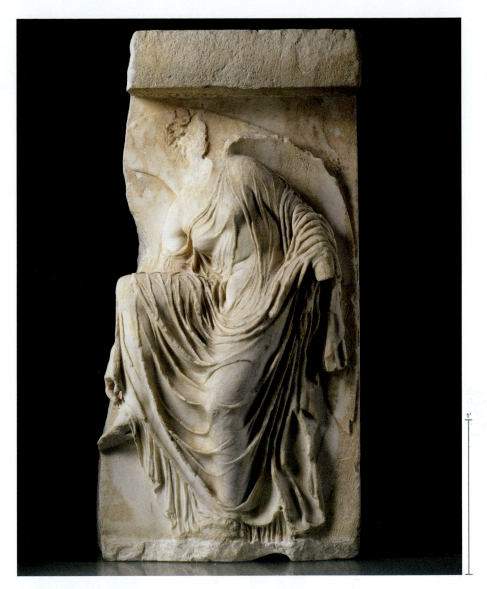

Polykleitos of Argos and His Kanon

The interest in balance and ideal proportions seen in the Periklean building program on the Akropolis is also evident in sculptures by Polykleitos of Argos, a well-known sculptor of the Classical age. Polykleitos was so interested in ideal proportions that he wrote a treatise outlining his system called *Kanon*. (The word *kanon* means "measure" or "rule" in Greek, and it gives us the English word "canon.") He created a bronze sculpture of a man to illustrate his *kanon* of ideal proportions, thus creating a visual expression of the Greek philosopher Protagoras's concept that "man is the measure of all things." In attempting to create a work of ideal, harmonious proportions, Polykleitos sought to convey *arete*, an important concept in ancient Greek society that means moral virtue or excellence. Not long after the creation of this bronze sculpture, the Greek philosopher Plato asserted that the concept of beauty was based on proportion.

Although Polykleitos's treatise is lost and no other bronze sculpture by him has been discovered, about fifty Roman marble copies of what is now known as the *Doryphoros (The Spear Bearer)* have been found. Based on

14.19 *Nike Adjusting Her Sandal,* parapet, Temple of Athena Nike, Athens, after 407 BCE. Marble, height 3 ft. 6 in. (1.07 m). Akropolis Museum, Athens.

Cyclopean masonry a stone building technique in which large boulders are roughly shaped and fitted together to create well-knit, structurally sound walls.

akroteria sculptures that adorn the roof of a temple.

these copies, scholars have tried to re-create Polykleitos's canon of proportions, but working from what may be unreliable copies makes this task difficult.

DORYPHOROS (THE SPEAR BEARER) This Roman marble copy (**Fig. 14.20**) demonstrates a more advanced stage of *contrapposto* than Early Classical sculptures, such as the *Kritios Boy* (see Fig. 13.17). It depicts a male warrior, perhaps Achilles, who originally held a spear in the hand of his bent left arm. To balance the composition harmoniously, the warrior's bent arm is opposite the straight weight-bearing leg, whereas the bent leg is opposite the straight arm. The figure is very muscular. While it seems to be a development of the Archaic *kouroi* (statues of young men in rigid standing poses), the turn of the head and the shift in body weight, seen most visibly in the pelvis, seem to imply a sense of subtle movement. The awkward stump behind the straight leg provides support that would not have been necessary in the bronze

original, because bronze has more tensile strength than stone. The sculpture represents a youth in a naturalistic way, capturing muscles, veins, and sinews, but it is also idealized. Rather than representing specific individuals with portrait features, the Greeks of the Classical age favored more generic, youthful figures that demonstrated the Greek ideals of perfection and beauty. The youth is almost otherworldly, gazing well beyond the viewer.

Classical Bronzes

Bronze was the favored medium for sculpture in Classical Greece, but because of the metal's value, most bronze artworks were melted down for reuse. To examine original bronze statues of that period it is necessary to look to the sea. In 1972, an amateur diver made a chance discovery of two original Classical bronze sculptures off the coast of Riace, in southern Italy. It is likely that they were being carried from Greece to Rome on a ship that went down sometime after the Romans conquered Greece in 146 CE.

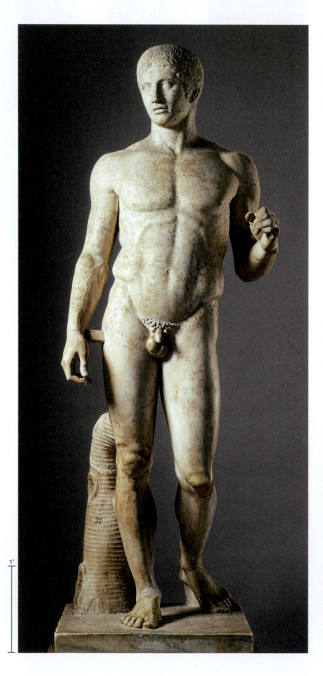

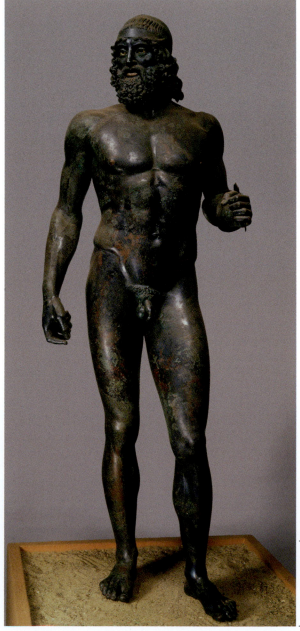

14.20 RIGHT **Polykleitos of Argos,** *Doryphoros (Spear Bearer),* Roman marble copy of a Greek bronze of *c.* 450–440 BCE, height 6 ft. 7⅝ in. (2.02 m). Museo Archaeologico Nazionale, Naples, Italy.

14.21 FAR RIGHT **Riace Warrior A,** found in the sea off Riace, Italy, *c.* 450 BCE. Bronze, silver, and copper, height 6 ft. 9 in. (2.06 m). National Archaeological Museum, Reggio Calabria, Italy.

RIACE WARRIOR A The bronze figures, one of which is illustrated here (**Fig. 14.21**), represent warriors who once held shields in their left hands and swords in their right. The beards tell us these individuals are older men, although their bodies and skin appear youthful and highly idealized, in keeping with the Classical style. Their nudity lends a sense of heroism to these warriors, for Greek men did not go into battle without clothes.

The warrior here retains his inlaid eyes. His lips and nipples are distinguished from the rest of the skin with copper, and the teeth are silver, adding to the great care and expense that went into creating this larger-than-life-size sculpture. Such details also enhance the statue's naturalism, particularly in the face (see p. 238). Because bronze reflects light so well, the artist played with a variety of surface textures, especially in the hair, with its extraordinary curls. Although the warrior was originally holding weapons, he is shown in repose, modeling the *contrapposto* stance seen in the *Doryphoros* (see **Fig. 14.20**). The clay core inside the two Riace bronzes suggests that they were probably made in the area of Argos in the Peloponnese. That original Greek sculptures, such as the Riace warriors, made their way to Roman collectors in Italy hundreds of years after they were created for their Greek audience suggests the great value placed on these works over a long period of time.

Women in Classical Art and Ritual

In contrast to the many sculptures of male athletes, warriors, and gods and goddesses, there are few representations of mortal women dating to the Classical period—unlike the ubiquity of female *korai* sculptures in the previous Archaic era. The probable reason is that the realm of affluent Greek women in *poleis*, such as Athens, was the home rather than the public sphere (although see the discussion of the painting on the **lekythos**, **Fig. 14.23**, p. 253). Relief sculptures of women do exist, however, on grave **steles** in cemeteries outside the city walls. Many of these steles are carved with domestic scenes in which the deceased woman is bidding farewell to loved ones, or engaging in activities typical of wealthy women at the time. These scenes convey a tender solemnity fitting for a grave monument. Deceased women and men were both memorialized in this way, and they were sometimes shown together.

GRAVE STELE OF HEGESO Grave steles were set up along the roads leaving the city, so they were intended for public viewing. They demonstrated the wealth of a family who could afford such a monument, but they also conveyed the accepted ideals of the time. This painted marble stele of a deceased young woman named Hegeso (**Fig. 14.22**) dates to around 410 BCE and was originally located in the Dipylon Cemetery of Athens. Hegeso sits on an elegant chair with a footstool. She examines an item of jewelry once represented in paint, perhaps a necklace, that she has just taken from a jewelry box brought to her by a dutiful servant. Her drapery is delicately carved, similarly to that of the seated goddesses on the Parthenon (see Fig. 14.9). The relief is fairly shallow, but the artist creates the illusion of deeper space through the use of

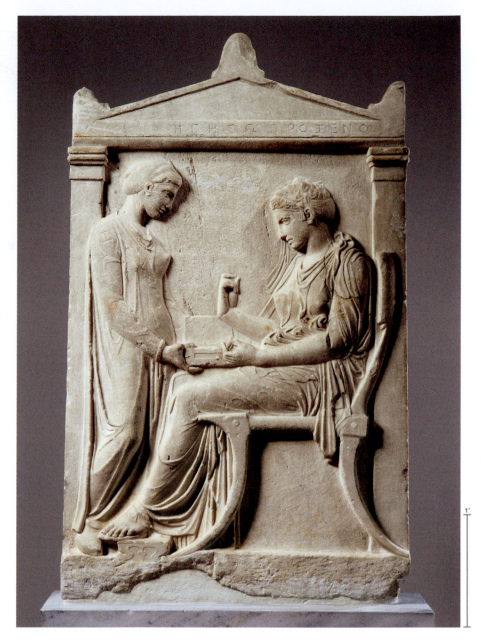

foreshortening, for example in the lifelike foot on the footstool. A sense of three-dimensionality is also achieved by varying the depth of the relief. The deceased's veil, which falls on the far side of her head, and her drapery, some of which falls over her chair in the foreground, are carved in very **low relief**.

Like many works of the Classical period, the carving of Hegeso lacks specific portrait features. The young woman is shown as passive and meant to be gazed upon. She looks at her jewelry, which would have been provided by her father or husband. She is placed in a domestic setting, as indicated by the columns to the side and the pediment above, where an inscription reads "Hegeso, daughter of Proxenos." She is therefore defined by her relationships with, and support from, men.

WHITE-GROUND *LEKYTHOS* WITH FUNERARY SCENE
While the stele of Hegeso depicts the public ideal of a woman as being passive, belonging to the domestic realm, and defined by her relationships with the men in

14.22 Grave stele of Hegeso, from Dipylon Cemetery, Athens, c. 410 BCE. Marble and paint, 5 ft. 1 in. × 38½ in. (1.55 × 0.98 m). National Archaeological Museum, Athens.

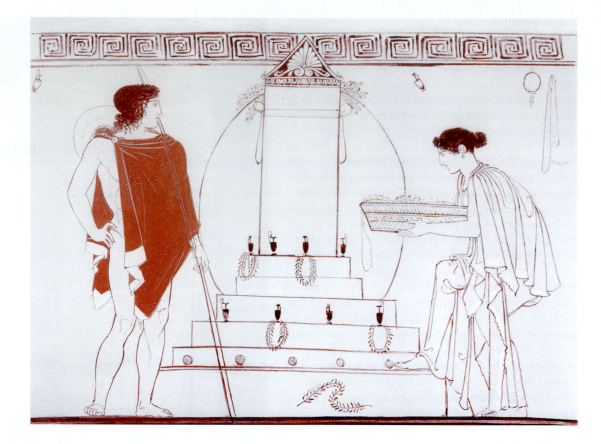

14.23 ABOVE *Lekythos* with **funerary scene,** *c.* 440 BCE. White-ground painted ceramic. National Archaeological Museum, Athens.

14.23a ABOVE RIGHT **Funerary scene from** *lekythos* **(roll-out drawing).**

slip a layer of fine clay or glaze applied to ceramics before firing.

black-figure a style of pottery painting developed in Corinth; black decoration on a red background.

red-figure a style of pottery painting for which Athens was famous; red decoration on a black background.

krater large vessel usually used for diluting wine with water.

her life, in reality the social contributions of women in ancient Greek society were far more complex and context-dependent. As in the Archaic period, women in Classical times played an important role in religious rituals for the dead. Paintings of women appear on *lekythoi*. After use, many of these vessels—either whole or broken—were deposited in tombs.

The white-ground technique, a style of decorating ceramics in which outlines and details are painted in color onto a white **slip** background, became popular for *lekythoi*. This technique is principally limited to vessels deposited in tombs. This usage makes perfect sense, because the pigments were applied to the white slip after firing. The unfired colors were heat sensitive and would not have lasted long on a vessel that was heavily used in daily life.

The scenes painted on *lekythoi* are often funerary, and many of them feature women engaging in rituals that took place before and after the body was interred. For example, women are shown washing and anointing the body, making gestures of mourning while the body is being laid out, and bringing offerings of perfumed oil, food, wine, and garlands to the tombs after interment. In Classical Greece, offerings were brought to the grave during a period of mourning, and later on specific dates. The *lekythos* shown here (**Fig. 14.23**) depicts a grave stele in the center topped by a pediment with a decorative palmette (radiating petals that resemble the leaflets of a palm tree). The stele is elevated on a raised base, with garlands and vases, including *lekythoi*, which were left on the steps as offerings. To the right of the stele a woman carries a basket with some sort of offering, and to the left is a young man who wears a mantle and holds a spear. He

may represent the woman's deceased husband, perhaps a warrior who died in battle. There is a solemnity to the scene that indicates loss, but also a strong connection between the woman and the deceased through the rituals she carries out at the tomb.

Athenian Red-Figure Pottery

There were two main types of pottery in Athens, which long dominated the pottery market throughout Greece and beyond: **black-figure** and **red-figure**. The red-figure style was introduced during the Archaic period, around 530 BCE, and it co-existed with black-figure pottery for about forty years, as we can see very clearly on so-called bilingual pottery, which is decorated with a red-figure scene on one side and a black-figure scene on the other, often of the same or similar subjects. During the Classical period, however, the popularity of red-figure pottery greatly increased, perhaps because this technique meant that rather than working in silhouettes, artists could paint fine details to create illusion of three dimensions and infuse their works with greater dynamism or movement. This interest in naturalism is in keeping with artistic developments during the fifth century BCE in other media, including sculpture.

NIOBID *KRATER* An impressive *krater* (**Fig. 14.24**) by the so-called Niobid Painter highlights some of the progress made in red-figure painting by the mid-fifth century BCE. In ancient Greece, *kraters* were used for mixing wine with water, and therefore frequently graced symposia (gatherings where aristocratic men reclined on couches and drank while enjoying lively conversation and music). The subject matter of this specific *krater*, however, is

strikingly non-festive for a drinking party, but may have resonated with the upper-class male attendees of a symposium. It depicts a scene in which the gods Apollo and Artemis avenge the honor of their mother, Leto by ruthlessly killing all fourteen children of Niobe, who had boasted she had more progeny than Leto. Niobe's children are the helpless victims of the arrows of Artemis, goddess of the hunt, and Apollo, one of whose nicknames is "far-shooting."

The composition deviates from earlier red-figure works in that the figures are not set on a single line indicating the ground or floor. Rather they are placed at different heights across the vase to show the figures interacting with one another in deep space. For example, Artemis and Apollo are located above two of Niobe's children, who have been struck by arrows. The figures are also placed in a variety of positions, including three-quarter views, and some parts of the figures are heavily foreshortened, again suggesting an interest in creating the illusion of three dimensions. And yet, the heightened emotion one might expect from such a violent scene is decidedly lacking, as the calm and poised gods murder the Niobids, who fall in seemingly graceful poses. It is not until the subsequent Late Classical and Hellenistic periods that the calm and idealized figures of the Classical period give way to heightened individualism and emotion in art, reflecting the downfall of the *poleis* and the rise of Hellenistic kingdoms.

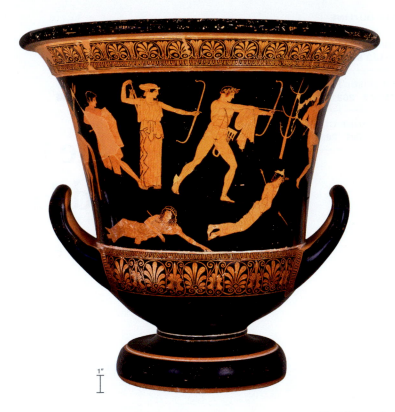

14.24 Niobid *Krater*, found in Orvieto, Italy, *c.* 450 BCE. Athenian red-figure ceramic, height 21 in. (53.3 cm). Musée du Louvre, Paris.

Discussion Questions

1. How is the display of humanism in Classical art of the second half of the fifth century BCE characteristic of both democratic ideals and imperialism? Provide at least two artistic and/or architectural examples.

2. There was debate over whether to rebuild the Athenian Akropolis after its destruction by the Achaemenid Persians. Those who did not want to rebuild cited its importance as a war memorial. Can you think of other, more recent, examples? What can these debates tell us about the importance of space and place?

3. What are some of the roles that women played in Classical Greek society? Provide at least two artistic examples.

4. Choose an artwork discussed in this chapter that is both highly naturalistic and idealized in appearance. Explain how and why this is the case.

Further Reading

- Beard, Mary. *The Parthenon*. Cambridge, MA: Harvard University Press, 2003.
- Derbew, Sarah. "An Investigation of Black Figures in Classical Greek Art." *The Iris: Behind the Scenes at the Getty,* April 25, 2018. https://blogs.getty.edu/iris/an-investigation-of-black-figures-in-classical-greek-art
- Kimmelman, Michael. "Who Draws the Borders of Culture?" *New York Times*, May 5, 2010.
- Kaltsas, Nikolaos and Alan Shapiro. *Worshiping Women: Ritual and Reality in Classical Athens*. Alexander S. Onassis Public Benefit Foundation (USA), Hellenic Ministry of Culture, National Archaeological Museum, Athens, 2008.

Chronology

480–79 BCE	Decisive victories of the Greeks over the Persians at Salamis and Plataia in the Greco-Persian Wars
477 BCE	The Delian League is founded
461–429 BCE	Perikles dominates Athenian politics
454 BCE	The Delian League treasury is moved to Athens from Delos, and Perikles uses some of the wealth to rebuild Athens
***c.* 450–440 BCE**	*Doryphoros* and *Riace Warriors* are created
447–432 BCE	The Temple of Athena Parthenos (the Parthenon) is built
437 BCE	Construction of the Propylaia begins
432 BCE	The Parthenon sculptures are completed
431–404 BCE	Peloponnesian War between Athens and Sparta and their allies
421–404 BCE	Construction of the Erechtheion
421–415 BCE	The Temple of Athena Nike is built
after 407 BCE	*Nike Adjusting Her Sandal* is carved

15

Late Classical Greek and Hellenistic Art

400–31 BCE

Pythokritos of Rhodes (?),
Winged Victory (Nike) of
Samothrace (detail).

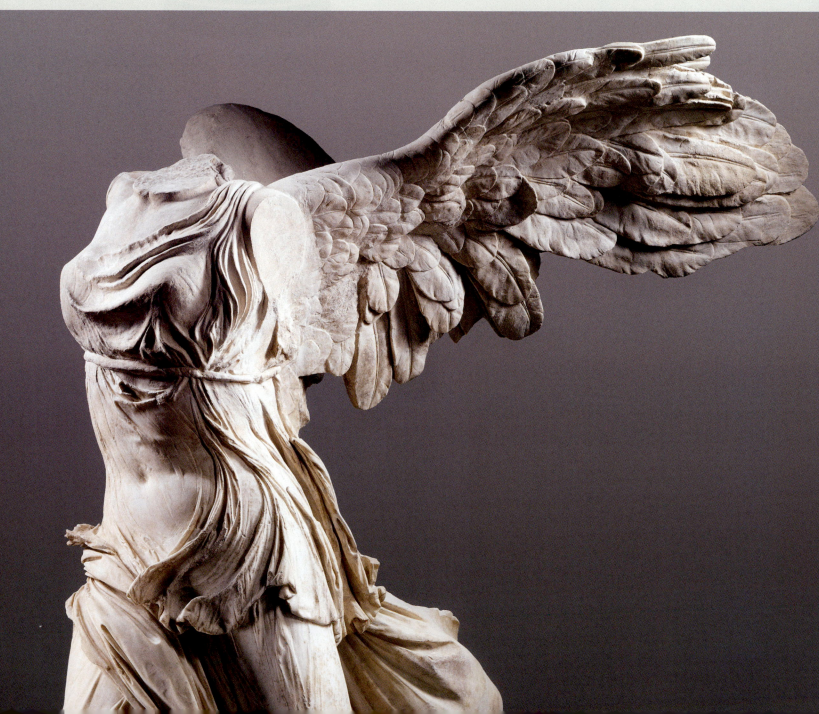

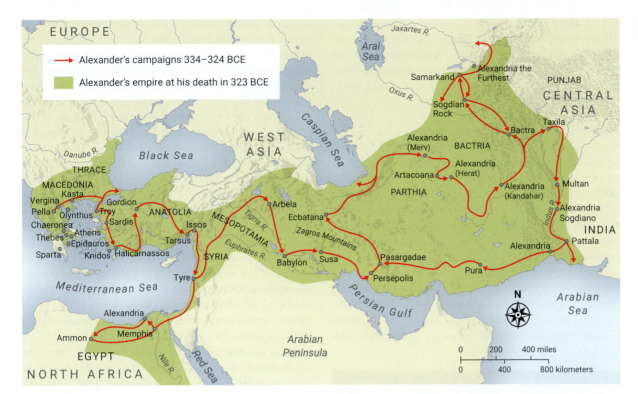

Map 15.1 The conquests of Alexander

Map legend:
→ Alexander's campaigns 334–324 BCE
Alexander's empire at his death in 323 BCE

Introduction

The fourth century BCE in Greece was a time of rapid change that had a profound effect on art. With its defeat by Sparta in 404 BCE, Athens lost its political and military primacy. Nonetheless, it continued to play an important cultural role. For example, it was there that the humanist philosopher Plato founded his academy in 387 BCE. His student Aristotle, who later tutored a young Macedonian prince who would become Alexander the Great, also founded a school in Athens. Perhaps even more defining for the period was the downfall of the Greek city-states, as the democracy of the Classical *polis* was eclipsed by the rule of kings, ushering in the Late Classical period in art. Following Athens's military losses, the Greek gods, heroes, and citizens were brought down from their pedestals, so to speak, as eternally youthful idealized figures in art gave way to realism. Artists now focused on the individual, who was often engaged in more mundane activities.

Alexander the Great's conquests between 336 and 323 BCE enabled Greek people and their culture to spread over a vast area, paving the way for the Hellenistic period. (The Greeks called themselves "Hellenes," their land "Hellas," and their culture "Hellenic," but "Hellenistic" means "Greek-like" and refers to the mixed culture that developed after the death of Alexander.) The diversity of the Hellenistic world, which spanned three continents—Europe, Africa, and Asia—was unparalleled, with Greeks living among Indigenous people from Egypt to India, often in the minority (see **Map 15.1**). Rather than pledging allegiance to a *polis*, Greeks increasingly found themselves living abroad and considered themselves cosmopolitans, or citizens of the world. Thus the art and architecture of the Hellenistic period, which can be described as eclectic, responded to and incorporated the diverse contexts for which it was created (see box: Looking More Closely: Indo-Greek Art, p. 263). Hellenistic art had to adapt in order to speak to new audiences, including kings and courts that had access to extraordinary wealth,

natural resources, talent, and artistic iconography and styles from a huge array of conquered lands. The shift away from the composed Classical artistic ideal toward a greater emphasis on the individual, begun in the late Classical period, reached new heights in Hellenistic art. In many cases, the result was dramatic and theatrical art that arouses a visceral emotional response in viewers, whether the subjects portrayed are human, mythological, or divine; in other cases, it is the everyday realism of the work that evokes a sense of pathos.

The Late Classical Period,
c. 400–323 BCE

In the first half of the fourth century BCE, following Athens's defeat in the Peloponnesian Wars, the city-states of Athens and Sparta continued to battle, and Thebes also entered the war arena with some success. The greatest threat to Greece, however, came from Philip II, ruler of Macedon, a kingdom to the north of the Greek peninsula. Even though the Greeks eventually united against this threat, they were defeated in 338 BCE at the Battle of Chaeronea. Philip's son Alexander, just eighteen at the time, led the charge. The concentration of power in the individual during this period is nowhere more evident than in the precipitous political rise of Alexander, who, after the assassination of his father in 336 BCE, inherited both power and Philip's plan to attack the Achaemenid Empire. At the time of his untimely death in 323 BCE at the age of thirty-two, Alexander ruled an enormous empire that covered two million square miles (3.2 million square km), from Greece, Egypt, and West Asia to present-day India.

Although Late Classical sculpture perpetuated many of the goals of Classical art from the fifth century BCE

—for example, the emphasis on naturalistic human forms—great change also occurred, including the movement toward more humanizing depictions, as artists shifted away from idealized depictions of mortals—and even gods and goddesses—in favor of more realist works that represent the everyday.

PRAXITELES, *APHRODITE OF KNIDOS* Praxiteles' original marble statue of the Greek goddess of love, Aphrodite (*c.* 350 BCE), from the city of Knidos in Asia Minor, is known only from numerous Roman copies (such as **Fig. 15.1**) and descriptions in ancient texts. Although monumental sculptures of Aphrodite certainly were not new (see the east pediment of the Parthenon, Fig. 14.9), the changes in the way the sculptor, Praxiteles, has depicted her are striking. Most obviously, Aphrodite here is completely naked, engaged in a modest attempt to cover herself with her right hand. Before the Late Classical period, men were commonly depicted naked in Greek art, often as a sign of heroism; but women (with the exception of courtesans, who were not the subjects of monumental

sculpture), and especially goddesses, were not portrayed naked. It was forbidden by the accepted cultural norms of the time, although some earlier works hinted at the nude female body through diaphanous drapery (see *Nike Adjusting Her Sandal*, Fig. 14.19). This Aphrodite's nakedness, therefore, signals a shift in artistic sensibilities. Given the location of Knidos in Asia Minor, at the crossroads of the Greek world and the Persian Empire, the nudity of the Greek goddess of love may also have been inspired by depictions of the West Asian goddess of love, Astarte or Ishtar, who was generally represented unclothed.

Aphrodite is preparing to bathe, a fairly mundane human activity, as indicated by the garments she holds in her left hand, which drape elegantly over a large *hydria*, or water container. There is a strong voyeuristic element here, as if the viewer has caught Aphrodite in a private moment. As in Polykleitos's *Doryphoros* (*Spear Bearer;* see Fig. 14.20), the copy of Praxiteles' *Aphrodite of Knidos* shown here demonstrates a clear **contrapposto** stance; it also captures the exaggerated S-curve of the goddess's body, for which Praxiteles is known. Notice how her right hip pushes out to one side, forming a loose S-shape when combined with the torso above and the leg below, adding to the sensuality of the figure.

Praxiteles was one of the most revered Greek sculptors of the Late Classical period. Ancient sources state that his skill as a sculptor was so impressive that "the hard stone appears as flesh and bone in every limb." His statue of Aphrodite clearly shows the increasing tendency toward humanizing depictions. Some scholars see the humanization of the gods in artistic depictions as evidence of the disillusionment of their worshipers, perhaps due to the political upheavals of the age. An alternative interpretation is that Praxiteles portrayed a more relatable deity in order to inspire devotion among the Greeks.

LYSIPPOS, PORTRAIT OF ALEXANDER THE GREAT A new sense of realistic dynamism in the Late Classical period can be seen in the work of the sculptor Lysippos, who made portraits of Alexander the Great and therefore must

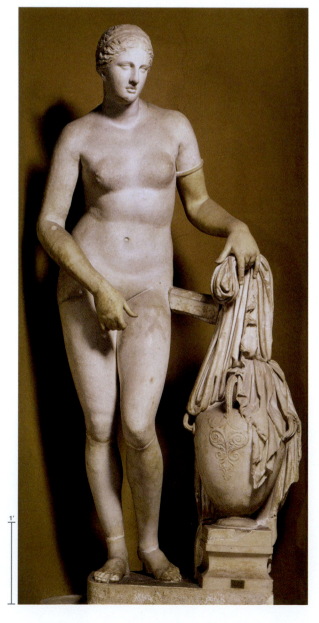

15.1 RIGHT *Aphrodite of Knidos*, Roman copy after a marble statue by Praxiteles, from present-day Turkey, *c.* 350 BCE. Marble, height 6 ft. 9 in. (2.06 m). Musei Vaticani, Rome.

15.2 FAR RIGHT **Head of Alexander**, from Pella, Greece, third century BCE. Marble, height 12 in. (30.5 cm). Archaeological Museum, Pella, Macedonia.

have been active in the years between 336 BCE and 323 BCE, possibly even longer. Several portraits of Alexander exist, including Roman copies, identifiable by his unruly, leonine hair with an off-center part. While we cannot definitely attribute them to Lysippos, certain characteristics of the young Alexander fit Lysippos's sculptural style, including the turn of his head, and his distant gaze, as seen in this portrait (**Fig. 15.2**). It comes from Pella, the birthplace of Alexander. Some of these characteristics are also apparent in the portrait of Alexander from the **mosaic** of the Battle of Issos located in the House of the Faun in Pompeii (see Fig. 18.14a).

LYSIPPOS, *APOXYOMENOS (THE SCRAPER)* One of Lysippos's most famous works is a bronze sculpture of a man engaged in the common Greek practice of scraping oil, sweat, and dirt off the skin after exercising, using a tool called a strigil. Called *Apoxyomenos (The Scraper)*, the work is known only through textual sources and Roman copies, such as this marble version (**Fig. 15.3**).

The banality of scraping a sweaty and dirty body after a workout humanizes the figure, which breaks out of the tight, Classical composition, instead confronting viewers in their space with one arm outstretched and the other in mid-scrape. The activity of the figure invites viewers to move around the athlete; in contrast, Classical works emphasize a frontal view. Equally dynamic is the athlete's hair, appropriately tousled for one who has just finished vigorous exercise.

The Roman Pliny the Elder tells us that:

the most important ideas he [Lysippos] brought to sculpture lay in his rendering of the hair, in making heads of figures smaller than earlier artists had made them, and bodies thinner and harder, by which means he made his figures seem taller.

Copies of *Apoxyomenos* do appear taller than Polykleitos's *Doryphoros*, which applies a different canon of proportions (see Fig. 14.20), although the later sculptures are not significantly taller.

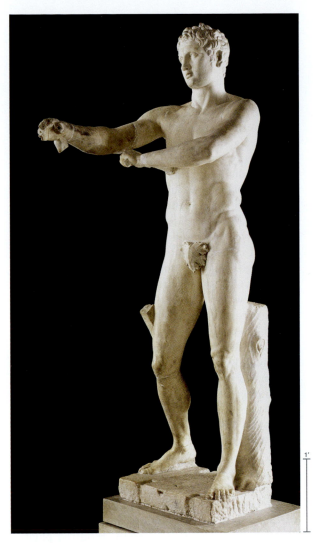

15.3 *Apoxyomenos (The Scraper)*, Roman copy after a bronze statue by Lysippos, *c.* 330 BCE. Marble, height 6 ft. 9 in. (2.06 m). Musei Vaticani, Rome.

THEATER AT EPIDAUROS In Greece, drama originated in religious ritual associated with Dionysos, the god of wine. Dramatic performances were important in Classical times and continued to play a significant role in the fourth century BCE, as evidenced by the theater at Epidauros (**Fig. 15.4**). The impressive acoustics, beauty,

mosaic a picture or pattern made from the arrangement of small colored pieces of hard material, such as stone, tile, or glass.

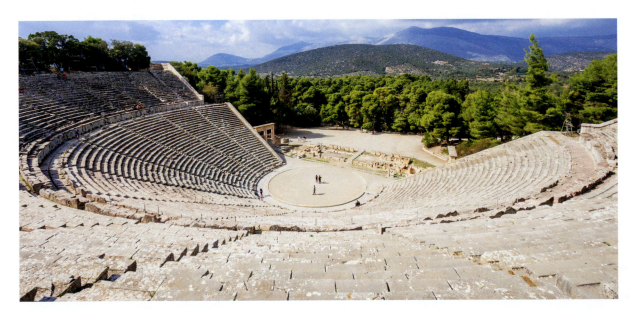

15.4 **Theater at Epidauros,** fourth century BCE. Peloponnese, Greece.

skene in ancient Greek theater, the structure at the back of the stage.

proskenion a raised platform or stage in front of the *skene* where the actors performed.

peristyle a line of columns enclosing a space.

tumulus a mound of earth raised over a burial or grave.

ashlar a stone wall masonry technique using finely cut square blocks laid in precise rows, with or without mortar.

fresco wall or ceiling painting on wet plaster (also called true or *buon fresco*). Wet pigment merges with the plaster, and once hardened the painting becomes an integral part of the wall. Painting on dry plaster is called *fresco secco*.

15.5 **Palace at Vergina (architectural drawing),** Entrance and facade (BELOW) and floor plan (BOTTOM). Macedonia, Greece, late fourth century BCE.

and symmetry of this theater were lauded even in ancient times. Like most Greek theaters, it included a circular performance area called the orchestra, which means "place to dance" in Greek. In the orchestra, the chorus interacted with the main characters of the play. They also described and commented on the play's dramatic action using dance, song, and recitation. The orchestra at Epidauros also included an altar where sacrifices to Dionysos (god of wine and theater) could take place before performances.

The audience viewing the drama sat in the *theatron*, meaning "place for seeing," a semicircle of tiered seating built into the hillside that overlooked the orchestra. At Epidauros there was a lower section and, later, an upper section divided by a walkway; altogether 55 rows accommodated 12,000 spectators. The *theatron* was divided into wedge-shaped sections with stairways in between each area. Opposite the seating, on the other side of the orchestra, was the *skene*, now largely lost, which served as a backdrop for the drama while providing space for dressing rooms and other backstage needs. Between the *skene* and the orchestra was the *proskenion*, or stage. Notably, only men acted in ancient Greek theater. They wore masks that served both as transformative costume and to project their voices to the audience.

VERGINA AND THE MACEDONIAN MONARCHY

Theaters, by definition, are public spaces. More private, but equally visible, are the palaces and burial sites of the Late Classical period. The rise to prominence of hereditary monarchies (replacing democracies, oligarchies, and other forms of decentralized authority) in the Late Classical and Hellenistic periods required palatial architecture and monumental burials befitting the high status, power, and wealth of individual kings and their families. One example of this trend is seen at Vergina, an important capital of the Macedonian monarchy, where a palace and luxurious royal tombs were constructed during the reign of Philip II (359–336 BCE) and his successors.

PALACE AT VERGINA The palace at Vergina (**Fig. 15.5**) was a large structure, around 345 × 300 feet (105 × 91 m) in size, with banqueting rooms around a central court with a Doric **peristyle**, and a veranda that ran along the entire north end. (For an explanation of the Doric and Ionic orders, see box: Looking More Closely: The Greek Orders, p. 225.) The palace, with its impressive mosaic floors, was large enough to serve as a residence, administrative center, and the site of Macedonian symposia (gatherings where aristocratic men drank and conversed). Service rooms surrounded a smaller peristyled court on the west side of the palace, further indicating the importance of entertainment in the Macedonian monarchy.

ABDUCTION OF PERSEPHONE FRESCO The wealth and elevated status of the Macedonian monarchy are also indicated in the royal tomb complex at Vergina. Three important royal tombs, known as Tomb I, Tomb II, and Tomb III, were found below an enormous human-made mound, 75 × 360 feet (22.86 × 109.73 m), known as the Great Tumulus. (Notably, the discoveries in the Macedonian Kasta Tumulus of the late fourth century—the largest Greek **tumulus** discovered so far—demonstrate that substantial, multi-chambered tombs with elaborate facades and striking artworks were not unique to Vergina.) The earliest is Tomb I, a cist tomb (a stone-lined pit topped with a slab) built of substantial **ashlar** masonry around 340 BCE and looted in antiquity. Three of the four walls include fine wall paintings, at least parts of which were created by applying pigment to wet plaster in the true **fresco** technique.

The north wall holds the best-known of the paintings: the *Abduction of Persephone* (**Fig. 15.6**). It depicts the kidnapping, meaning forced marriage and rape in this context, of Persephone, the daughter of Demeter (the harvest and fertility goddess), by Hades, the god of the Underworld. According to Greek myth, with the blessing of Persephone's divine father, Zeus, Hades carried her away to the Underworld to be his bride. When Demeter learned what happened to her daughter, she refused to allow grain to grow on Earth until Persephone was returned to her. With the human race and, therefore, their gifts and sacrifices to the gods at risk, Zeus finally sent for Persephone to return to her mother. But Hades had given Persephone a pomegranate seed to eat before her departure from the Underworld, which ensured her return to Hades for one-third of each year. This myth explained the changing of the seasons in ancient Greece: When Persephone lived with Hades in the Underworld, Demeter caused Earth to be cold and barren, but for the two-thirds of the year that Persephone lived with her mother on Mount Olympos, Earth was warm, green, and fertile.

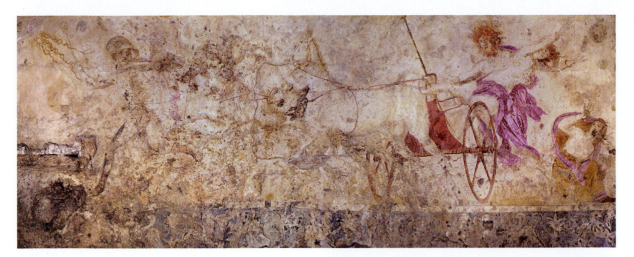

15.6 *Abduction of Persephone,* from tomb complex at Vergina, Tomb I, mid-fourth century BCE. Fresco. Vergina, Macedonia, Greece.

The way Persephone was bound to Hades may also reflect marriage customs in ancient Greece. A woman's marriage was arranged by her father, sometimes even against her mother's wishes. In addition, Greek women of the period may have seen some similarities between death and marriage, because marriage could result in the loss of a woman's individual identity. The parallels between Persephone's abduction and marriage also extended to Greek wedding rituals of the period, in which reenactments of abduction scenes highlighted the bride's powerlessness.

In the fresco, the abduction scene is set against a white background with splashes of bright color. Hades has just mounted his chariot and set it in motion. He holds the reins in his right hand and violently grips Persephone's breast in his left, as she makes a futile but passionate attempt to escape, thrusting her arms and body away from the chariot. Persephone is almost completely disrobed, with the exception of the purple garment that appears to entangle her further with Hades. Vigorous movement is evident in the billowing robes and flowing hair. With quick brushstrokes the artist clearly demonstrates the intensity of the situation, which is heightened by the sense of desperation on Persephone's face and the helpless look of her female companion behind the chariot of a confident Hades. The artist conveys a sense of depth using tools of **perspective**, such as convincing modeling (see the drapery) and **foreshortening** (see the wheel of the chariot). This confirms what we read about ancient Greek painting in primary-source texts, although very few actual paintings survive.

TOMB II, VERGINA Tomb II at Vergina, discovered unlooted and believed by some to belong to Philip II, father of Alexander the Great, was very different architecturally from Tomb I. This structure combines a Doric facade (**Fig. 15.7**) with two stone, **barrel-vaulted** chambers: an antechamber in front and another chamber behind (**Fig. 15.8**). The elaborate facade includes a Doric **frieze** that alternates blue **triglyphs** with white **metopes**.

Above the frieze is a poorly preserved scene on the **attic,** depicting clothed and naked young men in a variety of positions within a landscape, hunting animals including a lion, a boar, and a deer. One of the young men is

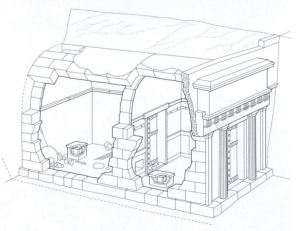

15.7 LEFT **Facade of Tomb II**, Vergina, *c.* 330–320 BCE. Macedonia, Greece.

15.8 BELOW LEFT **Tomb II** (sectional drawing), Vergina, *c.* 330–320 BCE. Macedonia, Greece.

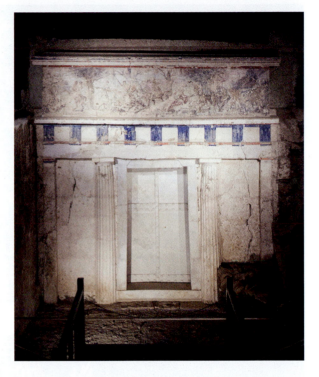

believed to represent Alexander. Although the painting is in poor condition, careful study reveals the consummate skill of the artist, who used diagonals, modeling, foreshortening, and figure placement to create the illusion of depth on a flat surface.

perspective the two-dimensional representation of a three-dimensional object or a volume of space.

foreshortening in two-dimensional artworks, the illusion of a form receding into space: the parts of an object or figure closest to the viewer are depicted as largest, those furthest as smallest.

barrel vault also called a tunnel vault, a semi-cylindrical ceiling that consists of a single curve.

frieze in architecture, the part of an entablature located above the architrave.

triglyph a block with three vertical bands separated by V-shaped grooves; triglyphs occur in between metopes on a Doric frieze.

metope a plain or decorated slab on a Doric frieze, between triglyphs.

attic on a facade or triumphal arch, the section above the frieze or just beneath the roofline, sometimes decorated with painting, sculpture, or an inscription.

sarcophagus a container for human remains.

diadem a crown or ornamented headband worn as a sign of status.

ROYAL TEXTILE AND DIADEM FROM TOMB II, VERGINA

In the antechamber of Tomb II, the excavators discovered a marble **sarcophagus** with a gold *larnax* (a chest made to hold human remains) inside. It contained the burned bones of a young woman in her mid-twenties wrapped in an elaborate royal textile (**Fig. 15.9**). The cloth was made of gold thread and fine woolen yarn dyed a regal purple. In the center of each of the two pieces that remain is a symmetrical floral design in purple, with details such as small birds. Around the edges of the textile is a running spiral motif. Weaving was an important artistic medium in the ancient Greek world and, on the basis of ancient Greek iconography and literature, we know that it was generally the work of women artists. The presence of the purple textile calls to mind Homer's description in *The Iliad* of the burial of the Trojan prince Hector; it demonstrates the desire of the Macedonian kings to connect themselves to the legendary heroes of the Greek Bronze Age.

Also discovered in the *larnax* was an extravagant gold-and-enamel **diadem** (**Fig. 15.10**) decorated with golden vines, leaves, and flowers. Additional flowers spring forth on thin gold wire, which would have vibrated with the wearer's movement. The symmetry of the piece is remarkable, given the level of detail in the work. A second gold headpiece, a wreath, was also found in the *larnax*, highlighting the wealth of the monarchies of this period.

LARNAX FROM TOMB II, VERGINA

The inner chamber of Tomb II contained a larger marble sarcophagus with an ornate, lion-footed, gold *larnax* (**Fig. 15.11**) that held the

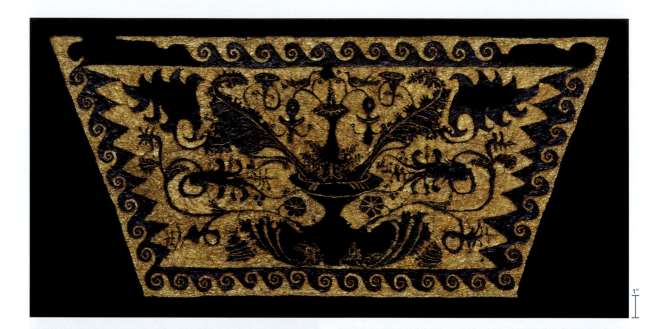

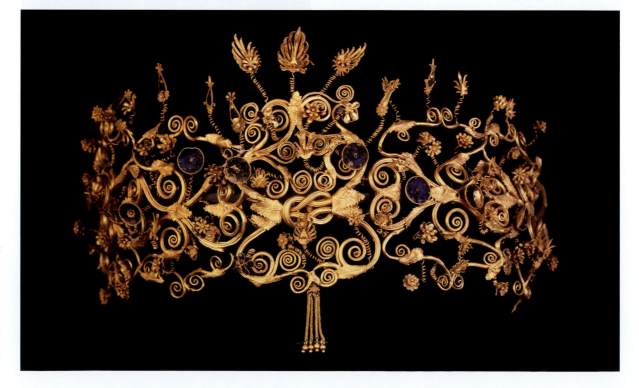

15.9 ABOVE RIGHT **Royal textile from the antechamber of Tomb II**, Vergina, Macedonia, *c.* 330–320 BCE. Purple dyed woolen yarn and gold thread, height 11 ¼ in. (28.5 cm). Museum of the Royal Tombs of Aigai (Vergina), Greece.

15.10 RIGHT **Diadem from the antechamber of Tomb II**, Vergina, Macedonia, *c.* 330–320 BCE. Gold and enamel. Museum of the Royal Tombs of Aigai (Vergina), Greece.

burned remains of a man in his forties. On top of the *larnax* in **repoussé** is a star with rays, which became the emblem of Macedonia. Gold rosettes (rose-shaped decorations) filled with blue-glass paste line the sides of the *larnax* in the central **register**. The registers above and below the rosettes depict plant forms and floral patterns in repoussé. Inside the *larnax* was found a 1.6-pound (0.7 kg) gold wreath with evidence of burning, suggesting that it may have adorned the deceased's head as the flames of a funerary pyre engulfed his body.

The other objects found in Tomb II are astonishingly rich in terms of quantity, material, and craftsmanship. They include dozens of silver vessels for banquets or symposia; containers used in the funerary rituals of washing and anointing the body; ceremonial and practical weapons of gold, ivory, and bronze; and the remains of couches made of ivory, gold, and wood, with high-quality sculptural decoration.

We do not know with certainty who was buried in these tombs. The excavators believed that Tomb II must have held the body of Philip II, king of Macedon and father of Alexander the Great. The antechamber would then have held the remains of his wife. This conclusion is based on analysis of skull fragments, which suggests that the person entombed in the inner chamber had sustained damage to his right eye socket: Philip II lost his right eye in battle. However, those who doubt this identification cite the Athenian pottery found in the tomb, which dates to later than 336 BCE, the year of Philip's assassination. In this case, perhaps Tomb I is the more likely candidate for Philip's burial, principally because of its earlier date.

Another possibility is that Tomb II belonged to the second son of Philip II, Arrhidaios , who was murdered, along with his wife, after Alexander's death. A silver urn in the less elaborate Tomb III contained the remains of a twelve-year-old boy, leading some scholars to suggest that Tomb III belonged to Alexander's son, Alexander IV, who was also assassinated, while still a child, in 311 BCE.

THE GREEK HOUSE

Tombs and palaces help us understand the politics and social hierarchies of the Late Classical and Hellenistic periods, while study of the remains of houses from the same periods helps us understand domestic relations. The few ancient descriptions of Greek houses that survive, generally written by upper-class men, suggest that the defining feature of the Greek house was the segregation of men's spaces and women's spaces. This conclusion is based primarily on the use of the Greek words *gynaikon* and *andron*, similar to the ancient Greek words for woman and man respectively, for rooms or areas of the house. However, scholarship on the archaeology of the Greek house suggests a more nuanced picture of social relations in the home.

At the site of the ancient city of Olynthos in northwestern Greece, on the Chalkidiki peninsula that bordered ancient Macedonia and that Philip II of Macedon ultimately conquered, more than seventy Classical to Late Classical houses were excavated, and the archaeological finds were recorded by room (**Fig. 15.12**). As in most of Greece, the houses were built of mudbrick walls on stone blocks, so what survives is the plan of the first story and, more rarely, remains of staircases in some houses, indicating that a second story once existed.

Although there is much variability within Late Classical and Hellenistic Greek homes, some consistently popular features are visible at Olynthos. For example, the houses tend to focus inward, with just one small door at the front, and an entrance that generally prevented people outside from looking in. The center of the house was an open-air courtyard, often with a shady colonnade, or *pastas*, on one or more sides. Finds in the courtyard and shaded space sometimes included pottery and loomweights (weights used to maintain string tension when weaving),

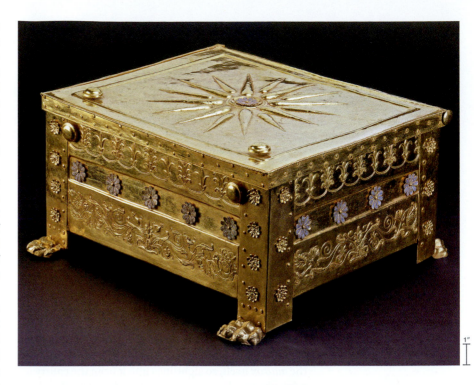

15.11 *Larnax* **from the inner chamber of Tomb II,** Vergina, Macedonia, *c.* 330–320 BCE. Gold and enamel, 14 × 13 × 8 in. (35.6 × 33 × 20.3 cm). Museum of the Royal Tombs of Aigai (Vergina), Greece.

repoussé a relief design created by hammering malleable metal from the reverse side (not the side to be viewed).

register a horizontal section of a work, usually a clearly defined band or line.

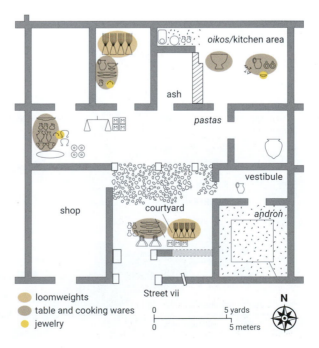

loomweights
table and cooking wares
jewelry

15.12 **House at Olynthos, House A vii 4 (plan drawing),** Chalkidiki peninsula, Greece, *c.* 432–348 BCE.

suggesting that weaving could have been carried out here. The fact that most rooms were accessed through the courtyard may suggest that this arrangement not only isolated those in the house from the external world but also facilitated communication within the home. Another common set of spaces in the houses at Olynthos is the so-called *oikos* unit, which included a large room, sometimes with a hearth. Household objects have been found in these large rooms. Two smaller spaces were attached to them: one perhaps used for cooking, suggested by the frequent presence of ash, bones, and pottery, and the other a bathroom.

The *andron*, a room in which men dined together and participated in symposia, is another common feature of the houses at Olynthos. It is distinguished by its more elaborate decoration, including colored plaster walls and a plaster or mosaic floor with a drainage channel to aid in cleaning (symposia could be messy affairs, including drinking games that involved flinging wine dregs into a basin or at another target). Unlike other rooms, it was typically entered through a small vestibule, the entrance to which was not aligned with the entrance to the *andron* itself, so sightlines into it from the courtyard were obscured. The door to the *andron* was always off center, allowing the wall space to be used for couches on which diners could recline. Excavations have also revealed threshold blocks, indicating that the *andron*'s door could be closed, suggesting some need for separation from the rest of the house.

Notably, a specific *gynaikon* (women's area) has not been discovered at Olynthos or anywhere else. One could argue that the *gynaikon* was located on a now-missing second story, but the finds suggest that women worked in several areas and had access to most of the house, except the *andron*. These finds contradict the idea that women were limited or relegated to the deepest, most private parts of the house. Rather, it is likely that family members were not segregated by sex, but that male visitors were kept separate from the household's girls and women.

A more luxurious variation on the *pastas* house included a peristyled courtyard, which provided additional shady space for leisure activities. Also notable is the fact that in wealthier homes the courtyard ceased to be used for domestic work activities. This development is consistent with the emphasis on the individual and the increasing wealth in the Late Classical and Hellenistic periods. The peristyle in Greek houses ultimately inspired affluent Romans to incorporate them into their homes (see Fig. 18.12).

The Hellenistic Period, 323–31 BCE

The early death of Alexander in 323 BCE without a clear heir plunged his empire into chaos (**Map 15.2**). Ultimately, his generals carved the empire into distinct Hellenistic kingdoms, which would be ruled by their descendants. The Antigonids, a dynasty of kings beginning with Alexander's general, Antigonus I, took control of Macedon and much of Greece. The Seleucids, founded by Alexander's general Seleucus I Nicator, dominated the area from Syria to the Indus. The Ptolemies ruled over Egypt until the defeat of Cleopatra at the Battle of Actium in 31 BCE at the hands of the young Roman Octavian (who would take the title Augustus as the first emperor of Rome; see Chapter 19). Other smaller, yet powerful, kingdoms, such as the Kingdom of Pergamon, also had an impact. In Sicily, the Syracusans and Carthaginians dominated politics until this large island became the first province of Rome in the mid-third century BCE. The art of these wealthy and powerful Hellenistic monarchies, while eclectic, is increasingly staged, taking on a theatrical role and incorporating heightened realism that is intended to evoke an emotional response from the viewer.

THE KINGDOM OF PERGAMON

The city of Pergamon in northwestern Anatolia, with its temples, palaces, library, and spacious **agora**, provides a clear example of the wealth and power of the Hellenistic world (**Fig. 15.14**), but it speaks also to the warfare and

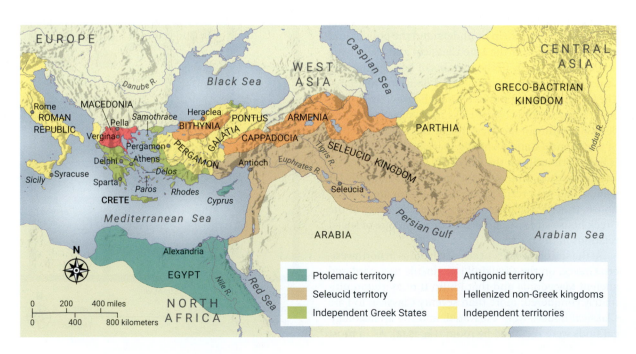

Map 15.2 The Hellenistic world, *c.* 188 BCE.

With Alexander's conquests and the subsequent establishment of Hellenistic kingdoms and Indo-Greek rulers in Bactria, Greek culture and language spread to Central and South Asia and mixed with local traditions. Rich in highly valued mineral resources, such as gold and lapis lazuli, this region was a crossroads of international trade between East Asia, the Indian subcontinent, and the Mediterranean. Classical and Hellenistic artistic and architectural styles quickly became part of a widespread elite visual vocabulary in the region. For example, the Indo-Greek city discovered in the 1960s at Aï-Khanoum on the Oxus (Amu) River in northern Afghanistan incorporated several hallmarks of a Greek *polis*, such as a large gymnasium and a theater where Greek drama was staged.

However, inhabitants integrated local and more distant traditions, including Iranian, with elements of Greek art and culture. Works of art and inscriptions suggest that the residents of Aï-Khanoum worshiped Greek gods, including Athena and Dionysos, but also practiced Zoroastrianism, an Indo-Iranian monotheistic religion common in Persian regions. The temples are not Greek in style, reflecting the importance of local religious traditions and the combining of multiple religions in the region.

A coin (**Fig. 15.13**) minted by the Indo-Greek King Menander in the mid-second century BCE further illustrates the fusion of Greek and local traditions in Bactria. On the front of the coin, Menander's image is labeled in Greek with the words *Basileus Sōtēr Menandros* ("King Savior, Menander"). The reverse side depicts the Greek goddess Athena, but with the king's title in the local language and script. Such blending of styles continued centuries later, between the second and third centuries CE, when early Buddhist sculptures from Gandhara in South Asia show clear Greco-Roman influence in the figures' drapery and sometimes their longer, wavy hair (see Fig. 16.8).

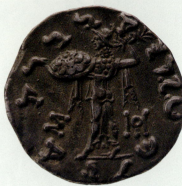

15.13 Coin of King Menander, with the image of Athena on the reverse, mid-second century BCE. Silver, 0.35 oz. (9.95 grams). British Museum, London.

shifting alliances of the period. Founded in the early third century BCE about 1,000 feet (305 m) above the plain of the Kaikos River, Pergamon was originally part of the Seleucid Empire, but broke away by 250 BCE. As an early ally of Rome, Pergamon expanded its territory in Anatolia, but its early claim to fame came in 241 BCE when Attalos I (ruled 241–197 BCE), founder of the Attalid dynasty, defeated in battle the formidable Gauls—a Celtic people who had settled in Galatia in the central highlands of Anatolia—and proclaimed himself king and savior. Although the Gauls remained in Anatolia and continued to fight against their neighbors, Attalos presented his

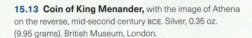
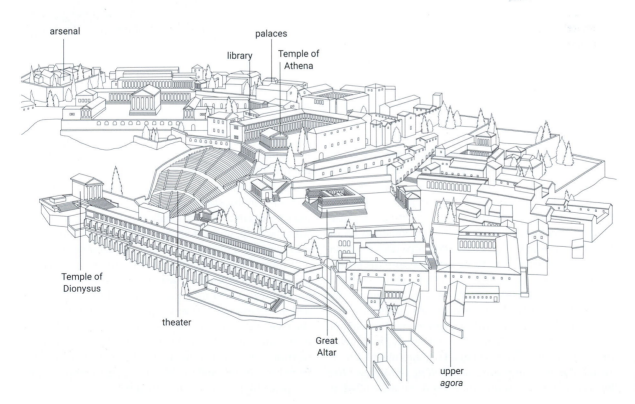

15.14 Pergamon in the Roman period (reconstruction drawing). İzmir province, Turkey.

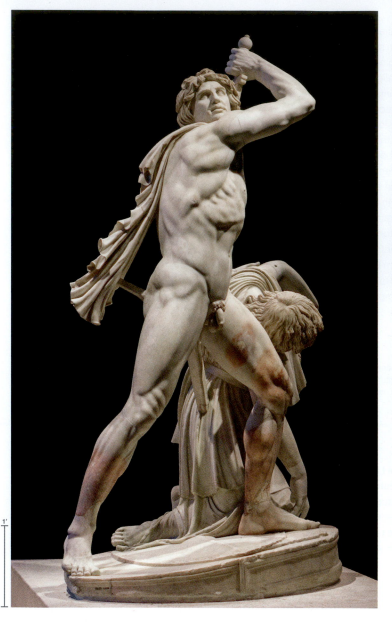

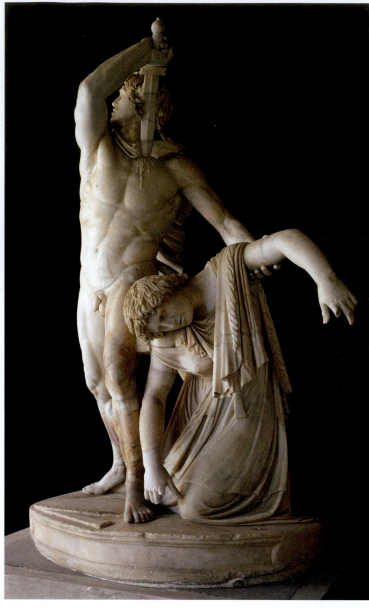

15.15 *Gaul Killing Himself and His Wife* (two views), Roman copy of bronze statue by Epigonos, from Pergamon (Izmir province, Turkey), *c.* 230–220 BCE. Marble, height 6 ft. 11 in. (2.11 m). Museo Nazionale, Rome.

Baroque a style of art and decoration in western Europe *c.* 1600–1750, characterized by a sense of drama and splendor achieved through formal exuberance, material opulence, and spatial projection in order to shape the viewer's experience.

sculpture in the round a freestanding three-dimensional sculpture that can be viewed from every angle; for example, by walking around it.

victories as decisive and boisterously commemorated them with monuments dedicated at Pergamon, Delos, Delphi, and Athens. Unfortunately, only stone bases and later Roman copies of these works survive.

EPIGONOS, *GAUL KILLING HIMSELF AND HIS WIFE*

A Roman sculpture in marble that probably imitates a bronze Pergamene original from around 230 BCE depicts a suicidal Gaul who has already taken the life of this wife (**Fig. 15.15**). It was discovered in 1622–23 with a sculpture of a dying Gallic trumpeter during the construction of the Villa Ludovisi in Rome. The Roman writer, Pliny, in his account celebrating bronze artworks and the artists who created them, states that the Pergamene sculptor Epigonos, who was responsible for several monuments commemorating Attalos I's victories over the Gauls, distinguished himself with his *Trumpeter*, and his *Child in Tears*, who caresses his murdered mother. Similarities with these two works suggest that Epigonos may also have created the original bronze *Gaul Killing Himself and His Wife*. This dramatic sculpture is representative of what

is known today as the Pergamene baroque style, a term borrowed from the **Baroque** (see Chapter 53). A warrior thrusts a knife into his own collar as he looks off into the distance, perhaps at an approaching Pergamene warrior; he is holding the limp body of his dead wife, whom he has killed with his dagger to prevent her capture by the enemy. Their hairstyles and dress make both figures recognizable as Gauls. The warrior sports thick, wild curls and a bushy mustache. His strong, upright body, with exaggerated muscles practically bursting forth, contrasts with the limp, heavy body of his wife. (Both arms of the wife have been restored, as has the warrior's right arm.)

Unlike most works from the preceding Late Classical period, this **sculpture in the round** forces viewers to walk around it to grasp fully the emotional intensity of the action. For example, if viewers position themselves to see the face of the lifeless wife, they cannot see the intense expression on the face of her husband. In addition to the warrior's twisting action and the blood heavily pouring from his self-inflicted wound, this need to move around the piece highlights its theatricality.

This work is clearly meant to evoke an emotional response—a hallmark of Hellenistic art—but what was the reaction of the Hellenistic viewer, and what is our reaction today? For the ancient Greeks, the sculpture would have elicited a sense of pathos, or pity, for the towering warrior and his fallen wife. However, they would have understood the Gaul's action as ultimately a cowardly act, antithetical to Greek heroic ideals. The propagandistic message of the piece was, therefore, complex. The ultimate defeat and barbaric death of the Gallic warrior and his wife unfolding before their eyes in stone would have given the Pergamenes a personal sense of pride, power, and even virtue. Today, we recognize this work, and others like it, as assault scenes against women, questioning the Gaul's heroism and his brutal decision.

GREAT ALTAR, PERGAMON Equally dramatic, but on a much larger scale, is the Great Altar at Pergamon, a large part of which has been reconstructed in Berlin's Pergamon Museum (**Fig. 15.16**; see also **Fig. 15.14**). It was dedicated by Eumenes II (ruled 197–158 BCE), perhaps to Zeus and Athena or all of the Olympian gods. The altar, which sat within a sacred precinct, dates to around 180–160 BCE, based on the dating of pottery discovered in its foundations. It was, therefore, probably erected to honor the celebrated victory of Eumenes II over the Gauls in the Gallic revolt of 166 BCE, which brought Pergamon great glory in the Greek world. The massive Ionic altar measured more than 100 feet (30 m) long and upward of 30 feet (9 m) high and was covered with larger-than-life painted sculpture. A smaller sacrificial altar was located at the top of the stairs inside the Ionic colonnade. On its **cornice** were sockets that were used to display military spoils, providing tangible evidence of the Pergamenes' military victories.

The altar's sculptural program was an extensive undertaking by numerous artists. The exterior sculpture is divided into three levels. The **podium** is carved in very **high relief** with an enormous, complex Gigantomachy, or legendary battle between gods and Giants (a mythical group with great strength who were born when the blood of their father, Uranus, fell to the earth), which wraps around the monument. Above the Gigantomachy and between the Ionic columns were freestanding sculptures of 7-foot-high (2.13 m) female figures, probably Muses (goddesses whom the Greeks believed inspired the arts, literature, and science). There were also *akroteria* representing lions, griffins, tritons (mermen), and teams of chariot horses. At the top of the stairs and inside the colonnaded courtyard, in the middle of which stood the sacrificial altar, was a 190 × 5 foot (57.91 × 1.52 m) relief narrative of the life of Telephos, Pergamon's mythical founder. Above this frieze on the cornice were statues of the twelve Olympian gods of Greece.

The 7-foot-high Gigantomachy ran an impressive 446 feet (135.94 m) around the exterior of the monument. Those ascending the staircase would feel as though they were actually participating in the mythical battle unfolding beside them, as the figures emerged into real space, resting limbs on the steps of the altar. Although inscriptions tell us that a team of sculptors from Pergamon, Athens, the Aegean island of Rhodes, and elsewhere were responsible for the Gigantomachy, the figures powerfully display the lively and emotionally intense baroque style for which Pergamon is known.

The gods' impending victory was clear, as they dominated the upper portions of the register, while the Giants, often represented by hybrid creatures, seemed trapped below. The example shown in **Fig. 15.17** (p. 266) represents Athena, recognizable by her protective aegis, during the height of battle. She is pulling the Giant Alkyoneos from the safety of his mother, the earth goddess Ge or Gaia. It is clear that victory is imminent for Athena, because the goddess of victory, Nike, swoops in (at her right) to crown her. The emotional intensity of the moment is clear in the figure of the Giant and his mother, with their wild hair and desperate gazes; their upturned eyes are deeply cut to create dark shadows. Both are aware of the doom that Alkyoneos faces as Athena's snake wraps itself around him, biting his chest. The diagonals created by the bodies of the figures, which link and overlap one another, add to the dynamic intensity of the piece. As on the Parthenon in Athens (Fig. 14.3), the Gigantomachy here reminded the Greeks of the power of their gods

cornice the uppermost strip of molding on a building's entablature.

podium a raised platform that serves as a base.

high relief raised forms that project far from a flat background.

akroteria sculptures that adorn the roof of a temple.

15.16 Great Altar of Zeus, Pergamon (İzmir province, Turkey) *c.* 180–160 BCE. Reconstructed at the Pergamon Museum, Berlin.

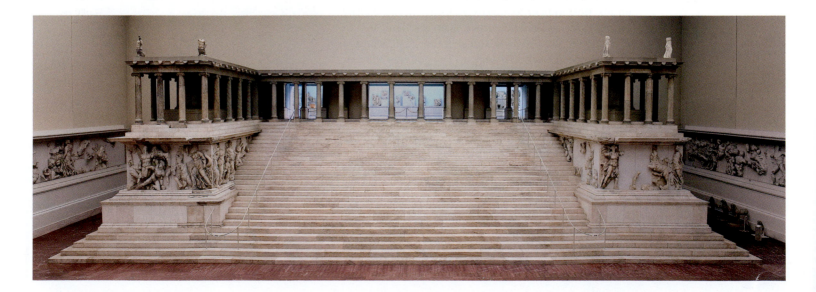

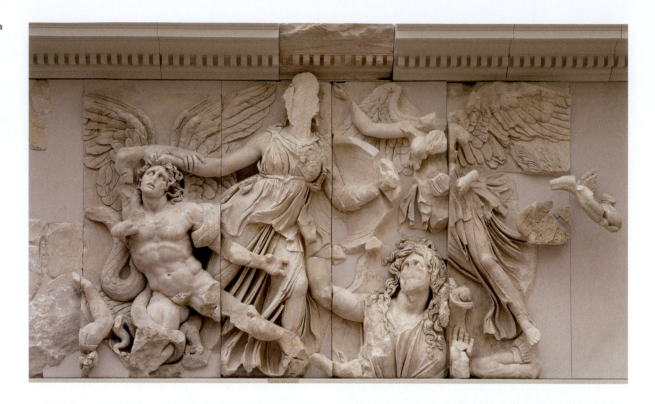

15.17 Gigantomachy (Athena Battling Alkyoneos), Great Altar of Zeus, Pergamon (İzmir province, Turkey), *c.* 180–160 BCE. Pergamon Museum, Berlin.

and, by extension, the strength of the Greeks themselves, with their ability to maintain order over the chaotic forces of nature and what they perceived as uncivilized beings, whether the Giants or their human stand-ins at the moment, the Celts.

THE HELLENISTIC STYLE BEYOND PERGAMON

The Hellenistic style, whether highlighting baroque, realist, or more eclectic features, had wide appeal, spreading throughout the Hellenistic realm and even to Rome. Indeed, Hellenistic style sculptures, including the *Winged Victory (Nike) of Samothrace*, the *Venus de Milo*, *Laocoön and His Sons*, and the *Seated Boxer*, are among the best-known sculptures in the world today.

WINGED VICTORY OF SAMOTHRACE Perhaps sculpted by Pythokritos of Rhodes, whose name was found on an inscription near its discovery location, the *Winged Victory (Nike) of Samothrace* (**Fig. 15.18**) was dedicated in the Sanctuary of the Great Gods on the small island of Samothrace in the north Aegean. The goddess Nike, or Victory, made in the white marble of the Cycladic island of Paros, alights mightily on the prow of a battleship carved from a blue-gray stone from the island of Rhodes in the south Aegean.

This kind of monument, now reconstructed in the Musée du Louvre, Paris, typically celebrated a naval battle, and the Nike of Samothrace was long believed to have crowned a fountain, which commemorated Rhodes's naval victories at Side and Myonessos in 190 BCE. The recent thorough restoration and renewed study of the sculpture, however, has led to new interpretations. Specifically, the Nike and warship on which she alights are no longer believed to have been part of a fountain and the date of the work has also been questioned. One

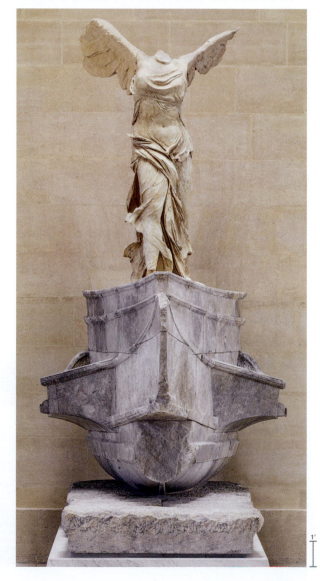

15.18 FAR RIGHT **Pythokritos of Rhodes (?),** *Winged Victory (Nike) of Samothrace,* from Samothrace, Greece, 220–150 BCE. Parian marble statue on gray Rhodian marble base, height 18 ft. 3 in. (5.56 m). Musée du Louvre, Paris.

scholar has argued that the monument was created to commemorate Rhodes's contribution to Attalos II of Pergamon's successful naval counter-offensive against Bithynia in 154 BCE.

The *Winged Victory of Samothrace* rightly deserves its place among the great baroque artworks of Hellenistic Greece. The sculptor skillfully reproduces in stone the specific textures of feathered wings, windblown drapery, and smooth, supple skin (see p. 254). The folds of fabric that press against the goddess's body reveal every detail of her form, including her navel, as well as her strong forward movement. Loose, diaphanous drapery whips behind her to emphasize her dramatic struggle against gale-force winds. Her wings, the left of which has been reconstructed, almost seem to beat, serving to balance her body's forward thrust.

ALEXANDROS OF ANTIOCH, *APHRODITE OF MELOS* In the nineteenth century, French excavators discovered the *Aphrodite of Melos* (**Fig. 15.19**), better known as the *Venus de Milo*, on the Cycladic island of Melos. Its style demonstrates the eclecticism of Hellenistic sculpture. The sculptor, Alexandros of Antioch, whose signature appears on the base, combines the proportions of Classical sculpture with the Late Classical S-curve of Praxiteles (see **Fig. 15.1**); characteristic of the Hellenistic period, he adds a sharper turn of the head, a twisting form, and a jutting knee, as well as deeply carved drapery, which adds to the play of light and shadow on the work. The slippage of Aphrodite's heavy drapery around her hips adds a sense of eroticism to the figure, appropriate for the goddess of love. Her left hand, fragments of which are preserved separately, holds the apple that Paris, prince of Troy, gave her when he judged her to be more beautiful than Hera and Athena in the contest that sparked the Trojan War, further highlighting the desire she evokes.

LAOCOÖN AND HIS SONS In Greek mythology, Laocoön was a priest of Apollo in Troy. He attempted to warn the Trojan people not to bring into the city the wooden horse that the Greeks had left outside the walls. The Trojans did not know that the horse was filled with Greek warriors ready to capture the city. To punish Laocoön for trying to warn the Trojans, the gods Athena and Poseidon, who supported the fated Greek victory, sent two sea serpents to destroy him and his sons. This story is recounted in Virgil's *Aeneid* (written 29–19 BCE), the foundation story of Rome, which was probably commissioned by the first Roman emperor, Octavian (see Chapter 19).

This statue group (**Fig. 15.20**, p. 268) was discovered in 1506 CE on the Esquiline Hill in Rome, in what was later realized to be the palace of the emperor Nero. The Renaissance artist Michelangelo (see Chapter 45), along with the architect Giuliano da Sangallo, were called to the scene of the discovery and recognized this sculpture as the lost Hellenistic masterpiece Pliny the Elder had attributed to Athenodoros, Hagesandros, and Polydoros of Rhodes, describing it as "a work superior to any painting and any bronze." Upon its discovery, the sculpture was purchased by Pope Julius II (1443–1513 CE), who also commissioned the construction of the new St. Peter's

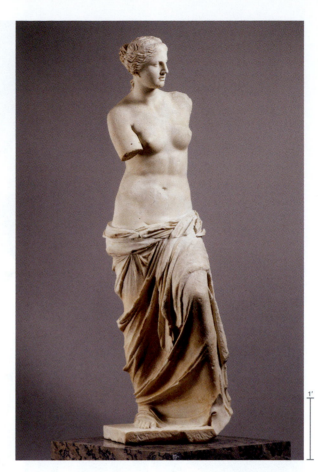

15.19 Alexandros of Antioch, ***Aphrodite of Melos (Venus de Milo),*** Greece, *c.* 100 BCE. Marble, height 6 ft. 7 in. (2.01 m). Musée du Louvre, Paris.

basilica (see Fig. 45.12) and Michelangelo's ceiling painting in the Sistine Chapel (see Fig. 45.15).

The sculpture is a masterpiece of Hellenistic baroque style. Its movement and theatricality draw the viewer into the scene: the torso twists to his right, while the head, left arm and leg are strained in the opposite direction. The wild hair, with deep drill marks in the stone, allows for a play of light and shadow that adds to the intense movement conveyed in this work. The diagonals formed by the limbs also add to the dynamism of the scene. The bulging muscles highlight Laocoön's strength, but they contrast with the intense agony on the face: The downturned eyes, heavily furrowed brow, and open mouth with teeth showing all evoke a sense of deep pathos in the viewer.

This sculptural group has been the subject of much debate since its discovery in 1506. Many believed it to be a product of the Hellenistic era, because parallels can be seen in baroque style Hellenistic works from Pergamon, such as the relief sculptures on the Great Altar of Zeus which date to the second century BCE (see **Fig. 15.17**). But in 1957, impressive sculptural groups carved in the baroque Hellenistic style were discovered in a cave at Sperlonga (about 90 miles, or 145 km, south of Rome). These were signed by Athenodoros, Hagesandros, and Polydoros of Rhodes, and therefore, it is now considered more likely that *Laocoön and His Sons* dates to the first century CE. In other words, the signed work at Sperlonga suggests that itinerant artists from Rhodes traveled west to the heartland of the Roman Empire for work, and applied the older Hellenistic baroque style to the sculptures from Sperlonga and to the Laocoön, even at this late date.

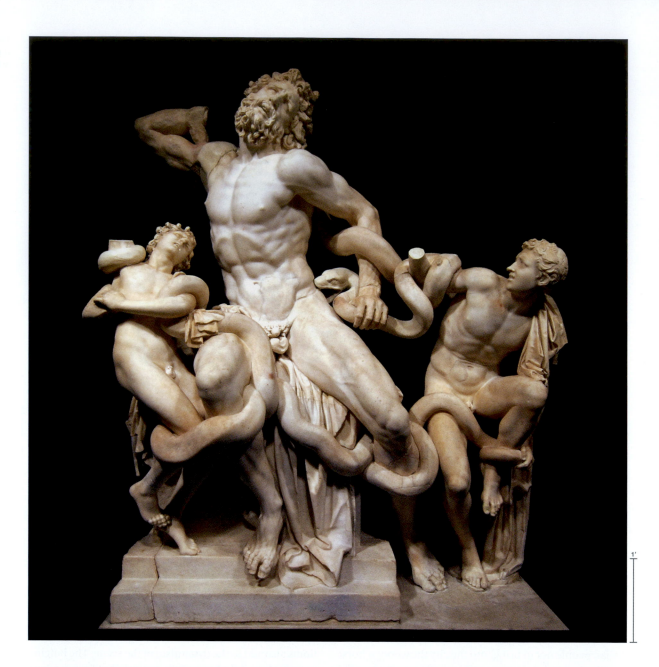

Chronology

431–404 BCE	Peloponnesian Wars between Athens and Sparta and their allies; Athens is finally defeated	**336 BCE**	Philip II is assassinated; Alexander comes to power	
c. **400–323 BCE**	The Late Classical period	**336–323 BCE**	Alexander the Great conquers much of Anatolia, Egypt, West Asia, Bactria (present-day Afghanistan), and northwest India	
fourth century BCE	The Theater at Epidauros is built	**323–31 BCE**	The Hellenistic period; after Alexander's death, his generals split the empire into several kingdoms	
380 BCE	Plato founds the Academy at Athens			
359 BCE	Philip II becomes king of Macedonia	*c.* **180–160 BCE**	The Great Altar of Zeus is constructed at Pergamon	
c. **359–320 BCE**	The palace and royal tombs are constructed at Vergina	**220–185 BCE**	*Winged Victory of Samothrace (Nike)* is sculpted	
c. **350 BCE**	Praxiteles sculpts *Aphrodite of Knidos*	**133 BCE**	The last king of Pergamon, Attalos III, wills his kingdom to Rome	
338 BCE	The Battle of Chaeronea; Philip II of Macedon rules the whole of Greece	**31 BCE**	Octavian (who would become the first Roman emperor, Augustus) defeats Cleopatra and Antony at the Battle of Actium	

16

The Development of Buddhist and Hindu Art in South Asia and Southeast Asia

250 BCE–800 CE

Shiva as Ardhanarishvara
(detail). Elephanta, India.

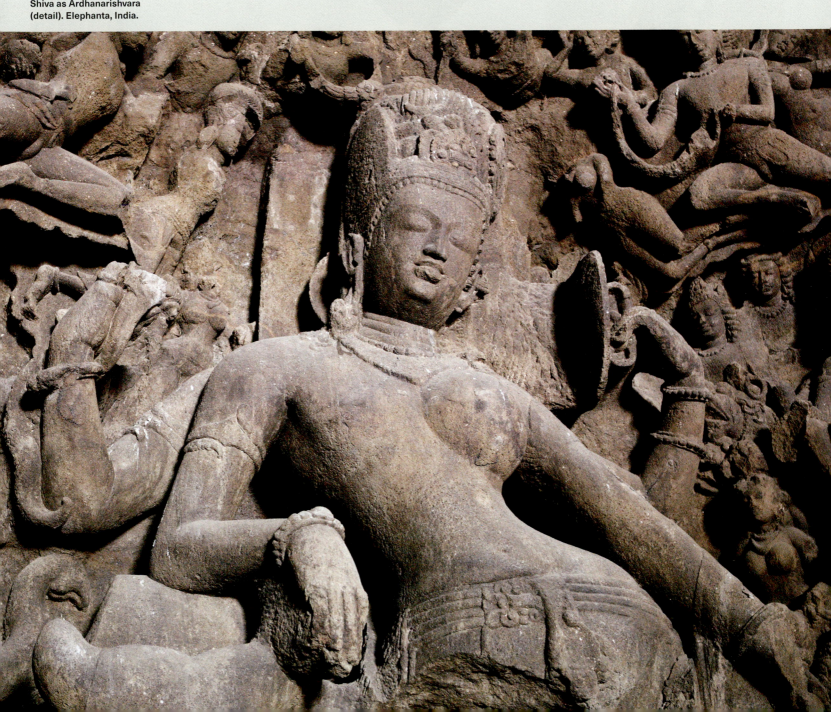

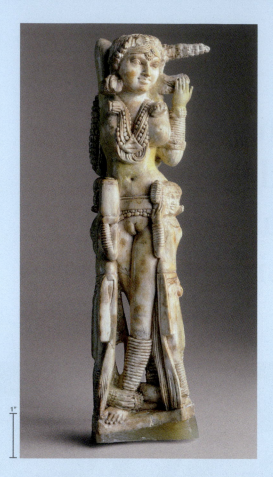

2 South Asian statuette from Pompeii, Italy, first century CE. Ivory, 9½ in. (24 cm) high. Museo Nazionale, Naples, Italy.

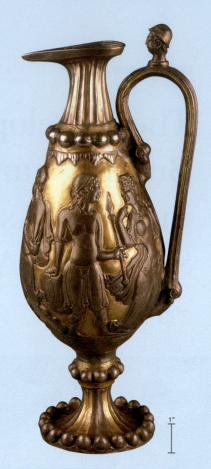

3 Ewer from the tomb (dated 569 CE) of Li Xian and his wife, fifth–sixth century CE. Gilt silver, height 14¾ in. (37.5 cm). Guyuan Museum, Ningxia Autonomous Region, China.

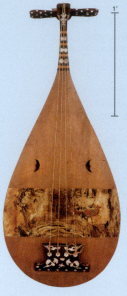

4 *Biwa* **lute.** Maple wood and bamboo with mother-of-pearl inlay and painted leather guard, length 38¼ in. (97 cm). Shōsōin, Imperial Household Agency, Nara, Japan.

The eclectic shape and ornament of this wide-mouthed jug, or ewer (**Fig. 3**) attests to the cosmopolitan tastes in Chinese regions throughout the centuries between the Han (206 BCE–220 CE) and Tang (618–906 CE) dynasties. Its overall shape recalls models produced in the Sasanian Empire (224–651 CE) centered in present-day Iran, while the figures are inspired by Greek myth, possibly episodes from the Trojan War or more generally, the image of a woman seeing her beloved off to war. Such details as the man's head atop the handle, and the camels' heads at either end of it, indicate Central Asian influence, perhaps Sogdian. Sogdian merchants (from Iran and the surrounding regions) played a pivotal role in Silk Road trade, and the Sogdian city of Samarqand was an important trade hub. The combination of Greco-Roman imagery with the resemblance of the female body's shape to South Asian precedents suggests the work of Bactrian artists who learned silversmithing from the Sasanians, and who were familiar with Greco-Roman mythology, South Asian styles, and Sogdian decoration. Excavated from the tomb of a military general and government official in China, this ewer is evidence of a cosmopolitan taste that was both stimulated and satisfied by Silk Road trade.

Cultural encounters made possible by the Silk Road continued for centuries. By the eighth century CE, Silk Road trade brought goods as far east as Japan. This *biwa* lute (**Fig. 4**) was possibly made in China, but it was influenced by musical instruments from West Asia, and it was owned by the Japanese Empress Kōmyō (701–760 CE). The image painted on the plectrum guard reflects those West Asian influences. Four entertainers perform atop a decorated white elephant—an animal found on the Asian continent but not in Japan. The bearded drummer and dancing singer both wear hats identifying them as Sogdian. Two flutists, a boy and a girl, provide melodies as the quartet journey through a mountainous landscape.

The diversity of art objects found along the Silk Road, and their often culturally eclectic nature and discovery together with disparate items, sometimes from three continents, speaks to the long history of the global economy in which we participate today and the cultural richness that it fosters.

Discussion Questions

1. What can artworks tell us about the extent of cultural and economic contact along the Silk Road?

2. What might have been the value of objects or artworks from distant lands to those who acquired them?

3. How do the contact and exchange of today's global societies compare to that of the time of the Silk Road?

Further Reading

- Hiebert, Fredrik and Cambron, Pierre (eds.). *Afghanistan: Hidden Treasures from the National Museum, Kabul*, Washington, D.C.: National Geographic Society, 2008.

- Millward, James A. *The Silk Road: A Very Short Introduction*. Oxford: Oxford University Press, 2013.

- Ten Grotenhuis, Elizabeth. *Along the Silk Road*. Washington, D.C.: Smithsonian Institution, 2002.

- Tucker, Jonathan. *The Silk Road: Art and History*. Chicago, IL: Art Media Resources, 2003.

Early Global Networks: The Silk Road

The name "Silk Road" may conjure up images of silk and spice merchants in camel caravans, selling in the bazaars of bustling cities from East Asia to the Mediterranean. In fact, the Silk Road was not a single road, nor was it solely focused on the trade of one commodity. Rather, it was a network of land and sea routes that distributed locally manufactured goods into dispersed but interconnected marketplaces (**Map 1**). The Silk Road also connected people, ideas, languages, religion, technology, and art, often leading to cultural enrichment alongside economic prosperity. Although the Han dynasty in China formalized use of the Silk Road for trade with entities to its west around 130 BCE, exchange across Asia, Europe, and North Africa can be traced to prehistoric times and was certainly well established by the time of the Achaemenid Persian (550–330 BCE) and Hellenistic (323–31 BCE) Empires.

Artworks provide tangible evidence of the nature and depth of Silk Road contacts

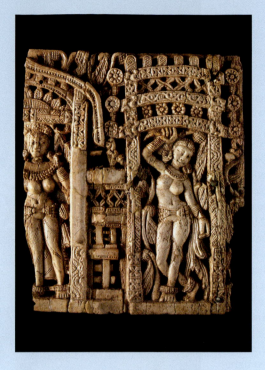

1 **Plaque with women standing under gateways**, from Palace at Begram, Room 13, Afghanistan, first century CE. Ivory. National Museum of Afghanistan, Kabul.

and exchanges throughout its long history. In the sealed palace rooms at Begram, located in present-day Afghanistan near the confluence of Silk Road trade routes, a hoard of eclectic objects demonstrates how the Silk

Road connected distant regions. Ranging in date from the first to the third century CE, the Begram palace objects include Roman glass and bronzes, lacquer from China, and South-Asian-style ivory and bone sculptures. Most of the ivories take the form of decorative plaques on wooden furniture. In this example (**Fig. 1**), the woman on the right, standing beneath a gateway, brings to mind the *torana* (gateway) and female figural sculptures at the Great Stupa at Sanchi in central India (see Fig. 16.4). This voluptuous woman is bedecked in jewelry and holds onto a fruit tree, linking earth's bounty with her fertility. Lively debate surrounds the origins of the Begram ivories. Stylistic comparison to South Asian sculptures suggests that they may have been carved in South Asia. However, the discovery of three unworked pieces of ivory at Begram implies the presence of an ivory workshop there—one that may have employed itinerant artists trained in South Asian traditions.

Another intriguing example is the South Asian-style ivory statuette (**Fig. 2**) discovered around 3,500 miles (around 5,600 km) from Begram in the ruins of a house in Pompeii, which was destroyed in 79 CE. Notice the similarities in stance and dress to the Begram figures. The presence of South Asian-style objects in ancient sites as far apart as Afghanistan and the Italian peninsula suggests a remarkable degree of international connection at this time.

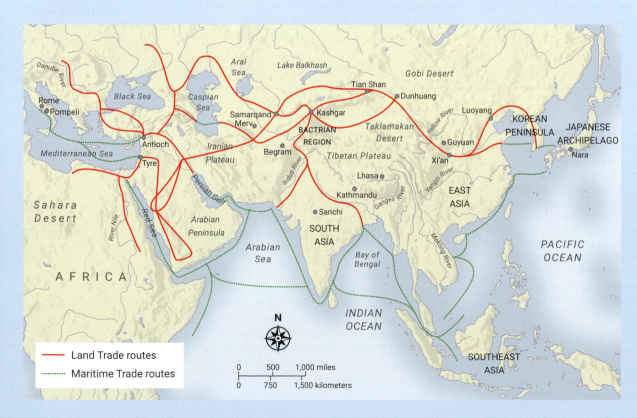

- Land Trade routes
- Maritime Trade routes

Map 1 Silk Road routes during the 5th century CE.

APOLLONIUS, *SEATED BOXER* The Romans' fascination with Hellenistic sculpture is also evidenced by the discovery in 1885 on the south side of the Quirinal Hill in Rome of a Hellenistic bronze statue of a seated boxer (**Fig. 15.21**), cast using the **lost-wax** technique (see box: Making It Real: Lost-Wax Casting Techniques for Copper Alloys, p. 62). The eyes were inlaid, probably with glass paste and/or stone, now lost. The date of this sculpture is often questioned, with proposals ranging between the late fourth and early first century BCE.

The *Seated Boxer* is well preserved, with the exception of its once-inlaid eyes, and it displays several hallmark characteristics of another popular category of Hellenistic art, that of extreme realism. First, the sculpture seems to portray very accurately the image of a weary boxer. The muscular and young-looking physique (only blows to the head were allowed during boxing matches) contrasts with the beaten face and head, broken nose, swollen and deformed cauliflower ears, and the numerous scars and wounds. The sculpture depicts a specific moment in time, just between fights: Greek boxers would continue to fight in sequential bouts until only one was left standing. The boxer depicted still wears leather straps on his hands, which would have inflicted considerable damage, and his seated position and hunched back, with arms just barely resting on his splayed thighs, indicate the overwhelming fatigue that would have set in after a violent match.

In addition, the boxer has new wounds, which are gouged into the bronze. They are dripping blood, represented by inlaid copper, which also lines the cuts to give the sense that the bronze is just a thin layer of outer skin. Some of the blood has dripped onto the boxer's shoulders and arms. The reddish color of the copper enhances the believability of the work and evokes even more empathy from the viewer. However, the realism seen in the statue's posture and wounds is not in keeping with the perfectly arranged and symmetrical balance of the hair and beard, reminding us of the staged presence of Hellenistic art.

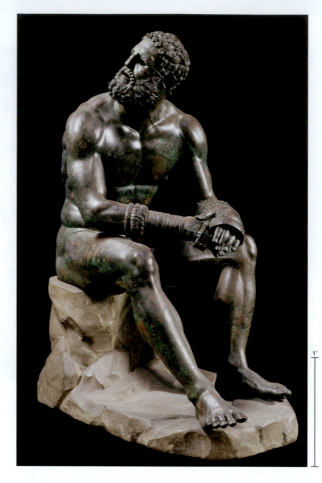

15.21 Apollonius, *Seated Boxer*, from the Baths of Constantine, Rome, *c.* 100–50 BCE. Bronze, height 47 in. (1.2 m). Museo Nazionale Romano-Palazzo Massimo alle Terme, Rome.

By the second century BCE, the lines between the Hellenistic world and Rome became blurred, as Rome expanded its power, defeating Carthage in North Africa in 202 BCE, and then the Greeks and Macedonians in the Aegean region in the following decades. The last king of the Attalid dynasty, Attalos III, realized that further resistance was futile and bequeathed Pergamon to Rome in 133 BCE.

lost-wax casting a method of creating metal sculpture in which a clay mold surrounds a wax model and is then fired. When the wax melts away, molten metal is poured in to fill the space.

Discussion Questions

1. The Late Classical and Hellenistic periods saw dramatic changes in art and architecture. Using three works of art from this chapter, at least one architectural and one sculptural, describe some of these changes and the political or social motivations behind them.

2. Our understanding of the past is constantly evolving as a result of innovative art historical research and archaeological excavations. Choose two works from this chapter and describe how recent research has changed or augmented our understanding of the works of Late Classical and/or Hellenistic social relations.

3. Hellenistic art is often intended to evoke an emotional response. Choose two to three works of art from this chapter and, using the tools of formal analysis (see this book's Introduction), describe the formal strategies the artist(s) used to elicit this response. Were they effective? Why or why not?

4. How is the art of the Hellenistic period more representative of kingship than the *polis*? Provide at least two examples to support your argument.

Further Reading

- Colburn, Cynthia and Gonzalez, Ella, "How to Teach Ancient Art in the Age of #MeToo." Hyperallergic (September 5, 2018): https://hyperallergic.com/456269/how-to-teach-ancient-art-in-the-age-of-metoo/.

- Daehner, Jens, and Lapatin, Kenneth (eds.) *Power and Pathos: Bronze Sculpture of the Hellenistic World*. Los Angeles, CA: The J. Paul Getty Museum, 2015.

- De Grummond, Nancy T. and Brunilde S. Ridgway. *From Pergamon to Sperlonga: Sculpture in Context*. Berkeley: University of California Press, 2000.

- Kousser, Rachel, "Creating the Past: The Vénus de Milo and the Hellenistic Reception of Classical Greece." *American Journal of Archaeology*. 109, no. 2 (2005): 227–250.

- Stewart, Andrew. *Art in the Hellenistic World: An Introduction*. New York: Cambridge University Press, 2014.

Introduction

Around 250 BCE, the Indian ruler Ashoka of the Maurya dynasty had imposing stone pillars constructed at various locations throughout his empire. The construction of these columns ended an almost 1500-year period for which we have no evidence of monumental art or architecture in South Asia. Ashoka was the first ruler to adopt Buddhism, and the pillars—through their specific locations, iconography, and inscriptions—served to connect his power to that of the Buddha. Although political rather than religious in function, the pillars initiated a period of artistic production on the Indian subcontinent closely tied to religious developments.

Between roughly the third century BCE and the sixth century CE, art related to Buddhism, Jainism, and Hinduism developed many of the forms that today are associated with these religions, including Buddhist *stupas*, sculptures of the Buddha and Jinas, Hindu temples, and images of Hindu gods. Buddhism and Hinduism eventually spread beyond India to other parts of South Asia, to Southeast Asia, and in the case of Buddhism, to East Asia as well. By the seventh century CE, Buddhist and Hindu art was flourishing as far away as on the Indonesian island of Java (Maps 16.1 and 16.2).

This chapter examines South Asian artworks dating through the sixth century CE, along with art produced in Southeast Asia during the seventh and eighth centuries CE. Analyzing artworks from these periods highlights, among other things, the specific role that art played within the development of each religion, the distinction between iconography and style, and the close relationships between art, politics, religion, and trade. It is important to remember that South and Southeast Asian artists of the period were producing secular (non-religious) art as well, although much less of that art survives. In the Buddhist, Jain, and Hindu art and architecture that they made, artists used visual strategies of narration and various styles to depict increasingly complex iconography. They created a visual vocabulary that helped worshipers engage with the stories of the human and divine figures of these religions, which were spreading throughout South and Southeast Asia.

In the past, art historians seeking to explain developments in one culture have often looked to the influence of other cultures. In doing so, they revealed their conscious or unconscious cultural biases. For example, early scholars looked to Hellenistic culture (see Chapter 15) to explain artistic developments in India during this period, and likewise looked to India to explain developments in Southeast Asia. Today, art historians recognize that local artists adapted visual traditions to fit regional contexts in creative and compelling ways.

The Emergence of Buddhist Art in South Asia

The threat of invasion by Alexander the Great of the ancient Greek kingdom of Macedonia (see Chapter 5 and Chapter 15) and his conquering armies enabled the territorial expansion of the Indian sovereign Chandragupta Maurya (ruled 322–298 BCE). Powerful and highly centralized, the Maurya Empire (c. 322–185 BCE) eventually

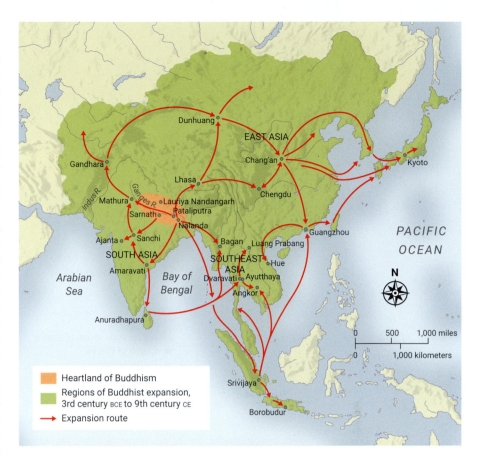

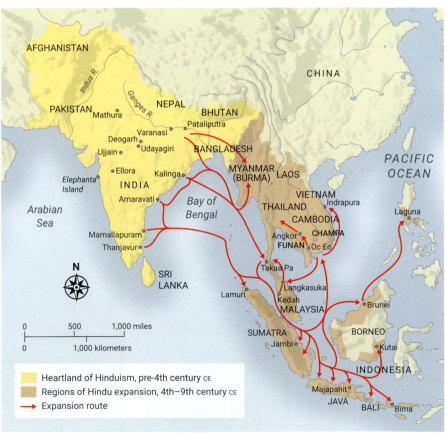

Map 16.1 TOP The spread of Buddhism throughout South Asia, Southeast Asia, and East Asia, third century BCE–ninth century CE.

Map 16.2 ABOVE The spread of Hinduism throughout South Asia and Southeast Asia, fourth century CE–ninth century CE.

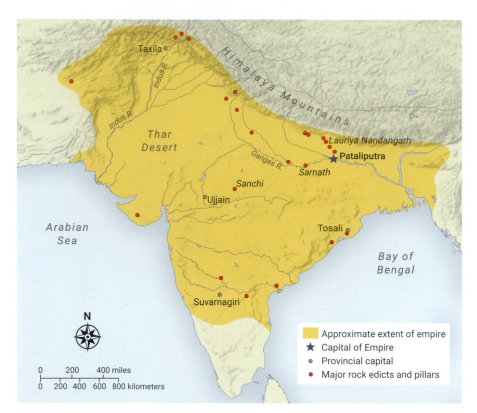

Map 16.3 ABOVE **Extent of the Maurya Empire,** and the placement of Ashoka's edicts and rock pillars, *c.* 250 BCE.

16.1 RIGHT **Ashokan edict pillar,** Lauriya Nandangarh, Champaran District, India, *c.* 250 BCE. Photograph by Sir Benjamin Simpson in 1865. British Library, London.

Buddha; the Buddha a buddha is a being who has achieved the state of perfect enlightenment called buddhahood. The Buddha is, literally, the "Enlightened One"; generally referring to the historical Buddha, Siddhartha Gautama, also called Shakyamuni and Shakyasimha.

monolithic formed of a single large block of stone.

capital the distinct top section of a column or pillar, usually decorative.

drum a cylindrical stone block that forms part of a column.

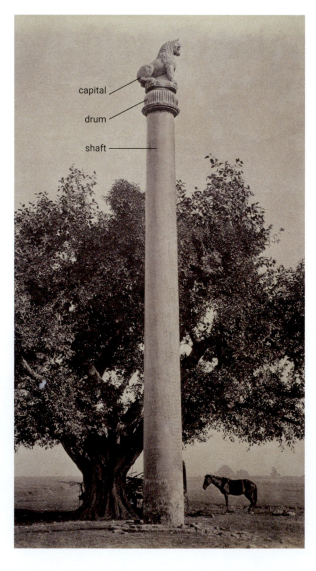

capital

drum

shaft

controlled most of South Asia from its capital Pataliputra in eastern India. The empire reached its height under the third ruler, Ashoka (ruled *c.* 272–231 BCE). Shaken by the amount of death and suffering his hard-fought conquests had caused, Ashoka converted to Buddhism and became a pacifist. He spent the rest of his life emphasizing ethical codes of behavior and contributing to the spread of Buddhism, in part through his patronage of monumental art.

The Buddhist religion was founded only a few centuries earlier by Siddhartha Gautama (lived *c.* fifth century BCE), a prince of the Shakya kingdom located near the modern border of India and Nepal (see **Map 16.1**, p. 273). By that time, Indo-European Vedic society, which had dominated northern India for roughly 1,000 years, had become highly stratified, with Brahmins (priests who maintain sacred knowledge) occupying the highest place. Vedism, the ancient belief system that formed the basis for Hinduism, centered on reincarnation as well as cosmic and social hierarchy. There was growing dissatisfaction among people who occupied the lower strata, and new spiritual movements reacting against the constraints of Vedism began to emerge. Buddhism was one of these movements. At the age of twenty-nine, Prince Siddhartha, deeply affected by the suffering he saw around him, left his palace in search of enlightenment. For six years he tried penance and asceticism before turning to meditation and moderation. While meditating beneath a pipal (or bodhi) tree, Siddhartha achieved enlightenment (spiritual awakening), after which he became known as **the Buddha**—"Enlightened One." At a place called Sarnath, he "put the wheel of law into motion"—the law referring to Buddhist doctrine—and began preaching the four noble truths of Buddhism: (1) Life is suffering; (2) Suffering is caused by desire; (3) To stop suffering, you must extinguish desire and liberate yourself from attachment; (4) To achieve liberation, you must follow the eightfold path of right views, intention, speech, action, livelihood, effort, mindfulness, and concentration.

Buddhism shares with Vedism the ideas of reincarnation, karma (the sum of a person's actions that determines his or her future existences), *dharma* (duty or righteousness), and *samsara* (the cycle of existence), with the ultimate goal being non-existence (called *nirvana* in Buddhism). Unlike Vedism, early Buddhism had no priests acting as intermediaries between the individual and the gods; no complicated, costly rituals; and no caste system of hereditary class divisions. The appeal of this new faith led the Buddha to gain followers, who continued to spread the message after his death.

ASHOKAN EDICT PILLARS By the time of Ashoka's conversion, Buddhism was widely practiced alongside Vedism and other religions, but Ashoka was the first ruler to adopt the faith, giving it new prominence. While there is no reason to doubt the sincerity of his conversion, it was also a shrewd political move because it constrained the power of the Brahmins and helped solidify his rule. Ashoka proclaimed the codes of behavior his subjects were to follow through edicts inscribed on rock faces and monumental freestanding stone pillars located

throughout his empire (**Map 16.3**). These edicts are the earliest surviving writings in South Asia since the Indus culture (see Chapter 7), and the pillars, nineteen of which remain, are the earliest surviving examples of monumental South Asian sculpture.

Rising 40–45 feet high (around 12–13 m), the pillars were made of sandstone, often polished to a high shine. The pillar at Lauriya Nandangarh, one of only two pillars still intact at their original sites of construction, consists of a **monolithic** shaft, on which the edicts were inscribed, and a **capital** featuring a lion seated on a bell-shaped, lotus-bud **drum** (**Fig. 16.1**). While not strictly religious, Ashoka's columns drew on the power of Buddhism. Many were erected near Buddhist monasteries, where monks, who were literate, could read the edicts to laypeople. The pillars acted as symbolic connections between heaven and earth, linking Ashoka's laws to the Buddha's. The lion imagery also reinforced the connection between Ashoka and the Buddha. In early India, as in many cultures around the world, lions symbolized kingship. Here, they also reference the Buddha, who was known as Shakyasimha (the lion of the Shakya clan) and whose voice was said to resemble a lion's roar.

LION CAPITAL FROM ASHOKAN PILLAR The most famous Ashokan pillar capital, which is also the national emblem for the Republic of India, is from Sarnath, the site of the Buddha's first sermon (**Fig. 16.2**). It features four lions placed back to back, facing out in the cardinal directions of north, south, east, and west, implying the universal reach of both Buddhism and Ashoka's power. The lions' faces and manes are carefully stylized, while their legs and claws are rendered in a naturalistic manner. Originally, a wheel (*chakra*), similar to those carved on the drum, sat atop their heads (see the small **relief** in the lower center of **Fig. 16.5**, p. 277). The wheel referenced both the "wheel of the law" that the Buddha set in motion at Sarnath and the idea of the emperor as the ideal, universal ruler, called a *chakravartin* ("wheel turner"). The drum is further adorned with four animals—a bull, a lion, an elephant, and a horse—that relate to a Buddhist myth of a lake at the earth's center, with each animal channeling a stream through its mouth to one of the four corners of the world.

Because no precedents for monumental sculpture of this type have been found in South Asia, art historians have long debated how and why such art emerged. Many scholars now suspect that some of the pillars predate Ashoka and that he had the inscribed edicts added. Recent excavations at Pataliputra also reveal the use of wood, brick, and **terra-cotta**—materials less durable than stone—which suggests that much of India's early visual culture no longer survives. Nevertheless, Ashoka's reign was an important turning point in the development of South Asian art.

relief raised forms that project from a flat background.

terra-cotta baked clay; also known as earthenware.

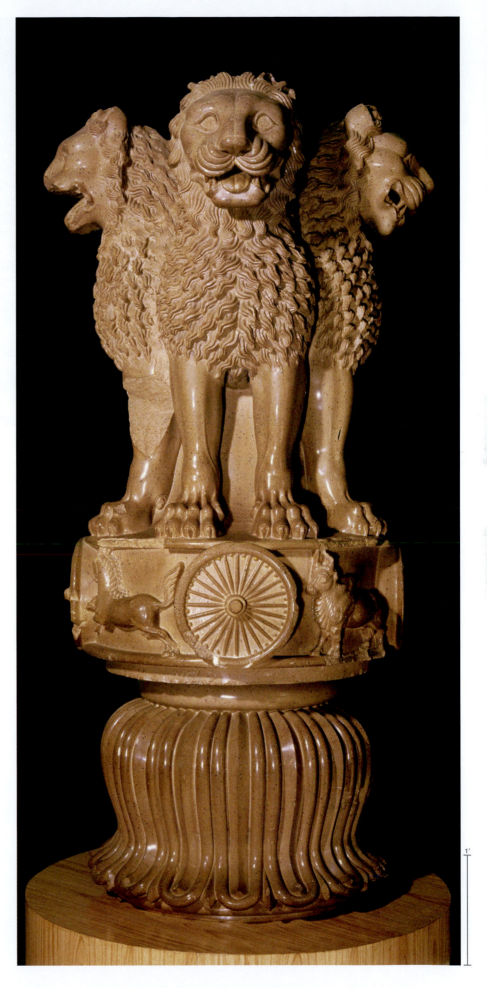

16.2 Lion capital from Ashokan pillar, Sarnath, India, Maurya period, *c.* 250 BCE. Sandstone, height 7 ft. 7 in. (2.31 m). Sarnath Museum, Varanasi, India.

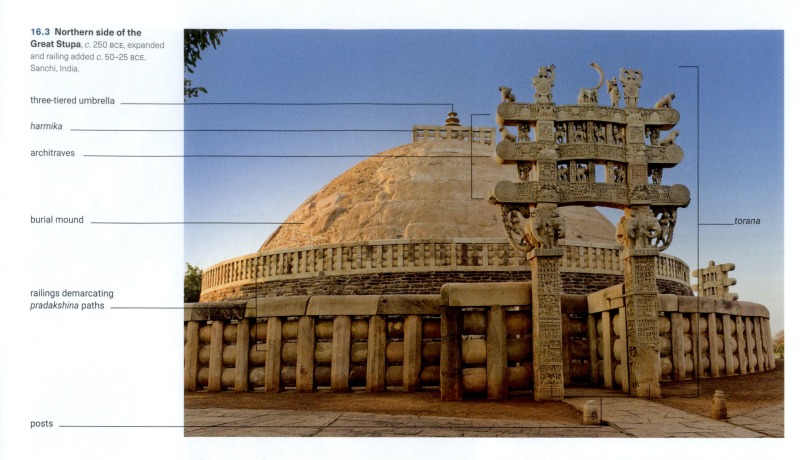

16.3 Northern side of the Great Stupa, *c.* 250 BCE, expanded and railing added *c.* 50–25 BCE. Sanchi, India.

three-tiered umbrella

harmika

architraves

burial mound

railings demarcating *pradakshina* paths

posts

torana

stupa a mound-like or hemispherical structure containing Buddhist relics.

harmika a square, fence-like enclosure that symbolizes heaven and appears at the top of a *stupa*.

pradakshina in Hindu, Buddhist, and Jain practice, the ritual of walking around (circumambulating) a sacred place or object.

torana a gateway marking the entrance to a Buddhist, Hindu, or Jain sacred structure.

architrave a beam resting on top of columns or extending across an entranceway.

auspicious signaling prosperity, good fortune, and a favorable future.

GREAT STUPA, SANCHI When the Buddha died, his disciples divided his cremated remains into eight parts, which they enshrined in eight **stupas**. Ashoka later redistributed the Buddha's ashes among a much greater number of simple brick *stupas* (traditionally said to be 84,000, but that number was likely an exaggeration), spreading Buddhism throughout his empire. One such *stupa* was at Sanchi in central India, the location of an important Buddhist monastery. About 200 years later (*c.* 50–25 BCE), at a time when Buddhist monasteries were thriving, the Ashokan-era *stupa* was enlarged and embellished. In many ways, *stupas* are the first Buddhist monuments, and the Great Stupa at Sanchi (**Fig. 16.3**) is the biggest and most complete early example. The Great Stupa fulfilled the three main functions of monumental art within Buddhism. First, it provided a focus for meditation. Second, through visual storytelling, it helped with religious teaching. Third, its sponsorship provided a means of gaining spiritual merit. Like much early Buddhist art, the Great Stupa was not the product of royal patronage. Rather, it was supported by around a thousand individual donors, both men and women.

The Great Stupa consists of a hemispherical mound 120 feet (36.58 m) in diameter, faced in brick and stone and originally probably plastered and painted, but otherwise unadorned. Because the *stupa* is a solid mound, there is no interior space. Instead, the exterior of the architecture was the site of ceremonial activities. On the top, a stone **harmika** encircles a three-tiered stone parasol that marks the central axis. The *harmika* symbolizes heaven, and the parasol symbolically shelters the Buddha's relics encased within. Its three tiers signify the three jewels of Buddhism: the Buddha, his doctrine, and the monastic community. Two railings encircle the *stupa*, demarcating the paths for **pradakshina**, a ritual circumambulation of the structure. This walking ritual helped focus the worshiper's mind in preparation for meditation. The smaller path, accessed by a stairway, is located about 15 feet (4.57 m) above the ground. The larger, ground-level outer railing is punctuated by four elaborately carved **toranas** marking the cardinal directions.

EASTERN *TORANA* OF GREAT STUPA, SANCHI Constructed of fine sandstone, each tall *torana* consists of two posts supporting three 8-foot-wide **architraves**. This structure, better suited to wood than stone because wood's tensile strength allows it to span distances with minimal support, suggests the *toranas* were based on an earlier tradition of wooden architecture. Just below the first architrave, each post is adorned with richly carved figures. These figures include an animal capital, which on the eastern *torana* features elephants, and a bracket composed of a voluptuous naked female figure bending from the hips and holding onto a mango tree; her fertility is such that her touch causes the tree to bear fruit (**Fig. 16.4**).

This imagery might seem surprising at the site of a Buddhist monastery, where celibacy is the rule and concentrated meditation is the path to enlightenment. However, Buddhist art did not exist in a vacuum, and it frequently combined spirituality and sensuality. In early South Asia, female fertility was strongly associated with abundance and prosperity, and **auspicious** female figures were often placed at gateways and other vulnerable points. Thus, the Sanchi sculptors were following common practice.

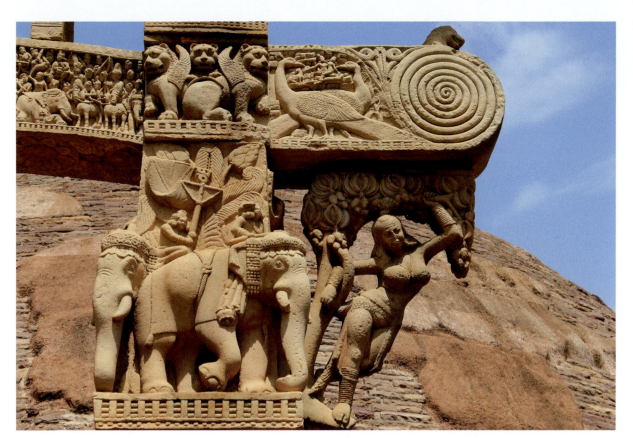

16.4 **Detail from the eastern** *torana* **of the Great Stupa** (showing female figure wrapped in a mango tree). Sanchi, India, *c.* 50–25 BCE.

THE GREAT DEPARTURE RELIEF, SANCHI Narrative reliefs depicting scenes from the Buddha's life and parables from his previous lives cover the *toranas'* architraves and posts. The reliefs are deeply carved, and the compositions are packed with people and objects. The sculptors' objective was not mimesis but rather readability: things are shown from their most recognizable viewpoints (trees from the side, footprints from above), and scale is varied as needed. Stories are told in a range of ways with regard to time—evidence of the sculptors' creativity. Some reliefs depict a single moment, while others summarize an entire story in one frame.

The Great Departure relief on the eastern *torana* uses **continuous narrative** to tell the story of Siddhartha Gautama leaving his palace in search of enlightenment (**Fig. 16.5**). The palace appears on the left, along with Siddhartha's horse, Kanthaka. Gods hold up Kanthaka's legs, allowing the animal to depart undetected. Kanthaka

continuous narrative multiple events combined within a single pictorial frame.

16.5 **The Great Departure,** on an architrave of the eastern *torana*, Great Stupa, Sanchi, India. *c.* 50–25 BCE. Relief carving.

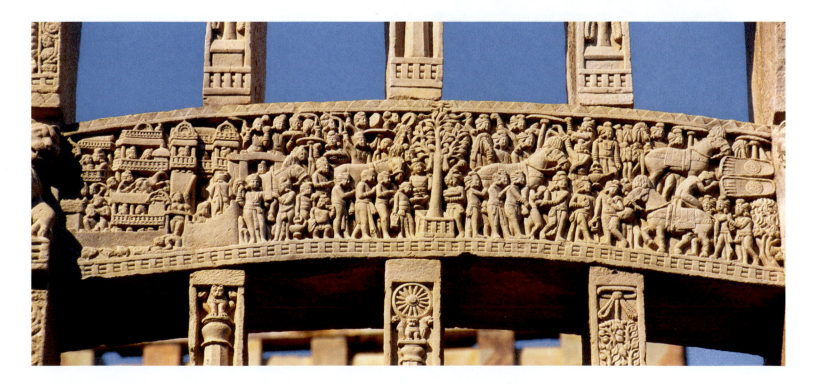

appears three more times moving to the right and once moving to the left. The relief does not depict Prince Siddhartha himself; instead, a parasol, a symbol of royalty in South Asia, indicates his presence. On the right edge, footprints inscribed with wheels indicate that Siddhartha has dismounted. His groom kneels before him to bid farewell before returning to the palace with Kanthaka, shown on the lower right. The absence of the parasol here indicates that Siddhartha is no longer on his horse.

Throughout the Sanchi reliefs and in other early Buddhist art, the historical Buddha is never shown in human form. Instead, key episodes of his life are represented by symbolic objects—for example, a pipal tree signifying enlightenment. In some cases, the reliefs depict later Buddhist worship of those objects, but in other reliefs, the objects seem to be stand-ins for the Buddha himself. Scholars still debate why the Buddha was not shown in human form and exactly when and why that changed; within a century or two, **icons** of the Buddha became focal points of Buddhist worship (for comparison, see box: Art-Historical Thinking: On the Initial Absence of Christian Imagery, p. 385).

Images of the Buddha

For several centuries after the fall of the Maurya Empire in 185 BCE, various small kingdoms vied for power until the Kushan Empire emerged around the first century,

and ruled until 375 CE. The Kushans, a nomadic group from western China, gained control over an area encompassing present-day Tajikistan, Uzbekistan, Afghanistan, and Pakistan, then eventually expanded eastward, conquering north India to the Ganges River. The overland trade routes now known as the Silk Road passed through the territory of the wealthy and cosmopolitan Kushans, who also controlled important Arabian seaports, leading to close contacts with the Roman Empire, the Persian Sasanian Empire, and the Chinese Han Empire (see Seeing Connections: Early Global Networks: The Silk Road, p. 270). A range of religions, including Persian Zoroastrianism, Greek and Roman polytheism, Buddhism, and Vedism, were practiced within Kushan borders; and various languages, including Greek, Bactrian, Pali, and Sanskrit, were spoken. The Kushans even minted distinctly designed coins in different parts of their empire to reflect local religious and linguistic practices. Like the Mauryan emperor Ashoka, the Kushan emperor Kanishka (ruled from around the early to mid-second century CE) helped propagate Buddhism, and it was around the time of his reign that images of the Buddha in human form began to be made.

GANDHARA AND MATHURA BUDDHA STATUES Although precise dating is difficult, evidence suggests that anthropomorphic representations of the Buddha, as well as **bodhisattvas**, were popular by the second century CE, appearing at roughly the same time in two distinct locations and styles. During Kanishka's reign, the Kushan Empire had two capitals. The summer capital was in the region of Gandhara (what is now northwestern Pakistan and eastern Afghanistan), where some of Alexander the Great's troops had settled five centuries earlier and which had strong ties to the Hellenistic world (see Map 15.1 in Chapter 15). The winter capital was in Mathura, a north Indian city (see **Map 16.2**). Both Gandhara and Mathura seem to have been centers of Buddhist image production.

Mathura artists used mottled red sandstone to create full-bodied, smiling figures such as this sculpture of the Buddha in a seated position (**Fig. 16.6**). Notice how the Buddha stares directly at the viewer, with his hand in a welcoming **mudra**. The hair is smooth, and the Buddha has a light-weight, sheer shawl draped over one shoulder. At Gandhara, in contrast, sculptors used gray schist stone and combined elements of provincial Roman portraiture with West Asian and South Asian visual traditions. These artistic connections are visible in the heavy, draped clothing and thick, wavy hair of the **bodhisattva** Maitreya (the Buddha of the Future) pictured in **Fig. 16.7**. Gandhara-sculpted figures also tend to look downward and bear serious expressions, as this Maitreya does.

In the past, art historians focused on establishing which location—Gandhara or Mathura—was first to depict the Buddha and **bodhisattvas**. Nineteenth-century European scholars argued that Gandhara was first and that the inspiration came from Greco-Roman statues of male gods, such as Apollo. In contrast, early twentieth-century Indian scholars asserted that Mathura was first, with indigenous benevolent male nature spirits called *yakshas* as the probable inspiration. In each case,

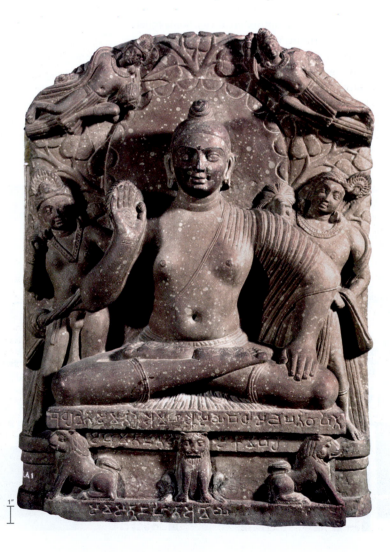

16.6 The Buddha, Mathura, India, Kushan period, early second century CE, Red sandstone, height 27¾ in. (70.5 cm). Government Museum, Mathura, Uttar Pradesh, India.

scholarly analysis was shaped by cultural bias and the colonial politics of the era: a useful reminder that we never interpret art from a neutral perspective. Rather, our interpretations reflect our own cultural assumptions and worldviews.

Today, the two styles (Gandhara and Mathura) are typically viewed as arising at the same time—the sculptural equivalent of the different Kushan coins responding to regional conventions—with the anthropomorphic turn in Buddhist art reflecting changes within the religion itself. During this period, Buddhism began to evolve. The idea gradually took hold that one should seek not just individual liberation but rather the liberation of all beings. Correspondingly, *bodhisattva*s gained prominence as compassionate figures who delayed *nirvana* in order to help others on the path to enlightenment. This new idea and the doctrines that developed to support it eventually became known as Mahayana Buddhism, which also recognized many more buddhas. (In contrast, Buddhist orders that maintained older practices of focusing on the historical Buddha and one's personal efforts to achieve enlightenment became known as Theravada Buddhism.) However, the growth of Mahayana beliefs cannot completely explain the appearance of buddha and *bodhisattva* images. The new imagery most likely also reflected a more general South Asian cultural shift toward depictions of religious figures as objects of

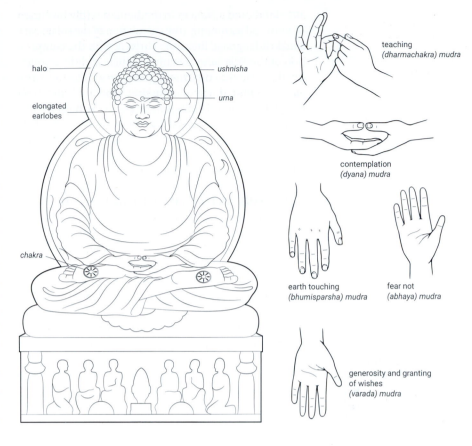

16.8 ABOVE The marks of the Buddha and common *mudras* (hand gestures).

devotion, because the development of Jain and Hindu imagery also dates to this period.

The standard **iconography** of Buddhist imagery seems to have been established quickly. The Buddha is typically shown frontally, in a seated, standing, or reclining position. If seated, he is shown in a meditative pose: his feet, soles facing up, rest on his thighs. Religious texts describe thirty-two signs indicating his perfection, but many of these attributes are not visually represented. The three most commonly portrayed markers are his **ushnisha, urna**, and elongated earlobes, the latter indicating the heavy jewelry he wore as a royal youth before renouncing it (**Fig. 16.8**). He often has a **halo**, signifying his divine aura. Occasionally his hands are webbed, and wheels (*chakra*) are imprinted on the soles of his feet and the palms of his hands. *Bodhisattvas* also bear many of these signs, but because they have not yet adopted monastic life, they are depicted as handsome princes wearing elegant clothes and jewelry. In later Buddhist art, *bodhisattvas* are also depicted as female; however, during this period, they were exclusively male. Specific *bodhisattvas* have additional iconographic elements, which occasionally changed as Buddhism evolved and spread to other regions. For example, in early depictions of Maitreya, he holds a sacred water flask in his left hand (see **Fig. 16.7**); in later representations, he may or may not have it.

Art of the Gupta Era, 320–550 CE

The Gupta Empire (320–550 CE) that followed the Kushan Empire was a time of cultural and intellectual achievement, including the founding of the Buddhist university

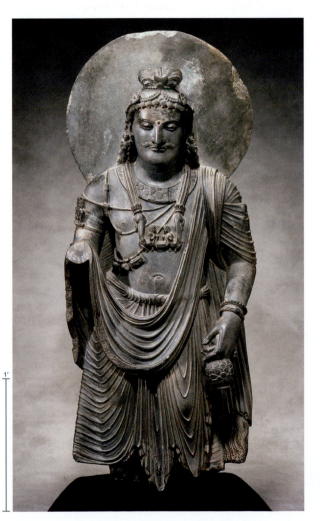

16.7 FAR LEFT **The Bodhisattva Maitreya**, Gandhara region, Pakistan, Kushan period, *c.* 100–300 CE. Stone (schist), height 41 in. (104.1 cm). Asian Art Museum, San Francisco.

16.8 ABOVE **The marks of the Buddha and common *mudras* (hand gestures).**

iconography images or symbols used to convey specific meanings in an artwork.

ushnisha one of the thirty-two markers of the Buddha, a buddha, or a *bodhisattva*: a protuberance from the head, usually a topknot of hair.

urna one of the thirty-two markers of the Buddha, a buddha, or a *bodhisattva*: a tuft of hair or small dot between the eyebrows that symbolizes a third eye.

halo a circle of light depicted around the head of a holy figure to signify his or her divinity.

at Nalanda and advances in mathematics (the invention of zero) and astronomy (the calculation of the solar year). Sanskrit-language literature thrived, with the composition of the *Panchatantra* animal fables and the *Puranas* (myths related to the Hindu gods), as well as the *Kama Sutra*, a Sanskrit text on sexuality, eroticism, and emotional fulfillment. The Gupta rulers were Hindus (by this point, Vedism had evolved into the practices and beliefs associated with Hinduism), but they supported multiple religions, leading to the flourishing of art related to Hinduism, Jainism, and Buddhism.

BUDDHIST ART IN THE GUPTA PERIOD

The Gupta era saw the development of what some art historians consider to be the quintessential representation of the Buddha. Gupta images of the Buddha became the inspiration for those made in other regions, from China to Java, with artists in each place modifying them to suit local needs. During this period, maritime trade increased, with Gupta merchants traveling to and occasionally settling in various Southeast Asian locations. Meanwhile, Buddhists from across Asia traveled to the Indian subcontinent to study at Nalanda University and to visit sites associated with the Buddha's life. This movement of people also led to the movement of ideas and objects, including portable bronze Buddhist devotional sculptures made by Gupta artists.

16.9 BELOW LEFT **The Buddha preaching the first sermon,** Sarnath, India, Gupta period, *c.* 475 CE. Sandstone, 61 × 34 × 10½ in. (154.9 × 86.4 × 26.7 cm) Sarnath Archaeological Museum.

16.10 BELOW RIGHT **Jain Tirthankara Parshvanatha,** India, Gupta period, sixth century CE. Sandstone, height 44 in. (111.8 cm). Metropolitan Museum of Art, New York.

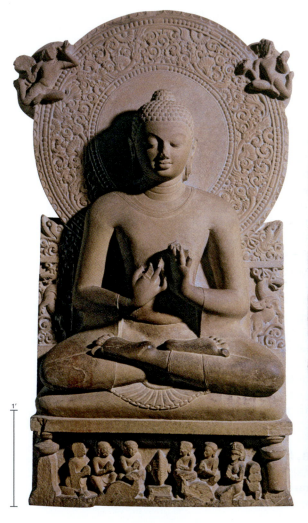

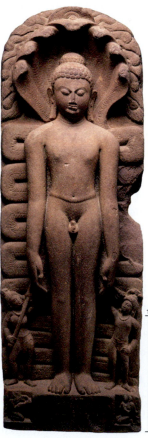

BUDDHA PREACHING THE FIRST SERMON, FROM SARNATH Gupta artists adopted aspects of Kushan-era images and combined them with fresh elements. A late fifth-century CE sandstone statue of the Buddha from Sarnath exemplifies this new representation (**Fig. 16.9**). He is seated, with his legs crossed and his hands in a teaching *mudra* (see **Fig. 16.8**), referencing Sarnath as the location of his first teaching sermon. The Buddha's standard iconography, including the *ushnisha* and elongated earlobes, is present, and the carving shows a high degree of refinement. The Buddha's cloak-like shawl is large and close-fitting, as in the earlier Mathura style, but it is no longer sheer and it now covers both shoulders. His hair is composed of distinctive, small snail-shell curls. His eyes are downcast, like those of Gandhara figures, but now his tranquil, oval face bears a slight smile. The elegantly carved round halo and rectangular base, paired with the triangular composition of the Buddha at center, add to the sense of stability and stillness. Altogether, the image presents the Buddha in a state of spiritual bliss that comes from attaining enlightenment.

JAIN ART IN THE GUPTA PERIOD

Alongside these developments, Jain sculpture blossomed. Like Buddhism, Jainism adopts the Vedic ideas of karma, *dharma*, and *samsara*, with liberation from existence as the ultimate goal, and it emphasizes personal actions rather than complicated rituals. Jainism's founder, Mahavira (*c.* 540–468 BCE), was a chieftain who left home at the age of thirty, gave up his worldly possessions, and adopted a path of austerity, penance, and meditation. Once he achieved enlightenment, he became a Jina, or "Spiritual Conqueror" (also referred to as a Tirthankara), and taught others the path. According to Jain beliefs, Mahavira was the last of twenty-four Jinas in this cosmos, each born into a royal family but renouncing the world in search of enlightenment. Jains are instructed to live modestly, perform acts of devotion, and practice nonviolence, including strict vegetarianism. Jainism does not seek converts and therefore did not spread as extensively as Buddhism, which does.

Statues of Jinas are the most common and recognizable form of Jain art. It is certain that sculptures of Jinas were produced at Mathura during the Kushan dynasty, but there is no archaeological record of them being made or used beyond Mathura before the Gupta era. By the sixth century CE, they were found throughout northern and western India. Jain sculptures are remarkably consistent, depicting the Jina sitting or standing in a rigid meditative posture, with a symmetrical, idealized form. In fact, it is nearly impossible to tell which of the twenty-four Jinas is being depicted, with two exceptions: Rishabhanatha is recognizable by his long hair, and Parshvanatha by the seven-headed cobra sheltering him.

STATUE OF THE JINA PARSHVANATHA Upon first glance, this sixth-century CE sculpture of Parshvanatha (**Fig. 16.10**) may seem to resemble the fifth-century CE seated Buddha closely (see **Fig. 16.9**). Their similarities result partly from being crafted in the same artistic style. The broad, rounded shoulders, the smooth planes of the chest, the

trident

third eye

matted dreadlocks

drum

meditative pose

animal skins

multiple arms holding different weapons

lion/tiger, the goddess's vehicle

Mahishasura being vanquished

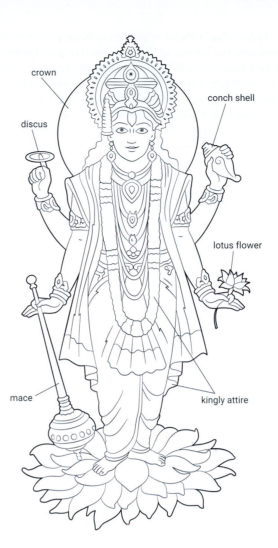

crown

conch shell

discus

lotus flower

mace

kingly attire

16.11 The three main Hindu deities and their iconography. CLOCKWISE FROM TOP LEFT **16.11a** Shiva, **16.11b** Vishnu, and **16.11c** Devi (in the form of Durga).

hair of snail-shell curls, and the oval face are all hallmarks of Gupta art. The sculptures share iconography, too, in parallel with the similarities in the two dharmic faiths. Like the Buddha, Jinas have elongated earlobes, signifying their early life as royalty who wore heavy earrings. Likewise, Jinas are often depicted with *ushnishas*. The Buddha is frequently depicted in meditation; Jinas always are. When standing, Jinas often have arms that reach to their knees; the Buddha is also sometimes shown with long arms.

What, then, are the distinguishing features of a Jina? A Jina often bears an auspicious mark on his chest called a *shrivatsa* (not visible on this figure), but the clearest difference is dress. The Buddha wears typical Indian monastic dress, including a simple undergarment and a large rectangular shawl covering one or both shoulders. Because Jainism emphasizes austerity rather than the middle path of Buddhism, Jain monks' clothes are more minimal. If the icon belongs to the Shvetambara or "white-clad" branch of Jainism, the Jina wears a loincloth. If the icon has been made for the Digambara or "sky-clad" branch, which regards any monk's clothing as an indulgence, the Jina is naked, as in this sculpture.

HINDU ART IN THE GUPTA PERIOD

Vedic traditions did not disappear during the centuries that Buddhism and Jainism developed, but they did transform into a collection of practices and beliefs that today are classified as Hinduism. Unlike Vedism, Hinduism emphasizes a personal relationship with a deity, and Hindu worship focuses on *darshan* and *puja* (prayer rituals in which one shows reverence to the god). Over time, older Vedic gods decreased in importance as local belief systems with their own gods and goddesses were incorporated into Hinduism.

While Hinduism is often described as a polytheistic faith, in fact Hindus ultimately believe in one god whose infinity is beyond human perception. A variety of gods and goddesses, therefore, are needed to represent different aspects of the One God. Further increasing the complexity of Hindu iconography, the major gods and goddesses exist in more than one form. In general, the three main deities worshiped, and therefore depicted in Hindu art, are Shiva, Vishnu, and Devi.

Shiva (**Fig. 16.11a**) is both the creator and the destroyer, embodying the paradoxical and cyclical nature of life. He appears in various manifestations, from meditating yogi to glorious dancer. His most powerful form is his **aniconic** representation, called a *linga* (see **Fig. 16.18**, p. 286). A columnar shape with a curved top, a *linga* can be interpreted as an erect phallus, referencing Shiva's role as creator and probably deriving from earlier religious practices that celebrated fertility. It also can be understood as an abstract signifier of divine energy.

darshan the auspicious devotional act of seeing and being seen by a deity, holy person, or sacred object in Hinduism.

aniconic the indirect visual representation of divine beings through symbols or abstract images.

linga an abstract representation of the Hindu god Shiva that denotes his divine generative energy.

Vishnu (**Fig. 16.11b**) is the preserver, the savior of humankind, and the creator of the universe (see box: Looking More Closely: Hindu Narrative Art). At times of crisis, Vishnu descends from his abode to this world. He has ten incarnations, called *avatars* ("ones who descend" in Sanskrit), including the hero Rama (see Chapter 51), Krishna, and the Buddha. This may explain why Buddhism declined in India while it was taking hold through the rest of Asia: Hinduism adopted it, turning the Buddha into one of Vishnu's incarnations. The tenth avatar, Kalki, has yet to come.

Devi is the Great Goddess, and she tends to take one of two general forms. When she appears as a consort of a male god (for example, as Parvati, Shiva's consort, or as Lakshmi, Vishnu's consort, as in **Fig. 16.13**), the goddess is beautiful, benevolent, and largely passive. When she is on her own, she is fierce, fearless, and full of energy, such as when she appears as Durga (**Fig. 16.11c**).

TEMPLE TO VISHNU, DEOGARH Images of Shiva, Vishnu, and Devi began to appear during the Kushan dynasty, and simple brick Hindu temples existed from as early as the third century CE. Monumental Hindu art, however, began to be made only during the Gupta era. One of the earliest freestanding stone temples is the sixth-century CE temple to Vishnu at the central Indian site of Deogarh (**Fig. 16.12**). A 16-foot-square sandstone structure, raised on a **plinth** and topped by a tower (now crumbling and therefore missing its top), provides an excellent example of a Hindu temple layout in its simplest, yet still refined, form.

A Hindu temple is the deity's home on earth, conceptualized, that is, theoretically understood, as a cave at the base of a sacred mountain. Because Hinduism is not a congregational faith, no large interior space is required. The *garbhagriha* ("womb-chamber"), symbolizing a cave, has a single entranceway and is topped by a *shikhara*, symbolizing a mountain peak. The majority of sculptural decoration is on the temple's exterior. A devotee of Hinduism would climb the plinth stairs and then perform *pradakshina* in order to view the exterior sculpture as well as stand at the *garbhagriha*'s doorway to receive *darshan*. At Deogarh, the shrine's main devotional icon is now missing, but historians assume it was a sculpture of Vishnu. It is likely that there were also four smaller shrines at the plinth's corners.

The temple's exterior decoration consists of a heavily ornamented doorframe on the west **facade** and three rectangular sculptural panels, one on each remaining side. The doorway is topped by a small image of Vishnu sitting on a serpent and framed by protective figures including **mithunas**, reminding us of the link between human fertility and auspiciousness in South Asia. The south panel depicts Vishnu creating the god Brahma, who is the creator of the world. The east sculptural relief depicts Vishnu in the form of twin sages meditating and preaching the importance of *dharma*, and the north panel shows Vishnu liberating an elephant king who had become trapped by a sea demon. At most Hindu temples, the entrance faces east, so circumambulation proceeds in what is classified today as a clockwise direction. However, because the Deogarh temple faces west, *pradakshina* was most probably performed in the other direction (counterclockwise). Thus, a devotee performing *pradakshina* would first encounter a birth/creation scene, then a scene promoting the importance of *dharma* on Earth, and finally a scene of liberation. While each panel is a complete artwork itself, together they convey a larger message that scholars call the iconographic program.

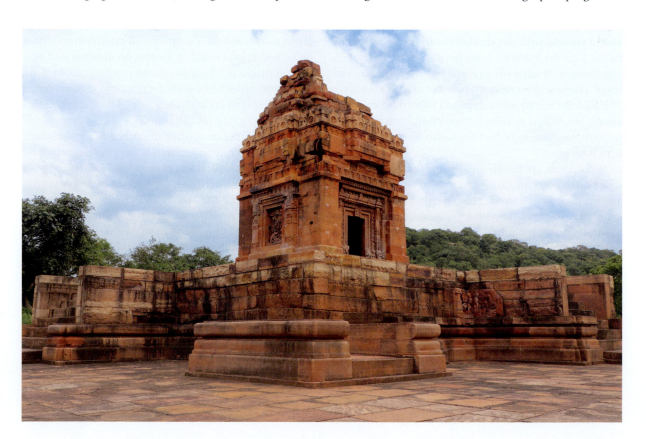

16.12 Temple to Vishnu, Gupta period, early sixth century CE. Deogarh, India.

Visually complex and laden with religious meaning, Hindu narrative art sometimes requires step-by-step unpacking. For example, let us take a closer look at the Deogarh temple's south panel.

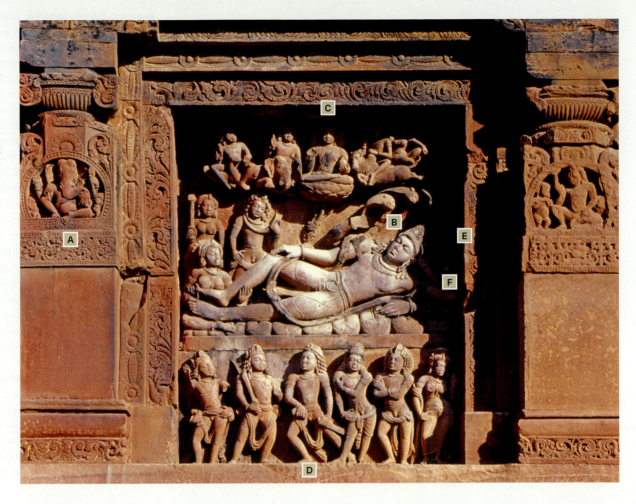

A First, notice that to the panel's immediate left is an image of the elephant-headed god Ganesha, remover of obstacles and worshiped at the start of a task. His presence suggests that *pradakshina* begins here.

B Next, study the panel's iconography to determine what is depicted. The royal crown on the central, reclining figure indicates that it is Vishnu. He sleeps cushioned by the serpent of infinity Ananta, identifiable by his multiheaded cobra hood. Here, the hood acts as a protective canopy. Vishnu's consort, Lakshmi, massages the god's leg. According to the *Puranas*, as Vishnu slept and dreamed, a lotus grew from his navel. The blossom eventually opened to reveal Brahma, the god of creation. Here, perhaps for artistic reasons, the lotus vine is not attached to Vishnu's navel, but rather drapes elegantly along his body.

C At the top of the panel, Brahma is shown seated on a lotus flower and flanked by other deities there to witness the miraculous event. For example, directly to Brahma's right are Shiva and Parvati, riding on Shiva's mount, the bull Nandi.

16.13 (A–F) Sculptural panel showing Vishnu reclining on the serpent Ananta, Temple to Vishnu, Deogarh, India.

D The figures positioned in a row at the base are personifications of Vishnu's four weapons (at right) stopping two demons (at left) from attacking Vishnu as he sleeps.

E Next, analyze the relief's style, which indicates roughly when it was made. In this case, Vishnu's broad, rounded shoulders, smooth chest, and oval face confirm the relief is in the Gupta style, dominant in central India during the fifth and sixth centuries CE.

F Finally, consider the visual strategies employed by the artist(s), and how they enhance the viewing experience. Here, the sculptors divided the composition into three rows, or registers, which increase the relief's legibility. This clarity provides the composition with a sense of stability and calm, echoing that of Vishnu's long slumber. Vishnu is both the largest figure and the only one positioned horizontally, increasing his prominence in the scene.

Cave Architecture in South Asia, from *c.* 100 BCE

Cave architecture, part of the broader category of **rock-cut** architecture, flourished in South Asia between around 100 BCE and 900 CE. It was used first for Buddhist monasteries and later for Hindu and Jain shrines. While caves make ideal retreats for meditation and prayer, Buddhist monks and nuns could not completely remove themselves from society because they depended on donations from laypeople, who in turn increased their merit toward karma by supporting them. Constructing cave monasteries along trade routes ensured a steady stream of visitors who might become patrons.

BUDDHIST CAVES AT AJANTA The monastery site of Ajanta, located along a horseshoe-shaped bend in the Waghora River on an ancient trade route in western India (see **Map 16.1**), contains approximately thirty caves dating to between 100 BCE and 500 CE (**Fig 16.14**, p. 284). The majority were carved over a surprisingly brief period, *c.* 460–500 CE, when the short-lived Vakataka dynasty ruled the region. Inscriptions at the site link patronage of many caves to the ruler Harishena (ruled *c.* 460–80 CE) and to princes and officials at his court. Like many patrons of the time, they were followers of Hinduism but supported the Buddhist site, finding no conflict between the two faiths.

The two main types of Buddhist caves are *viharas* for lodging and *chaityas* for prayer. Cut into the

rock-cut carved from solid stone, where it naturally occurs.

vihara a retreat for Buddhist monks and nuns.

chaitya a Buddhist prayer hall with a *stupa* at one end.

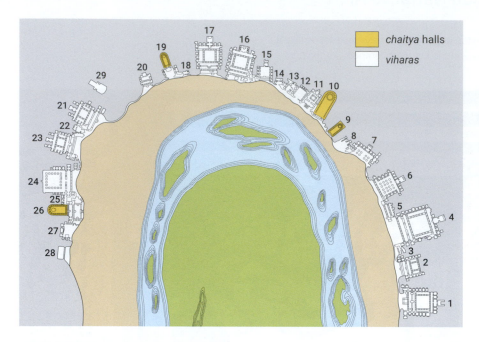

16.14 Buddhist caves at Ajanta, India (plan drawing), c. 100 BCE –500 CE.

chaitya halls

viharas

mountainside, a *vihara* consisted of a sizable, central, square hall surrounded by small cells where the monks resided. Each cell contained a carved stone bed and pillow as well as hooks and niches for the monks' meager belongings. At Ajanta, *viharas* also included small shrines with buddha images for worship. *Chaityas*, in contrast, were long, narrow rooms with a curved end featuring a *stupa*, the focus of devotion. At Ajanta, a carved buddha image adorns the front of each *stupa*, and columns along the sides flank the *pradakshina* path (**Fig. 16.15**). The curved ceiling beams and broad columns, structurally unnecessary in caves, suggest that the *chaitya* halls imitated

elements of earlier wooden architecture, just as the *toranas* at the Great Stupa at Sanchi (see **Fig. 16.4**) seem to be based on earlier wooden gateways.

MAHAJANAKA JATAKA MURAL PAINTING Ajanta's mural paintings are India's earliest surviving examples of the medium. The murals depict images of *bodhisattvas*, scenes from the life of the Buddha, and *jatakas* (stories of the Buddha's past lives). A scene in Cave 1 depicts the Mahajanaka Jataka (**Fig. 16.16**), in which the ruler Mahajanaka gives up his riches to go in search of spiritual fulfillment. On the left, Mahajanaka sits in his palace in a scene teeming with figures, and he looks detached as his wife tries to persuade him to stay. He appears again on the right, leaving on horseback.

The murals, which are **dry frescos**, were skillfully made and planned with care, featuring crowded compositions and complex narrative constructions. The artists defined forms with outlines, used **chiaroscuro** and **foreshortening**, and employed **perspective** when depicting architecture. Curiously, because of the caves' darkness, oil lamplight would have been required to see the paintings. Even then, viewers would have been able to see only one small part at a time, leading some scholars to wonder if the paintings' primary purpose was spiritual, despite their artistic splendor.

SHIVA CAVE TEMPLE, ELEPHANTA Around the time that construction stopped at Ajanta, Hindu and Jain rock-cut architecture began to flourish. The island of Elephanta in Mumbai Harbor contains several caves carved out of its basalt rock. The primary cave is dedicated to the Hindu god Shiva and most probably was commissioned by the ruler Krishnaraja I (ruled *c.* 550–75 CE) of the Kalachuri

dry fresco a wall or ceiling painting on dry plaster (*a secco*), as opposed to on wet plaster (true or *buon fresco*).

chiaroscuro in two-dimensional artworks, the use of light and dark contrasts to create the impression of volume when modeling objects and figures.

foreshortening in two-dimensional artworks, the illusion of a form receding into space: the parts of an object or figure closest to the viewer are depicted as largest, those furthest as smallest.

perspective the two-dimensional representation of a three-dimensional object or a volume of space.

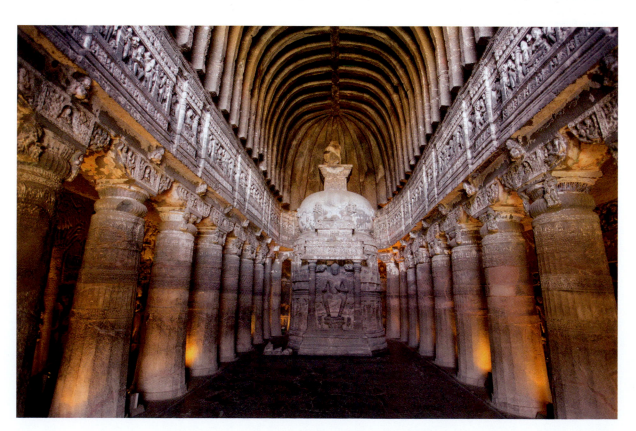

16.15 Chaitya Hall, Cave 26, Ajanta, India, c. 460–500 CE.

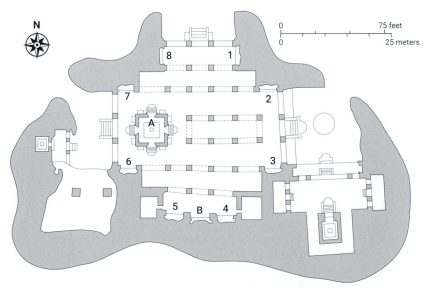

16.16 **Mahajanaka Jataka mural (detail), Cave 1,** Ajanta, India, *c.* 460–500 CE.

dynasty. It exemplifies the power of cave architecture. Beginning with the journey by boat from the mainland to the island, the entire experience of visiting this cave must have been an immersive one.

The Shiva cave temple has three columned entrances: the main entrance and two side openings to let in light (**Fig. 16.17**). Unusually for a Hindu temple, the cave features two shrines. Off center from the main entrance, but aligned with the two side openings, is a small square shrine with four doors (labeled A in **Fig. 16.17**). In its center is a stone *linga,* the aniconic form of Shiva. The sculptors placed the shrine off center so that it did not block the view of the large Eternal Shiva, a monumental **bust** sculpture with three visible "faces" or heads (one full-face

bust a sculpture of a person's head, shoulders, and chest.

A Linga shrine
B Eternal Shiva (3-faced *linga*)
1 Shiva as Master Yogi
2 Shiva trapping Ravana beneath Mount Kailasa
3 Shiva playing dice with Parvati

4 Shiva as Ardhanarishvara
5 Descent of the Ganges
6 Marriage of Shiva and Parvati
7 Shiva destroying Andhaka
8 Shiva dancing

16.17 **Shiva Cave temple (plan),** Elephanta, India, sixth century CE.

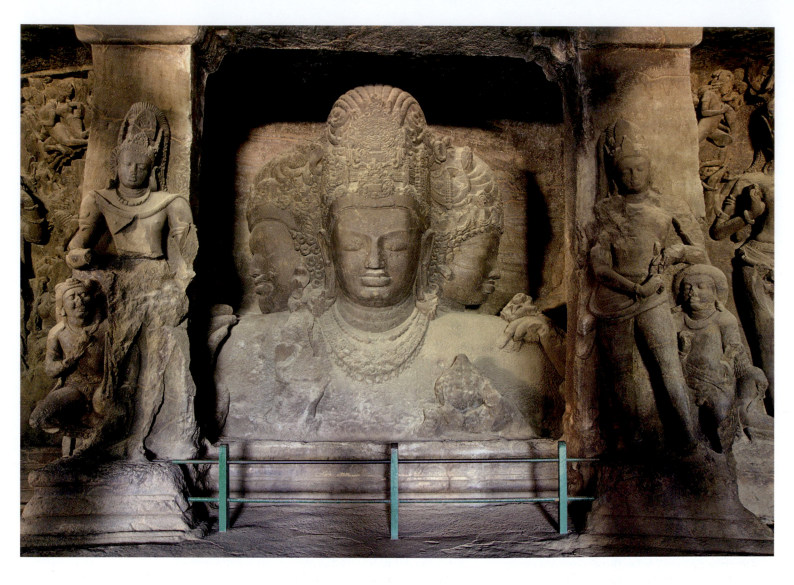

16.18 Eternal Shiva (three-faced *linga*) flanked by guardian figures, Shiva Cave temple, Elephanta, India, sixth century CE.

flanked by two in profile), in the center of the back wall (**Fig. 16.18**; labeled B in **Fig. 16.17**). Flanked by guardian figures and rising 18 feet (5.49m) from a platform in a deep recess, this second shrine, which is part abstract and part figural, displays the transition between the god's aniconic and iconic forms. Commonly called a three-faced *linga*, it both resembles a *linga* and presents Shiva's faces as they appear in his various manifestations. The column created by the locks piled on Shiva's head acts as the *linga*'s top, and his shoulders act as its base. The center face displays the god in his serene form. The face in profile to the right is Shiva's female form, and that in profile on the left is his wrathful form. Worshipers would have understood the *linga* to have a fourth face in the back and a fifth face on top.

The walls of the pillared interior feature eight large-scale, deeply carved sculptural reliefs, each presenting a different aspect of Shiva (labeled 1–8 in **Fig. 16.17**). For example, the relief directly to the left of the three-faced *linga* presents Shiva as Ardhanarishvara, his half-male, half-female manifestation (see p. 272; labeled 4 in **Fig. 16.17**), and that to the right shows him facilitating the goddess Ganga's (the Ganges River) safe descent to earth (for more on this story, see Chapter 26). By circumambulating the entire cave, visitors encounter

Shiva in his many manifestations, from meditative to wrathful, in a setting that is simultaneously imposing and intimate.

Early Buddhist and Hindu Art in Southeast Asia

Inscriptions and archaeological evidence suggest that Buddhism and Hinduism, along with ideas about kingship, elite culture, and philosophy discussed in Sanskrit-language literature, spread to Southeast Asia principally between the fourth and sixth centuries CE, concurrent with expansions in maritime trade (see **Maps 16.1** and **16.2**). At the same time that the Gupta Empire ruled in India, coastal city-states in Southeast Asia were emerging, prosperous from their participation in trade. These states included, among others, the kingdom of Dvaravati (sixth to eleventh century CE) in central Thailand and the Funan kingdom (first to seventh century CE) in the Mekong Delta region of mainland Southeast Asia. The earliest examples of Hindu and Buddhist art in these regions date to the late fifth century CE. Many more examples date to the early seventh century, with artistic production flourishing from that point onward.

Southeast Asia and early South Asia shared animist beliefs in supernatural powers that organize and animate the material universe. Animist belief systems attribute a soul to plants, animals, inanimate objects, and natural phenomena, such as mountains. As they developed, Hinduism and Buddhism integrated such beliefs, thus incorporating Southeast Asian traditions into these new religions. For example, a particular supernatural force might be reframed as a manifestation of a Hindu god. Sanskrit culture and its religions operated somewhat like an international language, and by adopting them, rulers became part of a wider system, one with a potent visual vocabulary that expressed their power and moral standing in ways that resonated at both local and regional levels. For these reasons, compelling variations of Buddhist and Hindu art emerged in these early states.

DHARMACHAKRA (WHEEL OF THE LAW) In the Dvaravati culture of central and western Thailand, monumental images of wheels seem to have had unique status, competing with icons of the Buddha for preeminence. Multiple large sandstone *dharmachakras* (wheels of the

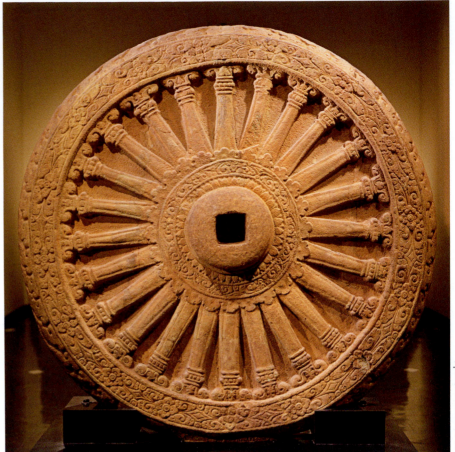

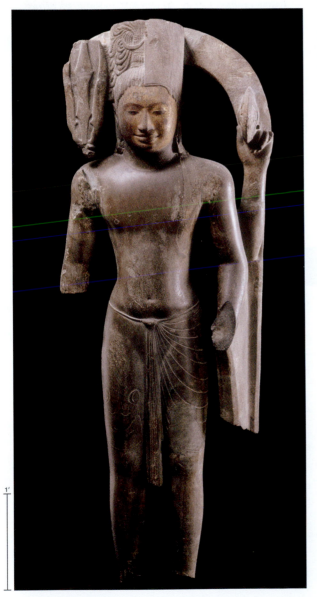

law), datable to the seventh and eight centuries CE, have been found there but nowhere else in Southeast Asia. The wheel, a key symbol from the aniconic phase of early Indian Buddhist art, carries associations with the idea of the *chakravartin*, the ideal king.

The wheel pictured here (**Fig. 16.19**) measures almost five feet high and four-and-a-half feet wide. It has twenty-four spokes and combines both delicate and bold carving. The wheels would have been placed on tall columns in a manner similar to Ashoka's pillars, except here the wheel took center stage in a way that it never had before. Many wheels, including this one, bear inscriptions in Pali, the language associated with Theravada Buddhism. The inscriptions are engraved between the spokes and describe the Buddha speaking about the four noble truths. However, the inscriptions would have been unreadable when the wheel was placed on top of a pillar, suggesting their importance was spiritual rather than visual.

HARIHARA STATUE Sculptures of the deity Harihara, such as this seventh-century Cambodian example (**Fig. 16.20**), provide a clear example of Hindu art's distinct development in Southeast Asia and its connection to regional expressions of power and identity. Harihara is the hybrid form of the gods Vishnu (Hari) and Shiva (Hara). He embodies the concept of unity in Hinduism: the idea that Shiva and Vishnu are just different aspects of the Supreme God. In this example, Harihara's right half (viewer's left) represents Shiva, as indicated by the

16.19 *Dharmachakra*, the **Buddhist wheel of the law,** Dvaravati culture, Thailand, seventh century CE. Sandstone, 59 × 55 × 11 in. (150 × 140 × 28 cm). Newark Museum, New Jersey.

16.20 FAR LEFT **Harihara,** Ta Keo province, Phnom Da, Cambodia, pre-Angkorian period, seventh century CE, Sandstone, height 5 ft. 10 in. (178 cm), Musée Guimet, Paris.

trident he holds (the trident's top is visible next to his face), the animal skin he wears, and the matted locks piled atop his head. Vishnu, on the left half (viewer's right), is recognizable by his kingly crown and the discus he holds in his leftmost hand. The regal, nearly six-foot-tall sculpted figure was originally framed by an arch, only a portion of which has survived. The figure has also lost its feet and hands, but the skill of its stone-carvers remains apparent, for example, in the subtle modeling of the flesh in the lower abdomen. This bodily attention is typical of sculptures from seventh-century Cambodia, which also corresponds to the height of Harihara's popularity.

By the sixth century, the Funan kingdom, which had ruled the Mekong Delta region since the first century CE, was in decline, and a series of small states were vying for power. Local rulers, drawing on the Sanskrit idea of the *chakravartin*, often presented themselves as god-kings. They would claim connection to either Vishnu or Shiva, depending on which particular area they governed. Worship of Vishnu was more popular in southern Cambodia, while Shiva dominated in northern Cambodia and nearby regions. During the seventh and eighth centuries, rulers sought to unify the areas, and sculptures of Harihara can be connected to their sponsorship. The reason they would have promoted Harihara is clear: the hybrid deity allowed them to demonstrate the possibility of religious and political unification.

Over the next 600 years, as both Hinduism and Buddhism thrived in Southeast Asia, artistic and religious innovations continued. Indeed, both the largest Buddhist monument (Borobudur) and the largest pre-modern Hindu temple (Angkor Wat) are located in Southeast Asia (see Chapter 26). Even after Hinduism declined in Southeast Asia (today it is mainly practiced on the island of Bali), its impact on the culture remained strong, as exemplified by the longstanding importance of the Hindu epic *Ramayana* on visual culture (see Chapter 51).

Discussion Questions

1. Compare the role that art plays in Buddhism to its function in Hinduism. What are the similarities, and what are the key differences?

2. One theme of this chapter is the distinction between iconography and style. Compare three Gupta artworks discussed in this chapter—one Buddhist, one Jain, and one Hindu—in terms of style and iconography.

3. Pick an example of narrative art from this chapter. Think about the visual choices made by the artist(s) to tell the story. What are some other ways to tell the same story visually, and how would they change the viewing experience?

Further Reading

• Asher, Frederick. "On Maurya Art." In Rebecca Brown and Deborah Hutton (eds.) *A Companion to Asian Art and Architecture*. Malden, MA: Wiley-Blackwell, 2011, pp. 421–43.

• "Beliefs Made Visible: Understanding South Asian Hindu and Buddhist Art." Asian Art Museum, San Francisco (May 16, 2004), http://education.asianart.org/sites/asianart.org/files/resource-downloads/Beliefs-Made-Visible_1.pdf

• Blurton, Richard T. *Hindu Art*. London: British Museum Press, 1992.

• Dehejia, Vidya. *Indian Art*. London: Phaidon, 1997.

• Guy, John (ed.). *Lost Kingdoms: Hindu–Buddhist Sculpture of Early Southeast Asia*. New York: The Metropolitan Museum of Art, 2014.

Chronology

c. 540–468 BCE	The life of Mahavira, the founder of Jainism	*c.* 100–300 CE	Anthropomorphic images of the Buddha appear
c. 5th century BCE	The life of Siddhartha Gautama, the founder of Buddhism	*c.* 300–500 CE	Early Hindu *Puranas* are composed
c. 322–185 BCE	The Maurya Empire rules much of South Asia	*c.* 320–550 CE	The Gupta Empire rules in north India; Gupta artists make both stone and portable bronze Buddhist sculptures
c. 272–231 BCE	The reign of the Maurya emperor Ashoka, who converts to Buddhism, constructs *stupas*, and erects stone pillars proclaiming ethical codes of behavior	*c.* 300–600 CE	Buddhism and Hinduism spread throughout Southeast Asia
c. 100 BCE–900 CE	Rock-cut and cave architecture flourishes in South Asia	*c.* 460–500 CE	Buddhist caves are carved and painted at Ajanta under the patronage of the Vakataka dynasty
c. 50–25 BCE	The Great Stupa at Sanchi is enlarged and embellished	early 6th century CE	Stand-alone Hindu temples are developed in South Asia; the Temple to Vishnu is built at Deogarh
1st century CE	Hindu epics the *Mahabharata* and the *Ramayana* are written	*c.* 550–75 CE	The reign of Krishnaraja I, who commissions the Shiva Cave temple on Elephanta Island, Mumbai
c. 1st century–375 CE	The Kushan Empire rules an area stretching from Central Asia to north India	7th century CE	The beginning of widespread Buddhist and Hindu art production in Southeast Asia
c. early-mid-2nd century CE	The reign of the Kushan ruler Kanishka		

17

Villanovan and Etruscan Art

900–270 BCE

Fibula from the Regolini-
Galassi Tomb, Cerveteri, Italy.

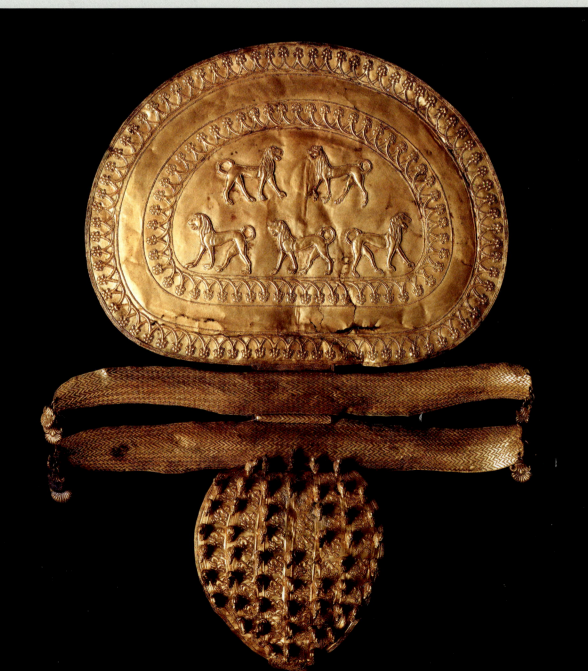

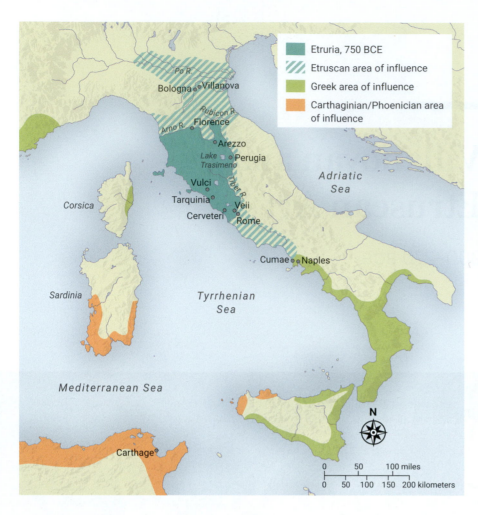

Map 17.1 Etruria and the Etruscan area of influence, 750 BCE.

Introduction

Societies flourished on the Italian peninsula long before the rise of the Roman Empire. The fertile land supported the development of agriculture, and rich copper and iron deposits spurred the development of mining and metal technologies. With easy access to the sea and with a network of rivers, the peninsula allowed its inhabitants to interact with foreigners and engage in trade, especially in metals. This chapter looks at the art of two ancient groups on the Italian peninsula: the Iron Age people we call the Villanovans, and the Etruscans, whose language appears around 700 BCE. The Etruscans played a prominent role in Mediterranean maritime trade, and as a result, their art reveals an exchange of ideas with, for example, Greeks and Phoenicians, both of whom founded colonies in the western Mediterranean. The Phoenicians founded Carthage in North Africa, which then established its own colonies in Sicily, Spain, and beyond. The Etruscans made important artistic contributions in metalworking, sculpture, and architecture, and their influence on later Roman culture was significant. One fascinating aspect of Etruscan society was that women—at least, wealthy women—had many more rights and privileges than was typical for women in neighboring cultures at the same time.

The people we now know as Etruscans called themselves Rasenna, but the Romans called them Etrusci and the region in which they lived, Etruria. The Greeks called them Tyrrhennoi, the source of the name of the Tyrrhenian Sea, the part of the Mediterranean that is off Italy's west coast. The Etruscans'

heartland was the area between the Arno and Tiber Rivers in central Italy in the region known today as Tuscany. Their presence was also apparent as far north as the Po River Valley and as far south as Campania, the area around Naples (Map 17.1). No Etruscan literature or historical documents have been discovered, but thousands of short inscriptions and fragmentary texts survive, providing some insight into their culture. The script used by the Etruscans is an alphabet derived from a Greek dialect, but their language is unlike any other spoken language in Italy at the time, all of which are part of the Indo-European language family.

The origins of the Etruscans have been the subject of contentious debate since ancient times. The Greek historian Herodotus, of the fifth-century BCE, argued that the Etruscans migrated to Italy from Anatolia (roughly the area of present-day Turkey) around 1200 BCE because of famine in their homeland. Dionysius of Halicarnassus, who lived in the first century BCE, claimed instead that the Etruscans were native to Italy. More recently, DNA evidence has offered some support for West Asia as a potential area of origin, though perhaps much further back in time than Herodotus thought. The combined linguistic, archaeological, and scientific evidence suggests the intermingling of natives and immigrants over the course of several hundred years during the Villanovan period and even earlier. Indeed, as is the case with most historical societies, a complex variety of ethnic, political, linguistic, and other factors played a role in the cultural development of Etruscan society. Perhaps at the root of the debate is how we define the terms 'Indigenous' or 'native' in a region known for the movement of people and ideas throughout the course of history.

Early Etruscan cities used their wealth from the mining and sale of copper and iron to develop a stratified society. High-status men and women highlighted their prosperity by sponsoring temples with terra-cotta sculpture, by acquiring luxury items, including finely worked gold jewelry, and by commissioning highly decorated tombs and life-size, naturalistic bronze sculptures. Etruscan artists freely adapted styles from the Greeks and other cultures, and ultimately influenced Rome.

Villanovan Society, *c.* 900–720 BCE

Villanovan is the name given to the society of farmers and warriors that appeared in the tenth or ninth century BCE in Italy. The Villanovans were probably the first to bring Iron Age technology to the peninsula; they controlled the region's abundant metal-ore mines and are known for their impressive metallurgical technology. Their name is borrowed from the village of Villanova, east of Bologna, where the culture was first identified in 1853 through excavations.

Villanovan communities were spread throughout the northern part of the Italian peninsula, and each consisted of a village for the living and a cemetery for the dead. Some of these Villanovan villages later developed into prominent Etruscan communities. Archaeological traces of Villanovan huts dating to the ninth and eighth centuries BCE have been discovered at Tarquinia, at Veii, and in Rome on the Palatine Hill. The huts were oval,

circular, or roughly rectangular in plan. Little remains of them, as they were constructed of materials that have not survived. Foundation trenches for **wattle-and-daub** walls and holes for the wooden upright posts that provided a framework and supported the roof tell us that the huts were generally built quite far apart, perhaps to leave space for farming and animals.

Cremation urns in the shape of miniature huts (such as **Fig. 17.1**) provide evidence regarding the shapes and roofs of the original dwellings. Most examples depict a sloping **thatched** roof with projecting **eaves** to protect the walls from rain. The thatch could have been held in place by crossed wooden poles. The crossing ends were sometimes carved to form birds or horns, which were perhaps believed to ward off evil influences. Sometimes the floor surface was extended outside of the hut in front of the door; this area may have been used as a space for work. Small windows or openings in the roof allowed smoke from the hearth to escape.

CREMATION URNS It is believed that the Villanovan culture is related to the Urnfield cultures of eastern Europe, so named because of their shared practice of placing cremated remains in urns, which they then buried. Hut-shaped urns appear more frequently in Tuscany than elsewhere. They are usually made of **terra-cotta**, but some are metal, such as the **embossed** sheet-bronze example from Vulci (**Fig. 17.1**), which demonstrates the Villanovan artists' advanced metalworking skills. The embossing on this and other hut urns suggests that the walls of some of the actual huts may have been painted. The ashes and bones of both men and women were found in hut urns, suggesting some gender equality among the Villanovans—a characteristic that arguably carried over into later Etruscan society, but not into Rome.

Cremation urns were set into a pit cut into the ground, which was sometimes lined with stone (**Fig. 17.2**). A larger ceramic vessel might also have been used as the lining. After the deceased was cremated, the remains were put into the urn, which was in turn placed in the lined pit.

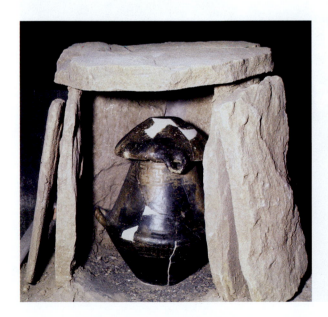

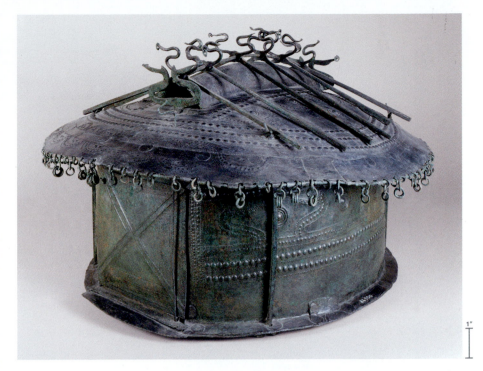

Urns came in different forms, including the hut shape described above, and this biconical urn (in the shape of two cones atop each other, widest ends connected) capped with a bowl, or sometimes more elaborately capped with a metal helmet or an imitation in ceramic. Offerings could be deposited in the grave, including food items in containers and personal belongings, such as jewelry, weapons, and tools for weaving or other tasks. The inclusion of such items suggests belief in an afterlife. The grave pit was then covered with a stone slab.

Etruscan Art of the Protoarchaic Period, *c.* 720–575 BCE

The Etruscans, who were probably related in some way to the Villanovans, were well established by the eighth century BCE. Their economy was based on agriculture and international trade, and their power reached its height in the sixth century BCE. Although the conquest of Etruria by Rome was complete by 264 BCE, Etruscan culture continued to have a long-lasting impact on Rome.

By the late eighth century BCE, Etruscan art and language was distinctly recognizable. The names used to describe the periods of Etruscan art—Protoarchaic (sometimes referred to as Orientalizing), Archaic, and Classical—are borrowed from those used to describe ancient Greek art. The first period, the Protoarchaic, sees influence from, for example, the Greek and Phoenician cultures and colonies with whom the Etruscans traded. Due to their control of important metal resources on the Italian peninsula, some Etruscans acquired great wealth at this time. Evidence from their art, architecture, and burials suggests that the new wealth led to increased social stratification.

The Etruscan city of Cerveteri (ancient Caere) was located just 4½ miles (7.2 km) from the Tyrrhenian Sea and controlled three ports, which made it an important

17.1 Hut-shaped cremation urn from Vulci, Italy, *c.* 750 BCE. Embossed sheet bronze with cast additions, height 10¼ in. (26 cm). Museo Nazionale Etrusco di Villa Giulia, Rome.

wattle-and-daub a building method in which wooden or other sturdy strips are woven together (wattle) and glued with an adhesive substance, often mud, soil, or clay (daub).

thatch covering or roofing for a building, usually made of sturdy, lightweight material, such as straw or reeds.

eaves the part of a roof that overhangs the walls of a building, generally to protect it from the elements.

terra-cotta baked clay; also known as earthenware.

embossed an object or surface that has been carved, molded, or stamped in relief.

17.2 FAR LEFT **Reconstruction of a Villanovan cremation burial,** ninth–eighth century BCE.

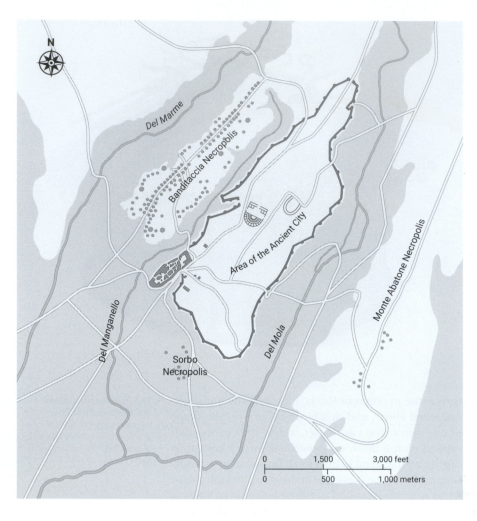

trading center (**Fig. 17.3**). The inhabitants gained much of their wealth from the exploitation of local iron-ore mines. Although the ancient city was among the richest and most important of Etruria, most of our information about it comes from the associated **necropoleis** rather than from the city of the living because, like the Villanovans, the Etruscans built primarily with ephemeral materials that have not been preserved, and many were constructed over in later periods.

In both the Villanovan and Etruscan periods, necropoleis were located outside of the city boundaries; but unlike the Villanovans, Etruscans constructed massive tombs and practiced both inhumation (the burial of a complete body) and cremation. High-status figures in Etruscan society highlighted their wealth through the size and decoration of their tombs, their valuable grave goods, and their funerary rituals. Grave goods included foreign luxury items acquired through trade, as well as items made in local workshops by artists who often adapted techniques and **iconography** from West Asian trading partners.

BANDITACCIA Three necropoleis surrounded Cerveteri. The largest and most important was Banditaccia, which contained thousands of tombs in a variety of forms and sizes. Some were covered by huge, round **tumuli** (**Fig. 17.4**). The tombs were at least partially cut into the soft local tuff (a porous volcanic rock, sometimes called tufa), which hardened once exposed to oxygen. The excavated stone was used to form a low retaining wall around the periphery of the cut tombs, and then a tumulus was

17.3 ABOVE **Ancient Etruscan city and necropoleis of Cerveteri, Italy (plan drawing),** eighth–third century BCE.

17.4 RIGHT **The Banditaccia Necropolis,** Cerveteri, Italy, eighth–third century BCE.

necropolis (plural **necropoleis**) a large cemetery; from the Greek for "city of the dead."

iconography images or symbols used to convey specific meanings in an artwork.

tumulus (plural **tumuli**) a mound of earth raised over a burial or grave.

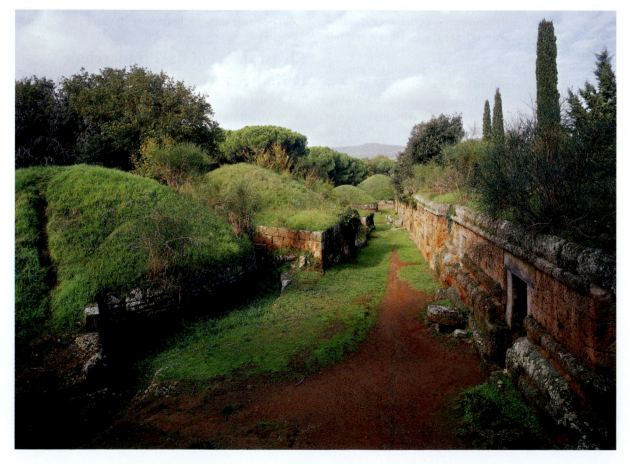

mounded above. In Etruscan culture, as in the Villanovan, there was a close connection between the living and the dead. The tumuli, the biggest of which were approximately 130 feet (around 40 m) in diameter and almost 50 feet (around 15 m) high, were laid out like the houses of the living along streets in a city-like plan, with squares and individual neighborhoods.

REGOLINI-GALASSI TOMB Within the necropoleis, wealthy Etruscans called attention to their social status through extravagant burial rituals, including the adornment of the deceased's body with luxury items. A striking example is the Regolini-Galassi Tomb (**Fig. 17.5** and **17.6**), which dates to about 650 BCE. The tomb was discovered in 1836 and is named after the two amateur archaeologists who excavated it: a priest and a general. Carved partially into the soft rock is a long rectangular corridor, or *dromos*, that also functions as an anteroom for a burial chamber found beyond a low wall toward the rear of the corridor. The tomb is roofed with a type of **corbeled vaulting**. On either side of the anteroom, an oval-shaped chamber is carved out of the rock. The chamber to the right contained a ceramic urn with the cremated remains of a man. The other oval chamber contained no human remains, but included several silver-gilt bowls.

The main burial chamber at the end of the tomb housed the body of a woman, whose high status is confirmed by the impressive array of offerings and possibly personal items that accompanied or adorned her. She may have used some of them during her lifetime: a silver spindle for weaving; inscribed silver vessels; and two bronze cauldrons whose style and iconography, including the decorative display of lions, griffins, and other animals on the body and **protomes**, parallel examples

17.5 **The Regolini-Galassi Tomb,** Cerveteri, Italy, c. 650 BCE.

from north Syria. Other offerings were believed to have been made for burial alone: status symbols made from thin sheet gold, including a gold **pectoral**, a pair of gold bracelets (or big earrings), a necklace of gold and amber, and an elaborate **fibula**.

GOLD FIBULA Fibulae are sometimes found in Villanovan cremation urns, but they are usually made of bronze. This extravagant gold disk fibula (**Fig. 17.7**, p. 294 and p. 289) from the Regolini-Galassi Tomb fully demonstrates Etruscan artists' metalworking skills. The upper part, which folds in two at the hinge, is decorated with a series of parading lions in profile, a West Asian motif created

dromos an entrance passage to a subterranean tomb.

corbeled vault an arched ceiling constructed by offsetting successive rows of stone (corbels) that meet at the top to form an arch shape.

protome a decoration in the form of the head or bust of a human or animal.

pectoral a piece of jewelry or armor worn on the chest.

fibula a large, decorative brooch for fastening clothing.

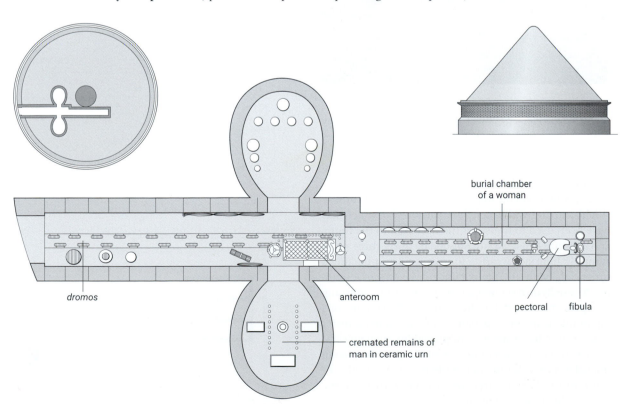

burial chamber
of a woman

dromos

anteroom

pectoral fibula

cremated remains of
man in ceramic urn

17.6 **Floor plan** (TOP LEFT), **elevation** (TOP RIGHT) and **enlarged plan of *dromos*** (CENTER), Regolini-Galassi tomb, Cerveteri, Italy, c. 650 BCE.

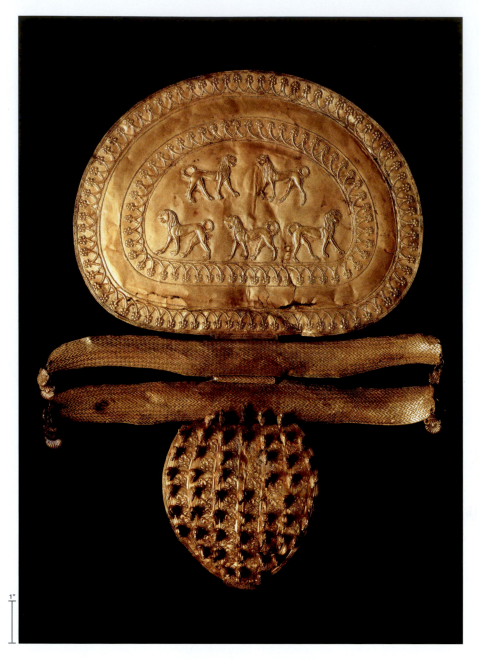

Etruscan Art of the Archaic Period, *c.* 575–480 BCE

During the Archaic period, Greek influence was increasingly visible in Etruscan art and architecture, though nonetheless it has its distinctions, and temples of the period would ultimately influence Roman temple style (see box: Making It Real: Etruria, Rome, and the Roman Arch, p. 296).

The Etruscans worshiped in open-air sanctuaries until around 600 BCE, when they began constructing temples, probably as a result of their interaction with the Greeks. Unlike the Greeks, who by that time were building their temples of stone, the Etruscans mostly used ephemeral materials, including mudbrick walls and wooden columns and **entablatures**. As a result, little survives beyond the stone foundations (which reveal the ground plan), roof tiles, and impressive terra-cotta sculptural decoration. A fairly detailed description of Etruscan temples was left by the Roman architect Vitruvius in his treatise on architecture, though it was written much later, in the first century BCE, approximately two hundred years after the Romans conquered the Etruscans. Modern reconstructions of Etruscan temples are based on archaeological evidence and Vitruvius' writings, as well as surviving ceramic **votive** models and depictions on vases and in tombs.

TEMPLE OF MNERVA OF VEII As their interactions with the Greeks intensified, the Etruscans incorporated Greek gods into their pantheon of deities, and they also borrowed elements of the form of Greek temples. Although the design of Etruscan temples varied, certain

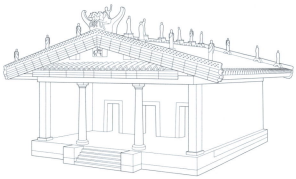

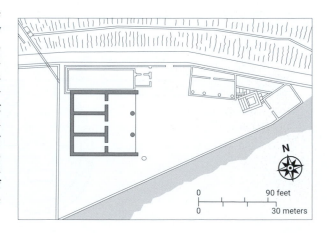

17.7 ABOVE **Fibula from the Regolini-Galassi Tomb,** Cerveteri, Italy, *c.* 680–660 BCE. Gold, height 12½ in. (31.8 cm). Museo Gregoriano Etrusco, Vatican City.

repoussé a relief design created by hammering metal from the reverse side (not the side to be viewed).

17.8a FAR RIGHT, TOP **Temple of Mnerva, Reconstruction drawing.** Sanctuary of Portonaccio, Veii, Italy, *c.* 510 BCE. Original temple of wood, mud brick, and terra-cotta.

17.8b FAR RIGHT, BOTTOM **Temple of Mnerva, Plan drawing.**

using **repoussé**. The lower part features rows of tiny birds in the round alternating with West Asian inspired relief figures, such as winged lions and sphinxes. All are decorated with the fine metalworking technique of **granulation**, showing the artist's skill.

The contents of the tomb's anteroom included bronze shields, an incense burner, three carts, one of which may have been used to transport the deceased to the tomb, and a bronze bedstead surrounded by thirty-three small standing figurines wearing long dresses and making a variety of gestures that might indicate wailing or mourning. These figurines may eternalize the ritual mourning that perhaps occurred in the vestibule of the home of a high-ranking deceased person, before his or her transfer to the tomb. Items made of imported luxury materials, such as ivory, and silver-gilt bowls of Cypro-Phoenician manufacture, offer further evidence of the wealth of this tomb and demonstrate the reach of Etruscan trade beyond the Italian peninsula.

characteristics stand out, as we can see in the temple dedicated to the goddess Mnerva (Greek Athena/Roman Minerva), constructed around 510 BCE in the sanctuary of Portonaccio at Veii (**Figs. 17.8a** and **b**). Veii was a fortified Etruscan city just 4½ miles (7.2 km) northwest of Rome on the Tiber River.

Etruscan temples, which used the **post-and-lintel** construction common in Greek architectural design, were rectangular, though, as at Veii, they were much closer to square than Greek temples were. (Vitruvius cited a 5:6 ratio for front to sides.) Each temple was raised on a podium, with a clear **facade** incorporating a staircase and columns only on the front. Greek temples, in contrast, had steps and columns on all four sides (for example, the Parthenon, Fig. 14.3). The staircase led to a deep front porch, or *pronaos*, supported by widely spaced columns. This spacing was made possible due to the temple's lighter wood construction. Tuscan columns, as they came to be called, are a variant of **Doric** columns, but they rest on a base and are unfluted. Beyond the porch was the *cella*, which was sometimes divided into three sections, as appears to be the case in the Temple of Mnrva at Veii. Each part was dedicated to a specific deity, such as Tinia (Greek Zeus/Roman Jupiter), Uni (Greek Hera/Roman Juno), and Mnerva. The temple faced a paved, triangular piazza with an altar and a *bothros*, a sacred pit for offerings to a god. Next to the temple was a large, rectangular pool, which probably had a ritual function.

STATUE OF APULU Similarly to Greek and Roman temples, Etruscan temples were highly decorated with painted architectural sculpture. Etruscan artists excelled in the art of modeling and firing large-scale clay sculptures, partly because of the lack of stone suitable for sculpture in Etruria. In addition to decorative **antefixes** and **revetments**, life-sized *akroteria* sculptures identified as gods, goddesses, and heroes were located on the roof of the Temple of Mnerva at Veii, along the ridge. These dynamic figures were made of terra-cotta and brightly painted. Perhaps the best-known surviving example is a statue of Apulu (Greek Apollo), which formed part of a group acting out a scene from Greek mythology, the third labor of Herakles.

Depicted is a battle between Apulu and Hercle (Greek Herakles/Roman Hercules) (**Fig. 17.9**) after Hercle stole a sacred deer with golden horns from Apulu's sister Artumes (Greek Artemis). It may have been created by the celebrated sculptor known as Vulca. Apulu (at right)

granulation a decorative technique in which beads of precious metal are fused onto a metal surface.

entablature a horizontal lintel on a building that consists of different bands of molding; might include an architrave, frieze, or cornice.

votive an image or object created as a devotional offering to a deity.

post-and-lintel a form of construction in which two upright posts support a horizontal beam (lintel).

facade any exterior vertical face of a building, usually the front.

pronaos the porch or vestibule at the front of a temple.

Doric a Greek (and later Roman) architectural order characterized by a column with a spare, circular capital, and a frieze of triglyphs and sculpted metopes.

cella (also called *naos*) the inner chamber of a temple; usually houses a statue of a deity.

antefix a vertical ornament at the eaves of a tiled roof.

revetment a protective and/ or decorative facing on a building's exterior.

akroteria sculptures that adorn the roof of a temple.

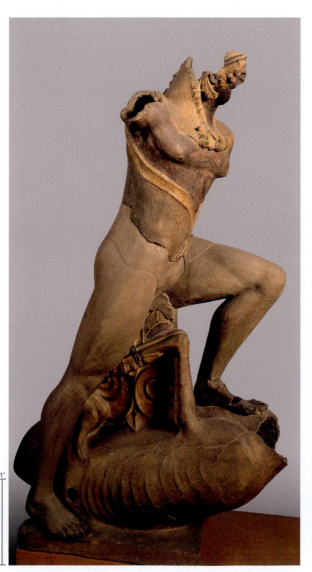

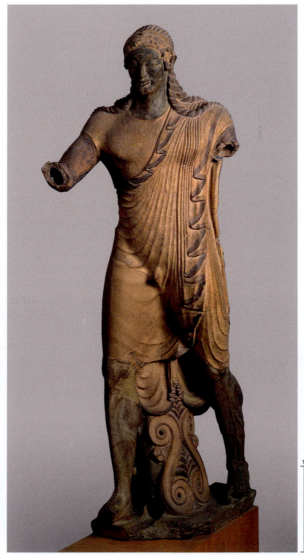

17.9 Vulca (?), Hercle (LEFT) **and Apulu** (RIGHT), from the roof of the Temple of Mnerva, Veii, Italy, *c.* 510 BCE. Painted terra-cotta, height 5 ft. 11 in. (1.8 cm). Museo Nazionale Etrusco di Villa Giulia, Rome.

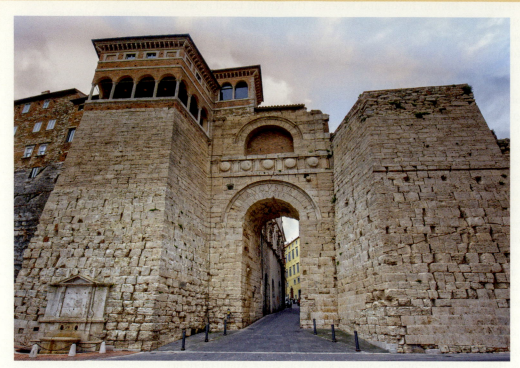

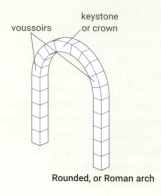

17.10 LEFT **Porta Augusta,** Perugia, Italy, 3rd–2nd century BCE.

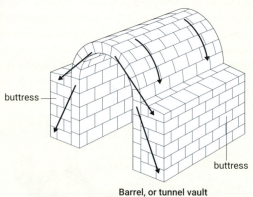

keystone or crown

voussoirs

Rounded, or Roman arch

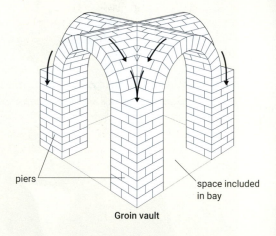

buttress

buttress

Barrel, or tunnel vault

piers

space included in bay

Groin vault

17.11 FROM TOP: **an arch showing keystone and voussoirs; a barrel vault with buttresses; and a groin vault with buttresses.**

Once seen as derivative of Greek art, Etruscan art and culture are now clearly recognized for their own qualities and for their influence on ancient Rome. These connections are not surprising, because a dynasty of Etruscan kings known as the Tarquins ruled Rome from 616 BCE until 509 BCE, when Tarquinius Superbus ("the Arrogant") was expelled. Before his expulsion, he was responsible for the construction of the most important temple in Rome, the Capitolium. Located on the Capitoline Hill, the political and religious center of ancient Rome, it was dedicated to the Roman gods Jupiter, Juno, and Minerva. For its construction and adornment, Tarquinius Superbus called on Etruscan architects and sculptors, including the well-known Vulca of Veii.

Perhaps the most influential architectural contributions the Etruscans made to Rome are the rounded arch (sometimes called a Roman arch) and the barrel or tunnel vault. Prominent examples can be seen in the Etruscan gates built into the later fortification walls of Perugia, including the Porta Augusta (**Fig. 17.10**) in the region known today as Umbria. Vaults, like the Porta Augusta, are built with a series of stone voussoirs held firmly in place by a keystone in the center (**Fig. 17.11**). Although earlier arches existed in neighboring Greece, the dominant architectural form there was post-and-lintel construction. While major architectural monuments, such as the Parthenon in Athens (see Fig. 14.4), have relied on post-and-lintel, the arch opened up the possibility of spanning greater spaces. The Romans later maximized this possibility, eventually far surpassing what could be accomplished in stone by inventing a form of concrete. A simple rounded arch can also be expanded to create a barrel, or tunnel, vault to cover a larger space. Given the downward and outward pressure created by the weight of the vault, barrel vaults are buttressed from the outer part of the walls to avoid collapse.

Architects soon learned that by crossing two barrel vaults at right angles to form a groin vault, they could open up the space even further and provide more versatility in terms of aesthetics and the movement of people in or through the space (see Colosseum, Fig. 20.3). The arch also paved the way for domed structures in ancient Rome, because a dome is simply an arch duplicated around a 180-degree axis.

is depicted wearing a **chiton** and mantle (cloak) that fall in patterns of sharp folds around his active body. An extra support embellished with scroll patterns fits between his legs. His long, rope-like hair frames his head and neck and falls down his back and shoulders, and his one partly preserved arm is raised as he moves forward, perhaps aiming his bow and arrow. The highly defined features of his face—including almond-shaped eyes, distinct eyebrows, and mouth upturned at the corners (imitating the Archaic smile)—are reminiscent of Archaic Greek sculptures (see, for example, Fig. 13.9). However, this sculpture does not replicate Greek examples exactly: the movement, gestures, and ornamental detail of the drapery and musculature of Apulu are very different from

chiton a form of Greek tunic.

those of Anavysos *Kouros* (see Fig. 13.11); also Apulu is clothed, not naked, and made of terra-cotta, not marble. Although less well-preserved, the sculpture of Hercle is also shown in active motion, dominating the deer below his foot and engaging Apulu in battle.

TOMB OF THE SHIELDS AND CHAIRS Just as Etruscan cemeteries can be seen as cities of the dead, laid out along streets, the tombs themselves have been interpreted as houses for the deceased. The Tomb of the Shields and Chairs, a complex of chambers within a tumulus at Cerveteri, dates to approximately 550–500 BCE in the Archaic period. It is named for the carved shields on its walls and the chairs in the main room (**Fig. 17.12**). The narrow entryway of the tomb is flanked by two burial chambers (**Fig. 17.13**). Beyond the entry corridor is a larger room with funeral beds carved into the stone along three of the walls, and chairs along the fourth. At the back of this room are three additional burial chambers.

The idea that this tomb is modeled on the houses of the living is supported by the representation of architectural elements, such as lintels and cross beams. These decorative features are carved out of the tuff and serve no structural function, but suggest that a house of the living, including its necessary structural elements, is being imitated. There are also some similarities between the layout of Etruscan tombs, including the Tomb of the Shields and Chairs, and later Roman houses (see Chapter 18).

17.13 Tomb of the Shields and Chairs (plan drawing), Cerveteri, Italy. c. 550–500 BCE.

SARCOPHAGUS OF THE SPOUSES The so-called Sarcophagus of the Spouses (*c.* 520 BCE), found in the Banditaccia necropolis in Cerveteri (**Fig. 17.14**, p. 298), reflects an interesting aspect of Etruscan society: women's relative privilege compared to the women of Greece and Rome. The Greek philosopher Aristotle, and the Roman historian Livy, commented on the perceived

independence and status of Etruscan women, and not in a positive way. Other textual and artistic evidence confirms Aristotle's and Livy's observations. Women could own property independently of their spouses, they were permitted to attend sporting events, and they retained their own names, which were often listed along with the father's in inscriptions commemorating their children.

Made of terra-cotta, the surface of the **sarcophagus** was probably burnished (rubbed to achieve a glossy sheen). In order to fit the work in the kiln, it was cut in half and then fired in pieces. Its size and quality point to the wealth and high status of the couple represented. Though it is sizable enough for the burial of two persons, it may have served as a cremation urn, because cremation was also practiced at this time. It shows a woman reclining with her husband on a bed, presumably at a banquet. This dining tradition was common in Etruria. In contrast, most Greek women did not attend banquets, which were reserved for men, boys, slaves, and courtesans. In the Greek art of the period, generally only men are shown reclining together.

Both figures on the sarcophagus are highly animated, in complete contrast to the figures represented in Archaic Greek sculpture. Also distinct is the lack of interest in the Etruscan figures' hips and legs, which appear rather flat compared to the upper parts of their bodies. However, the couple's faces have some commonalities with Archaic Greek figures', including the almond-shaped eyes and Archaic smile.

The close position of the couple and the intimate gesture of the husband's right arm over his wife's shoulder convey affection and the bond of marriage. His right hand may have held a drinking vessel or an egg, a symbol of fertility and rebirth. His left arm is supported by a pillow, and his left hand is held open before his wife. The wife may be pouring scented oil or perfume from a small container called an alabastron; the practice is depicted on a small cremation urn showing a reclining couple, found in another tomb. Anointing the deceased was an important part of funerary ritual in Etruria. As in other sculptures, in her left hand the wife may have held a pomegranate, a symbol of immortality.

TOMB OF HUNTING AND FISHING Banquet scenes with women and men reclining, feasting, and dancing are common in surviving Etruscan wall paintings. Highly typical are the **frescoes** on the walls of the rock-cut chamber tombs of high-status figures at the site of Tarquinia (ancient Tarchna or Tarquinii). A fine example from around 530–520 BCE can be seen in the Tomb of Hunting and Fishing. Here, in the **pediment** of the second of two chambers, a man and a woman recline together either outdoors, as suggested by the plants, or perhaps under a tent, as suggested by the garlands and a roof that looks like a tapestry (**Fig. 17.15**). A musician and other attendants, one of whom makes garlands while another fetches wine from a *krater*, also appear in the scene. All the figures are shown in profile and outlined. Below the

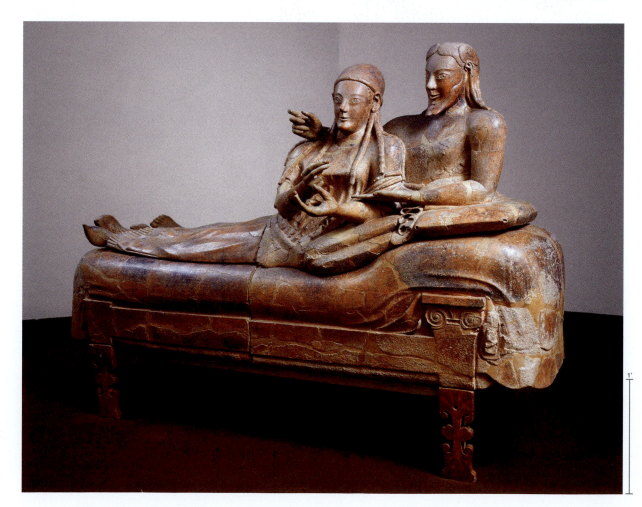

17.14 Sarcophagus of the Spouses, from the Banditaccia necropolis, Cerveteri, Italy, *c.* 520 BCE. Terra-cotta, 45½ in. × 6 ft. 7 in. (1.16 × 2.01 m) long. Museo Nazionale Etrusco di Villa Giulia, Rome.

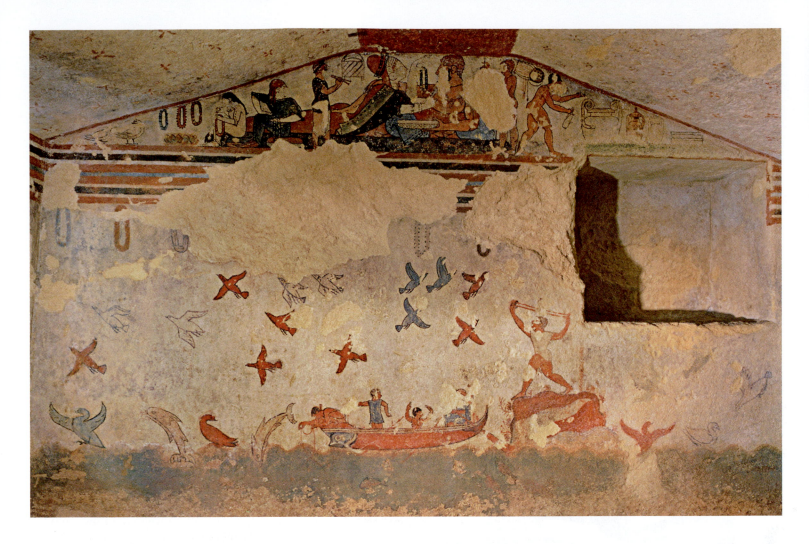

17.15 Tomb of Hunting and Fishing, *c.* 530–520 BCE. Fresco. Tarquinia, Italy.

pediment are horizontal lines of color with garlands hanging from the bottom line, and a scene of boys or men fishing from a boat as dolphins play nearby and brightly colored birds fly across the sky. Another male is depicted standing on a rock, hunting the birds with a slingshot. On one of the side walls is a seemingly playful scene of boys, one ascending a rocky hilltop as another ahead of him dives into the water below. This scene takes place in front of an oared boat containing three more figures.

Interpretations of these scenes vary. Some see them as representing the playful, carefree activities that the deceased enjoyed during life, while others view them as representing funerary rituals or games. Perhaps the dive into water mirrors the plunge of the deceased from this life to the next. Still others have suggested that such scenes may have been required to make provision for the afterlife, as in Egyptian tomb paintings. Such interpretations are not mutually exclusive, as the paintings may refer to the life, funerary ritual, and potential afterlife of the deceased.

Etruscan Art of the Classical Period, *c.* 480–300 BCE

In 474 BCE, the Etruscan fleet was defeated off Cumae by the Greeks, ending the Etruscans' dominance of sea trade and beginning their long decline in power. The formerly isolated Roman Republic (established 509 BCE, after the last Etruscan king was expelled from Rome) began its expansion during this period, and the Etruscans were its first conquest. Much like the Greek *poleis* (city-states), the Etruscan cities never came together as a nation, but rather were loosely united by language and culture. It is this lack of political unity that may have made them vulnerable to Roman conquest.

Veii was the first Etruscan city to fall to Rome in 396 BCE—after a ten-year siege—and others followed. The conquest of Etruria was completed in the third century BCE. Nonetheless, despite invasion and conflict, the Etruscans continued to produce artworks of the highest quality during the Classical period, even influencing Rome.

CAPITOLINE WOLF One artwork traditionally seen as having been created for the new Roman Republic by Etruscan artists, who had by then mastered metalworking techniques, including large-scale hollow bronze casting using the **lost-wax** technique (see box: Making It Real: Lost-Wax Casting Techniques for Copper Alloys, p. 62), is the so-called Capitoline Wolf (**Fig. 17.16**, p. 300). The artist shows a clear interest in capturing the anatomy of the she-wolf naturalistically, as seen in the rib cage, muscles, and veins underneath the skin. More stylized is the texture of the fur, rendered in a repetitively patterned design, that covers only part of the body: the head, neck, and tail.

lost-wax casting a method of creating metal sculpture in which a clay mold surrounds a wax model and is then fired. When the wax melts away, molten metal is poured in to fill the space.

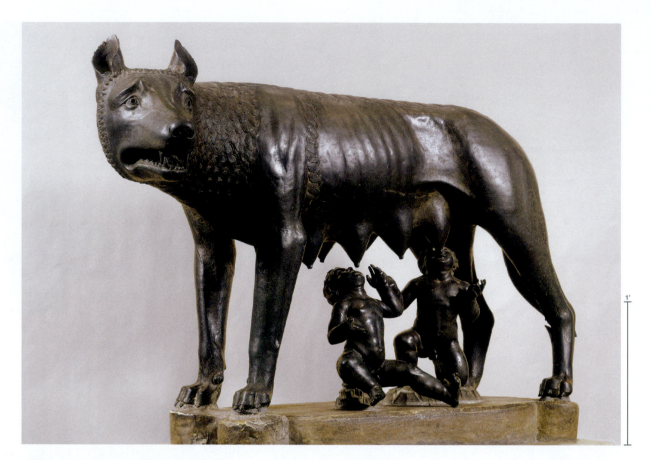

17.16 Capitoline Wolf, *c.* 500–480 BCE or medieval period. Suckling figures added in the Renaissance. Bronze, height 31½ in. (80 cm). Musei Capitolini, Rome.

17.17 BELOW **Chimera of Arezzo,** *c.* 400 BCE. Bronze, length 51 in. (1.3 m). Museo Archeologico Nazionale, Florence, Italy.

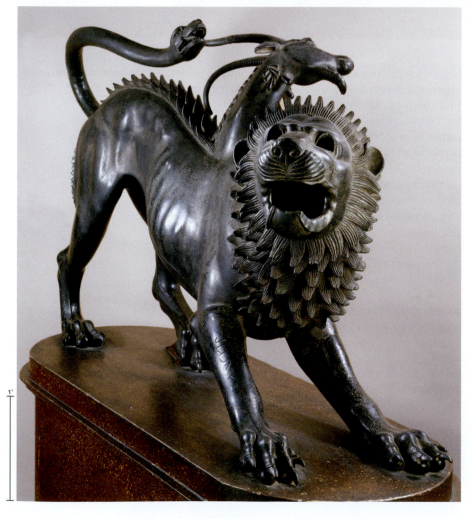

The sculpture is often associated with the tale of the she-wolf that suckled the legendary founders of Rome, Romulus and Remus, after they were thrown into the Tiber River as babies and left for dead. This she-wolf, with full teats, stands on firmly planted legs with stiff ears and half-open mouth, ready to protect her young. Her head is turned to confront those who approach. Her mouth is open, baring sharp teeth to scare off potential attackers. The suckling infants were added in the Renaissance, when the sculpture was transferred to the Capitoline Hill, the site of ancient Roman government, thus connecting the sculpture to ancient Roman history. They have been attributed to the sculptor Antonio Pollaiuolo.

After a study and restoration of the sculpture that began in 1997, some now suggest that the statue may be medieval rather than ancient. This assertion is based primarily on the way in which the hollow bronze-casting technique was carried out. In ancient Etruria and later in Rome, large bronze sculptures were cast in pieces and then soldered together and polished. In contrast, the Capitoline Wolf was cast as a single piece of hollow bronze, a technique more common to the Middle Ages. The debate continues, and Rome's Capitoline Museums, where the she-wolf resides, mention both possible dates for the work, ancient and medieval.

CHIMERA OF AREZZO The most securely dated bronze sculpture known as the Chimera of Arezzo (**Fig. 17.17**), created around 400 BCE, displays the Etruscans' superb metalworking skills. It also reflects their interest in Greek myths. The myth of Bellerophon slaying the chimera—a fire-breathing composite creature, part lion, part goat,

and part serpent—first appeared in the epic Greek poetry of Homer and Hesiod in the 700s BCE. For centuries and across cultures, this myth represented the victory of culture over nature, human over beast.

The bronze sculpture was created using lost-wax casting. It was a votive offering, and is inscribed with the word *tinscvil* (Etruscan for "gift to Tin") on one foreleg. This indicates that the sculpture was a votive offering to Tin or Tinia, god of the sky and the most important god of the Etruscan pantheon, similar to Zeus and Jupiter (of Greece and Rome, respectively). The chimera is shown in an active, twisting pose, leaning back on its hind legs. Despite wounds on the lion's left side (not shown here) and on the neck of the goat, the head of which protrudes from the creature's back, the chimera still appears ferocious. Its mouth roars, presumably with fire bursting forth, and it seems ready to fight to the death. The body is modeled naturalistically, with impressive anatomical details, such as its protruding rib cage and flowing veins covered by a thin layer of skin. The artist combined this naturalism with an interest in pattern and texture, as seen in the stylized mane with its prickly spikes of hair encircling the lion's head and the saw-like ridge of hair down its back. The serpent tail is a later addition, as most of the original tail was missing when the statue was discovered.

The chimera may have been part of a statue group, but it is impossible to know for sure based on present evidence. It was discovered in 1553 along with a group of small votive bronzes by workers who were building fortifications in Arezzo, which suggests that all of the bronzes may have been dedicated to the god Tinia. Cosimo I de' Medici, the Grand Duke of Tuscany, who fostered the notion that he descended from Etruscan royalty, took the sculptures to the Palazzo Vecchio, the seat of government in Florence. It now resides in the National Archaeological Museum of Florence.

BRONZE MIRROR WITH ENGRAVING OF KALKAS Given Etruscan artists' bronze-working and carving abilities, it may come as no surprise that they created many skillfully engraved bronze mirrors with elaborate figural designs, often depicting mythological scenes. Many mirrors survive because they were placed in tombs. One such mirror from around 400 BCE, found in Vulci, depicts the ritual practice of divination, specifically the reading of livers by a seer called a haruspex (**Fig. 17.18**). Engraved on the non-reflective side of the mirror is a winged male figure labeled Kalkas (the Homeric diviner who went with the Greek army to Troy). He is shown with his left foot raised on a rock and his left arm supported by his knee, examining an animal liver in his left hand. Other entrails sit in front of him on the table. Incised with a sharp tool, the illustration features spare but expressive lines. Later, under the Romans, the role of prophesying with entrails remained the preserve of Etruscan haruspices.

Etruscan Art under Rome

Rome completed its conquest of Etruria in 264 BCE. Yet, not surprisingly given their artistic talents, the Etruscans continued to play a vital role in Roman art, as well as in political and religious life, all while negotiating their new identity under Rome.

L'ARRINGATORE We see the integration of Etruscan and Roman life in many works of Etruscan art, including the bronze sculpture of an official now called *L'Arringatore* (the Orator), from the early first century BCE (**Fig. 17.19**, p. 302). This life-size, hollow-cast bronze sculpture of an official named Aule Metele was found in 1566 in the area of Lake Trasimeno, not far from Perugia. As with the Chimera of Arezzo and the Capitoline Wolf, it was created using the lost-wax casting technique.

Aule Metele is shown with his right hand raised, powerfully addressing an audience, taking in the crowd with his gaze (though his inlaid eyes are now lost), and with his mouth slightly open. We assume he thought of himself as Etruscan because his name is recorded in an Etruscan inscription on the hem of his toga, which also gives the name of his mother and father, and states that this work was a votive offering dedicated by Aule Metele himself. Yet this Etruscan man wears the toga and high-laced boots of a Roman elected official. His face is depicted with the realism, or **verism**, favored in portraiture of the Roman Republican period; there are wrinkles on his

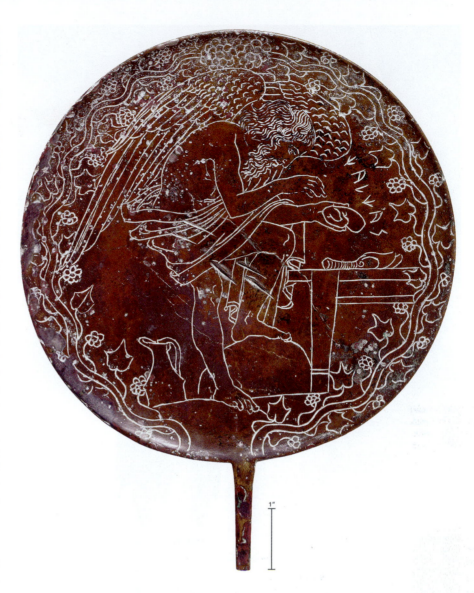

17.18 Mirror with engraving of Kalkas the haruspex examining a liver, Vulci, Italy, *c.* 400 BCE. Bronze, diameter 7 in. (17.8 cm). Musei Vaticani, Rome.

verism preferring realism, especially in portraiture, to the heroic or ideal; comes from the Latin *verus*, meaning "true."

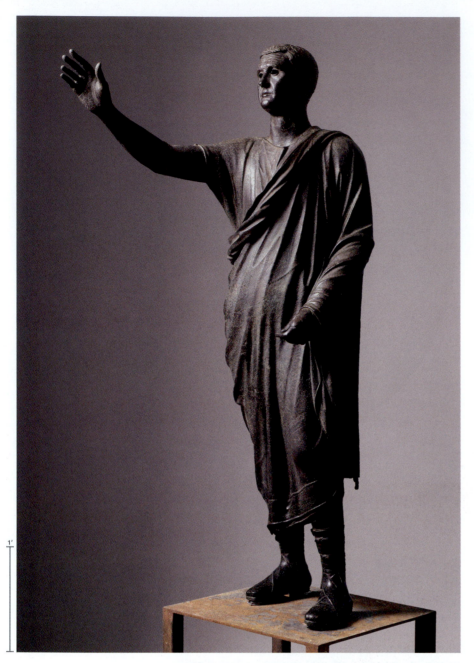

17.19 *L'Arringatore* (the **Orator),** recovered from the area of Lake Trasimeno, Italy, early first century BCE. Bronze, height 5 ft. 7 in. (1.7 m). Museo Archaeologico Nazionale, Florence, Italy.

forehead and neck, and his portrait features are identifiable (see Chapter 18). His body is depicted in a naturalistic *contrapposto* stance.

The sculpture of Aule Metele represents the need for the Etruscans, and others under the control of Rome, to continuously negotiate their multifaceted identities in the face of Roman sociopolitical dominance. At around the time that Aule Metele dedicated his sculpture, the third Social War in Italy was being fought, in which some of Rome's allies on the Italian peninsula revolted against Rome because it would not grant them Roman citizenship and the rights that came along with it. Although Rome was victorious, at the end of the war Roman citizenship was indeed granted to all inhabitants of Italy.

Discussion Questions

1. What are the key debates about the origins and identity of the Etruscans? What meaningful information, if any, comes from debating origins in terms of our knowledge of Etruscan art, culture, and society?

2. How did the Etruscans use art and architecture to construct identity, including social status and gender?

3. The Etruscans were constantly in contact with other cultures through trade, diplomacy, and war. Identify, describe, and discuss two works of art from this chapter that show evidence for cultural exchange between the Etruscans and their Greek, Roman, or West Asian neighbors.

Further Reading

- Haynes, Sybille. *Etruscan Civilization: A Cultural History*, Los Angeles, CA: J. Paul Getty Museum, 2000.
- Spivey, Nigel. *Etruscan Art*, London and New York: Thames & Hudson, 1997.
- Turfa, Jean M. (ed.). *The Etruscan World*, London: Routledge, 2013.
- Wade, Nicholas. "Origins of the Etruscans: Was Herodotus Right?" *New York Times* (April 3, 2007), http://www.nytimes.com/2007/04/03/health/03iht-snetrus.1.5127788.html

contrapposto from the Italian for "counterpoise," a posture of the human body that shifts most weight onto one leg, suggesting ease and potential for movement.

Chronology

c. 1200–900 BCE	The Proto-Villanovan culture develops	*c.* 510 BCE	The Temple of Mnerva is constructed at Portonaccio, Veii
c. 900–720 BCE	The Villanovan culture develops	509 BCE	The last Etruscan king, Tarquinius Superbus, is expelled from Rome; the beginning of the Roman republic
c. 720–575 BCE	The Protoarchaic period of Etruscan culture		
c. 700 BCE	Etruscans become identifiable by their unique language	*c.* 480–300 BCE	The Classical period of Etruscan culture
616 BCE	Tarquinius Priscus, an Etruscan-born general working for the Romans, is proclaimed king of Rome	474 BCE	The Etruscan defeat by the Greeks leads to the decline of Etruscan power and the domination of sea trade
		400 BCE	The Chimera of Arezzo is created
c. 575–480 BCE	The Archaic period of Etruscan culture	396 BCE	Veii falls to Rome after a ten-year siege
c. 550–500 BCE	The Tomb of the Shields and Chairs is constructed	273 BCE	Cerveteri falls to Rome

18

Art of the Roman Republic

509–27 BCE

Second Style mural painting (detail), Villa of the Mysteries, Pompeii, Italy.

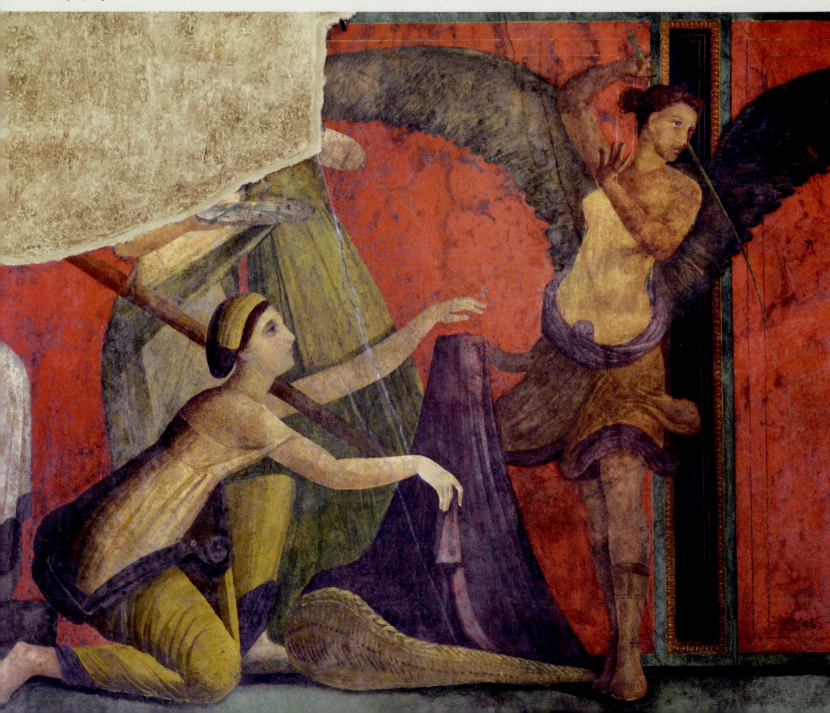

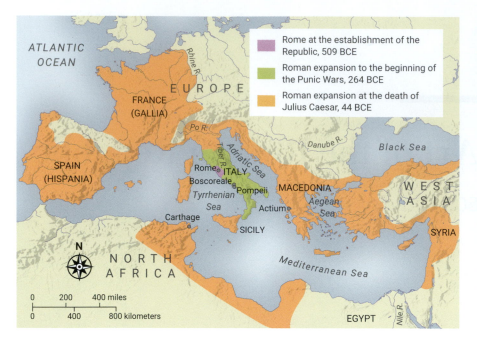

ATLANTIC
OCEAN

EUROPE

FRANCE
(GALLIA)

SPAIN
(HISPANIA)

Rhine R.

Po R.

Danube R.

Black Sea

Tiber R.

Rome ITALY

Boscoreale

Tyrrhenian
Sea

Pompeii

Carthage

SICILY

Actium

MACEDONIA

Aegean
Sea

WEST
ASIA

SYRIA

N

NORTH
AFRICA

Mediterranean Sea

EGYPT

Nile R.

▇	Rome at the establishment of the Republic, 509 BCE
▇	Roman expansion to the beginning of the Punic Wars, 264 BCE
▇	Roman expansion at the death of Julius Caesar, 44 BCE

0 200 400 miles
0 400 800 kilometers

Map 18.1 Expansion of Rome, *c.* 500–44 BCE.

porch a covered area usually connected to the front of a building.

temple precinct the enclosed area in which a temple is located.

cella (also called *naos*) the inner chamber of a temple; usually houses a statue of a deity.

colonnade a long series of columns placed at regular intervals that supports a roof or other structure.

podium a raised platform that serves as a base.

facade any exterior vertical face of a building, usually the front.

peripteral having a single row of columns surrounding a building, such as in a Greek temple.

engaged column a column attached to, or seemingly partially-buried in, a wall.

frieze in architecture, the part of an entablature located above the architrave.

Introduction

Rome began as a small Latin-speaking farming community on the Palatine Hill, ultimately growing to occupy a group of seven hills overlooking the Tiber River. The site was easily defendable, with a good supply of fresh water. In addition, the Tiber was navigable to the Tyrrhenian Sea, allowing for maritime trade (Map 18.1). Early Rome was ruled by a series of kings, including several from a family with Etruscan origins. The last king, Tarquinius Superbus ("the Arrogant"), was a tyrant, and after a revolt in 509 BCE he was expelled, allowing the Roman upper class, or patricians, to form a new constitutional government they called the Republic. The major legislative body was the senate, a council of elders originally drawn from the Roman patrician families. Two consuls were elected annually by the senate. They held the main military and judicial powers of the government. These positions could be superseded only by dictators in times of emergency. People of the lower class, known as plebeians, gradually gained some rights within Rome's rigid social hierarchy.

From its humble beginnings as an agrarian village, Rome managed to expand its control rapidly during the Republic, first over the Etruscans, Greeks, and others on the Italian peninsula, then, by the end of the Republic, to Sicily, Greece, parts of North Africa, most of Spain (Hispania), France (Gallia), West Asia, and beyond. Though it has been argued that Rome's native art was government, it is no surprise that this period of rapid political development and military conquest also saw great advances in art and architecture. The religious, cultural, and political needs of an increasingly powerful Rome cannot be underestimated in discussions of its artistic development. Much Roman art served to elucidate and glorify not only Rome's history and political power, but also its leaders. Conquests also brought the city into contact with many other artistic traditions that were eagerly appropriated, creating what most would agree is an eclectic and yet distinctly recognizable Roman style.

Roman Religion and the Eclecticism of the Roman Temple

The Romans absorbed into their official religion the gods and religious practices of the people they conquered, particularly those of the Greeks, substituting Latin for Greek names for deities. Patricians, the members of the Roman upper class, exerted substantial control over the state's religion, which permeated all aspects of Roman life. They appointed augurs (official diviners or seers), priests, and vestal virgins (priestesses of Vesta, the Roman goddess of the hearth, home, and family). The most important authority in the religious hierarchy was the chief priest, or *pontifex maximus*. The Roman senate played a key role in decisions regarding religious ceremonies and festivals. Because many priests were also members of the senate, there was no clear distinction between religion and government. Religious omens were consistently observed, and their interpretations influenced state business.

Each Roman city had at least one primary temple and usually other smaller shrines. Religious processions often began or ended at a temple or shrine. Most of the time, only priests were allowed inside the temples. Most public worship or ceremonies took place outside, on the **porch**, or in the **temple precinct**. Ritual objects might be presented, or a sacrifice might take place at an altar in front of the temple. The *cella* (or *naos*) of the temple housed a statue of the god to whom the building was dedicated, as well as often a small altar, perhaps for incense, libations (offerings in liquid form), or other offerings. Usually, the temple had another room or rooms for storage behind the *cella*.

TEMPLE OF PORTUNUS Stylistically, the Romans took from the Etruscans and the Greeks to create a new, eclectic Roman form of temple architecture. We see this eclecticism in the Temple of Portunus, the Roman god of harbors. It is located in Rome on the east bank of the Tiber River, just inside the area of the harbor (Fig. 18.1). The temple stood within a **colonnaded** precinct that housed a market for flowers and garlands. As a result, the area was a vibrant space, much like the piazzas surrounding churches in Italy today. The excavation of datable ceramics underneath the temple suggests it was built around 75 BCE.

The temple, which was converted to a church in the ninth century CE, is exceptionally well preserved. Similarly to the Temple of Mnerva at Veii (see Fig. 17.8) and other Etruscan temples, it is raised on a high **podium** with a frontal staircase leading to its entrance through a deep porch with freestanding columns at the front and sides (Fig. 18.2). In other words, unlike Greek temples, such as the Parthenon (see Fig. 14.3), it has a clear **facade** and is accessible from only one direction. The building has tall, narrow proportions and also incorporated elements of Greek **peripteral** temples, seen here in the non-functional columns **engaged** round the sides and back of the *cella*. The Greek-style Ionic columns rest on a base, and there is also an Ionic **frieze**. (For an explanation of the different architectural orders, see box: Looking More Closely: The Greek Orders, p. 225.)

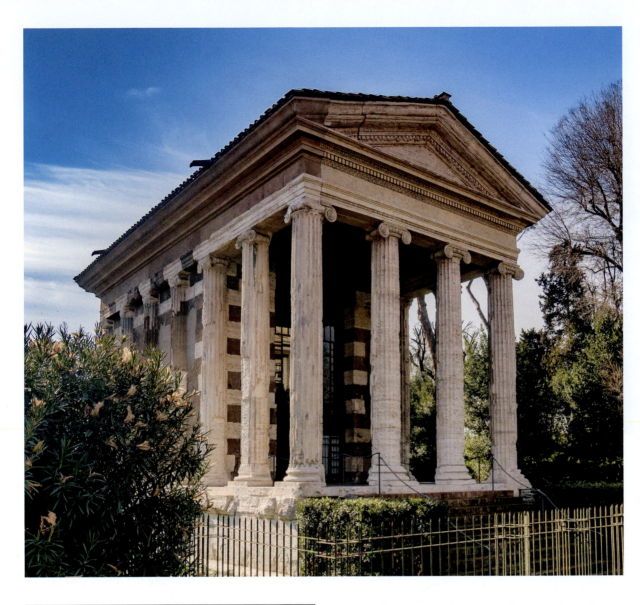

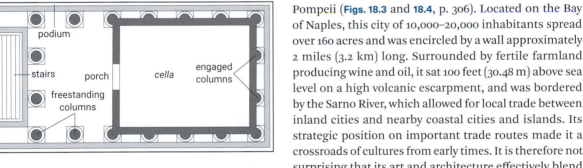

podium

stairs porch *cella* engaged columns

freestanding columns

The Temple of Portunus is made of local stone: travertine for the freestanding columns, and tuff for most of the rest of the building. The entire edifice was covered in **stucco** to give it the appearance of marble, the material the Greeks used for their temples. The building's decorative program was also made of stucco. Although most of the decoration has been lost, a frieze of garlands, with candelabra, cupids, and bulls' skulls supporting them, can be reconstructed on the basis of drawings from the Renaissance.

Pompeii and the Roman City

To learn more about town planning and house architecture during the expansion of the Republic, we turn to Pompeii (**Figs. 18.3** and **18.4**, p. 306). Located on the Bay of Naples, this city of 10,000–20,000 inhabitants spread over 160 acres and was encircled by a wall approximately 2 miles (3.2 km) long. Surrounded by fertile farmland producing wine and oil, it sat 100 feet (30.48 m) above sea level on a high volcanic escarpment, and was bordered by the Sarno River, which allowed for local trade between inland cities and nearby coastal cities and islands. Its strategic position on important trade routes made it a crossroads of cultures from early times. It is therefore not surprising that its art and architecture effectively blend diverse styles to create a distinctively Roman aesthetic.

In 79 CE, a volcanic eruption of Mount Vesuvius buried Pompeii, preserving streets, businesses, houses, and public buildings. (The city was rediscovered and excavations commenced in the mid-eighteenth century.) Pompeii did not begin its life as a Roman city, however. It was founded in the seventh or sixth century BCE by the Oscans, one of several Italic peoples that lived in Italy before Rome's rise to power. Late in the fifth century BCE, another people, the Samnites, who were heavily influenced by the Greeks in Italy, took control of Pompeii and expanded it greatly. It became a Roman colony in 80 BCE, after it sided with other Italian cities in the Social

18.2 FAR LEFT **Temple of Portunus (plan drawing).** Rome, *c.* 75 BCE.

stucco fine plaster that can be easily carved; used to cover walls or decorate a surface.

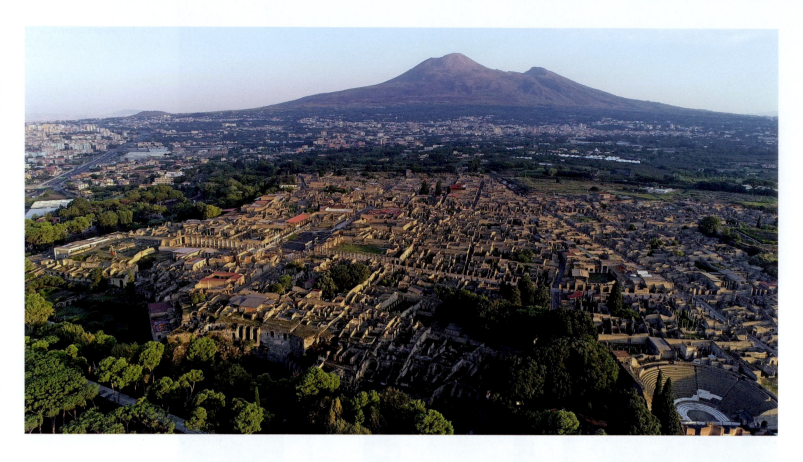

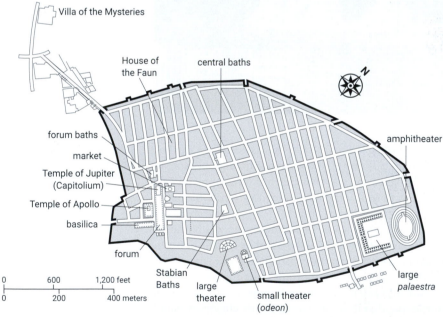

Villa of the Mysteries

House of the Faun

central baths

forum baths

market

Temple of Jupiter (Capitolium)

Temple of Apollo

basilica

forum

amphitheater

Stabian Baths

large theater

small theater (odeon)

large palaestra

| 0 | 600 | 1,200 feet |
| 0 | 200 | 400 meters |

18.3 TOP **Aerial view of Pompeii,** Italy, destroyed by the volcanic eruption of 79 CE.

18.4 ABOVE **Map of central Pompeii just before the eruption.**

forum an open area at the center of a Roman town where people shopped, worshiped, and participated in political or judicial activities.

War against Rome, which Rome won in 88 BCE. Rome, victorious, ultimately granted Roman citizenship to the defeated cities to avoid another war. Even a cursory view of the city's art makes it clear that Pompeii was a microcosm of the far reach and eclecticism of the growing Roman Empire, with influences coming from Greece, Egypt, and even India (see: Seeing Connections: Early Global Networks: The Silk Road, p. 270).

FORUM OF POMPEII The Romans excelled at town planning, including the orderly arrangement of public

buildings around the **forum**. This large open area, which generally included shops, **porticoes**, temples, and **basilicas**, was the center of Roman city life. In the forum, people of all classes shopped, worshiped, and participated in the political or judicial activities of the town. It was generally located where the main north–south street (*cardo*) met the main east–west avenue (*decumanus*). This was the case in Pompeii, where the forum was located at the geographic heart of the city, at least until its later expansion (**Fig. 18.4**).

Until recently, most scholars believed that the forum took on its monumental form, with a two-story colonnade on three sides, in the second century BCE, when the Samnites controlled the city. However, recent archaeological work and study at the forum have led some archaeologists to suggest that this columned portico was added after 80 BCE, when Pompeii became a Roman colony. In the area of the forum are the remains of statue bases, probably for portraits of local public figures and, later, Roman emperors.

TEMPLES OF JUPITER AND APOLLO, POMPEII The presence of two major temples in the immediate vicinity of the forum shows the strong connection between religion and politics in Pompeii, a link that was common in the ancient Roman world. At the north end of the forum is the Temple of Jupiter, the center of religious life in the city. Jupiter, as with Zeus for the ancient Greeks, was considered to be the ruler of the gods and the protector of Rome, and so worship of the deity became popular when the Romans came to Pompeii. It is believed that they converted the temple, probably constructed during Samnite rule, into a **Capitolium**. What remains of the

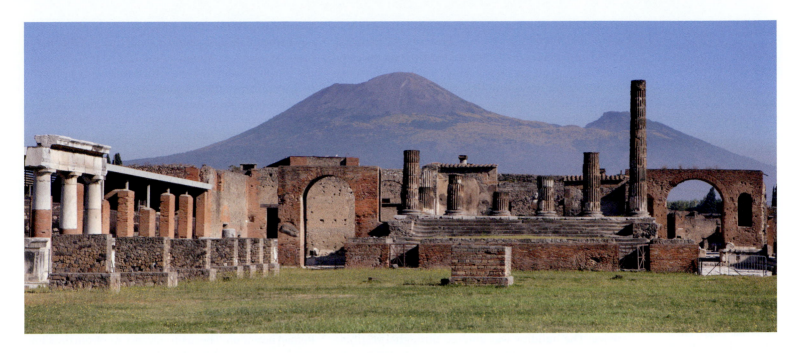

stucco-covered tuff Temple of Jupiter indicates that this Republican-style building sat on a high podium, reached by a staircase at the front, and had a clear facade (**Figs. 18.5** and **18.6**). It included a deep porch with free-standing Corinthian columns and at the front of the structure was an altar. The *cella* included spaces for statues of the deities Jupiter, Juno, and Minerva, and a chamber below was used for storage.

To the left of the forum's colonnade is the Temple of Apollo in its precinct (see **Fig. 18.7**). The temple combines more Greek with Etruscan elements than the Temple of Jupiter. For example, the Temple of Apollo has a freestanding **peristyle**, or colonnade, rather than

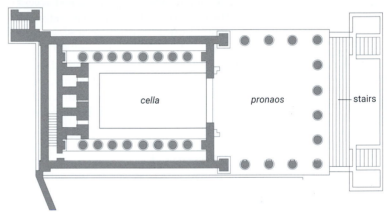

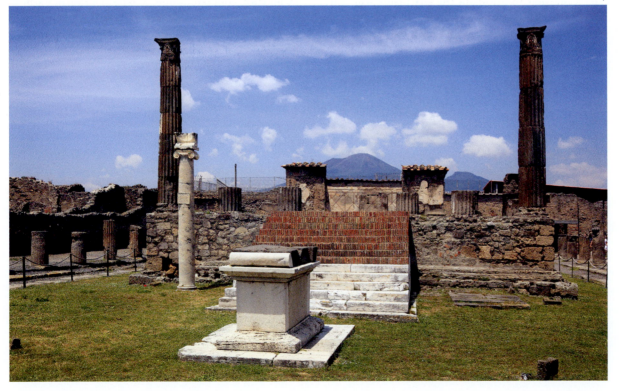

18.5 TOP **Temple of Jupiter with Vesuvius in the background,** Pompeii, Italy, built second century BCE and later.

18.6 ABOVE **Temple of Jupiter (plan drawing),** Pompeii, Italy.

portico a covered space defined by a series of columns placed at regular intervals to support the roof.

basilica a longitudinal building with multiple aisles and an apse, typically located at the east end.

Capitolium an ancient Roman temple dedicated to Jupiter, Juno, and Minerva, who are also known as the Capitoline Triad.

peristyle a line of columns enclosing a space.

18.7 LEFT **Temple of Apollo,** Pompeii, Italy, second century BCE.

freestanding columns only at the front of the temple in the porch. In Etruscan fashion, however, the temple is raised on a podium, and there is a narrow staircase at the front, setting off the facade quite clearly. The columns on the temple are Corinthian, those of the colonnade that surround the temple precinct are Ionic, while the **entablature** supported by the precinct colonnade is Doric, with a frieze of **metopes** and **triglyphs** (see box: Looking More Closely: The Greek Orders, p. 225). The combination of architectural elements again points to the city's eclectic style.

BASILICA, POMPEII In front of the precinct of Apollo are the remains of a basilica (see **Fig. 18.4**). Used as a law court and for administrative purposes, it was an important structure in Pompeii. It is believed that the structure dates to the late second century BCE, though, similar to the colonnade of the forum, some now argue for a later date of around 80 BCE. The basilica is long and narrow, with columns dividing the central **nave** from the side aisles. The building was entered through a vestibule on the east end, by which visitors gained access to the nave. At the west end of the nave is a two-story tribunal, a raised platform from which magistrates adjudicated. In its day, the tribunal had a timber roof. The basilica was a building form that was well suited to any large assembly, and it had a long life in Roman architecture (see Figs. 20.10 and 22.15) and beyond. Later on, early Christians adapted the form of the basilica for their first monumental churches (see Fig. 23.12).

BATHS OF POMPEII

The communal aspect of the forum carried over to Pompeii's public bathing facilities. The city had three sets of large public bathing complexes: the Stabian, Forum, and Central Baths. (These are modern names based on their locations in the city.) Here, the lower and upper classes mingled: the entrance fee was low, giving most people access, and even the wealthiest of Romans used public baths. Because the Romans generally bathed naked or almost naked, many of the marks of social class so common in Roman dress (for example, the purple-bordered toga, which was worn primarily by government officials, such as senators and magistrates) were removed. Roman baths therefore provided an ideal opportunity for social networking for all classes, as people exercised, steamed, oiled, swam, and bathed together. These public complexes could even include libraries and lecture halls. We also see in these complexes early examples of innovative architectural techniques and materials that revolutionize Roman engineering, including the use of concrete for impressive vaults and domes, such as in the Stabian Baths (see box: Making It Real: Roman Concrete, p. 335).

STABIAN BATHS The Stabian Baths (**Fig. 18.8**) are the oldest in Pompeii. The structure dates primarily to the middle of the second century BCE, before the Roman takeover, showing us that bath culture was not a uniquely Roman invention. The main entrance was from the shop-lined street named Via dell'Abbondanza. Visitors went in through a vestibule into a colonnaded courtyard used as a *palaestra* (area for sport or exercise). A secondary entrance from a side street led to somewhat smaller and less elaborately designed bathing rooms for women. Bathers would undress in an **apodyterium**. The men's *apodyterium* (**Fig. 18.9**) had an impressive concrete **barrel vault**; this type of vault, along with **groin vaults**, became important hallmarks of Roman architecture (see box: Making It Real: Etruria, Rome, and the Roman Arch, p. 296). The Stabian's vault was decorated with painted stucco relief. There was a bench around the room and niches for clothing.

After changing, visitors proceeded to the bathing rooms: the *frigidarium* (cold bathing room), covered by an early concrete dome, *tepidarium* (warm bathing room), and *caldarium* (hot bathing room). All were heated by a single wood-burning furnace that was connected

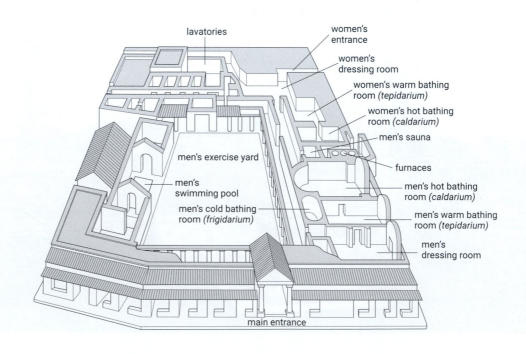

lavatories

women's entrance

women's dressing room

women's warm bathing room (*tepidarium*)

women's hot bathing room (*caldarium*)

men's sauna

men's exercise yard

furnaces

men's swimming pool

men's hot bathing room (*caldarium*)

men's cold bathing room (*frigidarium*)

men's warm bathing room (*tepidarium*)

men's dressing room

main entrance

18.8 Stabian Baths (plan drawing), Pompeii, Italy, mid-second century BCE and later.

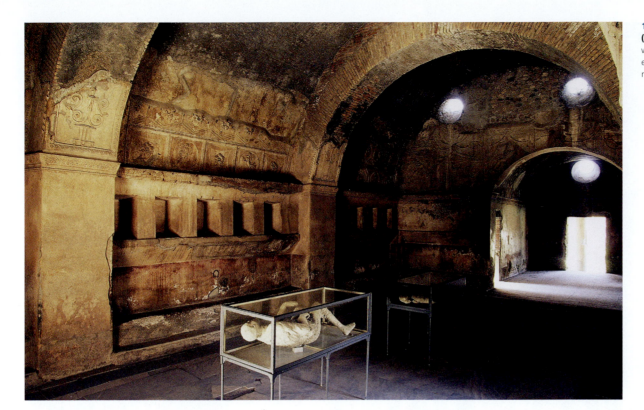

18.9 Men's changing room (*apodyterium*), Stabian Baths, with plaster casts of victims of the eruption of Vesuvius. Pompeii, Italy, mid-second century BCE and later.

to an underfloor heating system. The rooms closest to the furnace were for the hottest baths. Though many scholars suggest that Roman bathing was highly systematic—proceeding from cool to hot, finishing with a dip in a cold pool at the end—far freer movement was quite possible.

THEATERS OF POMPEII

Another type of important public architecture in the Roman Republic was the outdoor theater. In 79 CE, when Vesuvius erupted, Pompeii included two permanent stone theaters and a concrete and stone **amphitheater**. The more substantial of the two theaters dates to the second century BCE and was later enlarged to hold approximately 5,000 people. Both are smaller than the stone theaters in the capital city of Rome, but they were erected much earlier, while Rome was still using temporary wooden theaters, suggesting the importance of spectacle in Pompeii even before it became a part of Rome.

AMPHITHEATER The amphitheater at Pompeii, where gladiators competed against one another, is one of the earliest concrete and stone buildings of this type and held approximately 20,000 spectators (**Fig. 18.10**). The concrete

amphitheater a round or oval open-air theater with seats sloping down toward the central performance area.

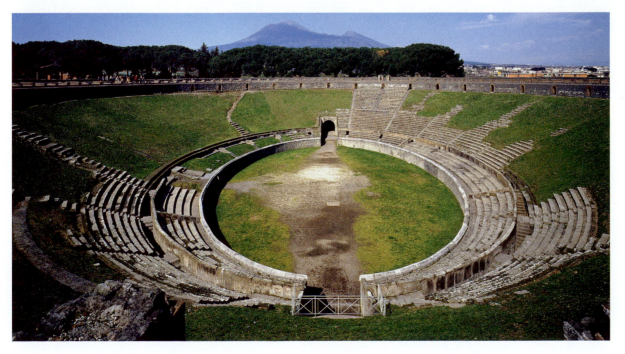

18.10 Amphitheater, Pompeii, Italy, c. 80–70 BCE.

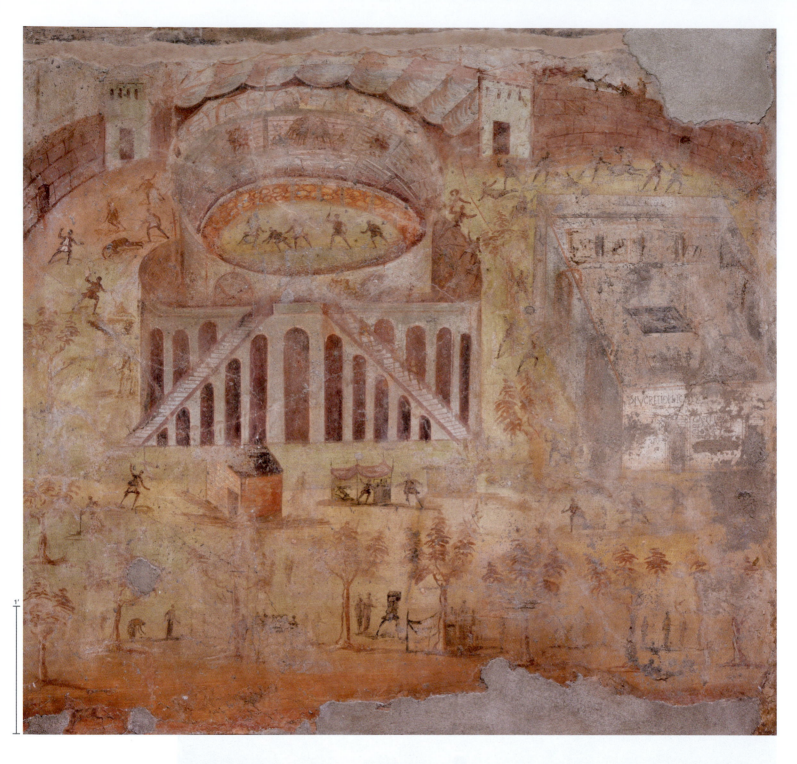

18.11 Brawl in the amphitheater of Pompeii, from House I,3,23, c. 60–79 CE. Fresco, 5 ft. 7 in. × 6 ft. 1 in. (1.7 × 1.85 m). Museo Archeologico Nazionale, Naples, Italy.

exterior of the theatre, which consists of barrel vaults (some of which lead all the way through to the arena) serves as a retaining wall for the sloping earthen mound that supports the stone and wooden seats inside, which slope down toward the arena floor. The seating was clearly differentiated by rank, with the more spacious front rows reserved for the patricians, who entered through one of the lower entrances. An entryway at the top of an external staircase was used by those in general seating. Women and enslaved people were relegated to the uppermost rows. Thus, unlike at the baths, the two social classes did not mingle at the amphitheater, where a large barrier divided one seating area from the other. The original seats, now lost, were mostly made of wood, with the exception of some of stone that were donated by local officials.

A painting found in a house in Pompeii brings the action inside the amphitheater to life (**Fig. 18.11**). It illustrates a brawl that took place in 59 CE between the Pompeiians and visitors from a neighboring town during a gladiatorial contest. The incident was serious enough to close down the amphitheater for ten years. To provide as much detail as possible, the painting depicts the theater from different viewpoints, including an almost bird's-eye view of the interior and a side view of the entrance from the outside. It also gives a rare glimpse of the *velarium*, or awning, which could be opened to protect the spectators from the sun and rain.

The Roman House

Though the upper and lower classes of Pompeii sometimes mingled, as we have seen, their living situations remained very different. Lower- and middle-class citizens often rented spaces in subdivided houses, or they could live in available spaces in or above shops, called *tabernae*. These were practical, affordable homes. In contrast, a wealthy Roman's house, or *domus*, was built not only to function as a home for the family and sometimes its servants, but also to highlight the family's social status. In addition, an upper-class Roman's house played an important role in business, politics, and social mobility, binding a wealthy and powerful patron, or *patronus*, a person seeking to build political support, to one or more clients, someone who benefited from the protection of the patron, for example, financially, or in the law courts. Formerly enslaved people became clients of their former owners. The client was expected to call on the patron each day. The deeper a client was allowed into his patron's home, the more connected and, therefore, successful he was.

Certain features are common to most wealthy Roman houses. The facade was generally understated, as the focus of the house was on internal courtyards, or **atria**, that let in light and air, and kept out noise and dust from the street. The front of the house often consisted of rooms on either side of the main entrance, which sometimes opened into the house but frequently did not, and could therefore be used or rented as shops. From outside the main entrance to the house, one could often see deep into the home, even to the gardens at the back. This sightline appears to have been intentional, so that people walking by on the street might get a glimpse of the depth and wealth of the house.

One entered through a narrow entry hall called the *fauces* (jaws). This led to a central atrium, in the middle of which was an *impluvium*, a sunken area designed to catch rainwater from a space in the roof. The atrium also generally included a *lararium*, or shrine to the guardian spirits of the Roman household, as religion was intimately tied to Roman family life. **Cubicula** were located around the atrium and were often used as bedrooms. Toward the back of the *domus* were larger rooms, including the patron's *tablinum* (home office and archive) and the **triclinium** (dining room). The houses often included a *hortus* (garden) at the rear, where herbs, fruits, and vegetables for the family were grown. This basic system appears to have been influenced by Etruscan houses, or at least what is shown of them in Etruscan tombs or houses of the dead. Peristyle gardens became popular in wealthy Roman houses after the Romans came into contact with Greeks, in whose houses such columned gardens were common. Within this, however, there was still great variety in the ground plans and elaboration of individual dwellings, even within a city.

While the patron/client relationship seems to privilege the man as head of the household (*paterfamilias*), women could play an important role in running the household, especially when men were away fighting or on business, sometimes for years at a time. In some cases, women even owned their own home. The distribution of household artifacts and activities within the home demonstrates that women had access to different parts of the Roman house.

HOUSE OF THE FAUN The largest and perhaps most extravagant home in Pompeii was the House of the Faun (**Fig. 18.12**). Occupying an entire city block of approximately 32,000 square feet (around 3,000 square meters), it was larger than the royal palace of Pergamon (see Fig. 15.14). Its impressive architectural features included two atria, two peristyled courts, and an elaborate decorative program, with **mosaics**, inlaid stone floors, sculptures, and wall

atrium (plural **atria**) a Latin term for an interior courtyard, either open or covered, which is surrounded by the walls or rooms of a building.

cubiculum (plural **cubicula**) a small room in a Roman house that could be used for different purposes, including bedrooms.

triclinium a formal dining room in a Roman house or other building; the word comes from Greek *tri*, "three," and *klinon*, a sort of couch or seat for reclining.

mosaic a picture or pattern made from the arrangement of small colored pieces of hard material, such as stone, tile, or glass.

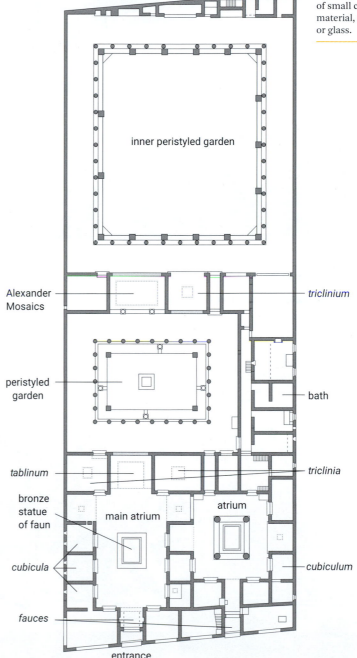

18.12 House of the Faun (plan drawing), Pompeii, Italy, second century BCE.

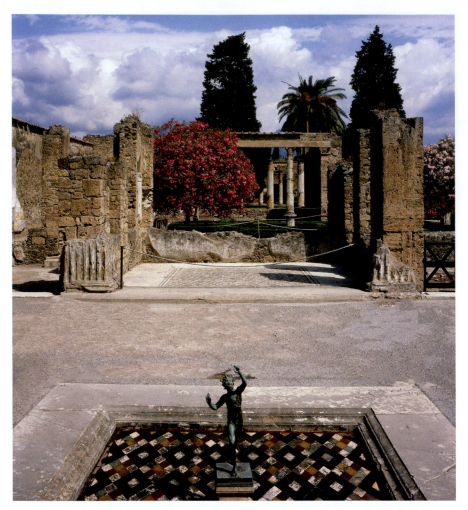

paintings that date primarily to the late second century BCE, most selected in imitation of Greek Hellenistic houses and palaces.

The facade of the House of the Faun included two main entrances and four other openings for shops. Looking into the house from the principal entrance, where the Oscan welcome *HAVE* ("HAIL") appears in mosaic on the floor, one could see into the *fauces* and main atrium, through a sizable window in the *tablinum* that gave onto the first peristyle, into an **exedra**, and onto the second peristyle beyond. The bronze faun, for which this house was later named, was located in the center of the *impluvium* in the atrium (**Fig. 18.13**) and so was a focus of this visual axis. This vista included not only the Alexander Mosaic but also other figural mosaics and wall paintings.

ALEXANDER MOSAIC The Alexander Mosaic (**Fig. 18.14**) was located on the floor of an *exedra* in the first peristyled court of the House of the Faun. Estimates of the number of **tesserae** used (in this case tiny cubes of stone or glass) range from 1 million to several million. The scale of this work, measuring approximately 8 ft. 10 in. × 16 ft. 9 in., is

18.13 LEFT **Atrium of the House of the Faun,** with bronze sculpture of a faun, looking toward the *tablinum* (office) and first peristyle, Pompeii, Italy, second century BCE.

18.14 BELOW **Alexander Mosaic,** perhaps a late 2nd- or early 1st-century BCE copy of a panel painting of the Battle of Issos by Philoxenos of Eretria, late fourth century BCE. Mosaic, approximately 8 ft. 10 in. × 16 ft. 9 in. (2.69 × 5.11 m). Museo Archeologico Nazionale, Naples, Italy.

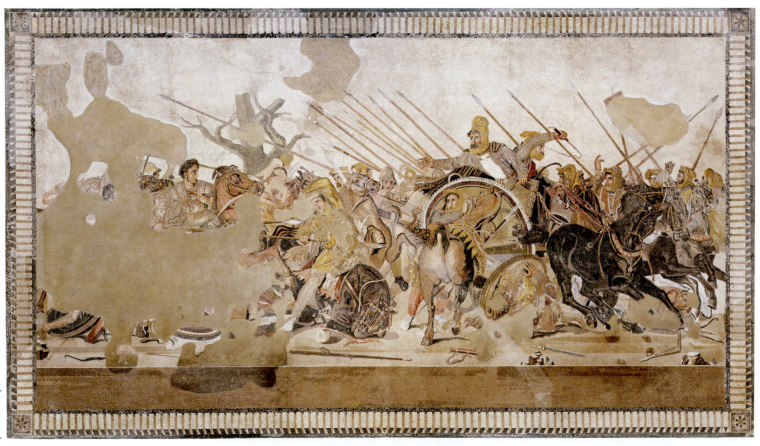

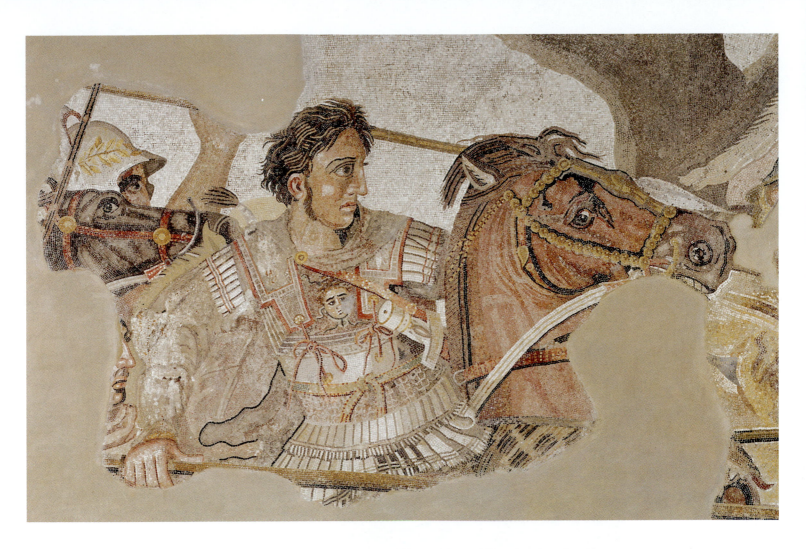

in itself striking, but the level of detail and the tools of perspective used to create the scene, such as modeling and **foreshortening** (dramatically shown in the horse's haunches), are truly remarkable. The visual effects are achieved using a fairly limited palette, but with an impressive range of **values**.

The scene is one of battle. Two men stand out from the chaotic foreground of felled men, weapons, and even the prominent hindquarters of a horse. The man riding his horse on the left, looking confident and focused, is identified as the Macedonian conqueror Alexander the Great, owing to his signature mane-like hair (shown clearly because he wears no helmet), his shining armor, and his Macedonian weaponry (**18.14a**). As he spears a victim, Alexander gazes intently at the prominent figure of a man riding in a chariot, identified as the Persian king Darius III. Darius and Alexander had fought at the Battle of Issos in southern Anatolia (present-day Turkey) in 333 BCE. Darius is placed higher than anyone else on the picture plane, but this prominence does not equate to strength or success, as he is shown at the very moment of retreat. Though his arm and body stretch toward Alexander, his men and horses are struggling to turn and flee. Even his own charioteer is whipping the black horses (on the right side of the composition) into a run; one of the horses appears to have three hooves off the ground. Darius's expression entreats Alexander to have compassion for his men. This pathos continues in the figure of a fallen Persian soldier who gives the viewer a glimpse of his face, reflected in his shield, in the instant before death.

The Roman historian Pliny the Elder (23–79 CE) recorded that this battle was the subject of a famous Hellenistic painting created by the Greek artist Philoxenos of Eretria in the late fourth century BCE, either during or shortly after Alexander's lifetime. Many scholars believe that the Alexander Mosaic may be a Roman copy of that lost painting, which Pliny claimed was "inferior to none." Another theory suggests that the mosaic is a copy of a painting of the Battle of Issos by a Greek woman artist known as Helen of Alexandria. Given how few women artists are known from this period, this theory is intriguing, but is impossible to prove. It is also possible that the mosaic is a Hellenistic Greek original plundered from ancient Greece during the Roman conquest. Indeed, the reinstallation of Greek booty in wealthy Roman homes is well documented, and many Romans saw Alexander as their forerunner as world conqueror.

FIRST STYLE WALL PAINTING

August Mau, a scholar of Roman painting, divided the surviving examples of Roman wall painting into four styles. The First Style and Second Style wall paintings date to the Roman Republic; the Third and Fourth Styles belong to Rome's imperial period (see Chapter 19). The House of the Faun included several fine examples of

18.14a Alexander, detail from the Alexander Mosaic, House of the Faun, Pompeii, Italy. Museo Archeologico Nazionale, Naples, Italy.

exedra an enclosed space or recessed area, usually semicircular.

tessera (plural **tesserae**) a small block of tile, glass, or stone used to make mosaic.

foreshortening in two-dimensional artworks, the illusion of a form receding into space: the parts of an object or figure closest to the viewer are depicted as largest, those furthest as smallest.

value the lightness or darkness of a tone or hue.

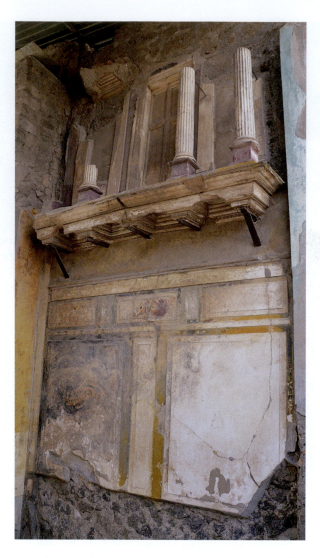

18.15 First Style wall painting in the *fauces* (entrance hall), House of the Faun, Pompeii, Italy, second century BCE.

VILLA OF THE MYSTERIES An impressive Roman residence, known for its intriguing wall paintings in the Second Style, is the Villa of the Mysteries (**Fig. 18.16**). The villa was located just one thousand feet (around 300 m) outside the city walls, where wealthy Pompeiians constructed their country villas. It was built during the early second century BCE and remodeled after 80 BCE into the form we know today. The ground plan of this villa was the reverse of that of a typical Pompeiian house, with the entrance through the peristyle. Visitors then passed through the atrium, ultimately arriving in the *tablinum*, which opened onto a terrace overlooking the Bay of Naples.

The villa takes its modern name from its mature Second Style paintings of a Bacchanalian mystery rite, which were added sometime after 80 BCE, during the remodeling. This unofficial mystery religion, which involved the worship of Bacchus (Greek Dionysos, god of wine and agriculture), was popular among women at the time. The paintings are located on the walls of a room that opens onto a shady portico with a view of the Mediterranean Sea. The room includes a First Style **dado**, above which is painted an illusion of a narrow ledge on which stands a single line of almost life-size figures, participating in what appear to be various scenes of one woman's initiation into the worship of Bacchus, pointing once again to the Greek influence on Roman culture and religion.

The action, set against a backdrop of brilliant Pompeian red-painted panels, unfolds around the viewer (**Fig. 18.17**). On the shorter far wall is the god Bacchus, identifiable by his *thyrsus*, a stick entwined with ivy and vine with a pinecone at the top; he is depicted resting on the lap of, perhaps, his wife, Ariadne. The artist convincingly conveys a sense of three-dimensionality by overlapping the figures, including Bacchus and Ariadne; by using light and shade to model them, as seen most clearly in the drapery; and through the use of foreshortening.

low relief (also called bas-relief) raised forms that project only slightly from a flat background.

dado the lower portion of a wall that is often of a different color or material to the rest of the wall.

the First Style, sometimes referred to as the masonry style. Paintings in this style were reminiscent of the luxurious stone inlaid walls in monumental Greek public buildings, and so gave the House of the Faun a stately feel. These paintings are similar to the Greek-influenced domestic peristyled courts in that they also demonstrate Greek influence on Roman houses. Popular from about 200 BCE to 80 BCE, the First Style was made with stucco modeled in **low relief** and painted in an effort to simulate colored marble and other stone veneers (**Fig. 18.15**). Real stone veneers were quite expensive, so the presence of painted imitations of such stonework was probably intended to elevate the status of the homeowner in the eyes of his clients and other guests. The paintings simultaneously showed the homeowner's pride in the expanding Roman empire because many of the depicted stones were types imported from beyond the Italian peninsula.

SECOND STYLE WALL PAINTING

Second Style paintings first appeared in Rome toward the beginning of the first century BCE, and slightly later in Pompeii. Though the Second Style includes some aspects of First Style painting, the Second Style emphasized painted illusions of three-dimensional features, such as columns, rather than the modeled stucco architectural elements so common in the First Style.

18.16 FAR RIGHT **Villa of the Mysteries (plan drawing),** Pompeii, Italy, second–first century BCE.

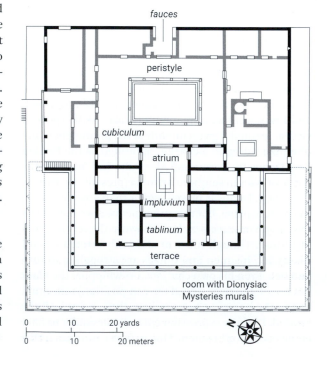

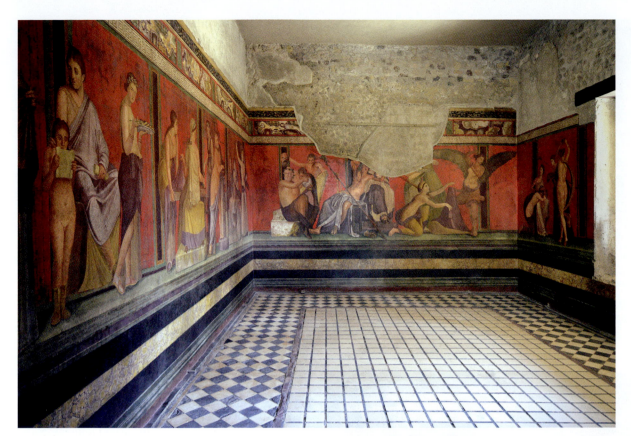

18.17a BELOW **Bacchanalian mystery rites, Second Style mural, (detail),** Villa of the Mysteries, room 5.

Silenus, a satyr (a drunken, lustful woodland being) and companion of Bacchus, is depicted to the left of the god as we view him, with, perhaps, maenads, female followers of Bacchus, to the right. Though the order in which we are to view the panels is uncertain, each individual tableau appears to form part of a single composition. One scene that unfolds across the corner to the right of Bacchus depicts a winged female figure moving to whip a woman kneeling with her head against the lap of a seated female. Next to the seated woman a naked dancer plays castanets as a fully dressed woman holding a *thyrsus* looks out from behind the dancer (p. 303 and **18.17a**). The billowing drapery of the dancing figure conveys a sense of movement.

Though we know very little about what happened during Bacchanalian rites, these paintings provide some hint. It is possible that during these ceremonies a young woman, or initiate, was joined in marriage with Bacchus, much as Ariadne was joined to Dionysos in Greek mythology. The function of the room that houses these paintings, however, is unknown. Some have suggested that it was used as a *triclinium*, while others suggest that Bacchanalian rituals indeed took place there.

WALL PAINTINGS, BOSCOREALE This wall painting from the mid-first century BCE, covering an entire bedroom in a villa at Boscoreale, near Pompeii, is an excellent example of what is sometimes called the architectural Second Style (**Fig. 18.18**, p. 316). It showcases illusionistic architectural elements and spaces, including painted columns with realistic shadows and imaginary scenes of buildings from the outside world. The painter denies the flat surface of the walls by treating them as if

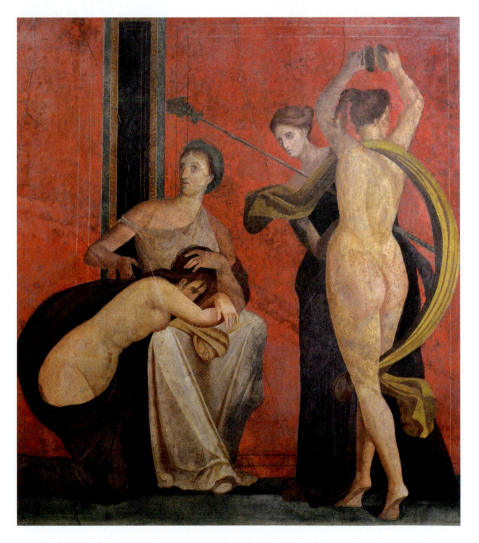

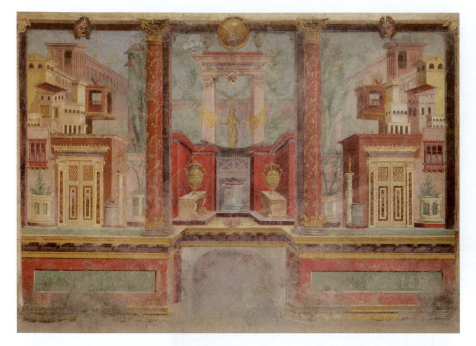

they are windows onto exterior views, complementing a real window in the back wall. The visual explosion of the flat picture plane is accomplished through the use of **linear perspective**, although this is not always accurately applied. The technique, probably used earlier in Greece as well, was later rediscovered in the Renaissance, which is often wrongly credited with its invention.

GETTY VILLA, LOS ANGELES J. Paul Getty, a U.S. businessman and billionaire philanthropist, based the plan of his villa near the Pacific Ocean in Los Angeles loosely on the plan of another Roman villa on the Bay of Naples: the Villa of the Papyri in Herculaneum, a town that, like Pompeii, was also buried by the eruption of Vesuvius. The Getty Villa (**Fig. 18.19**) now houses J. Paul Getty's collection of antiquities. It also attempts to emulate ancient Roman gardens with their sculptures, pools, fountains, and plants, as well as other decorative and functional features, such as mosaic floors, wall paintings, and lamps. Although it is not an authentic ancient Roman villa, the Getty Villa certainly evokes the sense of awe and privilege one must have felt upon moving deeper into the house of an exceptionally affluent Roman.

Portraiture of the Republic

Similar to public and private architecture, portraiture played several important roles in ancient Rome from the early Republic to the end of the empire. Portrait sculptures were often set up in public places, such as forums and theaters, inside or on the facades of the tombs that lined the streets leading out of Roman cities, or in private homes, especially those of patricians. The social, political, and religious impact of portraits in terms of establishing Romans' social identity, perpetuating their memory, and alleviating their concerns regarding immortality cannot be overestimated.

Most extant Republican portraits date to the late second century and first century BCE, though few Republican portraits have been found in a secure archaeological context. They are generally made of stone, often marble, and they take a variety of forms, including full-size statues, **busts**, carved heads, reliefs, and likenesses on coins and carved gemstones. Unlike architecture and painting, Republican portrait sculpture resisted Greek influences. Notable in many Republican portraits is what appears to be a highly realistic representation of the individual depicted, including such details that indicate advanced age, such as furrows in the forehead or wrinkles around the eyes. Roman **verism** differs from Classical idealism, with its beautiful depictions of ageless figures, in that Romans of this time venerated character and maturity—specifically, the experience, responsibility, and wisdom that come with age. A portrait showing advanced years, and possibly familial traits if one belonged to an old patrician family, advertised the subject's social status

18.18 ABOVE LEFT **Bedroom with wall paintings, House of Publius Fannius Synistor,** Boscoreale, near Pompeii, Italy, mid-first century BCE. Metropolitan Museum of Art, New York.

18.19 LEFT **Atrium of the Getty Villa,** Malibu, Los Angeles, CA. Modeled on the plan of the Villa of the Papyri in Herculaneum, Italy.

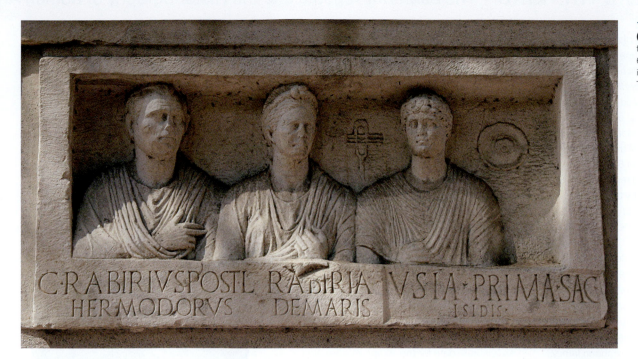

18.20 Tomb of the Rabirii (detail), Via Appia, Rome, late first century BCE. Marble, length 6 ft. 8½ in. (2.05 m). Plaster cast in the Museo Nazionale Romano, Terme di Diocleziano, Rome.

and profession to passersby, as well as the *dignitas* and *gravitas* (dignity and seriousness) so valued in Rome.

PORTRAITS FROM TOMB OF THE RABIRII The word "portrait" may bring to mind images of emperors, statesmen, and other important patricians, but there are also numerous Roman portraits of lesser-known individuals, including merchants and craftspeople, many of whom were freedmen, or formerly enslaved people. Mary Beard suggests that very roughly 20 percent of the total population of Italy in the middle of the first century BCE were enslaved people—approximately 1.5 to 2 million. Because enslaved people could be freed and granted Roman citizenship, sometimes for very practical reasons, such as the expense of caring for an elderly enslaved person, the Roman citizenry was incredibly diverse. The earliest extant portraits of freedmen date from the second quarter of the first century BCE and, in addition to memorializing the deceased, provide us with insight into the social mobility of freed people in ancient Rome. One intriguing example of a freedman relief was found on the Tomb of the Rabirii on the Via Appia, just outside of the city walls of Rome (**Fig. 18.20**), where passersby would be reminded of the deceased, now immortalized in stone. The relief features three portrait busts in **high relief** of a man (on the far left) and two women in a rectangular frame. The Latin inscription on the frame translates as "Caius Rabirius Hermodorus, freedman of Postumus; Rabiria Demaris; Usia Prima, Priestess/of the Devotees of Isis."

The freedman, Caius Rabirius Hermodorus, is depicted as an older man with a receding hairline, wrinkles, and hollow cheeks. He is dressed in a toga, which would have been possible only after his owner freed him from enslavement. (Enslaved men could not wear a toga.) The woman next to him, Rabiria Demaris, perhaps a freedwoman, is also depicted as older. She wears a tunic, over which a *palla* (mantle or cloak) is draped across her left shoulder. Dress often signified status in ancient Rome, and indeed Rabiria's clothing confirms that she is a Roman

citizen. She also wears a ring, which may suggest that she was married to Rabirius. Both figures, who turn their heads slightly toward the third figure, have been dated to the later part of the first century BCE—either the Late Republic or the early Augustan period.

The third figure, Usia, is more of an anomaly. The inscription tells us that she was associated with the cult of Isis, the Egyptian goddess of fertility, who was also worshipped in Rome. The low reliefs on either side of her head are a *sistrum*, an instrument used in the worship of Isis, and a *patera*, a shallow dish used to pour libations (liquid offerings). From what is depicted, one cannot quite see whether she is also wearing the tunic and *palla*, which would make her a Roman citizen. Interestingly, her hairstyle suggests a carving date in the first century CE, later than the other two figures. Indeed, the size of her head in relation to her body is not proportionate, which implies that the head was recarved from an earlier relief, her hairstyle indicating this to be in the last sixty years of the first century CE. It appears that the torso and inscription were recarved as well. The open space to Usia's left also suggests that at least one other figure was once present.

The veristic style developed greatly during the unrest of the Late Republic, as portraits of powerful individuals, particularly military figures, including Julius Caesar, took on even greater significance. Centuries of wars and conquest had taken a toll on Rome itself. Soldiers were away from their homes and land for long periods, returning to unstable circumstances brought on by their absence and the long period of war. Many chose to move to the cities, but there was little work to be had, owing to the influx of enslaved people (many prisoners of war were destined for this fate). During the wars, Roman generals became increasingly powerful, winning the support of their soldiers, who were often more faithful to their generals than to the Roman senate. The veristic portraits of these generals *cum* political leaders were crucial in establishing their new roles.

linear perspective a system of representing three-dimensional space and objects on a two-dimensional surface by means of geometry and one or more vanishing points.

bust a sculpture of a person's head, shoulders, and chest.

verism preferring realism, especially in portraiture, to the heroic or ideal; comes from the Latin *verus*, meaning "true."

high relief raised forms that project far from a flat background.

Historiography is the history of a discipline. According to one scholar, "One of the tallest houses of cards in Roman art historiography has been built atop the *Barberini Togatus*." The *Barberini Togatus* is a life-sized statue of a man wearing a toga and senatorial boots; he cradles a veristic portrait bust of an elderly man in each hand (**Fig. 18.21**). The head of the main figure is not original to this statue. The *Barberini Togatus* has often been described as representing the Roman tradition, described by the Roman writers Pliny the Elder and Polybius, of parading wax *imagines* (portraits) during funerary processions:

> In ... the atria of the ancestors ... portraits offered a spectacle to behold, not the statues by foreign artists either of bronze or of marble; but faces rendered in wax were arranged in separate cupboards, so that they should be "true portraits" [*imagines*] to accompany funerals in the extended family. (Pliny, *Natural History*, XXXV.6)

> [Romans] place a likeness of the dead man in the most public part of the house, keeping it in a small wooden shrine. The likeness is a mask especially made for a close resemblance both as regards the shape of the face and its coloring. They open these masks during public sacrifices and compete in decorating them. And whenever a leading member of the family dies, they introduce them into the funeral procession, putting them on men who seem most like them in height and as regards the rest of their general appearance. (Polybius, *Histories* 6.53.4–7)

As Elizabeth Marlowe discusses at length in *Shaky Ground: Context, Connoisseurship and the History of Roman Art* (2013), there are two problems with this assessment. First, the togate (toga-wearing) figure holds two heavy stone statue busts, not wearable wax masks, and so descriptions of the statue as illustrating the texts of Pliny and Polybius are inaccurate. Second, the original archaeological findspot of the *Barberini Togatus* is unknown. In other words, the work is not "grounded" in an archaeological context. Indeed, the statue is named for the Barberini collection, where it was first documented in 1627. It is recorded there as a gift from Filippo Colonna to Cardinal Francesco Barberini, and it was later acquired by the Capitoline Museum in Rome in 1937. Today it resides in the Capitoline Museum at Montemartini. Therefore, the statue lacks an archaeological context. We have no idea who owned the statue and whether it was displayed in the private home of a patrician, in a public square in Rome, in a tomb interior, on the facade of a tomb on a street just outside of a Roman city, or elsewhere. Nor do we have an accurate date for the sculpture's creation. So, while the statue certainly alludes in a general way to the importance of venerating ancestors in Roman society, much information is lost. The desire to justify primary sources, such as the practices described by Pliny and Polybius, sometimes leads us to over-interpret or misinterpret works of art. The lesson is that we must resist the urge to construct grand and detailed scenarios based on limited information. How different would the canon of art history look if all ungrounded works were removed?

Discussion Question

1. Choose a work of art from this chapter that is "grounded"—that is, for which we know the archaeological context. Fully identify the artwork and describe its archaeological context. What can we learn about the work from its context that would be impossible to know if this context were lacking?

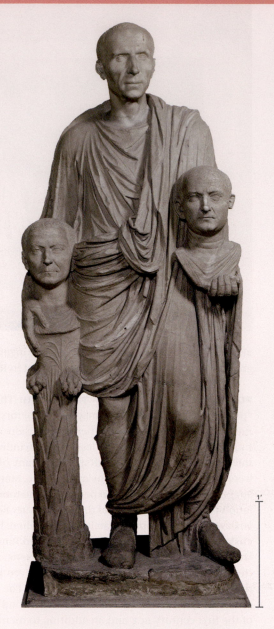

18.21 *Barberini Togatus,* or Man with portrait busts of his ancestors, late first century BCE(?). Marble, height 5 ft. 5 in. (1.65 m). Musei Capitolini-Centrale Montemartini, Rome.

DENARIUS OF JULIUS CAESAR In 59 BCE, the politicians Pompey, Crassus, and Julius Caesar formed a shaky political alliance, which lasted until 53 BCE. Ultimately, after a bitter power struggle, Julius Caesar declared himself dictator of Rome in 45 BCE. In 44 BCE, he had the phrase *dictator perpetuo*, or "dictator in perpetuity," emblazoned on his *denarius* (the standard Roman silver coin) with his portrait (**Fig. 18.22**). Traditionally images of divinities were found on Roman coins until the first century BCE, when some began to feature portraits of ancestors. The facility with which one could disseminate one's portrait by placing it on a coin was clearly apparent to Julius Caesar. However, this was an audacious move. He was assassinated shortly after. Julius Caesar's portrait on the coin is clearly veristic. He is shown in profile with a prominent aquiline nose (commonly depicted among Roman patricians), as well as a receding hairline, wrinkles on his face and neck, and somewhat sunken cheeks, advertising his more advanced age in order to show that he possessed the Roman ideals of experience and wisdom.

DENARIUS WITH PORTRAIT OF CLEOPATRA After the death of Julius Caesar, a long civil war ensued. It ended with the defeat of Mark Antony and Queen Cleopatra of Egypt by Octavian, Julius Caesar's grand-nephew and adopted son, at the Battle of Actium in 31 BCE. A portrait of Cleopatra on a *denarius* dating to 32 BCE illustrates the role of art in glorifying powerful individuals. Unlike

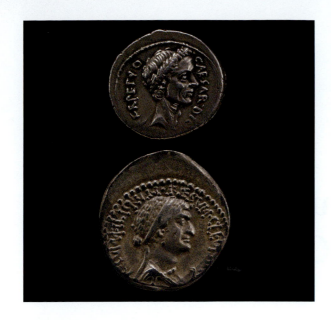

18.22 FAR LEFT ABOVE **Portrait of Julius Caesar as *dictator perpetuo* ('dictator in perpetuity') on denarius,** 44 BCE. Silver, weight 3.88 grams. British Museum, London.

18.23 FAR LEFT BELOW **Portrait of Cleopatra on reverse of denarius of Mark Antony,** 32 BCE. Silver, dimensions unknown. British Museum, London.

Discussion Questions

1. Because the Romans freely appropriated from other artistic traditions—particularly those of the people they conquered—Roman art and architecture of the Republic is eclectic. Choose one work from this chapter that you believe is eclectic, and explain which artistic traditions it draws from and what, nevertheless, makes it clearly Roman. Think in terms of both form and context.

2. Select a work of art (including architecture) from this chapter and describe how it may have been used to convey or enhance the social status of its owner or patron. What was the audience for such a work, and how do you think the work was received? Do you think it was effective? Why or why not?

3. Look at the website for the Getty Villa in Los Angeles, California at www.getty.edu/visit/villa and explore the architecture, gardens, and works of art. How would the experience of visiting a reproduction of an ancient Roman home be different from visiting an excavated home, such as at Pompeii?

Further Reading

- Beard, Mary. *The Fires of Vesuvius: Pompeii Lost and Found.* Cambridge, MA: The Belknap Press of Harvard University Press, 2008.
- Allison, Penelope M. "Engendering Roman Domestic Space." In Ruth Westgate, Nick Fisher, and James Whitley (eds.) *Building Communities: House, Settlement and Society in the Aegean and Beyond.* British School at Athens Studies 15 (2007), 343-350.
- Wallace-Hadrill, Andrew. *Houses and Society in Pompeii and Herculaneum.* Princeton, NJ: Princeton University Press, 1994.
- Yegül, Fikret and Diane Favro, *Roman Architecture and Urbanism: From the Origins to Late Antiquity.* Cambridge: Cambridge University Press, 2019.

coins featuring Hellenistic portraits of Cleopatra, which show a youthful and idealized image of the queen, here she is depicted as more masculine, with a larger frame and regal aspect (**Fig. 18.23**). As on the *denarius* of Julius Caesar, Cleopatra is shown in profile, and there is an attempt to depict her with an air of wisdom and experience by imbuing her with the traits typical in portraits of Roman statesmen. She looks older, with a thin neck and a prominent aquiline nose similar to Caesar's. This veristic portraiture was intended to legitimize the Hellenistic queen of Egypt as a prominent figure in Roman politics by endowing her visage with Roman *dignitas* and *gravitas*.

The defeat of Antony and Cleopatra led to the rise of Octavian, granted the title Augustus, first emperor of Rome. Octavian and his successors often brilliantly used art and architecture to consolidate and maintain power while establishing and upholding the *Pax Romana*, or Roman Peace (see Chapter 19).

Chronology

April 21, 753 BCE	The legendary foundation date of Rome by Romulus and Remus	**first century BCE**	Second Style murals are painted in the Villa of the Mysteries, Pompeii
509 BCE	The expulsion of last king from Rome and the beginning of the Roman Republic	**59–53 BCE**	The First Triumvirate
second century BCE	The Temple of Jupiter, the Stabian Baths, and basilica are built at Pompeii	**late first century BCE**	The Tomb of the Rabirii is carved/recarved outside Rome
second century BCE	The House of the Faun, Pompeii, is built; First Style murals are painted	**45 BCE**	Julius Caesar declares himself dictator of Rome
late second–early first century BCE	The Alexander Mosaic is made, perhaps copying an earlier Hellenistic painting	**44 BCE**	Denarius with portrait of Julius Caesar is issued
90–88 BCE	The Social War	**44 BCE**	Julius Caesar is murdered
80 BCE	Pompeii becomes a Roman colony	**31 BCE**	The Battle of Actium; Octavian defeats Cleopatra and Mark Antony
c. **80–70 BCE**	The amphitheater is built at Pompeii	**27 BCE**	The senate confers the title of Augustus on Octavian, making him the first emperor of Rome; the beginning of Imperial Rome
c. **75 BCE**	The temple of Portunus is constructed in Rome		

19

Art of the Roman Empire from Augustus through the Julio-Claudians

27 BCE–68 CE

Breastplate from sculpture of
Augustus as *imperator* (detail),
from the Villa of Livia, Italy.

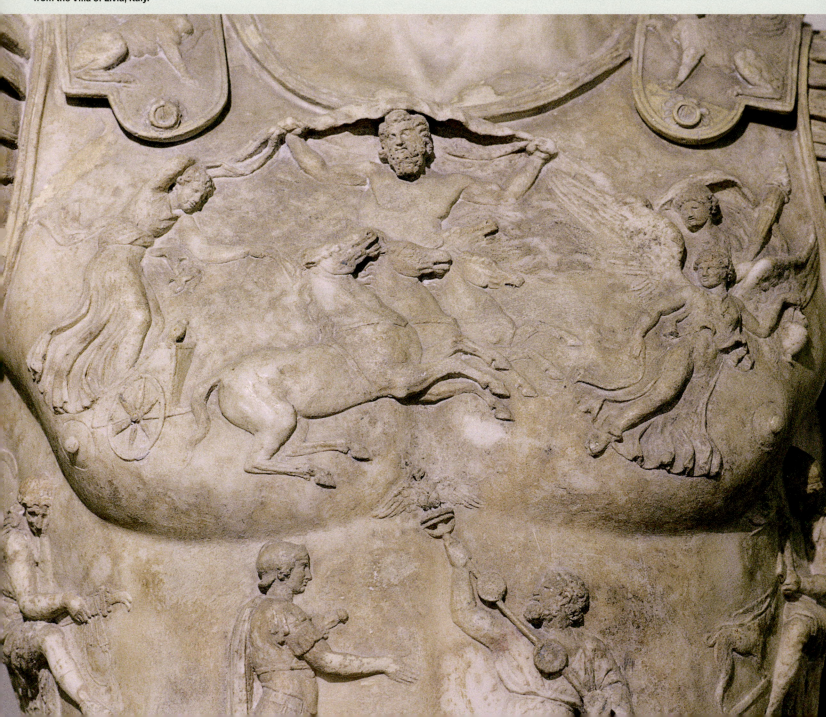

Introduction

The long period of civil wars in the latter years of the Roman Republic came to an end at the Battle of Actium in 31 BCE. There, Octavian, the great-nephew and adopted son of Julius Caesar (assassinated in 44 BCE), defeated his Roman foe, Mark Antony, as well as Cleopatra (the Ptolemaic ruler of Egypt and Antony's partner), bringing Egypt under Roman control. The senate conferred the title of Augustus, meaning great or venerable, on Octavian in 27 BCE. By 23 BCE Augustus had complete power as the first emperor of Rome, including the right to veto legislation, though he faced significant challenges in seeking to bring peace, strength, and stability to the Roman Empire. The long period of civil wars had led to pessimism and distrust of government among the citizenry, as well as to the neglect of traditional Roman virtues, such as *dignitas* (dignity), *gravitas* (seriousness), and *pietas* (dutifulness).

In addition to securing imperial power, Augustus needed to gain the trust of the Roman citizens and address the other ills plaguing Rome, such as poverty and lack of work. A brilliant statesman and propagandist who ruled for four decades, Augustus, with his third wife, Livia, initiated a program of cultural renewal, including social and religious reforms that appropriated Republican ideals in order to rebuild the Roman state and society. To legitimize his position, Augustus established a new imperial ideology that relied heavily on art and architecture, negotiating the risky shift in government from a republic to a monarchy. By invoking the traditions of the Roman Republic, but interpreting them in a new Classical artistic style based on Athens of the fifth century BCE, Augustus created a connection between the so-called Golden Age of Athens under Perikles, when such monuments as the Parthenon were built, and the Age of Augustus in Rome. Augustus's commissioned art not only commemorated his military campaigns but also depicted the imperial family as idealized figures that reflected his cultural reforms, his public piety, and the stability of his empire.

The visual traditions established by Augustus were adopted by the Julio-Claudians who succeeded him. (The dynasty is named "Julio-Claudian" from the lineage of Augustus's adopted father, Gaius Julius Caesar, and his successor Tiberius's birth father, Tiberius Claudius Nero.) The four Julio-Claudian emperors—Tiberius, Caligula, Claudius, and Nero—continued to use art as propaganda, favoring the Greek Classical style chosen by Augustus. But, as indicated quite clearly by the sumptuous palace of Nero, this self-aggrandizing final ruler of the dynasty did not practice the restraint demonstrated by Augustus, and piety was not his strong suit. Nero's untimely death led to the collapse of the dynasty in 68 CE.

The Imperial Ideology of Augustus

Augustus once boasted that he found Rome a city of brick and left it a city of marble. His cultural program consisted of a carefully planned set of works of art, architecture, and public infrastructure throughout the whole empire (**Map 19.1**). From portraits to temples to aqueducts, all of these works conveyed a message of strength and peaceful abundance to illustrate the *Pax Romana*, or Peace of Rome.

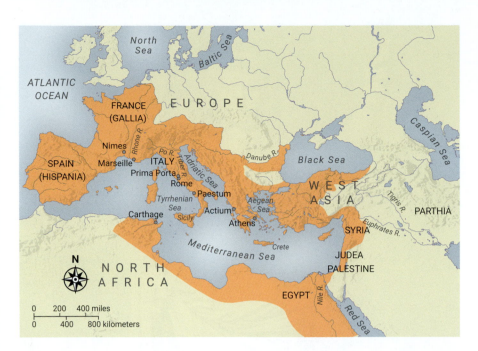

Map 19.1 The Roman Empire in 14 CE.

Augustus ushered in this period of relative stability (which lasted from 27 BCE to 180 CE) after the lengthy and bitter civil wars that ended the Roman Republic.

The use of portraiture to construct and convey identity continued during the age of Augustus, but, unlike the portrait sculptures of venerable elders in Republican Rome (see Chapter 18), that identity was now imperial. There may have been as many as 25,000–50,000 portraits of Augustus; the remains of more than 200 of them survive today. These portraits show great variety, depicting Augustus as *imperator* (commander-in-chief) of Rome's armies, *pontifex maximus* (chief priest), and even as an Egyptian pharaoh. A major shift in the style of portraiture also occurred at this time. Augustus chose not to draw on the **verism** of the portrait style of his adopted father, Julius Caesar, and his Republican forebears. Rather, his portraits look back to the idealized Classical Greek portraiture of fifth-century BCE Athens, with some adjustments.

STATUE OF AUGUSTUS AS *IMPERATOR* An excellent example of this shift is the over-life-size marble statue of Augustus as *imperator*, found in Livia's villa in Prima Porta, just north of Rome (**Fig. 19.1**, p. 322). The statue may be a posthumous copy of an earlier bronze original, because Augustus is shown with the bare feet of a god rather than wearing military boots, which suggests that the work was carved after his death and deification in 14 CE. No bronze original has been discovered, however.

The statue does not present a veristic portrayal of Augustus. Rather, its **contrapposto** stance and idealized, youthful features seem more similar to Polykleitos's *Doryphoros* (*Spear Bearer*) from *c.* 440–450 BCE (see Fig. 14.20), numerous copies of which have been found in Rome. Because the Greek Classical ideal adopted by Augustus required a youthful face and a strong physique, he was never depicted as elderly even though he lived well into his seventies. Statues of him departed from Classical Greek sculpture in that they included recognizable elements, such as his hairstyle and facial

verism preferring realism, especially in portraiture, to the heroic or ideal; comes from the Latin *verus*, meaning "true."

contrapposto from the Italian for "counterpoise," a posture of the human body that shifts most weight onto one leg, suggesting ease and potential for movement.

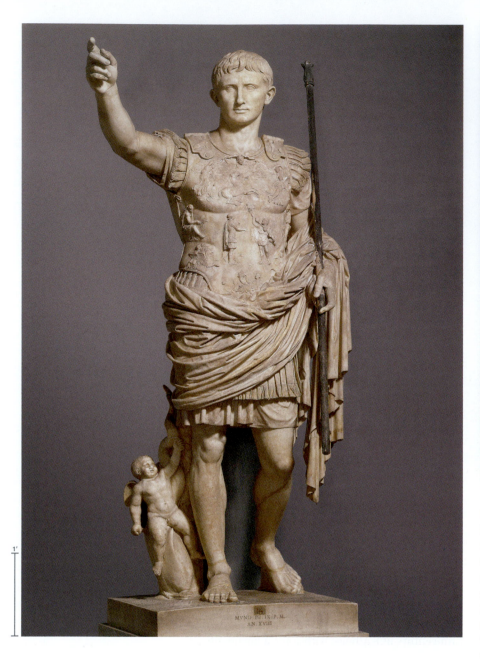

19.1 ABOVE **Augustus as** *imperator*, from the Villa of Livia, Prima Porta, Italy, early first century CE, perhaps a copy of a bronze original from late first century BCE. Marble, originally painted, height 6 ft. 8 in. (2.03 m). Musei Vaticani, Rome.

19.1a ABOVE RIGHT **Polychrome reconstruction of the statue of Augustus**.

iconography images or symbols used to convey specific meanings in an artwork.

features, in contrast to the more generic face and head of the *Doryphoros*. These elements suggest the use of an approved prototype that sculptors consulted.

The sculpture was originally painted, which would have made it even more lifelike (**Fig. 19.1a**). Augustus is shown with his arm raised as if addressing an audience, seen also in the statue of *L'Arringatore* (see Fig. 17.19). It is unclear what his left hand originally held; it may have been a spear. Combined with his representation as a triumphant general are symbols that evoke his authority as someone divine and connected to the founding of Rome. Cupid, god of love and desire, and the dolphin at Augustus's feet are subtle references to Cupid's mother, Venus (goddess of love), who was born from the sea, and from whom Augustus was supposed to descend.

The breastplate, shaped in the form of a muscular chest, is covered with scenes sculpted in relief (see p. 320). The complex **iconography** includes blatant reminders of Augustus's program of cultural renewal, and indeed of the *Pax Romana*. For example, in the center of the

breastplate, a Roman soldier (or possibly the goddess Roma herself, patron goddess of Rome) is shown receiving a Roman legionary standard (a symbol attached to the top of a pole, which identified a Roman legion or infantry) from a Parthian—a reference to the diplomatic, not military, victory in 20 BCE of the Romans over the Parthians (originally from northeast Iran, and who had established a powerful empire in West and Central Asia). The Parthian is identified by his dress, including baggy trousers. The image appears above a depiction of Tellus (Mother Earth) holding a cornucopia abundant with fruit. The entire scene takes place below Caelus, the sky god, above whom the head of Augustus rises, not subtly. The deities Apollo and Diana are at the bottom left and right, and the sun god Sol and the moon god Luna are above. On Augustus's shoulders are sphinxes, referring to his subjugation of Egypt. Overall, the iconographical program highlights the peace and abundance brought by Augustus and believed to be sanctioned by the gods.

STATUE OF LIVIA FROM PAESTUM It is impossible to generalize about women's rights in ancient Rome, because they changed during the long period of Roman rule. But it is possible to discuss some aspects of women's experiences. For example, freeborn women were considered citizens of Rome, but they did not enjoy the same rights accorded to men. Some women were educated and some held jobs, but they could not vote, nor could they hold public office. However, female members of the imperial family could influence politics through their connections.

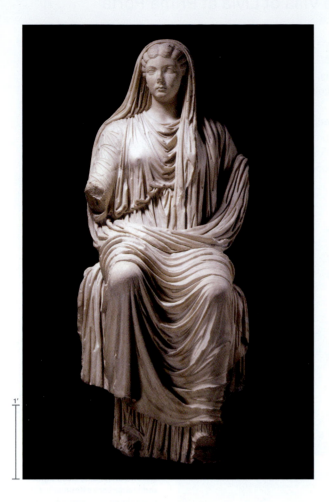

19.2 FAR LEFT **Seated statue of Livia,** from Paestum, Italy, 14–37 CE. Marble, height 5 ft. 8 in. (1.73 m). Museo Arqueologico Nacional, Madrid.

Livia lived to the age of eighty-seven, and the only thing that changed in representations of her over time was her hairstyle. Her public image remained youthful and represented an ideal model for women in the empire. Despite this, her son Tiberius vetoed some honors for her after he succeeded Augustus as emperor, which suggests that his personal views regarding women's role in society conflicted with his political need to showcase his mother publicly. Regardless, Livia clearly held power as a Roman woman, as indicated by her privileges, including the public display of her portraits.

ARA PACIS AUGUSTAE We also see the artistic evidence of Augustus's ideological program of cultural revitalization in the *Ara Pacis Augustae*, or Altar of Augustan Peace (**Fig. 19.3**), an open air, polychrome, marble altar that is oriented to the cardinal points. The senate commissioned this public monument in 13 BCE to commemorate Augustus's return to Rome after military campaigns in Hispania and Gallia (present-day Spain and France). It was dedicated on Livia's birthday in 9 BCE in the Campus Martius (Field of Mars, the god of war) on the route by which Augustus would have entered Rome on his triumphant return. Nearby was a large solar *meridiem*, perhaps erected to commemorate Augustus' election as *pontifex maximus* in 12 BCE, that used the shadow cast by an Egyptian **obelisk** on pavement markers to indicate the changing length of each day. Augustus had brought the obelisk back from Egypt, and it neatly advertised the Roman conquest of that country (see box: Art Historical Thinking: Obelisks, Mobility, and Meaning, p. 198). Notably, recent scholarship suggests pharaonic jubilee chapels were one of the architectural models for the Ara Pacis.

Although the *Ara Pacis* is dedicated to Pax, the Roman goddess of Peace, it is wise to remember the words of the Roman historian Tacitus (*c*. 56–120 CE): "No doubt, there was peace ... but it was a peace stained with blood." Like

diadem a crown or ornamented headband worn as a sign of status.

frieze in architecture, the part of an entablature located above the architrave.

obelisk a rectangular stone pillar with a pyramidal top; usually a landmark or a monument to a person or event.

Livia, the third wife of Augustus and first empress of Rome, played a crucial role in his social, political, and religious reforms.

Influential before her marriage as an aristocratic woman who had inherited property, Livia gained great renown and power as an imperial wife and mother during her long life. Like Augustus, Livia used portraiture to convey her rank and status. Sculptures of her were common throughout the empire and were generally recognizable, suggesting that a sanctioned model-portrait type existed for her statues, just as for Augustus. An over-life-size public statue of Livia from Paestum in south Italy presents her as a youthful, idealized image of a Roman woman **(Fig. 19.2)**. Originally seated on a throne, Livia was displayed with a seated statue of Augustus's successor, Tiberius, who was her son from a previous marriage.

In keeping with Augustus's focus on moral and cultural renewal, Livia is shown modestly draped in a mantle (cloak) and heavy tunic, with her head covered, indicating her piety. There is evidence of attachments for a metal **diadem** on this sculpture. Her large stature, with full hips and breasts, suggests her role as matron of the empire. The statue is based on Greek-goddess types, specifically enthroned figures and the reliefs of seated goddesses, such as Hera, from the east side of the **frieze** of the Parthenon in Athens (see Fig. 14.12). Classicizing elements are seen in Livia's youthful, unblemished visage and in the modeling of the drapery, which reveals her body underneath. The consistency of her facial features with other portraits makes her instantly recognizable.

19.3 *Ara Pacis Augustae* **(Altar of Augustan Peace),** Rome, 13–9 BCE. Carrara marble, approx. 34 ft. 5 in. × 38 ft. × 23 ft. (10.49 × 11.58 × 7.01 m)..

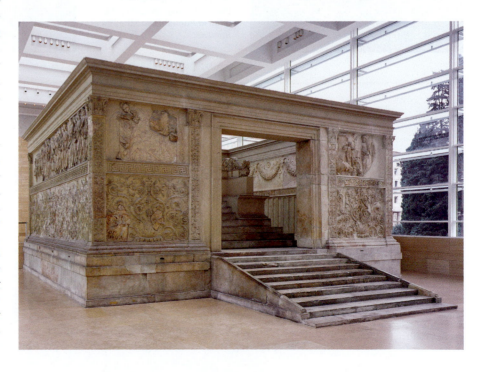

Livia's villa at Prima Porta, north of Rome, was a luxurious home on top of a hill. It housed not only the statue of Augustus as *imperator* (see **Fig. 19.1**) but also Second Style wall paintings of striking artistry. (The categories of Roman wall painting were defined by the scholar August Mau. The First and Second Styles originated in the Roman Republic: see Chapter 18.) A life-size, illusionistic, panoramic view of a garden, over all four walls of a vaulted room, located partially underground to regulate its temperature, demonstrates the painter's great skill (**Fig. 19.4**). The artist clearly studied nature and excelled at re-creating natural effects in paint.

The illusion of looking out into the deep space of a garden is made convincing through the artist's use of atmospheric perspective, which represents objects in the foreground clearly with distinct details, those in the middle ground as slightly blurred and with fewer details, and those in the background hazier still, just as the eye would see them in reality.

19.4 Gardenscape, Second Style wall painting from the Villa of Livia, Prima Porta, near Rome, late first century BCE. Museo Nazionale Romano, Rome.

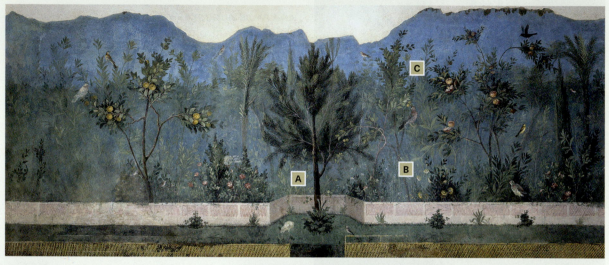

A The garden wall that appears to skirt around the tree (at center) recedes into space, hinting at the architectural Second Style seen in the wall painting from Boscoreale near Pompeii (see Fig. 18.18). Here, however, with the exception of this wall, nature rather than architecture is the focus.

B The artist dissolves the wall space by providing a view onto a verdant garden complete with a variety of birds and accurately depicted plants and flowers, including roses, irises, daisies, chrysanthemums, and fruit-laden pomegranate and quince trees. Everything is in bloom simultaneously, which would never happen in real life. The fecundity and abundance of this scene may symbolize the reign of Augustus and the *Pax Romana*.

C The artist also uses light and shade very effectively, for example on the leaves of the trees. Some of them are lit by the sun above, while others are cast in shadow. The effect is so convincing that the leaves appear to be rustling in a light breeze.

podium a raised platform that serves as a base.

bucranium (plural **bucrania**) the skull of an ox; a common form of decoration in Classical architecture.

register a horizontal section of a work, usually in a clearly defined band or line.

the Hellenistic Great Altar at Pergamon (see Fig. 15.16), the Altar of Augustan Peace is a monumental altar, located on a **podium** approached by a staircase, and surrounded by an enclosure wall, which is decorated with relief sculptures that would have conveyed a complex message to the Roman people. On the interior of the wall the relief sculptures are garlands with **bucrania**, alluding to the sacrifices of oxen to the gods that took place there, as well as the fruits of such sacrifices.

The exterior wall of the *Ara Pacis* is divided into two larger **registers** separated by a Greek key pattern. The relief sculpture of the lower register is vegetal, with intricately carved acanthus plants that allude to the abundance and order resulting from the Augustan peace. The upper register features figural reliefs that provide both historical and mythological propaganda to support a positive view of the emperor. The closed sides on the north and south are historical and highlight the imperial family and other important figures; the shorter west (front) and east (rear) sides, which have openings, focus on mythological and allegorical subjects. For example, the west side shown in **Fig. 19.3** depicts the origins of Rome. On the right is a relief that may represent the Trojan prince Aeneas making a sacrifice. According to legend, he was the son of the goddess Venus and an ancestor of Romulus and Remus, the founders of Rome, and therefore an ancestor of Augustus. This connection to Aeneas figured large in Augustus's ideological campaign; Virgil's epic poem about the founding of Rome, the *Aeneid*, was written during his reign. Another interpretation suggests

that, rather than Aeneas, Numa Pompilius, the second king of Rome, is making the sacrifice.

RELIEF OF TELLUS OR PAX ON THE *ARA PACIS* A mythological figure on the east **facade** of the enclosure wall has been variously interpreted, most often as Tellus (an earth goddess) or as Pax (Peace), to whom the altar is dedicated (**Fig. 19.5**). One argument for identifying her as Pax is that warlike Roma is depicted on the opposite side of the enclosure wall. Regardless of who she is, the style and surrounding iconography convey a clear message of peace and abundance in the Roman Empire under Augustus. Depicted in the Classical, idealized style of fifth-century BCE Athens, the figure sits in the center of the composition. Her drapery hugs and reveals her body underneath; her navel is clearly visible through the fabric. She holds two naked babies, alluding to fertility, perhaps in support of Augustus's efforts to increase the dwindling birthrate among the nobility. Surrounding the central figures is a variety of animals and crops. The two other figures, wearing windblown drapery, have been identified as personifications of breezes, both terrestrial (left) and marine (right).

RELIEF OF IMPERIAL FAMILY ON THE *ARA PACIS* On the longer, south side of the *Ara Pacis* is a procession of the imperial family, including very naturalistic children in informal poses (**Fig. 19.6**). Here, too, the youths may be present to encourage the members of the Roman nobility to increase the size of their families. The frieze shares several features of Athenian sculpture in the fifth century BCE and, more specifically, the Parthenon frieze: the focus on the procession, the idealized naturalism of the figures and their varied positions, the modeling of drapery to reveal the body underneath, and the use of shallow **low relief** to depict figures in the background

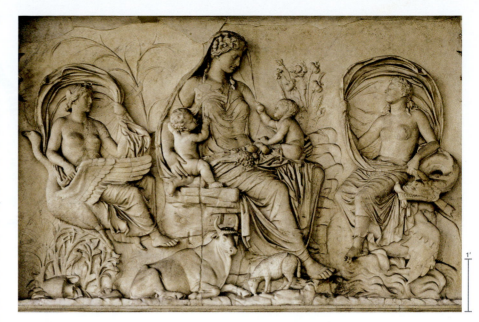

and **higher relief** for figures in the foreground. However, unlike the anonymous, almost otherworldly, figures on the Parthenon, the people depicted on the *Ara Pacis* have distinct portrait features. Augustus was highlighting the family members who would succeed him in the imperial line, and hence emphasizing the stability of his dynasty and of Rome itself.

The political agenda of the *Ara Pacis* did not end with the fall of the Roman Empire. The altar, which eventually fell into ruin, was not fully excavated until 1937–38. The excavator was Giuseppe Moretti, who worked under the watchful eye of Benito Mussolini, the Italian prime minister and National Fascist Party leader who sought to establish a new Roman Empire. Mussolini used such ancient Roman artifacts as the *Ara Pacis* in his

19.5 Relief of Tellus or Pax, detail from the enclosure wall of the *Ara Pacis Augustae*, Rome, 13–9 BCE. Marble, relief, approx. height 5 ft. 2 in. (1.57 m).

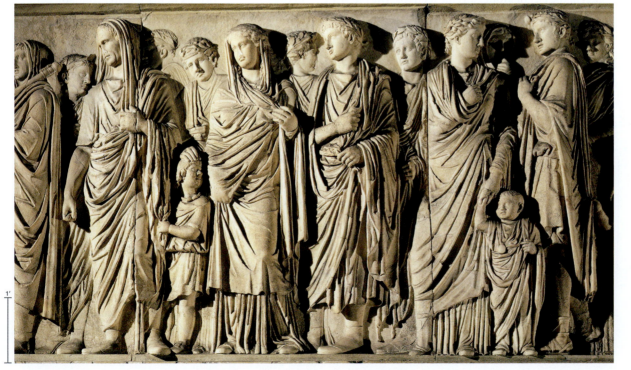

facade any exterior vertical face of a building, usually the front.

low relief (also called bas-relief) raised forms that project only slightly from a flat background.

high relief raised forms that project far from a flat background.

19.6 Procession of the imperial family, detail of the south frieze from the enclosure wall of the *Ara Pacis Augustae*, Rome, 13–9 BCE. Marble relief, height 5 ft. 3 in. (1.6 m).

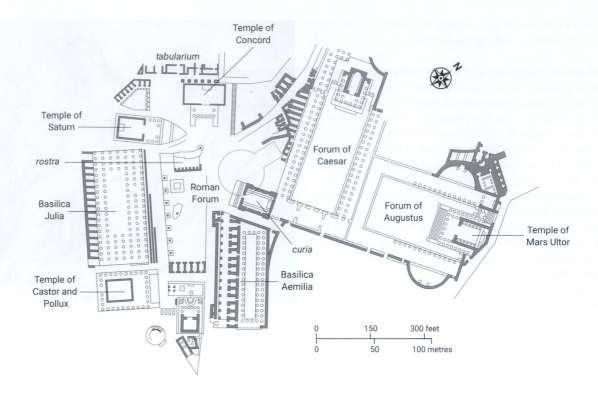

19.7 The Roman Forum and the imperial forums (plan drawing).

Temple of Concord

tabularium

Temple of Saturn

rostra

Basilica Julia

Roman Forum

curia

Forum of Caesar

Forum of Augustus

Temple of Mars Ultor

Temple of Castor and Pollux

Basilica Aemilia

| 0 | 150 | 300 feet |
| 0 | 50 | 100 metres |

19.8 Temple of Mars Ultor (reconstruction drawing), in the Forum of Augustus. After 27 BCE, unfinished Forum dedicated in 2 BCE.

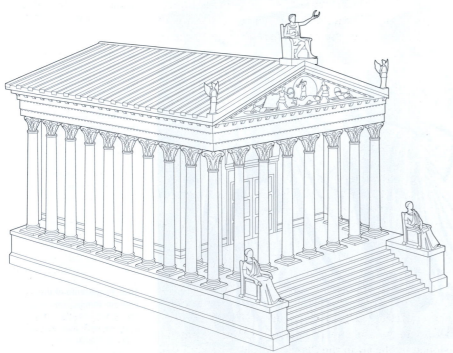

own ideological campaign, which speaks to the power of monuments to convey diverse messages to changing audiences throughout time. To commemorate the 2,000-year anniversary of Rome's first emperor, Mussolini had the altar reconstructed and re-sited in a special glass building near the Mausoleum of Augustus, where he planned to be buried. The glass enclosure housing the *Ara Pacis* was replaced in 2006 by a modern building commissioned by the city of Rome.

IMPERIAL FORUMS Like the Forum of Pompeii discussed in Chapter 18, the Roman Forum (located in the center of the city of Rome) was the focus of civic life, with considerable open-air space and buildings and structures serving a range of purposes. Romans gathered in the Basilica Aemilia (a Roman basilica was a civic building, sometimes used as a law court) for public meetings and shopped in one of the many markets fronting it. The senate met in the **forum's** Senate House, speeches were given from a platform called the *rostra*, and Romans participated in religious rituals at temples dedicated to the gods Saturn, Concord, and Vesta. Before the construction of open-air theaters in Rome, gladiatorial combats also took place in the forum. At the end of the Republic and into the imperial period, many activities shifted to the imperial forums being constructed adjacent to the Roman Forum, in order to highlight the emperor's power (**Fig. 19.7**).

FORUM OF AUGUSTUS The first imperial forum, the Forum of Julius Caesar, was located near the Roman Forum and dedicated by Caesar in 46 BCE. It included a large courtyard surrounded by a **colonnade** with a temple on the northwest side dedicated to Venus Genetrix (meaning foundress of the family), from whom Julius Caesar claimed divine descent. Inside the *cella* of the temple were statues of Venus, Caesar, and Cleopatra.

Later, after 27 BCE, Caesar's adopted son Augustus had a forum completed in his own name. Like the Forum of Julius Caesar—to show Augustus's connection to the deified Caesar—the Forum of Augustus was enclosed by a colonnade, with *exedrae* added behind the columns on the long sides. In the colonnade, Augustus dedicated numerous statues to important figures in Roman legend and history, including Aeneas, Romulus, and, of course, their supposed descendants, the Julio-Claudians. At the back of the forum was a temple dedicated to the god of war, Mars Ultor (Mars the Avenger) (**Fig. 19.8**), which Augustus had promised to build after avenging the murder of Julius

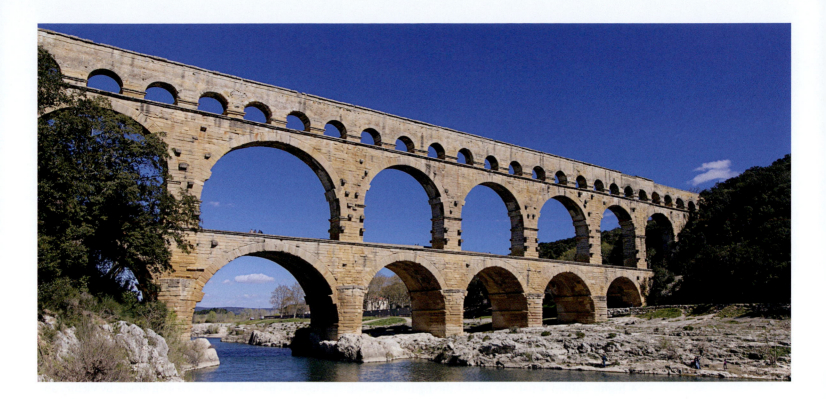

Caesar by several Roman senators who sought to end his dictatorship. Augustus held Roman military rituals in his forum, connecting them to the Temple of Mars.

The temple, raised on a high podium with a frontal staircase, was surrounded on three sides by **Corinthian** columns (see box: Looking More Closely: The Greek Orders, p. 225), which were far more popular in Rome than in Greece, where they originated. It was primarily constructed in brick and faced with marble, which was now readily available from the quarries in Carrara, Italy. As with sculpture, Augustus's architecture was heavily inspired by Classical Greece, once again drawing a connection between his rule and that of Perikles of Athens in the fifth-century BCE. Inside the Temple of Mars Ultor stood statues of Mars, Venus, and Julius Caesar. Augustus writes about the construction of the Temple of Mars Ultor in the *Res Gestae Divi Augusti* (Deeds of the Divine Augustus), a document about the emperor's accomplishments, the best preserved ancient copy of which was found on the walls of the Temple of Augustus and Roma in Ankara, Turkey.

PONT-DU-GARD Augustus did not limit his building campaign to the city of Rome, or even to Italy. During the Republican years, the provinces had suffered heavy taxation and other tribulations under corrupt officials, which had led to frequent unrest. Augustus reformed administration in the provinces and invested generously in their development, thereby winning the loyalty of many of their citizens. His public works left a deep visual imprint on the western provinces, especially in Gallia and Hispania, which saw the construction of roads, bridges, aqueducts, theaters, temples, and civic buildings.

Two prominent examples of public works from the first century CE that directly benefited the people in the region are the Pont-du-Gard, an aqueduct bridge in southern France that brought water to the city of Nîmes near Marseille, and the similar Pont de les Ferreres, also known as Pont del Diable, in Catalonia, Spain. The Pont-du-Gard (**Fig. 19.9**), which serviced a population of about 30,000, is a striking 161 feet high (49.07 m), with three stories of **arches**. Gravity moved the water, brought from a mountain spring about 30 miles (about 48 km) from the city, along the slightly sloping top story. Below, a footbridge allowed people to cross the Gardon River. The largest arches each span about 82 feet (24.99 m) and are constructed of carefully cut limestone blocks. The construction is so accurate that no mortar was necessary. Instead, the distribution of the weight of the precisely cut and placed blocks maintains the structural integrity of the arches and, therefore, the entire bridge—a testimonial to the reputation of the Romans as exceptional engineers.

Restraint and Excess during the Julio-Claudian Dynasty

Before Augustus's time, political offices in Rome were elected, but Augustus set up a system of familial succession that proved problematic for Roman administration given the lack of leadership qualities among those destined to rule. Given this new system of succession, some Roman art of the Augustan age was intended to help his family members inherit imperial roles; the relief of the procession of the imperial family on the *Ara Pacis* (**Fig 19.6**) is an example. Augustus died in 14 CE after a successful rule of more than forty years. He was deified (declared a god) by the Roman senate and succeeded by his stepson Tiberius (ruled 14–37 CE), Livia's son from her previous marriage. The Julio-Claudian dynasty, which began with Tiberius and ended with Nero, generally commissioned public art in the Classical Greek style preferred

19.9 Pont-du-Gard, first century CE. Near Nîmes, France.

forum an open area at the center of a Roman town where people shopped, worshiped, and participated in political or judicial activities.

colonnade a long series of columns at regular intervals that supports a roof or other structure.

cella (also called *naos*) the inner chamber of a temple; usually houses a statue of a deity.

exedra (plural ***exedrae***) an enclosed space or recessed area, usually semicircular.

Corinthian an order of Classical architecture characterized by slender fluted columns and elaborate capitals decorated with stylized leaves and scrolls.

arch a curved, symmetrical structure supported on either side by a post, pier, column, or wall; usually supports a wall, bridge, or roof.

by Augustus. This was a shrewd political move, given the success of his reign. However, some of the dynasty's private art, including the *Gemma Augustea* (see **Fig. 19.10**), suggests interest in the more emotionally charged style of the Hellenistic period.

GEMMA AUGUSTEA An exceptionally large and luxurious onyx **cameo**, known as the *Gemma Augustea* (**Fig. 19.10**), alludes to the transition of power from Augustus to Tiberius. The Roman emperor frequently gave cameos as gifts to Roman and foreign dignitaries. However, the original **provenance** of this cameo is uncertain. It was first documented in 1246 in the Basilica of St. Sernin in Toulouse, France (see Fig. 35.3). It was later acquired by King Francis I of France, who moved it to Paris in 1533. Ultimately, it was sold to Rudolf II of the Holy Roman Empire (ruled 1576–1612). The gold setting was added in the seventeenth century.

Creating cameo reliefs is very difficult, as the artist carves into a stone with two veins of distinct colors. In the *Gemma Augustea*, the figures are carved into the white vein of the stone. The rest of the white is removed down to the darker vein, which serves as background. A highly skilled artist can model the figures through shading, by allowing some of this darker background to show through. Because of their skill and their use of precious or semi-precious stone as a medium, ancient Roman cameo carvers held a higher status than sculptors. Given the impressive quality of the carving of the *Gemma Augustea*, some believe that Dioscurides, named as Augustus's personal gem carver, was responsible for the work.

The *Gemma Augustea* is divided into two registers, seemingly carved in the Greek Classical style favored by Augustus. The lower register, however, combines more emotion and movement—two features of Hellenistic art (see Chapter 15)—with an interest in historical detail, specifically Rome's defeat of its enemies. On the left, Roman soldiers raise a pole holding the weapons and armor of the defeated enemy (a trophy), while two prisoners wait underneath. On the right side, Roman soldiers drag a man and woman by their hair toward the trophy. The scene probably represents a military victory of Tiberius, because a scorpion, the zodiac sign under which he was born, appears on the trophy's shield.

The upper register, set at least partly in the divine world, shows the king of the gods, Jupiter, with his eagle at his feet. Seated next to the helmeted goddess Roma on his right (viewer's left), he is being crowned by Oikoumene, the personification of what Romans saw as the 'civilized' world. Jupiter has the portrait features of Augustus, whose zodiac sign, Capricorn, is shown near his head. Oceanus (the personification of the seas, or of water) and Tellus, again with two children as on the *Ara Pacis*, are also present. To the far left, Tiberius, wearing a toga, steps down from a chariot driven by Victory and looks toward Jupiter/Augustus. To the right of Tiberius, wearing a cuirass, is probably Germanicus, member of the Julio-Claudian line and important military general. Both Tiberius and the younger Germanicus fought successful campaigns in Northern Europe.

Some scholars argue that the cameo must have been carved after Augustus's death, because it shows him as a god. In life, he would have forbidden such a depiction, because it would have contradicted the image of piety he sought to project. Augustus always chose to mask his absolute authority in the trappings of Republican tradition and religion. However, the presence of Hellenistic elements in a work created under the reign of Tiberius is not surprising—he appears to have favored the Hellenistic style in his private art. Others have suggested that the cameo was indeed made during the life of Augustus and that his depiction as a god was acceptable because, like most cameos, it was intended solely for a private audience. Regardless of the date of production, the message that Tiberius was destined to rule is abundantly clear, as is the interest in both Classical and Hellenistic styles of art.

PORTA MAGGIORE The maternal great-grandson of Augustus, Gaius Julius Caesar Germanicus, better known as Caligula, was the first blood relative of Augustus to become emperor. Like Augustus, he adopted the idealized Classical style in his portraits, in which he even took on features of Augustus, but his rule was a cruel one, fueled by his irresponsibility and desire for absolute power, even claiming himself to be divine. He was known for his excess, which included the murder of some family members. In 41 CE, members of his own Praetorian Guard (the emperor's team of personal bodyguards) assassinated him. He was succeeded by his uncle Claudius, who ruled from 41 to 54 CE. Unlike Caligula, Claudius practiced more restraint in his rule than Caligula, and did not demand divine honors, although he did depict himself as Jupiter in

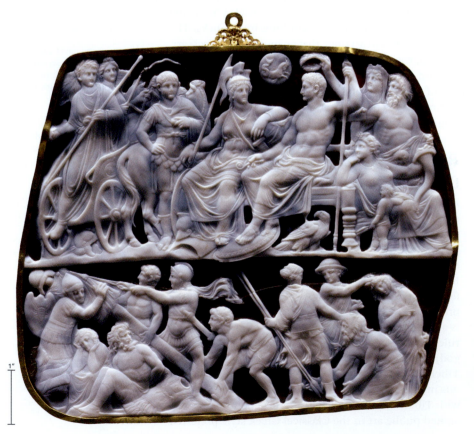

19.10 *Gemma Augustea*, early first century CE. Onyx cameo, 7½ × 9 × ½ in. (19.1 × 22.9 × 1.3 cm) Kunsthistorisches Museum, Vienna.

1"

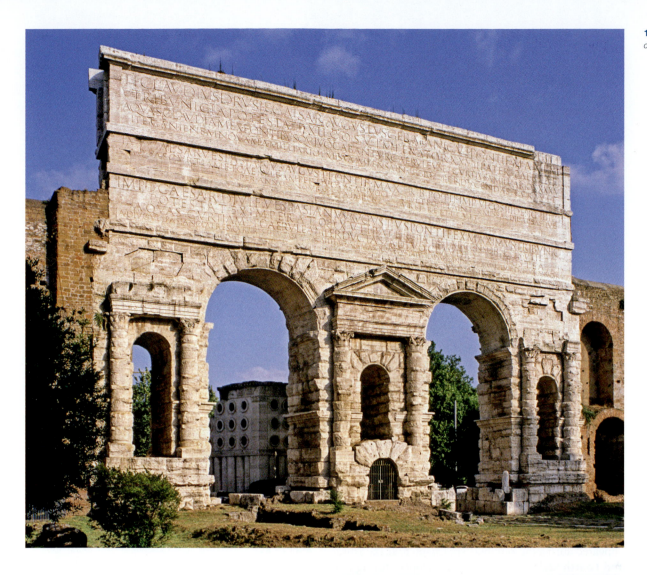

portraiture. Claudius is also known for important public works, including the Porta Maggiore (**Fig. 19.11**), which supported parts of two aqueducts, the Aqua Claudia and the Aqua Anio Novus. The water moved in two channels above the arches, under which passed two Roman roads. Incorporated into new city walls in the third century CE, this public monument became a gateway to Rome and is still visible today. The lower portion of the masonry is made of roughly carved stones; this rustic approach to the architecture of the Aqua Claudia contrasted with the finished Classicism favored by Caligula, and may symbolize a break from his reckless excesses.

DOMUS AUREA (GOLDEN HOUSE) Nero, the final emperor of the Julio-Claudian dynasty, is known for his extremely cruel and extravagant personal behavior and his excessive spending, especially on his sumptuous palace, the partly gilded Domus Aurea, or Golden House (**Fig. 19.12**). It contrasted sharply with the more Republican-minded, fairly modest home of Augustus on the Palatine Hill. Sprawling over parts of the Palatine, Esquiline, and Caelian hills, Nero's palace was built near the Roman Forum on prime real estate that he confiscated after fire destroyed much of the city. Popular legend tells us that Nero fiddled while Rome burned; a story that indicates the Romans' deep mistrust of him.

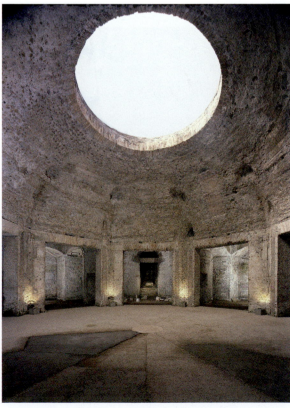

19.12 Octagonal room in the Domus Aurea (Golden House) of Nero, built by Severus and Celer (architect and engineer), *c.* 64 CE. Rome.

As described by the Roman biographer Suetonius, Nero's palace was located on a site with lavish gardens and an enormous artificial lake. The lake was surrounded by buildings that resembled cities, and the gardens consisted of "tilled fields, vineyards, pastures and woods, with great numbers of wild and domestic animals." Parts of the Domus Aurea were overlaid with gold and studded with precious stones and mother-of-pearl, and its dining rooms had ceilings of ivory panels that slid back to let flowers or perfume sprinkle down on Nero's guests. Suetonius also says that the main dining room revolved in time with the movements of the celestial bodies. Excavations in 2009 uncovered what seems to be this very room based on the remains of the architecture that would have allowed the room to rotate. A coin minted during the reign of Nero, which shows an elaborate structure with a **domed** room above a platform, labeled MAC AUG (*machina augusta*, or machine of the emperor), may depict Nero's marvel of engineering.

Other architectural features in the Domus Aurea laid the foundation for later feats of Roman construction, such as an octagonal domed room made of brick-faced concrete (see box: Making It Real: Roman Concrete, p. 335) with a large **oculus** (**Fig. 19.12**), which predates the Pantheon (see Fig. 20.13). Impressive vaulted rooms were also made of concrete. The entrance courtyard to the palace contained a roughly 100-foot-high (30 m) colossal statue of Nero. Suetonius tells us that when Nero dedicated his palace, he remarked that he was "at last beginning to be housed like a human being."

THIRD AND FOURTH STYLE WALL PAINTING

While the First and Second Style wall paintings first appeared during the Republic (see Chapter 18), the Third and Fourth Style wall paintings developed during the imperial period. Impressive examples of both the Third (**Fig. 19.13**) and Fourth (**Fig. 19.14**) Style were discovered in the Domus Aurea during the late fifteenth century. Several Renaissance painters, including Raphael, gained access to the Domus Aurea and found these Roman paintings so inspiring that they incorporated their style into their own works in the Vatican. In contrast to Second Style paintings that visually dissolve the wall by painting three-dimensional scenes, artists working in the Third Style painted large areas of solid color, such as red or white, decorated with delicate decorative floral or architectural designs that had nothing in common with reality.

THIRD STYLE PAINTING FROM THE DOMUS AUREA

A Third Style vaulted ceiling in the Domus Aurea featured areas of white framed by spindly rectangles and elegant decorative floral designs, with fantastical creatures making fairly regular appearances (**Fig. 19.13**). This style is a complete break from the illusion of three dimensions so central to the Second Style, whether in figures, architecture, or landscapes (see box: Looking More Closely: Gardenscape from the Villa of Livia at Prima Porta, p. 324, and Fig. 18.17). Not all Romans approved of

19.13 Third Style ceiling painting from the Domus Aurea (Golden House) of Nero, *c.* 64–68 CE. Rome.

Chronology

31 BCE	Octavian defeats Mark Antony and Cleopatra at the Battle of Actium
27 BCE	The senate confers the title of Augustus on Octavian; *Pax Romana* begins
after 27 BCE	Construction of the Forum of Augustus with Temple to deified Julius Caesar; the unfinished Forum is dedicated in 2 BCE
13 BCE	The *Ara Pacis Augustae* (Altar of Augustan Peace) is commissioned
12 BCE	Augustus is elected *pontifex maximus*
***c.* 30–20 BCE**	The Villa of Livia at Prima Porta is decorated with Second Style wall paintings
early first century CE	The Pont-du-Gard is built in France
14 CE	Augustus dies and is deified; Tiberius becomes emperor
29 CE	Livia, Augustus's wife, dies
37 CE	Caligula becomes emperor of Rome
41 CE	Caligula is assassinated; Claudius becomes emperor of Rome
***c.* 50 CE**	The Porta Maggiore is built by Claudius
54 CE	Nero becomes emperor of Rome
64 CE	The Great Fire of Rome destroys much of the city
***c.* 64 CE**	Nero builds the Domus Aurea, his extravagant palace
68 CE	Nero is forced to commit suicide after being declared a public enemy of the state; the Julio-Claudian dynasty comes to an end

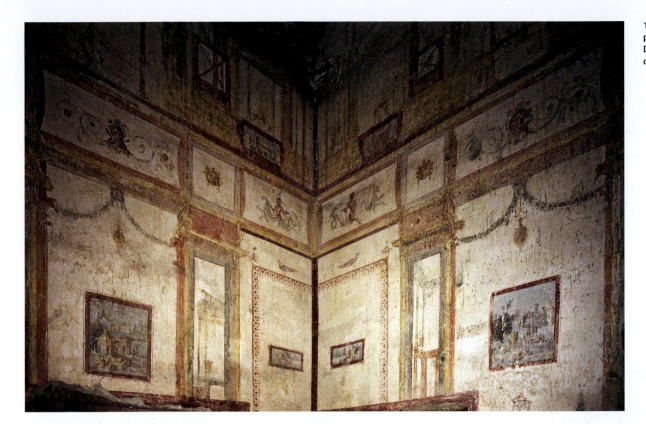

19.14 Fourth Style wall paintings in room 78 of the Domus Aurea (Golden House) of Nero, *c*. 64–68 CE. Rome.

the change. The architect Vitruvius scoffed, "We now have fresco paintings of monstrosities, rather than truthful representations of definite things." His lament calls to mind more modern critiques of innovative artistic styles.

FOURTH STYLE WALL PAINTING FROM THE DOMUS AUREA
Fourth Style wall painting is known for combining characteristics of the earlier styles. This is seen in the more plentiful Fourth Style paintings in the Domus Aurea. The example illustrated here (**Fig. 19.14**) draws on paintings of the Third Style, with white backgrounds and similar color schemes, but it shares with the Second Style an interest in **illusionism**. Here, landscapes appear in squares and rectangles resembling framed paintings on a white background, and architectural features in paint appear to have volume. The landscapes and architectural

vistas are generally not realistic, however, but rather imaginative and seemingly incomplete, such as columns that support nothing. Although they allude to the panoramic landscapes and architectural features of the Second Style, they are only decorative.

Nero's paranoia and self-indulgence ultimately led to his demise. In 68 CE, the senate declared him an enemy of the state and forced him to commit suicide, bringing the Julio-Claudian dynasty to an end. Nero's death resulted in a civil war that ended with the appointment of Vespasian as emperor and the beginning of the Flavian dynasty. Although Augustus popularized the Greek Classical style in his artistic campaign for cultural regeneration, the later association of Nero's corrupt reign with this style led the Flavian dynasty to turn back to Republican artistic traditions (see Chapter 20).

illusionism making objects and space in two dimensions appear real; achieved using such techniques as foreshortening, shading, and linear perspective.

Discussion Questions

1. Augustus and his wife, Livia, were responsible for ushering in the *Pax Romana* and a program of cultural renewal. What role did art play in advertising the *Pax Romana* and the cultural program? How did the style of art chosen by Augustus influence the message of the works of art?

2. The relief decoration of the *Ara Pacis Augustae*, or Altar of Augustan Peace, adds to the overall meaning of this monument. How might it have been read during the time of Augustus? What aspects of Augustus's rule did Mussolini perhaps want to emulate? Why?

3. Compare and contrast a monument of Augustus to the Domus Aurea of Nero. What can we learn from the artistic record about the personalities and ruling styles of these historical figures? You may find it interesting to consult Suetonius's biographies (see Further Reading).

Further Reading

- Augustus. *Res Gestae Divi Augusti* (*Deeds of the Divine Augustus*), *c*. 14 CE. Trans. Thomas Bushnell (1998) classics.mit.edu/Augustus/deeds.html (accessed May 26 2020).
- Claridge, Amanda. *Rome: An Oxford Archaeological Guide* (2nd edn.) New York: Oxford University Press, 2010.
- De Grummond, Nancy Thomson. "Pax Augusta and the Horae on the Ara Pacis Augustae." *American Journal of Archaeology* 94, no. 4 (October 1990): 663–77.
- Fullerton, Mark D. *Roman Art and Archaeology.* London and New York: Thames & Hudson, 2019.
- Suetonius. *The Twelve Caesars*, http://penelope.uchicago.edu/Thayer/e/roman/texts/suetonius/12caesars/home.html (accessed May 26 2020).

20

Art of the Roman Empire from the Flavians through the Good Emperors

69–192 CE

Column of Trajan
(detail), Rome

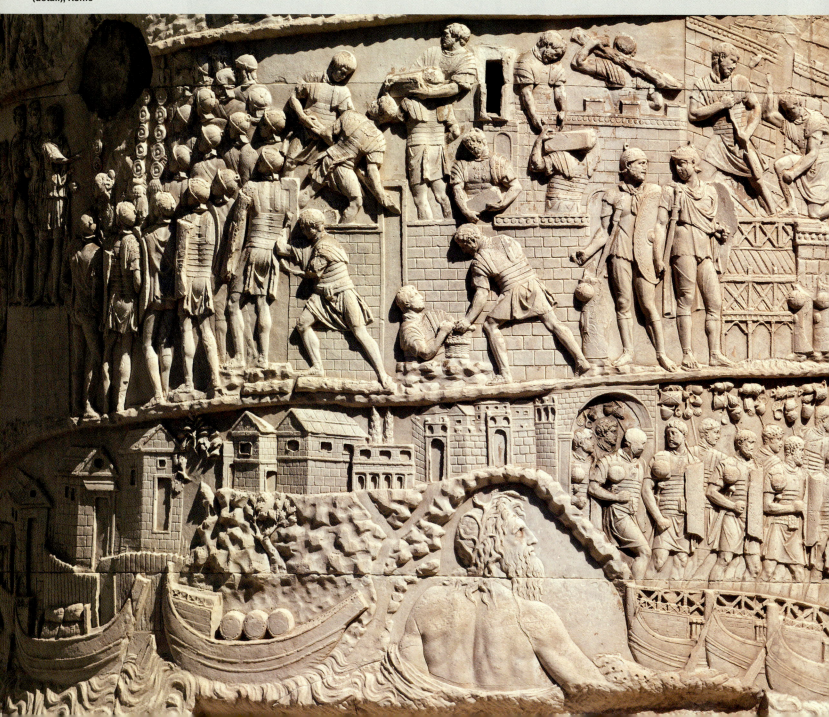

Introduction

After the downfall of Nero, the last emperor of the Julio-Claudian dynasty, a bloody civil war broke out as powerful men vied for control of the Roman Empire. The civil war ended when the general Vespasian, whom Nero had appointed to quash a revolt in the Roman province of Judea, was proclaimed emperor by his troops and marched on Rome. The senate recognized Vespasian as emperor in 69 CE, giving rise to the Flavian dynasty. The first two Flavian emperors, Titus Flavius Vespasian (better known as Vespasian; ruled 69–79 CE) and his oldest son, Titus (ruled 79–81 CE), were pragmatic military men who focused on the stability and solvency of the Roman Empire. Recognizing how shifts in artistic style and public monuments can sway public opinion, and in the wake of Nero's selfish extravagance, the Flavians chose to return to verism, a realistic (rather than idealistic) style in portraiture, to emphasize the wisdom and experience of the emperors (see Chapter 18). Their construction focused on building projects that benefited the Roman public.

The Flavians were succeeded by the Nerva-Antonine dynasty, which included the five so-called Good Emperors (Nerva, Trajan, Hadrian, Antoninus Pius, and Marcus Aurelius), who ruled during a time of increasing territorial expansion and political stability. The Good Emperors were not blood relatives. Instead, each emperor adopted his successor, presumably based on leadership qualities. The empire reached its greatest extent (**Map 20.1**) under Trajan (ruled 98–117 CE), who built on a scale not seen before. The next emperor, Hadrian, who took a more defensive stance militarily, is known for his travels throughout the empire and his love of all things Greek, both of which profoundly influenced the art and architecture created under his rule. During the reign of the powerful and philosophical Marcus Aurelius, art took on a more contemplative mood. This stability was not to last, however, as the age of the Good Emperors ended with the destructive behavior of Marcus Aurelius's son, the emperor Commodus.

The *Pax Romana* (Peace of Rome) begun by the first Roman emperor, Augustus, continued during the rule of the Flavians and the Nerva-Antonine dynasty. Under these emperors, Roman art emphasized historical narrative, commemorated military victories, and showcased advances in Roman engineering. In keeping with the diversity of those living throughout the vast Roman Empire, a plurality of styles continued to define the Roman aesthetic, especially in the provinces.

The Flavian Dynasty

Because of its great attention to detail, the artistic style of the Flavian dynasty is often called flamboyant. Yet in direct contrast to the self-indulgent works commissioned by Nero, and in a deliberate attempt to rebuild trust among Romans, the art and architecture of the Flavians were intended to benefit the citizenry rather than the emperor himself.

THE COLOSSEUM The Flavian amphitheater, the largest amphitheater in the Roman Empire, is Vespasian's

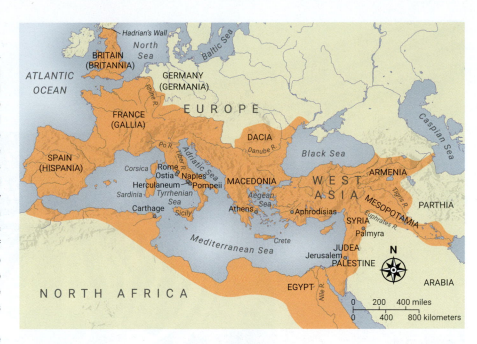

Map 20.1 The Roman Empire at its greatest extent under Trajan, 117 CE.

best-known contribution to Roman architecture (**Figs. 20.1** and **20.2**, p. 334). Since the Middle Ages it has been more popularly known as the Colosseum, owing to its location near the Colossus of Nero. (The Colossus was a 120-foot-high (36.58 m) statue of the excessive former emperor that was turned into a statue of the sun god Sol after Nero's death.) The Colosseum, a monumental arena for gladiatorial games (battles, often to the death, fought by highly trained fighters called gladiators—generally enslaved people, prisoners of war, or criminals—against other men or exotic wild animals) that were so popular in Rome, was begun around 70 CE and completed under Titus in 80 CE. Vespasian's decision to build it early in his reign was a shrewd maneuver, intended to earn the trust and support of Rome's residents after Nero's self-aggrandizement and extravagance. The siting of the Colosseum on what was once a lake on the grounds of Nero's Domus Aurea (Golden House) was another strategic move: Vespasian declared his loyalty to ordinary citizens by reclaiming the lands that Nero had confiscated from the Roman people.

With a capacity of more than 50,000 spectators, the Colosseum was a huge oval arena of approximately 615 × 510 feet (187 × 55 m). It was the grandest amphitheater in the empire, and the first permanent one in Rome. Its outer wall was 159 feet (48.46 m) high, which is more or less the height of a fifteen-story building. The building materials included an enormous concrete foundation, travertine (a light-colored limestone) **piers**, and concrete vaults (see box: Making It Real: Roman Concrete, p. 335). The exterior of the building was then faced with travertine. To grant easy access and to maintain the flow of foot traffic for the huge crowds, the architects incorporated seventy-six entrance doors that led to three levels of seating through a system of vaults and staircases. The vaults of the oval amphitheater slanted toward the arena floor to allow for continuously rising seating with unobstructed views of the action below. As in Pompeii, the seating was ranked, with those of higher status seated closer to the arena floor. On hot or rainy

pier an upright post that supports horizontal elements, such as a ceiling or arches.

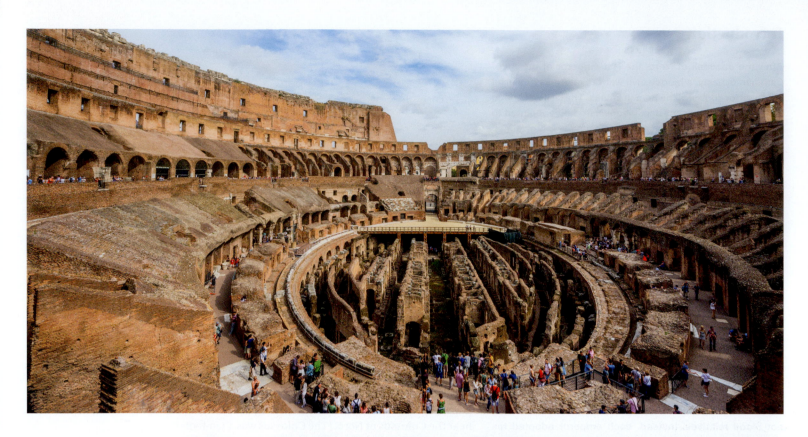

20.1 ABOVE **Interior of the Colosseum (Flavian Amphitheater),** *Rome, c.* 70–80 CE. Tufa and concrete faced with travertine.

20.2 RIGHT **Exterior of the Colosseum (Flavian Amphitheater),** *Rome, c.* 70–80 CE. Tufa and concrete faced with travertine.

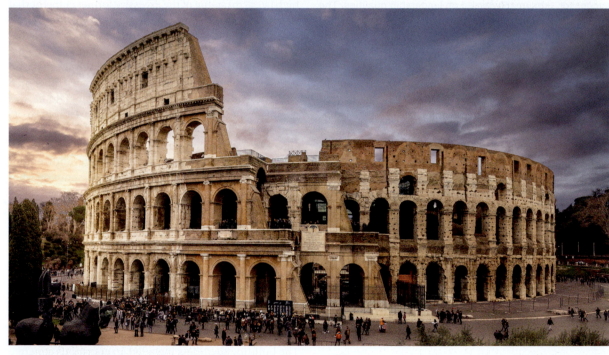

arcade a covered walkway made of a series of arches supported by piers.

arch a curved, symmetrical structure supported on either side by a post, pier, column, or wall; usually supports a wall, bridge, or roof.

engaged column a column attached to, or seemingly partially buried in, a wall.

pilaster a flat, rectangular vertical projection from a wall; usually has a base and a capital, and can be fluted.

days, the spectators were at least partially protected by an impressive mechanical awning, or *velarium* (similar to the one seen in a painting from Pompeii; see Fig. 18.11), the holes for which are still preserved in the uppermost level of the structure's outer walls. Below the arena floor was a system of passageways and rooms to hold gladiators and wild animals, who could be dramatically hoisted up to the arena floor when it was time for them to engage in combat (**Fig. 20.1**).

The exterior of the Colosseum, much of which remained visible even after the structure was used as a quarry for construction materials during the medieval and Renaissance periods, consisted of four levels (**Fig. 20.2**). The first three levels each featured an **arcade** of rhythmically repeating **arches** framed by **engaged columns**, while the fourth level had no arches. The ground level had Tuscan columns (similar to Doric, but with a base and no fluting), the second level had Ionic columns, the third level had Corinthian columns, and the fourth and topmost level had engaged Corinthian **pilasters** (for a guide to the Classical orders, see box: Looking More Closely: The Greek Orders, p. 225). Although these

The Romans played a major role in advancing concrete technology. When they began using concrete for arches and vaults, enabling large open interior spaces, they revolutionized the scale and style of architectural design and engineering in the capital and beyond. Concrete is a versatile building material that consists of an aggregate (typically pieces of stone or broken bricks) and a binding agent (cement). The binding agent was usually lime, gypsum, or, in the case of ancient Rome, pozzolana, a volcanic sand named after the city near Naples where it was mined. When mixed with water, the ingredients combine and harden into a very strong, long-lasting building material. Concrete made with pozzolana is extremely durable.

Before the development of Roman concrete and its expanded use during the Late Republic, most arches, vaults, and domes were made of stone (see box: Making It Real: Etruria, Rome, and the Roman Arch, p. 296). Stone was heavy, often had to be moved over great distances, could be rather expensive, and required considerable skill to cut and work. In contrast, the materials needed for concrete were relatively inexpensive and easier to transport. Concrete also required less skill to work than stone while offering more variety in shape: A framework of rough stones or wood was filled in with concrete, or had concrete poured over it.

In addition, concrete has greater structural integrity than stone. Larger spaces could be spanned without interior supporting columns, and openings for light could be added, thus allowing for greater innovation in Roman architectural design and style. A good example of a concrete structure that allows natural light is the large hall inside the Markets of Trajan, a multi-story complex of shops, offices, and passageways (**Fig. 20.3**).

Romans chose to conceal concrete, which they did not find pleasing to the eye, in a variety of ways. Stucco, a fine plaster used to finish walls, was an inexpensive way to cover a building and to give it a clean-looking finish. Expensive marble revetment (protective and/or decorative facing) was reserved for structures intended to be impressive, such as the Pantheon, a temple dedicated to all the Roman gods and goddesses (see **Fig. 20.13**). Sometimes bricks or other blocks were used to face concrete.

Concrete buildings were much less likely to burn down than earlier structures made partly from wood. Concrete vaults are also safer than masonry, as it takes only one loose stone to jeopardize the structural integrity of a stone-built vault or dome.

20.3 Concrete groin vault in the Markets of Trajan, Rome, c. 100–112 CE. The vault was originally faced with brick, as can be seen on the piers of the vaults.

features are hallmarks of **post-and-lintel** construction in Greek architecture, here, as in earlier Etruscan and Roman works, they have no structural purpose. Later, Renaissance artists and architects would use these decorative engaged columns as a starting point for their fifteenth-century designs.

Vespasian did not live to see the completion of the Colosseum. In keeping with Vespasian's desire to reclaim this space for the Roman people, his son and heir, Titus, dedicated the building in 80 CE with one hundred straight days of games. Writing about the games later in the third century CE, the historian Dio Cassius mentions gladiatorial combats, animal hunts, and even naval battles during which the arena floor was flooded.

THE ARCH OF TITUS, HISTORICAL NARRATIVE, AND THE TOOLS OF PERSPECTIVE

The Romans favored a monumental architectural motif known as the **triumphal arch**, which had the sole function of serving as visual propaganda. Triumphal arches were set up all over the empire. Historical narrative played a prominent role in their imagery, including in the relief sculpture on the Arch of Titus, which was built

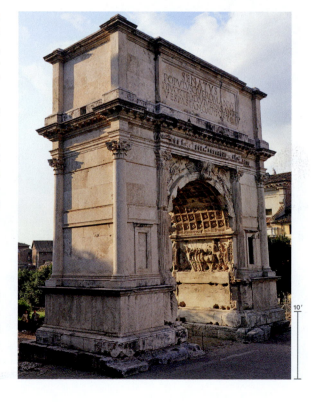

post-and-lintel a form of construction in which two upright posts support a horizontal beam (lintel).

triumphal arch a freestanding archway that often spans a road or marks an entrance; decorated with relief carvings alluding to a historical, often military, victory.

20.4 Arch of Titus, Rome, c. 81 CE. Marble, height 50 ft. (15.2 m).

attic on a facade or triumphal arch, the section above the frieze decorated with painting, sculpture, or an inscription.

spandrel the almost triangular space between the outer curve of an arch, a wall, and the ceiling or framework.

barrel vault also called a tunnel vault; a semi-cylindrical ceiling that consists of a single curve.

perspective the two-dimensional representation of a three-dimensional object or a volume of space.

high relief raised forms that project far from a flat background.

low relief (also called bas-relief) raised forms that project only slightly from a flat background.

of concrete and faced with marble (**Fig. 20.4**, p. 335). After Titus's death, his brother and successor Domitian erected this arch to commemorate his brother's victories in the Jewish Wars, during which Rome sacked Jerusalem and plundered and destroyed the Second Temple in 70 CE. (Notably, at this time the city of Rome was already home to a thriving Jewish population, many of whom came there seeking opportunities in the capital.) The Second Temple (originally built in the sixth century BCE and substantially renovated beginning in 20 BCE) was the Jewish holy temple, constructed on the Temple Mount in Jerusalem after the First Temple was destroyed by Nebuchadnezzar II of Babylonia around 586 BCE.

Significant Roman military victories were commemorated by a celebration and procession in which a general or emperor and his troops, having left their weapons outside of the city, paraded through Rome with captives and spoils of war. Such a procession appears to be the subject of the relief sculpture on the arch's inside walls. The arch is located in a prominent position on the Via Sacra, or Sacred Way, a major road between the Colosseum and the Roman Forum, on the prescribed route for all such processions in Rome. This ensured that all future processions would pass under this arch, literally in the shadow of Titus's triumph. Thus, in addition to commemorating Titus's win, the arch also formed part of the celebration of future victories.

The enormous dedicatory inscription carved in bold lettering on the **attic** of the arch opens with SPQR, which stands for *Senatus Populusque Romanus* ("The Senate and People of Rome"). The inscription continues, "... to the divine Titus, son of the divine Vespasian." In the vault of the arch is a scene of the emperor's apotheosis, or deification, indicating that this monument

commemorates the divine Titus after his death. In the **spandrels** are winged Victories standing on a globe and holding emblems of triumph, including trophies, palm fronds, and laurel wreaths. Above the spandrels a frieze showing a triumphal procession runs around the whole arch. The relief panels located on either side of the interior of the arch—and above eye level as visitors walk through the arch and under a **barrel vault**—function as pseudo-historical records of Titus's procession. As is often the case in Roman art, the narrative is probably more ideal than real.

RELIEF OF THE SPOILS OF JERUSALEM, ARCH OF TITUS

On one side of the arch's inner wall, Titus's soldiers push forward toward a triumphal arch that looks quite similar to the Arch of Titus itself (**Fig. 20.5**). They have captives and carry booty, including a large menorah (Jewish candelabrum, perhaps the gold menorah captured from the Temple of Jerusalem, as described by the first century CE Jewish historian Josephus in his history of the war in Judaea. The artist used several tools of **perspective** skillfully to create the illusion of three-dimensionality and to show movement and depth. For example, the arch is turned and projects into the viewer's space; the figures in the foreground are carved in **high relief** while the figures in the background are carved in **low relief**, giving the illusion of greater depth; and the bodies and drapery of the individuals are modeled and turned in order to give the sense that the crowd is pushing forward, with those to the right walking through the arch. The play of light and shadow across the figures intensifies the sense of movement among this crowd, which is much more dynamic than the staid figures in procession on the *Ara Pacis* of Augustus (see Fig. 19.6).

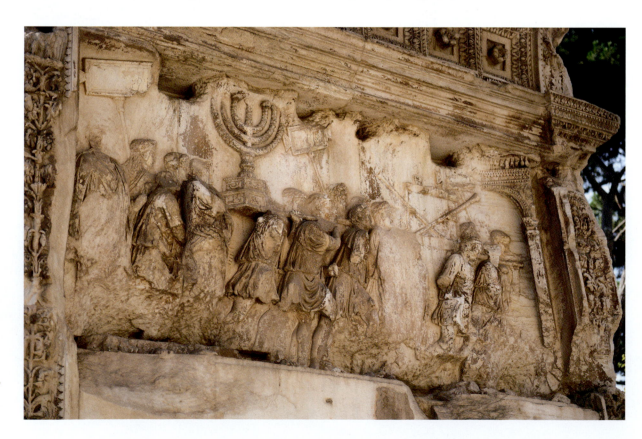

20.5 The Spoils of Jerusalem, from Arch of Titus (detail), Rome, *c.* 81 CE. Marble relief, height 7 ft. 10 in. (2.39 m).

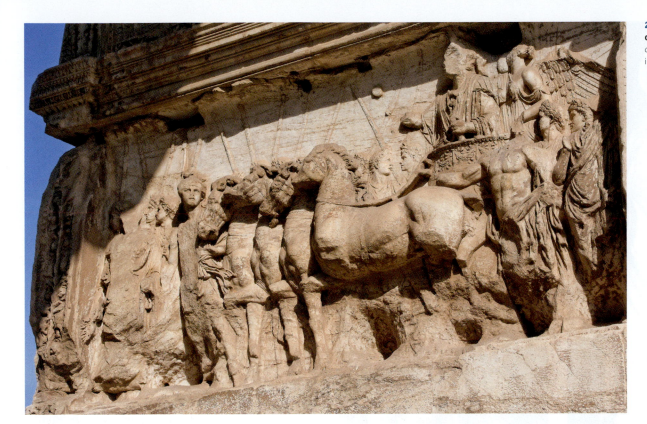

20.6 **The Triumph of Titus, detail from Arch of Titus,** Rome, *c.* 81 CE. Marble relief, height 7 ft. 10 in. (2.39 m).

RELIEF OF THE TRIUMPH OF TITUS, FROM ARCH OF TITUS

On the opposite wall of the inner part of the arch, Titus is shown in a chariot moving at an angle toward the crowd; the horses are shown in profile (**Fig. 20.6**). As with the carving in **Fig. 20.5**, figures in the background (note the heads behind the horses) are carved in low relief, while those in the foreground (including the horses and the emperor himself) are in high relief. Titus is being crowned by a personification of Victory. The goddess Roma (a personification of the city) or *virtus* (virtue, in the Roman sense of leadership and courage) leads the chariot in front of the horses. The inclusion of divine figures in the same space as the mortal emperor on a public monument, albeit after his death, was innovative. (The *Gemma Augustea* cameo, Fig. 19.10, shows Augustus as Jupiter and surrounded by other deities, but it was probably a private object.) After Titus's time, the depiction of divine and imperial figures together became a prominent part of Roman imperial narrative, even during the lifetime of the emperor represented.

FLAVIAN PORTRAITURE

Vespasian returned Flavian portrait sculpture to the **verism** of earlier Roman portraits. The decision was characteristic of his practical approach to Roman politics and his ability to relate to the common people. This was an intentional break from Nero, and one that emphasized the emperor's age and wisdom.

PORTRAIT OF VESPASIAN FROM OSTIA

We see this return to verism in the imperial portrait of Vespasian found in Ostia, the port of Rome. Emphasizing age, experience, and therefore wisdom, the emperor is shown with a receding hairline, wrinkles on the face and neck, and small, pursed

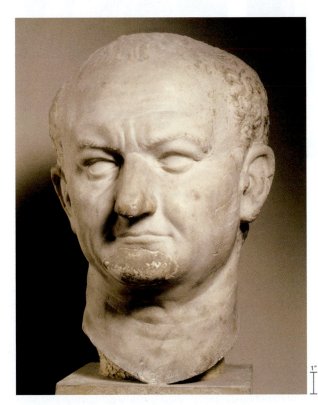

20.7 **Portrait of Vespasian,** found at Ostia, Italy, 69–79 CE. Marble, approx. height 15½ in. (39.3 cm). Museo Nazionale Romano, Rome.

lips (**Fig. 20.7**). This depiction of Vespasian looks back to the traditional portraiture style of the Republic, and it probably helped to legitimize his rule among Rome's common people, who had felt so alienated during Nero's reign. The artist succeeds here in presenting an image of an emperor who is concerned with keeping the empire stable and financially sound, and who has the ability and experience to do it.

verism preferring realism, especially in portraiture, to the heroic or ideal; comes from the Latin *verus*, meaning "true."

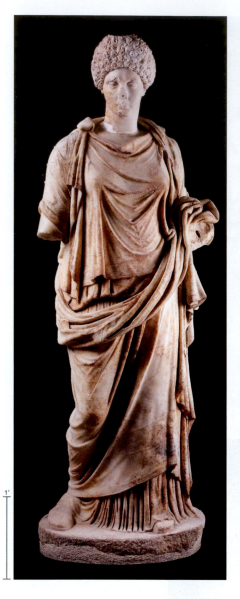

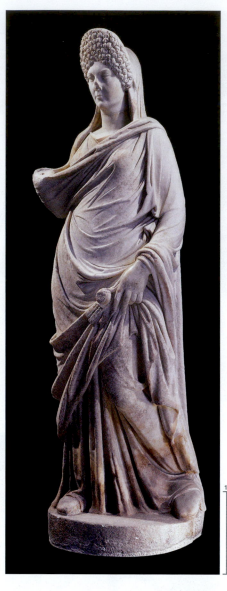

the Roman Empire. (Experimental archaeology suggests that the hair was actually sewn into place.) These sculptures clearly demonstrate that both youth and maturity were valued in Roman women, and that the styles popularized in Rome spread beyond the capital to the provinces.

The Nerva-Antonine Dynasty: The Roman Empire under the Good Emperors

Though Vespasian and Titus were emperors popular with the Roman citizenry, Domitian, who succeeded them, was a despot who was ultimately assassinated in 96 CE by members of the Praetorian Guard, who served as his bodyguards. On the same day, the senate appointed Nerva (ruled 96–98 CE) as emperor, the first of the Nerva-Antonine dynasty. All but one of the seven Nerva-Antonine rulers were adopted by their predecessor. Five of them are often called the Good Emperors because of their relative benevolence and the prosperity of their reigns: Nerva, Trajan (ruled 98–117 CE), Hadrian (ruled 117–138 CE), Antoninus Pius (ruled 138–161 CE), and Marcus Aurelius (ruled 161–180 CE). The last of the Nerva-Antonine dynasty, Commodus (ruled 180–192 CE), is the only one born to his predecessor, Marcus Aurelius. These emperors ruled during a period of great expansion of the Roman Empire, the grandeur of which is matched in the art and architecture of the time.

TRAJAN, *OPTIMUS PRINCEPS*

The Roman Empire reached its greatest geographic extent under Trajan, whom the senate declared *Optimus Princeps* ("the best ruler"). Born in Spain, Trajan earned respect through his illustrious military career as a general before being adopted by Nerva and becoming emperor. Militarily, Trajan is best known for his conquest of Dacia (roughly present-day Romania), which brought great riches to Rome as a result of the abundance of gold found there. With this new wealth, Trajan was able to build on an unprecedented scale in Rome and beyond.

The most famous of Trajan's building projects was his **forum**, which contained structures that served governmental, commercial, legal, and religious functions. Begun by Trajan around 110 CE, it was the largest of the imperial forums in Rome. It was entered from the Forum of Augustus (see Fig. 19.8) and located adjacent to the Forum of Julius Caesar, both of which it dwarfed in size. The architect was Apollodorus of Damascus, a Syrian-Greek who worked as Trajan's chief military engineer during the Dacian Wars.

TRAJAN'S FORUM The forum comprised several structures and monuments designed as a unit to glorify the emperor's impressive military and economic success (**Fig 20.9**). A bronze chariot group (known by a coin from the period that shows the entrance and its sculptural decoration) topped a triple-arched gateway that led into a very large **colonnaded** courtyard with a **portico**. A gilded bronze statue of Trajan on horseback was located in the center of the courtyard. On either side of the courtyard was a semicircular *exedra* similar to those in the

20.8a ABOVE **Statue of a Flavian woman wearing a** *peplos* and **20.8b** ABOVE RIGHT **Statue of Flavian woman in the guise of Ceres,** found together in Aphrodisias (Turkey), early second century CE. Marble, approx. height 6 ft 6 in. (2.03 m). Istanbul Archaeological Museum, Istanbul, Turkey.

PORTRAITS OF FLAVIAN WOMEN Portraits of Flavian women, known for their elaborate hairstyles, depict women at varying ages. Many also show clearly individualized portrait features. Two portraits that are considered a pair owing to their similarity in size, carving style, **iconography**, physiognomy, and hairstyles were excavated at Aphrodisias, an important Roman provincial capital in southwest Turkey. Though they share many similarities, there are distinct differences. The woman on the right (**Fig. 20.8b**), who appears older and holds a pomegranate and ears of wheat in her left hand, may be depicted as Ceres, the goddess of agriculture, fertility, and motherly love. She wears a veil over her head and a mantle (cloak), and her facial features, including a sagging chin and bags under her eyes, suggest maturity. The woman on the left (**Fig. 20.8a**) wears the *peplos*, a more traditional, old-fashioned, and perhaps conservative form of dress fit for a young woman, and her facial features are more youthful. The older figure may be the mother of the younger one. In both cases the hair is impressively carved into matching Flavian hairstyles, using drillwork that shows the sculptor's skill. Flavian women popularized this elaborate hairstyle, which became fashionable throughout

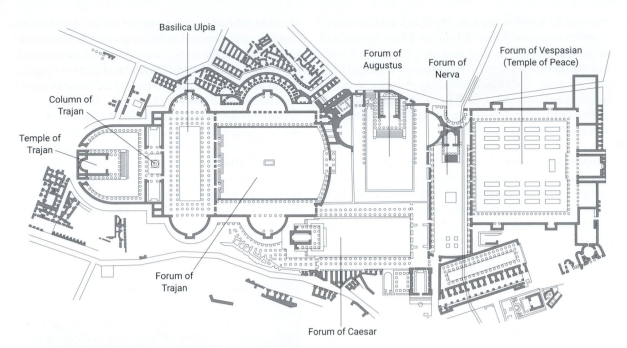

Basilica Ulpia

Forum of Augustus

Forum of Nerva

Forum of Vespasian (Temple of Peace)

Column of Trajan

Temple of Trajan

Forum of Trajan

Forum of Caesar

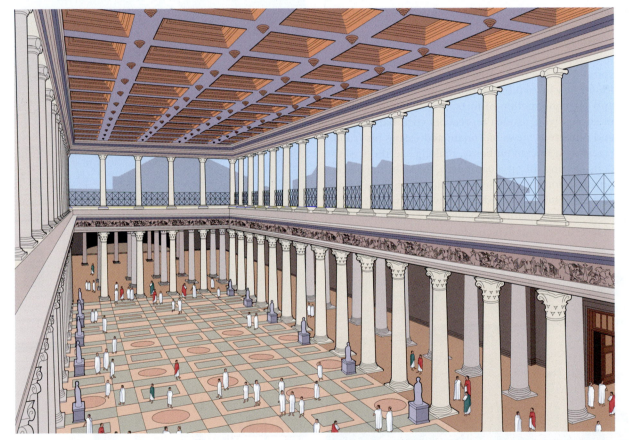

20.10 Interior of the Basilica Ulpia (reconstruction drawing), Rome, *c.* 110 CE.

iconography images or symbols used to convey specific meanings in an artwork.

forum an open area at the center of a Roman town where people shopped, worshiped, and participated in political or judicial activities.

colonnade a long series of columns at regular intervals that supports a roof or other structure.

portico a covered space defined by a series of columns placed at regular intervals to support the roof.

exedra an enclosed space or recessed area, usually semicircular.

basilica a longitudinal building with multiple aisles and an apse, typically located at the east end.

Forum of Augustus. At the back of the courtyard was the large Basilica Ulpia, and beyond that the Column of Trajan, which was originally flanked by libraries that held Trajan's Latin and Greek texts. It is still debated whether a temple dedicated to the divine Trajan was built beyond the column after his death. Finally, because part of Trajan's Forum took over a commercial area, Trajan had a new covered market constructed just beyond his forum that provided space for more than 150 shops. Part of the market's structure mirrors the *exedrae* of Trajan's Forum, and it also included an impressive main hall with brick-faced concrete groin vaults (see **Fig. 20.3**). The market, too, was probably designed by Apollodorus of Damascus.

BASILICA ULPIA The Forum of Trajan was the first of the imperial forums in Rome to include a **basilica**: the Basilica Ulpia, which was named after Trajan's family (**Fig. 20.10**). Although largely destroyed, the remains of columns give some idea of former glory of this building. This massive rectangular structure, which functioned as a court of law

and was designed to impress, stood in a position where temples appeared in the forums of Julius Caesar and Augustus. The central **nave** was 385 feet (117.35 m) long, not including the length of the **apses** on each end from which judges adjudicated. Flanking the nave were two colonnaded side **aisles**, and above the side aisles was either a **gallery** or **clerestory** to let in light. The basilica was entered from its long side.

TRAJAN'S COLUMN The 128-foot-high Column of Trajan (**Fig. 20.11**), built to commemorate his victorious Dacian campaigns, is an example of the narrative art that Trajan used for propaganda purposes. Located just beyond the Basilica Ulpia, it also served to indicate the height of the hill that Trajan removed in order to build the forum, a feat he considered impressive enough to document in the inscription on the column's base. The column is made of hollow marble drums placed on top of one another. The square base below the column, which became a mausoleum for Trajan and his wife Plotina after their ashes were placed there, was covered with sculptures of Dacian arms and armor. The very top of the column held a bronze statue of Trajan, though a later statue of St. Peter (1588) now occupies that position.

The relief sculpture on the column, which includes more than 2,500 figures, unfolds in a 625-foot (190.5 m) spiral from the bottom to the top of the column and illustrates in striking detail preparations for battle and the construction of forts. A continuous narrative of successive episodes represents vivid battle scenes and numerous views of Trajan: addressing his troops, receiving a Dacian embassy, making sacrifices to the gods, setting off on a campaign, and viewing Dacian prisoners (or just their heads) brought to him by Roman soldiers. While it is tempting to view these narrative reliefs as an accurate historical document of the Dacian Wars, in fact the column depicts stock scenes that convey the

extensive preparations for war, the battles, and the *virtus* (courage and character) of Trajan as commander-in-chief. In other words, the scenes send a powerful propagandistic message that glorifies Trajan and the Roman army.

For example, the lowest band of the column depicts the movement of soldiers through an arch and across a pontoon bridge over the River Danube, also personified as a river god, with boats moored along the shoreline and Dacian houses in the background (see p. 332). The soldiers carry their gear, including such simple necessities as pots and pans, over their shoulders. The two bands above show Roman soldiers constructing forts, bringing to life the first-century CE writer Josephus's description of how Roman armies carefully prepared their camps in advance of fighting. In the second band from the bottom

20.11 FAR RIGHT **Column of Trajan,** Rome, dedicated *c.* 110 CE, Marble, height 128 ft. (39.01 m).

20.11a BELOW **Roman soldiers in *testudo* (tortoise) formation attack a Dacian fortress.** Relief on the Column of Trajan (detail).

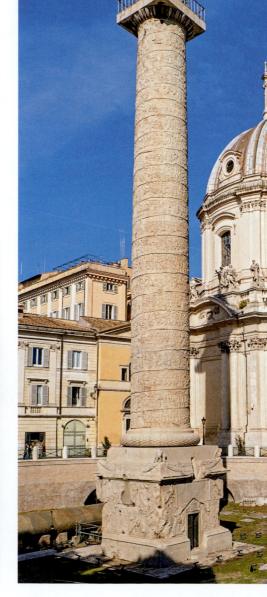

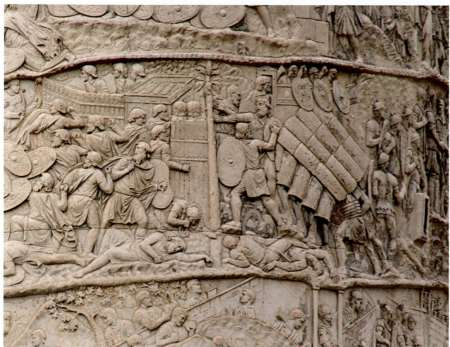

Trajan addresses his troops from a **podium** (on the left). Among the battle scenes is one that shows Roman soldiers in *testudo* (tortoise) formation, placing their shields together over their heads to make a shell or shield to protect them while they storm the Dacian fortress (see **Fig. 20.11a**). The Roman soldiers are easily distinguished from the Dacians by their dress. The bearded Dacians wear baggy trousers and a belted over-garment.

The action taking place on the column is clearly readable thanks to unrealistic proportions and a variety of viewpoints. Realistic scale is abandoned, with men shown as large as horses and boats, and distant and close figures often rendered in identical size. Developed tools of perspective are not used, but the artist took into account the viewer's position and increased the height of the narrative band as it moves up the column, from 3 feet on the bottom to 4 feet on the top. The figures were brightly painted, which would have helped viewers pick out details, though the higher levels would have been very difficult to see from the ground. Balconies on the libraries on either side of the column may have provided better viewing positions.

HADRIAN AND THE CLASSICAL REVIVAL

Upon Trajan's death, the position of emperor passed to Hadrian, a somewhat distant relative of Spanish descent. Trajan had become Hadrian's guardian after the death of his father. Though many previous emperors embraced Greek style and culture, Hadrian, who travelled extensively, was a true and learned Hellenophile (lover of Greece and Greek culture). He spoke Greek and is known for ushering in a Classical revival in the arts of Rome and the provinces. When in Italy, he enjoyed spending time in Tivoli (not far from Rome) at his elaborate country villa, with its sculptures and architecture heavily influenced by Greek and Egyptian styles. His rule demonstrated a philosophical shift from the battlefield to Classical learning.

Hadrian was responsible for numerous portraits and architectural structures throughout the vast Roman Empire. In fact, the number of extant portraits of Hadrian is exceeded only by those of Augustus. Like Augustus, Hadrian adopted the idealized portrait style of Classical Greece rather than the veristic style of previous emperors, but in contrast to Augustus and other emperors, he chose to depict himself as a Greek philosopher type with a beard. Although the construction of Hadrian's Wall (*c.* 122 CE) across the north of England provides evidence of the threats by invading forces on the frontier, it also demonstrates Hadrian's largely defensive stance, a shift from Trajan's expansionist politics.

TEMPLE OF BAALSHAMIN

No emperor before Hadrian spent so much time traveling around the Roman Empire. Public monuments, including arches and temples, were erected to commemorate Hadrian's visits to the provinces. These monuments often display a plurality of styles, combining local and more traditional Greco-Roman features. In some temples, Roman gods or even the emperor himself were worshiped, while others were dedicated to non-Roman deities.

20.12 **Temple of Baalshamin,** Palmyra, Syria, 131 CE, destroyed in 2015.

One fascinating and, until recently, extremely well-preserved example was the Temple of Baalshamin in Palmyra, (**Fig. 20.12**) an important oasis city and hub of cultural diversity in the Syrian desert that was a key stop for merchant caravans traveling the Silk Road from Asia to the Mediterranean (see: Seeing Connections: The Silk Road, p. 270). The temple was constructed in 131 CE and dedicated to Baalshamin, a Semitic sky god worshiped in Syria at this time. It combined Greco-Roman and West Asian traditions, highlighting the plurality of Roman culture in this provincial context. Its Roman elements included a deep porch with six Corinthian columns, and engaged pilasters on the sides and back. The four columns along the front originally supported a **pediment**. Windows on the sides of the *cella* are a West Asian feature.

The Islamic State of Iraq and the Levant (ISIL) destroyed this almost 2,000-year-old temple, and indeed much of the ancient site of Palmyra, in 2015. ISIL focused on important archaeological monuments, looting, defacing, and destroying them for propagandistic purposes and to fund its campaign of terror by taking advantage of the market for illicit antiquities.

PANTHEON Arguably the best-preserved and most innovative building in all of the Roman Empire, the Pantheon in Rome combines Hadrian's fondness for Classical Greek architecture on the **facade** with an expansive interior space that demonstrates Roman skill in concrete engineering (**Fig. 20.13**, p. 342). Though Hadrian tried his hand at architecture—he is even said to have had Apollodorus of Damascus, Trajan's architect, put to death for ridiculing his designs—it is not clear that he was responsible for the design of the Pantheon, which was probably begun by Trajan. Notably, this is not the first building on the site. The inscription on the facade gives credit for the building to Marcus Agrippa, son-in-law of Augustus. However, brick stamps confirm that the current temple was built during the reign of Hadrian and replaced the original temple built under Marcus Agrippa.

The Pantheon's name comes from *pan*, "every," and *theos*, "god," and it is traditionally believed to be a temple

podium a raised platform that serves as a base.

pediment in architecture, the triangular component that sits atop a columned porch, doorway, or window.

cella (also called *naos*) the inner chamber of a temple; usually houses a statue of a deity.

facade any exterior vertical face of a building, usually the front.

20.13 Exterior of the Pantheon, Rome, *c.* 110–28 CE.

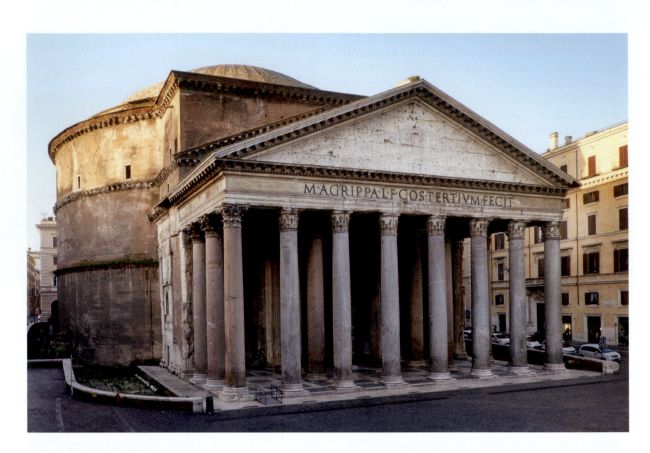

20.14 BELOW **Interior of the Pantheon,** Rome, *c.* 110–28 CE.

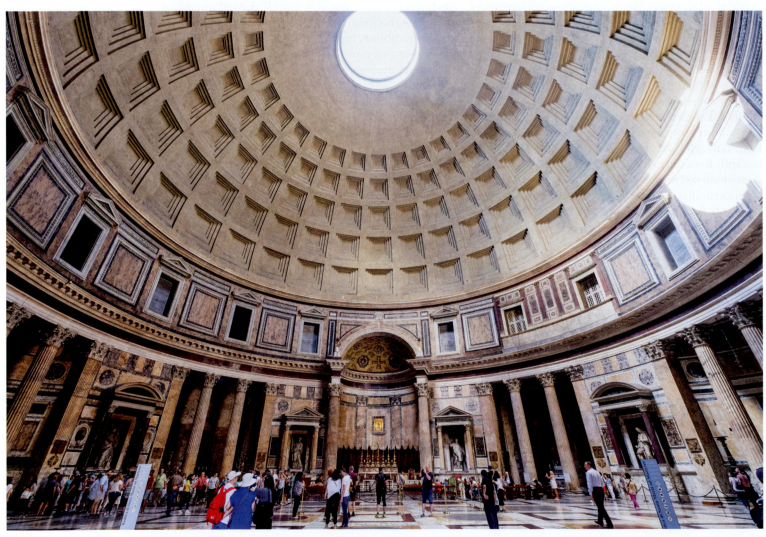

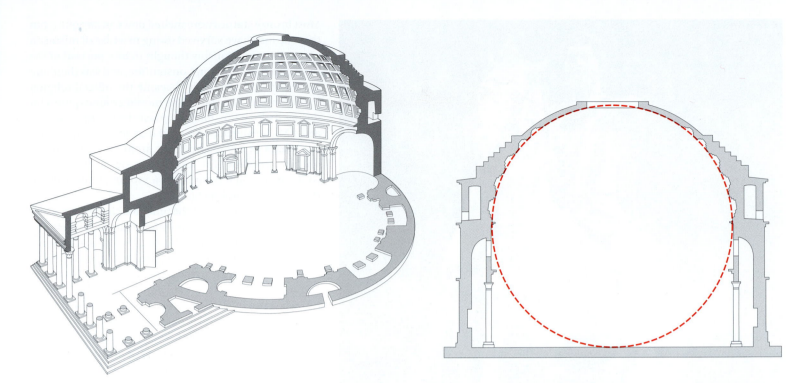

dedicated to all the gods of Rome, although some evidence suggests it was associated with the divine authority of the emperors. It originally sat at one end of an enclosed, porticoed rectangular courtyard. From the courtyard in front of the temple, which was much lower than the current piazza, the massive temple facade would have appeared much like other Roman temples, with a raised podium and frontal steps. The rectangular porch boasts sixteen huge Corinthian columns of gray or red granite imported from Egypt, each about 41 feet high (12.5 m) and almost 15 feet (4.6 m) in circumference. The **drum** and **dome** would not have been visible to ancient Roman viewers, due to the layout of the portico.

Upon passing through the impressive 24-foot-high (7.32 m) bronze double doors, however, visitors would have been amazed to see an interior architecture of immense open space, featuring a **rotunda** capped by an enormous dome with a 27-foot (8.23 m) **oculus** in the center, the only source of natural light other than the open doors (**Fig. 20.14**). The harmony and balance of the interior were, and still are, immediately evident. The play on the building's traditional rectangular facade and its rounded interior can also be seen in the lavish interior decoration, with marble squares and circles inlaid on the ground, as well as triangular and rounded pediments atop the niches. The massive oculus leaves the entire building open to the elements; rainwater can pour into the building and then quickly leave through an ancient Roman drain underneath the floor. Through the oculus shines a column of light, varying with the weather and season, and moving around the building with the time of day. Thus the ancient Roman visitor was constantly reminded of the presence of nature and, by extension, the gods in this religious space.

The height of the Pantheon's interior is the same as the diameter of the base of the dome, so that a perfect sphere could fit inside the building (**Fig. 20.15**). The dome

rests on the cylindrical, almost 20-foot-thick (6 m) wall of the drum below. Both the drum and the dome are made of concrete, the weight of which changes from heaviest on the bottom to lightest on the top. The concrete in the very top portion of the dome is made with pumice, a type of rock so light it floats. The **coffers** in the dome, which according to Renaissance drawings each originally included a gilded rosette (a rose-shaped decoration), also serve to lighten the weight of the dome. They also move the eye upward; each row of coffers becomes smaller as it goes higher up the dome, and the actual squares around the original rosettes shift upward.

The story of the Pantheon did not end in ancient Rome. The building has been maintained since antiquity because it was the first temple in Rome to be turned into a Christian church, in 609 CE.

MARCUS AURELIUS AND IMPERIAL PORTRAITS

Hadrian was very careful about who would succeed him, not only immediately upon his death, but also in the following generation, which is how Marcus Aurelius ultimately came to rule. Portraiture continued to be an important source of imperial propaganda throughout the Roman Empire during the rule of the Good Emperors. Like Hadrian, Marcus Aurelius chose to depict himself bearded, perhaps harking back to Greek philosopher portrait types, although with individualized portrait features.

EQUESTRIAN STATUE OF MARCUS AURELIUS Imperial equestrian statues (portraits of emperors on horseback) were very popular in ancient Rome. Late imperial sources list twenty-two equestrian statues in the city of Rome alone. The well-known, over-life-size, gilded bronze equestrian statue of Marcus Aurelius, the last emperor of this dynasty to be adopted by his predecessor (**Fig. 20.16**, p. 344), is the only such bronze to remain intact.

20.15a ABOVE LEFT **Cutaway drawing of the Pantheon.**

20.15b ABOVE **Cross-section drawing of the Pantheon,** showing how a perfect sphere would fit inside.

drum a wall, most often cylindrical, that supports a dome.

dome a roof that projects upward in the shape of the top half of a sphere.

rotunda a cylindrical building, or a cylinder-shaped room within a larger building.

oculus a round, eye-like opening in a ceiling or roof.

coffer a recessed panel, or series of panels, in a ceiling.

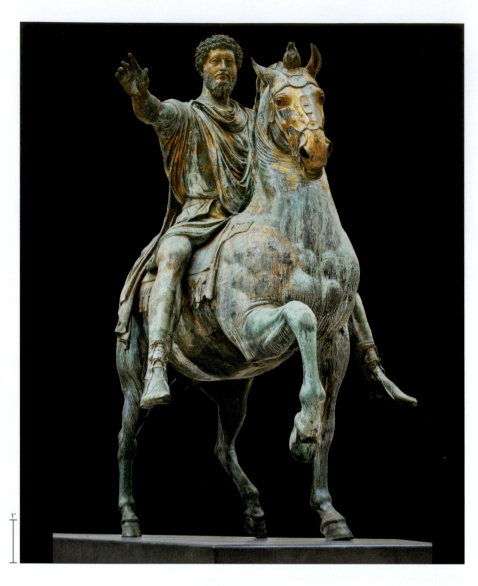

Most bronze statues were melted down in antiquity, but this one may have survived owing to a case of mistaken identity. It was probably thought to be a portrait of the first Christian emperor, Constantine, and was therefore spared when Christianity became the official religion in the empire. The statue was moved around quite a bit during its long life, most famously by the Renaissance artist Michelangelo, who used it as the centerpiece for the piazza of his magnificent architectural complex on the Capitoline Hill. A copy now stands in its place, while the original commands a prominent position in the nearby Capitoline Museums.

Marcus Aurelius wears the tunic and cloak of the leader of the army but bears no weapons or armor. He has one hand extended, perhaps indicating that he is addressing a crowd. He is quite large compared to the horse (notice how close his feet are to the ground), showing his power and might, but he is not so large that the horse loses its own sense of strength. The details of the sculpture, including the fittings on the horse and the rider's sandals, are finely worked. The emperor's face seems to convey thoughtful compassion and even concern or sadness, which is not surprising given the military challenges pressing on the borders of the Roman Empire for much of his reign. Marcus Aurelius's character comes through in his *Meditations*, a very personal, philosophical treatise in which he expressed his stoic philosophy: "Each and every hour make up your mind steadfastly ... to accomplish the matter presently at hand with genuine solemnity, loving care, independence, and justice, and to provide yourself with relief from all other worries."

The horse's raised hoof may once have had an enemy underneath to whom the emperor was making a gesture of clemency, though others have suggested that the individual was indeed being trampled. Marcus Aurelius has

20.16 Equestrian statue of Marcus Aurelius, *c.* 161–80 CE. Gilt bronze, approx. height 11 ft. 6 in. (3.51 m). Capitoline Museums, Rome.

Chronology

68 CE	Nero is forced to commit suicide	**122 CE**	Construction of Hadrian's Wall begins
69 CE	Vespasian becomes emperor after a short civil war	***c.* 110–128 CE**	Hadrian's reconstruction of the Pantheon
***c.* 70–80 CE**	The Colosseum is constructed	***c.* 131 CE**	The Temple of Baalshamin is built at Palmyra
79 CE	Vespasian dies and his son Titus becomes emperor; Vesuvius erupts, burying Pompeii and Herculaneum	**138 CE**	Hadrian dies and Antoninus Pius becomes emperor
81 CE	Titus dies and his brother Domitian becomes emperor	**161 CE**	Antoninus Pius dies and Marcus Aurelius becomes emperor
***c.* 81 CE**	The Arch of Titus is dedicated	***c.* 161–80 CE**	The equestrian statue of Marcus Aurelius is cast
96 CE	Domitian is assassinated and Nerva is proclaimed emperor, adopting Trajan as his heir	**177 CE**	Marcus Aurelius names his son Commodus as co-emperor
98 CE	Trajan becomes emperor	**180 CE**	Commodus becomes sole emperor on the death of his father
***c.* 110 CE**	The Forum of Trajan (including column and other structures), designed by Apollodorus, is dedicated	**190–92 CE**	The portrait bust of Commodus as Hercules is sculpted
117 CE	Trajan dies and Hadrian becomes emperor	**192 CE**	Commodus is assassinated

been read in different ways: either as a magnanimous ruler who was concerned for the enemy's plight and the lower classes of Roman society; or as a pragmatic one who concerned himself most with the safety of the empire and the comfort of the Roman ruling classes.

COMMODUS AND THE END OF THE *PAX ROMANA*

The Flavian dynasty and the Nerva-Antonine dynasty ruled for more than 120 years during a period of intense growth throughout the Roman Empire. During these years, Rome continued its rise as a military power, achieved extraordinary feats of engineering, and harnessed the power of its pluralistic society to become a cultural and artistic center. At the same time, the empire was in near-constant battle at its borders.

BUST OF COMMODUS AS HERCULES Upon the death of his father, Marcus Aurelius's son Commodus became sole emperor of Rome at the age of eighteen. The contrast between Marcus Aurelius and the arrogant Commodus, who had the senate declare him a god and rename Rome the *Colonia Commodiana* (Colony of Commodus), could not be sharper, as we can see by comparing a portrait of Commodus with the equestrian statue of Marcus Aurelius. Commodus, who was obsessed with gladiatorial combat, fancied himself a living Hercules, and in this bust he is shown with a club, lion skin, and apples of the Hesperides (nymphs from Greek mythology who guarded the Garden of Hera), all attributes of the Greek hero (**Fig. 20.17**). His curly, deeply drilled hair and beard are similar to those seen in portraits of his father, and as father and son, they share some facial features in their portraits. However, whereas Marcus Aurelius is depicted as a benevolent ruler whose portraits aged with him, Commodus, who died at the young age of thirty-one, is here depicted as an idealized megalomaniac.

The bust was originally found in an underground chamber in the Horti Lamiani, gardens on the Esquiline Hill that by this time were part of the imperial property. The statue was flanked by two marine tritons (mermen, demigod of the sea), perhaps symbolizing the apotheosis (deification) of the emperor. After his death, Commodus was subjected to *damnatio memoriae*. Meaning "condemnation of memory," this dishonor was inflicted on traitors and people who brought discredit on Rome. Their monuments were destroyed and their names erased from the records. This sculpture may have been hidden to protect it, although ultimately the *damnatio memoriae* was annulled under the emperor Septimius Severus and Commodus was deified a few years later.

For the Roman Empire, the extravagant rule of Commodus was a great tragedy. Rather than securing the borders of the empire as his father had hoped to do, Commodus ruled as a tyrant, weakening it considerably. He was assassinated on New Year's Eve, 192 CE in a conspiracy between his mistress and the head of the Praetorian Guard. Commodus's failing helped bring an end to the *Pax Romana*, which ultimately had a profound impact on the art of the Late Roman Empire.

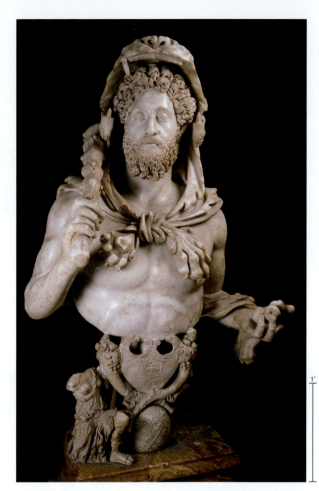

20.17 Commodus as Hercules, part of a group of sculptures from the Esquiline Hill, Rome, *c.* 190–92 CE. Marble, height 4 ft. 3 in. (1.3 m). Palazzo dei Conservatori, Capitoline Museums, Rome.

Discussion Questions

1. Concrete revolutionized architectural design and engineering in ancient Rome. Select one work of architecture from this chapter that utilizes concrete and describe the innovations made possible by its use.

2. The Roman emperors used narrative art to legitimize their rule and bring glory to their name. Choose one work of art in this chapter and discuss the message conveyed by its narrative. Is the message convincing? Why or why not?

3. Marcus Aurelius is known for his rule as emperor of Rome, as well as for his philosophical treatise, *Meditations*. (You can read excerpts of *Meditations* at the link in this chapter's Further Reading.) Based on his *Meditations* and his equestrian statue, what kind of ruler do you think he was and why? How does his use of art as propaganda differ from the way in which his son Commodus used art?

Further Reading

• Adam, Jean-Pierre. *Roman Building: Materials and Techniques*. Routledge, 2001.

• Flavius Josephus. "The Roman Army in the First Century CE," *The Jewish War*, III, 5–6. Trans. William Whiston (n.d.): http://sourcebooks.fordham.edu/ancient/josephus-warb.asp (accessed February 16, 2020).

• Marcus Aurelius. *Meditations*. Trans. George Long (1994–2009): http://classics.mit.edu/Antoninus/meditations.html (accessed May 31, 2020).

21

Art of Rising Empires in Japan and China

400 BCE–581 CE

Colossal seated Buddha
(detail), Yungang caves, China.

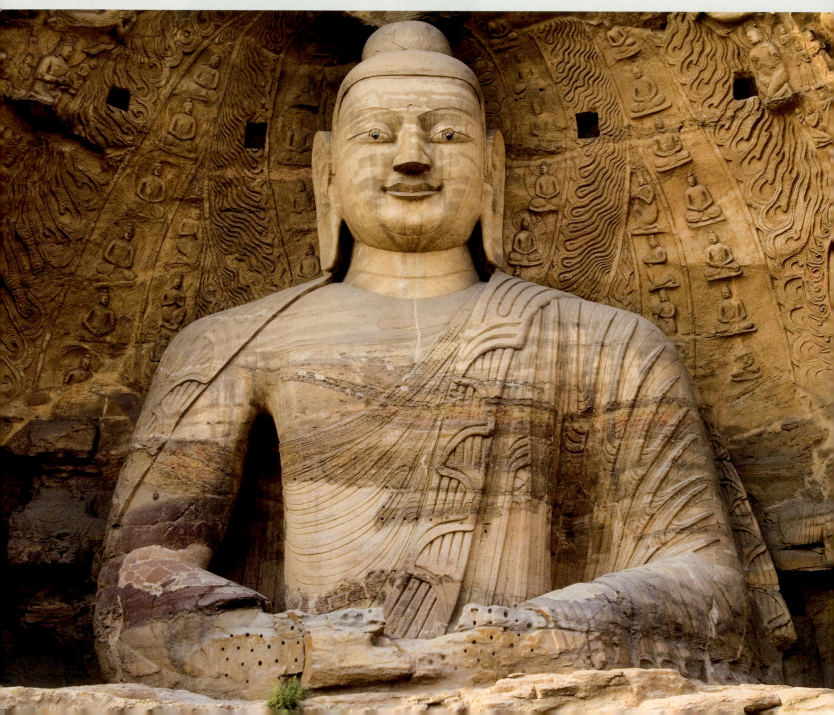

Introduction

In East Asia, agricultural productivity and technological improvements in the centuries approaching the Common Era (CE) fueled population growth and the formation of kingdoms and states. Migration and trade were factors, too, in flows of wealth, art, and culture. These migrations and flows did not result in the imposition of one culture on the other. Rather, local conditions drove decisions about adopting, adapting, and inventing artistic forms and techniques. Some artworks from this period may look typically "Chinese" or distinctively "Japanese," but these countries and their respective cultures had yet to take form. Thus, in this context, the names Japan and China are not intended to carry the weight of modern nation-states. Rather, the focus here is on a subset of the historical and diverse cultures that developed in the roughly one thousand years between the fifth century BCE and the sixth century CE.

On the Japanese archipelago, the development of rice production, permanent settlements, and bronze technology coincided with increasing centralization of political power characterizing the Yayoi (*c.* 400 BCE–*c.* 300 CE) and Kofun (*c.* 300–538 CE) periods. Excavations of settlements and tombs have yielded artworks that indicate growing wealth and ritual changes, related in part to migration from, and contact with, the Korean peninsula. Written documents (in Chinese) supplement the archaeological record, attesting to early historical events, including the role of powerful female rulers in establishing a centralized state.

On the Chinese mainland, the Han dynasty (206 BCE–220 CE) succeeded the powerful but repressive Qin. The Han empire lasted much longer than the previous dynasty and expanded its boundaries to include parts of the Korean peninsula (**Map 21.1**). Han dynasty art reflected and promoted belief systems that emphasized harmony, virtue, and the Confucian values of filial piety, the veneration of ancestors, and participation in government service. Additional artworks reflected Daoism, a different worldview that coexisted with Confucianism.

Fragmentation, military invasion, and political rivalry dominated the centuries after the Han collapse, and scholars give this period of division several names. Of the many relatively short-lived regimes, the Eastern Jin (317–420 CE) and the Northern Wei (386–534 CE) (see **Map 21.2**, p. 355) made a considerable impact on the history of art. With a capital in present-day Nanjing, the Eastern Jin court was reestablished by Han refugees who had migrated southward to the Yangtze River region. There, the arts of the learned and leisured scholar— poetry, calligraphy, and painting—flourished. In the north, the arts of Buddhism spread with court patronage from states such as the Northern Wei. Buddhism brought new ideas and art forms to East Asia, such as devotional icons and monumental rock-cut cave chapels.

Art and Culture of the Yayoi and Kofun Periods in Japan, *c.* 400 BCE–538 CE

On the islands of Japan, a cooling climate and declining food resources contributed to shrinking populations that brought an end to the Neolithic Jōmon culture

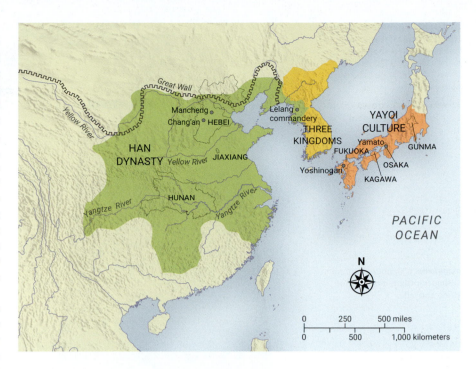

Map 21.1 **East Asia, *c.* 200 BCE.**

(see Chapter 8). Over the course of the first millennium BCE, a new culture emerged, with distinctive ceramics and bronze artifacts dating to the Yayoi period (*c.* 400 BCE– *c.* 300 CE).

THE YAYOI PERIOD

Fueled in part by immigration and technology transfers from continental East Asia, especially the southern Korean peninsula, the Yayoi culture is recognizable by large-scale permanent settlements, wet-rice agriculture, and the making of bronze and iron objects. Yayoi sites such as Yoshinogari (in present-day Kyūshū, the island nearest the Korean peninsula), with its moat, watchtowers, storehouses, and differentiation between ordinary and elite dwellings, demonstrate the shift from farming villages to more socially stratified chiefdoms. Within these chiefdoms, artisans fashioned objects of clay and bronze, and people placed valuable artifacts in graves as evidence of the high social status of some members of their community.

***DŌTAKU* (BRONZE BELL)** By casting bell-like objects known as *dōtaku*, the Yayoi demonstrate adaptation of bronze technology from the East Asian continent. *Dōtaku* may have been inspired by small bells from the Korean peninsula, but the Yayoi bells range in height from 4 inches to over 4 feet (from 10 cm to over a meter). Some have fairly plain surfaces, while others are boldly decorated in **low relief**. This example has typical sawtooth patterns and spirals located on the upper loop and running down the side flanges (**Fig. 21.1**, p. 348). Less commonly, it also features figural decoration on twelve panels, six on each face. The scenes include animals, human activities, and architectural structures.

On the side pictured here, the top row depicts (from left to right) a salamander and a dragonfly. The second row includes a human figure leaping and another shooting a deer. In the bottom left panel, two human figures grasp

low relief (also called bas-relief) raised forms that project only slightly from a flat background.

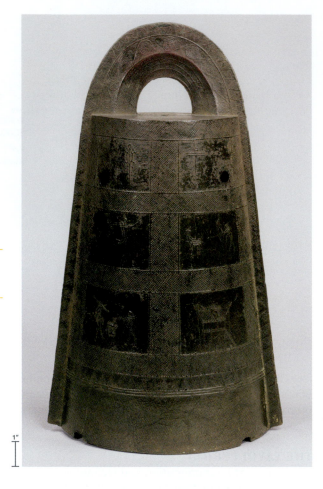

21.1 Dōtaku (bronze bell), reportedly from site in Kagawa prefecture, Yayoi period, second to first century BCE. Bronze, height 16¾ in. (42.5 cm). Tokyo National Museum, Tokyo.

magatama a Japanese term for C-shaped ornaments made of stone and jade.

21.2 Sword blades, halberd, spearhead, tubular beads, *magatama* bead, and mirror, from Yoshitake Takagi, Fukuoka prefecture, Yayoi period, second century BCE. Bronze and steatite, length of sword at left: 13⅛ in. (33.3 cm). Fukuoka City Museum, Fukuoka, Japan. Agency for Cultural Affairs.

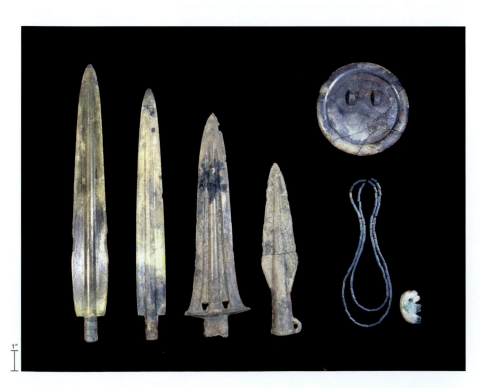

long implements, directing them toward a central vessel. They could be pounding rice. The panel at bottom right illustrates a raised structure with an elaborate projecting roofline. The structure might be a storehouse, an important building that protected the community's harvest from moisture and pests. It also bears some resemblance

to a later Shintō temple, the Inner Shrine at Ise. Shintō (literally, "the way of the gods") is the indigenous, animistic religion of Japan. This major temple is dedicated to Amaterasu, the sun goddess and legendary ancestor of the Japanese imperial family (see: Seeing Connections: Art and Ritual, p. 462). Although the building illustrated on the *dōtaku* cannot be identified with certainty, and any connection to later Shintō temples is conjectural, the picture nevertheless preserves evidence of an early architectural form and its symbolic importance.

Some *dōtaku*, like Zhou dynasty bells (see Fig. 8.16), were made to produce sound. These *dōtaku* had clappers hanging inside them that struck internal rims. Other *dōtaku* lacked these features, and their highly ornamented surfaces suggest that they were meant primarily to be looked at. In both cases, *dōtaku* served ritual purposes, and they were deliberately buried, commonly in even-numbered groupings—sometimes with bronze weapons and mirrors—in isolated hilltop locations.

GRAVE GOODS FROM A YAYOI TOMB Bronze objects and other prestige items have been excavated from Yayoi tombs, such as one in northern Kyūshū—some 20 miles (around 32 km) north of Yoshinogari—which yielded bronze swords, a halberd, a spearhead, and a mirror (**Fig. 21.2**). At the time, functional weapons were made of a stronger metal, iron, so the tomb's bronze blades may have been for ceremonial use only. The mirror's concave surface bends light, concentrating it in the distorted reflection, like a spoon. The mirror's power to manipulate light suggests that it, too, had a symbolic function. The tomb also contained beaded necklaces and a distinctive E-shaped stone bead, known in later Japanese periods as a *magatama*, which may also take a C-shape. By virtue of their fine craftsmanship, their rarity or exotic nature, and/or their symbolic meaning, all of these objects functioned as prestige goods and together confirm the high status of the unidentified tomb occupant. One hypothesis suggests the person was a spiritual leader.

In addition to offering clues to the tomb occupant's status and role in society, the artifacts locate the Yayoi culture in a larger geographical context and historical chronology. The bronze blades echo the Liaoning-type dagger (see Fig. 8.13), and the bronze mirror may have been made on the Korean peninsula. As with the blades and the mirror, the resemblance between the E-shaped bead and C-shaped jade beads on such artifacts as the crown from the Silla kingdom (57 BCE–676 CE) in Korea suggests contact—through trade, migration, or another conduit—between the cultures on the Japanese archipelago and the Korean peninsula (see: Seeing Connections: The Cultural Power of Gold Across the World, p. 362). Described in the earliest Japanese chronicle *Kojiki*, or "Record of Ancient Matters" (eighth century CE), this grouping of a sword, a mirror, and a bead is known as the Three Sacred Treasures. In the Shintō religion, they constitute the regalia given by the sun goddess Amaterasu to her earthly, royal descendants. However, the Yayoi materials predate the chronicle by as much as a millennium, so any connection between the two is tenuous and provisional.

THE KOFUN PERIOD

The third-century CE transition from the Yayoi period to the Kofun period (c. 300–538 CE) was marked by the abandonment of Yayoi ritual practices, as evidenced by the deliberate destruction of *dōtaku*. Resources and ritual focused instead on monumental tombs, which appeared not only on the Japanese archipelago but also on the Korean peninsula. *Kofun* literally means "ancient tomb," and the Kofun culture is named for the thousands of mounded tombs they left behind. The term "Mounded Tomb Cultures" refers to the early states of both the Kofun in Japan and the Three Kingdoms of the Goguryeo, Baekje, and Silla in Korea, and it acknowledges their connections to one another.

According to the *Weizhi* (a Chinese text from the Jin dynasty, 265–420 CE), competition among numerous chiefdoms during the Yayoi–Kofun transition ended with unification and the creation of a state called Yamatai by Queen Himiko in about 180 CE. It also records a younger female relative who subsequently ascended the throne. By contrast, Japanese chronicles written in the eighth century (*Kojiki* and *Nihon Shoki*) describe the reign of Empress Jingu (169–269 CE), who is credited with conquering areas of the southern Korean peninsula. But burial sites associated with either female ruler have not been excavated, and questions about their identities persist. Still, the evidence suggests remarkable roles for female leaders in early state formation. The historical picture that emerges toward the end of the Yayoi period features a crisis in which one or more powerful women assume leadership positions. The resolution of the crisis involves adopting new rituals and ritual forms, notably monumental, mounded tombs furnished with elite goods, and the crisis ends with the rise of the powerful state of Yamato, tentatively identified with Yamatai, during the Kofun period.

DAISEN TOMB Many *kofun* are located in Yamato (present-day Osaka-Nara). The Yayoi had built tombs and buried valuable objects with high-ranking individuals, but during the Kofun period the keyhole-shaped tomb—circular at one end—came to prominence. Scholars debate the origin and meaning of this shape, which may be related to beliefs about the mythical Queen Mother of the West (a Daoist deity), or it may have emerged by broadening one end of the access path across the moat to the typically round tombs of the preceding Yayoi period. Besides shape, another difference in Kofun tombs is their markedly larger size. Among them, the Daisen Tomb, attributed to the ruler Nintoku (ruled 395–427 CE), is the largest.

Located near present-day Osaka, the Daisen Tomb covers an area of 458 acres. It is approximately 1,640 feet long (around 500 m), and its burial mound rises to a height of 90 feet (27.43 m) (**Fig. 21.3**). Beneath the circular portion of the keyhole-shaped mound is where the burial chamber likely lies, but because the Daisen Tomb is associated with the imperial family, it has not been excavated. Three concentric moats separate the world of the dead from that of the living. Its construction required an immense workforce, unprecedented in Japan. The ability to mobilize this level of resources suggests an expanding state and the concentration of power.

Power and wealth are also apparent in the contents of *kofun*, which have yielded gold and gilt-bronze crowns, jade ornaments, bronze mirrors, iron weapons, equestrian trappings, and high-fired **stoneware**. These prestige goods, in combination with historical records, reveal ongoing cultural contact between Kofun-period Japan and kingdoms on the Korean peninsula, such as Goguryeo (37 BCE–668 CE) and Baekje (18 BCE–660 CE).

HANIWA FIGURE The furnishings for *kofun* were not limited to their interiors. *Kofun* mounds were marked on the outside with *haniwa,* hollow **terra-cotta** figures (**Fig. 21.4**). *Haniwa* means "clay cylinder," though they took a variety of forms, including shields, houses,

stoneware a type of ceramic that is relatively high-fired and results in a non-porous body (unlike terra-cotta or earthenware).

terra-cotta baked clay; also known as earthenware.

21.3 BELOW LEFT **Daisen Tomb, aerial view,** Sakai, Osaka prefecture, Japan. Kofun period, late fourth–early fifth century CE.

21.4 BELOW **Distribution of** *haniwa* **on the Futatsuyama Tomb,** Gunma prefecture, Japan, late sixth century CE.

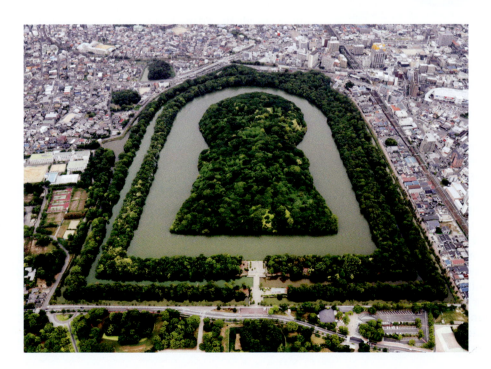

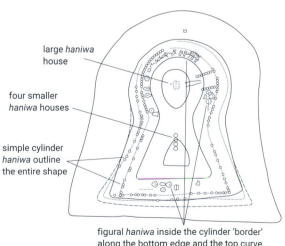

large *haniwa* house

four smaller *haniwa* houses

simple cylinder *haniwa* outline the entire shape

figural *haniwa* inside the cylinder 'border' along the bottom edge and the top curve

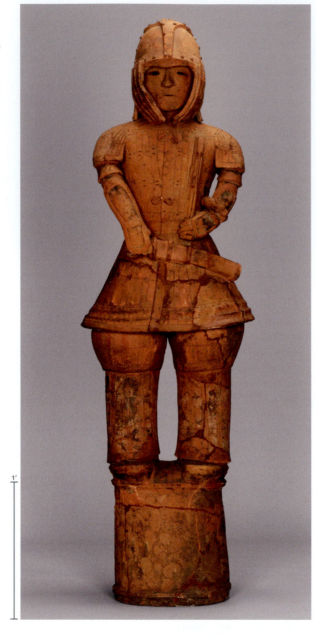

21.5 *Haniwa* **warrior,** from Iizuka-cho, Ōta City, Gunma Prefecture, Kofun period, sixth century. Earthenware, height 51⅛ in. (1.3 m). Tokyo National Museum.

1′

register a horizontal section of a work, usually a clearly defined band or line.

bi flat, perforated disks made of nephrite or other hardstones, made in early cultures in China.

animals, and humans, like the example illustrated here (**Fig. 21.5**). Wearing the armor and helmet of a warrior, this *haniwa* appears to stand atop a pedestal, but originally that cylindrical component would have been buried.

The sculptor used several different techniques to shape this warrior figure. Flat slabs of clay were cut to model the feet and sword sheath. Coils of clay were stacked to form cylindrical leg guards, or worked and attached to form straps. Incisions with sharp implements created the patterns on the armor. Longer cuts formed the warrior's eyes. The effect is simplified yet arresting, principally owing to the warrior's facial expression, which can be interpreted as either wary or indifferent, as well as to the ambiguity of the gesture. Is the warrior about to draw his sword, or will he keep it sheathed? When combined with many more *haniwa*, perhaps numbering into the thousands for the largest *kofun*, this warrior would have contributed to an impressive

array that included military troops, servants, entertainers, animals, and buildings. The number of figures present generally confirmed the deceased's status, but their precise purposes are not altogether clear. Their shapes suggest symbolic functions in the unseen afterlife. *Haniwa* in the form of spiritual leaders ostensibly provided ritual performances; those clad as warriors offered protection; and those shaped like houses represented shelter. Some scholars suggest that the cylinders of non-figural *haniwa* once held offerings, perhaps for the deceased.

Diverse Worldviews during the Han Dynasty in China, 206 BCE–220 CE

When knowledge of wet-rice farming and metalworking was spreading beyond the Korean peninsula to the Japanese archipelago, numerous warring states on the Chinese mainland were being defeated by the Qin army. The Qin unified the realm, but its repressive government policies hastened its collapse (see Chapter 8). Whereas the Qin dynasty lasted a mere fifteen years, the subsequent Han dynasty endured for nearly four centuries. During that time, artworks attest to the coexistence of diverse worldviews.

The Han dynasty adopted Confucianism for governance. As taught by Master Kong (also known by the Latinized name Confucius, 551–479 BCE), Confucianism urged learned gentlemen to cultivate an ethical viewpoint, act morally, and participate in government service. Confucius also advocated a set of reciprocal relationships based on respect and care, rather than a strict set of rules and punishments, as the foundation for a harmonious world. These relationships included those between subjects and rulers, and between parents and children. According to Confucius, the voluntary fulfillment of such mutual obligations, as well as the practice of ethical activities, ensured that human societies would flourish. By representing those who embodied Confucian ideals, artwork enshrined and promoted values such as filial piety, which included the veneration of ancestors.

Although Confucian philosophy played a central role during the Han dynasty, it did not provide satisfaction for all human yearnings. For example, artworks excavated from Han dynasty tombs preserve marvelous visions of the afterlife, which was not a particular concern for Confucius. Some of these artworks may be related to Daoism, a competing worldview advanced by Master Zhuang (also known as Zhuangzi, 369–286 BCE). To answer the question of what happens after death, Daoism offered paths to immortality and to paradises populated by immortal beings such as the Queen Mother of the West. Whereas Confucius maintained that government service was a gentleman's highest goal, Zhuangzi believed that society's artificial practices posed an obstacle to human flourishing. Instead of taking positions at royal courts, Daoist sages sought refuge in wilderness, where they pursued the Way, a perfect condition of being, as exemplified in the harmonious patterns of the natural world and the cosmos.

LADY OF DAI'S FUNERARY BANNER Cosmic patterns are pictured in a silk funerary banner that draped the coffin belonging to a woman identified (through her marriage to a nobleman) as the Lady of Dai. Remarkably, the Lady of Dai's banner survived over two millennia in a water-logged tomb. The banner's central scenes appear to depict the journey of the human soul to the afterlife (**Fig. 21.6**). The T-shaped painting, featuring serpentine bodies of fantastic animals, creates a dizzying effect, but the composition has an internal logic. The space is divided into three **registers**, each corresponding to distinct realms.

In the bottom register, just above fishlike animals, a squat, muscular figure supports a scene of ritual (**Fig. 21.6b**). Behind a set of sacrificial wine containers and lidded cauldrons, a half-dozen or so human figures face a mound-shaped object painted with swirls of red and white, and trimmed with dabs of white on black. The patterns on this object resemble those on the Lady of Dai's robe, suggesting that the mound represents her shrouded body.

In the middle register above a jade disk or *bi* (see Fig. 8.5), which by the Han dynasty was associated with the celestial aspect of the cosmos, or "heaven," a ramp leads to a platform where a central figure—the Lady of Dai—wears an elaborately decorated robe (**Fig. 21.6a**).

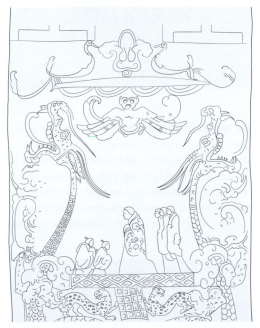

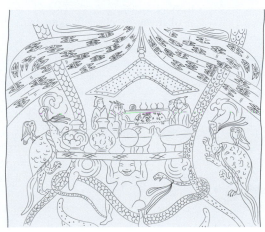

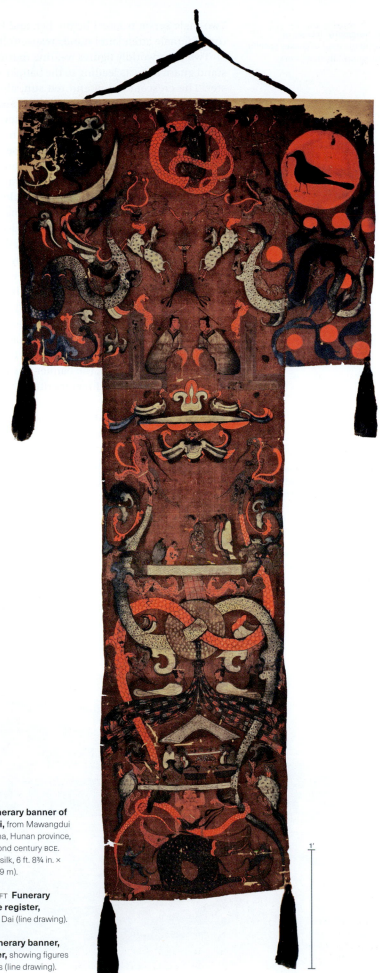

21.6 RIGHT **Funerary banner of the Lady of Dai,** from Mawangdui Tomb 1, Changsha, Hunan province, China, early second century BCE. Ink and color on silk, 6 ft. 8¾ in. × 36¼ in. (2.05 × 0.9 m).

21.6a ABOVE LEFT **Funerary banner, middle register,** showing Lady of Dai (line drawing).

21.6b LEFT **Funerary banner, bottom register,** showing figures and ritual vessels (line drawing).

iconography images or symbols used to convey specific meanings in an artwork.

Two male servants kneel before her, and behind her a trio of female attendants stands respectfully.

Two otherworldly figures wearing mortarboard hats stand guard at posts leading to the banner's upper register. The crescent moon and red sun, along with the creatures affiliated with them—the toad and the crow—indicate the heavenly expanse. At center, the creator goddess Nü Wa (depicted as a woman with a snake's tail) presides over this strange cosmos composed of the living and the dead, the watery underworld and the celestial realm, the mundane and the supernatural.

The artist's pliable brush and vivid colors conjure in exquisite detail the worlds of human imagination. Art historians are not yet certain of the precise meaning of the depictions, which do not align exactly with either Confucian or Daoist texts and **iconography**. Nevertheless, the banner clearly brings together the visible world—including ritual objects that would have been familiar to past cultures of the Neolithic period and Bronze Age, as well as contemporary costumes and practices—and the invisible realm beyond the grave. Thin stays, or straps, at the top of the banner suggest that prior to being buried with the Lady of the Dai, the banner was hung and displayed as an element of funerary ritual.

JADE BURIAL SUIT OF LIU SHENG Concerns about death and the afterlife led to the making of the final outfit of a Han prince, Liu Sheng (died *c.* 113 BCE). His entire body was encased in a burial suit made of jade pieces fastened with gold thread (**Fig. 21.7**). The suit includes an antique *bi* at the crown of the head (not visible in the photograph) and several jade plugs to seal bodily orifices. Since the Neolithic period, jade had been valued not only for its attractive color but also and especially for its unchanging properties. It did not tarnish with time, and it remained cool to the touch (see Chapter 8). Liu Sheng and his wife, Princess Dou Wan, who also wore a jade suit in death (not pictured), may have expected that the unchanging characteristics of jade could preserve their bodies in the afterlife, bestowing immortality on them.

21.7 BELOW **Jade burial suit of Prince Liu Sheng,** from Tomb 1, Mancheng, Hebei, Western Han Dynasty, *c.* 113 BCE. Jade and gold thread, length 6 ft. 2 in. (1.88 m). Hebei Provincial Museum, China.

21.8 FAR RIGHT **Incense burner in the form of the Island of the Immortals,** from Tomb 1 of Liu Sheng, Mancheng, Hebei, Western Han Dynasty, *c.* 113 BCE. Bronze inlaid with gold, height 10¼ in. (26 cm). Hebei Provincial Museum, China.

BRONZE INCENSE BURNER OF LIU SHENG Another object excavated from Prince Liu Sheng's mountainside tomb suggests a related belief in an island far out at sea populated by Daoist immortals (**Fig. 21.8**). This bronze incense burner consists of two parts: a bowl-shaped base elevated on a foot composed of writhing dragons, and a perforated cover in the shape of a craggy mountain. The smoke

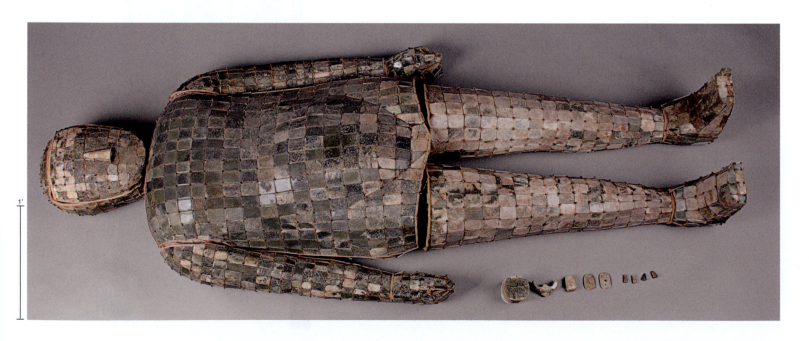

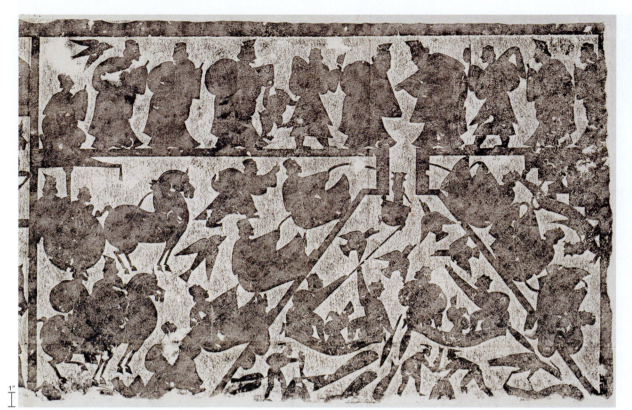

21.9 Scene of the Raising of the Cauldron, Wu Family Shrines, Jiaxiang county, Shandong province, China, Eastern Han dynasty, *c.* 147–151 CE. Ink rubbing of a stone relief, height 28¼ in. (71.8 cm). Princeton University Art Museum, New Jersey.

and perfume of incense burning in the base emerged through the holes, thereby surrounding the miniature mountain with an envelope of mist. Such immediate sensory stimulation was perhaps thought to help bridge the distance between the mundane world and the Island of the Immortals. On Liu Sheng's incense burner, finely inlaid gold depicts the roiling waves surrounding the island. Their stylized curves and hooks are related to the decoration on bronzes of preceding periods (see Fig. 8.15), to such paintings as the Lady of Dai's banner, and to embroidery, as seen on the Lady's robe depicted in the banner. Tiny animals and human-like creatures amid the mountain cliffs complete the illusion.

THE WU FAMILY SHRINES Whereas the Lady of Dai's banner and Prince Liu Sheng's incense burner depict fantastical places, some images from the funerary shrines of an otherwise unknown Wu family in Shandong province turned to history for inspiration. The pictorial program of the Wu Family Shrines may be studied through **rubbings**, many of which were made in the early twentieth century. Made against the interior face of a stone slab that was once part of the shrines, this rubbing depicts a dramatic scene (**Fig. 21.9**). The upper register shows the large **silhouettes** of officials wearing caps and long robes. Finer lines represent their faces, hair, fingers, and patterned sleeves. They and their assistants, identifiable according to **hierarchical scale** by their smaller size, face an opening slightly right of center. The opening leads to a triangular space, and the resulting shape bears some resemblance to a flask. Within the thick outline of that space, crucial action takes place on a river or canal, as indicated by fishermen working at the bottom and the waterfowl taking flight above. In between, two crews on

boats direct their attention to a falling bronze cauldron, which has escaped the efforts of seven men on either side of the river to get hold of it. Their rope has been severed by a dragon whose head emerges from the cauldron, they tumble backward onto their rears, and the cauldron sinks deeper into the water. Why has a mere cooking vessel drawn the attention of so many, including a high-ranking minister, or perhaps a head of state, shaded beneath the canopy of a horse-drawn carriage?

The unknown artisans of the Wu Family Shrines would have expected informed viewers to recognize the story of the mythical Nine Cauldrons. Purportedly cast in the Shang dynasty (*c.* 1500–*c.* 1050 BCE), the cauldrons represented the realm and, importantly, bestowed political legitimacy, understood as Heaven's Mandate upon their owner. It was believed that, upon the fall of the Shang, the cauldrons transferred to the Zhou (*c.* 1050–256 BCE). After the Zhou collapsed, one of the cauldrons fell into a river. The subject of this scene is the failed attempt of the First Emperor of Qin to recover it. Recognizing his tyrannical tendencies, Heaven refused to grant him political legitimacy; as an instrument of Heaven, the dragon prevents him from possessing the bronze cauldron.

The representation of space here can be described as simplified or unrealistic: the line of officials in the top register, for example, floats improbably above the canopied chariot and falling cauldron. But consistency of viewpoint and **illusionism** are less important, as the artist intentionally prioritizes the elements of narrative and scene. The bronze cauldron serves as the composition's visual heart, around which all other motifs are arrayed.

The morally instructive images at the Wu Family Shrines promote the Confucian values of order, virtue,

rubbing an image made by rubbing powdered ink onto a sheet of paper placed against a shallowly carved or textured surface.

silhouette a portrait or figure represented in outline and solidly colored in.

hierarchical scale the use of size to denote the relative importance of subjects in an artwork.

illusionism making objects and space in two dimensions appear real; achieved using such techniques as foreshortening, shading, and perspective.

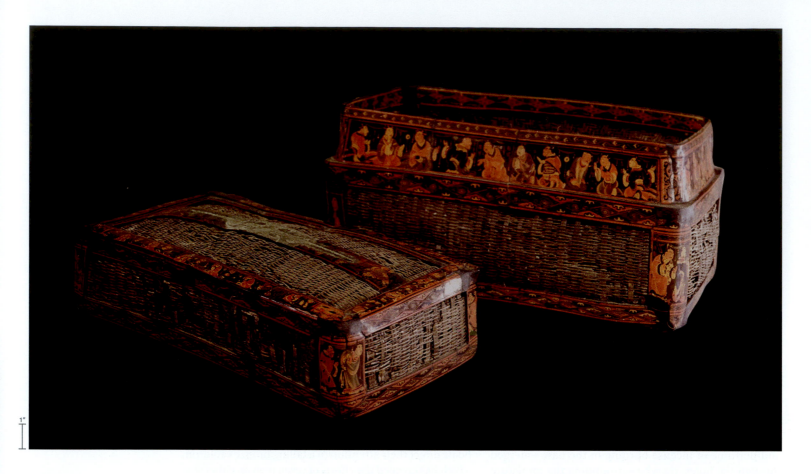

21.10 Painted lacquer basket and lid, from Lelang (Nangnang, North Korea), Eastern Han dynasty, first century CE. Basketry and lacquer, length 15⅜ in. (39 cm). Central Historical Museum, Pyongyang.

and disapproval of brutality not only by capturing a significant lesson from history about Heaven's attitude toward tyrants, but also through such formal qualities as the gravitas of the huge silhouettes of officials and the orderly composition. In addition, the shrines themselves promoted the Wu family as one that espoused Confucian virtues, chief among them filial piety. Respect for ancestors is demonstrated not only in the resources expended in making the shrine, but also in the serious subject matter of its decorative program.

PAINTED LACQUER BASKET Further evidence of Confucian belief comes from an object from another tomb. This lacquer basket comes from the tomb of a minor official posted to Lelang (Korean: Nangnang), located at the far northeastern edge of the Han empire in what is today North Korea. The basket and its lid have been varnished with **lacquer**, which dries to a hard, durable finish that protects perishable materials (**Fig. 21.10**). In this case, lacquer has preserved not only the wood and fibers of the basket, but also the paintings depicting ninety-four figures, the majority of whom are paragons of virtuous behavior.

Although the paintings include some women, most are men, whose moral actions gave them lasting reputations. Seated against a dark background with an occasional freestanding screen separating them, the figures lean toward each other, sometimes gesturing in animated conversation. The flexibility of the brush enabled the painter to capture the billowing drapery of robes and the subtle shapes of noses. Variations of color, posture, gesture, and gaze generate an overall liveliness and naturalism. These are not individualized portraits, however, nor are they inserted into narrative contexts. Instead, nearby inscriptions provide names such as Shan Dajia and Li Shan (on the long side of the basket, not seen in this photograph). The painting on the basket does not depict Li Shan rescuing his youthful master, Shan Dajia, from marauders nor assisting with the rightful restoration of family properties; rather, the inscriptions nudge viewers to recall this exemplary story of loyalty. This strategy of using images and words together is also found in some of the compositions at the Wu Family Shrines, and it continued in later East Asian painting.

Period of Division: Elite Art in South China, 220–581 CE

After the Han dynasty collapsed in 220 CE, a period of division ensued. After some fifty years of civil war, the empire split into southern and northern halves. Fleeing the turmoil, Han refugees left the cities such as Chang'an and Luoyang that had long served as dynastic capitals. In the south, they established new, regional courts. These courts, especially that of the Eastern Jin dynasty, located in the vicinity of present-day Nanjing, drew talented officials whose activities reached beyond governance into poetry, **calligraphy**, and painting. Previously the domain of anonymous artisans, calligraphy and painting gained status, becoming essential components of elite culture.

The earliest writing in East Asia, the **oracle bones** of the Shan dynasty (see Chapter 8, and Seeing Connections:

lacquer a liquid substance derived from the sap of the lacquer tree; used to varnish wood and other materials, producing a shiny, water-resistant coating.

calligraphy the art of expressive or carefully descriptive hand lettering or handwriting.

oracle bones turtle plastrons and ox shoulder bones used for divination in the Shang state.

Ancient Writing Systems, p. 132), make clear the close relationship between writing and power. In that context, writing was bound to ritual sacrifices of food and drink, presented in bronze vessels to deceased ancestors who could appeal to the gods to ensure the well-being of the state. However, even though viewers might find much to praise in examples of oracle-bone script from the Shang dynasty and seal script from the Zhou dynasty, such writing was not considered art (see box: Looking More Closely: Writing as Art, p. 356). Not until the Eastern Jin period was writing transformed from an instrument of power into a vehicle of aesthetic expression.

WANG XIZHI, *ORCHID PAVILION PREFACE* The art of calligraphy, as distinct from the practice of written language, may be traced back to the Eastern Jin official Wang Xizhi (c. 303–c. 361 CE). Because calligraphy is greatly esteemed in East Asia, it is fitting that Wang is the first artist to be associated with a specific artwork in this region. In earlier works, typically the names of patrons are preserved (see Figs. 8.8a and 8.14a), indicating that their stature far exceeded that of the anonymous artists.

Wang Xizhi's masterpiece, the *Orchid Pavilion Preface*, is a prose essay that precedes poems Wang and his friends composed while on holiday. Although the original is lost, Wang's preface is preserved in instructive, tracing copies such as this one (**Fig. 21.11**). In the absence of genuine examples, copies became highly valued in East Asian cultures. Collectors have affixed their vermilion

(cinnabar-paste pigment) seals to this copy, attesting to its value and **provenance**. In these contexts, copies were made without intent to deceive. Rather, they emerged from the desire to perpetuate artworks made of perishable materials and to disseminate them to wider audiences as instructional examples.

Wang's writing begins at top right and proceeds in columns to left. The text reads in part:

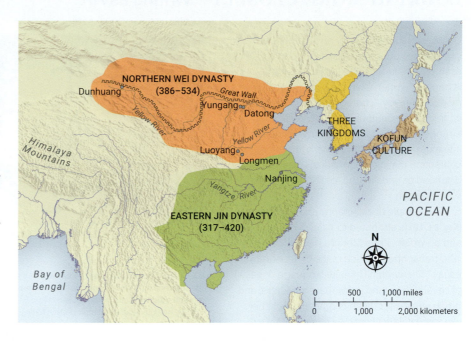

Map 21.2 **East Asia, *c.* fifth century,** during the period of division on the mainland of China.

provenance the history of an artwork's ownership.

一世或取諸懷抱悟言一室之內
媒信可樂也夫人之相與俯仰
所以遊目騁懷足以極視聽之
觀宇宙之大俯察品類之盛
是日也天朗氣清惠風和暢
盛一觴一詠亦足以暢敘幽情
列坐其次雖無絲竹管弦之
滿暎帶左右引以為流觴曲水
有峻領茂林脩竹又有清流激
崇山
羣賢畢至少長咸集此地
于會稽山陰之蘭亭脩禊事
永和九年歲在癸丑暮春之初會

21.11 *Orchid Pavilion Preface,* **detail,** Tang dynasty copy attributed to Feng Chengsu after a lost original by Wang Xizhi. Handscroll: ink on paper, 9⅝ × 27½ in. (24.4 × 69.9 cm) Palace Museum, Beijing.

Unlike languages that rely on an alphabet to translate sounds into visible marks (for example, the language in which this book is printed), written Chinese uses graphs, or more commonly, "characters." Visually, each character is a composition unto itself, an arrangement of straight and curved lines that fit into a designated, often unmarked, space. The characters may be symmetrical or asymmetrical, balanced or unbalanced, spacious or dense, lively or static.

The sample of calligraphy reproduced here (**Fig. 21.12**) is attributed to Yuan dynasty official and polymath, Zhao Mengfu (1254–1322 CE), who transcribes the title of the "Thousand Word Essay." The written Chinese language consists of several thousand individual characters, and brush strokes for these characters must be executed in strict order. As a result, it takes years to develop competency and mastery with brush and ink. With its poetic lines and use of one thousand different characters exactly once each, the "Thousand Word Essay" functioned as early as the sixth century as a primer for learning written Chinese. Already an accomplished scholar, Zhao uses it instead for practicing the art of calligraphy. He writes the essay's title six times, using a different script each time. The repetition of the same characters—the title words "thousand," "word," and "essay"—allows viewers to distinguish between the conventions shared by all scripts and the distinctive features of a particular script.

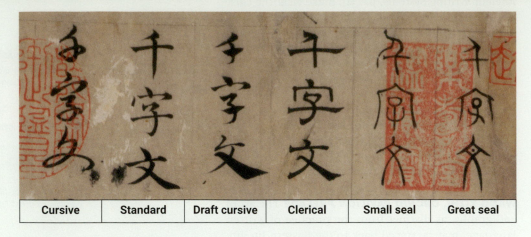

| Cursive | Standard | Draft cursive | Clerical | Small seal | Great seal |

21.12 Six Chinese scripts: the same three characters, for "thousand," "word," and "essay," are repeated in each column. Detail from *Thousand Word Essay in Six Scripts*, attributed to Zhao Mengfu. Palace Museum, Beijing.

Early writing on bones and clay required a sharp, pointed implement, leaving lines of even thickness. Zhao mimics the archaic forms and lines of two variations of seal script in the rightmost columns of **Fig. 21.12**. By contrast, characters written with a pliable brush and ink—whether on bamboo slips, silk, or paper—have greater range. Ink can be darker or fainter, wetter or drier. Lines can be thicker or thinner, or they can be highly modulated—that is, shifting quickly from thick to thin as the sensitive brush responds to the rapid changes in pressure from the writer's hand. Such modulation is visible in the other four columns of Zhao's calligraphy.

Clerical script, named for the clerks who transcribed documents, shows the effect of the new medium of brush and ink. In clerical script, individual brushstrokes may constrict or flare, as in the case of Zhao's third column from the right. Yet overall, in writing in clerical script, he maintains a degree of restraint. By contrast, cursive script appears quite fluid and free, and accordingly Zhao connects all the strokes that comprise a character into a single fluid line in the column at far left. The development of cursive script was the foundation for an association between calligraphy and a person's character. The idea that an individual's writing style and moral fiber were interconnected led to the recognition of writing as art.

In the ninth year of the Yonghe reign [353 CE] ... early in the final month of spring, we gathered at the Orchid Pavilion ... for the ceremony of purification. Young and old congregated, and there was a throng of men of distinction. Surrounding the pavilion were high hills with lofty peaks, luxuriant woods, and tall bamboo. There was, moreover, a swirling, splashing stream, wonderfully clear, which curved round it like a ribbon, and we seated ourselves along it in a drinking game, in which cups of wine were set afloat and drifted to those who sat downstream ...

As the words are read for their meaning, they are simultaneously appreciated visually for their form. Wang writes some characters in standard script, indicated by individual, clearly separated strokes. For other characters, he does not lift his brush but instead connects strokes in semi-**cursive** script (see box: Looking More Closely: Writing as Art).

Wang's writing demonstrates control and discipline in the balanced composition of each character within an invisible box and in the careful completion of individual strokes. Yet his writing is also elegant and spontaneous,

cursive (of a script) flowing, with some letters (or characters, in the case of East Asia) joining together.

which results from his modulation of strokes from thin to thick and back again, and from the variety of ways in which he writes repeated characters. For example, the character for the number 1—a single horizontal line—appears four times in **Fig. 21.11**, but he has written it differently each time. Characters requiring more strokes permit greater variation. Wang's level of proficiency is such that he can write with the kind of natural fluidity that outstanding jazz musicians bring to their improvisation. In both cases, knowledgeable audiences know what patterns to expect and can appreciate subtle variations.

In the case of Chinese calligraphy, however, there is the additional dimension of moral judgment. Writing—the outcome of years of sharpening the mind and disciplining the hand—is believed to convey an individual's character. In this regard, Wang's calligraphy represents the highest level of Confucian self-cultivation, which regards moderation as a virtue. Wang could have written with greater energy or added idiosyncratic flourishes, but instead he carefully curbed such tendencies to produce a work that balances shared conventions with individual expression.

Celebrated in his lifetime as the sage of calligraphy, Wang's style of calligraphy was emulated by emperors and

commoners alike. Although he was in fact taught by a woman surnamed Wei (possibly his aunt), early Chinese culture did not admit a woman as head of its most revered art. Calligraphy joined art with integrity, but clearly it was not free of gender bias. Still, its power attracted future artists—male and female—who pursued this esteemed tradition (see *Ise Shu* in Seeing Connections: The Art of Writing, p. 560 and Figs. 31.5 and 44.3).

GU KAIZHI, *ADMONITIONS OF THE INSTRUCTRESS TO COURT LADIES*

Wang Xizhi was not the only talented official associated with the Eastern Jin court. His younger colleague Gu Kaizhi (344–406 CE) demonstrated remarkable gifts in a different medium: painting. Like Wang's calligraphy, Gu's *Admonitions of the Instructress to Court Ladies* (**Fig. 21.13**) survives only in a later copy. It, too, should be understood in the context of Confucian virtues.

In the fourth of nine scenes that make up the *Admonitions*, Gu features two palace ladies attending to their toilette. The woman on the right uses a hand-held mirror to check her appearance. To the left, a servant fixes the hair of the second woman. Several black-and-red lacquered cosmetic boxes are on the floor beside her, and the lacquered stand in front of her holds a circular mirror. The space is otherwise empty. As with calligraphy, in which unmarked areas are integral to the composition, East Asian painters paid careful attention to negative space. Thus their paintings need not be completely covered with pigment in order to be considered finished. In addition, painters imbued their lines with calligraphic discipline and expressiveness. The outlines of the figures in *Admonitions* are taut and supple.

Two additional characteristics of East Asian painting may be observed in Gu's *Admonitions*. First, the painting's format is a **handscroll**. Holding the painting with their own hands, viewers must unroll it from right to left, conforming to the same direction in which the language is conventionally written and read. The resulting experience is intimate and, like a film, it unfolds in time. Second, *Admonitions* integrates words and images. Not only does Gu base his painting on a poem by Zhang Hua (232–300 CE), an official who served the preceding Western Jin court, but he has also transcribed the salient passages onto the painting itself. These texts divide the scenes, and the resulting artwork may be described as an alternating sequence of texts and discrete scenes. The passage directly to the right of the scene in **Fig. 21.13** reads:

> Men and women know how to adorn their faces,
> But there is none who knows how to adorn their character.
> Yet if the character be not adorned,
> There is a danger that the rules of conduct may
> be transgressed.

Gu depicts women, but not men, adorning themselves. Unlike the image of the Lady of Dai on her funerary banner, these ladies come alive as Gu uses their observable activities to delve into their underlying psychology. On the one hand, self-righteous viewers might rebuke the vain behaviors of these women. On the other hand, those same viewers are lured into the very act of gazing at female beauty. Using mirrors to multiply points of view, Gu invites viewers to reflect on the variety of ways of seeing even as his painting offers instruction in Confucian principles.

handscroll a format of East Asian painting that is much longer than it is high; it is typically viewed intimately and in sections, as the viewer unrolls it from right to left.

21.13 *Admonitions of the Instructress to Court Ladies* **(detail),** Tang dynasty copy of a fourth- or fifth-century handscroll painting by Gu Kaizhi. Ink and color on silk, 9¼ in. × 11 ft. 6 in. (23.5 cm × 3.51 m), British Museum, London.

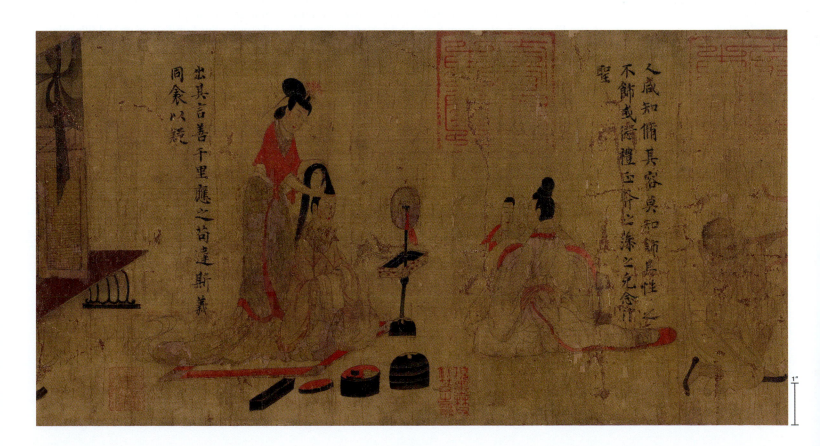

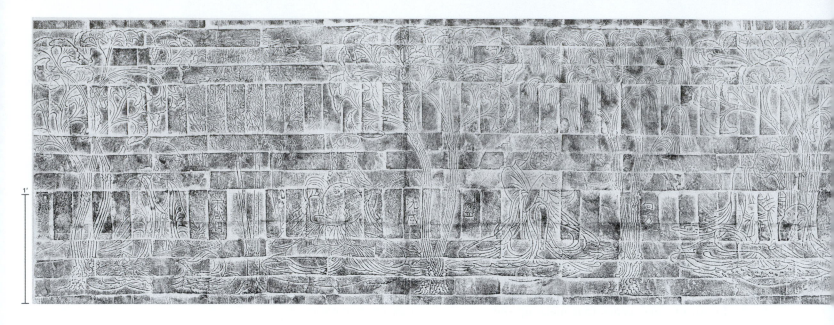

1'

21.14 *Seven Sages of the Bamboo Grove* **and Rong Qiqi,** rubbing of tomb tile relief, Nanjing, Jiangsu province, China. Eastern Jin dynasty, *c.* fifth century. Ink on paper, height 31½ in. (80 cm).

TILE RELIEF OF *SEVEN SAGES OF THE BAMBOO GROVE*
Along with the principles of Confucianism, Daoist views were also represented in the art of the Eastern Jin. Early images of men with Daoist leanings are preserved on the brick tiles of a tomb, from which these rubbings were taken (**Fig. 21.14**). The relief depicts the *Seven Sages of the Bamboo Grove* along with the recluse Rong Qiqi (far left, playing the zither), believed to be a contemporary of Confucius. Seated beneath a variety of leafy trees, some of the men play musical instruments, including the zither and the lute. Others drink, sit idly, or sleep. All wear loosely tied robes, and their exposed bodies signal their rejection of the proper etiquette pertaining to the life of a Confucian official. Refusing to serve the government during a time of factionalism and decay prior to the Eastern Jin, the Seven Sages purportedly gathered in a bamboo grove near the home of Ji Kang (fourth from the right, playing the zither resting upon one knee). There, unencumbered by duties and obligations, they enjoyed the pleasures of rustic life in their pursuit of the Daoist Way.

As in the paintings of Confucian worthies on the lacquer basket from Lelang (see **Fig. 21.10**), the unknown designers of the tomb tiles rely on names to identify the sages, who share similar dress and physical features. Still, the designers show marked attention to the human body and the manner in which drapery falls over the shoulders and knees. They also demonstrate an understanding of how to represent three-dimensional objects on a flat surface, in such details as **isometric** rendering of the small table propping up the elbow of one sage (far right). However, the point of this image is not to put artistic ingenuity on display. Rather, it captures the rustic conviviality of the Seven Sages' chosen way of life. To that end, trees with decorative foliage substitute for the sages' bamboo grove, creating a natural setting. The trees also function as compositional dividers, so that each sage occupies his own space. Although there is visual separation between figures, the consistent use of fine, flowing lines to depict the sages and the setting creates a unified and lively composition.

isometric perspective a system of representing three-dimensional space and objects on a two-dimensional surface in which the angle between any two of the three coordinate axes is approximately 120 degrees; unlike linear perspective, the lines have no vanishing points.

icon an image of a religious subject used for contemplation.

Period of Division: Buddhist Art in North China, 220–581 CE

While calligraphers and painters developed increasingly refined ways to convey the Confucian and Daoist ideals of learned gentlemen in the Yangzi River area, to the north a new religion—Buddhism—began taking root. Originating in South Asia (see Chapter 16), Buddhism spread via trade routes of the Silk Road that connected East Asia with the rest of the Eurasian continent. Han dynasty texts make reference to the Buddha, but at that time, Buddhism did not encounter an audience altogether eager to adopt its teachings. For example, the Buddhist injunction for monks to leave their families and practice celibacy conflicted with deeply held Confucian values that emphasized continuous family lineage and filial piety.

By contrast, during the ensuing period of division, Buddhism—which offered an alternative world-view and could include promises of salvation—appeared more attractive. Moreover, Buddhism could be enlisted to help achieve political goals. Sponsorship of Buddhist art served as a visible sign of the emperor's religious piety, presenting him as a *chakravartin*, or ideal universal ruler (see also Figs. 16.1 and 16.2). During the politically unstable period of division in the years 220–589 CE, Buddhism found potential adherents among those who witnessed the weakness and collapse of the Confucian-oriented Han state, as well as those who competed for political primacy. Consequently, many Buddhist artworks, including small **icons**, monumental sculptures, narrative mural painting, and donor portraits, were created during this period.

SEATED BRONZE BUDDHA Buddhism promotes the making of religious images not only as a devotional act, but also as a means of acquiring religious merit. The religion incorporates a belief in rebirth, which is determined by karma, the sum of one's moral and immoral actions. By sponsoring the making of Buddhist images that help to disseminate the Buddha's teachings—a moral action—individuals positively affect their karma. They thus increase the probability of advantageous rebirth as

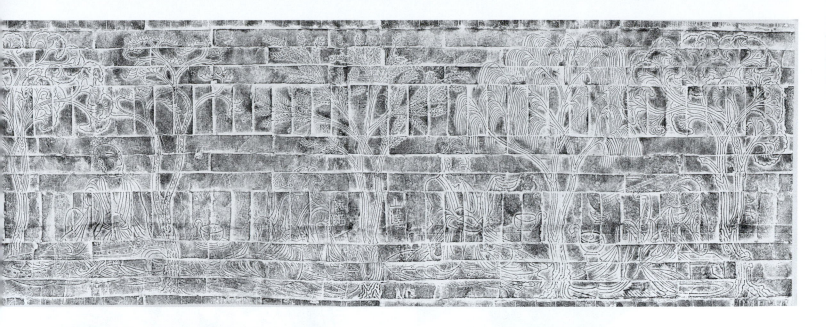

the basis of iconographical features: the ***ushnisha***, the monastic clothing consisting of a sarong-like undergarment and a large shawl, and the meditative posture (see Fig. 16.17). The Buddha's hands are evidently intended to be in the *dhyana **mudra*** of meditation, but they are rotated so that the palms do not face up, demonstrating the variation that occurs when artists encounter and adapt new forms from other cultures. Stylistic features of this Buddha, including the slight smile and the heavy appearance of the drapery, recall earlier models from South Asia (see Fig. 16.8). Like the icons of other faiths, this bronze sculpture would have been consecrated to complete the transformation from inert metal to an embodiment of the Buddha, who could then receive the prayers and offerings of worshipers.

Because this bronze image has been gilded, the sculpture reflects light. Literally radiant, it suggests the Buddha's luminous aura, described in texts. The high cost of gold imparts value to the sculpture, too. The Buddha's position and authority are further communicated through composition. A pedestal elevates and separates him from the mundane world. His body—knees to shoulders to *ushnisha*—forms a triangle, a stable shape that conveys strength and immutability. The Buddha's meditative posture and serene expression remind the viewer of his enlightenment, which is the goal of Buddhism. His monk's shawl falls in a manner that combines a degree of naturalism with implausible but attractive symmetry. Overall, the sculpture conveys authority and otherworldliness without appearing intimidating.

COLOSSAL SEATED BUDDHA Monumental **rock-cut** cave chapels at the sandstone cliffs of Yungang, literally Cloudy Ridge, are evidence that the Tuoba clan from the Mongolian steppe region, who founded the Northern Wei dynasty (386–534 CE), were patrons of Buddhist art (**Map 21.2**). The site, just west of the Northern Wei capital of Pingcheng (now Datong), is home to about 51,000 Buddhist sculptures, some in shallow niches and others in deeper caves. Some were made under imperial auspices and in expiation for a persecution of Buddhists

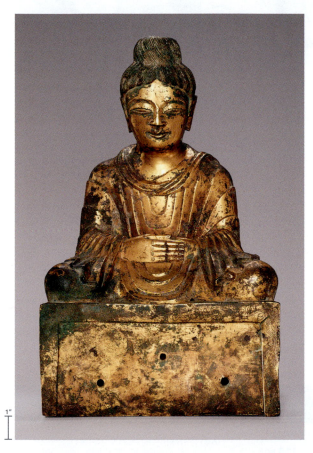

human beings in this world, and decrease their chances of being reborn as animals, or worse, hungry ghosts in a hellish realm. In effect, the creation of Buddhist images leads to the possibility of more people learning about Buddhism. Those people, in turn, sponsor the creation of more Buddhist images.

A small bronze figure of a **buddha** is datable by its inscription to 338 CE, when an Indo-Iranian group known as the Jie ruled the northern area of China during the time of the short-lived Later Zhao kingdom (**Fig. 21.15**). The figure is recognizable as the historical Buddha not because his physical likeness is captured, but rather on

21.15 FAR LEFT **Seated Buddha,** from Hebei province, China, later Zhao period (319–51), 338 CE, Gilt bronze, height 15¾ in. (40 cm). Asian Art Museum, San Francisco, California.

buddha; the Buddha a buddha is a being who has achieved the state of perfect enlightenment called buddhahood. The Buddha is, literally, the "Enlightened One"; generally refers to the historical Buddha, Siddhartha Gautama, also called Shakyamuni and Shakyasimha.

ushnisha one of the thirty-two markers of the Buddha: a protuberance from the head, usually a topknot of hair.

mudra a symbolic gesture in Hinduism and Buddhism, usually involving the hand and fingers.

rock-cut carved from solid stone, where it naturally occurs.

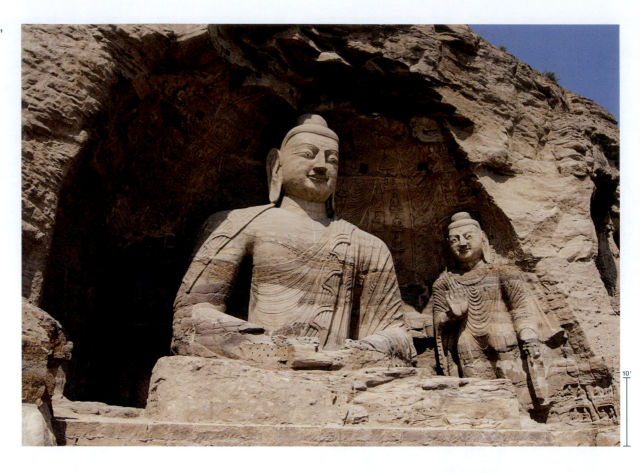

21.16 Colossal seated buddha, Yungang Caves (Cave 20), Shanxi province, China, northern Wei dynasty, c. 460–65. Sandstone, height 45 ft. (13.72 m).

10'

that took place from 446 to 452 CE. Among them, Cave 20 features a 45-foot-high seated buddha and a much smaller, standing buddha to the viewer's right (**Fig. 21.16**). Another such buddha stood on the opposite side to make the original composition symmetrical, and the entire trio would have been enclosed in an artificial, cave-like structure. The extant figures share iconographical markers of the Buddha. In addition to the *ushnisha*, long earlobes, monk's attire, and posture, the sculptures at Cave 20 are marked by the **urna**, haloes around their heads, and **mandorlas** around their bodies. The figures emerge in **high relief** from the rock. By contrast, the alternating patterns of stylized flames and seated buddhas in the haloes are carved in low relief (see p. 346). The iconography of the original trio suggests a possible identification as the Buddhas of the Past, Present, and Future.

Square notches cut into the cliff indicate an earlier attempt to use architecture to protect the sculptures after the Northern Wei period artificial cave wall had fallen. That architecture is now gone, as well as the pigments that once colored the sculptures. The figures themselves persist, however. Their smooth, geometric forms, cheerful smiles, and outward gaze recall early models from South Asia (see Fig. 16.6), while the elaboration of two-dimensional patterns on the robes and haloes suggests long-standing local interest in the expressive possibilities of line.

urna one of the thirty-two markers of the Buddha: a tuft of hair or small dot between the eyebrows that symbolizes a third eye.

mandorla (in religious art) a halo or frame that surrounds the entire body.

high relief raised forms that project far from a flat background.

Chronology

	JAPAN		c. 113 BCE	A jade burial suit and bronze incense burner are made for Prince Liu Sheng of the Western Han dynasty
c. 400 BCE–c. 300 CE	The Yayoi period			
c. 200–100 BCE	Bronze blades and mirror are deposited in the Yoshitake-Takagi site Yayoi tomb		220–581 CE	The Period of Division, includes: Eastern Jin (317–420 CE) Later Zhao (319–51 CE) Northern Wei (386–534 CE)
c. 300–538 CE	The Kofun period			
c. 375–425 CE	The Daisen Tomb is constructed		338 CE	Bronze seated buddha is cast during the later Zhao period
	CHINA		353 CE	Wang Xizhi writes the *Orchid Pavilion Preface* (now lost)
206 BCE–220 CE	The Han dynasty (includes Western Han, 206 BCE–9 CE, and Eastern Han, 25–220 CE)		c. 460–65 CE	Colossal Buddhist figures are carved at Yungang, Northern Wei dynasty

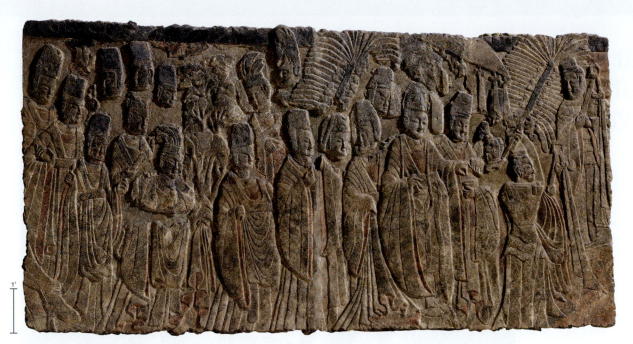

21.17 Emperor Xiaowen as donor, from Central Binyang Cave (Cave 3), Longmen Caves, Luoyang, Henan province, China. Northern Wei dynasty, c. 522–23. Limestone relief with traces of paint, 6 ft. 10 in. × 12 ft. 11 in. (2.08 × 3.94 m). Metropolitan Museum of Art, New York.

RELIEF OF EMPEROR XIAOWEN These possibilities are evident in a low-relief panel depicting Emperor Xiaowen, who ascended to the Northern Wei throne in 471 (**Fig. 21.17**). His son, Emperor Xuanwu, commissioned posthumous images of his parents for a Buddhist cave chapel at Longmen (literally, Dragon Gate), close to the new capital of the Northern Wei, which had shifted southward to Luoyang (**Map 21.2**). In this artwork, Emperor Xuanwu demonstrates one way of reconciling Buddhism and Confucianism.

Standing beneath a decorated parasol, the nearly life-sized Emperor Xiaowen directs his attention to an incense burner held by one of his many attendants. The figures fill the entire composition, which does not rely on trees or furnishings to provide a setting or divide space. Nor is the composition governed by the rules of symmetry. Instead, the unknown artist has pursued naturalism by using such strategies as overlapping figures to indicate depth, varying the patterns of falling drapery, and representing heads in three-quarter view and shifting the angles and directions they face. Traces of pigment indicate another means to mimic reality. Still, no actual resemblance to Emperor Xiaowen was necessary, as conventions of ritual and attire would have been enough to identify him and for the artwork to fulfill its functions. Paired with a similar relief panel depicting the empress, this sculpture represented the imperial couple in the role of donors, worshipping the Buddha (the central icon of the cave chapel, not pictured) in perpetuity. The cave chapel not only expressed the Northern Wei's commitment to Buddhism, but also demonstrated the Confucian virtue of filial piety, expressed by Emperor Xuanwu toward his father.

After Emperor Xuanwu's death, the Northern Wei dynasty lasted only two more decades, but the imperial sponsorship of art that combined Buddhist beliefs and Confucian virtues would endure for centuries. Moreover, with the centralization of power and concentration of wealth, which would occur with the reunification of Chinese regions in the late sixth century, imperial patronage would produce ever larger and more elaborate Buddhist monuments. Similarly, ambitious rulers in Korean and Japanese areas would embrace Buddhism as a source of political legitimacy and instrument of religious authority. Henceforward, abundantly furnished tombs would continue to be a valuable source for art history, but increasingly, artworks would be preserved in the collections of courts and prominent temples.

Discussion Questions

1. Visual art is often the vehicle for communicating such profound human values as respect for parents or devotion to religion. Choose an artwork from this chapter to explain how it represents those values.

2. Some artworks in this chapter were buried in tombs; others picture realms associated with the afterlife, such as the Island of the Immortals. Choose two artworks to compare and contrast how they convey ideas about life after death.

3. How does writing, a technology for recording information or instrument of power, become an artform in East Asia?

Further Reading

- Barbieri-Low, Anthony J. *Artisans in Early Imperial China*. Seattle, WA: University of Washington Press, 2007.

- Barnes, Gina L. *Archaeology of East Asia: The Rise of Civilization in China, Korea and Japan*. Philadelphia, PA: Oxbow Books, 2015.

- Hai, Willow Weilan, et al. *Art in a Time of Chaos: Masterworks from Six Dynasties China, 3rd–6th Centuries*. New York: China Institute in America, 2016.

- Harris, Victor (ed.). *Shintō: The Sacred Art of Ancient Japan*. London: British Museum Press, 2001.

The Cultural Power of Gold across the World

The natural element gold possesses unusual properties. It is highly malleable; it does not tarnish or corrode; it both absorbs and reflects light in such a way as to appear radiant; and it can be easily combined with other materials, such as silver and copper, to change its color and increase its strength. These attributes have made gold highly valued across numerous distinct societies that have endowed it with symbolic meaning and cultural value.

In the last centuries of the Silla kingdom (57 BCE–676 CE) of the Three Kingdoms period on the Korean peninsula, highly skilled artisans fashioned gold into elaborate crowns that accompanied royalty into the afterlife (**Fig. 1**). To maximize this crown's visual impact, goldsmiths carefully cut thinly hammered sheets of gold and punched dotted lines and patterns along the edges of the largest pieces before joining them together. From the headband, thin forms resembling stylized trees and animal antlers rise upward, bestowing additional stature upon the regal head. Painstakingly attached with gold wire, hundreds of gold spangles shimmer and dozens of curved, jade ornaments (called *gogok*) dangle, drawing attention to the royal face. Because the tree forms relate to local, shamanic beliefs, the crown implies that royalty commanded a degree of religious power. Because this crown is quite fragile, it may not have been worn prior to its burial with a queen.

Ancient Greek and Roman cultures also valued gold highly, and they particularly associated the material with the gods. The most famous religious statues in Classical Greece were made of gold and ivory, a combination called chryselephantine. Examples include the Archaic chyselephantine statue of Apollo at Delphi (Fig. 13.8) and the now-lost colossal statues of Athena in the Parthenon and Zeus at Olympia (Chapter 14). The radiance of gold, and the fact that it does not tarnish, made it a symbol of immortality, appropriate

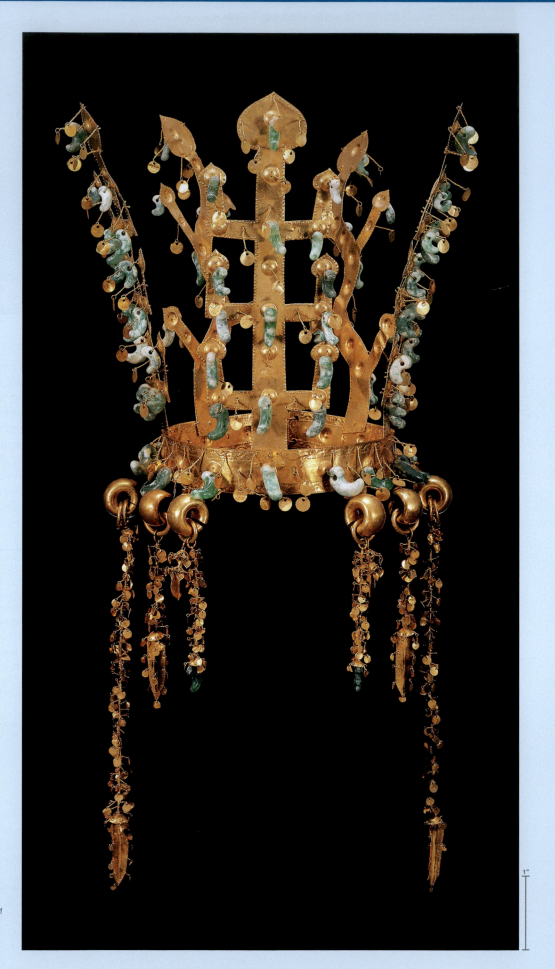

1 Crown, Silla kingdom, excavated from the north mound of the Great Tomb at Hwangnam (Hwangnamdaechong). Second half of fifth century CE. Gold and jade, height 10¾ in. (27.5 cm). Gyeongju National Museum, Korea.

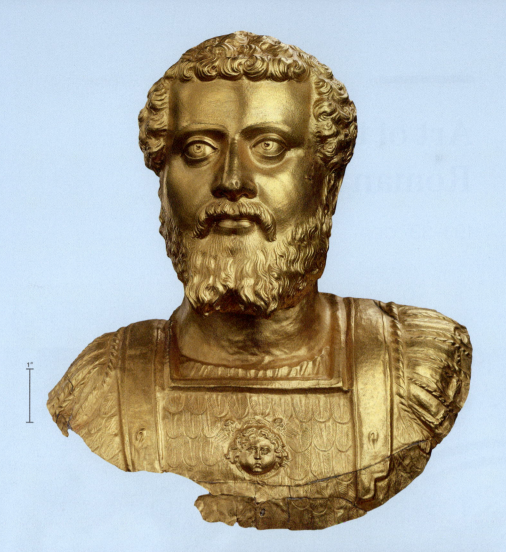

Ancient cultures of South America believed that gold was created by the solar god. Gold's color, sheen, and reflective properties made it easy to associate with the sun. When worn by rulers, with sunlight shimmering on its surface, gold demonstrated a direct connection to one of the chief deities. These gold and silver ear ornaments (**Fig. 3**) feature images of condors, huge birds of prey that flourish in the high altitudes of the Andes Mountains. A powerful individual would have placed the round shafts through perforations in the earlobes and worn them facing outward. After wearing such ornaments at state occasions, rulers eventually took one or more with them to the grave. The condors adorning these ornaments are worked in silver and attached to the gold ground. The artist has inlaid the eyes with shell and emphasized the sharp claws by depicting them at enlarged scale. The bird's fearsome aspect, along with its apparent proximity to the sun, made it an appropriate symbol for Andean rulers.

Sifted from the surface of the earth and mined from deep underground, undistinguished lumps of golden ore have been transformed by artists around the world into powerful cultural symbols of earthly and divine authority.

2 ABOVE **Bust of the Roman emperor Septimius Severus,** Excavated from Plotinoupolis (Didymoteichon, Thrace), Greece. *c.* 200 CE. Gold, height 9⅞ in. (25 cm). Archaeological Museum of Komotimi, Greece.

3 RIGHT **Pair of Moche ear ornaments with condors,** from the north coast of Peru, *c.* 100–300 CE. Gold and silver with shell inlay, diameter 3 in. (7.6 cm). Metropolitan Museum of Art, New York.

for depicting the divine. Romans used gold for imperial imagery. Like the colossal Greek statues of Athena and Zeus, large-scale gold statues of Roman emperors have long since disappeared, but smaller, hollow gold statues such as this bust of Septimius Severus (ruled 193–211 CE) survive (**Fig. 2**). Malleable gold was hammered to produce a naturalistic, but nevertheless idealized, likeness of the emperor's wide forehead, curly hair, wavy split beard, and alert gaze. Severus wears an opulent feathered breastplate with leather straps. The breastplate is decorated with the face of a gorgon, one of three Greek mythical sisters with serpents for hair. Traces of copper on the back of the bust indicate that it may have been mounted on a pole and carried by the army as a military standard. Such standards advertised the power of the emperor and of Rome to far-flung areas of the empire, including the ancient city of Plotinoupolis, Greece, where this bust was found. Golden imperial busts could also be worshiped, thus blurring the boundary between secular and divine power.

Discussion Questions

1. Compare the formal effects of the golden bust of Septimius Severus (**Fig. 2**) with a portrait bust in another medium, such as marble (see Chapters 18–20). How does the material of a sculpture affect its appearance and meaning?

2. Gold continues to carry powerful symbolic and cultural value in contemporary society. Find an example of a gold object made or used in the present day and discuss its meaning.

3. Watch this short video ("The Artist Project: Teresita Fernández" https://www.youtube.com/watch?v=FRuCwNXKfC0) of the contemporary artist Teresita Fernández discussing pre-Columbian gold at the Metropolitan Museum of Art. Discuss the cultural values that Fernández identifies in the objects and their display.

Further Reading

- Lapatin, Kenneth. *Luxus: The Sumptuous Arts of Greece and Rome*. Los Angeles, CA: J. Paul Getty Museum, 2015.
- Lee, Soyoung and Leidy, Denise Patry. *Silla: Korea's Golden Kingdom*. New York: The Metropolitan Museum of Art, New York, 2013.
- Pak, Young-sook. "The Origins of Silla Metalwork," *Orientations* 19, no. 9 (1988): 44–53.

22

Art of the Late Roman Empire

193–337 CE

*Portraits of the Tetrarch*s
(detail).

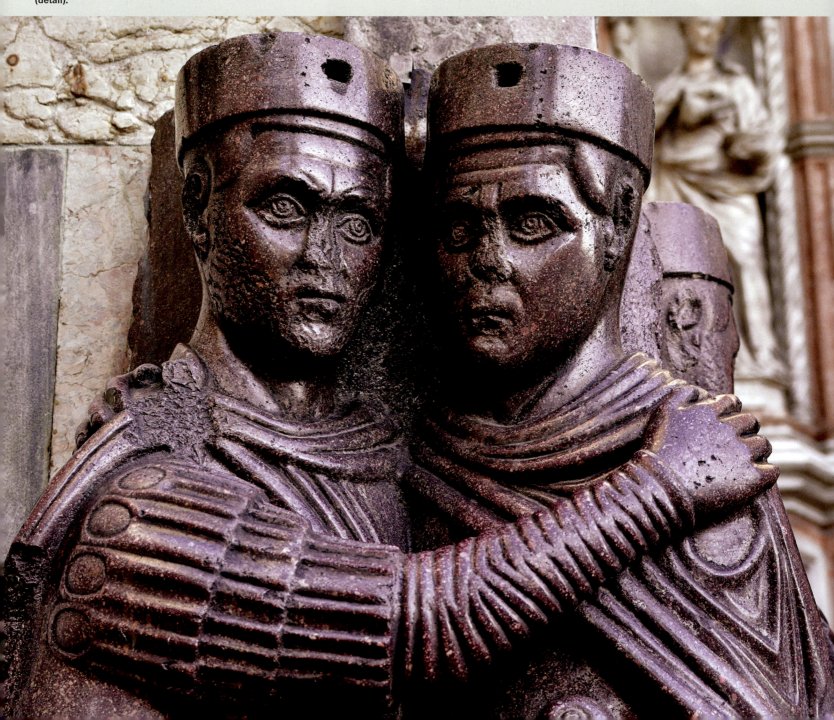

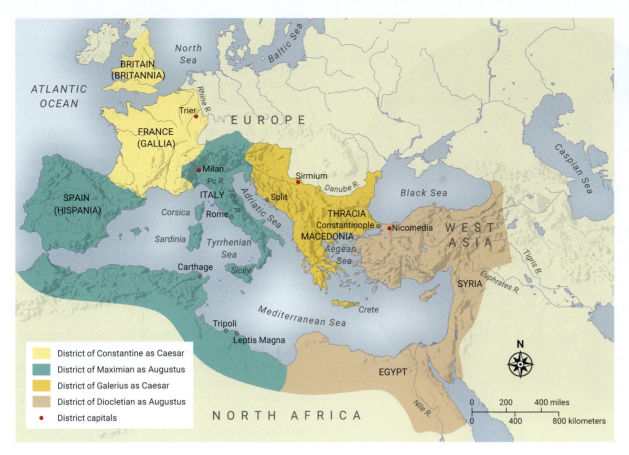

Map legend:
- District of Constantine as Caesar
- District of Maximian as Augustus
- District of Galerius as Caesar
- District of Diocletian as Augustus
- District capitals

Introduction

As a result of internal civil strife and increasing threats on the borders, the beginning of the late Roman Empire saw the end of the *Pax Romana* (Peace of Rome), a two-hundred-year period of relative peace and stability. Dramatic changes in Rome's political and administrative organization ensued. This in turn brought diverse approaches to the art and architecture of the Late Roman period, as the propagandistic and ideological messages conveyed by art were shaped by these new circumstances.

During the reign of Marcus Aurelius (ruled 161–80), the borders of the Roman Empire were already under serious threat, especially along the Danube and Rhine Rivers. The assassination in 192 of the power-hungry emperor Commodus resulted in a struggle among military leaders. The North-African-born general Septimius Severus came out on top, establishing the Severan dynasty, which was responsible for impressive monuments in Rome and the provinces.

The power vacuum that began when the last of the Severan emperors was murdered in 235 gave way to renewed civil strife and fifty years of great instability known as the period of the soldier emperors. Each of these men was declared emperor by the military, rather than appointed by the senate, and assassinations occurred on a regular basis. The period of the soldier emperors ended when Diocletian came to power. In a highly strategic move intended to stabilize the empire—and to protect himself from the fate of his predecessors—Diocletian chose to share power with his rivals, giving rise to the Tetrarchy, or rule by four, in 293 (see **Map 22.1**).

Two more decades of conflict followed the retirement of Diocletian in 305. Constantine I ("the Great") was ultimately victorious, taking the position of emperor. The persecution of Christians had reached its peak under Diocletian, but that did not stop conversions to this new monotheistic religion. Constantine seized this opportunity and conquered Rome in the name of the Christian God, ultimately reuniting the empire and establishing a new eastern capital at Constantinople.

The Severan Dynasty, 193–235

The Severan dynasty began in 193 when the Roman senate appointed army general Septimius Severus emperor. The Severans were great builders and patrons of art, and they drew on a variety of artistic styles. Their architecture featured more decorative—even flamboyant—elements, especially in the provinces, and their figures were less naturalistic and more static than those of earlier Roman dynasties.

TEMPERA PORTRAIT OF SEPTIMIUS SEVERUS AND FAMILY

In an attempt to legitimize his rule, Septimius Severus had himself adopted into the Antonine family as son of the deified Marcus Aurelius. (The Nerva-Antonine dynasty included the five so-called Good Emperors; see Chapter 20.) This connection was reinforced visually in all known portraits of Septimius Severus, who is always depicted with a split beard with large corkscrew curls in the style of Marcus Aurelius. (For a portrait bust of Severus in gold, see: Seeing Connections: The Cultural Power of Gold Across the World, p. 362). The only extant painted portrait of any emperor from antiquity is a family

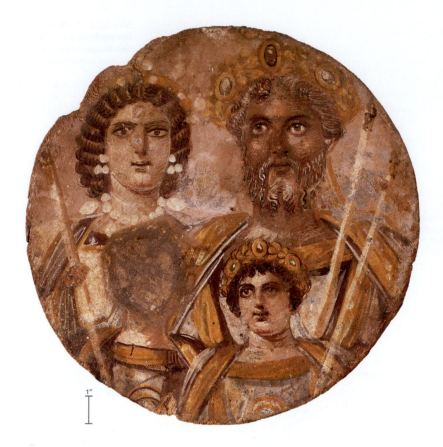

22.1 Septimius Severus, Julia Domna, Caracalla, with Geta (?) intentionally erased. Egypt, c. 200. Tempera on wood, diameter 14 in. (35.6 cm). Antikensammlung, Berlin.

golden, jewel-encrusted wreath, as does the one son who is preserved; the other son probably did as well. Notably, the face and part of the wreath of one of the sons were destroyed. This could be Geta, who in 211 Caracalla ordered assassinated and issued the *damnatio memoriae* against, a dishonor usually reserved by the senate and intended to erase a person from memory. However, given the taller stature of the erased figure, it has also been suggested that it could represent the older son Caracalla after the end of his ruthless rule. Julia Domna, an educated woman and a prominent empress in Roman politics, wears a crown with jewels atop her distinctive hairstyle of parallel curled rows. During her lifetime, she surrounded herself with philosophers and other intellectuals, went on campaigns with her husband, and was given the title "mother of the army camps." After the death of Septimius Severus, she played an important role in the reign of Caracalla, who gave her the title "mother of the senate and of the fatherland."

ARCH OF SEPTIMIUS SEVERUS The North African provincial city of Leptis Magna, with its impressive harbor connecting it to other Mediterranean ports, was the birthplace of Septimius Severus. Located 75 miles east of Tripoli on the Mediterranean Sea in present-day Libya, the settlement was originally a Phoenician colony. It was later associated with early Rome's great rival, the North African city of Carthage, until the Roman defeat of Carthage at the end of the Punic Wars in 146 BCE. Later, Leptis Magna became part of the Roman province of Africa with a harbor connecting it to other Mediterranean ports (see **Map 22.1**). Under Severan rule, it received a new **forum**, a **basilica**, and a **colonnaded** street running from the city center to the harbor (**Fig. 22.2**). After the city was abandoned, it was ultimately buried in sand, until Italian archaeologists uncovered it in the 1920s.

Like other Roman emperors, Septimius Severus erected **triumphal arches** across the empire. The Arch of Septimius Severus in Leptis Magna (**Fig. 22.3**) glorified the Severan dynasty and commemorated the emperor's visit to his birthplace and his victory over the Parthians (who were originally from northeast Iran, and established

scene that depicts Septimius Severus, his powerful Syrian wife, Julia Domna, and their two sons, Caracalla and Geta, whom Septimius Severus appointed as co-emperors during his reign. This **tondo** was found in Egypt and is painted with **tempera** on wood (**Fig. 22.1**). Stylistically, the figures and the level of realistic detail in the facial features, hairstyles, and jewelry are reminiscent of mummy portraits from Roman Egypt (see Further Reading), as is the medium of tempera on panel, although many mummy portraits used **encaustic**.

The figures, who wear white with gold and purple trim fitting for the imperial family, face frontally, with large, intense eyes. The emperor is shown as mature, with graying hair and beard. On his head he wears a

tondo (plural **tondi**) a circular work of art.

tempera a fast-drying paint made from a mixture of powdered pigment and a binding agent, typically egg yolk.

encaustic paint made from a mixture of pigment and heated wax.

22.2 Plan of Leptis Magna, Libya, showing forum, basilica, triumphal arch, and lighthouse.

[Map labels: N, lighthouse, theater, basilica, harbor, colonnaded street, triumphal arch, forum, 0 600 1,200 feet, 0 200 400 meters]

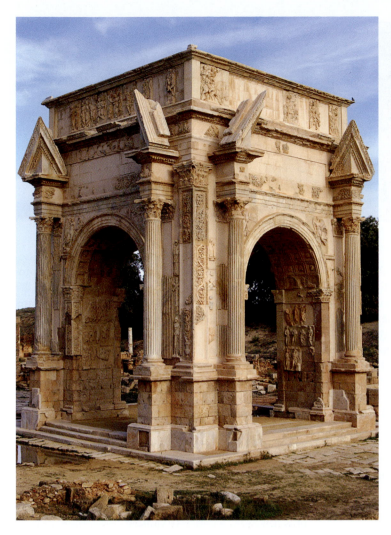

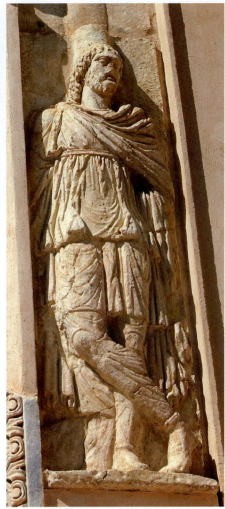

forum an open area at the center of a Roman town where people shopped, worshiped, and participated in political or judicial activities.

basilica a longitudinal building with multiple aisles and an apse, typically located at the east end.

colonnade a long series of columns at regular intervals that supports a roof or other structure.

triumphal arch a freestanding archway that often spans a road or marks an entrance; decorated with relief carvings alluding to a historical, often military, victory.

cardo the main north–south street in a Roman city.

decumanus the main east–west street of a Roman city.

Corinthian an order of Classical architecture characterized by slender fluted columns and elaborate capitals decorated with stylized leaves and scrolls.

pediment in architecture, the triangular component that sits atop a columned porch, doorway, or window.

relief raised forms that project from a flat background.

high relief raised forms that project far from a flat background.

spandrel the almost triangular space between the outer curve of an arch, a wall, and the ceiling or framework.

pilaster a flat, rectangular vertical projection from a wall; usually has a base and a capital, and can be fluted.

capital the distinct top section, usually decorative, of a column or pillar.

attic on a facade or triumphal arch, the section above the frieze, decorated with painting, sculpture, or an inscription.

a powerful empire in West and Central Asia). In contrast to more traditional two-way triumphal arches in and closer to Rome (see the Arch of Titus, Fig. 20.4), the Arch of Septimius Severus is an eclectic four-way arch, or tetrapylon. This flamboyant structure is located at the intersection of the city's **cardo** and **decumanus**. Its **Corinthian** columns on raised pedestals hold intentionally "broken" **pediments**: Only two triangular corners are positioned above the columns, and the middle part of the pediment is missing. This intriguing style, which departs from Classical traditions for its visual effects, was more common in Rome's eastern provinces. The arch as it stands today has been largely reconstructed using original pieces, though the **relief** sculptures are casts of originals now located in the Castle Museum in Tripoli.

RELIEF OF PARTHIAN ON ARCH OF SEPTIMIUS SEVERUS
The extensive and deeply drilled relief cycle on the arch is highly elaborate, with floral or plant motifs as well as figural images. The North African sun enhances the contrast of light and shade within the grooves and cavities of the **high relief** carving. As in many other triumphal arches, Nikes (representing victory) are depicted in the **spandrels**. Here the figures are virtually naked, wearing only a piece of drapery that does nothing to conceal the body. Captives stand below trophies and between the **pilasters** and the **capitals**. The captive in **Fig. 22.3a** is a Parthian, as indicated by his tunic, mantle, and trousers; the Romans considered such non-Roman people, and their clothing, barbaric. The pilasters' vegetal reliefs, including vines with grapes, are not surprising, given this African city's devotion to the Phoenician god Shadrapa, who was associated with Dionysos, the Greek god of wine.

RELIEF OF CHARIOT PROCESSION ON ARCH OF SEPTIMIUS SEVERUS
The **attic** of each side of a triumphal arch is usually preserved for the dedication. However, in the Arch of Septimius Severus, the attics are given over to relief sculpture. Three of the four sides are well preserved. One relief (**Fig. 22.4**, p. 368) depicts Septimius Severus in a chariot, taking part in a procession. He stands between his two sons, Caracalla and Geta, presumably whose sculpted head was later destroyed. The procession probably depicts the return of Septimius Severus and his family to Leptis Magna, the occasion that this arch (partly) commemorates. The location is identified as Leptis Magna by the depiction of its lighthouse in the upper mid-right of the relief panel (see also **Fig. 22.2**).

The imperial procession on the earlier Arch of Titus (see Fig. 20.6) shows the movement of bodies underneath drapery and conveys the forward motion of the procession. In contrast, Septimius Severus, Caracalla, and Geta are all frontal, and they show little movement, while the equally still team of horses is rendered in profile.

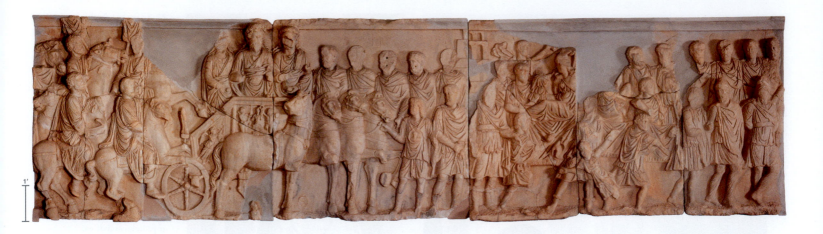

22.4 Chariot procession, detail of attic relief from Arch of Septimius Severus, Leptis Magna, Libya, 203. Marble, relief approx. height 5 ft. 6 in. (1.68 m). Assaraya Alhamra Museum (Red Castle Museum), Tripoli.

This style gives the static figures a dignified look, one that focuses less on naturalism and more on their important positions in Late Roman society. Also interesting are the figures in the back row. Some of them, though seemingly standing behind the figures and horses in front, are not attached to the ground, as they have no legs or feet. This less naturalistic representation, which looks back to plebeian traditions, continued to gain in popularity in imperial circles throughout the Late Roman era. Another relief on the attic shows Septimius Severus shaking the hand of Caracalla. They are joined by Geta, Julia Domna, and the goddess Roma, thus demonstrating harmony among the members of the ruling family in an attempt to convey a strong dynastic line, as well as the favor of the patron goddess of Roma. In reality, the future relationships among members of the Severan dynasty were anything but harmonious.

BATHS OF CARACALLA Not all of the Severans' public projects focused on glorifying the ruler and his family. Like previous emperors, such as Titus and Trajan, the Severans appealed to the citizens of Rome with building programs that met their needs and interests, including luxurious public bathing complexes. Going to public baths was an ordinary part of life for Romans (see Stabian Baths, Fig. 18.6). The Baths of Caracalla, begun by Septimius Severus and completed by Caracalla in the early third century CE, were the grandest of all the baths, accommodating an estimated 1,600 people (**Fig. 22.5**). The complex was huge, covering almost 50 acres, with walls up to 140 feet (42.67 m) high. The main bathing areas were located inside a walled enclosure (not illustrated in the plan). The complex, which demonstrates **bilateral symmetry**, also included an enormous **domed** *caldarium*, or hot bath; a *tepidarium*, or warm bath; a concrete **vaulted** *frigidarium*, or cold

bilateral symmetry symmetrical arrangement along a central axis, so that the object or plan is divided into two equal halves.

dome a roof that projects upward in the shape of the top half of a sphere.

vault an arched structure, usually made of stone, concrete, or brick, that often forms a ceiling.

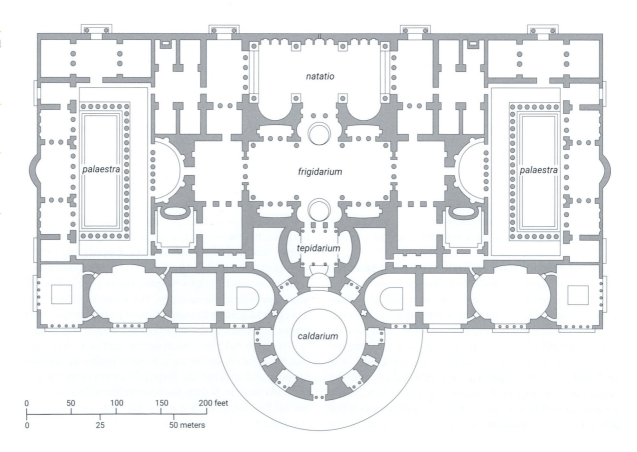

22.5 The Baths of Caracalla (plan drawing), Rome, early third century.

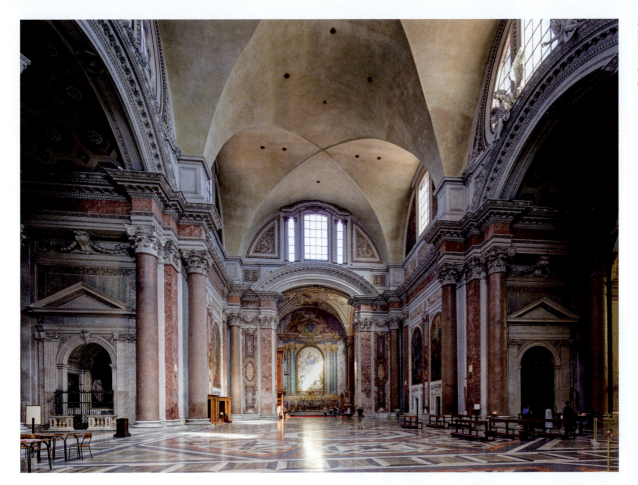

22.6 *Frigidarium*, **Baths of Diocletian,** Rome, *c.* 298–306. Remodeled by Michelangelo Buonarroti as the central aisle of the church of Santa Maria degli Angeli, 1563.

bath; and an open-air *natatio*, or swimming pool. It also had two open areas for gymnastic exercises (*palaestra*), gardens, libraries, and meeting halls.

Caracalla spared no expense on the decoration of his baths, which had marble **inlays** covering the floors and the brick-faced concrete walls. The baths also featured mosaics, paintings, and sculptures; one colossal sculpture is the ten-and-a-half-feet-tall *Farnese Hercules*, which is modeled on the *Weary Hercules* by the Late Classical sculptor Lysippus from around 320 BCE.

BATHS OF DIOCLETIAN (NOW CHURCH OF SANTA MARIA DEGLI ANGELI) To get a sense of the grandeur of the original concrete Roman vaults with a **clerestory** in the Baths of Caracalla, we can look at the later, similarly designed Baths of Diocletian in Rome— specifically, the *frigidarium* that Michelangelo remodeled during the Renaissance to create the Church of Santa Maria degli Angeli (**Fig. 22.6**). This church arguably provides visitors with an authentic feeling of being inside the vaulted interior space of an ornately decorated Roman building.

The Soldier Emperors and Imperial Portraiture in a Period of Disunity, 235–284

Caracalla's ruthless rule was cut short when he was assassinated in 217, after just six years as sole emperor. The last of the Severan emperors, Severus Alexander, was murdered in 235, ending the fragile stability they brought

to the empire. Over the next fifty years, no fewer than twenty-eight individuals took the title of emperor. Most were military men who were not elected by the senate but rather proclaimed emperor by their soldiers. These were highly uncertain and tense times, with assassinations every few months or years, and frequent skirmishes and wars at the empire's borders.

SESTERTIUS OF MAXIMINUS THRAX Given the short duration of each emperor's rule at this time and the empire's lack of financial stability, few monumental works were erected. Instead, new emperors focused their efforts on portraits on coins and in sculpture to legitimize their position. Because coins could be easily and quickly distributed throughout the empire, the official

inlay decoration embedded into the surface of a base material.

clerestory the upper section of a wall that contains a series of windows allowing light to enter the building.

22.7 Sestertius coin of Maximinus Thrax, 238. Brass, 22.54 grams. British Museum, London.

imperial portrait on coinage served as a form of mass advertising for each new regime. The *sestertius* (a type of Roman coin) of Maximinus Thrax (**Fig. 22.7**, p. 369), an army general from Thrace in modern Greece who ruled as emperor from 235 to 238, depicts him with the Roman aquiline nose seen on the much earlier coin of Julius Caesar (see Fig. 18.22). He has closely cropped hair that resembles today's military cuts, and his intense expression, with lines across his forehead, may indicate the anxious times. Indeed, Maximinus was murdered by his own soldiers less than three years after his accession.

Diocletian and the Tetrarchy, 284–305

It took a complete overhaul of Rome's political organization to stabilize an empire that was now seemingly too large and diverse for one individual to rule effectively

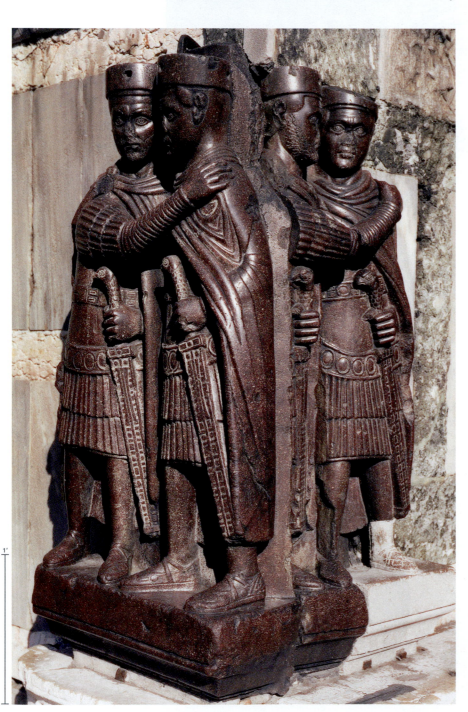

22.8 *Portraits of the Tetrarchs*, formerly in Constantinople (Istanbul, Turkey), *c.* 305. Porphyry, height 51 in. (1.29 m). Currently in the facade of the Cathedral of St. Mark, Venice, Italy.

from a single capital. Like his immediate predecessors, Diocletian was proclaimed emperor by the army; but unlike previous rulers, he chose to share power with his potential rivals, appointing a co-emperor, Maximian, in 286. Diocletian ruled as Augustus of the East, and Maximian as Augustus of the West. In 293 he appointed two junior rulers, or Caesars, thus developing the Tetrarchy, or rule by four (the two Augusti and the two Caesars). The political alliance was strengthened by the marriage of the Caesars to the daughters of the Augusti. This sea change allowed for a brief period of political, social, and economic stability, but the ultimate cost was the division of the Roman Empire. That division arguably set the stage for the later split between the Byzantine East and the Latin West during the medieval period. There were now four capitals of the Roman Empire (**Map 22.1**): Diocletian ruled from Nicomedia in Turkey; Maximian from Milan, Italy; Constantius from Trier in Germany; and Galerius from Sirmium in Serbia. Conspicuously absent from this list of capitals was Rome, demonstrating the beginning of a permanent shift in the focus of power away from the empire's original capital, although Rome's legacy remains strong even in modern times (see box: Art Historical Thinking: Rome's Legacy in American Political Art and Symbolism, p. 373).

PORTRAITS OF THE TETRARCHS Following the empire's division into parts, the tetrarchs worked diligently to convey a message of unity and joint power, focusing on the office rather than the individuals holding the positions. Earlier portraits of Roman rulers emphasized their individual features and sometimes even their personalities. In the *Portraits of the Tetrarchs* (**Fig. 22.8**)—two sculptures put together, each depicting an Augustus and a Caesar in a tight embrace— generality and abstraction replace individuality and naturalism. The sculptures were carved in porphyry, a hard, purple stone from Egypt reserved for sculptures of the imperial family and the gods. There are no distinctions between the rulers in terms of facial features, stature, dress, and gesture, with the exception of the beards worn by the Augusti to demonstrate their more advanced age (the bearded Augusti are on the left of each pair; see also p. 364). Their bodies are squat, and there is no interest in revealing the structure of the body underneath the military dress, which is carved in schematic patterns. Wearing the **cuirass** and cloak of the military general, each figure grasps the hilt of a jewel-inlaid, eagle-headed sword. The emphasis here is the *concordia*, or harmony, of the tetrarchs at the expense of their individuality. The chaos of the previous period of the soldier emperors had made it clear to the four co-rulers that the impression of unity was essential; much was at stake, including their lives.

Constantine and the Reunification of the Roman Empire, 312–337

The relative peace that tetrarchic rule brought to Rome collapsed after Diocletian and his co-Augustus Maximian retired in 305. After the death of the tetrarch Constantius, his son Constantine was declared Augustus by his troops,

in accordance with the plan established by Diocletian but against the wishes of the other tetrarchs. Constantine defeated his rival Maxentius in 312 in a battle near the Milvian Bridge just outside Rome, unifying the western part of the Roman Empire.

Despite the persecution of Christians under Diocletian's rule, conversions to the new faith had continued. On his march to the Milvian Bridge, Constantine is reported to have seen a cross of light above the sun and to have heard the words "*In hoc signo vinces*," which translates as "In this sign you will conquer." The cross may have been the cross of the Christian Crucifixion, or it may have been a cross formed by the *Chi* (X) and the *Rho* (P), the first two letters of "Christ" in Greek. The following year, in 313, Constantine and his co-emperor Licinius issued the Edict of Milan, proclaiming religious tolerance in the Roman Empire, and ending the persecution of Christians. This edict was a major turning point in the history of Rome and Christianity (see Chapter 23).

By 324, Constantine put an end to the crumbling Tetrarchy by defeating the Augustus of the East, Licinius. He became the sole emperor of the reunited empire with a new capital at Byzantium, which was renamed Constantinople and New Rome.

ARCH OF CONSTANTINE Constantine was masterful at using visual propaganda to legitimize his rule. He advertised his victory over Maxentius on an impressive triple-span triumphal arch (**Fig. 22.9**) erected just outside the Colosseum and near the Roman Forum on the traditional triumphal route. Though triumphal arches were not new to Rome, this was the first to commemorate a victory over a Roman rival in a civil war. The dedicatory inscription on the attic, duplicated on both sides, states that the senate and people of Rome dedicate this arch to the triumphs of Constantine, who, inspired by the will of god (*instinctu divinitatis*), used his army to save the state from a tyrant and his faction. Two things are notable in this inscription. First is the reference to Maxentius, a tetrarch, as a tyrant. Second is the ambiguous reference to the "will of god," which could refer to any god. Even if Constantine was indeed referring to the Christian God, his lack of specificity speaks to his tolerance and even respect for all religions in Rome. This tolerance aided him in reuniting the empire.

The Arch of Constantine also deviates from earlier triumphal arches in that it combines contemporary Constantinian reliefs (seen in the segmented frieze above the small bays, spandrels, and column pedestals) with **spolia**, producing an eclectic assortment of the traditional and the novel. Perhaps to strengthen and legitimize his rule, Constantine incorporated sculptural reliefs removed from monuments of Trajan, Hadrian, and Marcus Aurelius, three of the Good Emperors (see Chapter 20).

spolia building materials or reliefs salvaged from other works and reused in a different structure.

22.9 Arch of Constantine, 312–315, Rome. Marble, approx. height 69 ft. (21 m).

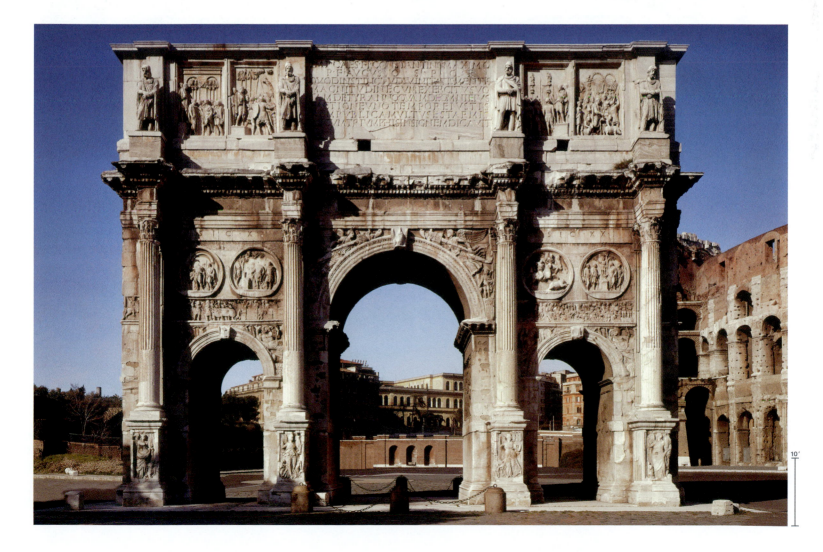

bay a space between columns, or a niche in a wall, that is created by defined structures.

frieze any sculpture or painting in a long, horizontal format.

perspective the two-dimensional representation of a three-dimensional object or a volume of space.

hierarchical scale the use of size to denote the relative importance of subjects in an artwork.

22.10 BELOW **Hadrianic tondi with *Oratio* relief, on the Arch of Constantine**, 312–315, Rome. Marble relief, height 40 in. (1.02 m).

22.11 OPPOSITE ***Donatio* relief on the Arch of Constantine**, Rome, 312–315. Marble relief, height 40 in. (1.02 m).

He even had their heads recarved to reflect his own features. The freestanding sculptures of Dacian prisoners (identified by their dress) on the attic probably originated in Trajan's Forum, as did the Great Trajanic Frieze split among the short ends of the attic and the inside of the central **bay**. The eight rectangular relief panels on the attic were perhaps taken from an arch dedicated to Marcus Aurelius, and the eight sculpted tondi (**Fig. 22.10**) originally decorated a Hadrianic monument. The borrowed scenes depict the Good Emperors performing such important virtuous or pious public activities as hunting, engaging in war, making sacrifices, and addressing civilians and the army.

CONSTANTINIAN RELIEFS A segmented **frieze** dating to the reign of Constantine runs below the much earlier Hadrianic tondi and just above the small bays of the Arch of Constantine. Some of its relief sculptures represent historical scenes specific to Constantine, including the battle of the Milvian Bridge. Other scenes represent themes that were common in monuments of the Good Emperors. The *oratio* (public speaking) relief depicts Constantine addressing an audience from the Rostra, or speaker's platform, in the Roman Forum, between statues of Hadrian and Marcus Aurelius (see **Fig. 22.10** bottom). Constantine is at the center and shown frontally, while the other figures look toward him. With the exception of Constantine, whose head (now lost) was carved separately and would probably have had identifiable portrait features, the figures are quite indistinguishable from one another. As in earlier art of the tetrarchy, the bodies are fairly squat and have disproportionately large heads, indicating a lack of concern for realistic proportions. In contrast to the more naturalistic, Classical Hadrianic roundels above the relief, there is little modeling of bodies or drapery. An additional row of heads is placed above the figures in the foreground to represent depth, though rather unconvincingly, as in the Arch of Septimius Severus (see **Fig. 22.4**). And yet, though the relief lacks naturalism and a convincing **perspective**, the subject and even the setting in the forum are clear.

On the same side as the *oratio* relief is a scene of *donatio*, or the distribution of largesse, by Constantine to Roman citizens (**Fig. 22.11**). Constantine is again depicted frontally, in the center of the composition, but now he is seated in **hierarchical scale** on a throne

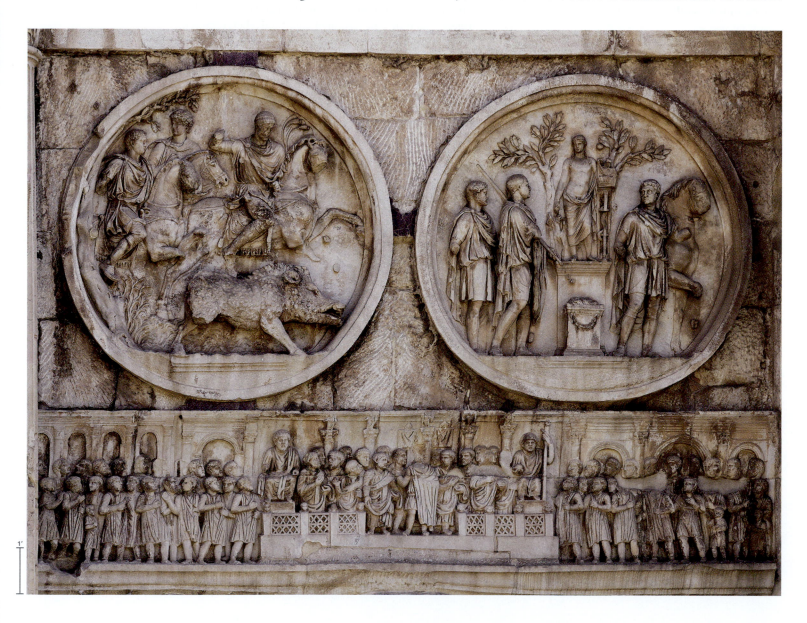

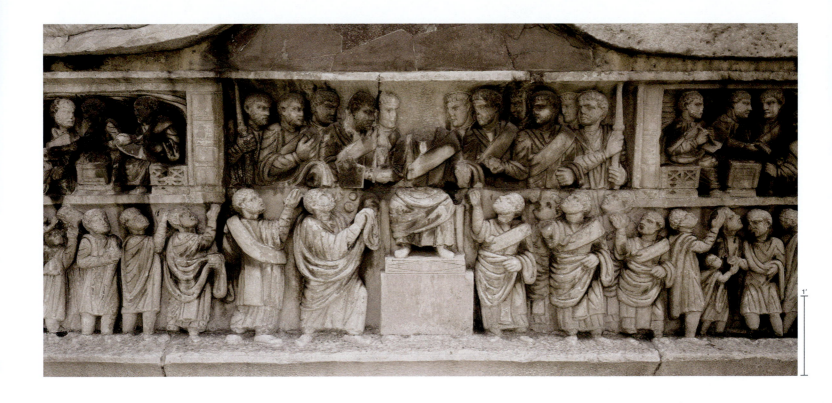

Ancient Rome has long captured the popular imagination, influencing politics, art, and culture throughout the world, but for the new American republic in the late eighteenth and early nineteenth centuries, the social, cultural, and political connections were especially striking. The founding fathers of the United States of America saw clear parallels between Republican Rome and the young American republic, both of which had to overthrow a monarchy to gain independence. Republican and Imperial Rome became almost a mirror for the new nation, with a similar history of continental and colonial expansion, cultural plurality, and the cruelty of slavery. From political institutions such as the Senate, to powerful emblems of strength and liberty, such as the eagle on the Great Seal of the United States and the Roman military standard, the American nation drew freely on ancient Roman models.

The Capitol Building in Washington, D.C. used the Pantheon in Rome as inspiration. It incorporated a Classical temple facade with a circular domed interior built to the proportions of the rotunda in the Pantheon. Though the dome's original design was altered before construction to sit higher than the temple's pediment on an octagonal base, the Pantheon's influence on the original dome can be seen in this photograph from 1846 (**Fig. 22.12**). Even the current cast-iron dome, which replaced the original in 1855, alludes to the city of Rome. Below the oculus

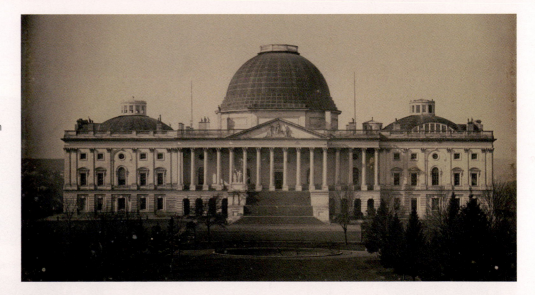

22.12 John Plumbe, United States Capitol with Charles Bulfinch dome, 1846. Washington, D.C.

(a round, eye-like opening in a ceiling or roof) of the current dome is a painting of the apotheosis of George Washington. In ancient Rome, such imagery symbolized elevation to divine status, but here it likely refers to the elevation of Washington to a glorified ideal or national icon. The image clearly parallels apotheosis imagery of the Roman emperors, as seen, for example, on the vault of the Arch of Titus (see Fig. 20.4). These examples serve as clear reminders of how art and the messages it conveys can be variously interpreted over time, depending on the desires and needs of a given person or society.

Discussion Questions

1. Discuss two symbols borrowed from ancient Rome by the young American republic. How were these symbols reinterpreted in their new context?

2. Do you see any contradictions in the borrowing of Roman symbolism by the young American republic? If so, describe them.

22.13 Basilica Nova (Basilica of Maxentius and Constantine), Rome, c. 306–313.

above those receiving donations. The imperial image was transforming into one of superhuman majesty, distinct from the ordinary world. Details on the drapery are **incised** rather than modeled, and, as in the *oratio* scene, the figures lack individualized portrait features, with the likely exception of Constantine, whose head is lost. This less naturalistic, more iconic, and more symbolic style, which we see in some earlier Roman art as well, was once considered inferior to the Classical style and thought to represent a decline in artistic ability resulting from the rise of Christianity and the breakdown of order in the Late Roman Empire. More nuanced interpretations are now proposed. It should be clear by now that Rome frequently embraced cultural and artistic plurality, and so it is not surprising to see on the Arch of Constantine the intentional mix of Classical style, as in the reused reliefs from the second-century CE, with the more two-dimensional and static style of the Constantinian reliefs, which arguably make the visual narrative more legible. It is this more conceptual style that prevails in medieval art.

BASILICA NOVA (BASILICA OF MAXENTIUS AND CONSTANTINE)

After reuniting the Roman Empire, Constantine completed the basilica begun by Maxentius in the area of the Roman Forum. Now known as the Basilica Nova, or the Basilica of Maxentius and Constantine (**Fig. 22.13**), this civic building was among the largest ever built in Rome. The dedication of this assembly hall and court of law in Constantine's name served to legitimize his rule, and the overwhelming scale of the building brought glory to him. Though the floor plan was similar to earlier basilicas, with a central aisle flanked by side **aisles**, and an **apse** in the short, west end, the architects of the Basilica Nova abandoned the traditional flat-ceilinged, columned-hall construction. They opted instead for a tall, central aisle of 127 feet (38.17 m) with three massive brick-faced concrete **groin vaults**, similar to those in the Baths of Caracalla and Diocletian.

Roman engineering skill is apparent in the vaults of the central aisle, which were supported by eight huge **piers** (**Fig. 22.14**). The side aisles each had three **coffered barrel vaults** of 75 × 56 feet (22.86 × 17.07 m). All that is left of the building is the north side aisle, but its height and massive walls still awe visitors. The concrete construction permitted a clerestory of windowed vaults, which allowed light to fall on the elaborate marble inlays and **stucco** design of the interior. The original entrance was off a side road to the east, but Constantine added a **portico** with four porphyry columns on the south side that opened onto the Via Sacra in the area of the forum. Across from this entrance, Constantine built a second apse in the north wall.

COLOSSAL STATUE OF CONSTANTINE

Constantine's use of visual propaganda extended to portraiture as well. In 1487 the remains of an enormous statue of the seated

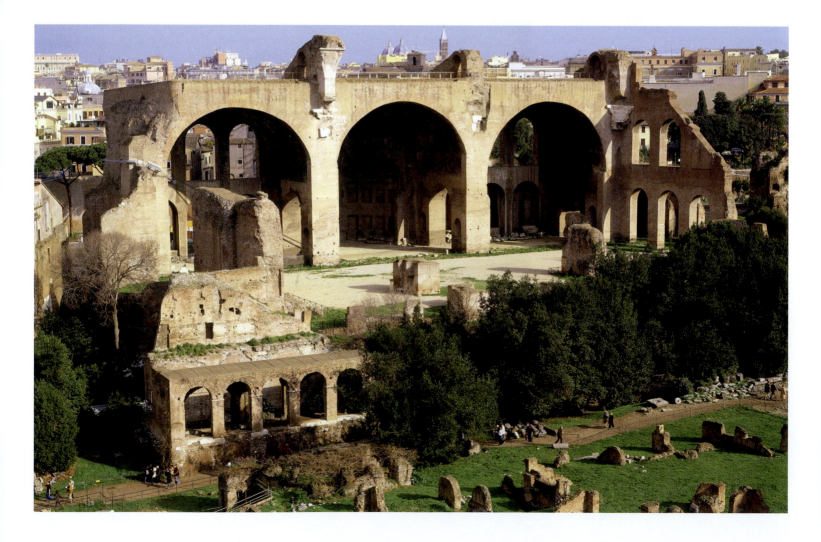

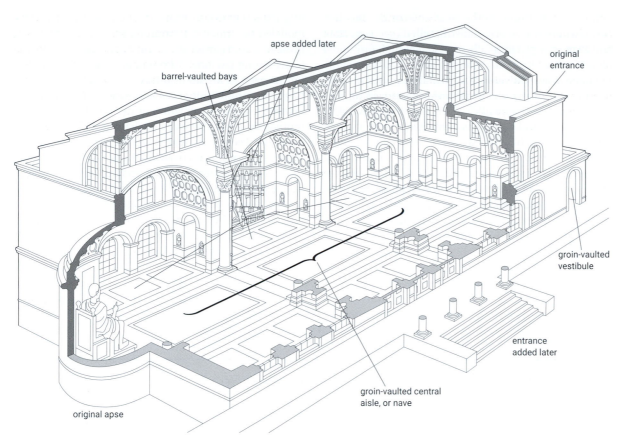

apse added later

barrel-vaulted bays

original entrance

original apse

groin-vaulted vestibule

groin-vaulted central aisle, or nave

entrance added later

stucco fine plaster that can easily be carved; used to cover walls or decorate a surface.

portico a covered space defined by a series of columns placed at regular intervals to support the roof.

barrel vault also called a tunnel vault; a semi-cylindrical ceiling that consists of a single curve.

22.15 Fragments of colossal seated statue of Constantine, from the Basilica Nova, *c.* 315–330. Marble, approx. height of original statue over 30 ft. (9 m). Palazzo dei Conservatori, Musei Capitolini, Rome.

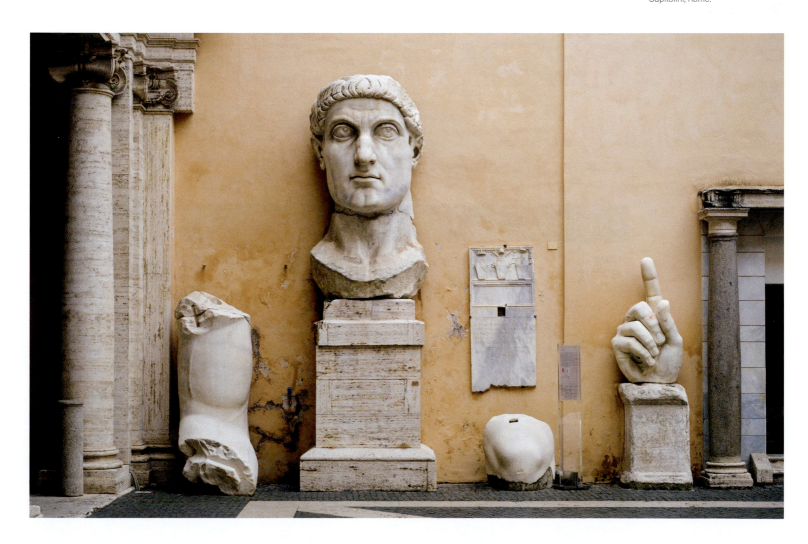

chryselephantine made of gold and ivory; from the Greek words for "gold" and "elephant".

emperor were found in the west apse of the Basilica Nova, where it was originally installed (see **Figs. 22.14** and **22.15**, p. 375). Originally over 30 feet high (around 9 meters) with a head of 8½ feet (2.59 m), it was certainly intended to awe the viewer and to make a powerful statement of the emperor's virtual presence, presiding over all business in the basilica, even in his absence. The statue had a head and limbs of marble, some of which remains, and perhaps a body of brick and wood covered in gilded bronze. It descends directly from statues of the gods in the Greco-Roman world, with affinities in scale and location to Phidias's famed **chryselephantine** statue of Zeus at Olympia and later Roman statues of Jupiter. Here, though, a secular ruler is depicted instead of a god.

Intentionally breaking from the abstraction of the Tetrarchy, Constantine embraced a more Classical style for this portrait and established visual connections between himself and earlier, highly successful imperial rulers. For example, the youthful-looking Constantine is clean-shaven, recalling portraits of Trajan and even Augustus (Octavian) himself. His hairstyle is clearly modeled on Trajan's. Portrait features are present but idealized, as in earlier statues of Augustus. Constantine has a strong jaw line; a Roman aquiline nose, similar to that seen in a coin of Julius Caesar (Fig. 18.25); and huge, upward-looking eyes with deeply drilled pupils. Although we still see some of the abstraction of the sculptures of the Tetrarchy, such as in the shape of the head and eyes, it is clear that this massive sculpture represents a powerful individual ruler with aspirations toward global dominion, and certainly not the shared rule of the Tetrarchy.

The already diverse population of the vast Roman Empire continued to transform in the Late Roman period as messianic religions, especially Christianity, continued to gain adherents. When Constantine chose to move the capital of the empire eastward from Rome to Byzantium, which was renamed Constantinople, the transition from the polytheistic Roman world to the Christian Byzantine Empire was well under way.

Discussion Questions

1. How did Severan architecture in Leptis Magna differ from the styles more commonly seen in Rome? What does this suggest about artistic style in the capital city versus cities in the provinces?

2. What effects would the *damnatio memoriae* of a very prominent person have had on art of a period? What message was the Roman government trying to send? Explain whether or not you believe that erasure from monuments was an effective way to erase someone from public memory.

3. Compare and contrast the formal qualities of the *Portraits of the Tetrarchs* to the colossal statue of Constantine. How did the distinct styles used in each serve as visual propaganda and convey the emperor's messages? Why do you think Constantine broke from the overall abstraction of tetrarchic portraiture?

Further Reading

- Beard, Mary. *SPQR: A History of Ancient Rome.* New York and London: Liveright (W.W. Norton), 2015.
- Getty Museum. "Mummy Portrait of a Woman". https://www.getty.edu/art/collection/objects/9421/attributed-to-the-isidora-master-mummy-portrait-of-a-woman-romano-egyptian-ad-100 [Last accessed 6/2/2020].
- Holloway, R. Ross. *Constantine and Rome.* New Haven, CT: Yale University Press, 2004.
- Klein, Julia M. "'Ancient Rome and America' in Juxtaposition: A World-Premiere Show Examines the Reference and Ambivalence Classical Models Inspired in Our Nation." *The Wall Street Journal,* updated April 21, 2010.

Chronology

193–211	Septimius Severus reigns as emperor		**c. 305**	The *Portraits of the Tetrarchs* are made
203	The Arch of Septimius is built at Leptis Magna		**312**	Constantine defeats Maxentius at the Battle of the Milvian Bridge
211–217	Caracalla reigns as sole emperor, after murdering his brother		**c. 306–313**	The Basilica of Maxentius and Constantine (Basilica Nova) is built in Rome
early third century	The Baths of Caracalla are built at Rome		**312–315**	The Arch of Constantine is built in Rome
235	The Severan dynasty ends		**313**	The Edict of Milan, issued by Constantine and Licinius, his co-emperor, proclaims religious tolerance in the Roman Empire and ends the persecution of Christians
235–284	Period of disunity, with brief reigns of twenty-eight soldier emperors			
284	Diocletian becomes emperor		**324**	Constantine becomes sole emperor; founds a new capital that becomes known as Constantinople
293	Diocletian creates the Tetrarchy (rule by four)			
305	Diocletian retires to Split, Croatia		**337**	The death of Constantine

23

Jewish and Christian Art in Late Antiquity

150–500 CE

Christ and the Apostles
(detail), Church of Santa
Pudenziana, Rome.

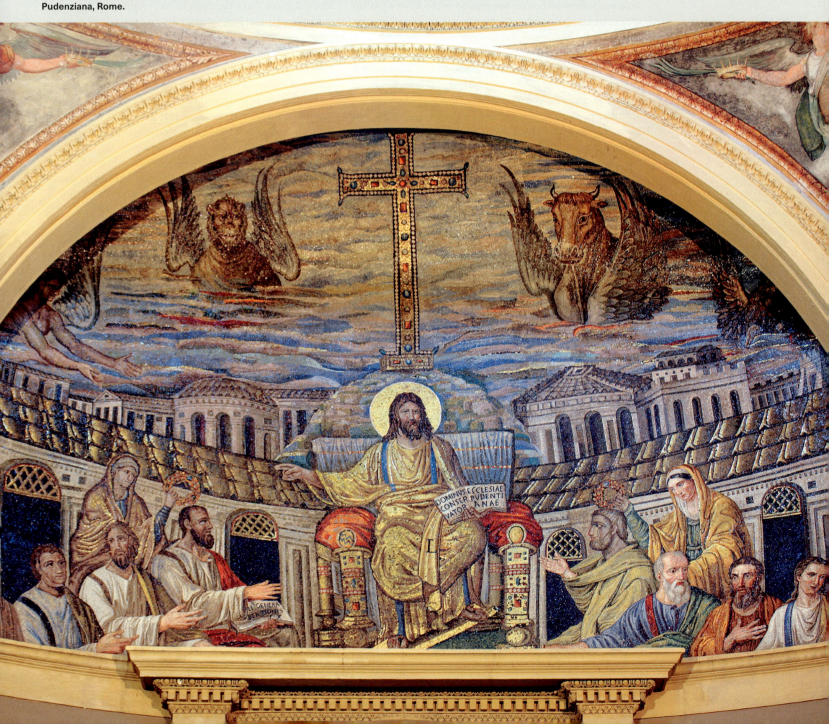

Introduction

Religious diversity flourished in Late Antiquity. The Roman Empire allowed many religions to thrive across its vast regions at the start of the Common Era, as long as devotion to the divine emperor remained uncompromised. Religious rebels opposing imperial power were sometimes cruelly crushed; for example, the Romans put down the Jewish revolt of 66 CE with great brutality, as demonstrated by the depiction of the sack of Jerusalem on the Arch of Titus (see Fig. 20.4). Christians and members of other faiths were also sometimes persecuted for their religious practices and beliefs, especially when they interfered with the expectations of imperial authority. Alternatives to the official state religion continued to exist, however, for example the "mystery religions" of Artemis from Ephesus and Isis from Egypt, attracting followers throughout the empire. At the same time, as followers of Jesus of Nazareth spread his gospel across the Mediterranean region, Christianity developed out of a sect of Judaism (**Map 23.1**).

In the fourth century, Christianity became Europe's dominant religion. The Roman rulers Constantine and Licinius declared religious tolerance across the empire in the Edict of Milan (313 CE), putting an end to Diocletian's policy of persecuting Christians. Under Constantine, Christianity became much more popular, fostering the development of an explicitly Christian iconography that had a major effect on church architectural design. Judaism continued as a minority religion, but other faiths and local religions gradually became extinct.

Judaism, Christianity, and the other religions of the late Roman Empire shared a common set of artists, art forms, opulent materials, techniques, and architectural forms. Each faith adapted these elements of art to express its theology and history, developing new symbols, images, and styles to reflect changes in its ideologies as Constantine supported Christianity and shifted the center of the empire east, away from Rome. In the Edict of Thessalonica (380 CE), the Roman emperor Theodosius I proclaimed Christianity the official state religion. Although the western half of the Roman Empire fell in 493 CE, the Christian faith continued to grow throughout Europe.

Art and Religious Plurality in Late Antiquity

While religious practice in the early Roman state centered on the pantheon of Roman gods and on sacrificing to the Roman state and emperor, its rulers also permitted a broad plurality of religions, including Egyptian religions, Judaism, Zoroastrianism, Christianity, Mithraism, and many others. Within the same neighborhood of a city, residents were able to attend religious services at a temple, a church, a synagogue, or a shrine dedicated to a specific deity. They had freedom to worship as they pleased, and they interacted with people of other faiths on a daily basis. The village of Dura-Europos in West Asia provides a clear example of this religious diversity and the art related to it.

Founded around 300 BCE, this small trading post on the banks of the Euphrates River in present-day Syria had been held by the Hellenistic Seleucids and then by the Parthians until the Roman Empire captured it in 165 CE. It served as an important Roman military outpost until the Persian Sasanian Empire took it over. It was then abandoned intact in 256 CE and never resettled. Although intimate in scale, Dura-Europos was quite cosmopolitan. Its citizens came from diverse ethnic groups, and they embraced a number of religious faiths, building or adapting structures for worship and employing art for a variety of purposes.

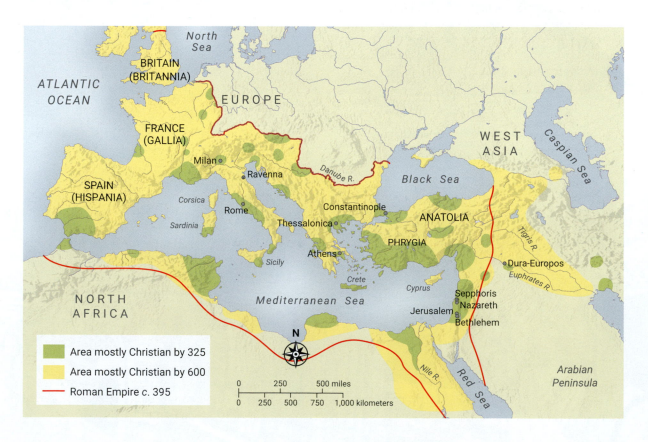

Map 23.1 The spread of Christianity in the Roman Empire, *c.* 300–*c.* 395 CE.

Legend:
- Area mostly Christian by 325
- Area mostly Christian by 600
- Roman Empire *c.* 395

0 250 500 miles
0 250 500 750 1,000 kilometers

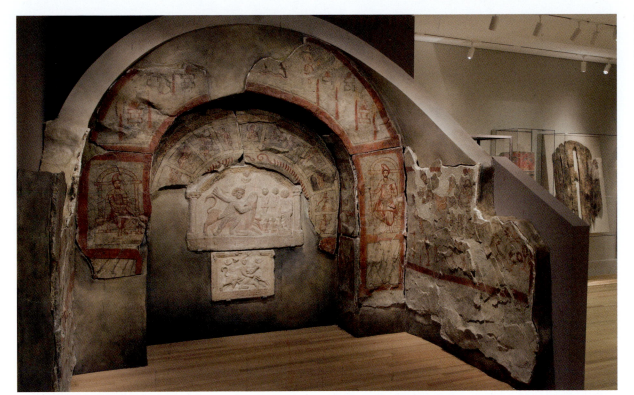

23.1 *Mithras Slaying the Bull,* from the Mithraeum at Dura-Europos, *c.* 170 CE. Limestone relief, lunette 41¾ × 30 in. (106 × 76.2 cm). Yale University Art Gallery, New Haven, Connecticut.

RELIEF OF *MITHRAS SLAYING THE BULL* One of the many religions practiced in Dura-Europos was Mithraism, the worship of the Persian deity Mithras. Little is known about the specifics of Mithraism because its adherents were so secretive. We do know that it was popular among Roman soldiers, that it included complex initiation rites and a ritualistic banquet, and that it probably excluded women. Mithras was worshiped in a Mithraeum, usually an underground, windowless space that mimicked the cave where, worshipers believed, the god killed a cosmic bull and released justice into the world—this is the central image usually found in a Mithraeum. In Dura-Europos, the underground Mithraeum contained a sculpture carved in **low relief** set within an arched niche, framed by paintings of the zodiac and legends from the deity's life (**Fig. 23.1**).

23.1a *Mithras Slaying the Bull* (detail).

Mithras is shown larger in **hierarchical scale**, dressed in an exotic costume and headdress, slaughtering the powerful creature. In a pose that echoes many **Classical** works, Mithras pushes the beast to the ground with his knee on its back, pulling the animal's head up in order to cut its throat with his knife. The god is depicted larger than the other figures in the scene. The work's patron, Zenobius, who is identified by the inscription, is shown making a sacrifice at the altar to the right of Mithras (**Fig. 23.1a**). Mithras's violent deed is thus imitated in a ritual that offers blood sacrifices for a victory of good over evil. Beside and below the altar are several smaller figures that have been identified as the ancestors and sons of Zenobius.

DURA-EUROPOS SYNAGOGUE Among its multiple religious buildings, Dura-Europos included at least one synagogue for its Jewish community. Judaism is monotheistic, the first of the so-called Abrahamic religions (which include Christianity and Islam) that trace their origins to the covenant made by God with the patriarch Abraham as described in the book of Genesis. The central text of Judaism is the Hebrew Bible, which includes the five books of the Torah and other sacred writings.

Jewish worship takes place in a synagogue, where the Torah is read in sequence over the course of the year, accompanied by teaching and explanation, moral and ethical lessons, and discussion of the ancient laws for the living community. Together, the stories and laws of the Torah, as they are read and interpreted, represent the core of Jewish identity: as the descendants of Abraham, as the slaves who emerged from Egypt, and as the people who received the laws from God at Mount Sinai. The text and the physical scroll of the Torah are at the center of Jewish life and of the synagogue.

According to Jewish tradition, the most sacred site of Jewish ritual, the temple, was built in Jerusalem during the reign of King Solomon, in the tenth century BCE,

low relief (also called bas-relief) raised forms that project only slightly from a flat background.

hierarchical scale the use of size to denote the relative importance of subjects in an artwork.

Classical artworks from, or in a style deriving from, ancient Greece or Rome.

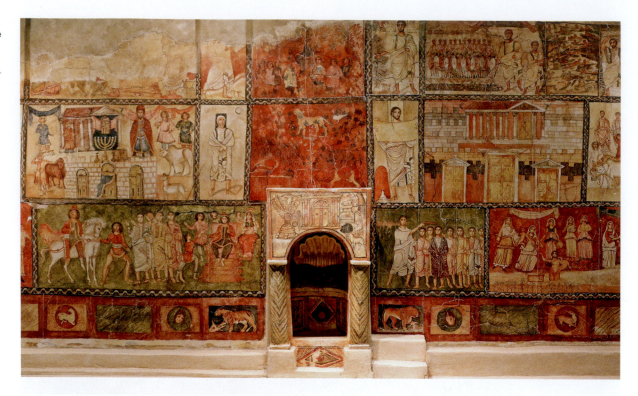

23.2 *Consecration of the Tabernacle*, western wall of the synagogue at Dura-Europos. Painted tempera, *c.* 245 CE. Damascus, Syria, National Museum.

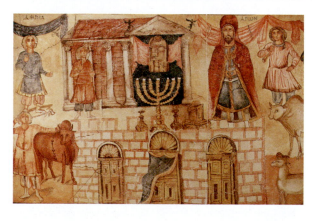

23.2a The figure of Aaron, detail from the *Consecration of the Tabernacle*.

mosaic a picture or pattern made from the arrangement of small colored pieces of hard material, such as stone, tile, or glass.

mural a painting made directly on the surface of a wall.

register a horizontal section of a work, usually a clearly defined band or line.

dry fresco wall or ceiling painting on dry plaster (*a secco*), as opposed to on wet plaster (true or *buon* fresco).

tabernacle a sanctuary space, designed for a congregation to gather in a house of worship.

on what is today called the Temple Mount. The first temple was destroyed by the Babylonians in 586 BCE and rebuilt seventy years later; the Romans destroyed the second temple in 70 CE. Although the contents of the temple's inner sanctum were lost, some books of the Hebrew Bible describe its contents, which included the Ark of the Covenant (a chest containing the stone tablets with the Ten Commandments) and a golden menorah (seven-branched candelabrum) among other sacred objects. After the temple was destroyed, study of the laws and details of the temple served to replace the rituals that had been performed there.

In times of political turmoil, especially after the destructions of the first and second temples, Jews were forced from their homes and expelled from the city of Jerusalem. Many migrated to places scattered across the globe, a movement known as the Jewish Diaspora. Today, the term diaspora has come to refer to all people dispersed from their homelands (see: Seeing Connections: Diaspora in the Modern World, p. 1190).

Few synagogues, or the texts that described them, survive from antiquity. The Ten Commandments prohibit creation and worship of "graven images" (idols), so sculptural forms are forbidden in synagogues. Two-dimensional imagery, however, seems to have been accepted. The rare examples of painting and **mosaic** that can still be seen today feature visual narratives of stories from the Torah, including the stories of Adam, Noah, Abraham, and Moses, as well as religious symbols and objects.

***CONSECRATION OF THE TABERNACLE*, DURA-EUROPOS SYNAGOGUE MURAL** Although much of its decoration has been lost, the interior of the Dura-Europos synagogue contained extensive **murals** representing nearly sixty episodes from the Hebrew Bible. Twenty-eight panels arranged in three **registers** (**Fig. 23.2**) were intended to decorate the space and to teach viewers about the Jewish faith, its history and laws.

The paintings, rendered in **dry fresco**, covered all four walls of the worship space. On the western wall, a niche made to contain the Torah, faces Jerusalem. Paintings just above the niche may show the consecration of the **tabernacle**, the portable earthly home of God during the Jewish peoples' forty-year journey to the Promised Land. The tabernacle is represented as a Classical temple at the top. Inside the open front are the Ark of the Covenant and a menorah. To the right stands Aaron, the first high priest of the Jewish tradition, in highly decorated robes, identified by a Greek inscription to the right of his head. (**Fig. 23.2a**).

***VISION OF EZEKIEL*, DURA-EUROPOS SYNAGOGUE MURAL** On the northern wall, the *Vision of Ezekiel* is represented (**Fig. 23.3**). According to the biblical text, God took the prophet Ezekiel into a valley filled with dry bones. In the vision, the prophet witnesses God giving the skeletons flesh and bringing the dead back to life. In the mural,

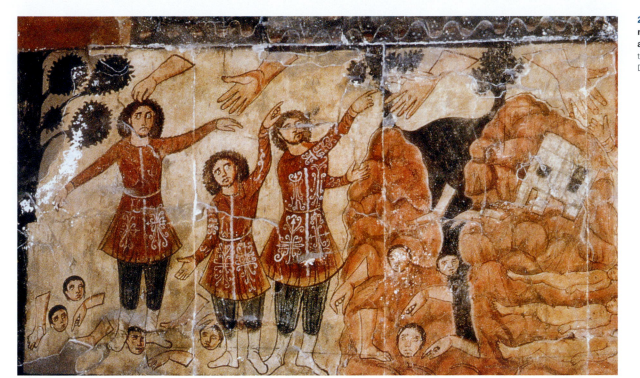

the right hand of God is repeatedly placed above three resurrected figures, who are frontally posed side by side. Another hand is located over a pile of dismembered bones and severed heads, implying that the miraculous work continues. Ezekiel's vision and this fresco remind viewers of the power of God to reunite and rescue his people, scattered though they may be throughout the world.

HOUSE-CHURCH AT DURA-EUROPOS Christians believed that the promised messiah of Judaism had already arrived in the form of Jesus of Nazareth, God incarnate. Born from the Virgin Mary and conceived by the Holy Spirit, Jesus Christ, innocent of sin, performed divine miracles and preached to his followers. For his teachings, especially his proclamation that he was the Son of God, Jesus was condemned to death by crucifixion. Christians believe he was resurrected from the dead after three days and ascended to heaven. They also believe that the resurrection of Jesus will redeem humans for their sin, and they look forward to Christ's second coming, the moment when he will return to rule the earth and

make final judgment over the living and the dead. After the death and resurrection of Christ, his apostles spread the gospel, hoping to convert others to the faith. Stories of Jesus's life, along with acts and letters of the apostles, were collected and later canonized as the New Testament to the Hebrew Bible.

Like the Mithraeum and the synagogue, the church in Dura-Europos had painted images on walls for decorative and instructional purposes. Christian worshipers regularly met in the largest room of a building that had once served as a home (**Fig. 23.4**). Previously, that room probably functioned as a *triclinium*, or dining room. The space was therefore appropriate for celebrating the Eucharist (the Christian sacrament commemorating Christ's Last Supper), and it was large enough to accommodate about seventy worshipers. The courtyard and the other rooms of the house were used for teaching and other purposes. One sizable room was used as a baptistery, where new converts were ritualistically baptized—fully or partially immersed in water as a purification of sin—and welcomed into the Christian community.

The baptistery room features a baptismal font with one column on either side under a **vault**, badly damaged frescoes covering the north and south walls, and a ceiling painted with stars that represent heaven. The north wall features an image of Christ and his apostle Peter walking on water, with the other disciples shown in a boat. This image is in bad condition, and the head of Christ and a portion of the ship have been lost. Beneath this scene, three women, believed to be the three Marys who attended Christ's tomb after his burial, walk toward a **sarcophagus**.

LUNETTE WITH GOOD SHEPHERD AND ADAM AND EVE, DURA-EUROPOS Above the font in the niche, where baptisms took place, a badly damaged **lunette** painting

vault an arched structure, usually made of stone, concrete, or brick, that often forms a ceiling.

sarcophagus a container for human remains.

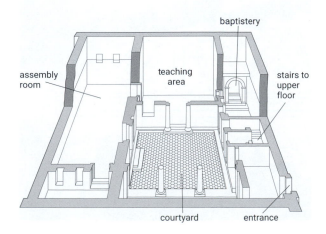

23.4 FAR LEFT **House-church at Dura-Europos, Syria (cross-sectional drawing),** before 256 CE.

23.5 Lunette with Good Shepherd and Adam and Eve, Baptistery, Dura-Europos, Syria. Before 256 CE. 51½ × 60½ in. (130.8 × 153.7 cm). Yale University Art Gallery, New Haven, Connecticut.

23.5a RIGHT **Reconstruction drawing of lunette.**

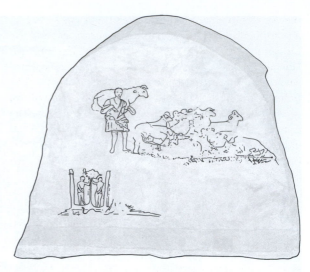

lunette a semicircular or arch-shaped space on a wall or ceiling, usually with a frame.

iconography images or symbols used to convey specific meanings in an artwork.

facade any exterior vertical face of a building, usually the front.

(**Fig. 23.5** and **23.5a**) contains two distinct but ideologically linked scenes. The primary image presents the Good Shepherd, an allegorical reference to Christ as the shepherd who cares for all of his flock equally and will lay down his life for his sheep, an idea mentioned many times throughout the Bible. Here, the shepherd, perhaps the most explicit early Christian image, carries one of the sheep over his shoulders, returning it to the flock. Below this figure is a much smaller depiction of Adam and Eve after God expelled them from Eden for eating the forbidden fruit. Aware of their sin and disobedience, and conscious for the first time of their nakedness, they are covering themselves.

Different grounds divide the two scenes. The shepherd is on a lighter cream ground while Adam and Eve are on a darker ground, perhaps showing the divide between the heavenly and earthly realms. Depicted next to one other within this lunette, these images suggest that the original sin with which humans are born, according to Christian belief, will be cleansed through baptism. The participants will be welcomed back to the flock, like the sheep that the shepherd is saving.

Christians and Jews at Dura-Europos probably employed the same workshop to render their sacred imagery, as the style of their paintings is consistent across the faiths. For example, figures are flat and schematic, not naturalistic. However, their interpretations can differ. For example, although the house-church includes Old Testament imagery, its **iconography**, unlike that of the synagogue, was intended to serve as a prefiguration of events and characteristics associated with Jesus Christ.

HAMAT TIBERIAS SYNAGOGUE FLOOR MOSAIC Artworks reflecting the plurality of religions and styles can be seen in other regions of the Middle East as well. Many major mosaic ornaments have been found in domestic and public structures near the ancient city of Tiberias in present-day Israel. The floor mosaics in the Hamat Tiberias Synagogue from the late fourth century extend the constellation of Jewish symbols while combining them with other symbols and imagery (**Fig. 23.6**). The floor of the synagogue is divided into seven sections

delineated by geometric borders. The image bands feature biblical scenes. At the center of the design, the largest section features a broad circular depiction of the zodiac—derived from an ancient Babylonian image of the cosmos and corresponding with the twelve months of the year—with the Roman sun god Helios in the middle, his chariot pulled by rearing horses. In the four corners outside the zodiac are representations of the four seasons. Although profoundly non-Jewish, unlike the scenes above and below it, the image of Helios, who travels around the earth daily, reinforces the interest in time and ritual cycles.

The mosaic above the circle shows either the **facade** of the first Temple of Jerusalem or the Ark containing the Torah scrolls, flanked by two seven-branched menorahs. In the area around the menorahs are symbols relating to annual Jewish holidays, including the shofar (a musical

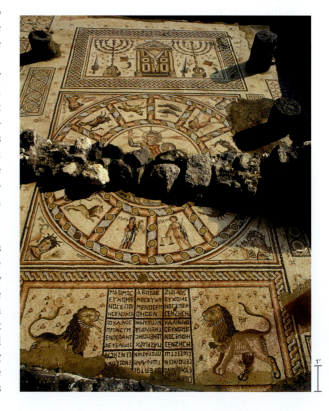

23.6 FAR RIGHT **Hamat Tiberias floor mosaic,** late fourth century CE. Central zodiac mosaic 9 ft 10⅛ in. × 9 ft 10⅛ in. (3 × 3 m). Hamat Tiberias National Park, Israel.

instrument made from a ram's horn), an incense shovel, a palm leaf, and a citrus fruit. The shofar is regularly blown at synagogues, marking the beginning of Rosh Hashanah (New Year's Day on the Jewish calendar) and the end of Yom Kippur (the Day of Atonement). The palm frond and citron, along with myrtle and willow, were linked with Sukkot, a celebration of harvest. The incense shovel was an implement used in Temple ritual and serves as a reminder of the connection between the practices of the synagogue and those of the now-lost Temple.

Although the iconography of the synagogue floor is closely aligned with aspirations specific to Jews, the mosaic form was common throughout the Mediterranean world, where mosaics were used to decorate wealthy homes and sacred spaces. In addition, the style of representation closely resembles that found in areas once under Roman control. These mosaics seem to have been adapted from Greco-Roman pictorial practices to serve Jewish religious narratives.

Developing a Christian Iconography

Early Christians had a troubled relationship with the Roman Empire, primarily because of their refusal to participate in official Roman ritual practices. Persecutions of Christians—and of Jews and adherents of other religious systems—were periodically conducted and then relaxed. Driven by his desire for greater centralized authority and

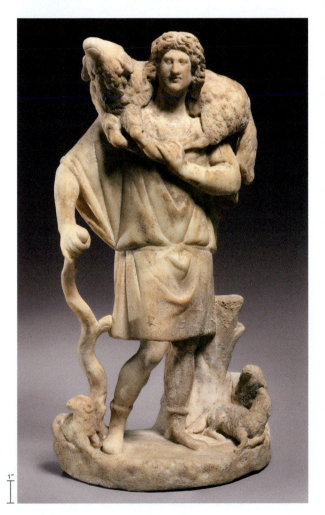

by Christians' refusal to venerate his image, Emperor Diocletian renewed persecution of Christians in 303 CE. Despite his efforts, Christianity continued to attract converts. In 311 CE, Galerius, one of the Roman tetrarchs (see Chapter 22), signed the Edict of Serdica, recognizing Christianity as a legal religion within his territory. Two years later, the Roman rulers Constantine and Licinius issued the Edict of Milan, legalizing Christianity throughout the whole empire.

GOOD SHEPHERD STATUE Early Christian imagery was uncommon in sculpture before the Edict of Milan. Nonetheless, a few rare, portable marble carvings, commissioned by wealthy patrons, survive and reveal the persistence of Classicism. Chief among them is a cache from Phrygia in central Anatolia (present-day Turkey) that contained this third-century CE marble sculpture of the Good Shepherd (**Fig. 23.7**). Early Christians incorporated stylistic motifs from ancient sources, simultaneously developing new imagery and iconography to depict their religious narratives and convey their teachings. With a facial type popular in early Christian representations, this young, handsome, and beardless Christ resembles the Greek god Apollo rather than the later convention of a more mature Jesus with a beard. As in the painting in the Dura-Europos baptistery (see **Fig 23.5**), the shepherd carries the sheep across his shoulders.

FRESCO ON CUBICULUM VAULT Some of the earliest examples of Christian art are found in tombs. During the third and fourth centuries CE, Roman Christians, like their neighbors of various faiths, buried their dead in **catacombs**. These underground tunnels with hollows and chambers were dug out of volcanic rock, often outside the city walls. Catacomb paintings often included depictions of narratives intended to help onlookers remember key moments in the past and link these narratives to prophetic events in the future. Representations of religious symbols and of sacred persons are also common. For example, the depiction of an anchor was intended to elicit the hope of salvation, while the depiction of a sacred person likely provided comfort to observers by evoking the presence of the divine in the here and now. Such pictures can also evoke a greater sense of longing by stimulating the desire to overcome the distance between the viewer and the sacred person portrayed in the painting.

In the Catacomb of Saints Peter and Marcellinus outside of Rome, named after two third-century CE martyr-saints, the vault of a **cubiculum** was covered with frescoes (**Fig. 23.8**, p. 384). The composition's layout and the simplified, sketch-like style of the imagery are not unique to Christianity. In fact, they are similar to art found in catacombs of other groups, suggesting that artist workshops did not serve the needs of only one religion. At the center of the painted ceiling, a **medallion** represents Christ as the Good Shepherd. He stands with one knee slightly bent, surrounded by sheep that might represent the Christian flock. The circular space outlined in red is surrounded by four lunettes depicting the Old Testament story of Jonah. On the viewer's right,

catacomb a network of underground burial tunnels.

cubiculum a small room in a catacomb that functions as a resting place for the dead. Some of these spaces were later used as mortuary chapels for the living.

medallion circular or oval shaped medal.

23.7 FAR LEFT *Good Shepherd* **statue,** probably from Anatolia, second half of the third century CE. Marble, height 19¾ in. (50.2 cm). Cleveland Museum of Art. John L. Severance Fund.

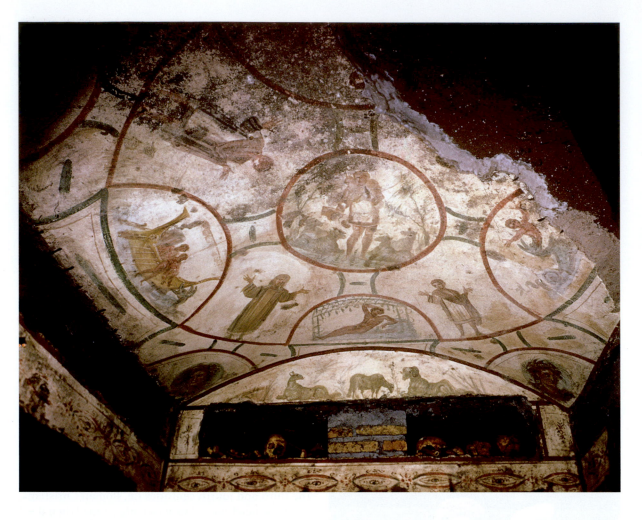

Jonah, having spent three days in the belly of a whale, is an exultant living figure cast out of the sea-creature's mouth. Jonah's prefiguration of Christ's death and resurrection is a fitting design for the catacombs, as it depicts how the dead, like Jonah and Christ, will be reborn in heaven. In response to his release, Jonah extends his arms. This prayerful gesture or orant is repeated by four figures placed between the outlined lunettes.

APSE MOSAIC OF SANTA PUDENZIANA When figures of Christ started to appear in art during Late Antiquity, there was no standard way to represent Christ. Depictions were often based on images of such mythological figures as Orpheus and Apollo. At the beginning of the fifth century, a new model began to emerge. Representations of Jesus increasingly resembled the bearded god Jupiter, a likeness also favored by Roman emperors.

In the early fifth-century **apse** mosaic of the church of Santa Pudenziana (**Fig. 23.9**), the oldest surviving place of Christian worship in Rome, Christ does not appear as a shepherd boy. Instead, he is enthroned as a philosopher-king and surrounded by apostles dressed as Roman senators. A large bejeweled cross directly above his head marks his triumph over death. The city surrounding the cross is Jerusalem (where Christ himself had lived), depicted as a Roman town. The cloud-filled sky represents the celestial realm, filled with the winged evangelical beasts mentioned in the New Testament Book of Revelation, suggesting that the

event depicted in the mosaic has not yet taken place. Rather, it represents the promise of a kingdom to come, when Christ will rule heaven and earth.

Within this courtly setting, two female personifications place victory wreaths of martyrdom above the heads of St. Peter and St. Paul. Christ, the only haloed figure, wears a golden toga with blue trim (see also p. 377). He is positioned in the middle of the entourage, reinforcing his central authority. Like a Roman emperor in the act of oration (see Fig. 19.1), Christ extends his right hand, a gesture signifying his delivery of the law. In his left hand, Christ holds an open book, which bears an inscription that praises him as Lord and Conservator of the church of Santa Pudenziana. The placement of this mosaic is significant; in pre-Christian **basilicas**, the apse was the site of authority and the seat of the magistrate or, in imperial basilicas, the emperor. Placing an image of Christ as a philosopher–king in that location connects him with these secular rulers. His authority is not merely equated with Roman emperors, however; in his eternal rule over the heavenly city of New Jerusalem, he supersedes them.

SARCOPHAGUS OF JUNIUS BASSUS The closest sculptural analogy to the huge frescoes and mosaic cycles in public church interiors comes from Roman carved sarcophagi, newly adapted to Christianity after Constantine and Licinius declared Christianity legal. The **relief** carvings on the sarcophagus of Junius Bassus, a Roman prefect (magistrate), begin to present a specifically Christian

apse a recess at the end of an interior space, often semi-circular, and typically reserved for someone or something important, such as the altar in a church or the throne of a ruler.

basilica a longitudinal building with multiple aisles and an apse, typically located at the east end.

relief raised forms that project from a flat background.

According to the ancient Greek scholars Plato and Aristotle, philosophy begins in wonder. The same can be said of art history. Interpretations are often rooted in the desire to make sense of something that puzzles us. We wonder about things that we see in images and objects from the past, but we also can be puzzled by the absence of something we expect to be depicted.

There are no visual representations of Jesus Christ prior to the middle of the third century. Nor are there any clear symbols or stories told in pictures that can be readily linked to the faith. This absence of Christian imagery should not be confused with practices in other religions, such as early versions of Buddhism. There, the goal may have been to prevent viewers from mistakenly treating the Buddha, an ascetic sage, as if he were a deity like those worshiped in Hinduism. By contrast, Christians have always believed the historical Jesus to be God in the flesh. Consequently, the explanation must lie elsewhere.

At one time, the lack of explicitly Christian art during the first two hundred years of the religion was viewed in terms of theological intent—a matter of religious doctrine. During the 1960s, the German scholar Theodore Klauser argued that early Christians were initially opposed to visual representations of the divine. As evidence, he cites the Christian refusal to venerate depictions of the emperor—images that Christians deemed idolatrous—and their ardent desire to worship the invisible God in spiritual purity. Klauser believes that in the early third century CE, Christians were corrupted by their desire to assimilate, and for that reason, began to create visual depictions of Jesus.

Today, most art historians disagree with Klauser's interpretation, noting that early Christians lacked the political power and financial resources necessary for the production of such large-scale projects as public monuments. Moreover, fears of persecution, which meant that Christians could not worship openly, may have also played a significant role in the absence of such monuments. Nonetheless, there may be an alternative explanation. The apparent lack of images may itself be an illusion; Christians may have fashioned sacred representations for more intimate settings. These depictions either may be lost, or their religious nature may not be apparent. Such works may be indistinguishable from Roman art in style and content, making them impossible to separate them from non-Christian imagery. For example, oil lamps showing a man with a sheep draped across his shoulders could be representations of Christ as the Good Shepherd, but they could also simply be depictions of philanthropy. According to this hypothesis, we may be imagining a lack of early Christian imagery because we do not recognize the role of context in letting us know that an object tells a sacred story. Placement in a religious setting, not visual appearance, may offer the first indication of a distinctively Christian art.

Discussion Questions

1. Why is it so difficult to identify Christian imagery prior to the mid-third century CE? Perhaps more significantly, why do you think Christians later produced religious imagery more readily connected to their faith?

2. What kinds of discoveries of ancient art and architectural settings would be most useful in terms of helping art historians answer the questions about early Christian imagery discussed in this box?

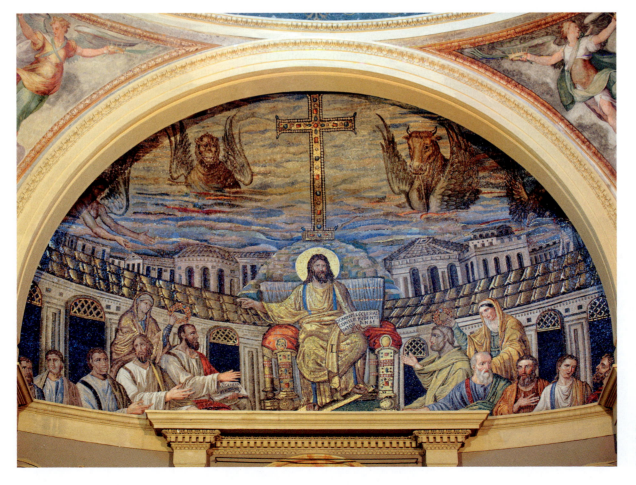

23.9 Christ and the apostles, from apse mosaic of church of Santa Pudenziana, Rome, c. 400 CE.

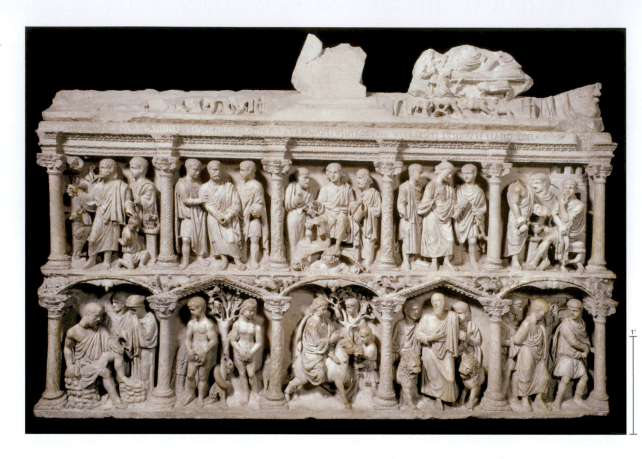

23.10 Sarcophagus of Junius Bassus with Christian scenes, from grottos of St. Peter, Vatican City, Italy, c. 359. Marble, 4 × 8 ft. (1.22 × 2.44 m). Museo del Tesoro della Basilica di San Pietro, Vatican City.

high relief raised forms that project far from a flat background.

23.11 Projecta Casket with Christian inscription and Classical imagery, from Esquiline Treasure, Rome, c. 380. Silver gilt, 21½ × 11 in. (54.6 × 27.9 cm). British Museum, London.

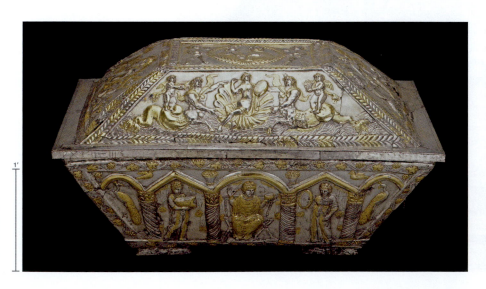

art, even though the overall visual appearance of this sarcophagus from St. Peter's Basilica remains explicitly Classical (**Fig. 23.10**).

The use of a marble coffin for an elite burial, and the carving in **high relief**, are both quite conventional. The carved reliefs present a variety of narratives in two horizontal registers. This surface uses spiraled columns and niche spaces to frame and isolate scenes, which are filled with carefully carved, well-proportioned figures. What makes the Bassus sarcophagus different from Classical examples is its subject matter, not its style. In the upper central panel, enthroned and frontal, a youthful and beardless Christ sits dispensing law like a Roman emperor. He is seated higher than the flanking figures of Peter and Paul. The bearded figure beneath his throne

personifies heaven, indicating that this upper register is celestial. Immediately below the bearded figure, the earthly Jesus enters Jerusalem in triumph on an ass, a scene reminiscent of the splendid triumphal processions of Roman emperors. The juxtaposition of these two scenes may have held special significance for a Roman political leader—Junius Bassus himself—who was also a Christian anticipating his own entry into New Jerusalem.

The Bassus sarcophagus uses four biblical Old Testament narratives to epitomize and foreshadow Jesus's grace in suffering trials under divine providence. For example, the scenes in the top register include Abraham about to sacrifice his son Isaac, in obedience to divine command (at far left). Notably, in contrast to its significance in Jewish art as symbolizing a test of faith, here the scene of Abraham with Isaac prefigures the sacrifice of Jesus, Son of God, in the New Testament Crucifixion. The lower register shows from the left the suffering Job, who refuses to believe that God has forgotten him, sitting atop a dung heap; Adam and Eve in the Garden of Eden; and the prophet Daniel, who survives within the lions' den, overcoming death by the grace of God. Not all the scenes in the bottom register are from the Old Testament. On the far right, an event from the New Testament, the Arrest of St. Peter, is represented.

PROJECTA CASKET During the development of Christian iconography, imagery from other religions was not simply erased. Within Late Antiquity, well-to-do Christian patrons continued to embrace Classical figures and motifs. In 1793, a large bridal casket or treasure chest was discovered in Rome (**Fig. 23.11**). The engraved metal box, which probably held items associated with bathing,

bears a Latin inscription that translates as "Secundus and Projecta, live in Christ." Although these words offer a Christian blessing to the newlyweds, the imagery depicted on the silver gilt container derives entirely from pre-Christian sources and has a strong female emphasis. Mythological water motifs, such as nereids (sea nymphs) and a bathing Venus (the Roman goddess of love) are represented, with no pictorial reference to Christianity. Venus, not the Virgin Mary, is presented as the feminine ideal for the bride Projecta to emulate.

Early Christian Architecture

After Constantine became the sole ruler of the Roman Empire, he commissioned a monumental triumphal arch (see Fig. 22.10) and remodeled a basilica initiated by Maxentius (see Fig. 22.14), both in the city of Rome. Although Christian symbolism never appears as part of his imperial imagery, he adopted Christianity as the official state religion in 325 CE and helped shape the orthodoxy of the faith when he presided over the first general council of Christian leaders at the Council of Nicaea. The Council's pronouncements continue to be recited in Christian services as the Nicene Creed. As the first Christian emperor, Constantine also built numerous churches, **mausolea**, and other religious structures in cities throughout the Roman Empire, including Jerusalem and Constantinople (formerly Byzantium and today Istanbul), which he made the new capital of the empire.

Supported by the emperor and no longer facing official persecution, Christianity attracted many converts and developed into an organized religion with a hierarchy of priests and bishops. Christians were now free to develop public structures for their rituals and practices. As a congregational religion, Christianity called for assembly spaces extensive enough to accommodate communal rituals, such as the Eucharist. Although Christians initially worshiped in homes, as they had in Dura-Europos, they needed larger spaces as the number of followers grew. Roman temples did not provide an effective model because they were associated with what Christians considered pagan practices and because they were primarily designed to house statues of other deities, with rituals performed in a public space outside. Instead, early Christians turned to another Roman architectural

structure, one with a grand interior: the basilica, which the early Romans had designed for use as an assembly hall and legal court, among other secular purposes.

ST. PETER'S BASILICA The largest of Constantine's architectural projects was Old St. Peter's Basilica. Construction began around 320 CE and was completed around 360 CE. Built on the west side of the Tiber River on Vatican Hill, the church was constructed over a cemetery that was believed to be the resting place of the apostle Peter, the first Bishop of Rome. Intended to memorialize Peter's remains, the basilica held a particular and growing importance as a monument to the founder of the Christian Church, and it remained the largest church in western Europe for nearly one thousand years. It was demolished in the sixteenth century and replaced by Pope Julius II's new St. Peter's (see Fig. 45.13).

Similar to the Basilica Ulpia law court (see Fig. 20.10), the basilica of St. Peter's consisted of a tall, central rectangular hall, or **nave**, flanked laterally by aisles, with a roof supported by columns (**Figs. 23.12a** and **b**). The enormity of St. Peter's—approximately 350 × 210 feet (106 × 64 m)—demanded two sets of side aisles. The entrance was through a colonnaded atrium and then a **narthex**,

mausoleum (plural **mausolea**) a building or free-standing monument that houses a burial chamber.

nave the central aisle of a civic or church basilica.

narthex the entrance hall or vestibule of a church.

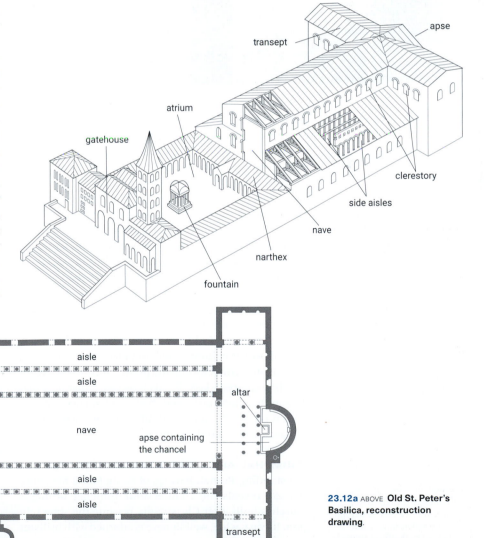

23.12a ABOVE **Old St. Peter's Basilica, reconstruction drawing**.

23.12b LEFT **Old St. Peter's Basilica, floor plan**. Rome, c. 360.

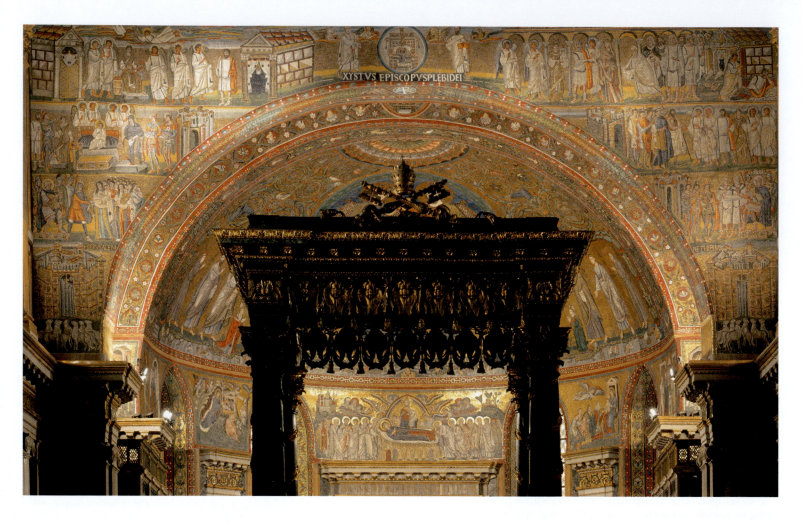

with an apse on the far opposite wall. The length of the interior space enabled processions of pilgrims and clergy down the nave to the altar. An enormous commemorative shrine to St. Peter in the form of a stone **baldachin**, stood on a set of spiral columns at the crossing of nave and **transept**. Visually this baldachin marked the liturgical focus of the church, as Mass was celebrated on a fixed altar under its canopy and prayers were addressed to the dead saint from this consecrated site. Later, the seventeenth-century artist Gianlorenzo Bernini re-created the baldachin in gilded bronze for Pope Urban VIII.

The decoration of Old St. Peter's was destroyed along with the original church in the sixteenth century. According to surviving documents, lavish materials were used for its liturgical furnishings. The records say the walls above the columns were decorated with narratives, either painted directly into the plaster or constructed out of cubic, colored glass tiles as mosaics, a medium that Romans had previously used chiefly for floor decorations. A triumphal arch, decorated (like the apse) with gilded mosaics, separated the transept and nave.

TRIUMPHAL ARCH, SANTA MARIA MAGGIORE The
still-standing Roman basilica of Santa Maria Maggiore (432–40) reveals the architectural opulence of major churches built after Christianity became the state religion. Its vast, wide, well-lit nave is adorned with brilliant mosaics, particularly on a triumphal arch (**Fig. 23.13**). The mosaics in the archway depict scenes from Christ's

infancy, and the nave mosaics show Old Testament stories in the first and finest surviving public examples of early Christian narrative art. The figures, rendered too large to fit within the depicted buildings, are placed with simplified landscapes, similar to representations found in illustrated manuscripts from the same period.

The infancy scenes use the radiance of gold to underscore the sanctity of Christ. Attended by angels, the Virgin Mary in the top register (on the left as the viewer looks at it) sits enthroned in regal robes, an image that asserts her dual roles as queen of heaven and mother of God. In the register below, the Adoration of the Magi (also known as the Three Wise Men) also stresses Christ's divinity and regal nature by placing him on a magnificent throne, backed by angels and flanked by the Virgin. Atop the entire triumphal arch, a medallion presents another imperial throne filled with symbols of Christ: cross, signifying his Crucifixion; crown, signifying his role as Prince of Peace; and lamb, signifying his sacrifice. Both the grandeur of the Santa Maria Maggiore basilica and the splendor of its mosaics assert the spiritual authority of Christ and, by extension, of the popes as vicars (representatives) of Christ in Rome and throughout the Christian world.

CHURCH OF SANTA SABINA Something of the original
effect of Old St. Peter's can be gauged from the surviving smaller church of Santa Sabina (**Figs. 23.14** and **23.15**), the oldest extant basilica in Rome. Built on the Aventine Hill, the church is a good example of the basilica plan that

baldachin a canopy over an altar or throne.

transept a section of a church perpendicular to the nave; transepts often extend beyond the side aisles, making the "arms" of a cruciform-shaped church.

was used widely throughout the late Roman Empire and beyond. An inscription in mosaic on the inner wall of the facade notes that Peter of Illyria founded the church and that it is dedicated to St. Sabina, a rich Roman woman who allegedly owned a house on the site on which the church now stands. More importantly, Sabina was a martyr-saint, beheaded by Roman authorities for her Christian beliefs, and her relics reside in the church.

Like numerous Roman buildings, the church was constructed with brick and mortar. Its exterior seems rather austere and simple, lacking ornament and expensive materials. In contrast, the interior was awe-inspiring in its luxurious design, remnants of which survive. Although built without a transept, this fifth-century church includes a framing triumphal arch before its apse. Marble columns with **Corinthian** capitals that frame the nave were taken as **spolia** from an earlier building. A series of arches topped with colored-marble panels decorated with items associated with Christ's Passion and the Eucharist above the columns, leads to the apse (**Fig. 23.16**). Mosaics originally decorated the nave walls and the apse. The wall surfaces above the aisles open to windows for the generous **clerestory**, giving the interior a great sense of light and airiness. Despite Rome's decline as a political power after the capital shifted east to Constantinople, buildings such as Santa Sabina attest to Rome's religious centrality as the main city of Christendom, flourishing during the fifth century as the home of the Bishop of Rome, later formalized as the pope.

DOORS OF SANTA SABINA Worshipers entered the church of Santa Sabina through a set of wooden doors that were more than 17 feet high and carved with twenty-eight

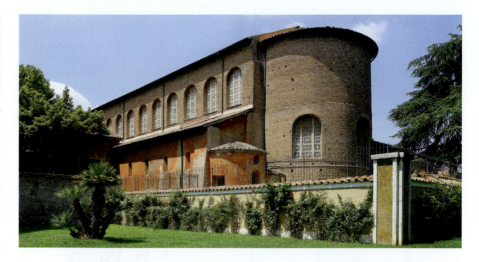

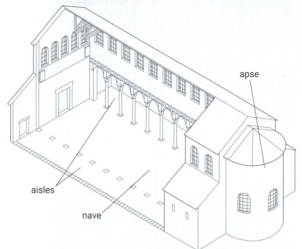

23.14 ABOVE **Church of Santa Sabina,** Aventine Hill, Rome, c. 422–32.

23.15 LEFT **Church of Santa Sabina (cross-sectional drawing),** Rome, c. 422–32.

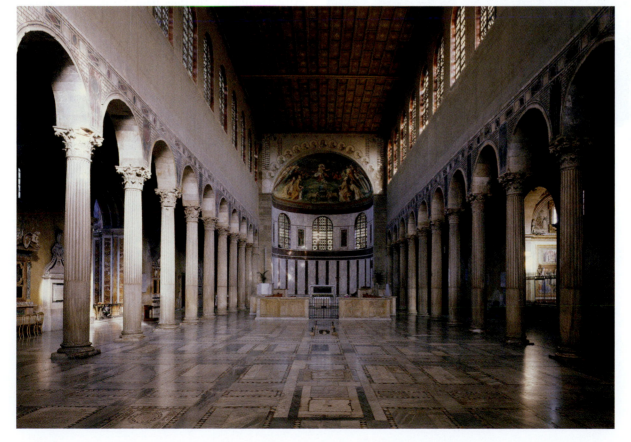

Corinthian an order of Classical architecture characterized by slender fluted columns and elaborate capitals decorated with stylized leaves and scrolls.

spolia building materials or reliefs salvaged from other works and reused in a different structure.

clerestory the upper section of a wall that contains a series of windows allowing light to enter the building.

23.16 Church of Santa Sabina, Aventine Hill, Rome, c. 422–32.

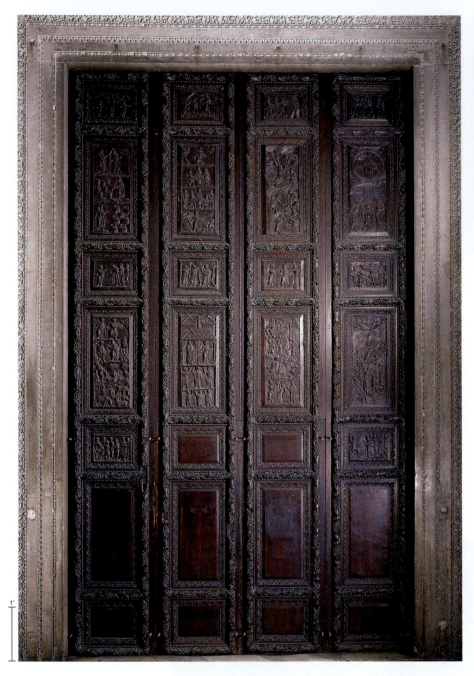

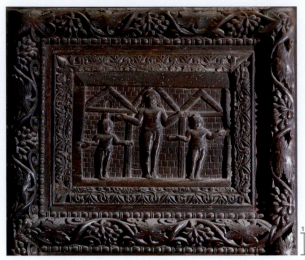

23.17 ABOVE **Doors of Church of Santa Sabina,** Rome, c. 422–32. Cypress wood, 17 ft. 7½ in. × 10 ft. 6¾ in. (5.37 × 3.22 m).

23.17a ABOVE RIGHT **Crucifixion scene, panel from doors of the Church of Santa Sabina,** Rome, c. 422–32. Cypress wood, 11 × 15¾ in. (27.9 × 40 cm).

tholos a round, vaulted tomb shaped like a beehive.

arcade a covered walkway made of a series of arches supported by piers.

narrative scenes from the Old and New Testaments (**Fig. 23.17**). Only eighteen survive. The threshold offers access to the church while simultaneously marking a boundary, the division between secular and sacred space. Santa Sabina's doors have been heavily restored and reconstructed, and the original arrangement of the panels is unknown.

The doors were made of cypress wood, a relatively cheap material that is easy to carve. There may have been other reasons for the selection of this material. According to the Old Testament, Noah used cypress wood to construct the ark, a substantial boat that saved its passengers from the devastation of the Great Flood. In addition, the term "nave" has nautical associations, readily connecting the church with Noah's ark, which protected God's chosen from catastrophe. Also, the cypress, an evergreen tree that grows straight and narrow, was linked to immortality throughout the Greco-Roman

world. Not surprisingly, cypresses were often planted in Christian and other cemeteries. Thus, at Santa Sabina, the wooden doors may have suggested to Christian visitors the gift of everlasting life offered on the other side of the threshold.

One of the door panels shows the Crucifixion (**Fig. 23.17a**). Although scenes of the Crucifixion seem ubiquitous in Christian art today, the story was not depicted until the middle of the fourth century. In fact, this panel is one of the earliest depictions. In Late Antiquity, the idea of a crucified deity would have been nearly incomprehensible; crucifixion had previously been associated with the capital punishment of criminals.

In this panel, Christ is positioned between two thieves, who are rendered in a smaller scale, in front of a set of stylized buildings. The three figures stretch their arms in a posture reminiscent of orant. There are no indications of suffering or death. Although their palms are impaled by nails, the men seem to smile with open eyes. Their feet touch the ground and the crosses are not clearly indicated. These apparent pictorial hesitations are probably tied to challenges that the Crucifixion posed for those accustomed to believing in the immortality of the gods. Nonetheless, the narrative's presence in this panel marks the threshold between sacrificial death and renewed life.

MAUSOLEUM OF CONSTANTINA (SANTA COSTANZA) In addition to churches, early Christians constructed mausolea. Instead of employing the longitudinal plan of a church basilica with a directed axis, these tombs had a round or polygonal plan, akin to **tholos** tombs and the Pantheon (see Fig. 20.14), using domes to suggest the vault of heaven. More importantly, they recalled the now lost Rotunda of the Anastasis, an edifice covering what Christians consider Christ's tomb within the Church of the Holy Sepulcher in Jerusalem. Like that building, they also emphasize death and resurrection.

The Roman prototype of Christian mausolea was built for Constantina, daughter of Constantine, around 350 CE (**Fig. 23.18**). Now called Santa Costanza, this mausoleum, which is entered through a narthex or gathering place, stood beside a covered cemetery. Its domed vault rises from a circular **arcade** composed of twelve pairs of columns.

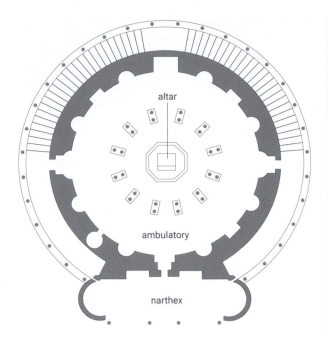

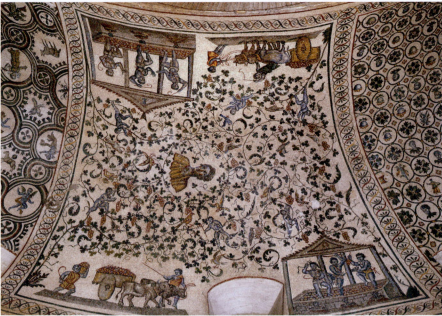

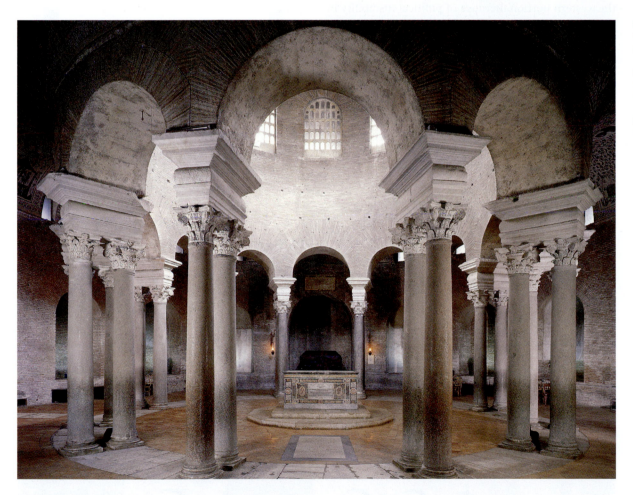

23.18 ABOVE LEFT **Santa Costanza (plan drawing)**, Rome, *c.* 350.

23.19 ABOVE **Ambulatory mosaic (detail)**, Santa Costanza, Rome, *c.* 350.

23.20 LEFT **Santa Costanza**, Rome, *c.* 350.

Twelve tall clerestory windows flood the center, the site of Constantina's sarcophagus, with light (**Fig. 23.20**).

A darker passage, or **ambulatory**, around the interior perimeter of the building contains preserved mosaics. The festive subjects of the ceiling mosaics, including vine scrolls and *putti*, derive from the bacchanals of other religions and are similar to those used in secular spaces. The trampling of grapes, readily associated with the Bacchus, the Roman god of wine, also has connotations of the Eucharist, a Christian sacrament. In the center of this mosaic segment (**Fig. 23.19**), the vines coil around in a circle, creating a framing device for a portrait bust of a woman. She is believed to be Costanza herself, portrayed in a manner similar to the goddess Juno or a Roman matron. Originally the central space contained mosaics with scenes of the Elysian Fields, the ancient

ambulatory a place for walking, especially an aisle around a sacred part of a religious space.

putto (plural ***putti***) a chubby male child, usually nude and sometimes winged.

Greek paradise. As befits the Christian doctrine of resurrection, both the ornate setting and the mosaic subjects suggest joyous celebration.

Like Constantina's mausoleum, **martyria** are typically **central-plan** designs. Sacred relics are often located in the middle of the floor plan, giving viewers the opportunity to circumnavigate the presence of the sacred as they remember a specific holy person. For later Christian buildings, the spiritual rebirth conveyed by baptism dictated similar round structures, especially when these baptisteries were built adjacent to basilica churches. The similarity between baptisteries and martyria makes sense; both types of buildings mark the death of the old self and celebrate life anew.

Ravenna and the Fall of the Western Roman Empire in 493 CE

In 393, Emperor Theodosius I, ruling from Constantinople, split the Roman Empire in two, giving his eldest son Arcadius control of the eastern half and his son Honorius the western portion. Because of political instability in the Italian peninsula and invasions of Roman Europe by Germanic tribes, Honorius moved his capital from Rome to Milan and then, in 402, to coastal city of Ravenna on the Adriatic Sea. During the late fourth and early fifth centuries CE, Christian art became much easier to discern as its iconography and style became more closely identified with the faith. These visual representations did not function as passive illustrations. Rather, they served to foster a more coherent definition of orthodox Christianity as the western Roman Empire began to collapse.

ORATORY OF GALLA PLACIDIA In 410, Alaric I, king of the Visigoths (a western branch of the Germanic tribes), conquered Rome and captured Honorius's sister Galla Placidia, who was then forced to marry Alaric's successor Ataulf to strengthen diplomatic relations between the Visigoths and the Romans. She later fled to Ravenna, where she became regent following Honorius's death in 423. While in Ravenna, she commissioned a palace-church named after Santa Croce (the Holy Cross), of which only the once-attached **oratory** remains today (**Figs. 23.21** and **23.22**). The cross-shaped brick oratory is decorated with

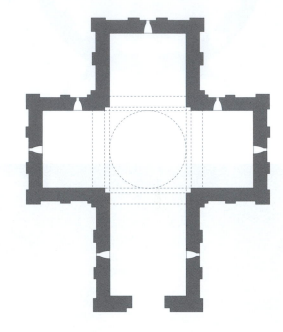

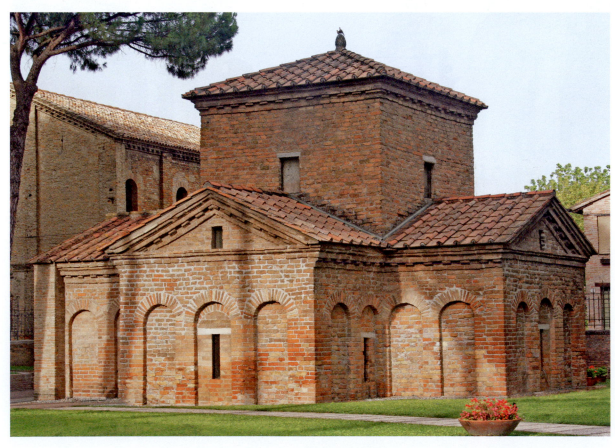

23.21 ABOVE RIGHT **Plan of the Galla Placidia,** c. 425. Ravenna, Italy.

23.22 RIGHT **Oratory of Palace-Church of Galla Placidia,** c. 425. Ravenna, Italy.

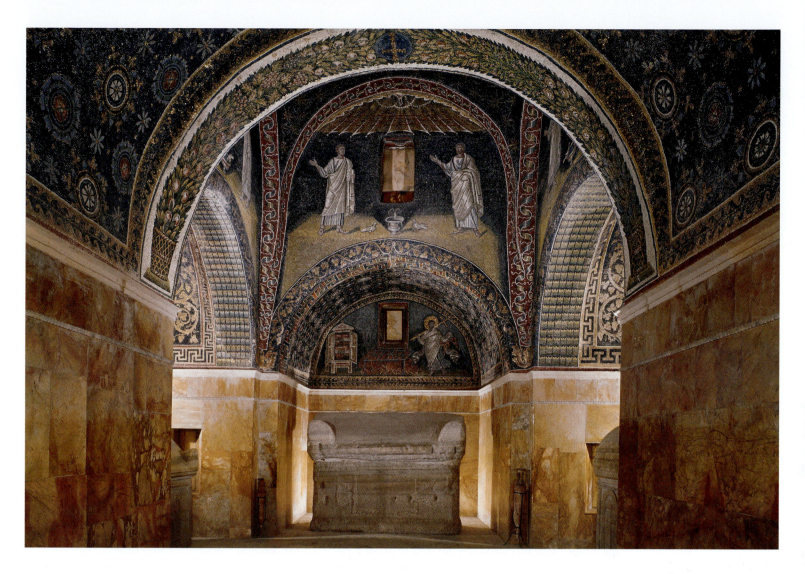

blind arcades on its exterior walls and a small square tower over its crossing. Inside the intimate chapel are three sarcophagi, enticing earlier scholars to label the building (mistakenly) as a mausoleum. However, there are no indications that Galla Placidia or her family ever intended to be buried there.

ST. LAWRENCE MOSAIC, ORATORY OF GALLA PLACIDIA

The upper portion of the oratory's interior is illuminated by small windows made of thin sheets of alabaster. When finely cut into slabs in this way, alabaster becomes translucent, allowing light to enter. The play of light also reflects against the purposely uneven surfaces of the chapel's lavish and costly mosaics, creating a shimmering effect and enhancing the sense of opulence.

In the southern lunette (Fig. 23.23), opposite the oratory's entrance, St. Lawrence is represented. According to biographies of the saints, St. Lawrence was a deacon responsible for the church's treasury in the third century CE. The closet depicted on the left portrays one of the church's most costly assets: copies of the four gospels, each with its writer's name inscribed on the spine. St. Lawrence was martyred, roasted on a fiery grill (represented in the middle of the lunette) for refusing to give money to the rich and corrupt rather than donate to the poor and needy. Although in the mosaic both the closet and grill recede in space, when taken together they do not line up with the expectations of perspective. In addition to this inconsistency, the mosaic seems to oscillate between accepting the surface's flat appearance and denying it through pictorial illusion.

GOOD SHEPHERD MOSAIC, ORATORY OF GALLA PLACIDIA

In the lunette above the entrance of the oratory, Christ is shown as the Good Shepherd, seated among his flock (Fig. 23.24, p. 394). Seated in a twisting pose, Christ seems to tame the animals, rather like the Greek mythological figure of Orpheus, who tamed wild beasts with his music. Instead of carrying a sheep across his shoulders, as in numerous early Christian examples, here Christ holds a cross in victory and gently touches the jaw of a nearby sheep. Christ possesses a halo, reinforcing his connection to the divine, and he is dressed in regal clothing with a golden garment and purple cloak.

Although Christ is presented as a shepherd, he is also rendered as a king. Within this lunette, naturalism and abstraction are intertwined. Christ's face and limbs are naturalistically modeled in light. Yet the sheep's wool consists of abstract V-shaped patterns. Although the figures appear within a landscape setting, the place seems relatively flat.

23.23 St. Lawrence mosaic, south view of Oratory of Galla Placidia, Ravenna, Italy, c. 425.

blind arcade arches used as a decorative motif, with no actual openings in the wall.

perspective the two-dimensional representation of a three-dimensional object or a volume of space.

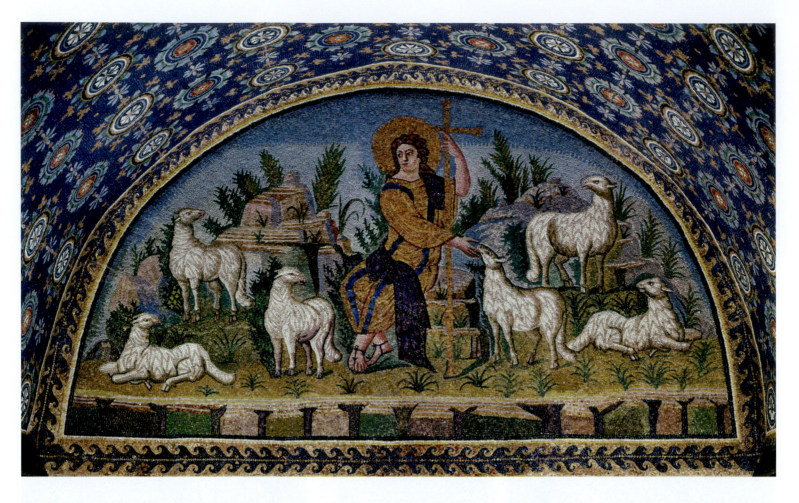

23.24 Good Shepherd mosaic, north side of the Oratory of Galla Placidia, Ravenna, Italy, *c.* 425.

SANT'APOLLINARE NUOVO In 476 CE, the last emperor of the western Roman Empire was deposed, and his territory was divided into various Germanic and regional kingdoms. The Italian peninsula was nominally a dependent of the Eastern Roman Empire, governed by a local king. In 493 CE, Theodoric I, king of the Ostrogoths (the eastern branch of the Germanic tribe), conquered Ravenna. Educated in Constantinople and familiar with its leadership, Theodoric hoped to establish himself as ruler of the West, in alliance with the Eastern Roman emperor. Like many Germanic Christians, however, Theodoric was an Arian Christian, believing that Christ was begotten by God, rather than having existed eternally as part of the Holy Trinity. This belief rendered him a heretic in the eyes of eastern orthodoxy and made reconciliation with Constantinople next to impossible.

While reigning in Ravenna, Theodoric commissioned Sant'Apollinare Nuovo, a palace-church dedicated to Christ. Because Theodoric chose to assert his new rule through typically Roman displays of power, he wrote to the pope and asked for a number of trained mosaicists to decorate his new church. The decoration has a distinctly Roman appearance, indicating the success of Theodoric's request. This kind of visual display cast the Ostrogoths as successors to the Roman Empire rather than as invaders.

The church's apse mosaic is now lost, but brilliant mosaics in three registers decorating the nave above the arcade remain in place. Unlike earlier mosaics, all of the scenes have gold backgrounds, evoking a sense of heavenly transcendence. On the top register, scenes of Christ's ministry are depicted on the north wall, while

Chronology

70 CE	Emperor Titus sacks Jerusalem and destroys the Temple after the Jewish revolt against Rome	**380 CE**	The Edict of Thessalonica declares Christianity the official religion of the Roman empire
135 CE	To suppress further insurrection against the Romans, Jews are barred from Jerusalem	**393 CE**	Theodosius I splits the Roman empire into western and eastern halves
***c.* 245 CE**	The Dura-Europos synagogue is decorated with murals	**402 CE**	Honorius makes Ravenna the capital of the western half of the Roman empire
313 CE	The Edict of Milan declares religious tolerance across the Roman empire	***c.* 425 CE**	The *St. Lawrence* and *Good Shepherd* mosaics are created in Oratory of Galla Placidia
***c.* 320–*c.* 360 CE**	Old St. Peter's basilica is built in Rome	**493 CE**	Theodoric I, king of the Ostrogoths, conquers Ravenna and the western Roman empire falls

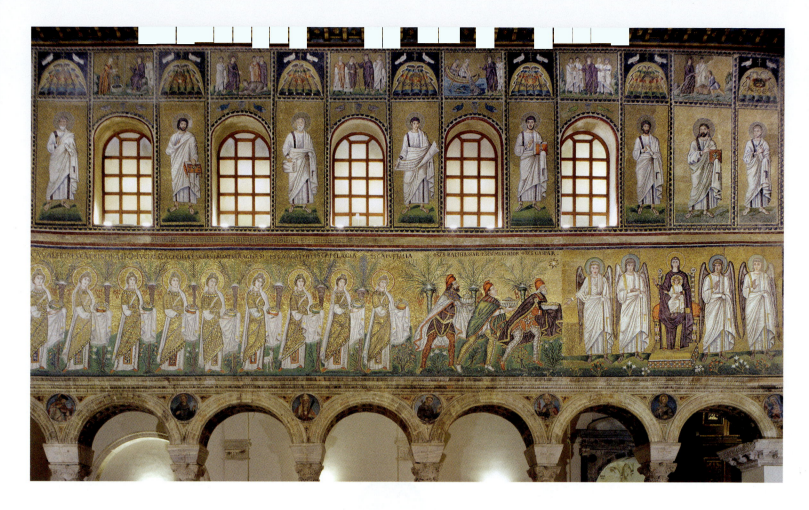

23.25 Mosaic on the nave, north wall of Sant'Apollinare Nuovo, Ravenna, Italy, *c.* 500.

representations of Christ's Passion appear on the south wall. In the middle zone, standing apostles and prophets are portrayed between the building's clerestory windows. At the bottom level, processions of male and female saints appear.

MOSAIC OF SAINTS, SANT'APOLLINARE NUOVO On the south wall, male martyr-saints proceed toward Christ enthroned in heaven between angels. Meanwhile, on the north wall of Sant'Apollinare, a parade of virgin-saints, holding crowns of victory and led by the Three Magi bearing gifts, march toward the enthroned Madonna and Child (**Fig. 23.25**).

Initially, Sant'Apollinare included figures of the Ostrogothic king and court. These images were erased and replaced with curtains after Byzantines overran the city in 539 CE. The frontline of the parade of male saints was also altered. St. Martin, a warrior-saint known for his animosity toward Arian Christians, now led the victorious witnesses of the faith. The Byzantines renamed the church after St. Martin to mark their triumph over the Ostrogoths. (Later, in the ninth century, the church was rededicated to St. Apollinaris, a popular local saint, and is now known as Sant'Apollinare Nuovo.) The reworking of visual images in this church offered effective ways to define religious orthodoxy more closely, as it provided a powerful means to convey the rising political authority of the Byzantine Empire.

Discussion Questions

1. Compare and contrast three houses of worship at Dura-Europos.
2. What role did Greco-Roman art play in the establishment of Jewish and Christian imagery?
3. What do you think are the pros and cons of comparing deities to political leaders?

Further Reading

- Elsner, Jaś. *Imperial Rome and Christian Triumph: The Art of the Roman Empire, AD 100–450*. Oxford and New York: Oxford University Press, 1998.
- Fine, Steven. *Art and Judaism in the Greco-Roman World: Toward a New Jewish Archaeology*. Cambridge: Cambridge University Press, 2005.
- Hachlili, Rachel. *Ancient Mosaic Pavements: Themes, Issues, and Trends*. Leiden: Brill, 2009.
- Jensen, Robin Margaret. *Understanding Early Christian Art*. London: Routledge, 2000.
- Levine, Lee. *The Ancient Synagogue: The First 1000 Years*. New Haven, CT: Yale University Press, 2000.
- Mathews, Thomas. *The Clash of Gods: A Reinterpretation of Early Christian Art*. Princeton, NJ: Princeton University Press, 1999.
- Wharton, Annabel J. *Refiguring the Post-Classical City: Dura-Europos, Jerash, Jerusalem and Ravenna*. Cambridge: Cambridge University Press, 1995.

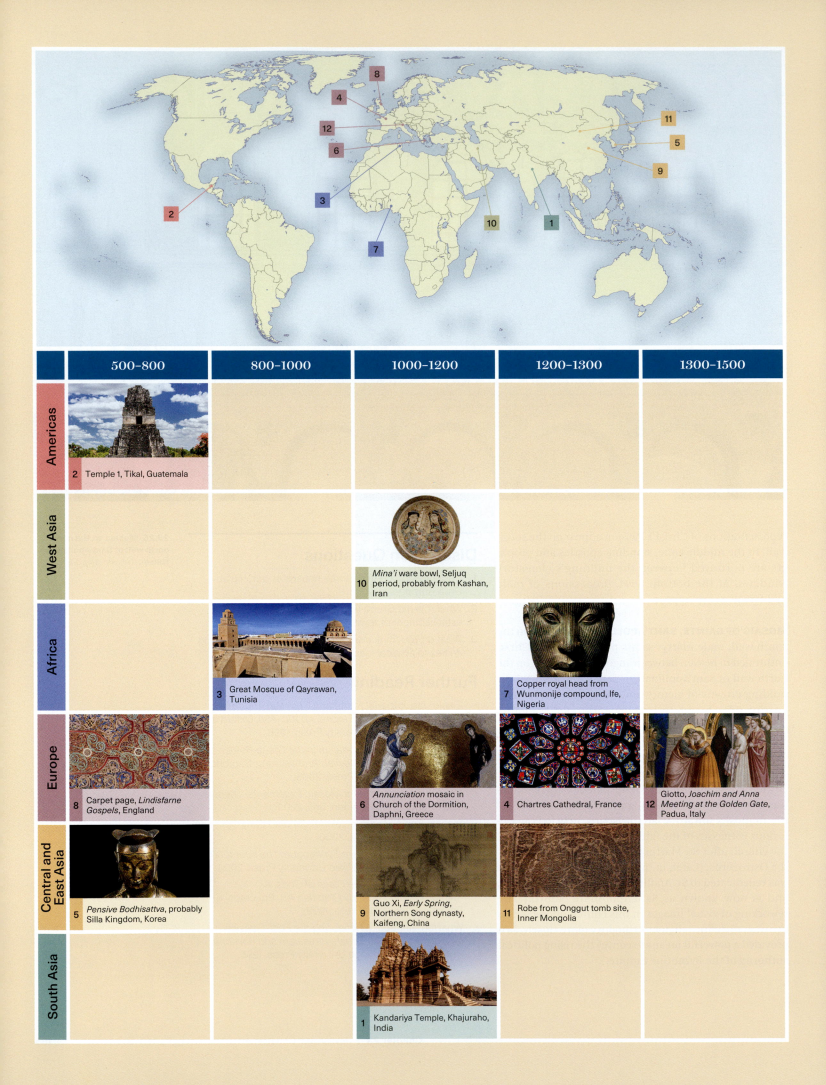

	500–800	800–1000	1000–1200	1200–1300	1300–1500
Americas	2 Temple 1, Tikal, Guatemala				
West Asia			10 *Mina'i* ware bowl, Seljuq period, probably from Kashan, Iran		
Africa		3 Great Mosque of Qayrawan, Tunisia		7 Copper royal head from Wunmonije compound, Ife, Nigeria	
Europe	8 Carpet page, *Lindisfarne Gospels*, England		6 *Annunciation* mosaic in Church of the Dormition, Daphni, Greece	4 Chartres Cathedral, France	12 Giotto, *Joachim and Anna Meeting at the Golden Gate*, Padua, Italy
Central and East Asia	5 *Pensive Bodhisattva*, probably Silla Kingdom, Korea		9 Guo Xi, *Early Spring*, Northern Song dynasty, Kaifeng, China	11 Robe from Onggut tomb site, Inner Mongolia	
South Asia			1 Kandariya Temple, Khajuraho, India		

The Spread of Religions

Part 3

The fifth through fifteenth centuries were characterized by intensified trade, especially by sea, and increased migration, making cultures even more varied and blended. New empires formed, notably the Byzantine Empire around the eastern Mediterranean Sea, and later the huge Mongol Empire, which stretched from eastern Asia to central Europe. Religions with universalistic messages—at first Buddhism and Christianity, and later Islam—spread across Eurasia and Africa, interacting with regional practices and existing political structures. Many older religions endured, including Hinduism, Judaism, Confucianism, Daoism, and local faiths in Africa and the Americas.

As in previous eras, religious practices and beliefs shaped much of visual culture. Monumental religious architecture flourished, including intricately carved temples to Hindu deities on the Indian subcontinent and temples erected by the Maya in Mesoamerica. Innovations in religious architecture included mosques, a form developed to serve the Muslim emphasis on communal prayer, and the soaring Christian cathedrals of medieval Europe, with their elaborate decorations and stained-glass windows. Many images of deities were produced, including sculptures of the Buddha and *bodhisattvas*, mosaics of Christian figures, and copper heads made by West African artists to represent the intersection of the human and divine in royal personages. Embellished writing that conveyed sacred texts became highly refined, as evidenced in Islamic calligraphy and illuminated Christian manuscripts.

Ruling classes and wealthy merchants not only patronized religious art but also commissioned secular architecture, art, and luxury items to display their power and status. For instance, members of the intellectual elite in Song dynasty China commissioned monumental landscape paintings featuring mountains and water, and in North Africa and West Asia, artists produced fine-quality metal and ceramic vessels for affluent patrons. Intercultural contacts, even those brought by war, led to dynamic blends of visual culture, as seen in the Mongol warrior robes fashioned from luxurious Chinese silks patterned with Persian motifs. Toward the end of this era in Italy, the rise of a merchant and banker class produced new patrons, and painting and sculpture became more naturalistic.

397

24

The Development of Islamic Art in North Africa, West Asia, and Central Asia

600–1000

Interior mosaics on drum of Dome of the Rock (detail), Jerusalem.

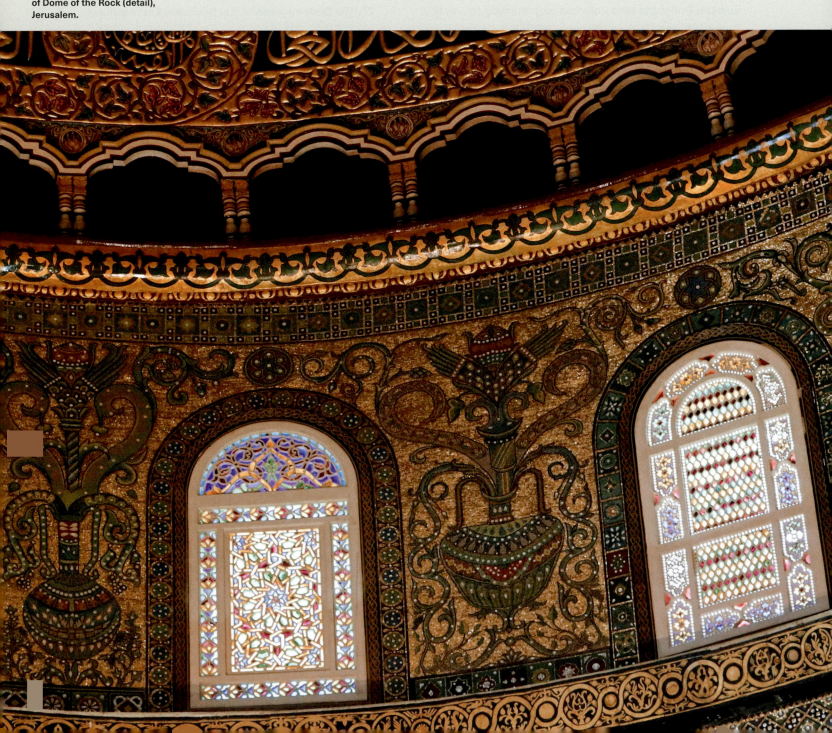

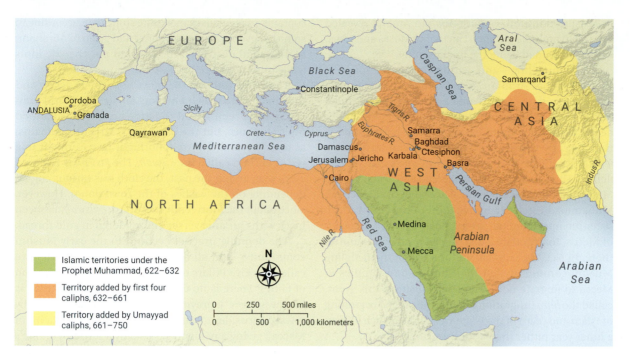

Map 24.1 The spread of the Islamic caliphate, *c.* 622–750.

Map legend:

- Islamic territories under the Prophet Muhammad, 622–632
- Territory added by first four caliphs, 632–661
- Territory added by Umayyad caliphs, 661–750

Introduction

The seventh century CE saw momentous and far-reaching change in North Africa, West Asia, and Central Asia. As the century began, most of the area was under the control of two feuding superpowers. The Roman Byzantine Empire, with Christianity as its official religion, governed North Africa and the western part of West Asia from its capital, Constantinople (present-day Istanbul). The Persian Sasanian Empire (224–651 CE), with Zoroastrianism as its state religion, ruled the eastern regions of West Asia and parts of Central Asia from its capital Ctesiphon (in present-day Iraq). Arabia, controlled by neither empire, was divided between a settled, agricultural society in the south (roughly present-day Yemen), port-oriented cities in the east (present-day Oman and United Arab Emirates), and a largely nomadic, tribal society in the rest of the peninsula (present-day Saudi Arabia). Arabia's nomadic inhabitants, known as the Bedouin, followed an indigenous polytheistic belief system that reinforced local tribal structures. Mostly deserts with a few oasis towns, western and central Arabia had no unified government but did boast a robust trading economy: the peninsula's overland routes connected China and India with the Mediterranean region and eastern Africa. By the time the seventh century ended, the political and religious landscapes of all these regions had been transformed by the new religion of Islam, which spread with amazing rapidity, and the new political order led by the Prophet Muhammad and his successors (**Map 24.1**).

The creation of a new religion necessitates new forms of art, but at the same time, those forms never emerge from a vacuum. Early Islamic visual culture was in many ways a continuation of Mediterranean and West Asian Late Antiquity. For the first two centuries of the Umayyad dynasty, art drew heavily on precedents from Greco-Roman Byzantium and ancient Iran, adapting them to Islamic ideology. From early on, Arabic calligraphy and manuscripts of the Qur'an, the holy book of Islam, held a central place in the visual culture of Islam. In addition, as the religion spread into North Africa

and Central Asia, the Umayyad dynasty used its new-found wealth and power to sponsor monumental art throughout the empire, establishing many of Islam's architectural forms to demonstrate that it could compete with the visual and religious traditions of the empires it supplanted. During the ninth and tenth centuries, under the rule of the Abbasid dynasty, art went through a period of innovation, concurrent with intense activity in the fields of science, medicine, and philosophy. It was then that the visual culture developed many of the stylistic characteristics, such as repeating geometric patterning, today identified with Islamic art.

The Beginnings of the Islamic Faith

To understand the foundations of Islamic art, we must understand the beginnings of the Islamic faith. The Prophet Muhammad (*c.* 570–632 CE) was born in Mecca, an important trading and pilgrimage city in western Arabia. Orphaned at an early age, Muhammad was raised by his uncle, a Bedouin long-distance trader. Like him, Muhammad became a merchant, developing a reputation for fairness. He married a wealthy widow named Khadija (died 619) and led her trading caravans, meeting people of various religions during his travels. According to tradition, in 610, at the age of forty, Muhammad began receiving divine messages instructing him to preach a new monotheistic faith. This new religion, which became known as Islam, meaning "submission to God's will," focused around the idea of one God and a single community of believers. Those believers became known as Muslims, "ones who submit to God's will," and the divine revelations received by Muhammad became the Qur'an, which is written in Arabic. Islam is an Abrahamic faith, meaning that it is closely related to Judaism and Christianity; all three regard Abraham, who according to tradition is the father of the Jewish people, as the first monotheist.

mosque a Muslim place of worship.

qibla the direction Muslims face to pray, toward the Ka'ba in Mecca.

portico a projecting structure with a roof supported by columns; typically functions as a porch or entrance.

In Muslim tradition, God (or *Allah* in Arabic) revealed himself to multiple prophets, including Moses and Jesus, with Muhammad being the final prophet.

The compelling—and, within the context of polytheistic, tribal Arabian society, radical—ideas that everyone is part of the same community and equal before God, and that paradise awaits the faithful after death, drew followers to Islam. As these beliefs spread, they directly threatened Bedouin social structures, which depended on fierce loyalty to one's clan and its deities. Thus, members of the Meccan elite sought to kill Muhammad and his followers. Before they could succeed, Muhammad received an invitation to travel to Yathrib (later renamed Medina), a city 200 miles (322 km) north of Mecca, to negotiate a dispute between communities there. In 622, Muhammad and the rest of the fledgling Muslim community left their homes and families in Mecca to migrate northward. For Muslims, this event, called the *hijra* (migration), marks the official beginning of Islam and year 1 of the Islamic calendar, which follows a lunar year rather than a solar year.

KA'BA By 630, just eight years later, the Muslim community had grown sufficiently in size and strength that it was able to defeat the Meccan armies and return triumphantly to Mecca. Upon entering the city, it is said, Muhammad went straight to the Ka'ba (**Fig. 24.1**), a square structure built of gray-blue stone that housed images of the main Arabian deities. It is believed that Abraham and his son Ishmael originally built the Ka'ba, which was probably just a simple altar at first. Over time, walls were added to form the square structure. One of these walls

24.1 Pilgrims at the Ka'ba, al-Haram Mosque, Mecca, Saudi Arabia.

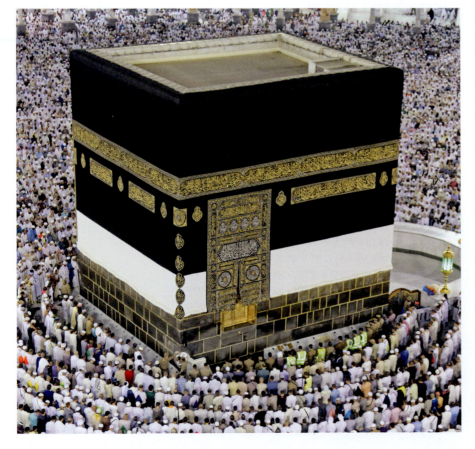

contains a sacred black meteorite stone that, according to some believers, the angel Gabriel had given to Abraham. Muhammad destroyed the Arabian polytheistic idols while preserving the black stone.

The Ka'ba today is the most holy site in Islam and the direction to which Muslims all over the world pray. It has been rebuilt and the area around it expanded multiple times, but the basic cubic structure remains, as does the tradition of honoring it by covering it in a veil or curtain called the *kiswah*. The *kiswah* is replaced every year, and in the past, the cloth was various colors, depending on the wishes of the royal donor. However, since about the fourteenth century, the *kiswah* has been black with Qur'anic verses embroidered in gold thread.

The defining practices central to the early Muslim community—and all devout Muslims since then—are called the Five Pillars of Islam. They are the profession of faith ("There is no God but God and Muhammad is his messenger"); praying five times each day (originally toward Jerusalem, but after 624 toward the Ka'ba in Mecca); giving a percentage (usually a fortieth) of one's income to charity; fasting from sunrise to sunset during Ramadan, the ninth month of the Muslim calendar; and, if able, performing the pilgrimage to Mecca at least once in one's life. The pilgrimage, called the *hajj*, is undertaken during Dhu'l-Hijja, the last month of the Muslim calendar, and it is based on rituals originally performed by Abraham and recreated by Muhammad.

PROPHET'S HOUSE/MOSQUE, MEDINA Muslim prayer is a physical and spiritual act in which worshipers kneel and touch their foreheads to the ground while reciting certain Qur'anic verses. For Friday noon prayer, the community comes together to pray in a **mosque** or, in Arabic, *masjid* ("a place of prostration"). Muhammad's house in Medina (**Fig. 24.2**), built around 622 CE, set the model for subsequent mosques. While the original structure no longer survives, having been greatly expanded and rebuilt multiple times over the centuries, archaeological evidence suggests it was a simple building made of mud brick. Compared to such other religions as Christianity, Islam has very few liturgical needs. A mosque needs to do only three things: provide an open space for communal prayer; give shelter from the elements; and visually indicate the **qibla**. Muhammad's mosque did all of these things. It was arranged around an open courtyard large enough for Muslims to line up shoulder-to-shoulder for communal prayer, and its north and south walls had columned **porticoes** with palm-frond roofs that provided shade from the blistering Arabian sun. Originally, a simple rod placed in the ground, and later a stepping stool on which Muhammad stood to give sermons, signaled the direction of prayer.

After Muhammad's death in 632, the leadership of the Muslim community passed to a series of men chosen from his inner circle. This era, called the Period of the Four Rightly Guided Caliphs, lasted from 632 until 661. Caliph translates as "successor" or "deputy" and indicates a leader of both the religious and political realms. During this period the Islamic caliphate (meaning an area ruled by a caliph, just as a kingdom is an area ruled by a king)

spread with a rapidity seldom matched in history (see **Map 24.1**). No monumental art survives from this time, perhaps because the rulers were too busy establishing their ever-expanding empire. This absence also reflects a stance in early Islam against extravagant architecture and other material displays of wealth, as money could be better used for philanthropic purposes. Grand Islamic artworks would come with the advent of dynastic power and the solidification of state ruling structures.

Monumental Art of the Umayyad Dynasty, 661–750

In 661 CE, during a period of civil war, the fourth caliph, 'Ali, who was also Muhammad's cousin and son-in-law, was assassinated. A few months later, 'Ali's older son and successor, Hasan, was forced to abdicate in favor of the governor of Damascus, who turned the position of caliph into a hereditary one, thus starting the Umayyad

dynasty (661–750). Not everyone agreed that the governor should be caliph, due to a wider dispute, dating back to 632 CE, over who should have succeeded Muhammad. Members of one faction, who came to be known as Shi'i (or Shia) Muslims, believed the caliph must be related to the Prophet, and that, in this case, one of 'Ali's sons was therefore the rightful successor. The other group, whose members came to be known as Sunni Muslims, disagreed. This sectarian difference still exists within Islam, with about 10 percent of Muslims today identifying with Shi'ism, and the rest following Sunni Islam. Hasan was poisoned in 670, and his brother, Husayn, was killed in 680 at the Battle of Karbala, after which the Umayyads consolidated power. Under the Umayyads, the Islamic caliphate reached its greatest size. By the first decades of the eighth century, it spanned from the Andalusian region of southern Spain to the Indus River in present-day Pakistan. Under the Umayyads, from 690 onward, monumental art began to be produced. The consolidation of wealth at the top, paired with the caliphs' need to make visible and justify state rule, explains the shift.

DOME OF THE ROCK The first monument the Umayyads constructed was the Dome of the Rock, an iconic structure located in the old walled city of Jerusalem. Today the Dome of the Rock is the third most holy site in Islam, after the Ka'ba in Mecca and the Prophet's Mosque in Medina. Many considered it to be the first major work of Islamic art. Commissioned by Caliph 'Abd al-Malik (ruled 685–705 CE) and completed in 691–92, the monument sits on the extended elevated rectangular area (**Fig. 24.3**) traditionally accepted as the site where the Second Jewish

24.2 FAR LEFT **The Prophet's house/mosque (reconstruction drawing),** Medina, Saudi Arabia, c. 622.

24.3 **The Dome of the Rock and part of the al-Haram al-Sharif,** Jerusalem, Israel, Umayyad period, c. 691–92.

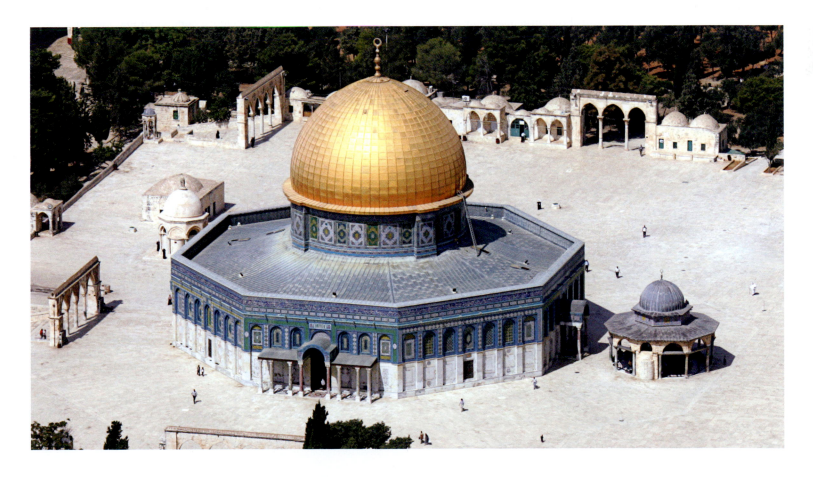

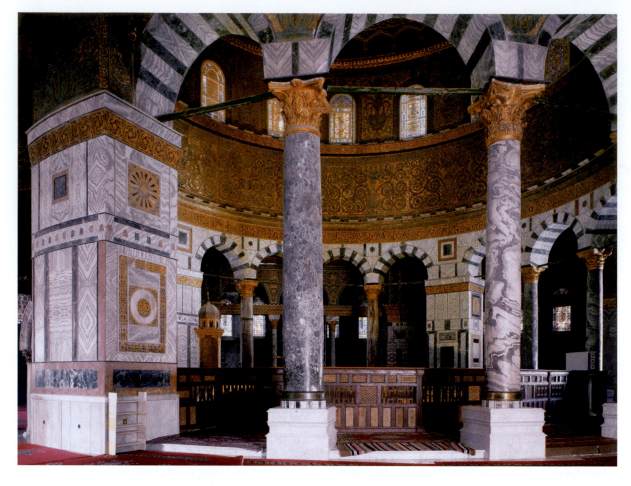

24.4 The Dome of the Rock, interior, Jerusalem, Israel, Umayyad period, c. 691–92.

congregational mosque also called a Friday mosque, or *jama masjid* in Arabic, it is the main mosque in a city or town and the location of Friday prayers, when the entire community comes together.

central plan design for an architectural structure, whether round, polygonal, or cruciform, that features a primary central space surrounded by symmetrical areas.

ambulatory a place for walking, especially an aisle around a sacred part of a religious space.

24.5 The Dome of the Rock (cross-sectional diagram), Jerusalem, Israel, Umayyad period, c. 691–92.

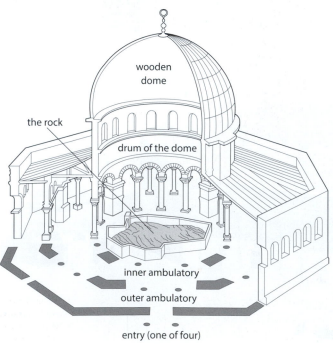

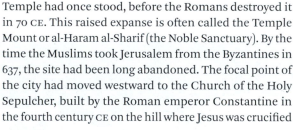

wooden dome

the rock

drum of the dome

inner ambulatory

outer ambulatory

entry (one of four)

Temple had once stood, before the Romans destroyed it in 70 CE. This raised expanse is often called the Temple Mount or al-Haram al-Sharif (the Noble Sanctuary). By the time the Muslims took Jerusalem from the Byzantines in 637, the site had been long abandoned. The focal point of the city had moved westward to the Church of the Holy Sepulcher, built by the Roman emperor Constantine in the fourth century CE on the hill where Jesus was crucified and buried. 'Abd al-Malik had the Temple Mount area cleared of debris, the walls and gates rebuilt, and two new edifices constructed: a **congregational mosque** known as al-Aqsa Mosque and the Dome of the Rock.

The Dome of the Rock raises two important questions. Because it was clearly intended to be a sacred space but is not a mosque—there is no large interior space for prayer—what was its original function? And, how were the Umayyads able to build something so visually refined and technically skilled on their first attempt? While the debate is ongoing, art historians agree that this unique monument functioned, at least in part, as a victory symbol, affirming the Islamic Empire's position as the new and dominant regional power.

The Umayyads' astute adoption of earlier artistic traditions allowed them to create the Dome of the Rock, which follows a **central plan** (**Fig. 24.5**), as did such celebrated Roman monuments as the Pantheon (see Fig. 20.13) and such early Christian monuments as Santa Costanza in Rome (see Figs. 23.20 and 23.21). It is octagonal in shape, about 155 feet (47 m) in diameter, with a central dome covering a rocky outcrop. Below the rock is a small underground room fashioned from a natural cave. Columned double **ambulatories** encircle the area beneath the dome, with entrances marking each of the four cardinal directions.

The exterior decoration (see Fig. 24.3) was completely altered in the sixteenth century under the patronage of the Ottoman ruler Süleyman I (see Chapter 50), but the interior (**Fig. 24.4**) retains most of its original design,

including marble columns and glass **mosaics** featuring gold and **inlaid** mother-of-pearl.

The location of the Dome of the Rock is sacred to both Jews and Muslims. Jews honor the rock under the dome as the place from which Abraham was prepared to sacrifice his son, Isaac. Muslims revere the rock as the spot from which Muhammad ascended to the heavens on the winged horse, Buraq, during his mystical night journey, called his *mir'aj*; however, no evidence exists to confirm that this belief dates all the way back to the seventh century. Art historians have therefore put forward other theories about the Dome of the Rock's original meaning for Muslims—for example, that it served as an alternative pilgrimage spot to the Ka'ba—but these theories cannot be definitively proven.

Whatever its specific religious commemorative function, the monument's location, shape, and ornamentation unequivocally demonstrated to its seventh-century visitors that the Islamic caliphate could compete with the artistic and religious traditions of the empires it displaced. It did so primarily by adopting Byzantine forms and decorative techniques, visible in its use of mosaics (compare, for example, Fig. 28.7). These mosaics, originally located on the exterior as well as the interior, feature foliage, vases, jewelry, and winged crowns (see p. 398). The winged crown motifs are drawn from royal symbols found in Sasanian art of ancient Iran. The other motifs come from the Byzantine tradition, in which the Dome of the Rock's craftspeople would have trained. Some art historians believe that these motifs symbolize paradise, which, according to Islamic belief, Muhammad visited during his *mir'aj* and which awaits all faithful Muslims.

An Arabic inscription in gold mosaic, roughly 780 feet (238 m) long, is the earliest use of Qur'anic passages on a monument and provides additional clues to the building's significance. The specific verses chosen from the Qur'an emphasize the differences between Islam and Christianity: namely that, in Islam, God has no son, no partner in sovereignty. This pointed reference to Jesus, who in Islamic belief is considered a prophet but not divine, continues in the building's shape and location. Its dome was designed to be the same size as that of Christ's tomb in the complex of the Church of the Holy Sepulcher, and the buildings follow roughly the same plan, except that the Dome of the Rock occupies, quite literally, higher ground.

GREAT MOSQUE OF DAMASCUS The best-known example of an early Umayyad mosque is the Great Mosque of Damascus, Syria (**Fig. 24.6**). Though partially rebuilt and restored, it remains close to its original form today. Commissioned in the early eighth century by Caliph al-Walid I (ruled 705–15 CE), 'Abd al-Malik's son, it stood in the middle of what was then the empire's capital, with the caliph's palace directly behind it. It was built on the site once occupied by a Byzantine church dedicated to John the Baptist, which itself had been built on the older holy site of pre-Christian temples. The local Christians and Muslims shared that church for a while, but when the Muslim community grew too large for the space, the caliphate bought the land and tore down the church, using its outer walls for the new mosque.

The Great Mosque of Damascus displays the architectural elements that have come to be standard in many mosques, even though they are not required by the religion.

mosaic a picture or pattern made from the arrangement of small colored pieces of hard material, such as stone, tile, or glass.

inlay decoration embedded into the surface of a base material.

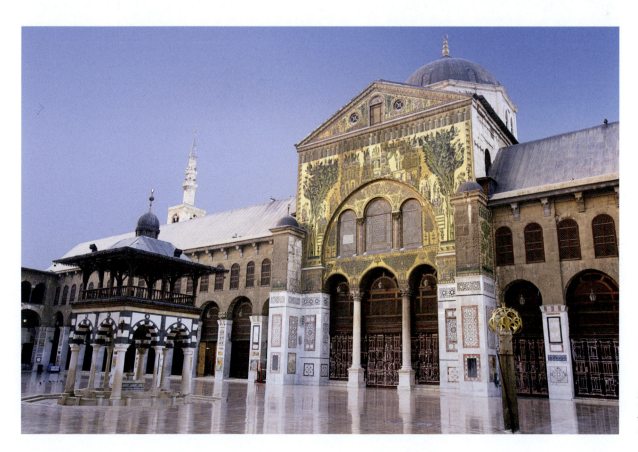

24.6 The Great Mosque of Damascus, courtyard and main facade, with ablution fountain at left, Syria, Umayyad period, *c.* 715.

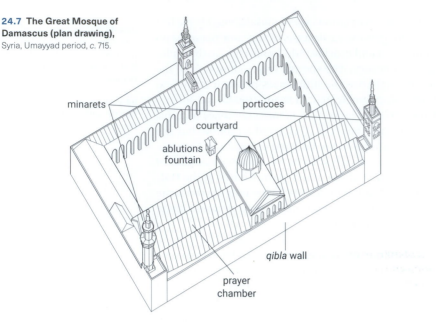

24.7 The Great Mosque of Damascus (plan drawing), Syria, Umayyad period, c. 715.

minarets

porticoes

courtyard

ablutions fountain

qibla wall

prayer chamber

ablution fountain typically located in the courtyard of a mosque, a water fountain in which Muslims wash ritually before prayer.

facade any exterior vertical face of a building, usually the front.

hypostyle hall large room with rows of columns or pillars supporting the roof.

gabled roof a roof with two sloping sides.

mihrab prayer niche, usually concave in shape with an arched top, located in the qibla wall of a mosque and indicating the direction of Mecca.

qibla wall the wall in a mosque that indicates the direction toward which Muslims face to pray, usually indicated by the presence of a mihrab.

minbar a stepped pulpit from which the sermon at Friday noon prayer is given in a mosque; usually placed directly next to the mihrab on the qibla wall.

minaret a tower at a mosque; can be used to give the call to prayer and also functions as a visible marker of the mosque on the skyline.

aniconism opposition to visual depictions of living creatures or religious figures.

A spacious courtyard is surrounded on three sides by porticoes and contains an **ablution fountain** (see **Figs. 24.6** and **24.7**). The courtyard leads to a covered prayer hall, the **facade** of which looks onto the courtyard rather than out onto the street. This inward-facing orientation is a hallmark of much Islamic architecture, particularly those structures built in dense urban environments. Here, the prayer chamber takes the form of a substantial **hypostyle hall**, wider than it is deep. A **gabled roof** with a dome forms a central axis leading to the main **mihrab**.

The **qibla** wall, typically the focal point of a mosque, is marked by both a *mihrab* and a **minbar**. (For examples of a *mihrab* and *minbar*, see **Fig. 24.17**.) The Damascus mosque also features three **minarets**, but these towers were not original to the eighth-century structure; minarets did not appear on mosques until the ninth century.

MOSAICS FROM THE GREAT MOSQUE OF DAMASCUS

The Great Mosque of Damascus is perhaps best known for the exquisite glass mosaics lining its walls, which depict panoramic views of landscapes abounding with both small and grand buildings, tall trees, and streams (**Fig. 24.8**). The absence of fortifications and the predominance of greenery give the scenery a peaceful, idyllic feel, suggesting it was meant to represent paradise, the prosperity of cities under Umayyad rule, or both. Like those of the Dome of the Rock, the glass mosaics make heavy use of gold and feature inlaid mother-of-pearl. Also like that earlier structure, the mosaics have no anthropomorphic imagery (that is, no images of living beings). Because of its strong stand against idolatry (the worship of idols), Islam has from the beginning rejected figural imagery in religious spaces or on religious objects. While the Qur'an does not address the issue, sayings attributed to Muhammad (called *hadith*) discourage the use of figural images. Islam is not unique in its practice of **aniconism**: both Christianity and Judaism also had reservations about figural representations—because of statements in the Old Testament against graven images—and, beginning in the mid-eighth century CE, around the same time that

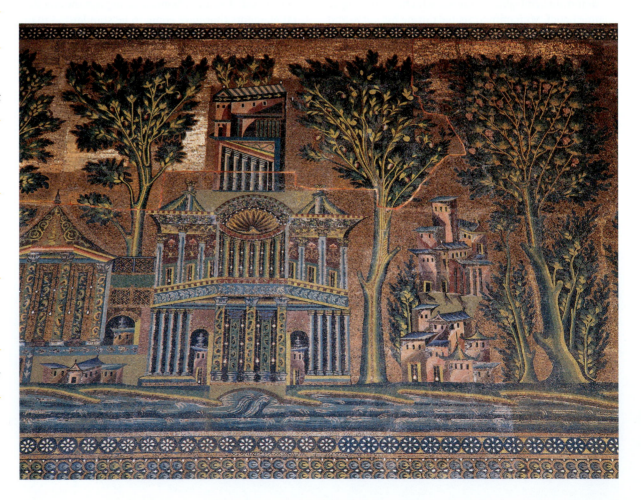

24.8 Mosaics of landscapes, west portico, Great Mosque of Damascus, Syria, Umayyad period, c. 715. Glass, tile.

the Umayyads were constructing their religious monuments, the Byzantines went through a period of intense **iconoclasm** (see Chapter 28). That said, the Umayyads freely used anthropomorphic imagery in secular spaces.

STUCCO FIGURE FROM KHIRBAT AL-MAFJAR The Umayyad use of figural imagery is evident in the archaeological remains of their country estates. These complexes, more than thirty-five of which were constructed between 696 and 730 in Syria and Palestine, were much like Roman villas: agricultural estates that also served as administrative centers and as prestige architecture designed to show off the owner's status. Typically, the Umayyad complexes consisted of a hall where guests would have a formal audience with the ruler, a mosque, residences, service buildings, and farms. In the tradition of Mediterranean Late Antiquity, each also included a sizable bathhouse that served as a place for the elite to socialize.

The Khirbat al-Mafjar estate, built between 724 and 744 CE and destroyed by an earthquake in 747, had a particularly grand bathhouse. The bath's arched entrance portal featured a portrait of the owner, either Caliph Hisham or Walid II, made from **stucco** and placed in a niche at the arch's apex (**Fig. 24.9**). This Umayyad prince is attired like a Persian Sasanian king: bearded, with baggy pants, pointed slippers, and a long coat, and holding a dagger or sword. The pedestal on which he stands is decorated with **heraldic** lions.

The Sasanian and Roman influence continued inside the bathhouse. In one alcove where the prince would have sat enthroned, a carved stone crown hung from a chain, recalling a well-known Sasanian palace in which a jeweled crown hung from a gold chain over the emperor's throne. Stucco ornamentation, including small sculptures of half-naked young men and women, as well as various animals, decorated the bath's walls and domed ceilings. **Polychrome** tiled mosaics, most of which survive, covered the floor.

TILE MOSAIC FROM KHIRBAT AL-MAFJAR A private reception hall at Khirbat al-Mafjar contained a particularly fine tile mosaic depicting a pomegranate tree with gazelles grazing peacefully on one side of its trunk and a lion viciously attacking a gazelle on the other side (**Fig. 24.10**). While the specific meaning of the **iconography** is ambiguous, it clearly implied the caliph's power. The floor mosaic was placed at the **apse** end of the small room, where the caliph sat. His advisors would have sat on benches on the flanking walls. As they conversed with the caliph, they would have looked toward the niche in which he sat and had a full view of the lion attacking the powerless gazelle. Another interesting aspect of the floor mosaic is its border: Note the tiny tassels ringing the braided edge, as one would find on a textile. This mosaic thus provides scholars with an important clue related to the appearance of early rugs, for which little other evidence survives.

The Umayyads' adoption of prestige architecture may have backfired: one later caliph had to promise publicly not to build lavishly and instead to use his money to

iconoclasm the intentional destruction or rejection of images on religious or political grounds.

stucco fine plaster that can be easily carved, used to cover walls or decorate a surface.

heraldic symbolizing authority, often royal authority.

polychrome displaying several different colors.

iconography images or symbols used to convey specific meanings in an artwork.

apse a recess at the end of an interior space, often semi-circular, and typically reserved for someone or something important, such as the altar in a church or the throne of a ruler.

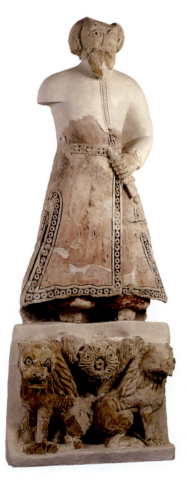

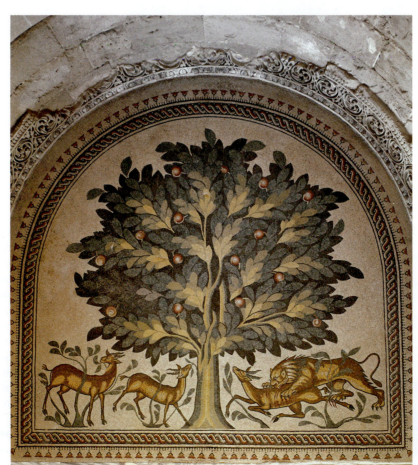

24.9 FAR LEFT **Umayyad prince at entrance of bathhouse, Khirbat al-Mafjar,** near Jericho, Palestinian Territories, Umayyad period, c. 724–44. Stucco sculpture. Rockefeller Archaeological Museum, Jerusalem.

24.10 LEFT **Mosaic with a lion and gazelles, from reception hall in bathhouse, Khirbat al-Mafjar,** near Jericho, Palestinian Territories, Umayyad period, c. 724–44. Glass tiles.

help the poor. Opposition to the Umayyads continued to grow, particularly among the non-Arab Muslim subjects resentful of the privileges Arabs received, and in 750, the Umayyad caliphate fell. The royal family was assassinated soon after, except for one prince who managed to escape to Spain, where he set up another Umayyad caliphate. (For a discussion of Umayyad art in Spain, see Chapter 35.)

Artistic Innovations of the Early Abbasid Dynasty, 750–1000

A clan claiming descent from the Prophet's uncle, al-Abbas, defeated the Umayyads and set up the Abbasid dynasty (750–1258). One of their first actions was to move the capital eastward, away from Damascus and closer to their Persian support base. In 762–63 Caliph al-Mansur (ruled 754–75) founded Madinat al-Salam (City of Peace; present-day Baghdad, Iraq) at the point where the Tigris and Euphrates Rivers flow close together. No physical remains of the Abbasid-era capital survive, but written sources tell us that it was planned as an ideal, round city with a double wall for protection and four entrance gates marking the four cardinal directions. (Round cities, rather than the rectangular grid of the Roman empire, were common in ancient West Asia.) At its center, next to the main congregational mosque, stood the caliph's massive residence, the Palace of the Golden Gate. The design was meant to embody the caliph's and his capital's perceived status as the center of the world.

During the ninth and tenth centuries, particularly under Caliph al-Ma'mun (ruled 813–33), the city did indeed function as a cosmopolitan and powerful center of government, trade, and learning. The House of Wisdom, founded by al-Ma'mun's father, brought together scholars from all over the caliphate to undertake translations and scientific research. Ancient Greek, Persian, and Sanskrit texts covering math, medicine, astronomy, philosophy, and government were translated into Arabic. These works, by such thinkers as Aristotle, Plato, Ptolemy, and Hippocrates, were not simply translated. Instead, the Arabic scholars rejected some ideas and built on others, leading to productive mixtures and innovations. For example, the scholar Khwarizmi developed algebra during al-Ma'mun's reign. Others experimented with alchemy, investigated optics, and debated the nature of God. By the year 1000, physicians in Baghdad were successfully performing cataract eye surgery. These advances in science and philosophy had a profound impact on the development of Islamic art. Today we may think of art, philosophy, and science as separate fields of inquiry, but they really are not—and they certainly were not during the Abbasid dynasty.

CITY OF SAMARRA The Abbasids employed enslaved soldiers called *mamluks* to keep control of their domain. The increasing number of *mamluks* in Baghdad, many of whom felt entitled to bully ordinary civilians, led to confrontations with the city's residents. Eventually the unrest caused Caliph al-Mu'tasim (ruled 833–42 CE) to build a new administrative and capital city about 35 miles (56 km) up the Tigris River, where the troops could be safely segregated. This city, called Samarra, was used for only fifty-six years, between 836 and 892, after which it was largely abandoned. Today it is one of the largest archaeological sites in the world, although it has suffered damage and looting due to recent wars and previous centuries of neglect. Because it was the first Islamic site to be systematically excavated (in the 1910s), Samarra occupies an important place in the history of Islamic art.

The city originally spread over 22 miles (35 km) along the river and contained two congregational mosques, multiple military barracks, markets, game reserves, polo grounds, racecourses, and palaces. The caliph's palace is said to have been the most extensive royal complex ever built in Islamic lands. It covered more than 300 acres (for comparison, the Forbidden City in Beijing, China covers 178 acres; see Fig. 43.12) and had underground tunnels, latrines, and pipes to carry water for baths and fountains.

GREAT MOSQUE OF AL-MUTAWAKKIL Samarra's Great Mosque of al-Mutawakkil, built between 848 and 852, had the distinction of being the largest mosque in the

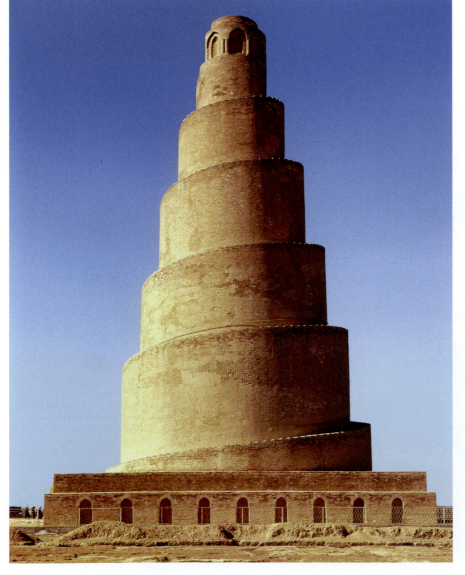

24.11 Spiral minaret of the Great Mosque of al-Mutawakkil, Samarra, Iraq, Abbasid period, 848–52.

Although no Abbasid palaces survive intact and only fragments of royal textiles remain (**Fig. 24.12**), written sources give us an idea of their splendor. One eleventh-century account describes the experiences of two Byzantine envoys who traveled to Baghdad in 917. The following passage recounts how the men were led on a long journey through various halls lined with soldiers and animals and decorated with expensive textiles, revealing how the Abbasids used architectural space like a stage-set, designed to intimidate and impress.

> The number of draperies hung up came to 38,000, according to what was reckoned in the budget prepared by 'Ali b. Muhammad al-Hawari, the keeper of the furniture treasury. Among these were 12,500 curtains of gold brocade, [some] with medallions containing images of horses, camels, elephants, and lions, and [some] having inscriptional bands [*tiraz*] beautifully embroidered in gold [thread]. [There were] also 25,500 large Chinese, Armenian, and Wasiti drapes with designs, as well as [those of] embroidered linen voile and other kinds ... 22,000 pieces of floor furnishings: carpets and runners from Juhrum, Armenia, and Dawraq were spread, all of them, in the passageways and courtyards [leading] from the New Public Gate to al-Muqtadir bi-Allah's residence, and on these the army generals and the Despot's [Byzantine emperor] envoys walked. [This was] apart from the floor furnishings that were spread in the private chambers and sitting halls. A hundred resting places were furnished with sofa-like mattresses of heavily embroidered brocade, and carpets all bearing [images of] flowing rivers ... Then the envoys [were led to] the passageways and vestibules of the animal enclosure. Here were herds of tamed animals of various kinds, which came up close to people, sniffing at them, and taking food from their hands. Then they were led out to a hall inside which were four elephants, each attended by eight persons, together with two giraffes, which amazed the envoys. Next they were led out to a hall containing a hundred lions, fifty on the right side and fifty on the left, each held by a lion-trainer and having an iron chain around its neck.

24.12 **Textile fragment (detail) featuring a medallion pattern with equestrian falconer king,** Iran or Iraq, Abbasid period, ninth century. Lampas weave, silk, 40⅝ × 34 in. (103.2 × 86.4 cm). Cleveland Museum of Art, Cleveland, Ohio.

Discussion Question

1. Imagine being one of the Byzantine envoys. How would each element of the visual environment you encountered—the vast spaces, luxurious textiles, exotic animals—affect you? What would you be feeling by the time you reached the caliph?

world until modern times. Nearly two-and-a-half times the size of the Great Mosque of Damascus, it featured a hypostyle hall plan with an open courtyard, and its outer walls measured roughly 800 × 500 feet (244 × 152 m). Outside the main entrance, on axis with the *mihrab*, stands a 170-foot-tall (51.82 m) minaret with a ramp wrapping around its exterior (**Fig. 24.11**). The inspiration for this unusual spiral minaret is unclear, but this was the period in which minarets first started to appear at mosques. Their imposing height and prominent visual presence on the skyline served as yet another display of caliphate power.

STUCCO WALL PANEL FROM SAMARRA The scale of Abbasid building was immense, but it was Abbasid architectural ornamentation that had lasting impact on the development of Islamic art. The structures at Samarra were constructed of unbaked and baked brick and then faced with a variety of materials: marble, teakwood, and occasionally mosaics. Fragments of brightly colored figurative wall paintings also survive, but the most common finish was stucco covered with a repeating, all-over decorative motif that gives the impression it could go on indefinitely and be applied to any surface. The effect is similar to wallpaper, but with more physical substance because the symmetrical repeating design is carved or pressed into the stucco (**Fig. 24.13**).

Art historians have identified several distinct design styles of this stucco ornamentation, but they all feature some combination of plant-inspired shapes, curving lines, and geometric patterning, and all are non-representational (in contrast to the mosaic designs at the Great Mosque of Damascus, which are non-figurative

24.13 **Stucco wall panel from a private house,** from Samarra, Iraq, Abbasid period, c. 836–93. Carved stucco, Samarra Style, 51¼ in. × 7 ft. 4⅝ in. (1.3 × 2.25 m). Museum für Islamische Kunst, Berlin.

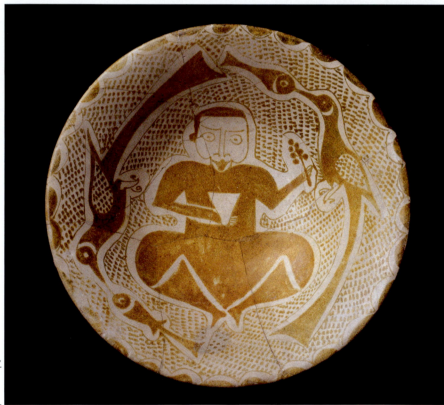

24.14 TOP **Bowl with Kufic inscription,** from Iraq, probably Basra, Abbasid period, ninth century. Earthenware, painted in blue on opaque white glaze, height 2⅜ in. (6 cm), diameter 8 in. (20.3 cm). Metropolitan Museum of Art, New York.

24.15 ABOVE **Bowl depicting a man holding a cup and flowering branch,** Basra, Iraq, Abbasid period, tenth century. Earthenware; luster-painted on opaque white glaze, height 2½ in. (6.2 cm); diameter 9⅜ in. (23.7 cm). Metropolitan Museum of Art, New York.

but still representational). Scholars first assumed that many of these motifs were made with the use of molds pressed into wet stucco, but now some hypothesize instead that the patterns were hand carved with the aid of a grid. It is unclear, too, whether the stucco originally was painted. Regardless of the techniques used to create it, this decoration seems to synthesize the cultural developments of the period. The use of geometry reflects developments in math; the potential for infinity speaks to philosophical debates about the nature of God; and the negation of a fixed vantage point aligns with theories regarding optics. This Samarra Style, as it is sometimes called, was developed specifically for stucco, based on the use of beveled (slanted) cuts, but soon it was applied to a variety of materials and spread across the caliphate.

BOWL WITH KUFIC INSCRIPTION The Abbasid period also saw innovations in ceramics, including new glazes and firing techniques, that arose from a desire to imitate other materials, specifically Chinese whiteware (both **porcelain** and **stoneware**) and Sasanian gold and silver dishes. Beginning in the eighth century CE, direct sea routes from present-day Iraq to East Asia and Southeast Asia expanded international trade and the importation of various items, including Chinese ceramics of the Tang period (see Chapter 27). Porcelain and stoneware in particular were treasured for their luminous, hard, white surfaces, created by clay fired at high temperatures.

Ninth-century Abbasid ceramists, who had access only to yellow clay but desired to imitate the Chinese objects, developed an opaque white glaze using tin imported from Southeast Asia. This glaze effectively hid the clay and created a smooth surface. They then took to decorating the surface with cobalt-blue designs, including **calligraphy**. One ninth-century bowl features the Arabic word for "happiness" repeated twice at its center (**Fig. 24.14**). The word is written in **Kufic**, an early Arabic script. The way in which the angular and sweeping forms of the letters are echoed in the abstract decoration at the rim gives the bowl its elegance. The contrast between the white and blue glazes was so striking that the practice ended up being exported back to China, leading to the development of Chinese blue-and-white ware (see: Seeing Connections: Blue-and-White Porcelain: A Global Commodity, p. 792).

LUSTERWARE BOWL The Abbasid center for ceramic production was the city of Basra, located near the point at which the Tigris River meets the Persian Gulf and overland trade routes converge with maritime routes. This location provided most of what was needed for ceramic production: access to water, sand, clay, fuel, and transportation, both to export the finished products and to import ingredients not locally available. In addition to tin and cobalt, Basra ceramicists needed metals, including copper, to use in another innovation: a luster glaze that mimics the look of gold and silver vessels. They found that they could create an iridescent luster finish if they blended metal oxides with clay and a gum agent, then painted the mixture on top of an item that had already been glazed white and fired once. They then gave the item

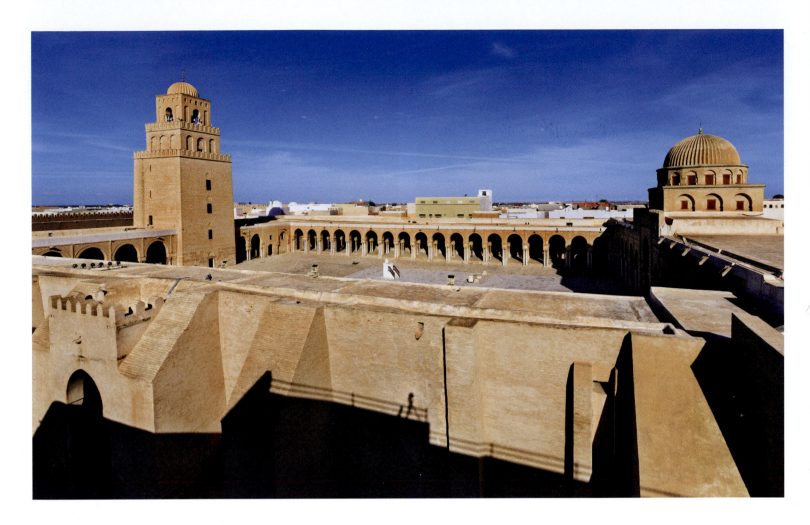

a second firing at a low temperature in a kiln specially designed to keep out oxygen. Essentially, they developed a chemical process that caused metallic compounds to break down and bond to the ceramic vessel.

In a photograph, **lusterware** appears tan or brown because it is seen from a single viewpoint. In three dimensions, with light moving across its surface, it shines. To maximize this effect, artists liked to cover as much of the object's surface as possible with luster designs, as shown in this tenth-century bowl featuring the stylized figure of a seated man holding a cup and flowering branch (**Fig. 24.15**). Two birds, each playfully holding a fish in its beak, encircle the figure, with small luster dots filling the background and a scalloped design marking the rim.

GREAT MOSQUE OF QAYRAWAN Artistic developments in Iraq rapidly spread throughout the caliphate, where they mingled with local traditions. This effect is perhaps best seen in the Great Mosque of Qayrawan in present-day-Tunisia. The monument was mainly constructed in 836 CE under the patronage of the Aghlabids, a local dynasty ruling at the behest of the Abbasids. Its plan is similar to that of other mosques of the period: a hypostyle prayer hall and spacious courtyard surrounded by **arcades**, with a minaret near the main entrance, on axis with the *mihrab* (**Fig. 24.16**). Here, however, the minaret's square design is based on a nearby Roman lighthouse, and the prayer hall makes use of Roman marble columns, locally abundant (Tunisia had been part of the Roman Empire

for nearly 600 years before the region fell to the Vandals in the fifth century).

Particularly notable are the building's *mihrab* and *minbar*, added in 862–63, at the same time that Samarra was flourishing (**Fig. 24.17**, p. 410). The *minbar*, the oldest in existence, is made of teakwood, which comes from the island of Java in Southeast Asia (**Fig. 24.17a**, p. 410). It uses a frame construction into which smaller rectangular panels are set. Those panels, which probably were carved in Iraq and assembled on site, feature the same abstract, plant-inspired, geometric patterning as Samarra's stuccowork. The concave portion of the *mihrab* contains rectangular marble panels that probably were carved locally, as they alternate between Samarra Style designs and Roman-inspired seashell motifs. The top of the *mihrab* and the wall behind it are decorated with lusterware tiles, which must have been expensive and thus were spread out in a pattern for maximum effect. Written sources suggest the tiles were sent, along with a master craftsman, by the central government in Baghdad. These newly developed luster tiles would have sparkled in the light of the candelabras and drawn worshipers' attention to the *qibla* wall, expressing the power of God and the power of the caliphate simultaneously.

For all of its cultural authority, the Abbasid caliphate was already starting to weaken and fragment politically by the beginning of the tenth century. For example, in 909, only forty-seven years after the mosque's *mihrab* and *minbar* were added, Qayrawan fell to the

24.16 Great Mosque of Qayrawan, Tunisia, Abbasid period, 836 and later.

porcelain a smooth, translucent ceramic made from kaolin clay fired twice at very high temperatures.

stoneware a type of ceramic that is relatively high fired and results in a non-porous body (unlike terra-cotta or earthenware).

calligraphy the art of expressive, decorative, or carefully descriptive lettering or handwriting.

Kufic one of the oldest Arabic scripts, angular in form, often used to copy the Qur'an.

lusterware a type of pottery or glassware with a metallic glaze.

arcade a covered walkway made of a series of arches supported by piers.

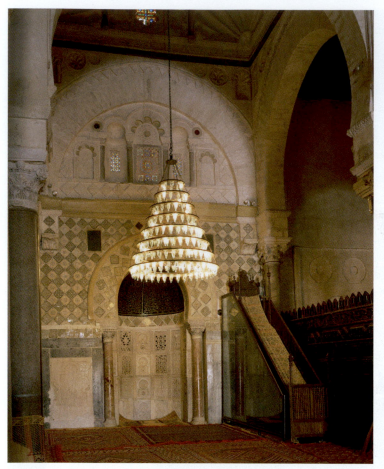

24.17 ABOVE *Mihrab and minbar*, **Great Mosque of Qayrawan,** Tunisia, Abbasid period, 862–63.

24.17a ABOVE RIGHT *Minbar* **(detail), Great Mosque of Qayrawan,** Tunisia, Abbasid period, 862–63.

Fatimids, a Shi'i dynasty opposed to Abbasid rule. Yet, the empire's fragmentation seemed only to aid the spread of Abbasid artistic developments, as local rulers scrambled to commission prestigious artworks to demonstratet their status.

Calligraphy and the Qur'an

Writing played a central role in the development of Islamic culture. Even in pre-Islamic Arabia, words were key. Among nomadic communities, spoken Arabic poetry was the highest form of art, and for merchants, written documents facilitated long-distance trade. The Arabic language took on a new sacred status after the founding of Islam because it is the language of the Qur'an, believed by Muslims to be the direct word of God.

The Prophet Muhammad began receiving what he believed to be divine messages around 610 CE when the angel Gabriel appeared to him in a vision and said, "Recite" (Qur'an means Recitation). The prophet continued to receive these revelations until his death in 632, and they comprise the Qur'an. It is unclear how much of it was written down during Muhammad's life, but it is believed that the Qur'an was codified in the form that it exists today, with its 114 chapters organized by length, within a few decades after his death.

The early history of the Qur'an is somewhat obscure because dating the surviving material evidence is difficult. Still, scholars have drawn several conclusions from the corpus of seventh- and early eighth-century Qur'anic pages, referred to as Hijazi Qur'ans. The text on them is

nearly identical to that found in later Qur'ans, supporting claims that the words of the Qur'an have remained substantially unchanged from its first revealing. The Hijazi Qur'an pages are simple, with little to no ornamentation.

24.18 FAR RIGHT **The letter baa' in the Arabic alphabet,** showing isolated, initial, medial, and final forms, and diacritical marks indicating vowel sounds and doubled consonants.

Letter	baa'
isolated	ب
initial	بـ
medial	ـبـ
final	ـب
Letter and vowel combinations	
b = ب	
b + a (*fathah*) = ba بَ	
b + u (*dammah*) = bu بُ	
b + i (*kasrah*) = bi بِ	
b + (*sukun*) = b (vowelless) بْ	
b + (*shaddah*) = bb (doubled consonant) بّ	

They feature a slanted script that, while carefully written, can be difficult to read if the reader does not already know what it says.

To understand this point, it is helpful to know a bit more about Arabic, which is both the name of a language and the name of a script. Arabic runs from right to left, in contrast to English and other languages written in Latin script, which run from left to right. Also, unlike Latin-based languages that have both print and cursive forms, Arabic is written only in cursive (flowing script, with some letters joined together), and letters have different shapes depending on whether they appear at the beginning, middle, or end of a word (**Fig. 24.18**, top). Spoken Arabic involves twenty-eight distinct sounds, but the written Arabic script comprises only eighteen letters. The remaining ten sounds are indicated by diacritical marks, which are dashes, dots, or other markings placed above or below the letters. Additionally, because only the three long vowel sounds in Arabic have letters, short vowels must also be indicated by diacritical marks (**Fig. 24.18**, bottom). The fact that early Qur'an pages are almost completely devoid of such marks (though they can be found on other, non-Qur'anic writings from the period) supports the idea that the transmission of the Qur'an was primarily oral; these early copies of the Qur'an were intended merely as memory aids to someone who already knew what they said.

Even when large, luxury Qur'ans began to be produced during the Umayyad dynasty, the texts, which were copied in bold Kufic calligraphy (see **Fig. 24.14** for an example of Kufic), still lacked diacritical marks, suggesting they were designed for beauty and display more than reading. The Umayyads took to producing these sumptuous Qur'ans at the same time that they started commissioning monumental architecture, such as the Dome of the Rock, and clearly the same impulses were at work. These expensive copies of the Qur'an were meant to reflect their patrons' piety and status.

BLUE QUR'AN Perhaps the most lavish Qur'an ever made is the so-called Blue Qur'an (**Fig. 24.19**), which was originally housed in the library at the Great Mosque of Qayrawan. It is not clear exactly where or when this copy of the Qur'an was created, but most probably it was made in either North Africa or Abbasid Iraq during the mid-ninth to mid-tenth centuries. Today, its pages are scattered in museums around the world; more than 100 survive from the estimated original 600 pages, which would have been bound into multiple volumes.

The Blue Qur'an takes its name from the brilliant blue of its indigo-dyed **parchment** pages. Notably, rather than reserving gold solely for chapter headings or other special features, as earlier luxury Umayyad Qur'ans did, here the entire text is written in the precious metal. The lines have been copied so that each one is exactly the same width on the page, adding to the graphic impact of the gold against blue. (For more on the artistic potential of the Arabic script, see: Seeing Connections: The Art of Writing, p. 560.) The only ornamentation, apart from the rich coloring, is the occasional silver circle (now faded and tarnished) in the margins, each indicating a new chapter. Notice the complete lack of diacritical marks.

parchment a writing surface prepared from the skin of certain animals that has been treated, stretched, and polished.

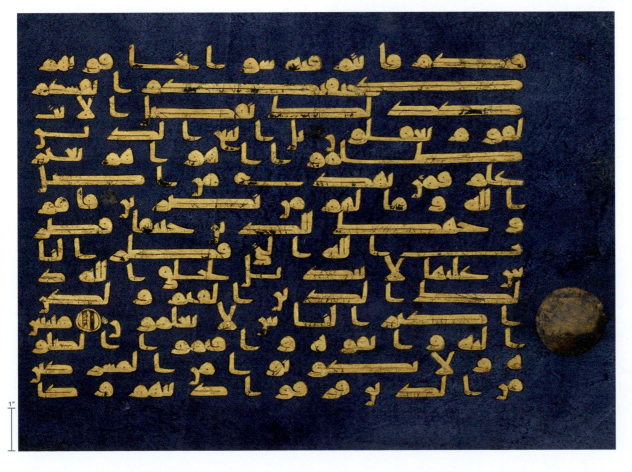

24.19 Folio from the Blue Qur'an (detail), from Tunisia, probably Qayrawan, Abbasid period, *c.* 850–950. Gold and silver on indigo-dyed parchment, 12 × 15⅞ in. (30.5 × 40.3 cm). Metropolitan Museum of Art, New York.

IBN AL-BAWWAB, COPY OF QUR'AN During the Abbasid dynasty, writing became increasingly important, particularly within governmental bureaucracy, where content needed to be clear and unambiguous. As a result, around the year 900 CE, a high official named Ibn Muqla is said to have developed a proportional system for writing. Designed to ensure clarity, consistency, and visual balance, the system was based on the height of the letter *alif*, which is the first letter of the Arabic alphabet and corresponds with a long "A" sound. That measurement became the diameter of a circle, and each of the other letter shapes is based on specific fractions of the circle.

No examples by Ibn Muqla survive, but there is a Qur'an written by Ibn al-Bawwab, a calligrapher trained by Ibn Muqla's daughter. Because this copy of the Qur'an (**Fig. 24.20**) is intact with its **colophon** page giving the calligrapher's name (Ibn al-Bawwab), the date (391 AH, equivalent to 1000–1001 CE), and the place of creation (Baghdad), it is a significant object in the history of Islamic art. It is relatively small, at only 7 × 5 inches, and comprises 286 **folios**. The writing is in brown ink with blue, gold, white, green, and red coloring used for chapter headings and other decorative details. All of the diacritical marks are present, and all the letters are proportional to one another. Every sound is visually distinguished, and the overall effect is one of legibility as well as attractiveness.

The other crucial aspect of Ibn al-Bawwab's Qur'an is its material: paper. Paper is so ubiquitous today that it is hard to imagine it as a revolutionary substance, but for the development of Islamic culture it most certainly was. Paper was inexpensive (and thus more easily obtained) than parchment, which was made from calf, goat, sheep, or gazelle skin that had gone through the time-consuming process of being cleaned, stretched, scraped, wetted, dried, and polished. In contrast, any humble fibrous material, such as textile scraps, hemp, or tree bark, can be made into paper by pounding it into a pulp, adding water, and spreading the resulting mixture onto screens to dry in sheets. Paper is not only easier to make than parchment; it is thinner, too, meaning that the resulting book can be more compact.

The Chinese invented paper sometime around the second century BCE; the story repeated in Islamic histories is that the technology spread to the Islamic world in 751 CE when Arab soldiers captured several Chinese papermakers at a battle in Samarqand, a city in present-day Uzbekistan that was a major stop on one of the trade routes known as the Silk Road. While this account is probably fictionalized, it does seem likely that knowledge of paper-making spread from Central Asia westward around that time under a unified Islamic empire. By the end of the eighth century CE, a paper mill had been established in the Abbasid capital of Baghdad.

Because of the fragile nature of the medium, only a few early examples of works on paper from Baghdad survive. In fact, Ibn al-Bawwab's copy of the Qur'an is one of the earliest. The fact that the colophon does not list a patron, coupled with its small size, suggests that the Qur'an was made for sale at a market. In addition, historical sources describe a market in the southwest portion of the city that contained more than 100 shops selling books on various topics, indicating that in Abbasid Baghdad, paper was widely available, and there was a literate population sizable enough to support such a market.

Both of these factors were crucial to the scientific and cultural developments of the period. Certainly, all of the translations carried out by Baghdad's House of Wisdom would not have been possible without the availability of paper. Paper also allowed works to be copied, and a relatively robust literate population meant that the ideas in those texts would be read and further disseminated. Finally, the portability of books and the status of Arabic as the language of Islam allowed for the transmission of complex ideas and scientific developments across vast distances, creating a degree of cultural unity all the way from North Africa to the eastern edge of Central Asia, and cementing the artistic developments of the ninth and tenth centuries.

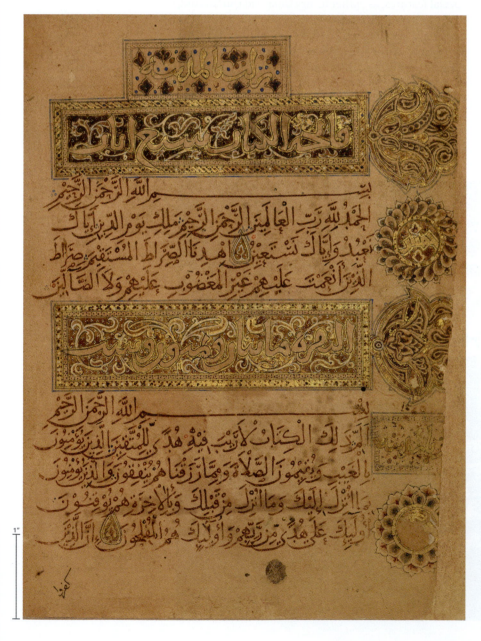

24.20 Folio from Qur'an copied by Ibn al-Bawwab, Baghdad, Iraq, Abbasid period, 1000–1001. Ink and gold on paper, 7 × 5 in. (17.8 × 12.7 cm). Chester Beatty Library, Dublin.

Art historians define Islamic art in two ways. The first, relatively straightforward definition refers to art related to the religion of Islam, just as Christian art refers to art related to Christianity, and Hindu art to art related to Hinduism. The second definition—commonly used in art history—is more complex and includes both religious and secular art created as part of what is broadly understood as Islamic culture in all aspects of life. In this case, we might see Islamic art as similar to the idea of Western art: a constructed category that carries certain geographical and cultural implications, but about which people do not always agree (see box: The Idea of the West and Western Civilization, p. 927). This concept of Islamic art generally refers to art made in North Africa, West Asia, and Central Asia between the seventh and nineteenth centuries CE. It also typically refers to art made for the Muslim dynasties of Spain between the seventh and fourteenth centuries and for the Muslim dynasties of South Asia between the eleventh and nineteenth centuries. Art historians see art from these periods and locales, distinct as they are in many regards, as sharing certain visual and cultural norms that today are labeled as Islamic. These shared elements can include, but are not limited to, the prominence of the written word, including Arabic calligraphy and the arts of the book; specific architectural features, including arches and domes; an emphasis on two-dimensional surface decoration, incorporating geometry and stylized plant-inspired designs; and the importance of luxury items, such as textiles, metalwork, ceramics, glass, and carved or inlaid wooden objects.

These two distinct definitions sometimes cause misunderstandings about what Islamic art is. Because the same adjective, Islamic, refers to both a culture and a religion, people often assume that all Islamic art is aniconic. While Islam strictly forbids idolatry and thus Islamic religious art avoids anthropomorphic imagery, Islamic secular art frequently depicts people and animals.

At times the boundaries of the category can seem arbitrary as well. For example, in the past, many art historians did not consider objects created by or for Indonesian Muslims to be examples of Islamic art, even though Indonesia has the world's largest Muslim population. Of course, as in any constructed category, the boundaries are continually shifting. What art historians today consider Islamic art is different than it was in the past and will be in the future. Nonetheless, the term Islamic art can be useful, especially if taken in its broadest possible form to mean *both* art related to the religion of Islam *and* art related to Islamic culture. It reminds us how diverse Islam and Islamic culture are and illuminates the interconnectedness of people, objects, and ideas throughout world history.

Discussion Questions

1. Compare two artworks from this chapter made in different places and at different times that might be considered examples of Islamic art. What visual and cultural characteristics do they share, if any?

2. This box mentions a few of the shortcomings and benefits of the art-historical category "Islamic art." What are some of the other effects (both positive and negative) of categorizing the art in this way?

Discussion Questions

1. Some art historians view the Dome of the Rock as the first monumental work of Islamic art. Others view Islamic art as beginning with the artistic developments of the Abbasid period. Why, in this case, might it be difficult to pinpoint the beginning of the artistic tradition?

2. The Umayyads and Abbasids commissioned monumental architecture to express their power and prestige. Choose one monument discussed in this chapter and analyze the specific design elements that communicated dynastic power.

3. Abbasid artistic developments of the ninth and tenth centuries were related to other cultural innovations, including those in the field of science. Choose one artwork from this chapter and explain how it relates to an advance in another field.

Further Reading

- Carey, Moya, et al. *The Illustrated Encyclopedia of Islamic Art and Architecture.* London: Lorenz Books, 2010.
- Ekhtiar, Maryam. *How to Read Islamic Calligraphy.* New York and New Haven, CT: Metropolitan Museum of Art and Yale University Press, 2018.
- Grabar, Oleg. *The Dome of the Rock.* Cambridge, MA and London: The Belknap Press of Harvard University Press, 2006.
- Al Khemir, Sabiha. *Nur: Light in Art and Science from the Islamic World.* Seville, Spain and Dallas, TX: Focus-Abengoa Foundation and Dallas Museum of Art, 2014.

Chronology

c. 570–632	The life of the Prophet Muhammad
622	Year 1 of the Islamic faith; marks the migration (*hijra*) of Muhammad and his followers
622	The Prophet's house/mosque is built in Medina
661–750	The Umayyad dynasty
691–92	The Dome of the Rock is completed in Jerusalem
705–15	The Great Mosque of Damascus is founded
724–44	The bathhouse of Khirbat al-Mafjar estate is built
750–1258	The Abbasid dynasty
762–63	The founding of the Abbasid capital, Madinat al-Salam (Baghdad)
836	The Great Mosque of Qayrawan is built
836–92	The City of Samarra is constructed, with houses decorated with wall paintings and Samarra Style stucco motifs
848–52	The Great Mosque of al-Mutawakkil is built at Samarra
ninth/tenth centuries	Innovations in ceramics, including lusterware, take place at Basra
c. 850–950	The Blue Qur'an is copied
1000–1	Ibn al-Bawwab copies the Qur'an on paper

25

Art of African Kingdoms and Empires

300–1500

Figure of an Oni (detail), Ancestral Yoruba.

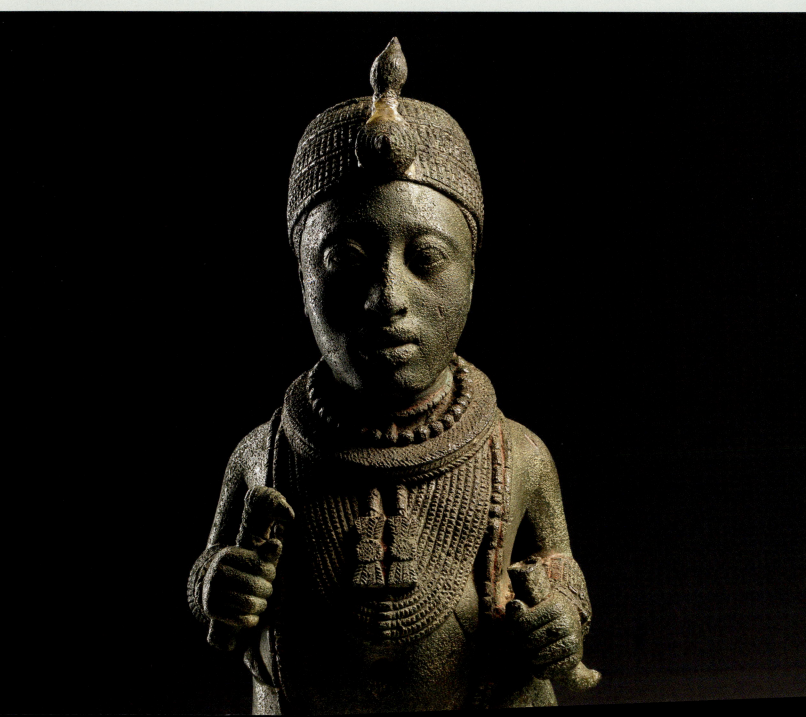

Introduction

Centralized states had ruled the Nile Valley for thousands of years when powerful new kingdoms began to arise in many other regions of the continent. Between about 300 and 1500 CE, some of these kingdoms gained the allegiance of diverse populations, developing into vast empires (Map 25.1). Rural areas may also have flourished, even as urban centers were growing into cosmopolitan hubs, but smaller, democratically organized communities have generally left fewer traces in the archaeological record.

The ancient empire of Aksum gained wealth and political power by seizing existing trade routes around 350 CE, while other centralized kingdoms in northeastern Africa grew rich from the ongoing movement of people and goods through their territory. By 500 CE, the ancient kingdom of Wagadu (known to the Arabic-speaking world as Ghana) was establishing new trade routes across the Sahara that connected the Niger River to the Mediterranean Sea. It was followed by the empire of Mali, which expanded the trans-Saharan trade in gold, salt, and other minerals. By 1000 CE, in southern Africa, Mapungubwe had formed trade networks that brought goods from the Central African interior to the Indian Ocean.

The histories of some of these empires were chronicled in written texts, or in epic poems composed many centuries ago. All of these early African states, though, produced monuments and artifacts that reinforced their political and social structures, and their art expressed their religious beliefs and cultural traditions. In the highlands of what is today known as Ethiopia, for example, Aksum and the kingdoms that followed it constructed churches and commissioned artworks that supported their Christian faith. Mosques and libraries nurtured Islam in the lands along the upper Niger River, and the construction of mosques and palaces marked the spread of Islam to Kilwa and other cities along the eastern coast of Africa. The architecture of Great Zimbabwe was tied to religious institutions (such as divine kingship and the veneration of the ancestors) found throughout that region of southern Africa. Finally, the royal arts of Ife demonstrate the antiquity of Yoruba religious practices, the forms of devotion and sacrifice that later took root in the Americas and in other parts of West Africa. The twelve centuries from 300 to 1500 CE thus laid the foundation for the cultural life and religious beliefs of many African populations, and surviving examples of art and architecture provide insights into early religions and the histories of the distant past.

Aksum and the Highlands of Ethiopia, 300–1500

By 700 BCE, two closely related cultures had built cities on both shores of the Red Sea, in what are today Ethiopia and Eritrea (in Africa) and Yemen (on the Arabic Peninsula). Their trade routes stretched westward to Meroe and the Nile Valley (see Chapter 2), and northward into regions that are today in Israel, Jordan, Syria, and Lebanon (see Map 25.1). An old Ethiopian legend that still endures today illustrated the common history of these Red Sea cultures. It involves a ruler named Menelik, who would have lived

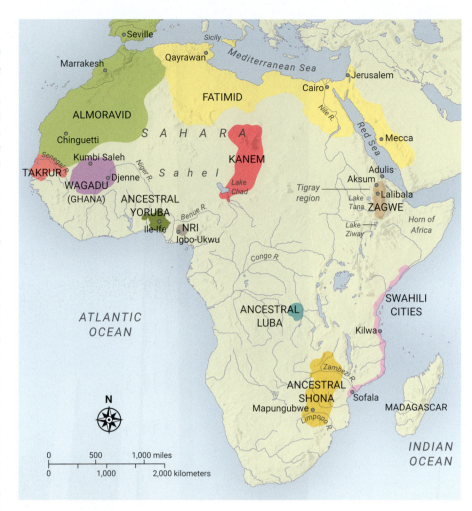

Map 25.1 African kingdoms and populations, c. 1100.

around 900 BCE, and is said to have been the son of the Jewish king Solomon, and the wealthy queen of Sheba or Saba (a kingdom located on the eastern shores of the Red Sea). Solomon had built a temple in Jerusalem that housed the Ark of the Covenant, the chest containing the stone tablets that his people believed God had given to the prophet Moses during the Israelites' flight from Egypt. According to the legend, Menelik and his followers took the Ark from Solomon's temple and transported it to the city of Aksum in the highlands of Ethiopia. Today, Ethiopian Christian celebrations display similarities with Jewish forms of worship, and every important Ethiopian church has at least one *tabot*, a chest that replicates the Ark of the Covenant. Several dynasties of Ethiopian kings and queens have claimed descent from Menelik, including Ras Tafari Makonnen, who ruled his empire under the name Haile Selassie until he was deposed in 1974.

By 100 BCE, the monuments left by the cities west of the Red Sea and those of the Arabian Peninsula began to reveal more cultural differences. African kings founded the city of Aksum, on a high plateau almost 7,000 feet (2,134 m) above the Red Sea, and began to conquer the other populations of this highland region, forming a powerful empire. Today, only the foundations of their imposing stone palaces remain, but the tall stone monuments placed over the graves of the Aksum rulers are still standing. Each of these tomb markers was carved from a single piece of rock, with a flat front and back,

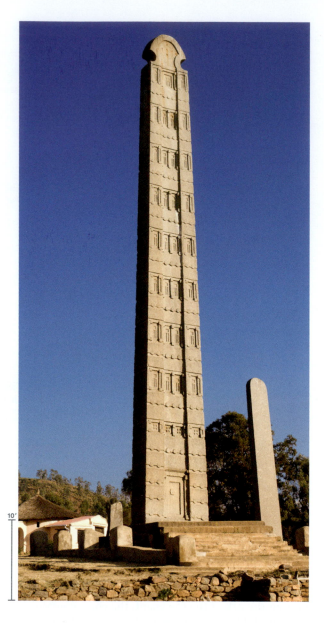

25.1 Royal tomb monument, Aksum, Ethiopia, kingdom of Aksum, 200–400. Solid stone, height 69 ft. (21.03 m).

reinstalled (see: Seeing Connections: Stolen Things: Looting and Repatriation of Ancient Objects, p. 219). Another notable example, 69 feet tall, still stands in place, sixteen centuries later (**Fig. 25.1**).

One or more of these enormous tomb monuments may have been carved for Ezana (ruled *c.* 320–360 CE), the emperor who recorded his conquest of Meroe and issued gold coins bearing his portrait. Ezana became a Christian around 350 CE and decreed that Christianity would become the official religion of Aksum at about the same time that Emperor Constantine made a similar proclamation for the Roman Empire. Thus, Aksum was one of the first centralized states in the world to adopt Christianity. Few, if any, of the monoliths were carved at Aksum after Ezana's reign, suggesting that they expressed pre-Christian religious ideas that were abandoned after the imperial court embraced Christianity.

The early Christians of Aksum were in close contact with even older Christian communities in Egypt, where churches had been founded less than a century after Christ's birth. They also hosted monks and missionaries from Syria, and other lands close to the homeland of Jesus of Nazareth, where Christianity had taken root. While large churches were built in Aksum and other cities, much more modest places of worship were associated with missionaries from Syria and other Christian regions of the Byzantine empire (the successor to the empire of Rome) who converted the rural populations of the empire of Aksum around 500 CE. The small churches are usually named for the saint (often one of the Syrian missionaries) who founded them.

In the mountains surrounding Aksum in the northern Ethiopian region of Tigray, dozens of churches and monastery complexes were built high up on plateaus, and worshipers could reach them only by climbing up the sides of cliffs. Monks who desired solitude lived in or near these churches, which provided sanctuary for religious texts, artworks, and the priests themselves during times of conflict. Pilgrims made arduous journeys across the rocky peaks to visit these churches as an act of devotion to God.

ABUNA YEMATA GUH Climbers reach one church, Abuna Yemata Guh (**Fig. 25.2**), by using footholds and handholds to ascend a dramatic pillar of rock, crossing a natural stone bridge over a 750-foot (about 225 m) drop, and walking along a narrow ledge to get to its low entrance. According to tradition, the small chapel was hollowed out of a natural cave in the sixth century CE, and was named for the Syrian missionary who founded it. Within the tiny space, the rock was carved to replicate architectural elements, including rounded arches that appear to hold up the domed ceiling. Naturally occurring openings in the rock wall were filled with stacked stones to enclose the space, though a window was left to let in light and air.

The interior walls and ceiling of Abuna Yemata Guh are covered with images of heroic saints, some on horseback, and all with haloes in different colors. On one of the columns, the infant Jesus is held in the arms of his blue-robed mother, Mary, and the center of the ceiling displays the Nine Saints (**Fig. 25.3**), who included the

and sides that tapered and culminated in a rounded top. The metal emblems originally attached to the curved top surfaces have been lost, but their contours might refer to the lunar crescent, a prominent symbol for several of the gods and goddesses who were worshiped on both sides of the Red Sea at the time.

The largest and most elaborate of these royal monuments allude to the architecture of the multi-storied palaces of Aksum. Some have a small imitation door at the base, topped by rows of imitation windows. The allusion to architecture includes reproductions of the rounded ends of wooden beams that once protruded from the palace walls. They thus link together royal architecture, political authority, and beliefs about death and the afterlife in ways that are intriguing, even if not yet completely understood.

The tallest **monolith** has fallen over, probably as it was being set into place. Originally, it would have reached 108 feet (32.92 m) into the sky. The second tallest, measuring 79 feet high (24.08 m) and weighing 160 tons (145,150 kg), was hauled away by the Italians when they invaded Ethiopia in the 1930s; it has recently been returned and

monolith a single large block of stone.

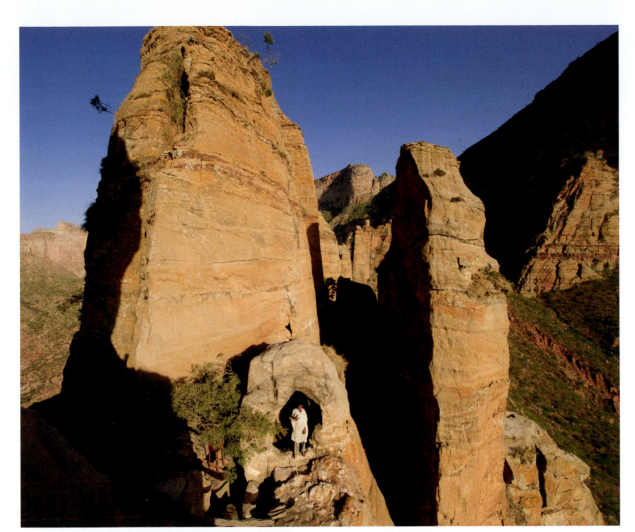

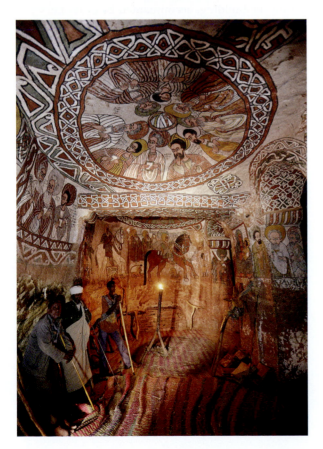

church's founder and the other Syrian missionaries. Colorful patterns and interweaving lines, similar to those seen in embroidered textiles and in baskets, divide the various groupings of closely packed figures. After comparing these bold paintings to the many styles of religious art created in the highlands of Ethiopia and Eritrea over the last 1500 years, art historians now believe that the stone walls, first carved around 500 CE, were covered with these devotional images about one thousand years later.

BETE GIYORGIS (CHURCH OF ST. GEORGE) Abuna Yemata Guh and other churches cut into the cliffs of the Tigray region may have inspired the group of eleven churches carved into the bedrock at Lalibala (also in Ethiopia) more than 100 miles (160 km) to the south of Aksum. Construction of these eleven churches began around 1200 CE during the reign of Gebre Mesqel Lalibala in his capital city Roha, whose name was later changed to Lalibala in his honor. Lalibala belonged to the Zagwe dynasty (*c.* 900–1250 CE), which had conquered the empire of Aksum.

During this time period, European Crusaders and Muslim defenders were battling over sites in Jerusalem that were considered to be holy by Jews, Christians, and Muslims alike, and it was quite dangerous for pilgrims to travel to the region. Lalibala presented his **rock-cut** churches as a reconstruction of Jerusalem

rock-cut carved from solid stone, where it naturally occurs.

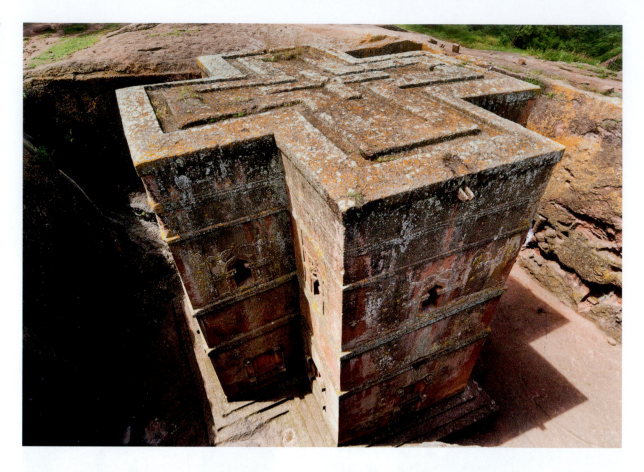

25.4 Bete Giyorgis (Church of St. George), carved into bedrock. Lalibala, Ethiopia, Zagwe dynasty, *c.* 1200.

and its Christian churches, and he named the stream running through Roha the River Jordan. The stories about its construction reveal the deeply religious nature of Lalibala's enterprise. They recount that when the stonemasons laid down their hammers and chisels at the end of day, angels would continue the work through the night. This legend assumes that the churches were completed in a miraculously short period of time, but art historians identify a sequence of building activity that might have stretched over 150 years.

Each of the Lalibala churches was either carved into the exposed surface of a cliff or downward into the reddish bedrock (**Fig. 25.4**). Stonecutters carving the church of Bete Giyorgis (the house of St. George) worked their way down into the rock from the surface to create the cross-shaped structure and the open space around it. Then they began to carve away the windows and door, finally hollowing out the interior of the building. Though the exterior roof of the church is flat, the interior ceiling is curved to form vaults and a shallow dome. Horizontal ridges extend around both the exterior and interior walls, dividing the smooth surfaces into upper and lower sections, and raised tendrils of stone frame the windows on the outside of the church.

To enter Bete Giyorgis, visitors walk down narrow passages that tunnel into the rock, emerging into the small courtyard surrounding it. There is very little room for worshipers inside the church, since the square domed chamber at the back is the curtained Holy of Holies, which only priests may enter. It contains the *tabot*, the replica of the Ark of the Covenant. Crosses of brass or silver, painted wooden panels and

banners, manuscripts, and musical instruments may also be stored in the church. During annual celebrations such as Timkat (called Epiphany in Greek), priests conduct the worship service in the courtyard rather than within the building, accompanied by drummers and a chorus of singers. Rows of worshipers stand above the church at ground level, surrounding the excavated opening and chanting in response to the ceremony unfolding below them. The church is thus a sculptural focus for dramatic celebrations of Christian faith.

GADL (**BOOK OF THE LIVES OF SAINTS**) The Zagwe dynasty was overthrown around 1270 CE by a new group of rulers who claimed to be the heirs of the imperial rulers of Aksum. They also claimed to be the descendants of King Solomon and the Queen of Sheba, so they are referred to as the Solomonic dynasty. Although the continuity of this dynasty into the eighteenth century has been called into question, it ruled the highlands of Ethiopia for at least five hundred years from a region around Lake Tana, to the west of Lalibala.

One of the Solomonic emperors, Dawit I (ruled *c.* 1382–1413), is said to have commissioned a particularly important manuscript. Its size, **calligraphy**, and richly ornamented illustrations support its attribution to an artist working for an imperial court. This *gadl*, an illustrated book recounting the lives of Ethiopia's most venerated Christian saints, is written in Ge'ez (the archaic language used by the Ethiopian church) on pages made of goatskin or the specially prepared hides of other animals. One page arranges the sacred text, written in red and black, in three columns, and vine-like ornaments

calligraphy the art of expressive, decorative, or carefully descriptive hand lettering or handwriting.

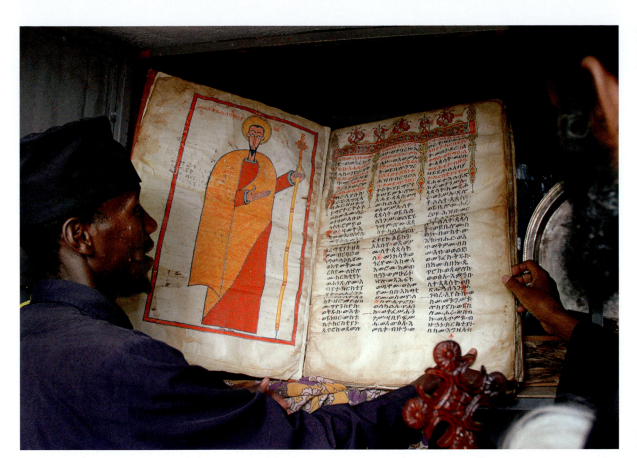

25.5 Priest holding a *gadl* (book of the lives of saints), Monastery of Debre Zion, Lake Ziway, Ethiopia, *c.* 1400.

Map 25.2 African kingdoms and populations, *c.* 1400 CE.

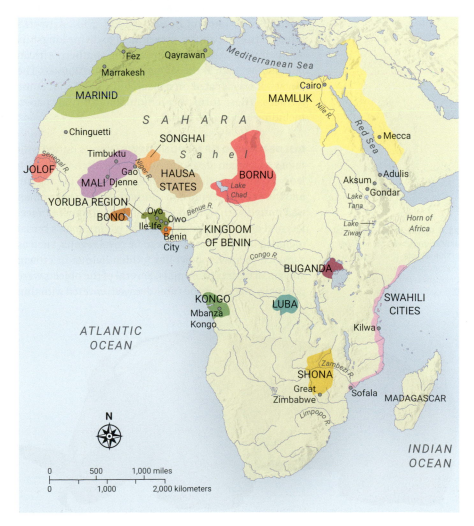

recall the tendrils around the windows of the church of Bete Gyorgis (**Fig. 25.5**). The facing page is filled with the image of a saint whose halo and robes are constructed of curved shapes in bright colors. Unlike the saints in Abuna Yemata Guh, neither the dark outlines nor the flat areas of color are concerned with three dimensional space; the image almost seems to be a collage of patterned cloth.

The *gadl* has been preserved for centuries in a monastery on a remote island on Lake Ziway, over 300 miles (almost 500 km) south of Dawit I's homeland. The monastery may have been founded as a place of refuge during the conquest of the Zagwe dynasty. This book, however, appears to have been sent to the monastery for safekeeping around 1530 CE to protect it from destruction during the invasion by a Muslim army coming into the highlands from the south. Manuscripts such as these are now globally recognized as Ethiopia's cultural treasures.

Southern African Kingdoms and the Swahili Coast, 1000–1500

About the time that Aksum was gathering strength in the highlands of Ethiopia, the Red Sea port city of Adulis was an important stop on the new trade routes that crossed the Arabian Sea and the Indian Ocean (see **Map 25.2**). Small sailing vessels took advantage of monsoon winds to carry luxury goods, such as ivory, minerals, and aromatic spices, from the Horn of Africa to India and the Persian Gulf. By the beginning of the Zagwe dynasty, however, Adulis had been eclipsed by cities further south. Boats now sailed across the Indian Ocean to places as distant as Indonesia and southern China, and they were

often piloted by Muslims. Islam provided Muslim merchants with a set of straightforward ethical principles that fostered intercultural economic relationships. Many communities along the coast of east Africa converted to Islam as they entered into trading partnerships with populations around the Indian Ocean. Their populations became known as the Swahili (derived from an Arabic word for "coast"), and Swahili cities prospered as they joined this intercontinental trade.

Meanwhile, between 1000 and 1200 CE, the foundations for wealthy kingdoms were being laid in the interior of the continent. The earliest Luba kingdoms arose in what is now the Katanga region of the Democratic Republic of Congo, where mourners buried their dead with implements of copper and iron, and with ceramic vessels. Further south, the archaeological site known as Mapungubwe was the capital of a kingdom located on the Limpopo River, which now divides the present-day nations of South Africa and Zimbabwe. Glass beads imported from India have been found at the site, indicating that Mapungubwe flourished after it joined the trade network that linked inland cities to the Swahili cities on the coast. By the twelfth century, Mapungubwe was in decline, and the Katanga cultures were trading with its successor, Great Zimbabwe.

The archaeological site of Mapungubwe, inhabited from about 1000 through 1200 CE, is about 350 miles (550 km) north of the Mpumalanga region of South Africa, where an earlier population (*c.* 500–800 CE) buried a group of **terra-cotta** heads (see Fig. 2.10). Artworks found at this site appear to be linked to divine kingship, an institution with deep roots among southern African populations such as the Shona, Venda, and Barotse. The city itself was located on a steep hill ringed with stone terraces. These formed ceremonial and ritual spaces, including an area for burials.

GOLDEN RHINO OF MAPUNGUBWE Objects buried with men and women at Mapungubwe were often made with ivory taken from the herds of elephants in the region, and from the gold mined in southern Africa. One woman was buried with around one hundred gold-wire bracelets and one thousand gold beads, while a man's burial included objects that appear to be royal regalia, such as a golden scepter, a bowl-like golden helmet or crown, and small figures of animals. Several of the objects were originally made of wood (now decayed) covered with thin sheets of gold. The best preserved is a sturdy rhinoceros (**Fig. 25.6**). It was constructed with overlapping plates of gold attached to the wooden core with pins, giving the animal the look of an armored vehicle. The head of the rhino is lowered, as if it were charging, and this pose gives the small object a powerful presence. Although there are no comparable examples of rhinos in later art from South African kingdoms, the strength and determination of this wild beast make it a suitable metaphor for a royal leader.

GREAT ZIMBABWE

About two hundred miles (300 km) north of Mapungubwe, in a hilly region closer to ancient gold mines, the site known today as Great Zimbabwe began to be settled around the early eleventh century (**Fig. 25.7**). It is now located in southern Zimbabwe, the present-day nation named for this city and its kingdom (see **Map 25.2**). In the language of the Shona people whose ancestors built this complex out of blocks of stone, *zimbabwe* is a term linked to royal residences and stone enclosures. In fact, populations related to the present-day Shona built many stone-walled, terraced sites over the course of the next five or six centuries. Each *zimbabwe* was the residence of a king, whose connection to previous divine rulers was believed to give him supernatural power as well as political authority. The people of Mapungubwe, inspired by these inherited religious beliefs, constructed stone terraces enclosing the hilltop dwellings and graves of their sacred leaders. Great Zimbabwe, the stone enclosures of which were built between about 1250 and 1400, is the earliest, largest and most complex of these sites.

Archaeological finds from Great Zimbabwe show that the kingdom traded goods over long distances. These include iron gongs and copper crosses, the insignia of rulers in the Katanga region of central Africa, along with glass beads from South Asia and porcelain imported from East Asia during the Song dynasty (960–1279 CE). The beads and porcelain came to Great Zimbabwe through the Swahili port of Sofala, in what is today Mozambique, but which was then under the control of the powerful city of Kilwa, in present-day Tanzania (discussed later in this chapter).

Regular blocks of granite, split off from the boulders that are strewn across the landscape, were smoothed and carefully stacked to form the many walls of Great Zimbabwe. Because no mortar was used, they are examples of **dry masonry**. The oldest walls at the site form the Hill Complex, the terraces of which provide a view of the valley below. At one end of the Hill Complex is a natural cave that was apparently used as a megaphone, since it can project prayers and songs so that they are heard from over a mile away. By drawing on present-day Shona religious ideas concerning their environment and their deceased leaders, archaeologists believe that the stone walls on this hilltop, which close or narrow the gaps between boulders, were built to enclose sacred spaces where the kings of Great Zimbabwe worshiped God and the ancestors, and where they prayed for rain.

25.6 Rhinoceros, from burial at Mapungubwe, South Africa, *c.* 1000. Sheets of gold fastened to a wooden core, length 6 in. (15.2 cm). University of Pretoria, Museums and Collections, South Africa.

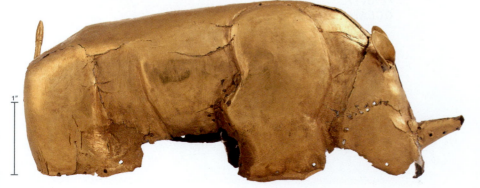

1"

The imposing encircling walls of the Great Enclosure, the largest structure in the valley below, are up to 36 feet (10.97 m) high. Interior walls divided spaces for throne rooms, meeting halls, and other thatched dwellings made of polished clay. A long, narrow passage, just inside the towering inner surface of the enclosure wall, begins at one of the entrances and ends just in front of a massive, solid structure built of stone blocks (**Fig. 25.8**). This conical structure seems to be an enormous replica of the granaries that stored Zimbabwe's crops. It probably referred to the ruler's ability to provide rainfall for abundant harvests, but it may have had additional symbolic associations. Like the walls, the stones of this conical structure were carefully hewn and stacked without mortar.

Close to the base of this towering feature was a wide stone shelf, perhaps about waist high, now tumbled into the heap of stones that resulted from excavations by both treasure hunters and archaeologists. Broad bands of dark stone marked the wall that separated this shelf (or shelves) and the conical monument, and a portion of that wall is still standing (see **Fig. 25.8**). On the shelf-like platform, archaeologists found miniature stone dishes and small statues, similar to the sculpture in mud and wood that was displayed in the twentieth century to girls in southern Africa when they were being prepared for adulthood. (In Venda communities, for example, older women manipulated such figures like puppets, acting out stories and morality plays to teach the girls about

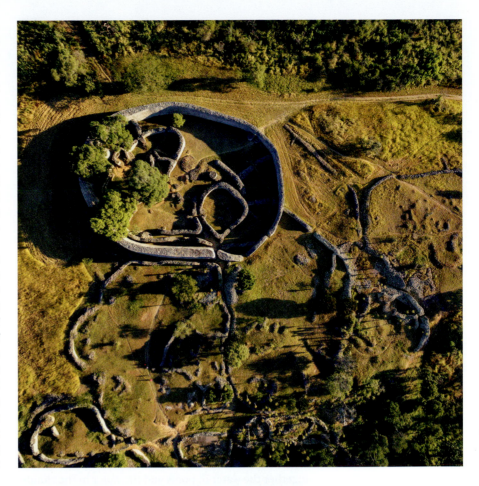

25.7 ABOVE **Great Zimbabwe,** Ancestral Shona, Zimbabwe, c. 1250–1400.

25.8 LEFT **The Great Enclosure at Great Zimbabwe,** Ancestral Shona, Zimbabwe, c. 1250–1400. Stone blocks; tallest wall height 32 ft. (9.75 m).

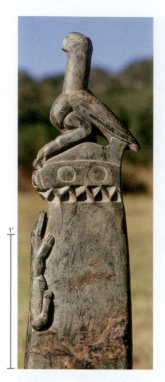

25.9 Royal emblem in the form of a fish eagle, Ancestral Shona, Great Zimbabwe, Zimbabwe, 1250–1400. Soapstone, height of bird 12 in. (30.5 cm). National Museums and Monuments, Masvingo, Zimbabwe.

social relationships and sexual behavior.) One of the stone statues was a little zebra. Both the figure, and the dark bands on the wall behind it, might have been references to a zebra's stripes. Shona oral traditions explain that men and women are as distinct, but as reliant upon each other, as the stripes on the hide of a zebra. Some observers thus believe that this area may have served as a backdrop for the instruction of young women in Great Zimbabwe, noting that royal women were assigned many leadership roles in the kingdom and that girls needed to be prepared for those responsibilities.

ROYAL EAGLE EMBLEM, GREAT ZIMBABWE At its peak, around 1400 CE, about 10,000 people were housed in and around the low walls of the Valley Enclosures. In one of the smaller ruins, in a group of dwellings believed to be the palace of the king's wife or the king's sister, a large stone post was found (**Fig. 25.9**). Crawling up the pole is a crocodile—a dangerous creature that lurks in the deep pools of water where, according to Shona religious beliefs, the spirits of deceased rulers might rest. Above the crocodile are zigzagging lines representing lightning, and above these lines are round eyes, possibly those of a vigilant owl. On the top of the stone post is a fish eagle—a creature capable of hurtling down from the sky to seize fish from the water. The flash of lightning has been likened to the rapid descent of the eagle, and the zigzag motif referred to the eagle's flight as it crosses the sky. The eagle is thus an avatar for the king, whose prayers bring together the water in pools and the water in the clouds. Zigzags or **chevrons** run along the upper rim of the Great Enclosure's exterior walls, where they were created by leaning a row of stones at alternating angles. On the eagle's chest is a row of round **bosses** (not pictured),

which may represent the pins used to attach metal to a wooden core. They suggest that this sculpture was a stone replica of a gold-covered wooden image similar to the rhino from Mapungubwe (see **Fig. 25.6**). Other stone eagles on posts were found in the Hill Complex, another part of Great Zimbabwe where the authority of the king would have been invoked.

THE SWAHILI COAST

Kingdoms that arose to the north of Great Zimbabwe continued to trade with Sofala and other cities of the Swahili Coast. The most powerful of the Swahili cities was Kilwa, considered a Sultanate by its Arabic trading partners. During its period of greatest prosperity, the community's **mosque** and the ruler's palace were located on the island of Kilwa Kisiwani, in what is now Tanzania (see box: Going to the Source: The *Rihla* of Ibn Battuta).

GREAT MOSQUE, KILWA Construction of the Great Mosque of Kilwa (**Fig. 25.10**) began around 1000 CE. Although modest wooden mosques had probably been constructed for the community in the previous century, the earliest phase of stone construction consisted of sixteen **bays** supported by nine pillars and a short **qibla wall** that oriented worshipers toward Mecca. The building was expanded around 1300 CE to almost three times its original size, and its broad prayer hall was roofed by a succession of small pointed domes. Each dome rises above four arches, supported by polygonal pillars. Set into the qibla was the **mihrab**, the empty niche reminding the assembled congregation of the presence of God (see Chapter 24). Like the door visible in this view, parallel grooves cut into the stone on the qibla wall emphasize the contours of the mihrab.

chevron pattern in the shape of a V or upside-down V.

boss a round, knob-like projection.

mosque a Muslim place of worship.

bay a space between columns, or a niche in a wall that is created by defined structures.

qibla wall the wall in a mosque that indicates the direction toward which Muslims face to pray, usually indicated by the presence of a *mihrab*.

mihrab prayer niche, usually concave with an arched top, located in the *qibla* wall of a mosque and indicating the direction of Mecca.

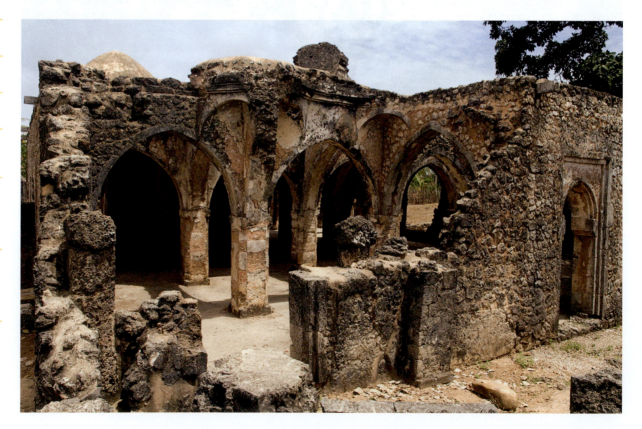

25.10 Prayer hall of Great Mosque, Kilwa, Tanzania, Swahili, c. 1300. Coral blocks and cement.

In 1353 CE (AH 731), the Sultan of Morocco ordered the poet Ibn Juzayy to assist a famous traveler, Abu Abdallah ibn Battuta, in preparing an account of his journeys (*rihla*) titled *A Gift to the Observers Concerning the Curiosities of the Cities and the Marvels Encountered in Travels*. Unlike most Muslim pilgrims, Ibn Battuta journeyed far beyond Mecca, visiting most of the lands that had converted to Islam. He describes cities from Guangzhou (in China) to Granada (in Spain), from Constantinople (in Turkey) to Kilwa (in Tanzania), providing a fascinating glimpse into the Muslim world as it was developing about 700 years ago.

Early in his travels, he visited the Swahili coast. Unfortunately, his memories of Kilwa's stone architecture were somewhat faulty by the time he recorded his visit:

> The city of Kulwa [Kilwa] is amongst the most beautiful of cities and most elegantly built. All of it is of wood, and the ceilings of its houses are of [reeds] …. Their uppermost virtue is religion and righteousness.

Ibn Battuta's last journey was a rigorous trans-Saharan expedition to the capital of the Mali empire, in the Inland Niger Delta. He describes his impressions of the imperial court. His observations about a bard (a singer hired to sing the praises of the emperor) who wore a feathered costume and a wooden mask, could easily be describing the masquerades still performed by such musicians in the modern era:

> The interpreter Dūghā stands at the door of the audience chamber wearing splendid robes …. He is girt with a sword whose sheath is of gold … In his hands there are two small spears, one of gold and one of silver with points of iron. The soldiers, the district governors, the pages, and the … others are seated outside the place of audience in a broad street which has trees in it. Each commander has his followers before him with their spears, bows, drums, and bugles made of elephant tusks. Their instruments of music are made of reeds and calabashes [gourds] and they beat them with sticks and produce a wonderful sound.
>
> The men-at-arms come with wonderful weaponry; quivers of silver and gold, swords covered with gold, their sheaths of the same, spears of silver and gold and wands of crystal …. When it is a festival day and Dūghā has completed his play, the poets called the *jula* (and the singular is *jali*) come. Each one of them has got inside a costume made of feathers to look like a thrush with a wooden head made for it …

Discussion Questions

1. After reading Ibn Battuta's description of the presentation of arms and armor to the king of Mali, what new questions or observations do you have about the statue of a warrior represented in fired clay, which was found at the site of the royal city of Djenne (see **Fig. 25.13**)?

2. In Mali today, the hosts of weddings and other celebrations hire bards known as *jeli* (pl. *jeliw*) to sing, and musicians from Mali perform for audiences around the world. Locate a video or audio recording of a concert featuring musicians from Mali. Can you identify the musical instruments made of "reeds and calabashes" that are described by Ibn Battuta? Is it useful to learn about music while studying Mali's early art and architecture?

While some features recall Persian mosques (including the pointed domes), the building materials and architectural techniques of the mosque are uniquely Swahili. For at least seven centuries, Swahili architects have constructed multi-storied family homes as well as mosques, both using unusual forms of limestone. They first cut blocks of relatively soft fossilized coral out of the seabed, and then set these fresh stone blocks in a thick mortar made of dried, crushed, and fermented coral limestone to form the columns and walls. Finally, they burned dried coral to produce a plaster that they used to cover the surfaces, and then burnished it to a shiny white.

The Great Mosque of Kilwa once had all the usual features of an urban mosque in North Africa or West Asia, including a large, well-ventilated prayer hall and a section at the entrance for washing hands, head, and feet. However, its walls did not enclose an open courtyard or a tower where the call to prayer could be announced. Few Swahili mosques have **minarets**, perhaps because tombs in their cemeteries featured tall, tapering stone pillars that were their visual equivalents.

Empires of the Upper Niger and the Sahel, 500–1500

As the Niger River flows northward from its headwaters, the waterway irrigates the arid landscape in the Inland Niger Delta before ending in a wide arc, the Niger Bend, to turn southward. After entering dense forests, the Lower Niger forms another delta as it empties into the Atlantic. Near the Upper Niger, prosperous cities arose around 100 CE. Only in the 1980s did archaeologists begin to uncover evidence of the origin and growth of these cities, and they believe that many were formed by the ancestors of populations speaking Mande languages. By about 500 CE, the kingdom of Wagadu had established its capital in present-day Mauritania, just north of what is now Mali. By 1000 CE, the kingdom had an active role in the growing trans-Saharan trade. To the west, ancestors of Fulani and Wolof communities founded rival states, which controlled the gold mines in the hills along the Senegal River.

Muslim merchants called the grassy savannah south of the Sahara Desert the Sahel, a term that, like the name Swahili, is taken from the Arabic word for "shore" or "coast." The vast Sahara Desert was seen as the equivalent to an ocean: its oases were like islands, and the cities along its southern edges in the Sahel were welcoming ports for travelers. Merchants travelling to the Sahel from the lands north of the Sahara brought the practice of Islam with them. When the rulers of kingdoms such as Wagadu adopted Islam, their architects built mosques, adapting North African models with local materials, techniques, and motifs. After Muslims from the kingdoms of the Sahel went on pilgrimage to Mecca, or studied in religious colleges attached to North African mosques, these devout travelers began to collect both secular and religious manuscripts. Cities such as

minaret a tower at a mosque; can be used to give the call to prayer and also functions as a visible marker of the mosque on the skyline.

Chinguetti (in present-day Mauritania) and Timbuktu (in present-day Mali) became centers of religious and scientific scholarship with important libraries.

GREAT MOSQUE, CHINGUETTI The oldest mosque in the Sahel was built at Kumbi Saleh for the Soninke ruler of Wagadu by about 1000 CE, but only its ruins have survived. A mosque built merely a century or two later in the oasis of Chinguetti (**Fig. 25.11**) seems to have been constructed by Soninke builders, using similar techniques, for the nomads who controlled the city and its trade routes. Influenced by the Great Mosque of Qayrawan far to the north in Tunisia (see Fig. 24.16), the minaret of this congregational mosque (**Fig. 25.11**) has a similar square base. The Chinguetti minaret is not topped by a dome, however, but by horn-like projections, and on each is a piece of iron that supports an ostrich egg. Mande beliefs tie these durable eggs to ideas about life and regeneration—beliefs that can be easily meshed with Muslim teachings about blessings known as *baraka*. Whereas the architects in Qayrawan used Roman and Byzantine ruins as a source for columns and stone blocks, the walls of the mosque at Chinguetti were built from locally available rock. Builders cut the thin slabs of stone into regular shapes and stacked them up without mortar.

The Chinguetti Mosque has little ornamentation on either the interior or exterior, in keeping with the austere form of Islam that spread through this region of the Sahara and Sahel around 1000 CE. In fact, Chinguetti was a source of religious and military movements that affected far-flung populations in Europe as well as in Africa. Warriors who were Imazighen (known to outsiders as "Berbers"), studied in these desert mosques and trained to become the military force of the Almoravid dynasty. The Almoravids conquered the Moroccan city of Marrakesh in 1062, and had seized territories in Spain by 1090.

GREAT MOSQUE, DJENNE In an epic conflict that occurred around 1235 CE, the Malinke hero Sundiata, a leader of the Keita clan, defeated other rulers, and went on to found the vast multi-ethnic empire of Mali. Over time, the Mali Empire expanded westward and gained control of important goldfields, and Mali grew eastward along the Niger Bend to annex the city of Timbuktu in 1324. Mansa Musa, the emperor (or *mansa*) who ruled in the early 1300s, created a sensation when he crossed the Sahara and entered Cairo with his impressive retinue during his *hajj* (or pilgrimage) to Mecca. Mosques were built throughout the empire, and some of the oldest are still are in use in Timbuktu. At Djenne, a bustling city on a tributary of the Niger River, a king who converted to Islam constructed the community's first mosque around 1300 (**Fig. 25.12**).

Djenne's mosque was relocated and rebuilt in different versions within the city over the course of centuries. After Djenne fell to French military forces in the late nineteenth century, becoming part of the colony named French West Africa, the mosque fell into ruin. It was rebuilt most recently in 1907 in Djenne under the direction of Ismael Traore, head of the masons' guild, using the same materials and techniques that had been used to construct homes, palaces, and mosques in the city since the 1300s. The masons of Djenne set irregular sun-dried bricks of processed clay into a mortar made of a mixture of mud and other substances, and then coated the entire surface with a mud-based plaster. Today, the Great Mosque is the world's largest **adobe** building.

Like the Great Mosque at Qayrawan, the high walls of the Great Mosque of Djenne enclose a large open courtyard, which is placed beside a covered prayer hall.

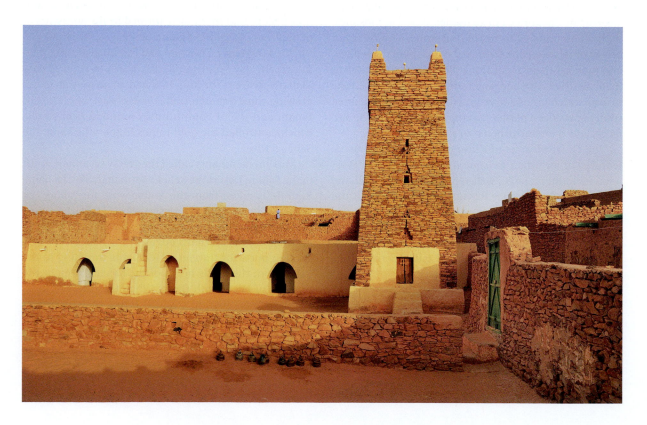

25.11 Exterior and minaret of the Great Mosque, made by Soninke and Moors, *c.* 1200. Chinguetti, Mauretania.

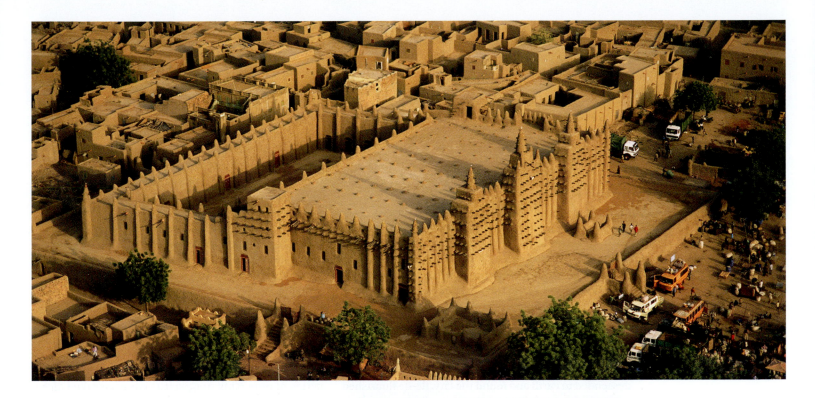

Three roughly square minarets rise on the *qibla* wall facing Mecca, each topped by a rounded cone and (as at Chinguetti) an ostrich egg. The central tower is about 48 feet (over 14 m) high. Inside the prayer hall, long rows of arches support the heavy roof.

The adobe walls of Djenne's mosque require regular maintenance to repair erosion damage from rain and wind, as do the homes of the city's inhabitants. In an exuberant annual festival, competing neighborhoods send teams of women to carry water from the river, and children help mix and carry the mud-based plaster. Young men, under the supervision of the masons, climb wooden ladders to re-plaster the walls, clinging to the bundles of wood that jut out from the surface. In addition to serving as useful scaffolding, these wooden extensions express local beliefs in a type of energy known by the Mande term *nyama*, for they are similar to the iron and wooden antenna-like poles that were said to transmit supernatural forces into pre-Islamic shrines.

DJENNE STYLE EQUESTRIAN FIGURE The sculptures in terra-cotta found at Jenne-Jeno, an archaeological site close to present-day Djenne, also relate to pre-Islamic religious practices. These ceramic sculptures, and many others unearthed in the Upper Niger and Inland Niger Delta regions, have mostly been dated to about 1200–1400. The terra-cottas exhibit an amazing variety of poses and subject matter. Unfortunately, Jenne-Jeno and other archaeological sites in Mali (and elsewhere in Africa; see Chapter 2) have suffered heavy damage at the hands of looters, and many clues about the original context of these artworks have been destroyed. The style of works found at Jenne-Jeno is quite distinctive, as the heads of the figures are long and rounded, and angled so that the faces appear to look upward. Some are posed in positions that are still used in rural areas of Mali to pray

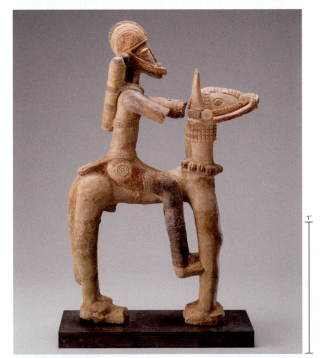

25.12 ABOVE **The Great Mosque at Djenne,** Inland Niger Delta, Mali, founded *c.* 1300, restored 1907. Adobe.

25.13 LEFT **Djenne Style equestrian figure,** from inland Niger Delta, Mali, 1200–1400. Fired clay, height 27¾ in. (70.5 cm). Smithsonian National Museum of African Art, Washington, D.C.

to particular spirits or ancestral beings. Others display raised bumps of clay that suggest skin diseases. Because so many works in this style are convincing forgeries made for unsuspecting foreign buyers, scholars have difficulty interpreting these features.

A common subject for the artists of ancient Djenne is the mounted warrior, which is understandable given the epic tales of military valor that accompanied the rise of the empire of Mali. One large horseman in this style is equipped with a helmet and a quiver of arrows (**Fig. 25.13**). He and his horse are made up of multiple tubular forms. Traces of red **slip** can be seen; the figure

slip a layer of fine clay or glaze applied to ceramics before firing.

once had the same polished surface as locally made ceramic vessels. This figure's purpose is unknown, but judging from the meager information available from archaeological contexts, it might have come from a tomb and could have been a funerary portrait honoring a dead soldier. It might also have been buried at the threshold of a home or shrine, serving as a guardian that invoked protective forces.

The Yoruba Kingdom of Ile-Ife, 800–1400

Although archaeologists have been able to associate early artworks with small communities in the West African savannah, and even identify elaborate bronze sculpture as the treasury of a king or religious leader in the lower Niger region, few traces of urban centers before about 1200 have been found in the dense forests of West Africa. The prominent exception is the city of Ile-Ife, located west of the Niger River in present-day Nigeria (see **Map 25.1**). It is not only the oldest of the Yoruba city states, settled before 800 CE, but it is also a legendary place, whose inhabitants claim that the first of its divine kings descended to earth and found the city. Ile-Ife flourished between about 100 and 1400. However, there were many raids from populations from the north in the sixteenth century, and in the seventeenth century it was eclipsed by the rise of the powerful Yoruba kingdom of Oyo. Today, the city is simply known as Ife. Despite the disruption

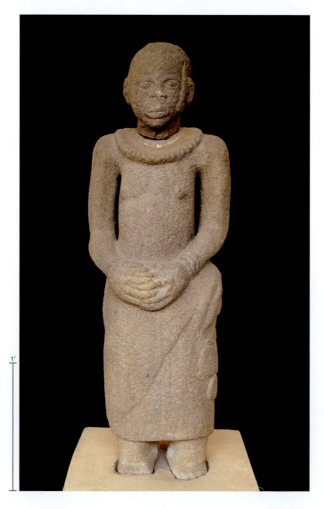

25.14 *Idena* (gatekeeper), Ife, Nigeria, Ancestral Yoruba, 800–1000. Granite, height 40⅝ in. (1.24 m). National Commission for Museums and Monuments, Nigeria.

of the past, the current king, or Oni, still claims descent from the legendary founder of Ile-Ife. His coronation in 2015 was widely televised, and was featured on the Oni's website. As was true throughout Africa, most art and architecture created for Yoruba homes and for places of worship in the past was made of ephemeral materials and has not survived. The kings of Ile-Ife, however, commissioned artworks in copper alloys, terra-cotta, and stone—materials that have endured for over seven hundred years. Most of these royal art forms were once used in religious ceremonies that reinforced the supernatural powers of the king and the royal family, and protected the city-state of Ile-Ife.

***IDENA* (GATEKEEPER) FROM ILE-IFE** The oldest surviving monument in Ife is a 12-foot-tall (about 3.5 m) granite monolith, embedded with iron nails, named for one of its founding kings. Archaeologists believe that it may date from as early as 800 CE. The dates of a smaller figure (3½ feet tall) carved from granite are also uncertain, but the iron pins driven into the carved granite hair resemble the iron nails in the monolith, and this suggests that the figure and the monolith were carved during the same period of time. This stone statue has been called *Idena*, the Gatekeeper (**Fig. 25.14**), because it once stood at the entrance to one of the sacred groves of trees left within the city walls for the worship of an *orisha*, or spiritual being. Its contemplative pose, the position of its hands, and its downcast eyes all suggest that the figure is in an attitude of prayer, and the carefully carved collar and wrapped skirt show that it depicts a man of high status—possibly even an early king.

CERAMIC POT FOR LIBATIONS Throughout the city of Ife, construction projects have unearthed over one hundred antiquities of stone, copper alloy or terra-cotta that were used or reused in shrines and other sacred spaces. One ceramic vessel, dating from the thirteenth to the fourteenth century, comes from a site where sacrifices were offered (**Fig. 25.15**). It had been embedded in the pavement of a palace courtyard, and its bottom was deliberately broken. When **libations** of water or palm wine were poured into the pot, they would flow into the ground, where the bodies of the dead resided.

The pot also appears to provide directions for how to organize offerings for a shrine. **Reliefs** of various ritual instruments encircle the sides of the vessel. These include iron pendants that could have been the insignia of male and female elders charged with dispensing justice. One relief seems to represent the circular tray used today in rituals that determine whether or not individuals are fulfilling their personal destiny and honoring the character given to them by the gods (see Fig. 49.6). A snake curves around the vessel and descends over a rectangular image that seems to depict a roofed shelter. Inside the shelter is a human head flanked by two abstracted ones, suggesting that it represents a shrine to the head (in this case, the head of the Oni). The contrast between the naturalistic and abstract heads underscores the differences between what the Yoruba call the "inner head" and the "outer head." These terms describe the interplay

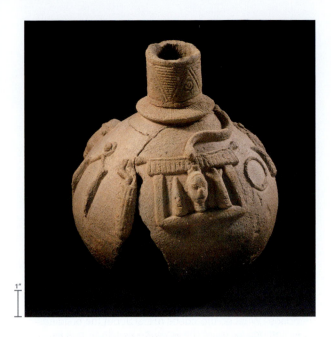

1"

between a person's appearance and his or her true character. Conical and cylindrical heads of terra-cotta have been unearthed in Ile-Ife, as have very lifelike portraits in both fired clay and copper alloy. It therefore appears that this ceramic vessel describes how both "inner" and "outer" heads were originally displayed.

COPPER ROYAL HEAD A group of over a dozen of the life-like heads of Ile-Ife were unearthed in the household of the Wunmonije family, near the palace of the Oni. Shown as neither very young nor very old, all of the heads in this

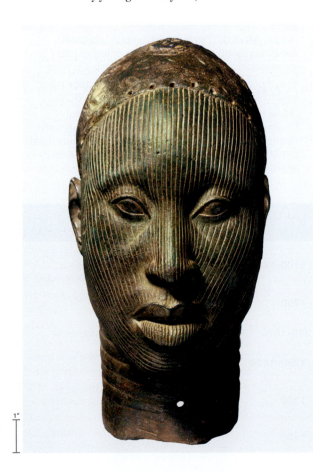

1"

group appear serene, and are life-sized. Early Yoruba met-alsmiths sculpted the heads in brass or in other copper alloys using a technique known as **lost-wax casting** (see box: Making It Real: Lost-Wax Casting Techniques for Copper Alloys, p. 62). At least four centuries earlier, the same technique had been employed to cast bronze regalia for a leader of the Igbo people at the site of Igbo-Ukwu, about 250 miles to the southeast (Figs. 2.16 and 2.17).

Analyses of fragments of the clay core left within one of these copper heads (**Fig. 25.16**) broadly date it as made between 1215 and 1575, but some scholars argue that all of the heads were made around 1300.

Perforations around the hairline have retained strands of thread that might have tied a beaded crown onto the head. Some art historians believe that these sculptures protected and displayed the crowns of the Oni and his ancestors, possibly during coronation rituals in Ile-Ife. As Yoruba crowns and other beaded items of regalia are seen as highly sacred today, they would have needed to be kept safe in the past as well, especially in times of transition.

Modern Yoruba rulers own beaded, often conical crowns with strings of beads that veil their faces, and some observers have interpreted the fine lines covering the face of this portrait (and the faces of some of the other heads in terra-cotta and copper alloy) as a type of veil. Others interpret the lines as **scarification** similar to the *ichi* marks of status worn by the Igbo, as seen in very early sculptures (see Fig. 2.19). In the case of Ile-Ife, these parallel lines might have shown that leaders belonged to specific lineages or dynasties, or they may simply be an aesthetic device used to reflect the light in a subtle, unusual way. Whatever the explanation, these idealized heads of copper or brass are not portraits of a specific royal individual. Rather, they are expressions of regal authority—an ideal vision of the intersection of the human and the divine.

BRASS FIGURE OF AN ONI The importance of beaded crowns and other royal attire can also be seen in a small brass statue (**Fig. 25.17**, p. 428), the only complete figure of an Oni found thus far in Ile-Ife. In addition to a crown, the Oni wears heavy beads that were once painted red. The figure holds a hammer-like scepter and an animal horn full of medicinal materials. The two pendants hanging over a breastplate of beads or fiber seem to reproduce the regalia worn by a tiny terra-cotta figure made much earlier in the Nok Style (see Fig. 2.15), found over 300 miles (almost 500 km) to the northwest. This small brass figure suggests that the glossy glass beads worn by the Oni of Ife today, which are color-coded to draw upon the powers of specific deities and ancestral forces, may share religious associations with the elaborate beaded regalia of Nigeria's distant past.

Two features of this cast brass statue of the Oni are striking. The first is its full stomach, an indication that the king is well fed and prosperous. The second is the disproportionately large size of the head, which Yoruba religion identifies as the location of an individual's character and the source of a person's effective power or strength (*ashe*). It shares the same unexpected proportions with

25.15 FAR LEFT **Pot for libations,** Ancestral Yoruba, 1250–1350. Fired clay, height 9¾ in. (24.7 cm). Ife, Nigeria. National Commission for Museums and Monuments, Nigeria.

lost-wax casting a method of creating metal sculpture in which a clay mold surrounds a wax model and is then fired. When the wax melts away, molten metal is poured in to fill the space.

scarification permanent marks created by incising or irritating the skin; used to enhance beauty or establish status.

25.16 FAR LEFT **Head from Wunmonije Compound,** Ife, Nigeria, Ancestral Yoruba, 1250–1350. Copper, height 12 in. (30.5 cm). National Museum of Ife, Nigeria.

a tiny bronze deposited in Igbo-Ukwu during the ninth century (see Fig. 2.16). The Yoruba and Igbo insistence on the enduring truth, rather than fleeting qualities of an individual's personal appearance, is indicated in this case by the emphasis on the head rather than on more naturalistic body proportions. In fact, this interest in the universal, rather than the particular, informs much of African art (see Chapter 49).

Analysis of the copper alloy used in some of the fourteenth-century artworks from Ile-Ife reveals that the metal was mined in Europe. Evidently the copper had been traded to North Africa and then brought across the Sahara by camel caravan, either along the trade routes controlled by the empire of Mali, or through the center of the continent through trade networks established by the empire of Kanem, before arriving in Ile-Ife. These empires, and all of the kingdoms and centralized states of Africa, would soon be forced to adapt to a radically different economic system when, after 1500, European traders began to appear on every African coast. In the sixteenth century, new kingdoms and empires would engage with a new transatlantic trade network.

25.17 Figure of an Oni, Ife, Nigeria, Ancestral Yoruba, 1250–1350. Copper alloy, height 19¼ in. (48.9 cm). National Commission for Museums and Monuments, Nigeria.

Discussion Questions

1. Compare and contrast the stone pillar from Great Zimbabwe (**Fig. 25.9**) with the portrait of the Oni from Ile-Ife. What advantages and disadvantages did the artist face when deciding whether or not to include various human features of the king in this Yoruba artwork?

2. Locate a video about the annual re-plastering of the Great Mosque at Djenne (see **Fig. 25.12**), and another on a Timkat celebration in one of the churches at Lalibala (see **Fig. 25.4**). (The National Museum of Natural History or the UNESCO website are good sources for videos.) What do the videos reveal about the buildings as settings for ritual; the ways the buildings look at different times; and how they also engage the senses of touch, smell, hearing, and taste? (Worshipers who pray in Djenne touch their foreheads to the floor, while pilgrims in Lalibala kiss the walls of the churches.)

3. Both the Great Mosque from Chinguetti and the Great Enclosure from Great Zimbabwe are made of stone, and were settings for assembly and (perhaps) worship. What other features do they have in common, either in their form or in their cultural context?

Further Reading

- Harvey, Philip Lee. *Photographing the World's Most Dangerous Church*: https://www.youtube.com/watch?v=Riz7klVidDI&t=44s (accessed October 1, 2019).

- Horton, Mark C. "The Swahili Corridor." *Scientific American* (September 1987): 86–93; online at http://www.academia.edu/1199031/The_Swahili_Corridor

- The churches of Lalibala: https://www.youtube.com/watch?v=eTlwvQfkjVc (accessed March 12, 2020).

- "Meet the 800-year-old Golden Rhinoceros that Challenged Apartheid South Africa." *The Conversation* (September 16, 2016), http://theconversation.com/meet-the-800-year-old-golden-rhinoceros-that-challenged-apartheid-south-africa-64093.

Chronology

c. 100–*c.* 900	The Empire of Aksum, Ethiopia	*c.* 1100–1400	Sculpture in copper alloy is produced at Ile-Ife, Nigeria; the Great Mosque at Chinguetti is constructed in Mauretania
c. 350	Ezana of Aksum converts to Christianity	*c.* 1200	King Lalibala commissions rock-cut churches in Ethiopia
c. 500–1500	The pilgrimage church of Abuna Yemata Guh, Ethiopia is constructed	1235–1670	The Mali Empire, Mali and Mauritania
800–1000	Stone monuments are erected at Ile-Ife	*c.* 1250–1400	Great Zimbabwe is constructed from stone blocks
836	The Great Mosque at Qayrawan, Tunisia, is completed	*c.* 1300	Construction of the Great Mosque at Djenne, Mali begins; royal portrait heads are cast at Ile-Ife
c. 1000–1200	Kingdom with capital at Mapungubwe, South Africa		
c. 1000–1505	Mosques and palaces are built at the Swahili city of Kilwa, Tanzania	*c.* 1400	*Gadl* (book of the lives of the saints) is commissioned by Emperor Dawit, Ethiopia

26

Monumental Art in South Asia and Southeast Asia

700–1400

Churning of the Sea of
Milk relief (detail), Angkor
Wat, Cambodia.

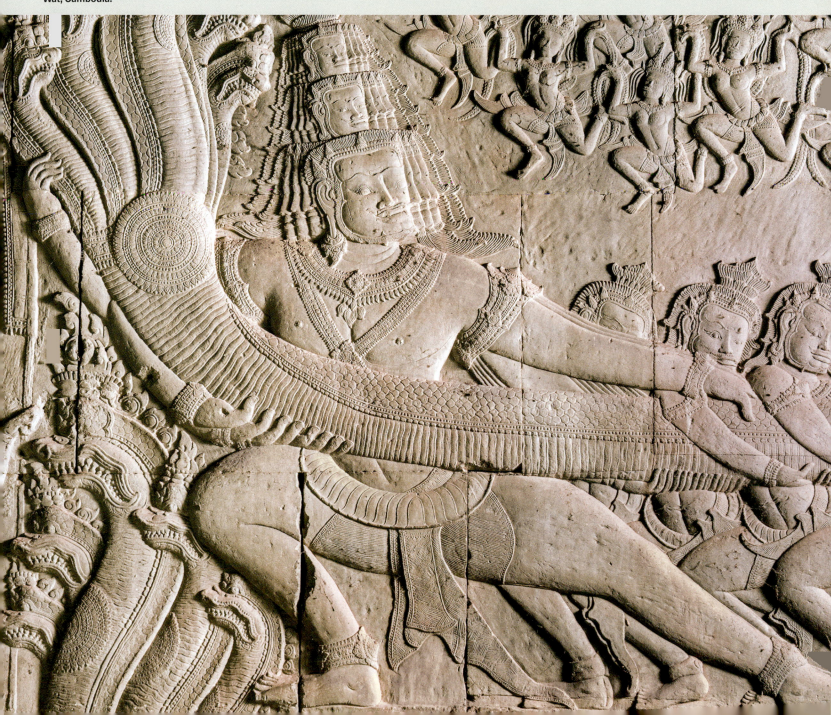

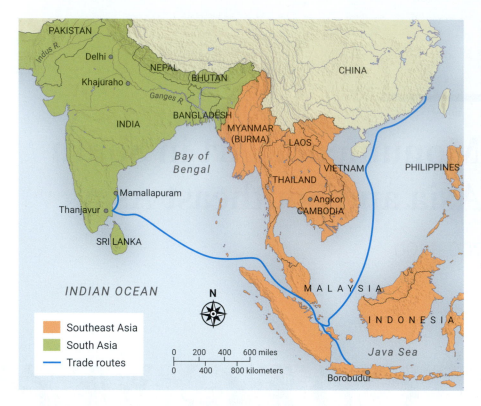

Map 26.1 South Asia and Southeast Asia, showing major trade routes and current nation states.

sites speaks to the complexity of the societies that built them, calling into question categories that people today tend to see as fixed (such as finished and unfinished) and challenging contemporary viewers to think in multiple ways beyond a single cultural context.

Monuments with Multiple Meanings: Mamallapuram and Borobudur

Throughout the seventh to ninth centuries, maritime trade routes across the Indian Ocean, South China Sea, and Java Sea—the same pathways that helped spread Buddhism and Hinduism in the fifth century (see Chapter 16)—continued to flourish, as did those faiths. The Indonesian island of Java and peninsular south India were two main nodes in this network, and the importance of maritime trade in these regions is evident at several surviving sites, including Mamallapuram (India) and Borobudur (Indonesia). These two royally sponsored sites are multivalent—that is to say, they have multiple meanings, interpretations, and appeals. The concept of multivalence is useful for understanding these monuments' interwoven layers of meaning.

GREAT RELIEF AT MAMALLAPURAM Around 630, a Hindu ruler of the Pallava dynasty (early fourth to late ninth centuries) named Narasimha, also known as Mamalla or "Great Warrior," founded a new port city on the east coast of southern India. The city was called Mamallapuram ("City of the Great Warrior") after Narasimha, who had its port expanded to accommodate ships sailing to and from locations as far away as present-day Thailand. Over the next century, but most probably concentrated during the reign of the Pallava ruler Rajasimha (c. 700–728), artists constructed a series of granite monuments featuring Hindu imagery at the site. One structure, the Shore Temple, was made from quarried stone. The rest are **rock-cut**, many carved from the same large granite outcropping near the town's center. Mamallapuram, also called Mahabalipuram, has three main types of rock-cut monuments: **monolithic** structures fashioned from sizable boulders, cave temples adorned with pillared entrances, and cliff faces carved with narrative **reliefs**.

Almost all of Mamallapuram's rock-cut monuments would today be considered unfinished. This has led some art historians to hypothesize that the site served as a workshop where sculptors learned their craft, rather than as a center for devotional practices. Others suggest that the works were not left incomplete, but that the concept of "finished" was flexible. Today we take "finished" to mean every inch completed to refinement, but perhaps in South Asia at the time, a work was considered finished once it was functional, and anything beyond that was superfluous. For example, we know that the reliefs on a Hindu temple did not need to be completely carved for it to be functional; the main **icon** only needed to be ceremonially awakened by the priests for it to be ready for devotional practice. Complicating the analysis of Mamallapuram's monuments is the fact that there was likely no clear divide

Introduction

Politically and culturally, South Asia and Southeast Asia (see Map 26.1) were diverse and constantly in flux during the period between 700 and 1400. An array of local powers held sway in the regions, although a few more expansive empires, such as the south-India-based Chola dynasty and the Cambodia-based Khmer dynasty, also left their mark. The dominant religions, languages, social structures, and artistic styles varied considerably over time and place. Among this immense variety, one overarching trend stands out: a range of rulers had imposing sacred centers constructed. These sites forged links between worshipers and gods, and they connected earthly rulers with spiritual power.

Many of the iconic works of South and Southeast Asian art date to this period, including Indonesia's Borobudur, which is the world's largest Buddhist monument, and Cambodia's Angkor Wat, which is the world's largest pre-modern Hindu temple. India's Qutb Mosque complex, the site of the world's tallest masonry minaret, was constructed during this time. Also dating to this period are the temples at Khajuraho, famous for their densely carved sculpture, and the celebrated south Indian bronze sculptures of Hindu deities.

Builders frequently designed the individual parts of their monuments to work together to convey a specific iconographic program, such as telling stories from the life of the historical Buddha or connecting the protective power of a particular Hindu deity to that of the ruling dynasty. In other cases, they left the significance ambiguous. Meanings might be layered to appeal to a broader audience, to heighten the religious experience, or to link local displays of piety and status with wider networks of identity and power. In some cases, the meaning of a specific element may have shifted over time. In other cases, later rulers and builders altered the physical form of the monument itself. The multifaceted nature of these

rock-cut carved from solid stone, where it naturally occurs.

monolithic formed of a single large block of stone.

relief raised forms that project from a flat background.

icon an image of a religious subject used for contemplation.

between sacred art and secular art at the time. Rather, the categories were fluid and overlapping.

The most prominent of Mamallapuram's rock-cut works is a massive relief, 98 feet (29.87 m) across and 49 feet (14.94 m) high. The vertical cliff on which it is carved faces the ocean and, in the eighth century, it would have been one of the first monuments people saw upon arriving at the port. The sculptors turned a natural cleft in the rock, which divides the relief roughly in half, into a representation of a river populated with *nagas*, snake divinities associated with water (**Fig. 26.1**). A deep rectangular basin sits below the relief and runs along its length. Originally, on the ledge above, a tank collected rainwater. Scholars hypothesize that the water was probably released to flow down the cleft to the basin as a spectacle on special occasions. On either side of the cleft, more than one hundred larger-than-life-sized figures of humans and animals appear to materialize out of the solid granite. Notably, the relief's lower left quarter appears unfinished.

Art historians have long debated which of two Hindu stories the relief depicts. The relief's emphasis on water, including the river carved into the rock's cleft, suggests that the story depicted is the Descent of the Ganges, in which the king Bhagiratha performs penance to ask for the gods' help bringing the river goddess, Ganga (the

Ganges River), to earth, so that his land will no longer be barren. In this interpretation, the seated figure in front of the small shrine to Vishnu immediately to the left of the cleft (**Fig. 26.1 A**) could be Bhagiratha thanking Vishnu for helping to convince Shiva to break Ganga's fall with his matted locks. Yet crucial features typically included in visual retellings of that story, such as an image of Ganga, are absent from the relief.

The alternative story of Arjuna's Penance is suggested by such details as a hunting scene in the upper left quadrant. In that tale, the king Arjuna performs penance so that the god Shiva will give him a sacred weapon with which to win back his kingdom. The scene (**Fig. 26.1 B**)

26.1 BOTTOM **Great Relief at Mamallapuram,** Mahabalipuram, India, Pallava dynasty, late seventh–early eighth century.

26.1 A–E BELOW AND MIDDLE **Details from the Great Relief at Mamallapuram.**

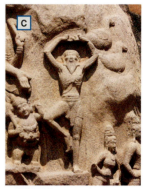

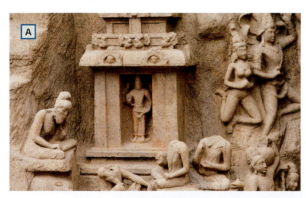

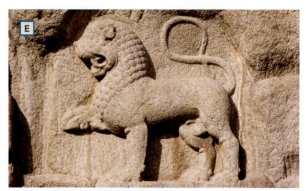

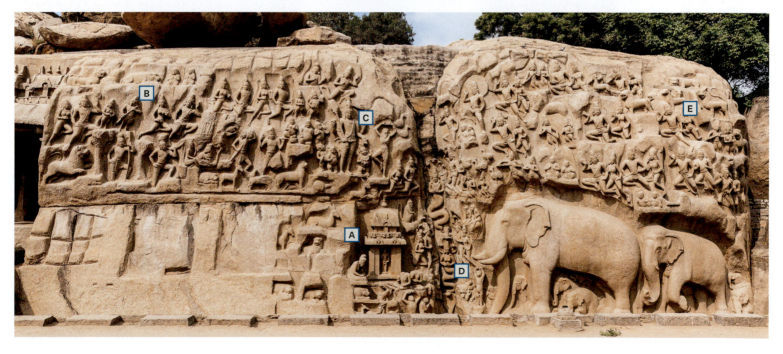

perhaps shows Shiva, disguised as a hunter, arguing with Arjuna over a boar. Typically, however, the boar in this tale is depicted dead, but here it is shown alive. The absence of crucial narrative elements makes either interpretation inconclusive. Moreover, neither story is depicted in any sort of order, either chronological or spatial.

One compelling line of scholarship has proposed that the relief is purposefully—and playfully—ambiguous in order to be multivalent. The sculptors could have made the narrative clear had they chosen to do so, but by combining aspects from both stories, they stress the shared theme of a king performing penance to help his people. For example, directly above the Vishnu shrine a man—who could be either Arjuna or Bhagiratha—stands on one leg, hands over his head, in a posture of penance (**Fig. 26.1 C**). To his right, stately Shiva holds his hand out in a wish-granting *mudra*. A dwarf with a lion face on his belly, who may be a personification of the weapon Shiva gave to Arjuna, stands between the two men. A family of elephants—the adult elephant's massive body protecting the babies—dominates the relief on the right side, furthering the theme of protection, but the elephants do not directly relate to either story. Below the largest elephant's tusk, a cat (**Fig. 26.1 D**) tricks mice into trusting it by pretending to perform penance, in a parody of the human balanced on one leg diagonally above the cat. This element adds humor as well as a warning for viewers: beware of false leaders. Other sculptural details also seem to emphasize the message of protective leadership and connect it back to the Pallava rulers. The Pallavas' royal emblem—a lion with one paw raised (**Fig 26.1 E**)—appears several times at the edge of the cliff to the right, linking the rulers to this multivalent message of royal penance and protection. These disparate elements work together in such a way that viewers must actively decipher, and thus fully engage with, the relief's message. At the same time, the visual references are diverse enough to provide not only local residents but also foreign visitors with various ways to engage with the relief.

BOROBUDUR At roughly the same time that work stopped on the rock-cut monuments at Mamallapuram in south India, the Shailendra dynasty (*c.* 750–850) was consolidating its power on the large island of Java to the southeast across the Indian Ocean. The Shailendra rulers commissioned both Hindu and Buddhist works of art, of which the best-known is the Buddhist monument of Borobudur. The monument is datable to the early ninth century, 1,200 years after the death of Siddhartha Gautama, the historical Buddha (also known as Shakyamuni), the founder of Buddhism. Measuring 387 feet (117.96 m) per side and featuring more than 1½ miles (over 2.4 km) of relief carvings, Borobudur is the largest Buddhist monument in the world and is unique among them in form. Like the Pallava monuments at Mamallapuram, the structure raises many questions, foremost among them its original function. Did its builders intend it as an elaborate *stupa*, as a three-dimensional **mandala**, as an experiential embodiment of the three realms of Buddhist existence, or as a representation of Mount Meru, the sacred mountain at the center of the universe in Buddhist and Hindu cosmology? Or is it, as most scholars currently believe, multivalent—that is, some combination of all these things and more?

Borobudur is an open-air structure (there is no interior) built on a natural hill. Constructed from slabs of volcanic stone, it is composed of a base and eight upper levels—five square terraces and three round ones—capped by a large *stupa* (**Fig. 26.2**). A central staircase on each of the four sides allows pilgrims to ascend, descend, and perform *pradakshina* around each level. From above, Borobudur takes the shape of a mandala. From the side, it resembles a stone mountain, with 432 statues of **buddhas** looking outward from niches on the balustrades. The Shailendras, whose

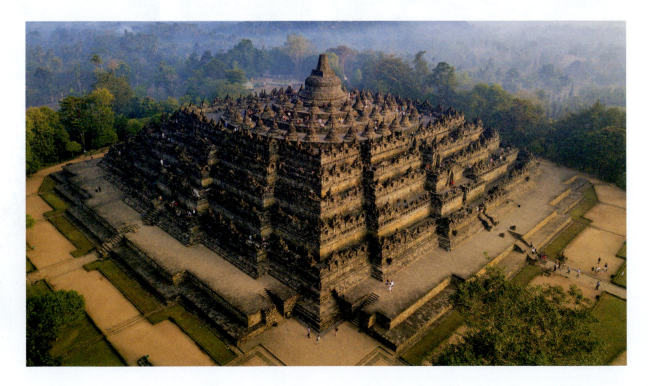

26.2 Borobudur, Java, Indonesia, Shailendra dynasty, early ninth century.

name means Lords of the Mountain, built Borobudur in south central Java between two pairs of volcanoes. Perhaps the five peaks—four natural and the one constructed at Borobudur—refer to the five peaks of Mount Meru, with the sea around Java representing the cosmic ocean surrounding the sacred mountain. If so, then the monument would equate the Shailendras' kingdom with the cosmos and align the earthly and spiritual realms.

Adding to the monument's spiritual import, numerology seems to have played a key role in Borobudur's design. Eight, representing infinity, is one of the most sacred numbers in Hindu–Buddhist belief systems, and 108 (or 1,008) is a longstanding **auspicious** number. Its significance pre-dates the founding of Buddhism and can be traced back to ancient Indian Vedic traditions. Multiples of the numbers 8 and 108 recur throughout Borobudur, sometimes in visible ways and sometimes in subtle ways or even in ways a visitor cannot readily discern, a reminder that an artwork's meaning, particularly in Southeast Asian culture, often goes beyond the visible. For example, 72 perforated *stupas* containing buddha images are arranged on the three circular terraces; adding them to the 432 buddha sculptures on the balustrades yields 504 buddha statues in total. A pilgrim who makes the journey to the central *stupa* at the top and then back down would thus walk past 1,008 buddhas.

Borobudur's design can also be interpreted as representing the three realms of Buddhist existence (**Fig. 26.3**). The base corresponds with the realm of desire (*kamadhatu*), the state that precedes the spiritual journey. It features 160 relief carvings (another multiple of 8) showing scenes illustrating the karmic laws of cause and effect, such as "speaking ill of others leads to ugliness." At some point shortly after construction, these reliefs were covered from view by a second wall (labeled in **Fig. 26.3** as the "base encasement"), perhaps for religious symbolism, but more likely for structural reasons. The five square levels in the middle parallel the realm of form (*rupadhatu*), in which one is no longer guided by desire, but the world is still shaped by form. The high walls on either side of the path around the four sides of the monument obstruct the view outward, encouraging devotees to focus on the walls' reliefs. The outer wall panels depict *jatakas* (stories of the Buddha's past lives), while the inner walls recount the life of the historical Buddha, Shakyamuni, as well as the adventures of virtuous persons as they search for spiritual awakening (**Fig. 26.4**). One narrative is depicted along the inner walls' upper **register**

26.3 Cross-sectional diagram of Borobudur.

Diagram labels: main *stupa*, empty room, perforated *stupas*, balustrades, *arupadhatu*, *rupadhatu*, base encasement, *kamadhatu*, main *stupa*, circular platforms, square platforms, hidden foot

auspicious signaling prosperity, good fortune, and a favorable future.

register a horizontal section of a work, usually a clearly defined band or line.

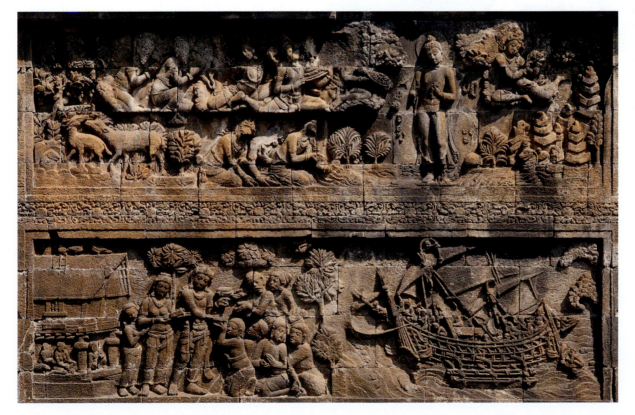

26.4 First gallery wall, Borobudur, north side, east end, Java, Indonesia, Shailendra dynasty, early 9th century.

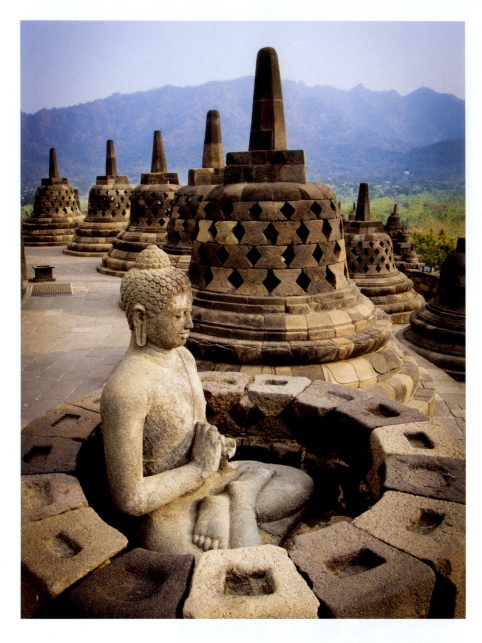

except for a small empty chamber in the middle. Whether that chamber originally held a sculpture or was empty is unclear. Regardless, the final *stupa*'s lack of a sculpture suggests that the Buddha has been released from human form.

Although Borobudur's primary concerns seem to be spiritual, aspects of the monument's reliefs also reflect life in ninth-century Java. For example, in the scene of Hiru and Bhiru arriving at Hiruka (**Fig. 26.4**), the ministers' ship is meticulously depicted with masts, outriggers, crew, and passengers. In total, eleven seagoing vessels are depicted at Borobudur, reflecting the importance of maritime trade to the Shailendra dynasty and providing a wealth of information for maritime historians. The detail and technical accuracy are such that in 2003 these images were the basis for an international team's replica of an early Javanese ship that sailed from Java across the Indian Ocean and around the Cape of Good Hope to Ghana. In many respects, Borobudur's significance to contemporary scholars in the fields of art, religion, and shipbuilding remains as multivalent as it was for its ninth-century pilgrims.

North and South Indian Hindu Temples

Like Borobudur and the Great Relief at Mamallapuram, Hindu temples also carried multivalent meanings. Hindus venerate a multitude of deities, and Hindu temples serve simultaneously as homes of the gods, symbols of Mount Meru, and places for devotees to receive *darshan*. A single temple might be adorned with dozens of sculptural forms, each an artwork on its own to be analyzed in terms of religious beliefs or political priorities. At the same time, just as the entire experience of visiting a museum, from entering the lobby to reading an informational wall label, affects how a visitor experiences an individual painting, so too the original context of the temple, from a pilgrim's ritualized movements to the height of its walls, shapes how a specific sculpture would have been seen and understood.

Hindu temples must conform to certain religious specifications and principles. (For an introduction to the basic parts of a Hindu temple, see Chapter 16, p. 282.) Ancient texts lay out the specific **iconography** of gods and goddesses, the ideal proportions of buildings, and the rules for selecting a temple site, among other requirements. At the same time, local conditions—from available materials to prevailing stylistic norms—affect designs. Within South Asia, temples had developed distinct regional styles by the eighth century. Contemporaneous texts labeled these styles Northern (Nagara), Southern (Dravida), and Mixed (Vesantara). Like all such classification structures, these categorizations are imperfect. They obscure other regional variations, and in the past, particularly during the British colonial period, they were conflated with racial classifications (Aryan and Dravidian) that are now recognized as deeply problematic. Nonetheless, the Nagara and Dravida categories, through their distinct plans and **elevations** (**Fig. 26.6**), provide a useful introduction to the visual vocabulary of Hindu temples. The Nagara

26.5 Exposed buddha statue with perforated stupas in the background, Borobudur, Java, Indonesia, Shailendra dynasty, early 9th century.

ushnisha one of the thirty-two markers of the Buddha, a buddha, or a *bodhisattva*: a protuberance from the head, usually a topknot of hair.

darshan the auspicious devotional act of seeing and being seen by a deity, holy person, or sacred object in Hinduism.

iconography images or symbols used to convey specific meanings in an artwork.

elevation typically, the external facade of a building, but can be any exterior face of a building viewed as a vertical plane.

and another is illustrated below, so that two separate stories run concurrently. In the segment illustrated in **Fig. 26.4**, the top register shows Shakyamuni (identifiable by his halo and **ushnisha**) bathing in a river and being attended to by gods. In the bottom scene, two virtuous ministers, Hiru and Bhiru, arrive by boat at the country of Hiruka and are greeted by locals. The scenes are carved in a detailed and highly animated fashion, with figures crowded together.

The complexity and denseness of the carvings on these middle levels contrast with the sense of spaciousness on the final three circular terraces, which denote the realm of formlessness (*arupadhatu*). Here, the pilgrim, with a sweeping view over the surrounding landscape, encounters the seventy-two perforated *stupas*, each containing a statue of a buddha sitting in meditation (**Fig. 26.5**). Originally, only glimpses of the buddhas were visible through the square or diamond-shaped openings. (When Borobudur was restored, several *stupas* were left uncovered so that modern visitors could admire the buddha sculptures in full.) The final, large central *stupa* is solid,

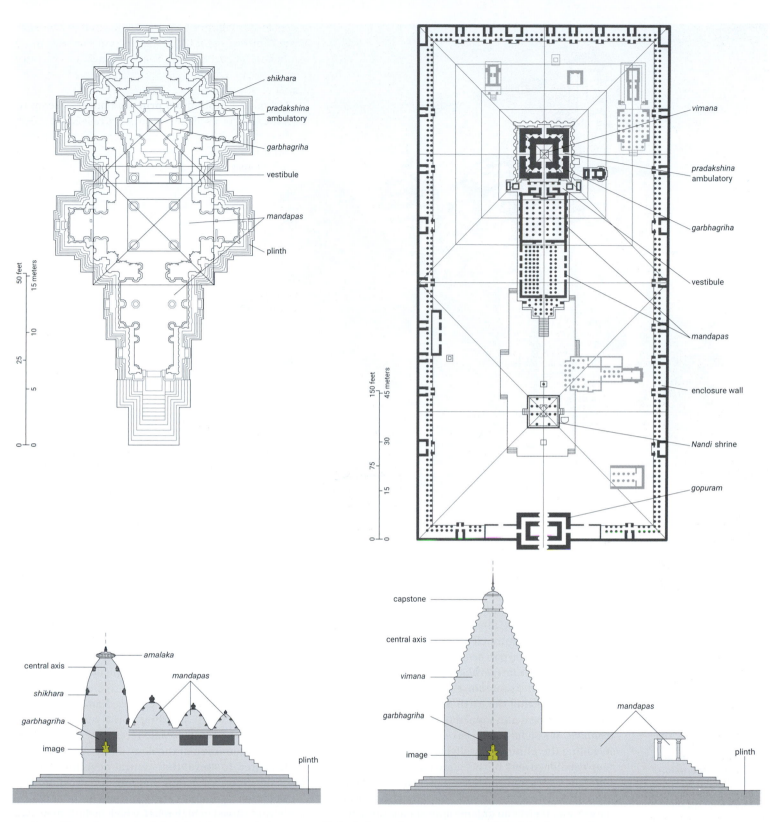

and Dravida styles reached their height around the year 1000, as exemplified by the two temples, Kandariya and Rajarajeshwara, discussed here.

KANDARIYA TEMPLE During the tenth century, the north Indian ruler Yashovarman Chandela (ruled *c.* 925–950) seized a sculpture of Vishnu from his regional overlord and founded a temple at Khajuraho to house it. With this act of defiance, Yashovarman established a home for Vishnu in his realm and created a monument that linked the god's power to the Chandela dynasty (831–1308). Over the century that followed, royal patronage of temple construction at Khajuraho flourished, with reportedly eighty-five Hindu and Jain temples constructed there. Twenty-five remain, with fragments of another twenty-five visible. The Kandariya temple, also called the Kandariya Mahadeva temple, was built by Vidyahara (ruled *c.* 1003–35) and is dedicated to the god Shiva. It is the largest temple at the site and is considered by many art historians to mark the high point of Nagara

26.6 Comparison of north and south Indian Hindu temples
TOP LEFT Plan of the Kandariya Temple, Khajuraho, north India, Chandela dynasty, *c.* 1035. BOTTOM LEFT Elevation of Kandariya Temple. TOP RIGHT Plan of Rajarajeshwara Temple, Thanjavur, south India, Chola dynasty, *c.* 1003–14. Lighter grey areas are ancillary structures, many of which are later additions to the complex. BOTTOM RIGHT Elevation of Rajarajeshwara Temple.

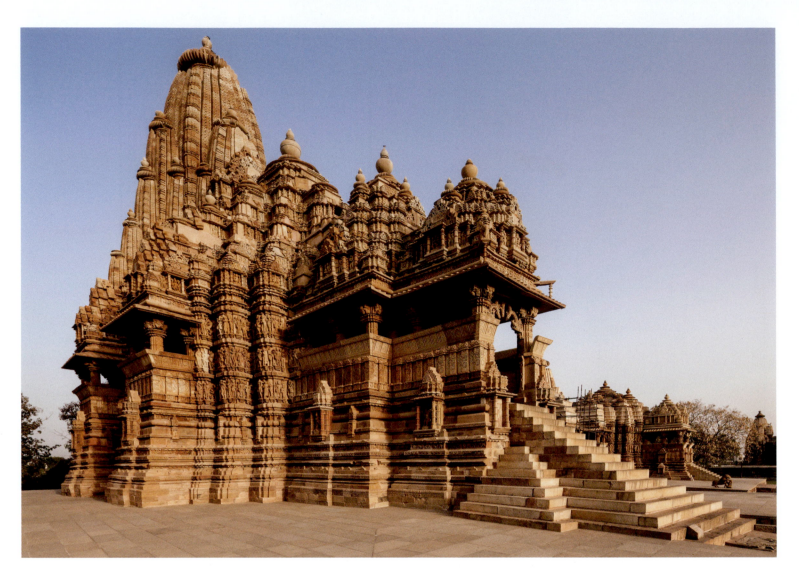

temple design. Its construction, which probably took over a decade, was completed around 1035.

Like other Nagara temples, Kandariya (**Fig. 26.7**) is a freestanding structure elevated on a high **plinth** and composed of several porches or halls (*mandapas*) leading to the inner sanctum (*garbhagriha*). The *shikhara* rises directly above the sanctum, the two together acting as an axis connecting the earth and heavens. The tower is slightly curved and topped by a fluted, fruit-shaped *amalaka*. At Kandariya, the *shikhara* (98 feet tall (29.87 m) including the plinth and walls) is composed of eighty-four smaller towers of the same curved shape but at different scales and clustered together. The repetition of shapes and patterns at various scales also appears in nature, and it gives an organic appearance and sense of verticality to the mountain-like tower. Indeed, successively higher pyramidal roofs cap the porch and halls, resembling an entire mountain range in miniature, leading up to the *shikhara*, the temple's tallest peak.

The exterior walls alternately project and recess, creating spaces for numerous sculpted images, adding to the structure's organic feel and representing the divine energy emanating from the sanctum. The walls below the roofs are composed of two main horizontal zones. A high base decorated with rows of moldings reaches 13 feet (3.96 m) above the plinth. The section above this base, pierced by projecting balconies, features three horizontal bands of sculpted figures. A devotee visiting the temple at some point would circumambulate the exterior to take in these sculptures. Ascending the stairs he or she would move through the porches to circumambulate in the interior through the enclosed **ambulatory** (**Fig. 26.6,** top left). When standing at the vestibule to the *garbhagriha*, the devotee would receive *darshan* from the main representation of the deity. At Kandariya, which is dedicated to Shiva, that central devotional image is a *linga*, Shiva's **aniconic** and most powerful form.

Khajuraho's temples are renowned for their figural sculptures carved in **high relief**, which include images of deities, celestial maidens, *mithunas*, and erotic groups. At Kandariya, there are approximately 650 figures in total, each about half life-size. On the sculptural bands adorning the undulating walls, front-facing gods mark the outwardmost projections and are flanked by celestial women, many in complicated twisting postures (at the left and right edges of **Fig. 26.8**). The female celestial figures, with their sheer clothing, curvaceous forms, elongated eyes, and arched eyebrows, highlight the sculptors' skills as well as the importance of beauty in

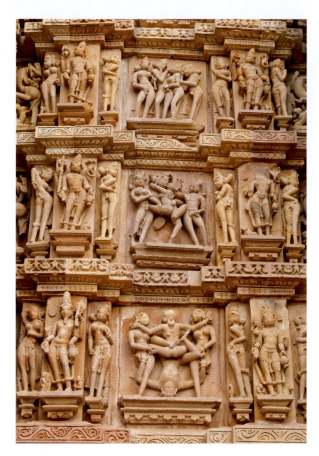

26.8 FAR LEFT **Figural sculpture from exterior wall, Kandariya Temple,** Khajuraho, India, Chandela dynasty, *c.* 1035.

Khajuraho's erotic scenes differ depending on their placement on the temples. For example, a **frieze** on one temple's plinth depicts a scene of bestiality between two men and a horse. That scene almost certainly had a quite different meaning from that of the elegant loving couples on the upper part of the temples. Most likely, no single explanation can account for all of the sexually suggestive imagery, nor would all worshipers have interpreted it in the same way. The multivalence of the imagery was probably intentional, with the ambiguity and layers of meaning heightening the worshipers' experiences. In addition, the aesthetic and religious experiences provided by Khajuraho's temples reflected the status of their royal patrons. Complex religious monuments served not only to reinforce the Chandela kings' piety and close links to the gods but also to establish the rulers as connoisseurs who appreciated the intricacies of the visual arts and Sanskrit literature as embodied in the temple's design.

RAJARAJESHWARA TEMPLE During the same period that the Chandela capital of Khajuraho was flourishing in north India, the long-lasting Chola dynasty (848–1279), ruling from the Tamil Nadu region of south India, was reaching its height. As soon as he took the throne, the king Rajaraja Chola I (ruled 985–1014) began expanding his empire, conquering more of south India as well as the island of Sri Lanka and the Maldives islands, and sending a diplomatic mission to Java. In 1003–4, the same year he took the title Rajaraja ("King of Kings") in honor of his military victories, he initiated construction of the Rajarajeshwara Temple (**Fig. 26.9**, p. 438). Dedicated to Shiva, the temple is located in Rajaraja's capital, Thanjavur. At 100 feet (30.48 m) per side and 216 feet (65.84 m) high, the Rajarajeshwara Temple, also called the Brihadeshvara Temple, was nearly five times bigger than any previous south Indian temple. It was the tallest structure of its day in India and provided visible proof of Rajaraja's power.

The Rajarajeshwara Temple exemplifies Dravida temple design. Like other south Indian Hindu temples but unlike north Indian temples, Rajaraja's temple is enclosed in a large walled compound. Originally surrounded by a 45-foot-wide (13.72 m) moat, the complex has an east-facing gateway topped by *gopuram*. Precisely laid out, its courtyard is twice as long as it is wide. If the courtyard is divided into two equal squares, the pavilion housing Shiva's sacred mount, the bull Nandi, is located in the middle of the front square, and the temple's *garbhagriha* marks the center of the other (see **Fig. 26.6**).

While Nagara temples appear organic, with undulating walls covered in sculpture and with gently curving, vertically oriented towers, Dravida temples emphasize geometry, with flat walls and a tower (called a *vimana* in south India, rather than a *shikhara*, as in north India) composed of clearly delineated horizontal tiers. Dravida *mandapas* tend to be long, pillared rooms capped with flat roofs, and the exterior figural sculptures are primarily of deities (without the *mithunas* and erotic imagery found on north Indian temples). Furthermore, each exterior sculpture is housed in its own niche, rather than being

the culture. In ancient and medieval South Asia, female beauty was defined by large, lotus-petal-shaped eyes, graceful limbs, a slim waist, and full hips and breasts. Beautiful women were seen as auspicious and thus central to successful art and architecture (see also Fig. 16.4). As one ninth-century text explains, "As a house without a wife, as a frolic without a woman, so without a figure of a woman the monument will be of inferior quality and bear no fruit." The text then describes sixteen different types of women that should be represented on a monument, from a mother with her child to a woman looking into a mirror. The latter seems to have been a favorite of Khajuraho's stone carvers.

Even though they account for only a small fraction of the total sculptures, Khajuraho's erotic scenes (center of **Fig. 26.8**) have received abundant attention. Various theories attempt to explain them: they may relate to esoteric religious practices; they may represent the intense desire of a devotee's love for the divine; or they may be an architectural pun showing the builders' knowledge of Sanskrit texts that describe how temple joins should come together as beautifully as a man and woman on their wedding night. (Sanskrit is the ancient Indian language in which many important Hindu texts were written.) The strong link between fertility, sexuality, and auspiciousness means that similar, but less explicit, imagery appears on many Indian monuments and was an accepted and valued part of visual culture during this period in South Asian history. In fact, according to ancient Indian aesthetic theory, love—including eroticism—ranks first among the nine aesthetic emotions (*rasas*) that the arts should evoke.

linga abstract representation of the Hindu god Shiva that denotes his divine generative energy.

aniconic the indirect visual representation of divine beings through symbols or abstract images.

high relief raised forms that project far from a flat background.

mithuna amorous couple, representing fertility and considered auspicious.

frieze any sculpture or painting in a long, horizontal format.

gopura (plural *gopuram*) a monumental tower at the entrance of a Hindu temple complex, especially in south India.

vimana the tower above the inner sanctum of a Hindu temple in south India.

26.9 Rajarajeshwara Temple, Thanjavur, India, Chola dynasty, c. 1003/4–1014.

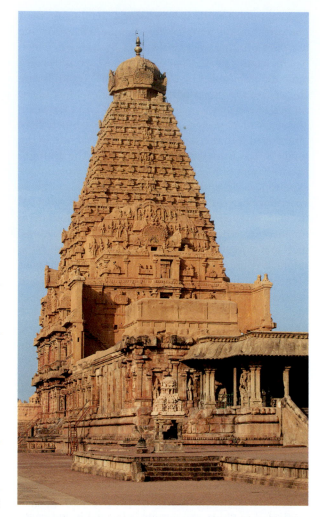

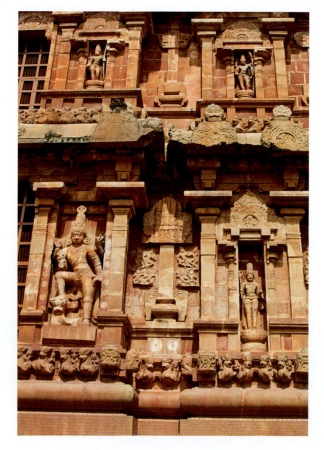

26.10 Exterior wall, Rajarajeshwara Temple, showing the Hindu god Shiva in the lower right niche and Shiva as Tripurantaka in the two niches above. A large door guardian is visible on the left. Thanjavur, India, Chola dynasty, c. 1003/4–1014.

part of a larger assemblage of figures. At Thanjavur, the plinth is 15 feet (4.57 m) high and the walls rise up another 45 feet (13.72 m), punctuated by over-life-sized images of Shiva in his various manifestations.

The temple has an enclosed ambulatory for circum-ambulation around its sanctum. This inner pathway is divided into **bays** adorned with **fresco** painting. Its *garbhagriha* is just 24 square feet. No matter how grand the structure, Hindu sanctums traditionally are not designed to accommodate congregations of people; rather, their sole purpose is to hold the main image of the god. The monolithic *linga* housed in Rajarajeshwara's *garbhagriha* is 12 feet (3.66 m) high, so tall that priests stand on a second-story **gallery** to anoint it ceremonially with milk and other sacred substances in preparation for *darshan*.

Every aspect of the temple, beginning with its impressive size, was designed to fuse Rajaraja's power with Shiva's. A large outer walled enclosure originally held both Rajaraja's palace compound and Shiva's temple compound, thus equating the king's home with the god's. The temple itself was constructed of granite that was quarried and transported from more than 30 miles (nearly 50 km) away and then lifted into place. The large slabs making up the *vimana*'s **capstone**, which together weigh approximately 80 tons (around 72,000 kg), had to be raised over 200 feet (over 60 m). It is probable that this feat was accomplished through the use of mud ramps and elephants, the latter also a vital component of the king's armies. While the first level of sculptural niches on the exterior walls contains a variety of forms of the god (bottom right of **Fig. 26.10**), those on the upper level repeatedly portray Shiva as Tripurantaka ("Destroyer of Three Cities"), making a connection to Rajaraja's military prowess (top of **Fig. 26.10**).

The temple's importance went beyond religion and politics. It was also an economic and cultural institution with more than 800 employees, including dancing girls, musicians, priests, watchmen, accountants, astrologers, and jewel appraisers. Rajaraja required all villages, including those in newly conquered Sri Lanka, to give a percentage of their income to support the temple. In addition, he and his nobles gifted land grants, war booty, and gold and jewels to the temple, which was the city's main banking institution, granting loans at a 12.5 percent interest rate. We know these details because, like most Chola temples, its walls bear lengthy inscriptions detailing administrative and financial procedures. Indeed, the records are so specific that they provide the name and address of each temple dancer.

Rajarajeshwara's inscriptions also record the gifting of sixty metal images to the temple, twenty-two donated by Rajaraja himself, and the rest by his family and nobles. Most were bronze icons of Hindu deities. The use of such images at south Indian temples began during the late Pallava dynasty, but bronze statuary did not become a major art form until the Chola dynasty (848–1279). Under the patronage of Chola rulers, particularly Queen Sembiyan Mahadevi (c. 941–1001), artists produced magnificently detailed 2- to 3-foot-high (around 60 to 90 cm) bronze sculptures using the **lost-wax casting** technique. Intended as mobile forms of deities, these sculptures

were ceremonially bathed, anointed with sacred substances, richly clothed, and adorned with jewelry and garlands before being viewed. While the main image in the temple's inner sanctum is large and immobile, these smaller bronze images could be carried on palanquins (an enclosed litter carried on poles) or pulled in wooden chariots. Accompanied by a retinue of people, they were processed around the city during festivals and moved to different parts of the temple complex for ceremonies. Their popularity grew alongside changes to south Indian temple compounds, the scope of which increased from the Chola period onward. Eventually reaching the size of small towns, complexes might include multiple smaller shrines, halls, and water tanks in addition to the main temple.

SHIVA NATARAJA The most iconic Chola bronze form is that of Shiva Nataraja, or Shiva as the Lord of Dance. In his manifestation as Nataraja, Shiva simultaneously creates and destroys the universe, embodying the union of opposites represented by the four-armed god. After this visual form of the god Shiva developed during the tenth century, it became—and remains—an extraordinarily popular way to depict him. This example (**Fig. 26.11**) dates to the eleventh or twelfth century and is typical of Shiva Nataraja bronzes from the Chola period. In it, Shiva's outer left hand holds the fire of destruction, while his outer right hand holds the drum of creation. With his other two hands he makes the fear-not *mudra* (see Fig. 16.7) and points to his upraised foot, under which the worshiper may seek refuge. While he dances, he tramples on a demon who embodies the ignorance that stops one from gaining liberation. Shiva's matted locks splay out, showing his movement, but his face remains calm, representing his tranquility. The circle of flames around him indicates the boundaries of the cosmos and also symbolizes *samsara*, the cycle of birth, death, and reincarnation.

The sculpture is balanced visually as well as spiritually: the circle of flames provides a stabilizing frame for Shiva's dynamic, open form. Yet, as harmoniously as its meaning and form seem to come together, scholars cannot prove that the current understanding of the iconography dates back further than the thirteenth century. The sculptural form may have had a different religious meaning when it was first developed. However, once the accepted iconography fell into place, it clearly stuck. Chola bronzes remind us that just as religion shapes art, art also shapes religion.

Angkor Wat and Khmer Art

People tend to associate monumental Hindu temple construction with India, but in fact the largest pre-modern Hindu temple complex is located in Cambodia. Angkor Wat ("City Temple"), as it is known today, was built for the Khmer dynasty ruler Suryavarman II (ruled *c.* 1113–1145/50). The complex covers 494 acres, an area four times more extensive than Vatican City in Rome.

Angkor Wat (**Fig. 26.12**, p. 440) is located in Angkor, which served as the capital of the Khmer Empire for nearly six hundred years. In the 790s, the Khmer king

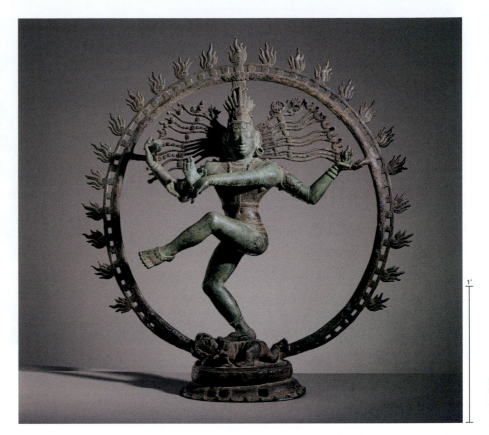

Jayavarman II (ruled *c.* 802–850) united the mainland Southeast Asian kingdoms of Funan and Chenla under his control. Then in 802, he proclaimed himself a universal ruler (*chakravartin*) and god-king (*deva-raja*), an act commonly seen as marking the official start of the Khmer Empire (*c.* 802–1431). At some point in the ninth century, the region of Angkor, north of the freshwater lake, Tonle Sap, became the empire's capital. Over the next few centuries, Angkor developed into one of the largest pre-industrial cities in history, with up to 750,000 residents, a plethora of temples, and an elaborate water-reservoir system that aided rice production. Khmer rulers derived power from their status as *deva-rajas*. As such, each adopted a title that fused his name with that of a deity: Shiva, Vishnu, or a specific Buddhist **bodhisattva**. Each king then commissioned a temple in or around Angkor to that same deity. The temple would often contain an image that served as both a representation of the deity and the king's portrait.

ANGKOR WAT During the twelfth century, when Suryavarman II reigned, the Khmer Empire was at its height, ruling over much of what is now Cambodia, Thailand, Vietnam, and Laos. Artistic expression was also at its zenith, as demonstrated by Angkor Wat. Dedicated to the Hindu god Vishnu, protector of the established order, Angkor Wat is not only the largest Khmer temple but also considered by many art historians to be the finest in design and execution.

Yet the full scope of the temple's functions remains somewhat unclear. Was it also intended as Suryavarman's funerary memorial? Was it used as an administrative capital? Although we do not know all the temple's

26.11 Shiva Nataraja, south India, Chola period, eleventh–twelfth century. Bronze, height 32⅜ in. (82.3 cm). Museum Rietberg, Zurich.

bodhisattva in early Buddhism and Theravada Buddhism, a being with the potential to become a buddha; in Mahayana Buddhism, an enlightened being who vows to remain in this world in order to aid all sentient beings toward enlightenment.

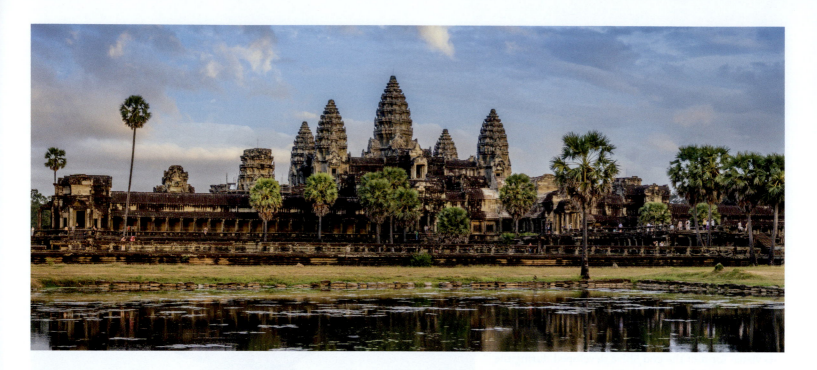

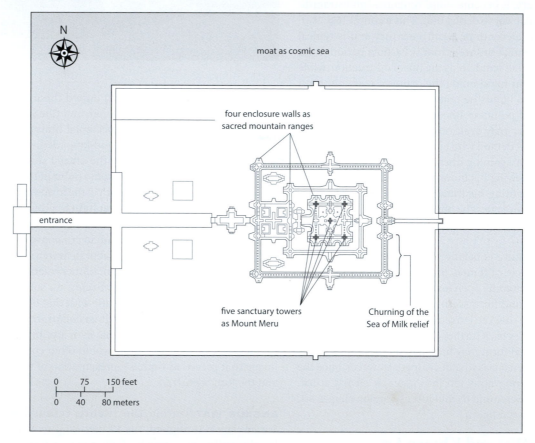

26.12 ABOVE **Angkor Wat,** Angkor, Cambodia, Khmer dynasty, *c.* 1113–45 or later.

26.13 RIGHT **Angkor Wat (plan drawing),** showing the enclosures and five symbolic towers.

N

moat as cosmic sea

four enclosure walls as sacred mountain ranges

entrance

five sanctuary towers as Mount Meru

Churning of the Sea of Milk relief

0 75 150 feet
0 40 80 meters

functions, we do know that, like South Asian Hindu temples and Borobudur in Java, it worked as a microcosm of the Hindu–Buddhist universe, giving physical form to the temple-mountain concept. At Angkor Wat, the visual references to the cosmic Mount Meru are explicit: the temple's central sanctuary is marked by five towers, corresponding with Meru's five peaks, and the complex is enclosed by a three-mile-long (4.8 km) moat or reservoir that represents the cosmic ocean

(**Fig. 26.13**). Visitors today (and presumably in the past as well) first cross the moat by a wide stone causeway edged with balustrades that take the shape of *nagas*. A high wall surrounds the outer edge of the complex, so visitors cannot see the temple until they have passed through the gateway. The causeway with *naga* balustrades continues, spanning a large area that would have been the site of a variety of buildings, but today is mostly empty. Finally, visitors arrive at a monumental entrance guarded by stone

lions. The temple itself comprises three concentric rectangular enclosures, intended for circumambulation, with each enclosure becoming narrower and more elevated as visitors approach the center. The staircases leading up to the final enclosure are at a steeply pitched 70-degree angle, making visitors feel as if they have climbed a mountain of carved stone to reach the inner sanctum. Topped by a tower that is 213 feet (64.92 m) high, the inner sanctum originally housed a statue of Vishnu.

CHURNING OF THE SEA OF MILK RELIEF The long galleries of the third enclosure feature four-and-a-half square miles (about 11.5 square km) of relief carvings depicting Suryavarman II and his armies, as well as scenes from various Hindu epics. The best-known relief illustrates the Churning of the Sea of Milk, a creation myth that thematizes the triumph of good over evil. In the story, the gods (*devas*) convince the antigods (*asuras*) to work with them to obtain the elixir of life, even though both sides know that the release of this immortality potion will cause war. To obtain the elixir, the gods and antigods must churn the cosmic ocean. The churning is accomplished through a sort of tug-of-war that is depicted in the relief by a row of repeating figures, with the gods on the right and antigods on the left (**Fig. 26.14**). The five-headed *naga* king agrees to act as the rope, and Mount Mandara (another mythical mountain) is the churn. Vishnu is depicted twice at the center: as his tortoise incarnation Kurma below, and again in his four-armed human form in front of the mountain, with his back toward the viewer. Directly above is Indra, the king of gods, who gathers the elixir and thereby saves the world by preventing the antigods from obtaining it.

The Khmer adapted this commonly depicted Hindu story by incorporating figures from another Hindu epic, the *Ramayana*. For example, the left-most antigod, positioned at the head of the snake, is depicted as the multiheaded *Ramayana* antagonist, Ravana (see p. 429). The relief, favoring shallow carving and linear detail, exemplifies Khmer artistic style. It spans 160 feet (48.77 m) along a narrow corridor, preventing the viewer from seeing the whole composition at once. The sculptors cleverly divided the relief compositionally into three horizontal levels to provide visual coherence. The bottom level depicts the chaotic churning of the ocean, the middle level shows the balanced struggle between good and evil, and the top level features *apsaras* (joyous celestial maidens), representing the creation of life.

Because a Khmer king was responsible for ensuring harmony between the earthly and spiritual realms, every aspect of the temple's design—from its narrative reliefs to its measurements—was carefully calibrated to ensure its cosmological alignment. Angkor Wat faces west, like the Vishnu temple at Deogarh (see Fig. 16.12). On the spring and autumnal equinoxes, the sun rises directly over the central tower. The twelve staircases of the first enclosure represent the twelve months of a solar year, and some scholars believe that the lengths of the main causeway's various sections correspond with the four ages (*yugas*) in Hindu cosmology. One study of the monument has proposed that the Churning of the Sea of Milk relief acted as a calendar of sorts, with the center representing the equinoxes and each end the summer and winter solstice. Like the other art of this period, the monument lends itself to multivalent readings.

Early Islamic Architecture in South Asia: The Qutb Complex

Unlike Hinduism and Buddhism, which began in South Asia and spread from there, Islam was an import to the

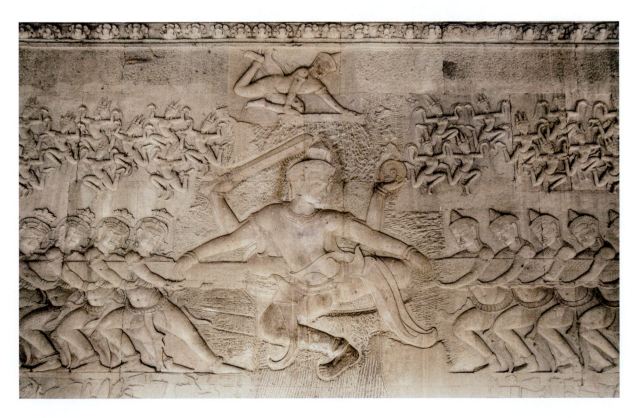

26.14 Churning of the Sea of Milk (detail showing Indra and Vishnu), Angkor Wat, Angkor, Cambodia, Khmer dynasty, *c.* 1113–45 or later. Stone relief.

Traditionally, art history has focused on the major works of painting, sculpture and architecture that were considered the heights of cultural achievement. Because grand monuments required considerable resources to construct, they were typically the purview of the ruling classes, and for that reason they capture only a thin sliver of a period's visual culture. In recent years, art historians have begun looking at a wider range of material culture (the materials, objects, and technologies that accompany everyday life), asking what it might reveal about the lives of ordinary people and the broader visual context in which they experienced these monuments. However, conducting this analysis can be difficult for early time periods because much of the original context has disappeared. A case in point: In Cambodia, thick jungles, a monsoon climate, and a recent period of war and genocide have all had detrimental effects on the surviving heritage and made archaeological excavation difficult (and, because of landmines, dangerous).

On surviving monuments, occasional details capture aspects of everyday life from the period of their construction. Examples can be found amongst the reliefs at the Bayon, a Buddhist temple built at the Khmer capital of Angkor about fifty to one hundred years after the construction of Angkor Wat. One segment depicts a lively community of people preparing food outdoors, beneath a lace-like canopy of trees (**Fig. 26.15**). Other details show women tending to children, wrestlers engaging in competition, and other activities.

Recent technological developments provide exciting new ways to learn more about Khmer material culture. For example, several Angkor-based organizations have started using a remote sensing method called LiDAR (light detection and ranging). From the air, helicopters equipped with sensors scan an area. LiDAR, which works like radar but uses laser light instead of radio waves, cuts through the dense vegetation to reveal underlying ground patterns, including ancient roads and structural foundations. The resulting picture helps pinpoint potentially productive areas for archaeologists to dig. It also provides a plan of what Angkor originally looked like beyond the surviving stone temples. Specifically, the LiDAR imagery shows gridded

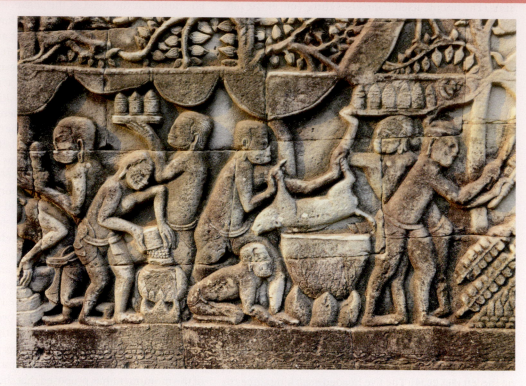

settlements outfitted with artificial ponds in the rectangular areas between the temples and their surrounding moats (**Fig. 26.16**). A network of roadways and settlements connected the expansive areas between temple complexes, confirming Angkor as the largest low-density urban center of its age, covering 1,100 square miles (2,849 square km).

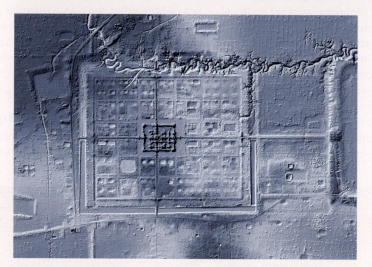

26.15 ABOVE **People cooking and other scenes of daily life, Bayon Temple,** Angkor Thom, Cambodia, Khmer dynasty, late twelfth–early thirteenth century. Stone relief.

26.16 LEFT **Aerial LiDAR image showing the outlines of gridded settlements around Beng Mealea,** temple at Angkor, Cambodia, twelfth century.

Discussion Question

1. In what ways does considering the larger urban environment of Angkor affect how you understand an individual monument such as Angkor Wat?

region. The earliest Muslims in South Asia were traders along the coasts of southeast India and Sri Lanka, as well as Arabs from the Umayyad Caliphate (see Chapter 24) who conquered Sindh, a region along the Indus River (today part of Pakistan). However, Islamic art and architecture did not significantly affect Indian visual culture until the late twelfth century, when a substantial Muslim state was firmly established in the Indian subcontinent. In the early 1190s, the armies of the Ghurid dynasty (from a region that is today part of Afghanistan), under the command of the general Qutb al-Din Aybak, defeated a local Hindu king and seized Delhi. In 1206, after the death of the Ghurid ruler, Aybak declared his independence and made Delhi his capital. His successor, Iltutmish (ruled

1211–1236), was proclaimed sultan (king) by the Abbasid caliph in Baghdad. For the next three hundred years the Sultanate of Delhi, under the rule of five different Muslim dynasties, controlled north India and sometimes much of south India as well. The sultans of Delhi, most of them Persian-speaking Central Asian Turks, were keen patrons of the arts, sponsoring poets and painters and overseeing the transformation of Delhi from a regional center into an imperial metropolis. They built fortifications, palaces, water reservoirs, and numerous religious structures, but the heart of their capital from the start was the Qutb Mosque complex.

QUTB MOSQUE The Qutb Mosque complex (also called Quwwat al-Islam, "Might of Islam," although this is not the structure's original name) in Delhi is an **architectural palimpsest**, with three main phases to its development (**Fig. 26.17**). These phases provide insights into the beginnings of South Asian Islamic architecture. The Qutb Mosque's builders creatively combined visual traditions to construct something both familiar and innovative. While still a Ghurid general, Aybak initiated construction of this **congregational mosque**. Inscriptions on the mosque give the date of 1191–2, but more likely it was begun about 1193. In Islamic tradition, having a leader's name recited at Friday prayer legitimized the political power, and so building a mosque in a newly conquered area was a priority. Construction typically began in the first months of rule, and the structure needed to be large enough to accommodate the community's entire Muslim male population (women generally did not attend public prayer). Aybak's mosque adapts a rectangular **hypostyle hall** plan (1st phase in **Fig. 26.17**): Here,

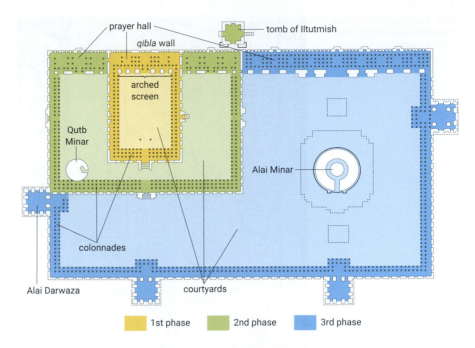

26.17 **Qutb Mosque complex (plan drawing),** showing its three main phases of construction. Sultanate of Delhi, India, c. 1192–1311.

an open-air courtyard is surrounded on three sides by covered **colonnades**, while the fourth side—the *qibla* **wall**—originally held the pillared prayer hall. The hall no longer survives; the complex is partially in ruins today. As is typical in many warm climates, the courtyard took up the majority of the 214 × 149-foot plan (65.23 × 45.42 m), with only a small pillared hall.

Notably, the structure makes use of **spolia**, primarily columns, repurposed from twenty-seven Hindu and Jain temples, stacked two high to achieve the necessary height for the roofs of the colonnades (**Fig. 26.18**). The spolia's

architectural palimpsest a structure that has been changed over time and shows evidence of that change.

congregational mosque also called a Friday mosque, or *jama masjid* in Arabic, it is the main mosque in a city or town and the location of Friday prayers, when the entire community comes together.

hypostyle hall a large room with rows of columns or pillars supporting the roof.

colonnade a long series of columns at regular intervals that supports a roof or other structure.

qibla **wall** the wall in a mosque that indicates the direction toward which Muslims face to pray, usually indicated by the presence of a *mihrab*.

spolia building materials or reliefs salvaged from other works and reused in a different structure.

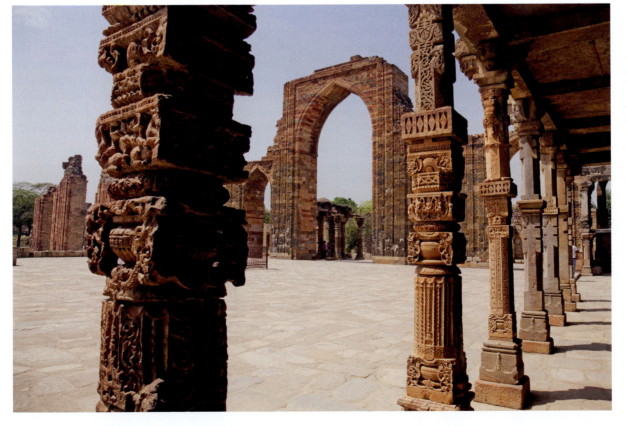

26.18 **Qutb Mosque complex,** view from the side of the prayer hall toward the *qibla* wall and five-arched screen, Sultanate of Delhi, India, c. 1192–1198.

26.19 Arched screen in front of the *qibla* wall (detail), Qutb Mosque complex, Sultanate of Delhi, India. Screen constructed 1198.

to display the Vishnu statue he had seized. The way in which the spolia was modified in the Qutb Mosque suggests an appreciation for the Indian stone-carvers' skills. Anthropomorphic imagery, central to Hindu art, was not acceptable in a Muslim religious context, so any human or animal form had to be disfigured or disguised in some way. In many of the Qutb's Mosque's pillars, the nose or eyes of a figure were carefully removed, leaving the rest of the carving intact.

In 1198 Aybak had a sandstone screen (a partition wall) pierced by five monumental arches built in front of the mosque's prayer chamber (**Fig. 26.19**; see also **Fig. 26.18**). The arched screen reveals the interaction between patron and artisans as they worked out the transfer of traditions. For example, the local craftspeople, following their training, built the arches using **corbels** rather than a **keystone**, the typical method in Islamic architecture. Visually, however, the arches resemble the typical Islamic pointed arches found in Aybak's Central Asian homeland. Indeed, the screen was probably intended to make the building look more like contemporaneous mosques from Central Asia, which often featured grand arched openings (see Fig. 33.2). Likewise, inscriptions on earlier Ghurid dynasty architecture feature distinctive undulating vines behind the Arabic **calligraphy**. The Indian artisans emulated that tradition on the Qutb screen, but they turned the vine into a (locally prized) lotus creeper and endowed the carving with organic exuberance.

QUTB MINAR In 1199, Aybak began construction on a **minaret** called the Qutb Minar. Its base alternates round and wedge shapes, a plan found on earlier minarets in the Afghan region that was the Ghurid's homeland. Aybak's successor Iltutmish initiated another round of construction to the Qutb Minar. He added three stories separated by balconies (on the left in **Fig. 26.20**), making the Qutb Minar the tallest minaret of its age and a symbol of Delhi's status as a center of Islamic authority. It remains the tallest masonry minaret in the world. Iltutmish expanded the complex in other ways as well. He had his tomb constructed at the site, and doubled the mosque's size by building courtyards and colonnades on three sides and extending the *qibla* screen (second phase in **Fig. 26.17**).

significance is a debated issue: Was it used for expediency, to embody the Ghurids' military conquest, out of appreciation for local artistic practices, or other reasons? Reused materials were often employed in early mosques for pragmatic reasons; here, however, with inscriptions noting exactly how many temples were plundered for materials, the spolia also appear to be a victory statement. During this period, South Asian rulers from a variety of religious traditions often deliberately made use of spolia and seized statues to display power; as we saw, the Hindu Chandela ruler Yashovarman built a temple at Khajuraho

corbel a wood, stone, or brick wall projection, such as a bracket, that supports a structure above it.

keystone a central stone, wider at the top than the bottom, placed at the summit of an arch to transfer the weight downward.

calligraphy the art of expressive, decorative, or carefully descriptive hand lettering or handwriting.

minaret a tower at a mosque; can be used to give the call to prayer and also functions as a visible marker of the mosque on the skyline.

Chronology

Early 4th–late 9th centuries	The Pallava dynasty rules in south India		**848–1279**	The Chola dynasty rules in south India
late seventh–early eighth century	Rock-cut monuments are constructed at Mamallapuram		**10th–11th centuries**	Bronze images of Hindu deities become popular under Chola royal patronage
c. 750–850	The Shailendra dynasty rules in Java		**c. 930–1035**	Hindu and Jain temples are constructed at Khajuraho, north India
c. 802–1431	The Khmer dynasty rules greater Cambodia from Angkor		**c. 1003/4–10**	Rajarajeshwara Temple is constructed in Thanjuvar, south India
ninth century	Borobudur is constructed in Java		**c. 1113–45 or later**	Angkor Wat is constructed in Cambodia
			c. 1192–1311	The Qutb Mosque complex is constructed in Delhi, India
831–1308	The Chandela dynasty rules in north India		**1206–1555**	The Delhi Sultanate rules north India

Completed by 1229, these additions featured decoration that was more geometric than organic, emphasizing Persian rather than Indic forms. While this work was ongoing, Delhi's Muslim population was rapidly increasing as a result of repeated Mongol incursions across much of Eurasia (see Chapter 33). These new groups of war-fleeing émigrés most likely included artisans who helped to shape Delhi's visual environment.

ALAI DARWAZA In 1303, after a key victory against the Mongols, the sultan 'Ala' al-Din Khalji (ruled 1296–1316) attempted to double the mosque's size again (third phase in **Fig. 26.17**). Not all of his additions were completed or survived. For example, he ordered the construction of the Alai Minar, intended to eclipse the Qutb Minar, with a base twice the size. Its final height would have reached 475 feet (144.78 m), equivalent to a modern 40-story building, but the minaret only made it to 80 feet (24.38 m) before construction was abandoned. Of the surviving elements, most notable is the Alai Darwaza, a ceremonial gateway near the Qutb Minar (**Fig. 26.20**; right), completed in 1311. A square, domed structure, it shows the final stage of development at the site. Its four arched entrances make use of keystones, by this point part of India's architectural vocabulary. Featuring **architectural polychromy**, the red sandstone is creatively offset with white marble trim, an innovation adopted by the later Mughal dynasty (see Chapter 51). The structure features copious calligraphy, and its carved decoration, including controlled, delicate lotus-bud friezes and intricate *jali* screens, highlights geometric repetition and symmetry, demonstrating the synthesis of artistic cultures.

The Qutb Mosque exemplifies the complexity of the monuments of South and Southeast Asia between 700 and 1400, along with the range of traditions that they represent. Monuments such as the Qutb Mosque, Borobudur, the Hindu temples of India, and Angkor Wat illustrate the layered, multivalent richness of the arts during this period. These works speak to the interconnectedness of architecture, religion, and political authority, and they also demonstrate the range of ways in which art conveys meaning.

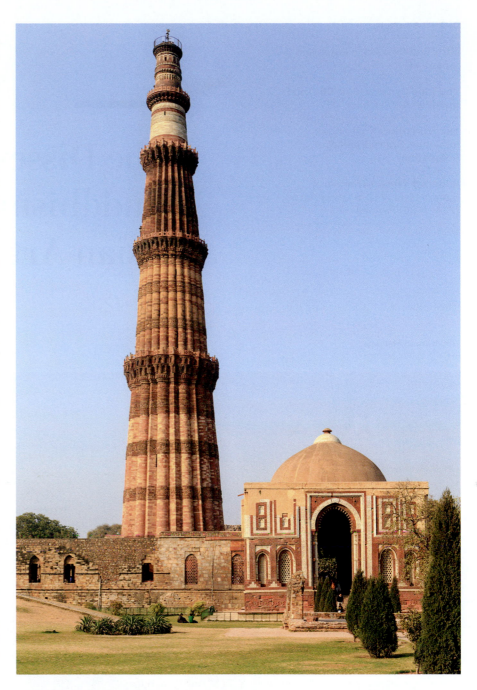

26.20 Qutb Minar (minaret, built *c.* 1199–1220; left) and **Alai Darwaza** (ceremonial gateway, completed in 1311; right), Qutb Mosque complex. Sultanate of Delhi, India.

Discussion Questions

1. A key concept in this chapter is multivalence. Choose one work discussed in this chapter and explain how this concept helps us better understand it.

2. Compare Khajuraho's Kandariya Temple to the Rajarajeshwara Temple in Thanjavur. The two monuments exemplify north and south Indian Hindu temple design, respectively. What are the main differences between the two, and what visual elements do they share?

3. The analysis in this chapter assumes movement and dialog, rather than silent gazing from a static viewpoint, as the typical experience of the visitor. Think about the ways in which we experience art today. When is art typically experienced from a static standing or seated position? When is movement involved? When is dialog involved? How do these things change the viewing experience?

Further Reading

- Asher, Catherine B. *Delhi's Qutb Complex: The Minar, Mosque, and Mehrauli*. Mumbai: Marg, 2017.

- Dehejia, Vidya. "Reading Love Imagery on the Indian Temple." In *Love in Asian Art & Culture*. Washington, D.C. and Seattle, WA: Arthur M. Sackler Gallery, Smithsonian Institution and University of Washington Press, 1998: pp. 97–113.

- Evans, Damian and Fletcher, Roland. "The Landscape of Angkor Wat Redefined." *Antiquity* 89 (2015): 1402–19.

- Kaimal, Padma. "Playful Ambiguity and Political Authority at the Large Relief at Mamallapuram." In Rebecca M. Brown and Deborah S. Hutton (eds.) *Asian Art (Blackwell Anthologies in Art History)*. Malden, MA: Blackwell Publishing, 2006, pp. 43–56.

- Miksic, John N., et al. *Borobudur: Golden Tales of the Buddhas.* Hong Kong: Periplus Editions, 1996.

architectural polychromy using different colored materials to create decorative patterns in architecture.

jali a perforated stone or lattice screen, usually featuring a calligraphic or geometric pattern.

27

The Dissemination of Buddhism and East Asian Art

500–1200

Womb World Mandala (detail), Kyoto, Japan.

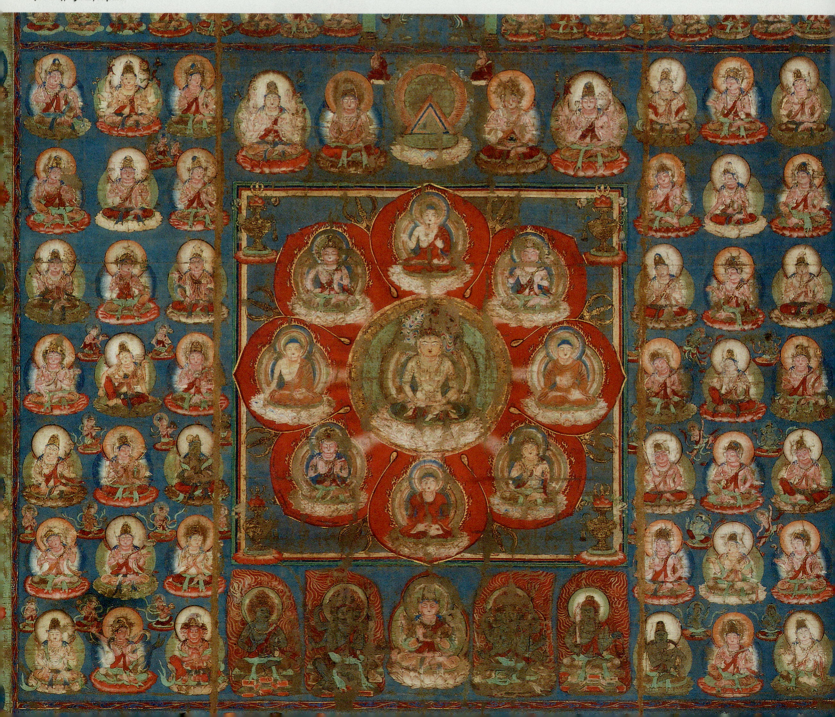

Introduction

Centuries after the life of the historical Buddha, Buddhism spread from South Asia to East Asia (**Map 27.1**), where it encountered indigenous religions and philosophies (see Chapter 16 and Map 16.1). Rulers and powerful clans did not always welcome this foreign religion, and their policies sometimes forced monks and nuns to return to lay life when governments closed temples, seized valuables, and put previously tax-exempt temple properties to revenue-generating uses. At other times, courts and commoners alike embraced Buddhism, and their donations—extravagant or modest—provided funding to create Buddhist architecture, sculpture, and painting.

Buddhism arrived on the Korean peninsula in the fourth century CE during a time of political division called the Three Kingdoms period (c. 300–668 CE). Indigenous religious beliefs and practices persisted, but Buddhism gained favor at the courts of the Goguryeo, Baekje, and Silla kingdoms. These rulers saw in this new, foreign religion a mixture of art, architecture, and religious practices that bound faith with power and prestige. By the early sixth century all three kingdoms had adopted Buddhism as a state religion.

Religious transmission continued eastward across the sea after a diplomatic mission from Baekje approached the court of Japan's most powerful clan, Yamato, in the mid-sixth century. Hoping to form an alliance, the mission brought a Buddhist icon and Buddhist texts, or *sutras*, which were believed to be potent protectors of the state. In the ensuing Asuka (538–710) and Nara (710–94) periods, the Yamato clan established its supremacy, and during that time imperial and aristocratic Japanese families commissioned Buddhist temples, shrines, icons, and paintings.

During the period of division (220–581; see Chapter 21) in northern Chinese regions, various rulers promoted Buddhism, and during the Tang dynasty (618–906) this foreign faith grew even more prominent and popular. At that time, vigorous trade across the transcontinental Silk Road fed a cosmopolitan culture in the Tang capital, Chang'an. Diplomatic missions from throughout Asia came to Chang'an and subsequently disseminated images, ideas, and technologies to their home regions.

Across East Asia, the period from the eighth century to the twelfth century CE was one of cultural transmission, encounter, negotiation, and adaptation. From the regions of China to Korea to Japan, artworks demonstrate not only imperial and elite patronage but also shifting religious beliefs and practices, as rulers demonstrated political authority and supported Buddhism by building temples and pagodas and sponsoring other types of Buddhist art.

Early Buddhist Art in Korea and Japan

Beliefs and practices associated with Mahayana Buddhism reached the Korean peninsula and Japanese archipelago in the fourth and sixth centuries, respectively. Mahayana is one of the major strands within Buddhism and is itself divided into a number of different schools. In Mahayana Buddhism, the goal is the liberation of all beings, and **bodhisattvas** play prominent roles. (For Buddhism and early Buddhist art, see Chapter 16.) Even as older indigenous beliefs persisted in the region, members of the ruling classses commissioned Buddhist art and architecture. In the sixth and seventh centuries, Buddhists in East Asia believed that Buddhism had protective and beneficent powers. These beliefs fused with artistic sensibilities and well-developed technologies of bronze manufacture as artists created Buddhist **icons**. New architectural forms provided places for Buddhist worship, and Buddhist stories found expression in painting. As rulers and ministers of state embraced the religion, the visible manifestations of Buddhist belief—icons, temples, and painting—advanced state interests.

On the Korean peninsula, the kingdoms of Goguryeo, Baekje, and Silla are the basis for naming the Three Kingdoms period (c. 300–668 CE). A fourth political entity, the Gaya Confederacy of city-states, was absorbed in 532 by neighboring Silla, which would later conquer the other two kingdoms, establishing the Unified Silla period (668–935). The political history of these kingdoms is connected to other societies, too; for example, Goguryeo destroyed the Han Chinese administrative district of Lelang in 313, thereby expanding its own territory. The dynamic political situation, especially as the competing kingdoms sought alliances with governments on the East Asian mainland and the Japanese archipelago, propelled cultural contact. Cultural dissemination across Eurasia is evident in the dazzling gold crowns of the Silla kingdom (see: Seeing Connections: The Cultural Power of Gold Across the World, p. 362). Traces of political history and cultural contact are also seen in Buddhist artworks of this period, such as bronze sculptures of *bodhisattvas*.

PENSIVE BODHISATTVA This gilt bronze sculpture of a *bodhisattva* dates to the Three Kingdoms period and is probably from the Silla kingdom (**Fig. 27.1**, p. 448). The figure sits with the right leg crossed over the left thigh. His left foot rests on a lotus, a plant that produces an

Map 27.1 East Asia, c. seventh century CE. (The Gaya Confederation of city-states was conquered by Silla in 532.)

bodhisattva in early Buddhism and Theravada Buddhism, a being with the potential to become a buddha; in Mahayana Buddhism, an enlightened being who vows to remain in this world in order to aid all sentient beings toward enlightenment.

icon an image of a religious subject used for contemplation

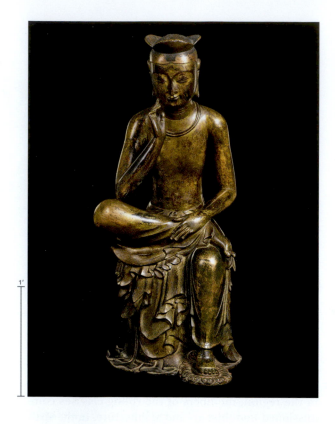

27.1 *Pensive Bodhisattva,* **probably Maitreya** (Korean Mireuk), Three Kingdoms period, early seventh century. Gilt bronze, height 36⅞ in. (93.5 cm). National Museum of Korea, Seoul.

unblemished flower despite its habitat of muddy waters, and therefore provided an apt metaphor for the Buddha, who became enlightened in an imperfect world. His left hand grasps his lower right leg, and the fingers of his right hand gently touch his cheek. With downcast eyes and slight smile, he seems immersed in thought. The triple-lobed lotus crown points to the sculpture's origin on the Korean peninsula, and the expensive gilt bronze and exceptional artistry suggest royal patronage.

The statue's posture traces back to images of the historical Buddha, Prince Siddhartha, thinking about life's sorrows and misery. Its creation in Korea during the Three Kingdoms period, a high point in the worship of the *bodhisattva* Maitreya, increases the likelihood that the icon depicts Maitreya, who will be the **Buddha** of the future epoch, just as Siddhartha became the Buddha of the present epoch.

Aspects of the sculpture, including the medium, **iconography**, and treatment of the body, face, and drapery, are reminiscent of earlier Buddhist icons. (For a review of iconography in Buddhist art, see Fig. 16.7.) For example, a seated Buddha made in the fourth century (see Fig. 21.15) is also made of gilt bronze, and both figures have elongated earlobes and idealized faces with downcast eyes and slight smiles. However, unlike the earlier seated Buddha, the *Pensive Bodhisattva* has a supple, slender upper body, and the drapery creates elegant patterns at the hem. These refinements attest to developments in the bronze sculptors' art as well as to shifting aesthetic preferences.

HŌRYŪJI ("TEMPLE OF THE FLOURISHING LAW") Before the sixth century, Buddhism was already practiced among emigrant communities from the Korean peninsula, but only with a diplomatic mission from the Baekje kingdom did this religion come to the attention of the Yamato court, centered in the Asuka region of Japan. There, Buddhism encountered an indigenous religion, Shintō (literally "the way of the gods"). Comprising diverse beliefs, ranging from myths that explained the origins of the world to the worship of *kami*, or spirits of natural forces, landscape elements, and revered ancestors, Shintō prescribed ritual practices to ensure victory in war, a successful harvest, and the general well-being of individuals

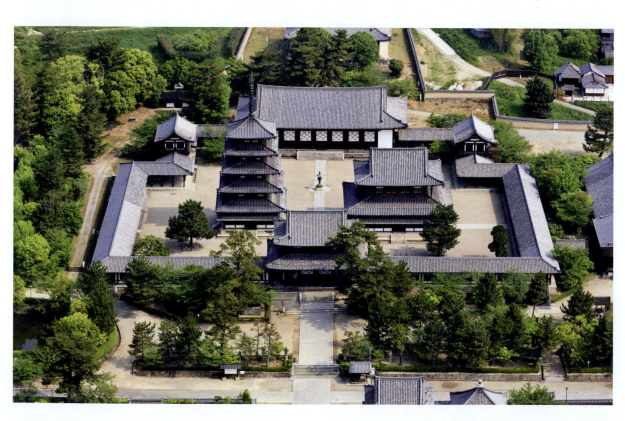

27.2 **Hōryūji**, Asuka period, seventh century. Nara prefecture, Japan.

Art and Ritual

Throughout history, art has been intimately linked to ritual. Though the forms and uses of ritual art are as varied as the cultures and eras that produced them, they share a common function of providing a visual focus for important events in the lives of individuals and groups.

Many buildings provide settings for rituals, but the construction of the Shintō shrine at Ise, Japan, is itself a ritual. The first formalized rebuilding of the Inner Shrine occurred in the late seventh century CE, and since then, the state has assumed responsibility for its periodic reconstruction (now set at every twenty years). This photograph (**Fig. 1**) shows the two adjacent sites of the Inner Shrine, home to Amaterasu, the Shintō sun goddess and ancestor of the Japanese imperial family. When the new shrine is completed, a process that takes eight years and is accompanied by thirty-two ceremonies, the old one is ritually disassembled. This periodic renewal consumes enormous resources, but it effectively affirms an intrinsic Shintō belief in the natural cycle of growth, decay, death, and rebirth.

Rituals may dramatize events of the natural world or enact supernatural events. Stories of heroic supernatural warriors and their battles circulated around the Mississippi River valley of North America in the period after 1100 CE, and

1 **Inner Shrine, Ise Jingu,** Mie prefecture, Japan. On the left is the new complex; on the right, the old.

this carved shell illustrates one of them (**Fig. 2**). Two combatants face each other, each with one fist raised to the enemy's throat and a pointed flint sword in the other hand. Both figures wear wings attached to their arms, and their feet are depicted as menacing bird claws, indicating that these are deities fighting in the sky. Great chiefs and warriors of the region dressed as these

warriors and ritually re-enacted their celestial battles as war dances. A chief may have worn this shell, which has two holes drilled near the top for suspension in a necklace.

Other types of rituals use objects directly to transmit a religious experience visually. In the male initiation rituals of the Abelam of New Guinea, viewing art is the focus. These rites consist of a sequence of ceremonies that take place over many years at various stages in an individual's life. Each centers around an elaborate display created by fully initiated

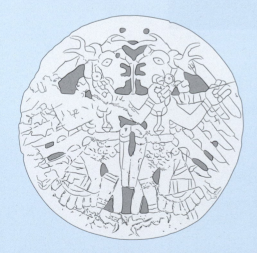

2 ABOVE **Drawing of engraved shell with two figures,** from Tennessee, Hamilton County, Hixon Site, *c.* 1250–1350 CE. Original: marine shell, diameter 4½ in. (11.4 cm). McClung Museum, University of Tennessee.

3 RIGHT **Initiation display of the Abelam culture,** Bongiora village, Papua New Guinea, mid-twentieth century. Wood, paint, fiber, feathers, leaves, fruit.

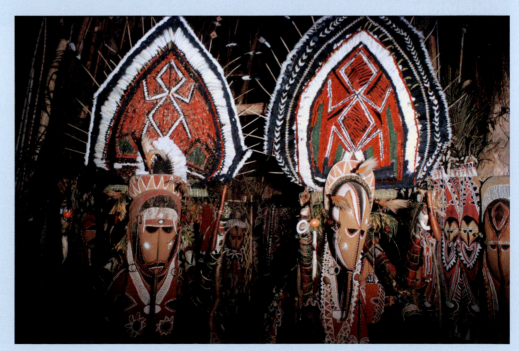

These include the **isometric** representation of tables and pedestals, overlapping objects, attention to physical scale, and use of three-quarter views.

Unlike the illustrations for *The Tale of Genji*, *Frolicking Animals* seems to oppose all the conventions of Heian painting: ink **monochrome** instead of heavy pigments, dynamic brushwork rather than meticulous outlines, visible facial expressions and physical gestures instead of indirect means of expressing emotions, and the substitution of humorous anecdotes for profound human themes. These two paintings belong to distinct stylistic modes, or categories, called ***onna-e*** and ***otoko-e***. *Onna-e*, meaning "women's painting," applies to the illustrations to *The Tale of Genji*, while *Frolicking Animals* belongs to the category of *otoko-e*, meaning "men's painting." Although the use of gendered terms for painting categories might suggest underlying beliefs about gender, they do not mean that audiences were composed exclusively or primarily of women or of men. Nor do the terms refer to the gender of the artists. Instead, they suggest the stylistic range of paintings available to both men and women in the Heian period.

From the seventh-century gilt bronze *Pensive Bodhisattva* icon (see **Fig. 27.1**) to the twelfth-century ink paintings of *Frolicking Animals*, the history of Buddhist art and culture in East Asia is one of cultural exchange, appropriation, and adaptation. Buddhism changed the cultures and art of East Asia, but East Asia also changed Buddhism. In the ensuing centuries, Buddhism would continue to be a source of creative inspiration, generating deceptively simple images as well as manifestly complicated forms, At the same time, interest in secular subjects drawn from both the natural world and urban experience would grow. The artistic record of East Asia would include landscapes of monumental proportions, startlingly realistic portraits, and the development of a most wondrous and coveted material—porcelain.

Discussion Questions

1. As the focus of worship, icons play an essential role in many religions. What makes an icon visually compelling and effective for religious practice? Choose one or more Buddhist icons in this chapter to explain your reasoning.

2. Words and images convey stories differently. Choose a narrative image from this chapter and discuss the visual strategies that the image uses to tell the story.

3. Architecture transforms space into meaningful places of human activity. Describe and analyze how architecture facilitates Buddhist practice. Refer to a temple or building in this chapter.

Further Reading

- Kathleen Ashley and Véronique Plesch. "The Cultural Processes of 'Appropriation.'" *Journal of Medieval and Early Modern Studies* 32 no. 1 (Winter 2002): 1–15.
- Leidy, Denise Patry. *The Art of Buddhism: An Introduction to Its History and Meaning*. Boston, MA and London: Shambhala, 2008.
- Washizuka, Hiromitsu, Park, Youngbok, and Kang, Woo-bang. *Transmitting the Forms of Divinity: Early Buddhist Art from Korea and Japan*. New York: Japan Society, 2003.
- Watanabe, Masako. *Storytelling in Japanese Art*. New York: The Metropolitan Museum of Art, 2011.
- Whitfield, Roderick, Whitfield, Susan, and Agnew, Neville. *Cave Temples of Mogao at Dunhuang: Art and History on the Silk Road*. Los Angeles, CA: Getty Conservation Institute and the J. Paul Getty Museum, 2000.

Chronology

	CHINA			JAPAN	
589	The Sui dynasty (581–618) unifies China		538–710	The Asuka period	
618–906	The Tang dynasty		623	Tori Busshi's workshop sculpts *Shaka Triad*	
676	*Colossal Vairochana and Attendants*, commissioned by Emperor Gaozong and Empress Wu, is completed		710–94	The Nara period	
723	Sculpture of camel carrying musicians is buried as tomb furnishing		*c.* 711	Rebuilding of Hōryūji is complete	
	KOREA		752	The First Great Buddha Hall is constructed at Tōdaiji; *Birushana Buddha* icon is consecrated	
c. 300–668 CE	The Three Kingdoms period		794–1185	The Heian period	
early seventh century	*Pensive Bodhisattva* is sculpted		*c.* 1053	Phoenix Hall at Byōdōin is built; Jōchō sculpts *Amida Buddha*	
668–935	The Unified Silla period				
751–74	*Seated Buddha* is sculpted at Seokguram Grotto		twelfth century	The earliest illustrated handscrolls of Murasaki Shikibu's *The Tale of Genji* are made	

connect emotionally with the other, but they do not make eye contact. Moreover, the movable curtains and the boundaries of the bright green *tatami* mats emphasize their isolation from one another. The **ground plane** tilts up sharply, and no horizon line offers spatial relief or counterbalances the diagonal lines of floor and furnishings. (Similar visual strategies were used later in woodblock prints of the Edo period (1615–1868) and subsequently adapted by nineteenth-century European and American artists; see Chapters 44 and 62).

Because Heian culture judged outward displays of emotion to be vulgar, painters supplemented conventionally represented faces and restrained expressions with indirect cues in the composition. For example, the tight positioning of motifs such as furniture produces a sense of psychological pressure, and the steep angle of the ground plane in combination with diagonally placed screens convey emotional instability and disarray. Such strategies of representation became conventions that were readily understood by both artists and audiences. Another convention used in the illustrations to *The Tale of Genji* is the point of view: a high vantage unimpeded by ceiling or rooftop, which is called *fukinuki yatai*, literally, "blown-off roof."

The privileged glimpse into private family matters is underscored by the presence on the (viewer's) right of court ladies, who wait anxiously at the periphery. They are, like the viewers of the painting, unable to alleviate the sorrows of the Third Princess, her father, or her husband. Instead, the onlookers bear witness to a scene of karmic consequences. Deeply lamenting her fate, the young Third Princess determines to take Buddhist vows, and her father, unsuccessful in his entreaties, resigns himself to her decision. Genji's fate is especially poignant. In his own youth, Genji had an affair with his father's consort, and an illegitimate son was born of that liaison. Now, Genji is wounded by his wife's infidelity, and he must silently bear the shame. Even though the centuries-old painting is worn, the artistry of the scene—the fine depiction of the opulent robes of the ladies, the bright colors of the furnishing—persists, heightening the poignancy of the tragedy and imparting a sense of *mono no aware*.

SCROLLS OF FROLICKING ANIMALS Although feelings of melancholy are pervasive in the late Heian period, it was also a time of razor-sharp wit. In the realm of literature, the court lady Sei Shōnagon (a contemporary of Murasaki Shikibu) recorded in her *Pillow Book* all manner of unsparing critiques of daily irritations and doltish lovers. In art, there is the four-scroll set of the *Scrolls of Frolicking Animals*.

The *Scrolls of Frolicking Animals* depict both humans and anthropomorphic animals engaged in a variety of leisure activities and sacred rituals. In this detail from one of the two scrolls thought to date to the Heian period (**Fig. 27.21**), a monkey abbot kneels before a Buddhist altar. Seated in meditative position upon a lotus leaf and backed by a plantain-leaf mandorla, the frog icon raises a webbed hand in the *mudra* signaling not to fear. Hares, foxes, and a monkey observe the religious ritual in what may be a cheeky parody of Buddhism.

For audiences accustomed to oil painting, *Frolicking Animals* resembles a sketch. Indeed, the handling of brush and ink suggests swift and spontaneous execution. It would be a mistake to describe this painting as simplistic or elementary, however. The medium, ink on paper, is unforgiving. Errors cannot be corrected, and thus it takes years of practice and experience to produce the sure and nuanced lines that describe knotted branches, wispy breath, and perky ears. Careful control of ink tonality must substitute for a rainbow of colors. The artist's understanding of spatial relationships creates order and hierarchy among the motifs, so that even though the monkey abbot is closest to the middle of this particular scene, the frog icon occupies the center of attention. In addition, the painter has used several techniques to create space and mass on a two-dimensional surface.

27.21 *Scrolls of Frolicking Animals (Chōjū jinbutsu giga)*, **attributed to Toba Sōjō.** Detail from scroll I, mid-twelfth century. Handscroll, ink on paper, height 12½ in. (31.8 cm). Kōzanji/Kyoto Museum, Japan.

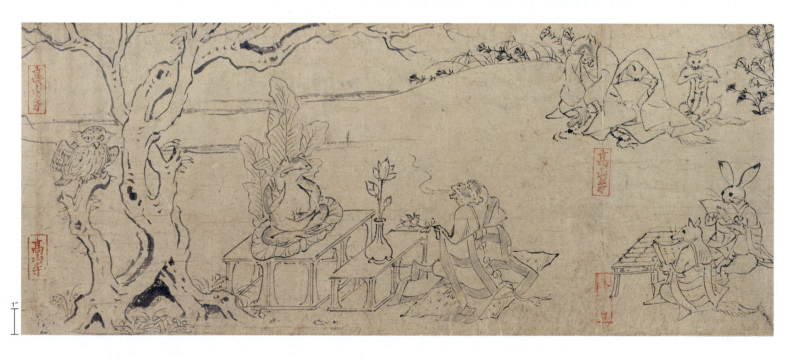

followers will be reborn in individual lotus flowers. Amida's palace has covered galleries stretching to either side, and imitation watchtowers rise from false second stories at the corners where the corridors turn toward the pond. Behind the central hall, another **gallery** stretches backward like a tail (**Fig. 27.19**).

The plan of Phoenix Hall, with its corridor "wings" and "tail," along with the mythical bronze birds that crown the **hip-and-gabled roof**, give the building its avian name. A materialization of the Pure Land, it facilitated the visualization practices central to Pure Land Buddhism. It was believed that the very act of envisioning the Pure Land and deliverance to that paradise would bring about *raigō* and rebirth.

THE TALE OF GENJI As a variety of schools, or sects, of Buddhism developed during the Heian period, Buddhist beliefs and practices also colored secular life. With the onset of *mappō*, the sense of belatedness felt by late Heian Buddhists fueled an aesthetic sensibility described as *mono no aware*, a keen, bittersweet awareness of the transience of things. The feeling of *mono no aware* pervades *The Tale of Genji*, written by Murasaki Shikibu, an eleventh-century lady-in-waiting to an imperial princess. Hailed as the world's first novel, *The Tale of Genji* follows the loves and regrets of Genji, the son of the emperor and a secondary consort. Throughout the story, Murasaki describes the intrigues of courtly romances and the complexities of the human heart. The recurring theme of the ephemeral nature of life resonated with Buddhist attitudes of life as illusory, and it underlies the novel's extreme sensitivity to the fading of beauty. Though *The Tale of Genji* is fiction, Murasaki's meticulous observations offer a glimpse into the culture of the Heian court.

The Tale of Genji inspired artistic competitions among courtiers and ladies. A set of illustrated **handscrolls** (Japanese: *emakimono*) from the twelfth century combines the skills of papermaking, **calligraphy** (see: Seeing Connections: The Art of Writing, p. 560), and painting to capture the novel's elegance and pathos. The "Oak Tree (*Kashiwagi*)" chapter recounts how Genji's nephew, Kashiwagi (whose name literally means "oak tree"), pursued the Third Princess, one of Genji's wives. That affair produced a child whose birth was followed by the Third Princess's decision to join a Buddhist convent and by Kashiwagi's untimely death.

This scene from the "Oak Tree" chapter takes place in the private chambers of the Third Princess (**Fig. 27.20**). At the far left (as the viewer looks at it), she is identifiable by her long black hair. Her father—the retired emperor, whose shaved head indicates his status as a Buddhist monk—faces her. Genji, wearing the customary black hat of the Heian courtier, sits below him. Each is deeply troubled, but feelings are not excessively displayed in facial expressions or physical gestures. Each yearns to

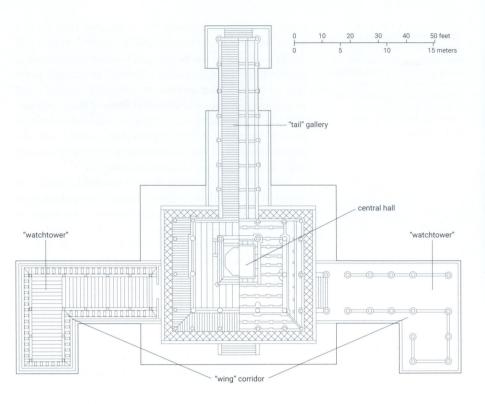

27.19 Plan of Phoenix Hall.

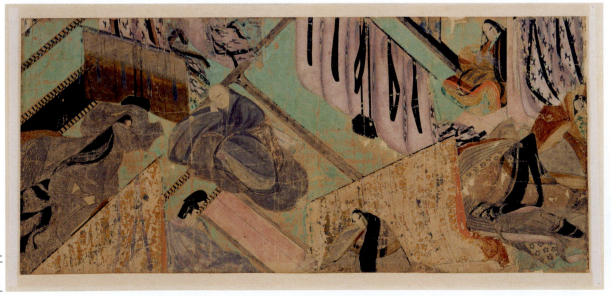

27.20 Illustration from the "Oak Tree (*Kashiwagi*)" chapter from The Tale of Genji, late Heian period, twelfth century. Handscroll, ink and color on paper, height 8⅝ in. (21.9 cm). Tokugawa Art Museum, Nagoya, Japan.

gallery an interior passageway or other long, narrow space within a building.

hip-and-gabled roof composite roof design that combines a hip roof in the lower portion, and in the upper portion, one that slopes from two opposite sides with two gables (vertical triangular) at the ends.

handscroll a format of East Asian painting that is much longer than it is high; it is typically viewed intimately and in sections, as the viewer unrolls it from right to left.

calligraphy the art of expressive, decorative, or carefully descriptive hand lettering or handwriting.

27.17 Jōchō, *Amida Buddha (Amitabha),* c. 1053. Gold leaf and lacquer on wood, height 9 ft. 8 in. (2.95 m). Phoenix Hall, Byōdōin, Uji, Kyoto prefecture, Japan.

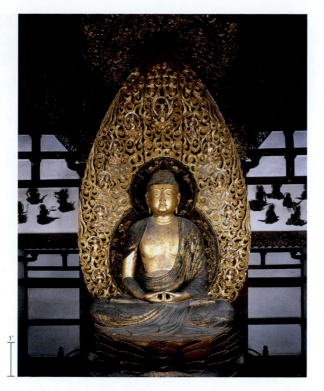

urna one of the thirty-two markers of the Buddha, a buddha, or a *bodhisattva*: a tuft of hair or small dot between the eyebrows that symbolizes a third eye.

27.18 **Phoenix Hall,** Byōdōin, Uji, Kyoto prefecture, Japan, c. 1053.

splendid, he wears a serene expression. Below Amida's broad forehead, Jōchō has carved elegantly elongated brows, half-closed eyelids, and utterly relaxed and perhaps slightly parted lips. The snail-shell curls that stud Amida's head and *ushnisha* may be traced back to Nara period precedents in Japan, and ultimately to the Gupta period in north India (see Chapter 16). Like other images of the Buddha, Amida bears the **urna** and elongated earlobes. His shawl falls in shallow folds, and his hands form the *mudra* of concentration.

Above Amida hangs an elaborate, gilded canopy with an abundance of floral scrolls and large, stylized lotus petals framing a bronze mirror for reflecting light onto the sculpture. An ornate halo and openwork mandorla—replete with curling clouds and ascending flames—offer a contrasting frame for Amida's calm expression and plain appearance. *Apsaras* in the form of tiny attendants, dancers, and musicians float in the mandorla and on the surrounding walls. They constitute the heavenly contingent that accompanies Amida as he descends from his Pure Land in answer to prayers. The purpose of this *raigō*, or "welcoming descent," is to convey the faithful to their rebirth into Amida's Pure Land.

PHOENIX HALL, BYŌDŌIN What does Amida's Pure Land look like? Whereas the mural at Dunhuang offers a two-dimensional image (see **Fig. 27.12**), Phoenix Hall and its setting provide a three-dimensional representation (**Fig. 27.18**). From his elevated lotus throne at the center of the Phoenix Hall, Amida presides over an artificially formed pond, which represents the place where faithful

were subsequently fitted together and finished. Thus, the efficiency of Jōchō's workshop increased, partly in response to a growing demand and competitive market for Buddhist icons.

At Phoenix Hall, Amida sits in lotus position on a raised lotus throne. Depicted as awe-inspiring and

WOMB WORLD MANDALA The relocation of the imperial capital led to the shift of power and patronage away from the Buddhist institutions in Nara, which affected the later development of Buddhism. Monks returning from studies on the East Asian continent introduced schools of **Esoteric Buddhism** (in other regions of Asia, these schools may be referred to as Vajrayana or Tantric), including Tendai and Shingon. Centered on *The Lotus Sutra*, Tendai maintains that all human beings possess the Buddha nature and, therefore, can become enlightened by fully realizing this nature within themselves. Based on texts transmitted by founding monk Kūkai (774–835), Shingon recognizes two aspects of the Buddha—a temporary body, as manifested in the historical Buddha, and a transcendental body, represented by Birushana Buddha—but upholds a doctrine of non-duality in which these bodies are not separate but belong to a common absolute.

Like earlier Buddhist schools, Tendai and Shingon built temples and created icons, but they also required new images to serve new purposes. In Shingon, the full realization of the ultimate Buddhist truth and of enlightenment is impossible without images. Kūkai explained, "With a single glance [at drawings and paintings] one becomes a Buddha. The secrets of the *sutras* and commentaries are depicted in a general way in diagrams and illustrations, and the essentials of the Esoteric teachings are actually set forth therein." **Mandalas** attest to Shingon belief in the temporary, or phenomenal and the transcendent realms, and they may have helped with visualization practices as suggested by Kūkai. Mandala is the Sanskrit word for "circle," and Buddhist mandalas take the form of a cosmic map of a sacred enclosure, arranging buddhas, *bodhisattvas*, and other deities systematically and hierarchically.

For example, in the *Womb World Mandala*—"womb" referring to the womb of great compassion—the cosmic Buddha presides at the composition's conceptual pinnacle, the central square (**Fig. 27.16**). From the center, the universe expands outward like a mountain viewed from above (see Fig. 26.3). In the *Womb World Mandala*, that spatial expansion is expressed as nested squares. The cosmic Buddha occupies a position higher than the historical Buddha, who is placed in the third **register** from the top. Still, the historical Buddha sits at the center of thirty-four half-sized disciples and personifications of virtue.

The mandala does not tell a story such as the *Mahasattva Jataka* (see **Fig. 27.4a**), nor does it attempt an illusionistic representation as in the *Amitabha Buddha Presiding over the Western Pure Land* (see **Fig. 27.8**). Instead, it uses contrasting colors, **hierarchical scale**, iconography, and symmetrical patterns to give visual form to abstract Buddhist concepts. In Shingon belief and practice, the *Womb World Mandala* is paired with the transcendental *Diamond World Mandala*, not illustrated here. Displayed in initiation halls or revealed only on special occasions, the mandalas were also used in initiation rites to determine a personal deity among those represented in the mandala. Thereafter, initiates could welcome and invoke their personal deities to empower those deities' images in the mandala.

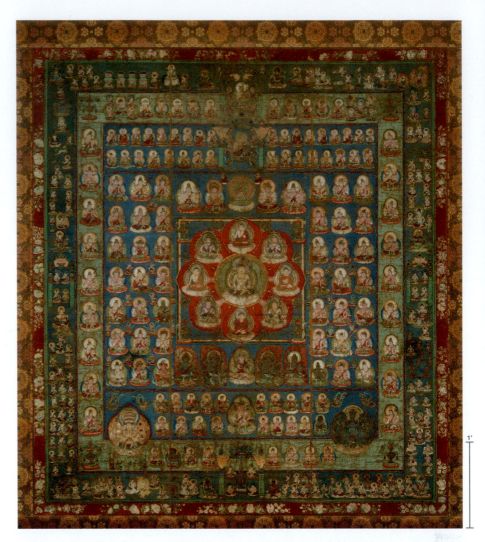

JŌCHŌ, *AMIDA BUDDHA* Both the Shingon school and followers of Amida Buddha (Sanskrit: Amitabha Buddha) practiced visualization. But, whereas the former advocated visualization as a path to enlightenment, the latter practiced a series of visualizations in order to be reborn into Amida's Pure Land. Interest in Pure Land emerged from Tendai practices and gained popularity in the late Heian period, a time that (for Heian Buddhist followers) coincided with *mappō*. *Mappō*, translated as the "latter days of the law," refers to the corrupt age when there was little chance for enlightenment and therefore rebirth in Amida's Pure Land provided an interim step.

Late Heian belief in *mappō* finds vivid expression in the art and architecture of Byōdōin. The site was formerly the suburban villa of a powerful aristocratic family, the Fujiwara. In 1052, with the consecration of a main hall, the villa was named Byōdōin, or "Temple of Equanimity." The following year, coinciding with the onset of *mappō*, saw the completion of the Amida Hall, now commonly known as the Phoenix Hall, which houses the gilt wood icon of *Amida Buddha* by the renowned sculptor Jōchō (d. 1057) (**Fig. 27.17**, p. 458).

Jōchō perfected a new technique for making wood sculptures. Rather than shaping a single block of wood, he joined together multiple pieces, a process called *yosegi zukuri*. Using this method, several sculptors could simultaneously shape different parts of the icon, which

27.16 *Womb World Mandala,* Tōji, Kyoto, Japan, Heian period, late ninth century. Hanging scroll, color on silk, 6 ft. × 5 ft. 1½ in. (1.83 m × 1.56m).

mandala typically comprised of concentric circles and squares, a spiritual diagram of the cosmos used in Hinduism, Buddhism, and other Asian religions.

register a horizontal section of a work, usually a clearly defined band or line.

hierarchical scale the use of size to denote the relative importance of subjects in an artwork.

27.14 Drawing based on engraved image on the bronze lotus petal base of Birushana Buddha, Nara period.

auspicious signaling abundance, prosperity, and good fortune.

facade any exterior vertical face of a building, usually the front.

bay a space between columns, or a niche in a wall that is created by defined structures.

hip roof a roof that slopes upward from all four sides of a building.

Esoteric Buddhism schools of Buddhism that feature secret teachings, requiring the assistance of an advanced instructor to access and understand.

on the palms of his hand or the *svastika*—an **auspicious** sign with a history traceable to 500 BCE, or roughly the lifetime of the historical Buddha—on his chest. Stylistic qualities of this Buddha, such as the relaxed, full-bodied figure, a rounded face, and flowing drapery, are shared by the *Colossal Vairochana* in Longmen Cave 19 in China and the *Seated Buddha* at Seokguram Cave Temple in Korea. All three are examples of the Tang International Style, which succeeded the earlier style of elongated figures

seen throughout East Asia, including that of the *Shaka Triad* (see **Fig. 27.5**).

DAIBUTSU-DEN (GREAT BUDDHA HALL) Owing to its large size, this sculpture of the Birushana Buddha is also known as Daibutsu, meaning "great Buddha." Thus, the structure that houses it is the Daibutsu-den, or Great Buddha Hall (**Fig. 27.15**). With a **facade** measuring 187 feet (57 m) across, the Great Buddha Hall has immense proportions, requiring not merely additional **bays** (seven compared to the five of Hōryūji's *kondō*) but also significantly larger posts and lintels. The current building is only two-thirds the size of the original, which was set afire and destroyed in the civil war at the end of the Heian period, but it unmistakably shares the language of Tang palace architecture (see the buildings depicted in **Fig. 27.12**). The sweeping, double-eave **hip roof**—one eave extending over all seven bays, a hip roof above—and the complex array of brackets announce silently but unambiguously the alliance of politics and religion, of material resources and spiritual matters.

The alliance of politics and religion did not last. From the Asuka to the Nara periods, the Yamato court promoted Buddhism and its accompanying artistic forms, and as Buddhism grew in popularity, temples accrued wealth and power. With constituencies and wealth of their own, temples were seen as rivals rather than as partners to the court, and the erosion of the mutually beneficial relationship between politics and religion brought about the end of the Nara period in 794. In part to curb the power of numerous Buddhist temples located within Nara, the court decided to move the capital. After a failed attempt to construct a capital at Nagaoka, the imperial house succeeded with Heian-kyō, present-day Kyoto, which gives its name to the Heian period (794–1185). Like Nara, Heian-kyō took the Tang capital of Chang'an as a model, but the new city strictly limited the number of Buddhist temples within its boundaries.

27.15 Great Buddha Hall (Daibutsu-den), Tōdaiji, Nara prefecture, Japan. Original structure completed in 752; destroyed in 1180; reconstruction completed in 1707, with restorations in 1906–13.

the sandstone cliff. Together, these are known as the Mogao ("Peerless") Cave Temples.

Built in the eighth century, Cave 217 features on its south wall an image of the Buddha Amitabha presiding over his Western Pure Land (Fig. 27.12). Within Mahayana Buddhist traditions, belief in Amitabha proposes the concept of rebirth in a Pure Land as an intermediary step towards release from *samsara*, the endless cycle of death and rebirth. For some, the corrupt age—a time so far removed from the life of the historical Buddha—presented an obstacle to reaching enlightenment, but Amitabha offered help. By chanting Amitabha's name and visualizing his Pure Land (thought to lie in the west, where Buddhism originated), Buddhists believed they could be reborn there.

The mural in Cave 217 represents Amitabha's Western Pure Land in spectacular fashion. In the foreground, celestial musicians and dancers provide joyous entertainments. Modeled with light and shadow, the bodies appear three-dimensional. The diagonal lines of balustrades and the relatively smaller sizes of buildings and figures in the distance suggest spatial recession (see: Seeing Connections: The World in Perspective, p. 674). At the center, a retinue of *bodhisattvas* attends Amitabha, who sits on an elaborate lotus throne. Like the baldachin sculpted by Gian Lorenzo Bernini marking the site of St. Peter's tomb, the bejeweled canopy above Amitabha is a sign of reverence. Furthermore, it distinguishes Amitabha from other buddhas, who share common iconographical features. Behind him rises a magnificent palace with watchtowers to the sides, preserving for us the appearance of rarely preserved Tang architecture. The fluttering scarves of flying spirits (called *apsaras*) fill the sky. Amid the festivity, the pond where Pure Land adherents are reborn in individual lotus flowers almost disappears. Looking more like a canal, the pond cuts a rectangular course around platforms teeming with musicians, dancers, and *bodhisattvas*.

Consistent with Buddhist visualization practices, which prescribe rigorous picturing in one's mind as a means of religious transformation, this ornate and colorful mural seeks to induce an overwhelming and palpable experience of the Amitabha's Pure Land. It is both extravagant and **illusionistic**, and it required the combined efforts of a workshop. Some artisans prepared the walls with layers of plaster, while others transferred preparatory drawings to the wall. Senior artists painted the outlines, while apprentices filled in the colors.

Buddhist Art and Themes in Japan's Nara (710-94) and Heian (794-1185) Periods

As the Tang dynasty's power grew over the seventh century, the Yamato court was also gaining strength during the Asuka period in Japan. Eventually, Yamato would establish hegemony over most of the archipelago, becoming synonymous with Japan. In prevailing over their aristocratic opponents and regional rivals, the Yamato court was aided by its adoption of Buddhism, written language, and a centralized bureaucratic system

of governance—all imports from the East Asian mainland. By the late seventh century, the court decided to establish a permanent capital for its bureaucracy, and it founded Heijō-kyo, now known as Nara, in 710. The city gives this era its modern name, the Nara period (710–94). Adopting the regular, south-facing plan of Chang'an, the city's form demonstrates the local prestige accorded Tang dynasty culture. At Tōdaiji, the central temple of the state in Nara, two related Buddhist projects—the casting of a monumental bronze Buddha and the construction of one of the world's largest wooden buildings to house it—reveal the continued fusion of politics and religion at court.

BIRUSHANA BUDDHA Believing that religious piety could bring Buddha's protection to the nation, Emperor Shōmu (ruled 724–749) commissioned in 743 a monumental sculpture of Vairochana Buddha, or in Japanese, Birushana Buddha (Fig. 27.13). Under the management of Kuninaka no Muraji Kimimaro (d. 774), whose grandfather emigrated from Baekje, nearly a decade of work culminated in the icon's ritual consecration by the Indian monk Bodhisena in 752. Attended by heads of state, the aristocracy, and the clergy, the consecration, or "eye-opening" ceremony transformed the statue into a potent religious icon. In the centuries since the consecration, the Buddha hall and the statue of the Birushana Buddha have been destroyed or partially destroyed by fire, but each time, both were restored. As a result, the present 53-foot-high statue of the Birushana Buddha comprises original portions with areas of restoration dating to the thirteenth and seventeenth centuries.

The stylistic preferences of several periods co-exist in the statue's body, but much of the lotus pedestal is original. Engraved petals of that pedestal preserve a Nara period image of the historical Buddha (Fig. 27.14, p. 456). It shows iconographical markers that are not always visible or present on other representations, such as the wheels

illusionism making objects and space in two dimensions appear real; achieved using such techniques as foreshortening, shading, and perspective.

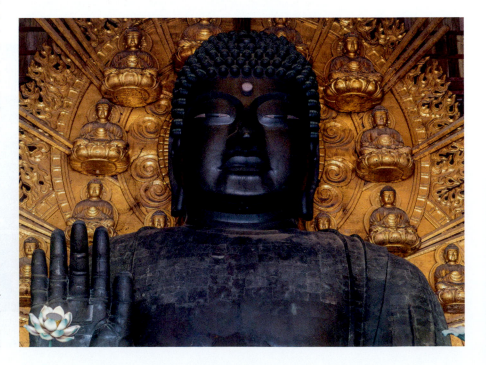

27.13 **Vairochana (Birushana) Buddha,** Daibutsu-den, Tōdaiji, Nara prefecture, Japan. Original 743–52, Nara period; reconstruction seventeenth century. Bronze, height 53 ft (16.15 m).

Near the southeast coast of the Korean peninsula at Mount Toham, the Seokguram Grotto houses an extraordinary granite sculpture of the Buddha (**Fig. 27.11**). Commissioned by Kim Daeseong (701–74), a government minister of the Unified Silla government, Seokguram Grotto was completed between 751 and 774. Its granite masonry construction makes it unique among Buddhist cave temples, most of which were rock-cut. The artistic strategy of carving the icon's halo on the wall behind it is unusual, too, as is Seokguram's particular blend of iconography. The "earth-touching" *mudra* suggests the historical Buddha at the moment of enlightenment, but given the popularity of the *Avatamsaka sutra* (also known as the "Flower Garland" *sutra,* a Mahayana text important in East Asia), the figure in Seokguram Grotto may also be Vairochana, the cosmic Buddha from which all other buddhas emanate.

In trying to analyze and understand the Seokguram Grotto and its Buddha, art historians might look for the influence of earlier works. They might, for example, ask if the Tang dynasty *Colossal Vairochana* (see **Fig. 27.10**) influenced the Seokguram Buddha. However, the search for influence often reflects an implicit bias in that influence implies a preferred model acting on a lesser follower. Such thinking can help establish chronological relationships, but it can be blind to local circumstances and inventions.

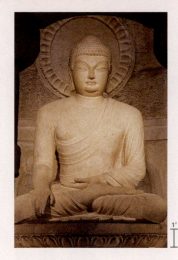

27.11 *Seated Buddha* at **Seokguram Grotto,** North Gyeongsang province, South Korea. Unified Silla period, *c.* 751–74. Granite, height of Buddha 11 ft. 2 in. (3.42 m).

The concepts of appropriation and adaptation are useful alternatives to thinking in terms of influence. Both recognize that artists and cultures make choices rather than strictly adhere to established forms, styles, subject matter, or conventions. Note that appropriation here means the borrowing of preexisting images, object, or ideas, but it does not have the negative connotation of taking unjustly, as often implied in popular usage. In the context of East Asia during this period, appropriation considers (among other things) how sculptors, architects, and patrons on the Korean peninsula and Japanese archipelago chose to adopt (or not to adopt) aspects of

Tang-dynasty art to suit their goals, just as their counterparts in the Tang dynasty did or did not choose to adopt aspects of the Buddhist art and architecture of South Asia. Adaptation further emphasizes the introduction of local alterations and adjustments.

Appropriation and adaptation suggest that mimicry of earlier models cannot be explained as a lack of creativity by later artists. Rather, local conditions determine whether the appropriation and adaptation of foreign styles are religiously effective, politically expedient, or culturally prestigious. Recognizing an artistic source thus becomes less an answer ("Aha, it looks like the *Colossal Vairochana*!") and more an inquiry ("How and why did the artists at Seokguram appropriate and adapt the practice of building Buddhist cave temples?").

Discussion Questions

1. Identify another instance of appropriation and/or adaptation of Buddhist art in this chapter. Discuss how the later artwork is similar to and different from the earlier source(s).

2. Look at the Tang dynasty palace architecture represented in Amitabha's Western Pure Land (**Fig. 27.12**). How would you describe the relationship between Tang dynasty palace architecture and Phoenix Hall at Byōdōin?

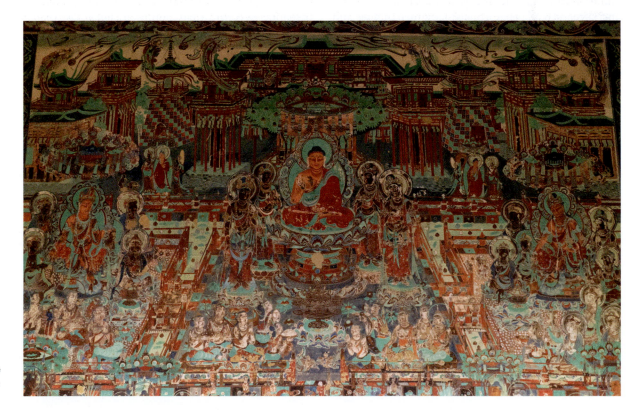

27.12 *Amitabha Buddha Presiding over the Western Pure Land.* Detail of mural on north wall of Cave 217, Mogao Cave Temples, Dunhuang, Tang dynasty, *c.* 713–66. Gansu province, China.

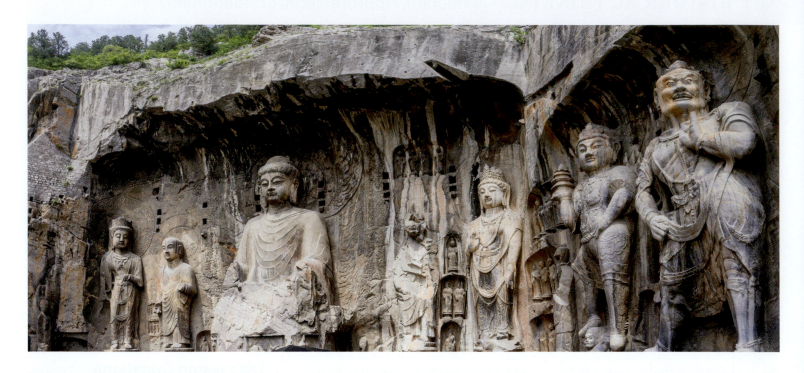

COLOSSAL VAIROCHANA AND ATTENDANTS Although Tang society was worldly, religion was not far from the minds of its people. Since the late fifth century, the cliffs at Longmen, or Dragon Gate, had attracted royal patrons of Buddhism (see Fig. 21.17). Conveniently located near Luoyang, the eastern capital of the Tang dynasty, the **rock-cut** cave-temples and smaller sculptural niches at Longmen continued to receive support from ardent Buddhists both within and outside the royal court. In 660, workers began excavations for a sculptural group on a massive scale. Completed in 676, the *Colossal Vairochana and Attendants* at the Temple of Honoring Ancestors, enumerated Cave 19 by archaeologists and art historians, surpassed all other icons at Longmen in scale and magnificence (**Fig. 27.10**).

Vairochana Buddha is the cosmic Buddha, who transcends space and time. He is, furthermore, the primordial and unchanging form of other, temporary buddhas, such as the historical Buddha Shakyamuni. As with other Buddhist icons, iconographical markers—including the halo, the **ushnisha,** and the elongated earlobes—help with identification. The sculpture has suffered significant damage, but remnants of a lotus throne suggest a seated position and preserve an inscription that identifies the central figure as Vairochana. Because the lower arms and hands are gone, Vairochana's *mudra* cannot be determined. Two monks immediately flank Vairochana: the young monk Ananda to the viewer's left, and the old monk Kashyapa to the viewer's right. Paired *bodhisattvas*, and, on the sides of the niche, paired guardian kings and *dvarapalas* (protectors of gateways) complete the composition.

The architectural edifice of wood and other perishable material that once covered the sculpture is gone, and with it, protection from natural erosion and human activity. The latter includes the distracting, though devout, pre-modern additions of numerous smaller niches containing Buddhist figures. Nevertheless, slight traces

of pigment survive, indicating that the sculptures of Cave 19 were originally painted. The softly modeled faces with sharply defined features and fuller, rounded bodies demonstrate a shift away from the elongated figure styles of earlier sculptures. The group's sheer size and the level of artistic skill, evident in the drapery that falls so naturalistically and in the exquisite patterns of the jewelry and haloes, indicate imperial patronage. Historical records name both the third Tang emperor Gaozong (ruled 649–683) and his wife, Empress Wu (624–705), as the patrons. When her husband's health was declining, Empress Wu brought Cave 19 to completion.

The imperial couple was unusual in their joint participation in court rituals, and the *Colossal Vairochana* group expresses their shared faith in Buddhism. As in other instances of royal patronage since the time of Ashoka (see Chapter 16), religious expression cannot be separated from politics. The Buddhist idea of a universal ruler who sets into motion the teachings of the Buddha provided a potent form of political legitimacy that would prove attractive elsewhere in East Asia, too. At Cave 19, the cosmic Vairochana calls to mind the image of a universal ruler—a position to which both Emperor Gaozong and Empress Wu, who later became the only woman to reign outright as Emperor of China, aspired. At the same time, by dedicating Cave 19 as Fengxian si, or the "Temple of Honoring Ancestors," the imperial couple performed within a Buddhist context the core Confucian virtue of duty to elders.

AMITABHA BUDDHA PRESIDING OVER THE WESTERN PURE LAND Far west of Chang'an, a vast quantity of Buddhist sculptures and **murals** survive in hundreds of rock-cut cave temples near the oasis city of Dunhuang, which flourished with the Silk Road. Between the fourth and fourteenth centuries CE, courts, local governors, merchants, and travelers directed some of their wealth to building and furnishing Buddhist temples hewn from

27.10 *Colossal Vairochana and Attendants,* Fengxian si ("Temple of Honoring Ancestors"), Cave 19, Longmen, Luoyang, Henan province, China. Tang dynasty, 660–76. Limestone, height of tallest figure 56 ft. (17.07 m).

rock-cut carved from solid stone, where it naturally occurs.

ushnisha one of the thirty-two markers of the Buddha, a buddha, or a *bodhisattva*: a protuberance from the head, usually a topknot of hair.

mural a painting made directly on the surface of a wall.

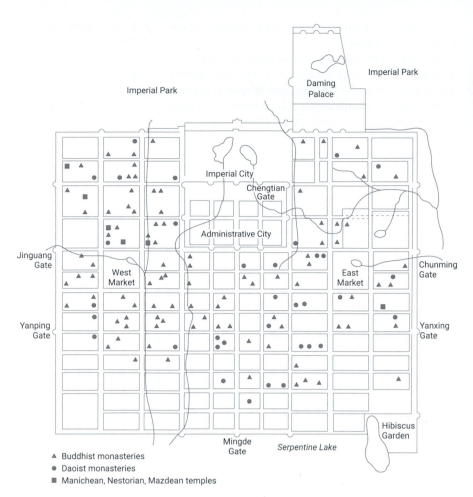

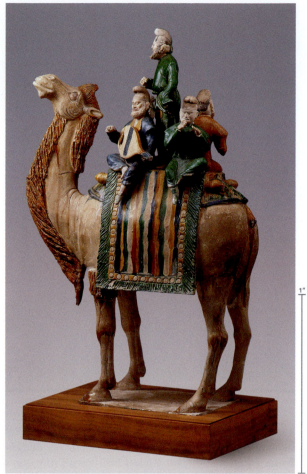

1"

27.8 ABOVE **Plan of the Tang capital,** Chang'an, China, Tang dynasty (618–906).

27.9 ABOVE RIGHT **Camel carrying musicians,** excavated in 1957 from the tomb of Xianyu Tinghui, Xi'an, Shaanxi province, dated to 723. Earthenware with three-color (*sancai*) glaze, height 26 in. (66.04 cm). National Museum of China, Beijing.

Chang'an was one of the three largest cities in the world during the ninth century. (The other two were Constantinople and Baghdad.) The city plan embodies geomantic principles, but it also reveals a concern for controlling residents and visitors. For example, 18-foot-high (5.49 m) outer walls not only served to protect the city's approximately one million inhabitants, but also facilitated close monitoring of traffic in and out of the city's gates. Order and surveillance within the city were aided by additional walls and gates for each of the its 108 wards.

Chang'an owed its size and wealth in part to trade, and the Tang dynasty extended its control westward to include towns and garrisons along the Silk Road, which connected Chinese regions to Central Asia and points further west, including Constantinople and Baghdad. The trade routes continued further east, too, carrying exotic goods to cities on the Korean peninsula and Japanese archipelago (see Seeing Connections: Early Global Networks: The Silk Road, p. 270). Tang exports included tea, ceramics, and silk. At the West Market in Chang'an, consumers could purchase imported peaches, dates, figs, sugar, cotton, and other foreign products.

EARTHENWARE CAMEL CARRYING MUSICIANS The
Tang taste for the exotic found its way into locally made goods such as this **earthenware** sculpture depicting a camel—the primary means of transport across the desert Silk Road—carrying a troupe of five musicians,

some of them recognizably foreign (**Fig. 27.9**). Two figures could be Han Chinese, but the other three have deep-set eyes, high-bridged noses, and thick beards, indicating their Central Asian heritage. One man holds a pear-shaped lute, an instrument from Central Asia that Tang dynasty music-lovers called a *pipa* (in Japanese, *biwa*; for an example of this instrument, see Seeing Connections: Early Global Networks: The Silk Road, p. 270).

The camel's proud bearing and the troupe's dynamic postures testify to the artist's skill in modeling lifelike sculptures. When compared to the accurate but stiff soldiers of the First Emperor's **terra-cotta** army (see Fig. 8.18), this camel and musicians suggest that the preference for naturalism had further developed by 723 CE, when the sculpture was interred as a grave good to accompany the deceased. The use of glazes, which produce a watertight seal, adds color that further enlivens the sculpture.

The work is typical of Tang dynasty ceramics called *sancai*, literally three-color ware, though not all of them include precisely three colors. Rather, the term is used loosely to refer to ceramics featuring multicolored glazes. During the Tang dynasty, brightly colored earthenware came in an astounding variety of forms, from dishes for household use to fantastic guardian figures to protect the dead. The need to furnish tombs, in particular, resulted in the creation and preservation of many earthenware versions of the animals, servants, officials, athletes, and entertainers of the Tang world.

earthenware pottery fired to a temperature below 1,200 degrees Celsius. Also called terra-cotta.

terra-cotta baked clay; also known as earthenware.

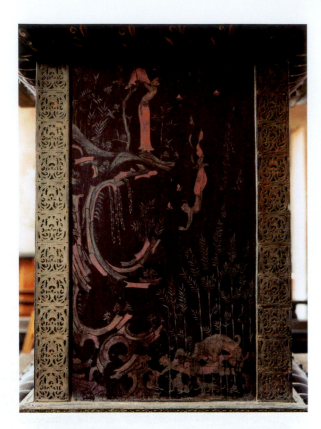

27.7 FAR LEFT *Mahasattva Jataka,* detail of the Tamamushi Shrine, Asuka period, *c.* 650. Lacquer painting on wood. Gallery of Temple Treasures, Hōryūji, Nara prefecture, Japan.

lead viewers back to the start, imparting a cyclical aspect to this Buddhist lesson.

This representation of Buddhist virtue also serves as evidence of the early history of East Asian painting. Compared to the Han dynasty lacquer box from Lelang (see Fig. 21.10), which placed lively but somewhat generic figures against a plain black background, the *Mahasattva Jataka* portrays the action of a specific, religious figure and uses the landscape setting to enhance the dramatic narrative. Still, the two paintings share visual strategies, including a contrasting **palette** and expressive lines. The *Admonitions of the Instructress to Court Ladies*, attributed to Gu Kaizhi (344–406) (see Fig. 21.13), is slightly closer in time to the *Jataka*, and the two works share some similarities. For example, both painters prefer sinuous bodies and fluttering drapery for representing their subjects.

The Tang Dynasty (618–906) and Buddhist Art in China

Although Buddhism was known on the Chinese mainland during the Han dynasty, not until the period of division did the faith garner widespread support, which continued in the Tang dynasty (618–906). Buddhism was not the only religion practiced during that time, however. The Tang capital city Chang'an was home to not only Buddhist and Daoist monasteries, but also to temples of the Manichean, Nestorian Christian, and Mazdean faiths (**Fig. 27.8**, p. 452). In addition, Confucian rituals took place at court as well as at ancestral shrines both inside and outside the city (for more on Confucianism, see Chapter 21).

Such religious tolerance and, more generally, cosmopolitanism arguably contributed to the dynasty's stability and wealth, but the Tang also benefited from the unification of the realm, which occurred earlier, during the short-lived Sui dynasty (581–618). The Sui rulers may not have been as ruthless as the First Emperor of Qin (see Chapter 8), but nevertheless their combination of military campaigns, including those waged unsuccessfully against the Goguryeo kingdom in Korea, and major infrastructure projects, such as the Grand Canal connecting the northern and southern regions of the empire, exacted a heavy toll. Opposition turned to outright rebellion. The Sui emperor was assassinated, and a new dynasty—the Tang—was founded.

CHANG'AN The Tang quickly occupied the former Sui capital and renamed it Chang'an, or "everlasting peace." The hopeful attitude expressed in the city's name is also evident in its form, set by the Sui and inherited by the Tang. The north–south axis, the uniform street grid, the east–west symmetry, and the privileged, north-central position of imperial and administrative precincts were all dictated by centuries-old beliefs that proper alignment of human activities to cosmological patterns ensured society's well-being (**Fig. 27.8**). These beliefs led to a system of practices, called geomancy or *fengshui*, that also include siting and orientation in accordance with topography, natural light, meteorological patterns, watersheds, and seasonal changes.

Tamamushi Shrine, a semi-portable **votive** shrine that resembles the *kondō* at Hōryūji (**Fig. 27.6**). *Tamamushi* is the Japanese term for a jewel beetle with iridescent wings, and the shrine is named after the beetle because its wings once adorned its **filigree** metalwork frames.

The Tamamushi Shrine features an icon housed inside a sanctuary hall elevated by an elaborate pedestal. The four sides of the pedestal are decorated with **lacquer** paintings of *bodhisattvas*, the Four Heavenly Kings, and *jatakas* on wood panels. *Jatakas* are stories of the Buddha's past lives. The painting on one side of the shrine pedestal illustrates the *Mahasattva Jataka*, popularly known as the Tale of the Hungry Tigress, which tells the story of Siddhartha's past life as Prince Mahasattva (see **Fig. 27.7**). While traveling in the wilderness, the prince chanced upon a starving tigress and her cubs. Moved to compassion, the prince gave his body to feed them. This painting depicts three distinct moments simultaneously, but the narrative unfolds spatially against a plain black-lacquer background. At the top of the cliff, the slender figure of Prince Mahasattva disrobes; to the (viewer's) right he plunges through the air; and below on the ground the mother tiger and her cubs devour his body.

The *jataka* has distressing and gruesome aspects, and yet the image is not repulsive. Elegant curves substitute for rocky terrain, and a fine tree receives the prince's clothing. Without hesitation or heaviness, his supple body falls as if performing a swan dive. Lotus buds in the air add sweetness and delicacy to his selfless act. A natural screen of bamboo softens the final scene, inspiring in viewers feelings of admiration, not horror. The *jataka* ends with the prince's act of selfless sacrifice, but the vermilion colors and swooping lines of the cliff

votive an image or object created as a devotional offering to a deity.

filigree a type of decoration, typically on gold or silver, characterized by ornate tracery.

lacquer a liquid substance derived from the sap of the lacquer tree, used to varnish wood and other materials, producing a shiny, water-resistant coating.

mudra a symbolic gesture in Hinduism and Buddhism, usually involving the hand and fingers.

mandorla (in religious art) a halo or frame that surrounds the entire body.

Manjushri, the *bodhisattva* of wisdom, and the layman Vimakalakirti. Another depicts the *parinirvana*—the event at the end of the Buddha's life when he experiences a complete liberation from embodied being and transformation into nothingness. The pagoda functions simultaneously as a reliquary site for *pradakshina*, a source for disseminating important Buddhist stories, and (from afar) a visual signpost to guide Buddhist visitors to Hōryūji.

SHAKA TRIAD Occupying the central position among numerous sculptures within the *kondō* at Hōryūji is the *Shaka Triad* (**Fig. 27.5**). The historical Buddha, known in Japanese as Shaka, sits in meditative posture on a raised dais over which the drapery of his monk's robe cascades. He smiles gently, raising his right hand in a **mudra** signaling viewers not to fear and lowering his left hand in a variation of the *mudra* of beneficence. An elaborate halo radiates around Shaka's head, and a flaming **mandorla** featuring seven, small seated buddhas nearly encompasses two smaller attendants standing at his sides. With haloes of their own and wearing crowns and sashes, these figures appear to be *bodhisattvas*. The sculptors' delight in line and pattern, readily apparent in the flowing drapery and swaying sashes, is fully realized in the exuberant haloes and crowns, which feature dazzling patterns of swirling flames, scrolling vines, beaded pearls, and lotus petals.

The *Shaka Triad* bears some stylistic resemblance to the Silla *Pensive Bodhisattva* (see **Fig. 27.1**), which was made at approximately the same time or slightly earlier. Robes and sashes drape elegantly over lithe bodies; haloes frame elongated faces. Like shared iconography, stylistic resemblance among sculptures reveals paths of cultural transmission. In the case of the *Shaka Triad*, genealogy and migration may be factors, too. The *Shaka Triad* is attributed to Tori Busshi (meaning "Tori the maker of Buddhist icons"), whose grandfather emigrated from the East Asian mainland. More generally, seventh-century Buddhist artwork from areas of both the Korean peninsula and the Japanese archipelago may be related to Northern Wei prototypes (see Chapter 21).

The sumptuous medium of the *Shaka Triad*, gilt bronze, points not only to metallurgical skill but also to royal patronage. An inscription on the back of the mandorla suggests that members of the Kashiwade family, close relatives by marriage to Prince Shōtoku, were the primary patrons. They commissioned this icon in 621. During that year Prince Shōtoku fell ill not long after his wife, the Princess of Kashiwade, died. The *Shaka Triad* expressed the family's hope for his recovery or his rebirth in a Buddhist pure land. The inscription also records the Prince's death in 623, and it attributes the icon to Tori. As the radiant icon captured viewers' attention and turned their thoughts toward Buddhist teachings, those involved in its making and to whom it was dedicated accrued religious merit, or karma, the sum of a person's actions that determines his or her future existences. At the same time, the sculpture demonstrated political allegiance by sealing the bond between the Kashiwade clan and Prince Shōtoku.

TAMAMUSHI SHRINE The *Shaka Triad* at Hōryūji's *kondō* demonstrates the relationship between icons and architecture: icons serve as the focus of rituals, while architecture provides sacred spaces to house icons and facilitate rituals. We see this relationship in miniature form in the

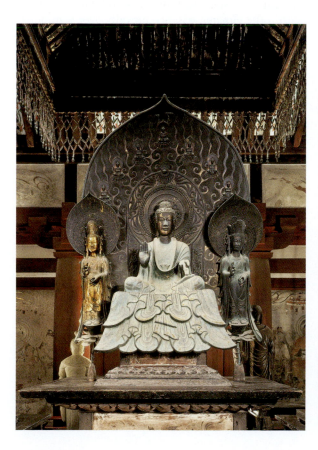

27.5 RIGHT **Tori Busshi,** *Shaka Triad,* Hōryūji, Nara prefecture, Japan, Asuka period, dated to 623. Gilt bronze, height 46 in. (1.17 m).

27.6 FAR RIGHT **Tamamushi Shrine,** Hōryūji, Nara prefecture, Japan, Asuka period, *c.* 650. Cypress and camphor wood, with lacquer, height 7 ft. 7½ in. (2.32 m). Gallery of Temple Treasures, Hōryūji.

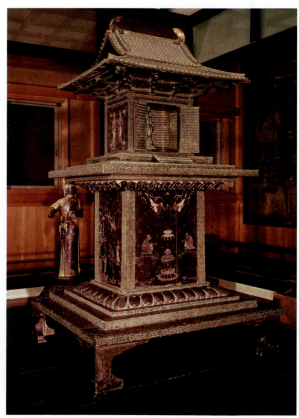

and communities. One major Shintō ritual is the periodic re-building of the Inner Shrine at Ise, the sanctuary of Amaterasu, who is the Sun Goddess and divine progenitor of the imperial family. Initial construction of the Inner Shrine is thought to date to the first century CE (see Seeing Connections: Art and Ritual, p. 462).

The diplomatic gifts from Baekje to Yamato included a Buddhist icon and *sutras*. Historical records indicate a mixed reception toward Buddhism at the Yamato court. When the emperor raised the question of whether to adopt this new religion, some aristocratic clans expressed support while others voiced opposition. The *kami* were said to be displeased, and the court split into two factions. Buddhism began to take root only after the Soga clan— who embraced Buddhism unequivocally—vanquished their rivals at court. With close relationships to peoples from the Korean peninsula and spouses from the imperial family, the Soga bridged cultures. They built a great temple; they supported monks, nuns, and artisans; and Buddhism grew in prominence during the Asuka period (538–710), so named for the location of the Yamato court.

Ultimately, the Soga's efforts and their success drew the imperial court's attention. Among the first of the Yamato court to embrace Buddhism were Empress Suiko (554–628) and her nephew and heir apparent,

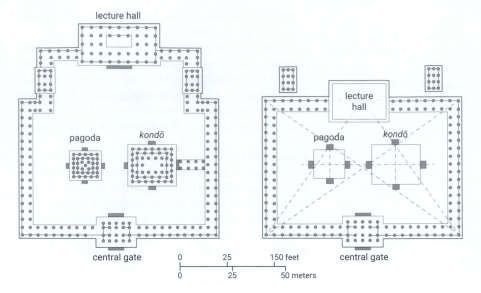

27.3 ABOVE **Plan of Hōryūji.** Original plan, early seventh century (right) and plan of the reconstruction, c. 711 (left).

Prince Umayado, who is better known as Prince Shōtoku (574–622). The latter was the patron of Hōryūji, founded in 607. Unfortunately, much of the original temple (**Fig. 27.3**, right) was destroyed by fire in 670, but it was rebuilt by about 711, and it remains one of the oldest surviving temples in Japan. *Ji* means "temple," and Hōryūji may be translated as the "Temple of the Flourishing Law," with "law" referring to Buddhist teachings.

In the aerial photograph of Hōryūji (**Fig. 27.2**), rooftops predominate, but the architectural plan is nevertheless clear (**Fig. 27.3**, left). Pierced by a central gate at the south and a lecture hall at the north, the **cloister** creates an enclosed space, carving a sacred precinct out of the secular world, an architectural strategy shared by the structures of Greco-Roman and Abrahamic religions. Within the cloister, balance prevails over symmetry. There, a five-story **pagoda** is matched by the shorter but broader *kondō*, or sanctuary hall. The pagoda and *kondō* are both made of wood, using a **post-and-lintel** system with **cantilevered brackets** to support tiled roofs that extend far beyond the timber frame. The pagoda's height draws the viewer's attention. Its elegant profile, created by the diminishing size of each story and the buoyant rooflines, directs the viewer's gaze skyward (**Fig. 27.4**). Several aspects of construction make the pagoda a marvel of structural engineering, giving it the flexibility and strength to withstand earthquakes. First, the post-and-lintel system does not use nails, reducing rigidity. Second, the central timber, or heart pillar, bears most of the pagoda's weight. Third, the primary material— wood—has a natural pliability compared to stone or brick.

Although the pagoda does not closely resemble its South Asian prototype in shape or material, it is essentially a *stupa*. The bronze **finial** connects to the single timber at the heart of the structure, marking the central location of relics hidden in a crypt beneath the structure. Bodily remains within a *stupa* are not meant to be seen, and similarly a pagoda is not designed to display relics. Instead, both structures are designed for *pradakshina*.

In addition, Hōryūji's pagoda features four sculpted **tableaux** of Buddhist narratives viewable from each of the four doorways. One tableau depicts the debate between

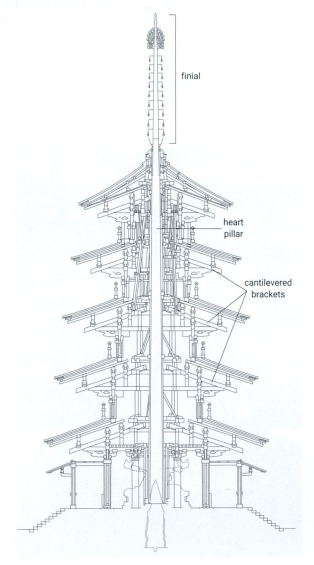

27.4 FAR LEFT **Hōryūji pagoda (cross-sectional drawing).**

pagoda in East Asia, the *stupa* form: a tall structure that houses Buddhist relics.

kondō literally, "golden hall"; the main hall of a Japanese Buddhist temple.

post-and-lintel a form of construction in which two upright posts support a horizontal beam (lintel).

cantilever a horizontal beam, slab, or other projecting structural member that is anchored at only one end.

brackets wooden supports that channel the weight of the roof to the supporting lintels and posts; used in East Asian architecture.

stupa a mound-like or hemispherical structure containing Buddhist relics.

finial a decorative knob, usually found on top of a pole or part of a building.

pradakshina the ritual circumambulation (walking or moving around) of a sacred place in Hinduism, Buddhism, and Jainism.

tableau a stationary scene of people or objects, arranged for artistic impact.

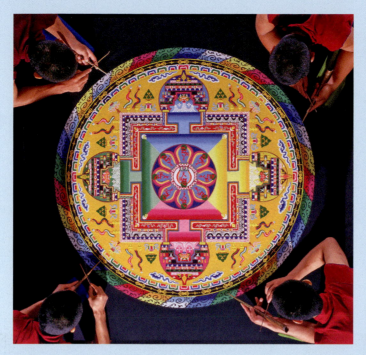

4 RIGHT **Amitayus sand mandala** (*Mandala of Amitabha*) made by the Tibetan monks of Drepung Loseling Phukhan Khamtsen, undated.

5 FAR RIGHT **Votive crown of Recceswinth,** from Visigothic Spain, seventh century CE. Gold, sapphires, and pearls, diameter 8½ in. (21.6 cm). Museo Arqueológico Nacional, Madrid.

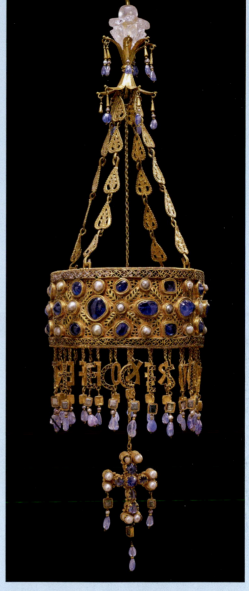

men to represent powerful clan spirits, called *nggwalndu*, and other supernatural beings (**Fig. 3**). To visually convey the spirits' dazzling supernatural power, initiators strive to make the displays as magnificent as possible. At the climax of each rite, initiates are brought inside the ceremonial house and shown the display but given virtually no information about the beings represented. Viewing the imagery becomes, in itself, the religious experience. Initiates do not learn the displays' significance until later in life, when they themselves become the initiators.

The religious experiences facilitated by Buddhist mandalas (**Fig. 4**) include visualization. Mandalas function like maps, but instead of navigating physical locations, devotees visualize the two-dimensional mandala as a three-dimensional universe with a deity or enlightened being residing at center. Here, the enlightened being is Amitabha (also called Amitayus), the Buddha who presides over the western paradise (see Figs. 27.12 and 27.17). Through intense identification with Amitabha, devotees realize the central Buddhist tenet of non-duality (the false perception of separateness). Mandalas made of colored sand, such as this one, offer another religious lesson as well. After painstakingly placing millions of grains of sand, the monks perform a ritual that destroys the mandala. With brushes and working in a prescribed order, they sweep away the sand, reminding viewers of the Buddhist belief in the impermanence of the world.

Politics and religion often intertwine in ritualistic activities, as in the case of the crown of Recceswinth from the seventh-century CE.

Recceswinth (ruled 649–672 CE) was king of the Visigoths in the area of present-day Spain. He used this crown (**Fig. 5**) to imitate a ritual performed by Byzantine emperors in Constantinople, the center of Christian orthodoxy (see Chapter 28). The king donated this golden crown, analogous to his own, to be placed over a church altar as a votive offering, to be symbolically "worn" by Christ, who was believed to be present on the altar. Letters dangling from the diadem read "RECCESVINTHVS REX OFFERET" ("King Recceswinth offers this"). This ceremonial gift reveals Recceswinth's recognition of Christ as the King of Kings while suggesting the Visigothic leader's political aspirations.

Discussion Questions

1. Ritual remains an integral part of cultural and artistic practices around the world. Ceremonies—ranging from the installation of leaders to marriages and college graduations—may use sacred objects, comparable to those described here, or secular ones. Discuss a ritual in which you have participated that included an image or ceremonial object.

2. Choose two of the artworks in this section and discuss the similarities and differences in the way various cultures have used art as a part of ritual.

Further Reading

- Ager, Barry. "Byzantine Influences on Visigothic Jewelry." In Chris Entwhistle and Noël Adams (eds.) *Intelligible Beauty:*

Recent Research on Byzantine Jewellery. British Museum Research Publication 178. London: British Museum, 2010, https://www.britishmuseum.org/research/publications/research_publications_series/2010/byzantine_jewellery.aspx.

- Coaldrake, William H. "Ise Jingu." In *Architecture and Authority in Japan*. London and New York: Routledge, 1996, pp. 20–42.

- Reilly, F. Kent, and Garber, James (eds.). *Ancient Objects and Sacred Realms: Interpretations of Mississippian Iconography*. Austin, TX: University of Texas Press, 2007.

- "Timelapse: Tibetan Sand Mandala Demonstration: The Monks of Drepung Loseling Phukhang Monastery." Asian Art Museum, San Francisco, August 17–19, 2012. https://www.youtube.com/watch?v=Sr1i5E3GbUA.

28

Art of the Byzantine Empire

540–1450

Theodora, apse mosaic
(detail), Church of San
Vitale, Ravenna, Italy.

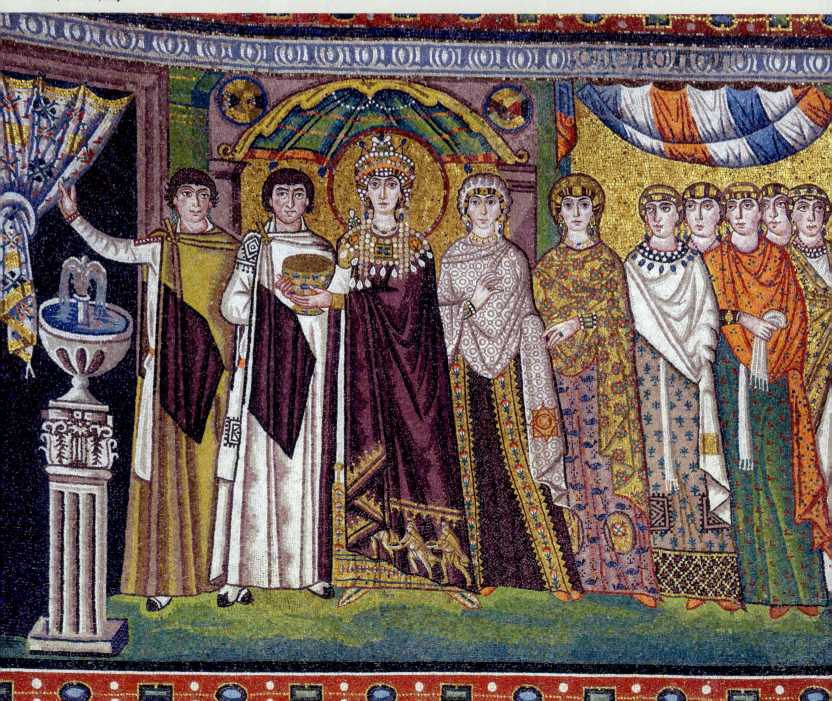

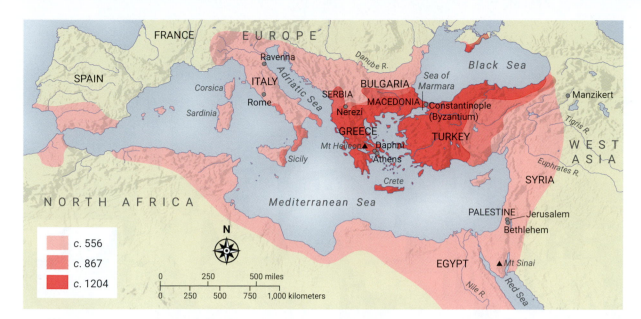

Map 28.1 The Byzantine Empire, c. 556–1204.

Introduction

In 324 CE, the Roman emperor Constantine consecrated the ancient Greek city of Byzantium as the New Rome, his imperial capital, and later renamed it Constantinople after himself. Following the fall of Rome in 476 CE, Constantinople became the primary city of the eastern part of the Roman Empire, now known as the Byzantine Empire. Located on the shores of the Bosporus, the natural strait connecting the Sea of Marmara and the Black Sea, Constantinople linked Europe and Asia and became the greatest seaport of the age. Goods from the Mediterranean world were traded alongside those transported from the east along the Silk Road. As a consequence, the city prospered and its political leaders became extremely wealthy.

Throughout their empire, Byzantine emperors sponsored grand churches that built on Roman, Greek, and West Asian artistic traditions. Between 540 and 1450 CE, Christian narratives fused political and religious authority in mosaics, illustrated books, and other precious objects. Emperor Justinian I (ruled 527–565), a major patron of art and architecture, used art to encourage religious piety and to enhance his political authority. By contrast, the Byzantine emperor Leo III (ruled 717–41) prohibited the production and public display of sacred icons to promote his religious beliefs and his political power. Subsequent Byzantine rulers reaffirmed the use of devotional imagery, which increasingly called attention to Christ's humanity and suffering. Although the size of the Byzantine Empire and the political might of its leaders waned after the Venetians took Constantinople in 1204, the city remained a cosmopolitan center of commerce, bridging Asia and Europe, and continued to be renowned for its extraordinary artistic accomplishment.

Justinian's Constantinople, 527–565

During Justinian I's reign, the Byzantine Empire expanded, extending its power across modern Greece, the Balkans, Turkey, and most of the eastern Mediterranean, including North Africa, Sicily, and Palestine (**Map 28.1**). Justinian and his empress, Theodora (497–548), presided directly over the military, the civil service, and the Church. To display his royal and ecclesiastical authority, Justinian constructed large and splendid buildings, including the church of Hagia Sophia ("Holy Wisdom").

HAGIA SOPHIA In 532 CE, riots, instigated by political factions cohering around supporters of rival chariot-race teams, destroyed nearly half of Constantinople, including the imperial palace and several major churches. After putting an end to the violent unrest, commonly called the Nike ("Victory") revolt, Justinian embarked on a major building program to restore the city. In addition to reconstructing the palace, he built a new Hagia Sophia (**Fig. 28.1**, p. 466) on the site of the previous church. Architects Anthemius of Tralles (a mathematician) and Isidorus of Miletus (a physicist) fused mathematical purity and simplicity—based on the round profile of a dome—with the complex engineering task of providing structural support for the dome while maintaining the openness of the space below (**Fig. 28.2**, p. 466). The monumental church, measuring 270×240 feet (82.3×73.15 m), is built on a **basilica** plan, with a wide **nave** and broad side **aisles** with **galleries** above (**Fig. 28.3**, p. 466).

Supporting half-domes on secondary **piers** flank the central dome and provide the longitudinal axis of the basilica, which is further emphasized by a projecting **apse** at one end and an inner **narthex** at the other. This dramatic centralized design produces a synthesis of the two previous types of Christian public buildings: the longitudinal basilica and the **centrally planned martyrium** (**Fig. 28.4**, p. 467). The resulting vast open space was the largest **vaulted** structure in the world before the construction of the new St. Peter's Basilica in Rome in the sixteenth century (see Fig. 45.12).

In contrast to the ancient Roman Pantheon (see Fig. 20.13), built of concrete and faced with marble bricks, the Hagia Sophia was built with masonry construction. In addition, the Byzantine church's magnificent central

basilica a longitudinal building with multiple aisles and an apse, typically located at the east end.

nave the central aisle of a civic or church basilica.

aisle a passage along either side of a nave, separated from the nave by a row of columns or piers.

gallery an interior passageway or other long, narrow space within a building.

pier an upright post that supports horizontal elements, such as a ceiling or arches.

apse a recess at the end of an interior space, often semicircular, and typically reserved for someone or something important, such as the altar in a church or the throne of a ruler.

narthex the entrance hall or vestibule of a church.

central plan a design for an architectural structure, whether round, polygonal, or cruciform, that features a primary central space surrounded by symmetrical areas.

martyrium a building constructed to commemorate the site of a saint's execution or the location of holy remains.

vault an arched stone structure, usually forming a ceiling.

28.1 Hagia Sophia,
Constantinople (Istanbul), Turkey, 532–37 CE. Architects Anthemius of Tralles and Isidorus of Miletus. The external buttresses and four minarets were added later.

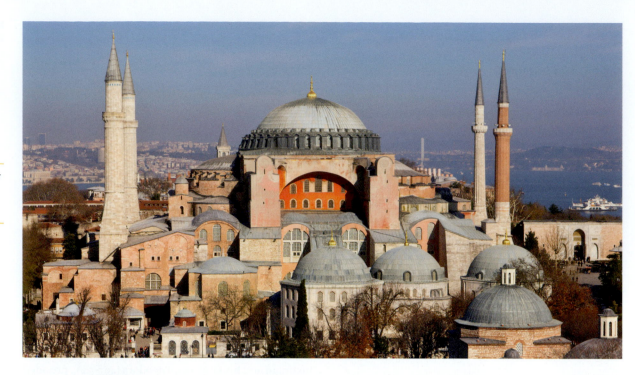

pendentive a curved triangular wall section linking a dome with a supporting vertical pier or wall.

28.2 BELOW **Hagia Sophia, cross-sectional diagram.**

28.3 BOTTOM **Hagia Sophia, plan drawing.**

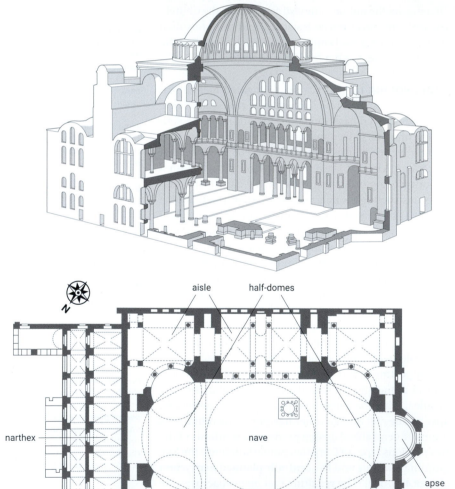

aisle half-domes

narthex

nave

apse

0 90 feet

0 30 meters

dome

dome, more than 100 feet (30 m) in diameter, does not rest atop cylinder walls. Rather, it is carried on four enormous arches that rest upon corner piers on a square ground plan. To provide structural support, **pendentives** (see **Fig. 28.5**) were strategically placed at the transition point between the straight walls and the curved dome to reinforce the dome and keep it from collapsing. They appear to hang like pendants from the dome's base. The base of Hagia Sophia's central dome, more than 100 feet above the floor, is pierced by forty small windows, giving the impression that the dome is floating above the rest of the building in brilliant light, without any material support.

As Justinian's palace church, Hagia Sophia provided visible evidence of the emperor's power, while linking his reign back to that of Constantine. Together with his co-emperor Licinius, Constantine had legalized Christianity in the Roman Empire and had commissioned the monumental Church of the Holy Apostles, which was in severe disrepair and rebuilt by Justinian (only to be lost after the Ottoman conquest). Justinian was not simply satisfied by connecting himself to first Christian emperor of Rome: he strove to outdo Constantine by commissioning the most grandiose sacred place ever constructed. Fusing political with religious authority, its magnificent vaulted space suited the new emperor-centered rite of Divine Liturgy (the Byzantine celebration of the Eucharist, a commemoration of Christ's Last Supper with his disciples that is ritualistically performed in thanksgiving for the gift of salvation).

Hagia Sophia became the site in which the theocratic (priestly, or led by divinely guided officials) rituals of the Byzantine state were performed in public. The nave was reserved for the clergy and the emperor, whose presence reinforced the union of Church and State. The laity, separated by gender, watched the performance of Divine Liturgy from the margins: men from the side aisles and women from the galleries above. This segregation,

intended to minimize erotic interest, removed women from the actions occurring on the ground floor.

Upon entering Hagia Sophia on the day of its dedication, the emperor reportedly exclaimed, "Solomon, I have surpassed you!" To Justinian, the newly consecrated church of Constantinople exceeded the famous Temple of Solomon (Jerusalem), which had been destroyed in 587 BCE. The quotation also suggests that in building Hagia Sophia, Justinian felt he had eclipsed King Solomon, who was renowned for his holy wisdom.

CHURCH OF SAN VITALE, RAVENNA In 535 CE, Justinian's forces, under the direction of his general Belisarius, defeated the Ostrogoths in Italy and reclaimed the city of Ravenna, which had been the former capital of the Western Roman Empire and then of the Ostrogothic kingdom of Italy (see Chapter 23). Their goal was to restore the imperial boundaries in the west. Construction of the Church of San Vitale started nine years before Justinian's victory but was not completed until 547 CE.

San Vitale's polygonal design is based on the central plan that Justinian favored for palace churches and

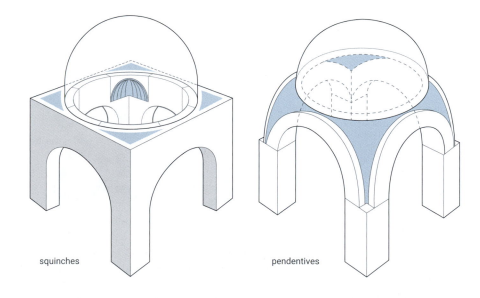

squinches pendentives

28.5 **Methods of supporting a dome:** with squinches (left) and with pendentives (right).

28.6 RIGHT **Christ as Pantocrator,** apse mosaic, Church of San Vitale, Ravenna, Italy, c. 546.

28.7a and **28.7b** **Plan drawing** (BELOW LEFT) and **cross-sectional drawing** (BELOW RIGHT) **of Church of San Vitale,** Ravenna, Italy, c. 546.

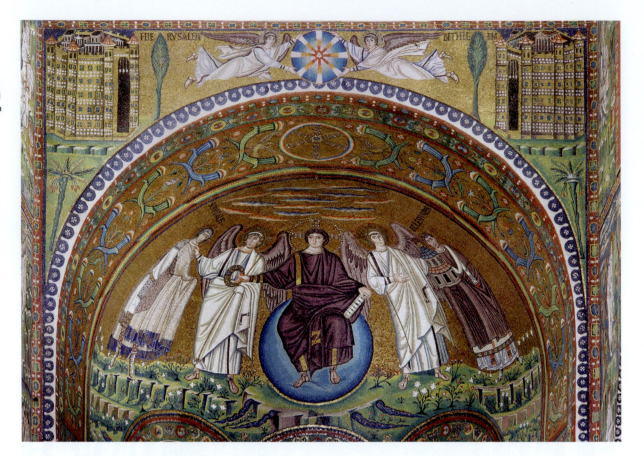

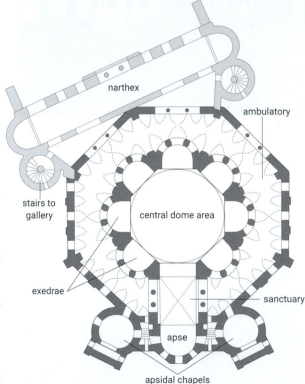

mausoleum (plural **mausolea**) a building or freestanding monument that houses a burial chamber.

ambulatory a place for walking, especially an aisle around a sacred part of a religious space.

mosaic a picture or pattern made from the arrangement of small colored pieces of hard material, such as stone, tile, or glass.

conch a quarter-spherical cupola, or dome, over an apse.

high relief raised forms that project far from a flat background.

register a horizontal section of a work, usually a clearly defined band or line.

mausolea. Eight piers support a dome and a two-story structure of **ambulatory** and gallery (**Fig. 28.7**). One segment of the octagon—the easternmost niche—is expanded outward to become a chancel (a space reserved for the choir) with an apse, thus subtly introducing the axial emphasis of a basilica church into the otherwise central plan of a polygon.

APSE MOSAIC OF *CHRIST AS PANTOCRATOR* The chancel and apse of the Church of San Vitale contain luxurious decoration, highlighted by well-lit, colorful **mosaics**. In the **conch** of the apse above the altar table, a mosaic shows the youthful figure of Christ as Pantocrator (ruler of all) in a golden sky with rainbow clouds (**Fig. 28.6**). He is seated on a globe representing the cosmos. The four

rivers of paradise flow beneath him and offer nourishment to an extended landscape adorned with white flora. The enthroned Pantocrator, flanked by two angels, sits at the center of this celestial hierarchy. With his right hand, Christ extends a crown of martyrdom to St. Vitalis, the patron saint of the church. In his left hand, Christ holds a seven-sealed scroll to be opened up at the Apocalypse (the end of the world), against his knee. Rainbow bands form an arch above the sky, marking the fulfillment of God's promise from the Book of Genesis never again to destroy life on earth in a great flood. Opposite St. Vitalis stands Ecclesius, the church's chief patron, with an architectural model of his donation.

APSE MOSAIC OF JUSTINIAN, CHURCH OF SAN VITALE

The walls of the apse at the Church of San Vitale are covered with court portraits in mosaic. The haloed and crowned Justinian, dressed in royal purple, stands in the middle of the north side mosaic (**Fig. 28.8**). Although the emperor never entered this church, he is shown in the altar space bearing a gift: an expensive communion plate, or paten. To his right stand his secular advisors and members of his army. One of his soldiers holds a shield decorated with Constantine's symbol of the *Chi-Rho*, the first letters of Christ's name in Greek. To the emperor's left are clergymen. One of them is identified as Maximianus, the church's bishop, whom Justinian appointed and who served as his surrogate in reconquered Italy.

APSE MOSAIC OF THEODORA, CHURCH OF SAN VITALE

In the mosaic on the south side of the apse, the empress Theodora, wearing a bejeweled tiara, appears with a retinue of eunuchs (castrated males) and ladies (**Fig. 28.9**). As noted above, women watched the Divine Liturgy from an upper gallery at San Vitale. The fountain in the mosaic indicates that the entourage is gathered outside the sanctuary; women were not allowed in the apse. The fact that this depiction of the empress, who was renowned as a skilled political advisor, and her companions is found in the apse (an area that they would not be allowed to enter) indicates the enormous power she held.

Like her husband, Theodora is dressed in purple, and in her hands, she extends the donation of a costly Eucharistic chalice. The hem of her garment is decorated with images of the Three Magi, who according to the Bible brought gifts to the baby Jesus. The depiction of Justinian and Theodora near the altar, an area reserved for a privileged few, marks the royal couple's theological and political authority through their proximity to the holy. The figures of Justinian and Theodora seem to project forward, reinforcing their desire to commune with God.

JUSTINIAN DEFENDING THE FAITH, Justinian's power as both emperor and defender of Christianity is also expressed in a striking ivory carving (**Fig. 28.10**, p. 470), later given to Cardinal Barberini in the seventeenth century. Obtained from the tusks of African elephants, ivory was a precious material used by Roman artisans to make luxury goods. The crowned Byzantine ruler is depicted in **high relief** on horseback as if emerging from the center of the

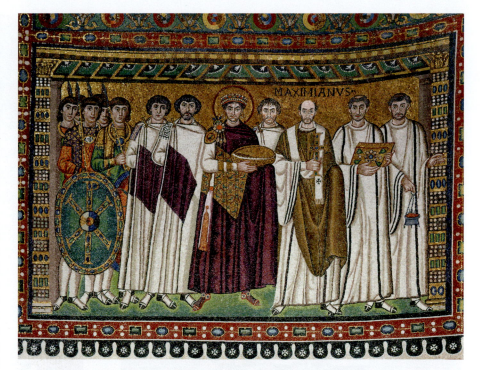

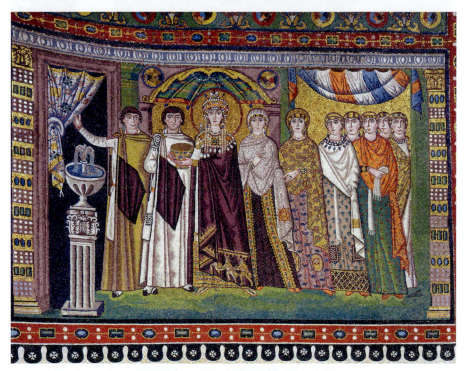

panel. Like the breastplate of the statue of Augustus from Prima Porta (see Fig. 19.1), this ivory carving depicts imperial military conquest. Justinian plants his royal standard before a startled enemy. A winged figure of Victory hovers on a globe, and a personified Earth sits below the raised hooves of Justinian's stallion. From the (viewer's left) side, a soldier brings another trophy of victory. A similar figure presumably once stood in the empty panel on the right. Divine sanction appears in the **register** above, where the frontal and beardless figure of Christ, centrally located between angels, blesses Justinian's conquest. Below the emperor, in the bottom register, smaller depictions of people whom the Byzantines would have considered

28.8 TOP **Justinian and his entourage,** apse mosaic, north side, Church of San Vitale, Ravenna, Italy, *c.* 546 CE.

28.9 ABOVE **Theodora and her entourage,** apse mosaic, south side, Church of San Vitale, Ravenna, Italy, *c.* 546 CE.

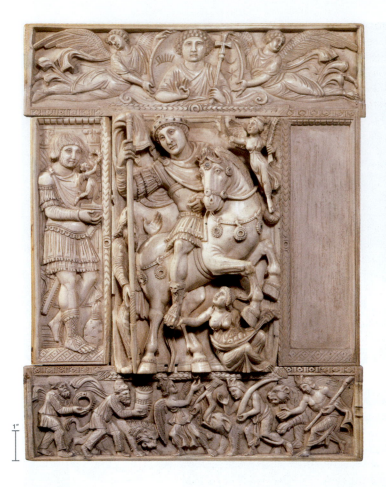

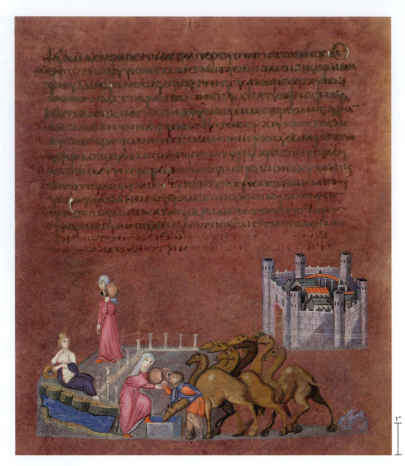

28.10 ABOVE *Justinian Defending the Faith,* mid-sixth century. Imperial ivory plaque, 14¼ × 11 in. (36.2 × 27.9 cm). Musée du Louvre, Paris.

28.11 ABOVE RIGHT **Rebecca at the well, from the** *Vienna Genesis,* (fol.7r), early sixth century. Tempera, gold, silver, on purple-stained vellum, 13½ × 9⅞ in. (34.3 × 25.1 cm). Österreichische Nationalbibliothek, Vienna.

diptych a two-part work of art, often two panels attached together.

codex (plural **codices**) a handwritten bound book.

vellum a writing surface originally made from calfskin.

parchment a writing surface prepared from the skin of certain animals that has been treated, stretched, and polished.

folio one leaf of a book.

illumination decorative designs, handwritten on a page or document.

recto the right-hand or front side of a folio.

pagans and barbarians, accompanied by exotic wild animals from Africa and Asia, approach him and offer diplomatic tributes. The Justinian panels, joined together by tongue and groove, record Christ's approval of the emperor's military deeds and was likely produced as an opulent gift to an imperial supporter.

Justinian's ivory carving resembles a **diptych**, which were often commissioned to commemorate the election of ancient Roman consuls. The format of consular diptychs is rooted in an earlier tradition in which letters of appointment were preserved within hinged covers prior to being sent to political allies. Although *Justinian Defending the Faith* is frequently described as a diptych, it is substantially larger than consular ivories (too big for a writing tablet) and lacks any trace of a hinge. Instead of serving as the surviving half of a diptych, the Justinian panels may be nearly complete.

VIENNA GENESIS In addition to creating luxurious mosaics and ivories for the imperial court, early Byzantine artists made costly objects that indicated their owners' wealth and religious devotion. These objects included books, which were expensive to produce and served to convey the power, piety, and social prestige of those who commissioned them.

In antiquity, the written word was typically inscribed on papyrus rolls, a format initiated by the Egyptians. The first Christian gospels were written as scrolls, but in the second century CE, scribes started to produce **codices**. These bound books were much sturdier than scrolls, which were prone to damage each time they were

rolled and unrolled. Early codices were typically made of bleached calfskin (**vellum**) or sheepskin (**parchment**) **folios** that were sewn together. Although this new format was a more durable medium, the thickness of the skins limited the length of the text. Producing the entire Bible required several codices.

During the late fourth and early fifth century CE, Christians began adding **illuminations** to their books. The density of vellum and parchment enabled the application of paint, and the pictures illuminated, or brightened, the text. Though the earliest surviving Christian codices, the *Quedlinburg Itala* (depicting four scenes from the biblical Book of Kings) and the *Cotton Genesis* (charred in a fire in the eighteenth century), are badly damaged, their style resembles that found in contemporary illustrations in non-Christian texts.

The *Vienna Genesis*, a Byzantine codex of the early sixth century that was probably produced in Syria or Palestine, is in much better condition. Written in Greek with silver ink (now severely tarnished) on purple-dyed vellum (now faded), it would have been quite costly and was probably made for a member of the imperial family. The surviving fragment of the original includes twenty-four colorful illustrations, depicted on the bottom half of the pages below the text.

On the **recto** of folio 7, the Old Testament story of Rebecca and Eliezar (Genesis 24) is described in word and image. According to the tale, Abraham's servant Eliezar was sent on a mission to find a suitable bride for his master's son Isaac. In the illustration (**Fig. 28.11**), Rebecca, dressed in pink with a light-blue

headscarf and carrying a jug, walks outside the walled city of Nahor to fetch water. She strolls past a Greco-Roman **colonnade** as she approaches a semi-naked reclining figure, a **Classical** personification of the source of water. In **continuous narrative**, Rebecca is depicted a second time in the picture, encountering Eliezar and ten camels and offering them a drink. Naturalistic details, such as the use of highlight and shadow on the camels, reveal an interest in rendering three-dimensional volume. The colorful illustration not only complements the text written above but also makes Rebecca's generosity more vivid, reinforcing the idea that she is an ideal bride for Isaac.

Icons, Iconoclasm, and the Presence of the Divine in Early Byzantine Art, 565–843

The word **icon**, in the sense of its Greek origin *eikon*, simply means image or likeness. Nonetheless, within the discipline of art history, icons are typically defined as sacred representations of religious subjects worthy of veneration. In the Bible, Christ is described as the "image of the invisible God" (Colossians 1:15). For Orthodox Christians—that is, those who follow the rituals of the eastern Church—images, as well as words, can function as sacred passages that bring the faithful closer to God. Icons are therefore not passive illustrations of biblical narratives or theological ideas. On the contrary, they actively foster greater intimacy with the divine, offering opportunities for mediation between pious viewers and the holy person represented.

Eastern Christian worshipers came to expect icons to provide help and healing just as relics, the physical remnants of holy figures, were believed to do. For example, an icon of Christ was prominently placed on the Chalke Gate in Constantinople, protecting citizens from foreign invasion. Like the original *palladium*, a powerful image of Pallas Athena located at a gateway into ancient Athens, the Chalke icon was thought to provide security to those residing in Constantinople. A large statue of Athena Polias (protector) also stood in front of the Erechtheion on the Akropolis (Fig. 14.14). In addition, Byzantine Christians celebrated images called *acheiropoietai*, believed to be miraculous creations, not made by human hands. For example, the *mandylion*, a representation of the Holy Face of Jesus impressed on a linen cloth and presented to King Abgar of Edessa, became a sacred Christian relic in the fifth century CE. Stories like this one may have informed later legends associated with sacred items such as the full-length body imprint on the Shroud of Turin, which some believe is Christ's burial garment.

Reacting to the excesses of Byzantine image devotion, critics claimed that human-made images replaced their divine prototypes with earthly idols, and **iconoclasm** broke out in 717 during the reign of Emperor Leo III (ruled 717–41). According to the iconoclastic patriarch John the Grammarian, icons hindered true worship, distracting beholders from the more praiseworthy representations of the divine in verbal descriptions. According to this view, icons showed only a person's outward appearance, but words revealed his or her character. After a period in which the Empress Irene temporarily restored the use of religious imagery (797–814), iconoclasm returned under Leo V. His successors intensified iconoclasm by stipulating stern punishments for all who made use of icons. During the eighth and ninth centuries, iconoclasts systematically destroyed panels and mosaics representing the sacred. Even the Chalke Christ was removed from the city gate and replaced with the symbol of the cross, which iconoclasts accepted as a sacred image. Despised

colonnade a long series of columns at regular intervals that supports a roof or other structure.

Classical artworks from, or in a style deriving from, ancient Greece or Rome.

continuous narrative multiple events combined within a single pictorial frame.

icon an image of a religious subject used for contemplation.

iconoclasm the intentional destruction or rejection of images on religious or political grounds.

GOING TO THE SOURCE • The Icon Debate

The Syrian monk John of Damascus (*c.* 675–749) was an iconophile: a person devoted to the veneration of icons. He lived far away from Emperor Leo III's reach, and he strongly defended the use of icons:

How can the invisible be depicted? How does one picture the inconceivable? How can one draw what is limitless, immeasurable, infinite? How can the formless be made? How does one paint the bodiless? How can one memorialize what is a mystery? It is obvious that when you contemplate the bodiless becoming man, then you may represent him in human form. When the invisible becomes visible in the flesh, you may then depict the likeness of the one seen. When the one who is bodiless and formless, immeasurable and boundless in his own nature, existing in the form of God,

takes the form of a servant in substance and in stature and is found in a body of flesh, then you may draw his image and show it to anyone wishing the visual contemplation of it.

For John of Damascus, the doctrine of the Incarnation—the conviction that God was made flesh in the person of Jesus—indicated that a material, earthly presence of the divine was already sanctioned. Therefore, John argued, denying the representation of Jesus rejected his humanity. Of course, icons needed to function as a means to an end, rather than as an end in themselves. Otherwise, the veneration of icons would be no different from the worship of idols.

The iconoclastic Council of 754 voiced its opposition to the veneration of icons: "How senseless is the painter's notion when he from

sordid love of gain pursues the unattainable, namely to fashion with his impure hands those things that are believed to be in the heart and confessed by the mouth." According to the Council, the use of icons attempts the impossible: the containment of the sacred in the here and now. They argued that efforts to localize the divine in art address only the visible materiality of creatures and fail to recognize the spiritual presence of the sacred and the irreducible omnipresence of God.

Discussion Questions

1. Why is the distinction between veneration and worship important for iconophiles?
2. Compare the ideas of Byzantine iconoclasts to those of early Buddhists, who did not create representations of their spiritual leader.

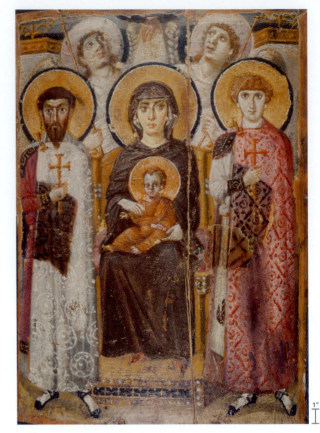

28.12 FAR RIGHT *Virgin and Child with Angels and Saints,* Monastery of St. Catherine, Mount Sinai, Egypt, *c.* 700. Encaustic on wood, 27 × 19⅜ in. (68.6 × 49.2 cm).

by enemies of the faith, the cross was an effective symbol marking the identity of the Christian religion.

The controversy over icons may have been deepened by power struggles between emperors and Orthodox clerics, especially as Islam spread and began to threaten the borders of the Byzantine Empire. In addition, Islam's even stricter prohibition against religious images might have evoked a comparable response within the community of the Christian faithful in a regional struggle for hearts and minds.

VIRGIN AND CHILD ENTHRONED WITH ANGELS AND SAINTS

This icon of the Virgin and Child (**Fig. 28.12**), made for St. Catherine's Monastery on Mount Sinai in Egypt (*c.* 700), is a rare survivor of later iconoclasm. The monastery's remote location allowed the icon to escape destruction at the hands of Byzantine image-breakers. In this work, the seated Virgin Theotokos (meaning "Bearer of God") and her son are shown frontally, positioned in hierarchy. They are flanked by two warrior-saints, Theodore and George, who gaze intensely at viewers. Behind them, two angels strain their necks, directing onlookers' vision to the heavens, as a centrally placed hand of God offers a blessing. The icon is quite crowded, discouraging devotees' eyes from wandering and encouraging the faithful to discover the means of their salvation.

CHURCH OF HAGIA EIRENE

Iconoclasts challenged the validity of images as divine likenesses, but they were not against the use of all depictions, only those that they believed could promote idolatry. During the reign of Constantine V (741–75), the saints and the Eucharist were often evoked as appropriate representations of Christ. The austere Church of Hagia Eirene (Holy Peace) is an example of this approach. Originally constructed in Constantinople shortly before Hagia Sophia, Hagia Eirene was rebuilt in 740–53, during a period of iconoclasm. The apse is decorated with mosaics representing an empty cross against a golden background (**Fig. 28.13**).

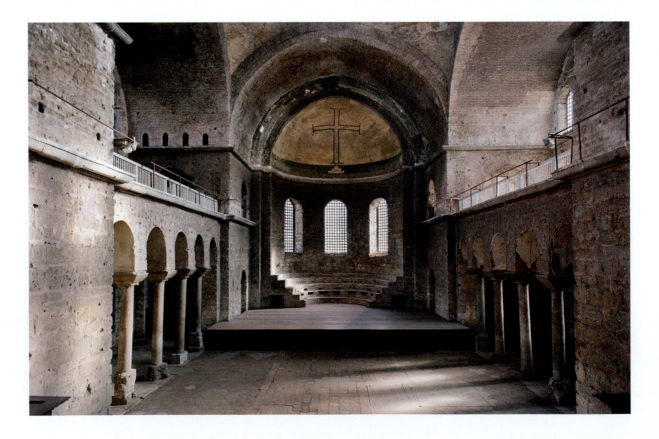

28.13 Hagia Eirene, Constantinople (Istanbul), Turkey, 740–53.

Iconoclasts did not worry that someone might start worshiping the cross as an idol; after all, it was the tool used to execute their God. Its depiction drew attention to Christ without showing his likeness. In words attributed to Constantine V, "We bow down before the figure of the cross because of him that was stretched upon it." Today, many Protestant churches display images of the cross in isolation, with no representation of Jesus.

KHLUDOV PSALTER In 787, the Byzantine regent Empress Irene restored the use of religious imagery. This interruption of iconoclastic policies continued until 814, soon after Leo V became emperor. Leo V and his successors reintroduced the attack against visual representations of the divine. However, after the death of her husband Theophilos in 842, Empress Theodora (not to be confused with Justinian's wife), ruled as regent on behalf of her two-year-old son, and she reinstated the practice of venerating icons in 843, an event celebrated thereafter as the Triumph of Orthodoxy. The mosaic of the enthroned Virgin Theotokos and Child—the very picture of the Incarnation—was reinstalled in the apse of Hagia Sophia, and the icon of Christ reappeared on the Chalke Gate.

After the rejection of iconoclasm, the *Khludov Psalter* of the ninth century, a codex initially housed at Mount Athos and later acquired by Aleksey Khludov, called attention to what was perceived as the impious folly of icon destruction. One page of this heavily illustrated manuscript, created in Constantinople, is inscribed with verses from Psalm 69, an Old Testament passage summoning God to crush the enemies of the faith. It contains an illustration from Christ's Crucifixion showing soldiers mocking Christ (**Fig. 28.14**). One of the soldiers offers Christ a vinegar-soaked sponge to quench his thirst. Below the biblical narrative, two iconoclasts, labeled John the Grammarian and the Bishop of Constantinople, apply vinegar to a sacred icon in an attempt to erase Christ's depiction. Their destructive gesture echoes the deeds of the tormentors represented above. The soldiers who treated Jesus with such disdain are thus equated with iconoclasts who make Christ suffer by defacing his image, thus committing an act of violence against God.

Art of the Middle Byzantine Period, 843–1204

The rejection of iconoclasm in 843 opened up new opportunities for ecclesiastical imagery. Wealthy aristocrats renewed their sponsorship and churches were once again filled with icons. Even though the empire was under frequent attack, periodically losing territory to the Muslim Abbasid Empire and its vassal states, members of the Byzantine court continued to establish monasteries across the empire and to fund Christian missionaries in Russia and other Slavic lands.

Political tensions between eastern and western Europe increased throughout the ninth and tenth centuries. Charlemagne, crowned Holy Roman Emperor by the pope in 800, believed his newly obtained position made him the western co-equal of the Byzantine leader. The court in Constantinople disagreed and considered him to be only the king of the Franks, a "barbarian" tribe active in the Rhineland (an area in west Germany along the river Rhine). Diplomatic relations between the Church in Rome and the Orthodox Church became increasingly strained. In 1054, a papal delegation went to Constantinople in hopes of achieving unity. Negotiations broke down, leading to the Great Schism, with the pope in Rome and the patriarch of Constantinople promptly excluded each other from participating in the sacraments by officially taking away the rights of church membership (excommunication). Nonetheless, roughly forty years later, the Byzantine emperor successfully solicited the help of Pope Urban II in his effort to recapture the city of Jerusalem, initiating the First Crusade (1095), which resulted in a short-term victory for European Christians.

The Byzantine Empire remained poised between western Europe and the expanding world of Islam in the Eastern Mediterranean under the Seljuqs, who wrested Anatolia (present-day Turkey) from the Byzantines in 1071 at the Battle of Manzikert (see Chapter 33). Within Constantinople, civil war ensued. The entire region was further destabilized by the Crusades, military expeditions carried out over two centuries by western European Christians to regain the region of the eastern Mediterranean that they considered to be the Holy Land. As Byzantine imperial power diminished, sailors from Venice who were responsible for the transport of troops on the fourth crusade to retake the Holy Lands, were paid to maintain order and to protect Constantinople from attack. In April 1204, however, the Venetians decided to forgo the fourth military campaign to take Jerusalem and

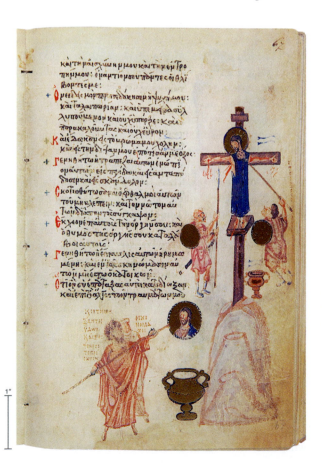

28.14 FAR LEFT **The Crucifixion with iconoclasts, from the *Khludov Psalter*** (fol. 67r), *c.* 850–75. Tempera on parchment, 7¾ × 6 in. (19.7 × 15.2 cm). State Historical Museum, Moscow.

cross-in-square design a square floor plan, quite popular in Middle and Late Byzantine churches, featuring internal elements in the shape of a cross and a large central dome.

barrel vault also called a tunnel vault; a semi-cylindrical ceiling that consists of a single curve.

bay a space between columns, or a niche in a wall, that is created by defined structures.

squinch a support, typically at the corners of a square room, used to carry a dome or other superstructure.

sacked Constantinople instead, shipping much of their acquired loot back home. Despite the political instability of the Middle Byzantine era, the visual arts continued to flourish, encouraging some scholars to label this period a second golden age, analogous to the opulence enjoyed during the reign of Justinian.

DAVID COMPOSING PSALMS, *PARIS PSALTER* In the mid-tenth century, the imperial scriptorium (where royal manuscripts were made) produced a magnificent illuminated version of the biblical Book of Psalms. The *Paris Psalter*, named after its present location, shows David (revered as king, poet, and ancestor of Jesus) composing the psalms (**Fig. 28.15**). Within a square frame that suggests an independent picture, David the shepherd (not yet king) sits with his lyre amid his flocks in a delicately rendered landscape setting that includes rocks, buildings, and foliage. Behind him the personification of Melody provides inspiration. A laurel-crowned male figure, labeled "Bethlehem," the hometown of David and the birthplace of Jesus Christ, listens and lounges like an ancient river god in the lower-right corner. All the figures turn in space and gesture with natural ease; one listening woman even peers from behind a stone column. She seems to echo the attentiveness of the animals calmed by David's Orpheus-like song. (In Greek myth, Orpheus's music could soothe even wild beasts.)

28.15 David composing psalms, folio 1 verso from the *Paris Psalter,* c. 950 (detail). Tempera on parchment, 14 × 10¼ in. (35.6 × 26 cm). Bibliothèque Nationale de France, Paris.

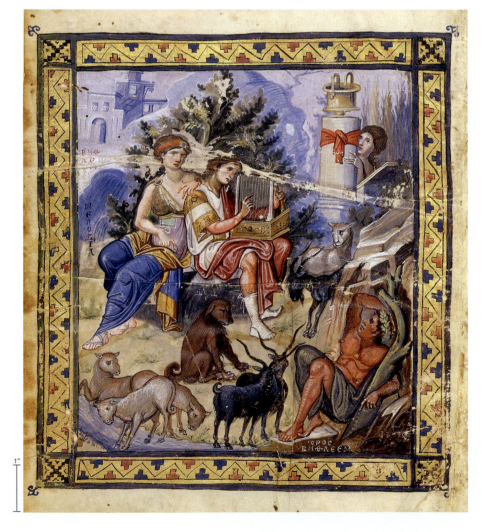

Emperor Constantine VII may have commissioned the psalter as a gift to his son Romanos II. Christians praise King David not only for his military prowess but also for his appreciation of, and participation in, the arts. Tales from the life of this talented Old Testament monarch may thus have served as a model for the young prince to imitate.

KATHOLIKON, HOSIOS LOUKAS Throughout the Middle Byzantine period, numerous monasteries were built across the empire. Most of these religious complexes were relatively small, housing twelve or fewer monks. These monastic churches helped establish a new approach to church architecture, the **cross-in-square design**. Within this spatial organization, a central dome is placed above the crossing of four arms of equal length. These four **barrel-vaulted** arms, which form a cross, are enclosed by a square consisting of additional vaulted **bays**. Following convention, the apse faces east toward sunrise, anticipating the day when Christians believe that Christ (the light of the world) will triumphantly return. The apse is usually flanked by two separate chambers, the *prothesis* (a place reserved for the preparation of the Liturgy) and the *diaconicon* (a storage room for liturgical items). A vaulted narthex is often added to the west side of the church.

The Katholikon (**Fig. 28.16**), or main church, of the Hosios Loukas monastery in Greece, like the adjacent older church of the Theotokos, is a cross-in-square structure (**Fig. 28.17**). Located in the foothills of Mount Helicon, a site associated with the Muses in ancient Greek mythology, the Katholikon contains superb examples of Middle Byzantine church decoration. The monastery is dedicated to the Blessed Luke, a local hermit of the tenth century (not to be confused with the gospel writer) who predicted military victory over the Muslim subjects of the Abbasids on the island of Crete. Although the church is part of a monastery, pilgrims regularly visited the Katholikon in hopes of obtaining divine grace.

The building, which lacks a longitudinal plan and ambulatory, is not particularly well suited for large public processions. Instead, it functions as an intimate gathering place, evoking communion with the saints. As the art historian Otto Demus argues, the church serves as "an icon in space." Within the edifice, the space of the worshiper is joined with the pictorial space in which holy figures exist. The placement of images is hierarchical, with the most important icons located at the highest elevation and closest to the altar. The loftiest spot in the church, the central dome, is decorated with a mosaic once showing Christ as Pantocrator (now lost), surrounded by angels and the Theotokos, who stands with arms outstretched in prayer. The vaulted dome nearest to the altar shows the Pentecost, the moment when, according to Christian belief, the Holy Spirit descended on Christ's followers and gave them the power to speak in numerous tongues. This mosaic is located directly above the site where the officiating priest offered a homily or sermon during Divine Liturgy. In the conch of the apse, the Theotokos appears enthroned with the Christ child. Like the Eucharistic chalice, the paten, and the church itself, she holds that which cannot be held, namely God Incarnate.

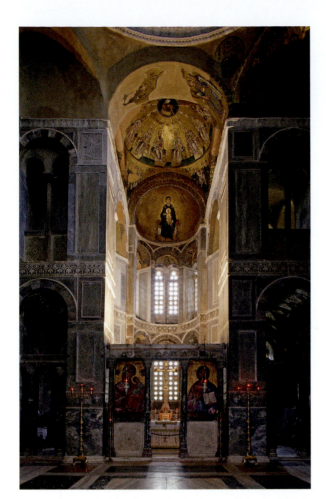

BAPTISM OF CHRIST, KATHOLIKON SQUINCH MOSAIC

The central dome of the Katholikon rests directly on **squinches**, reminiscent of pendentives, that serve as a base for the setting of a dome (see **Fig. 28.5**). Mosaics located in the four squinches represent narratives linked to key events from Christ's life that are celebrated on specific religious holidays. One of these images, a scene

28.16 FAR LEFT **Katholikon,** Hosios Loukas. Near Stiris, Greece, *c.* 1000–25.

28.17 BELOW **Katholikon (plan drawing),** Hosios Loukas, near Stiris, Greece, *c.* 1000–25.

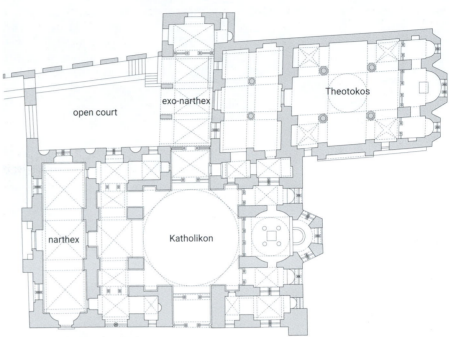

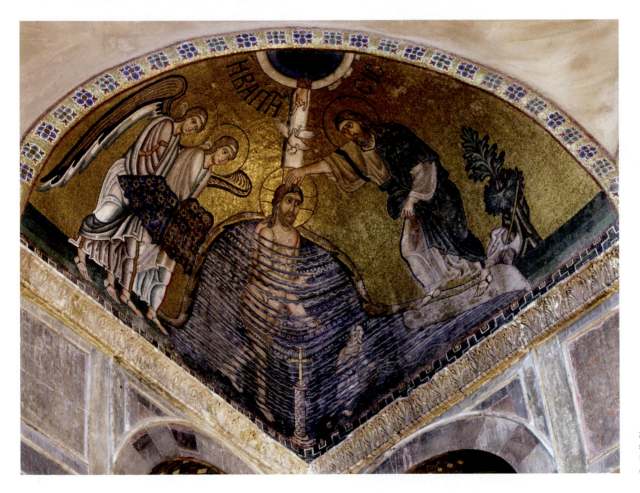

28.18 *Baptism of Christ,* squinch mosaic, Katholikon, Hosios Loukas. Near Stiris, Greece, *c.* 1000–25.

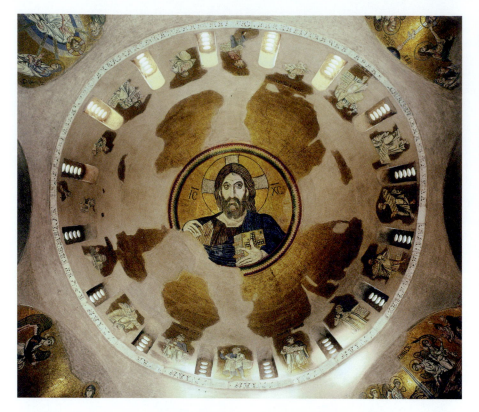

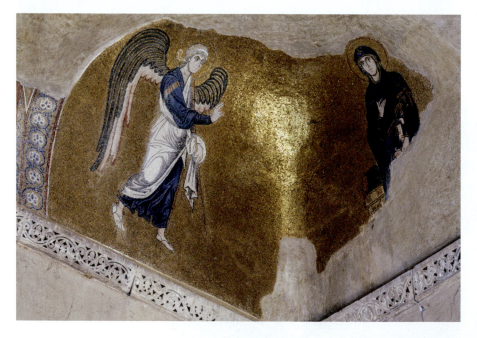

personifying the River Jordan can be seen in the foreground, completely immersed. Although the scene may have reminded beholders of the sacrament of baptism, Christians believe that Christ did not need to be cleansed of sin. The significance of this narrative thus lies in the divine acknowledgment that Jesus is the Son of God.

CHRIST AS PANTOCRATOR MOSAIC, CHURCH OF THE DORMITION

Another Middle Byzantine cross-in-square structure is the monastic Church of the Dormition (the "falling asleep" or death of Mary), which may have been commissioned by the emperor Basil II (ruled 976–1025). It is located in Daphni, site of an ancient laurel grove near Athens. Unfortunately, the building was sacked by Frankish crusaders in 1205, and it has been severely damaged by earthquakes. Nonetheless, a dramatic mosaic of the Pantocrator survives in its **cupola** (**Fig. 28.19**). Unlike the Apollonian image of a beardless, youthful Christ found at San Vitale (see **Fig. 28.7**), the Daphni Pantocrator looks quite stern, readily to admonish beholders. This Christ has a cruciform (cross-shaped) halo and grips sacred scriptures in his left hand. The deep shadows around his eyes and the heavy linearity of the image seem to confront beholders, demanding to know whether they are contrite and properly prepared to enter heaven.

ANNUNCIATION SQUINCH MOSAIC, CHURCH OF THE DORMITION

The central dome of the Church of the Dormition rests on four squinches decorated in mosaic. Clockwise from the northeast corner, they represent the Annunciation, the Nativity, the Baptism of Christ, and the Transfiguration (when Christ's body radiates in heavenly light on Mount Tabor). These mosaics depict earthly manifestations of the divine and celebrate major feasts in the Byzantine liturgical calendar. In the *Annunciation* (**Fig. 28.20**), the narrative is simplified, reduced to two figures that are cast against the abstract gold background of the squinch. The Archangel Gabriel and the Virgin Mary, devoid of an architectural setting, seem to float elegantly. By virtue of the squinch's curvature, the figures face one another. More importantly, the angel's message is delivered across the actual space of the church's interior rather than within the virtual space of the image. Although the Virgin Mary faces Gabriel, she looks down at the viewer, encouraging further psychological engagement. The mosaic does not merely function as a window, revealing a transcendental celestial scene. Instead, it offers beholders the opportunity to see the presence of the holy within the shared space of the church. In other words, the image effectively intertwines heaven and earth, uniting biblical events with the world of the viewer.

THE VIRGIN OF VLADIMIR

During the eleventh and twelfth centuries, the borders of Byzantium came under frequent attack, and imperial boundaries shrank. Nonetheless, Orthodox Christianity continued to grow, spreading to Russia and the Balkans. In the late tenth century, Vladimir, the Prince of the Kievan Rus (from which the name Russia derives), converted to Christianity and established a political alliance with the Byzantine

28.19 TOP *Christ as Pantocrator,* central dome mosaic in the Church of the Dormition, Daphni, Greece, c. 1090–1100.

28.20 ABOVE *Annunciation,* squinch mosaic in the Church of the Dormition, Daphni, Greece, c. 1090–1100.

cupola the underside of a dome; also a dome-like element set atop a dome or other roof.

of the Annunciation (the conception of Jesus Christ; March 25), has been lost. The remaining three depict the Nativity (December 25), the Baptism of Christ (January 6) (**Fig. 28.18,** p. 475), and the Presentation in the Temple (Christ's appearance in the Temple forty days after his birth; February 2).

In the *Baptism of Christ*, the hand of God and dove of the Holy Spirit descend from above, reinforcing Christ's divinity as the second person of the Holy Trinity. John the Baptist anoints Jesus's head with water. The full-length, naked figure of Christ is nearly covered by water. The river's movement is conveyed through the repetition of heavy lines. To Christ's left, an elderly man

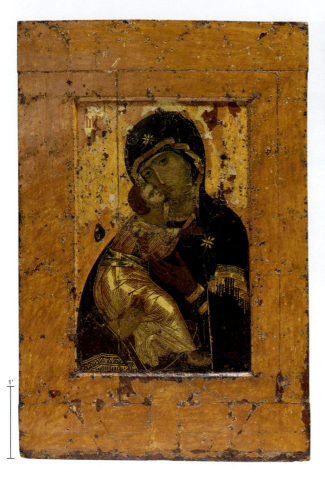

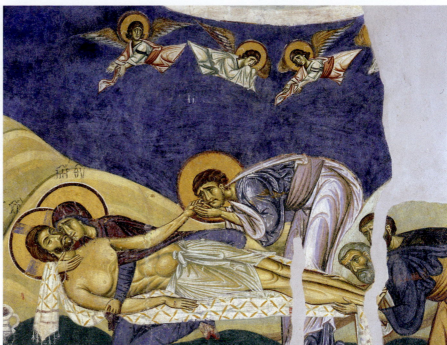

emperor. *The Virgin of Vladimir* (**Fig. 28.21**) was probably produced in Constantinople and brought to Kiev as a diplomatic gift. In the capital of the Rus, the icon quickly became associated with miracles and divine protection. As the center of the Russian kingdom shifted, the painted panel was moved in 1155 to the city of Vladimir, from which it receives its name. The icon was later transported (in 1480) to Moscow, where it served as a *palladium* or protective icon in defense against Mongol invasion.

The Virgin of Vladimir is an example of the Virgin Eleousa, a type of icon that conveys the deep affection between Mother and Child. By contrast, many icons represent the Virgin as a guide (Virgin Hodegetria) showing the way to salvation by pointing to the infant Jesus. This icon, however, concentrates on her compassion. The two figures evoke maternal sweetness as the Christ child lovingly presses his cheek against his mother, who gazes outward, making meaningful eye contact with the beholder. Her apparent sadness conveys her foreknowledge of Christ's impending suffering and death.

LAMENTATION, MONASTERY OF ST. PANTELEIMON The same tenderness and intimacy are also apparent in religious narratives painted in the Balkans. Wall murals in a monastery at Nerezi (near Skopje in North Macedonia), rendered in true **fresco**, feature an early and intense presentation of the final parting of the Virgin from her dead son (**Fig. 28.22**). This image shows mourners encountering Christ's corpse and offers an early anticipation of the Pietà (that intimate farewell that became popular in western

Europe during the late Middle Ages and Renaissance), excerpted from the Lamentation story to show only the Virgin and her deceased adult son for devotional purposes (Fig. 36.22). Here elongated holy figures touch cheeks as a tearful St. John, at a slight distance, caresses the wounded hand of Jesus. Heartfelt emotion dominates the scene, fostering greater empathy in viewers.

Late Byzantine Art, 1204–1453

After the Sack of Constantinople, western Europeans continued to occupy the city until 1261, when emperor Michael VII Palaiologos (ruled 1259–1282) reclaimed it. During his triumphal entry into Constantinople, Michael VII walked behind an icon of the Virgin Hodegetria (now lost), marking the city's continued dedication to the Theotokos while imploring her to provide much-needed protection. Although the Byzantines were able to re-establish their empire at a much-diminished scale, they were increasingly reduced to defending Constantinople until the city finally fell in 1453 to the Ottoman Empire. Although this period was one of political and economic turmoil in the Byzantine Empire, the visual arts continued to thrive as artists discovered new ways to engage the religious sentiments of beholders.

DEËSIS, MOSAIC, HAGIA SOPHIA A monumental mosaic (**Fig. 28.23**, p. 478), measuring nearly 18 × 20 feet (around 5 × 6 m), was placed in the south gallery of Hagia Sophia to commemorate the re-establishment of the Byzantine Empire. The icon, which includes a vast amount of gold, depicts the *Deësis*, a representation of Christ between the Virgin and John the Baptist. It was created on a grand scale with tens of thousands of tiny **tesserae**. The central figure of the all-ruling Christ is frontal. He holds a book and makes a blessing gesture. His softened gaze is reinforced by the bowed heads and tender expressions of the flanking holy figures. The faces' minute details suggest

28.21 FAR LEFT *The Virgin of Vladimir,* Constantinople (Istanbul, Turkey), *c.* 1131, with numerous later restorations. Tempera and gold on panel, 44¾ × 26¾ in. (113.7 × 67.9 cm). Tretyakov Gallery, Moscow.

28.22 ABOVE *Lamentation,* north wall of the Katholikon at the Monastery of St. Panteleimon, Nerezi, Macedonia, 1164. Fresco.

fresco wall or ceiling painting on wet plaster (also called true or *buon fresco*). Wet pigment merges with the plaster, and once hardened the painting becomes an integral part of the wall. Painting on dry plaster is called *fresco secco*.

tessera (plural **tesserae**) a small block of tile, glass, or stone used to make mosaic.

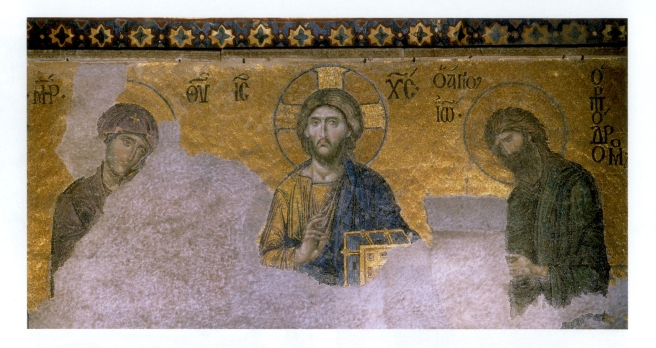

28.23 *Deësis,* Hagia Sophia, mosaic in the south gallery, Constantinople (Istanbul, Turkey), *c.* 1261.

a portrait-like precision, while the refined indication of highlight and shadow offers greater subtlety and elicits a heightened sense of the figures' presence in the church. The Virgin Mary and John the Baptist seem to implore Christ for mercy on the beholder's behalf. These compassionate figures contrast sharply with the remoteness of the earlier Byzantine mosaics in the apse (**Fig. 28.17**) and the central dome (**Fig. 28.19**) of Middle Byzantine churches.

ANASTASIS, FRESCO, CHURCH OF OUR SAVIOR IN CHORA The monastic Church of Our Savior in Chora (later renamed Kariye Camii, or Mosque outside the Walls) of the early fourteenth century contains the most comprehensive surviving decorative program—both mosaics and wall frescoes—in Constantinople. This late, small, suburban church was redecorated after the Fourth Crusade, not by the emperor but rather at the private expense of Theodore Metochites, the chief controller and advisor to the Byzantine ruler. Its mosaics present meticulous likenesses of Christ and the Virgin

Mary, akin to the Hagia Sophia *Deësis*. The donor also added to the original monastery a *parekklesion* (a side chapel, in this case a mortuary chapel), decorated fully with frescoes. Beneath a ceiling rendering of the Last Judgment, the semi-dome of the apse features the Harrowing into Hell, or *Anastasis* (**Fig. 28.24**), a festival in the Byzantine liturgical calendar and an appropriate resurrection topic in a funerary setting.

Although the image is relatively modest in scale, it appears monumental. Christ, clad in brilliant white robes and standing within a **mandorla**, energetically releases Adam and Eve from their tombs in a general rendering of the triumph of grace over death, of light over darkness. This dynamic intervention by Christ, witnessed by standing saints on the viewer's left, symbolizes the redemptive power of the Orthodox Church. The scene also offers Christians hope for personal salvation, for the victorious Christ has shattered the gates of Hell and bound Satan as his captive, who appears directly beneath two broken doors of his chaotic abyss.

mandorla (in religious art) a halo or frame that surrounds the entire body.

Chronology

526–47	The Church of San Vitale, Ravenna, is built		843	Empress Theodora reinstates the veneration of icons
527–65	The reign of Justinian I, who begins a major building program in Constantinople from 532		1054	The Great Schism divides the western and eastern branches of Christianity
532–37	Hagia Sophia is built		*c.* 1131	*The Virgin of Vladimir* is produced in Constantinople
717–87	The first period of iconoclasm			
740–53	The Church of Hagia Eirene is rebuilt without figurative decoration		1204	Venetians sack Constantinople and occupy the city
797–814	Empress Irene temporarily restores the use of religious imagery		1261	Emperor Michael VII Palaiologos reclaims Constantinople; *Deësis* mosaic added to Hagia Sophia in celebration
814	Leo V restarts policy of iconoclasm		1453	The Ottoman Turks conquer Constantinople and rename the city Istanbul

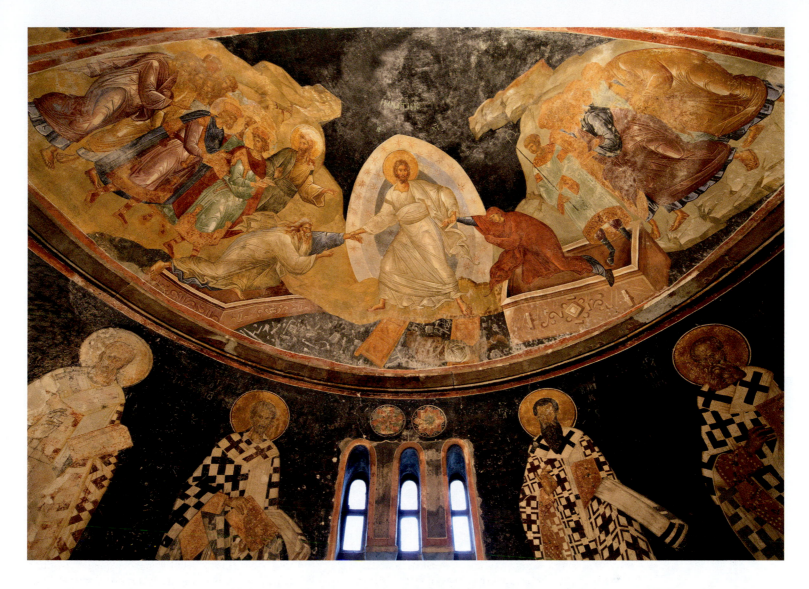

In 1453, the Ottoman Turks took over Constantinople and began calling it Istanbul (Turkish for "The City"). Hagia Sophia and the Church of Our Savior were converted into **mosques**. **Minarets** were added to Justinian's Hagia Sophia and its interior decoration of figurative imagery was covered up, occasionally supplanted with geometric motifs and sacred **calligraphy**, to fit the needs of a Muslim house of worship. The Ottoman Turks brought the Byzantine Empire to an end, but Orthodox churches can still be found throughout the world. In addition, although Constantinople (the New Rome) had been defeated, Ottoman Turks actively pursued the revival of Classical antiquity. Finally, Russians, converted by the Byzantines and led by a *tsar* (caesar), strove to make Moscow into the Third Rome.

28.24 *Anastasis,* **Church of Our Savior in Chora (Kariye Camii),** apse fresco of the funerary chapel, Constantinople (Istanbul), Turkey, 1316–21.

Discussion Questions

1. Considering the sacred icons featured in this chapter, discuss what it means to render a likeness and how likeness relates to notions of presence. How important is artistic naturalism in conveying the apparent immediacy of someone or something?

2. Why did Byzantine artists use expensive materials in the production of items intended to adorn church interiors? Why did they not seek less costly solutions?

3. What visual strategies did Byzantine artists employ to elicit emotional responses from beholders, and what was their purpose in doing so?

Further Reading

- Barber, Charles. *Figure and Likeness: On the Limits of Representation in Byzantine Iconoclasm.* Princeton, NJ: Princeton University Press, 2002.

- Brubaker, Leslie. *Inventing Byzantine Iconoclasm.* Bristol: Bristol Classical Press, 2012.

- Cormack, Robin. *Byzantine Art.* Oxford: Oxford University Press, 2000.

- Demus, Otto. *Byzantine Mosaic Decoration: Aspects of Monumental Art in Byzantium.* London: Kegan Paul, Trench, Trubner, 1948.

- Mathews, Thomas F. *Byzantium: From Antiquity to the Renaissance.* New Haven, CT: Yale University Press, 2010.

mosque a Muslim place of worship.

minaret a tower at a mosque; can be used to give the call to prayer and also functions as a visible marker of the mosque on the skyline.

calligraphy the art of expressive or carefully descriptive hand lettering or handwriting.

29

Art of Early Medieval Europe

600–1250

Lindau Gospels (back cover,
detail), Lindau, Germany.

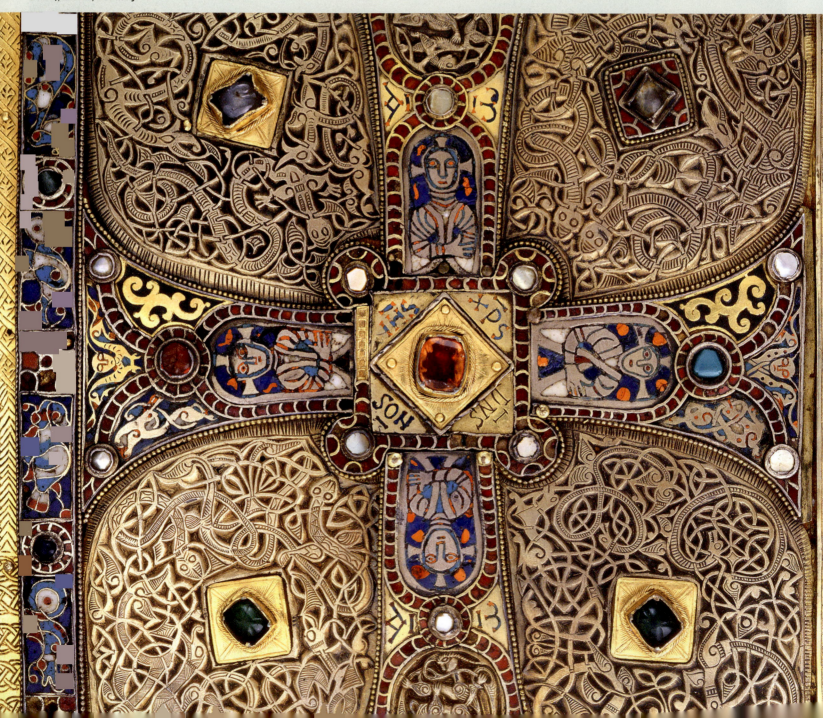

Introduction

After the fall of the western Roman empire in the fifth century CE, the regional groups that had pressed at the imperial boundaries over the centuries began to move more freely on the Continent and soon assumed local control of territories in northern Europe, Spain, Italy, and North Africa. These fragmented groups were quite diverse. They spoke different languages, practiced different religions, chose their rulers in varying ways, and produced their own styles of art and architecture.

Discovering the pre-Christian history of the different groups inhabiting northern Europe is difficult, as later Christians were effective at erasing much of their cultural pasts. Moreover, earlier architecture was built primarily with timber, which lacks the permanence of brick and stone and has not survived. In addition, these cultures left few or no written documents. Missionaries from Rome spread the religion to such outposts as Britain and Ireland, which produced decorated manuscripts at their monasteries. Nonetheless, the pre-Christian past was not completely forgotten. In fact, older traditions helped shape early medieval Christian visual imagery and occasionally influenced the locations at which churches were constructed.

The word "medieval" was never used by the people who lived during the more than one thousand years between the ancient Roman empire and the revival of Classical culture in the Italian Renaissance ("renaissance" means rebirth). Renaissance intellectuals used the term "Middle Ages" to describe the period, during which political integration and Classical learning were almost lost in Europe. However, the art of early medieval Europe was not naive and demonstrates a rich blend of influences. Throughout the early Middle Ages, European rulers and increasingly powerful religious leaders sponsored churches, monasteries, palaces, precious objects, and manuscripts, blending the indigenous cultural practices with ancient Roman forms and styles as a way to legitimize their power.

Insular Imagery, c. 600–1000

Between the fifth century BCE and the seventh century CE, much of northern Europe was home to various ethnic groups who shared many cultural beliefs and practices. The Greeks labeled them Celtic (*Keltoi*)—barbarians beyond their control. On the European continent, Celtic culture gradually came under Roman rule. In Ireland and northern Britain, however, these ethnic groups resisted Roman control and retained their indigenous practices for longer. Celtic imagery survives in decorative metal objects, especially **torques** and **fibulae**. Many of these combine abstract designs with figural imagery, displaying intricate, curvilinear geometrical patterns, including **triskeles**. Around 450 CE, Germanic groups began migrating to the British Isles, dominating much of the land and synthesizing their cultural practices with those of Celtic culture. The populations of the British Isles gradually adopted Christianity, and the blend of artistic conventions in this era is often described as Insular (denoting the connection to islands).

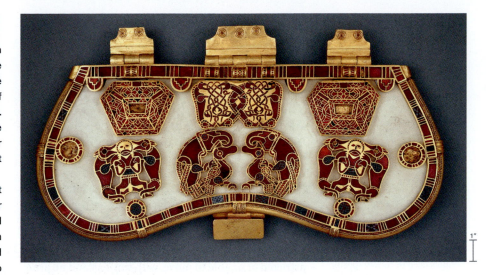

29.1 Purse cover, from the Sutton Hoo ship burial, Suffolk, England, *c.* 625. Gold, glass, garnets and enamels, length 8 in. (20.3 cm). British Museum, London.

SUTTON HOO PURSE COVER In 1939, the burial mound of an early English ruler from the seventh century CE was excavated at Sutton Hoo in England. Inside, the excavators discovered the clearly imprinted outline of a complete warship, prepared to transport the nobleman (who may have been a king) into the afterlife. The ship, approximately 80 feet (24 m) long, contained a funeral **cache** with numerous metal objects, including military items, such as a metal helmet and shoulder clasps. A Byzantine plate and Gallic coins were also among the grave goods, indicating a connection with the Mediterranean world.

A purse cover (**Fig. 29.1**) with **inlaid** gold, glass, **enamel**, and garnet (a deep-red semiprecious stone), probably once attached to a leather pouch, fully displays the technical artistry of the unknown artists. The entire design shows **bilateral symmetry**. At the top center, an intricate interlace pattern of curving lines terminates in larger, head-like loops. It is flanked by matching polygons divided into enamel fields (*cloisonné*) around a hollow center. Below, figural groups are clearly defined. In the middle is a pair of eagles facing each other. Both eagles perch on a duck with wing feathers exquisitely delineated in gold. At either end of the purse lid, a frontal heroic figure (evocative of the warrior hero of *Beowulf*, a verse epic dated between 925 and 1025) resists attack from wolf-like beasts rendered in profile. Together, these images of conflict and symmetry characterize the warlike leader buried at the site and suggest the sense of order that he provided.

BOOK OF DURROW The same manner of representation also appears in Christian art in the emerging tradition of manuscript **illumination**. Beginning around 550 CE, the Irish missionary St. Columba founded remote monasteries (self-sufficient religious refuges) in northern Ireland and Scotland. These secluded locations isolated the monks from society, but did not prevent them from incorporating local artistic designs in their imagery. Within these monasteries, monks produced handwritten, painted Christian gospel manuscripts, sometimes ornamented with full-page decorations derived from the intricate geometric patterns of Insular metalwork.

torque a neck ring, usually metal.

fibula a large, decorative brooch for fastening clothing.

triskele a tri-lobed design consisting of spirals within a circle.

cache a deposit of materials or objects that does not include a burial.

inlay decoration embedded into the surface of a base material.

enamel an opaque ornamental coating made of powdered glass.

bilateral symmetry symmetrical arrangement along a central axis so that the object or plan is divided into two matching halves.

cloisonné decorative enamelwork technique in which cut gemstones, glass, or colored enamel pastes are separated into compartmented designs by flattened strips of wire.

illumination decorative designs, handwritten on a page or document.

Sacred manuscripts were often kept in metal shrines and treated as **relics**. These books were believed to possess miraculous powers, including the ability to heal or to defend in warfare.

Named after a monastery, the *Book of Durrow* features traditional Celtic patterns surrounding the symbols of the Four Evangelists, who wrote the gospels of the New Testament. On the page dedicated to St. Matthew (**Fig. 29.2**),the image of a man symbolizes Matthew's gospel—a book that opens with a description of Christ's human ancestry rather than that of his divine status. This figure is surrounded by a border of intertwining ribbons that animate the surface, giving the page a quality of continuous motion. The decoration seems to reinforce the power and dynamic force of the sacred text.

In contrast, the human figure looks flat and appears restricted or unable to move, with tiny feet and no arms. His legs are in profile, though the rest of his body is frontal. His round face was constructed with a compass and his checkerboard-patterned garment recalls metalwork. The representation lacks the naturalism associated with Greco-Roman imagery, but this lack of naturalism does not reflect technical inadequacy. On the contrary, it reveals the artist's desire to preserve local artistic conventions. The figure is depicted as an Irish monk. In Ireland, monks shaved their foreheads, wearing their hair long and parting it in the middle, rather than shave a circle on the top of their heads (tonsure), as was common practice among Christian monks elsewhere in western Europe.

LINDISFARNE GOSPELS The *Lindisfarne Gospels* (*c.* 698–721), which take their name from the island monastery

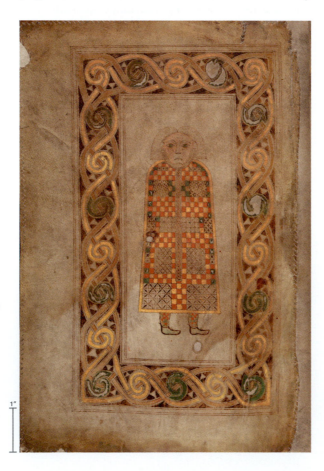

29.2 RIGHT **St. Matthew, from the *Book of Durrow*** (MS. 57, fol. 21v), Durrow, County Laois, Ireland, *c.* 650–700. Ink and tempera on parchment, 9⅝ × 6⅛ in. (24.4 × 15.5 cm). Trinity College Library, Dublin.

29.3 ABOVE FAR RIGHT **St. Matthew, from the *Lindisfarne Gospels*** (Cotton MS. Nero D.4, fol. 25v), Lindisfarne, Northumberland, England, *c.* 698–721. Ink and tempera on vellum, 13⅜ × 9½ in. (34 × 24 cm). British Library, London.

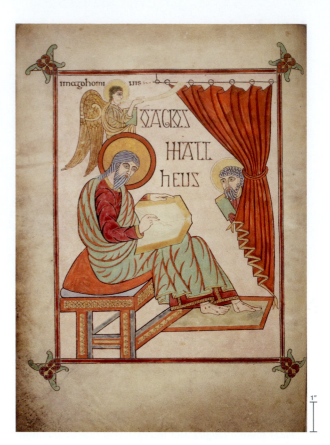

where they were produced, include introductory portraits of the Four Evangelists (seated and working, and accompanied by symbols) that appear to be based on Roman imperial illustrations from the Mediterranean world. St. Matthew, clothed in a green toga (a Roman garment), is rendered in a three-quarter view and placed on a bench that slants into spatial depth (**Fig. 29.3**). Although the saint's seat seems to recede, it does not follow the rules of **linear perspective** and lacks modeling. St. Matthew seems preoccupied with inscribing the text. A winged man, symbolizing the gospel writer, blows an elongated horn above the saint's head. On the right, a figure peeks from behind a curtain. He might represent the Old Testament author Moses; the meaning of his closed **codex** will be unveiled in Matthew's open book.

Unlike the St. Matthew page from the *Book of Durrow*, this page includes text. The words *O Agios* (Greek for "holy") are written in Latin. The terms *Mattheus* (Latin for Matthew) and *imago hominis* (Latin for "image of humankind") indicate an interest in **Classical** learning. Although some pages of the *Lindisfarne Gospels* affirm local traditions of decoration, this page suggests an increased affinity with Mediterranean design and **iconography**. Nevertheless, local artistic conventions have not completely vanished from the page, as the ornamental motifs on the four corners framing the scene demonstrate.

The *Lindisfarne Gospels* were quite costly to produce. Not only were they labor intensive, but they were also fashioned from expensive materials. It took around three hundred prepared calfskins to make the richly illuminated pages. Some of the pigments used were derived from local plants and minerals, but the manuscript also

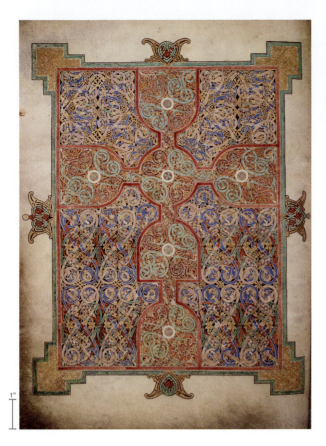

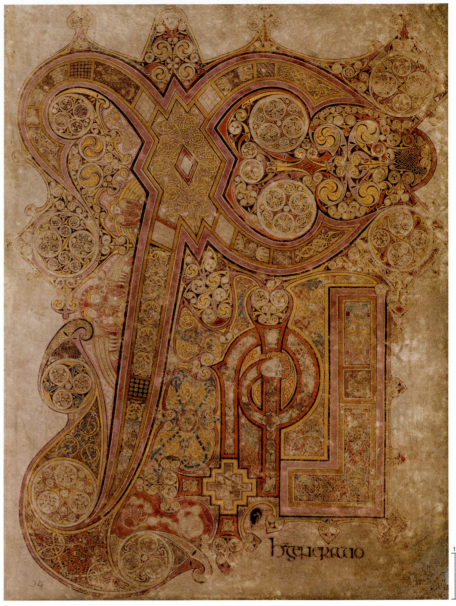

includes lapis lazuli, imported from the Himalayas, and kermes, red dye produced from crushed insects found in southern Europe.

CARPET PAGE FROM *LINDISFARNE GOSPELS* Insular art often brought together different artistic traditions – Celtic, Germanic, and Roman. Like many other Insular manuscripts, the *Lindisfarne Gospels* include **carpet pages** filled entirely with ornamentation. These pages were not merely abstract decorations separating texts: making and viewing these vibrant designs served as aids to religious meditation, fostering greater participation in the mysteries of the faith. An active perusal of the dynamic imagery was believed to animate the soul of both the artisan and the beholder. On this page, a large cross symbol extends across the entire energetic pattern of looping, intertwined spirals formed of elongated bird-like creatures rendered in four colors (**Fig. 29.4**). This page combines Germanic use of animal ornament with the ribbon interlace rooted in Roman culture. Within this, the cross appears to be static, unmoved by the effects of time. In contrast to the rhythmic interplay of twists and turns, the stationary cross relates to the Christian belief that Christ is eternal.

BOOK OF KELLS The most dazzling of the Insular manuscripts, the *Book of Kells* (*c.* 800 CE) incorporates its interlaced intricacies into the opening initials of the Gospel of Matthew (**Fig. 29.5**). Using X-P-I (*Chi-Rho-Iota*), the first three letters of the word Christ in Greek, and then continuing in the lower-right corner with the Latin (Roman) word *generatio*, this lettering begins the text that specifies the genealogy of Jesus. Amid its whirling triskeles and loops, the fine network of lines includes

subtle imagery of animals: a mouse, cats, moths, and an otter catching a fish. The head of a human appears at the end of the *Rho*, and angels are visible along the length of the *Chi*. Like the *Book of Durrow*, the *Book of Kells* was protected in a metal container and treated as a holy item. In the Annals of Ulster, recorded in 1007, it is called "the most precious object of the western world." It was probably produced in the *scriptorium* (room used for writing) of the monastery on the Scottish island of Iona, and it may have been brought to the monastery of Kells in Ireland after a series of Scandinavian attacks. From the late eighth century, the British Isles were beset by Scandinavian invasions along their eastern coasts and riverways, including attacks on Lindisfarne in 793.

MUIREDACH CROSS In addition to creating illuminated manuscripts, Irish monasteries also erected **monolithic**, freestanding stone crosses to signal their faith, and possibly to mark the boundaries of their territories or the sites of miracles. Most of these works, which probably derived from earlier painted wooden crosses, employ

29.4 ABOVE LEFT **Carpet page, from the *Lindisfarne Gospels*** (Cotton MS. Nero D.4, fol. 26v), Lindisfarne, Northumberland, England, *c.* 715–20. Ink and tempera on vellum, 13⅜ × 9½ in. (34 × 24 cm). British Library, London.

29.5 ABOVE **Chi-Rho-Iota page, from the *Book of Kells*** (MS. 58, fol. 34r), possibly Iona, Scotland, *c.* 750–800. Ink and tempera on vellum, 12¾ × 9½ in (32.5 × 24 cm). Trinity College Library, Dublin.

carpet page a decorative page resembling a textile; often used to introduce a gospel in early medieval manuscripts.

monolith a single large block of stone.

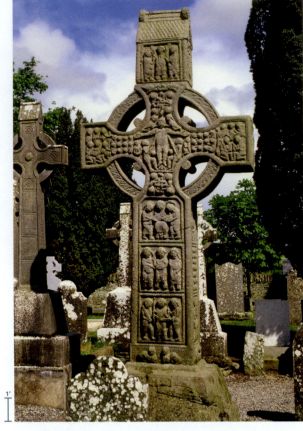

29.6 Muiredach Cross (west side), Monasterboice, County Louth, Ireland, 923. Sandstone, height 17 ft. (5.2 m).

Map 29.1 The Carolingian Empire, 768–843.

ATLANTIC OCEAN

Urnes
Borgund
SCANDINAVIA
Tønberg

Lindisfarne

Monasterboice
Kells
Durrow
BRITAIN

North Sea

Baltic Sea

Sutton Hoo

Essen · Hildesheim
Corvey
Aachen · Cologne
Paris
Reims

Rhine R.

FRANKISH KINGDOM
Tours

Lindau
Reichenau

Danube R.

KINGDOM OF ASTURIAS

CHARLEMAGNE'S EMPIRE

UMAYYAD CALIPHATE

Adriatic Sea

Rome

Mediterranean Sea

Tyrrhenian Sea

SICILY

Ionian Sea

0 125 250 miles
0 250 500 kilometers

N

- Frankish Kingdom before Charlemagne, 768
- Carolingian Empire at the death of Charlemagne
- Division by Treaty of Verdun

Celtic decoration with interlocking curvilinear patterns; additionally, several include small **relief** figures.

At 17 feet tall, the Muiredach Cross (**Fig. 29.6**) is inscribed with a prayer on behalf of its donor Muiredach (d. 923), the abbot of Monasterboice (a monastery in County Louth, Ireland). It features a halo-like circular link of the four arms of the cross, which end in rectilinear forms. The west face (pictured) shows Christ on the cross, whereas the east side features the Last Judgment, in which Christ presides over the division of souls, weighed in scales directly beneath him. The name Muiredach appears on the bottom of the western side of the cross in an inscription imploring beholders to pray for the abbot, encouraging some scholars to believe that he may have been buried under the cross. Later cemeteries were frequently built around large crosses such as this one, offering the deceased holy ground for their interment.

Charlemagne and Carolingian Culture, c. 800–900

After the frontiers of the western Roman Empire dissolved, other Germanic groups from eastern Europe migrated west and south. The Franks settled in what is now France, and King Clovis, a convert to Christianity, unified the territory and founded the Merovingian dynasty. Although he married a Christian woman, Clotilda, and agreed to have his children baptized, Clovis did not accept Christianity immediately. As Emperor Constantine had done, he appealed to Christ prior to his battle with the Alemanni (another Germanic group) in 496 CE. Upon his victory, Clovis accepted the Christian faith and was baptized, along with 3,000 of his Frankish subjects, on Christmas Day of that year. Twelve years later, Clovis, now a Christian monarch, attacked the Visigothic capital Toulouse. The Visigoths, another Germanic tribe, gradually retreated to Iberia, where they established Toledo as their new royal city (see Chapter 34). Under Clovis's leadership, Christianity became the chief religion of France.

In 720, when Clovis's heirs proved to be incompetent leaders, a very shrewd chief administrator within the court, Charles Martel (Charles "the Hammer"), took control, blunting the advance of an Umayyad army from Iberia into France at the Battle of Tours in 732. His grandson, known to history as Charles the Great, or Charlemagne, became king of the Franks in 768 and king of Italy in 774. In 800, Pope Leo III in Rome crowned him as the first Holy Roman Emperor in western Europe since the collapse of the western Roman Empire three centuries earlier (**Map 29.1**). In the expanded Frankish state, called the Carolingian Empire (from *Carolus*, the Latin name for Charles), Charlemagne emphasized Christian rule and revived cultural leadership. His consolidation of power and affirmation of Christianity began to characterize a major new cultural region of Europe, distinct from the contemporary Byzantine and Islamic cultures that flourished in the Mediterranean region.

In his effort to reconstitute Rome's imperial greatness, Charlemagne maintained a centralized administration, using Latin instead of local tongues as the official

language of his government. He sponsored ambitious projects in literature, architecture, and the arts that imitated Classical Roman models. He chose Aachen, located in the middle of his territory in present-day Germany, to serve as the center of his empire. The city offered numerous recreational benefits, including natural hot springs and a lush forest with abundant game. Headed by the English scholar Alcuin of York, Aachen became a center of learning.

Like the Christian Roman emperor Constantine, Charlemagne used church institutions effectively to support his government. To help consolidate his rule over different lands, he supported abbey churches, including St. Denis in France, and a cluster of new royal abbeys in Germanic regions. The residents of these great monasteries prayed for the successes and salvation of their pious king, but they also served as hosts to his visits, defenders of his territories, developers of his lands, and centers of the scholarship he assiduously cultivated. In addition, they played a significant role in advancing the arts of horticulture, architecture, and manuscript painting, even during periods of political strife.

PALATINE CHAPEL, AACHEN Charlemagne built a palace complex at Aachen and commissioned a chapel connected to it (**Figs. 29.7, 29.8**, and **29.9**). Designed by Odo of Metz, the chapel was dedicated to Christ the Savior and to the Virgin Mary. Drawing on structures from previous centuries as models, chiefly Ravenna's Church of San Vitale (see Fig. 28.7), the Palatine Chapel features a centralized, domed octagon with an eastern **apse**. Its elevation on heavy **piers** suggests sturdiness and

power rather than the luxury and elegance of San Vitale's interior; the Palatine Chapel is built of stone and not the lighter brick of Byzantine structures. A new vertical emphasis was created by high arches in the **gallery** story, which support the base of the dome. The chapel, which contained numerous relics, is decorated with porphyry columns and marble-inlay flooring. But the building's **voussoirs** and massive piers, marked in alternating colored stone, dominate, drawing attention away from the opulent ornament used elsewhere.

Charlemagne's throne was placed on the second story of the chapel, opposite the apse. This location offered him an elevated place to worship, with an unobstructed view of the Eucharist (a ritual commemorating Christ's Last Supper). From this upper **loggia**, modeled after the imperial gallery of Hagia Sophia, Charlemagne could present himself in balcony appearances before crowds standing in the **rotunda** below. The emperor's Palatine Chapel satisfied many of his ecclesiastical needs: imperial **mausoleum**, palace church, and site for sacred relics.

gallery an interior passageway or other long, narrow space within a building.

voussoir a wedge-shaped stone block used in the construction of an arch.

loggia a covered gallery or walkway open on one or more sides and supported by columns or arches.

rotunda a cylindrical building, or a cylinder-shaped room within a larger building.

mausoleum a building or free-standing monument that houses a burial chamber.

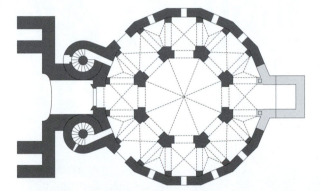

29.7 LEFT **Palatine Chapel (plan drawing)**, Aachen, Germany.

29.8 BELOW LEFT **Odo of Metz, Palatine Chapel, interior** (facing west toward Charlemagne's throne), Aachen, Germany, 792–805.

29.9 BELOW **Charlemagne's throne, Palatine Chapel.**

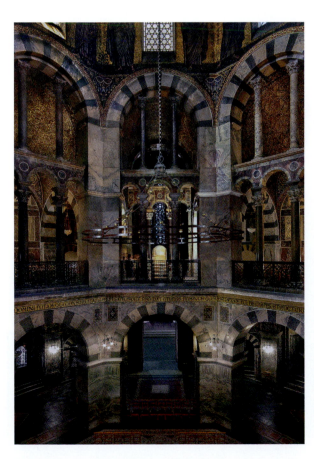

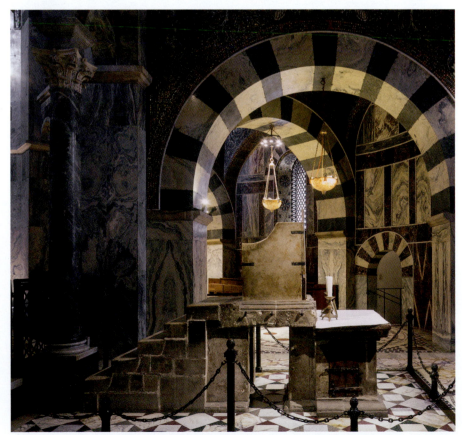

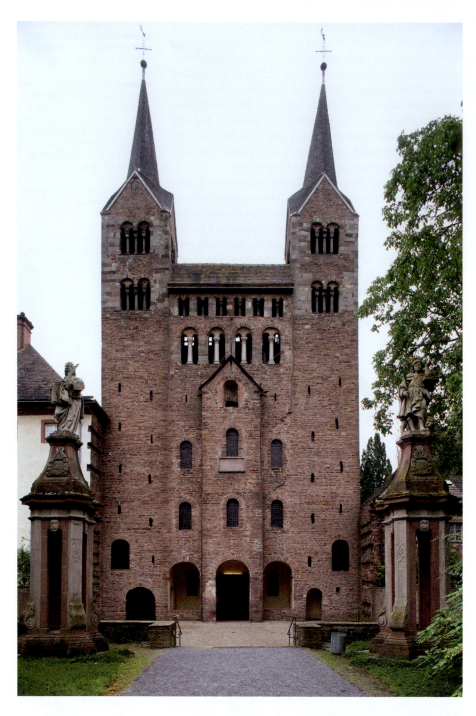

Carolingian monasteries followed the Rule of St. Benedict, a sixth-century CE manual for monastic life specifying that monks must spend their days in work and prayer. Benedictine communities were self-sufficient and modeled after the family, with spiritual brothers and an abbot (father) who ruled within this communal setting.

NINTH-CENTURY PLAN FOR A MONASTERY In the early ninth century, Haito, the abbot of the Benedictine monastery at Reichenau (an island in Lake Constance, southern Germany), commissioned an architectural plan to be given to Gozbert, the abbot of St. Gall in present-day Switzerland. This drawing, which was probably produced in the Reichenau scriptorium, is rendered on five pieces of parchment sewn together (**Fig. 29.11**). Strictly speaking, it is not a blueprint, but it served as an ideal model to imitate.

The inked plan includes numerous buildings. The largest is a **basilica** church located near the center of the drawing. On its south side, a **colonnaded** courtyard or **cloister** would have offered a retreat for meditation. Among the other places depicted are a bakery, a brewery, a hospital, and workshops. Although Benedictine monasteries were designed as closed communities, the plan also provided rooms for pilgrims and royal guests, as dictated by monastic rule.

CORONATION GOSPELS Charlemagne not only promoted Benedictine monasticism, but he also ordered that the Roman rite (the liturgy set by the church of Rome) be performed in church services throughout his empire, thus bringing political and religious unity to lands where

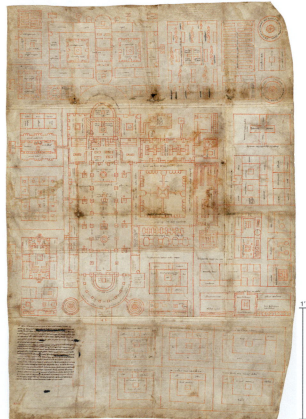

29.10 ABOVE **The Imperial Abbey,** Corvey, Germany, c. 873–85.

29.11 FAR RIGHT **Plan of an ideal monastery** (Cod. Sang. 1092), from Reichenau, Germany, c. 816–37. Red ink on parchment, 44⅛ × 28 in. (112.1 × 71.1 cm). Stiftsbibliothek, Saint Gall, Switzerland.

facade any exterior vertical face of a building, usually the front.

IMPERIAL ABBEY AT CORVEY The western **facade** of the Palatine Chapel at Aachen announces the massive interior. This same Carolingian architectural innovation in church design also appears at the western entrance of the Imperial Abbey at Corvey in present-day Germany (**Fig. 29.10**). Although the upper stories of the facade, rendered in different masonry, were added later, the austere grandeur is still recognizable. Like Aachen, Corvey includes a gallery on the second floor opposite the apse. In addition to serving as a choir loft, the space may have been used by local authorities and wealthy patrons.

Charlemagne commissioned numerous monasteries and often placed members of his court or family at the helm of these religious complexes. His cousin, Adalard of Corbie, served as the first abbot of Corvey.

multiple languages were spoken. Under Charlemagne, the standardized liturgy, with prayers and ceremonial pronouncements only spoken in Latin, also fostered the production of new manuscripts, often with elaborate and costly illuminations, for use in both the royal palace and royal abbeys.

The earliest dated manuscript of this kind comes from 781 and indicates the presence of an established book-producing workshop at court. These manuscripts were often copied from early Christian or Byzantine models (see the *Vienna Genesis*, Fig. 28.11). Typically, the Carolingian texts were produced on durable **parchment** or **vellum**, and carefully penned and decorated by teams of monastic scribes and illuminators. They synthesized a decorative model inspired by both the elaborate ornamentation of Insular books and figural models from the Classical heritage of Rome.

One of the finest Carolingian manuscripts, the *Coronation Gospels* (**Fig. 29.12**), was preserved in the German imperial treasury and was allegedly found on the knees of Charlemagne himself when his tomb was opened in the year 1000. It includes a signature by a Greek artist, Demetrius Presbyter, so it may have been the work of a Byzantine visitor. Precious materials abound, from the gold ink used for the careful Latin lettering to the imperial purple dye on the expensive parchment. A naturalistic illustration of the seated Evangelist writing, while turned in space, derives from Classical models.

EBBO GOSPELS Illuminated manuscripts were produced beyond the Carolingian court at Aachen. In the early ninth century, Ebbo, the Archbishop of Reims (in present-day France), who had previously served as the imperial librarian at Aachen, commissioned a set of the gospels. Although the posture of St. Matthew from the *Ebbo Gospels* (**Fig. 29.13**) may derive from the *Coronation Gospels* or a similar manuscript, it has a style of its own. The saint lacks the calm grandeur found in the pensive figure of the *Coronation Gospels* page. This Matthew seems highly energetic, writing down sacred words as quickly as he can.

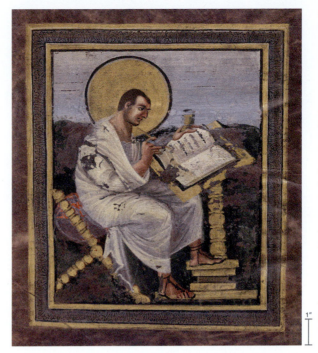

29.12 St. Matthew, from the *Coronation Gospels* (inv. XIII 18, fol. 15r), c. 800–10. Ink and tempera on purple vellum, 12¾ × 9⅞ in (32.4 × 24.9 cm). Schatzkammer, Kunsthistorisches Museum, Vienna.

basilica a longitudinal building with multiple aisles and an apse, typically located at the east end.

colonnade a long series of columns at regular intervals that supports a roof or other structure.

cloister a covered walkway, lined with a colonnade, walled on the outside and open to a courtyard; usually found in religious buildings.

parchment a writing surface prepared from the skin of certain animals that has been treated, stretched, and polished.

vellum a writing surface originally made from calfskin.

29.13 St. Matthew, from the *Ebbo Gospels* (MS. 1, fol. 18v), 816–35. Tempera on vellum, 10¼ × 8¾ in (26 × 19.7 cm). Bibliothèque Municipale, Épernay, France.

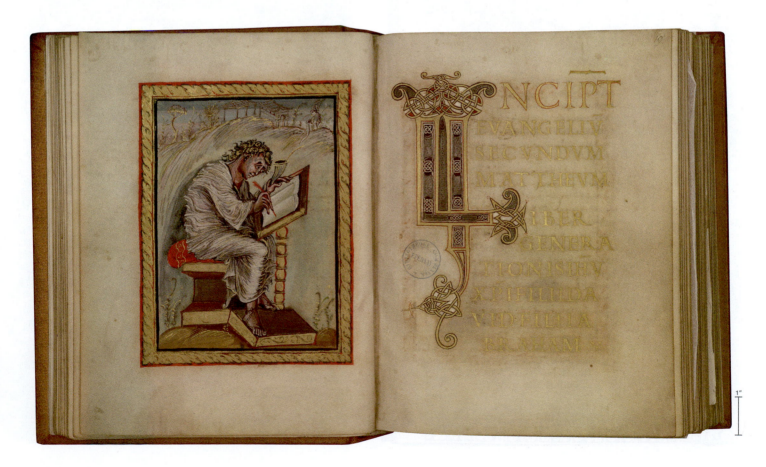

The flickering lines and sketch-like quality of the image convey a powerful sense of movement and immediacy. Although the saint is depicted with a sense of volume, his weight and mass seem impossible to determine. Adorned in agitated drapery, St. Matthew appears to be frantically inscribing words revealed through divine inspiration.

LINDAU GOSPELS Carolingian metalwork included elaborate covers for books. The two covers of the *Lindau Gospels*, a manuscript originally housed in a wealthy nunnery on the island of Lindau in the Bodensee (Lake Constance, in present-day Germany), were made at different times. The back cover (**Fig. 29.14**) was produced around 760–90 CE, about a century prior to its text. It is decorated with flat abstract figures and dynamic animal interlace, reminiscent of Insular manuscript illuminations and metalwork. Four enamel half-length figures of Christ (p. 480) appear on the arms of a large cross. This back cover may have served as the front of an earlier book; parts of the border and corner figures of the Evangelists were added to match the front cover of the new book.

By contrast, the front cover of the *Lindau Gospels* (**Fig. 29.15**), which is contemporaneous with the book's text (*c.* 870–90), resembles imagery associated with the Carolingian court during the reign of Charlemagne's son, Charles the Bald. This sumptuous cover may have been produced at the imperial workshop at Saint-Denis, outside of Paris, a Benedictine monastery where Charles served as a lay abbot. The central figure of Christ, rendered in

repoussé, appears to have volume and mass. Although hanging on the cross, he displays little sign of suffering; only a few drops of blood fall from his open palms. Ten additional figures are represented, hammered in golden relief. Directly above Christ's head are personifications of the sun and moon, heavenly bodies said to have stopped to mourn Christ's death. The Virgin Mary and St. John the Evangelist kneel below the arms of Jesus, and two unidentified figures express their grief. The front cover is also studded with numerous rubies, emeralds, sapphires, and pearls. While enhancing the economic value of this precious book, these gems probably also served as **amulets** protecting the contents of the codex.

The lavish use of gold for book covers (often enhanced by precious stones) and in illuminations indicates the desire to symbolize sanctity and the glowing mystery of light, associated in Christian thought with the heavenly nature of spirituality. Production of religious ivory carvings also flourished in Carolingian manuscript workshops, often for insertion on book covers.

Bishop Bernward and Ottonian Art, *c.* 900–1050

After the death of Charlemagne in 814, the Carolingian dynasty began to flounder, and border invasions by Scandinavians and Magyars (Hungarians) further disrupted social order. In 843, the empire was divided among Charlemagne's three surviving grandsons according to the

29.14 BELOW **Back cover of the** *Lindau Gospels* (MS 1), Lindau, Germany, *c.* 760–90. Silver gilt with enamels and gems, 13⅜ × 10⅛ in (34 × 25.7 cm). The Morgan Library and Museum, New York.

29.15 BELOW RIGHT **Front cover of the** *Lindau Gospels* (MS 1), possibly from Saint-Denis, France, *c.* 870–90. Gold, pearls, and gems, 13⅜ × 10⅛ in. (34 × 25.7 cm). The Morgan Library and Museum, New York.

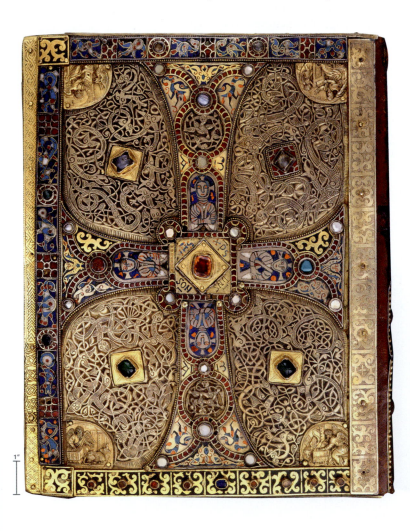

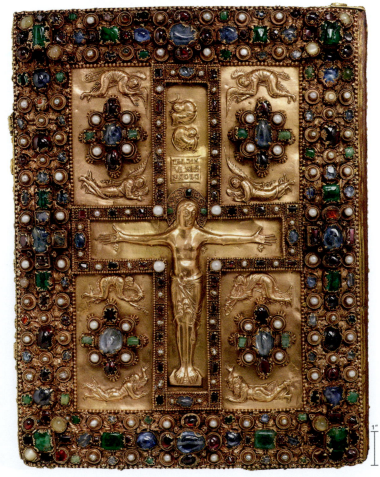

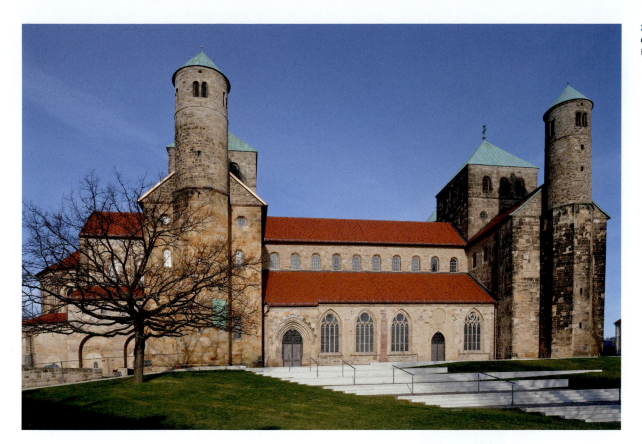

terms of the Treaty of Verdun. As a result, Charlemagne's unified European empire became fragmented, and increasingly, the monastic communities that he established assumed greater local autonomy.

In the tenth century, a new Saxon dynasty called Ottonian (for its succession of kings named Otto) restored political stability and renewed Charlemagne's aspirations. The Ottonians were far more successful than their predecessors in building diplomatic relations with the Byzantine court in the east. To reinforce the alliance, Otto II married Theophanu, a Byzantine princess. Their son Otto III was later enthroned as the Holy Roman Emperor.

Although the empire had diminished in scale since Charlemagne's time, the Ottonians intensified the effort to revitalize the Classical past. With the financial support of such donors as Bishop Bernward and Abbess Mathilda, they discovered new ways to promote imperial authority and religious piety through art and architecture.

ABBEY OF ST. MICHAEL, HILDESHEIM Bishop Bernward (960–1022), learned tutor to Emperor Otto III, built the Abbey of St. Michael at Hildesheim in northern Germany (**Fig. 29.16**). A large-scale building, but also a monastic church, St. Michael's boldly introduces two **transepts** and multiple apses. A huge chapel, elevated at the west end, replaces a conventional public entrance and rests upon a basement chapel, or crypt, where Bernward is buried. Worshipers enter through four main doorways located on the north and south sides of the building. In St. Michael's interior, columns and rectangular piers alternate along the edifice's length, breaking up the visual monotony associated with many basilica plans (**Fig. 29.17**).

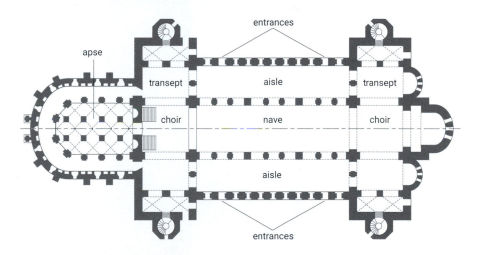

29.17 Abbey of St. Michael (floor plan), Hildesheim, Germany, 1001–31.

COLUMN OF BISHOP BERNWARD To ornament his ambitious structure, Bernward (in Rome with Emperor Otto III in 1001) commissioned a pair of boldly cast, large-scale works in bronze that imitate ancient Roman models. A 12-foot-high column (**Fig. 29.18**, p. 490) shows scenes from the life of Christ, read from bottom to top. As on the Column of Trajan (see Fig. 20.11), the narratives are arranged in a helix, spiraling upward. The monument suggests religious triumph, just as its ancient Roman model suggests military victory. However, the column's dynamic figures do not imitate Classical models and seem more reminiscent of those found in the *Ebbo Gospels*.

Bernward's column originally had a cross on its top and was placed at the eastern end of the church, directly behind the altar. Inaccessible to the laity, it probably

transept a section of a church perpendicular to the nave; transepts often extend beyond the side aisles, making the "arms" of a cruciform-shaped church.

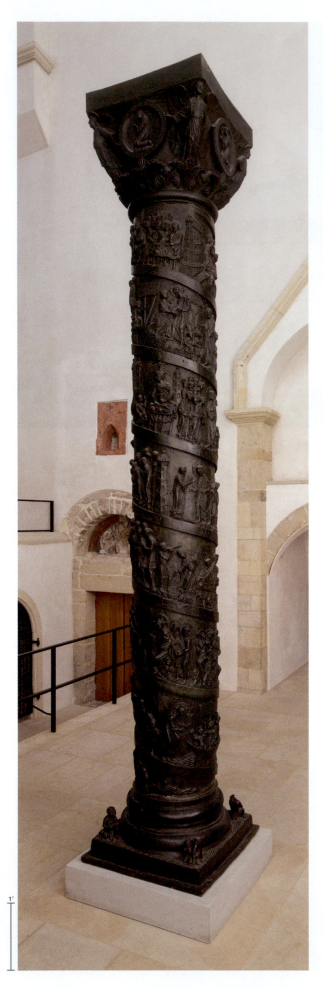

29.18 Column of Bishop Bernward, *c.* 1000. Bronze, height 12 ft. 5 in. (3.79 m), diameter 23 in. (58 cm). originally from St Michael, now in Hildesheim Cathedral, Germany.

iconoclast a destroyer of images, typically those used in religious worship.

high relief raised forms that project far from a flat background.

did not primarily serve as a tool for teaching tales of the life of Christ. Instead, the column's location suggests that its main purpose was to affirm the power of Christ and by extension, that of the Eucharist over sin and death. In 1544, Protestant **iconoclasts** destroyed the cross, recasting the bronze into a cannon. The rest of the column survived the attack and was relocated to the city's cathedral.

DOORS OF ST. MICHAEL, HILDESHEIM Bishop Bernward's other Hildesheim masterwork is a giant pair of bronze doors, probably originally placed on the church's south-western side (**Fig. 29.20**). The doors feature figures in **high relief** gesturing dramatically against flat grounds with outlined details of their setting. The bishop's commission may have been inspired by his visit to Rome, where he would have encountered decorated wooden doors at churches such as Santa Sabina (see Fig. 23.17). Casting bronze works of such grandeur, including the lion's head handles, was an extraordinary technical achievement.

Bernward probably played a significant advisory role in determining the complex iconographical program of the doors (**Fig. 29.19**), which pair scenes from the biblical Book of Genesis with their gospel counterparts. On the (viewer's) left, moving top to bottom, the story of the Fall of Adam and Eve unfolds. The pair disobeyed God by eating the forbidden fruit. As a result, they were expelled from the Garden of Eden, bringing sin into the world. Their son Cain committed the first murder. The narrative begins with the Creation of Eve and ends with Cain killing his brother Abel; the eyes of beholders literally descend as they witness the downward trajectory of sin. Bernward's choice to begin with Eve, rather than Adam, may relate to concerns about the dangers of carnal pleasures. The bishop may have used the image to encourage monks to remain true to their vows of celibacy rather than indulge in matters of the flesh. In this depiction, lust, not pride, appears to have been the primary impetus for the Fall. Within this misogynistic iconographical program, the Creation of Eve serves as the starting point for humanity's descent into sin.

On the other door, the narrative proceeds upward, from the Annunciation (the miraculous conception of Christ, who is both human and divine) to *Noli Me Tangere* (John 20:17; when the resurrected Christ implores Mary Magdalene, his closest female follower, to avoid touching him since he has not yet ascended to heaven). The tale of redemption is one of ascent as viewers are invited to see the means of salvation and life anew in upward projection. The panels, which resemble manuscript miniatures or ivories, can also be read across the doors. By showing the Fall of Adam and Eve alongside the Crucifixion, Bernward instructs the viewer that Christ is the New Adam, who takes away the stain of original sin. The tiny, naked First Parents appear vulnerable and frail, separated from and admonished by a haloed Christ-like God as they gesture across blank space to pass blame from themselves to the dragon-like serpent (**Fig. 29.20a**). Attempting to conceal their shame and the source of their disobedience, the primordial couple cover their genitalia with leaves.

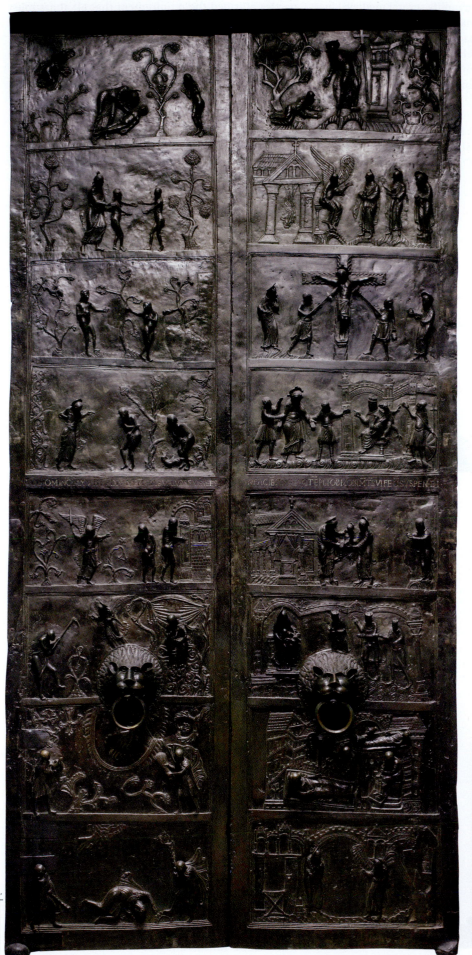

Old Testament	comparison of themes	New Testament
The creation of Eve	Birth and Resurrection	*Noli Me Tangere*
Eve presented to Adam	Striving to unite	The three Marys at the empty tomb
Temptation and the fall	Sin and salvation	The Crucifixion
The Admonition of Adam and Eve	Judgement of the guilty and the innocent	The trial of Jesus before Pilate
Expulsion from Paradise	Separation from God and reunion with God	Presentation in the temple
Adam and Eve working	Punishment and reward	Adoration of the Magi
The offerings of Cain (grain) and Abel (lamb)	Sacrifice and grace	The Nativity
Cain slaying Abel	Death and the gift of life	The Annunciation

29.19 ABOVE **The theological program of the doors of St. Michael, Hildesheim.**

29.20 LEFT **Doors of Abbey of St. Michael,** Originally from St. Michael, later moved to Hildesheim Cathedral, Germany, 1015. Bronze, height 16 ft. 6 in. (5.03 m).

29.20a BELOW **The Admonition of Adam and Eve,** fourth panel, left side.

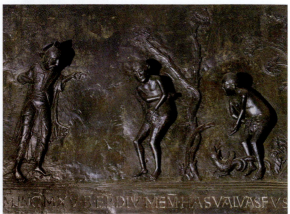

29.21 **Gero Crucifix,** Cologne Cathedral, Germany, c. 970. Painted and gilded wood, height 6 ft. 2 in. (1.88 m).

Together, the panels exemplify several medieval justifications for religious imagery: to offer a visual Bible, a public presentation of sacred stories for the illiterate majority, and to awaken religious sentiments or inspire private meditation. Contemporaries would have readily recognized the instructional and devotional power of the imagery.

GERO CRUCIFIX Christians in both the Byzantine empire and in western Europe shared a deep appreciation for sacred relics. At the Council of Nicaea (787), both parties affirmed the requirement that all altars must have a relic within or beneath them. Without relics, altars could not be sanctified, and the Eucharist could not be celebrated.

Unlike Orthodox Christians, Christians following the Roman rite did not venerate icons. They believed that, unlike relics, icons were not touched by God. Thus, by and large, it was accepted in the west that visual images lacked the sacred power of relics, though images continued to be created as a vehicle for theological instruction and a means of awakening religious feelings. In addition, exquisite containers or **reliquaries** (see box: Making it Real: The Golden Madonna of Essen) were often made to house relics, reinforcing their precious sanctity.

In the late tenth century, Gero, the Archbishop of Cologne, commissioned the life-size Gero Crucifix (**Fig. 29.21**). It was once thought to hold holy items—a piece of the consecrated host, or eucharistic bread believed to be transformed into Christ's body, and a fragment of the wooden cross on which he was crucified—in a cavity behind Christ's head. Thus the sculpture was described as a **speaking reliquary**, using its exterior form to reveal contents concealed inside. The piece of the cross was represented by the crucifix, and the sacred bread by the figure of the crucified Jesus. Contrary to longstanding tradition, however, modern technical examinations indicate that there is no hollowed space for relics. Although it was treated as a speaking reliquary, the sculpture is not.

Although Jesus Christ is consistently considered to be both fully human and divine, this innovative sculpture places greater emphasis on his humanity. Here Jesus is rendered in a naturalistic form and is depicted on a human scale. Earlier representations of Christ on the cross (which do not appear until the fifth century) show him as alert and feeling no pain. In contrast, the Gero Crucifix conveys terrible suffering. Christ's sagging body reveals the weight of gravity. The sculpted figure originally wore a crown of thorns (now lost), and small drops of blood appear on his forehead. Christ's downcast posture reinforces the quiet agony of his death and encourages believers to empathize and identify with their savior. The emotional intensity of the work may have been informed by contemporary Byzantine imagery of Christ's suffering and death, but the visceral quality of this naturalistic sculpture would have seemed dangerously close to idolatry during the iconoclastic periods in Byzantine history.

Early Medieval Art and Architecture in Scandinavia, *c.* 1100–1250

Christianity did not gain a foothold in Scandinavia (Denmark, Sweden, Finland, and Norway) until the tenth century, when the Danish king Harold Bluetooth and the Norwegian king Olaf Tryggvason converted. The old Nordic gods were gradually replaced, but indigenous visual traditions continued to be practiced in the service of the Church. Unlike the Carolingians and Ottonians, Scandinavians were not enamored with Mediterranean imagery and did not emulate the

To understand the visual appearance and function of medieval objects it is helpful to consider how they were made. The Essen Madonna (**Fig. 29.22**), one of the earliest three-dimensional representations of the Virgin Mary (Madonna) and her child, offers a good case study. Commissioned by Abbess Mathilda, the granddaughter of Otto I, the sculpture depicts the Christ child seated on his enthroned mother's lap, a subject often associated with Byzantine culture. The Virgin Mary appears to stare at viewers, apparently ready to mediate on their behalf (**Fig. 29.22a**). In her right hand, she holds an ornate sphere, probably the apple or fruit of salvation. Whereas Eve brought sin into the world, the Virgin Mary offers the means of redemption. The golden surface of the nearly 2½-foot-tall sculpture affirms its economic and religious worth.

Producing this object would have been labor intensive. First, a block of poplar was carved in the form of the sacred pair. Then, very thin sheets of gold leaf were pressed against the wood. Tiny golden bolts were used to fasten layers to the object's surface. Precious stones were set into the gospel cover that Christ holds against his chest, and the viewer can see the delicate filigree (ornamental openwork) on the orb grasped by the Virgin. Her eyes and those of her son are made of enamel. The Madonna's eyes are placed in two openings. By contrast, Christ's eyes are applied on the surface. This complicated process gave the sculpture greater durability (after all, gold is a soft metal).

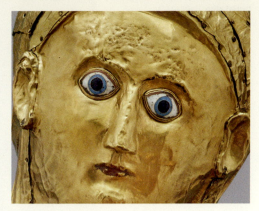

29.22a Detail of the Golden Madonna of Essen.

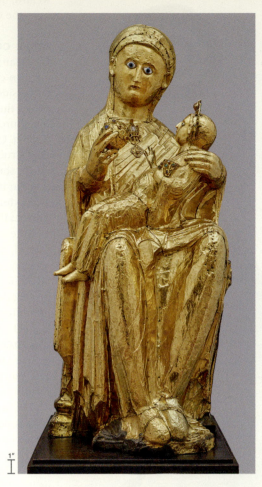

29.22 Golden Madonna of Essen, 973–82. Gold over wood, with enamel, filigree, silver, and gems, height 29⅛ in. (74 cm). Cathedral Treasury, Essen, Germany.

Sadly, the object has suffered damage. In the late Middle Ages, Christ's right arm was lost and later replaced with one made of silver, a stronger material. In addition, the sculpture received subsequent restorations (in 1905 and 2004) to repair substantial damage from insects boring into the wooden core. Unfortunately, due to the deterioration of the wooden interior, it is impossible to determine if the object ever held holy relics. Nonetheless, a close examination of the Essen Madonna's elaborate construction and application of precious materials enhances our understanding of the early medieval sculpture and its religious significance.

imperial art of ancient Rome. Scandinavians are often called Vikings (people of the *viks*, or coves), but this term is misleading. Although it rightly calls attention to those who were sea-explorers and traders, it diminishes the significant role that farmers and merchants played in medieval Scandinavia.

The Norsemen were very powerful. Not only did Scandinavians successfully attack and plunder wealthy monasteries such as Lindisfarne (in 793), but they also controlled the northern coast of France, known as Normandy after the Norsemen. In the ninth and tenth centuries, Scandinavians settled in parts of England, Iceland, and Greenland. One of their adventurous travelers, Leif Erikson, was probably the first European to set foot in North America (in about 1000 CE). In addition, Scandinavian traders sailed down Russian rivers and across the Black Sea until they reached the cosmopolitan city of Constantinople (present-day Istanbul).

OSEBERG BURIAL SHIP In 1904, a Norse ship buried in a mound was discovered near Tønberg, Norway (**Fig. 29.23**, p. 494). Inside the boat, the remains of two women were found, one believed to have died in her late seventies or early eighties, and the other in her fifties. No male skeleton was uncovered, suggesting that the ship belonged to one of the women. She may have been a royal, a spiritual leader, or both. Sacrificial animals—fourteen horses, three dogs, and an ox—were also buried in the boat. The seaworthy vessel, constructed almost entirely of oak, was also packed with household items to be used by the travelers on their journey after death. A cart and four sleds were also included as alternative modes of transportation.

The spiraling snake shapes of the ship's bow and stern (**Fig. 29.23** and **29.23a**, p. 494) resemble the interlace patterns found in the art of other European cultures. This **zoomorphic** form may have been intended to defend the boat from sea serpents. On the top and bottom of the hull, decorative bands of animals biting and gripping one another are intricately carved in **low relief**. Order and conflict, and stability and motion, are evoked by their intertwining forms. This exquisite ornamentation suggests a statement of conspicuous

zoomorphic having an animal-like form.

low relief (also called bas-relief) raised forms that project only slightly from a flat background.

MANLIET EITTECH The Golden Watchmaker Europe

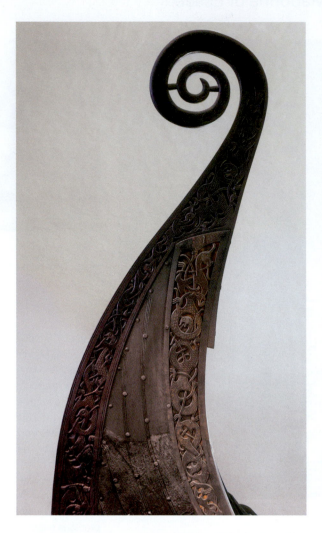

29.23a Prow of the Oseberg burial ship, *c.* 815–34, The Viking Ship Museum, Oslo, Norway.

cross-in-square design a square floor plan, popular in Middle and Late Byzantine churches, featuring internal elements in the shape of a cross and a large central dome.

wealth, but the makers probably also believed it would help the vessel to get from this world to the next.

STAVE CHURCH OF ST. ANDREW Among surviving Christian structures from medieval Scandinavia, a simple wooden church dedicated to St. Andrew still stands at a riverside near the village of Borgund, in a remote part of southeastern Norway (**Fig. 29.24**). The location of the church may be the site of a previous pre-Christian temple. Upright timber posts called staves bear the vertical structure's weight and give this type of building its name: stave church. Although stave churches were once popular in Scandinavia, today fewer than thirty survive. The exterior of St. Andrew is coated with pine tar to prevent the wood from rotting.

Like other Northern European structures of this period, St. Andrew combines Christian and Nordic imagery. Its roofline is decorated with numerous crosses and four abstract depictions of dragon heads believed to protect the church from evil spirits, but which also serve as drainage. In addition, the church combines the traditional Nordic use of vertical support with a basilica plan (**Fig. 29.25**). In the interior, a row of large crisscrossing timbers placed above the nave arcade brace the strutted ceiling, a method probably based on shipbuilding techniques.

The stave church may have been informed by Byzantine **cross-in-square** structures such as the Hosios Loukas monastery in Greece (Fig. 28.17), yet St. Andrew has no windows. Without candles, the interior would have been pitch black, intensifying mystical sentiments as it reinforced the division between the secular world

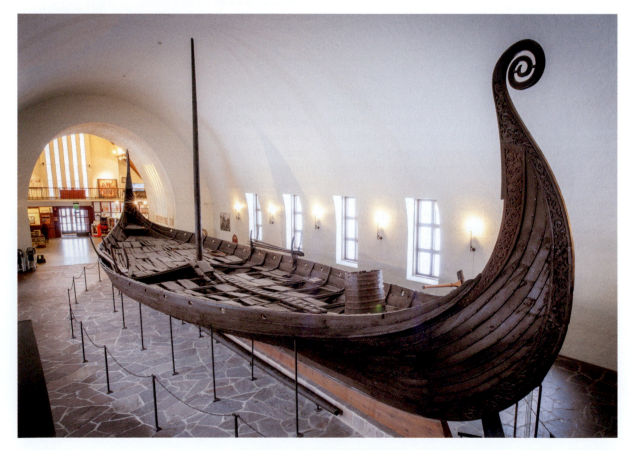

29.23 Oseberg burial ship, *c.* 815–34. Wood, length 71 ft. (21.64 m). The Viking Ship Museum, Oslo, Norway.

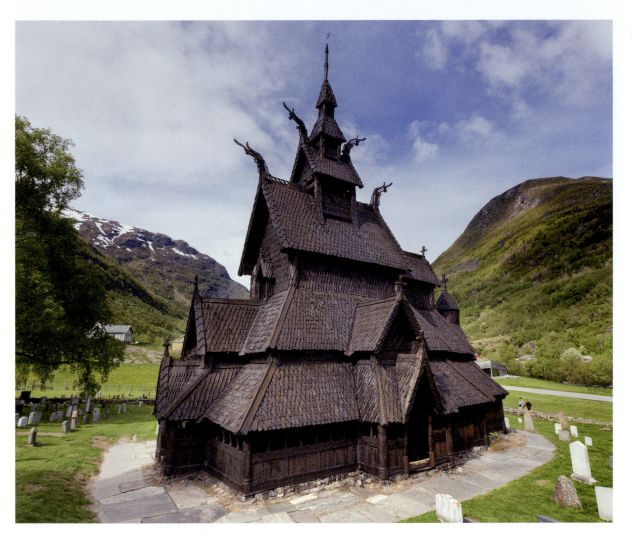

29.24 **Stave Church of St. Andrew,** Borgund, Norway, *c.* 1180–1250.

and the sacred world. Whether the mysteries associated with the church's interior are rooted in Norse religion is uncertain.

CARVINGS ON STAVE CHURCH, URNES The northern exterior wall of the community's stave church at Urnes, an idyllic Norwegian village located on a fjord (a long, narrow inlet between high cliffs), is carved with dynamic depictions of intertwining animals (**Fig. 29.26**, p. 496). These carvings may originally have been placed on the western facade or main entrance, but moved when the wooden church was rebuilt in the twelfth century. The zoomorphic forms, similar to those found on the Oseberg burial ship, twist and turn with rhythmic energy.

The carving's iconography is enigmatic. Some art historians believe that the struggle between the serpents and the four-legged beast resembling a deerhound depicted in relief symbolizes the eternal battle between good and evil, but there are insufficient grounds to support this hypothesis. Located on the exterior of a church, the carving probably carries Christian meaning, but the battle between hound and snake, like the work's entangled curvilinear design, seems to be rooted in pre-Christian Norse tradition.

Throughout the early Middle Ages, indigenous cultural practices continued to inform the art and architecture of northern European converts to Christianity. Even as

29.25 FAR LEFT **Stave Church of St. Andrew (plan drawing),** Borgund, Norway, *c.* 1180–1250.

29.26 Carved portal and wall reliefs, stave church at Urnes, **north side,** Norway, *c.* 1080–1130.

Carolingian and Ottonian leaders tried to consolidate their power by looking to ancient Rome, vestiges of indigenous traditions persisted, ensuring the past was not lost through the introduction of a new faith. Although these local practices did not entirely disappear, their significance diminished as later medieval Christians discovered alternative ways to articulate the relationship between political power and religious sanctity.

Discussion Questions

1. How did the depiction of interlocking animals and curvilinear forms function in Insular and Scandinavian art? Why is it insufficient to discuss it as mere decoration?

2. What elements of church construction and spatial arrangement had become standard in Europe by 1000? How do the parts of the church function as part of Christian ceremony?

3. Compare and contrast the front cover of the *Lindau Gospels* with the Gero Crucifix. How and why do their representations of Christ differ?

Further Reading

- Diebold, William J. *Word and Image: An Introduction to Early Medieval Art*. Boulder, CO: Westview, 2000.
- Graham-Campbell, James. *Viking Art*. London: Thames & Hudson, 2013.
- Henderson, George. *From Durrow to Kells: The Insular Gospel Books, 650–800*. London: Thames & Hudson, 1987.
- Lasko, Peter. *Ars Sacra, 800–1200* (2nd edn.) New Haven, CT: Yale University Press, 1994.
- Nees, Lawrence. *Early Medieval Art*. Oxford: Oxford University Press, 2002.

Chronology

c. 550	St Columba establishes remote monasteries in northern Ireland and Scotland
c. 625	The Sutton Hoo ship burial
c. 698–721	*The Lindisfarne Gospels* are written and illuminated
732	Charles Martel defeats Spanish Umayyad troops at the Battle of Tours
792–805	The Palatine Chapel is built in Aachen, Germany
800	Charlemagne is crowned as Holy Roman Emperor
c. 800–10	The *Book of Kells* and the *Coronation Gospels* are written and illuminated
843	Charlemagne's three grandsons divide his empire in the Treaty of Verdun
923	The Muiredach Cross is erected in Ireland
1001–31	The Abbey of St. Michael is built at Hildesheim
c. 1180–1250	The Stave Church of St. Andrew is built in Borgund, Norway

Pendant with bat deity, Tairona, Colombia.

30

Art of the Americas

600–1300

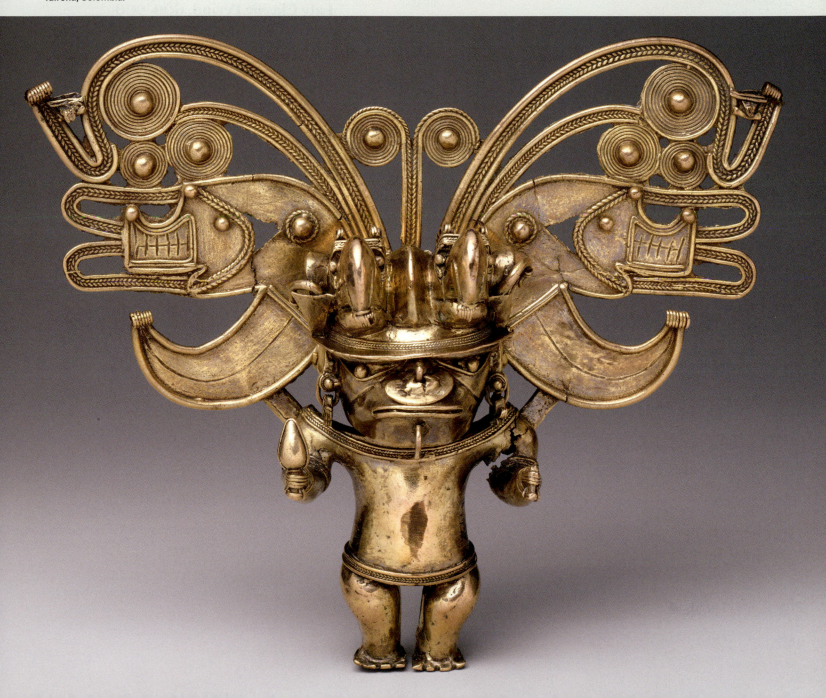

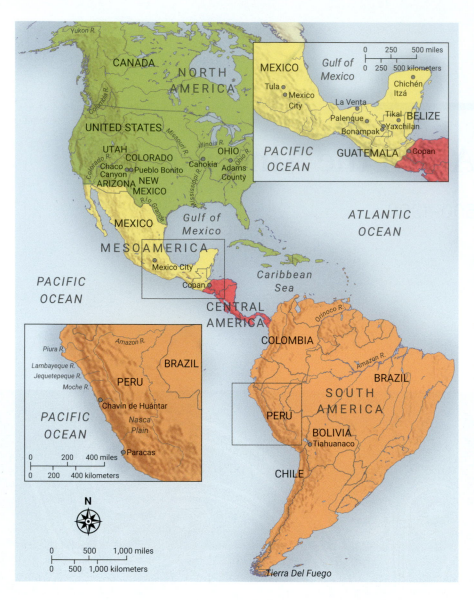

Map 30.1 The Americas, with major sites, 600–1300 CE.

Introduction

The period between 600 and 1300 CE saw the maturing of complex cultures in the Andes and Mesoamerica, as well as significant developments in Central and North America (Map 30.1). Artists across the American continents—from the Wari in the Andes, to the Maya in Mesoamerica, to the Ancestral Puebloans in North America—created precious objects and monumental public and private spaces to exalt political and religious leaders, using shared visual vocabularies and images related to the feasts, sacrifices, rituals, and games that linked rulers to the gods and connected societies across great distances.

By 600 CE, cultures in the Andes and Mesoamerica had a continuous artistic tradition extending back well over one thousand years. In Mesoamerica, the decline of the great metropolitan center of Teotihuacan around 600 paved the way for the rise of numerous smaller cities that vied for preeminence in trade, power, and the arts. Artists strove to outdo one another in exalting the local rulers with monumental public artworks and images made from precious materials. In Central America (the region immediately south and west of Mesoamerica, from present-day Honduras to Colombia in

South America), the same competition led to intricate metal-worked objects made to adorn the bodies of rulers. In the Andes (Peru), the Wari formed the first major empire in the region. Wari artists focused not on monumental royal portraits but rather on elegant combinations of geometry and color.

During this same period in North America, the practice of building monumental earthen structures reached its apogee in what is now the Midwest of the United States. In this region and in the present-day southwestern United States, objects in stone, shell, and clay were decorated with increasingly complex symbols. We should remember that almost all the objects created in perishable materials, such as paper, wood, and textiles, are lost to us but would have been very important to these cultures. For many years, archaeologists thought that these Native American cultures were isolated from their neighbors to the south. New evidence reveals that cultures of North America knew of, and exchanged goods with, the cultures of Mesoamerica and beyond.

Maya Art and Architecture in the Late Classic Period, 600–900

The Maya of Mesoamerica developed complex and refined art during what scholars call the Late Classic period (600–900). The term "Late Classic" is a vestige of earlier scholarship that tried to create an evolutionary scheme for Maya history that was similar to the progression of Greek culture in the Old World. We no longer believe that Maya history fits a Greek model, but "Late Classic Maya" remains as a useful designation for a period of exceptional artistic production by the Maya. The chief impetus for these artistic advances was the desire to project the power and prowess of the ruler, who was the center of attention in artworks large and small. Because the Maya ruler was also the chief religious leader, many Classic Maya works of art depict important religious rituals undertaken by the king and/or queen and close associates. The ability to depict detailed aspects of these rituals faithfully—the pattern on a dress, the jewelry worn by the ruler—was highly valued, which explains why Classic Maya artists evolved one of the most naturalistic styles in ancient American art history. Commemorating royal deeds was important for the Maya in earlier periods (see Chapter 12 for Maya artworks prior to the Late Classic period), but it reached its zenith in the Late Classic.

Throughout their history, the Maya primarily occupied the hot lowland forests of present-day Belize, northern Guatemala, Mexico's Chiapas state and Yucatán peninsula, and small parts of western Honduras and El Salvador. All Maya groups spoke related languages and had similar cultural practices, but they did not have a single central political authority like that of Teotihuacan in Central Mexico. During the Late Classic period, dozens of independent Maya cities, or polities, each controlled their own region and traded with other cities near and far. Bigger polities often grouped smaller allies around them, creating a ranked system of regional nobility with the largest polity at the apex of the social hierarchy. The ruler of each polity held court in a palace in the city center,

surrounded by towering pyramids that honored gods and often contained the remains of revered ancestors.

Palace scribes wrote in **screenfold books** (also known as **codices**) made of bark paper using Classic Maya **hieroglyphs**, which have only recently been deciphered. The books produced during the Late Classic period have been lost to the humid climate, but long public inscriptions in temple panels and on stone monuments (**steles**) survive, recounting royal deeds and the stories of ancestors and gods.

CHOCOLATE VESSEL, SHOWING MAYA PALACE SCENE

The Maya royal palace complexes, along with the closely related temples, were the center of much ceremony and political activity. The court, which included not only the royal family but also many retainers, underlings, and visitors, was a frequent source of subject matter for Maya painters.

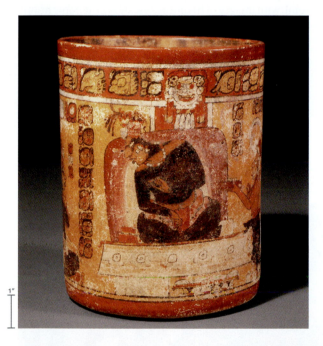

1″

This Maya vessel may have been used to hold the whipped chocolate drink favored by elite Maya (**Fig. 30.1**). The chocolate drink was produced from pods of the cacao plant, native to this region, and was probably spiced rather than sweet. The image on this vessel, shown in a "roll-out" photo (**Fig. 30.1a**), depicts a palace scene, with a ruler enthroned and seated cross-legged, and flanked by attendants. The figure on the ruler's left offers a plate filled with food. The attendant on the other side crosses his arms as a sign of loyalty, while the figure just behind the ruler seems to be communicating with him. Two other individuals converse on the far left (as the viewer looks at it), and the leftmost grips a cylindrical receptacle with white foam showing at the top; perhaps this container holds the chocolate drink.

Above the scene, a row of hieroglyphs records the owner of the vessel and notes that he was a leading athlete, skilled in the Mesoamerican ball game. Athletes competed to strike a solid rubber ball towards the opposing team's area. Some accounts suggest that the winning team would drive the losers back to the very end of the court. Kings and other nobles would also play a theatrical version of the game that would re-create the games of ancient heroes or show their dominance over conquered foes.

Chocolate vessels similar to this one were often given as gifts, not only between members of a royal court but also by Maya rulers of differing polities when they met to confirm trade and military alliances. Such events would have looked much like the scene portrayed on this container. Access to fine painting was a sign of social power in the Maya world, and talented artists were highly valued. Some painters indicated their prestige by signing their work, as here (see the **glyphs** to the right of the seated ruler, as the viewer looks at the photo). Such signatures might seem to suggest that these vessels were intended for display only, but residues remaining in the ceramic walls indicate that they did indeed hold beverages during the feasts that accompanied meetings of privileged members of society.

screenfold book a method of book-binding in which pages are attached to one another by their sides and folded into an accordion shape.

codex (plural **codices**) a handwritten bound book; pre-Columbian codices are made in a screenfold format, from paper or vellum.

hieroglyph a type of written script that uses conventionalized signs to represent concepts, sounds, or words.

stele a carved stone slab that is placed upright and often features commemorative imagery and/or inscriptions.

glyph (sometimes hieroglyph) in a writing system, a single symbolic figure that consistently represents a word, syllable, or sound.

30.1 FAR LEFT **Chocolate vessel with palace scene,** Maya, *c.* 600–900 CE. Ceramic, height 8 in. (20.3 cm). Dumbarton Oaks, Washington, D.C.

30.1a BELOW **Roll-out photograph of chocolate vessel with palace scene.**

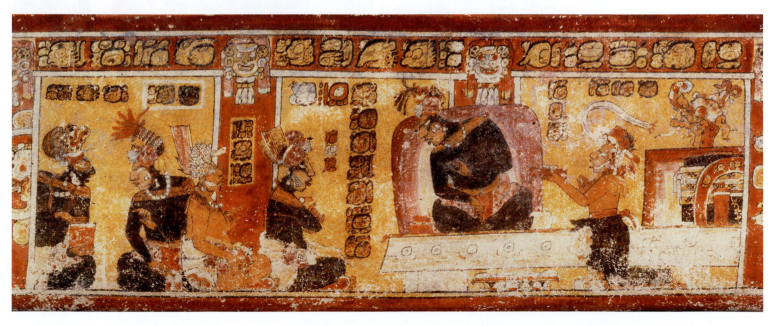

BONAMPAK MURALS The Maya word for ruler—*ajaw*—may be translated into English as "king," although there were several important queens throughout Maya history. The full title was *k'ujul ajaw*, literally meaning "blood lord" or "holy lord," indicating that Maya rulers saw themselves as semi-divine leaders, chosen by the gods. They viewed themselves as directly descended from earlier rulers and as enjoying the favor of the local gods (who were often noble ancestors who had been deified). These claims of ancient divinity would then support the polity's claim to political power in the competitive Maya world. A series of **murals** done in **fresco** technique at the relatively small Maya polity of Bonampak reinforces these claims. The murals cover all three rooms of a small palace used principally for the reception of visitors. Together, they form a coherent narrative of courtly life in the Classic period: they show the presentation of an heir, an example of the ruler's military prowess, and the elaborate celebrations after a successful war effort. The documentation of such royal acts—intended to impress and intimidate foreign visitors and other elite people—was one of the central tasks of Maya artists.

In this detail of the center room's mural (**Fig. 30.2**), the king of Bonampak, Lord Chan Muwan, stands at the center of the composition, at the top of a stepped structure. He holds a decorated spear in his right hand while a captive cowers at his feet, signaling the king's power and military victories. Other captives are laid out on the lower stairs. On either side of the king are members of the royal court, many of them elaborately dressed in jaguar pelts or radiant white garments, the latter probably of fine cotton. A pyramid of human bodies leads up from each of the bottom corners to the king at the summit. He is shown in profile with idealized features: a youthful countenance and the sloping forehead found in most portraits of Maya kings.

PLASTER PORTRAIT OF PAKAL In addition to recording the ruler's accomplishments and symbolic scenes of their importance, Maya artists created royal portraits. Inscriptions at the palace of the Maya city-state of Palenque mention one king as particularly central to its history: Pakal (603–83). He ruled Palenque for more than sixty years, and he was largely responsible for the city's rise to power in the seventh century. Pakal is credited with numerous construction projects, including a section of the palace and the Temple of the Inscriptions, which serves as his tomb.

A portrait head of Pakal (**Fig. 30.3**), displayed in his tomb with images of his ancestors, shows the conventions that indicate the ideal Maya king, such as the youthful visage and the elongated forehead. Pakal was old when he died, but his portrait does not show him as significantly aged. Maya rulers were typically depicted as eternally youthful; such Roman emperors as Augustus were portrayed similarly. Yet the structure of Pakal's face has an individuality in the small mouth and specific nose proportions that identifies the sculpture as his portrait, relating more closely as it does to other images of Pakal than to any other Maya king's. Clearly, the Maya artist

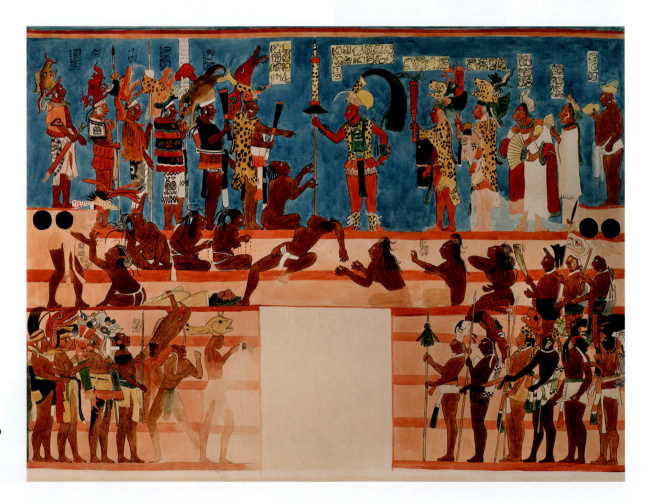

30.2 Presentation of captives to Lord Chan Muwan (reproduction), Maya, *c.* 791, Bonampak, Mexico. Fresco. Peabody Museum, Harvard, Cambridge, Massachusetts.

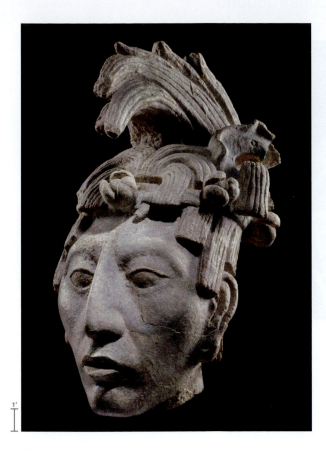

balanced the desire for a recognizable individual portrait with the need to depict the eighty-year-old king as he was supposed to be (not as he was).

LID OF PAKAL'S SARCOPHAGUS The discovery of Pakal's tomb inside the Temple of the Inscriptions was one of the great events in twentieth-century American archaeology. After years of searching through dense rubble, Mexican archaeologist Alberto Ruz and his crew uncovered the completely intact tomb. Pakal's richly outfitted funerary chamber contained items of jade, shell, fine ceramics, and other elite goods, many of them in very good condition (see box: Art Historical Thinking: Archaeological Reconstructions, p. 502).

Pakal's body was covered with a finely carved limestone **sarcophagus** lid (**Fig. 30.4**) that was found in a pristine, intact state. It depicts Pakal at the center of the composition and in the guise of the Maize (or Corn) God (see Fig. 12.8 for an earlier representation). Wearing the beaded net skirt and elaborate necklace associated with this deity, he is shown from the side, emerging from the jaws of the underworld. In sacred narratives, the Maize God is rescued from the clutches of the Underworld gods and returns to earth, just as the maize seed escapes from the earth to become the all-important maize plant. In this way Pakal is personified as the maize plant that sprouts from the earth every growing season to provide sustenance to the Maya people. Pakal is also shown against a cross motif that symbolizes a central sacred tree, probably the majestic ceiba tree of the Maya forests. Classic Maya kings were fond of likening themselves to enormous sacred trees, immovable and eternal guarantors of the orientation and shape of the forests and the cosmos.

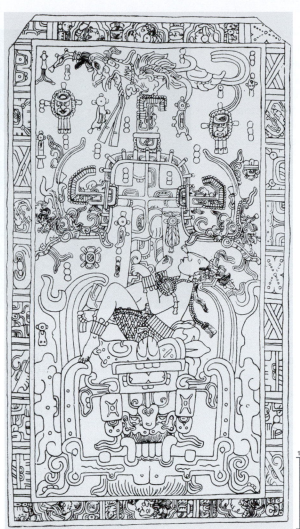

30.3 FAR LEFT **Portrait head of Pakal,** from the Temple of the Inscriptions, Palenque, Mexico, Maya, *c.* 683 CE. Stucco and traces of red paint, height 16⅞ in. (42.9 cm). Museo Nacional de Antropología, Mexico City.

30.4a LEFT **Drawing of carving on sarcophagus lid from tomb of Pakal.**

30.4 BELOW **Sarcophagus lid (detail), from tomb of Pakal,** Temple of the Inscriptions, Palenque, Mexico. Maya, *c.* 683. Limestone, 7 ft. × 12 ft. (2.2 × 3.6 m).

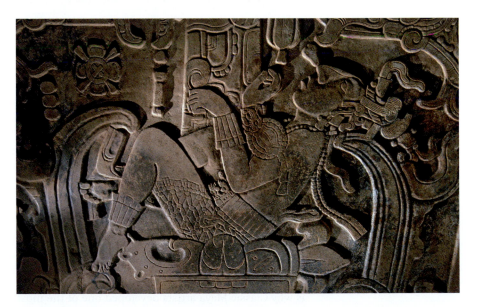

Atop the tree sits a sacred bird, with elaborate plumage, representing the sky and completing the picture of the Maya world view (**Fig. 30.4a**). Thus the sarcophagus lid eloquently expresses the centrality of the Maya king by depicting his direct relationship with the crop that feeds the community (maize) and his placement at the very heart of the cosmos.

sarcophagus a container for human remains.

Many ancient objects, in Mesoamerica and elsewhere, are not found intact. Instead, they may be discovered in several pieces or with significant damage; sometimes they have been crushed by a structure that collapsed. Ceramics are rarely found whole, and stone objects are subject to erosion by weather and the growth of tree roots. A key job of art conservators (those who care for and responsibly repair art objects) and archaeologists is to put these pieces back together in the most historically accurate way.

When the team at Palenque removed Pakal's sarcophagus lid, they discovered the skeletal remains of the king and several grave goods. Pakal was evidently wearing a mosaic mask made of fine jade stones, but the backing for the mosaic had deteriorated and the stone pieces had fallen around the skull. The pile of stones gave the team little guidance for the mask's reconstruction.

The art conservators decided to use the plaster head of Pakal (see **Fig. 30.3**), found in the same tomb, as their model for reconstructing the mosaic, assuming that the king's burial mask would resemble his portrait. It soon became clear that the pieces of jade simply would not fit together to create something that looked like Pakal's portrait head. The idea of a portrait-like mask was too strong to resist, however, and the rather ungainly reconstructed mask was finished and put on display.

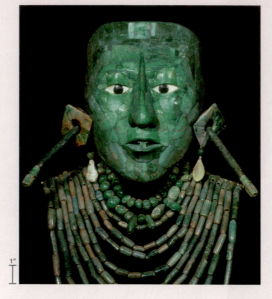

30.5 Mosaic funeral mask of Pakal, from Palenque, Maya, c. 683. Jade tesserae with backing material, height 8.5 in. (22 cm). Museo Nacional de Antropología, Mexico City.

Much later, two archaeologists went back to the evidence and re-examined where each mosaic piece had been found. They then constructed a map of the original relationships between the pieces. Combining this evidence with a deeper knowledge of Maya art history, they reconstituted the mask in an entirely

different way (**Fig. 30.5**). They found that it resembled not Pakal's portrait but rather a stone mask from ancient Teotihuacan (for an example, see Fig. 12.12). When assembled this way, the pieces fit together elegantly to create a mask comparable to other great Mesoamerican mosaics. Abandoning the old reconstruction and trying a new one was a daring move, but the end result makes sense, given how much the Maya venerated Teotihuacan imagery and symbolism, and how much the Palenque royal family revered that ruined, but still holy, city.

Over time, conservators have developed a set of standards for the ethical preservation of historic materials. One important standard focuses on the reversibility of any conservation measure, allowing for the possibility that new techniques or information will offer better and more sensitive means for preserving or restoring objects. Therefore, previous reconstructions can be reversed and improved.

Discussion Questions

1. How did the first reconstruction of Pakal's mask affect how we know the past?

2. How do certain artworks, such as Pakal's sarcophagus lid, use stories about the past to justify things in the present? Examine the ways in which the lid evokes the past, and for what reasons the past is invoked.

relief raised forms that project from a flat background.

lintel a horizontal support above a door or other opening.

30.6 FAR RIGHT **Maya rulers Shield Jaguar II and Lady K'ab'al Xook, Lintel 24 of Temple 23,** from Yaxchilan, Mexico, c. 725. Limestone, 43 × 30 in. (1.09 m × 76.2 cm). British Museum, London.

YAXCHILAN LINTEL 24 Like many of their descendants and all other Mesoamericans at the time, the Classical Maya believed that humans owed a debt to the gods, who had created all humankind. The Maya repaid this debt through blood sacrifice, including the human sacrifices that shocked the Spanish eight hundred years later. Less often discussed, but more important, were the rituals of autosacrifice, in which rulers would let their own blood from the ears and other body parts in honor of, and to communicate with, the gods. A ruler's blood sacrifice was the most important offering a polity could make and, as the Maya ruler was the polity's religious leader, much Maya art recounts such sacrifices and key religious rituals undertaken by the king and/or queen and close associates. The ability to depict detailed aspects of these rituals faithfully was highly valued, and is why Classic Maya artists developed one of the most naturalistic styles in ancient American art history.

A **relief** sculpture on a temple **lintel** from the Classic Maya city of Yaxchilan depicts an autosacrificial rite by a queen who hopes to contact an important ancestral deity. The sculpted relief in Lintel 24 (**Fig. 30.6**) shows two figures facing each other, with the one on the viewer's left wearing elaborate regalia and holding a great torch with its flames licking the upper right corner.

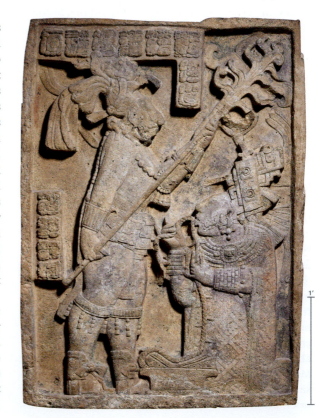

The inscription in the upper left—a typical example of Classic Maya hieroglyphic writing—identifies him as the king of Yaxchilan, known to us as Shield Jaguar II. Lady K'ab'al Xook, a queen of Yaxchilan, kneels below the torch on the (viewer's) right.

To open the pathways of communication between the human and the divine, the kneeling queen draws a barbed rope through her tongue in an invocation ritual that was still practiced eight hundred years later when the Spanish arrived. The woven wicker basket at her feet holds bark paper that is smattered with a dark substance, almost certainly her blood. Sources tell us that the blood-soaked paper was burned as part of the rite, in the belief that as the smoke rose to the sky, it would reach the ancestors.

Hieroglyphic writing frames this scene in the top left corner. The scribe constructed the text so that it appears reversed, as if in a mirror. The text emphasizes the fact that both the king and queen of Yaxchilan are "present" in the image. Such texts suggest that the Maya, and other Mesoamericans, believed that an image shared some of the fundamental substance of the figure depicted. In other words, a part of the person's essence or self somehow adhered in the image, animating it with active force. Thus the king and queen would continue to invoke the gods via this panel long after their deaths.

All the lintels in this Yaxchilan temple are carved with raised, naturalistic outlines, with elaborate detail on the reliefs. Similarly to other Classic Maya artists, the sculptors of these lintels reproduced the design of textiles to a degree not seen before in the ancient Americas. The geometric motifs on her woven garment were more than mere decoration, and probably related to her family lineage and her own noble position; even today, many Maya women wear similar abstract designs to indicate their family or village affiliation. This naturalism has its limits, however; there is almost no attempt at lifelike rendering of the environment (probably the interior of a temple) or other elements the artist considered non-essential.

This panel was installed above a doorway in the temple owned by the queen; two nearby doorways included lintels with other scenes related to the same sacrifice. Anyone entering the temple would have had to look up to see the detailed carving, which was covered with bright **polychrome** painting, traces of which still remain. In Classic Maya cities and throughout Mesoamerica, the royal palaces were both living spaces and the scene of ceremonies, while the interior spaces of temples were reserved for rituals involving royalty and the highest elite, which means that the great majority of Maya never saw these lintels or the intimate bloodletting rites they portrayed. By contrast, the public plazas around the great stepped pyramids held the majority of the polity population during the most important public sacred rites.

TEMPLE 1, TIKAL Maya stepped pyramids were built as mainly solid structures with only tombs inside. Conceived as man-made sacred mountains, these pyramids often echoed the identity of a nearby natural mountain. That tradition seems to have been prevalent

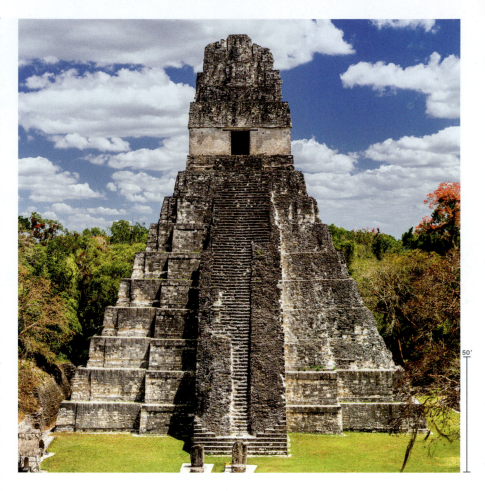

30.7 **Temple 1,** Tikal, Guatemala, *c.* 734. Height 154 ft. (46.94 m).

throughout Mesoamerica, notably in the earlier pyramids of Teotihuacan (see Fig. 12.13).

Small temple buildings, which often contained multiple rooms with benches, were situated at the summit of Maya pyramids. The largest of these pyramids, found in the center of Maya cities, seem to have been spiritually connected to the royal house and patron deities invoked in the temple rites. The pyramid of Temple 1 at the Maya polity of Tikal, in present-day Guatemala, from *c.* 734 (**Fig. 30.7**), one of the oldest and most prestigious kingdoms for the Classic Maya, contained the richly furnished burial of the ruler Jasaw Chaan K'awiil, who led a renaissance of the polity after a humiliating defeat by a rival some decades before, in 679 CE.

Temple 1 at Tikal soars 154 feet above the public plaza below, and the temple building at the top contains a small space for such elite rituals as the one illustrated in the Yaxchilan lintel. The temple is capped by a large stone and **stucco roof comb** that is now ruined but once depicted the Tikal ruler, seated, in three-dimensional plaster sculpture. The people who gathered in the plaza at the base of Temple 1 did not have direct views of the rituals taking place inside the temple building, but they did see various signals, such as smoke rising in front of the roof comb, indicating that important rites were being performed for the benefit of the polity.

The very steep staircase to the temple was used only by small, elite groups during the ceremonies held for public viewers in the plaza below, as illustrated in the scene of the presentation of captives in the Bonampak

polychrome displaying several different colors.

stucco fine plaster that can be easily carved, used to cover walls or decorate a surface.

roof comb lattice structure surmounting the roof of a temple; often used to support monumental sculpture.

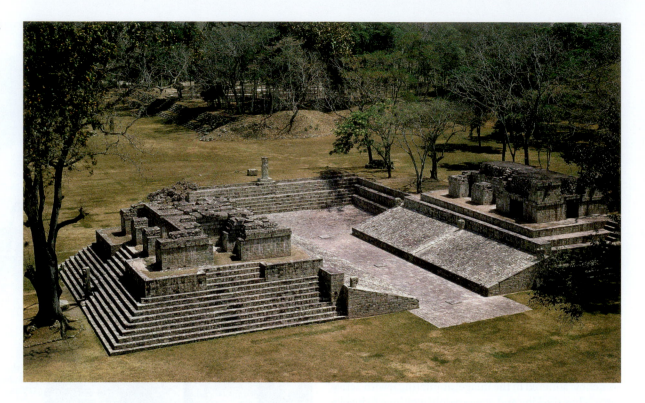

30.8 Central ball court, Copán, Honduras. Maya, completed 738.

murals (see **Fig. 30.2**). Calendric celebrations and other state rituals were held in the adjoining large plaza, where generations of Tikal rulers placed stone steles commemorating their celebration of public royal rites, thus charging the space with a sacredness that was highly important to Maya rulers.

COPÁN BALL COURT In addition to small gatherings of elite people in summit temples, Mesoamerican cities also hosted more popular rites. A pan-Mesoamerican rubber-ball game, known by modern Maya as *Pok-ta-pok*, was a popular sport in the Classic period. Athletes competed in a rectangular court defined by parallel buildings that served to keep the rubber ball in the playing area, while hundreds or thousands of spectators looked on. The rules of the game varied over time and between regions, but most variants involved striking the ball with the hips, which were well protected with hide or leather padding. Creation myths recounted how ancient heroes played and eventually outwitted the Lords of Death in a particularly important ball game in the Underworld. In a key episode from one of the myths, two great players were trapped by the Lords of Death. One of the ballplayers was decapitated by the Death Lords, but his teammate was able to replace his head and thus overcome death.

The Classic Maya ball court at Copán, Honduras (**Fig. 30.8**), has sloping side walls to channel the ball back to the central playing field. This ball court contained several sculptures that referred to one of the Death Lords, and others to the first king of the Copán royal dynasty who ruled in the fifth century, some 300 years before this version of the court was built. The presence of these sculptures reminded the audience that the ball court was a sports field that was sanctified by ancient games played between gods and ancestral heroes. Unlike the very private pyramid temples, this court was open

to the plaza surrounding it, and much of Copán's population in the eighth century watched the games played there. *Pok-ta-pok* remains a popular sport today, and teams from Belize, Mexico, and Guatemala compete in international tournaments.

Changes in Mesoamerica, *c.* 900

Many of the Late Classic Maya polities were in decline by 900 CE, owing to drought, overpopulation, competition for resources, and other factors. Groups migrated from the central lowland tropics north into the Yucatán peninsula or south into the highlands of Guatemala and Mexico. At the same time in distant Central Mexico (present-day Mexico City and its environs), which had earlier served as the cradle of Teotihuacan's power, the city of Tula rose to prominence. Tula developed a close relationship with Chichén Itzá, the new center of Maya power in the Yucatán.

For many later Mesoamerican societies, Tula was considered a great seat of culture. Even its name—Tollan in the ancient Nahuatl language—means "Place of the Reeds," suggesting the presence of water in this arid climate and a metaphor for a magnificent and hallowed city. A resident of Tula was called a Toltec, which also meant a supremely gifted and cultured person. At Tula, the later Aztec societies encountered monumental sculptures, called **atlantids** by Euro-American archaeologists. The term "atlantid" derives from the Greek story of Atlas, who bears the weight of the world on his shoulders. Some fanciful theorists link these sculptures with the myth of the island of Atlantis—a connection completely unsupported by scientific evidence due to Atlantis's entirely fictional origin.

The Aztec took some of the atlantids from the summit of a Tula temple in an attempt to bring some of their power and sacredness back to Tenochtitlán (present-day

atlantid a monumental figural sculpture that supports a roof or other architectural element.

atlatl a thin stick with a notch to hold a spear in a way that allows the user to throw the spear faster and farther.

pectoral a piece of jewelry or armor worn on the chest.

Mexico City), the Aztec capital. They did not take all the figures, however, leaving enough at Tula for later archaeologists to reconstruct the original Toltec program.

COLOSSAL ATLANTIDS, TULA Four atlantids stood atop one of the major pyramids at Tula (Pyramid B) and are now reconstructed there (**Fig 30.9** shows three of them). Together with a set of rectangular columns, these four monumental stone figures once held up the flat roof of the temple at the summit of the pyramid. Each is a sacred warrior, carrying an *atlatl* in one hand and a ceremonial pouch (suggesting a priestly or ritual function) in the other. The conception of the human figure conforms to the blocky rectangular shape of the architectural pillar. The artists used a rougher carving style with less detail than is seen in other Mesoamerican traditions, but certain regalia elements are obvious, especially the butterfly **pectoral** on the chest and the large, circular mirror attached at the small of the back. Both of these items were indicative of Toltec warriors. Enough paint traces remain on the atlantids to reconstruct the stunning original polychromy. The figures' legs were painted in thin red stripes on a white ground; in later codices this pattern was used to depict great warriors descending from the sky.

CASTILLO, CHICHÉN ITZÁ The Maya polity of Chichén Itzá on the Yucatán peninsula rose to prominence following the decline of, and immigration from, other Maya city-states, beginning around 850 CE. Though it is more than 650 miles (1100 kms) from Tula, it shared many significant aspects of Toltec style and iconography, including the focus on sacred warriors and the more direct, raw method of carving that the Maya now preferred.

A monumental pyramid at the center of Chichén Itzá, named Castillo or "castle" by the Spanish (**Fig. 30.10**), who conquered much of the region in the mid-sixteenth century, shares the sacred mountain symbolism of pyramids at Tikal, Teotihuacan, and Palenque, and like many other pyramids of this period, was built over an earlier pyramid on a sacred site. Some of the Castillo's furniture has also survived unharmed, including a jaguar throne, long a sign of royalty in the region, at its summit. The throne is paired with a warrior's back mirror inlaid with turquoise, of the sort worn by the elite warriors of Tula.

The more accurate name of the Castillo is the Temple of Kukulkan, the Maya name for the pan-Mesoamerican

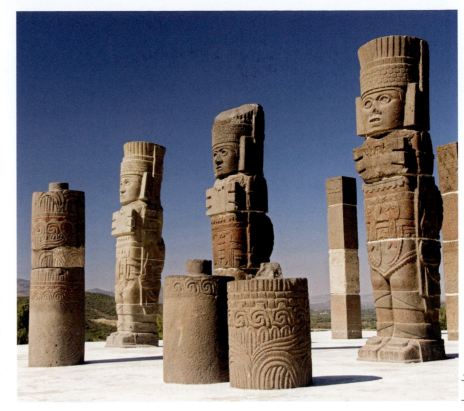

30.9 Colossal atlantids and other sculpture, Tula, Hidalgo, Mexico. Toltec, *c.* 900–1100. Stone, height approx. 16 ft. (4.88 m).

30.10 Castillo, Chichén Itzá, Mexico, *c.* 850–1000.

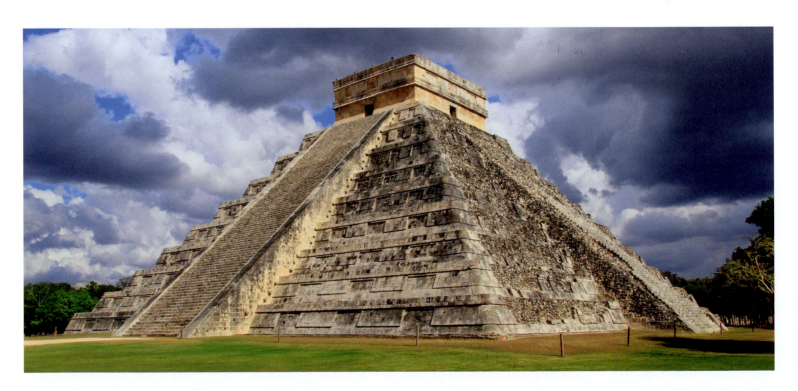

feathered serpent deity associated with the life-giving rains of the spring and the onset of death in the fall. The temple has nine levels, corresponding to the Mesoamerican perception of the Underworld, conceived of as a set of watery caves divided into nine levels inside a mountain, where the gods of death, disease, and riches lived. In addition, the temple's position is related to the spring and fall equinoxes, when the sun moving across the northwest corner of the pyramid casts a shadow in the form of a slithering serpent, a Mesoamerican symbol of transformation and power. The serpent moves down the balustrade of the stairway as the sun moves across the sky. This ephemeral serpent body, seen only during the equinoxes, is memorialized by two sizable feathered serpent heads carved in stone at the base of the balustrade. The Maya celebration of important passages of the sun, such as the equinox and solstice, was evident in monumental Maya architecture built 1,000 years before the Castillo and in codices similar to almanacs of the seasons that survive from the Postclassic period.

Regional Developments in Mesoamerica and Central America, 600–1300

At the same time that the Maya were flourishing and Tula was rising, several other regions in the Americas experienced significant developments. The Classic Veracruz culture was located directly between the Maya and Tula in the former lowland home of the Olmec (see Chapter 12). To the south and east of the Maya region, the societies of Central America (from present-day Costa Rica south to present-day Colombia) developed a remarkable skill in working gold and other precious metals.

CLASSIC VERACRUZ YOKE Finely carved **effigy** ball-game equipment that is at least 1,000 years old has been found in many parts of Mesoamerica. By far the greatest number of such items come from the Mexican Gulf Coast region

(the present-day Mexican states of Veracruz and Tabasco); they belong to the tradition that scholars have dubbed Classic Veracruz. That designation refers to art from the cities on the Mexican Gulf Coast that flourished between the years 1 and 1000 CE.

The skill and heroics necessary to play the ball game well were traits associated in the Mesoamerican mind with the nobility. However, that does not mean that the players wanted to be hurt during the competition. As later Spanish observers tell us, striking a solid heavy rubber ball with the hip without protection can cause grave internal injuries, making safety equipment necessary. Remnants of the athletes' defensive gear were found in a palace at Copán, highlighting its importance and underlining the association of the ball game with the nobility. This finely polished, U-shaped yoke (**Fig. 30.11**) is a greenstone effigy of such a protective device, and it must have been the prized possession of an elite person. As with the protective belts (probably made of textiles and fibers) worn by players of the ball game, it is shaped to fit around the waist.

The yoke takes the general form of a crouching toad, with large almond-shaped eyes and a lolling, rectangular tongue in the central curved portion (the tongue is the raised rectangle towards the bottom center of the image). The toad's legs are depicted in a crouch on the long sides of the yoke (not shown here). Myths associate the ball game with miraculous springs and agricultural fertility, and it is perhaps this association that makes the toad such a popular motif on yokes.

BAT DEITY PENDANT The cultures of the Central American regions to the south and east of the Maya did not create the same kind of complex urban culture as those of Mesoamerica and the Andes. The chiefs of these smaller societies had no hereditary right to rule. They could be unseated or their followers could simply leave to follow another chief. Chiefs competed for power and prestige, attempting to attract followers with their

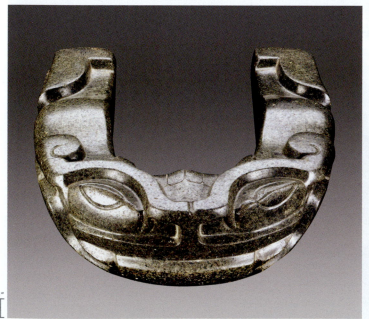

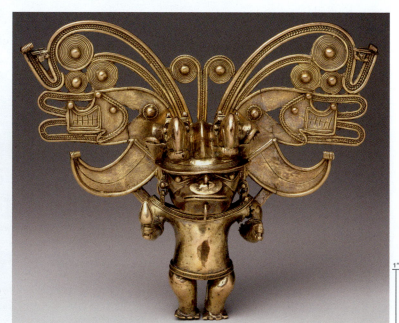

religious prowess and their acumen in war. One clear sign of their high status was the number of finely crafted gold objects they obtained and wore, which created a highly competitive industry in metalworking in the area. Although metalworking in the Americas was first invented in the Andean region (see Chapter 11), goldworking soon became the most important art form of Central America.

The small figure in this pendant (**Fig. 30.12**) depicts a broad-shouldered, muscled male who is naked except for a thin belt and an enormous, complex headdress. The focus of the headdress is a **zoomorphic** head out of which spin symmetrically arranged patterns in gold wire, masterfully brought together into circular forms on either side. Small clappers just above the zoomorphic head and at the outer edges of the wire spirals suggest that this piece was meant to make noise when worn by chiefs in a dance rite. The rhythmic sound of the clapping precious metal during a dance would have emphasized the chiefs' power and called attention to their hard-won finery. Although this piece looks like gold, it is actually made of a gold-copper alloy, called tumbaga, that was treated with chemicals and heat to bring as much gold as possible to the surface.

Combined with the winglike imagery of the headdress, the nature of the face of this pendant and others like it has led some scholars to identify the figure as either a bat deity or a human impersonating one. Bats often symbolize darkness and the caves in which they are found. The divine entity rendered in this shining pendant may therefore reflect the significance of caves, which often house pools or underground streams in the tropics, as subterranean sources of fresh water. Chiefs who wore these pendants may have been associating themselves with these important natural phenomena.

Wari Art in the Andes, 600–1000

In the Andean region in present-day Peru and Bolivia, power became centralized at the expense of the numerous regional cultures, producing the first empire in the region: the Wari. Archaeologists call the period from 600–1000 CE the "Middle Horizon" to describe the Wari dominance and its aftermath, just as the Chavín religion (see Chapter 11) had produced the "Early Horizon" in the first millennium BCE. The Tiwanaku culture of highland Bolivia, sometimes characterized as an enemy of the Wari, remained important during the Middle Horizon.

The historical movement away from smaller regional cultures to a much larger political unit during the Middle Horizon had a distinct effect on the arts. Wari imagery is characterized by standardization and the development of shared artistic conventions. At the same time, artistic techniques reached virtuosic levels, especially in **tapestry weaving**. In addition to weaving, much artistic effort was also placed on ceramic vessels used in important feasts.

WARI *KERO* (DRINKING CUP) Feasts for the Wari and other Andean societies were imbued with religious significance and served to bolster shared ideas of cosmic and societal order. The sacred nature of these feasts is indicated by the imagery on their drinking cups, which often focuses on important deities or their impersonators. The later Inka called this type of cup a *kero* (sometimes spelled *quero*), a name that is now used for all examples of this form, regardless of where they are found. The cup had a cylindrical body and flaring sides, and it held a very popular maize (corn) beer, known as *chicha*, that was drunk during the feasting rituals of the Wari and other Andean cultures.

This example (**Fig. 30.13**) is made of wood, but *keros* were often ceramic or made of precious metals, such as gold or silver, depending on the social standing of the person hosting the feast. Four figures circle the body of the cup, each kneeling and holding a beaded staff that may be associated with authority. The figures are human, but two of them exhibit jaguar-like heads while the other two have the features of birds of prey. All of them also sport wings, similar to the flanking figures in the Gateway of the Sun at the Tiwanaku capital, Tiahuanaco (see Fig. 11.15), who kneel in a similar posture. The mixing of human and animal characteristics suggests that these figures are supernatural. Feline heads indicate a predatory nature, agility, and nocturnality while wings reflect flight. Combining the features of different animals elevates a figure to a more than human status.

WARI TUNIC Textiles were another prestigious artistic medium among the Wari. The Wari method of weaving fine textiles, called tapestry weaving, involves carefully and closely packing the thread to create a dense, lush fabric that the Spanish likened to silk. Whereas earlier Paracas textiles (see Fig. 11.5) used **embroidery** to sew much of the imagery onto woven cloth, Wari weavers created true tapestries, in which the designs are woven directly into the cloth.

The strict limits of the loom's **warp and weft** at right angles may have been one reason for the increasing presence of geometric patterning in Wari textiles, such

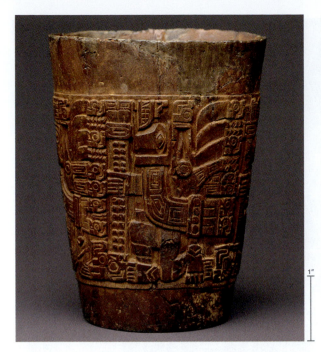

30.13 *Kero* (drinking cup), **Wari**, 600–1000. Wood, height 4½ in. (11.4 cm), diameter 2½ in. (6.4 cm). Metropolitan Museum of Art, New York.

zoomorphic having an animal-like form.

tapestry weave a process in which patterns are woven directly into the textile, not sewn on or otherwise added later in the process.

kero an Andean decorated drinking cup used in feasts.

embroidery decorative stitching usually made with colored thread on woven textile.

warp and **weft** in textile weaving, warp threads are the stationary vertical threads held taut to the loom and weft refers to the yarn that is woven horizontally over and under the warp threads to make cloth.

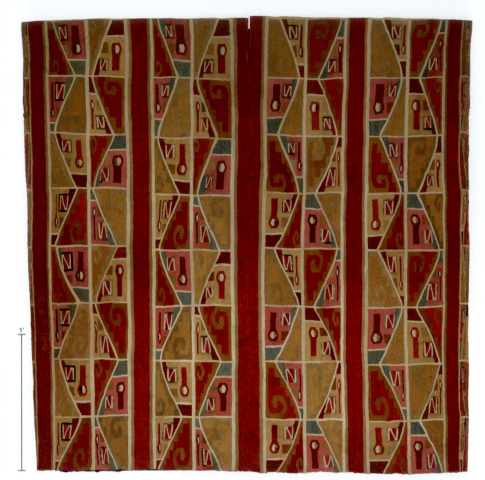

as that in the shirt or tunic in **Fig. 30.14**. The extreme geometric quality makes the subject matter difficult to see, but it is possible to make out a repeating eye motif outlined in deep red. The repeating eye is always paired with a fret, or stairstep motif directly above or below. Here, the entire tapestry is covered with repeating eyes paired with frets.

Some scholars have suggested that the Wari geometric patterns may have been a type of visual language that represented the tunic wearer's prestige and status. Indeed, this visual language may have been so prestigious that it was guarded as secret knowledge, "readable" only by those of high enough status to have access to the techniques required to make it. Lower-status people could only assume that the patterns and fine quality of the weaving indicated that the wearer was an important person.

Art in North America, 600–1300

The people living in what are now the United States and Canada between 600 and 1300 CE developed vibrant and varied cultural traditions of their own. Many Native American and First Nation societies produced permanent arts, such as architecture and sculpture, while more mobile groups focused on arts that could be easily transported.

GREAT SERPENT MOUND, OHIO The practice of building earthen mounds by painstakingly bringing basket after basket of earth to a site, piling it up, and compacting

30.14 Wari Tunic, 600–1000. Camelid fiber and cotton, 40¼ × 40¼ in. (1.02 × 1.02 m). Dallas Museum of Art, Texas.

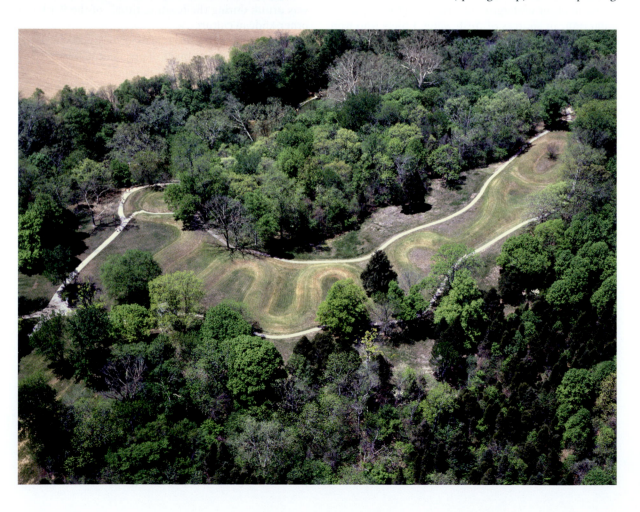

30.15 Great Serpent Mound, Adams County, Ohio, *c.* 1070. Length over 1,300 ft. (over 400 m).

it until it reached monumental proportions (known as **rammed-earth** construction) began in North America by 1600 BCE, and it continued for more than two thousand years. All of these mounds seem to have been used as stages for performing sacred rites and as burial places for important ancestors.

First excavated in the 1880s, the Great Serpent Mound (Fig. 30.15) in southern Ohio is one of the earliest Native North American rammed-earth mounds to be explored archaeologically. This mound does not have the typical pyramidal or conical shape one might expect of an earthen structure of this nature. Rather, it was purposefully designed to resemble a writhing snake with a curled tail. The serpent effigy is over 1,300 feet (almost 400 m) long and varies in height between 1 and 3 feet, The mound was created atop a natural escarpment.

Although many earthen mounds in the region were made to house the remains of important individuals, no burials have yet been found in the Great Serpent Mound, leading scholars to speculate that it may have been an astronomical observatory. The dates of its construction have also been keenly debated. Early researchers attributed the Great Serpent Mound to the Adena culture (800 BCE–100 CE) based on the presence of Adena burial mounds nearby; later theories suggested the earthwork may have been created to commemorate Halley's Comet. The most recent excavations have produced radiocarbon dates around 300 BCE, suggesting that the monument may have been built over a long period of time, spanning multiple cultural traditions.

ADENA PIPE The people who constructed the mounds in Ohio, and others around the Mississippi River in North America, often placed important objects in the tombs of their honored dead. This finely carved stone pipe (Fig. 30.16) was found in another earthen mound in Ohio. It was used in important tobacco-smoking rites and then deposited with the deceased for use in the afterlife. Tobacco is a crop native to the Americas, and it was often used, similarly to chocolate or maize drinks, in ceremonial events.

The carved figure stands at attention, wearing a loincloth (the garment around its waist). Three deeply incised lines on the torso define the figure's mid-section. The complex headdress features a small well drilled into the top for inserting and burning tobacco. The figure's mouth is open, potentially speaking or singing. In addition, the figure wears two enormous **earflares**, a type of ornament popular throughout the Americas and especially prized in the south of Mesoamerica (a Maya example appears in Fig. 30.5). These similarities in adornment styles are some of the evidence that scholars use to understand the long-distance connections among ancient cultures of the Americas.

CAHOKIA In the same general region as the Great Serpent Mound, a city emerged that was as large and complex as many Maya cities. Cahokia, near St. Louis, Missouri, had its apogee from approximately 1000 to 1300 CE, when up to as many as 15,000 people lived in the urban area, with another 10,000 Cahokians residing in the surrounding agricultural lands. As the reconstruction (Fig. 30.17) shows, a wooden wall defined the ceremonial district in the center of the city, while homes and public spaces spread out on either side. At the heart of the central space, a monumental multi-leveled rammed-earth pyramid called Monk's Mound covers 15 acres and stood 100 feet tall. The mound's axis marks the place on the horizon

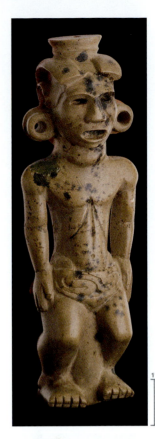

30.16 Pipe, Adena culture, Ohio, *c.* 100 BCE–100 CE. Stone (Ohio pipestone), length 8 in. (20.3 cm). Ohio Historical Society, Columbus.

rammed earth building technique in which damp earth is compressed within a frame or mold, to form a solid structure.

earflare large ear ornament, often passed through an extended earlobe.

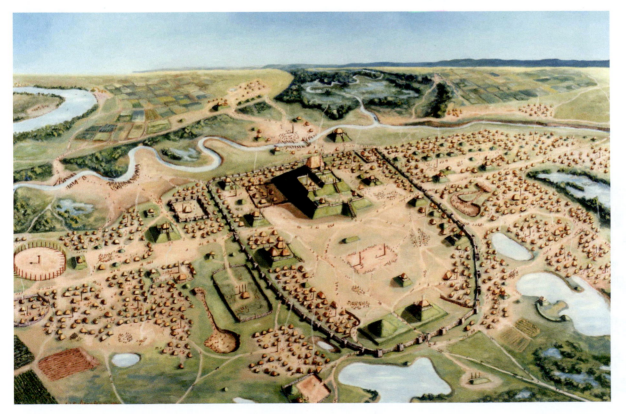

30.17 Central Cahokia as it would have appeared about 1150–1200. Settlement area shown approx. 2 × 2 miles (3.2 × 3.2 km); height of central mound approx. 100 ft. (30 m). Painting by William R. Iseminger, courtesy of Cahokia Mounds Historic Site.

where the sun rises on the equinox, suggesting that significant celestial events were important to the city, just as they were to the Maya of Chichén Itzá, who built the Temple of Kukulkan.

The central walled enclosure at Cahokia probably had a defensive purpose in addition to defining the sacred precinct. Warfare is often marked by taking the enemy's most sacred objects and sites, and the wall at Cahokia would have made that difficult for potential attackers. Cahokians also erected large circles of upright wood poles near Monk's Mound, probably as to mark the motion of the sun as timekeeping devices.

PUEBLO BONITO The large apartment buildings seen at Teotihuacan (see Chapter 12) were not unique to central Mexico. In North America, a similar type of housing called a pueblo developed after 900. A pueblo was of a semi-circular design and housed hundreds of people, providing spaces for food and other storage, human burials,and religious rituals. It appears that these buildings were connected by a shared economy and religious culture.

Pueblo Bonito was one of several similar apartment buildings scattered around the area now known as Chaco Canyon (New Mexico). Although only the outlines of the first floor are visible today, the building originally had at least four stories and contained as many as 800 rooms (**Fig. 30.18**). Dotted throughout the public spaces of Pueblo Bonito and the larger vicinity of Chaco Canyon were below-ground round rooms called *kivas*, which served as a major religious space. It is believed that these were for men only, as is the case with similar spaces for later Native North Americans. The rooms were entered through holes in the *kiva*'s roof; men descended by a ladder into the kiva, alighting in a square pit in the floor called the "navel of the world," which symbolized the place where ancestral people had first emerged onto the earth. It is likely that the men of Chaco Canyon were recalling their ancestors, who lived in similar round structures underground.

The people who lived at Chaco Canyon and similar sites are known today as the Ancestral Puebloans, based on their connections to the pueblo cultures first encountered by the Spanish and active today. Early Ancestral Puebloans emerged by the sixth century in the Four Corners region of what is now the southwestern United States (the region where Colorado, Arizona, Utah, and New Mexico meet). Over the next five centuries, they built extensive irrigation systems to allow the relatively dry area to produce enough food to support a growing population. They lived in pit houses, which were round living areas

30.18 Pueblo Bonito, Pueblo culture, Chaco Canyon, New Mexico, 830–1250. Pueblo Bonito is shown in the foreground.

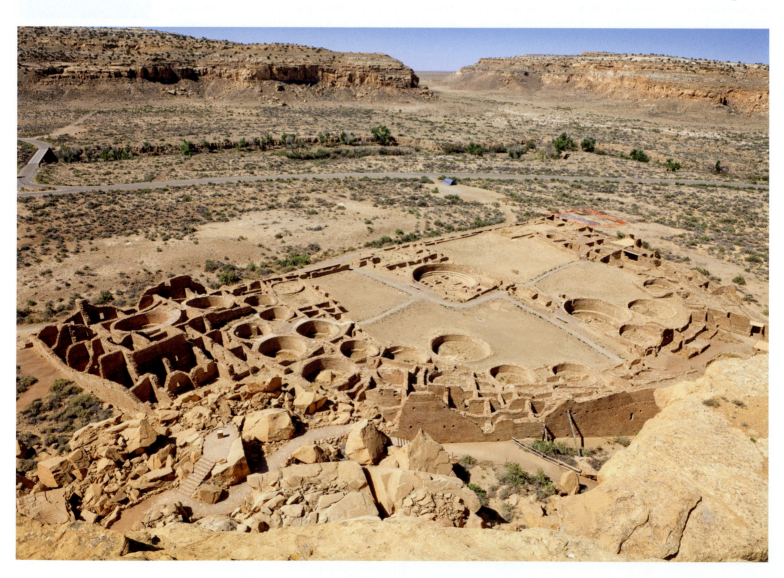

dug into the earth. By 900, the *kivas* of Chaco Canyon were constructed to echo these early house forms.

About 1150, after several centuries at Pueblo Bonito, the people began to build in more secure locations on the side of a cliff, suggesting that the apartments on the valley floor were no longer defensible, perhaps owing to an increase in warfare. Even in these cliffside dwellings, the builders maintained the apartment-room structure of Pueblo Bonito. Their construction ceased by 1250 CE, and new religious patterns emerged in the region, focused on a group of deities called *kachinas*, who are still worshiped in the southwestern United States by people associated with historic Pueblo cultures (see Chapter 41).

SEED JAR The people who were beginning to move away from Pueblo Bonito and the other large apartment structures made this ceramic container (**Fig. 30.19**). It probably held seeds for planting because it has holes that could be used to suspend the jar above the floor and thus keep its contents away from hungry mice and other rodents. Artists decorated the jar with sharp geometric motifs that are carefully controlled and repeated. This pattern has an interlocking quality resembling knotted rope or nets, materials that certainly would have been used by the Ancestral Puebloans. Further, string could have been used to help create some of the geometric patterns by serving as a guide for lines and compass for oval and circular forms. The painted pattern on the jar's cream-colored ceramic body is called a black-on-white design, known for strikingly abstracted all-over patterning.

GORGET WITH WARRIOR The use of precious materials to create items of dress with strong symbolic value was key to Native North American cultures throughout their history. The inhabitants of what is now the southeastern United States developed a particularly rich symbolic system, which they used on worked seashells and other precious materials worn by the region's elite people. This carved and incised shell piece (**Fig. 30.20**) attributed to the Mississippian culture (present in the Mississippi River Valley and adjacent areas between *c.* 800–1600 CE) shows a profile figure in an active pose, possibly running, and wearing large earflares, much like the Adena pipe figure created more than a millennium earlier (see **Fig. 30.16**). The man sports either a tattoo or painted design around his eye that scholars believe resembles a falcon's markings. Falcons were important in Mississippian traditions; strong predatory birds, they were associated with the mythological warrior known as Redhorn or Morningstar.

The figure holds a human head in his right hand, suggesting that a decapitation ritual has just taken place. His left hand holds a club with sharp protrusions, which also suggests a sacrificial rite, perhaps associated with warfare. The man's elaborate headdress incorporates an arrow pointing up. All of these features indicate that this person is a warrior, perhaps even the deity Redhorn/Morningstar himself. Near the figure's left hand are two holes drilled through the shell. We know from other representations that high-ranking officials wore these as **gorgets** or pectorals, just as the important people in

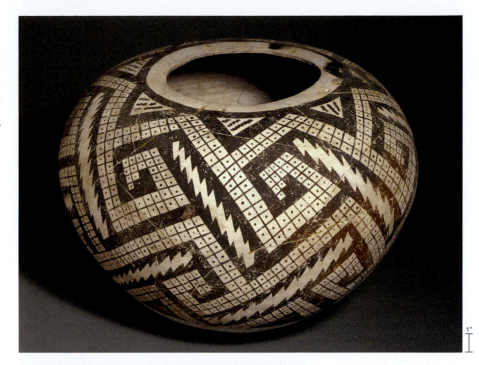

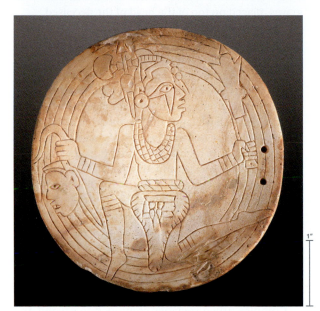

30.19 ABOVE **Seed Jar**, Ancestral Puebloan, *c.* 1050–1250. Earthenware with slip, 12 × 13 ½ in. (30.5 × 34.3 cm). Saint Louis Art Museum, St. Louis, Missouri. Funds given by the Children's Art Festival 175:1981.

30.20 LEFT **Gorget with running warrior**, from Sumner County, Tennessee, *c.* 1250–1350. Whelk shell, diameter 4 in. (10 cm). National Museum of the American Indian, Washington, D.C.

Central American society wore gold jewelry on the chest. The shell objects would eventually be buried with the individuals who wore them in life.

MIMBRES BOWL WITH CRANES While Native North Americans often used precious stones and shell from distant oceans for their finest and most complex objects, a humble material—clay—could also serve as the medium to express important stories and beliefs. The Mimbres, a culture that flourished between about 1000 and 1250 CE in southwestern New Mexico and southeastern Arizona, is known for lively painted depictions on ceramics. These paintings are always found on the inside (concave) part of a simple bowl form. Mimbres bowls, which were most probably made by women, often feature black-on-white designs that concentrate animal and/or human figural forms, which frequently exhibit strong

gorget an object worn near the neck area as a costume item.

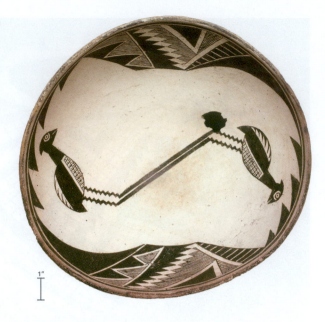

30.21 Mimbres bowl with two cranes and geometric motifs, New Mexico, c. 1250. Painted ceramic, diameter 12½ in. (31.8 cm). Art Institute of Chicago, Illinois.

around the palace of the ruler. Maya artists fashioned vessels for the drinking of chocolate and decorated the interior of palaces with murals. In other parts of Mesoamerica and Central America, nobles commissioned fine stone sculpture and wore gold ornaments to indicate their elite status. In the ancient Andes, weaving traditions, which had always been a key art form, continued to be central in the Wari empire that rose after 600. Wari artists produced finely woven cloth with complex geometric decoration. North America witnessed the rise of complex culture in the Mississippi River valley and the Southwest. In both areas, artists produced elite objects with religious symbolism. In all these regions, people built significant religious structures as the center of their increasingly complex settlements.

symmetry or radial effects, in the center and geometric motifs around the rim. These bowls were often found in graves, placed on top of the head of the deceased.

In the bowl shown here (**Fig. 30.21**), two cranes are depicted in stark contrast against the clean cream background, while around the rim the artist has placed a series of different geometric forms that resemble the motifs on the Ancestral Puebloan seed jar (**Fig. 30.19**). Cranes were chosen to feature on this piece because they migrate through what was the Mimbres territory of New Mexico every year, and are closely associated with bodies of water, which are highly valued in the dry environment of southern New Mexico and Arizona. The artist chose to merge the birds by extending the line of their feet toward each other, complementing the lines of their legs and accentuating the mirror effect across the center of the bowl. Near the feet of the crane on the (viewer's) right is a hole, made on purpose before the bowl was buried. Scholars suggest that the hole may have been intended to kill the spirit that animated the ceramic bowl, or to serve as a passage for the dead soul in the burial.

Complex urban societies continued to expand and evolve in ancient Mesoamerica during this period, including in the Maya area, where nobles were organized

Discussion Questions

1. Using specific examples, identify the naturalistic traits of Late Classic Maya art. How does Classic Maya art compare to Andean art of the same time? What might account for these stylistic differences?

2. Compare the fine jewelry worn by high-status individuals of North America and Central America. What elements are similar in each tradition? What might account for these similarities?

3. What could ceramic vessels be used for during this period, given the examples in this chapter? Does the function of a vessel impact its decoration?

Further Reading

• Bergh, Susan E., and Castillo, Luis Jaime. *Wari: Lords of the Ancient Andes*. New York: Thames & Hudson, 2012.

• Berlo, Janet C. and Phillips, Ruth B. *Native North American Art*. Oxford: Oxford University Press, 1998.

• Miller, Mary Ellen, and Martin, Simon. *Courtly Art of the Ancient Maya*. San Francisco, CA: Fine Arts Museums of San Francisco, 2004.

• Pasztory, Esther. *Pre-Columbian Art*. Cambridge: Cambridge University Press, 1998.

• *Pottery in the Southwest*. Gilcrease Museum, Tulsa, https://collections.gilcrease.org/pottery-southwest

• *Xcaret–Pok-ta-Pok Mayan ball game*, https://www.youtube.com/watch?v=jKvQjgC9slY

Chronology

c. 100–1000	Classic Veracruz culture; portable sculptures celebrating the ball game are made	*c.* 734	Maya build Temple 1 at Tikal, Guatemala
600	The destruction of Teotihuacan, Mexico	830–1250	Pueblo Bonito is built and occupied in Chaco Canyon, New Mexico, USA
600–900	The Maya Late Classic period	*c.* 850–1000	The Castillo monumental pyramid is constructed at Chichén Itzá, Mexico
600–1000	The Wari empire, Andes	900–1200	The rise of Tula and Toltec style in Central Mexico
603–83	The life of Pakal, Maya ruler of Palenque, who commissioned many buildings, including the Temple of the Inscriptions	1000–1300	The city of Cahokia flourishes in Missouri, USA
		c. 1070	The Great Serpent Mound is constructed in Ohio, USA

31

Art during the Song and Yuan Dynasties of China

960–1368

Mandala of Vajrabhairava
(detail), Yuan dynasty, China.

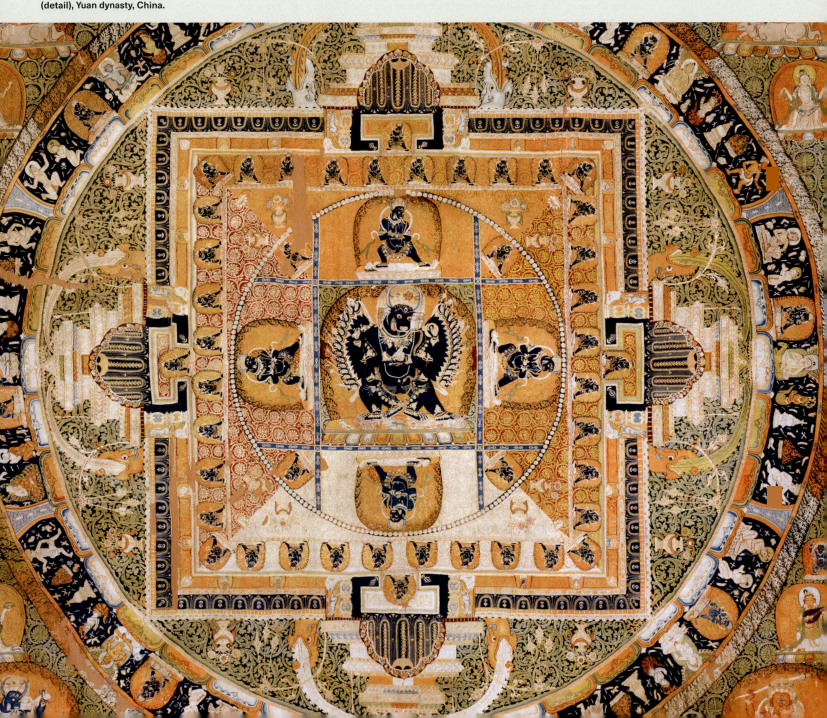

Introduction

The Song (960–1279) and Yuan (1279–1368) dynasties in China may at first appear to be complete opposites. The Song was an indigenous dynasty in which Confucian attitudes, including the cultivation of virtue and adherence to social rituals, dominated matters of government and culture. A robust economy, philosophical and scientific inquiry, and technological innovation all contributed to an era that became much celebrated during later periods in China. Images of monumental landscapes and thriving urban activity aptly captured the confident ethos. Even though foreign incursions led to a diminished empire during the second half of the dynasty, aspects of Song culture survive and inform our understanding of what is considered typically Chinese art today.

By contrast, the nomadic Mongols lived outside Confucian tradition. After they conquered China and established the Yuan dynasty—part of a vast, pan-Asian empire—many Chinese resented their presence. Significant disruptions resulted from this dynastic change. Mongolian culture, which was based on pasturing animals and nomadic ways of life, differed from that of the Chinese, who considered them "barbarians" and who sometimes used art to express their frustration and discontent with Mongol rule. Nonetheless, the relative peace and stability across the Mongol empire increased intercultural contact, providing artistic stimuli and leading to the creation of some of the most treasured paintings in Chinese art, many of which looked back to idealized earlier periods in Chinese history.

Paintings played a central role in the relationship between art and politics. In China, landscape painting developed well before that genre gained status in Europe. Featuring mountains and water, landscape painting became a major vehicle both for championing imperial views and voicing political dissent. In addition to furnishing the court with monumental landscape paintings, imperial workshops provided a wide variety of artworks, including fans, ceramics, and textiles, demonstrating significant skills and technological achievements. At the same time, scholar-officials used poetry and calligraphy to emphasize authenticity and individuality.

Sociopolitical changes were not the only drivers of artistic development during the Song and Yuan dynasties. A previous and severe prohibition against Buddhism (in 845, late in the Tang dynasty) led indirectly to the later prominence of the Buddhist sect of Chan (known in Korean as Seon and in Japanese as Zen), and the Mongol court supported a form of Esoteric Buddhism (schools of Buddhism that feature secret teachings, requiring the assistance of an advanced instructor to access and understand). As Buddhist beliefs and practices changed, new forms emerged in Buddhist art.

Art of the Southern Tang Kingdom, 937–975

After the Tang dynasty collapsed in 906, numerous governments ruled over regional Chinese territories. In the north, five dynasties rose and fell in quick succession. To the west and south, roughly a dozen kingdoms—including one known in retrospect as the Southern Tang (937–975)—held sway. This time of disunion is thus known as the Five Dynasties and Ten Kingdoms period.

Contemporaneous accounts and modern histories often view periods of disunion unfavorably, yet these crises proved to be catalysts for the formation of vital new ideas for government, society, and culture. For example, the regional Southern Tang kingdom drew talented officials and painters to its court in present-day Nanjing (**Map 31.1**), and in that relatively peaceful kingdom, the arts of music, poetry, **calligraphy**, and painting flourished. The kingdom's last ruler, Li Yu (937–978), was an active patron of art and a talented poet and calligrapher himself, and he provided a model for later emperors (such as Emperor Huizong, see below). Li Yu assembled an art collection, which was later seized by conquering Song forces. This transfer of cultural patrimony symbolized the late capitulation of Southern Tang to the Song government, and greatly enriched Song collections. But it also made Southern Tang painting—especially landscapes—known to artists of the Song dynasty and generations to come.

DONG YUAN, *WINTRY GROVES AND LAYERED BANKS*

Among the most important paintings associated with the Southern Tang is *Wintry Groves and Layered Banks*, attributed to the Southern Tang painter Dong Yuan (d. 962) (**Fig. 31.1**). It represents an early stage of Chinese landscape painting. In this **hanging scroll** (see **Fig. 31.2b**), Dong (note that Dong is the artist's family name, and in Chinese convention, family names precede given names) uses a moist brush, layers of ink wash, and limited color to construct a marshy landscape with gently sloped mountains, typical of the Yangtze River territory of the Southern Tang. (When initially completed, this landscape would have appeared brighter. As in the case of other early

Map 31.1 East Asia, c. 1000 (in 1127 Song dynasty is reduced to Southern Song area only).

Gobi Desert

Mongolian Steppe

Taklamakan Desert

LIAO DYNASTY (KHITAN)

Shangjing

Sungari River

Liao River

Yellow River

GORYEO DYNASTY

HEIAN PERIOD

Heian-kyō (Kyoto)

Chang'an

Kaifeng

Yellow River

(NORTHERN SONG)

SONG DYNASTY

Nanjing

Huangzhou

Yangtze River

Yangtze River

Lin'an (Hangzhou)

(SOUTHERN SONG)

Xi River

PACIFIC OCEAN

N

0 · 250 · 500 miles
0 · 500 · 1,000 kilometers

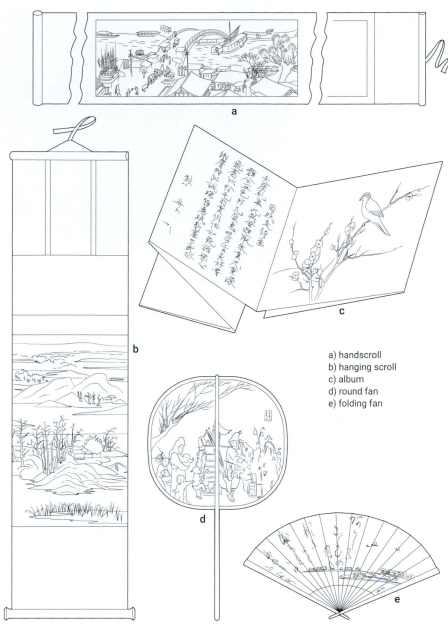

a) handscroll
b) hanging scroll
c) album
d) round fan
e) folding fan

paintings, the silk has darkened over the centuries.) The composition is divided roughly into three parts. Reeds grow along a sandy spit in the foreground; a bridge at far right leads the eye to the middle ground, where bamboo groves and bare trees surround rustic dwellings; and in the background, rounded mountains rise from wetlands that recede into the distance.

Although houses and boat masts (visible to the left of the rounded mountains) indicate human presence, Dong's quiet landscape focuses on two main elements, mountains and water. This pairing matches the Chinese term for landscape, *shanshui*. In Chinese philosophy, water is considered feminine, or *yin*, whereas mountains are associated with the masculine, or *yang*. Consequently, by combining physical embodiments of *yin* and *yang*—generative of all matter and phenomena—the landscape genre has the character of a microcosm.

Art during the Northern Song Dynasty, 960–1127

The art, culture, and ideas developing in regional kingdoms such as the Southern Tang came together with the reunification brought about in 960 by the Song dynasty. Due to foreign conquest of northern areas of the empire in 1127, the Song dynasty is in retrospect divided into two periods—the Northern Song of 960–1127 and the Southern Song of 1127–1279 (**Map 31.1**). The conquest also forced the Song court to relocate its capital from Kaifeng in the north to Lin'an (present-day Hangzhou) in the south. Believing that the fall of the Tang dynasty was a direct consequence of insufficient central control, Song emperors disarmed potential rivals and promoted a civil bureaucracy based on Confucian principles of governance, encouraging intelligent and ambitious men to focus their energies on preparing for civil service examinations. Success in the examinations led to prestigious government appointments.

With the support of legions of scholar-officials, the emperor ruled over a stable and flourishing empire. In the Northern Song capital, Kaifeng, highly skilled court artists produced exquisite and elaborate paintings that attested to society's good order and thereby proclaimed the emperor's fitness to rule. They also manufactured extremely refined objects, notably ceramics, for imperial use. Generally, emperors collected and commissioned

31.1 ABOVE LEFT **Attributed to Dong Yuan,** *Wintry Groves and Layered Banks,* Southern Tang dynasty, *c.* 950. Hanging scroll: ink and color on silk, 5 ft. 11¼ in. × 45⅝ in. (1.81 × 1.16 m). Kurokawa Institute of Ancient Cultures, Hyogo, Japan.

31.2a–e ABOVE **Formats of East Asian paintings.**

31.3 Fan Kuan, *Travelers among Streams and Mountains,* Northern Song dynasty, *c.* 1000. Hanging scroll: ink and colors on silk, 6 ft. 9⅛ in. × 40⅝ in. (2.06 × 1.03 m) National Palace Museum, Taipei.

Fan's painting is a quintessential example of monumental landscape. Its physical dimensions are large—it is over 6 feet high—but more importantly, the scale of the imagery is towering. The rugged terrain in *Travelers,* characteristic of Fan's native Shaanxi province (toward the northwest of China), is rigorously depicted. Declaring "It is better to have nature as a teacher," Fan retired to the mountains to study and to paint.

GUO XI, *EARLY SPRING* Fan's style was continued by painters serving at the Song court, which had also acquired the art of fallen kingdoms and former enemies such as the Southern Tang, whose court painters were forcibly moved to serve the new regime at Kaifeng. With many talented painters and scholar-officials, the Song capital became the center of significant artistic innovations and profound cultural changes. Tendencies in southern and northern approaches to landscape, as exemplified by Dong Yuan and Fan Kuan, respectively, came together at the Song court, and Guo Xi (*c.* 1001–1090) drew on both for his *Early Spring* of 1072 (**Fig. 31.4**). The pervasive presence of water—river, waterfalls, vapors, mists, and clouds—and the receding "deep distance" seen in the valley in the middle ground at the viewer's left, are related to such southern landscapes as Dong's *Wintry Groves and Layered Banks* (see **Fig. 31.1**). From the northern tradition come the monumental scale and the tall mountains, along with a point of view that Guo describes as "high distance" (see **Fig. 31.3**). In his treatise on landscape painting, Guo identifies a third point of view, "level distance," which refers to seeing far from a high vantage point (see box: Going to the Source: Guo Xi's Writing on Landscape).

artwork, but occasionally they themselves painted and practiced calligraphy.

FAN KUAN, *TRAVELERS AMONG STREAMS AND MOUNTAINS* In contrast to Dong Yuan's restrained and watery landscape, *Travelers among Streams and Mountains* by Northern Song painter Fan Kuan (*c.* 950–*c.* 1031) overwhelms viewers with a massive mountain that fills nearly the entire space (**Fig. 31.3**). Sheer cliffs and a steep waterfall emphasize the composition's verticality. The foreground and middle ground occupy a smaller area, and tiny figures at the mountain's base—pack mules and peasants, below the largest tree on the right—provide a sense of scale, magnifying the peak's height. Below the waterfall, elegant rooftops are nearly camouflaged by the dense surrounding woods, but careful observation yields a wealth of details, including a variety of trees, ripples of flowing water, and carefully rendered rocky crevices. Additionally, tucked into the foliage at lower right, Fan Kuan's signature suggests not only pride in this work, but also the rising status of artists more generally.

31.4 FAR RIGHT **Guo Xi,** *Early Spring,* Northern Song dynasty, 1072. Hanging scroll: ink and color on silk, 5 ft. 2¼ in. × 42½ in. (1.58 × 1.08 m). National Palace Museum, Taipei.

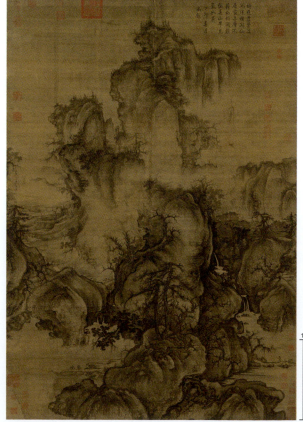

Writing by artists helps to shed light on their intentions and motivations, but in pre-modern eras it was uncommon for artists to write and the preservation of such writing was not at all ensured. Thus, Guo Xi's surviving treatise on landscape painting, *The Lofty Appeal of Forests and Streams*, is of particular value. Wide-ranging and detailed, Guo's essay not only illuminates the meaning and significance of his own paintings but also provides insight into the artistic culture of his time. The *Lofty Appeal* begins:

> Of what does a gentleman's love of landscape consist? The cultivation of his fundamental nature in rural retreats is his frequent occupation. The carefree abandon of mountain streams is his frequent delight. The secluded freedom of fishermen and woodmen is his frequent enjoyment. The flight of cranes and the calling of apes are his frequent intimacies.

In this ideal landscape, the educated man occupies himself in the activity of self-cultivation:

> The bridles and fetters of the everyday world are what human nature constantly abhors. Transcendents and sages in mist are what human nature constantly longs for and yet is unable to see. ... It is now possible for subtle

hands to reproduce [ideal landscapes] in all their rich splendor. Without leaving the mat in your room, you may sit to your heart's content among streams and valleys.

In addition to characterizing landscape painting as an expression of the Confucian scholar-officials' longing to escape the fetters of government duty in order to pursue self-cultivation, as a Daoist recluse might (see Fig. 21.14), Guo also judges landscapes according to

> those through which you may travel, those in which you may sightsee, those through which you may wander, and those in which you may live. Any paintings attaining these effects are considered excellent, but those suitable for traveling and sightseeing are not as successful an achievement as those suitable for wandering and living. Why is this? If you survey present-day scenery, in a hundred miles of land to be settled, only about one out of three places will be suitable for wandering or living ...

In addition, he urges the painter

> to go in person to the countryside. ... To discover the overall layout of rivers and valleys in a real landscape, you look at them

from a distance. To discover their individual characteristics, you look at them from nearby.

Yet, for all Guo's attention to natural phenomena, he nevertheless conceives of landscape as a vehicle for expressing social norms. The artifice and symbolism of landscape paintings are apparent when he writes:

> A great mountain is dominating as chief over the assembled hills, thereby ranking in an ordered arrangement the ridges and peaks, forests and valleys as suzerains of varying degrees and distances. ... A tall pine standing erect is the manifestation of a host of trees. Its outward spreading indicates that it brings order to the vines, creepers, grasses, and trees, like a commander of an army bestirring those who rely on him.

Discussion Questions

1. Choose a single sentence from Guo Xi's writing that deepens your understanding of Guo's painting, *Early Spring*, and explain how it does so.
2. Use Guo Xi's judgments about "excellent" and the most "successful" landscapes to discuss and evaluate landscapes by such other painters as Dong Yuan (see **Fig. 31.1**) or Fan Kuan (see **Fig. 31.3**).

Guo's deliberate use of multiple points of view is integrated seamlessly into a single landscape. In *Early Spring*, these perspectives facilitate the close representation of scenes of daily life (the peasant family in the foreground and the temple complex in the right middle ground) while also permitting the view of the serpentine mountain peak and the distant river valley. A single, fixed viewpoint would have been limiting, and would not have allowed viewers to experience the landscape painting as if traveling through an actual landscape.

The multiple perspectives underlie a composition that is firm, but—unlike Fan's *Travelers*—also dynamic. No longer are foreground, middle ground, and background separated into discrete parts. Instead, the craggy boulders and ancient pine trees propel viewers into a landscape of circuitous forms and pathways. A sinuously shaped mountain presides over a mist-filled realm that appears to be in constant flux. The moisture in the air and the movement implied by curved forms signal the season of early spring, a time of rebirth.

Guo Xi's naturalistic style captures a persuasive image of hopeful, seasonal change. It also aptly conveys a political agenda. In the year 1072, the emperor was embarking on a set of major reforms. *Early Spring* is at once **illusionistic** in its rendering of space, topography,

ecology, and atmosphere, and idealized in its balanced composition and orderly arrangement of human activities: peasants in the lower foreground, an official traveling across a bridge in the middle ground, and temple buildings in higher elevations. In combination, these aspects of the landscape deliver a political message: the Song emperor has made the realm orderly, and that order validates his rule.

As the emperor's favorite artist, Guo was put in charge of creating paintings for the newly renovated court buildings in the capital at Kaifeng. *Early Spring* now takes the format of a hanging scroll, but its composition also works well as a **screen painting** (see, for example, the screens pictured in Fig. 43.3). It is possible that *Early Spring* was originally mounted as a screen, framing the emperor's throne in a building called the Jade Hall. The Jade Hall housed the prestigious academy of scholar-officials, an important constituency in the context of political change. The harmonious order captured in *Early Spring* would have reflected well on the emperor and appealed to Confucian scholar-officials.

ZHANG ZEDUAN, *PEACE REIGNS ALONG THE RIVER*
While monumental landscapes featuring precipitous cliffs and plummeting waterfalls could signify imperial

illusionism making objects and space in two dimensions appear real; achieved using such techniques as foreshortening, shading, and perspective.

screen painting a format of East Asian painting, consisting of one or more panels; functions as a moveable piece of furniture to frame a significant area or subdivide a space.

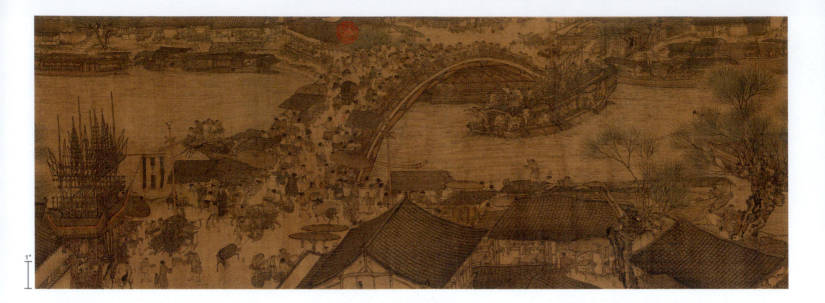

handscroll a format of East Asian painting that is much longer than it is high; typically viewed intimately and in sections, as the viewer unrolls it from right to left.

ruled-line painting paintings that render architecture and other complex, engineered structures with meticulous care, often with the aid of rulers and compasses.

isometric perspective a system of representing three-dimensional space and objects on a two-dimensional surface in which the angle between any two of the three coordinate axes is approximately 120 degrees; unlike linear perspective, the lines have no vanishing points.

facade any exterior vertical face of a building, usually the front.

literati painters educated artists, including scholar-officials, who brought literary values into painting, and pursued abstraction and self-expression in their art.

album leaf format of two-dimensional artwork, such as painting, calligraphy, or photography, in which individual leaves, or pages, may e bound together like a book form an album.

legitimacy by picturing a harmonious microcosm, the long **handscroll** painting *Peace Reigns along the River* offers insight into the economic activities underlying dynastic power and wealth.

Painted by the otherwise unknown court artist Zhang Zeduan, *Peace Reigns along the River* begins with rural scenes in the early morning. The painting is designed to be viewed by a single person or a small group seated at a table. At their own pace and with their own hands, viewers unroll the handscroll from right to left. They see a river appear and carve a path toward increasingly populated areas. Taking advantage of the sequential viewing process, Zhang structures his composition as a journey along the river. The anticipation of seeing what is concealed in the scroll reaches a climax in the scene of the rainbow bridge reproduced here (**Fig. 31.5**). Gathering on the bridge, which is already crowded with vendors, spectators watch a frantic crew trying to lower the mast and safely guide their boat beneath the bridge. Someone has thrown a coiled rope to the sailors; onlookers gawk at the unfolding drama. On the other side of the bridge, the prow of another boat emerges, foreshadowing a safe outcome. Following the river to the left, viewers eventually encounter a road leading to a city gate and the scroll's conclusion within the bustling city (not pictured here).

Zhang has invested tremendous skill and care in his meticulous depiction of watercraft, architectural structures, commercial activities, and street scenes. No detail escapes his eye: not the eddies of the turbulent water, nor the shapes of tiny scissors for sale. Seen in its entirety, *Peace Reigns along the River* documents daily sights and commercial activities across the rural-to-urban spectrum of the Song dynasty, but it does not present an altogether objective view. The Song court that commissioned the handscroll wanted to project a positive image; the artist wanted to meet the patron's expectations. In this case, the court claims credit for the good governance that facilitates the peaceful, productive activities pictured in *Peace Reigns along the River*, and Zhang ensures his continued status with an image that pleases the rulers.

We can read the painting as evidence of Song culture in other ways, too. Zhang demonstrates skill in a genre or style called **ruled-line painting**. Artists sometimes used a ruler and compass to aid in drawing such exacting representations of architecture, but Zhang appears to have worked freehand. The rendering in **isometric perspective** of the lashed-bamboo structure at the viewer's lower left (the **facade** to a wine shop where patrons may enjoy a drink) demonstrates his skill. More significantly, the impulse to represent things precisely, as evidenced in ruled-line paintings, indicates an empirical approach to measuring and understanding the physical world.

SU SHI, *POEMS WRITTEN ON THE COLD FOOD FESTIVAL*

Whereas court painters often demonstrated careful observation and meticulousness in their artworks, scholar-officials who served the government forged an alternate set of aesthetic values in their calligraphy, poetry, and paintings. Among the talented scholar-officials, Su Shi (1039–1101) emerged as a leading voice. Adept in fields as different as hydraulic engineering and poetry, Su Shi parlayed his intellect into a long government career that was both distinguished and checkered. At times he wielded enormous influence, but he was also the victim of political machinations and was three times banished from court.

Banishment was never desirable, but time away from court could spur creativity. Su wrote *Poems Written on the Cold Food Festival* in 1082 during his first political exile in Huangzhou (**Fig. 31.6**). Reading in columns from right to left, the poem begins:

> Since I came to Huangzhou,
> Already three cold food festivals have come and gone.
> Each year I wish to linger with spring,
> But spring's departure admits no delay.

The melancholy tone continues, and toward the end of the poem Su laments his isolation from court and kin: "The emperor's gates are nine layers deep, my family's tombs are ten thousand miles away." He wonders, too, if his life will end soon and in so mean a state.

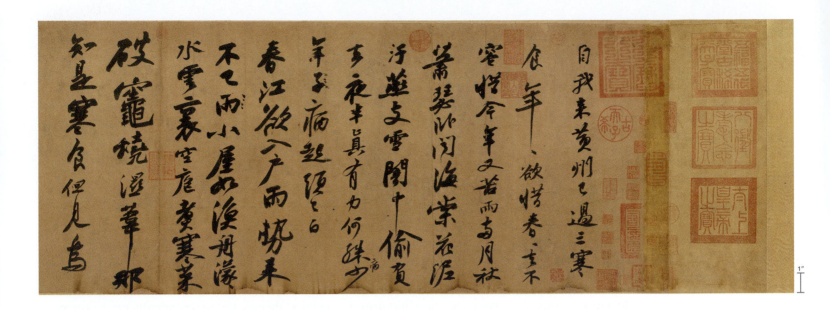

Su's calligraphy does not strive for grace, balance, or moderation. He rejects the polished elegance of Wang Xizhi (see Fig. 21.11) and instead embraces an unvarnished directness. The first column (at the far right) shows the most control, but in the very next line, Su elongates the second character, "year," visually conveying a sense of duration and perhaps also frustration with his time in exile. In the lines that follow, characters vary markedly in size, and brushstrokes are thick, blunt, and emphatic. Casting off standards of beauty set by the court or previous tradition, Su's calligraphy proposes that spontaneity and authenticity are the more important values in art.

Su's views on calligraphy as an expressive art are the basis for an alternative approach to painting. He criticized artists whose primary concern was "form-likeness," or fidelity to physical appearances. Instead, Su promoted painting as a medium closer to poetry and calligraphy, which aimed to express the artist's thoughts and feelings.

Consequently, Chinese **literati painters**—who belonged among the social elite and brought literary values to bear on painting—rejected technical refinement, which they associated with the lesser class of artisans whose abilities were limited to mere mimicry of nature. Instead, they deliberately pursued awkwardness and abstraction, which conveyed a sense of uncalculated authenticity and individuality.

EMPEROR HUIZONG, *FIVE-COLORED PARAKEET ON BLOSSOMING APRICOT TREE* The poetic values that informed Su Shi's artistic attitudes spread beyond literati circles. At the late Northern Song court, for example, Emperor Huizong (ruled 1101–1125) is credited with this meticulously painted bird and flowering branch, which accompanies a poem written in his distinctive calligraphy (**Fig. 31.7**). This oversized **album leaf**, titled *Five-Colored Parakeet on a Blossoming Apricot Tree*, combines the fine

31.6 Su Shi, *Poems Written on the Cold Food Festival* (detail), Northern Song dynasty, 1082. Handscroll: ink on paper, 13½ in. × 6 ft. 6½ in. (34.29 × 199 cm). National Palace Museum, Taipei.

31.7 Attributed to Emperor Huizong, *Five-Colored Parakeet on Blossoming Apricot Tree*, Northern Song dynasty, c. 1110. Handscroll (originally oversized album leaves): ink and color on silk, 21 × 49¼ in. (53.3 × 125.1 cm). Museum of Fine Arts, Boston, Massachusetts.

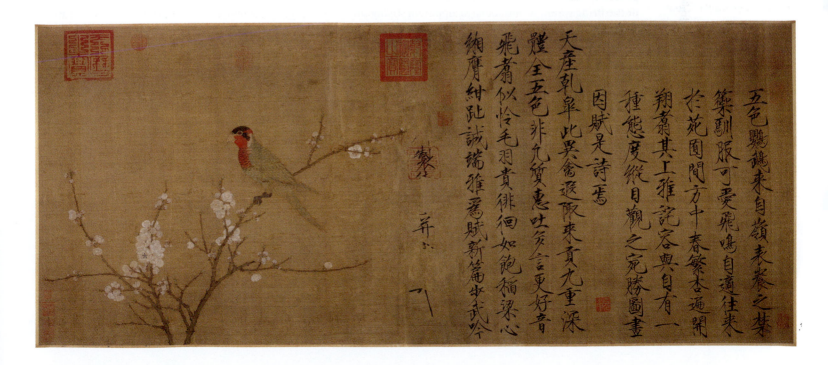

arts of poetry, calligraphy, and painting—the "three perfections"—to attest to the emperor's mastery of the three most celebrated Chinese art forms.

Rendered in profile, a parakeet perches on branches that arc elegantly to the left and right. Fine brushes were used to color the soft feathers and outline the delicate petals. The effect is a heightened, almost magical, realism in which the bird has been extracted from its natural environment and artificially posed. To the viewer's right, the emperor's preface and poem describe how this exotic parakeet, a tribute from a southern region, had been tamed and trained to talk. (Originally, the **inscription** may have been to the left of the painting, but it has been remounted in reverse order.) One spring day, the parakeet alighted atop a blooming apricot tree, and the delightful sight moved the emperor to record it in both word and image. His calligraphy consists of sharp, angular strokes, written confidently and consistently in a tight, invisible grid. Emperor Huizong's writing has been nicknamed "slender-gold," which aptly captures its preciousness.

Five-Colored Parakeet attests to Emperor Huizong's appreciation of poetic values and his artistic skills, yet it also stresses the legitimacy of his reign by recording a marvel of the physical world, proof of heaven's blessing for the emperor's rule. During his reign, Emperor Huizong and his retinue of highly accomplished court painters produced many **auspicious** images documenting similar signs of good fortune.

NARCISSUS BOWL The exceptional attention that Emperor Huizong directed to painting and calligraphy extended to other artistic media. The simple oblong shape of this narcissus planter, or bowl (**Fig. 31.8**), displays to good advantage the lustrous pale blue-green glaze characteristic of *ru* ware. A type of **stoneware**, *ru* ware was produced almost exclusively during Emperor Huizong's reign. *Ru* ware forms have restrained, disciplined shapes derived from simple flowers or, as in this case, basic geometry. Thus, any flaws in the application of the glaze or the firing would be immediately apparent. Using tiny grains of clay to prevent the bowl from adhering to the kiln during the firing process, the potter applies glaze to the vessel's entire body, giving the finished *ru* ware a jade-like texture and sheen.

Emperor Huizong is well known for the artistic accomplishments of his time, yet these same accomplishments

became the rationale for contemporaries and later historians to denounce him for his failure to prevent the collapse of the Northern Song dynasty. In 1125, armies of the Jurchen tribal peoples from Manchuria invaded the Northern Song, kidnapped the emperor and his immediate family, and established a Chinese-style dynasty of their own called Jin (1115–1234). Remnants of the Song imperial family and court fled south, and in Lin'an (present-day Hangzhou) they eventually re-established the dynasty, known retrospectively as the Southern Song.

Art at the Southern Song Court, 1127–1279

Once peace and stability had been restored in a new geo-political configuration, the Southern Song (1127–1279) resumed the routines of the Chinese bureaucracy. As before, artists were charged with making artwork on political themes. Cultural continuity can be perceived in images that do not address questions of legitimacy directly, too.

MA YUAN, *APRICOT BLOSSOMS* Evidence of cultural continuity is visible in Ma Yuan's (active *c.* 1190–1225) *Apricot Blossoms* (**Fig. 31.9**), which bears stylistic similarities to Emperor Huizong's *Five-Colored Parakeet* (see **Fig. 31.7**). Ma's knobby branch emerges asymmetrically from the lower left-hand corner of the album leaf. Fine ink outlines and opaque white and crimson colors describe the blossoms. Against a blank ground, the branch reaches toward the upper right before splitting, encouraging the viewer's gaze to alight on an inscribed poem.

Ma Yuan did not compose and inscribe the poetic couplet; nor was an emperor the poet and calligrapher. Rather, credit goes to the empress Yang Meizi (1162–1232). Numerous examples of her skills in poetry and calligraphy survive on paintings by Ma, attesting to their frequent collaboration. On *Apricot Blossoms*, she writes:

> Receiving the breeze, she presents her unsurpassed beauty;
> Moistened with dew, she reveals her red charms.

31.8 RIGHT **Narcissus bowl,** Northern Song dynasty, *c.* 1101–25. Ru ware, 2⅝ × 6½ in. (6.7 × 16.5 cm). National Palace Museum, Taipei.

31.9 FAR RIGHT **Ma Yuan, *Apricot Blossoms,* with an inscription by Empress Yang Meizi,** Southern Song dynasty, early thirteenth century. Album leaf: [ink] and colors on silk, 10¼ × 10¾ in. [25.8 ×] 27.3 cm). National Palace [Mus]eum, Taipei.

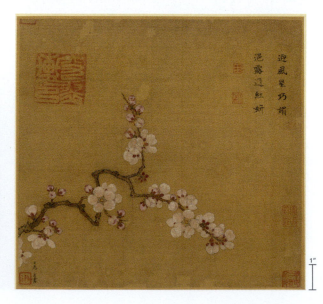

Yang's lines combine with Ma's painting to personify the apricot blossoms, creating a seductive invitation to the emperor to come and enjoy the pleasures of the bed-chamber with her. Intelligent and talented, the empress fully understood that her surest means to secure power was to become pregnant and give birth to a male heir. Just as emperors used painting as a vehicle to demonstrate their right to rule, so could others directly enlist art to win imperial favor.

LI SONG, *KNICK-KNACK PEDDLER* While some court paintings emphasized poetic expression, others featured careful observation of the physical world. A contemporary of Ma Yuan, Li Song (active 1190–1230), casts his perceptive eye on a traveling salesman and the excitable children lured by his merchandise in *Knick-knack Peddler* (**Fig. 31.10**). The **fan-painting** format (see **Fig. 31.2d**) also makes a useful object during the warm, humid summers of Lin'an.

Li's painting is a *tour de force*. On the tree, just above and to the right of where the bamboo stalk meets it, Li has written in minute characters, "three hundred items." Enticed by the peddler's racks, which are crowded with tools, medicines, edibles, and toys, one child clambers onto the base the better to extend his reach. His pals are close behind, and even the suckling baby dangles a hand toward the tower of delights. The peddler wears a necklace featuring three round disks decorated with human eyes. This type of necklace was worn by eye doctors, but in this picture, it signals one of the painting's themes, vision. For the children, vision leads to material desire; seeing boisterous potential customers, the peddler must take action. For the viewer, the sheer abundance of objects in so small a painting becomes an amusing challenge to the limits of vision. At the far right, one stealthy child has eluded the peddler's sight and may sneak away with a modest treasure in hand.

The *Knick-knack Peddler* takes as its subject matter peasants and everyday life, and in this regard may be compared to *Peace Reigns along the River* (see **Fig. 31.5**). Both paintings use fine ink outline as the primary method of representing a physical world characterized by abundance and narrative charm. For imperial audiences, such idealized paintings suggested a world of peace and plenty, made possible by good governance. Thus, the paintings also served to legitimize and validate imperial power and position.

Art during the Yuan Dynasty, 1279–1368

The functioning, but fragile, order of the Southern Song dynasty collapsed in 1279 after armies led by Kublai Khan completed the Mongol conquest and reunification of all of China. Ruling as the Yuan dynasty from their capital at Dadu (now Beijing), the Mongols remained in power until 1368. The Mongol emperor, who concurrently held the title Great Khan, reigned supreme over the three other khanates in Eurasia. Together the khanates formed the largest contiguous land empire that has ever

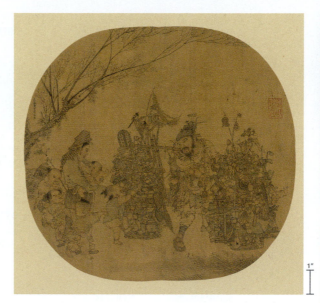

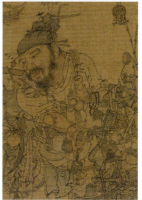

existed (**Map 31.2**, p. 522; see also: Seeing Connections: *Pax Mongolica*, p. 528).

The Mongol conquest of the Song dynasty brought numerous changes to government institutions as well as to art and culture. A vast bureaucracy of scholar-officials was still needed to administer the empire, but Mongol rulers gave preference to Mongolians and non-Chinese peoples in filling government positions. As a result, many Chinese scholar-officials were disenfranchised. Whether motivated by loyalty to the fallen Song dynasty or prevented from pursuing the traditional path to political success, some scholar-officials and literati turned to painting to express frustration and dissent. The political conditions of the Yuan dynasty propelled the development outside of the context of the imperial court of more abstract styles of landscape painting.

Another change occurred with the dissolution of the robust painting academy formed during the Song dynasty. But painters remained employed at the court, albeit in somewhat lower-status household agencies, and the Mongol regard for excellent craftsmanship introduced different artistic priorities in the Chinese realm. For example, technique was prized above individual style, which benefited painters specializing in the ruled-line technique, such as Wang Zhenpeng (active c. 1271–1368). Additionally, portraiture was preferred to landscape, and textiles were considered more prestigious than paintings. These preferences underlie a silk tapestry **mandala** (see **Fig. 31.17**), which because of its religious nature will be discussed in the last section on Buddhist art. Meanwhile, the Yuan dynasty returned a measure of security to the continental trade routes known as the Silk Road, facilitating economic activity and spurring intercultural contact.

ALTAR VASES (THE DAVID VASES) Restored trade led to the development of a product that has since become ubiquitous throughout the world and is considered quintessentially Chinese: blue-and-white **porcelain** (**Fig. 31.11**, p. 522). While the earliest porcelain wares date to the late Tang period, the distinctive blue-and-white color combination began to gain popularity only during the

31.10 TOP LEFT **Li Song,** *Knick-knack Peddler,* Southern Song dynasty, 1210. Fan mounted as an album leaf: ink and colors on silk, 10¼ × 11¾ in. (26 × 29.8 cm). National Palace Museum, Taipei.

31.10a and **31.10b** ABOVE **Details from** *Knick-knack Peddler.*

fan painting a format of East Asian painting in which the image is painted on an oblong, round, or folded fan.

mandala typically composed of concentric circles and squares, a spiritual diagram of the cosmos used in Hinduism, Buddhism, and other Asian religions.

porcelain a smooth, translucent ceramic made from kaolin clay fired at very high temperatures.

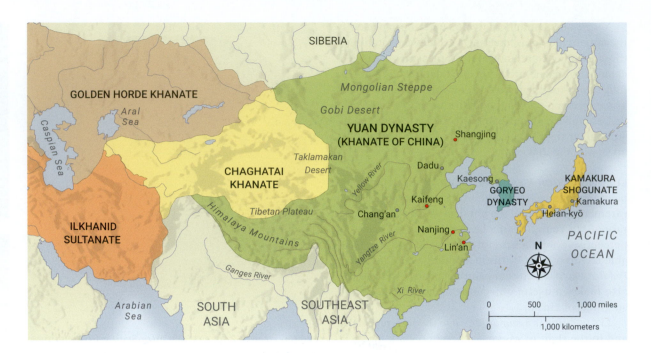

Map 31.2 West, Central, and East Asia, *c.* 1300.

register a horizontal section of a work, usually a clearly defined band or line.

Yuan dynasty (see: Seeing Connections: Blue-and-White Porcelain, p. 792). At this time, artisans used blue pigment derived from cobalt imported from West Asia to decorate the white bodies of porcelain vessels, producing vivid and appealing objects that circulated throughout and beyond the empire. Known by the name of collector Percival David, this pair of blue-and-white porcelain altar vases is elaborate in both form and decoration. Between the foot and the mouth, each vase is divided into numerous bands, or **registers**, of different widths and ornament. Further, the registers are of different diameters, with some having a concave or convex shape, resulting in a complicated silhouette, punctuated by elephant-head handles emerging from the neck. Floral scrolls, stylized plantain leaves, and cloud patterns appear throughout the

vases, but two supernatural animals, the dragon and the phoenix, are featured on the body and the neck, respectively. As supernatural animals capable of bringing rain for growing crops, dragons are considered auspicious throughout East Asia. Although dragons—especially five-clawed dragons—symbolized imperial power, these mythical creatures appear in a variety of contexts. On these vases, the serpentine shapes of four-clawed dragons writhe amid clouds, and, as symbols of *yang* (the active, male force), they are matched with phoenixes, symbols of *yin* (the receptive, female force). In Chinese philosophical thought, especially Daoism, *yin* and *yang* in dynamic combination are the generative principles, or energies, of all phenomena. More generally, Daoism advocated pursuit of the Way, as manifested in the harmonious workings of the natural world and the worship of immortal beings.

The inscription on each vase reinforces a Daoist interpretation by recording its ritual purpose. (Some bronze vessels from the earlier Zhou dynasty have similar inscriptions; see Figs. 8.14 and 8.14a.) The donor, Zhang Wenjin, dedicated these vases and an incense burner to a deified military figure, General Hu Jingyi. Seeking blessing upon his family, Zhang gave the vases to a Daoist temple. The inscription gives the precise date of dedication as May 13, 1351.

ZHAO MENGFU, *MIND LANDSCAPE OF XIE YOUYU*

Even though the Mongol conquest brought peace and new prosperity to the empire, not everyone welcomed the new dynasty. The political situation posed a dilemma for Chinese scholar-officials. That dilemma, along with the expressive possibilities of landscape painting, is demonstrated in the person and artwork of Zhao Mengfu (1254–1322).

Rather than serve the foreign Mongols, some Song dynasty loyalists committed suicide, while others withdrew from society to become recluses. Zhao was born to a distant branch of the Song imperial family and might

31.11 Altar vases (the David Vases), Yuan dynasty, 1351. Porcelain with underglaze blue design, height 25⅛ in. (63.8 cm); diameter 7¾ in. (19.6 cm). British Museum, London.

have been expected to take a loyalist stance, but instead he agreed to serve in the Yuan government. He had a long and distinguished career, including positions as secretary of the Board of War and director of the Imperial Academy. His creative talent in both calligraphy and painting was also recognized by Yuan emperors who collected artworks by Zhao as well as by his wife, Guan Daosheng (see Fig 31.13). Still, some of Zhao's paintings privately expressed ambivalence about serving at court.

For example, Zhao's short handscroll, *The Mind Landscape of Xie Youyu*, communicates his dilemmaa through both style and subject matter (**Fig. 31.12**). Rejecting the naturalism of such Song dynasty artists as Guo Xi and Li Song, Zhao's *Mind Landscape* embraces abstract qualities that allude to earlier periods of Chinese history. The dominant blue-green colors of the landscape recall scenes of Buddhist paradises prominent in the Tang dynasty of 618–906 CE (see Fig. 27.12). The fancifully shaped trees and discrete spaces between them echo artworks of an even earlier time, the Period of Division of 220–581 (see Fig. 21.14). Zhao's style is a form of **archaism**, and his audience would have understood *Mind Landscape* as an expression of a widespread belief that a golden age lay somewhere in the past.

Zhao's subject is the early court official Xie Youyu (280–322) who professed an affinity for hills and valleys. During his life, Xie earned a reputation as an official whose appointment at court did not compromise his integrity. Paradoxically a recluse at court, Xie serves as a model for Zhao. Toward the center left of the scroll, Xie is seen seated on a tiger skin. Zhao's painting does not represent Xie in the physical environment of the court, nor does it refer to natural topography. Rather, it shows a landscape of the mind. In other words, Zhao combines motifs drawn from the natural world (trees and rocks) with stylistic choices, such as abstraction and a blue-green color palette, to signal his personal vision and his affinity for times past.

GUAN DAOSHENG, *BAMBOO GROVES IN MIST AND RAIN*

Zhao Mengfu was, like Su Shi, foremost a scholar-official whose education informed his artistic practice, and so he is recognized as a literati painter. Not all literati painters were men, however: Guan Daosheng (1262–1319) demonstrates her abilities as poet, calligrapher, and painter in *Bamboo Groves in Mist and Rain* (**Fig. 31.13**). Using only ink on paper—the materials associated with the literati arts of poetry and calligraphy—Guan creates a quiet scene of bamboo clusters growing at the edge of a river. She uses dry, hemp-fiber-textured strokes to depict earth, and she sets delicate patterns of leaves against the blank mist. As with *Mind Landscape* by her husband Zhao Mengfu, Guan shifts away from illusionism toward abstraction. Her spare style lays bare the work of brush and ink, and her choice of format—the short handscroll—facilitates an intimate aesthetic experience for her intended recipient, the woman named Lady Chuguo in Guan's **colophon** (which follows the painting at the far left).

The meaning and significance of Guan's *Bamboo Groves* derive from art history, mythology, and symbolism. First, the genre of ink bamboo painting was purportedly invented when a woman surnamed Li observed the shadows of bamboo cast upon a window. Second, waterside bamboo is an image of grief; according to a Chinese legend, the tears of the widowed consorts of the mythological king Shun marked a variety of speckled bamboo. Finally, because bamboo has the capacity to bend without breaking, it is a symbol of resilience under adversity. Precisely which of the multiple meanings of bamboo Guan intended Lady Chuguo to recognize is not certain, but the painting surely participates in a sophisticated system of communication.

archaism the use of forms dating to the past and associated with a golden age.

colophon a statement at the end of a work in which the writer (the artist, patron, or an admirer) records information or offers commentary. Colophons may include dates, locations, and names of artists and patrons.

31.12 BELOW **Zhao Mengfu,** *The Mind Landscape of Xie Youyu,* Yuan dynasty, *c.* 1287. Handscroll: ink and colors on silk, 10¾ × 46 in. (27.3 × 116.8 cm). Princeton University Art Museum, New Jersey.

31.13 BOTTOM **Guan Daosheng, Bamboo Groves in Mist and Rain,** Yuan dynasty, 1308. Handscroll: ink on paper, 9 × 44⅞ in. (22.9 × 114 cm). National Palace Museum, Taipei.

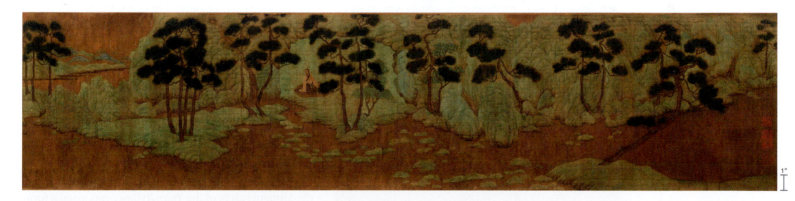

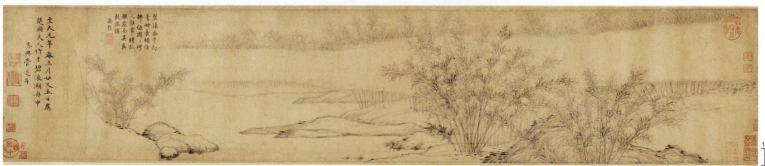

monochrome made from shades of a single color.

pingdan an aesthetic sensibility promoted by the literati, *pingdan* is reserved in style, mild in taste.

icon an image of a religious subject used for contemplation.

bodhisattva in early Buddhism and Theravada Buddhism, a being with the potential to become a buddha; in Mahayana Buddhism, an enlightened being who vows to remain in this world in order to aid all sentient beings toward enlightenment.

NI ZAN, *THE RONGXI STUDIO* Interest in pre-Song painting and experiments in abstraction during the early Yuan dynasty provided the foundation for further developments in landscape. One beneficiary was the literati painter Ni Zan (1301–1374). In *The Rongxi Studio* (**Fig. 31.14**), painted near the end of his life, Ni finds inspiration in the work of tenth-century painter Dong Yuan (see **Fig. 31.1**) and further distills the spare, **monochromatic** style seen in Guan's *Bamboo Groves* (see **Fig. 31.13**). No ripples enliven the blank water; no mist softens the stark atmosphere. The addition of a rustic pavilion only emphasizes human absence. Likewise, the withered trees indicate a desolate environment.

The painting deliberately shuns beauty and visual excitement. Instead, Ni's choice of motifs, along with his dry brushwork and gray ink, capture a reserved and mild aesthetic called *pingdan*. This aesthetic is in keeping with both his anti-Mongol political stance and his personal fastidiousness. Given its subjective, abstract style of representation, *The Rongxi Studio* might arguably be

called a landscape of the mind. The artist's composition, showing a grove of trees in the foreground and low-lying hills beyond a river, appears generic. But Ni retroactively asserts that the landscape represents a real location. In the long inscription at the composition's top center, Ni describes how the painting's original recipient returned in 1374 to ask that he rededicate it to a physician whose retreat was modestly called "Rongxi Studio"—literally, the studio just large enough to accommodate one's knees. That place becomes, after the fact and according to the artist himself, the site represented in this artwork.

Even though the date of *The Rongxi Studio* technically places it in the Ming dynasty (1368–1644), Ni Zan lived nearly all of his years under Yuan rule. Also, for him as well as for other literati painters, the conditions of Mongol government—including the curtailment of the civil service bureaucracy—determined in large measure their decision to take up the brush. To distinguish their art from that of professional court painters, the literati pursued subject matter and styles that conveyed their learning, their individuality, and their point of view.

Buddhist Art during the Song and Yuan Dynasties, 960–1368

Beginning in the Six Dynasties period (222–589), and continuing during the Tang dynasty, Buddhism inspired the creation of magnificent temples and myriad **icons** in areas of present-day China (see Chapters 21 and 27). Illustrated stories and texts (*sutras*) also helped spread the *dharma* (the "law," or Buddhist teachings) across the empire. As Buddhist temples and other religious institutions gained wealth and power, the Tang court perceived threats to tax receipts and political control. Thus, in 845, temples were targeted in a major ban. Temple properties were seized, and monks and nuns were forced to return to lay life. Still, Buddhism persisted, albeit in changed forms as new sects emerged from the wreckage.

During the Song dynasty, Chan Buddhism gained prominence and drew followers among scholar-officials. Literally meaning "meditation," Chan is a school, or sect, of Mahayana Buddhism. (Mahayana is one of the major strands within Buddhism and is itself divided into a number of different schools. In Mahayana Buddhism, the goal is the liberation of all beings, and *bodhisattvas* play prominent roles.) Chan adapted aspects of Daoism, and in doing so, it offered new paths to enlightenment that could be immediate and unorthodox, and it emphasized transmission of teachings from master to disciple. By contrast, the Mongol rulers of the Yuan dynasty espoused a form of Esoteric Buddhism (in other regions of Asia, schools of Esoteric Buddhism may be referred to as Vajrayana or Tantric), which involves secret teachings available only to initiates who have with the aid of an advanced instructor completed certain rituals or reached certain levels of understanding. The three Buddhist artworks illustrated here—a sculpture, a painting, and a tapestry—make clear the variety of religious expression, which was not separate from the political arena or social life. Rather, Buddhist art during the Song and Yuan dynasties was knit into the cultural fabric.

31.14 Ni Zan, *The Rongxi Studio*, Yuan dynasty, 1372. Hanging scroll: ink on paper, 29½ × 13⅞ in. (74.9 × 35.2 cm). National Palace Museum, Taipei.

BODHISATTVA GUANYIN (AVALOKITESHVARA) IN WATER-MOON FORM Among *bodhisattvas*, Avalokiteshvara, the *bodhisattva* of infinite compassion and mercy, is the most beloved in East Asia. In Chinese, Avalokiteshvara is commonly called "Guanyin," a condensed form of "Guanshiyin," which means "observing the sounds of the world." Thus, Guanyin is the *bodhisattva* who is particularly responsive to prayers. Such responsiveness fueled Guanyin's widespread popularity and informed the making of this sculpture (**Fig. 31.15**), which dates to the Liao dynasty (907–1125) of the Khitan (**Map 31.1**). The Khitan, whose name is the source of Cathay—an alternate European term for China—were semi-nomadic peoples from northeast Asia. The Khitan ruled over parts of present-day Mongolia, northeast China, and far eastern Russia, and in the tenth and eleventh centuries, they were powerful neighbors of the Northern Song. In the early twelfth century, both the Liao and the Northern Song would be conquered by the Jurchens. But during their time in power, the Liao were active patrons of Buddhism, sponsoring the construction of temples and the making of icons such as this *Guanyin in Water-Moon Form.*

There is a standard **iconography** that allows viewers to identify forms of the Buddha and *bodhisattvas* (see Chapter 16). All *bodhisattvas* wear jewelry, but the tiny Amitabha Buddha figure in the crown identifies this figure specifically as Guanyin. Formed of multiple pieces of willow wood, the figure of Guanyin assumes a relaxed posture of royal ease, seated with its right arm resting on a raised knee. This pose further indicates a particular manifestation, the Water-Moon Guanyin, who presides over an island Pure Land, Mount Potalaka. (compare to Amitabha Buddha who presides over the Western Pure Land, see Figs. 27.12 and 27.17). Naturalism in the representation of Guanyin's face, body, and drapery continues the direction of Tang International Style (see

Fig. 27.10). Traces of pigment indicate that the sculpture was at one time fully painted. Resplendent in its original color, and regal in form, the figure of Guanyin would have appeared simultaneously otherworldly and immediately tangible. These formal qualities underscore Guanyin's capacity to comfort Buddhists seeking relief from suffering, and religious rituals would have transformed the sculpture, for believers, from mere **effigy** into efficacious icon.

Now in a museum collection, the statue of Guanyin may originally have been housed in one of the many temples built by the Khitan, who were prodigious sponsors of timber architecture. Contemporaneous records also describe landscape walls that combined the arts of painting and sculpture to create a semblance of Mount Potalaka for icons of the Water-Moon Guanyin. In approaching the icon, worshipers echo the actions of the pilgrim boy Sudhana, as described in the *Avatamsaka ("Flower-Garland") Sutra.* In his quest for enlightenment, Sudhana visited fifty-three spiritual teachers, the twenty-eighth being Guanyin.

FACHANG MUQI, *WHITE-ROBED GUANYIN, GIBBONS, AND CRANE* Other Buddhist texts, among them the *Lotus Sutra* and the *Heart Sutra*, recount stories of Guanyin rescuing worshipers from calamities, or emphasize his meditative practice. These different conceptualizations underlie a variety of forms that this shape-shifting *bodhisattva* assumes in art. For example, *White-Robed Guanyin, Gibbons, and Crane* (**Fig. 31.16**, p. 526), a **triptych** of hanging scrolls by the Chan monk and painter Fachang Muqi ("Fachang" is the artist's monastic name, "Muqi" is the name by which he is known in art, *c.* 1200–after 1279), shows a form that is similar to, yet distinct from, the Water-Moon Guanyin (**Fig. 31.15**). As in the earlier sculpture, Guanyin wears a crown featuring Amitabha Buddha. The landscape setting, which includes a rocky outcrop and lapping waters, evokes Guanyin's Pure Land of Mount Potalaka. Near Guanyin is a vase containing pure water and a willow branch, items used in rituals and healing. The absence of the pilgrim Sudhana, in combination with the *bodhisattva*'s distinctive plain white robe, makes clear that this is the salvific, or rescuing, White-Robed Guanyin and not the instructive Water-Moon Guanyin.

Muqi's *White-Robed Guanyin* is further distinguished in terms of style. The evident naturalism in the representation of facial expression, clothing that plausibly drapes over a physical body, and the moisture in the air and texture of the rocks, indicate a high degree of technical proficiency. In addition, Muqi's Guanyin does not sit confidently upright in the posture of royal ease but slumps slightly forward, suggesting interiority. The *bodhisattva*'s bearing seems more human, making him an exemplar for Chan practitioners and especially appealing to laymen of the scholar-official class. Finally, unlike many Buddhist and other religious painters, Muqi has rejected the use of rich colors in favor of ink alone. In this regard, his monochrome composition attests to the spread of the literati aesthetic, with its emphasis on expressive brushwork.

iconography images or symbols used to convey specific meanings in an artwork.

effigy sculpture or model, usually created for its symbolic and/or material value in relation to the thing it represents.

triptych a three-part work of art, often three panels attached together.

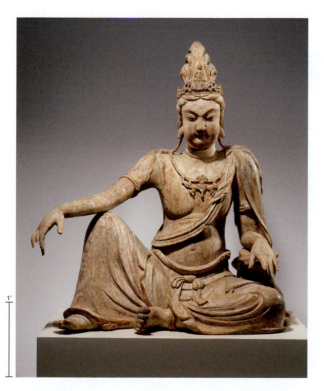

31.15 FAR LEFT *Bodhisattva Guanyin (Avalokiteshvara) in Water-Moon Form,* Liao dynasty, eleventh century. Wood with traces of pigment, height 46½ in. (118.1 cm). Metropolitan Museum of Art, New York.

31.16 Fachang Muqi, *White-Robed Guanyin, Gibbons, and Crane,* Southern Song dynasty, thirteenth century. Set of three hanging scrolls, ink and colors on silk; each approx. 5 ft. 7 in. × 38⅞ in. (170 × 98.7 cm). Daitokuji, Kyoto, Japan.

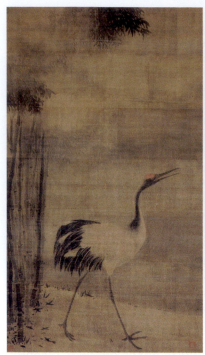 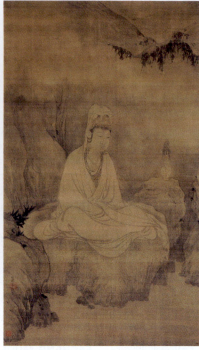 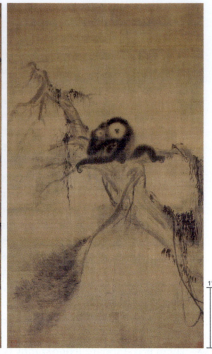

Guanyin is flanked by a mother gibbon clutching her baby and by a calling crane. Capturing their physical shape and attentive to feathers and fur alike, Muqi imbues these creatures with vitality. Their religious meaning is not immediately apparent, however. Without an iconographical source in Buddhist *sutras,* the triptych has elicited lively discussion. The fact that the paintings were transmitted to Japan, where continuous esteem ensured the preservation of Muqi's artwork, raises the possibility that approaches to display in Muromachi period (1336–1573) Japan brought the three paintings together on the basis of aesthetic sensibility or thematic similarity. Recent research, however, has brought to light writing by Muqi's Chan master, the abbot Wuzhun Shifan (1178–1249). In a poetic inscription to a now-lost

painting of Guanyin, the abbot yokes together the melancholy sounds of the cries of a solitary monkey and a crane atop a wintry pine with the image of Guanyin. These two creatures' sounds had a prior history in Chinese literature of startling human listeners into awareness, or insight, a history that Guo Xi also draws on (see box: Going to the Source: Guo Xi's Writing on Landscape, p. 517). In this case, Wuzhun Shifan emphasized the role of sound followed by silence as a mechanism for Chan enlightenment. Following his master's idea, Muqi may have in fact originally intended these three paintings to be arranged together.

A prolific artist, Muqi belonged to one of the five major Chan temples located in the Southern Song capital. These temples not only supported religious practice but also

Chronology

907–1125	The Liao (Khitan) dynasty		**1115–1234**	The Jin (Jurchen) dynasty
937–75	The Southern Tang kingdom		**1127–1279**	The Southern Song dynasty
c. 950	Dong Yuan paints *Wintry Groves and Layered Banks,* an early example of Chinese landscape painting		**early 13th century**	Empress Yang inscribes a poetic couplet onto *Apricot Blossoms* by court painter Ma Yuan
960–1279	The Song dynasty: the Jurchen conquest of areas of this empire in 1127 results in historical divisions: Northern Song and Southern Song		**13th century**	Chan monk-artist Fachang Muqi paints *White-Robed Guanyin, Gibbons, and Crane*
960–1127	The Northern Song dynasty		**1279–1368**	The Yuan (Mongol) dynasty
1072	Guo Xi paints *Early Spring*		**c. 1287**	Zhao Mengfu paints *Mind Landscape of Xie Youyu*
late 11th–early 12th century	Zhang Zeduan paints *Peace Reigns along the River*		**1330–32**	*Mandala of Vajrabhairava* includes portraits of its imperial Mongol patrons
1101–25	The reign of Northern Song Emperor Huizong; *Ru* ware is made for the Northern Song court		**1351**	Altar vases (the David Vases) are made and dedicated

nourished intellectual exchange with scholar-officials and with monks from outside the Southern Song borders. This context proved advantageous for Muqi and his art. Scholar-officials provided the model of monochrome ink painting that Muqi would adapt, and monks hailing from the Japanese archipelago returned home with not only a new school of Buddhism known in Japanese as Zen (see Chapter 32) but also with many paintings by Muqi. This triptych is now in the collection of Daitokuji, a prominent Zen temple in Kyoto, Japan.

MANDALA OF VAJRABHAIRAVA Esoteric schools of Buddhism, known in China since the Tang dynasty, advocated visualization practices and identification with personal deities. These rituals were facilitated by the use of a mandala (**Fig. 31.17**; for comparison, see Fig. 27.16). This mandala dating to the Yuan dynasty imagines a religious cosmos with the deity Vajrabhairava, the wrathful manifestation of the *bodhisattva* of wisdom, at its center. With a grimacing expression and horned bull's head, the multi-limbed Vajrabhairava seems to resemble images of evil as pictured in other artistic traditions. This fierce *bodhisattva*'s superhuman physical power, however, is directed toward literally stomping out impediments toward enlightenment. His four stocky legs trample tiny human and animal figures, which represent ignorance.

Completing the kaleidoscopic composition are lesser deities who occupy—in rank order—the positions around Vajrabhairava. Some inhabit the central square court; others fill the corner spaces. Registers at top and bottom accommodate some human figures. For example, numerous monks, identifiable by their patchwork robes, occupy bright-orange, lotus-petal-shaped niches. The bottom corners feature donor portraits. At (the viewer's) left are the Yuan emperor Tugh Temür (known as Wenzong, ruled 1328–1332) wearing a white robe and his elder brother wearing blue; their consorts appear in the opposite corner. The imagery of the mandala attests to Mongol patronage of Buddhism and, more generally, to the close relationship between politics and religion during the Yuan dynasty.

The mandala's medium—silk **tapestry** (Chinese: *kesi*) with gilded paper representing jewelry—speaks to the encounter of cultures. The Mongol esteem for textiles led to the preference for tapestry over painting for important imperial commissions. Thus, the mandala image employs the most sophisticated technologies of Chinese silk manufacture.

Between the tenth and fourteenth centuries, cultural contact generated tremendous wealth and played a prominent role in art in China. After journeying to the Yuan capital of Dadu, one eyewitness to the riches of the Mongol Yuan empire wrote, "The quantity of merchandise sold there exceeds also the traffic of any other place; for no fewer than a thousand carriages and pack-horses, loaded with raw silk, make their daily entry; and gold tissues and silks of various kinds are manufactured to an immense extent." The eyewitness was the Venetian traveler Marco Polo, and his descriptions of the fabulously affluent and highly cultured empire at this end of the Eurasian continent would fuel European imaginations and their age of exploration.

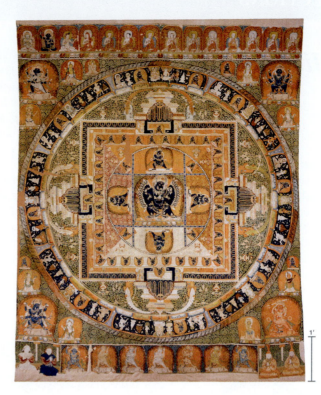

31.17 *Mandala of Vajrabhairava,* Yuan dynasty, c. 1330–32. Silk tapestry (*kesi*), 8 ft. ⅝ in. × 6 ft. 10⅜ in. (2.45 × 2.09 m). Metropolitan Museum of Art, New York.

Discussion Questions

1. Literati painters preferred abstraction to naturalism or illusionism. Why? Explain by referring to paintings in this chapter.

2. Royal courts are often major patrons of art. Identify the stylistic characteristics of court-sponsored artworks in this chapter, and explain how style relates to subject or content.

3. How and why are animals, natural or mythological, represented in art? Use one or more artworks from this chapter to explain.

4. The Buddhist artworks in this chapter demonstrate a great deal of variety. How can such strikingly different artworks nevertheless be understood as Buddhist?

Further Reading

- Lee, Hui-shu. *Empresses, Art, and Agency in Song Dynasty China.* Seattle, WA: University of Washington Press, 2010.

- McCausland, Shane. *The Mongol Century: Visual Cultures of Yuan China, 1271–1368.* Honolulu: University of Hawai'i Press, 2015.

- Lippit, Yukio. "Seer of Sounds: The Muqi Triptych," In Gregory P. A. Levine, Andrew M. Watsky, and Gennifer Weisenfeld (eds.) *Crossing the Sea: Essays on East Asian Art in Honor of Professor Yoshiaki Shimizu.* Princeton University Press, 2012, pp. 243–66.

- Watt, James C. Y. (ed.). *The World of Khubilai Khan: Chinese Art in the Yuan Dynasty.* New York: The Metropolitan Museum of Art, 2010.

tapestry a decorative textile in which pictures and/or designs are woven into the fabric.

Pax Mongolica

Military invasions and conquests typically result in the destruction of art: cities sacked, monuments damaged, artisans killed, and economies and patronage systems disrupted. Paradoxically, war can also foster new cross-cultural connections, which in turn spur economic development and artistic creativity. The period of Mongol rule in Asia and Europe during the thirteenth and fourteenth centuries CE clearly illustrates both sides of this

equation, with cultural destruction and cultural development as two enmeshed byproducts.

Under the leadership of Chinggis Khan (also spelled Genghis; c. 1162–1227) and his descendants, the Mongol armies swept across the Central Asian steppe, moving east and west, to create the largest land-based empire in world history. They achieved this feat through widespread devastation and killing, but also through military superiority: fast horses, expert archers, and smart strategic planning. Decades of brutal confrontations yielded to a period of relative stability, which historians often call the *Pax Mongolica* (Latin for "Mongolian Peace"). This peace facilitated active overland trade and led to artistic cross-fertilization. Under Chinggis Khan's grandsons, the empire was divided into

four parts, called khanates: the Yuan in present-day China (the most powerful of the four); the Chaghatai in Central Asia; the Ilkhanids in the Iranian plateau region; and the Golden Horde in the area of present-day southern Russia and eastern Europe (see **Map 31.2**). In each region, the Mongol elite settled, employed local administrators, and combined aspects of their nomadic culture with local traditions. For example, in Ilkhanid Iran, they converted to Islam, spoke Persian, and set up royal workshops to produce illustrated manuscripts and paintings on paper.

The Mongols' predilection for recording history and their own accomplishments can be seen in many of these artworks. One painting from the fourteenth century (**Fig. 1**) commemorates the taking of Baghdad in 1258. This victory, during which the Mongols killed the Muslim caliph—officially ending the 500-year Abbasid Caliphate—was a crucial one, and the painting carefully records the siege techniques used to achieve it.

The many strands in Mongol culture are perhaps most evident in their dress and accessories. Clothing may conceal the body, but it reveals the person and the culture. For example, the cut of this robe (**Fig. 2**), or tunic—with its long, fitted sleeves, overlapping collar, and flared skirt—makes it suitable for horseback riding. A wide waistband culminates in numerous ribbons for fastening the garment securely. The tunic was excavated in 1978 at an Onggut tomb site in Inner Mongolia. The Onggut (also spelled Ongud) were Turkic-speaking Christian people who lived in Mongolia during the time of Chinggis Khan. In the early thirteenth century, they allied themselves to the Mongols, and marital unions, including that between Chinggis's daughter and the son of an Onggut chief, ensued. The robe's fabric merges diverse visual cultures. By the time of the *Pax Mongolica*, silk manufacturing had spread well beyond its origins in fourth-millennium BCE Neolithic cultures in China. Nevertheless, Chinese silks remained among the most prized commodities, and this tunic is made from a luxurious silk woven with a figural pattern. The lining is of gold brocade with a motif of winged lions, and large roundels featuring pairs of stylized lions with human faces wearing crowns (**Fig. 2a**). Such patterns may be traced to Persian Sasanian culture (c. 224–651 CE) inherited by the Ilkhanids, further illustrating the multicultural nature of the Mongol Empire.

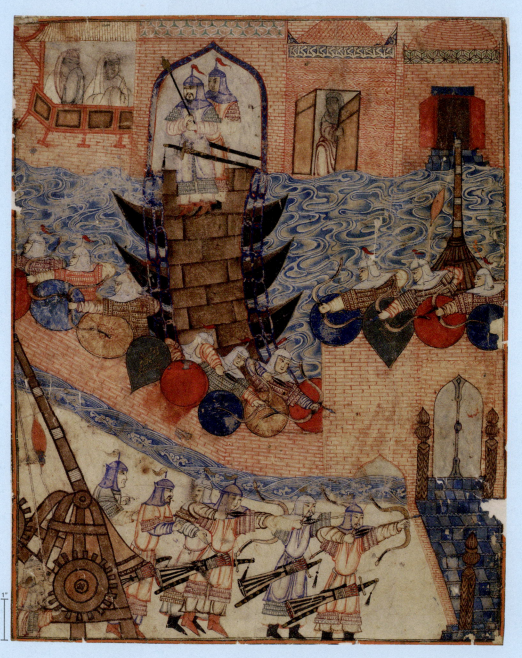

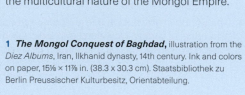

1 The Mongol Conquest of Baghdad, illustration from the *Diez Albums*, Iran, Ilkhanid dynasty, 14th century. Ink and colors on paper, 15⅛ × 11⅞ in. (38.3 × 30.3 cm). Staatsbibliothek zu Berlin Preussischer Kulturbesitz, Orientabteilung.

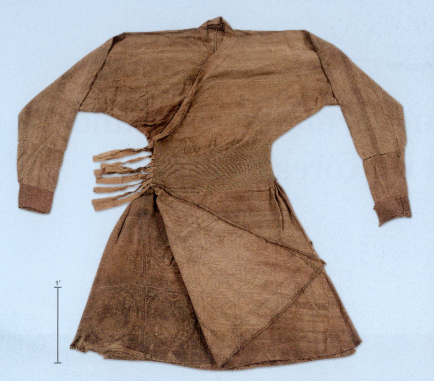

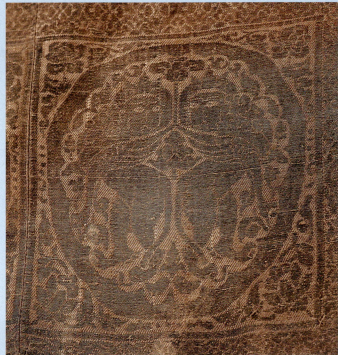

2 ABOVE **Robe or tunic,** found at the Onggut tomb site, Mongolia, thirteenth–fourteenth century. Silk with gold brocade, 56 in. × 8 ft. ⅞ in. (142.2 × 246.1 cm). Inner Mongolia Museum, Hohhot, China.

2a ABOVE RIGHT **Motif from the robe lining (detail).**

Another example of blended Chinese, Persian, and Mongolian material traditions is this shallow cup, or "dipper," from the Tobolsk region of Russia (**Fig. 3**). A member of the Golden Horde would have tied the object to his belt through the loop hanging from the dragon's mouth on the handle, thus making the cup both readily accessible and a visible marker of his status. Scholars believe that this type of vessel originated during the Liao dynasty (907–1125) of the semi-nomadic Khitan tribes who ruled over the eastern steppe of Eurasia. The Golden Horde continued the tradition as a show of wealth, with cups made of gold or silver. Chinggis Khan adopted the Chinese dragon motif as a sign of power, and its inclusion on this dipper marks the object's owner as a high-status member of Mongolian society. Notably, the other prominent decoration on the cup, around the lip, is an abstract band of ornamentation that looks like Arabic calligraphy, but does not actually form any letters or words.

Objects such as this one embody both the rich artistic output fostered by the *Pax Mongolica* and the Mongol military culture, which enabled the conquest of so many people and so much land.

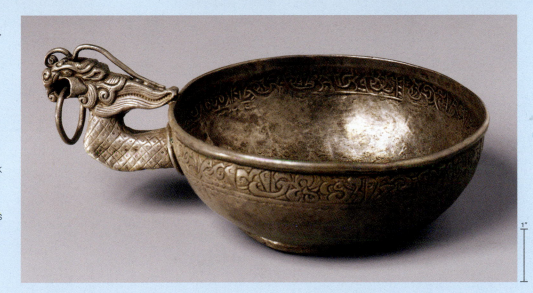

3 Dipper, Golden Horde, Tobolsk region, Russia, thirteenth–fourteenth century. Silver, height 1¾ in. (4.4 cm), diameter 4⅜ in. (11.1 cm). Hermitage Museum, St. Petersburg, Russia.

Discussion Questions

1. Can you think of other examples from history when war and destruction eventually led to increased cultural contact and artistic developments?

2. Arts from the Yuan and Ilkhanid dynasties are also discussed in Chapters 31 and 33. Choose two artworks from one or both dynasties in those chapters and compare them to the examples discussed here. What common traits or themes do you see?

Further Reading

- Carboni, Stefano and Komaroff, Linda (eds.). *The Legacy of Genghis Khan: Courtly Art and Culture in Western Asia, 1256–1353.* New York: The Metropolitan Museum of Art, 2002.
- McCausland, Shane. *The Mongol Century: Visual Cultures of Yuan China, 1271–1368.* Honolulu, HI: University of Hawai'i Press, 2015.

Seo Gubang, *Water-Moon Gwaneum Bosal* (detail), Goryeo dynasty.

32

Transformative Eras and Art in Korea and Japan

1200–1600

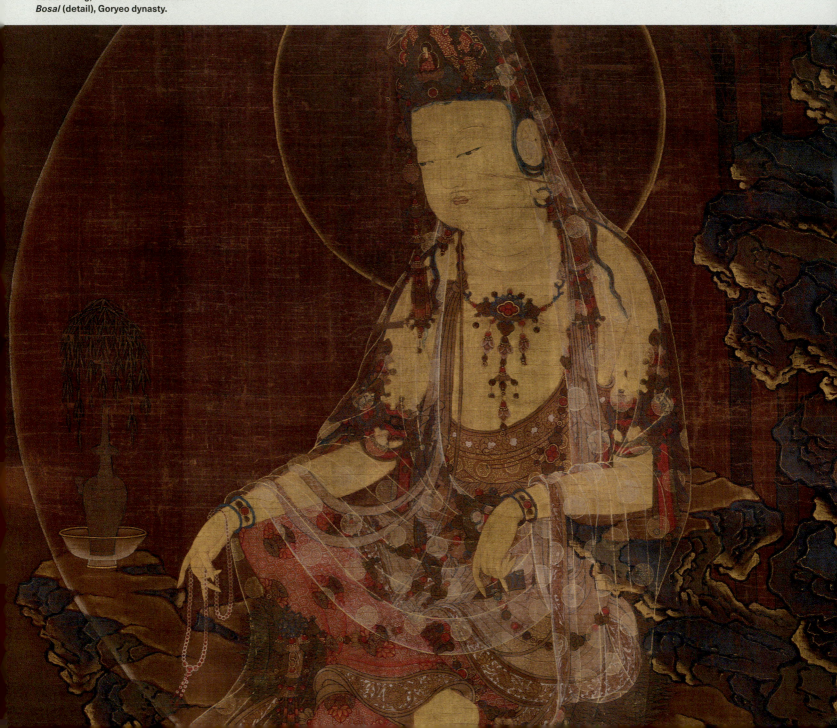

Introduction

Arts of the Korean peninsula and those of the Japanese archipelago are often discussed separately, but areas of these two regions form a zone of political, social, and cultural interaction (Map 32.1). Sometimes the histories of these two areas unfolded independently, but at other times migration, trade, diplomacy, and war created a shared history. From the thirteenth century to the end of the sixteenth century, such interactions—both peaceful and violent—were transformative in terms of artistic development.

Studying both regions together reveals how shared sources, such as Buddhism or the culture of scholar-officials on the Chinese mainland, inspired diverse artforms. This approach also facilitates analysis of the dynamic interaction of geopolitics and art. Notably, late sixteenth-century invasions of the Korean peninsula led by the warlord Hideyoshi directly resulted in the abduction of ceramic artisans and the transfer of ceramic technology and styles from Korea to Japan.

Between around 1200 and 1600, art from the Korean peninsula reveals a shift in emphasis from Buddhist to Confucian beliefs. The Goryeo dynasty (918–1392), the source of the word "Korea," drew political legitimacy from Buddhism. Consequently, no expense was spared in royal and aristocratic patronage of Buddhist art. Buddhism continued to be practiced during the following Joseon dynasty (1392–1910), but its prominence gave way to Confucian ideas, espoused by the founding Joseon king and his supporters. These ideas were built on the views of Master Kong, or Confucius (551–479 BCE), a Chinese philosopher who advocated harmony in human relationships and a government founded on the fulfillment of reciprocal obligations (see Chapters 8 and 21). Thus, arts of the early Joseon demonstrate heightened attention to subjects and styles with Confucian significance, such as ancestral portraits and landscape painting.

On the Japanese archipelago, these same centuries saw dramatic changes in art as civil war and military rivalry swept the country. At the same time, courtly taste and earlier styles continued to be sources of cultural prestige, even in images of important battles. Change and continuity co-existed in Buddhist art in this region, too, particularly in the icons, paintings, and gardens associated with Zen Buddhism. But by the late sixteenth century, such continuity had faded: mighty castles, rustic teahouses, and splendid screens featuring Portuguese missionaries and exotic animals attest to a much-changed landscape of architecture and art.

Buddhism and Art of Goryeo Korea, 918–1392

First introduced to the Korean peninsula in the fourth century CE, Buddhism initially found favor with the ruling aristocracies of regional kingdoms and then gained popularity among the general population (see Map 16.1 and Chapter 27). Buddhism's broad appeal had grown during the Unified Silla period (668–935), and it persisted during the Goryeo dynasty (918–1392). Wang Geon (877–943) founded the Goryeo dynasty, established Songdo as the capital, and declared Buddhism the state religion.

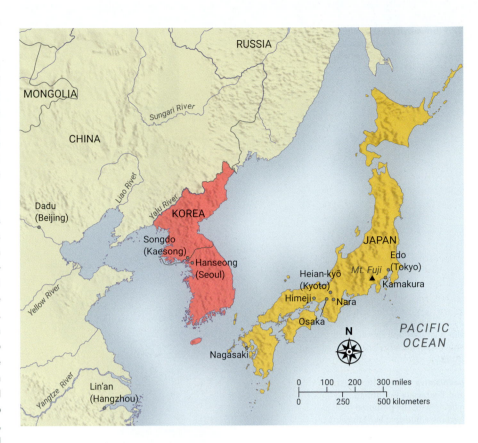

Map 32.1 Korea and Japan, c. 1200–1600.

The magnitude of official support and faith in the religion is demonstrated by the dynasty's twice commissioning the complete Buddhist canon in **woodblock editions** (*Goryeo Tripitaka*) in the belief that these would protect the state.

Just as the state turned to Buddhism for defense against calamities, so individuals directed their private prayers to Buddhist deities. Devotees sponsored a variety of artistic activities, including building temples, writing *sutras*, sculpting and painting **icons**, and manufacturing ritual implements.

CELADON *KUNDIKA* This Buddhist ritual implement is a water-sprinkler, or *kundika* (**Fig. 32.1**). The curved mouth at the side is for filling, while the narrow spout at the top is for sprinkling. Used in purification rituals, some Goryeo *kundika* are made of bronze with inlaid silver wire, while others, such as this one, are **celadon**.

"Celadon" refers to a wide range of ceramics from Asia (see Fig. 31.8). Regardless of whether they are low-fired **earthenware**, higher-fired **stoneware**, or **porcelain**, celadons share a predominant greenish color of glaze and are therefore also known as green ware. For local audiences, the luster and hue of the glaze sometimes resembled jade, a highly regarded material. For Early Modern Europeans, the color called to mind the green costume of a character from French literature and drama, Céladon. Despite the term celadon being neither technical nor East Asian in origin, it continues to be used.

Made for both secular and sacred purposes, celadons of the Goryeo period demonstrate an exceedingly high standard. They come in an extraordinary variety of shapes, including imitation gourds and lively animals,

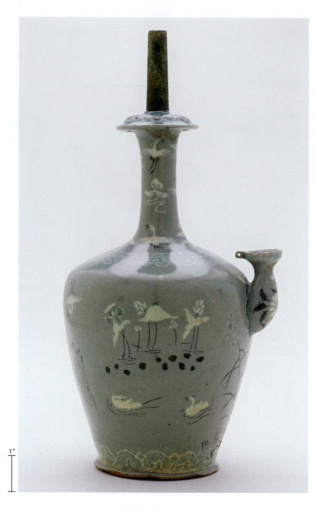

32.1 Unknown artist, *Kundika*, Goryeo dynasty, *c.* late twelfth–early thirteenth century. Stoneware with inlays under celadon glaze; bronze repair, height 12¼ in. (31.1 cm). National Museum of Asian Art, Washington, D.C.

slip a layer of fine clay or glaze applied to ceramics before firing.

bodhisattva in early Buddhism and Theravada Buddhism, a being with the potential to become a buddha; in Mahayana Buddhism, an enlightened being who vows to remain in this world in order to aid all sentient beings toward enlightenment.

mandorla (in religious art) a halo or frame that surrounds the entire body.

buddha; the Buddha a buddha is a being who has achieved the state of perfect enlightenment called Buddhahood; the Buddha is, literally, the "Enlightened One"; generally refers to the historical Buddha, Siddhartha Gautama, also called Shakyamuni and Shakyasimha.

iconography images or symbols used to convey specific meanings in an artwork.

32.2 FAR RIGHT **Seo Gubang,** *Water-Moon Gwaneum Bosal,* Goryeo dynasty, 1323. Color and gold on silk, 5 ft. 4¾ in. × 40 in. (164.5 × 101.6 cm). Sumitomo Collection (Senoku Hakokan), Kyoto, Japan.

Throughout East Asia, Avalokiteshvara is one of the most beloved Buddhist deities, known for the capacity for compassion and mercy. Reflecting this, the local name for this *bodhisattva* literally means "to see the sounds of the world." In Chinese, the name is Guanyin, abbreviated from Guanshiyin (see Chapter 31). The corresponding Korean names are Gwaneum and Gwanse-eum. *Bosal* is Korean for *bodhisattva*. In the *Flower-Garland Sutra*, an important Buddhist text that reconciled competing schools in the Goryeo period, Gwaneum is one of fifty-three spiritual teachers visited by the pilgrim Sudhana, who seeks enlightenment.

In this painting by Seo Gubang, Gwaneum appears resplendent in a specific manifestation called "Water-Moon" (**Fig. 32.2**). Time has darkened the silk on which Seo has painted the image, but its exquisite details are nevertheless visible (note that Seo is the artist's family name, and in Korean convention, family names precede given names). Gwaneum is framed by a gold halo and **mandorla**, both round like the full moon. He wears a diaphanous scarf and abundant jewelry, including a crown featuring a tiny Amitabha Buddha, a **buddha** whose image is used as an **iconographic** marker for Gwaneum.

A rocky outcrop that emerges from the right not only provides a natural throne but also identifies the location as the *bodhisattva*'s mythical island realm, Mount Potalaka. At the lower right, water pours through the rocky crags into the foreground, where corals and flowers adorn the shoreline. Seated in a posture called "royal ease,"

and Goryeo potters boldly expermiented with unusual techniques such as openwork. To create this *kundika*, the potter adapted a widely used metalworking technique, inlay. The process for making inlaid celadons involved carving the leather-hard clay body, filling the shallow cavities with either white or red **slip**, and then firing the vessel. The entire vessel then received a greenish glaze and was fired a second time. For the *kundika* pictured here, white slip gives form to waterfowl and lotus, and red slip (which turns black when fired) gives form to stems and duckweeds. Other inlaid decorations include a chrysanthemum on the curved mouth, cranes and stylized clouds on the long neck, and cranes and a willow tree on the side opposite the mouth (not seen in the view illustrated here). The motifs are both decorative and symbolic. The lotus, for example, is a popular Buddhist symbol for purity. The willow tree, which is the source of healing substances similar to aspirin, alludes to the *kundika*'s purpose as a container of purified water.

SEO GUBANG, *WATER-MOON GWANEUM BOSAL* The connection between the *kundika*, purified water, and the willow is visible in this image of the ***bodhisattva*** Avalokiteshvara (see p. 530 and **Fig. 32.2**). An attribute of Avalokiteshvara, the *kundika* sits in a bowl made of glass or crystal and holds a willow branch. (Note that the wood used for the Liao dynasty icon was willow wood, Fig. 31.15.)

Gwaneum rests his foot on an ornate lotus, a popular Buddhist symbol for purity. The *bodhisattva*'s gaze, his right arm, and the crystal prayer beads dangling from his hand direct attention to the pilgrim Sudhana, the small figure kneeling in the lower-left corner.

When juxtaposed with earlier Avalokiteshvara icons from areas of present-day China (see Figs. 31.15 and 31.16), Seo's painting testifies to the dissemination and transformation of images of this revered *bodhisattva*. The iconographic marker of the crown set with Amitabha Buddha is consistent across all representations. Other features are new, such as the diaphanous quality of, and embroidery on, Gwaneum's white veil, which may allude to the net of light with which the suffering of sentient beings is removed. In terms of the artistic medium, Goryeo Buddhist icons are also distinguished by the use of gold ink, notably as visual accents on rocks.

A gold-ink inscription along the painting's lower left records the artist's name, Seo Gubang, and a date equivalent to 1323. The inscription, which includes a reference to Seo's position as a court artist, also attests to imperial sponsorship. *Water-Moon Gwaneum Bosal* and paintings of other Buddhist icons demonstrated religious devotion among Goryeo aristocracy and would probably have been displayed in **votive** chapels, whether in private temples or homes. However, the painting's current location is in Japan. Centuries ago, Goryeo Buddhist icons were transferred by pilgrims, pirates, or as plunder from war to collectors and temples in the Japanese archipelago. Their origins forgotten, such paintings were subsequently misidentified as the work of anonymous Chinese artists of the Song or Yuan dynasties. Over the course of the twentieth century, however, Goryeo artists, such as Seo Gubang, and Goryeo Buddhist paintings—of which only about 140 are known to have survived—have become properly recognized.

As a result of the many military conflicts on the Korean peninsula, much Korean art has been destroyed. However, despite so few Goryeo Buddhist paintings still being in existence, many more celadons, for both ritual and secular use, remain. These vessels demonstrate the exceedingly high standards of the Goryeo dynasty and the extraordinary range of transformations achieved in art during the period.

Confucianism and Art of Early Joseon Korea, 1392–1592

Although Buddhism permeated Goryeo society, the state also established a Confucian system of scholar-officials such as that created in Song dynasty China. Having studied Confucian texts and passed government-sponsored examinations, scholars could qualify for appointments to official positions in civil administration. As a social force, scholar-officials exerted less influence during Goryeo, but they gained more power in the subsequent Joseon dynasty (1392–1910) when the government replaced Buddhism with a new state ideology, Neo-Confucianism. This philosophy, which originated in Song dynasty China, and endures in areas of East and Southeast Asia, draws on Confucianism, Daoism, and

Buddhism to provide a system of beliefs aimed at establishing harmony in state and society. A flourishing Joseon culture oriented to the taste and values of scholar-officials is particularly evident in two paintings—a portrait and a landscape—from the mid-fifteenth century.

PORTRAIT OF SIN SUKJU By definition, portraits represent their subjects. But how closely do representations correspond to true physical appearance? The representations of powerful individuals vary according to portrait conventions and cultural standards relating to **physiognomy**. Rather than being straightforward records of physical appearance, portraits of important individuals are designed to convey certain ideas to the viewer. Portraits of powerful people often use visual strategies to assert authority and legitimacy.

This painting of the scholar-official Sin Sukju (1417–1475) combines generic conventions of formal portraiture with an individualized face (**Fig. 32.3**). Seated with feet resting on an ornately carved footstool, Sin wears a black hat with starched wings and a green robe, which features a gold-embroidered badge, including a pair of peacocks, to indicate his official rank in the bureaucratic hierarchy. (Each rank was assigned a different motif.) The costume, furnishings, unpainted background, and posture are formulaic, but Sin's face is particularized. His straight eyebrows, steady gaze, rounded jaw, mustache, and whiskers are probably the work of a portrait specialist.

Produced at court, which was at the capital Hanseong (present-day Seoul), formal portraits of officials such as Sin

1'

32.3 Unknown artist, Portrait of Sin Sukju, Joseon dynasty, second half of fifteenth century. Hanging scroll: ink and colors on silk, 5 ft. 5¾ in. × 43 in. (167 × 109.2 cm). Goryeong Sin Family Collection, Cheongwon, South Korea.

votive an image or object created as a devotional offering to a deity.

physiognomy the shape, proportion, and composition of facial features.

demonstrate the Confucian ideal of a reciprocal relationship between emperor and members of the civil service. Officials served the emperor not only by administering the realm but also by lending legitimacy to his rule. In return, the emperor provided officials with employment, rank, and recognition. By demonstrating the subject's merit, this portrait brought honor to Sin's family and may have been the focus of rituals of venerating ancestors. As Neo-Confucianism gained favor relative to Buddhism, ancestral rituals became increasingly important.

In East Asia, government officials were also scholars of history, religion, literature, and art. Sin Sukju was especially skilled in linguistics; together with other officials and the king himself, he invented Hanguel, the system for writing Korean, which is used to this day. Sin was also knowledgeable about art: in 1445 he authored *Record on Painting*, which documents 222 paintings and **calligraphies** in the collection of Prince Anpyeong (1418–1453). Predating the Italian Renaissance architect and writer Giorgio Vasari's *Lives of the Most Excellent Painters, Sculptors, and Architects* by a century, Sin's *Record* participates in an East Asian tradition of art-historical writing. That tradition stretches back to *Record of Famous Painters of All Periods* (847 CE), written by the Tang dynasty official Zhang Yanyuan. Zhang's scope was encyclopedic, whereas Sin's *Record* focuses solely on Prince Anpyeong's collection.

AN GYEON, *DREAM JOURNEY TO PEACH-BLOSSOM LAND*

Throughout the *Record*, Sin attests to Prince Anpyeong's antiquarian taste for Chinese paintings of the Song and Yuan dynasties. According to the *Record*, the prince also owned thirty-six paintings by the Joseon court painter An Gyeon (active *c.* 1440–1470), whose style suited Prince Anpyeong's taste. Sin writes, "Having studied many ancient paintings, [An Gyeon] grasped all their essentials, combining the strengths of various masters … Search antiquity and still one rarely finds his equal." In 1447, the prince commissioned yet another artwork from An, *Dream Journey to Peach-Blossom Land* (**Fig. 32.4**).

The landscape opens from right to left. It is painted on silk (which has darkened over time) with ink and light colors. Toward the upper-right corner are a few modest buildings overlooking a mist-filled grove of flowering peach trees, which are enclosed on all sides by strangely shaped, unevenly eroded peaks. Next, visible at interludes

from the center to the left of the scroll, water flows through a narrow gorge to the foreground. A winding path nearby suggests the tenuous connection between the dreamlike peach grove at right and the more restrained, mundane world to the left, which concludes the composition.

The landscape's structure reverses typical compositions on the subject of the peach-blossom spring (see Fig. 67.12), a utopia described by the Chinese recluse and poet Tao Qian (365–427 CE). Traditionally, viewers would follow the fisherman-narrator's journey on a stream that winds through grove and grotto into paradise. Instead, viewers unrolling An's painting begin with the paradise of peach trees and then leave it behind, as if returning from a reverie. The painting was commissioned by Prince Anpyeong, who had woken from a dream in which he found himself in the fabled land. The scroll's inverted structure adheres to the prince's recollection of this dream, recorded in the **colophon** at the end of the hand-scroll (not pictured).

An Gyeon's style—watery passages, fog-filled atmosphere, irregular **contours**, careful shading, and finely detailed trees and buildings—draws inspiration from the Northern Song court painter Guo Xi (see Fig. 31.4), whose paintings An would have seen in his patron's collection. An has adapted those techniques to respond directly to Prince Anpyeong's experience by creating an innovative composition imbued with the mysterious immediacy of a dream.

BUNCHEONG WARE The scholar-official culture of Joseon informed not only painting but also ceramics, fueling interest in austere, plain white porcelain. From the Confucian point of view, plain porcelain vessels suggested values of restraint, moderation, and integrity, in contrast to finely polished or ornate pieces, which were seen as superficial or merely decorative. First invented in China, porcelain came into wide use after the Joseon court established official kilns in the 1460s. At about the same time, a new type of stoneware emerged from the celadon tradition. This new type, **buncheong**, involved adapting some celadon techniques for decoration, such as inlay and **incision**, but it used coarser clay and relied more heavily on white slip.

Because porcelain potters met the needs of the court and elite consumers, *buncheong* potters were free to

32.4 An Gyeon, *Dream Journey to Peach-Blossom Land*, Joseon dynasty, 1447. Handscroll: ink and light colors on silk, 15¼ × 41¾ in. (38.7 × 106 cm). Important Cultural Property of Japan, Tenri Central Library, Tenri University, Nara, Japan.

experiment with less refined, more audacious, and even witty designs to appeal to popular taste, as opposed to that of the scholarly elite. Some *buncheong* imitate plain white porcelain, while others are painted with iron-oxide patterns. Still others—such as this flask—feature a touch of humor in its **underglaze** carved decoration (**Fig. 32.5**). With white slip covering all but the foot and the mouth, this flask could have been an economical alternative to porcelain. But the carved shapes of a half-dozen fish transform what would have been a plain, austere vessel into a whimsical one. A single upside-down fish, which swims in a direction opposite its mates, has been cleverly squeezed into the negative space formed by its immediate neighbors. Variation among the fish forms, too, suggests artistic inventiveness. Thus, the flask may have once provided both a delightful image and delicious drink to accompany a meal of fish.

The unpretentious, imperfect qualities of *buncheong* also found favor among aficionados overseas. *Wabi-cha*, a style of Japanese tea ceremony emphasizing rustic qualities, fueled an interest in Japan for collecting *buncheong*. In the late sixteenth century, the warlord Toyotomi Hideyoshi launched a series of invasions into the Korean peninsula. The invasions failed, but Hideyoshi's forces captured thousands of Korean potters, relocating them to Japan and effectively ending the *buncheong* tradition. Hideyoshi's invasions, known as the Imjin Wars (1592–98), also mark the end of the early Joseon period.

Civil War and Art of Kamakura Period Japan, 1185–1333

Over the course of the late Heian period (794–1185) in Japan (see Chapter 27), the power of the nobility in Kyoto declined as military landowners in the provinces forged alliances with ambitious leaders of competing clans at court. Rivalries led to civil wars. These wars ended in 1185 when Minamoto no Yoritomo (ruled 1192–99) vanquished his enemies. In 1192, he received from the emperor the title of *Sei-i Taishōgun* (commonly known as "**shogun**") and established a new form of government, the *bakufu*. Also known as the shogunate, the *bakufu* is a form of military government that preserves the emperor as a figurehead while the real power is exercised by a shogun, the military leader and de facto ruler. While the emperor continued to reside in Kyoto, Minamoto located his government headquarters in Kamakura. Not surprisingly, the Kamakura period (1185–333) brought not only military themes to art, but also a pressing need to rebuild devastated structures, resulting in fusions of old and new.

NIGHT ATTACK ON THE SANJŌ PALACE Long-standing artistic conventions and terrifying events of civil war come together in several extant *emaki*, or handscrolls, that portray events of the Heiji rebellion (1159–60), a conflict between the Taira and Minamoto clans. One such scroll, *Night Attack on the Sanjō Palace*, depicts the dramatic kidnapping of the retired emperor Go-Shirakawa, the slaying of his military supporters, and the burning of his palace in 1159 (**Fig. 32.6**). In this detail, smoke billows

32.5 FAR LEFT *Flask with Fish,* ***Buncheong*** *ware*, 1400–1499, Joseon period. Stoneware with underglaze carved decoration, 8¾ × 7⅞ × 5⅛ in. (22.2 × 20 × 13 cm). Art Institute of Chicago, Illinois.

underglaze a color or design applied to pottery before it is glazed and fired.

shogun a title granted by the Japanese emperor to the military leader and de facto ruler during the Kamakura, Muromachi, Momoyama, and Edo periods.

emaki (also ***emakimono***) Japanese term for a handscroll painting typically viewed in sections, from right to left. It is wider than it is tall, and when rolled up, it is easily stored and portable.

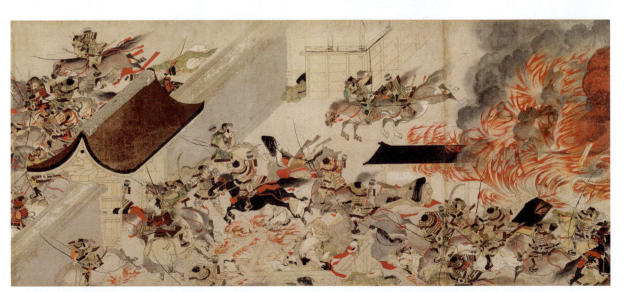

32.6 LEFT AND ABOVE **Unknown artist,** *Night Attack on the Sanjō Palace* **(details).** From the *Illustrated Scrolls of the Events of the Heiji Era* (*Heiji monogatari emaki*), Kamakura period, second half of thirteenth century. Handscroll: ink and colors on paper, 16¼ × 22 ft. 11¾ in. (41.3 cm × 7 m). Museum of Fine Arts, Boston.

material culture the materials, objects, and technologies that accompany everyday life.

from a vivid and destructive inferno engulfing the Sanjō Palace. The actions portrayed in this scene are consistent with a textual record:

> The situation at the Sanjō Palace was beyond description. ... Wild flames filled the heavens, and a tempestuous wind swept up clouds of smoke. The nobles, courtiers and even the ladies-in-waiting of the women's quarters were shot down or slashed to death. ... When they rushed out, so as not to be burned by the fire, they met with arrows. When they turned back, so that they would not be struck by arrows, they were consumed by the flames. Those who were afraid of the arrows and terrified by the flames even jumped into the wells in large numbers, and of these, too, the bottom ones in a short time had drowned, those in the middle had been crushed to death by their fellows, and those on top had been burned up by the flames themselves.

Although the text calls the situation "beyond description," the painting nevertheless depicts the actions and physical items—architecture, armor, weaponry—in exceptional detail, providing a wealth of information about **material culture** of the time. For example, the foot soldier standing just inside the gate wears under-armour clothing with a *tomoe* pattern (comma-like swirl). Elsewhere in the handscroll, Minamoto no Yoshitomo appears, wearing a distinctive horned helmet. In and near the well (center bottom edge of the scene), disheveled and dying women may be recognized by their long hair and layered robes, characteristics seen previously in Heian-period paintings (see Fig. 27.20).

The composition of *Night Attack* takes advantage of the handscroll format, which requires the viewer to unroll portions of the image from right to left, intensifying the narrative suspense. Warriors and horses rush from the right to the left, stimulating viewers' curiosity as to what will be unrolled next. Events unfold in chronological time, too. The scroll begins with foot soldiers, carts, and cavalry converging at the palace, and it ends with triumphant forces guarding the cart imprisoning Go-Shirakawa. In the middle, the detail illustrated here, the conflagration marks the composition's climax. The way that handscrolls such as these shape stories seems to prefigure cinematic structures and techniques.

UNKEI AND KAIKEI, *NIŌ: AGYŌ* AND *UNGYŌ* The civil wars damaged not only imperial palaces, but also religious institutions. For example, after the Buddhist temple Tōdaiji sided with the Minamoto, the Taira set it afire in 1180. The blaze destroyed over half of the complex, including the Great Buddha Hall (Daibutsu-den) and the colossal bronze sculpture of Vairochana Buddha, the cosmic Buddha (see Figs. 27.13 and 27.14). The priest Shunjōbō Chōgen

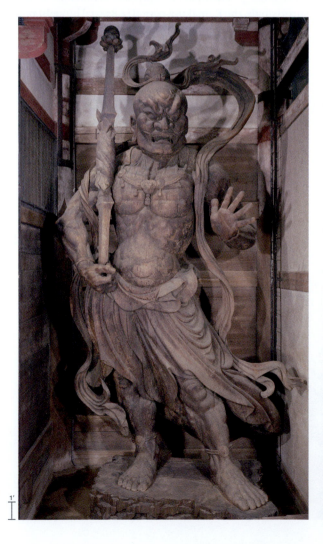 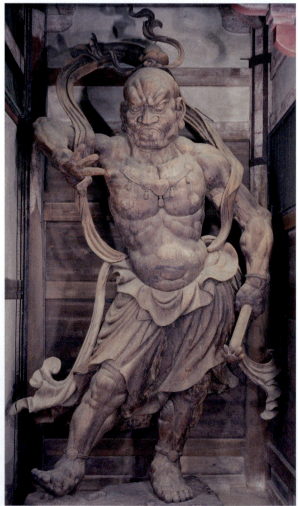

32.7a and **32.7b** Unkei and Kaikei, *Niō: Agyō* LEFT and *Ungyō* RIGHT, Kamakura period, 1203. Wood with paint, respective heights 27 ft. 4¾ in. (8.35 m) and 27 ft. 7¼ in. (8.41 m). Outermost bays of Nandaimon (Great South Gate), Tōdaiji, Nara, Japan.

(1121–1206) took charge of repair and reconstruction, commissioning numerous sculptors to restore and replace icons made some 450 years earlier during the Nara period. Master sculptor Kōkei (active *c.* 1175–1200), along with his assistants and students—together known as the Kei school—undertook much of this work. Their close engagement with Nara period sculpture informed a new style marked by unflinching realism and, when called for, deepened pathos or robust drama.

In 1203, the sculptors Unkei (d. 1223) and Kaikei (d. before 1227) led a collaborative team to create a pair of guardian deities, Agyō and Ungyō (**Fig. 32.7**). Together these guardians form the monumental *Niō* that flank the new Great South Gate to the rebuilt Daibutsuden at Tōdaiji. Remarkably, these over 27-foot-tall sculptures were completed in just seventy-two days. With two other master sculptors and sixteen assistants, Unkei and Kaikei made efficient use of the *yosegi-zukuri* technique pioneered in the late Heian period by Jōchō, the sculptor to whom the Kei school traces its lineage (see Fig. 27.17).

Installed in the outer **bays** of the Great South Gate, the *Niō* face the central walkway, and visitors must turn to see one and then the other. Look closely at their mouths. To the left, the statue of Agyō's open mouth suggests the sound "ahh" (**32.7a**). To the right, the statue of Ungyō has closed lips, which imply the sound "hmm" (**32.7b**). These open and closed Sanskrit syllables give the *Niō* their names. Agyō wields a *vajra*, or thunderbolt mallet. Ungyō holds a sword (the edge and tip are obscured by his body). Massive and mighty, both figures take powerful, active stances. Their state of readiness is also visible in their furrowed eyebrows, flaring nostrils, flexed fingers, tensed muscles, and swollen veins. Such detailed attention to the mechanical operations of the body demonstrates the sculptors' familiarity with realism, but these bodies—bones, flesh, sinews—are highly exaggerated, as befitting guardian deities. Draperies, too, swirl dramatically to suggest supernatural energy. Thus, Unkei and Kaikei have infused the *Niō* with a sense of religious ferocity.

Zen Buddhism and Art in Kamakura (1185–1333) and Muromachi (1392–1573) Japan

Even as great energy poured into the rebuilding of such major temples as Tōdaiji, new Buddhist institutions and sects took root in Japan. Prominent among these is Zen Buddhism, which recognizes the Indian monk Bodhidharma as its patriarch and traces its beginnings to Tang dynasty China, where it is called Chan (see Chapter 31). When Chan spread to the Korean peninsula, it became known as Seon; in Japanese it is called Zen. Zen (as well as Chan and Seon) literally means "meditation," and over the centuries an association between Zen and meditation became prevalent. Zen Buddhism includes widely shared Buddhist traditions, too, such as the creation and worship of icons. One type of icon with special importance in Zen Buddhism is known as *chinsō*. Used for ritual purposes and memorial services, painted *chinsō* provided evidence of religious lineage when teachers bestowed such images on their disciples.

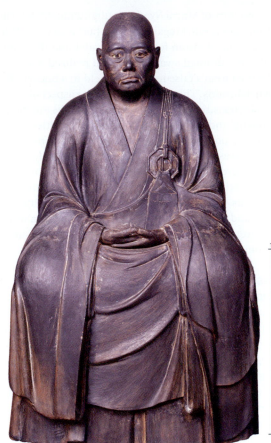

32.8 Unknown artist, Portrait (*chinsō*) of Mugai Nyodai, modern replica of the Kamakura period original (13th century). Wood, height 28⅞ in. (73.2 cm). Kanazawa Bunko, Japan.

As sacred objects of devotional worship, sculpted *chinsō* preserve for followers the spiritual essence of important clergy, both male and female.

PORTRAIT (*CHINSŌ*) OF MUGAI NYODAI This replica of a sculpture *chinsō* captures the likeness of the first female Zen master, Mugai Nyodai (1223–1298) (**Fig. 32.8**). In the Kamakura period, Mugai founded the head temple of the Five-Mountain Convents Association (a parallel Five-Mountain Monasteries system existed for Zen monks). In this portrait sculpture, the elderly abbess sits in a meditative position, bringing her hands together and gazing steadily. Mugai's expression suggests she is neither agitated nor relaxed, but quietly alert. In keeping with her religious position, Mugai has a shaved head and wears priestly garb. She sits on a high-backed chair (a type of furniture foreign to Japan and, at this time, adapted for use by Zen clergy), and her clothing drapes over the seat.

Zen portraits, or *chinsō*, whether paintings or sculptures, combine realism and convention to commemorate revered clergy. Informed by the Kei school style, the unknown sculptor has captured the particular shape of Mugai's facial features and has set crystals into her eyes, enhancing the statue's lifelike quality. At the same time, the costume and composition adhere to formulas common to *chinsō*. The costume includes Mugai's monastic robe and the clasp and ribbon, which are meant to fasten the robe, on her left shoulder; the composition combines the rigid shape of the chair with Mugai's formal posture of meditation.

Niō (also known as *kongo rikishi*) paired guardian statues often found at Buddhist temples in Japan.

yosegi-zukuri a Japanese technique for making wood sculpture by joining multiple blocks together.

bay a space between columns, or a niche in a wall that is created by defined structures.

chinsō commemorative portraits of revered Zen teachers.

The story of Mugai Nyodai's enlightenment describes a mundane event: Mugai carrying a bucket of water. When the bucket's bottom fell out, the water and the moon's reflection drained away, and Mugai realized reality was like the moon's false reflections held in a bucket of her own delusions. This story captures one aspect of Zen: its novel proposition that enlightenment may be experienced suddenly and in the course of everyday activities. By contrast, the portrait sculpture demonstrates continuity in the sect's espousal of making icons. Additionally, Mugai's *chinsō* reveals a penchant for discipline and hierarchy; it is a serious expression of reverence to an important religious teacher. The characteristics of novelty, tradition, and strictness resonated in the Kamakura warrior culture, and in subsequent periods Zen found support among shogun and samurai families.

SESSHŪ TŌYŌ, *HUIKE OFFERING HIS ARM TO BODHIDHARMA*

Foreign invasions and domestic rivalry marked the late Kamakura period. From the Korean peninsula, the Mongols launched (unsuccessful) invasions of Japan in 1274 and 1281. Memory of the attempted invasions has survived in histories, handscroll paintings, and the word *kamikaze*, or the "divine winds" that helped repel the Mongol Goryeo fleet. Although fruitless, these invasions tested Kamakura military capability and political strength.

Ultimately, it was not foreign invasion but domestic rivalry that upended the Kamakura *bakufu*. Sixty years of division began in 1333, when the emperor mounted a return to imperial rule. Although the Kamakura *bakufu* fell, the emperor could not consolidate power. Military forces placed an alternate royal on the throne and drove the emperor from Kyoto, resulting in a period of rivalry known as the Nanboku-chō (literally, "south and north courts") period (1336–92). Not until 1392 was Japan reunified under the command of shogun Ashikaga Yoshimitsu (1358–1409). So began the Ashikaga, or Muromachi, period (1392–1573), when the seat of power moved to the Ashikaga headquarters in Kyoto's Muromachi district.

Once again, Kyoto became a major center for art and culture, as Ashikaga shoguns built private gardens and exquisite pavilions, commissioned paintings and sculpture, and patronized Buddhist temples. They also practiced varieties of tea ceremony, a complex secular ritual that effectively cemented social and political relationships. Drinking tea was an important component of the tea ceremony, but participants would also engage in aesthetic appreciation. During the Muromachi period, and with Ashikaga patronage, the culture and arts related to Zen Buddhism especially flourished. For example, the monk and painter Sesshū Tōyō (1420–1506) studied at a temple founded by Ashikaga Yoshimitsu. Evidence of Sesshū's religious and artistic study, along with Zen emphasis on lineage and discipline, may be seen in his *Huike Offering His Arm to Bodhidharma* (**Fig. 32.9**).

Right of center in this painted **hanging scroll**, the legendary founding patriarch of Zen Buddhism, Bodhidharma (Japanese: Daruma), sits in a meditative position. He wears a plain white garment that covers his head, revealing only his hirsute profile. A thick brow frames a single large eye that gazes fixedly upward, reminding viewers of Bodhidharma's uncompromising commitment to meditation: frustrated at having fallen asleep during meditation, the monk was said to have cut off his eyelids to prevent a relapse. The other figure in Sesshū's painting is the Chinese monk Huike (Japanese: Eka), who would become the second patriarch, following Bodhidharma. Wearing a monk's robe and patchwork *kesa* (an outer garment worn by Buddhist monks and priests) over his left shoulder, Huike enters the composition at the lower left. The shape of his upper body and his bearded profile echo Bodhidharma's, but Huike bows his head slightly in deference, and his furrowed brow suggests that he is anxious or pained. In the narrative shown here, Bodhidharma has previously refused Huike's request for Buddhist instruction. Now, to demonstrate his resolve, Huike has cut off his arm. Sesshū portrays a moment of dramatic anticipation as Huike, with amputated limb in sleeved hand, approaches Bodhidharma to convey again his desire to learn.

The theme of learning is captured, too, in the artwork's style. After initially studying painting locally with the monk-artist Tenshō Shūbun, Sesshū traveled to China, where he pursued his religious studies and purchased paintings on behalf of his patrons. During that sojourn, Sesshū hoped to see more paintings by Song dynasty masters whose style had inspired his own (see Fig 31.16). Adaptation of Southern Song style and technique is visible in Sesshū's asymmetrical composition and the "ax-cut"

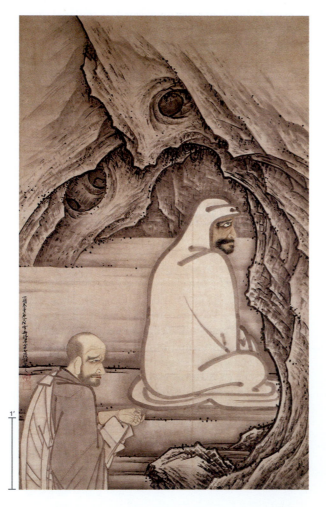

32.9 Sesshū Tōyō, *Huike Offering His Arm to Bodhidharma*, Muromachi period, 1496. Hanging scroll: ink and light color on paper, 6 ft. 6¾ × 44¾ in. (2 × 1.14 m). Sainenji, Aichi, Japan.

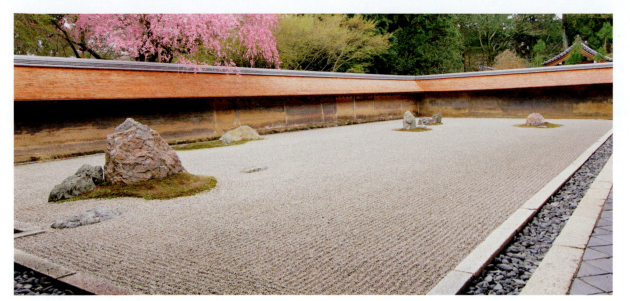

32.10 Dry landscape garden, Ryōanji, Kyoto, Japan, Muromachi period, *c.* 1480. 75 × 29 ft. (22.86 × 8.84 m).

brushstrokes that give texture to the rocky surfaces surrounding Bodhidharma. The calligraphic lines that make up Huike's robe, too, have their origins in the painterly vocabulary of such Southern Song court painters as Ma Yuan (see Fig. 31.9). To these stylistic qualities, Sesshū has added a dramatic juxtaposition of more and less abstract styles. He has used just a few blunt, curved lines to capture the patriarch's clothed body, which contrasts strikingly with the more fully realized crevices of the cave, the very shape of which seems fitted to Bodhidharma. Thus, Sesshū portrayed Bodhidharma simultaneously situated in and apart from the mundane world.

DRY LANDSCAPE GARDEN AT RYŌANJI Perhaps the most famous artwork associated with Zen is not an icon or a painting but rather the *karesansui* at Ryōanji (**Fig. 32.10**). In a nearly rectangular 75 × 29-foot space (the northern edge is slightly lengthened toward the east, resulting in a 90-degree indent near the large grouping of rocks at the eastern edge of the garden), moss and fifteen rocks are clustered into five groupings. Today, visitors do not walk into this garden, but instead sit along the veranda at the garden's northern side. With so little competing for attention, eyes become attuned to subtleties of pattern and texture, and the mind entertains a plethora of possible meanings. A late eighteenth-century guidebook to gardens in Kyoto is just one source that describes the garden as "tiger cubs crossing the river," with the arrangement of rocks representing a mother tiger carrying cubs on her back. In viewers' minds, gravel turns to water and back again; stones morph into creatures and back again.

That these illusory effects are as palpable now as they were approximately two centuries ago is an argument for the garden's timeless appeal. But, in fact, the dry landscape garden at Ryōanji came to prominence only in the second half of the twentieth century. For a period of time, the garden was by turns neglected, the site of a stray plant here or there, and possibly entered, as documented by an early twentieth-century photograph featuring marks that resemble footprints or tracks in the unraked sand. (The photograph was taken by Tamura

Tsuyoshi (1890–1979) and is reproduced and discussed by Shoji Yamada in his book, *Shots in the Dark: Japan, Zen, and the West.*)

Attempts to determine the origins of Ryōanji's dry landscape garden likewise result in unclear and unfixed attributions, and what emerges from greater scrutiny is a more complicated reality. Credit for the garden has gone variably to the artist Sōami (d. 1525), a favorite of Ashikaga shoguns; to Hosokawa Katsumoto (1430–1473), a deputy to the shogun and founder of Ryōanji; to Kotarō and Seijirō (or Hikojirō), two otherwise unknown individuals—possibly hailing from the low class of *kawaramono*, or riverbed people—whose names are inscribed onto one of the rocks; and to unnamed monks at Ryōanji. Long after its initial creation, Ryōanji's dry landscape garden garnered worldwide acclaim, bolstered by growing interest in Zen Buddhism in the post-World War II period. In this regard, the garden is not unlike underappreciated artists whose fame had to await changed tastes, different values, and later audiences.

Hideyoshi, Warlord and Patron in Momoyama Period Japan, 1573–1615

After Ashikaga power collapsed in 1573, a forty-year struggle for control ensued. That period, the Momoyama (1573–1615), is named for the "Peach Hill" location outside Kyoto where the warlord Toyotomi Hideyoshi built his Fushimi Castle. Hideyoshi (1536–1598) played a pivotal role in Momoyama history. Along with Oda Nobunaga (1534–1582) who preceded him and Tokugawa Ieyasu (1543–1616) who came afterward, Hideyoshi pursued military actions and political reforms that eventually reunified the country. In the course of his conquests, Hideyoshi also played a major role in art history, building and renovating castles, commissioning paintings, collecting art objects and demonstrating avid interest in tea ceremony. Just as Ashikaga shoguns had previously collected art, fashioned gardens, and practiced tea ceremony, likewise, Hideyoshi connected art to authority.

karesansui Japanese dry landscape garden; commonly known as a Japanese rock garden.

In Muromachi period Japan, scenes of everyday life gained new visibility in the painting formats of door panels (*fusuma*) and screens (*byōbu*). On these sizable surfaces, painters depicted teeming cities, seasonal activities, theatrical performances, and private entertainments inside brothels. Other subjects of choice were the curious appearances and activities of foreigners. These were featured in *namban byōbu*, or "southern barbarian screens."

At the time, "southern barbarian" generally referred to foreigners, but *namban byōbu* are especially associated with the Portuguese, the first Europeans to reach Japan. Portuguese merchant ships arrived in the Japanese archipelago in 1543, and the Portuguese Jesuit missionary Francis Xavier came in 1549.

While merchants were keen to profit from all manner of trade, missionaries hoped to spread Christianity. The Japanese eagerly purchased Chinese goods and European firearms brought by the Portuguese, and some Japanese converted to Catholicism. But relations could be strained, as when the Portuguese expanded their trade in enslaved peoples to include Japanese, and when Hideyoshi, wary of foreign influence, banned Christianity and ordered the arrest and execution of twenty-six Christians. Still, like many during the Momoyama period, Hideyoshi was both intrigued by and apprehensive of the foreigners.

This early example of *namban byōbu*, by Kanō Naizen (1570–1616) of the distinguished Kanō school of painting, depicts Portuguese vessels departing from a colony, possibly Macao on the south coast of China, on the left and arriving on Japanese shores on the right. As artifacts born of cultural encounter, Naizen's paintings offer a glimpse into how Europeans were depicted as the exotic "Other." Generous use of gold leaf (which may appear tan-colored in photographs) for clouds and ground in both screens is typical and conveys a sense of luxury and splendor in keeping with the high social status of Naizen's patrons, including Toyotomi Hideyoshi.

32.11 **Kanō Naizen, *Namban Byōbu*,** Momoyama period, 1593. Pair of six-fold screens, with details below; colors and gold leaf on paper, each screen 5 ft. 1 in. × 11 ft. 10⅞ in. (1.5 × 3.63 m). Kobe City Museum, Japan.

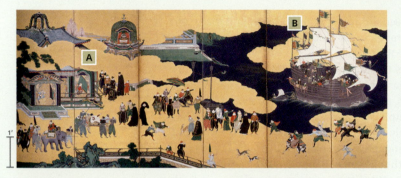

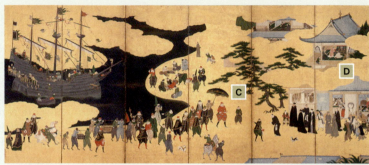

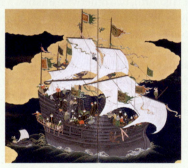

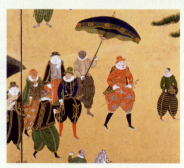

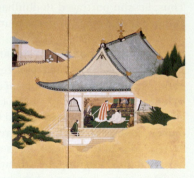

A Colorful and ostentatious buildings at the upper left of the left-hand screen suggest Chinese styles and Buddhist structures. However, the ornaments enclosed in the bell-shaped alcove atop the temple-like building and directly atop the *stupa*-like building are cross-shaped, thus identifying the buildings as Christian ones built by the Portuguese in their Indian, Chinese, or Southeast Asian colonies, as imagined by Naizen and his Japanese audience.

B For dramatic contrast, Naizen places two ships where the compositions of the left- and right-hand screens meet. On the left (pictured here), strong winds fill the sails of the departing ship, and people ashore run, frenzied, and gesture wildly. To the right (see **Fig. 32.11** top-right), a second ship is anchored in calm waters.

C The prominent figure wearing a red costume is the *Capitão-mor*, a nobleman appointed by the Portuguese king to oversee trade in East Asia. He leads a parade consisting of Europeans and laborers, possibly enslaved people, who could be from Africa, India, or Malaysia. The merchants wear gold-embroidered clothing; servants dress in stripes or plaid. Further to the left and outside the scope of this detail, there are captive, exotic animals, too.

D Mirroring the architecture on the opposite screen, in the upper-right corner of the right-hand screen, a rooftop cross identifies this Japanese-style building as a *namban* temple, or church. Inside, five worshipers—both Europeans and Japanese—gather at an altar set before a painting of a figure bearing a cross.

HIMEJI CASTLE In turbulent times, especially after Portuguese traders arrived in Japan in the mid-sixteenth century and introduced firearms to the archipelago (see box: Looking More Closely: *Namban Byōbu*), castles served as protective fortresses. As highly visible structures, castles also functioned symbolically, communicating power to vast audiences. The lords of large estates, *daimyō*—literally meaning "great name"—were the primary retainers of the shogun during the *bakufu* governments. They chose strategic hilltop locations on which to build magnificent residences to mark their authority and to intimidate one another.

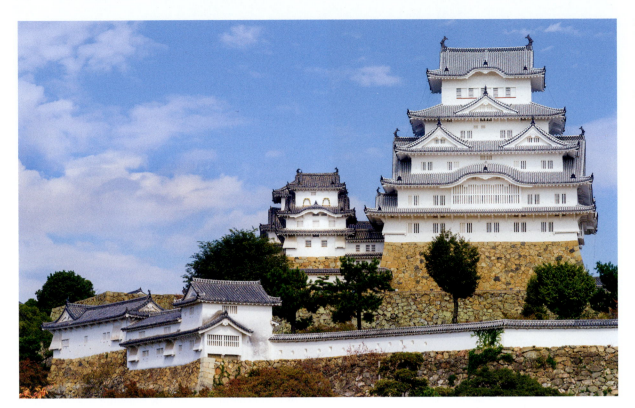

32.12 LEFT **Himeji Castle,** Hyogo prefecture, Japan, Momoyama period, expansion and renovation by Toyotomi Hideyoshi completed in 1581; enlarged 1601–9.

32.13 BELOW LEFT **Himeji Castle, plan drawing** noting the main keep (fortified tower), moats, baileys (castle courtyards), and front gate.

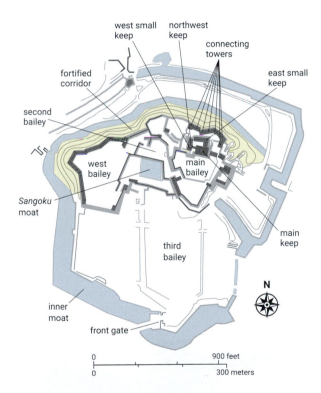

tiles, Himeji Castle (nicknamed "White Heron Castle") rises from a masonry foundation atop a hill. The castle complex comprises around eighty buildings, including storehouses, gates, and corridors. The six-story *tenshu*, or keep, dwarfs everything in its vicinity. Elegantly curved roofs and pointed **gables** give the *tenshu* a graceful, buoyant character, which belies its impregnable quality. For defensive purposes, the castle plan uses high-walled, narrow corridors that connect in circuitous fashion to **baileys**, or open courtyards (**Fig. 32.13**). Enemies who managed to cross the moat would find themselves slowed by the former and made vulnerable by the latter.

SEN NO RIKYŪ, TAIAN TEAHOUSE In his rise to power, Hideyoshi not only constructed opulent castles but also commissioned a rather unassuming teahouse from his tea master Sen no Rikyū (1522–1591). The Taian teahouse is modest in size, measuring just nine feet on each side (**Figs. 32.14** and **32.15**, p. 542). Its rustic style—neutral colors, minimally treated timber and bamboo, and wood shingles—derives from Rikyū's aesthetic vision. Rikyū, who previously served as tea master to Oda Nobunaga, assisted Hideyoshi in performing rituals of *chanoyu* (literally, "hot water for tea," commonly translated as "tea ceremony") for the emperor, as well as at the Grand Kitano Tea Ceremony in 1587, to which Hideyoshi invited the entire population of Kyoto. Notwithstanding splendid occasions, Rikyū advocated the humble character of *wabi-cha*, or "austere" tea, for which the Taian teahouse creates an ideal setting.

Guests would have arrived via a meandering garden path and left their swords outside the tearoom, thereby symbolically casting aside social status. After crawling through a confined entry, they would have sat opposite the host, all on

Among the castles that have survived fire and enemy onslaught is Himeji Castle, located about 60 miles (100 km) west of Osaka (**Fig. 32.12**). The history of Himeji Castle begins before the Momoyama period, but Hideyoshi had it renovated in 1581. After a decisive battle signaling the waning of Toyotomi power in 1600, the future shogun Tokugawa Ieyasu awarded the castle to his son-in-law and supporter Ikeda Terumasu, who rebuilt Himeji, adding three moats and greatly expanding it. Resplendent in white plastered walls and silver-gray

tenshu the keep or fortified tower of a Japanese castle.

gable the roughly triangular upper section of an exterior wall created by a roof with two sloping sides.

bailey in castle architecture, a high-walled courtyard that exposes attackers.

32.14 RIGHT **Sen no Rikyū, Taian teahouse,** interior view, Myōkian temple, Kyoto prefecture, Japan, Momoyama period, 1582–83.

32.15 BELOW RIGHT **Taian teahouse (cross-sectional drawing).**

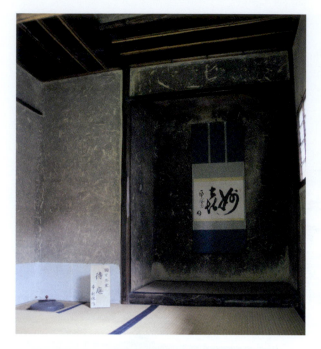

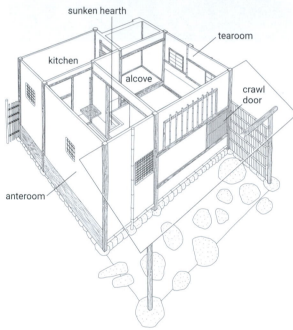

sunken hearth

tearoom

kitchen

alcove

crawl door

anteroom

tokonoma an indoor alcove used to display artwork and seasonal plant cuttings.

32.16 FAR RIGHT **Chōjirō, Muichibutsu (Holding Nothing),** Momoyama period, late sixteenth century. *Raku* ware: earthenware with transparent glaze, height 3⅜ in. (8.6 cm). Hyogo Prefectural Museum, Japan.

teahouse informed ceramic wares for *wabi-cha*, including water jars, tea caddies, flower vases, and such teabowls as this one by Chōjirō (1516–1592, **Fig. 32.16**). Chōjirō's modestly named *Muichibutsu*, or "Holding Nothing," is less than four inches high, yet it possesses a strong sculptural quality. Its irregular contours and rough surface complement the natural, earthy colors of the fired clay.

Muichibutsu is an example of *Raku* ware. The unassuming aesthetic quality of *Raku* ware developed within the context of *wabi-cha*. *Wabi* means austere, and *Muichibutsu* favors rustic understatement over obvious refinement. To appreciate the teabowl's restrained beauty, viewers shifted their aesthetic expectations and slowed their habits of eye, mind, and body. Such adjustments were effected in *wabi-cha* when host and guests engaged in measured motions of preparation, appreciation, and drink. The host used a bamboo whisk to whip the frothy, powdered green tea—a bright contrast in color and texture to the unassuming bowl—before carefully presenting the bowl to the guest. The guest reciprocated with unhurried gratitude.

To generate the *wabi* qualities of earthenware teabowls such as *Muichibutsu*, potters combined old techniques, such as handbuilding (in contrast to throwing on a wheel) with new experimentation. By plucking teabowls from the kiln while still hot and then plunging them into water or placing them on beds of straw that ignited upon contact, potters relinquished a degree of control. The resulting natural accidents became part and parcel of *Raku* ware. The transformation from ordinary object to cherished teabowl is brought to completion with the bestowal of a name. Naming practices were canonized in *chanoyu* writings, the most important of which was the *Records*, written in the 1580s by Yamanoue no Sōji, a student of Sen no Rikyū. Names for teabowls and other tea accessories could allude to poetry, refer to famous places, or invoke profound and paradoxical ideas, such as "holding nothing." Alternatively translated as "emptiness," *Muichibutsu* invokes more apparently the quality, or reality, that Zen Buddhist teachings ascribe to the world of human experience.

The very name *raku* also has layered meanings, which bind together power and art. Literally meaning "pleasure," the word *raku* is embedded in the name of Hideyoshi's palace in Kyoto, Jurakudai. *Raku* has been used for later

tatami mats, a type of flooring made of rush-covered straw. In combination, the setting and the prescribed actions created a fictional world of noble hermits (See Figs. 43.1 and 43.2). Long revered from both Confucian and Daoist perspectives, hermits were individuals who renounced worldly values and therefore were virtuous and incorruptible. By enacting the role of the hermit, or recluse, *wabi-cha* participants proposed themselves as ideal candidates for holding powerful political positions. While the host prepared tea near the sunken hearth, the guests would have examined artwork displayed in the **tokonoma**, or alcove. In discussing the calligraphy or painting, as well as drinking tea together, participants would have demonstrated mutual admiration and further solidified their relationships.

CHŌJIRŌ, *MUICHIBUTSU* (*HOLDING NOTHING*) A similar sense of rustic intimacy to that created in the Taian

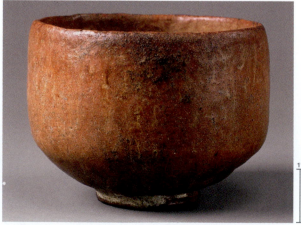

generations of potters who, maintaining that Hideyoshi bestowed upon Chōjirō a seal inscribed with that word, adopted it as a family name and proclaimed to the present an unbroken and direct lineage to their famous founder. Whether Hideyoshi actually did present such a seal to Chōjirō, his role as a patron in the development of *wabi-cha* and the taste for *Raku* ware is certain.

But Hideyoshi's patronage, his quest for famous objects related to *chanoyu*, and his zeal for certain types of ceramics had negative consequences, too. For example, in 1591 Hideyoshi ordered Rikyū to commit suicide, and Rikyū's family were forced into hiding. The circumstances around the suicide are not entirely clear, but they may relate to Rikyū's misjudgment in including a portrait sculpture of himself in the restoration of the main gate at Daitokuji temple. Violence and tragedy on a far greater scale would result from Hideyoshi's unsuccessful military campaigns, which were launched the following year, to conquer Joseon Korea and Ming China. These Imjin Wars, or "Pottery Wars," of 1592–8 transformed both Japan and Korea. Aided by reinforcements from Ming China, Joseon beat back Hideyoshi's forces, and although Japan's ceramics industry benefited from the infusion of captured Korean potters, generations afterward had little appetite for military adventures abroad. After reunifying Japan and establishing the Tokugawa *bakufu* in 1603, Ieyasu adopted isolationist laws. Likewise, in the aftermath of invasions by Hideyoshi and later the Manchu military, the Joseon dynasty adopted policies of seclusion. For centuries, cross-cultural encounters had inspired artists and patrons on the Korean peninsula and Japanese archipelago, but the new policies curtailed such opportunities. Yet, borders were not entirely closed, nor was creativity stifled. Instead, new conditions in the seventeenth to nineteenth centuries provided for vigorous exploration of immediate places and pleasures.

Discussion Questions

1. This chapter discusses several different types of ceramics (see **Figs. 32.1**, **32.5** and **32.16**). How do underlying socio-political contexts inform innovations in styles and techniques?

2. Different kinds of power—military, political, religious, and cultural—may be projected in portraits, icons, architecture, and narrative painting. Compare two artworks from this chapter and the different ways they portray power.

3. Cultural contact can occur under peaceful exchange, as when Sesshū traveled to China, or horrible violence, as when Hideyoshi invaded Korea. When studying art history, how much emphasis do you think should be placed on circumstances that bring about contact between cultures?

Further Reading

- Brown, Kendall H. *The Politics of Reclusion: Painting and Power in Momoyama Japan*. Honolulu, HI: University of Hawai'i Press, 1997.
- Burglind, Jungmann. *Pathways to Korean Culture: Paintings of the Joseon Dynasty, 1392–1910*. London: Reaktion Books, 2014.
- Coaldrake, William Howard. *Architecture and Authority in Japan*. London and New York: Routledge, 1996.
- Kim, Kumja Paik. *Goryeo Dynasty: Korea's Age of Enlightenment*. San Francisco, CA: Asian Art Museum, 2003.
- Yamada, Shoji. *Shots in the Dark: Japan, Zen, and the West*. Chicago, IL: University of Chicago Press, 2011.

Chronology

	KOREA		1274 and 1281	Attempted Mongol invasions of the Japanese archipelago
918–1392	The Goryeo dynasty; exceptionally high-quality celadon wares are made		Late thirteenth century	*Chinsō* of Abbess Mugai Nyodai is made
1323	Seo Gubang paints *Water-Moon Gwaneum Bosal*		1336–92	The Namboku-chō period
1392–1910	The Joseon dynasty; the Early Joseon Period: 1392–1592		1392–1573	The Muromachi (Ashikaga) period
			1496	Monk-painter Sesshū Tōyō paints *Huike Offering His Arm to Bodhidharma*
1445	Sin Sukju writes *Record on Painting*		1543	The Portuguese arrive in Japan
1447	An Gyeon paints *Dream Journey to Peach-Blossom Land*		1573–1615	The Momoyama period
1592–98	The Imjin wars, prompted by Hideyoshi's invasions of the Korean peninsula		1581	Hideyoshi's expansion and renovation to Himeji Castle is completed
	JAPAN		1582–83	The Taian Teahouse, designed by Sen no Rikyū, is built
1185–1333	The Kamakura period		sixteenth century	Chōjiō makes *Raku* ware teabowls
1203	Unkei and Kaikei sculpt Agyō and Ungyō		1593	Kanō Naizen paints *Namban Byōbu*

33

The Regionalization of Islamic Art in North Africa, West Asia, and Central Asia

1000–1400

Cast-brass bucket (Bobrinsky
Bucket), Herat, Afghanistan.

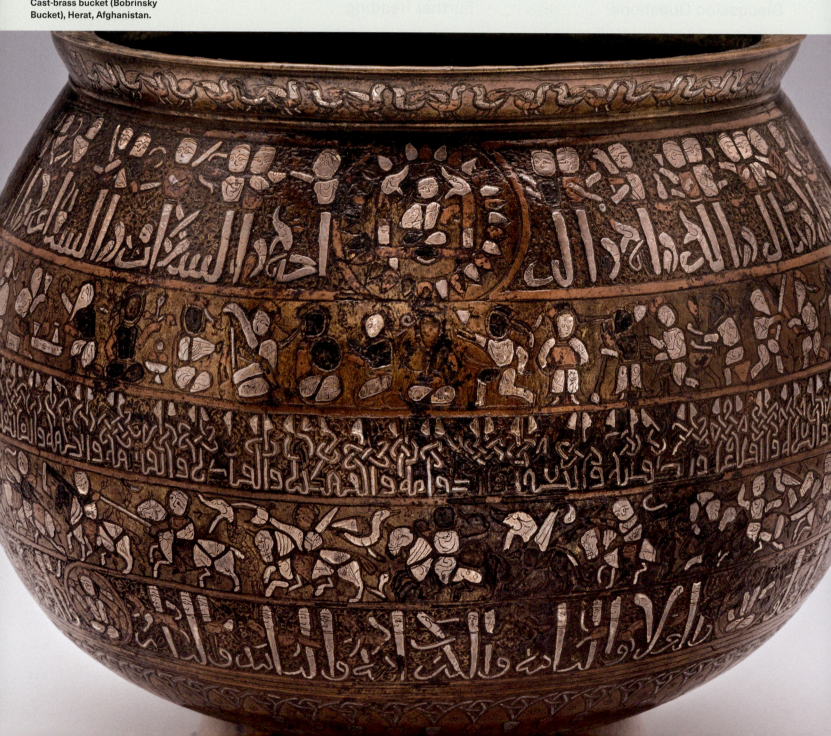

Introduction

North Africa, West Asia, and Central Asia experienced considerable change in the tenth through mid-thirteenth centuries. Whereas these territories had in the preceding centuries been united under the Abbasid Caliphate (750–1258; a caliphate is the area ruled by a civil and spiritual Muslim leader called a caliph), they were in this period marked by the regionalization of political and religious power. In 909, the founder of the Fatimid dynasty in North Africa declared himself caliph, denying the legitimacy of the Abbasid caliph in Baghdad. Then, just two decades later, in 929, the leader of the Spanish Umayyad dynasty boldly declared himself caliph as well (see Chapter 34). Even in areas still ostensibly loyal to the Abbasid caliph, independent Muslim kingdoms were springing up. These states are often called sultanates because their political leaders held the title of sultan. Persians and Central Asian Turks ruled many of the new sultanates and oversaw the rejuvenation of local culture. As a result, artistic production diversified; architectural developments included new building types and forms; urban areas witnessed the growth of a wealthy elite class with a taste for sophisticated, beautiful objects; and the production of metalwork, ceramics, textiles, and illustrated manuscripts flourished.

Due to this fragmentation of power, the Abbasid caliph increasingly became a figurehead. Beginning in 1219, repeated Mongol invasions further weakened the Abbasid state. Then, in 1258, the Mongols sacked Baghdad and killed the last caliph, bringing an end to the established political order. Two new powers quickly rose to prominence: the Ilkhanid Mongols, who controlled territory encompassing present-day Iran and Iraq, and the Mamluks, whose lands included present-day Egypt and Syria. These dynasties employed art to legitimize their rules, further transforming the regions' visual environments. For both dynasties, monumental royal funerary complexes became increasingly important. Under the Ilkhanids, who had close links to Yuan China (see Chapter 31), court artists adopted Chinese stylistic elements, transforming Persian painting and, in many ways, creating an artistic split between the eastern and western Islamic lands. The area between Cairo and Herat—the focus of this chapter—was rich in terms of artistic production, in large part because of the many regional developments.

Architectural Advances under the Later Abbasids and their Successor States, c. 900–1250

One of the first local Persian groups to exercise regional power within the Abbasid caliphate was the Samanid dynasty (819–1005). The Samanids, who traced their ancestry to the pre-Islamic Sasanians (224–651 CE), ruled over the Khurasan region, covering parts of present-day Iran, Afghanistan, Uzbekistan, and Turkmenistan. They were important **patrons** of Persian language and culture. They also sponsored architectural projects, including at least one **mausoleum**. Strictly speaking, the Muslim faith does not encourage lavish tomb construction; the Prophet Muhammad, the founder of Islam, was against such

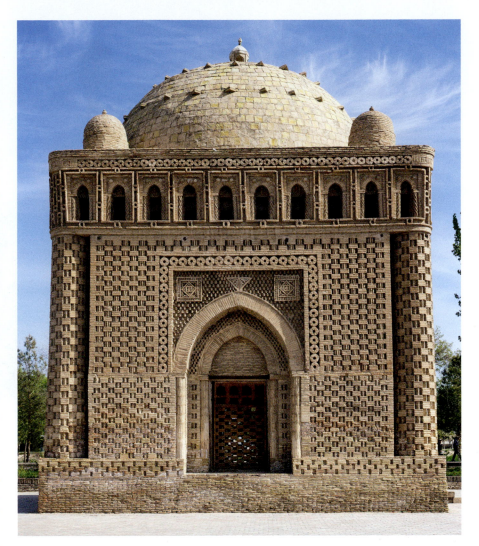

33.1 **Tomb of Isma'il Samani,** Bukhara, Uzbekistan, Samanid dynasty, c. 920.

commemoration and asked that he be buried directly in the ground with no elaborate marker. However, tomb building had been an important pre-Islamic regional practice, and after a while the tradition was revived to honor religious and royal figures.

MAUSOLEUM OF ISMA'IL SAMANI The so-called Mausoleum of Isma'il Samani (**Fig. 33.1**), built in the early tenth century in Bukhara (in present-day Uzbekistan) has long been associated with the Samanid leader Isma'il (ruled 892–907), although the structure was probably built as a family mausoleum after Isma'il's death. The earliest surviving Muslim royal tomb, it provides evidence of a new building type in Islamic architecture. Its form derived from Zoroastrian places of worship called fire temples (Zoroastrianism is a monotheistic Persian religion that was widely practiced in the region before the arrival of Islam).

The Samanid tomb is a tapering cube topped by a central **dome** with a **cupola** at each corner. Each side has an identical recessed, arched doorway and **clerestory**. The tomb's basic layout—a symmetrical central space marked by a dome—was repeated over the centuries in many Muslim royal tombs. Constructed in a region where stone was scarce, the Samanid tomb is known for its elaborate brickwork. Through the strategic use

patron a person or institution that commissions artwork.

mausoleum a building or freestanding monument that houses a burial chamber.

dome a roof that projects upward in the shape of the top half of a sphere.

cupola the underside of a dome; also a dome-like element set atop a dome or other roof.

clerestory the upper section of a wall that contains a series of windows, allowing light to enter the building.

33.2 RIGHT **The Great Mosque of Isfahan,** *qibla iwan* and **central courtyard.** First built *c.* 800; added to through twentieth century; domes and four-*iwan* plan added during Seljuq dynasty, eleventh and twelfth centuries. Isfahan, Iran.

33.3 BELOW **Plan of the Great Mosque of Isfahan, Iran.**

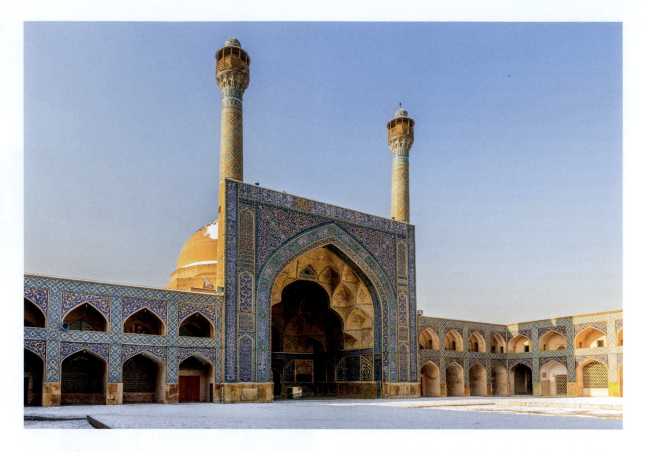

GREAT MOSQUE OF ISFAHAN The most powerful early sultanate was ruled by the Seljuq dynasty, made up of Central Asian Turkic tribesmen who had originally served in the armies of Persian sultanates before seizing control from them. At their peak, the Great Seljuqs (*c.* 1040–1194) ruled not only Khurasan but also parts of Arabia, Anatolia, and Iraq (**Map 33.1**). They adopted Persian culture while still retaining aspects of their Turkic heritage.

The Seljuqs made their capital city at Isfahan (in present-day Iran), where they built the city's **congregational mosque**. The Great Mosque of Isfahan (**Fig. 33.2**), a massive brick structure ornamented with glazed tiles, is in fact not just the product of Seljuq patronage. It is an **architectural palimpsest**, with its many components amalgamated from over one thousand years of patronage by almost every dynasty that ruled Iran from the eighth century onward. The Seljuqs added its defining features, however, including its **four-*iwan* plan** (**Fig. 33.3**). This new layout for mosques consisted of four vaulted rooms, each open on one side, arranged to encircle a courtyard. An open, vaulted room of that type was known as an *iwan*, a pre-Islamic architectural form that was often used for royal audience halls. The Abbasids probably featured *iwans* in their palaces in Baghdad and Samarra too, but the Seljuqs adopted the form for religious architecture.

Once developed, the four-*iwan* plan became the standard layout for Iranian mosques, perhaps because it had several advantages. First, in Iran, the **qibla** *iwan* is always on the south side and opens northward onto the courtyard, meaning that for most of the year it receives only indirect sunlight, which is neither too sunny nor too shady and is ideal for communal prayer. The remaining three *iwans* were used for other activities, such as

congregational mosque also called a Friday mosque, or *jama masjid* in Arabic, it is the main mosque in a city or town and the location of Friday prayers, when the entire community comes together.

architectural palimpsest a structure that has been changed over time and shows evidence of that change.

four-*iwan* plan four vaulted halls, each open on one side, positioned around a courtyard to form one large, interconnected space.

qibla the direction Muslims face to pray, toward the Ka'ba in Mecca.

of different brick shapes and placements, the builders gave the tomb a textured surface, similar to an intricately woven basket, across which patterns are created by the play of light and shadow. Light is a recurring element in Islamic design; it serves to animate and beautify objects and in certain contexts also references God, whom the Qur'an (the central sacred text of Islam) describes as the light of heaven and earth.

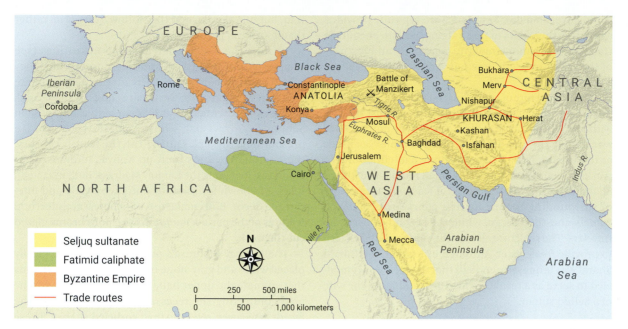

Map 33.1 Seljuq Sultanate and surrounding regions, c. 1050–1100.

facade any exterior vertical face of a building, usually the front.

mihrab a prayer niche, usually concave with an arched top, located in the *qibla* wall of a mosque and indicating the direction of Mecca.

hypostyle hall a large room with rows of columns or pillars supporting the roof.

minaret a tower at a mosque; can be used to give the call to prayer and also functions as a visible marker of the mosque on the skyline.

caravanserai lodgings constructed along trade routes at regular intervals for use by travelers; also called *ribat* or *han*.

madrasa a school, especially for Sunni Islamic law and theology.

teaching and resting. Second, the interior courtyard provides the mosque with a visual focal point and a quiet but public refuge in the middle of a crowded, bustling city. Finally, without a crucial external **facade** to maintain, the structure can be expanded as needed, as the Great Mosque of Isfahan was, melding into the surrounding urban environs.

In 1086–87, a high-ranking Persian advisor named Nizam al-Mulk (1018–1092) had twenty-four columns in front of the *mihrab* in the original **hypostyle hall** of the Great Mosque taken down. There, he added a domed chamber for the use of the sultan and his court. At the time, the dome was one of the largest ever built in the region. A fire in 1121–22 damaged the mosque, and at some point afterward the bulk of the hypostyle hall was replaced with four *iwans* surrounding a sizable rectangular courtyard. The *qibla iwan* is marked by a pair of **minarets**, visually framing Nizam al-Mulk's dome.

Nizam al-Mulk is remembered not only for the mosque's dome. In the 1080s, he authored the influential *Book of Governance*, which laid out what a good ruler should do. According to the book, a leader should, among other things, construct roads, bridges, and fortifications; take care of the sick and poor; promote trade; and support religious and educational institutions. These last two priorities led to the development of two new building types, respectively the **caravanserai** and the **madrasa**.

RIBAT-I SHARAF CARAVANSERAI In the twelfth century, trade routes stretched across Khurasan to link such prosperous urban centers as Baghdad and Damascus (in present-day Syria) with their Chinese counterparts, such as Xi'an and Beijing. Numerous caravanserais were built on the routes, along which traveled substantial groups of people, usually traders, and their camels; these groups were known as caravans. One of the earliest surviving caravanserais is the Ribat-i Sharaf, sponsored by a local governor around 1114–15 (**Fig. 33.4**). Ideally, caravanserais were placed about 19 to 25 miles (about 31 to 40 km) apart, the distance that a caravan of camels laden with goods

33.4 Ribat-i Sharaf caravanserai, Khurasan, Iran, Seljuq dynasty, first built c. 1114–15; renovated c. 1154.

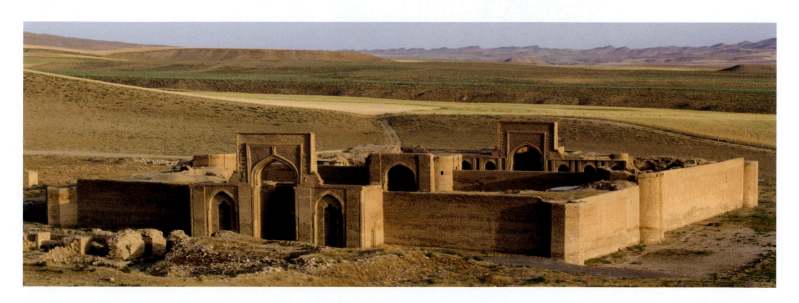

33.5 Exterior view of portal, **Karatay Madrasa,** Konya, Turkey, Seljuq dynasty, *c.* 1251–53.

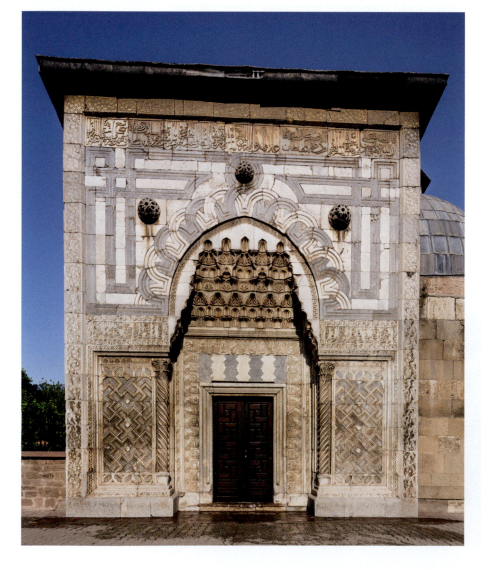

could cover in a day. Travelers were typically provided with up to three days of free lodging, both to encourage trade and to demonstrate the generosity and justness of the ruler (in Islam, one has a duty to show charity toward travelers).

The architecture of a caravanserai followed a set layout. The structure had to be lightly fortified against thieves, with a single **portal** to control access. The entranceway was usually the grandest part of the complex, as it was at the Ribat-i Sharaf. Caravanserais had either one or two large courtyards framed by small rooms. The Ribat-i Sharaf's two originally featured at least one upper story of surrounding rooms. Its first courtyard stored the camels and their cargo, while the second housed the travelers. The structure also had an underground cistern to provide fresh water. Although utilitarian, the Ribat-i Sharaf was impressive enough that in 1154 it was remodeled to serve as a residence for Turkan Khatun, the wife of a Seljuq sultan.

KARATAY MADRASA The first madrasas were built in the eleventh century in present-day Iran and Iraq. They adopted the four-*iwan* plan, which provided flexible space for teaching and housing students. The best-preserved early madrasas, however, are not in Iran or Iraq, but in Anatolia, and they follow a one-*iwan* rather than four-*iwan* plan.

In 1071, the Seljuqs defeated the Byzantines (see Chapter 28) at the Battle of Manzikert, from which they gained the Anatolian region. Thereafter, the Seljuq empire split into two branches: the Great Seljuqs (*c.* 1040–1194), whose capital remained at Isfahan, and the Anatolian Seljuqs (*c.* 1077–1307), whose capital was Konya (in present-day Turkey). During the thirteenth century, the Anatolian Seljuqs built up Konya, adding several madrasas, including the Karatay Madrasa. Built in 1251–53, it is best known for its stone entrance facade and interior tile decor. Both make use of two new architectural features of the period: *muqarnas* and **polychrome** glazed **cut-tile work**.

The Karatay Madrasa's portal employs strategically placed white and gray stone to form interweaving bands that animate the upper half (**Fig. 33.5**). Below, under the arch connecting the recessed door to the rest of the facade, are seven rows of small **corbeled** shapes. These are *muqarnas*, forms specific to Islamic architecture (although artists trained in Islamic design did on occasion apply these forms elsewhere, as in the *muqarnas* ceiling in the Cappella Palatina Church in Palermo, Sicily; see Fig. 34.12). *Muqarnas* provide one visual solution for transitional areas that bridge two architectural forms or spaces, such as the top of a doorway where wall and door meet, or the connection between a round dome and a square room. The Karatay Madrasa's individual *muqarnas* are a variety of three-dimensional shapes, including small niches and prism pieces. These cells are assembled into a shape similar to a honeycomb, with each row projecting slightly more, allowing them to transition from one plane to another while creating a visually pleasing play of light and shadow. *Muqarnas* can be any size and made from any material, but they are not usually structural. Scholars still debate when and where *muqarnas* first developed; by the twelfth century, they were commonly employed from North Africa to eastern Khurasan.

In addition to *muqarnas*, the Seljuqs introduced the use of polychrome ceramic-tile decoration on building interiors, favoring a distinctive color palette of eggplant-black, turquoise, and white, as at the Karatay Madrasa. Here, the surviving decoration is focused around the interior of the dome and the archway of the *iwan* (**Fig. 33.6**). The iwan's pointed arch features an inscription from the Qur'an. The dome's decoration consists of three main parts: a repeating sunburst pattern on the dome itself; around the dome's base, a **frieze** with the same Qur'anic inscription as on the *iwan*, but now written in a highly decorative style of knotted **calligraphy**; and geometrically patterned triangular **pendentives** at each corner. The dome and pendentive decoration are formed from glazed tiles, which are cut into specific shapes and then set into gypsum, a soft chalk-like mineral. Sometimes the technique is called cut-tile mosaic; however, in traditional **mosaic**, such as that decorating the interior of the Dome of the Rock (Fig. 24.4) and the Church of San Vitale (Fig. 28.6), the **tesserae** are all roughly the same shape, while in cut-tile work, the individual pieces vary to fit the pattern.

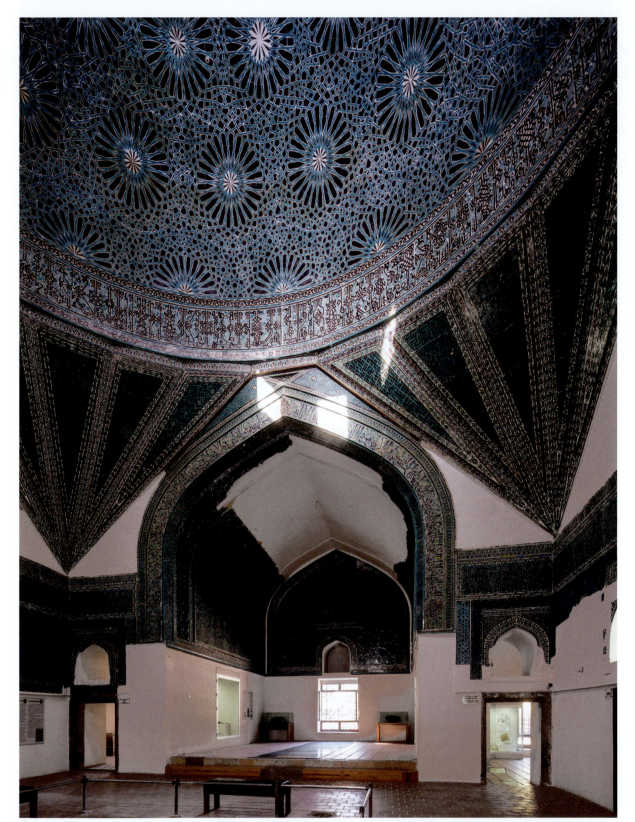

33.6 Interior view of Karatay Madrasa, showing the single *iwan* behind the centralized domed space decorated with cut-tile work, Konya, Turkey, Seljuq dynasty, *c.* 1251–53.

On the pendentives at the Karatay Madrasa, the tile is meticulously designed so that what seems to be a geometric pattern is in fact **Kufic** script, giving the names of Muhammad, the first four caliphs, and the prophets David, Jesus, and Moses.

The dome's interior is covered with an interlocking geometric pattern featuring circles with twenty-four points or "rays" that make them look as if they are stars or suns,

highlighting the symbolism of the dome as representative of the celestial realm. The pendentives, each divided into five parts, and the central **oculus** further emphasize this theme, with the entire dome resembling a sun.

Similar usage of polychrome cut-tile work to create complex, repeating geometric surface designs could eventually be found throughout much of the Islamic world. The practice reached its height in Spain and Morocco,

frieze any sculpture or painting in a long, horizontal format.

calligraphy the art of expressive, decorative, or carefully descriptive hand lettering or handwriting.

pendentive a curved triangular wall section linking a dome with a supporting vertical pier or wall.

mosaic a picture or pattern made from the arrangement of small colored pieces of hard material, such as stone, tile, or glass.

tessera (plural **tesserae**) a small block of tile, glass, or stone used to make mosaic.

Kufic one of the oldest Arabic scripts, angular in form, often used to copy the Qur'an.

oculus a round, eye-like opening in a ceiling or roof.

zellij small pieces of glazed terracotta tile set into plaster to form geometric designs ornamenting interior architectural surfaces.

decorative art any of the applied arts, such as furniture, textiles, ceramics, and metalwork, that are intended to be functional and are also designed to be aesthetically pleasing.

inlay decoration embedded into the surface of a base material.

niello a black alloy of sulfur and other metals, often used for inlay.

register a horizontal section of a work, usually a clearly defined band or line.

manuscript a handwritten book or document.

fritware ceramic vessels made using a combination of quartz, glass frit (partially fused glass), and fine white clay; thinner and whiter than vessels made using regular clay.

overglaze a second decorative coating applied to already glazed ceramic ware.

luster a metallic over-glaze produced by oxides, used on ceramics.

mina'i derived from the Persian word for enamel, it describes a multicolored and gilded over-glaze process used on ceramics, typically white fritware.

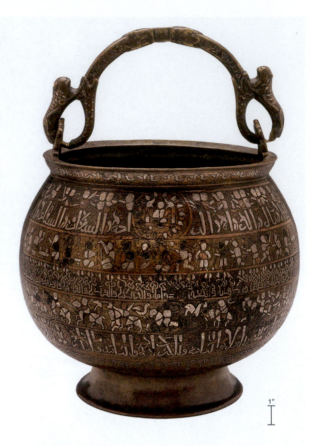

where it is known as *zellij*. Excellent examples can be found at the fortress-palace of the Alhambra, which also features *muqarnas* domes unequaled in their intricacy (see Fig. 34.18).

Luxury Art under the Later Abbasids and their Successor States, *c.* 1000–1250

Across West Asia and Central Asia, efforts to promote good governance and trade led to the growth of prosperous cities with an educated, wealthy merchant class. Another result was the production of luxury objects for consumption by this new class, as well as those in power and their government officials. Widely valued for their artistry, such objects played an important role in the economy and in traditions surrounding hospitality. Different regions became known for specific media and artistic techniques, but overall, a taste for figural imagery—designs featuring figures of animals or humans—dominated, with the decoration often reflecting the status and lifestyles to which their owners aspired.

Here, we should note that the hierarchy of materials sometimes applied to European art (that is, painting and sculpture at the top, with **decorative arts** below them) was never present in Islamic art. For example, metalwork was respected just as much as painting. In fact, metalworkers, who handled precious materials, were especially esteemed, and technical innovations in any medium were valued.

AL-WAHID AND AHMAD, CAST-BRASS BUCKET (BOBRINKSY BUCKET) During the twelfth century in Mosul (in present-day Iraq) and Herat (in present-day Afghanistan), metalworkers developed a laborious but visually striking **inlay** technique. They began by making a vessel out of a hard alloy, such as bronze or brass, onto which they hammered into place small pieces of softer metals, such as silver. They finished by adding **niello** to the crevices to highlight the design.

One of the best-known early examples of such inlay work is the so-called Bobrinksy Bucket (named for a later owner, the Russian Count Bobrinsky), made in Herat in 1163 (**Fig. 33.7**). This cast-brass bucket, only 7 inches high, is covered in intricate silver-and-copper inlay. Even its handle is ornamented. The body of the bucket has **registers** that alternate between calligraphy and figural scenes (see p. 544). Different styles of calligraphy are showcased: Kufic, cursive (a style in which characters are joined in a flowing manner), an ornate type in which the vertical stems of the letters are knotted, and an even more elaborate type in which the tops of the letters turn into human forms. The figural scenes are equally diverse, depicting people playing polo, fencing, hunting, drinking, and playing backgammon. An intriguingly detailed inscription around the rim identifies not only the production date but also who commissioned it ('Abd al-Rahman ibn 'Abdallah al-Rashidi); who cast the form (Muhammad ibn 'Abd al-Wahid); who did the inlay work (Hajib Mas'ud ibn Ahmad); and who ultimately received the vessel (Khuja Rukn al Din Rashid al-Din 'Azizi ibn Abu-l-Husayn al-Zanjani).

This inscription, the object's small size and its exquisite decoration have led art historians to puzzle over its purpose. It has been suggested that the bucket was a kind of sampler, made to show the quality and variety of options available to a potential buyer of luxury inlay metalwork. In this interpretation, al-Rashidi, the man who commissioned it, probably ran the workshop in which the two metalwork artists, Muhammad ibn 'Abd al-Wahid (the caster) and Mas'ud ibn Ahmad (the inlayer), were employed, and al-Zanjani, the gentleman who received it, was a merchant who displayed it to his customers. The existence of such an intricate object made solely as a model for potential future commissions points to the extensive interest in, and dynamism of, metalwork production at the time.

AL-WASITI, *MAQAMAT* The late twelfth through early thirteenth centuries witnessed a marked increase in the number and type of illustrated **manuscripts**, suggesting changes in the function of images in North Africa, West Asia, and Central Asia during the late Abbasid period. Persian and Arabic illustrated books exist from the eleventh century (and were probably made even earlier), but they tend to be scientific treatises that require pictures to add clarity to the text—for example, maps in geography books or images of specific plants in medicinal volumes. By the thirteenth century, the number and variety of illustrated books surged. Works that did not necessarily need images nonetheless contained them.

The *Maqamat*, or "Assemblies," best exemplifies this shift. Written in the early twelfth century by the author al-Hariri, it consists of fifty humorous episodes involving

a rogue named Abu Zayd and his companion al-Harith, who also functions as the narrator. Al-Harith is horrified and amazed by Abu Zayd, who travels around adopting various personas with which to con people. He gets away with it because of his elegant mastery of Arabic; indeed, much of the *Maqamat*'s humor comes from the characters' linguistic banter. For this reason, it is not particularly suited to illustration. Yet, in the thirteenth century, multiple illustrated copies of the popular story were made.

One such manuscript was copied and painted by Yahya ibn Mahmud al-Wasiti in 1237 in Baghdad, probably to be sold at the city's book market. Its ninety-nine paintings only nominally depict the story's events. Instead, they seem to focus on the episodes' settings—mosques, markets, schools, caravans, ships—and the everyday people and animals populating those spaces. On the page reproduced here, Abu Zayd and al-Harith are on camels in the foreground, having just arrived in a new town, which is depicted behind them with domestic detail (**Fig. 33.8**). On the left is a mosque with a minaret behind a market made of brick. Chickens sit on domed roofs at center top; directly below, two people seem to barter over a price. On the right, a man with a spear stands guard, animals graze, and a woman makes yarn on a drop spindle (an instrument for turning fiber into thread). As was typical of the period, the paintings are made with water-based natural pigments, and they prioritize surface detail over the illusion of volume or spatial depth. The illustrations are animated, inventive, and entertaining. Clearly, they are intended to make the experience of reading the manuscript more pleasurable.

MINA'I WARE BOWL Elite social events, whether substantial feasts or intimate parties, provided hosts with a chance to demonstrate their generosity and status. They also allowed attendees to display their erudition through appreciation of good food, drink, music, and literature. In this environment, such items as plates, bowls, and cups served simultaneously as useful objects, status symbols, and visual references to shared cultural ideals. In the twelfth and early thirteenth centuries, Persian ceramicists, operating at centers in Kashan and Nishapur (in present-day Iran), favored **fritware**. Using frit enabled them to create thin, smooth, white vessels that could be decorated with various **overglaze** techniques, including **luster** (see Fig. 24.15) and the new, polychromatic **mina'i**. Applying *mina'i* glaze to fritware was an expensive and complicated process, requiring multiple firings, but it provided an ideal medium for figural imagery, allowing the artists to create visuals similar to those featured in book illustrations. Indeed, *mina'i* decoration often related to well-known stories and poems, sometimes featuring poetic verses alongside images of people.

This *mina'i* fritware bowl, made in about the late twelfth or early thirteenth century, features a man playing a harp and a woman holding a wine glass, both bending to fit the curve of the vessel (**Fig. 33.9**). The figures are dressed in the fine apparel that elite individuals would wear at a social gathering. The subject mirrors the object's function, as the bowl was probably intended for use at upper-class parties. The pair also reference

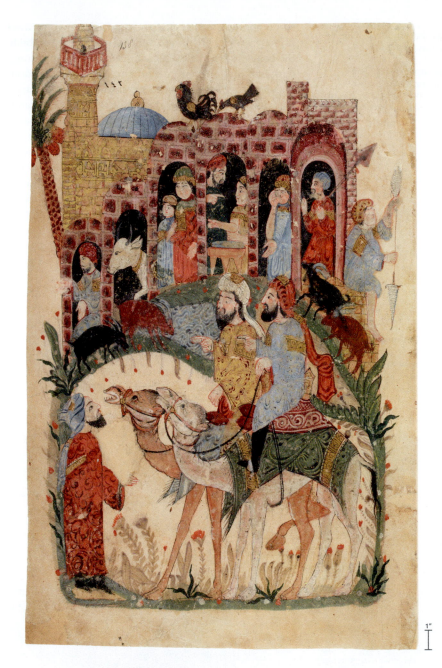

33.8 ABOVE **Yahya ibn Mahmud al-Wasiti, Abu Zayd and al-Harith arriving at a village,** folio from *Maqamat* by Al-Hariri, copied and illustrated 1237, Baghdad, Iraq, Abbasid caliphate. Ink and color on paper, 14½ in. × 11 in. (36.8 × 27.9 cm). Bibliothèque Nationale de France, Paris.

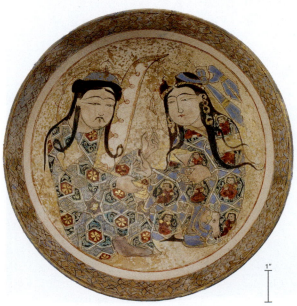

33.9 LEFT *Mina'i* ware bowl, probably Kashan, Iran, Seljuq period, late twelfth–early thirteenth century. Stone-paste body with polychrome overglaze, height 3½ in. (8.9 cm), diamter 9 in. (22.9 cm). Freer Gallery of Art, Smithsonian Institution, Washington, D.C.

tiraz fine textile embroidered with an inscription.

pile carpet textile floor covering with an upper layer of pile (knotted pieces of yarn) attached to a woven backing.

contemporaneous Persian poetry, which was concerned primarily with earthly and spiritual love. They embody the beauty of the beloved as described in poems: long, dark hair and a face as round and white as the moon. They also have idealized arched eyebrows, almond-shaped eyes, and delicate noses and mouths. Note that this standard of beauty is androgynous. Only the man's goatee beard and slight differences in headdress indicate the figures' genders. In other examples not shown here, gender is completely elusive. Persian (or New Persian as it was called, to distinguish it from the Persian spoken in pre-Islamic times) is written in Arabic script, but it is a distinct language that does not have gendered pronouns—no distinct "he" or "she." Therefore, a verse describing the beloved's beauty could be referring to a young man or woman, and this ambiguity is sustained in visual depictions.

To add to the pair's attractiveness, the *mina'i* artists lavished attention on the figures' robes. The man's displays a complex interlocking geometric pattern, and the woman's is decorated with a repeating figure within a geometric design. Both have ***tiraz*** bands on their sleeves. Similar attention is paid to textiles in the *Maqamat* illustration (see **Fig. 33.8**). Abu Zayd and al-Harith also wear

tiraz bands indicative of their status, and in the background village scene, a woman makes yarn. Such details reflect the importance of textiles at every level of society. Textiles provided protection from elements; gave comfort and afforded privacy; served as markers of social status; acted as containers and portable furniture; and defined living spaces. They also were a vital part of the economy, both for local sale and export.

CONFRONTED ANIMAL RUG Many types of textiles were produced in the diverse regions stretching from the Iberian peninsula to South Asia during pre-modern times, but carpets, both flat-woven and **pile**, have come to be particularly associated with Islamic culture. Often called "Oriental carpets" in Europe and North America, rugs from North Africa, West Asia, Central Asia, and South Asia have long been prized by foreign collectors and others who appreciate their beauty, artistry, and associations with luxurious living.

Some of the earliest surviving carpets come from thirteenth- and fourteenth-century Anatolia, around Konya. One particularly well-preserved wool-pile rug features a design of confronted animals (a term used to describe animals facing each other) on a red background (**Fig. 33.10**). The four large, stylized creatures, with decorative tails rising from their backs, seem to be lions or some other sort of animal. Each is depicted with its mouth open, one of its front legs lifted, and a smaller lion inside its body. The smaller forms are identifiable as lions because of their curved tails and triangular ears. Three are positioned on yellow panels of what may be stylized birds standing back to back (small beaked heads are visible at the top of the panels). The fourth lion, in the upper right, is positioned on a blue panel. This main arrangement is enclosed by five border designs featuring geometric patterns typical of Konyan rug production.

Due to the fact that carpets were heavily used, few survive intact, and they can be difficult to date. The best-preserved early rugs often exist far from their places of production, in locales where they were treasured as rare items (see box: Making It Real: Pile-Carpet Construction). This one was found in Tibet before it was acquired by the Metropolitan Museum of Art, and two similar confronted animal rugs were found in Italy and Sweden, indicating just how extensive the trade for the product was. Because carpets were so prized, European artists of the era frequently depicted them in paintings, and these representations help us to date them. For example, a similar animal carpet appears in an early fifteenth-century painting from Siena, Italy, depicting the marriage of the Virgin Mary. In the painting, Mary stands on a confronted animal carpet. Its inclusion in the scene tells us that this type of rug was being produced by the time the painting was made.

Art under the Ilkhanids, *c.* 1250–1350

Life in cities from Baghdad to Beijing, Kiev to Kabul, was disrupted, if not completely destroyed, by the Mongol invasions of the mid-thirteenth century (**Map 33.2**). Some places were spared: the Anatolian Seljuqs agreed to become vassals of the Mongols and were generally left

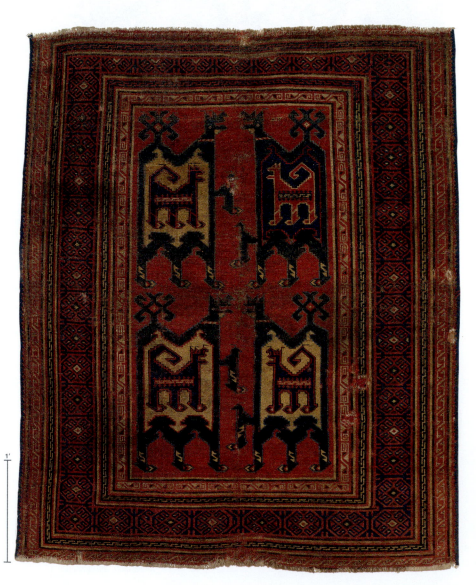

33.10 Confronted animal rug, Turkey, Seljuq period, fourteenth century. Wool, 5 ft. 2 in. × 4 ft. 6½ in. (1.65 × 1.38 m). Metropolitan Museum of Art, New York.

1'

People from many cultures have been making pile carpets for thousands of years; the oldest existing example was found in Siberia and dates to the fourth century BCE. When crafted by hand rather than machine, carpet construction is relatively consistent. Silk, cotton, and other fibers can be used, but wool—sheared from a sheep, then cleaned, combed, spun into yarn, and dyed different colors—is the most common material. Using a loom (an instrument for weaving fabrics), the rug-maker first attaches lengths of yarn to the upper and lower beams, making sure the tension is even (**Fig. 33.11**). This process is called warping the loom, and these vertical lengths are known as the warp. The length and total width of the warp strings determines the carpet's size.

Next, the rug-maker winds yarn, which will become the weft string, around a small wooden implement called a shuttle that is passed in between the warp strings. By moving part of the loom (called the heddle or the leash rod depending on the type of loom), the weaver can shift every other warp string forward or back for each pass of the weft so that the strings are interlocked. This is the fundamental construction technique for all woven fabric, and left as is, it creates a flat-woven rug.

For a pile carpet, another step is added. In between weft threads, small pieces of yarn are individually knotted around the warp threads and then secured in place by the next weft string (**Fig. 33.12**). The ends of the knots form the pile that makes the rug plush. By choosing different colors of yarn for the various knots, the maker creates patterns. These designs can be simple or complex, made from memory or by following a carefully planned drawing. In general, carpet designs tend to consist of two main parts: the field (or center) and the border(s). How detailed the pattern is depends on the fineness of the yarn and the number of knots per square inch. Much like pixels in a digital photograph, the more knots per area, the more detailed the resulting image. When finished, the carpet is cut off the loom, the pile is trimmed, and the ends of the warp strings are tied to form a fringe at the top and bottom edges.

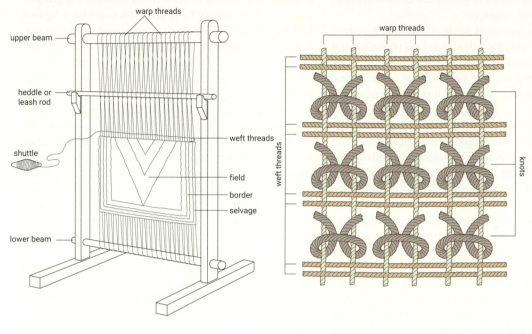

33.11 Parts of a loom and carpet.

33.12 Detail of warp, weft, and knots.

alone, which explains why architectural construction and rug production continued throughout the thirteenth century in such places as Konya. But other areas, such as Herat, were decimated. In some cases, the Mongols murdered entire urban populations, burned libraries, sacked treasuries, and kidnapped artists to take back to Mongolia. Some cities, such as the once-prosperous Merv (in present-day Turkmenistan) never recovered. In other places, ceramic production ceased for forty years as inhabitants struggled to recover from the attacks.

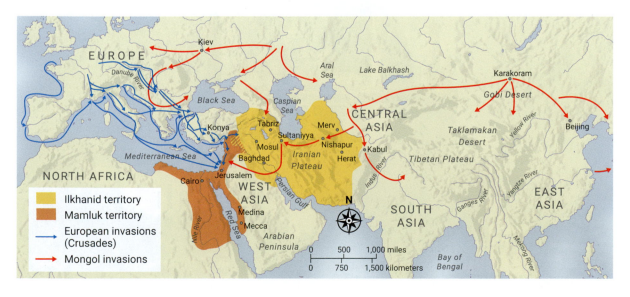

Map 33.2 Map of the Ilkhanid and Mamluk territories, c. 1250–1350, indicating the routes of the European invasions (Crusades) between the eleventh and thirteenth centuries and the Mongol invasions of the thirteenth century.

stucco fine plaster that can be easily carved; used to cover walls or decorate a surface.

cenotaph a marker or memorial to someone buried elsewhere.

Under the leadership of Chinggis Khan (also spelled Genghis; c. 1162–1227) and his descendants, the Mongols created one of the largest empires in world history, stretching across Asia into Europe (see Seeing Connections: Pax Mongolica, p. 528). Prior to his death, Chinggis Khan divided the empire into four parts to be governed by his descendants. Hulagu (1218–1265) had the task of consolidating his grandfather's conquests in West Asia, and by 1256 he set up the Ilkhanid dynasty (1256–1353) centered in what is now northwest Iran (see **Map 33.2**). Two years later, Hulagu's army sacked Baghdad and killed the caliph, ending the Abbasid caliphate.

Although they governed for less than one hundred years, the Ilkhanids profoundly affected the region's visual culture. While the first few decades of Ilkhanid rule saw economic hardship and the cessation of most artistic production, this situation changed around 1295 when the leader Ghazan (ruled 1295–1304) converted to Islam, hired Persian advisors, instituted economic reforms, and supported art and culture as a way of gaining legitimacy and consolidating power. His successors continued all of these practices. Of particular importance was their patronage of monumental architecture and illustrated manuscripts.

TOMB OF ULJAYTU One of the preeminent surviving works of Ilkhanid architecture is the Tomb of Uljaytu, built 1305–14 in Sultaniyya (in present-day Iran). In 1305, Uljaytu (ruled 1304–16), Ghazan's brother and successor, founded Sultaniyya, meaning "the Imperial," as a summer capital (the Ilkhanids used Baghdad as their winter capital). Most of the original city is gone; only Uljaytu's massive tomb remains, a brick building 125 feet (38.1 m) in diameter and 164 feet (50 m) high (**Fig. 33.13**). Glazed turquoise tiles originally adorned its pointed dome, which was framed by eight slender minarets, adding to its impressive profile. (The dome's tiling has been restored, but only the lower portions of the minarets remain.) The tomb's size and octagonal layout influenced later royal Muslim tomb construction from India to Turkey.

Curiously, at some point between the tomb's completion in 1314 and Uljaytu's death two years later, it was renovated. A rectangular room was added on the building's south side, and the interior was redecorated to feature richly colored tiles, painted and gilded **stucco**, inscriptions from the Qur'an, and *hadiths* (sayings attributed to the Prophet Muhammad) pertaining to pilgrimage. Why did Uljaytu have his brand-new tomb revamped? Similarly to his brother Ghazan, Uljaytu was a convert to Islam. In fact, he had a complex religious history. Born to a family that practiced the Mongols' indigenous religion of Tengerism, he was baptized Christian and later became a Buddhist. In 1296, he converted to Sunni Islam, the main branch of the faith, but then, around 1310, he switched affiliations to the other major Muslim sect, Shi'ism, and shortly thereafter traveled to several important Shi'i shrines (for more on the distinction between Sunni and Shi'i (Shia) Islam, see Chapter 24). It seems probable that Uljaytu, inspired by those shrines, wanted to make his tomb a place of pilgrimage too. The renovations expanded and embellished the monument to better suit that purpose. The new rectangular room held his **cenotaph**, allowing the main octagonal space to act as a gathering place. Its inscriptions reminded visitors of the importance of pilgrimage, and its gilded decoration provided a rich visual experience. Adding to the spectacle, professional readers recited the Qur'an from a sizable, thirty-volume manuscript set especially made for Uljaytu's tomb.

JAMI' AL-TAWARIKH Manuscript production reached new heights under the Ilkhanids. The creation and copying of particular texts helped to legitimize the dynasty's rule, especially when illustrated with images carefully crafted to emphasize the desired message. Such

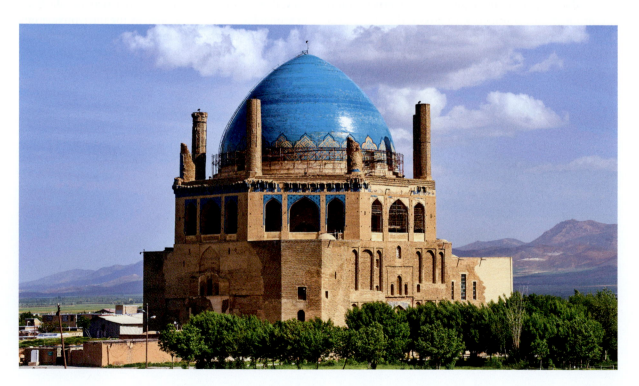

33.13 Tomb of Uljaytu, Sultaniyya, Iran, Ilkhanid dynasty, first built c. 1305–14; renovated 1316.

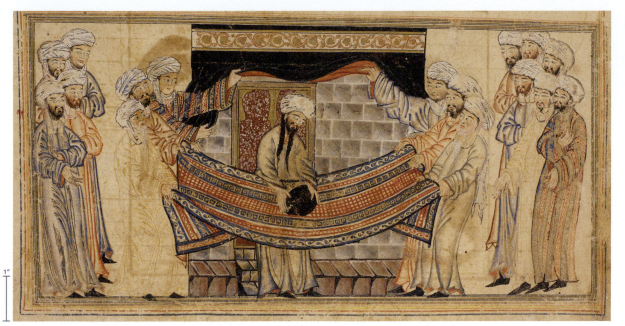

33.14 The Prophet Muhammad solves a Dispute, detail from *Jami' al-Tawarikh*, by Rashid al-Din, Tabriz, Iran, Ilkhanid dynasty, *c.* 1314. Ink and color on paper. Full page: 16⅜ × 13½ (41.5 × 34.2 cm). Edinburgh University Library.

is the case with the *Jami' al-Tawarikh* (*Compendium of Chronicles*) by the author Rashid al-Din (1247–1318), a Persian Jewish doctor who converted to Islam and became a high-ranking advisor to both Ghazan and Uljaytu.

Ghazan asked Rashid al-Din to write a history of the Mongols. Uljaytu then requested he expand it to include the life of the Prophet Muhammad, the events of the Old Testament (an important text within Islam, in that Christianity, Judaism, and Islam are related faiths, and the Old Testament was also viewed as an important source of history during this period), and the histories of the various people living under Mongol rule, from China to Europe. Rashid al-Din and his employees gathered all known histories and had them translated and assembled. The resulting text of the *Jami' al-Tawarikh*, completed by 1310, was four volumes long, probably about 1,200 pages in total, and had roughly 540 illustrations.

Rashid al-Din had established and funded a large charitable institution in Tabriz (in present-day Iran) employing more than three hundred people, and one of its functions was to produce manuscripts. The foundation's legal deed lays out Rashid al-Din's plans for the *Jami' al-Tawarikh*. He specified that two copies of it be made each year, one in Arabic and one in Persian, in perpetuity, to be sent to different parts of the empire. Essentially, he was arranging a very substantial publication project designed to glorify the Mongols and connect them to these wider histories.

In 1318, political enemies executed Rashid al-Din, and we do not know how many copies of the manuscript were actually completed. The earliest fragmentary example is in Arabic and dates to 1314. There are two important things to note about its illustrations. First, while the images are diverse, overall they display an unmistakable influence from Chinese painting: light washes of color, strong black outlines and, in some cases, depictions of plants, such as bamboo, not found in West Asia where the manuscript was made. The pictures, which cover only a portion of each page, adopt the horizontal format of Chinese **handscrolls**. The Ilkhanids had close connections with the Yuan dynasty (1279–1368, see Chapter 31), and the resulting free flow of artistic ideas profoundly affected Persian painting. Second, the scenes chosen for illustration were those to which the Ilkhanids wanted to connect themselves. For example, scenes of the conquests by Persian and Turkic rulers of previous centuries were heavily featured. In those images, the figures (who were not in fact Mongol) hold Mongol weapons, wear Mongol armor, and ride Mongol ponies in a sort of Mongolizing of the past. Similarly, scenes from the Old Testament and life of the Prophet Muhammad were illustrated to underscore the Ilkhanids' allegiance to monotheism, the worship of a single god.

The painting reproduced in **Fig. 33.14** depicts the Prophet Muhammad solving a dispute at the Ka'ba, the most revered site in Mecca (Fig. 24.1). While the structure was being renovated after fire damage, an argument erupted over which tribal elder should have the honor of replacing the shrine's sacred black stone. Muhammad suggested placing the stone on a cloak so that each man could carry a corner and so share in the task. He was then given the distinction of taking the stone from the cloak and placing it in the wall next to the door, where it still resides.

The *Jami' al-Tawarikh*'s illustrations are some of the earliest known depictions of Muhammad. While today people often assume that Islam bans images of the Prophet, the Qur'an and *hadiths* condemn only the worship of images, not images themselves. In fact, there is a tradition of paintings of Muhammad in Islamic art. Most, including this one, were produced in the greater Iranian region. In later centuries, it became standard for artists to depict Muhammad with a white veil covering his face (out of respect), but this image is typical of his depiction in fourteenth-century painting.

GREAT ILKHANID *SHAHNAMA* Another important Ilkhanid artwork is a manuscript, most probably made in Tabriz in the 1330s, commonly called the Great Ilkhanid

handscroll a format of East Asian painting that is much longer than it is high; typically viewed intimately and in sections, as the viewer unrolls it from right to left.

folio one leaf of a book.

cornice the uppermost strip of molding on a building's entablature.

ablution fountain a water fountain in which Muslims wash ritually before prayer, typically located in the courtyard of a mosque.

33.15 Bahram Gur fights the Karg, folio from the Great Ilkhanid *Shahnama*, Tabriz, Iran, Ilkhanid dynasty, *c.* 1330s. Opaque watercolor, gold, and silver on paper, 16⅜ in. × 11⅞ in. (41.6 × 30.2 cm). Harvard Art Museums, Boston, Massachusetts.

Shahnama (to distinguish it from other illustrated copies of the same text). Originally two volumes long, the manuscript was made for a member of the court in order to link the Ilkhanids to Persian culture. Some scholars believe the patron was Rashid al-Din's son, Ghiyath al-Din, who was chief administrator to the last Ilkhanid ruler, Abu Sa'id (ruled 1316–35). The text, the *Shahnama*, or Book of Kings, is the single most important work of Persian literature. Considered the national epic of Iran, it is still recited at events today and has inspired art since the Seljuq period. Composed in rhyming verse by the Persian poet Firdawsi around 1010, its 50,000 couplets (pairs of rhyming lines) tell the story of the Iranian world from its creation to the defeat of the Sasanians in 651 by the armies of the early Muslim caliphate. The text combines history and legend around the theme of the never-ending struggle between good and evil; this is a central concept of Zoroastrianism, the religion of the Sasanians, and reveals that belief system's lasting

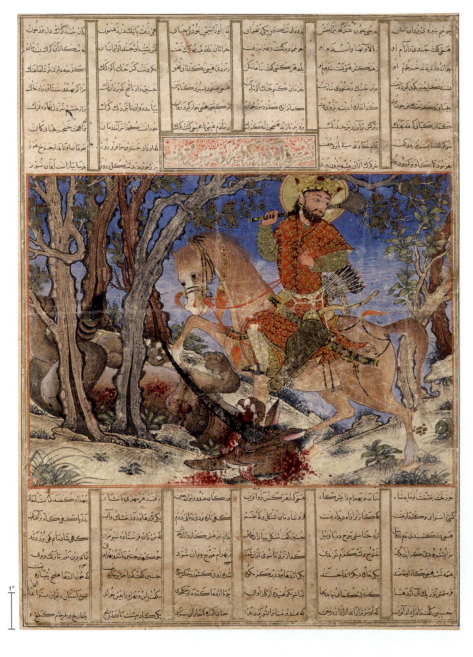

impact on Persian culture. The *Shahnama*'s lengthy text has so many themes and storylines that an illustrated manuscript of the epic can be tailored to fit a patron's situation just by choosing which scenes to paint and how to depict them.

The Great Ilkhanid *Shahnama* is somewhat difficult to study because only fifty-seven of the approximately 190 original illustrations survive, and those **folios** are scattered among various museum collections. Among the surviving paintings there is an emphasis on kingly duty and the fragility of life. The stylistic development of Ilkhanid painting is also evident. The images are taller and take up more of the page than those in the *Jami' al-Tawarikh* and, perhaps as a result, they have more complicated compositions. Figures show emotion, and every detail of the scene is visually articulated. Additionally, the pigments are richer and more heavily applied than in the *Jami' al-Tawarikh*. Chinese influence remains but is not as dominant; artists took inspiration from a range of sources and combined them into something new and dynamic.

The illustration reproduced here depicts the Sasanian prince, Bahram Gur—renowned for his hunting skill—having just slain a formidable horned wolf-like monster called the Karg (**Fig. 33.15**). Bahram Gur sits triumphantly on his horse while the dying beast writhes in the foreground. The Karg's back legs and tail are wedged between trees inspired by those found in Chinese landscape painting, and Bahram Gur is bedecked in a robe of European fabric. These details reflect the cosmopolitanism of the Ilkhanid court and the city of Tabriz, which by the early fourteenth century had become an important commercial center linking Europe and East Asia. And so we can see how, over the course of a single century, the Ilkhanids destroyed, disrupted, and then re-energized artistic production, leaving an enduring legacy on the greater Iranian artistic landscape.

Art under the Mamluks, *c.* 1250–1400

The one group able to halt the Mongols' expansion in West Asia was the Mamluk dynasty, whose armies defeated and pushed back Hulagu's advancing forces in 1260. In societies controlled by Muslim rulers, *mamluks* were enslaved soldiers: men taken as boys from non-Muslim families, converted to Islam, and trained to be members of elite troops. They were expected to serve the ruler with unquestioning loyalty, and they often became wealthy and powerful as a result (note that enslavement in this context is distinct from trans-Atlantic enslavement, in that *mamluks* and other enslaved people could own property and, occasionally, gain power). If successful, *mamluks* had the ability to rise through the ranks to become regional governors and, in rare cases, sultans. The Mamluk dynasty was formed by *mamluks* of Central Asian origin who came to prominence during the Ayyubid dynasty (1171–1260) due to their ability to defeat European invaders, called the Crusaders. (The Crusades were a series of military expeditions carried out by western European Christians between 1095 and 1291 to retake what they considered to be the Holy Land in the eastern Mediterranean.) Two successive Mamluk

dynasties ruled the areas of present-day Egypt and Syria from their capital in Cairo from 1250 to 1517.

Victorious over both the Mongols and Crusaders, the Mamluks held high status as the defenders of Sunni Islam. At the same time, erudite Arabs looked down on them for their Turkic tribal origins. The Mamluks also did not follow hereditary royal succession. Rather, the next ruler was elected from among the current sultan's *mamluks*. This system, while designed to be merit-based, resulted in damaging rivalries and legitimacy questions. In response to these challenges, Mamluk rulers took to architectural patronage, sponsoring substantial charitable and educational institutions that demonstrated their sophistication, piety, and right to rule. Additionally, the tax-exempt financial endowment used to support such institutions provided a way to ensure income for the ruler's descendants by appointing them as foundation overseers with a healthy salary. As such, under the Mamluks, Cairo saw a building boom.

COMPLEX OF SULTAN HASAN The biggest, most expensive, and most ambitious of these institutions was the Complex of Sultan Hasan, built 1356–63 (**Fig. 33.16**). Sultan Hasan (ruled 1347–50 and 1354–61) came to power when he was only twelve years old and was dead by the time he was twenty-seven. He is remembered today chiefly for this monument. To have it built, he tore down a palace built just thirty years earlier by his father on a prominent spot near Cairo's citadel (the city's main fortress). The new complex contained Sultan Hasan's tomb, a four-*iwan* congregational mosque with four madrasas, a primary school for orphans, a kitchen, a hospital, a dispensary for drinking water, baths, and a covered bazaar with shops. The charitable foundation supported 506 students, 200 schoolboys, and 340 staff members. The building scale was also huge: the main portal, 124 feet (37.8 m) high, was originally to be flanked by two tall minarets; it was to have four in total (**Fig. 33.17**). Sadly, in 1361, one of the minarets collapsed during construction, killing many of the children in the adjacent school. The people of Cairo saw this collapse as a bad omen, and perhaps it was: Sultan Hasan was assassinated soon after, and his body was never recovered. Instead, his two sons were later buried in the tomb.

Sultan Hasan's complex epitomizes Mamluk style in its layout, which responds to the wider cityscape and combines such local materials as limestone and marble with aspects of Persian and Ilkhanid architecture. Similarly to several of the buildings discussed in this chapter, it also employs light to enhance the viewer's experience. As its plan shows, the main portal projects at an angle from the rest of the structure, increasing its visual prominence. As a visitor approaches, the portal appears as if it is an enormous *mihrab* topped by a *muqarnas* shell. More *muqarnas* form a **cornice** along the top of the facade; the honeycomb design creates a pattern of light and shadow that changes throughout the day.

Once inside, a bent passage leads to the central courtyard, paved in marble with a large **ablution fountain** at its center. Strong sunlight bounces off the marble, contrasting with the shaded *iwans* and dark passageway.

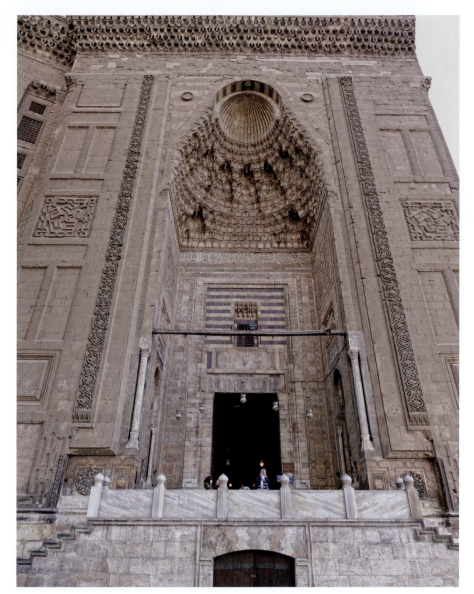

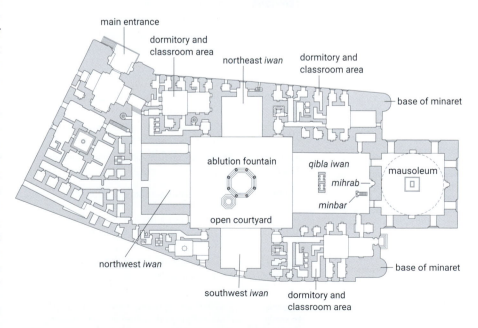

33.16 TOP **Portal, Complex of Sultan Hasan,** 1356–62, Mamluk dynasty, Cairo.

33.17 ABOVE **Plan of the Complex of Sultan Hasan,** 1356–62, Mamluk dynasty, Cairo.

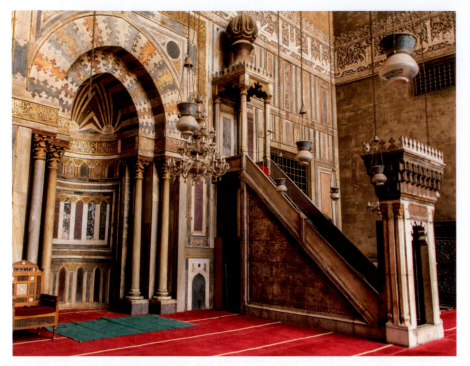

33.18 Interior of *qibla iwan* showing prayer chamber, **Complex of Sultan Hasan,** Cairo, Egypt, Mamluk dynasty, 1356–62.

The four-*iwan* plan references Persian architecture. The *qibla* wall makes use of **architectural polychromy** to dazzling effect (**Fig. 33.18**). Thin slices of multicolored marble form patterns, including a sunray motif around the arch of the *mihrab*, with gold bands of calligraphy further framing it. The stone **minbar** next to it has a bronze door with a geometric sunburst design. A substantial plaster band runs above the marble on the wall; it features Qur'anic calligraphy and lotus-blossom decoration, the latter showing the influence of Chinese art via the Ilkhanids.

LAMP FROM COMPLEX OF SULTAN HASAN The splendor of Sultan Hasan's complex was enhanced by its furnishings: custom-made carpets, luxury Qur'ans, wooden stands, and glass lamps. Fifty lamps survive in various museum collections; many more, hanging in rows from the ceiling, originally lit the space. Mamluk glassmakers were highly skilled artists, creating refined shapes decorated with multicolored **enameling** and **gilding**. This example, featuring a wide neck, a round body with six handles, and a foot, is typical of fourteenth-century Mamluk lamps (**Fig. 33.19**). The red-and-blue enameling with gilded detail forms bands of geometric and calligraphic decoration. The wide band around the neck features three **roundels** proclaiming the name of Sultan Hasan, as well as boldly written inscriptions bearing a verse from the Qur'anic chapter, *Surat al-Nur* (The Light), as was common on lamps of the period. This verse translates as follows:

God is the Light of the heavens and the earth; the likeness of His light is as a niche wherein is a lamp (the lamp in a glass, the glass as it were a glittering star) kindled from a Blessed Tree, an olive that is neither of the East nor of the West whose oil wellnigh would shine, even if no fire touched it; Light upon Light; (God guides to His light whom He will.) (And God strikes similitudes for men, and God has knowledge of everything.)

architectural polychromy using different-colored materials to create decorative patterns in architecture.

minbar a stepped pulpit from which the sermon at Friday noon prayer is given in a mosque; usually placed directly next to the *mihrab* on the *qibla* wall.

enamel an opaque ornamental coating made of powdered glass.

gilded covered or foiled in gold.

roundel a small disk, especially a decorative medallion.

Chronology

750–1258	The Abbasid Caliphate rules various parts of North Africa, West Asia, and Central Asia from its capital, Baghdad	1219	Mongol invasions into Central Asia and West Asia begin
819–1005	The Samanid dynasty rules Khurasan and oversees a rejuvenation of Persian culture	1250–1517	The Mamluks rule parts of North Africa and West Asia from their capital, Cairo
c. 920	The tomb of Isma'il Samani is constructed	1251–53	The Karatay Madrasa is built in Konya
c. 1040–1194	The Great Seljuqs rule Khurasan, Iraq, Anatolia, and parts of Arabia	1256–1353	The Ilkhanids rule the greater Iranian region and parts of present-day Iraq
1071	The Seljuqs defeat the Byzantines at the Battle of Manzikert	1258	The Ilkhanid Mongols sack Baghdad and kill the last Abbasid caliph
c. 1077–1307	The Anatolian Seljuqs rule from their capital, Konya		
1080s	Nizam al-Mulk authors the *Book of Governance*	1291	The Mamluks force out the last of the Crusaders
1099	European invaders called Crusaders capture Jerusalem and set up Latin Christian states in Palestine and Syria	1305–14	The tomb of Uljaytu is built in Sultaniyya
twelfth century	The four-*iwan* plan is added to the Great Mosque of Isfahan	1310	Rashid al-Din completes the *Jami' al-Tawarikh* (*Compendium of Chronicles*) and commissions illustrated copies of it
twelfth to early thirteenth century	The flourishing production of illustrated manuscripts in Baghdad and surrounding regions, inlaid metalwork in Mosul and Herat, and *mina'i* ware in Kashan and Nishapur	1330s	The Great Ilkhanid *Shahnama* illustrated manuscript is produced
		1356–63	The Complex of Sultan Hasan is constructed in Cairo

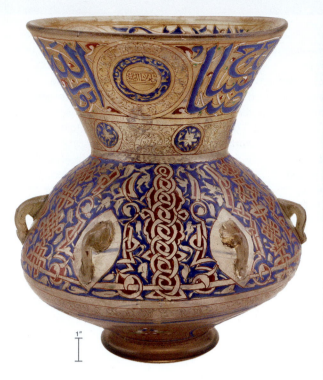

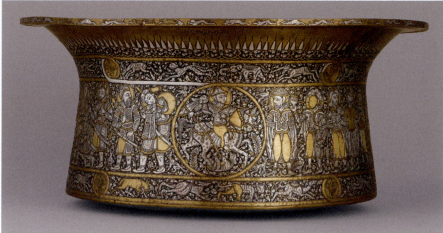

Originally, the glass lamp contained a saucer filled with olive oil and a floating wick, and it glowed when lit, echoing the Qur'anic verse emblazoned on it. In the case of Sultan Hasan's monument, such lamps furthered the light symbolism found throughout the complex.

MUHAMMAD IBN AL-ZAYN, BASIN (BAPTISTÈRE DE SAINT-LOUIS)

The Mamluks were renowned for their metalwork, which they exported, along with their glass, throughout West Asia and into Europe. One reason for the caliber of these items was the arrival of many talented craftspeople who had fled Central Asia, moving westward to escape the Mongols. These metalworkers continued the earlier tradition of inlay but increasingly used gold to add to the luxury of the objects. The most famous example of Mamluk metalwork is the so-called Baptistère de Saint Louis, a basin of hammered brass with gold, silver, and niello (**Fig. 33.20**). Datable to the early fourteenth century, the basin features expressive, detailed figures, and it is almost entirely covered with inlay. It most probably was intended as a luxury basin for hand washing. The exterior decoration includes four roundels depicting men on horseback, separated by processions of Mamluk nobles, in which each nobleman is presented distinctly: in one grouping, a man cocks his head, hand on chin; another holds a goblet; and another walks a leopard on a leash. The inside rim features hunting scenes and two roundels with enthroned rulers holding wine cups. The interior base is inlaid with an interlocking geometric design composed of various sea creatures, with a circle of fish at the center. The artist, Muhammad ibn al-Zayn, was justifiably proud of his achievement: he signed it not just once, but six times.

It is unclear whether the basin was made for a local Mamluk ruler, which might explain the specific **iconography** and liberal use of gold, or for European export. By the fourteenth century, figural programs on metalwork had gone out of style in Egypt and Syria, where bold calligraphic designs were now in vogue. The European market, however, still favored figural imagery. At some point the object did make its way to Europe, where it was prized; the basin eventually came to be used for French royal baptisms, and much later it became part of the Musée du Louvre's collection. Study of this object emphasizes that art history is primarily shaped by the artworks that have survived, and their survival, in turn, is often affected by the movement of both objects and people.

33.19 FAR LEFT **Lamp from Complex of Sultan Hasan,** Cairo, Egypt, Mamluk dynasty, c. 1360. Glass with enamel and gilt, 13¼ in. × 12 in. (33.7 × 30.5 cm). Freer Gallery of Art, Smithsonian Institution, Washington, D.C.

33.20 ABOVE **Muhammad ibn al-Zayn, basin ("Baptistère de Saint-Louis"),** Egypt or Syria, Mamluk dynasty, c. 1320–40. Hammered brass, gold, silver, and niello inlay, height 8⅝ in. (21.9 cm), diameter 19¾ in. (50.2 cm). Musée du Louvre, Paris.

Discussion Questions

1. The Great Mosque of Isfahan is an architectural palimpsest. Why are such monuments both difficult and rewarding to study?

2. Compare two works from this chapter that feature light as a visual element. How, why, and to what effect is light used in each work?

3. Many artworks connect to written texts, whether stories, poems, or histories. By comparing two or three relevant artworks from this chapter, explore the different ways in which this relationship can play out.

4. The history of art and trade are often intertwined. Choose one artwork discussed in this chapter that highlights the symbiotic relationship between art and trade, and explain how it does so.

Further Reading

- Broug, Eric. *Islamic Geometric Design*. London and New York: Thames & Hudson, 2013.
- Canby, Sheila R., et al. *Court and Cosmos: The Great Age of the Seljuqs*. New York: Metropolitan Museum of Art, 2016.
- Denny, Walter B. *How to Read Islamic Carpets*. New York: Metropolitan Museum of Art, 2014.
- Komaroff, Linda, and Stefano Carboni (eds.) *The Legacy of Genghis Khan: Courtly Art and Culture in Western Asia, 1256–1353*. New York: Metropolitan Museum of Art, 2002.

iconography images or symbols used to convey specific meanings in an artwork.

The Art of Writing

Words that are written down last longer than those that are spoken. Yet the human desire to read these words often causes readers to forget that the act of writing is itself a visual practice: it is a process of inscribing conventional marks in an orderly fashion on a smooth surface. By extension, reading involves interpreting what is seen, and knowing how to decipher particular symbols, such as numbers and letters, and comprehending their relationships.

In some cases, ornament draws greater attention to the significance of certain words. Such decorative embellishment often hinders the immediate legibility of words but it fosters a deeper appreciation of the text as a special form of communication. Calligraphy, from the Greek for "beautiful writing," can serve a variety of functions.

Richly ornamented calligraphic script is an important visual feature of the *Lindisfarne Gospels*, a book named after the island near the northeast coast of England where it was probably made. For instance, on the page showing the first chapter of the Book of Matthew, the Latin text—which translates as "The book of the generation of Jesus Christ, son of David, son of Abraham"—is difficult to read due to the extensive use of abbreviations and dense ornament (**Fig. 1**). Words are rendered in extraordinary visual detail, with the aid of a straightedge and compass. The intricate patterning closely resembles that found in contemporaneous jewelry, calling attention to the precious character of the sacred text. The dynamic complexity of the linear design, the use of multiple colors (including pigments imported from the area of present-day Afghanistan), and the labor and expense of making calligraphic imagery all indicate the book's material and spiritual value.

Although the *Gospels* can be read, that was not its primary function. In the same manner as a sacred relic, the book was placed on the altar and carried in religious processions; it was used to evoke the presence of Christ, whom Christians consider to be the Word (of God) made Flesh. Only on special occasions was the book opened to particular pages, revealing its splendid calligraphy. In medieval Europe, calligraphy was often reserved for books of high esteem, such as sacred and devotional writings, to heighten their significance relative to other texts. Similar practices can be found in other places in the world.

Writing combined with the arts of poetry and papermaking in the Heian period in Japan (794–1185) (**Fig. 2**). Using a flexible brush, the unknown calligrapher wrote fluid columns of text beginning at top right and ending at bottom left. In this example, the animated lines are at times dark and thick, then turn pale, dry, or attenuated (reduced in thickness). In places, the brush changed direction rapidly, producing sharp angles and tight circles; in others, it traced wider, smooth arcs. The calligrapher's visual rhythms interact with the papermaker's art: Against a background of peacocks and flowers printed with a subtly sparkling ground-mica ink, small birds are depicted, flying amid leaves and wind-tossed silver branches.

The text, composed by Lady Ise (died *c.* 939), suggests a romantic exchange:

The man came and stood at her gate; hearing a cuckoo singing in a flowering orange tree, he composed the following verse and sent it to the lady:

Standing at your gate
Forlorn am I as the mournful
Cuckoo that sings
My sadness from his perch among
The branches of your blossoming
orange tree.

1 **Page from the *Lindisfarne Gospels*,** fol. 27r, Northumberland, England, *c.* 715–20. Ink and tempera on vellum, 13⅜ in. × 9½ in. (34 × 24.1 cm). British Library, London.

2 Page from the "Lady Ise Collection" (*Ise shū*), from the Nishi-Honganji edition of the *Thirty-Six Poetic Immortals (Nishi-Honganji-bon Sanjūrokuninshū)*. Late Heian period *c.* 900–1185. Mounted as a hanging scroll: ink on decorated paper, 8 × 6¼ in. (20.3 × 15.9 cm). Metropolitan Museum of Art, New York.

3 Bowl, Nishapur, Iran, Samanid period, 10th century. Earthenware; white slip with black-slip decoration under transparent glaze, height 7 in. (17.8 cm), diameter 18 in. (45.7 cm). Metropolitan Museum of Art, New York.

To this she replied:

 Hardly can he know
 What errand brings you here
 The cuckoo in my tree
 Is it not his tuneful nature
 Thus to come and sing?

Lady Ise wrote poetry during a pivotal cultural moment, and here the *kana* system of writing (a system of Japanese script), the thirty-one-syllable *waka* poems (a style of classical Japanese poetry), the decorated paper, and the calligraphic style all testify to the transformation of writing into art.

Calligraphy is the most esteemed form of art in Islamic culture. Its status stems not only from the importance of writing in Islam, as articulated in the Qur'an, the holy book of Islam, but also from the adaptability of the Arabic script (Arabic is both the name of a language and a script). Beginning in the seventh century CE, artists across North Africa, West Asia, and Central Asia adorned a variety of media, from architecture to jewelry, with Arabic calligraphy. The chosen passages represent a range of literary genres, from love

poems to proverbs. The ceramic bowl illustrated here, from tenth-century Iran, expresses the adage "planning before work protects you from regret" and wishes "good luck and well-being" to the viewer (**Fig. 3**).

In its original context, the bowl would have signaled its owner's wealth, refinement, and hospitality. It also exemplifies the Arabic script's ability to provide bold, simple, and beautiful ornamentation. The brown-black glaze of the letters—written in a visually striking script

called "new style Kufic"—contrasts with the vessel's smooth, white-slip surface. The artist has carefully arranged the writing so that it fits perfectly around the bowl's edge and has played with the letters, elongating some and compressing others, to create a rhythmic, almost abstract, patterning. The letters' elegantly rendered vertical shafts draw the viewer's eye to the bowl's center, where a single dot, functioning as both a displaced diacritical mark and focal point, resides.

Discussion Questions

1. Is it necessary to be able to read the language in order to appreciate a work of calligraphy? Choose an example in a language you can read to discuss how your interpretation of the work changes when you understand the words. Compare this experience to viewing an example in a language you do not understand.

2. Though each of the above examples looks very different, they are all forms of calligraphy. Explain what calligraphy is and discuss how each of these different styles qualifies as a type of calligraphy.

Further Reading

- Ekhtiar, Maryam D. *How to Read Islamic Calligraphy* (Metropolitan Museum of Art—How to Read series). New York: The Metropolitan Museum of Art, 2018.
- McKendrick, Scot, and Doyle, Kathleen. *The Art of the Bible: Illuminated Manuscripts from the Medieval World*. London: Thames and Hudson, 2016.
- Boudonnat, Louise, and Harumi, Kushizaki. *Traces of the Brush: The Art of Japanese Calligraphy*. San Francisco, CA: Chronicle Books, 2003.

34

Art of the Mediterranean World

500–1500

Mantle of Roger II (detail),
Sicily.

Introduction

The early fifth century CE brought great movement across Eurasia. Germanic and Norse tribes left their homelands and migrated south into former Roman territories surrounding the Mediterranean. The Vandals, an East Germanic tribe, moved to the Iberian Peninsula, an area in southwest Europe that consists primarily of Spain and Portugal. Within a few decades of their arrival, the Vandals were pushed out of Iberia by invading Visigoths, another Germanic tribe. The Visigoths, who were Christian, governed most of the Iberian Peninsula for the next three centuries (418–711). Their rule came to an end in 755 CE, when Arab and North African forces under Abd al-Rahman I, a prince from the Umayyad dynasty (see Chapter 24), conquered Iberia without major violence (see Map 24.1). For the next seven hundred years until 1492, various dynasties, some Muslim and some Christian, fought over control of the peninsula.

The island of Sicily was also a major site of contention. The Aghlabids, a regional Muslim power based in North Africa, took the territory from the Eastern Roman Empire in 827. In 1091, Normans (descendants of Norse settlers in Normandy, France) took control of the island and reinstituted Christianity as the state religion. During the Norman reign, local Christians and Muslims coexisted in relative harmony. However, this tranquility was interrupted by the Crusades, a series of military excursions in which armies from western Europe sought to restore Christian rule over Jerusalem. Arabic histories refer to the conflicts as the "Frankish invasions" and as evidence of western European aggression, rather than as a religious war. Some of these crusaders stopped in Sicily on their way to Jerusalem, where animosity between the invaders and the locals, especially the Muslim community, produced a new set of tensions. Ultimately, Muslims who refused to convert to Christianity were expelled from the island in 1245.

Although European history often frames the conflicts of this period in terms of religion, the reality was more complex. Similarly, even though Christianity played a significant role in the development of European art during the Middle Ages, the importance of Islam and Judaism should not be overlooked. These three monotheistic religions are defined by the interpretation of sacred texts. They are sometimes known as Abrahamic faith-traditions, since in all three religions, followers believe in a God who revealed himself to the prophet Abraham. Christian, Muslim, and Jewish artisans did not produce objects solely for donors or patrons from their own religious communities. On the contrary, they worked on secular and religious projects commissioned by adherents to one of the other two religions. Whether patrons knew or cared about the religious beliefs of the artists that they employed remains an open question. Nonetheless, religious artworks occasionally employed imagery from competing Abrahamic traditions, and style frequently bridged religious and dynastic boundaries, making this period of art history rich in cross-cultural contact and exchange.

Early Medieval Iberia, 500–1000

The Roman provinces of Hispania (the Roman name for Iberia and the birthplace of emperors Trajan and Hadrian) were settled by retired soldiers and merchants. These included Jews who fled Palestine after the armies of the Babylonian king Nebuchadnezzar II destroyed the Jewish Temple in Jerusalem (also known as the Temple of Solomon) in 586 BCE. After the destruction of the Temple, a site closely tied to Yahweh's presence on earth, many Jews left their homeland and scattered across the Mediterranean world. Some of them moved to Iberia, where they continued to reside during the Roman Empire and throughout the Middle Ages.

After the collapse of the Roman Empire, Visigoths took control of the area of the Iberian Peninsula on the western shore of the Mediterranean. These invaders frequently blended the artistic ideals and practices of ancient Rome with their own artistic traditions. Led by Alaric I (370–410), the Visigoths sacked Rome in 410. To discourage further attack, western Roman Emperor Honorius (384–423) offered the Visigoths lands in southern Gaul in exchange for military alliance. The Visigoths accepted this arrangement, becoming a powerful kingdom in southern Gaul, centered at Toulouse, and expanding into the Iberian Peninsula. In 507, Clovis (c. 466–511), the king of the Franks, drove the Visigoths out of Toulouse and into Iberia, where they quickly conquered much of the peninsula.

In 589, the Visigoths embraced mainstream Christianity as articulated by the Church in Rome, a religious move that fostered closer unity with those of Roman heritage. Decades later, the Visigothic king Recceswinth (ruled 649–72), patterning himself after the Byzantine emperor, commissioned a votive crown (a gift in the shape of a regal headdress) to be suspended over the altar of a church in Toledo, marking his recognition of the lordship of Christ (see: Seeing Connections: Art and Ritual, Fig. 4, p. 463.)

EAGLE-SHAPED FIBULAE The Visigoths were skilled jewelers who often encased precious stones and **enamels** in metal **cloisonné** settings. Like their Roman counterparts, Visigothic soldiers often wore **fibulae** or brooches as a means of fastening their cloaks at the shoulder. A pair of these—fashioned in the shape of eagles—was discovered in a sixth-century CE tomb near Badajoz in southeastern Spain (**Fig. 34.1**). The fibulae are made of precious materials: gold over bronze inlaid with amethyst, crystals, garnets, and colored glass. The metal loops on the bottom suggest that pendants may have once dangled from them. The birds have open wings, indicating flight. The sun disk in the center of each eagle likely suggests an alliance with Rome, as the Romans had used the ancient symbol of the sun flying through the sky as a symbol of imperial power. The prominence of the solar disk may also be connected to St. John's description of Christ as the light of the world; St. John's symbol was an eagle. If this interpretation is accurate, then the fibulae may have also served as markers indicating the wearer's faith.

IMAZIGHEN AND THE SPANISH UMAYYADS

In 711, Amazigh troops (Imazighen in plural; also known as Berbers) from northern Africa crossed the Strait of Gibraltar and entered Iberia. Within a year, these

enamel an opaque ornamental coating made of powdered glass.

cloisonné a decorative enamelwork technique in which cut gemstones, glass, or colored enamel pastes are separated into compartmented designs by flattened strips of wire.

fibula (plural **fibulae**) a large, decorative brooch for fastening clothing.

34.1 Eagle-shaped fibulae, from tomb near Bandajoz, Spain, sixth century. Gold, bronze, gemstones, colored glass, 5⅜ × 2¾ × 1¼ in. (13.7 × 7 × 3.2 cm) each. The Walters Art Gallery, Baltimore, Maryland.

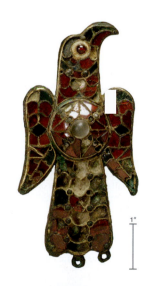

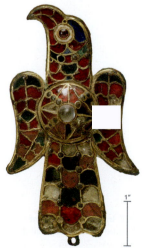

mosque a Muslim place of worship.

qibla the direction Muslims face to pray, toward the Ka'ba in Mecca.

Corinthian an order of classical architecture characterized by slender fluted columns and elaborate capitals decorated with stylized leaves and scrolls.

spolia building materials or reliefs salvaged from other works and reused in a different structure.

arcade a covered walkway made of a series of arches supported by piers.

horseshoe arch a keyhole-shaped arch, the opening of which widens before rounding off.

arch a curved, symmetrical structure supported on either side by a post, pier, column, or wall; usually supports a wall, bridge, or roof.

bay a space between columns, or a niche in a wall, that is created by defined structures.

maqsura the space in a mosque reserved for the caliph and his entourage.

mihrab a prayer niche, usually concave in shape with an arched top, located in the qibla wall of a mosque and indicating the direction of Mecca.

mosaic a picture or pattern made from the arrangement of small colored pieces of hard material, such as stone, tile, or glass.

Kufic one of the oldest Arabic scripts, angular in form, often used to copy the Qur'an.

Muslim soldiers had conquered Toledo, the capital of the Kingdom of the Visigoths. They also seized much of Portugal and Spain, which they named al-Andalus. They continued to advance northward through the peninsula and well into Gaul until they were stopped by forces led by the Franks at the Battle of Tours in 732.

In 750, the Abbasid dynasty overthrew the Umayyad dynasty in Syria for rulership of the Islamic caliphate. (A caliphate is an area ruled by a caliph, the political and religious leader of a Muslim community; see Chapter 24). The only surviving member of the Umayyad royal family, Abd al-Rahman I (731–788), fled to Iberia, where the Imazighen accepted him as their ruler. In 756, al-Rahman proclaimed the independent Emirate of Córdoba, which included most of present-day Spain and Portugal, while nominally recognizing the authority of the Abbasid caliphate. As emir, or royal commander-in-chief, al-Rahman led a Muslim coalition of multiple ethnic groups to establish a new Umayyad dynasty. For the next three hundred years, his descendants controlled the peninsula, and Umayyad art had a major impact on artistic developments in the region. Although informed by Roman and Visigothic art and architecture, the Spanish Umayyads introduced a new visual culture to western Europe, one that recalled the Syrian past and contributed to the combination of styles generated in Iberia.

GREAT MOSQUE OF CÓRDOBA When the Umayyads first settled in Córdoba, they purchased San Vicente, a late sixth-century church that had been constructed on the site of a Roman temple. In 785, they demolished the building to make room for the Great Mosque of Córdoba. The **mosque**, which followed a hypostyle plan, was composed of an enclosed courtyard that led to a hall supported by numerous columns. On the north side, an enclosed courtyard with a fountain and orange grove offered a space for teaching and purification. The sweet fragrance of oranges—fruit imported from Syria—would have reminded the Umayyads of their homeland. Mosques typically face Mecca, but Córdoba mosque's **qibla** wall is positioned on the building's south side. This unusual placement echoes the **qibla**'s location in the Great Mosque of Damascus (see Fig. 24.6), the primary Islamic house of prayer in the capital city that the Umayyads lost to the Abbasids.

The builders appropriated **Corinthian** columns and other **spolia** from the destroyed Visigothic church, as well as the local ruins of earlier Roman temples and public buildings, to fill the mosque's interior (**Fig. 34.2**). Because these marble columns are relatively short, the builders placed another set above them, producing a series of two-tiered **arcades** that resemble ancient Roman aqueducts. This addition not only made a higher ceiling possible but also created a greater sense of monumentality. Alternating red bricks and white stones, reminiscent of earlier Umayyad monuments such as the Dome of the Rock in Jerusalem and the Great Mosque of Damascus, decorate the interior, and accentuate the shape of its numerous **horseshoe arches**. These **arches** have openings resembling keyholes, an architectural feature that the Visigoths had previously used in Spain and Portugal.

Like the later Qutb Mosque in India (see Fig. 26.17), Córdoba's mosque was expanded several times. Under Abd al-Rahman's descendants, the size of the mosque was greatly enlarged to accommodate the growing Muslim

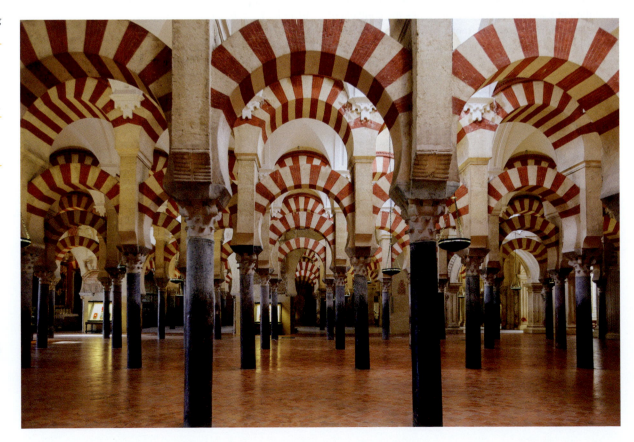

34.2 Interior of the Great Mosque of Córdoba, facing east, Spain, 785–987.

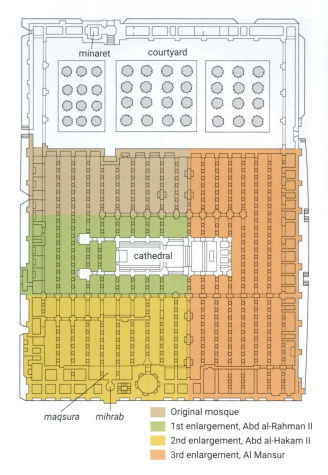

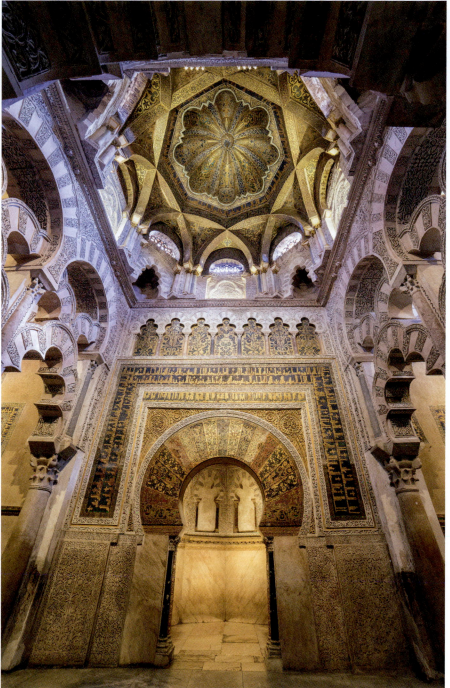

community, and new architectural features were added (**Fig. 34.3**). In 929, Emir Abd al-Rahman III (891–961) declared himself caliph of Córdoba, no longer recognizing the sovereignty of the Abbasid caliph in Baghdad. As a caliph, al-Rahman III not only wielded the power of an emir, he also claimed to be the legitimate successor of the Prophet Muhammad, a title far more prestigious than being solely a princely commander. To reassert the influence of the Umayyad Caliphate, his son al-Hakam II (915–976) expanded the length of the prayer hall in the Great Mosque of Córdoba by twelve **bays**, completing the project in 976. More importantly, he added a *maqsura* and constructed a new *mihrab*.

***MAQSURA*, GREAT MOSQUE OF CÓRDOBA** The *maqsura*, a space designed for use by royalty and the imam (leader of muslim worship), consists of three bays and is framed by highly ornate, multilobed stone arches featuring curved shapes, sometimes interlocking (**Fig 34.4**). The arches are elaborately carved with plant motifs. The *maqsura*'s visual prominence and sophisticated decoration reinforce the ruler's authority and increase the sense of the sacred as one approaches the *mihrab*, the focal point indicating the direction of prayer. Adding to the effect, a melon-shaped ribbed dome, supported on an octagonal base, is located above the *maqsura*'s central bay. It is decorated with **mosaics** arranged in geometric and floral patterns. In imitation of the mosque in Damascus, inscriptions from the Qur'an, rendered in gold **Kufic** script against a blue background, appear on the glazed glass and ceramic tiles in the *maqsura*'s dome and on the area framing the opening of the *mihrab*.

To reinforce political continuity with their ancestors' glorious past, the artists incorporated techniques and design elements associated with early Umayyad rulers in Damascus and Jerusalem. However, this was no easy task. Although they knew that the Great Mosque of Damascus featured mosaics, they had neither the materials nor any artists trained in the specialized technique, which by the tenth century was practiced chiefly in Byzantium. Consequently, the caliph sent an ambassador to the Byzantine emperor in Constantinople to request help. Although the emperor was Christian, he was happy to contribute to the construction of a mosque for the Spanish Umayyads because they shared a common enemy: the Abbasid caliph in Baghdad. The emperor sent the ambassador back to Spain with a

34.3 ABOVE LEFT **Expansion of the Great Mosque of Córdoba, Spain:** 1st enlargement 833-52; 2nd enlargement completed in 976; 3rd enlargement completed in 987.

34.4 ABOVE *Maqsura*, **Great Mosque of Córdoba**, Spain, 976. View (facing south) of the dome and into the *mihrab*.

Image labels (Fig. 34.3):
minaret • courtyard • cathedral • maqsura • mihrab
Original mosque
1st enlargement, Abd al-Rahman II
2nd enlargement, Abd al-Hakam II
3rd enlargement, Al Mansur

mosaic master artist and a gift of approximately 35,000 pounds of mosaic **tesserae.**

Most *mihrabs* are constructed as a niche in the *qibla* wall, but this is not the case in the Córdoba mosque. Although no one enters this sacred space, the *mihrab* at Córdoba is deeply recessed and has an octagonal rather than semi-circular plan. Nonetheless, Córdoba's *mihrab* serves its traditional function as a focal point of prayer, and the light that emanates within the space is reinforced by the sunray-like bands of mosaic decoration framing the *mihrab*'s horseshoe arch. Two doorways flank the *mihrab*. One leads to the mosque's treasury, which houses sacred relics, and the other opens onto a corridor to the royal palace, offering the caliph a safe passageway.

When Christians reconquered Córdoba in 1236, they converted the mosque into the city's cathedral. During the sixteenth century, the mosque's interior was radically remodeled. A church, complete with a **nave** and an **apse** facing east, was built within the center of the former mosque's expansive hall, disrupting the continuity of the structure's multiple arcades. Charles V, the Spanish king and Holy Roman emperor, lamented the building's alteration and admonished the locals for destroying something unique and replacing it with something commonplace. Nonetheless, the vast majority of mosques in Iberia were destroyed and replaced with churches. If any part of such mosques remains, it is typically the **minaret,** which could readily be converted to a Christian bell tower. By contrast, much of the mosque at Córdoba remains intact. Christian kings may have been overwhelmed by the beauty and monumentality of the building and consequently protected it. However, they may have preserved much of the mosque in an effort to draw visual attention to their conquest over the Umayyads.

PYXIS OF AL-MUGHIRA Royal workshops in Córdoba produced magnificent luxury goods for the Umayyad court, housed at Madinat al-Zahra, the nearby palace-city (a fortress including royal residence). One exemplary item is the ivory *pyxis* of al-Mughira (**Fig. 34.5**). Its entire surface was made from a cross-section of an elephant tusk. Ivory is an expensive and durable material, but it is easy to carve. Figurative scenes cover the canister's ornate surface. Based on an Arabic inscription surrounding the lid, we know that the object was given to an eighteen-year-old prince, perhaps to celebrate his coming of age. The inscription reads, "Blessings from God, goodwill, happiness, and prosperity to al-Mughira, son of the Commander of the Faithful, may God's mercy be upon him, made in the year 357 [968 CE]."

Four octagonal medallions, defined by eight curved lobes, decorate the container. In one of these, a musician stands on a platform supported by lions. To the musician's left is a seated fan bearer (associated with religious and courtly rituals), and to the right is a seated man holding a braided scepter and flask (items associated with dynastic power). The medallion is flanked by falcons and a falconer, references to the courtly pastime of hunting. This bird of prey may allude to Abd al-Rahman I,

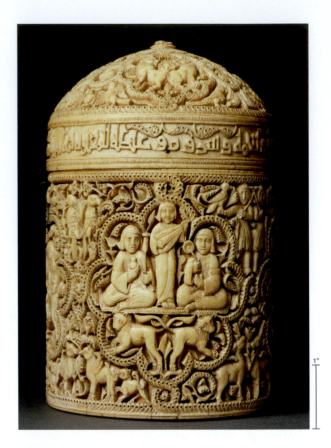

the founder of the Spanish Umayyad dynasty, whose nickname was "the Falcon."

Although this *pyxis* is a luxury object covered with images of courtly leisure, its political connotations should not be overlooked. It reinforces the authority of the Umayyads and al-Mughira's place within the dynasty. Later, Christians regularly used these precious ivory containers, covered with Islamic inscriptions and motifs, to house Christian relics.

MUSLIM, CHRISTIAN, AND JEWISH RELATIONS

Within the Muslim Córdoba caliphate, Christians and Jews were tolerated as members of Abrahamic religions, as they were in other Islamic regions. Under the Umayyads, the Sephardic (Spanish) Jews were less vulnerable to anti-Semitic attacks, as they had been under the Visigoths and Romans. Though Christians and Jews were prohibited from public displays of devotion or attempting to convert Muslims, those who remained in al-Andalus quickly adopted Arabic language and culture. The **appropriation** of Umayyad visual imagery can readily be seen in Christian and Jewish art and architecture produced in Iberia.

However, not all Christians were happy living under Umayyad rule. Some of them migrated to Asturias and Léon, kingdoms in northern Spain, from which they frequently attacked Umayyad forces, but with limited success. Although the Reconquista (a series of attempts by Christian states to reclaim territory in Iberia) started in these northern kingdoms, Christians did not always represent a unified force against Muslims. Sometimes Muslims fought alongside Christians against other Christians, and

at other times Christians fought with Muslims against other Muslims. Some Christian Benedictine monks who fled the Córdoba caliphate called for resistance against the Umayyads and actively supported the Reconquista, but they nevertheless often incorporated Islamic artistic conventions in their imagery. (For more background on Islamic art, see box: Art Historical Thinking: Defining Islamic Art, p. 413.)

EMETERIUS AND ENDE, *GIRONA BEATUS* In the eighth century, the Spanish monk Beatus of Liébana (*c.* 730–800) wrote a celebrated commentary on the Apocalypse (the Book of Revelation), the final book of the Bible. In the tenth century, numerous **illuminated** copies of this **manuscript** were produced in monastic *scriptoria* across northern Iberia. At the San Salvador Monastery of Tábara in the Christian kingdom of Léon, the artist-monk Emeterius collaborated with the artist-nun Ende to produce the *Girona Beatus*, so-named for its present location. Their painting represents the opening of the first four seals at the world's end and the arrival of the Four Horsemen of the Apocalypse (**Fig. 34.6**): Conquest (with a stretched bow), Pestilence (with a raised sword), Famine (with a set of scales), and Death (mounted on a pale horse and followed by a demon, suggesting the presence of Hell).

Although the illuminations are part of a Christian manuscript, they often include Visigothic designs and Umayyad motifs. Like the Visigothic eagle-shaped fibulae (see **Fig. 34.1**), the Four Horsemen (depicted against pink and blue color fields) appear flat, with no indications of modeling. The riders' garments and their bridles resemble items worn in Muslim Iberia. In the remaining two **registers**, which have yellow and orange color fields, the

author of Apocalypse, St. John, is pulled by four different chariots whose wheels are either star-patterned or spiraled disks. At the helm of each wheel is one of the beasts of the apocalypse, including a man. Atop the full-page illumination, the *Agnus Dei* (Lamb of God) appears, holding the cross in triumph against a blood-red sun.

BATLLÓ CRUCIFIX Cross-cultural appropriations did not threaten religious orthodoxy in the Christian kingdoms of medieval Spain. The Batlló Crucifix (**Fig. 34.7**) is named after Enric Batlló, who donated the object to the Barcelona museum. The cross was probably suspended above a church altar, the figure of Christ appears to be living. His eyes are open and he seems free of pain. A Latin inscription on the cross describes Christ of Nazareth as the King of the Jews. Nonetheless, Christ's bowed head and downcast eyes reveal his humility and his solemn recognition that death is imminent.

The majestic Christ (*majestat*), a popular sculptural type, does not wear the typical white loincloth. Instead, he is dressed in a costly long-sleeved silk tunic, colored red with blue floral designs. This garment is painted with

illumination decorative designs, handwritten on a page or document.

manuscript a handwritten book or document.

scriptoria rooms used for writing, often in a monastery or library, where manuscripts are hand-copied by scribes.

register a horizontal section of a work, usually a clearly defined band or line.

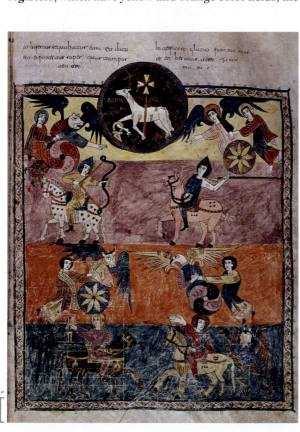

34.6 LEFT **Emeterius and Ende, Four Horsemen of the Apocalypse (detail),** fol. 126r from *Girona Beatus*, *c.* 975. Tempera on vellum. 15¾ × 10¼ in. (40 × 26 cm). Museu-Tresor de la Catedral, Girona, Spain.

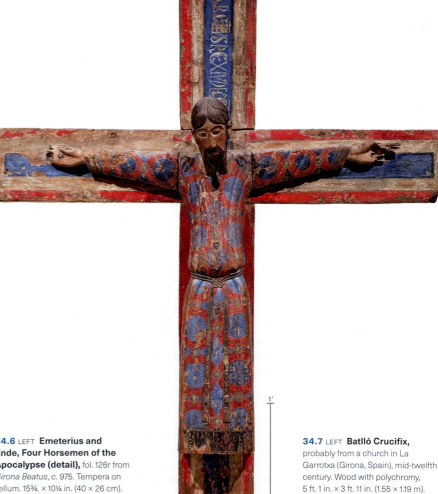

34.7 LEFT **Batlló Crucifix,** probably from a church in La Garrotxa (Girona, Spain), mid-twelfth century. Wood with polychromy, 5 ft. 1 in. × 3 ft. 11 in. (1.55 × 1.19 m). Museu Nacional d'Art de Catalunya, Barcelona, Spain.

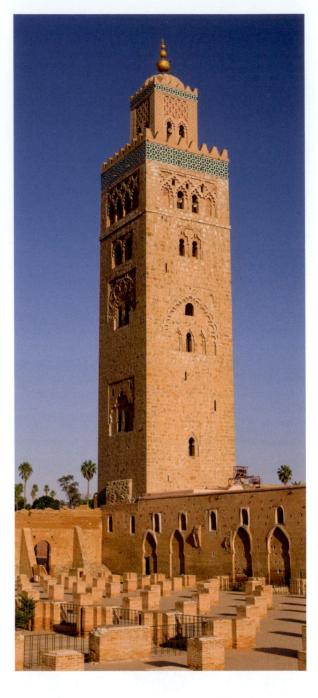

geometric patterns found in Islamic art and includes pseudo-Arabic writing on its hem. Although the tunic's design is Umayyad in origin, its beauty and expense provided an effective way to advocate Christ's lordship.

The Batlló Crucifix was venerated as an extension of the Volto Santo (Holy Face), a crucifix attributed to Nicodemus, who was said to have witnessed the Crucifixion (at which Christ was put to death) and to have helped place Christ into his tomb. During the eighth century, the Volto Santo was allegedly brought to the Tuscan city of Lucca, where it resided for five hundred years, until it was damaged beyond repair by pilgrims who wanted to return home with a piece of the sacred object.

Iberia and North Africa, 1000–1230

In 1009, disgruntled Imazighen mercenaries destroyed the royal palace at Madinat al-Zahra. Civic strife between rivals claiming leadership over the caliphate disrupted political unity, and in 1031 Córdoba became divided into competing *taifas,* or independent Muslim principalities. The competition between *taifa*-kings or party rulers for political power made it easier for Christian kingdoms to reconquer land. Desperate for political stability, *taifa* rulers regularly paid tribute to Christian kings. In 1086, after the *taifa*-king of Seville solicited support from the Almoravids, a Muslim dynasty that ruled Morocco after the disintegration of the Fatimid caliphate, the Almoravids decided to rule southern Iberia themselves. Their harsh policies against Jews and Christians drove many to move north.

The Almoravid caliphate (1040–1147) did not last long. Their Moroccan rivals, the Almohads, captured the Almoravids' North African capital city, Marrakesh, in 1147, and they tried to erase all visual traces of their defeated enemy. In Marrakesh, the Almohads (1147–1269) built a hypostyle mosque on the ruins of the Almoravid royal palace. The Koutoubiya Mosque is far less ornate than the Umayyad mosque in Córdoba, corresponding to the Almohads' religious conservatism and prohibition of wearing expensive or ornate garments. Artistic restraint was not universal, however. For instance, Almohad books were often decorated with exquisite **calligraphy** and elaborate geometrical patterns.

calligraphy the art of expressive, decorative, or carefully descriptive hand lettering or handwriting.

crenellation a fortified wall with notches or openings on top.

gilded covered or foiled in gold.

keystone a central stone, wider at the top than the bottom, placed at the summit of an arch to transfer the weight downward.

arabesque an ornamental design featuring interlacing organic patterns, such as vines and leaves, that derive from Islamic art.

KOUTOUBIYA MOSQUE Though humble in design, the Koutoubiya Mosque in Marrakesh includes a monumental minaret, over 250 feet (76 m) tall, that can be seen from miles away (**Fig. 34.8**). The minaret contained a long, winding internal ramp, enabling riders on horseback to reach its original summit. This commanding square-based minaret—a common format in northern Africa (see Fig. 25.11)—calls the faithful to prayer from all four directions. While the primary function of the edifice is religious, it also effectively demonstrates the Almohads' power.

Constructed of brick and sandstone, the **crenellated** minaret is crowned by a smaller tower and capped with **gilded** copper orbs and an observation deck that reinforces its function as a watchtower. Although the mosque itself is relatively plain, the exterior walls of its minaret are decorated with elaborate diamond-shaped patterns and scalloped **keystone** arches located above

each opening. Ceramic bands adorn the top of the minaret's two main sections. The prayer tower's windows are located at different heights, corresponding to the spiraling ramp inside.

GIRALDA, CATHEDRAL OF SEVILLE When the Almohads defeated the Almoravids, they also took control of the Almoravids' Iberian territory. The Almohads chose the city of Seville as their Andalusian capital and built a substantial mosque there. Its tower, the Giralda, originally served as its minaret (**Fig. 34.9**) and reinforced Seville's place within the Almohad caliphate. It closely resembles the prayer tower found in Marrakesh, employing *sebka*—a refined rhomboid patterning filled with intricate **arabesques** of intertwining foliage—to decorate the minaret's surface. These designs were associated with the beauty and order of God's creation.

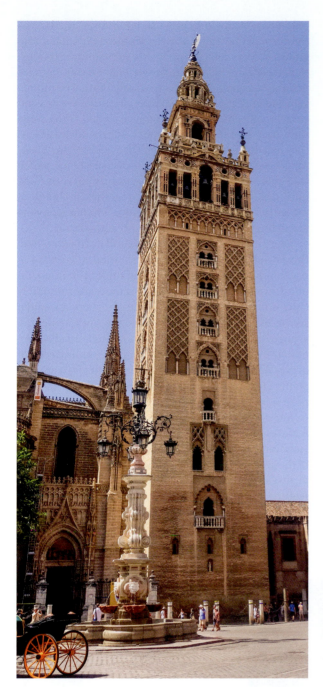

BANNER OF LAS NAVAS DE TOLOSA The Almohads also commissioned expensive textiles. This silk **tapestry**, which may have been part of a military leader's tent, includes gold and silver threads (**Fig. 34.10**). Adorned with geometric and floral motifs, its production was labor intensive. An eight-pointed star at the center dominates its design. The decoration also includes a calligraphic inscription from the Qur'an (61:10–12):

> O you who have believed, shall I guide you to a transaction that will save you from a painful punishment? It is that you believe in God and His Messenger and strive in the cause of God with your wealth and your lives. That is best for you, if you shall know. He will forgive you your sins and admit you to gardens beneath which rivers flow and pleasant dwellings in gardens of perpetual residence. That is the great attainment.

Thus, the tapestry reinforces the idea of God as the refuge from evil and praises him as the provider of paradise. Eight circular pendants hang from the cloth. Unfortunately, the words inscribed on these pendants can no longer be read. Nonetheless, like the eight-sided star, these disks correspond to the gates of heaven and to the number of angels said to carry God's throne on the Day of Final Judgment.

The tapestry was once believed to have been taken from its original owner during the Battle of Las Navas at Tolosa (1212), but more likely it was captured later in one of Fernando III's military campaigns. When Fernando defeated the Almohads, the looted textile acquired an alternative meaning. It was donated to a Cistercian

tapestry a decorative textile in which pictures and/or designs are woven into the fabric.

Like the Marrakesh minaret, the Giralda contains an interior ramp that facilitates the call to prayer. Although constructed in brick and designed in manner similar to the Almohad minaret in Marrakesh, the Giralda also includes marble columns that are spolia from Umayyad buildings, thus connecting the Seville minaret with Andalusia's esteemed past.

After Fernando III of the Christian kingdom of Castile reconquered Seville in 1248, the mosque was converted into a church. In 1401, the structure was destroyed, and construction began on the huge Seville Cathedral. The Christian victors spared the minaret, converting it into a bell tower; this preservation functioned as a symbol of Muslim defeat. The tower's top floor, housing the church's bells, and balconies were added later. Today, the structure is called the Giralda after the weathervane (*giralda* in Spanish) placed atop the former minaret.

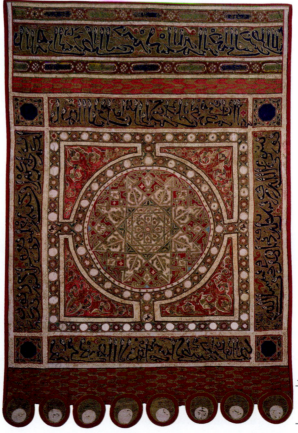

34.10 **Banner of Las Navas de Tolosa**, 1212–50. Silk and thread wrapped in gold and silver, 10 ft. 10 in. × 7 ft. 3 in. (3.3 × 2.21 m). Museo de Telas Medievales, Burgos, Spain.

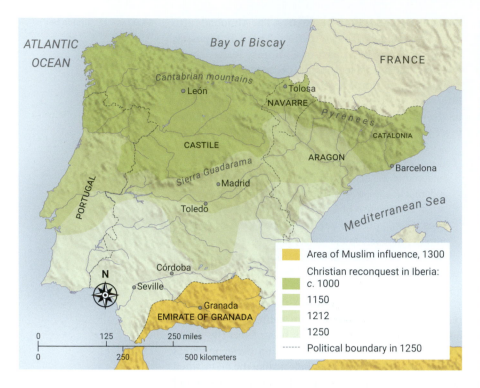

Map 34.1 **The Reconquista of Iberia.**

religions continued to grow. In addition, Christians to the north periodically criticized Arabized Christians, also known as Mozarabs, for not being sufficiently orthodox. Nonetheless, members of different religious communities maintained enough contact to ensure mutual economic gain and political stability, exchanging artistic styles and occasionally employing the same artisans. At the same time, they kept their own distinct cultural identities, as they had done earlier under the Umayyads. Some historians have labeled these moments of coexistence, which were more common under Umayyad rule but continued until 1492, as *convivencia* ("living together"). This term recognizes that these religious groups' interactions were not defined solely by animosity and antagonism.

One example of *convivencia* is found in Toledo, where the Jewish community commissioned a synagogue resembling a mosque while living under the rulership of a Christian monarch. Later named after its likely chief donor, Joseph ben Meir ben Shoshan, a wealthy son of the finance minister to the king of Castile, the synagogue's interior includes horseshoe arcades decorated with intricate patterns that are reminiscent of hypostyle-hall mosques and, more specifically, Almohad architecture (**Fig. 34.11**). The synagogue's arches are supported by octagonal pillars rather than columns, and its interior is painted pristine white. Today, both of these features are associated with Almohad mosque design. However, it is unclear whether the builders and worshipers of the synagogue would have made the same association or just viewed them as stylish and appropriate design features for a place of worship.

Constructed one hundred years after the *taifa* kingdom of Toledo fell to King Alfonso VI of Castile, the Toledo synagogue was probably built by *mudéjars,* Muslims

monastery in Burgos in northern Spain, where it served as a trophy commemorating Fernando's victory in the Reconquista (**Map 34.1**).

IBN SHOSHAN SYNAGOGUE (SANTA MARÍA LA BLANCA)
Beyond the borders of the Almohad caliphate, Muslims and Jews continued to live in Iberian territories controlled by Christian monarchs. Within these kingdoms, tensions between adherents of the three Abrahamic

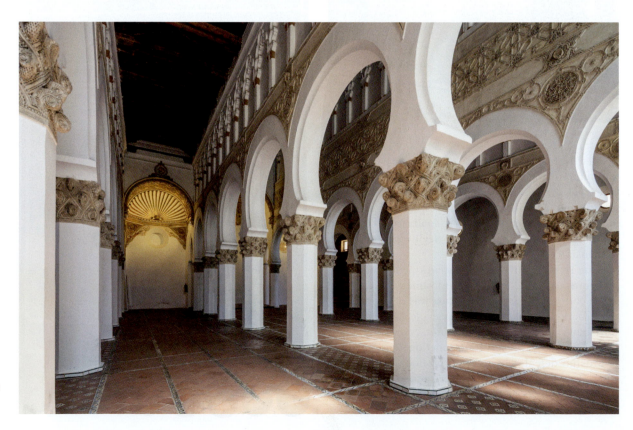

34.11 **Ibn Shoshan Synagogue (Santa María la Blanca),** Toledo, Spain, 1180.

who remained in Christian territories without forfeiting their faith. Unfortunately, *convivencia* did not last. In 1391, a crowd of local Christians, roused by the anti-Semitic preaching of a Dominican priest, massacred most of the city's Jews. Soon after, the Toledo synagogue was converted into the monastic church of Santa María la Blanca, a term signifying that the edifice had been "whitewashed" or purified of its Jewish past.

Norman Sicily, 1090–1230

During the eleventh century, territories in the Mediterranean under the control of the North African Fatimid dynasty fell to a new wave of Christian invaders of Scandinavian descent from northern Europe. Normans—from the region of Normandy in northern France—had aided Byzantine forces in their attempt to regain control of Sicily and southern Italy during the eleventh century. In return, the Normans were granted Apulia and Calabria on the Italian mainland, and they conquered the Fatimid-held island of Sicily in 1091.

Like the Iberian Peninsula, Sicily had a diverse population that included people from a variety of Jewish, Christian, and Islamic traditions. During its period of Fatimid occupation, Sicily flourished as a trade center, with the city of Palermo as its capital. In 1130, nearly forty years after their triumph, the Normans crowned Roger II (1095–1154) as ruler of the Kingdom of Sicily, which included much of the southern Italian peninsula. Although Normans converted some mosques into churches, they were, like their predecessors, tolerant of other religions. Roger II welcomed Muslim and eastern Orthodox scholars and diplomatic advisors into his court, but he also attacked north African and Byzantine forces to extend the reach of his power.

CAPPELLA PALATINA Roger II built his residence on a hilltop above Palermo on a site that may previously have been occupied by the palace of a ninth-century Aghlabid emir. If so, this gesture may have served as a marker of Roger's dominion. Although he followed the Roman liturgy and was of Norse descent, Roger longed for the power and prestige of a Byzantine emperor.

Roger also commissioned the Cappella Palatina, a magnificent chapel in the center of his palace (**Fig. 34.12**). Cappella Palatina combines a **basilica** plan, traditionally found in Western European churches, with the **cross-in-square** design associated with Middle Byzantine houses of worship (see Chapter 28), such as Hosios Loukas (Fig. 28.18). The interior of this palace chapel, which includes three apses—a feature often found in contemporary Byzantine churches—is covered with exquisite mosaics. Both the materials and laborers for this project were imported from Constantinople, as they had been for the decoration of the Great Mosque of Córdoba. In the chapel's single dome, Christ is depicted as **Pantocrator** offering his blessing, a motif repeated in the upper register of the central apse. In both scenes, the gospel is open, proclaiming "I am the light of the world" in both Latin and Greek.

basilica a longitudinal building with multiple aisles and an apse, typically located at the east end.

cross-in-square a square floor plan, popular in Middle and Late Byzantine churches, featuring internal elements in the shape of a cross and a large central dome.

Pantocrator literally "all-ruler", usually associated in Byzantine art with the lordship of Christ as sovereign of the cosmos.

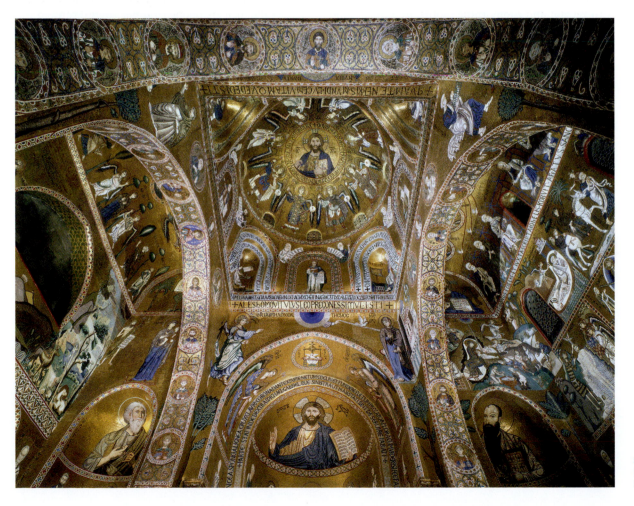

34.12 Interior of Cappella Palatina (facing east), Palermo, Sicily, *c.* 1140–70.

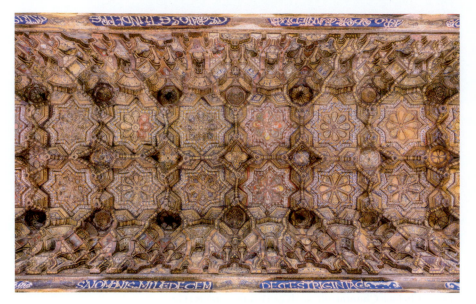

34.13 Carved ceiling, Cappella Palatina, Palermo, Sicily, *c.* 1140–70. Cedar wood.

muqarnas alternating convex and concave niche-like cells, clustered like a honeycomb; used to decorate transitional spaces in Islamic architecture.

truss a rigid framework made of metal or timber beams fastened to form triangles; used to support a roof or heavy load.

zoomorphic having an animal-like form.

Although the church's interior looks Byzantine, the religious services and rites performed there followed traditional practices dictated by the Church in Rome. The chapel's cedar ceiling, however, appears neither Byzantine nor Roman in style. Instead, it is covered with twenty star-shaped panels framed by *muqarnas* (Fig. 34.13). This Fatimid-style woodcarving, suspended from the base of **trusses**, was clearly produced by artisans trained in Fatimid architectural practices. The gilded woodwork contains Kufic inscriptions and is painted with vegetal and **zoomorphic** motifs, as well as multiple images of the enthroned Norman king attending a banquet, thus intertwining his earthly reign with the joys of heaven.

MANTLE OF ROGER II The Norman king of Sicily also possessed a large Fatimid-style mantle or royal cloak made of scarlet silk and embroidered with gold threads, thousands of pearls arranged in double rows, garnets, sapphires, and two gold cloisonné enamels, near the neckline, with eight-sided star patterns, consisting of two interlocking squares (Fig. 34.14). This opulent garment, which weighs over twenty pounds, was worn only during important ceremonies. It was produced either by Fatimid artists or by makers trained in north African or Arabic textile traditions. A lengthy calligraphic Arabic inscription, praising the king as well as the royal workshop, is written on its semicircular hem. The cape is also dated 528 AH (rather than 1134 CE) in accordance with the Islamic calendar.

The mantle displays figurative imagery readily associated with North Africa and West Asia in style and content. At its center, a palm tree indicates the continuity and growth of life. When the mantle was worn, the tree would run down the wearer's spine, emphasizing the person's height. The tree is flanked on each side by a lion attacking a camel (see p. 562). The lions symbolize regal power over those who arrived in Sicily from North Africa, as represented by the camels, which would crumple at the bottom where the mantle's edge touched the floor. Roger's mantle was later erroneously believed to have been worn by Charlemagne (748–814), the first Holy Roman Emperor, though it was worn by subsequent Holy Roman Emperors during their coronation ceremonies.

In the thirteenth century, the cooperation between Christians and Muslims in Sicily came to an end. To minimize insurrection, the Holy Roman Emperor Frederick II (1194–1250), who succeeded the Norman kings of Sicily, deported all Muslims on the island to a colony at Lucera on the Italian mainland in 1239–40). Sixty years later, armies led by Charles II of Naples slaughtered the displaced Muslim community. Survivors were sold into slavery and their abandoned mosques were destroyed and replaced by churches. Increasingly, the Mediterranean world became less harmonious. Conflicts in Europe, reinforced by contemporary Crusades in Palestine, served to intensify violence and animosity.

Iberia and the Crusades, 1230–1500

Christian crusaders arrived in the Holy Land, deemed sacred due to its association with Old Testament prophets and Jesus Christ, from all parts of Europe, bringing with them their own artistic conventions and expectations.

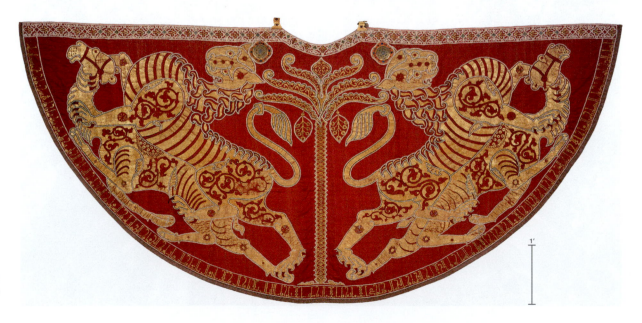

34.14 Mantle of Roger II, from Sicily, *c.* 1134. Silk, gold and silver threads, jewels, and pearls, 4 ft. 7 in. × 11 ft. 4 in. (1.4 × 3.45 m). Kaiserliche Schatzkamer, Vienna.

Pope Urban II initiated the First Crusade in 1095 at the Council of Clermont, calling on Christians to free the territory from Muslim control. (Various Muslim dynasties and factions ruled over Jerusalem ever since Umar ibn al-Khattab conquered the city in 636/7.) At first, the Crusaders experienced success, capturing Jerusalem in 1099. They quickly established kingdoms and principalities in the region, and the blending of diverse traditions is visible in the imagery linked to the Crusades. Then, in a devastating blow to Christian forces, Saladin, the founder of the Ayyubid dynasty, recaptured Jerusalem in 1187. Nonetheless, the Crusaders persisted, and they continued to control parts of the region until the late thirteenth century, when they lost Acre, their last stronghold, in 1291.

ICON OF SAINTS SERGIUS AND BACCHUS Christian artists and **patrons** in the Holy Land remained active, and the heterogeneous character of their imagery did not wane. For example, **icons** of mounted warrior-saints are rare in Byzantine art, yet they became popular in visual imagery produced by crusading artists. A painted panel depicting the fourth-century soldier-saints Sergius and Bacchus offers a strong case in point (**Fig. 34.15**). The representation is one side of a bilateral (two-sided) icon; a badly damaged image of the Virgin Hodegetria (Mary pointing to the Christ child) appears on the reverse. Christians probably carried the icon in religious processions. The holy warriors wearing heavenly crowns were martyred in nearby Syria, intensifying their significance for Crusaders and their supporters.

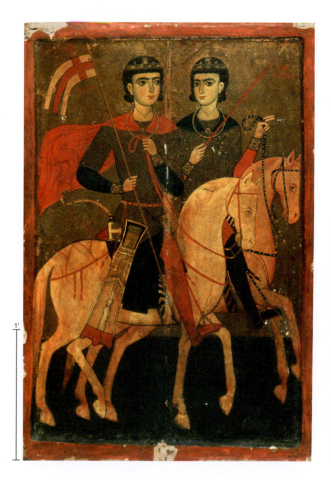

Sergius and Bacchus are not standing upright. Instead, the armored saints are riding on horseback as if on parade, and they wear **torques** around their necks, a feature indicating military prestige. At left, Sergius's scarlet cape and Crusader flag, displaying a red cross against a white background, billow as if in a breeze. A large quiver, decorated with Arabic geometric patterns, hangs prominently from Sergius's waist. Behind him, a bow pokes out of his saddlebag. Although some Christian knights shot arrows from horseback, the depiction of horse archery is more commonly associated with secular hunting scenes in Islamic art. Paradoxically, the icon was probably influenced by the very enemies that the panel called Christians to defend against.

GOLDEN HAGGADAH The Crusades, although fought in western Asia, proved to be disastrous for Jews across Europe. Like Muslims, Jews were considered enemies of Christ. In 1096, hundreds of Jews were massacred in the German cities of Worms and Mainz. After the Fourth Lateran Council of 1215, a major meeting of clerics organized by Pope Innocent III, Jews were forced to wear clothing—typically pointed hats or yellow badges—to indicate their Jewish identity. They were repeatedly exiled from lands held by the French Crown during the Middle Ages. Jews were also frequently expelled from particular European cities and regions beyond the control of the French monarchy. In the aftermath of the expulsions, properties were confiscated and synagogues were destroyed. Despite this violent prejudice, Jews continued to reside in Iberia and some other parts of Europe.

Around 1320, a wealthy Sephardic Jew living in Catalonia, probably in Barcelona, commissioned the *Golden Haggadah*. This sumptuous manuscript, which includes over fifty gold-leaf illuminations, was made for domestic use. A *haggadah* ("telling" in Hebrew) is a Jewish devotional text that is read during the Seder, a Jewish ceremonial feast celebrated at the beginning of Passover to commemorate the Israelite (Jewish) exodus from Egypt. This ritual guide may have been painted by Christian artists, accustomed to making figurative imagery in the **Gothic** style. More likely, a Jewish scribe familiar with Hebrew copied the text.

This page from the *Golden Haggadah* is divided into four scenes (**Fig. 34.16**, p. 574). The pictures, like Hebrew writing, are arranged from right to left and top to bottom. In the upper right, the Angel of Death brings about the tenth plague by slaying the first-born sons of the Egyptians, in order to persuade them to release their Israelite slaves. The angel "passed over" Israelite households, an event celebrated during the Seder (not depicted here). The Egyptian pharaoh, who refused to obey God's commandment to free the enslaved Jews, wears the crown of a European king as he and his wife mourn the loss of their own child. A funeral procession is depicted below them. In the adjacent scene on the upper left, the grieving pharaoh tells the Israelites to leave. They descend a set of stairs on their way out. The departing Hebrews raise their right hands, acknowledging their divine blessing. In their left hands, they hold unrisen dough, for they had no time to let it rise. During the Seder,

34.15 FAR LEFT **Icon of Saints Sergius and Bacchus,** one side of a bilateral icon, *c.* 1260. Tempera on panel, 37⅛ in. × 24¾ in. (94.3 × 62.9 cm). Saint Catherine's Monastery at Mount Sinai, Egypt.

celebrants remember the hastiness of their ancestors' exit by eating unleavened bread, or matzoh. On the lower right, Egyptian soldiers sent by the pharaoh, who had changed his mind, pursue the fleeing Israelites. In the final scene, at lower left, Moses and the Israelites cross the miraculously parted Red Sea, as fallen members of the pharaoh's army are left to drown.

Although the book was used in a Jewish ritual and the sequence of the narrative is presented right to left, the style of the **miniature** or small-scale illustration closely resembles contemporary Christian imagery, suggesting cross-cultural appropriation. Unfortunately, the religious tolerance necessary for such interaction was short-lived. The manuscript probably left Catalonia prior to 1391, when hundreds of Catalan Jews were killed in the name of Christian purification while others fled to northern and central Europe. By 1492, the majority of surviving Sephardic Jews had either converted to Christianity or left the peninsula, and the Reconquista against Muslims continued.

34.16 The Ten Plagues and the Exodus from Egypt, *Golden Haggadah* (fol. 15r), *c.* 1320. Tempera and gold leaf on vellum, 14½ × 11½ in. (36.8 × 29.2 cm). British Library, London.

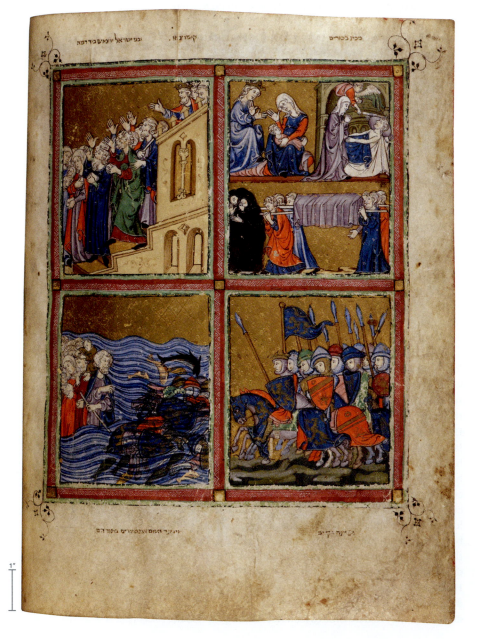

1"

THE ALHAMBRA

During the thirteenth century, the Christian kingdoms of Castile, Aragon, and Portugal retook much of Iberia. The small Emirate of Granada, ruled by the Nasrid dynasty, remained the last Muslim stronghold. The Nasrids had established the emirate in 1230 after defeating the Almohads, and they used architecture to project their power at a time when Muslim control of the peninsula was greatly diminished. Granada became the home to Muslims and Jews who had fled territories now under Christian rule. Their migration brought numerous skilled artisans into the Nasrid emirate and fostered an extraordinary flowering of the arts.

The stunning Nasrid palace complex called the Alhambra ("the Red One") was constructed on a hilltop high above the city of Granada. Although it served as a walled citadel (fortress), the Alhambra was not heavily fortified. It did not have to be, as the palace-city's elevated placement offered protection. The initial Alhambra was built in the late ninth century, but it was radically remodeled and expanded during the reigns of Yusuf I (ruled 1333–53) and Muhammad V (ruled 1353–91). Throughout the redesigned fortress, pleasure and defense are intricately intertwined. Poetic inscriptions and elaborate designs, intricately carved in geometrically ordered patterns, reveal the power of the Nasrid ruler. A labyrinth of corridors and doors that lead in different directions makes it difficult for those unfamiliar with the palace to navigate through it. This maze-like arrangement enhances the sense of mystery and surprise, encouraging visitors to wonder what lies hidden beyond the next threshold.

The Alhambra, constructed on the ruins of a Roman stronghold, consists of semi-independent royal residences, including the Palace of the Lions. In the nineteenth century, the Alhambra became the subject of much **Romantic** literature, which has helped popularize the palace-city while obscuring its political significance. The Alhambra includes many fountains, reflective pools, and gardens filled with fragrant plants. In addition, it has numerous towers, windows, and balconies overlooking inner courtyards and offering views of the countryside down below. These are not merely attributes for aesthetic delight. On the contrary, these features were designed to mark the power of the Nasrid emirs.

The **stucco** walls of the palace complex are covered with delicate geometrical patterning and original poetic inscriptions. The highly refined character of these carved **reliefs** and brightly colored **cut-tile work**, called *zellij* (see Chapter 33), reinforces the courtly elegance of the fortress. The intricacy of the ornamental design makes the complex's chambers seem light and airy. The ceilings of its chambers and **colonnades** are decorated with thousands of *muqarnas* with stalactite pendants. The Alhambra would have been experienced as an earthly anticipation of paradise; the subtle play of *muqarnas*— arranged in honeycombs that capture light and shadow as the sun passes—complemented the grace and sophistication of musical soirées and poetry recitals performed in the fortress.

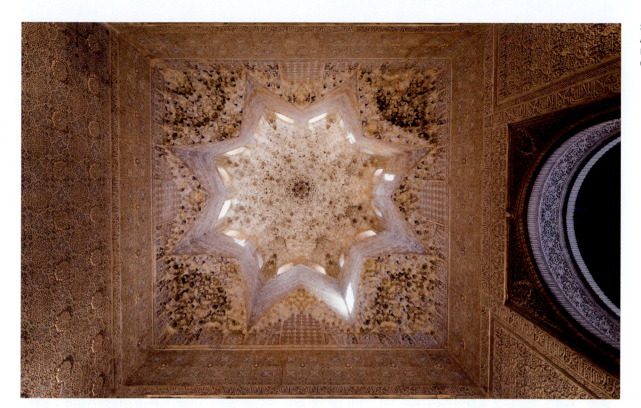

34.17 **The Hall of the Abencerrajes,** Palace of the Lions, Alhambra, c. 1370–90. Granada, Spain.

THE HALL OF THE ABENCERRAJES, PALACE OF THE LIONS, ALHAMBRA Some of the names for prominent parts of the palace complex, such as the Hall of Abencerrajes, derive from nineteenth-century tales and were bestowed well after the Alhambra was built. The Hall of the Abencerrajes is named after a legend about the slaying of a noble family at this location, a fictitious event that indicates nothing about the room's original function. The perfectly square hall has a twelve-sided marble basin in its center, but it is the eight-sided star-shaped vaulting, resting on elaborately carved **squinches**, that catches the eye (**Fig. 34.17**), in a manner that looks quite different than those found in the mosaic dome of the Cappella Palatina (Fig. 34.12). Sixteen small windows illuminate the varied surfaces of thousands of blue-painted *muqarnas*, producing a dazzling effect that seems to erase the weight of the vault. The Hall of Abencerrajes also has exceptional acoustics, enhancing its function as a music chamber.

Throughout the Alhambra, words and images complement one another. Many of the calligraphic inscriptions ask readers to offer God praise for the gifts of peace and prosperity. Directly below the Hall of Abencerrajes's starry dome, the words "There is no other help than the help that comes from God, the clement and merciful One" are carved into the stucco. Here, as elsewhere in the palace complex, the reference from the Qur'an is written in Kufic script. By contrast, secular poems and phrases appear in cursive inscription.

COURTYARD OF THE LIONS, PALACE OF THE LIONS, ALHAMBRA The fountains and pools of the Alhambra, which evoke the qualities of a luxurious oasis or a desert bloom, demand complex irrigation and drainage systems. In the Courtyard of the Lions, water channels are symmetrically ordered, dividing the setting into equal quadrants (Fig. 34.18, p. 576). This formal arrangement is typical of Islamic palace gardens, which are not merely containers for plants and trees. Rather, they are places where nature and artifice meet. They are part of the built environment, but unlike architectural supports, gardens are alive. Flowers and shrubs were regularly grown here. The particulars remain unknown, although a sixteenth-century source describes the presence of orange trees and myrtle bushes in some of the Alhambra's gardens. Transforming the landscape into a garden did not merely offer a private retreat; it also symbolized the emir's power of oversight, over his territories and his people.

The arrangement of the Courtyard of the Lions' numerous columns is not uniform, but neither is it chaotic. The variation is measured like rhythmic music, eliciting peace and harmony. At the center of the courtyard, twelve stone lions support a monumental fountain. Their number may suggest the passing of the months or signs of the zodiac. Water spurts from the lion's mouths, emitting sounds of peace and serenity. The contrast between falling water and still water further evokes feelings of tranquility. Four channels extend from the basin, evoking the rivers of paradise as well as the four directions of a compass, emanating from leonine symbols of royalty.

In 1492—the year that Christopher Columbus traveled to the Americas—the Spanish monarchs Ferdinand and Isabella completed the Reconquista when Granada surrendered to them. That same year, they called for the expulsion of unconverted Muslims and Jews from their kingdoms, but they chose to preserve the Nasrid palace of the Alhambra and use it as one of their residences. Their grandson, Charles V, the Holy Roman Emperor and King of Spain who criticized the construction of the cathedral within Córdoba's mosque, nonetheless built a new palace within the Alhambra (see Fig. 48.2). Designed by Pedro

stucco fine plaster that can be easily carved; used to cover walls or decorate a surface.

relief raised forms that project from a flat background.

cut-tile work small pieces of glazed tile arranged into patterns and set into plaster or gypsum to form geometric designs ornamenting interior architectural surfaces.

colonnade a long series of columns at regular intervals that supports a roof or other structure.

squinch a support, typically at the corners of a square room, used to carry a dome or other superstructure.

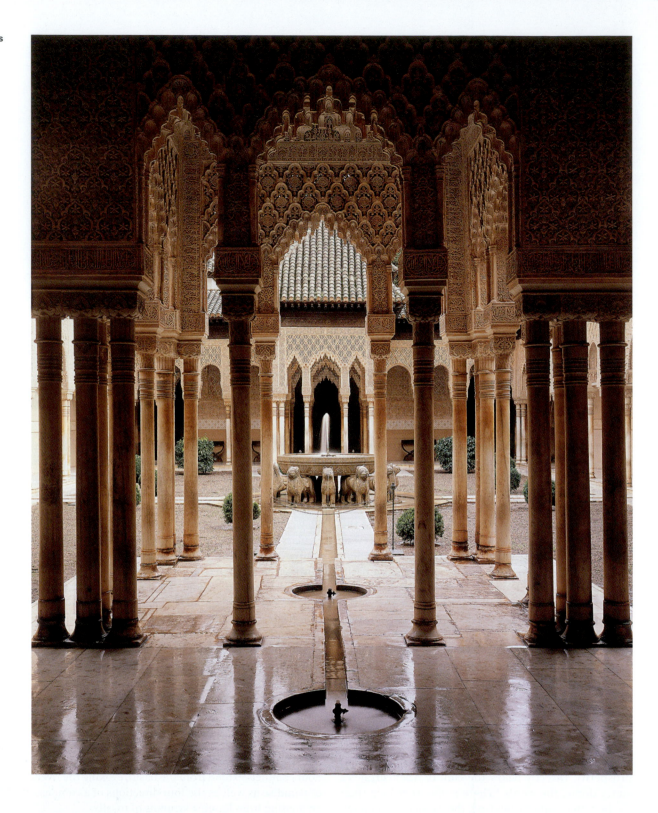

34.18 Courtyard of the Lions (looking east), Palace of the Lions, Alhambra, c. 1370–90. Granada, Spain.

Machuca, a student of Michelangelo and Pontormo, the bold edifice resembles Italian **Mannerist** architecture. Its presence within the Alhambra reasserts the Christian triumph over Islam but disrupts the enchanting subtleties of the red palace.

Muslim, Christian, and Jewish imagery provides evidence of the wide variety of interactions among religious groups, ethnic groups, and royal dynasties in the Middle Ages. Although this chapter has focused primarily on medieval Iberia and Sicily, cross-cultural interaction existed elsewhere, too; and, of course, it still does. Sadly, periods of hospitality and tolerance were increasingly interrupted by violent events, such as the Crusades, massacres, and religious persecutions, rooted in hostility and hatred. Romanesque and Gothic art and architecture may frequently seem closely aligned with Christianity; however, it is important to recognize that medieval Europe was not the domain of a single religion and that cross-cultural interactions between people of the Abrahamic religions during the Middle Ages helped shape later developments.

Mannerism particular stylistic characteristics—intellectual sophistication and artificial elegance—found in sixteenth-century European art.

Although buildings are constructed things, inanimate and stationary, we commonly give them human attributes in the ways that we talk about them. For example, we refer to their fronts as facades or faces. In addition, architectural styles are sometimes described as the buildings' vocabulary, and metaphorically, buildings can speak to us.

The Alhambra is different from many edifices in that it contains numerous inscriptions; it communicates not only metaphorically but also literally through the written word. Around the door and windows of the Lindaraja Mirador (room designed for panoramic viewing) in the Palace of the Lions, an Arabic poem, written in the first person, addresses the sight of the garden located below (**Fig. 34.19**). It reads:

In this garden, I am an eye filled with delight and the pupil of this eye is, truly, our Lord, Muhammad [V], praiseworthy for his bravery and generosity, with fame outstanding and virtue graceful;
He is the full moon on the empire's horizons, his signs are lasting and his light brilliant. In his abode he is none other than the sun,

the shade from which is beneficent.
In me he looks from his calital throne toward the capital of his entire kingdom....

The meaning of the eye described in the poem is ambiguous. It may refer to either the mirador or the emir's gaze.

Within the Alhambra, art and nature often seem interwoven. The Lindaraja Mirador is decorated in ceramic tile and elaborately carved stucco, and, like other miradors in the palace complex, it has large openings with panoramic views from an elevated place of privilege. It separates the viewer from the viewed, in a manner analogous to the distinction between king and kingdom.

A tension between private and public is also at play. The private garden seen from the mirador is concealed from the residents of the city below. Simultaneously, the emir controls and protects the surrounding countryside as far as his eye can see. The mirador's poetic inscription does not function as a secondary source pointing out the power of architecture to laud the emir; it is an integral part of the Alhambra itself.

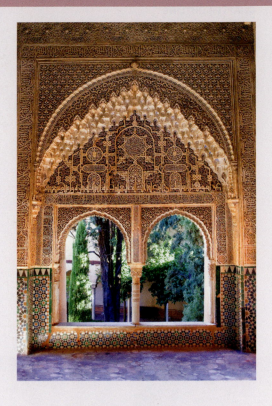

34.19 The Lindaraja Mirador, Palace of the Lions, Alhambra, Granada, Spain, c. 1370–90.

Discussion Questions

1. Compare and contrast the sacred architecture of Muslims and Jews in Iberia with examples found in western Asia.

2. What were some of the ways that Christians appropriated Muslim art, and that Muslims and Jews appropriated Christian art? What were the cultural advantages of doing so?

3. Compare and contrast the Courtyard of the Lions in the Alhambra to gardens and parks that you have experienced. Which features are similar and which are different?

4. Describe the cosmopolitan character of art and architecture associated with Roger II of Sicily.

Further Reading

- Dodds, Jerrilynn (ed.) *Al-Andalus: The Art of Islamic Spain.* Exhibition catalogue. New York: The Metropolitan Museum of Art, 1992.
- Dodds, Jerrilynn (ed.) *The Art of Medieval Spain, A.D. 500–1200.* Exhibition catalogue. New York: The Metropolitan Museum of Art, 1993.
- Rosser-Owen, Mariam. *Islamic Arts from Spain.* London: Victoria and Albert Museum, 2010.
- Ruggles, Dede Fairchild. *Gardens, Landscape, and Vision in the Palaces of Islamic Spain.* University Park, PA: Pennsylvania State University Press, 2000.
- Rowe, Nina. *The Jew, the Cathedral, and the Medieval City: Synagoga and Ecclesia in the Thirteenth Century.* Cambridge, MA: Cambridge University Press, 2011.
- Tronzo, William. *The Cultures of His Kingdom: Roger II and the Cappella Palatina in Palermo.* Princeton, NJ: Princeton University Press, 1997.

Chronology

711	The Imazighen invade the Iberian Peninsula
756	Abd al-Rahman I establishes the Emirate of Córdoba
1091	Normans take control of Sicily
1095	The First Crusade is initiated
c. 1140–70	The Cappella Palatina of Roger II is constructed
1180	Ibn Shoshan Synagogue (Santa María la Blanca) is built
1187	Saladin's armies recapture Jerusalem
1212	The Defeat of the Almohads at the Battle of Las Navas de Tolosa
c. 1320	The *Golden Haggadah* is produced
1492	The Nasrids are defeated and Jews are expelled from Spain

35

Romanesque Art and Architecture in Europe

1000–1200

The Last Judgment tympanum
(detail), Autun, France.

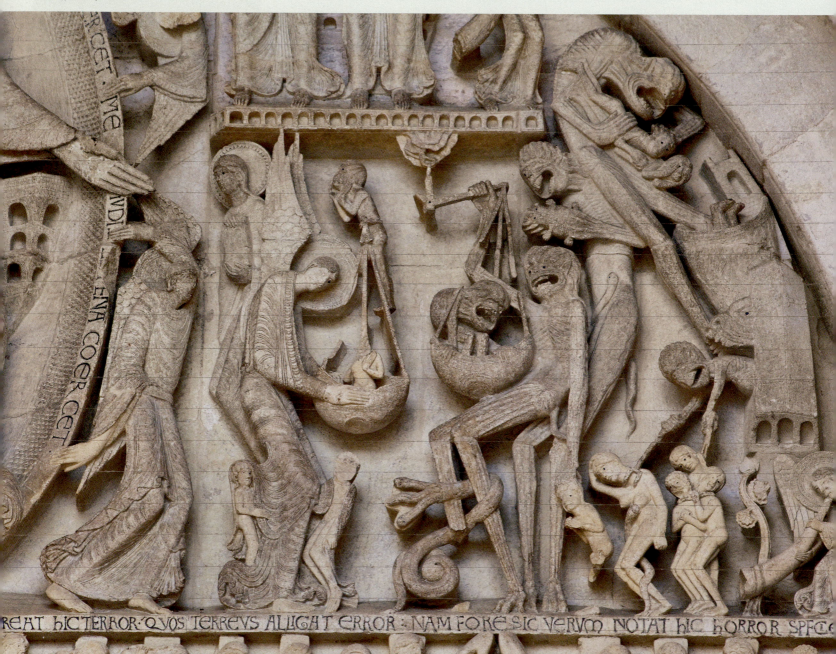

Introduction

Around the year 1000, western Europe slowly began to consolidate into more substantial territories with kings. In some places, regional lords ruled along with powerful new land-owning religious orders. Meanwhile, the papacy (the office of the pope) grew stronger in political as well as religious affairs. Even as Muslim dynasties increasingly threatened the Byzantine Empire's shrinking borders, the empire extended the reach of the Eastern Orthodox Church as far as Russia. The growing split within Christendom became definitive in 1054, when the Eastern Orthodox Church officially separated from the Church centered in Rome (The Great Schism).

Soon after the split, western European Christians initiated a series of military expeditions to wrest the city of Jerusalem from Muslim control. Jerusalem played a central role in the traditions of all three Abrahamic religions, and was considered holy by Jews, Christians, and Muslims alike. These campaigns, later called the Crusades, took place primarily between 1095 and 1291. During this period, many ecclesiastical leaders encouraged believers to perform acts of piety and devotion, including pilgrimages to celebrated churches housing sacred relics. (These churches courted such visits, often presenting the relics in sumptuous visual splendor.) Participating in the Crusades was itself considered a devotional practice, an act of self-sacrifice to protect holy sites and those making pilgrimages to see them.

Throughout the eleventh and twelfth centuries, western European artists and their patrons often made visual references back to the iconography and forms of ancient Rome as one way of asserting their independence from the eastern empire. Allusions to the Roman past, especially the use of stone vaulting, round arches, and figurative sculptures on architecture, have encouraged some scholars to deem this period the Romanesque, a term invented in the nineteenth century, and which is not always accurate or instructive.

However, numerous artistic and architectural innovations were introduced during this period. Pilgrimages and the Crusades brought western European Christians closer together in a transnational religious identity, but they did not eliminate cultural diversity or change. Regional and ideological differences continued to shape the development of art and architecture throughout the eleventh and twelfth centuries. As noted in the previous chapter, the continent was not solely Christian. Muslims and Jews also resided in Europe and increasingly suffered persecution in areas with Christian majorities.

Monastic Competition and Reform, *c.* 1000–1150

With political stability and economic recovery, the number of monasteries in western Europe substantially increased after the turn of the first millennium. Within these widely scattered religious communities, monks aimed to achieve a goal put forward in the Bible: to be in the world, but not of it. To do so, they followed regulations formulated by St. Benedict (480–*c.* 550), the founder of monasticism (see Chapter 29). Benedictine monks lived communally, often in remote areas and removed

35.1 Interior of the upper chapel of St-Martin-du-Canigou (facing east), Near Prades, French Pyrenees, 1001–26.

from civic life, and they agreed to forfeit their personal desires to maintain the unity and order of the group as a whole. Yet their monastic identity was not defined merely by asceticism (the avoidance of all forms of indulgence). After all, Benedictine monasteries were frequently established by aristocratic or royal gifts and were often quite wealthy. Their impact on the art and architecture of the period was substantial.

ST-MARTIN-DU-CANIGOU In the foothills of Mount Canigou in the Pyrenees Mountains, a new architectural type of Benedictine abbey was introduced during the early eleventh century (**Fig. 35.1**). Unlike most churches at this time in Europe, whose roofs were supported by timber **trusses**, the ceiling was supported by three elongated stone **barrel vaults** placed above a set of sizable **monolithic** columns. The extensive use of rounded **arches** and barrel vaulting is based on architectural principles and materials associated with ancient Rome. St-Martin-du-Canigou is an early example of this Romanesque style of thick masonry and round arches, capable of supporting heavy ceilings. The masonry engineering and general style were used in many churches and monasteries built in this period.

Stone masonry provided fire protection at St-Martin-du-Canigou, but this came at a cost. The abbey was more expensive and labor-intensive to build than a wooden abbey, and the building's vaults demanded massive walls to carry the weight. Windows were kept to a minimum so as not to weaken the supporting walls; there is no **clerestory**, and the ceiling is very low. Natural light enters solely through a series of small rounded windows, so the interior is cold and dark. Nonetheless, the flickering light of candles against the thick walls provides a warm glow and a sense of otherworldliness to ascetic worshipers longing for mystical transcendence.

truss a rigid framework made of metal or timber beams fastened to form triangles; used to support a roof or heavy load.

barrel vault also called a tunnel vault; a semi-cylindrical ceiling that consists of a single curve.

monolithic formed of a single large block of stone.

arch a curved, symmetrical structure supported on either side by a post, pier, column, or wall; usually supports a wall, bridge, or roof.

clerestory the upper section of a wall that contains a series of windows, allowing light to enter the building.

illuminated manuscript an illustrated, handwritten book, with such decorative elements as ornate initials, chapter headings, text borders, and framed images that supplement the text.

basilica a longitudinal building with multiple aisles and an apse, typically located at the east end.

nave the central aisle of a civic or church basilica.

transept a section of a church perpendicular to the nave; transepts often extend beyond the side aisles, making the "arms" of a cruciform-shaped church.

apse a recess at the end of an interior space, often semi-circular, and typically reserved for someone or something important, such as the altar in a church or the throne of a ruler.

ambulatory an aisle around an apse.

apsidioles secondary apses or small chapels radiating around the primary apse of a church.

groin vault a vault produced by the intersection of two barrel vaults placed at right angles to each other, forming pronounced "groins" or arcs at the meeting points.

bay a space between columns, or a niche in a wall, that is created by defined structures.

transverse ribs ribs or arches within a vault that define each side of a bay.

35.2 Pentecost, from the *Cluniac Lectionary* (fol. 79v), early 12th century. Tempera on vellum, 9 in. × 5 in. (22.9 × 12.7 cm). Bibliothèque nationale de France, Paris

MONASTERY AT CLUNY, FRANCE As the Church's wealth grew, so too did secular interference, such as the installation of local aristocratic family members into key positions within monasteries. Simony, the selling of ecclesiastical offices, was one of many worldly threats for those seeking a spiritual life of prayer, and monastic reforms were introduced to minimize this practice.

In 909, William, the duke of Aquitaine, had donated funds to establish a monastery at Cluny, France, free of local control. According to the Cluniac Reform, the abbot and monks were placed directly under the supervision of the pope, enabling them to keep a greater share of profits from property rentals on monastery land. Ordinarily, some of these profits would have gone to a local bishop or lord. During the eleventh and twelfth centuries, the congregation of Cluny, which had grown quite large, participated in elaborate liturgical (public worship) services that could last up to ten hours. Donations, including tribute money from Muslim taifa-kings defeated by the Castilian king Alfonso VI at Toledo in 1085, helped finance the construction of Cluny's immense abbey, which was larger even than Old St. Peter's Basilica (Fig. 23.12), the papal church in Rome. Ultimately, Cluny's wealth and prestige proved to be its undoing. Condemned for its decadence, it was destroyed during the French Revolution.

CLUNIAC LECTIONARY Monasteries such as Cluny preserved and transmitted learning by sponsoring the copying and binding of books, and many regional styles flourished in them. With Cluny's wealth and resources at their disposal, the Benedictine monks residing there produced lavish **illuminated manuscripts**, many including expensive illustrations painted in tempera and gold leaf. The *Cluniac Lectionary* is a collection of scriptural readings for daily worship. Its Pentecost page, marking the feast celebrating the gift of the Holy Spirit offered to Christ's apostles, depicts the forward-facing, half-length figure of Christ, resembling a Byzantine Pantocrator with a cruciform (cross-shaped) halo, as he appears above his disciples (**Fig. 35.2**). Christ's outstretched arms harmoniously echo the fiery rays, indicating the emanation of the Holy Spirit, below him. The disciples are represented with highly detailed facial features and delicate folds of drapery. St. Peter, the first pope, is enthroned directly below Christ. His physical centrality among the apostles may have been informed by the Cluniac Reform's affirmation of direct papal supervision.

The Way of St. James and Pilgrimage Churches, *c.* 1000–1150

In addition to monasticism, pilgrimage (a journey to a sacred place) was an important religious practice of the Romanesque period. As trade routes across Europe became safer, affluent travelers could visit sacred Christian sites along the pilgrimage routes that crossed France and Spain (see **Map 35.1**), and churches and other structures, such as inns, were built to serve them along the way. Pilgrims took these journeys for a variety of reasons, including the hope of receiving a miraculous cure, forgiveness for sin, or to satisfy the desire for adventure. Upon completing a long journey, sometimes hundreds of miles long, the excitement and wonder that pilgrims felt upon witnessing monumental churches, fantastic sculptures, and precious relics could readily be shared with others, encouraging additional travel.

Pilgrimages were said to offer opportunities to lessen the time of purgation, when the souls of sinners who have obtained grace are believed to be cleansed by fire before entering heaven. By participating in pilgrimages, joining a crusade, making ecclesiastical donations, and performing other good works, it was believed that Christians with remorseful hearts could, upon death, reach heaven more swiftly. During the late twelfth century, theologians started describing this time of purification as a particular place: purgatory. As the notion of purgatory became popularized and more greatly feared, the number of pilgrimages dramatically rose, and ecclesiastical structures underwent design changes to accommodate large crowds of travelers while still enabling the local congregation to gather undisturbed for Mass. The buildings' decoration programs conveyed powerful messages to religious travelers, contrasting the promise of salvation with punishment for sin.

The three primary pilgrimage sites in the Middle Ages were the tombs of St. Peter and St. Paul in Rome, the Holy Sepulcher (the site of Christ's empty tomb) in Jerusalem, and the Cathedral of Santiago de Compostela in northwest Spain, at the end of the network of pilgrimage routes called the Way of St. James (El Camino de Santiago). As St. James's popularity spread, pilgrims began traveling from across Europe to visit the cathedral built over his tomb and named for him. Other pilgrimage churches were also built along the Way of

St. James, many of them enshrining holy relics. They served either as stopping points for pilgrims or as end destinations for people who did not have the time or money for the long trip to Santiago. Because the cathedral at Santiago has been substantially remodeled since the seventeenth century, other churches on the Way of St. James better demonstrate the visual features of these medieval edifices and foster a deeper understanding of how such buildings affected the pilgrims who crossed their thresholds.

ST-SERNIN, TOULOUSE, FRANCE The Way of St. James primarily consists of four main pilgrimage routes, beginning at various points in France, that eventually converge as pilgrims progress through Spain toward their destination. One of the most popular sites along one route is the monastic church St-Sernin, built between *c.* 1080 and 1118 and named after the first bishop of Toulouse, France. This monumental pilgrimage church is an excellent example of the Romanesque style at its peak (**Fig. 35.3**).

The massive five-aisled **basilica** of St-Sernin was modeled after Old St. Peter's Basilica in Rome (Fig. 23.12). Its **nave** is intersected by a **transept** forming the arms of a long Latin cross. A corridor surrounding the **apse**, called an **ambulatory,** allows pilgrims to walk around the periphery of the building's interior and visit the site of St-Sernin's original tomb without interrupting activities performed on the high altar (**Figs. 35.4** and **35.5**, p. 582). The apse also housed additional smaller chapels called **apsidioles** that project from its semicircular wall; pilgrims accessed them from the ambulatory and additional apsidioles from the eastern side of the transept. Each of these small chapels contained sacred relics and an altar table for the celebration of the Mass.

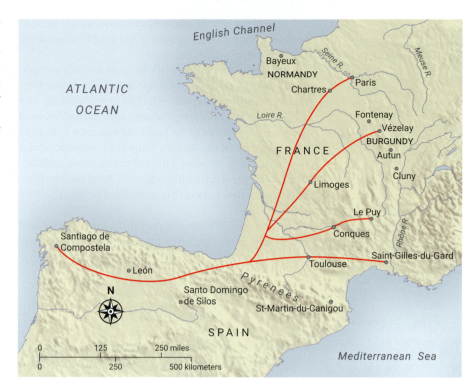

Instead of a traditional, fire-prone timber roof, a massive barrel-vaulted masonry structure covers the central aisle, while **groin vaults** protect the side aisles. St-Sernin has numerous windows and is substantially taller than St-Martin-du-Canigou (see **Fig. 35.1**). For pilgrims, the sheer height of the interior likely enhanced the drama of reaching their destination. The nave of St-Sernin consists of a large barrel vault, divided into **bays** by **transverse ribs.** These ribs, which extend across

Map 35.1 Pilgrimage routes and monasteries in France and Spain, *c.* 1100.

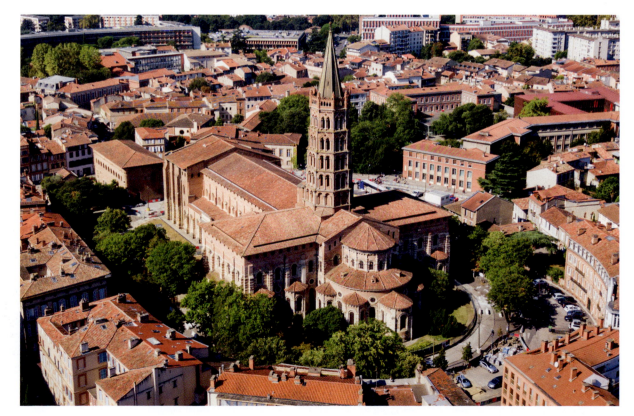

35.3 Aerial view of St-Sernin, Toulouse, France, *c.* 1080–1118, with later additions.

engaged column a column attached to, or seemingly half-buried in, a wall.

facade any exterior vertical face of a building, usually the front.

portal an opening in the wall of a building; usually an entranceway.

jamb each of the two upright parts of a doorframe.

archivolts moldings on the lower curve of an arch.

voussoir a wedge-shaped stone block used in the construction of an arch.

the nave, grow out of **engaged columns**, which provide vertical accents that also offer a sense of rhythm along the horizontal procession space.

The developed **facades** of Christian cathedrals built around the year 1100 were composed of coordinated elements, including sculpture attached to the building. The inclusion of large-scale figural sculpture as an element of architecture built of stone had not been seen in Europe since the end of the Roman Empire in the west, about five hundred years prior. Like the use of stone vaulting, this return to architectural sculpture from Roman precedent is another reason this period and its art are called Romanesque.

A Romanesque church **portal** typically consists of a rounded arch that rests above a set of supporting columns, called **jambs**, which were sometimes adorned with column figures and related sculptures (**Fig. 35.6**). The arch itself is composed of molded **archivolts**, and like arches, they have wedge-shaped segments called **voussoirs**. In some Romanesque churches, the archivolts were adorned with designs, including figurative or decorative motifs, to fill out or complement the major scene of the **tympanum**—an architectural feature popularized in the Romanesque era—which is the sizable semicircular

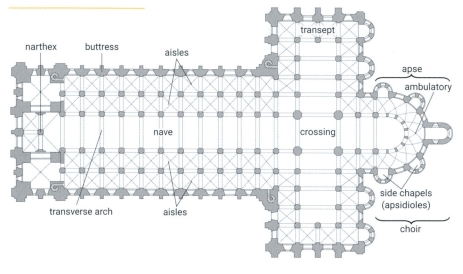

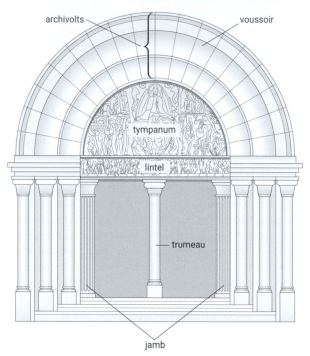

35.4 ABOVE **St-Sernin (plan drawing),** Toulouse, France.

35.5 RIGHT **Nave of St-Sernin,** Toulouse, France.

35.6 ABOVE RIGHT **Elements of a Romanesque church portal.**

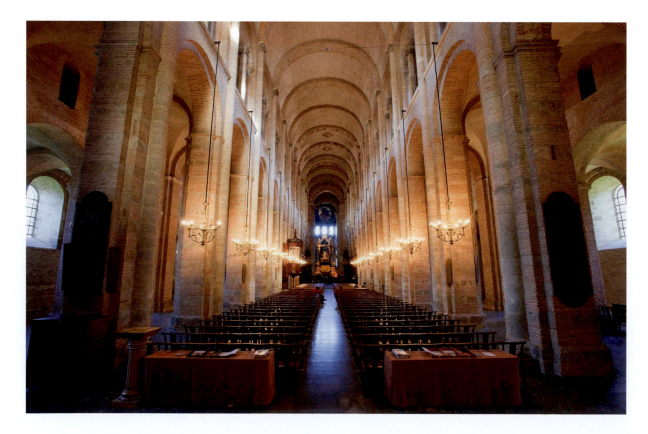

were elaborately decorated, conveying the marvelous power of the holy items as treasures from heaven. The sacred remains of Ste. Foy, a martyred twelve-year-old girl who refused to offer sacrifices to the deities of Rome, were placed into a spectacular reliquary (Fig. 35.10). This reliquary was protected within a new church, the Abbey Church of Ste-Foy, built to house the saint's relics. Like the Golden Madonna of Essen (see Fig. 29.23), the reliquary is sculpted as an enthroned figure coated with gold. Its surface is decorated with numerous gems and **cameos**. These items may have been donated by adoring pilgrims, seeking divine intervention and blessing. Ste. Foy's face may have been fashioned from an ancient Roman parade helmet, perhaps suggesting her perseverance and ultimate victory over Roman authority.

SANTO DOMINGO DE SILOS The Benedictine abbey of Santo Domingo de Silos, located in Castile near the Way of St. James, included a **cloister**, a courtyard for quiet meditation. The cloister included corner piers decorated with relief sculpture. In the northwest corner of the cloister, a scene from the Christian New Testament of pilgrims on the way to Emmaus is depicted (Fig. 35.11).

The three barefoot travelers, nearly life-size, look in different directions, suggesting unfamiliarity with one another. Although his fellow travelers do not recognize him, resurrected Christ leads the trio (at right). His crossed legs maintain the contours of the pier, ensuring that his foot does not extend beyond its edge. More importantly, this detail implies a pause in the action, marking the

moment when Christ asks these strangers the nature of their discussion, which focused on their disappointment that the messiah of Israel is dead. Only later, when the men share an evening meal, will they recognize Christ.

In this pier relief, Christ wears a satchel decorated with a scallop shell, resembling a pilgrimage badge from St. James and reinforcing the analogy between these travelers and those on the road to Santiago. At the same time, the relief reminds believers to recognize the presence of the divine beyond the limitations of normal vision.

ENTHRONED VIRGIN AND CHILD Sometimes called the Morgan Madonna (after the American banker J. P. Morgan, who once owned it), this sculpture originally served as a liturgical object, placed on a church altar in Auvergne, France (Fig. 35.12). In addition, it was likely carried in religious processions. The Virgin Mary and Christ child are shown enthroned in rigid frontality, affirming their regal status. The freestanding wooden sculpture is **polychrome**; the use of naturalistic color is still apparent on the figures' faces, and traces of red and blue paint can be seen on the Madonna's robe. The folds of her garment are regular in their repeated arcs, creating a rhythmic pattern. The sculpture has been damaged over time, and Christ's hands and arms are now missing. He probably held the Gospel in his left hand and made a gesture of blessing with his right.

The Madonna serves as the Throne of Holy Wisdom (*Sedes sapientiae*). Evoking maternal care, she holds the omniscient Christ, the personification of divine

relic the bodily remains of saints or items believed to have come into physical contact with the divine.

reliquary a container for holy relics (items associated with a deceased sacred individual), which is often elaborately decorated.

cameo a gem or other stone with a relief carving; the distinct background color is the inner vein of the stone.

cloister a covered walkway, lined with a colonnade, walled on the outside and open to a courtyard; usually found in religious buildings.

polychrome displaying several different colors.

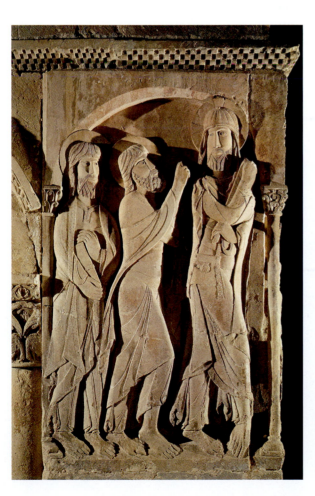

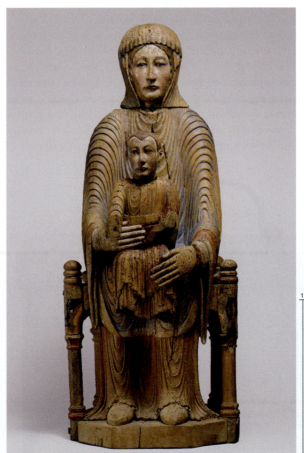

35.11 FAR LEFT **On the Road to Emmaus,** Santo Domingo de Silos, Spain, c. 1100. Stone relief on cloister pier.

35.12 LEFT **Virgin and Child** (The Morgan Madonna), 12th century. Wood with polychromy, height 31 in. (78.7 cm). Metropolitan Museum of Art, New York.

knowledge. Two cavities in the back of the sculpture indicate that it may have functioned as a reliquary. The figures' heads can be readily detached from the rest of the work, suggesting that on special occasions they may have been clothed with actual garments.

CASKET OF COURTLY LOVE In the French city of Limoges, exquisite metal objects, often decorated with **champlevé** enamels, were produced for sale to meet the demands of pilgrims on their way to St. James. Unlike the Byzantine technique of *cloisonné*, in which artists place gems or enamels within compartments of metal strips, in the champlevé technique artists pour powdered glass into grooves cut into a copper ground and then fire it at a high temperature. Then they polish down the enamel to fit the curvature of the surrounding **gilded** metal.

Not all of the metalwork produced in Limoges was designed for religious purposes. Some items, such as this gilded container (casket) with champlevé enamels, had a different function (**Fig. 35.13**). The front of this small box is decorated with scenes associated with courtly love, a notion deeply rooted in Hispano-Arabic poetic tales about the noble, though danger fraught, pursuits of love, sung by itinerant entertainers to royal audiences. On the left, a troubadour plays music to catch the attention of a maiden, who seems unattainable and unimpressed by his efforts, judging from the positioning of her hands on her hips. A bird glides between the two figures, revealing the troubadour's romantic desire to "fly through the air and deep within her house," as one medieval love song puts it. In the center of the panel, to the left of the keyhole, a guard armed with a sword protects the contents of the box and ensures the woman's chastity.

On this enameled container, love is defined in terms of capture. An amorous couple alternates between playing the roles of the hunter and the hunted as the two pursue a common goal—to be united with each other in love. To the right, the woman holds captive her male suitor, now in different clothes, and grips a leather strap that encircles his neck. In her left hand (at the viewer's right), the maiden, now also in a change of

dress, holds a domesticated falcon, evoking notions of an aristocratic hunt and suggesting that she is in control. At her mercy, the troubadour folds his hands in a pledge of faithful servitude. The scene implies that the woman is now in charge of their union, despite the man's erotic longings, his willingness to risk heartache in the face of all the odds, and his gift of the costly jewelry casket and whatever it held inside.

In addition to depicting courtly love, the casket itself also played a role in the art of romance as a precious gift signifying amorous devotion. Like a reliquary, this beautiful box probably contained treasure, though of a less heavenly sort—specifically, jewelry. Within this context, women could welcome or reject their male suitors' advances. By accepting a gift such as this, the recipient acknowledges the metal box's **iconographical** program of romantic love and agrees to offer her steadfast devotion in return.

The Norman Conquest of England, *c.* 1050–1200

During the eleventh century, aristocrats and kings consolidated territory in northern Europe and England. William the Conqueror (1027–1087), who was also the Duke of Normandy—a territory on the northwestern coast of France—became king of England after the Battle of Hastings in 1066. Soon after the Normans conquered England, they began replacing existing churches with grand new ones, resembling those constructed in their homeland.

DURHAM CATHEDRAL William of St-Calais, a prince-bishop appointed by William the Conqueror, built a sizable fortress on a peninsula high above a major bend on the River Wear in England. This Norman stronghold included a castle and a cathedral, now known as Durham Cathedral (**Fig. 35.14**). The cathedral was built to replace an existing church that contained a shrine housing the relics of St. Cuthbert (founder of the monastery associated with the *Lindisfarne Gospels*, see Figs. 29.3 and 29.4). The saint's sacred remains had been transported from Lindisfarne to Durham in 875 to safeguard them from the Vikings. Centuries later, the Viking's descendants built a new building to protect these relics.

The stone-vaulted ceiling of Durham Cathedral was constructed in an innovative fashion. Each bay consists of two sets of criss-crossing **ribs** supporting the vault, framed between powerful **transverse arches**, carried across the nave (**Figs. 35.14** and **35.15**). This experimental solution, which may have served as a visual aid for later architects and stonemasons in the production of Gothic vaulting (see box: Making It Real: Rib Vaults and Pointed Arches, p. 599), substantially reduced the thickness of the material needed for the ceiling and hence its weight, which is carried by massive alternating columns and compound piers.

Geometric patterns, rendered in vibrant color, are carved into the surface of the columns. The repetition of lines reinforces the sense of order found throughout the church's interior. These bold, abstract designs, consisting

35.13 Casket of Courtly Love, *c.* 1180. Champlevé enamel on gilded copper. 4½ × 8½ × 6½ in. (11.4 × 21.6 × 16.5 cm). British Museum, London.

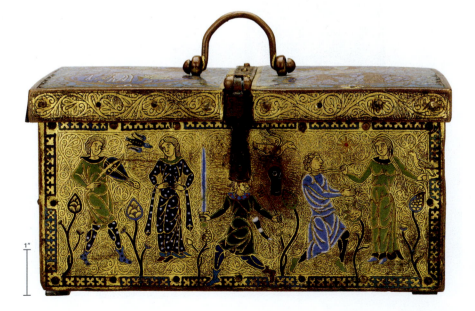

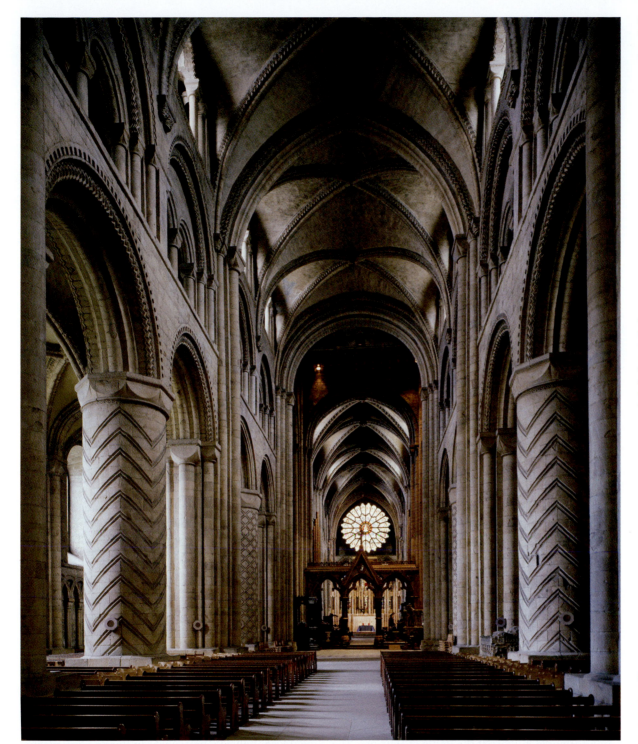

rose window a large, round stained-glass window set in stone tracery.

vellum a writing surface originally made from calfskin.

35.15 BELOW **Durham Cathedral (plan drawing).** Durham, England, *c.* 1093–1130. The eastern end of the church was later remodeled to include an additional transept and series of chapels.

of either diamond shapes or zigzags, seem to animate the monumental columns for those walking inside the church as they approach the altar. In the thirteenth century, the east end of the church was demolished and reconstructed with a sizable Gothic **rose window**.

BAYEUX EMBROIDERY William's successful invasion of England was the subject of what is probably the most imposing visual narrative of the later eleventh century, the Bayeux Embroidery (**Fig. 35.16**, p. 588). While manuscript production flourished in the monasteries of the eleventh and twelfth centuries, the story of the Norman Conquest is here told on cloth rather than on **vellum**

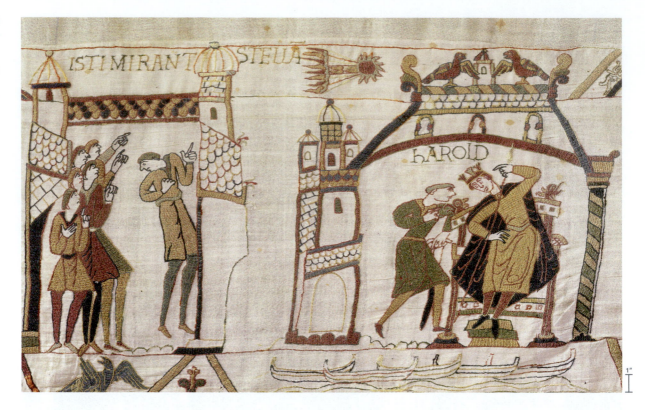

pages. Although it is frequently and inaccurately called a **tapestry** (which is constructed through weaving and knotting), this is instead an expansive work of **embroidery** on linen. It was commissioned by William's half-brother, Bishop Odo of Bayeux, France, who ruled England during the Norman leader's absence.

This extraordinarily long textile, which stretches for nearly 230 feet (70 m), was probably produced by needlewomen in England. It includes over fifty narrative scenes. Its epic visual history recalls the carved Column of Trajan in ancient Rome (Fig. 20.11) in that both document a historical battle from the victor's point of view. The textile also offers a rare depiction of secular history on a grand scale. Although it does not present a religious narrative, it was placed in Bayeux Cathedral, where Odo served as bishop from 1049–1097. The monumental linen's center register, which includes labeled figures and scenes, functions like a scroll, with a sequential narrative unfurling left to right, first showing warships crossing the English Channel, then equestrian combat among armored knights at the Battle of Hastings. The section illustrated in **Fig. 35.16** shows King Harold, the story's villain, cowering at the sight of an ominous comet seen in the sky in the year of the battle, 1066. Today called Halley's Comet, it was considered the harbinger of disaster.

Imperial Ambitions in Germanic Lands, *c.* 1050–1200

Charlemagne's early ninth-century vision of a Holy Roman Empire as powerful as that of ancient Rome (see Chapter 29) appealed to his descendants, though the later empire was smaller and its borders subject to constant change resulting from conflicts with other rulers and intermarriages uniting various royal families. By 1027, the title and powers of the Holy Roman Emperor had shifted from the Ottonian dynasty to the Frankish Salian dynasty. The size of the empire also diminished to what roughly is today known as Germany and Lombardy (northern Italy). Like Charlemagne and his Roman models Constantine and Justinian, Salian monarchs supported monasteries and built imposing places of worship.

SPEYER CATHEDRAL The largest of these imperial structures is Speyer Cathedral (or Kaiserdom) in central Germany (**Fig. 35.17**). Begun in 1030 by Conrad I, the first Salian Holy Roman Emperor, with major remodeling and construction under Henry IV (ruled 1056–1105), Speyer Cathedral served as a dynastic **mausoleum** and as a symbol of imperial majesty—Speyer is even longer than Old St. Peter's Basilica in Rome (see Fig. 23.12). Deceased emperors were buried in a massive crypt beneath the **choir** and in front of the altar, so that even in death they could symbolically participate in the ongoing masses within the church.

On the western side of this monumental church, two slender towers flank a massive octagonal turret. These features are matched at the eastern end, but with an even more imposing central dome over the crossing. Although Speyer Cathedral does not possess two transepts and apses, the symmetrical arrangement of its towers is reminiscent of that found in St. Michael's church at Hildesheim (see Fig. 29.17). Inside Speyer, many different vertical elements are integrated across multiple stories to create its thick walls and piers (**Fig. 35.18**). **Pilasters** and half-columns overlap the **arcade** piers and continue to the top of the clerestory windows. There, a series of arches tops the window zone, echoing the rhythms at ground

tapestry a decorative textile in which pictures and/or designs are woven into the fabric.

embroidery decorative stitching usually made with colored thread on woven textile.

mausoleum a building or free-standing monument that houses a burial chamber.

choir the space in a church, typically on the eastern end, reserved for the clergy.

pilaster a flat, rectangular vertical projection from a wall; usually has a base and a capital, and can be fluted.

arcade a covered walkway made of a series of arches supported by piers.

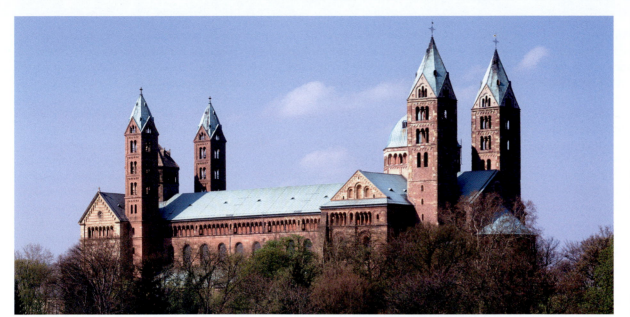

35.17 Speyer Cathedral (Kaiserdom), Speyer, Germany, 1030–61. Rebuilt with stone nave vaults and a new apse in 1080–1106, with later additions.

colonnette a small slender column.

35.18 BELOW **Nave of Speyer Cathedral.**

level. This coordination balances a horizontal rhythm of twelve discrete yet uniform square bays in a repeated system along the tall, wide nave.

Later construction under Henry IV reinforced the alternating piers with engaged **colonnettes** and added ribs to provide further support for six enormous stone vaults, replacing timber trusses, above the central aisle (107 feet, or 32.61 m, high), making Speyer one of the tallest churches of its time. The alternating piers and columns are typical of Ottonian basilicas, but now at Speyer these components enhance the overall sense of vertical grandeur.

Henry IV began remodeling the cathedral at Speyer after a clash with the pope over the emperor's right to appoint abbots and bishops, a conflict known as the Investiture Controversy, in which Henry IV claimed to be victorious. In 1075, Pope Gregory VII had decreed that only cardinals (not secular leaders) could elect a pope and that the emperor was ultimately subject to papal authority. The following year he excommunicated Henry IV, and the emperor initially responded by taking a pilgrimage in remorse, but ultimately answered with a military threat. Fearful of attack, Gregory VII sought help from the Normans in Sicily, but when the Normans arrived, they turned on the pope and sacked the city of Rome. While Henry's expansion of Speyer Cathedral may have been intended as a visual manifestation of his imperial authority, his victory over the pope was less certain, and the conflict between imperial and papal power continued long after his death.

HERIMANN CROSS Henry IV had been baptized and later crowned as King of Germany by Herimann, archbishop of Cologne. Herimann commissioned a small cross that shows a connection between himself and ancient Rome (**Fig. 35.19**, p. 590). The names and portraits of the archbishop and his sister Ida appear on the back of the cross along with a Latin inscription that reads, "Archbishop Herimann commanded that I should be made." On the front of the cross, Christ is rendered in gilded bronze,

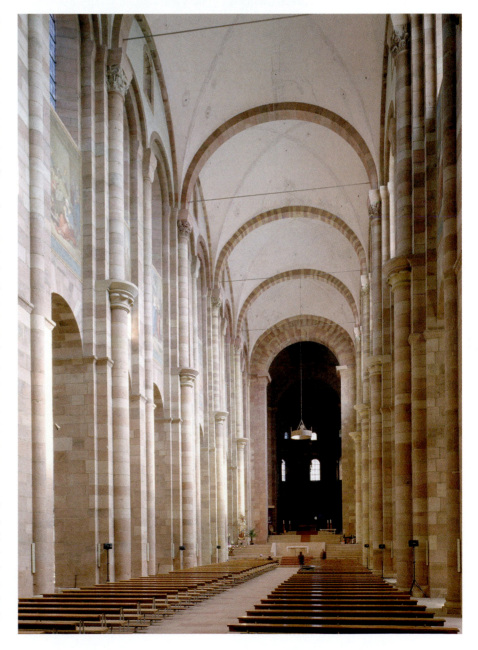

During the eleventh and twelfth centuries, theologians such as St. Bernard of Clairvaux (1115–53), criticized ostentatious artistic displays as costly distractions from worship. As he put it,

> Everywhere so plentiful and astonishing a variety of contradictory forms is seen that one would rather read in the marble than in books, and spend the whole day gawking at every single one of them than in meditating on the law of God. Good God! If not is not ashamed of the absurdity, why is one not at least troubled by the expense?

St. Bernard's remarks not only relate to religion; they also have economic and political ramifications. If money is not used for art, it can be used to support other things, like feeding the poor or paying for Crusades.

A Benedictine monk from northern Germany, who wrote under the pseudonym Theophilus, disagreed. He praised the work of artists.

Theophilus believed the visual arts, like the wonders of nature, could help beholders discover virtue and intensify their yearning for the divine. In his treatise *On Diverse Art* (*De Divertis Artibus*) (*c.* 1120), Theophilus writes, "do not despise useful and precious things, simply because your native earth has produced them for you unexpectedly. For foolish is the merchant who suddenly finds a treasure in a hole in the ground and fails to pick it up and keep it." Art may be made by human hands from earthly materials, but it can offer us intellectual and spiritual benefits.

Theophilus applauds those "who are willing to avoid and spurn idleness and the shiftlessness of the mind by the useful occupation of their hands and the agreeable contemplation of new things." Properly understood, the production of art is not a foolish waste of time, but meaningful labor with a higher purpose. Likewise, looking at art helps us think and imagine new possibilities.

Although Theophilus discusses techniques associated with painting, glass, and metalwork,

his treatise is not merely an instructional manual. His primary audience is viewers and he calls them to pay close attention, to look carefully at the visual arts as products of learned skills.

If you will diligently examine it, you will find in it whatever kinds and blends of various colours Greece possesses: whatever Russia knows of workmanship in enamels ...: whatever Arabia adorns with repoussé or cast work, or engravings in relief: whatever gold embellishments Italy applies to various vessels or the carving of gems and ivories: whatever France esteems in her precious variety of windows: whatever skilled Germany praises in subtle work in gold, silver, copper, iron, wood, and stone.

Theophilus mentions a variety of places, techniques, and media. He appreciates regional and artistic differences, revealing his cosmopolitan tastes, and encourages us to do likewise.

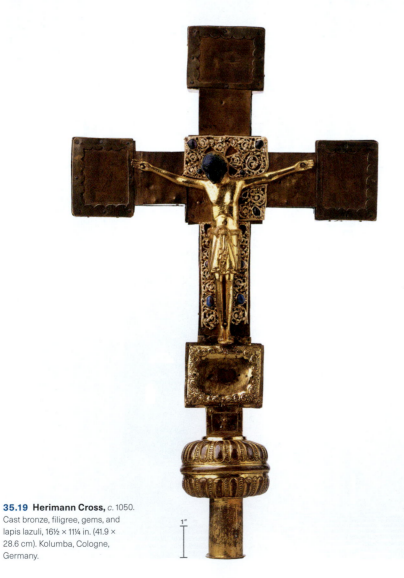

35.19 Herimann Cross, *c.* 1050. Cast bronze, filigree, gems, and lapis lazuli, 16½ × 11¼ in. (41.9 × 28.6 cm). Kolumba, Cologne, Germany.

but his head is sculpted from blue lapis lazuli. Close inspection reveals that the head is an ancient Roman portrait miniature; it depicts Livia, the wife of Caesar Augustus. Despite this likeness, Herimann probably did not notice its feminine form. Instead, he likely saw it as an image from ancient Rome fashioned from a precious material, an object that increased the cross's overall value and may have served as a subtle affirmation of imperial, rather than papal, authority.

STAVELOT TRIPTYCH Metalwork—mostly directed towards religious devotion—also flourished in the Meuse (Mass) River valley of the Holy Roman Empire. The Stavelot Triptych (**Fig. 35.20**), a bejeweled shrine with doors that open and close, was likely commissioned by Wibald, the abbot of an imperial monastery in Stavelot, near Liège (Belgium), around 1154. Two miniature **triptychs** located inside the scalloped central panel may be older, from the eleventh century, and their design appears Byzantine in origin. They may have been produced in Constantinople by an imperial workshop of artists to house relic fragments of the True Cross, the crucifix on which Christ was put to death. Both depict Crucifixion scenes and are enameled in *cloisonné*. Wibald, who occasionally served as an advisor to the pope and to two emperors, probably acquired them as a diplomatic gift during a visit to Constantinople. A century later, these items were inserted within the bigger triptych, which was made in the west although its design also appears Byzantine.

The interior wings of the Stavelot Triptych include six medallions enameled in champlevé, each showing scenes connected to the ancient Roman emperor Constantine. The image at lower left depicts his legendary vision signifying that in Christ he will conquer.

Above it, his victory at the Milvian Bridge is rendered, and the top scene shows his Christian baptism. To the right, Constantine's mother, Helena's discovery of the True Cross is represented, affirming the validity of the relics and the urgent need to seize control of Jerusalem. The iconography and cost of the triptych reveal the desire to strengthen diplomatic ties between the Holy Roman and Byzantine empires.

Wibald's remarkable triptych may have been the first in Western Europe. The triptych format, which initially appears in tenth-century Byzantine ivories, was introduced to accommodate the devotional needs of wealthy travelers. Two hinged wings protected interior imagery from the wear and tear of transportation. Like the inclusion of precious gems, the presentation of the two smaller triptychs within the Stavelot Triptych reinforces the reliquary's material and spiritual value.

Although the artists, architects, and **patrons** of the Romanesque period often looked back to ancient Rome for inspiration, they were not merely preoccupied with the historical past. On the contrary, eleventh- and twelfth-century Europeans were also concerned with the present condition and future of their souls. Christians joined monasteries and went on pilgrimages and Crusades in preparation for the afterlife. Although Norman conquest and imperial desires may have fostered some uniformity, strong regional and ideological differences remained. In the centuries that followed, however, a new, more unified style—namely, the Gothic—would spread across Europe, diminishing the rich variety of Romanesque art and architecture.

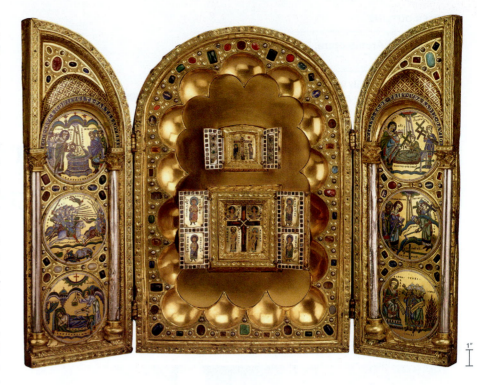

35.20 Stavelot Triptych, c. 1154. Champlevé and *cloisonné* enamels on copper gilt, with gems and pseudo-pearls, 19 × 26 in. (48.3 × 66 cm). The Morgan Library and Museum, New York.

Discussion Questions

1. What is the relationship between art and pilgrimage? How did visual imagery encourage people to travel on the Way of St. James? In pilgrimages, what is more important, the journey or the destination?

2. Compare either of the following pairs of Romanesque churches: the interiors of St-Martin-du-Canigou and Durham Cathedral, or the exteriors and floor plans of St-Sernin at Toulouse and the Speyer Cathedral.

3. Why did some medieval monks produce opulent devotional images while others created more austere visual representations?

4. Why do you think the narrative of the Last Judgment was chosen for depiction on the tympanum at St-Lazare, Autun?

Further Reading

• Dale, Thomas E. A. *Pygmalion's Power: Romanesque Sculpture, the Senses, & Religious Experience.* University Park, PA: Pennsylvania State University Press, 2019.

• Gearhart, Heidi. *Theophilus and the Theory and Practice of Medieval Art.* University Park, PA: Pennsylvania State University Press, 2019.

• Hearn, Millard F. *Romanesque Sculpture: The Revival of Monumental Stone Sculpture in the Eleventh and Twelfth Centuries.* Ithaca, NY: Cornell University Press, 1985.

• Petzold, Andreas. *Romanesque Art.* New York: Harry N. Abrams, 1995.

• Rudolph, Conrad. *The "Things of Greater Importance." Bernard of Clairvaux's 'Apologia' and the Medieval Attitude Toward Art.* Philadelphia, PA: University of Pennsylvania Press, 1990.

Chronology

910	The Cluniac Reform is established	1075–1122	The Investiture Controversy between popes and emperors
c. 1050	Pilgrims from beyond the Pyrenees begin traveling across northern Spain to Santiago de Compostela	1095–99	The First Crusade
		c. 1120–35	The pilgrimage church of St. Lazare is constructed in Autun, France
1054	The Great Schism divides western and eastern branches of Christianity	1146–49	The Second Crusade
1066	The Battle of Hastings	c. 1154	The Stavelot Triptych is produced

triptych a three-part work of art, often three panels attached together.

patron a person or institution that commissions artwork.

36

Gothic Art and Architecture in Europe

1200–1400

Uta (detail from choir sculpture), Naumburg Cathedral, Germany.

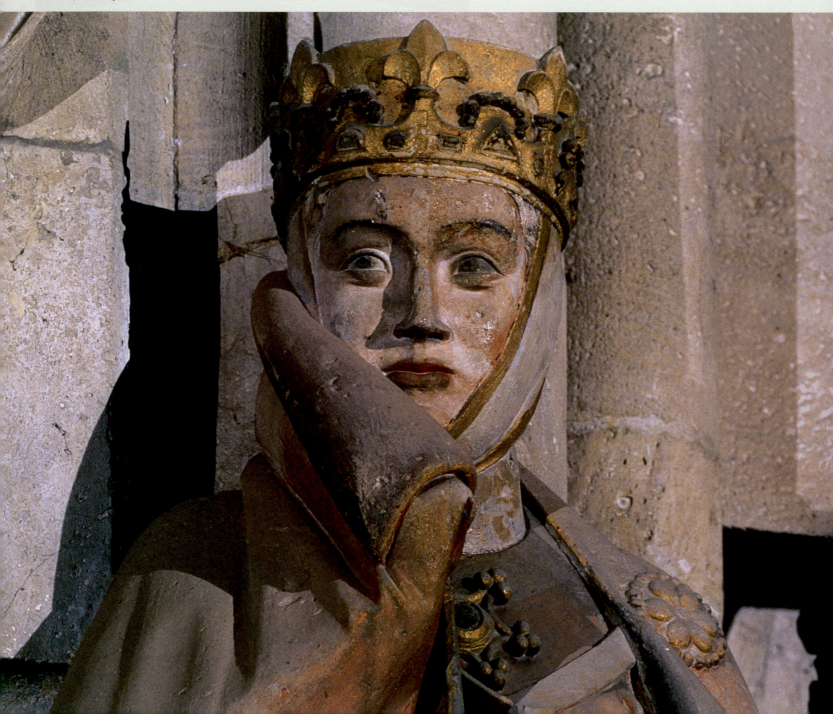

Introduction

During the thirteenth and fourteenth centuries in Europe, the cathedral (the seat of a bishop) began to replace the monastery as the primary center of higher learning and the arts. Universities, such as those at Bologna, Paris, and Oxford, initially functioned as cathedral schools for preparing future priests. But even for those pursuing theological training, universities increasingly served the needs of those with more secular interests.

In France, the authority of the king expanded, as did his territory. Centuries earlier, in 987, Hugh Capet had been elected as the French monarch, and his descendants governed France for nearly three hundred years. Through diplomatic efforts and tactically arranged marriages, the Capetian kings absorbed numerous landholdings controlled by barons and dukes. This political unification coincided with the construction of France's magnificent cathedrals. The monarchy's centralized power in France heightened tensions with the English kings, who, following the Norman Conquest, were essentially vassals of the French leader. (Vassals were people who received land and title in return for their subordination, military support, and sometimes tribute.) As the English monarchs grew increasingly resentful of this arrangement, they frequently fought French monarchs over territories.

Elsewhere in Europe during the thirteenth and fourteenth centuries, the Holy Roman Empire (see Map 36.1) remained fragmented, split into numerous duchies (territories under the control of dukes or duchesses), bishoprics (districts under the control of bishops), and independent cities. Emperors were elected by their noble peers and subsequently crowned by the pope. In 1355, Charles IV of Bohemia became Holy Roman Emperor. He established his capital, Prague, as an important cultural center, strengthening the unity of the Holy Roman Empire with his diplomatic prowess.

During this historical period, architecture flourished, most notably in building new cathedral churches filled with light. The soaring height of these new churches, famous for their impressive stained-glass windows, was made possible by innovations in construction techniques. In addition, Europe's political and religious leaders commissioned sculpture, paintings, manuscripts, and other objects that displayed a new emotional intensity and naturalism. Later, this style came to be known as Gothic.

French Gothic Architecture, 1140–1260

The word "Gothic" describes a style of later medieval art and architecture. This chapter addresses art and architecture made between 1200 and 1400, but Gothic works were made long afterward. The term was popularized by the Italian painter-historian Giorgio Vasari (1511–74), who used it as a derogatory label. It implied that, in the centuries preceding the Italian **Renaissance**, the knowledge and grace found in **Classical** antiquity had been lost. Linking the entire medieval era to European cultures who brought the Roman Empire to an end—namely, the Visigoths and the Ostrogoths (hence the word "Gothic"),

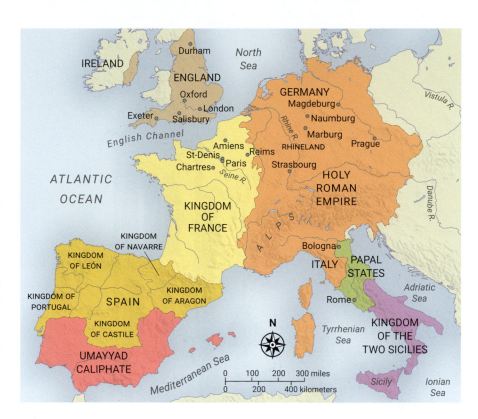

Map 36.1 **Europe around 1200.**

Renaissance intellectuals deemed it barbarous. But perceptions change, and eighteenth- and nineteenth-century **Romantic** poets and artists embraced the Gothic (see Chapter 58), looking back nostalgically to the Middle Ages as a period before the perceived contamination caused by the Industrial Revolution. Scholars continue to use the term Gothic today. However, it is important to remember that this term would have made little sense to those living in thirteenth- and fourteenth-century Europe. To them, the Gothic style was *opus francigenum* ("French work") or *opus modernum* ("modern work"), unconnected to the fall of Rome and its cultural values.

ABBEY OF ST-DENIS Gothic style is most visible in architecture, notably in the soaring height of cathedrals and in the open spaces, pointed arches, and extensive windows that replaced massive walls, round arches, and fewer windows, characteristics associated with numerous Romanesque churches (see Chapter 35). The Benedictine Abbey of St-Denis, just north of Paris, was one of the first structures to employ elements that later came to be called Gothic. It was named after St. Denis, a third-century Christian martyr who converted the Gauls to Christianity. The abbey's Carolingian **basilica** church, consecrated in 775, had long been the burial site of French kings. It housed precious relics, including the *oriflamme*, a forked crimson banner that, according to legend, was originally attached to a lance that could emit flames and had once belonged to Charlemagne, who was crowned King of the Franks at an even earlier edifice located in St-Denis (768).

By the early twelfth century, the aging church needed extensive repairs. Abbot Suger took the opportunity not only to mend damaged parts of the church but also to expand and rebuild portions of it, synthesizing

Renaissance a period of Classically inspired cultural and artistic change in Europe from approximately the fourteenth to the mid-sixteenth centuries.

Classical artworks from, or in a style deriving from, ancient Greece or Rome.

Romantism; Romantics a movement from the late eighteenth through the mid-nineteenth centuries in European culture, concerned with the power of the imagination, and valuing intense feeling.

basilica a longitudinal building with multiple aisles and an apse, typically located at the east end.

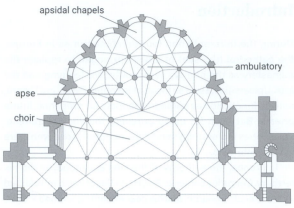

apsidal chapels

ambulatory

apse

choir

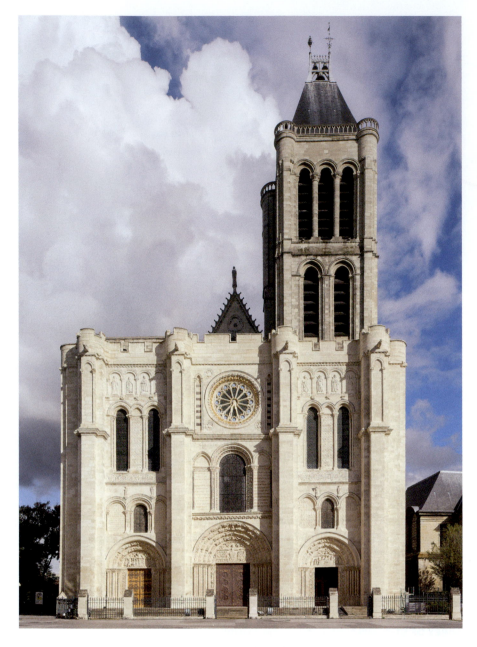

36.1 ABOVE **Western facade, Basilica of St-Denis,** France, c. 1135–40.

36.2 ABOVE RIGHT **The choir of St-Denis (plan drawing).**

facade the face of a building, a wall of entry, usually the front.

portal an opening in the wall of a building; usually an entranceway.

arch a curved, symmetrical structure supported on either side by a post, pier, column, or wall; usually supports a wall, bridge, or roof.

architectural developments that allowed him to introduce new design elements and approaches to space. Suger's architectural advances were incorporated into and expanded on in other churches throughout France and Europe, particularly in Germany and England.

Suger's remodeling began with a monumental new western **facade**, consecrated in 1140 (**Fig. 36.1**). Three substantial **portals** with rounded **arches** are the same width as the **nave** and two side aisles. The **facade** opens to a **narthex** that enlarges the historic Carolingian basilica. Suger added sculpture to the **jambs**, **voussoirs**, and **tympana**, similar to the Basilica of Ste-Marie Madeleine of Vézelay (see Fig. 35.7) and St-Lazare of Autun (see Fig. 35.8), choosing the Last Judgment for the subject over the central portal. Figures of Old Testament kings and prophets are carved into the door jambs, a tradition borrowed from southern France that became a defining hallmark of later French cathedrals. Adorning the upper part of the western facade is a **rose window**, which was a new type of window, one that alluded both to the traditional

symbol of light and of Christ, and to the Virgin Mary, who was sometimes called the beautiful rose without thorns. St-Denis lost one of its towers in the nineteenth century.

Beyond the Carolingian church nave, Suger and his architect, whose name is not known, added a new **choir**, begun in 1140 (**Fig. 36.2**). As in Romanesque pilgrimage churches (see Chapter 35), Suger's choir includes an **ambulatory** (**Fig. 36.3**), from which chapels radiate. These chapels are not divided by walls. Rather, the chapel spaces merge, separated only by columns under a webbing of **vaults** supported by visible arches. The use of **rib vaulting**—similar to the technique used at Durham Cathedral (see Fig. 35.14)—meant that the amount of stone used to construct the choir could be greatly reduced because the ribs support the vaults. Moreover, the vaults themselves use pointed rather than rounded arches in order to carry the weight of the ceiling more effectively (see box: Making It Real: Rib Vaults and Pointed Arches, p. 599). This technique had been employed earlier in some Romanesque churches, such as the abbey church at Cluny, and it became characteristic of Gothic architecture.

As a result of these innovations, the walls required less structural mass, allowing more open space and larger windows, making the interior lighter and brighter. Suger indulged his love of glowing light, symbolic of the divine in his theology, by giving over much of the wall surface to stained-glass windows. In addition to suggesting divine light, the use of so many windows seems to deny the materiality of the wall supports. For Suger, these new walls and windows offered the antithesis to the heavy masonry and limited natural light of earlier churches. By using technical advances pioneered by his predecessors, Suger fulfilled his own spiritual ambition: to produce a vision of the shining city of God.

The method for making medieval stained-glass windows is described in a twelfth-century treatise, *De Diversis Artibus*, attributed to Theophilus (see box: Debating the Value of Art, p. 590). The process was costly and complex. A mixture of sand (silica), potash (a copper-colored salt that contains potassium), and lime (a calcium-containing mineral) was placed under intense heat until it became molten. Various metallic oxides were introduced to create different colors. The liquefied material was then blown into glass and flattened. A **cartoon**, or diagram drawn at actual scale, was used to indicate the window's layout. With a hot iron tool, the glass was

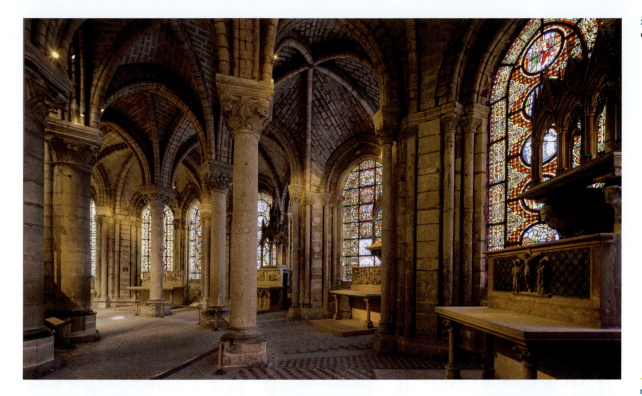

cut into pieces corresponding to the shapes marked on the cartoon. Sometimes, artisans applied pigment to the glass to suggest modeling. These painted fragments were then fired in a kiln to fuse the pigment and glass together. Upon cooling, these pieces were assembled into lead frames before being inserted into the wall. As glass artisans gained expertise, they began to put together bits of variously colored glass to depict figures and narrative scenes, and the art of stained glass replaced the mosaics of Early Christian and Byzantine churches.

With its precious stones, gold, and stained glass, St-Denis proudly celebrates the union of piety and wealth. Its lavish interior and innovative design reveal Abbot Suger's extraordinary vision. Unlike the Cistercian abbot St. Bernard, who was deeply concerned about the seductive power of material beauty and consequently advocated austerity, Suger believed that such earthly riches could reveal the glory of God and offer a preview of the heavenly treasures to come. In his treatise *De Administratione*, Suger describes an inscription he wrote to appear on the bronze doors of St-Denis. It reads:

All you who seek to honor these doors,
Marvel not at the gold and expense but at the
 craftsmanship of the work.
The noble work is bright, but, being nobly bright,
 the work
Should brighten the minds, allowing them to travel
 through the lights
To the true light, where Christ is the true door.
The golden door defines how it is immanent in these
 things.
The dull mind rises to the truth through material
 things,
And is resurrected from its former submersion
 when the light is seen.

Abbot Suger's fascination with light was closely linked to his adoration of St-Denis; he was inspired by a text falsely attributed to the saint during the ninth century. The text was actually written by a mystic from the fifth or sixth century CE, who noted that the contemplation of light and color can help viewers transcend the bodily, physical realm and promote mystical ascent toward union with the divine. Suger appropriated these ideas and applied them to the lavish architecture he commissioned. Many of the windows at St-Denis are difficult to read in natural light and depict allegories with complicated meaning. Nonetheless, for Suger, these windows were capable of illuminating the soul and moving beholders to seek the splendor of the sacred.

CHARTRES CATHEDRAL Suger's innovations were quickly adopted for religious structures throughout the Ile de France region around Paris. Perhaps the finest surviving ensemble of early innovations is the cathedral of Chartres, southwest of Paris. Chartres had a prized relic that made it a popular pilgrimage site: what was believed to be the tunic of the Virgin, worn when she gave birth to Christ. Chartres thus developed into a major center for the veneration of the Virgin Mary in France.

While Suger was renovating St-Denis, new portal sculptures were added as part of the western facade reconstruction at Chartres (**Fig. 36.4**, p. 596). The development of Gothic style in stone sculpture can be seen in the carved figures adorning these portals. A unified program revolves around the central tympanum, where **iconography** from the Bible is depicted: the Second Coming of Christ (his return to the world after his ascension into heaven) unfolds amid symbolic beasts from the Book of the Apocalypse. The serene and gentle Christ at center contrasts with the highly energetic, oversized figure at Vézelay (see Fig. 35.7). These three entryways on

nave the central aisle of a civic or church basilica.

narthex the entrance hall or vestibule of a church.

jamb each of the two upright parts of a doorframe.

voussoir a wedge-shaped stone block used in the construction of an arch.

tympanum (plural **tympana**) a lunette-shaped space above a portal; often filled with relief sculpture.

rose window a large, round stained-glass window set in stone tracery.

choir the space in a church, typically on the eastern end, reserved for the clergy.

ambulatory an aisle around an apse.

vault an arched stone structure, usually made of stone, concrete, or brick, that often forms a ceiling.

rib vaulting a vault consisting of numerous intersecting ribs, often associated with Gothic architecture.

cartoon derived from the Italian word *cartone*, which refers to a large piece of paper; a to-scale drawing made in preparation for a wall painting.

iconography images or symbols used to convey specific meanings in an artwork.

36.4 West portals, Chartres Cathedral (Notre-Dame), France, *c.* 1145.

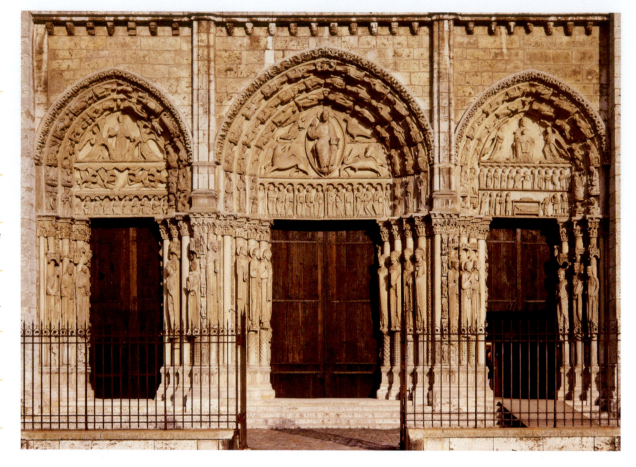

transept a section of a church perpendicular to the nave; transepts often extend beyond the side aisles, making the "arms" of a cruciform-shaped church.

bay a space between columns, or niche in a wall, that is created by defined structures.

triforium a gallery placed above the nave arcade and below the clerestory in a church.

clerestory the upper section of a wall that contains a series of windows allowing light to enter the building

pier an upright post that supports horizontal elements, such as a ceiling or arcade.

buttress an external support to an architectural structure, usually made of brick or stone.

flying buttress in architecture, a supporting pier that extends, or "flies," from an external wall, with an arch that provides additional support to the wall while allowing space for windows.

porch a covered area usually connected to the front of a building.

lancet a tall narrow window with a pointed arch at its top.

36.5 Chartres Cathedral (plan drawing).

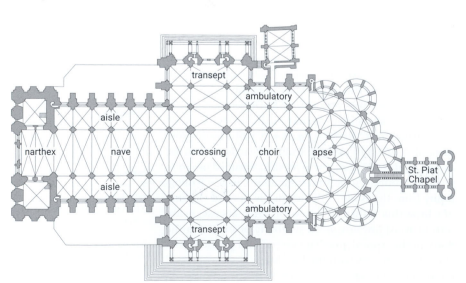

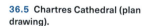

the cathedral's western facade are called royal portals because figures of Old Testament kings and queens appear on their door jambs, following a precedent set at St-Denis. These elongated statues conform closely to the shape of the columns. As a result, they provide an integrated vertical emphasis while symbolically serving as the support for the scenes in the arches above them. The New Testament subjects in the arches literally stand atop their Old Testament predecessors in the jambs. This entire scheme therefore brings together all of time according to Christians, from Creation to Apocalypse, encompassing the entire cosmos of nature and learning, of reason and revelation.

A large labyrinth, over 42 feet (12.8 m) in diameter, was set into the stone floor of Chartres's new nave (**Fig. 36.6**). The maze may have functioned as a means for imaginative or spiritual pilgrimage to Jerusalem, which was recaptured by Muslim armies at the end of the twelfth century. It offered an alternative to the more dangerous and arduous journey. The schematic maze at Chartres may have served as a tribute to the ingenuity of the cathedral's architects.

In 1194, a fire ravaged the cathedral. Only the western block and crypt survived. Soon after, a new church was constructed; most of it completed between 1195 and 1220. At the rebuilt Chartres, a double-aisled ambulatory and radiating chapels are combined with a long nave and wide **transept** (**Fig. 36.5**). Chartres is organized according to a belief in the purity of mathematical relations, following simple ratios between elements of height and width. As a result, despite the immense height of the nave peak—approximately 120 feet (36 m)—a sense of balance and order prevails. Likewise, the sequence of **bays** progressing toward the choir counterbalances the soaring rise of the slender columns into the ribs of the vault. The systematic elevation balances the nave arcade with a narrow **triforium**, or gallery, beneath the expanse of **clerestory** windows filled with stained glass (**Fig. 36.6**). Compound **piers** carry the eye upward to the soaring vaults, which are constructed in each bay out of four-part ribs on pointed arches.

The key to supporting the building's soaring height lies in its exterior, where **buttresses** extend along the length of the building perpendicular to the aisles. At the

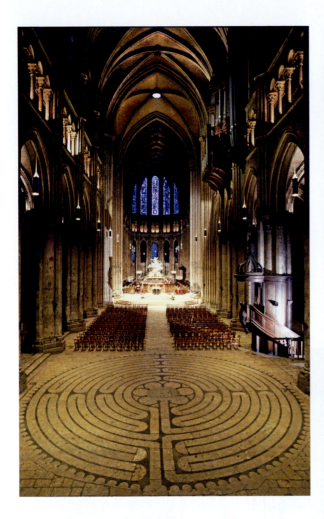

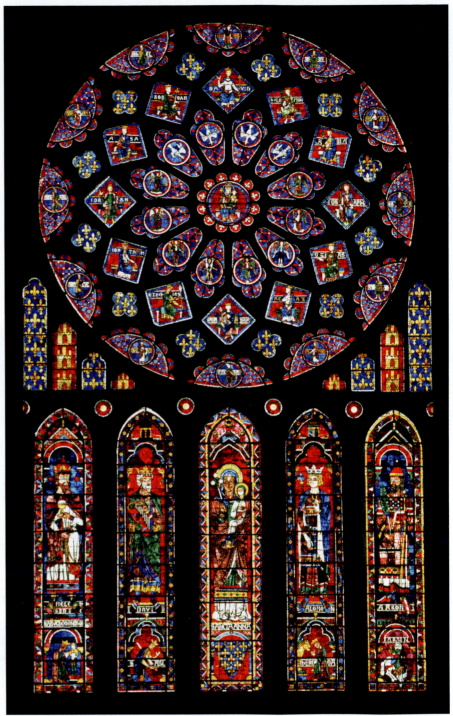

top of those buttresses, **flying buttresses** (see **Fig. 36.10**) reach across to bolster the top walls of the nave. This innovation allowed windows in the upper part of tall buildings as well as at ground level. The stained-glass windows between the mighty buttresses illuminate the interior of Chartres with a mysterious colored light that fully realizes Suger's vision for a house of worship.

WINDOWS AT CHARTRES CATHEDRAL Chartres Cathedral includes nearly two hundred stained-glass windows (**Fig. 36.7**). Twelfth-century glass has survived in the Royal Portal, but most of the glass at Chartres, including that in the windows connected to the construction of the transept **porches**, dates to the thirteenth century. These later windows are organized into smaller narrative scenes, presenting geometrical clarity. The north portal includes an immense rose window, commissioned by the French queen Blanche of Castile (Louis IX's mother) and dedicated to the Virgin Mary; it glows with deep blues and bright reds. Nearly 43 ft. (13 m) in diameter, this is one of three large rose windows at Chartres, another innovation adopted from St-Denis. In the center of the north transept rose, Mary, holding her divine son, is depicted as the Queen of Heaven. She is surrounded by representations of four doves and eight angels, which are encircled by diamond-shaped panels showing the twelve Old Testament kings from the Tree of Jesse, Christ's ancestors. On the periphery of the rose, semicircular windows depict Old Testament prophets, who foretold Christ's birth. Twelve small quatrefoils representing golden three-petaled irises (fleur-de-lis) against a deep-blue background, symbolizing the French monarchy, are interspersed between the two outer rings of windows.

Five, long and narrow, **lancet** windows are placed beneath the rose. In the middle lancet, St. Anna, whose sacred relics had recently been acquired by the cathedral, holds her daughter, the Virgin Mary, above a royal heraldic shield. The remaining four lancet windows depict Old Testament priests and kings prefiguring the life of Christ (left to right; Melchizedek, David, Solomon, and Aaron). Beneath them, sinister kings (left to right; Saul, Jeroboam, Nebuchadnezzar, and an Egyptian pharaoh) are shown. Their lower placement indicates the triumph

36.6 ABOVE LEFT **Nave of Chartres Cathedral.**

36.7 ABOVE **Rose window and lancets, Chartres Cathedral,** north transept. France, c. 1220–30.

tracery ornamental stonework, often carved in a pattern of vines and/or other organic decorative forms.

gable the roughly triangular upper section of an exterior wall created by a roof with two sloping sides.

archivolt moldings on the lower curve of an arch.

mullion a vertical or horizontal bar dividing windows into units.

of virtue over vice. Between the rose and lancet windows, representations of the fleur-de-lis and the donor's coat of arms (a yellow, three-towered castle against a red background) alternate with one another. These symbolic references to Queen Blanche suggest her desire to appropriate divine justice as she imitates Old Testament leaders and the Virgin Mary.

Members of the French aristocracy also paid for windows at Chartres, and it is possible that guilds (associations of craftsmen and merchants) did so, too. Scenes in the stained glass show the members of these organizations, their patron saints, donors' trade activities, and selected biblical narratives involving similar trades, such as carpentry, baking, and winemaking. Thus the forms and subjects of the cathedral's decoration seem to assert its importance for the entire community. However, such an interpretation probably underestimates the social tension that existed between tradesmen and clergy. Guild members may not have donated windows freely but rather under duress from clergymen. Thus, the community implied by the windows, united by ecclesiastical authority, may not have been so harmonious in reality. Whatever the case, the scenes depicted in the trade windows probably do not simply mirror everyday life. Instead, they represented an ideal, validating the work of clerics and guild members alike.

REIMS CATHEDRAL Reims Cathedral, the site of the coronation of French kings, was rebuilt shortly following a fire in 1211. The facade has three doorways (**Fig. 36.8**) that are all gabled, meaning they have an ornamental triangle of **tracery**. The combination of heavy **gables** and deep portals offers structural support to the ornate stonework of the tall facade and towers in a manner that shallower thresholds, built more into the facade, did not. Tracery and glass have replaced sculptural relief in the tympana, and sculpture and stained glass continue up the matching lattice-like bell towers.

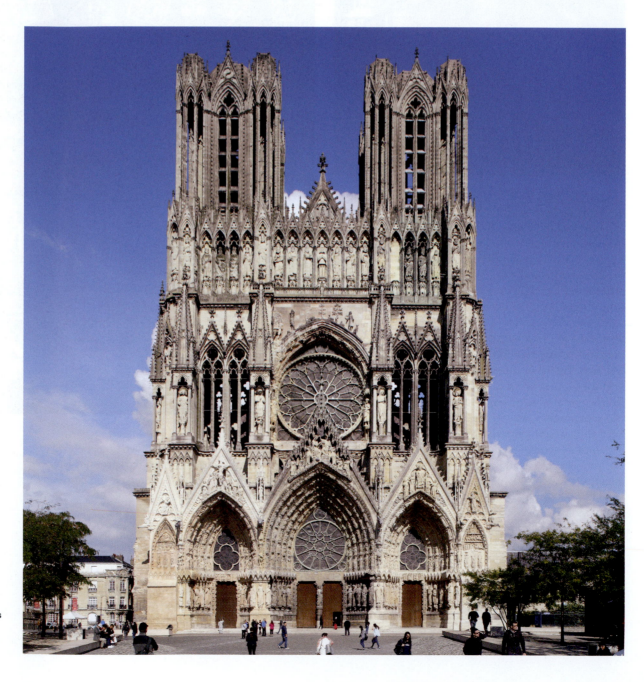

36.8 Western facade of Reims Cathedral (Notre-Dame), France. Facade work began *c.* 1252; towers completed 1475.

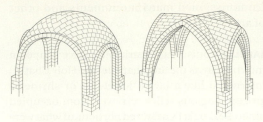

36.9 Semicircular vaulting (LEFT) **and rib vaulting** (RIGHT).

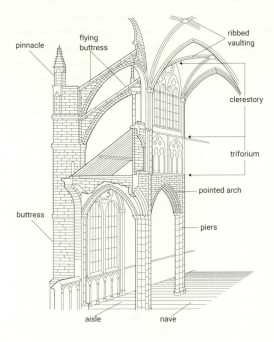

(labels: pinnacle, flying buttress, ribbed vaulting, clerestory, triforium, pointed arch, buttress, piers, aisle, nave)

During the Romanesque period, stonemasons at such places as Durham Cathedral (see Fig. 35.14) experimented with numerous vaulting systems (ways to support a ceiling with arches), hoping to discover more effective ways to bear the weight of the ceiling while providing greater light and height to the building. In the Gothic period, the use of the rib vault made the great cathedrals of Chartres and Reims possible.

The rib system, which serves as a kind of scaffold supporting the web sections of the vault, is versatile and strong enough to accommodate numerous bays because it is able to carry weight downward in a more effective manner than earlier vaulting systems. This new kind of vaulting depended on the use of pointed arches. Builders in the Sasanian empire (located in present-day Iran, *c.* 224–651 CE) and Muslim masons in western Asia and northern Africa had used the pointed arch prior to the Gothic era. However, they did not employ it as a device to support soaring vaults.

The stone vaults of Romanesque churches were typically arranged in square bays and had semicircular arches to support the weight of the ceiling (**Fig. 36.9**, left). The apex of each vault had to be positioned higher than all of the archways and the need for continuous masonry left little opportunity for window openings. In an effort to produce taller naves and add more window space, stonemasons experimented with vaulting systems and began to use pointed arches (**Fig. 36.9**, right), the height of which could be easily adjusted to bridge narrower spans. Greater confidence in the stability of each pointed arch was achieved through the addition of slender ribs, criss-crossing at the apex of each bay, or crossing the nave at the edge of each individual bay. Pointed arches permitted greater height than the rounded arches and offered greater flexibility to design a variety of shapes and sizes of vaults, including those in the side aisles and ambulatory. They also allowed for more window space, enabling Gothic interiors to soar in elevation with an abundance of light.

Additional supports, such as the use of flying buttresses, balanced with the counterweight of pinnacles (small spires that crown a buttress), enabled masons to construct taller churches with enlarged clerestories (**Fig. 36.10**). For example, the nave of Amiens Cathedral, the largest of the Gothic cathedrals built in France during the thirteenth century, reaches a height of approximately 144 feet (44 meters), while the clerestory comprises nearly two-fifths of the building's height.

36.10 LEFT **Elevation drawing of Amiens Cathedral** (Notre-Dame), Amiens, France, *c.* 1220–88.

Above the large rose window stands a row of (mostly reconstructed) statues of French royalty, depicted at over life-size, under a gallery of uniform niches. The baptism of Clovis I, the first Christian monarch of the Franks, is represented in the center of the row. According to legend, this event happened at the site where Reims Cathedral was later built. In the gable above the **archivolts** of the central portal, Christ crowns the Virgin Mary as the Queen of Heaven, a gesture that echoes the royal coronations that occurred inside the church.

Nearly 125 feet (38 m) at its highest, the interior of Reims Cathedral also shows tight vertical integration of parts and high pointed arches along the nave. With an even larger clerestory, the nave opens emphatically to stained glass within thin stone **mullions,** and the rose window and tympana glow within the intricate patterns of the masonry tracery. Height and light dominate the church, simulating a radiant, heavenly space.

The jamb sculptures at Reims, carved decades prior to the western facade's construction, do not conform to the shape of the columns, as they do on the royal portals at Chartres (**Fig. 36.4**). Instead, on the central portal at Reims, larger-than-life-size figures on small pedestals turn to face each other in pairs (**Fig. 36.11**). Clutching his cape, the winged angel Gabriel (at far left) turns his head and shoulder and flexes his right knee, creating an S-shaped curve. Smiling, he faces the demure Virgin Mary (second from left) in the Annunciation, a scene in the New Testament in which Gabriel tells Mary she will conceive Christ. Beside that pair, to the viewer's right, is a Visitation scene, in which the veiled Virgin visits with her older cousin Elizabeth (at far right), mother of John

36.11 **Annunciation and Visitation,** Reims Cathedral, France, *c.* 1230–55. Jamb figures from the central portal of the western facade.

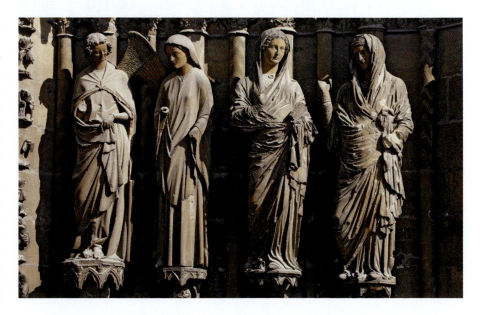

the Baptist. Exchanging gestures and sidelong glances, the pair appear to be calmly conversing. Their bodies seem to sway on their pedestals. Although only traces remain, **polychromatic** color was originally applied to these figures, enhancing their naturalistic appearance. A different group of artists likely carved this pair. In the Visitation scene the heavier, more animated robes with narrow folds reveal the women's pregnancies and suggest familiarity with Roman models. These stockier figures contrast with the delicate gracefulness of Gabriel. Such subtle stylistic differences suggest that multiple workshops completed this sculptural ensemble.

Louis IX and the Courtly Style, 1240–1350

The thirteenth century was a time of economic prosperity in western Europe. In Paris, the economic and political center of power in France, further Gothic stylistic innovations were developed under the patronage of rulers as well as churches. The pious and politically astute King Louis IX of France, who reigned for

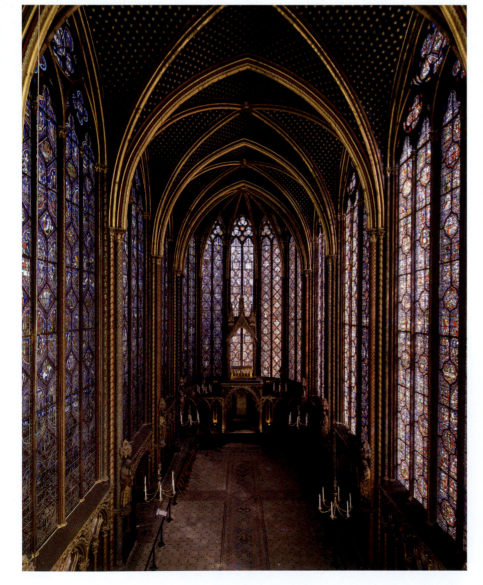

36.12 Upper chapel, Ste-Chapelle, Paris, 1243–48.

forty-four years (1226–70) and was later canonized (1297), commissioned many monuments and other works of art.

STE-CHAPELLE Louis IX's remarkable palace chapel in Paris, known today as the Ste-Chapelle (the Holy Chapel) was constructed like a lavish jewel-box or shrine to house prized religious relics retrieved from occupied Constantinople. Louis IX acquired portions of what were believed to be the crown of thorns (placed mockingly on the head of Christ), the holy cross, and other relics of the Crucifixion (in which Christ was said to be put to death on the cross) from his cousin Baldwin II, who ruled Constantinople during the Latin occupation of the city. Nineteenth-century art historians described the dazzling Gothic style of Ste-Chapelle as *rayonnant*, named after the radiating spokes of its decorative tracery. Although it was considered the court style of Louis IX, it would go on to be emulated by royalty and aristocracy throughout Europe.

Louis IX's Ste-Chapelle was built in two parts. Its upper story connected with the private royal apartments of the palace and was reserved for the royal family's exclusive use, while the lower story was used as a church by members of the royal household. The upper chapel (**Fig. 36.12**), at almost 50 feet (15 m) high, is an open room in which the walls seem to have almost disappeared. It emphasizes the taste for height typical of the Gothic style. Its unbroken shafts culminate in ribbed vaults. The seemingly weightless architecture provides the frame for an apparently continuous expanse of gleaming stained glass, supported within thin mullions similar to those of the windows of Reims Cathedral. The cycle of Old Testament scenes emphasizes royal coronations, as later fulfilled by Christ's crowning with thorns during his Crucifixion. Together, these images blend kingship with sanctity. Originally, the western windows (replaced by a rose window in the 1480s) depicted the Apocalypse and the Last Judgment.

Between 1355 and 1414, the choir of Charlemagne's Palatine Chapel (see Figs. 29.7 and 29.8) was remodeled in a manner that closely imitates the design of Ste-Chapelle. The resemblance between these two royal buildings reinforced the connection between Charlemagne and Louis IX as French monarchs, just as it reaffirmed the precious quality of the relics in their possession.

PSALTER OF ST. LOUIS The splendor of both the architecture and stained glass at Ste-Chapelle is also captured in the small pages of Louis IX's ornate **psalter**. The full-page **illuminations** of this **manuscript** were decorated with costly pigments. In addition to containing the liturgical calendar, the Psalter of St. Louis includes the anniversaries of royal relatives and the dedication of Ste-Chapelle.

These illuminations depict Old Testament narratives that often reinforce a thirteenth-century belief that the French had displaced the Israelites as God's chosen people. Here, two sequential scenes are shown in one frame (**Fig. 36.13**). On the left, the patriarch Abraham

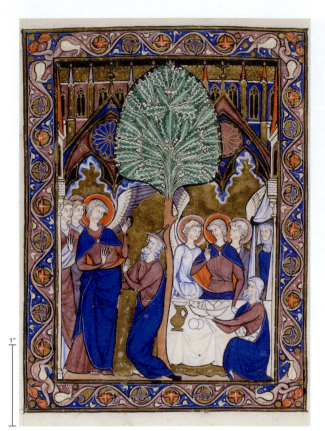

receives the three angels, who are associated with the Christian doctrine of the Trinity (God the Father, the Son, and Holy Spirit as three-in-one). The delicate features, small heads, and swaying poses of these angels are similar to those of the Reims Gabriel sculpture (**Fig. 36.11**). On the right, Abraham serves the angels at a table. Behind the figures, a building with pointed arches and rose windows echoes contemporary architectural design. Overall, the strong outlines and glowing colors of the illumination resemble a stained-glass window.

HOURS OF JEANNE D'EVREUX A later Gothic manuscript, commissioned by the French queen Jeanne d'Evreux and painted by the Parisian miniaturist Jean Pucelle, evokes courtly elegance (**Fig. 36.14**). Rather than relying on colorful splendor, as in the Psalter of St. Louis, Pucelle paints his gracefully swaying figures in shades of gray (*grisaille*), making them appear like ivory sculptures. This technique, together with the intimate scale of the book, creates a sense of delicacy. The tiny, carefully crafted **Book of Hours**—only 3½ inches tall—is a compendium of prayers, organized around the monastic daily schedule. During the late Middle Ages, books of hours proved to be quite popular among aristocrats; the books indicated their owners' religious devotion and their elevated social and economic status.

On the left page, the Passion cycle begins with the arrest of Jesus and his betrayal by Judas, through a sinister kiss. Christ, in the center of the group, is depicted gracefully. His body sways, echoing the shape of the Virgin Mary on the opposite page. Toward the left, St. Peter, intent on defending his leader, cuts off the ear of Malchus, the high priest's servant. Yet the placement

of Christ's right arm (to the viewer's left) seems to foretell the guard's miraculous healing. The elevation of a lantern at top center indicates that the event occurred at night. Below the holy figures is another courtly scene that may also reference the sacred: Knights riding wild beasts attack a wine barrel with their lances, perhaps referring to the shedding of Christ's blood.

On the right page, beneath the main image, which depicts the Annunciation, Pucelle depicts his crowned queen, Jeanne d'Evreux, kneeling with open prayer book in hand. She appears inside the initial D (the first letter of Domini, or Lord). The setting for the main scene is a serene interior, with angels praying in the attic and a special opening on the roof for the dove of the Holy Spirit to enter the chamber. Space and scale are suggested here, but the figures have priority, and dwarf the setting. An angel on the lower right lifts the Virgin's home, an allusion to the story of angels transporting her house to Loreto, Italy. At the bottom of the page, the artist has depicted a medieval game of tease called frog-in-the-middle, played by aristocrats at the onset of a courtship. Rabbits, which could serve as symbols of both chastity and procreation, also appear at the feet of those playing the game. The meaning of the vignette is ambiguous, but it may refer to the springtime beginnings of secular romance, or to that of sacred love. After all, the Feast of the Annunciation, celebrating the mystical bond between God and the Virgin Mary, occurs on 25 March, nine months before Christmas.

This Book of Hours was probably given to Jeanne d'Evreux on the occasion of her wedding at the age of fourteen to Charles IV, who had been married twice before, but was without a male heir. Under these circumstances, the miniature book may have held special significance for the young queen seeking the gift of a son. Jeanne went on to have three daughters, but the lack of a male heir meant the end of the Capetian dynasty. The ensuing dispute over royal succession was a major factor in the outbreak of the Hundred Years' War.

36.13 FAR LEFT **The Hospitality of Abraham, from the Psalter of St. Louis** (fol. 7v), 1252–70. Tempera, ink, and gold leaf on vellum, 5 × 3½ in. (12.7 × 9 cm) Bibliothèque nationale de France, Paris.

Book of Hours a Christian devotional book corresponding to the liturgical hours honoring the Virgin Mary.

36.14 Jean Pucelle, **The Betrayal of Christ and The Annunciation from the *Hours of Jeanne d'Evreux**, (fol. 15v and fol. 16r), Paris, *c.* 1324–8. Grisaille, ink, and tempera on vellum, each page 3½. × 2½ in. (8.9 × 6.4 cm) The Cloisters Collection of the Metropolitan Museum of Art, New York.

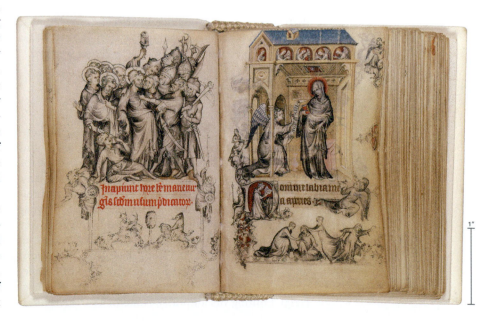

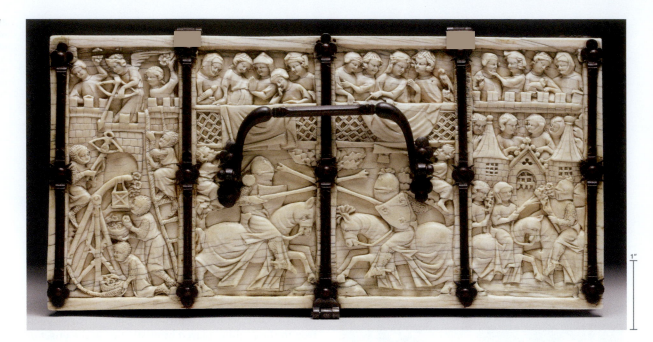

ATTACK ON THE CASTLE OF LOVE Courtly love played a major role in the lives of nobility, as a fourteenth-century ivory jewelry box shows. The lid of the luxurious container, which was probably constructed by a Parisian workshop during the heyday of the trans-Saharan ivory trade, depicts an attack on the castle of love (**Fig. 36.15**), a common motif in contemporary romance literature. On the left, male suitors attempt to penetrate the fortress with catapults and crossbows. The castle is protected from above by women, who pelt the attacking soldiers with flowers. Cupid, personifying erotic love, defends the maidens, although he is also ready to pierce the hearts of men with his arrow. In the middle panels, two knights joust to capture the attention of the ladies. On the right, a maiden and her knight point long-stemmed roses at each other, while a female witness grips oak branches, symbolizing the long-term durability of their devotion.

This jewelry box was likely commissioned as a gift, representing the depths of the couple's love and the virtue of its recipient. The sides of the casket are also carved with tales of courtly romance and a scene of a wounded unicorn. According to legend, the ivory-horned beast could be tamed and captured only by chaste women.

English Gothic Architecture, 1200–1400

The technical accomplishments of Chartres and contemporary cathedrals spread internationally and dominated church construction in western Europe for centuries to come. During that period, England, Germany, Spain, and Italy developed important regional variations on the aesthetics of height and light made popular in France. In the early thirteenth century, the power of the English monarchy diminished. King John (the villain in the tale of Robin Hood), nicknamed Soft Sword and Lackland, lost land holdings to Philip of France, and local barons forced him to sign the Magna Carta (1215), limiting his authority. Nonetheless, the Church

in England continued to thrive. When ecclesiastical edifices were damaged by fire or in need of renovation, they were readily rebuilt, frequently in stylistic dialog with the latest French style, namely the Gothic. Sometimes, French architects were even employed to complete these projects. Newly constructed English churches often incorporated Gothic elements, such as lancet windows and pointed arches, in their design without forfeiting traditional expectations concerning horizontality and the use of decorative lines.

SALISBURY CATHEDRAL While English Gothic architecture was informed by developments in France, not least because of the country's Norman rulers, it exhibited its own distinct character. French churches emphasized both height and light, but English churches modified this approach to underscore vast length with increasingly decorative ornament, with the goal of enhancing splendid religious processions. One example is Salisbury Cathedral (**Fig. 36.16**), an early English Gothic church founded by Bishop Richard Poore. With an elongated nave, the plan features a double transept and culminates in a square chapel. In many English churches, this chapel, dedicated to the Virgin Mary, is called a Lady Chapel.

Poore tore down the old church and relocated the site of the area's new cathedral from the previous placement at the cramped fortress of Old Sarum to his own undeveloped property. The city of Salisbury subsequently grew around the newly constructed church, which is still set in a park-like setting today. In contrast to the soaring facade at Reims, Salisbury's facade is low and shallow, giving little suggestion of the arrangement of internal building spaces behind it. Rather than paired bell towers, it bears a crossing tower and spire (the tallest in medieval Britain). Salisbury has neither the enormous height nor the sizable clerestories of French Gothic cathedrals, and its flying buttresses, added later to support the tower's construction, are more modest in scale.

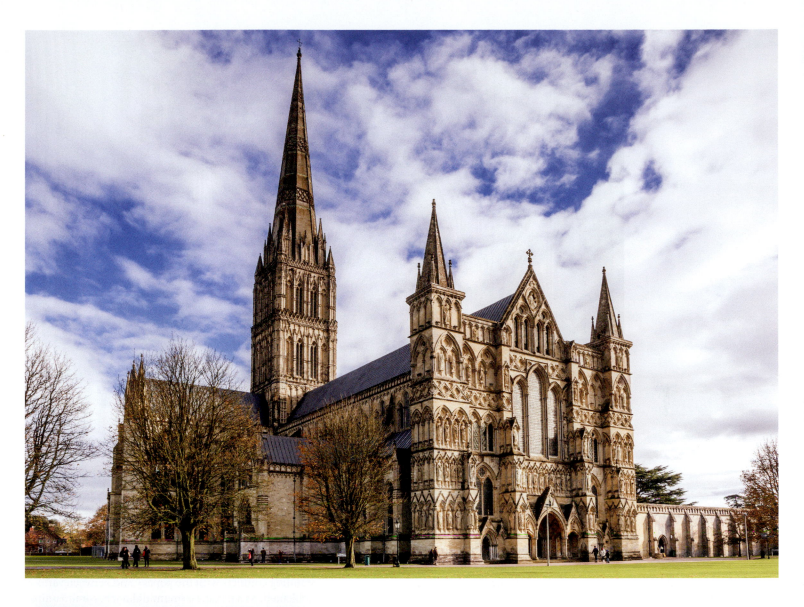

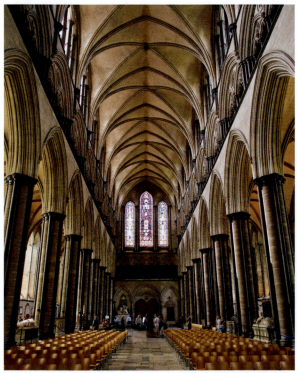

In the interior of Salisbury Cathedral, the ribbed vaulting is supported by corbels (projections from the wall to support the vaulting) resting on the triforium (**Fig. 36.17**), unlike the massive piers that extend to the church floor in Chartres and Reims. Although this architectural arrangement disrupts vertical unity, it places greater emphasis on horizontal continuity, which is further reinforced by the application of darker Purbeck marble—named after the Isle of Purbeck—in the columns of the triforium.

EXETER CATHEDRAL In the mid-thirteenth century, English Gothic architecture began to change, as it had in France. The rebuilt interior of Exeter Cathedral, although less than seventy feet high, is far more ornate than that of Salisbury. Within each bay, eleven ribs spring from diamond-shaped piers, meeting at the summit of the elongated nave (**Fig. 36.18**, p. 604). Sizable windows are accentuated by elaborately patterned tracery; these are key features in defining the building as an example of Decorated Gothic style, emulating characteristics of the *rayonnant*. At Exeter, ornamental flourishes take precedence over structural clarity. The preoccupation with ornamental ceiling design in English church architecture expanded during the fourteenth century, with the introduction of fan vaulting,

36.16 ABOVE **Salisbury Cathedral** (Blessed Virgin Mary), southwest view. England, 1220–58; spire *c.* 1320–30.

36.17 LEFT **Salisbury Cathedral** (facing west).

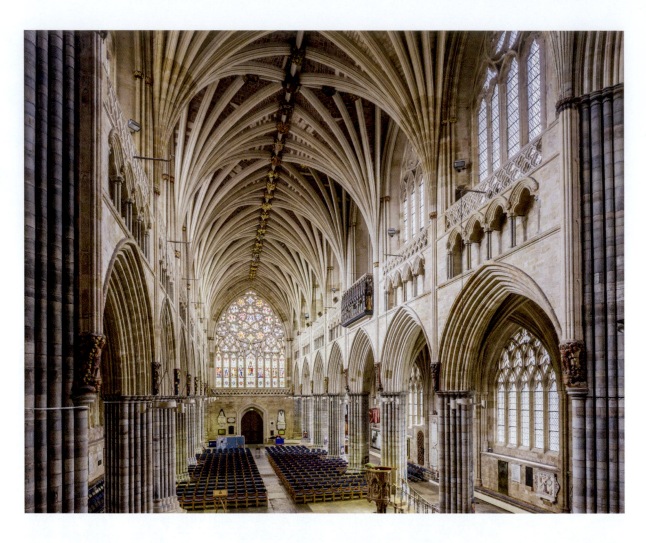

36.18 Exeter Cathedral
(St. Peter), facing west. England, c. 1270–1350.

which includes curved ribs that spread out and appear to rotate across the surface of the ceiling, like a fan, from a single point on the adjacent wall.

Late Medieval Germany and Bohemia, 1200–1400

After the death of Frederick II, the Holy Roman Empire, which consisted of German-speaking territories and Bohemia (the western region of the present-day Czech Republic), deteriorated. It remained weakened by long-standing conflicts with the papacy and between various noblemen. As a result, Germany did not become a united nation-state until the nineteenth century. Although the Holy Roman Empire continued to lack political strength during the thirteenth to the fifteenth century, the Church was able to exercise its authority. In the second half of the fourteenth century, Charles IV of Bohemia was crowned emperor. Under his leadership, art and architecture flourished in his capital city of Prague. Nonetheless, Charles IV was unable to revitalize the empire to the level it had enjoyed in its glorious past under Charlemagne in the early Middle Ages.

STRASBOURG CATHEDRAL A clear kinship of faces and draperies links the Reims sculptural workshops (as seen in the Annunciation and the Visitation scenes, **Fig. 36.14**) to nearby Strasbourg Cathedral, then part of a German-speaking borderland region of the Upper Rhine. In the Dormition, or Death of the Virgin, tympanum above Strasbourg's south transept portal, Christ is depicted toward the center of the scene, above the figure of Mary on her deathbed (**Fig. 36.19**). Closer inspection reveals a doll-like form in his hands, representing the soul of his mother as she leaves the earthly realm. The dying Virgin is clad in the same tight, clinging drapery as her depiction in the Reims Visitation. The garments, rendered

36.19 The Dormition, Strasbourg Cathedral,
tympanum from the south transept. Strasbourg, France, c. 1230.

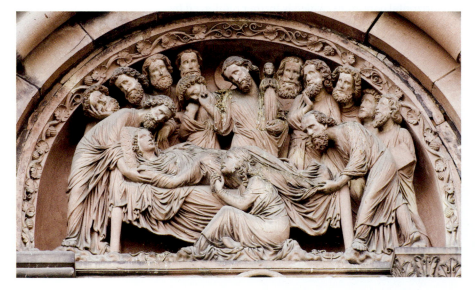

in an abundance of folds, also echo the supple movements of bodies across the foreground of the scene. One of Christ's earliest and closest followers, Mary Magdalene, the female mourner in profile at the bottom center, displays a heartfelt gesture of grief. Within the semi-circular tympanum shape there is a densely packed group of heads, primarily the bearded faces of the anguished apostles (Christ's disciples minus Judas, with the addition of St. Paul), which introduce new varieties of emotional intensity and natural description into the sculptural narrative. Although the carved tympanum at Strasbourg may have been informed by imagery at Reims, it elicits a stronger psychological response. Art and architecture throughout German-speaking lands may have borrowed elements of the French Gothic style, but this should not be interpreted in terms of a passive imitation. On the contrary, this appropriation is deeply intertwined with the active desire for innovation.

MAGDEBURG CATHEDRAL Thirteenth-century German figurative sculpture, like that in France, was naturalistic in appearance. And yet, it is more frequently a straightforward portrayal than a delicate ideal. In 1207, Magdeburg Cathedral, located in present-day eastern Germany, was nearly destroyed by a fire. Subsequently, it was rebuilt in the Gothic style. The church houses the relics of St. Maurice, a Christian warrior-saint of the third century CE from Egypt who led a brigade to Germany, where he

was martyred for refusing to worship Roman deities or persecute Christians. New sculptures were commissioned to decorate the new building, including a life-size representation of the heroic St. Maurice (**Fig. 36.20**). The polychromatic figure is striking in its naturalism. Its features and dark complexion reinforce St. Maurice's African identity; this is a rare medieval European representation of a person of color in an accepted position of power. The saint is dressed in medieval armor, including chain mail and a leather breastplate. In his right hand, he probably once held a lance (now lost). The figure initially had legs, and may have worn spurs.

St. Maurice was revered by Christian military leaders, including the Holy Roman Emperor Otto I, who donned Maurice's legendary sword and spurs for his coronation in 962 CE. He was anointed emperor at the altar of St. Maurice in the Roman basilica of St. Peter. Subsequent emperors often followed Otto I's lead, offering special devotion to the military saint. Although the sculpture was originally placed on the church's exterior, it has been relocated to the church's choir, near the imperial tomb of Otto I.

EKKEHARD AND UTA, NAUMBURG CATHEDRAL The naturalistic depiction of figures also flourished across western Europe. In the town of Naumburg, Germany, Bishop Dietrich II of Wettin commissioned a series of life-size sculptures (**Fig. 36.21**). The subjects were his

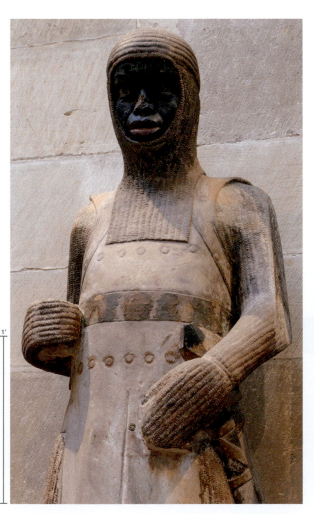

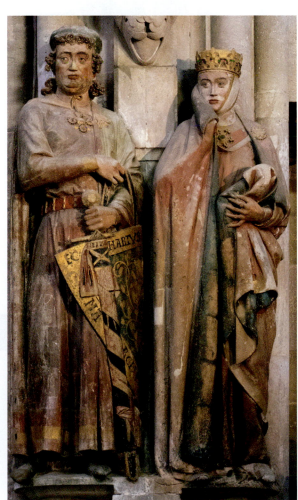

36.20 FAR LEFT **St. Maurice, Magdeburg Cathedral,** Germany, c. 1240–50. Sandstone sculpture with polychromy, height 3 ft. 9 in. (1.14 m).

36.21 LEFT **Ekkehard and Uta, Naumburg Cathedral,** Germany, c. 1245–60. Choir sculptures; stone with polychromy, height 6 ft. 2 in. (1.88 m).

aristocratic ancestors, who served as benefactors of Naumburg Cathedral, and the sculptures were placed in the cathedral's choir, between the nave and the altar. Two of the figures, Ekkehard and Uta, are especially noteworthy. Although the margrave (a princely military commander) and his wife lived in the eleventh century, long before their carved representations were produced, these sculptures seem as if they are portraits. Ekkehard leans against his ceremonial sword, ready to defend Christendom from potential attack, as he reaches across his body for the edge of his cloak. Uta's right hand lifts her collar to cover the nape of her neck, while her left hand gathers the folds of her garment. Traces remain of the polychromy that once enhanced the figures' naturalistic appearance.

PIETÀ ROETTGEN In the Rhineland (the area near the Rhine river separating modern France and Germany), the visual arts were frequently employed to stir emotions in viewers. One example is this wooden sculpture of the Virgin Mary embracing her dead son, a scene known as a *Pietà* (**Fig. 36.22**). Named the Pietà Roettgen after a former collector, the object was initially placed on the altar within a nunnery's chapel. The sculpture is designed to provoke an intense psychological response to Christ's suffering and horrific death. His bony body with its tightly stretched skin is depicted as broken. Thick blood explodes from gruesome wounds in his side, feet, and hands, evoking greater compassion for the deceased son and his grieving mother.

Unlike the well-known later *Pietà* (see Fig. 45.11) by Michelangelo, this sculpture is difficult to view due to its warped proportions and unflinching representation of bodily suffering and grief. Yet the hauntingly gruesome character of the Pietà Roettgen and the attention it calls to Christ's blood are purposeful. The late medieval mystic Heinrich of Suso encouraged the faithful to meditate on Christ's suffering, in the belief that the means of redemption resided in his wounds. Through empathetic identification, he hoped that Christians might move from the visual to the visionary, ultimately achieving mystical union with the divine.

CHAPEL OF THE HOLY CROSS, KARLŠTEJN CASTLE The desire to make sacred figures more accessible was also occasionally employed to reinforce implicit connections between the power of secular monarchs and that of the divine. In Bohemia, the Holy Roman Emperor Charles IV, who was related to the French kings on his maternal side, commissioned a new castle—Karlštejn Castle—to be built atop a hill 20 miles (around 32 km) outside Prague. Like Louis IX and Charlemagne, Charles IV built his chapel to house his collection of sacred relics. In his extravagant Chapel of the Holy Cross (**Fig. 36.23**), highly ornate rib vaults, covered in gold, stretch across the room. The lower portions of the walls are decorated with polished precious stones—jasper and amethyst—arranged in cross-shaped patterns. These costly materials showed the emperor's great wealth while also marking his devotion, for according to the Book of the Apocalypse, the

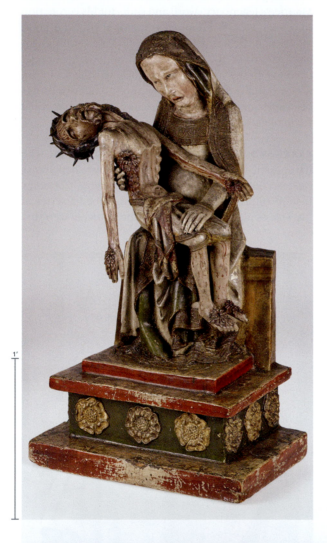

36.22 Pietà Roettgen, *c.* 1330. Wood with polychromy, height 34½ in. (87.63 cm). LVR-LandesMuseum Bonn, Germany.

Chronology

c. 1135	Abbot Suger initiates the remodeling of St-Denis	1337	The Hundred Years' War begins
1194	Construction of Chartres Cathedral starts	1355	Charles IV of Bohemia becomes Holy Roman Emperor
1215	King John of England signs the Magna Carta at Runnymede	13th–14th centuries	Salisbury Cathedral is built
1211	Reims Cathedral is rebuilt		
c. 1324–28	The *Hours of Jeanne d'Evreux* is produced	15th century	The introduction of fan vaulting

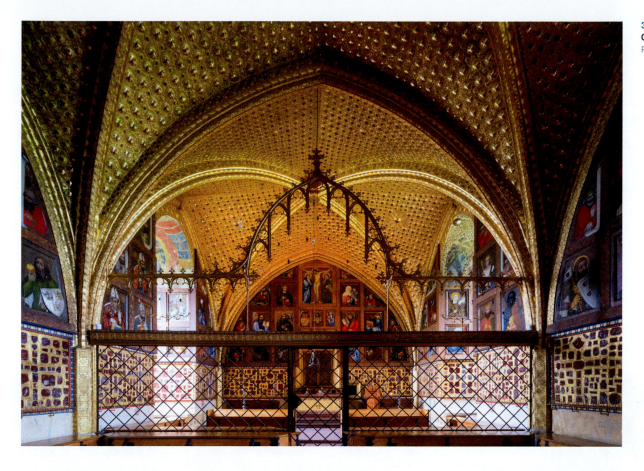

walls of the heavenly city of Jerusalem are adorned with jasper and every kind of precious stone.

Above the gemstones, the archways of the walls are filled with three tiers of panel paintings framed in gold. The paintings, mostly attributed to the court painter Master Theodoric and his workshop, include 130 portraits of Christian saints, including some of the emperor's ancestors, such as Charlemagne, who Charles hoped would reach sainthood. A scene of the Crucifixion is located at the top center of the altar wall. The surrounding portraits function as a crowd of witnesses affirming the presence of the divine.

Charles, who was educated in Paris at the Sorbonne (University of Paris), was familiar with Ste-Chapelle (**Fig. 36.12**). In many ways, Karlštejn was his alternative to that *rayonnant*-style chapel. Rather than employing stained glass and delicate designs to show the sanctity of his relics, Charles used gold, precious stones, and painted **icons** to house his sacred treasure.

Throughout the thirteenth and fourteenth centuries, royalty and the visual arts helped shape each other. Political leaders and ecclesiastical authorities, who were often affiliated with European courts, commissioned works of art to convey their wealth, their piety, and their taste for precious objects. Gothic architecture, which was closely associated with the French monarchy, quickly became the dominant model to emulate. Yet, outside of France, the Gothic was interpreted in a variety of ways as local artists discovered new ways to blend artistic and architectural innovations with traditional modes of construction, including those rooted in Classical antiquity. Despite Vasari's infamous condemnation of the Gothic, it is difficult to imagine the Renaissance, in either northern Europe or Italy, coming to fruition without it.

Discussion Questions

1. How did Abbot Suger's vision of architecture differ from that offered by the Cistercian leader St. Bernard of Clairvaux?
2. How did architects at Salisbury and Exeter in England respond to French Gothic architecture in different ways?
3. Compare and contrast the way in which the Virgin Mary is depicted on the portal sculptures at Reims Cathedral with her representation in the Pietà Roettgen.
4. What is courtly love? How did works such as the *Attack on the Castle of Love* promote its ideals?

Further Reading

- Avril, François. *Manuscript Painting at the Court of France: The Fourteenth Century, 1310–80*. New York: George Braziller, 1978.
- Bony, Jean. *French Gothic Architecture of the 12th and 13th Centuries*. Berkeley, CA: University of California Press, 1983.
- Camille, Michael. *Gothic Art: Glorious Visions*. Englewood Cliffs, NJ: Prentice Hall, 2005.
- Recht, Roland. *Believing and Seeing: The Art of Gothic Cathedrals*. Trans. Mary Whittall. Chicago, IL: University of Chicago Press, 2008.
- Williamson, Paul. *Gothic Sculpture, 1140–1300*. New Haven, CT: Yale University Press, 1998.

icon an image of a religious subject used for contemplation.

37

Art of the Late Middle Ages in Italy

1200–1400

Detail of Ambrogio Lorenzetti's
*Allegory of the Effects of
Good Government.*

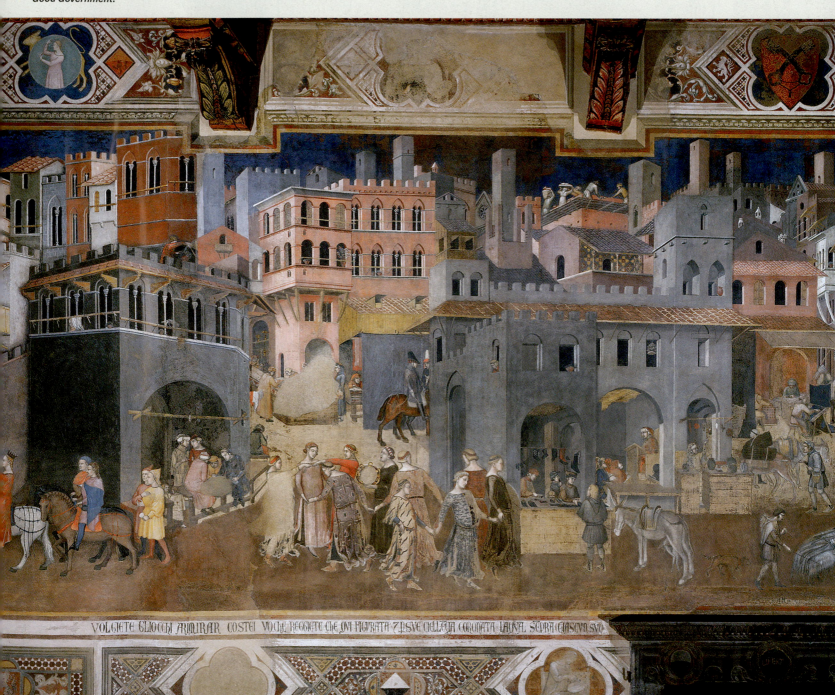

Introduction

During the thirteenth and fourteenth centuries, the Italian peninsula was divided into numerous political territories (**Map 37.1**) variously controlled by the papacy, the Holy Roman Emperor, regional kings, or hereditary titled rulers such as dukes. In Tuscany (a region in central Italy) powerful cities with growing populations and prosperity demanded greater autonomy and began functioning as independent states, controlling surrounding areas. Liberated from aristocratic rule, the people of Florence established a republic governed by the *Signoria*, a town council, the members of which were selected by the *gonfaloniere* (the community's highest officer), who was in turn elected by the city's guild members. The citizens of Pisa and Siena also broke free from feudal lords in the late Middle Ages and established republics of their own.

By contrast, Venice did not obtain independence from local aristocrats. The lagoon city in the northeast of the peninsula was ruled by the Great Council, which consisted of local nobility who inherited their membership. The Great Council appointed the republic's chief magistrate, or *doge*, for life. Unlike dukes, who gained their position by birthright alone, Venetian *doges* were chosen for their political prowess.

The strength of Venice and these other city-republics was closely tied to the rising influence of merchants and bankers, whose economic power was enhanced by long-distance trade. The Venetian navy controlled much of the Mediterranean Sea, granting access to commerce with north Africa and Asia. Venetian merchants—such as Marco Polo, who traveled to Asia—returned home with imported spices and silk. During the late thirteenth century, Florentine and Venetian currencies (the florin and the ducat) became international monetary standards, and Italian bankers offered loans to popes and kings.

The unprecedented increase in wealth on the Italian peninsula created new patrons for the arts beyond the Church and the nobility, giving artists new opportunities to obtain greater economic prosperity and social prestige. During this period of significant innovation, the visual arts became more naturalistic in appearance as patrons sought to build stronger communities by cultivating civic virtue, international trade, and religious piety. More naturalistic styles communicated information on an easily understood, human level to a popular audience, developing widespread support not only for political entities but also for religious beliefs.

Seeking the Common Good

To foster civic unity and encourage greater prosperity, prominent families in Italian city-states made alliances. Although these alliances did not eliminate all rivalries, they provided additional security for the community and a greater sense of shared governance, at least among the wealthy. However, they did not curtail tensions between the new republics and other principalities, and outbreaks of war and disease periodically struck the communities hard. All of these factors had a major impact on the production and consumption of art and architecture on the Italian peninsula.

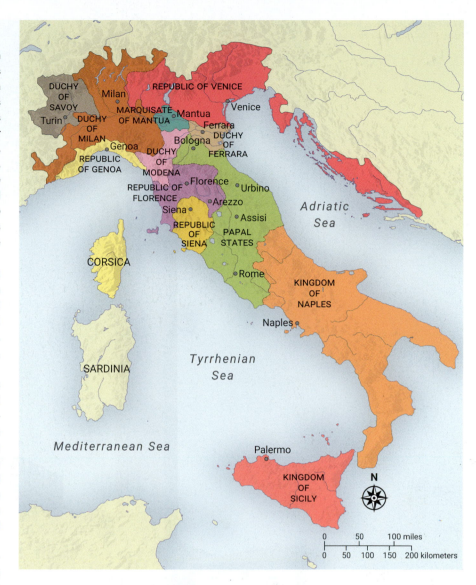

Map 37.1 Italian city-states *c.* 1400.

PALAZZO PUBBLICO, SIENA Tuscan city-republics invested in public architecture to enhance their prestige, to foster local pride, and to consolidate power. Cities competed with one another over the height of their towers and the size of town halls, where elected councils met and conducted business. The republic of Siena had gained independence from the Tuscan counts and local bishops in 1167. After 1315, the governing town council operated out of the Palazzo Pubblico (public palace) (**Fig. 37.1**, p. 610), a new town hall constructed in the Piazza del Campo, an open area in the center of the city. The palace **facade** is slightly curved to accommodate the irregular fan-shape of the piazza. The piazza is paved with bricks of a reddish-brown color (later called burnt sienna) with nine lines of white travertine (a form of limestone), symbolizing the number of elected members of the executive council.

With its **crenellated** roofline, the palazzo resembles a fortress, symbolizing the city's political power and military strength. Unlike a castle, however, it includes many wide windows, displaying little concern for vulnerability to attack. In addition, the palazzo did not serve as a residence for royalty or aristocrats. On the contrary, family rivalries were set aside to emphasize the common good.

facade any exterior vertical face of a building, usually the front.

crenellation fortified wall with notches or openings on top.

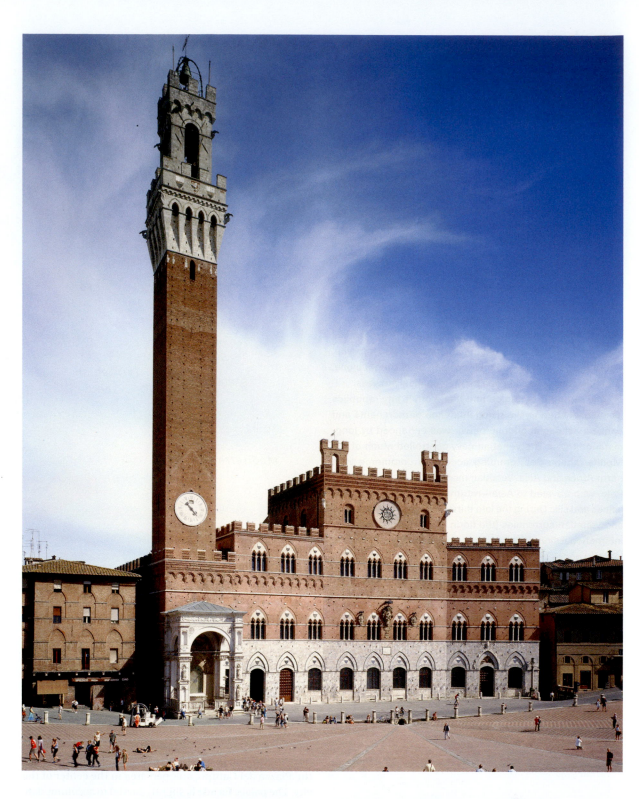

37.1 Palazzo Pubblico, Siena, Italy, *c.* 1297–1310, tower, 1325–44.

campanile an Italian word meaning "bell tower."

fresco wall or ceiling painting on wet plaster (also called true fresco or *buon fresco*); wet pigment merges with the plaster, and once hardened the painting becomes an integral part of the wall; painting on dry plaster is called *fresco secco*.

The slender, soaring **campanile**, Torre del Mangia, was added to the structure shortly after the palazzo's construction. In 1354 a chapel (Capella di Piazza) was added at the base, which between 1468 and 1470 received a marble canopy. Although the *campanile* may have served as a watchtower, its primary function was to announce council meetings with the chime of its bells. Siena's tower was constructed to be taller than that of Florence's Palazzo della Signoria (named after the city's ruling class and later renamed the Palazzo Vecchio or "old palace"), but its height is equal to that of Siena's cathedral, suggesting a balanced partnership between Church and State.

AMBROGIO LORENZETTI, SALA DEI NOVE FRESCOES
The interior of the Palazzo Pubblico included a wing for the *podestà*, a person whose function was similar to that of a city's mayor, and a chamber called the Sala dei Nove (or the Sala della Pace, the "Peace Hall") for the Council of Nine magistrates. In 1338, the Sienese painter Ambrogio Lorenzetti (1290–1348) was contracted to paint enormous panoramic **frescoes** (see box: Making It Real: Fresco) on three walls of this meeting room, two of which are illustrated here. These monumental secular paintings are among the first in Europe since antiquity, reflecting significant political patronage beyond the

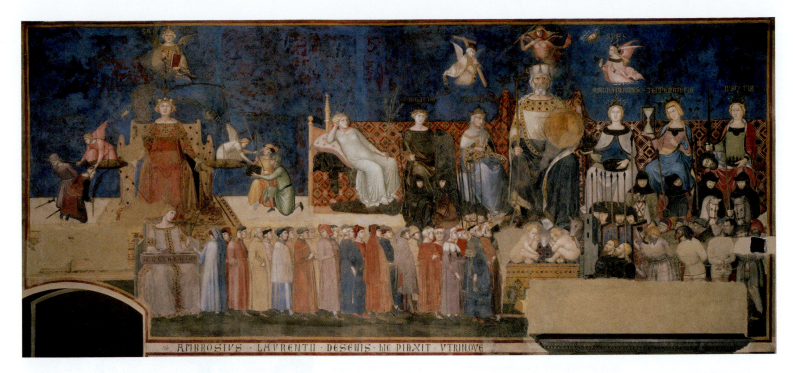

37.2 Ambrogio Lorenzetti, *Allegory of Good Government*, north wall of the Sala dei Nove, Palazzo Pubblico, Siena, Italy, 1338–39. Fresco.

Church or nobility. At the same time, the **iconography** deliberately connects the current secular leadership to religious themes as well as to the mythological history of Siena's founding.

On the north wall, Lorenzetti painted an elaborate personification of the Common Good (*buon commune*), the seated male shown in **hierarchical scale**, protected by a shield decorated with an image of the Virgin Mary and the infant Jesus (**Fig. 37.2**). The letters cscv, an abbreviation for Commune of Siena, City of the Virgin, encircle the allegorical figure's head, reinforcing the link between politics and piety in the community. The Christian virtues (Hope, Faith, and Charity) fly above the personification of Siena's Common Good, reinforcing the city's promotion of morality. Below him, Romulus and Remus (the legendary twins associated with the foundation of Rome) suckle upon the she-wolf, affirming the local myth that sons of Remus founded Siena.

In the lower right, triumphant Sienese soldiers present captured enemies, an indication of their success in battle and in maintaining social order. To the far left, the enthroned figure of Justice appears. She is informed by Wisdom, who hovers above, punishes the guilty, and distributes rewards to the deserving.

The eastern wall holds *The Effects of Good Government in the City and in the Country* (**Fig. 37.3** and p. 608). This fresco displays the anticipated results of proper governance through a naturalistic representation of contemporary Siena, with the cathedral's dome and *campanile* in the upper left. At the center is the Roman Gate (*Porta Romana*), which marked the threshold between the city and the countryside. Many types of buildings are shown, including shops and palaces, and one building with a group of masons working on the roof. The painting represents not only Siena's current appearance but also a glimpse of its idealized future. Within this

iconography images or symbols used to convey specific meanings in an artwork.

hierarchical scale the use of size to denote the relative importance of subjects in an artwork.

37.3 Ambrogio Lorenzetti, *The Effects of Good Government in the City and in the Country*, east wall of the Sala dei Nove, Palazzo Pubblico, Siena, Italy, 1338–39. Fresco.

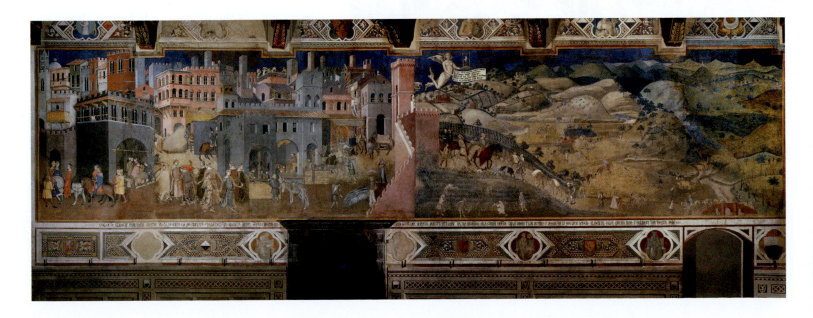

37.4 FAR RIGHT **Nicola Pisano, pulpit**, Baptistery, Pisa, Italy, 1260. Marble and granite, height 15 ft. 3 in. (4.65 m).

pulpit a raised lectern from which priests read biblical passages and deliver sermons.

baptistery a building or room reserved for the sacrament of baptism.

basilica the central aisle of a basilica or church.

polychrome displaying several different colors.

Corinthian an order of Classical architecture characterized by slender fluted columns and elaborate capitals decorated with stylized leaves and scrolls.

capital the distinct top section of a column or pillar, usually decorative.

sarcophagus a container for human remains.

relief raised forms that project from a flat background.

37.5 Nicola Pisano, *The Annunciation, Nativity, and Adoration of the Shepherds*, baptistery, Pisa, Italy, 1260. Marble panel, 33½ × 44½ in. (85 × 113 cm).

thriving community, buildings are constructed, business transactions occur without conflict, and locals, probably men, dance in the broad street, their graceful movement eliciting social harmony. Serenity extends beyond the city's walls, with open gates and merchants and pilgrims able to travel across the country with security and ease. The agricultural landscape is fertile, with peasants working in the fields and signs of abundant harvest. Lorenzetti has rendered the distant fields and mountains with a degree of spatial depth unknown since ancient Roman painting.

On the west wall (not shown here), Lorenzetti painted an allegory of the effects of bad government. Although the mural is severely damaged, the dreadful results of bad governance are sufficiently visible. This community is ruled by the devilish cross-eyed figure of Tyranny, who is flanked by personifications of the Vices (categories of moral depravity). The crime-infested city is in ruins and the countryside has been devastated by fire and warfare. In Lorenzetti's fresco program, the moral of the story is clear: Perversion of the good brings death and destruction, whereas moral leadership ensures peace and prosperity. Unfortunately, the pursuit of virtue was unable to stop plague from spreading. Less than a decade after the painting was produced, the Black Death ravaged Siena, taking Lorenzetti as one of its victims.

NICOLA PISANO, PULPIT Unlike Siena, Pisa—known today for its leaning tower—did not build a grand town hall. Instead, its cathedral was the symbol of the city. In 1260, fifty-five years before the Palazzo Pubblico was built in Siena, the archbishop of Pisa commissioned Nicola Pisano (1220–1284) to make a freestanding stone **pulpit** for the city's **baptistery** adjacent to the cathedral (**Fig. 37.4**). In Tuscan cities, round or octagonal baptisteries stood apart from both **basilican** churches and their *campaniles*. The baptistery held religious and political significance. In addition to introducing infants into the

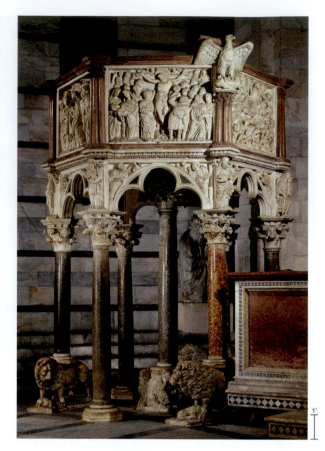

Christian faith, baptism also was used as a political ritual conferring the rights of citizenship.

Nicola Pisano's hexagonal pulpit rests on seven **polychromatic**, variegated marble-and-granite columns likely taken from ancient ruins in the Roman city of Ostia and repurposed in a Christian context. Their tops are decorated with broad leaves, reminiscent of **Corinthian capitals**, and three of the columns rest on the backs of newly sculpted lions hovering over killed prey, with the felines looking inward toward grotesque figures depicted on the base of the central pillar. Personifications of the Virtues (categories of moral excellence) are represented above the columns. They seem to derive from Roman models, chiefly **sarcophagus reliefs** from the nearby Campo Santo, an ancient Roman cemetery. In the personification of Fortitude (not pictured), a naked muscular man stands in a relaxed stance. He resembles Herakles (Roman: Hercules), known in ancient Greek mythology for his great strength.

Atop the pulpit's **trefoil** arches, Nicola sculpted carved marble panels on five sides (the sixth side is the staircase) representing the infancy of Jesus, his crucifixion, and the Last Judgment (the Christian belief of God's judgment of humankind at the end of the world). Carved in **high relief** against a blank background, these large figures fill the crowded space. The Nativity panel (**Fig. 37.5**), celebrating the birth of Jesus, includes the Annunciation (the moment when the Archangel Gabriel announces that Mary will be the mother of Jesus) and the Adoration of the Shepherds (who bear witness to Jesus's birth) in the upper corners. This inclusion of multiple stories in a single space suggests a **continuous narrative**. The Virgin

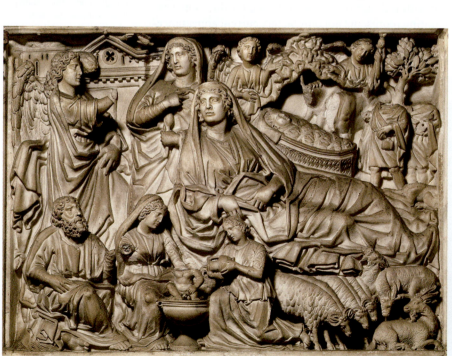

Mary makes multiple appearances. She stands next to the Archangel Gabriel, and she appears again directly below, reclining on a bed adjacent to her infant child, who is being washed. In both representations, Mary is larger than the other figures in the scene. Nicola's use of hierarchical scale reinforces Mary's importance within the narrative.

Nicola's relief carving reveals the influence of **Classical** Roman sculpture (see Fig. 19.3). The Virgin, reposing at the composition's center, wears a Roman *stola* (robe) with heavy drapery. Her round, fleshy face and straight nose resemble a curly-haired Roman matron (see Fig. 19.2) or the goddess Juno. In the lower left corner, an elderly Joseph appears amazed at the birth of Jesus. The foreground also adheres to the **Byzantine** tradition of depicting midwives attending to the newborn. Jesus appears a second time, in a manger in the upper right, awaiting the arrival of the angels and shepherds. The artist's combination of ancient Roman models for Christian (including Byzantine) subjects marks a shift in approach and a revitalization of Classical styles.

ANDREA PISANO, BAPTISTERY DOORS During the late Middle Ages, guilds gained influence and played a major role in the economic, political, and religious life of Italian city-states. These associations of craftsmen protected their hometowns from outside competition and fostered the emergence of a money-based economy. Guilds set quality guidelines for the items they imported and produced, and they also determined who could join their organization. A rigorous system of apprenticeship ensured technical proficiency, and guild decisions were often made to enhance political clout; for example, members of the city council were selected from Florence's major guilds. Women were prohibited from joining guilds and were thus ineligible for apprenticeship training, severely curtailing their ability to become artists. This exclusion also kept women from actively participating in city governance. Nonetheless, women continued to serve as important patrons of the arts.

In 1329, members of Florence's wealthy wool importers' guild commissioned Andrea Pisano (1290–1348, no relation to Nicola) to make a set of bronze doors for the baptistery of San Giovanni (**Fig. 37.6**). The doors are divided into a total of twenty-eight relief panels, with the bottom eight offering representations of the virtues and the remaining twenty depicting scenes from the life of Saint John the Baptist (*San Giovanni*), the baptistery's namesake and the city's patron saint. Each of the scenes is framed by **quatrefoil**, a motif that also reinforced uniformity across the panels. Intimate groups, consisting of a few key figures gilded in gold leaf, are placed against simple architectural settings or landscapes.

The panels are arranged on a sequential grid so that, like words on a page, each door is to be viewed top to bottom and left to right. John's infancy and mission are depicted on the left door. The narrative opens at the upper left, with Zechariah receiving the news that his wife Elizabeth will miraculously bear a son, and it closes on the lower right with a scene of Christ's baptism. The right door addresses John's martyrdom: in the upper left,

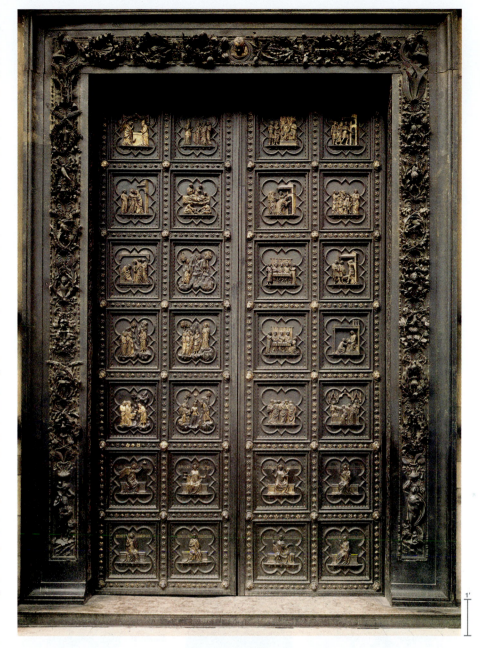

37.6 Andrea Pisano, South Doors, baptistery of San Giovanni, Florence, Italy, 1330–36. (Originally on the east side of the building). Gilt bronze, 16 ft. × 9 ft. 2 in. (4.88 × 2.54 m).

trefoil a decorative shape consisting of three lobes; resembles a three-leaf clover.

high relief raised forms that project far from a flat background.

continuous narrative multiple events combined within a single pictorial frame.

Classical artworks from, or in a style deriving from, ancient Greece or Rome.

Byzantine relating to the East Roman Empire, centered on Constantinople (present-day Istanbul) from the fifth century CE to 1453.

quatrefoil a decorative shape consisting of four lobes; resembles a stylized flower.

the saint reprimands King Herod for marrying the ex-wife of his own brother and the narrative ends in the tenth panel on the right with a vignette of John's beheading followed by a depiction of his burial.

Like the bronze doors at the abbey of St. Michael in Hildesheim (Figs 29.19, 29.20), the baptistery doors functioned as a teaching aid. Andrea Pisano's figures seem less animated, however, and they are cast in lower relief than the Hildesheim Doors. In addition, the Florentine doors address only one storyline, with Pisano emphasizing clarity over theological sophistication. Pisano's doors originally faced the unfinished duomo (cathedral), but they were later moved from the east side of the baptistery to the south side to accommodate the installation of the *Gates of Paradise* (see Fig. 38.6), which were created by the sculptor Lorenzo Ghiberti (*c.* 1378–1455). Despite their relocation, Pisano's panels continued to foster a strong sense of community by presenting the life of the city's patron saint in an easily understood manner.

Piety, Politics, and the *Maniera Greca*

While en route to Jerusalem during the Fourth Crusade (1202–4), European Christians, led by Venetian sailors and soldiers, sacked and occupied the city of Constantinople, further alienating Eastern Orthodox Christians from their western counterparts. Numerous Byzantine **icons** and objects were looted and carried back to Italy, many to Venice. During the thirteenth century, Italian artists became preoccupied with a kind of Byzantine imagery characterized by flat figures on shallow gold backgrounds—a style later called the *maniera greca*, or Italo-Byzantine style. Byzantine icons were often associated with miraculous cures and protection through divine intervention (see Chapter 28). Their appropriation may have been based on a desire to possess art with such power. Italian artists and their patrons may have appropriated the *maniera greca* in hopes of acquiring similar benefits.

Also in the thirteenth century, the Fourth Lateran Council in Rome (1215) affirmed the doctrine of transubstantiation, which teaches that once consecrated in the Eucharist (Holy Communion), bread and wine are miraculously changed into the body and blood of Jesus. In addition, the council called laypeople to confess their sins regularly and participate in the sacrament (ritual) of Holy Communion at least once a year. Priests were also encouraged to teach believers the meaning of the sacraments. Increasingly, **altarpieces** were placed behind altar tables, where priests performed the Eucharist ritual. The painted panels provided a backdrop for the elevation of the consecrated host (blessed bread now transformed), which was believed to offer the real presence of Christ to those participating in the sacrament.

BONAVENTURA BERLINGHIERI, *SAINT FRANCIS ALTARPIECE* A painter from the city of Lucca, Bonaventura Berlinghieri (1210–1287), produced a large altarpiece for the church of San Francesco in Pescia (**Fig. 37.7**). As an altarpiece, the painting is intimately connected to the altar, where the presence of Christ in believers' earthly life is celebrated in the Eucharist. The painted panel resembles a Byzantine **historiated icon**. Berlinghieri's subject, Saint Francis, had been canonized in 1228, less than a decade before the altarpiece was produced.

According to biographies of the saint, God spoke to the young Francis of Assisi, calling on him to dedicate his life to Christ and to rebuild the Church, considered corrupt. Francis renounced his father's wealth by removing his own clothing in a public gesture of humiliation, and from that point forward he lived as a mendicant (beggar) and modeled his life after Christ. One day, while intensely meditating on the Passion (the suffering of Jesus leading up to his crucifixion), Francis received the stigmata—five marks on his hands, side, and feet, in imitation of the wounds of Christ.

Around 1207, Francis received papal approval to establish a new order of monks who agreed to forfeit the ownership of property and become preachers to ordinary people. (Most other orders lived in seclusion in well-endowed monasteries located away from towns and cities.) Though the Franciscans lived in cities, they were not confined to a particular location. Rather, they often served as missionaries, with some traveling to the shores of the eastern Mediterranean in hopes of converting others to Christianity. In addition, in an effort to

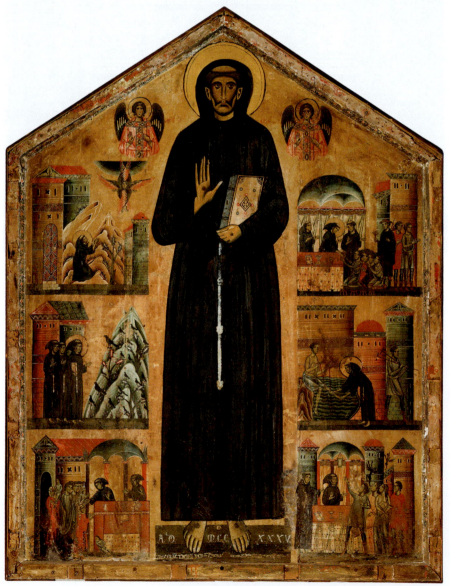

37.7 **Bonaventura Berlinghieri,** *Saint Francis Altarpiece,* church of San Francesco, Pescia, Italy, 1235. Tempera and gold leaf on panel, 5 ft. × 44¾ in. (1.52 × 1.16 m).

develop closer relationships between the various sects of the Church, Franciscans actively pursued unity between western and eastern branches of Christianity, and their strong desire to imitate the suffering of Christ resonated with the rich Byzantine tradition of pathos imagery (see Fig. 28.22). Within a couple of years of his death, Francis was recognized as a saint, and the number of Franciscan friars (a friar is a spiritual brother) dramatically increased.

Berlinghieri's appropriation of the *maniera greca* complemented his promotion of Franciscan ideals. In his altarpiece, the nearly life-size Francis, holding the Gospel and with the stigmata marking his bare feet and hands, is flanked by angels. The sunken-cheeked Francis has a monastic tonsure (the top of his head is shaved), and he is dressed in the simple brown robe of his order, with three knots on his rope belt symbolizing the vows of his religious order: poverty, chastity, and obedience. He seems to float weightlessly against the gold background, his feet not planted on solid ground, suggesting a celestial realm the value of which extends well beyond earthly treasure. The flat appearance of his robe minimizes his physicality and suggests greater spirituality. His saintliness is reinforced by six small scenes from his life rendered with a few vivid details. On the upper left, the saint receives the stigmata, and in the scene below it, he preaches to birds in the wilderness. Although Berlinghieri has indicated the presence of a hillside, there seems to be little interest in rendering three-dimensional space.

COPPO DI MARCOVALDO, CRUCIFIX The first artist from Florence whose name and works are documented, Coppo di Marcovaldo (1225–1276), also produced works in the Italo-Byzantine style. Coppo painted a historiated crucifix (**Fig. 37.8**) for the Franciscan convent of Santa Chiara in San Gimignano, a hilltop town near Siena. The large cross was probably mounted on top of the **choir screen**, which separated the clergy from the laity.

As in late Byzantine imagery, Christ's torso and limbs appear stretched out. His legs slightly overlap, and his loincloth hangs low at the hip, accentuating the twisting distortion of his anatomy. His head tilts forward in death, with eyes closed and thick shadows above the sockets, evoking a greater emotional response. His halo is painted on a carved disk with deep wedge-shaped grooves, intensifying the sense of brokenness. Six Passion scenes frame Christ's torso, and mourners appear in vignettes near his fingertips. The emphasis placed on his suffering encourages viewers to share in his pain, and it complements Franciscan piety by promoting empathic identification with physical pain that seems intensely human.

Coppo's preoccupation with human emotion may have been informed by his experiences as a Florentine soldier and prisoner of war. In September of 1260, the Florentines were poised to attack Siena, prompting one of Siena's prominent citizens, Bonaguida Lucari, to remove his garments and cap of status and to walk barefoot in humility. Leading a procession of concerned residents into Siena Cathedral, he embraced the bishop in a gesture of civic and ecclesiastical unity. Then he lay prostrate on the church floor before an image of the Madonna, imploring her for mercy and divine intercession. The next day,

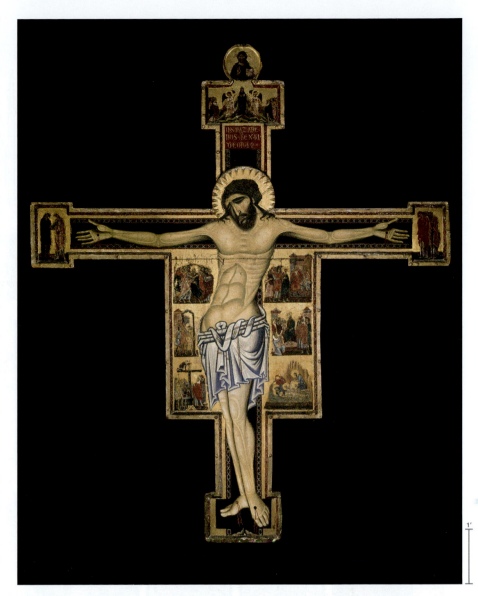

a white cloud was said to have descended upon the battlefield and confused the Florentines, resulting in their retreat and ultimate defeat. In thanksgiving, the Sienese dedicated their city to the Virgin Mary.

DUCCIO DI BUONINSEGNA, *MAESTÀ* The painter Duccio di Buoninsegna (active *c.* 1278–1318) was commissioned to produce a monumental altarpiece, the largest of its day, for Siena's cathedral. On June 9, 1311, the **polyptych** was carried in an elaborate procession from the artist's studio to the church, which was also dedicated to the Virgin as the Queen of Heaven in Majesty (*Maestà*). Given the size of the altarpiece, Duccio probably employed numerous apprentices to assist him. The immense altarpiece was painted on both sides with dozens of figures (**Fig. 37.9**, p. 616). Its **predella** included a series of small paintings. The top of the altarpiece was decorated with ornamental peaks resembling **pinnacles** found on the exterior of Gothic cathedrals.

During the late eighteenth century, the polyptych was removed from the high altar and dismantled, and several of the smaller panels were sold off. Some of those panels are lost, but a number of them, including the

37.8 Coppo di Marcovaldo, **crucifix from Santa Chiara,** Pinacoteca, San Gimignano, Italy. *c.* 1261. Tempera and gold leaf on panel, 9 ft. 7½ in. × 8 ft. ¼ in. (2.93 × 2.47 m).

choir screen an architectural barrier separating the area reserved for priests and for those singing the Mass.

polyptych a work of art with more than three parts, usually attached together.

predella a wooden step or platform that supports an altarpiece and is often painted with related scenes.

pinnacle a summit or peak, often capping a tower, gable, buttress, or other projecting architectural form.

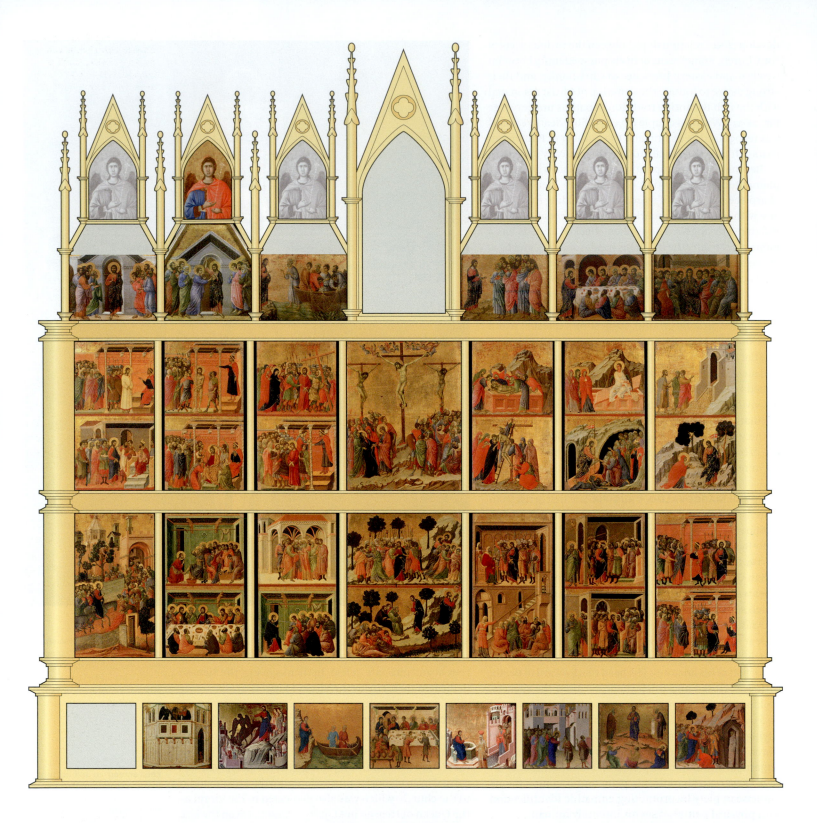

37.9 Duccio di Buoninsegna,
***Maestà* (back),** originally in
Siena Cathedral, Italy, 1308–11.
Tempera and gold leaf on panel.
(Altarpiece frame is a digital
reconstruction. Areas in grey
indicate missing panels.)

central one, never left the city, and today they are housed
in the cathedral's museum. In this main frontal panel
(**Fig. 37.10**), the Madonna is represented as a queen cen-
trally positioned on a throne with the Christ Child on
her lap. She towers over a heavenly crowd of angels and
saints against a gold background. An inscription at the
base of her marble throne reads, "Holy Mother of God,
be the cause of peace for Siena and of the life of Duccio,
because he painted you thus." Four local saints kneel at
the foot of her marble throne, imploring her to continue
protecting the city. The angels and saints turn toward one

another casually, in apparent dialogue. The undulating
contours of figures in repeating rows and the details of
their exquisite costumes, such as the thin gold thread
edging Mary's deep blue robe, heighten the patterned,
ornamental effect. In addition, the Virgin Mary's elon-
gated fingers enhance the sense of elegance and grace.

Twenty-six small-scale scenes of Christ's Passion
dominate the back of Duccio's altarpiece. One of the
largest of these panels depicts in elaborate detail Christ's
entry into Jerusalem (**Fig. 37.11**). Although Duccio's sky is
golden, other elements of his panel shift away from the

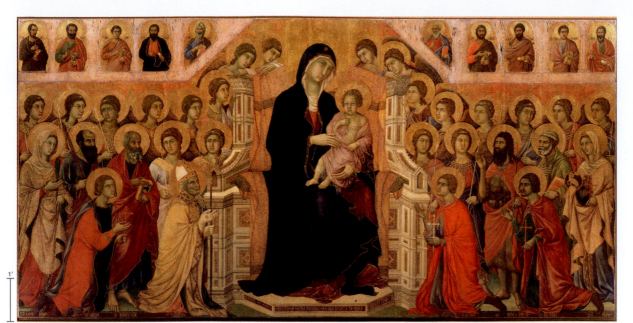

37.10 Duccio di Buoninsegna, *Maestà* (main frontal panel), 1308–11. Tempera and gold leaf on panel, 7 × 13 ft. (2.13 × 4.12 m). Museo dell'Opera del Duomo, Siena, Italy.

Italo-Byzantine style. The painting has a high horizon and an abbreviated foreground that includes a single tree, with the scene arranged in such a way that that the viewer seems to be located nearby in an elevated position outside of the narrative, looking down on it. The eye is encouraged to meander through a variety of spaces rendered in twisting perspective, both inside and outside the walled city with its open gate.

In the middle ground, Christ, accompanied by an entourage of his disciples, rides a donkey. A crowd rushes out, carrying palm branches and laying down cloaks to welcome him. An audience gathers within an enclosed courtyard; some of the people peek over a wall, while others climb trees to get a better view and one onlooker witnesses the scene from a balcony window adjacent to the gate. The architecture in the background resembles contemporary Siena, inviting comparisons with the holy city of Jerusalem.

SAN MARCO, VENICE Whereas Siena was dedicated to the Virgin, the city of Venice took the Gospel writer Mark as its patron saint. In the thirteenth and fourteenth centuries, Venice was an economic and maritime powerhouse with close ties to the Byzantine Empire. Venice also served as a major port of departure for pilgrims and crusaders on their way to Jerusalem. In 828, Venetian merchants stole and transported the relics of St. Mark from Alexandria, Egypt, and during the height of the Middle Ages, a new church, San Marco, was built to house these sacred remains. Construction of the edifice, modeled after the now-demolished Church of the Holy Apostles (commissioned by the Byzantine emperor Justinian) in Constantinople, began in the late eleventh century. After the sack of Constantinople in 1204, San Marco was remodeled with the addition of a U-shaped **narthex**, a new facade, and **mosaic**-lined domed vaults (**Fig. 37.12**, p. 618). Loot plundered from the Byzantine capital was also brought into the church. Indeed, the interior of San Marco was so opulent that contemporaries nicknamed it "the church of gold."

Above the central doors on the building's facade sits a bronze sculpture of four horses (now shown as modern

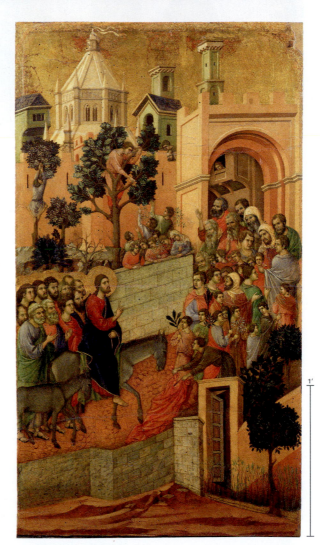

reproductions), an ancient work that was originally placed in the circus (chariot racetrack) in Constantinople. Its present location effectively communicates Venice's subjugation of the Byzantine city. Although less noticeable, some of the carved marble slabs decorating the

narthex the entrance hall or vestibule of a church.

mosaic a picture or pattern made from the arrangement of small colored pieces of hard material, such as stone, tile, or glass.

37.11 Duccio di Buoninsegna, *Triumphal Entry, Maestà* (panel on the reverse), 1308–11. Tempera and gold leaf on panel, 40½ × 21⅛ in. (1.03 m × 53.7 cm). Museo dell'Opera del Duomo, Siena, Italy.

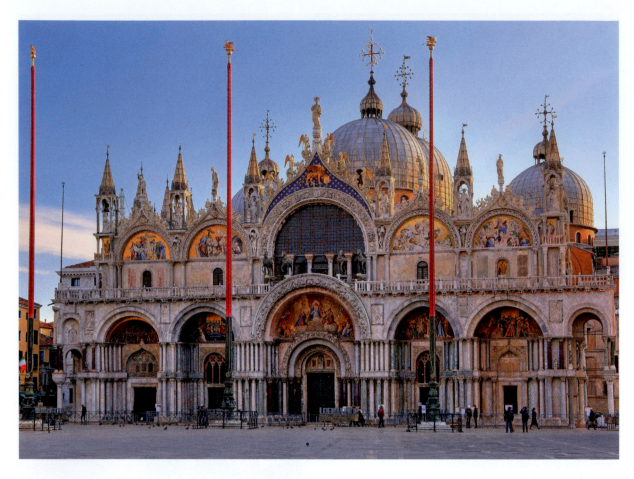

doorways were also taken as booty to Venice, along with additional slabs that were locally produced in the Greek manner.

San Marco's marble facade has pinnacles, **tympana**, and other architectural features associated with western European churches, but it differs from this tradition in certain aspects. For instance, the tympana are filled with mosaics rather than sculpted stone reliefs. Although the tympanum above the central door and those located on the second story are nineteenth-century additions, the remaining four tympana, depicting the discovery and relocation of Saint Mark's relics to Venice, were constructed during the thirteenth century. These mosaics closely resemble Byzantine works and, unlike Tuscan **appropriations** of the *maniera greca*, they assert Venice's dominion over Constantinople.

Proximity to the Divine

In his canonical collection of biographies entitled *Lives of the Most Excellent Painters, Sculptors, and Architects* (1550), the painter and architect Giorgio Vasari credited two Florentine artists, Cenni di Pepe, better known as Cimabue (active *c.* 1272–1303), and his pupil Giotto di Bondone (*c.* 1277–1337), for bringing the visual arts out of the supposed darkness of the Middle Ages. These *primi lumi* (first lights), according to Vasari, effectively challenged the *maniera greca* by introducing greater naturalism, favoring observation over idealization. However, Cimabue and Giotto did not see style as an end in itself. On the contrary, they used naturalism to suggest greater intimacy with the sacred by humanizing divine characters and stories. Their figures appear more dynamic and solid, and backgrounds and settings look as if they occupy real space rather than seeming to be mainly flat. Expressions and gestures convey human emotions. In the late Middle Ages, other artists, following on from the work of Cimabue and Giotto, continued to integrate this naturalism with elements of Italo-Byzantine style in Italy.

CIMABUE, *MADONNA AND CHILD ENTHRONED WITH ANGELS AND PROPHETS* Cimabue placed the Virgin Mary in the center of his large, unusually tall altarpiece (**Fig. 37.13**) in the Florentine church of Santa Trinità. Hierarchical scale manifests the Madonna's importance. Her face is delicately modeled, making her head appear more three-dimensional and, like Duccio's depiction of the Virgin Mary, she is enthroned in majesty. She wears a blue robe (which has blackened over time) painted with gold streaks that indicate the garment's folds, a pictorial gesture that harkens back to Byzantine models, as does the Madonna's frontal pose. Overlapping angels surround the enthroned Mother and Child, implying three-dimensional space, but the lack of diminution —whereby figures look smaller as they recede in space— flattens out the image, making the angels appear as if they are stacked on top of one another. Below the royal chair, Old Testament prophets hold scrolls foretelling the birth of Christ.

Although the figures in Cimabue's panel convey a sense of volume, the painting's composition lacks spatial clarity. For instance, it is difficult to determine whether the architectural element framing the central prophets

at the bottom should be interpreted as an arch above their heads or as a niche behind them. In addition, the Virgin seems to float weightlessly in front of her chair. The Madonna, based on a Byzantine tradition of iconography known as the Virgin Hodegetria, looks directly at the beholder as she points to her son as the way to salvation, but her elevated position, with stairs that do not touch the ground, renders her less accessible to viewers.

GIOTTO DI BONDONE, *MADONNA AND CHILD ENTHRONED*
Cimabue's pupil, Giotto di Bondone, painted an altarpiece for the church of Ognissanti (All Saints) in Florence about thirty years later. Giotto's altarpiece (**Fig. 37.14**) presents the same subject, Madonna and Child enthroned, but his work shows marked developments in naturalism and invites greater psychological engagement from the beholder.

The two paintings share the same basic format: The Madonna, colossal in relative scale, resides against a gold background. She sits on a throne holding the infant Jesus, and angels surround her. Nonetheless, there are significant differences. Giotto achieves a greater illusion of spatial depth. His Virgin looks substantial, appearing to have three-dimensional volume and mass. Her robe

does not have gold striations to indicate volume, as in the Cimabue altarpiece. Rather, it is modeled in light and shadow, as are all her garments, clearly revealing the placement of her knees, her rounded breasts, and the folds of different kinds of fabric. The surrounding angels stand on a plausible ground and turn their heads casually toward the holy pair; the angels' overlapping heads reinforce the sense that some of the angels are standing farther back in the scene. The Madonna embraces her son as Christ offers a blessing with his right hand, and a short set of stairs allows for access, making the divine seem more approachable.

ARENA CHAPEL, PADUA
Before painting the altarpiece for Ognissanti, Giotto painted the interior of a private **oratory** for Enrico Scrovegni, a wealthy banker in Padua, a city-state in northeast Italy. Scrovegni built a palace, including a prayer chapel that was also to serve as a family **mausoleum**, on land that had once been a Roman arena. The ceiling of the Arena Chapel (**Fig. 37.15**, p. 620) is painted as the heavens, with **medallions** representing Christ, the Virgin Mary, four evangelists, and four prophets. Frescoes also cover the threshold, marking entry into the **apse**.

oratory a prayer chapel.

mausoleum (plural **mausolea**) a building or free-standing monument that houses a burial chamber.

medallion a circular or oval-shaped emblem.

apse a recess at the end of an interior space, often semicircular, and typically reserved for someone or something important, such as the altar in a church or the throne of a ruler.

37.13 BELOW LEFT Cimabue, *Madonna and Child Enthroned with Angels and Prophets*, *c.* 1280. Tempera on panel, 12 ft. 9 in. × 7 ft. 4 in. (3.53 × 2.2 m). Galleria degli Uffizi, Florence, Italy.

37.14 BELOW Giotto di Bondone, *Madonna and Child Enthroned*, *c.* 1305–10. Tempera on panel. 10 ft. 8 in. × 6 ft. 8 in. (3.25 × 2.04 m). Galleria degli Uffizi, Florence, Italy.

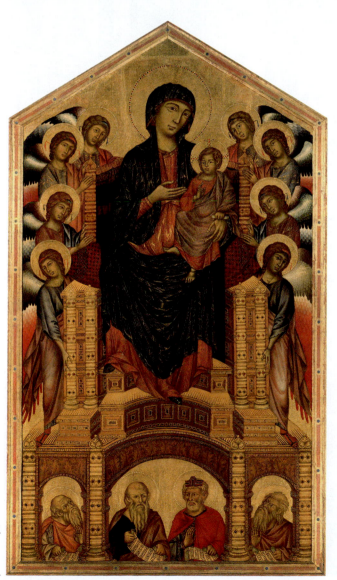

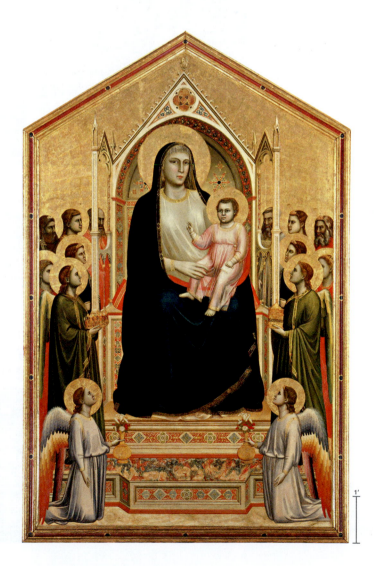

Giotto organized the scenes into a unified, though complex, theological program. At the base of the windowless north wall, **grisaille** personifications of the seven Vices, rendered as if sculpted, are interspersed between painted imitations of marble (**Fig. 37.16**), although the Vice of Avarice is not pictured. On the south side, grisaille personifications of the seven Virtues appear between representations of stone, and the middle two **registers** of the north and south walls present scenes of Christ's infancy, ministry, and Passion. The top tier of the south wall is decorated with narratives from the life of Mary, and the north wall with scenes from the life of her elderly parents, Joachim and Anna, who were unable to have children. According to the *Golden Legend*, a thirteenth-century hagiography (lives of saints), Joachim and Anna, directed by divine visions, kissed at the golden gate of Jerusalem (**Fig. 37.17**). Upon their embrace, the Virgin Mary was miraculously conceived. Anna's garment billows outward in anticipation of her pregnancy. Giotto painted deep shadows to define the folds of all the figures'

37.15 Giotto di Bondone, frescoes from the Arena Chapel, Padua, Italy, *c.* 1304–5. North wall (left), south wall (right), and east wall (straight ahead, with a view into the apse).

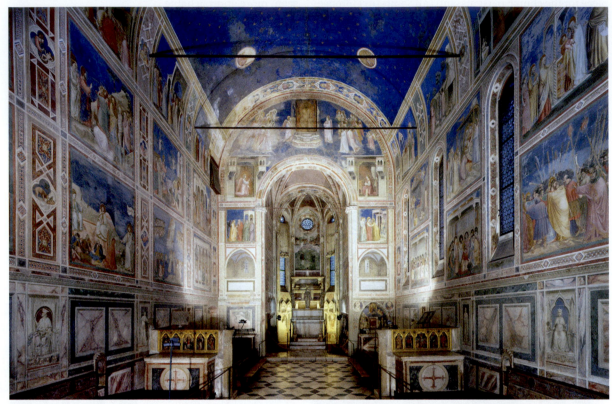

saints and biblical narratives appear in the quatrefoil medallions

scenes from the life of Joachim (the south wall shows scenes from the life of the Virgin)

scenes from the life of Christ

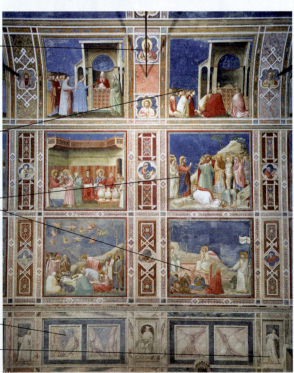

painted imitation marble

the Seven Vices (the south wall shows the Seven Virtues)

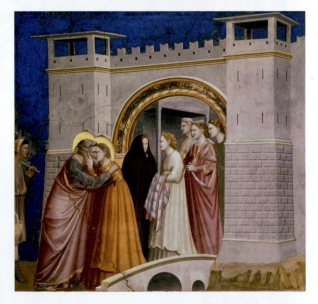

37.16 LEFT **Giotto di Bondone, frescoes from the north wall,** *c.* 1302–5. Arena Chapel, Padua, Italy.

37.17 ABOVE **Giotto di Bondone, *Joachim and Anna Meeting at the Golden Gate,*** *c.* 1302–5. Fresco from the Arena Chapel, Padua, Italy.

garments, which fall in a natural way. Although working in a restricted palette, Giotto offers a variety of psychological responses to this poignant episode. Joachim and Anna share a loving embrace, filled with the excitement of the angel's news, while female onlookers gawk at the sight and another woman, veiled in black, turns away in disapproval of their public display of affection. To the left, a traveler cut off at the margin is about to enter the scene.

SIMONE MARTINI, *THE ANNUNCIATION* Like Giotto, Sienese painters produced naturalistic imagery that encouraged beholders to recognize and feel the proximity of the divine, although in a more elegant manner. Duccio's successor at Siena's cathedral, Simone Martini, produced an altarpiece for the cathedral (**Fig. 37.18**) with the help of his assistant and brother-in-law, Lippo Memmi. With its pointed arches and miniature spires and abundant use of gold leaf, the painting's original ornate frame (which was reconstructed in the nineteenth century) complemented Duccio's *Maestà* (**Fig. 37.9**). At the same time, naturalistic details, such as the perspective of the floor paving and the solid throne, depart from Italo-Byzantine art, which favored flat, shallow spaces.

The Annunciation is depicted in the middle of the altarpiece, with the angel's words incised on the painting's surface. Extending from the angel Gabriel's mouth to the Virgin's ear, the Latin inscription reads, *Ave Maria gratia plena dominus tecum* ("Hail Mary, full of grace,

the Lord is with you"). The words and the halos are in punched relief, meaning they were imprinted into the gold leaf by a punch or tool; the use of these costly materials and refined techniques enhances the overall impression of sophistication and grace. Gabriel's wings, meticulously rendered in brilliant color, seem to open and close quietly as his lavish garment appears to swirl slowly in response to a gentle breeze.

Some painted details are startlingly realistic, such as the vase of lilies on the floor and the olive branch that Gabriel extends. The vase of lilies symbolizes Mary's purity and the possibility of life anew. Despite the peace offering represented by the olive branch, the enthroned Virgin Mary, who has been reading her devotional book, is startled by the angel's presence. She turns away in humility and fear, responding to this event with human emotions that beholders can readily understand. The dove of the Holy Spirit, surrounded by a host of angels, delicately flies above the sacred conversation, suggesting the miracle of Mary's forthcoming pregnancy. The upright saints flanking the Annunciation, who appear more static than Gabriel and the Virgin Mary, and who lack their fluid, graceful contours, are probably the work of Lippo Memmi.

ANDREA DA FIRENZA, *THE TRIUMPH OF THE CHURCH* The optimism conveyed by Simone Martini's *Annunciation*, however, would prove to be short-lived. During the

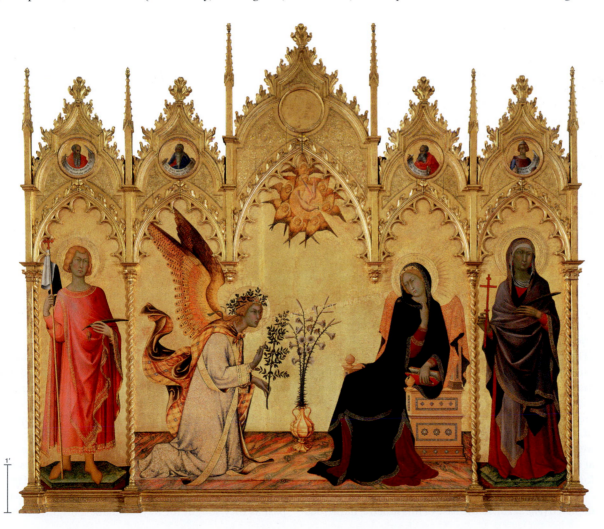

37.18 Simone Martini and Lippo Memmi, *The Annunciation*, 1333. Tempera and gold leaf on panel, 10 ft. × 8 ft. 9 in. (3 × 2.67 m). Galleria degli Uffizi, Florence, Italy.

There are two types of fresco: *buon fresco* (wet or true fresco) and *fresco secco* (dry fresco). *Buon fresco* paintings—such as those found in the Arena Chapel, and Andrea da Firenza's fresco in the Spanish Chapel, Santa Maria Novella—are labor intensive. Yet unlike *fresco secco*, *buon fresco* is more durable and maintains its vivid colors longer.

To make a true fresco (**Fig. 37.19**), the artist begins by applying a thick undercoat of rough plaster (*arriccio*) to the wall and allowing it to dry thoroughly. The artist then places an underdrawing in a brownish-orange wash called *sinopia* (plural *sinopie*) onto the dried surface. Later artists, such as Michelangelo and Raphael, used cartoons (in this context, preparatory drawings to scale) rather than *sinopie*. After completing the underdrawing, the artist spreads a thin layer of fine plaster (*intonaco*) over an area of the image that can be finished in one session. Next, the artist paints onto the damp surface with pigments (colors) diluted with water. The pigments and plaster unite chemically as the plaster dries, and the painting becomes a permanent part of the wall.

Artists had to work quickly and skillfully, and the mural had to be completed in sections. Each new addition was rendered adjacent to the last patch of daily labor (*giornata*, the Italian for "day's work") until the artistic program was finished. The Arena Chapel contains more than eight hundred examples of *giornate*.

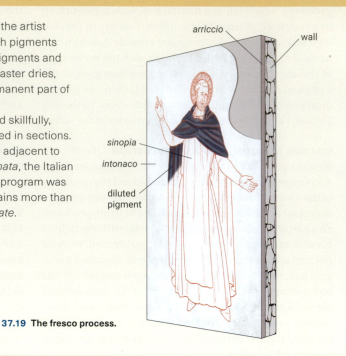

37.19 The fresco process.

mid-fourteenth century, numerous catastrophes struck Europe. The Italian peninsula was devastated by a series of floods and crop failures, which caused famine. Numerous local banks failed because borrowers were unable to pay back their loans. Beginning in 1347 the Black Death—bubonic plague—swept across Europe, and one-third to one-half of the population died from the disease. After the outbreak of the pandemic, some artists in Italy rejected naturalism and the Italo-Byzantine style, choosing an alternative means of addressing the connection between this world and the next. The plague profoundly interrupted the social order, and its economic, demographic, and psychological devastation cannot be overlooked. As a result of the overwhelming upheaval, new patrons and new artistic expectations were introduced. The artistic move away from naturalism and revival of hierarchical scale was not simply a return to happier times, when the order of everyday life was assured. On the contrary, it was also a matter of artistic experimentation, a look at the past to discover something anew. Stylistic innovations and the introduction of new subject matter characterized the period immediately after the Black Death.

For his family's chapel and final resting place, the rich Florentine merchant Buonamico Guidalotti commissioned a series of frescoes. The project was completed by Andrea di Bonaiuto (active *c.* 1343–77), more commonly known as Andrea da Firenza (Andrea from Florence). The oratory-mausoleum is located within the chapterhouse (meeting room) of Santa Maria Novella, a monastic church in the city of Florence, and it celebrates the Dominican order of monks. Although Dominicans, like the Franciscans, were mendicant monks residing in cities, they were often at odds with the Franciscans, with whom they competed for financial resources.

On the east wall, the triumph of the Church is depicted (**Fig. 37.20**). At the base of this **lunette**, numerous black-and-white dogs herd sheep and protect them against attacks from wolves. These canines symbolize the Dominican friars, who were sometimes described as *Domini canes*, watchdogs of the Lord. Directly above the dogs, Dominican priests, dressed in black habits, preach the Gospel to the laity and defend Christian orthodoxy against heresy. At the lower left, Pope Urban V gathers with secular leaders and priests in front of the yet unfinished Duomo of Florence. In the middle ground, young aristocrats carelessly play music and dance within a garden of love, ignoring the inevitability of death, a naive response in the wake of the plague. To the immediate left of that scene, a Dominican friar administers penance to a kneeling man, and another monk leads the saved toward the gate of heaven. At the top of the scene, Christ, who holds the Gospel and a hammer (to pound out heresy and sin), is seated above the four beasts of the Apocalypse (heavenly creatures foreseen in the Old Testament vision of Ezekiel) and surrounded by a choir of angels. His hands are balanced in perfect equilibrium in preparation for making divine judgment.

Although thirteenth- and fourteenth-century Italian art is often defined in terms of the waning of the Middle Ages or as a beginning of the **Renaissance**, both views underestimate the profound changes that took place during this period in this region. In response to urbanization and commercial success, artists discovered new ways to foster communal solidarity. Rather than passively adopting the *maniera greca*, artists adapted the Italo-Byzantine style to their own political and religious purposes, including their desire to promote greater intimacy with the divine. Although the Black Death decimated populations and claimed the lives of many artists and patrons, it did not eradicate artistic innovation. In fact, it encouraged some artists to seek new ways to address the past as they sought for ways to make a brighter future.

lunette a semicircular or arch-shaped space on a wall or ceiling, usually with a frame.

Renaissance a period of Classically inspired cultural and artistic change in Europe from approximately the fourteenth to the mid-sixteenth centuries.

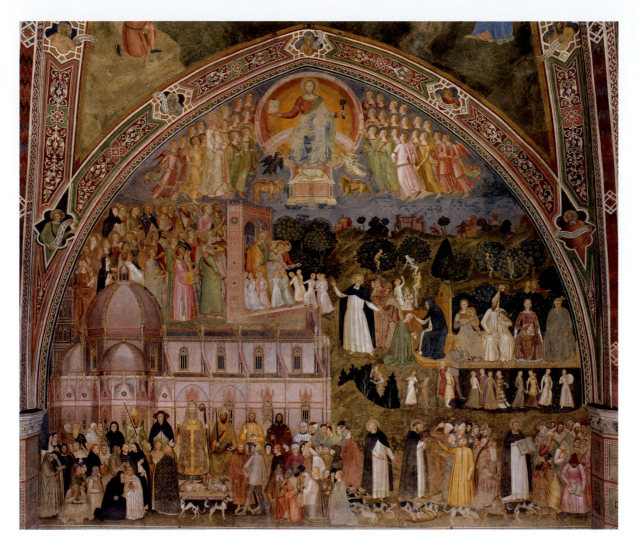

37.20 Andrea da Firenza, fresco of *The Triumph of the Church*, *c.* 1366–68. Guidalotti Chapel (later also known as the Spanish Chapel), Santa Maria Novella, Florence, Italy.

Discussion Questions

1. How did Cimabue and Giotto challenge the tenets of the Italo-Byzantine style?

2. How did Italian art and architecture of the late Middle Ages foster a strong sense of community? Specify some contemporary examples of art and/or architecture that bring people together.

3. What role did epidemics have in the production and reception of art? How did the Black Death affect art in fourteenth-century Italy? How have artists and viewers responded to catastrophic diseases, such as AIDS, more recently?

Further Reading

- Campbell, C. Jean. *The Commonwealth of Nature: Art and Poetic Community in the Age of Dante*. University Park, PA: Pennsylvania State University Press, 2008.

- Derbes, Anne and Sandona, Mark (eds.) *The Cambridge Companion to Giotto*. Cambridge: Cambridge University Press, 2007.

- Flora, Holly. *Cimabue and the Franciscans*. Turnhout, Belgium: Brepols, 2018.

- Maginnis, Hayden B. J. *Painting in the Age of Giotto: A Historical Reevaluation*. University Park, PA: Pennsylvania State University Press, 1997.

- Maguire, Henry and Nelson, Robert (eds.) *San Marco, Byzantium, and the Myths of Venice*. Washington, D.C.: Dumbarton Oaks, 2010.

- Steinhoff, Judith. *Sienese Painting after the Black Death: Artistic Pluralism, Politics, and the New Art Market*. Cambridge: Cambridge University Press, 2007.

Chronology

1204	The Venetians sack and plunder the Byzantine capital Constantinople; some of the plundered loot is used to remodel the church of San Marco, Venice
1207	St. Francis of Assisi establishes the Franciscan order of monks
1215	The Fourth Lateran Council is held in Rome; it affirms the doctrine of transubstantiation
1228	Francis of Assisi is canonized as a saint
***c.* 1297**	Construction of Siena's Palazzo Pubblico begins
***c.* 1302–5**	Giotto paints frescoes on the walls of the Arena Chapel, Padua
1311	Duccio's monumental altarpiece, the *Maestà*, is installed in Siena Cathedral
1347–51	The Black Death (bubonic plague) in western Europe is at its peak

Glossary

abacus the upper part of a **Doric column**'s **capital**; the square block that sits on top of the **echinus**, which together support the **entablature**.

ablution fountain typically located in the courtyard of a **mosque**, a water fountain in which Muslims wash ritually before prayer.

abstract altered through simplification, exaggeration, or otherwise deviating from natural appearance.

Abstract Expressionism a style of art originating in the United States after World War II in which artists rejected representation in favor of the gestural residue of paint dripped, splashed, and applied in other unorthodox ways.

abstract formalism an approach to art in which **forms** are made **abstract** by simplifying their shapes and structures.

abstraction artistic styles that transform a recognizable image into shapes and lines.

Academic art conventional painting or sculpture made under the influence of an art academy, a state-sponsored society for the formal training of artists and exhibition of their work.

acrylic paint available since the 1940s, made by suspending **pigment** in acrylic resin, a synthetic medium that dries quickly.

adobe made of sun-dried clay, usually combined with organic materials.

adze a carving tool with a horizontal blade that—unlike an ax—allows a sculptor to use downward strokes.

Aesthetic Movement a loose association of artists and writers in the 1870s and 1880s, mainly in Britain and the United States, who advocated that the arts should be judged by artistic standards only, not by political, moral, or social ones.

aesthetics principles, which vary from culture to culture, concerned with the nature of beauty and taste in art and architecture.

agora in ancient Greek towns, a public open space that functioned as a marketplace and center for politics and other assemblies.

aisle a passage along either side of a **nave**, separated from the nave by a row of **columns** or **piers**.

akroteria sculptures that adorn the roof of a temple.

album/album leaf or leaves a format of **two-dimensional** artwork, such as painting, **calligraphy**, or photography, in which individual **leaves**, or pages, may be bound together like a book to form an album.

albumen print a type of photographic print that uses an egg-white emulsion to bind the photographic chemicals to the paper; commonly used between the 1860s and 1890s.

allegory an image that symbolizes an abstract idea or concept.

altarpiece a painting or sculpture placed above or behind an altar table.

amalaka a stone disk shaped liked an amala (a lobed fruit said to have purifying medicinal powers), which sits atop the *shikhara* of a north Indian Hindu temple.

ambulatory (1) a place for walking, especially an **aisle** around a sacred part of a religious space. (2) an **aisle** around an **apse**.

amphitheater a round or oval open-air theater with seats sloping down toward the central performance area.

amphora an ancient pottery vessel with a narrow neck, large oval body and two handles, used for storage or bulk transportation of foodstuffs, such as wine, olive oil, or olives.

amulet an object that is worn or carried in the belief that it will protect its owner.

analogous colors colors that are close together on the color wheel (such as yellow, orange, and reddish-orange).

Analytic Cubism the first phase of **Cubism**, using many small overlapping planes to show fragmentary images of subjects arranged in a shallow picture space simultaneously from many different angles, with a minimum of color.

anamorphic a distorted image that is stretched out and must be viewed at an angle or with a mirror to see the image in its correct shape.

aniconic/aniconism (1) the indirect visual representation of divine beings through symbols or **abstract** images. (2) opposition to visual depictions of living creatures or religious figures.

animalier a sculptor specializing in small-scale representations of animals; applied mainly to a group of mid-nineteenth-century French artists.

anta (plural *antae*) slightly projecting **piers** on either side of the entrance to a Greek or Roman temple that terminate the *cella* and **porch** wall. Temples of this type are referred to as *in antis*.

antefix a vertical ornament at the **eaves** of a tiled roof.

aperture a hole through which light travels into a camera body, similar to how the pupil in a human eye operates.

apodyterium in ancient Rome, a dressing room in public baths that was used for changing and storing clothing or other belongings.

apotheosis the elevation of someone to divine status; deification.

apotropaic possessing the power to ward off evil influences.

applied arts media, such as furniture, textiles, ceramics, and metalwork, which are intended to be functional.

appropriation borrowing images, objects, or ideas and inserting them into another context.

apse a recess at the end of an interior space, often semicircular, and typically reserved for someone or something important, such as the altar in a church or the throne of a ruler.

apsidal relating to an **apse**: a semicircular recess.

apsidioles secondary **apses** or small chapels radiating around the primary apse of a church.

aquatint a variant of **etching** that coats the metal with a granulated resin to create a mottled effect; imitates the broad tones of watercolor or ink washes.

arabesque an ornamental design featuring interlacing organic patterns, such as vines and leaves, that derive from Islamic art.

arcade a covered walkway made of a series of **arches** supported by **piers**.

arch a curved, symmetrical structure supported on either side by a post, **pier**, **column**, or wall; usually supports a wall, bridge, or roof.

Archaic smile the upturned lips of a Greek Archaic sculpture.

archaism/archaizing the use of forms dating to the past and associated with a golden age.

archetype the best, ideal example, one that may be used as a model.

architectural palimpsest a structure that has been changed over time and shows evidence of that change.

architectural polychromy using different-colored materials to create decorative patterns in architecture.

architrave a beam resting on top of **columns** or extending across an entranceway.

archivolt moldings on the lower curve of an **arch**.

arriccio a rough coat of plaster applied on a wall in the process of making a **fresco** painting.

Art Deco a movement in the **decorative arts** and design that developed in the 1920s and replaced **Art Nouveau**, using luxurious materials, exquisite craftsmanship, and a machine-like gloss instead of exotic forms from nature.

Art Nouveau an international style originating in the 1890s that applies especially to the **decorative arts**, architecture, and design, from the French for "new art"; also known as *Jugendstil* (German for "youth style"), it is characterized by organic shapes and curved lines.

Arts and Crafts an international design movement that acquired its name in Britain around 1880 but had its roots in the mid-nineteenth century; it reacted against industrial manufacture, instead focusing on handcraft and high-quality materials.

ashlar a stone wall masonry technique using finely cut square blocks laid in precise rows, with or without mortar.

asymmetrical a type of design in which balance is achieved by elements that contrast and complement one another without being the same on either side of an axis.

atlantid a **monumental** figural sculpture that supports a roof or other architectural element.

atlatl a thin stick with a notch to hold a spear in a way that allows the user to throw the spear faster and farther.

atmospheric perspective a means of representing distance based on the way atmosphere affects the human eye, where details are lost, **outlines** are blurred, colors become paler, and color contrasts less pronounced.

atrium an interior courtyard, open or covered.

attic on a **facade** or **triumphal arch**, the section above the **frieze** or just beneath the roofline,

sometimes decorated with painting, sculpture, or an inscription.

aureole a circle of light or brightness surrounding something, particularly the head or body of a person represented as holy.

auspicious signaling prosperity, good fortune, and a favorable future.

automaton (plural **automata**) a moving mechanical device made in imitation of a living being.

Autumn Salon an annual art exhibition held in Paris beginning in 1903, which began as a reaction to the conservative policies of the official Paris **Salon**, and which became a forum for experimental modern art.

avant-garde an emphasis in modern art on artistic innovation, which challenged accepted values, traditions, and techniques; derived from the French for "vanguard."

axis mundi the center of the world and/or the connection between heaven and earth in certain belief systems.

background the portions of an artwork around and behind the central subject(s).

backstrap loom a weaving instrument that ties one end of the **warp** to something stable, like a tree, while the other end of the warp is wrapped around the weaver's back, allowing the weaver to create and control tension in the loom.

bailey in castle architecture, a high-walled courtyard that exposes attackers

baldachin a canopy over an altar or throne.

baluster a short pillar or **column**.

balustrade a decorative railing, especially on a balcony, bridge, or terrace.

baptistery a building or room reserved for the sacrament of baptism.

barkcloth cloth made from the inner bark of certain species of tree, often the paper mulberry; produced almost exclusively by women, it was the primary form of cloth throughout the Pacific Islands before **Western** contact.

Baroque a style of art and decoration in western Europe *c.* 1600–1750, characterized by a sense of drama and splendor achieved through formal exuberance, material opulence, and spatial projection in order to shape the viewer's experience.

barrel vault also called a tunnel vault; a semi-cylindrical ceiling that consists of a single curve.

basilica a longitudinal building with multiple **aisles** and an **apse**, typically located at the east end.

Bauhaus an experimental school of art and design founded in Germany in 1919 and closed by order of the Nazis in 1933.

bay a space between **columns**, or a niche in a wall, that is created by defined structures.

bay system the arrangement of spaces between architectural supports along the length of a building.

Beaux Arts **Classically** inspired architecture influenced by the teaching of the École des Beaux-Arts in France, found particularly in France and the U.S. in the late nineteenth and early twentieth centuries.

bel composto the unification of architecture, sculpture, and painting.

bi flat, perforated disks made of **nephrite** or other hardstones, made in early cultures in China.

bifurcated divided into two parts; often refers to an **arched** window.

bilateral symmetry symmetrical arrangement along a central axis so that the object or plan is divided into two matching halves.

biomorphic forms in **abstract** art characterized by free-flowing curves, echoing organic rather than geometric shapes.

black-figure a style of pottery decoration characterized by figures painted in black on a lighter background.

blind arcade **arches** used as a decorative **motif**, with no actual openings in the wall.

bodhisattva in early Buddhism and Theravada Buddhism, a being with the potential to become a **buddha**; in Mahayana Buddhism, an enlightened being who vows to remain in this world in order to aid all sentient beings toward enlightenment.

boiserie decorated wood paneling that surrounds a room.

Book of Hours a Christian devotional book corresponding to the liturgical hours honoring the Virgin Mary.

bosal the Korean term for *bodhisattva*.

boss a round knob-like projection.

bound/binder (of a dry **pigment**): mixed with a wet substance (a binder) to help it adhere to a surface.

bracket, bracketing wooden supports that channel the weight of the roof to the supporting **lintels** and posts; used in East Asian architecture.

brocade a type of luxury fabric woven with a raised design.

bucranium (plural **bucrania**) the skull of an ox; a common form of decoration in **Classical** architecture.

buddha; Buddha, the a buddha is a being who has achieved the state of perfect enlightenment called Buddhahood; the Buddha is, literally, the "Enlightened One"; generally refers to the historical Buddha, Siddhartha Gautama, also called Shakyamuni and Shakyasimha.

buncheong a variety of Korean **stoneware** created with white **slip**.

bunjinga Japanese "**literati painting**," in the Edo period inspired by Ming-dynasty Chinese literati painters such as Dong Qichang. Dong's theory of painting also provided the alternate name, "*nanga*," or "Southern [School] Painting," for *bunjinga*.

buon fresco see **fresco**.

burin a tool used in printmaking to **engrave** lines into wood or metal.

bust a sculpture of a person's head, shoulders, and chest.

buttress, buttressing an external support to an architectural structure, usually made of brick or stone.

byōbu a format of Japanese painting taking the form of flat or folding screens, often paired.

Byzantine relating to the East Roman Empire, centered on Constantinople (present-day Istanbul) from the fifth century CE to 1453.

cache a deposit of materials or objects that does not include a burial.

calligraphy, calligraphic (1) the art of expressive, decorative, or carefully descriptive hand lettering or handwriting.
(2) in East Asian painting, the formal, expressive properties of lines (e.g. thick/thin, dark/light, wet/dry) made with a flexible brush.

calotype the first practical **negative**–positive photographic process, using paper for both the negative and the positive print.

camay the power flowing through all things.

cameo a gem or other stone with a **relief** carving; the distinct background color is the inner vein of the stone.

camera obscura a precursor of the modern camera, a light-proof box with a small hole in one side through which an inverted image of the world outside is projected onto an opposite wall; from the Latin for "dark room."

campanile an Italian word meaning "bell tower."

candid photograph a photograph where the subject looks unposed.

canon a set of what are regarded as especially significant artworks.

cantilever a horizontal beam, slab, or other projecting structural member that is anchored at only one end.

capital the distinct top section, usually decorative, of a **column** or pillar.

Capitolium an ancient Roman temple dedicated to Jupiter, Juno, and Minerva, who are also known as the Capitoline Triad.

capstone a large stone marking the top of a tower or wall.

caravanserai lodgings constructed along trade routes at regular intervals for use of travelers; also called *ribat* or *han*.

cardo the main north–south street in a Roman city.

carpet page a decorative page resembling a textile; often used to introduce a gospel in early medieval **manuscripts**.

cartoon derived from the Italian word *cartone*, which refers to a large piece of paper; a to-scale drawing made in preparation for a wall painting.

cartouche (1) a carved or painted box, tablet, shield, or scroll that provides an inscription.
(2) inset boxes for short phrases, providing such identifying information as title, series, artist, publisher and/or date.

cassone (plural *cassoni*) a chest given to a bride; holds clothing and household textiles and is often richly decorated.

cast iron a process of making a metal form by running a liquid iron–carbon alloy into a mold.

casta painting a genre of painting depicting castes of people in colonial Spanish society.

casting a process of making a form by running liquified material into a mold and then letting the material set.

catacomb a network of underground burial tunnels.

celadon (also known as green ware): a wide range of ceramics with a common greenish hue.

cella (also called *naos*) the inner chamber of a temple; usually houses a statue of a deity.

celt an ax head that is typically only used ceremonially.

Celtic a style of Iron Age art produced by Celtic-speaking peoples in the temperate regions of continental Europe and in Britain and Ireland.

cenotaph a marker or memorial to someone buried elsewhere.

central plan a design for an architectural structure, whether round, polygonal, or cruciform, that features a primary central space surrounded by symmetrical areas.

chaekgeori literally "books and things"; a genre of Korean painted folding screens that sometimes uses *trompe l'oeil* techniques to depict books, **decorative art** objects, and foreign goods such as eye glasses, popular during the late Joseon period.

chaitya a Buddhist prayer hall with a *stupa* at one end.

chakravartin a Sanskrit term for ideal universal ruler.

chamfered corner a cut-away corner that forms a sloping edge.

champlevé a decorative technique in which hollows or cells in metalwork are filled with **enamel**.

chancel the space in a church around the altar, used by the clergy and choir during worship, usually on the east side of the building.

charbagh a Persian term referring to a garden divided into four equal parts.

chasing a metalwork technique in which designs are worked into the front surface of the object.

chevron a pattern in the shape of a V or upside-down V.

chhattri literally means "canopy"; a **dome**-shaped pavilion, usually elevated and used as a decorative element in South Asian architecture.

chiaroscuro in **two-dimensional** artworks, the use of light and dark contrasts to create the impression of volume when modeling **three-dimensional** objects and figures.

china painting the decoration of **glazed porcelain** objects such as plates and vases.

Chinoiserie objects and images characterized by European tastes and ideas about China.

chinsō commemorative portraits of revered Zen teachers.

chintz a type of multicolored, cotton fabric with a shiny finish.

chiton a form of Greek tunic.

choir the space in a church, typically on the eastern end, reserved for the clergy.

choir screen an architectural barrier differentiating the area reserved for priests and for those singing the Mass, usually on the eastern end of a church, from the rest of the sanctuary.

chromolithograph a color print produced by **lithography**, a method of printing in which the surface of the printing plate is treated to repel ink except where required; used particularly in the late nineteenth and early twentieth centuries.

chryselephantine made of gold and ivory; from the Greek words for "gold" and "elephant."

cist tomb a sunken pit usually lined with stone slabs, rough stones, or wood, and topped with a stone slab.

Classical from, or in a style deriving from, ancient Greece or Rome.

classical in the art history of Africa, artworks considered to represent the **canon** of African art, many of which arrived in Europe during the colonial period (1860–1960).

Classical column orders /Classical orders a codified grouping of **columns** and **capitals** that originated in ancient Greece with the **Doric** order (a spare, round capital), **Ionic** order (a scrolled capital), and **Corinthian** order (an ornate capital with acanthus leaves), to which the ancient Romans added the Tuscan order (a variant on the Doric) and Composite order (a mixture of the Ionic and Corinthian).

Classical ideal an ancient Greek belief that humans should strive for a balance of physical, mental, and spiritual qualities; and in art, a harmony of parts and balance of stasis and movement, color and line.

clerestory the upper section of a wall that contains a series of windows, allowing light to enter the building.

clerical script a form of Chinese **calligraphy** developed in the Han dynasty, so named for government clerks who used brush and ink to make written records.

cloisonné a decorative **enamelwork** technique in which cut gemstones, glass, or colored enamel pastes are separated into compartmentled designs by flattened strips of wire.

Cloisonnism a style of **Post-Impressionist** painting in which flat **forms** are often painted in bold colors, and are separated by dark contours.

cloister a covered walkway, lined with a **colonnade**, walled on the outside and open to a courtyard; usually found in religious buildings.

coarseware a type of thick, gritty pottery used for everyday purposes.

codex (plural **codices**) (1) a handwritten bound book; (2) a handwritten bound book; pre-Columbian codices are made in a **screenfold** format, from paper or **vellum**.

codpiece a piece of male dress dating to the fifteenth and sixteenth centuries in Europe, designed to cover the crotch and often shaped to emphasize the genital area.

coffer, coffered a recessed panel, or series of panels, in a ceiling.

collage a technique in which cut paper pieces and other flat materials of all types and sizes are combined and stuck to another surface to make a design; from the French *coller*, "to glue."

colonnade a long series of **columns** at regular intervals that supports a roof or other structure.

colonnette a small slender **column**.

colophon a statement at the end of a book, which records such information as the date and location of completion, name of calligrapher, and patron. In East Asia, colophons are also written on paintings and **calligraphy**, and their content may be expressive and wide-ranging.

Color Field painting a type of painting that emerged in the United States in the mid-1950s, characterized by broad areas of color applied in an **abstract** manner, and rejection of illusions of depth and gestural brushwork.

color harmonies colors placed next to one another in a way that creates a balanced **composition**.

colore the Italian term for color, which in Renaissance art refers to the primacy of color in the creation of art.

column in architecture, the upright, weight-bearing component.

complementary colors colors that are on opposite sides of the color wheel (such as yellow and purple).

composite bringing multiple materials and technologies of production together in the body of a single work.

composite viewpoint depicting a figure simultaneously from several viewpoints, such as both from the front and in profile.

composition the organization of elements in a work of art, distinct from its subject matter.

Conceptual art a term that emerged in the 1960s for art practices that emphasize ideas rather than any aesthetic qualities or physical materials.

conch a quarter-spherical **cupola** or **dome** over an **apse**.

cong hollow, squared tubes made of **nephrite** found in the Liangzhu culture of China.

congregational mosque also called a Friday **mosque**, or *jama masjid* in Arabic, the main mosque in a city or town and the location of Friday prayers, when the community comes together.

contextual analysis the method of examining and understanding an artwork by considering it in relation to its relevant context, whether historical, religious, social, and so forth.

continuous narrative multiple events combined within a single pictorial frame.

contour hatching a shading technique where parallel lines are contoured and sometimes crossed to follow the curvature of a **form**.

contour line the **outline** that defines a **form**.

contrapposto from the Italian for "counterpoise," a posture of the human body that shifts most weight onto one leg, suggesting ease and potential for movement.

convention in **representational** artwork, a prevalent and common method of representing **motifs**, space, and conditions of light, weather, and so on.

conversation piece an informal group portrait, especially those painted in Britain in the eighteenth century; distinguished by their portrayal of a group engaged in genteel conversation or an outdoor activity.

corbel a wood, stone, or brick wall projection, such as a bracket, that supports a structure above it.

corbeled roof a roof made of stone slabs that progressively overlap to create a **dome**, topped with a **capstone**.

corbeled vault an **arched** ceiling constructed by offsetting successive rows of stone (**corbels**) that meet at the top to form an arch shape.

corbeling an overlapping arrangement of wood, stone, or brick wall projections arranged so that each **course** extends farther from the wall than the course below.

Corinthian an order of **Classical** architecture characterized by slender fluted **columns** and elaborate **capitals** decorated with **stylized** leaves and scrolls.

cornice the uppermost strip of **molding** on a building's **entablature**.

copperplate engraving a type of printing in which a smooth sheet, or plate, of copper is incised with a design and then ink is applied onto the plate for printing.

course a layer of bricks or other building units arranged horizontally along a wall.

crenellation a fortified wall with notches or openings on top.

cross-hatching a technique in which groups of close parallel lines are drawn or painted across one another; used to darken or infill an area within a design.

cross-in-square design a square floor plan, popular in Middle and Late **Byzantine** churches, featuring internal elements in the shape of a cross and a large central **dome**.

crossing the juncture, or center, of the four arms of a cross-shaped church.

cubiculum (**cubicula**) (1) small rooms in a Roman house that could be used for different purposes, including bedrooms.
(2) a small room in a **catacomb** that functions as a resting place for the dead. Some of these spaces were later used as mortuary chapels for the living.

Cubism a style of art in which people, places, and things are simplified into flat, geometric shapes, often seen from multiple points of view.

cuirass a protective covering for the torso that includes a breastplate and backplate.

cupola the underside of a **dome**; also a dome-like element set atop a dome or other roof.

cursive (of a script) flowing, with some letters (or characters, in the case of East Asia) joining together.

cut-tile work small pieces of glazed tile arranged into patterns and set into plaster or gypsum to form geometric designs ornamenting interior architectural surfaces.

Cyclopean masonry a stone building technique in which large boulders are roughly shaped and fitted together to create well-knit, structurally sound walls.

Dada an informal international movement that arose during World War I; its adherents rebelled against established standards in art and what they considered morally bankrupt European culture.

dado (plural **dadoes**) the lower portion of a wall that is often of a different color or material to the rest of the wall.

daguerreotype a unique photograph fixed on a silver-coated copper plate, cased under glass.

darkroom for photography based on chemistry, a room that can be made very dark for processing light-sensitive materials, including photographic **negatives** and positive prints.

darshan the auspicious devotional act of seeing and being seen by a deity, holy person, or sacred object in Hinduism.

daub a thick, sticky building material often made of mud, clay, chalk, sand, animal dung, straw, and/or horse's hair to form a wall surface.

De Stijl a movement founded in the Netherlands in 1917 that used a pared-down **abstract** vocabulary of geometric shapes and **primary colors**; from the Dutch for "The Style."

decorative art(s) any of the **applied arts**, such as furniture, textiles, ceramics, and metalwork, that are intended to be functional and are also designed to be aesthetically pleasing.

decumanus the main east–west street of a Roman city.

Desert Acrylic an Indigenous Australian painting movement that began in desert regions of Australia in the early 1970s, in which painters primarily use **acrylic** paints on canvas to create works ultimately intended for the art market.

design the deliberate arrangement of formal elements into a **composition**.

di sotto in sù an Italian term meaning "as seen from below"; refers to a style of ceiling painting that, by **foreshortening** the ceiling figures, takes into account the viewer's position looking upward.

diadem a crown or ornamented headband worn as a sign of status.

digital media any content (including text, and visual and audio information) that exists in a computer-readable format.

diptych a two-**part** work of art, often two panels attached together.

disegno the Italian term for design, which in Renaissance art refers to the primacy of drawing in the creation of art.

Divisionism the characteristic painting method that formed the basis for **Neo-Impressionism**; following color theory of the era, artists applied contrasting dabs of color side by side that would be perceived by the retina as a unified glowing color.

documentaries images produced as a visual record, often with a narrative.

dogū clay figurines made during the Final Jōmon period.

dome a roof that projects upward in the shape of the top half of a sphere.

Doric a Greek (and later Roman) architectural order characterized by a **column** with a spare, circular **capital**, and a **frieze** of **triglyphs** and sculpted **metopes**.

dōtaku bronze, bell-shaped objects made during the Yayoi period.

double exposure in photography, the superimposition of two exposures to create a single image by opening the camera twice to record something on the same piece of light-sensitive material.

dromos an entrance passage to a subterranean tomb.

drum (1) cylindrical stone block that forms part of a **column**.
(2) a wall (most often cylindrical) that supports a **dome**.

dry fresco a wall or ceiling painting on dry plaster (*a secco*), as opposed to on wet plaster (true or *buon fresco*).

dry masonry a construction technique in which stones or bricks are fitted together so tightly that no mortar is needed.

earflare a large ear ornament, often passed through an extended earlobe.

earthenware pottery fired to a temperature below 1,200 degrees Celsius; also called **terra-cotta**.

earthwork a work of art making use of natural materials such as earth, rocks, turf, and water.

eaves part of a roof that overhangs the walls of a building, generally to protect it from the elements.

echinus the lower part of a **Doric column**'s **capital**; the circular block on top of the **shaft** of a column that supports the **abacus**.

editions a term used in printmaking to describe the number of **prints** struck from one plate; editions can be limited (finite in number) or open (limited only by the number of prints which can be sold or printed before the plate wears out).

effigy a sculpture or model, usually created for its symbolic and/or material value in relation to the thing it represents.

elevation typically, the external **facade** of a building, but can be any exterior face of a building viewed as a vertical plane.

emaki a Japanese term for a **handscroll** painting typically viewed in sections, from right to left. It is wider than it is tall, and when rolled up, it is easily stored and portable.

embossed an object or surface that has been carved, molded, or stamped in **relief**.

embroidery decorative stitching usually made with colored thread on woven textile.

enamel an opaque ornamental coating made of powdered glass.

encaustic paint made from a mixture of **pigment** and heated wax.

engaged column a **column** attached to, or seemingly half-buried in, a wall.

engraving a printmaking technique where the artist gouges or scratches the image into the surface of the printing plate; the engraved lines are filled with ink, which is transferred to the paper during the printing process.

Enlightenment, the a philosophical movement of the late seventeenth and eighteenth centuries that rejected traditional, particularly religious, authority in favor of rational and scientific inquiry into all aspects of human life.

entablature on a building, a horizontal **lintel** that consists of different bands of **molding**; might include an **architrave**, **frieze**, and **cornice**.

entasis the bulging center of a **column**, constructed to correct the optical illusion that may otherwise make the column's **shaft** appear concave.

estipite a type of **column** or **pilaster** in the shape of an inverted cone or pyramid; popular in Spanish and Latin American **Baroque** architecture.

etching a printmaking process that uses the action of acid to make a design scratched into a coating on a metal plate.

exedra (plural *exedrae*) an enclosed space or recessed area, usually semicircular.

exemplum virtutis an artwork with themes that are moral lessons or examples of virtue to be emulated.

exposure in photography, the amount of light that reaches a light-sensitive surface such as film, a glass plate, or paper, determined by the intensity of the light, the speed of the lens, and the speed of the chemical emulsion.

expressionism, Expressionism (1) art that is highly emotional in character, with colors, shapes, or space being distorted and **non-naturalistic** as a means to convey vivid extremes of subjective experience and feeling.
(2) modern Expressionism is associated with several movements, including German Expressionism in the early twentieth century and **Abstract Expressionism** in the mid-twentieth century.

facade any exterior vertical face of a building, usually the front.

facture in art, the characteristic way a particular artist handles paint.

faience a glassy substance that is formed and fired like ceramic, made by combining crushed quartz, sandstone, or sand with natron or plant ash.

fan painting a **format** of East Asian painting in which the image is painted on an oblong, round, or folded fan.

Fauves a group of early twentieth-century French artists whose paintings used vivid colors for **expressive** effect, liberated from **naturalistic** description; the term derives from *fauve*, French for "wild beast."

femme fatale a character perceived as an attractive, seductive woman who manipulates men, often leading them into danger or disaster—an **archetype** of art and literature; derives from the French for "fatal woman."

fetish a European term for a human-made substitute for God; used inaccurately to refer to objects related to African religious practices or beliefs.

fibula a large, decorative brooch for fastening clothing.

figurative art that portrays human or animal forms.

filigree a type of decoration, typically on gold or silver, characterized by ornate **tracery**.

film noir a term for **stylized** crime dramas from the black-and-white era of cinema, with a visual style that evokes German **Expressionist** film.

finial an ornament at the top, end, or corner of an object or building.

floor plan in architecture, a diagram showing the arrangement of a building's spaces, walls, and passages on a given floor.

flower-and-bird painting in East Asia, a genre of painting that includes vegetable, avian, and insect subjects.

flute or fluting/fluted shallow ridges running vertically along a **column**, or other surface.

Fluxus an international community of creative artists and writers active during the 1960s and 1970s; the group's experimental art performances emphasized artistic process over finished product.

flying buttress in architecture, a supporting **pier** that extends, or "flies," from an external wall, with an **arch** that provides additional support to the wall while allowing space for windows.

focal point in any **composition**, a dominant area that draws a viewer's eyes more often than any other area.

folio one leaf of a book.

foreshortening in **two-dimensional** artworks, the illusion of a **form** receding into space: the parts of an object or figure closest to the viewer are depicted as largest, those furthest as smallest.

form (1) an object that can be defined in three dimensions.
(2) the physical, visual, and other relevant aesthetic characteristics of an artwork.

formal analysis the method of examining and understanding an artwork's **form**, including its **medium** and materials, formal elements, and principles of design.

formal elements the characteristics of line, shape, color, light/shadow, texture/pattern, space/point of view, and (when relevant) time and sound.

formalism an artistic or critical emphasis on the visual elements, such as line, color, and **composition**, that give form to a work of art; an emphasis that dominated art criticism after World War II.

format in East Asia, painting types that include the **hanging scroll**, **handscroll**, **album leaf**, and **fan**.

forum an open area at the center of a Roman town where people shopped, worshiped, and participated in political or judicial activities.

found object material presented with or without any alteration, as part of a work of art, or as a work of art on its own.

foundries workshops or factories used to cast metal.

four-*iwan* plan four **vaulted** halls, each open on one side, positioned around a courtyard to form one large interconnected space.

French Academy an organization founded in 1648 that oversaw the training of artists and set artistic standards for France.

fresco a wall or ceiling painting on wet plaster (also called true fresco or *buon fresco*); wet **pigment** merges with the plaster, and once hardened the painting becomes an integral part of the wall; painting on dry plaster is called *fresco secco*.

fresco secco see **fresco**.

frieze (1) any sculpture or painting in a long, horizontal format.
(2) in architecture, the part of an **entablature** located above the **architrave**.

fritware ceramic vessels made using a combination of quartz, glass frit (partially fused glass), and fine white clay; thinner and whiter than vessels made using regular clay.

fusuma sliding doors or partitions, traditionally painted.

Futurism an art movement founded in 1909 in Italy that emphasized modernity, speed, technology, and the power of machines.

gable the roughly triangular upper section of an exterior wall created by a roof with two sloping sides.

gabled roof a roof with two sloping sides.

gallery an interior passageway or other long, narrow space within a building.

garbhagriha a Hindu temple's innermost sanctum; a small, dark space, where the main **icon** of a deity is housed.

garniture typically a collection of matching pieces, often metal objects—either for the decoration of a mantelpiece, or for plate armor or weaponry.

genre painting (or **genre scene**) an art historical category for paintings that show scenes of everyday life.

geometric abstraction art in which the subject is simplified into straight or curving lines or shapes used in geometry.

gesso a mixture of animal glue, chalk, and white **pigment** used to coat a wood surface in preparation for painting.

gilded covered or foiled in gold.

giornata a "day's labor" in the production of a **fresco** painting.

girder an iron or steel beam used as the main horizontal support for the framework of a bridge or large building.

glaze (1) thin layers of transparent, lightly pigmented colors painted on top of opaque colors to produce greater richness and depth by heightening the colors' reflective and refractive properties.
(2) a substance fused onto the surface of pottery to form a smooth, shiny decorative coating.

glyph (sometimes **hieroglyph**) in a writing system, a single symbolic figure that consistently represents a word, syllable, or sound.

gogok the Korean term for C-shaped ornaments made of stone and jade.

gopura (plural *gopuram*) a monumental tower at the entrance of a Hindu temple complex, especially in south India.

gorget an object worn near the neck area as a costume item.

Gothic a western European medieval style primarily of the mid-twelfth to fifteenth centuries, characterized in architecture by the use of pointed **arches** and **rib vaults**.

Gothic Revival the renewed popularity of the European **Gothic** style of architecture during the nineteenth century.

gouache an opaque, water-based painting medium.

Grand Manner a style that incorporates visual references to ancient and **Renaissance** art and culture to lend an air of nobility and timelessness to modern subjects.

granulation a decorative technique in which beads of precious metal are fused onto a metal surface.

graphic artist a person who produces illustrations, advertisements, posters, and other two-dimensional artworks.

griffin a mythological creature with the body of a lion and the head of a bird; often winged.

grisaille a method of painting in gray tones, typically to imitate sculpture.

groin vault a **vault** produced by the intersection of two **barrel vaults** placed at right angles to each other, forming pronounced "groins" or arcs at the meeting points.

ground a foundation layer for painting, usually made by coating a surface with **gesso** or a layer of paint of an even tone.

ground plane (referring to the ground represented in **two-dimensional** artwork): in **linear perspective**, the ground plane appears to recede to the horizon line; in a picture with a sharply uptilted ground plane, no horizon appears within the picture.

guohua a Chinese term meaning "national painting" and referring to painting created with traditional materials (ink and/or colors on silk or paper) and often in traditional **formats** and genres.

Gutai an avant-garde art group formed in Japan in 1954.

halo a circle of light depicted around the head of a holy figure to signify his or her divinity.

hand stencil an image created by placing a hand on the wall of a rock shelter or other surface and blowing paint over it to create a silhouetted image of the hand.

handscroll a **format** of East Asian painting that is much longer than it is high; typically viewed intimately and in sections, as the viewer unrolls it from right to left.

hanging scroll a **format** of East Asian painting that is typically taller than it is wide; generally, hanging scrolls are displayed temporarily and may be rolled up and stored easily.

haniwa literally, "clay circle." **Earthenware** cylinders and figural forms placed on the exterior of tombs of the Kofun period.

Happenings artwork that takes the form of an event, often improvised and with artist(s) and audience as participants.

Harlem Renaissance a dynamic period in Black culture and art in the 1920s and 1930s, with Harlem, a neighborhood in New York City, as a primary center.

harmika a square, fence-like enclosure that symbolizes heaven and appears at the top of a *stupa*.

hatching short, parallel lines used in drawing or **engraving** to represent light and shadow.

Hellenistic a period of Greek and Mediterranean art traditionally dating between the death of Alexander the Great in 323 BCE and the emergence of the Roman Empire in the late first century BCE.

henge an ancient monument with an outer circular ditch and inner bank.

heraldic (1) related to heraldry, which is the display of coats-of-arms and other symbols of ancestry. (2) symbolizing authority, often royal authority.

herm a squared stone pillar with a carved head on top.

hierarchical scale the use of size to denote the relative importance of subjects in an artwork.

hierarchy of genres an **Academic** system of ranking types (genres) of paintings, including **history**, portraiture, **genre**, **landscape**, and **still life**, in descending order, according to their perceived level of intellectualism and difficulty.

hieroglyph/hieroglyphic a type of written script that uses conventionalized signs to represent concepts, sounds, or words.

high relief raised forms that project far from a flat background.

hip-and-gabled roof a composite roof design that combines a **hip roof** in the lower portion, and in the upper portion, one that slopes from two opposite sides with two **gables** (vertical triangular) at the ends.

hip roof a roof that slopes upward from all four sides of a building.

historiated icon a frontal representation of a sacred figure surrounded by narrative scenes associated with that person's life.

history painting a genre of painting that takes significant historical, mythological, and literary events as its **subject matter**.

horseshoe arch a keyhole-shaped **arch**, the opening of which widens before rounding off.

hôtel particulier a large, freestanding private townhouse.

hozho a Diné word for beauty and harmony that is used for well-ordered artworks and healthy people.

hue color, regardless of **saturation** or modulation.

humanism an ideology based on the celebration of human achievements and civic virtue.

hyper-reality in art, an attempt to achieve a form that surpasses reality.

hypostyle hall a large room with rows of **columns** or pillars supporting the roof.

icon (1) an image of a religious subject used for contemplation.
(2) a person or thing regarded as a representative symbol or worthy of veneration.

iconoclasm the intentional destruction or rejection of images on religious or political grounds.

iconoclast a destroyer of images, typically those used in religious worship.

iconography images or symbols used to convey specific meanings in an artwork.

idealized a depiction that is more beautiful and perfect than the actual subject.

ignudo (plural *ignudi*) **idealized** nude male figures.

illuminated manuscript an illustrated, handwritten book, with such decorative elements as ornate initials, chapter headings, text borders, and framed images that supplement the text.

illumination decorative designs, handwritten on a page or document.

illuminators those who create decorative designs, handwritten on a page or document.

illusionism making objects and space in two dimensions appear real; achieved using

such techniques as **foreshortening**, shading, and **perspective**.

impasto the texture produced by paint applied very thickly.

Impressionism a style of painting developed in Paris beginning in the late 1860s; typically without extensive preparatory work, using bright color and broken brushwork, and capturing momentary effects of light, atmosphere, and color. Central subjects are landscapes and scenes of everyday life.

in antis arranging **columns** so that the end **piers** project further than those in the middle.

incised, incision cut or engraved.

industrial design the application of aesthetic and functional criteria to the design of products that are to be manufactured through machine techniques.

inlay decoration embedded into the surface of a base material.

inscription writing added to an artwork, either by the artist or by admirers and later collectors.

installation a work of art created at the site where it is located, often using physical elements on the site; creates an immersive experience for the viewer.

intaglio a printmaking technique where lines are **incised** into a surface and the incised lines hold the ink, in contrast to **relief printing**.

intarsia a type of wood **inlay** where pieces of stained wood of varying colors and shapes are set together into a pattern or image, usually on a wall surface or floor.

intensity the **saturation** or brilliance of a given color.

intercultural in art history, contact between cultures and/or those artworks that draw upon and integrate two or more distinct cultures; it may also recognize the already eclectic nature of a given culture.

International Gothic a late medieval style of art developed in royal courts across western Europe.

International Style a modern form of architecture that emerged in the 1920s and 1930s, characterized by the use of simple cubic forms, absence of applied ornamentation, open interior spaces, and the use of industrial steel, glass, and reinforced concrete.

intonaco an Italian term for a thin layer of fine plaster spread onto a wall, on top of which **pigment** is applied (while the plaster is still slightly damp) to make a **fresco** painting.

Ionic an order of **Classical** architecture characterized by the use of **volutes** on the **capital**.

isometric perspective a system of representing **three-dimensional** space and objects on a **two-dimensional** surface in which the angle between any two of the three coordinate axes is approximately 120 degrees; unlike **linear perspective**, the lines have no **vanishing points**.

Italo-Byzantine synonym for *maniera greca*.

iwan a large, **vaulted** hall with walls on three sides and open on the fourth.

jade a general term for hard, typically green minerals, including **nephrite** and jadeite.

jali a perforated stone or lattice screen, usually featuring a **calligraphic** or geometric pattern.

jamb each of the two upright parts of a doorframe.

Japonisme objects and images characterized by European taste and ideas about Japan.

jasperware a fine-grained, unglazed white **stoneware** ceramic developed in the eighteenth century by Josiah Wedgwood, often colored with metallic oxides.

jataka stories of the **Buddha's** past lives.

jingyeong sansuhwa Korean "true-view landscape painting" depicting real scenery on the Korean peninsula in styles demonstrating innovation and a degree of independence from earlier (Chinese) models (see also *shinkeizu*).

kachina in Pueblo culture, a deified ancestral or nature spirit; also a deity impersonator who wears the appropriate mask and costume in *kachina* rites; *kachina* dolls imitate the dancer costumes and are used to teach young women the different spirit identities.

karesansui a Japanese dry landscape garden; commonly known as a Japanese rock garden.

karyatid a stone statue of a young woman, which can be used like a **column** to support the **entablature** of a temple.

kero an Andean decorated drinking cup used in feasts.

keystone a central stone, wider at the top than the bottom, placed at the summit of an **arch** to transfer the weight downward.

khipu a group of knotted cords of different colors used by the Inka for record-keeping.

kinetic art art that is made to be set in motion, relying on mechanical means (such as motors) or natural forces (such as wind currents and gravity).

kitsch an object or design considered to be unrefined and in poor taste, typically due to garish ornamentation or overt sentimentality.

kiva in Pueblo culture, a subterranean ceremonial space that typically takes the form of a circle and often serves as the principal ritual space for important male societies.

kofun key-hole-shaped tombs that give the Kofun period its name.

kondō literally, "golden hall"; the main hall of a Japanese Buddhist temple.

kore (plural *korai*) a freestanding Archaic Greek statue of a clothed young woman.

kouros (plural *kouroi*) a freestanding Archaic Greek sculpture of a naked young man.

krater a large vessel usually for diluting wine with water.

Kufic one of the oldest Arabic scripts, angular in form, often used to copy the Qur'an.

kylix (plural *kylikes*) an ancient Greek drinking cup with a stem.

Kyūshū-ha an influential post-World War II avant-garde art group that formed in Kyūshū, Japan in the 1950s.

lacquer a liquid substance derived from the sap of the lacquer tree; used to varnish wood and other materials, producing a shiny, water-resistant coating.

lancet a tall narrow window with a pointed **arch** at its top.

landscape a genre that depicts natural environments as well as such human environments as cityscapes.

landscape perspective a **composition** in which the figures and landscape are depicted as if seen by an observer standing on the ground.

lantern an architectural feature that projects from a roof or **dome** and allows light into a building.

latticework a framework made of interlacing strips (usually of wood or metal) in a crisscrossed pattern.

leaf a single page from an **album** (a **format** of painting).

lekythos (plural *lekythoi*) a small bottle for perfumed oil used to anoint a corpse or a grave marker, or as an offering to the dead or the gods.

lens an optical device made of transparent material such as glass, which can focus light to form an image.

libation the ritual pouring of a liquid, often alcohol, to a spirit or deity as an offering while prayers are said.

linear perspective a system of representing **three-dimensional** space and objects on a **two-dimensional** surface by means of geometry and one or more **vanishing points**.

linga an **abstract** representation of the Hindu god Shiva that denotes his divine generative energy.

lintel a horizontal support above a door or other opening.

literati in Confucian cultures of East Asia, the social group of educated men who would typically pursue government service as a career, but could also put their skills in reading, writing, and related arts to work through tutoring, writing, and painting.

literati painters educated artists, including scholar-officials, who brought literary values into painting, and pursued **abstraction** and self-expression in their art.

lithography a printing process in which images are drawn on a flat surface, such as fine-grained limestone or a metal plate, using a greasy substance; ink is then applied to the wetted surface, being repelled by the damp areas and sticking only to the greasy areas to print the desired image.

local color the basic color of an object seen in daylight without any modifications by shadows, reflected light, or unusual illumination.

loggia a covered gallery or walkway open on one or more sides and supported by **columns** or **arches**.

logogram a sign that represents and stands in for a whole word or a phrase; logographic refers to a writing or communication system that uses such signs.

lost-wax casting a method of creating metal sculpture in which a clay mold surrounds a wax model and is then fired; when the wax melts away, molten metal is poured in to fill the space.

low relief (also called bas-relief) raised forms that project only slightly from a flat background.

lunette a semicircular or arch-shaped space on a wall or ceiling, usually with a frame.

lusterware a type of pottery or glassware with a metallic glaze.

madrasa a school, especially for Islamic law and theology.

magatama a Japanese term for C-shaped ornaments made of stone and jade.

mana supernatural power; *mana* can be manifest in many forms including humans, divine beings, animals, places, and natural or human-made objects.

mandala typically comprised of concentric circles and squares, a spiritual diagram of the cosmos used in Hinduism, Buddhism, and other Asian religions.

mandapa a **porch** or hall located before the inner sanctum of a Hindu temple.

mandorla (in religious art) a **halo** or frame that surrounds the entire body.

maniera an Italian word meaning manner or style that came to refer to particular style characteristics found in sixteenth-century art.

maniera greca Italian for "Greek manner," a style characterized by flat figures placed within a shallow space set against a gold background; a synonym for **Italo-Byzantine** style.

manifesto in art, a public declaration of an artist's or artistic movement's intentions, motives, and aims.

Mannerism particular stylistic characteristics—intellectual sophistication and artificial elegance—found in sixteenth-century European art.

manuscript a handwritten book or document.

maqsura the space in a **mosque** reserved for the caliph and his entourage.

marginalia notes or drawings made in the margin of a **manuscript** or printed book, which often add meaning to the work.

marquetry a woodworking process that makes detailed, illusionistic pictures from an elaborate jigsaw puzzle of thin veneers of wood.

martyrium (plural **martyria**) a building constructed to commemorate the site of a saint's execution or the location of holy remains.

masquerades the masks, choreography, music, costumes, lyrics, and staging of performances involving transformations of the human body.

mass especially in sculpture and architecture, three-dimensional volumes or dense aggregations of matter or material.

mass media communication—such as radio, television, cinema, or the press—designed to reach large audiences.

mastaba a massive, flat-topped rectangular tomb building with slanted side walls; built of either mud brick or cut stone.

material culture the materials, objects, and technologies that accompany everyday life.

matte a surface that does not reflect light; has no luster or shine.

maulstick a long stick used by artists to steady the hand while holding a paintbrush.

mausoleum (plural **mausolea**) a building or freestanding monument that houses a burial chamber.

medallion a circular or oval-shaped emblem.

medium (plural **media**) the generalized type of an artwork, primarily based on the materials used.

megalith a large stone used as, or as part of, a monument or other structure.

megaron an architectural form used in Mycenaean palatial complexes; it includes a **porch** and a main hall.

memento mori an artistic reminder of the passing of time and eventual death.

men's (ceremonial) house a structure for religious rites, storing sacred objects, socializing, or to discuss community concerns; typically restricted to initiated men.

metope a plain or decorated slab on a **Doric frieze**, between **triglyphs**.

mihrab a prayer niche, usually concave in shape with an arched top, located in the *qibla* **wall** of a **mosque** and indicating the direction of Mecca.

millefleur a **tapestry** background characterized by a green meadow populated with a profusion of plants and flowers; literally translates as "a thousand flowers."

mina'i derived from the Persian word for **enamel**, it describes a multicolored and **gilded** over-**glaze** process used on ceramics, typically white **fritware**.

minaret a tower at a **mosque** or Islamic tomb; can be used to give the call to prayer and also functions as a visible marker on the skyline.

minbar a stepped pulpit from which the sermon at Friday noon prayer is given in a **mosque**; usually placed directly next to the *mihrab* on the *qibla* **wall**.

miniature a small-scale book illustration.

Minimalism an artistic style in which elements are pared down to the bare minimum.

mithuna in South Asian cultures, an amorous couple, representing fertility and considered **auspicious**.

mixed media artwork made from a combination of different materials.

model the representation of a **three-dimensional form**.

Modernism a movement that promotes a radical break with past styles of art and the search for new modes of expression.

Modernist architecture a twentieth-century architectural movement that embraced modern industrial materials, a functional approach to design, and a machine aesthetic that rejected historical precedent and ornament.

modulated color an impure color, created through the mixture of more than one **hue**.

molding a decorative architectural feature that covers the transition between two surfaces, such as the dividing line from one story, portal, or window framing, to another, or to the roofline of a building.

monochrome made from shades of a single color.

monogram a **motif** made from letters, often overlapping or formed in a distinctive way to create a symbol.

monolith/monolithic a single large block of stone.

monotype a printmaking method where a design is drawn in paint or ink on an unworked plate and transferred to paper by pressure, usually yielding only one strong impression.

monumental having massive or impressive size or extent.

mortar a bowl-shaped object used to hold food or other substances for crushing.

mosaic a picture or pattern made from the arrangement of small colored pieces of hard material, such as stone, tile, or glass.

mosque a Muslim place of worship.

motif a distinctive visual element in an artwork, the recurrence of which is often characteristic of an artist's or a group's work.

Mudéjar a blend of **Gothic** and Islamic styles of art and architecture unique to Spain during the thirteenth through the early sixteenth centuries.

mudra a symbolic gesture in Hinduism and Buddhism, usually involving the hand and fingers.

mullion a vertical or horizontal bar dividing windows into units.

muqarnas alternating convex and concave niche-like cells, clustered like a honeycomb; used to decorate transitional spaces in Islamic architecture.

mural a painting made directly on the surface of a wall.

naos see *cella*.

narthex the entrance hall or vestibule of a church.

naturalism representing people or nature in a detailed and accurate manner; the realistic depiction of objects in a natural setting.

nave the central **aisle** of a **basilica** or church.

necropolis (plural **necropoleis**) a large cemetery; from the Greek for "city of the dead."

negative in photography, a reverse image where the tones of light and dark are the opposite of what they are in reality, created when light strikes a light-sensitive surface; a negative can then be used to print positives.

negative space areas of a **composition** not occupied by objects or figures.

Neo-Gothic an architectural movement beginning in the late 1740s in England that sought to revive the **Gothic** style.

Neo-Impressionism the art movement founded by Georges Seurat, an artist who wanted to apply a more scientific approach to **Impressionism** and who was inspired by optical theory to paint using uniform dabs of color to create light effects.

Neoclassicism/Neoclassical a style of art and architecture that emerged during the eighteenth century in Europe and the Americas, inspired by **Classical** Greek and Roman examples, and characterized by order, symmetry, and restraint.

Neolithic a period of human history in which polished stone implements prevailed, roughly beginning about 10,000 BCE and persisting until the use of bronze metal implements. In East Asia, the Neolithic ends and the Bronze Age begins roughly around the second millennium BCE.

nephrite a hard, fibrous mineral used in the Liangzhu culture for making ritual objects; often called jade.

niello a black alloy of sulfur and other metals, often used for **inlay**.

nihonga a Japanese term meaning "Japanese-style painting"; refers to painting in traditional materials (ink and/or colors on silk or paper) and often in traditional **formats** and genres.

niō (also known as *kongo rikishi*): paired guardian statues often found at Buddhist temples in Japan.

nonobjective art art that contains no visual representations of figures or objects; also called nonrepresentational art.

obelisk a rectangular stone pillar with a pyramidal top; usually a landmark or a monument to a person or event.

oblique neither parallel nor at a right angle to a specified or implied line; slanting.

Occidentalism refers to non-European cultures conceiving of European cultures in stereotyped ways, attributing either romanticized or negative qualities to them.

ocher a naturally occurring clay **pigment** that ranges in color from yellow to red, brown, or white.

oculus (plural **oculi**) a round, eye-like opening in a ceiling or roof.

Old Master an eminent European painter, especially one practicing before 1800.

one-point perspective a perspective system with a single **vanishing point** on the horizon.

onna-e literally "women's painting," the category of Japanese painting characterized by heavy **pigments**, indirect expression of emotional content, and themes of pathos.

openwork decoration created by holes that pierce through an object.

opisthodomos (also called *adyton*) the back porch or rear room of an ancient Greek temple.

oracle bones turtle plastrons and ox shoulder bones used for divination in the Shang state.

oratory a prayer chapel.

order in Mediterranean **Classical** architecture, categories of **columns** and their corresponding **capitals**: **Doric**, **Ionic**, and **Corinthian**. See also **Classical column orders**.

Orientalism refers to European cultures conceiving of North African, West Asian, and Asian cultures in stereotyped ways, attributing either romanticized or negative qualities to them.

orthodox in Chinese **landscape** painting, the style advocated by Dong Qichang; typically executed in ink only or with limited, light colors, paintings tend to be **abstract**, relying on schematic conventions for rendering rocks, mountains, trees, and buildings, and often make reference to earlier painters' styles.

orthogonal when creating **perspective** in **two dimensions**, the diagonal parallel lines (visible or invisible) that recede from an object in the foreground or midground to a **vanishing point** on the horizon line.

orthostat an upright, standing stone slab, often protecting the lower part of a mudbrick wall.

otoko-e literally, "men's painting," the category of Japanese painting characterized by ink **monochrome**, facial expressions, physical gestures, and themes of humor and action.

outline a line that marks the boundary of a shape.

overglaze a second decorative coating applied to an already **glazed** ceramic ware.

pagoda in East Asia, the *stupa* form: a tall structure that houses Buddhist **reliquaries**.

painterly characterized by color and texture, rather than line.

palette (1) an artist's choice of colors. (2) the tray, board, or other surface on which an artist mixes colors of paint.

palette knife a tool with a flexible blade, used for mixing colors and sometimes for applying paint.

Palladian a type of **Neoclassical** architecture that draws upon the principles of Italian architect Andrea Palladio's sixteenth-century studies of Greek and Roman architecture.

Pantocrator literally "all-ruler," usually associated in **Byzantine** art with the lordship of Christ as sovereign of the cosmos.

papier-mâché paper pulp mixed with glue and other materials, or layers of paper glued and pressed together, that is molded when moist and becomes hard when dry.

paragone the philosophical rivalry begun during the Italian **Renaissance** that debated the relative merits of painting and sculpture.

parapet a low wall barrier along the edge of a roof, balcony, or walkway.

parchment a writing surface prepared from the skin of certain animals that has been treated, stretched, and polished.

pastel powdered **pigment** mixed with gum and used in stick form for drawing.

pastoral a work of art portraying rural life or the life of shepherds, especially in an **idealized** form.

patina a thin layer of color applied to, or occurring naturally over time upon, an object.

patron, patronage a person or institution that commissions artwork or funds an enterprise.

pattern recurring arrangements in an artwork.

pectoral a piece of jewelry or armor worn on the chest.

pedestal a support or base for a sculpture.

pediment in architecture, the triangular component that sits atop a **columned porch**, doorway, or window.

pendentive a curved triangular wall section linking a **dome** with a supporting vertical **pier** or wall.

peplos (plural *peploi*) a simple, long, belted garment of wool worn by women in ancient Greece.

performance art linked to performing arts such as theater and dance, ephemeral events with a strong visual focus orchestrated by visual artists before an audience.

performance artists artists who enact (or re-enact) a series of actions that involve objects and visual images.

peripteral having a single row of **columns** surrounding a building, such as in a Greek temple.

peristyle a line of **columns** surrounding an enclosed space or structure.

perspective the **two-dimensional** representation of a **three-dimensional** object or a volume of space.

pestle a club-shaped implement used to crush materials in a **mortar**.

petroglyph an image created on a rock surface through **incision**, pecking, carving, or abrading.

photographic film a photographic material that uses a base of transparent plastic film coated with a gelatin emulsion of light-sensitive chemicals to make a **negative**.

photomontage a **composition** made using fragments of photographs, sometimes combined with other **two-dimensional** elements, pasted into new configurations.

physiognomy the shape, proportion, and composition of facial features.

piano nobile the main floor of a house, one that is "noble," or elaborately decorated.

pictorial narrative storytelling in pictures that presents a connected sequence of events.

Pictorialism a movement originating in the late nineteenth century by which artists sought to elevate photography to the status of painting and drawing by modeling their photographs after fine art.

picture plane the surface of a picture or the vertical plane in the extreme foreground of a picture, parallel to the surface.

picturesque an eighteenth-century aesthetic ideal of wild or natural beauty; in pictures, it tended to emphasize ruins, **asymmetrical composition**, and the grandness of nature.

piece-mold casting a method of metal casting in which the mold is formed around a clay model, then cut into several pieces, and reassembled for casting.

pier an upright post that supports horizontal elements, such as a ceiling or **arcade**.

pietà Italian for "pity"; an artwork depicting the Virgin Mary holding the dead body of her son, Jesus Christ.

pietra dura (also called *parchin kari* in South Asia) an **inlay** technique in which small pieces of carefully cut and fitted colored stone create **patterns** or images.

pigment any substance used as a coloring material in paint, such as dry powders made from finely ground minerals.

pilaster a flat, rectangular vertical projection from a wall; usually has a base and a **capital** and can be **fluted**.

pile carpet a textile floor covering with an upper layer of pile (knotted pieces of yarn) attached to a woven backing.

pilotis ground-level supporting **columns**.

pingdan an aesthetic sensibility promoted by the **literati**, *pingdan* is reserved in style, mild in taste.

pinnacle a summit or peak, often capping a tower, **gable**, **buttress**, or other projecting architectural form.

pishtaq in Persian and/or Islamic architecture, a gateway consisting of a rectangular frame around an **arched** opening.

pitched roof a roof that slopes downward, typically in two parts from a central ridge.

plate glass a type of glass, initially produced in a flat sheet, often used in windows.

plateresque a Spanish late **Gothic** and early **Renaissance** architectural style that consists of intricate **low-relief** carving with rich surface detail that recalls work in silver and other precious metals.

plein air refers to the practice of painting out of doors; derives from the French for "open air."

plinth a base or platform upon which a structure rests.

pochoir a refined stencil-based printing technique popular from the late nineteenth century to the 1930s; from the French term for "stencil."

podium a raised platform that serves as a base.

point of view the implied position of the observer generated within the artwork.

Pointillism in painting, applying dabs of color, either short strokes or dots, of uniform size.

polychrome displaying several different colors.

polyptych a work of art with more than three parts, usually attached together.

Pop Art a movement beginning in the mid-1950s that used imagery from popular or "low" culture, such as comic books and consumer packaging, for art.

porcelain a smooth, translucent ceramic made from kaolin clay fired at very high temperatures.

porch a covered area usually connected to the front of a building.

portal an opening in the wall of a building; usually an entranceway.

portico a projecting structure with a roof supported by **columns**; typically functions as a **porch** or entrance.

post-and-lintel a form of construction in which two upright posts support a horizontal beam (**lintel**).

Post-Impressionism a term coined by British artist and art critic Roger Fry in 1910 that refers not to a movement, but to a shared aesthetic attitude: namely, that an artist should develop novel ideas and techniques that move beyond both **Academic** convention and **Impressionism**.

postcolonial theory philosophical ideas formulated to explain relationships between colonized and colonizing nations and people.

Postmodernism a late twentieth-century reaction to **Modernism**, typically defined by a rejection of grand narratives, absolute truth, and objective reality.

pradakshina in Hindu, Buddhist, and Jain practice, the ritual of walking around (circumambulating) a sacred place or object.

Pre-Raphaelite a British art movement formed in 1848 by painters who rejected the **Academic** rules of art and often painted literary or moralizing subjects drawn from a wide range of sources in a style of bright colors and precise, sharply focused detail.

predella a wooden step or platform that supports an **altarpiece** and is often painted with related scenes.

prefabrication the manufacture of components of a structure away from a construction site, for rapid assembly when they reach the site.

primary colors blue, yellow, and red; called primary because any color in the visible spectrum may be mixed by blending them together.

primitive art a term that used to be applied to art made in cultures perceived by **Western** bias as uncivilized and not having changed from their earliest origins.

Primitivism an aesthetic movement begun in nineteenth-century Europe characterized by a fascination with tribal and folk art, and culture from around the world.

print an image or artwork resulting from the mechanical transfer of a design, generally used to produce multiple copies.

pronaos the **porch** or vestibule at the front of a temple.

proscenium (*proskenion* in Greek) a raised platform or stage in front of the *skene* where the actors performed.

protome a decoration in the form of the head or **bust** of a human or animal.

provenance the history of an artwork's ownership.

provenience the find spot, context, or place of discovery of an archaeological artifact (compare to **provenance**).

psalter a book of psalms used for liturgical purposes.

pulpit a raised lectern from which priests read biblical passages and deliver sermons.

pusaka an Indonesian term for a sacred heirloom imbued with spiritual power.

putto (plural *putti*) a chubby male child, usually nude and sometimes winged.

pylon a monumental stone gateway to an ancient Egyptian temple composed of two wide, tapered towers.

pyxis (plural *pyxides*) a small cylinder-shaped container with a separate lid.

qibla the direction Muslims face to pray, toward the Ka'ba in Mecca.

qibla wall the wall in a **mosque** that indicates the direction toward which Muslims face to pray, usually indicated by the presence of a *mihrab*.

quadratura a painting technique that blurs the distinction between painted and architectural space through *trompe l'oeil*, sculpture, and architectural features.

quadro riportato Italian term for "carried picture"; describes ceiling **frescoes** painted to resemble framed easel paintings.

quatrefoil a decorative shape consisting of four lobes; resembles a **stylized** flower.

radiocarbon dating a scientific method of determining the age of an object, based on the presence of carbon-14 in organic material.

raking light the illumination of objects from a light source at an oblique angle or almost parallel to the surface.

rammed earth a building technique in which damp earth is compressed, usually within a frame or mold, to form a solid structure.

readymade a term coined by Marcel Duchamp to describe a preexisting, mass-produced object given a new context and treated as a work of art.

Realism a phase of nineteenth-century art, when an attempt was made to create objective representations of the external world.

recto the right-hand or front side of a **folio**.

red-figure a style of pottery painting for which Athens was famous; red decoration on a black background.

reflection an optical phenomenon where a surface is capable of reflecting light.

refraction an optical phenomenon where a light wave changes direction when it enters a medium, such as a glass prism, at an angle.

regional style shared aesthetic qualities in a geographic area.

register a horizontal section of a work, usually a clearly defined band or line.

relational art a term created by curator Nicolas Bourriaud in the 1990s to describe art that creates a social context in which viewers participate in a shared activity and have a role in creating the meaning of the work.

relics the bodily remains of saints or items believed to have come into physical contact with the divine.

relief/relief sculpture raised forms that project from a flat background.

relief printing a printmaking technique where lines are cut out of a surface so that the surrounding area is recessed; the lines are then inked to create an image, in contrast to **intaglio** printing.

relieving triangle a triangular space above the **lintel**, designed to relieve the weight of the masonry.

reliquary a container for **relics** (items associated with a deceased sacred individual), which is often elaborately decorated.

Renaissance a period of **Classically** inspired cultural and artistic change in Europe from approximately the fourteenth to the mid-sixteenth centuries.

repoussé a relief design created by hammering malleable metal from the reverse side (not the side to be viewed).

repoussoir in **two-dimensional** art, a figure or object in the extreme foreground, used as a contrast and to increase the illusion of depth.

representational art that depicts a recognizable person, place, object, or other subject.

resist-dyeing when dyeing textiles, the various methods used to create patterns by preventing the dye reaching the cloth in certain areas.

retablo (also called a reredos) a decorated vertical structure behind an altar; typically includes painting and/or sculpture and an elaborate framework.

retrospective a survey of an artist's career, usually produced as an exhibition or catalog.

revetment a protective and/or decorative facing on a building's exterior.

rhyton (plural **rhyta**) a conical container with a hole at the bottom, thought to hold drinks or offerings.

rib an **arch** or **molding** that reinforces and defines the arcs of a **vault**.

rib vault a **vault** consisting of numerous intersecting **ribs**, often associated with **Gothic** architecture.

rilievo schiacciato an Italian technical term meaning "low relief"; refers to a flat carving of **incised** lines barely raised from their solid background.

rocaille a style of ornament characterized by the use of elaborate shell work, pebbles, scrolling, and similar devices.

rock-cut carved from solid stone where it naturally occurs.

Rococo a style of art and architecture that emerged in the eighteenth century, characterized by formal **asymmetry**, natural forms, scenes of leisure, and sensuous surfaces and materials.

Romanesque a medieval style of architecture (in the Roman style), characterized by rounded **arches**.

Romanticism, Romantics a movement from the late eighteenth through the mid-nineteenth centuries in European culture, concerned with the power of the imagination, and valuing intense feeling.

roof comb a lattice structure surmounting the roof of a temple; often used to support **monumental** sculpture.

rose window a large, round stained-glass window set in stone **tracery**.

rotunda a cylindrical building, or a cylinder-shaped room within a larger building.

roundel a small disk, especially a decorative **medallion**.

rubbing an image made by rubbing powdered ink onto a sheet of paper placed against a shallowly carved or textured surface.

rückenfigur a person in the foreground of an image facing away from the viewer, inviting the viewer to experience the person's perspective and emotional reaction; from the German for "back figure."

ruled-line painting using rulers and compasses to render architecture and other complex, engineered structures with meticulous care.

rusticated rough-cut stonework.

sacra conversazione Italian for "sacred conversation"; a group of saints pictured together with the Virgin and Christ Child, usually in an **altarpiece** painting.

salon a room in a house used for small gatherings and intimate conversation, sometimes called a drawing room; also refers to the events of sociable and intellectual conversation that took place in such rooms.

Salon des Refusés an exhibition in Paris in 1863 created to show work rejected that year from the official **Salon**.

Salon, The an official French exhibition of art held annually or biennially, sponsored by the government through the French Royal Academy of Painting and Sculpture from 1667 until 1881.

sanctuary in ancient Greece, a sacred space reserved for the worship of a deity (or deities); it was often enclosed by a wall and could include open-air altars, temples, and other structures and monuments.

sans-serif a category of typefaces without serifs (ornamental cross-lines at the ends of the main strokes).

sarcophagus a container for human remains.

satin a smooth, glossy fabric, often made of silk, produced by a weave in which the **weft** threads catch the **warp** threads only at certain intervals (rather than every row).

saturation the degree of purity of a color.

scabbard a sheath used to cover the blade of a sword or dagger.

scarification permanent marks created by incising or irritating the skin; used to enhance beauty, establish status, or identify individuals as initiated members of society.

schematic depicted in a simplified, graphic form.

screen painting a **format** of East Asian painting, consisting of one or more panels; functions as a moveable piece of furniture to frame a significant place or subdivide a space

screenfold book a method of book-binding in which pages are attached to one another by their sides and folded into an accordion shape.

scriptoria rooms used for writing, often in a monastery or library, where **manuscripts** are hand-copied by scribes.

sculpture in the round freestanding **three-dimensional** sculpture that can be viewed from every angle, for example, by walking around it.

seal (1) a small piece of hard material (stone) with an **incised** design; it is rolled or stamped on clay to leave an imprint. (2) in East Asian art, either the small object or the impression it leaves; signifies ownership or authenticity, similar to a signature.

self-portrait an artist's depiction of herself or himself.

sfumato an Italian term meaning "toned-down smokiness" that refers to an atmospheric haziness in painting.

shaft the vertical cylinder part of a **column**, topped by a **capital**; sometimes rests on a base.

Shanghai School not literally a school, but a style of Chinese painting characterized by bright colors, bold **compositions**, and lively content that responded to the eclectic and commercial tastes of audiences in late nineteenth- and early twentieth-century Shanghai.

shape the external form of an object or figure.

shikhara the tower above the inner sanctum of a Hindu temple, used specifically for north Indian temples.

shinkeizu Japanese "true-view" **landscape** painting; represents real places in styles informed by **literati** taste and European visual strategies (see also *jingyeong sansuhwa*).

shogun a title granted by the Japanese emperor to the military leader and de facto ruler during the Kamakura, Muromachi, Momoyama, and Edo periods.

shrine a building or space for honoring or worshiping a person, spirit, or deity.

silkscreen a print made by forcing **pigment** through a template or screen.

silkscreen printing a printmaking technique based on forcing ink or paint through a fine screen made of silk or mesh stretched on a frame, with stencils used to produce the design.

sinopia a reddish-brown or orange underdrawing used in the process of making a **fresco** painting.

sipapu a small sandpit near the middle of the *kiva* floor that Pueblo people believe represents the

place where the ancestors emerged from the underworld to our world.

site-specific a work of art created especially for a particular location.

skene in ancient Greek theater, the structure at the back of the stage.

slip a layer of fine clay or **glaze** applied to ceramics before firing.

snapshot from hunting terminology, a quick shot taken without deliberate aim; in photographic usage, informal photography that looks unplanned and candid.

Social Realism art that depicts subjects of social concern, in a style true to life.

Socialist Realism a style of art promoted in socialist nations, such as the People's Republic of China (PRC), and characterized by **naturalistic** but **idealized** representation of the body, clearly readable expressions and gestures, and narrative content promoting the socialist ideals.

spandrel the almost triangular space between the outer curve of an **arch**, a wall, and the ceiling or framework.

speaking reliquary a **relic** container in the shape of the holy object it holds.

sphinx a winged monster with a woman's head and a lion's body.

splat the vertical central element of a chair back.

spolia building materials or reliefs salvaged from other works and reused in a different structure.

squinch a support, typically at the corners of a square room, used to carry a dome or other superstructure.

stele (plural **steles**) a carved stone slab that is placed upright and often features commemorative imagery and/or inscriptions.

step pyramid a monumental stone pyramid built using stacked platforms or steps.

still life an artwork depicting an arrangement of objects, typically including fruit, flowers, bowls, or glassware.

stoneware a **type** of ceramic that is relatively high-fired and results in a non-porous body (unlike **terra-cotta** or **earthenware**).

striated marked by lines or grooves.

stringcourse a horizontal band of bricks or stone on a building.

stucco fine plaster that can be easily carved; used to cover walls or decorate a surface.

stupa a mound-like or hemispherical structure containing Buddhist **relics**.

style characteristics that distinguish the artwork of individuals, schools, periods, and/or cultures from that of others.

stylized, stylization treated in a mannered or non-**naturalistic** way; often simplified or **abstracted**.

stylobate the uppermost step leading to a temple, which creates the platform on which the columns are situated.

subject matter the subject of an artwork.

sublime an art term first used in the eighteenth century; connected with experiences of grandeur, vastness, or power that inspire awe, terror, or other strong emotions.

sunken relief **relief** that is carved into a sunken area and does not project above the surface.

Suprematism the name given in 1915 by Russian artist Kazimir Malevich to the **nonobjective** art he developed, characterized by severely simple geometric **forms** and a limited range of colors.

Surrealism an artistic movement in the 1920s and later, inspired by Freudian psychology, dreams, and the subconscious.

suspension bridge a type of bridge in which the roadway is hung below overhead cables.

sutra a sacred text of Buddhism.

Symbolism a movement in European art and literature, *c.* 1885–1910, that conveyed meaning by the use of powerful yet ambiguous symbols.

Synthetic Cubism a later phase of **Cubism**, characterized by building up images from preexisting **abstract** shapes, an increased use of color, and little to no depth.

tabernacle a sanctuary, space designed for a congregation to gather in a house of worship.

tableau (plural **tableaux**) a stationary scene of people or objects, arranged for artistic impact.

talud-tablero an architectural configuration consisting of a rectangular element set perpendicular to the ground (the *tablero*) sitting on a sloping element (the *talud*).

taotie the name given to the composite animal mask frequently found on Shang bronzes.

tapestry a decorative textile in which pictures and/or designs are woven into the fabric.

tapestry weave a process in which patterns are woven directly into the textile, not sewn on or otherwise added later in the process.

technique the method used to make an aspect of an artwork.

temenos a sacred enclosure surrounding a temple.

tempera a fast-drying paint made from a mixture of powdered **pigment** and a **binding** agent, typically egg yolk.

temple precinct the enclosed area in which a temple is located.

tenebrism a style of painting using very pronounced *chiaroscuro*, where there are violent contrasts of light and dark, and where darkness becomes a dominant feature of the image.

tenshu the keep or fortified tower of a Japanese castle.

terra-cotta baked clay; also known as **earthenware**.

tessera (plural **tesserae**) a small block of tile, glass, or stone used to make **mosaic**.

texture the surface quality of an artwork that can be physically felt or perceived.

thatch covering or roofing for a building, usually made of sturdy, lightweight material, such as straw or reeds.

tholos (plural *tholoi*) a round, **vaulted** building, often a tomb, shaped like a beehive.

three-dimensional a work of art that has length, width, and depth (and is thus an object experienced in the round).

tinkuy the force inherent in a place where two powerful elements meet.

tiraz a fine textile **embroidered** with an inscription.

tocapu geometric motifs on an Inka ruler's garments and on other high-status clothes; collectively the motifs form checkerboard patterns.

tokonoma an indoor alcove used to display artwork and seasonal plant cuttings.

tondo (plural *tondi*) a circular work of art.

tone the comparative lightness or darkness of a hue.

torana a gateway marking the entrance to a Buddhist, Hindu, or Jain sacred structure.

torque a neck ring, usually metal.

totem an animal, plant, or geometric design that is the identifying symbol of a family, clan, or other group of related individuals.

totem pole a wooden pole carved to illustrate important mythic beings and their relationships to humans; the totem pole is used by many Northwest Coast groups.

tournette a pivoted work surface that makes the shaping and decorating of pots easier and quicker.

tracery ornamental stonework often carved in a pattern of vines and/or other organic decorative forms.

transept a section of a church perpendicular to the **nave**; transepts often extend beyond the side **aisles**, making the "arms" of a cruciform-shaped church.

transverse arch a supporting **arch** that extends across a **vault** from side to side.

transverse rib **ribs** or **arches** within a **vault** that define each side of a **bay**.

treasury in ancient Greece, buildings paid for by individual Greek city-states to house their offerings at the sanctuaries to the gods.

trefoil a decorative shape, consisting of three lobes, like a clover with three leaves.

triclinium (plural *triclinia*) a formal dining room in a Roman house or other building; the word comes from Greek *tri*, "three," and *klinon*, a sort of couch or seat for reclining.

triforium a **gallery** placed above the **nave arcade** and below the **clerestory** in a church.

triglyph a block with three vertical bands separated by V-shaped grooves; **triglyphs** occur in between **metopes** on a **Doric** frieze.

trilithon two upright **megaliths** topped with a third, horizontal stone, the **lintel**.

triptych a three-part work of art, often three panels attached together.

triskele a tri-lobed design consisting of spirals within a circle.

triumphal arch a freestanding archway that often spans a road or marks an entrance; decorated with **relief** carvings alluding to a historical, often military, victory.

trompe l'oeil from the French meaning to "deceive the eye"; a visual illusion in art, in which a painted image appears as a **three-dimensional** object.

true fresco see **fresco**.

trumeau a section of wall or a post that divides two doors.

truss a rigid framework made of metal or timber beams fastened to form triangles; used to support a roof or heavy load.

tughra a calligraphic **monogram** or signature of an Ottoman sultan that was added to all official documents and stamped onto coins.

tumulus (plural **tumuli**) a mound of earth raised over a burial.

Tuscan column a **Classical column order** added to the architectural **canon** in the sixteenth century; characterized by a simple, round **capital**, a thin column, and minimal decoration in the **entablature** above.

two-dimensional a work of art that has length and width (and is thus a flat surface).

tympanum (plural **tympana**) a **lunette**-shaped space above a **portal**; often filled with **relief** sculpture.

ukiyo-e literally, "pictures of the floating world"; refers to paintings and especially **woodblock** prints that take as their subject matter the pleasures and sites of Edo Japan, including Kabuki theater, courtesans, and places of leisure and travel.

Ultra-Baroque (also called Churrigueresque) relating to a style of **Baroque** architecture of Spain and its Latin-American colonies; characterized by elaborate and extravagant decoration.

underglaze a color or design applied to pottery before it is **glazed** and fired.

unity a principle of design that strives for coherence and/or focus in the **composition**.

urna one of the thirty-two markers of the **Buddha**, a **buddha**, or a *bodhisattva*: a tuft of hair or small dot between the eyebrows that symbolizes a third eye.

ushnisha one of the thirty-two markers of the **Buddha**, a **buddha**, or a **bodhisattva**: a protuberance from the head, usually a topknot of hair.

value the lightness or darkness of a **tone** or **hue**.

vanishing point when discussing **perspective** in **two dimensions**, the point on the horizon at which parallel lines seem to converge and disappear.

vanitas Latin for "vanity"; a subgenre of painting, containing symbols of death or change as a reminder of their inevitability.

vault an **arched** structure, usually made of stone, concrete, or brick, that often forms a ceiling.

veduta (plural **vedute**) Italian for "view"; a genre of painting or prints that depicts a highly detailed view of a cityscape, place, or other vista.

vellum a writing surface originally made from calfskin.

verism preferring realism, especially in portraiture, to the heroic or ideal; comes from the Latin *verus*, meaning "true."

vernacular everyday, functional, and pertaining to the lives of ordinary people of a particular region; typically used to refer to language and built visual environments.

video art a form of art that uses moving images and sound recordings.

Vienna Secession an organization founded in 1897 by a group of Austrian artists who were opposed to the policies and beliefs of the conservative Association of Austrian Artists.

vihara a retreat for Buddhist monks and nuns.

vimana the tower above the inner sanctum of a Hindu temple in south India.

volume mass or **three-dimensional** shape.

volute a decorative element in the form of a coiled scroll.

votive an image or object created as a devotional offering to a deity.

voussoir a wedge-shaped stone block used in the construction of an **arch**.

wabi in traditional Japanese arts, acceptance and contemplation of simplicity, and detachment.

wabi-cha a rustic style of *chanoyu*, promoted by tea master Sen no Rikyū.

warp and weft in textile weaving, warp threads are the stationary vertical threads held taut to the loom; weft refers to the yarn that is woven horizontally over and under the warp threads to make cloth.

wattle and daub a building method in which wooden or other sturdy strips are woven together (wattle) and glued with an adhesive substance, often mud, soil, or clay (daub).

weft see **warp and weft**.

Western a term used in the modern era to claim shared civilization and institutions originating in Europe among predominantly white people; term extended to North America and other parts of the world heavily marked by European colonization.

Westernization the process, often compelled by European colonizers, of adopting or moving toward practices, customs, and ideals associated with predominantly white European and North American culture.

wet-plate photography a photographic process using a glass plate coated with collodion, a sticky substance, mixed with light-sensitive chemicals; the method requires the materials to be used while still wet, and is also known as the "collodion process."

woodblock printing a **relief printing** process where the image is carved into a block of wood; the raised areas are inked. (For color printing, multiple blocks are used, each carrying a separate color.)

woodcut a **relief printing** process where the image is carved into a block of wood; the raised areas are inked.

Woodcut Movement in 1930s China, the collective effort of the writer Lu Xun and artists to use **woodcuts** as a vehicle for education, mobilization, and social change.

x-ray style a tradition of painting in northern Arnhem Land in Australia in which artists depict the internal features (such as bones and organs) as well as external features of their subjects.

yōga a Japanese term for **Western**-style painting, or oil painting.

yosegi-zukuri a Japanese technique for making wood sculpture by joining multiple blocks together.

zellij small pieces of **glazed terra-cotta** tile set into plaster to form geometric designs ornamenting interior architectural surfaces.

ziggurat a stepped pyramid or tower-like structure in a Mesopotamian temple complex.

zoomorphic having an animal-like form.

Sources of Quotations

INTRODUCTION

p. 28 Nemerov, Howard. *A Howard Nemerov Reader*. Columbia, MO: University of Missouri Press, 1991, p. 223.

CHAPTER 5

p. 108 The Metropolitan Museum of Art, New York "Human-headed winged lion (*lamassu*)" (catalog entry): www.metmuseum.org/toah/works-of-art/32.143.2.

CHAPTER 8

p. 156 Moore, Oliver. *Reading the Past: Chinese*. London: British Museum Press, 2000, p. 33, pp. 38–47.

CHAPTER 9

p. 174 Thucydides. *History of the Peloponnesian War*. Book I, 4. Trans. Rex Warner. London and New York: Penguin Books, 1972, p. 37.

CHAPTER 14

p. 240 Plutarch. *Life of Perikles*. In *The Art of Ancient Greece: Sources and Documents*. Trans. J. J. Pollitt. Cambridge, U.K.: Cambridge University Press, 1990, p. 187. (First published by Prentice Hall in 1965 as *The Art of Greece: 1400–31 BC*.)

p. 246 British Museum, London. *The Parthenon Sculptures: The Trustees' statement* (n.d.): https://www.britishmuseum.org/parthenon-sculptures-trustees-statement.

CHAPTER 15

p. 256 Lucian. *Amores*, 13–14. In *Greek Art and Archaeology*. Trans. John Griffiths Pedley. Upper Saddle River, NJ: Pearson Education, Inc., 2012, p. 309.

p. 257 Pliny the Elder. *Natural History* XXXIV.65. In *Greek Art and Archaeology*. 4th edn. Trans. John Griffiths Pedley. Upper Saddle River, NJ: Pearson, Prentice Hall, 2007, p. 310.

p. 267 Pliny the Elder. *Natural History* XXXVI.37. Trans. D. E. Eichholz. Cambridge, MA: Harvard University Press, p. 29.

CHAPTER 18

p. 313 Pliny the Elder. *Natural History*, XXXV.110. In *The Art of Ancient Greece: Sources and Documents*. Trans. J. J. Pollitt. Cambridge, U.K.: Cambridge University Press, 1990, p. 169.

p. 318 Marlowe, Elizabeth. *Shaky Ground: Context, Connoisseurship, and the History of Roman Art*. London: Bloomsbury, 2013, p. 71.

p. 318 Pliny the Elder. *Natural History*, XXXV.6. In *Ancestor Masks and Aristocratic Power in Roman Culture*. Trans. Harriet Flower. Oxford, U.K.: Clarendon Press, 1996, p. 304.

p. 318 Polybius. *Histories* 6.53, 4–7. In *Ancestor Masks and Aristocratic Power in Roman Culture*. Trans. Harriet Flower. Oxford, U.K.: Clarendon Press, 1996, p. 309.

CHAPTER 19

p. 323 Tacitus. *The Annals*. Trans. Alfred John Church and William Jackson Brodribb. The Internet Classics Archive (n.d.): http://classics.mit.edu/Tacitus/annals.1.i.html.

p. 330 C. Suetonius Tranquillus. "The Life of Nero," 31. In *The Lives of the Twelve Caesars*. Trans. J. C. Rolfe. (n.d.): http://penelope.uchicago.edu/Thayer/E/Roman/Texts/Suetonius/12Caesars/Nero*.html.

p. 330 Suetonius. *The Lives of the Twelve Caesars: Nero 31*. Trans. Alexander Thomson. Philadelphia, PA: Gebbie and Co., 1889. Perseus Digital Library: http://data.perseus.org/citations/urn:cts:latinLit:phi1348.abo016.perseus-eng1:1.

p. 331 Vitruvius. *The Ten Books on Architecture*. Book VII, Chapter V. Trans. Morris Hicky Morgan. New York: Dover Publications, 1960.

CHAPTER 20

p. 344 Marcus Aurelius. *Meditations II*. In *The Essential Marcus Aurelius*. Trans. and introduction by Jacob Needleman and John P. Piazza. New York: J. Tarcher/Penguin, 2008, p. 12.

CHAPTER 21

p. 356 Wang Xizhi. *Orchid Pavilion* (preface). Trans. H. C. Chang. In John Minford and Joseph S. M. Lau (eds.). *An Anthology of Translations: Classical Chinese Literature: From Antiquity to the Tang Dynasty*, vol. 1. New York: Columbia University Press and The Chinese University of Hong Kong, 2000, p. 480.

p. 357 Zhang Hua. *Admonitions of the Instructress to Court Ladies*. In Shane McCausland, ed. *Gu Kaizhi and the Admonitions Scroll*. London: British Museum Press, 2003, p. 16.

CHAPTER 24

p. 407 al-Qaddumi, Ghada al-Hijjawi (Trans.). *Book of Gifts and Rarities (Kitab al-Hadaya wa al-Tuhaf)*. Cambridge, MA: Harvard Middle Eastern Monographs, 1996, pp. 150–55.

CHAPTER 25

p. 423 Ibn Battuta. *A Gift to the Observers Concerning the Curiosities of the Cities and the Marvels Encountered in Travels*. In *Ibn Battuta in Black Africa*. Trans. Said Hamdun and Noël King. London: Rex Collins, 1975, p. 19; pp. 37–38; and pp. 41–42.

CHAPTER 26

p. 437 *Shilpa Prakasha (Light on Art)*, Book 1, v. 391–92. In Vidya Dehejia. *Indian Art*. London: Phaidon, 1997, pp. 164–65.

CHAPTER 27

p. 457 Kūkai. *Goshōraimokurokku (Inventory of Imported Items)*. In "Canonizing Kannon: The Ninth-Century Esoteric Buddhist Altar at Kanshinji." Trans. Cynthea J. Bogel. *The Art Bulletin* 84, no.1 (March 2002): 39.

CHAPTER 28

p. 471 John of Damascus. *Apologia Against Those Who Decry Holy Images*. In *Figure and Likeness: On the Limits of Representation in Byzantine Iconoclasm*. Trans. Charles Barber. Princeton, NJ: Princeton University Press, 2002, pp. 70–71.

p. 471 Horos of the Council of 754. In *Figure and Likeness: On the Limits of Representation in Byzantine Iconoclasm*. Trans. Charles Barber. Princeton, NJ: Princeton University Press, 2002, p. 112.

p. 473 Constantine. *Enquiries*. In *Patrologiae Cursus Completus, Series Graeca*, vol. 100, 425D. Paris: J. P. Migne, 1857–66.

p. 474 Demus, Otto. *Byzantine Mosaic Decoration: Aspects of Monumental Art in Byzantium*. London: Kegan Paul, Trench, Trubner, 1948, p. 13.

CHAPTER 29

p. 483 Meehan, Bernard. *The Book of Kells*, London: Thames & Hudson, 2012.

CHAPTER 31

p. 516 Unknown author. "Fan Kuan" in *Xuanhe huapu (Catalogue of Painting of the Xuanhe Reign)*, 1120. Trans. De-nin Lee.

p. 517 Guo Xi. *Linquan gaozhi ji (Lofty Appeal of Forests and Streams)*. In Victor H. Mair *et al.* (eds.). *Hawai'i Reader in Traditional Chinese Culture*. Honolulu, HI: University of Hawai'i Press, 2005, pp. 380–87.

p. 518 Su Shi. *Poems Written on the Cold Food Festival*. Translation adapted from *Sunflower Splendor: Three Thousand Years of Chinese Poetry*. Wu-Chi Liu and Irving Yucheng Lo (eds.). Bloomington, IN: Indiana University Press, 1975, p. 347.

p. 520 Empress Yang Meizi. Translation adapted from Hui-shu Lee. *Empresses, Art, and Agency*. Seattle, WA: University of Washington Press, 2010, p. 170.

p. 527 Marco Polo. *The Travels of Marco Polo*. Peter Harris, ed. Trans. W. Marden and rev. by T. Wright. New York: Alfred A. Knopf, 2008, p. 145.

CHAPTER 32

p. 534 Sin Sukju. *Hwagi (Record on Painting)*, 1445. Trans. De-nin Lee. See also: Jungmann, Burglind. "Sin Sukju's *Record on the Painting Collection of Prince Anpyeong* and Early Joseon Antiquarianism". In *Archives of Asian Art* 61 (2011): 120.

p. 536 *Heiji monogatari [The Tale of Heiji]* (1159). In *Translations from Early Japanese Literature*. Trans. Edwin O. Reischauer and Joseph K. Yamagiwa. Cambridge, MA: Harvard-Yenching Institute, Harvard University Press, 1951, p. 301.

p. 539 Akisato, Ritō. *Miyako rinsen meishō zue (Illustrated guide to noted gardens of Kyoto)*, Yoshinoya Tamehachi (1799). In Shōji Yamada, *Shots in the Dark: Japan, Zen, and the West. Buddhism and Modernity*. Trans. Earl Hartman. Chicago, IL: University of Chicago Press, 2009, p. 107.

CHAPTER 33

p. 558 Qur'an, Sura 24, v. 3.

SEEING CONNECTIONS: THE ART OF WRITING

p. 560 Rosenfield, John. *Japanese Arts of the Heian Period: 794–1185*, New York: Asia Society, 1967, pp. 121–22.

p. 561 Ekhtiar, Maryam and Moore, Claire (eds.). "A Resource for Educators." In *Art of the Islamic World*. New York: The Metropolitan Museum of Art, 2012, pp. 6–7.

CHAPTER 34

p. 569 Qur'an, Sura 61, v. 10–12.

p. 577 In D. Fairchild Ruggles. "The Eye of Sovereignty: Poetry and Vision in the Alhambra's Lindaraja Mirador." *Gesta* 36, no. 2 (1997): 184–5.

CHAPTER 35

p. 590 St. Bernard of Clairvaux. *Apologia* to Abbot William of Saint Thierry 29 (1125). In Conrad Rudolph. *The "Things of Greater Importance." Bernard of Clairvaux's "Apologia" and the Medieval Attitude Toward Art*. Philadelphia, PA: University of Pennsylvania Press, 1990, p. 283.

p. 590 Theophilus. *De divers artibus* 3 (*c.* 1120). In Heidi Gearhart. *Theophilus and the Theory and Practice of Medieval Art*. University Park PA: Pennsylvania State University Press, 2019, p. 25; p. 24; and p. 26.

CHAPTER 36

p. 595 Abbot Suger. *De administratione* XXVII. Trans. David Burr. Internet History Sourcebooks: https://sourcebooks.fordham.edu/source/sugar.asp. [*sic*]

Bibliography

INTRODUCTION

Appiah, Kwame Anthony. "There is no such thing as western civilization." *The Guardian*, Nov. 9, 2016.

Betsky, Aaron. *The Complete Zaha Hadid*. London and New York: Thames & Hudson, 2018.

Brunt, Peter *et al. Art in Oceania: A New History*. London and New Haven, CT: Thames & Hudson and Yale University Press, 2012.

Clunas, Craig. "The Art of Global Comparisons." In Maxine Berg, ed. *Writing the History of the Global: Challenges for the 21st Century*. Oxford, U.K.: Oxford University Press, 2013, 165–176.

Coxon, Ann *et al. Anni Albers*. New Haven, CT: Yale University Press, 2018.

Kent, Rachel, ed. *Yinka Shonibare MBE: Revised and Expanded Edition*. Prestel, 2014.

Kjellgren, Eric. *Oceania: Art of the Pacific Islands in The Metropolitan Museum of Art*. New York and New Haven, CT: The Metropolitan Museum of Art, 2007.

Reilly, Maura. *Curatorial Activism: Towards an Ethics of Curating*. London and New York: Thames & Hudson, 2018.

Tate, Greg, Gaines, Charles, and Russell, Laurence. *Kerry James Marshall (Contemporary Artist Series)*. New York: Phaidon Press, 2017.

CHAPTER 1: THE BEGINNINGS OF ART (65,000 BCE–3200 BCE)

Bahrani, Zainab. *The Infinite Image: Art, Time and the Aesthetic Dimension in Antiquity*. London: Reaktion Books, 2014.

Bailey, Douglas W. *Prehistoric Figurines: Representation and Corporeality in the Neolithic*. London: Routledge, 2005.

Clottes, Jean. *What Is Paleolithic Art?: Cave Paintings and the Dawn of Human Creativity*. Chicago, IL: University of Chicago Press, 2016.

Hodder, Ian. "Materiality, art and agency." In *The Leopard's Tale: Revealing the mysteries of Çatalhöyük*. New York: Thames & Hudson, 2006, 185–218.

Joyce, Rosemary. *Ancient Bodies, Ancient Lives: Sex, Gender and Archaeology*. New York: Thames & Hudson, 2008.

Layton, Robert. *Australian Aboriginal Rock Art: A New Synthesis*. Cambridge, U.K.: Cambridge University Press, 1992.

Lewis-Williams, David. *The Mind in the Cave: Consciousness and the Origins of Art*. London: Thames & Hudson, 2011.

Mehari, Asmeret G. and Ryano, Kokeli P. "Maasai people and Oldupai (Olduvai) gorge: Looking for sustainable people-centered approaches and practices." In Peter R. Schmidt and Innocent Pikirayi (eds.). *Community Archaeology and Heritage in Africa: Decolonizing Practice*. London and New York: Routledge, 2016, 21–45.

Mokoena, Nthabiseng. "Community Involvement and Heritage Management in Rural South Africa." Special Series, African Perspectives on Community Engagement, guest-edited by Peter R. Schmidt.

Journal of Community Archaeology and Heritage 4 no. 3 (2017): 189–202.

Nakamura, Carolyn and Meskell, Lynn. "Articulate Bodies: Forms and Figures at Çatalhöyük." *Journal of Archaeological Method and Theory* 16 no. 3 (2009): 205–30.

Tringham, Ruth and Conkey, Margaret. "Rethinking Figurines: A Critical Analysis of Archaeology, Feminism and Popular Culture." In C. Morris and L. Goodison (eds.). *Ancient Goddesses: The Myths and the Evidence*. London: British Museum Press, 1998, 22–45.

CHAPTER 2: ART OF EARLY AFRICA (8000 BCE–1000 CE)

Connah, Graham. *Forgotten Africa: An introduction to its archaeology*. London: Routledge, 2004.

Coulson, David and Campbell, Alec. *African Rock Art: Paintings and Engravings on Stone*. New York: Abrams, 2001.

Fisher, Marjorie M., Lacovara, Peter, Ikram, Salima, and D'Auria, Sue. *Ancient Nubia: African Kingdoms on the Nile*. Cairo: The American University in Cairo Press, 2012.

Lewis-Williams, J. D. 2013. *San Rock Art*. Athens: Ohio University Press, 2013.

Mitchell, Peter and Lane, Paul (eds.). *The Oxford Handbook of African Archaeology*. Oxford, U.K.: Oxford University Press, 2013.

O'Conner, David and Reid, Andrew (eds.). *Ancient Egypt in Africa*. London: UCL Press, 2003.

Phillipson, David W. *African Archaeology*. 3rd edn. Cambridge World Archaeology. Cambridge, U.K.: Cambridge University Press, 2005.

Visonà, M. B., Poynor, Robin, and Cole, Herbert M. *A History of Art in Africa*. Revised edn. Upper Saddle River, NJ: Prentice Hall, 2008.

CHAPTER 3: ART OF MESOPOTAMIA AND WEST ASIA (5000–2000 BCE)

Aruz, Joan with Wallenfels, Ronald (eds.). *Art of the First Cities: The Third Millennium BC from the Mediterranean to the Indus*. New York: The Metropolitan Museum of Art, 2003.

Bahrani, Zainab, *Art of Mesopotamia*. New York: Thames & Hudson, 2017.

Collon, Dominique, *Ancient Near Eastern Art*. Berkeley, CA: University of California Press, 1995.

Feldman, Marian. *Diplomacy by Design: Luxury Arts and an "International Style" in the Ancient Near East, 1400–1200 BCE*. Chicago, IL: Chicago University Press, 2006.

Gansell, Amy Rebecca and Shafer, Ann (eds.). *Testing the Canon of Ancient Near Eastern Art and Archaeology*. New York: Oxford University Press, 2020.

George, Andrew. *The Babylonian Gilgamesh Epic: Introduction, Critical Edition and Cuneiform Texts*. Oxford, U.K.: Oxford University Press, 2003.

Kuhrt, Amélie. *The Ancient Near East: c. 3000–330 B.C.* 2 vols. London and New York: Routledge, 1995.

Moorey, Peter Roger Stuart. *Ancient Mesopotamian Materials and Industries: The Archaeological Evidence*. Oxford, U.K.: Clarendon Press, 1994.

Roaf, Michael. *Cultural Atlas of Mesopotamia and the Ancient Near East*. New York and Oxford, U.K.: Facts on File, 1990.

Winter, Irene J. *On Art in the Ancient Near East*. 2 vols. I: *Of the First Millennium* BCE; II: *From the Third Millennium* BCE. Leiden, The Netherlands: Brill, 2010.

CHAPTER 4: EGYPTIAN ART FROM THE PREDYNASTIC NILE VALLEY THROUGH THE OLD KINGDOM (4000–2000 BCE)

Aldred, Cyril. *Egyptian Art*. London: Thames & Hudson, 1994.

Baines, John and Malek, Jaromír. *Cultural Atlas of Ancient Egypt*. New York and Oxford, U.K.: Facts on File, 1996.

Bard, Kathryn A. *An Introduction to the Archaeology of Ancient Egypt*. Malden, MA and Oxford, U.K.: Blackwell Publishing, 2008.

Hanna, Monica. "Cultural Heritage Atrrition in Egypt." In Amy Rebecca Gansell and Ann Shafer, (eds.). *Testing the Canon of Ancient Near Eastern Art and Archaeology*. New York: Oxford University Press, 2020, 315–18.

Lehner, Mark. *The Complete Pyramids*. London: Thames & Hudson, 2008.

Lloyd, Alan B., ed. *A Companion to Ancient Egypt*. Chichester, U.K.: Wiley-Blackwell, 2010.

Manley, Bill. *Egyptian Art*. London: Thames & Hudson, 2018.

Pittman, H. "Constructing Context: The Gebel-el-Arak Knife." In J. Cooper and G. Schwartz (eds.). *The Study of the Ancient Near East in the Twenty-first Century*. Winona Lake, IN: Eisenbrauns, 1996, 9–32.

Riggs, Christina. *Ancient Egyptian Art and Architecture: A Very Short Introduction*. Oxford, U.K.: Oxford University Press, 2014.

Robins, Gay. *The Art of Ancient Egypt*. Cambridge, MA: Harvard University Press, 2008.

Wengrow, David. *The Archaeology of Early Egypt: Social Transformations in North-East Africa, c. 10,000 to 2,650 BC*. Cambridge, U.K.: Cambridge University Press, 2006.

CHAPTER 5: ART OF WEST ASIAN EMPIRES (2000–330 BCE)

Ataç, Mehmet Ali. *The Mythology of Kingship in Neo-Assyrian Art*. Cambridge, U.K.: Cambridge University Press, 2010.

Bahrani, Zainab. *The Graven Image: Representation in Babylonia and Assyria*. Philadelphia, PA: The University of Pennsylvania Press, 2003.

Brown, Brian A. and Feldman, Marian. *Critical Approaches to Ancient Near Eastern Art*. Boston, MA: Walter de Gruyter, 2014.

Cifarelli, Megan. "Gesture and Alterity in the Art of Ashurnasirpal II of Assyria." *Art Bulletin* 80, no. 2 (1998): 210–28.

Evans, Jean and Benzel, Kim. *Beyond Babylon: Art, Trade, and Diplomacy in the Second Millennium B.C.* New York: The Metropolitan Museum of Art, 2008.

Garrison, Mark. "Royal Achaemenid Iconography." In Daniel Potts, ed. *The Oxford Handbook of Ancient Iran.* Oxford, U.K. and New York: Oxford University Press, 2013, 566–95.

Harmanşah, Ömür. *Cities and the Shaping of Memory in the Ancient Near East.* Cambridge, U.K. and New York: Cambridge University Press, 2013.

Kertai, David. *The Architecture of Late Assyrian Royal Palaces.* Oxford, U.K.: Oxford University Press, 2015.

Root, Margaret C. "The Parthenon Frieze and the Apadana Reliefs at Persepolis: Reassessing a Programmatic Relationship." *American Journal of Archaeology* 89, no. 1 (1985): 103–20.

Russell, John Malcolm. "Bulls for the Palace and Order in the Empire: The Sculptural Program of Sennacherib's Court VI at Nineveh." *Art Bulletin* 69 (1987): 520–39.

CHAPTER 6: EGYPTIAN ART FROM THE MIDDLE KINGDOM THROUGH THE LATE PERIOD (2000–525 BCE)

Arnold, D. *Building in Egypt: Pharaonic Stone Masonry.* New York: Oxford University Press, 1991.

Björkman, Gun. *Kings at Karnak: Study of the Treatment of the Monuments of Royal Predecessors in the Early New Kingdom.* Uppsala, Sweden: Acta Universitatis Upsaliensis Boreas, 1971.

Bryan, Betsy M. "Memory and Knowledge in Egyptian Tomb Painting." In E. Cropper, ed. *Dialogues in Art History, from Mesopotamian to Modern: Readings for a New Century.* Studies in the History of Art 74. Washington, D.C.: National Gallery of Art, 2009, 19–39.

Curran, Brian A., Grafton, Anthony, Long, Pamela O., and Weiss, Benjamin. *Obelisk: A History.* Cambridge, MA: Burndy Library and MIT Press, 2009.

Hartwig, Melinda K., ed. *A Companion to Egyptian Art.* Chichester, U.K.: Wiley-Blackwell, 2014.

Harvey, Stephen. "Interpreting Punt: Geographic, Cultural and Artistic Landscapes." In David O'Connor and Stephen Quirke (eds.). *Encounters with Ancient Egypt: Mysterious Lands.* London: UCL Press, 2003, 81–91.

Hudáková, L., Janosi, P., and Kahlbacher, A. (eds.). *Change and Innovation in Middle Kingdom Art: Middle Kingdom Studies 4.* London: Golden House, 2016.

Miniaci, G. *Rishi Coffins and the Funerary Culture of Second Intermediate Period Egypt.* London: Golden House, 2011.

Morris, Ellen. *The Architecture of Imperialism: Military Bases and the Evolution of Foreign Policy in Egypt's New Kingdom.* Leiden, The Netherlands: Brill, 2005.

Wilkinson, Richard H. *The Complete Temples of Ancient Egypt.* London: Thames & Hudson, 2017.

CHAPTER 7: EARLY ART FROM SOUTH ASIA, SOUTHEAST ASIA, AND OCEANIA (2600 BCE–300 CE)

Bedford, Stuart, Sand, Christophe, and Connaughton, Sean P. (eds.). *Oceanic Explorations: Lapita and Western Pacific Settlement.* Terra Australis 26. Canberra: ANU E Press, 2007.

Chakrabarti, Dilip K. *The Oxford Companion to Indian Archaeology: The Archaeological Foundations of Ancient India, Stone Age to AD 13th Century.* Oxford, U.K. and New Delhi: Oxford University Press, 2006.

Clark, G. R., Anderson, A. J., and Vunidilo, T. (eds.). *The Archaeology of Lapita Dispersal in Oceania.* Canberra: Pandanus Books, 2001.

Higham, Charles. *Early Mainland Southeast Asia: From First Humans to Angkor.* Bangkok: River Books, 2014.

Kirch, Patrick V. *The Lapita Peoples: Ancestors of the Oceanic World.* Oxford, U.K.: Blackwell, 1997.

Reid, Anthony. *A History of Southeast Asia: Critical Crossroads.* The Blackwell History of the World. Chichester, U.K. and Malden, MA: Wiley Blackwell, 2015.

Swadling, P., Wiessner, P., and Tumu, A. "Prehistoric Stone Artefacts from Enga and the Implication of Links between the Highlands, Lowlands and Islands for Early Agriculture in Papua New Guinea." *Journal de la Société des Océanistes* 126–27, nos. 1–2 (2008): 271–92.

CHAPTER 8: ART OF EARLY EAST ASIA (4000–200 BCE)

Habu, Junko. *Ancient Jomon of Japan.* Cambridge, U.K.: Cambridge University Press, 2004.

Li, Liu and Chen, Xingcan. *The Archaeology of China: From the Paleolithic to the Early Bronze Age.* Cambridge, U.K.: Cambridge University Press, 2012.

Mason, Penelope. *History of Japanese Art.* 2nd edn., revised by Donald Dinwiddie. Upper Saddle, NJ: Pearson Education, 2005.

Bessho, Hidetaka, Tomii, Makoto, and Matsumoto, Naoko. *Coexistence and Cultural Transmission in East Asia.* Vol. 61. One World Archaeology Series. Walnut Creek, CA: Taylor and Francis, 2016.

Mizoguchi, Koji. *The Archaeology of Japan.* Cambridge, U.K.: Cambridge University Press, 2013.

Stark, Miriam T., ed. *Archaeology of Asia.* Vol. 7 in the Blackwell Studies in Global Archaeology. Malden, MA: Blackwell, 2006.

Wu, Hung. *Monumentality in Early Chinese Art and Architecture.* Stanford, CA: Stanford University Press, 1995.

Yang, Xiaoneng, ed. *The Golden Age of Chinese Archaeology: Celebrated Discoveries from the People's Republic of China.* Washington, D.C.: National Gallery of Art, 1999.

Yang, Xiaoneng, ed. *New Perspectives of China's Past: Chinese Archaeology in the Twentieth Century.* New Haven, CT: Yale University Press, 2004.

CHAPTER 9: CYCLADIC AND MINOAN ART (3000–1200 BCE)

CHAPTER 10: MYCENAEAN AND IRON AGE GREEK ART (1700–600 BCE)

Bindman, David, Gates Jr., Henry Louis, and Dalton, Karen C. C. (eds.). *The Image of the Black in Western Art, Volume 1: From the Pharaohs to the Fall of the Roman Empire.* 2nd edn. Cambridge, MA: Harvard University Press, 2010.

Broodbank, Cyprian. *An Island Archaeology of the Cyclades.* Cambridge, U.K.: Cambridge University Press, 2000.

Cline, Eric H., ed. *The Oxford Handbook of the Bronze Age Aegean (ca. 3000–1000 BC).* Oxford, U.K. and New York: Oxford University Press, 2010.

Colburn, Cynthia S. "Exotica and the Early Minoan Elite: Eastern Imports in Prepalatial Crete." *American Journal of Archaeology* 112, no. 2 (April 2008): 203–24.

Eaverly, Mary Ann. *Tan Men/Pale Women: Color and Gender in Archaic Greece and Egypt, a Comparative Approach.* Ann Arbor, MI: University of Michigan Press, 2013.

Dickinson, Oliver. *The Aegean Bronze Age.* Cambridge, U.K.: Cambridge University Press, 1994.

Galaty, Michael L. and Parkinson, William A. (eds.). *Rethinking Mycenaean Palaces II.* Monograph 60, Cotsen Institute of Archaeology. Los Angeles, CA: University of California Press, 2007.

Gill, David W. J. and Chippindale, Christopher. "Material and Intellectual Consequences of Esteem for Cycladic Figures." *American Journal of Archaeology* 97, no. 4 (Oct. 1993): 601–59.

Hemingway, Seán. "Art of the Aegean Bronze Age." *The Metropolitan Museum of Art Bulletin* 69, no. 4 (Spring 2012): https://www.metmuseum.org/art/metpublications/Art_of_the_Aegean_Bronze_Age_The_Metropolitan_Museum_of_Art_Bulletin_v_69_no_4_Spring_2012.

Hoffman, Gail L. "Painted Ladies: Early Cycladic II Mourning Figures?" *American Journal of Archaeology* 106, no. 4 (Oct. 2002): 525–50.

Hurwit, Jeffrey M. *The Art and Culture of Early Greece, 1100–480 BC.* Ithaca, NY: Cornell University Press, 1985.

Immerwahr, Sara Anderson. *Aegean Painting in the Bronze Age*, University Park, PA: Pennsylvania State University, 1990.

Lapatin, Kenneth. *Luxus: The Sumptuous Arts of Greece and Rome.* Los Angeles, CA: The J. Paul Getty Museum, 2015.

Lapatin, Kenneth. "Behind the Mask of Agamemnon: Not a Forgery. How about a Pastiche?" *Archaeology. Archive. A Publication of the Archaeological Institute of America* 52, no. 4. (July/August 1999): http://archive.archaeology.org/9907/etc/lapatin.html.

Lapatin, Kenneth. *Mysteries of the Snake Goddess: Art, Desire, and the Forging of History.* Boston, MA: Houghton Mifflin, 2002.

Marinatos, Nanno. *Minoan Religion: Ritual, Image, and Symbol.* Columbia, SC: University of South Carolina Press, 1993.

Peters, Mark. "Colour Use and Symbolism in Bronze Age Crete: Exploring Social and Technological Relationships." In Caroline M. Jackson and Emma C. Wager (eds.). *Vitreous Materials in the Late Bronze Age Aegean.* Sheffield Studies in Aegean Archaeology, Oxford, U.K.: Oxbow Books, 2008, 187–208.

Preziosi, Donald and Hitchcock, Louise. *Aegean Art and Architecture.* Oxford, U.K.: Oxford University Press, 1999.

Shelmerdine, Cynthia W., ed. *The Cambridge Companion to the Aegean Bronze Age.* Cambridge, U.K.: Cambridge University Press, 2008.

Strasser, Thomas F., Murray, Sarah C., van der Greer, Alexandra, Kolb, Christina, and Ruprecht Jr., Louis A. "Palaeolithic Cave Art from Crete, Greece." *Journal of Archaeological Science: Reports,* vol. 18 (April 2018): 100–8.

Strasser, Thomas F. "Location and Perspective in the Theran Flotilla Fresco." *Journal of Mediterranean Archaeology* 23/1 (2010): 3–26.

CHAPTER 11: ART OF EARLY SOUTH AMERICA BEFORE 600 CE

Bourget, Steve and Jones, Kimberly L. *The Art and Archaeology of the Moche: An Ancient Andean Society of the Peruvian North Coast.* Austin, TX: University of Texas Press, 2009.

Burger, Richard L. *Chavín and the Origins of Andean Civilization.* London: Thames & Hudson, 1992.

Dillehay, Tom D., Ocampo, Carlos, Saavedra, José, Oliveira Sawakuchi, Andre, Vega, Rodrigo M., Pino, Mario, Collins, Michael B. *et al.* "New Archaeological Evidence for an Early Human Presence at Monte Verde, Chile." *PloS One* 10, no. 11 (November 18, 2015): e0145471.

Lumbreras, Luis Guillermo. *The Peoples and Cultures of Ancient Peru.* Washington, D.C.: Smithsonian Institution Press, 1989.

Quilter, Jeffrey. *The Ancient Central Andes (Routledge World Archaeology).* London: Routledge, 2013.

Stone, Rebecca R. *Art of the Andes: From Chavín to Inca.* 3rd edn. London: Thames & Hudson, 2012.

Tello, Julio C. "Discovery of the Chavín Culture in Peru." *American Antiquity* 9, no. 1 (1943): 135–60.

Young-Sánchez, Margaret. *Tiwanaku: Ancestors of the Inca*. Denver, CO: Denver Art Museum, and Lincoln, NE: University of Nebraska Press, 2004.

CHAPTER 12: ART OF EARLY MESOAMERICA BEFORE 600 CE

Berrin, Kathleen and Pasztory, Esther (eds.). *Teotihuacán: Art from the City of the Gods*. New York: Thames & Hudson, 1993.

Coe, Michael D., Diehl, Richard A., Freidel, David A., Furst, Peter T., Reilly, F. Kent, Schele, Linda, Tate, Carolyn E., and Taube, Karl A. *The Olmec World, Ritual and Rulership*. Princeton, NJ: The Art Museum, Princeton University, 1996.

Covarrubias, Miguel. *Mexico South: The Isthmus of Tehuantepec*. New York: Knopf, 1946.

Diehl, Richard A. *The Olmecs: America's First Civilization*. New York: Thames & Hudson, 2004.

Piña Chan, Román. *The Olmec: Mother Culture of Mesoamerica*. New York: Rizzoli, 1989.

Townsend, Richard F., ed. *Ancient West Mexico: Art and Archaeology of the Unknown Past*. New York: Thames & Hudson, 1998.

CHAPTER 13: ARCHAIC AND EARLY CLASSICAL GREEK ART (600–460 BCE)

CHAPTER 14: ART OF CLASSICAL GREECE (450–400 BCE)

CHAPTER 15: LATE CLASSICAL GREEK AND HELLENISTIC ART (400–31 BCE)

Beard, Mary and Henderson, John. *Classical Art: From Greece to Rome*. Oxford, U.K.: Oxford University Press, 2001.

Belozerskaya, Marina and Lapatin, Kenneth. *Ancient Greece: Art, Architecture, and History*. Los Angeles, CA: J. Paul Getty Museum, 2001.

Blundell, Sue. *Women in Ancient Greece*. Cambridge, MA: Harvard University Press, 1995.

Boardman, John. *The History of Greek Vases: Potters, Painters, and Pictures*. New York: Thames & Hudson, 2001.

Brinkmann, V. and Wünsche, R. *Gods in Color: Painted Sculpture of Classical Antiquity*. Trans. Rodney Batstone. Munich, Germany: Stiftung Archäologie, 2007.

Carpenter, Thomas. *Art and Myth in Ancient Greece*. New York: Thames & Hudson, 1991.

Cohen, Ada. "Portrayals of Abduction in Greek Art: Rape or Metaphor?" In Natalie Kampen and Bettina Ann Bergmann (eds.). *Sexuality in Ancient Art: Near East, Egypt, Greece, and Italy*. Cambridge, U.K.: Cambridge University Press, 1996, 117–35.

Connelly, Joan Breton. *The Parthenon Enigma: A New Understanding of the West's Most Iconic Building and the People Who Made It*. New York: Alfred A. Knopf, 2014.

De Grummond, Nancy T. and Ridgway, Brunilde S. *From Pergamon to Sperlonga: Sculpture in Context*. Berkeley, CA: University of California Press, 2000.

Fullerton, Mark D. *Greek Art*. Cambridge, U.K.: Cambridge University Press, 2000.

Hamiaux, M., Laugier, L., and Martinez, J. L. (eds.). *The Winged Victory of Samothrace: Rediscovering a Masterpiece*. Paris: Musée du Louvre and Somogy Éditions de l'Art, 2015.

Hurwit, Jeffrey M. *The Akropolis in the Age of Perikles*. Cambridge, U.K.: Cambridge University Press, 2004.

Jenkins, Ian Dennis. *The Parthenon Sculptures*. Cambridge, MA: Harvard University Press, 2007.

Kousser, Rachel. "Creating the Past: The Vénus de Milo and the Hellenistic Reception of Classical Greece." *American Journal of Archaeology*. 109, no. 2 (2005): 227–50.

Lapatin, Kenneth D. S. *Luxus: The Sumptuous Arts of Greece and Rome*. Los Angeles, CA: J. Paul Getty Museum, 2015.

Lardinois, André and McClure, Laura (eds.). *Making Silence Speak: Women's Voices in Greek Literature and Society*. Princeton, NJ: Princeton University Press, 2001.

Marconi, Clemente. *The Oxford Handbook of Greek and Roman Art and Architecture*. Oxford, U.K.: Oxford University Press, 2014.

Mee, Christopher and Spawforth, Tony. *Greece: An Oxford Archaeological Guide*. Oxford, U.K.: Oxford University Press, 2001.

Neer, Richard T. *Greek Art and Archaeology: A New History, c. 2500–c. 150 BCE*. New York: Thames & Hudson, 2011.

Neils, Jenifer. *The Parthenon Frieze*. Cambridge, U.K.: Cambridge University Press, 2001.

Nevett, L. C. "Gender Relations in the Classical Greek Household: The Archaeological Evidence." *The Annual of the British School at Athens* 90 (1995): 363–81.

Pedley, John G. *Greek Art and Archaeology*. 5th edn. London: Pearson, 2011.

Pollitt, J. J. *Art and Experience in Classical Greece*. Cambridge, U.K.: Cambridge University Press, 1999.

—*The Art of Ancient Greece: Sources and Documents*. 2nd edn. Cambridge, U.K.: Cambridge University Press, 2001.

Rhodes, Robin F. *Architecture and Meaning on the Athenian Acropolis*. Cambridge, U.K.: Cambridge University Press, 1995.

Said, Edward. *Orientalism*. 1st edn 1978. London: Penguin, 2003.

Smith, R. R. R. *Hellenistic Sculpture: A Handbook*. New York: Thames & Hudson, 1991.

Snowden, Frank M. "Iconographical Evidence on the Black Populations in Greco-Roman Antiquity." In David Bindman, Henry Louis Gates Jr., and Karen C. C. Dalton (eds.). *The Image of the Black in Western Art, Volume 1: From the Pharaohs to the Fall of the Roman Empire*. 2nd edn. Cambridge, MA: Harvard University Press, 2010, 141–250.

Spawforth, Tony. *The Complete Greek Temples*. London: Thames & Hudson, 2006.

Valavanis, Panos. *The Akropolis Through Its Museum: Wandering Among the Monuments of the Sacred Rock and the Great Achievements*. Trans. Alexandra Doumas. Athens: Kapon Editions, 2013.

CHAPTER 16: THE DEVELOPMENT OF BUDDHIST AND HINDU ART IN SOUTH ASIA AND SOUTHEAST ASIA (250 BCE–800 CE)

Asher, Frederic M., ed. *Art of India: Prehistory to the Present*. Chicago, IL: Encyclopaedia Britannica, 2003.

Behl, Benoy K. *The Ajanta Caves: Artistic Wonder of Ancient Buddhist India*. New York: Harry N. Abrams, 1998.

Dehejia, Vidya. "On Modes of Narration in Early Buddhist Art." *Art Bulletin* 72 (1990): 374–92.

Embree, Ainslie T., ed. *Sources of Indian Tradition*, 2 vols. New York: Columbia University Press, 1988.

Fisher, Robert E. *Buddhist Art and Architecture*. London: Thames & Hudson, 1993.

Flood, Gavin. *An Introduction to Hinduism*. New York: Cambridge University Press, 1996.

Lavy, Paul. "As in Heaven, So on Earth: The Politics of Visnu, Siva, and Harihara Images in Pre-angkorian Khmer Civilisation." *Journal of Southeast Asian Studies* 34 (2003): 21–39.

McArthur, Meher. *Reading Buddhist Art: An Illustrated Guide to Buddhist Signs & Symbols*. London: Thames & Hudson, 2002.

Pal, Pratapaditya, ed. *The Peaceful Liberators: Jain Art from India*. London and New York: Thames & Hudson, 1994.

CHAPTER 17: VILLANOVAN AND ETRUSCAN ART (900–270 BCE)

Barker, Graeme and Rasmussen, Tom. *The Etruscans*. Oxford, U.K.: Blackwell, 1998.

Bonfante, Larissa, ed. *Etruscan Life and Afterlife: A Handbook of Etruscan Studies*. Detroit, MI: Wayne State University Press, 1986.

Brendel, Otto J. *Etruscan Art*. 2nd edn. New Haven, CT: Yale University Press, 1995.

Carruba, Anna Maria. *La Lupa Capitolina: Un Bronzo Medievale*. Rome: De Luca Editori D'Arte, 2006.

Martinelli, Maurizio and Paolucci, Giulio. *Etruscan Places*. Florence, Italy: Scala, 2006.

Steingräber, Stephan. *Abundance of Life: Etruscan Wall Painting*. Los Angeles, CA: J. Paul Getty Museum, 1996.

Torelli, Mario, ed. *The Etruscans*. New York: Rizzoli, 2001.

Wright, Alison. *The Pollaiuolo Brothers: The Arts of Florence and Rome*. New Haven, CT and London: Yale University Press, 2005.

CHAPTER 18: ART OF THE ROMAN REPUBLIC (509–27 CE)

CHAPTER 19: ART OF THE ROMAN EMPIRE FROM AUGUSTUS THROUGH THE JULIO-CLAUDIANS (27 BCE–68 CE)

CHAPTER 20: ART OF THE ROMAN EMPIRE FROM THE FLAVIANS THROUGH THE GOOD EMPERORS (69–192 CE)

Bartman, Elizabeth. *Portraits of Livia: Imaging the Imperial Woman in Augustan Rome*. Cambridge, U.K.: Cambridge University Press, 1999.

Beard, Mary and Henderson, John. *Classical Art: From Greece to Rome*. Oxford, U.K.: Oxford University Press, 2001.

Bindman, David, Gates Jr., Henry Louis, and Dalton, Karen C. C. (eds.). *The Image of the Black in Western Art, Volume 1: From the Pharaohs to the Fall of the Roman Empire*. 2nd edn. Cambridge, MA: Harvard University Press, 2010.

Boyle, A. J. and Dominik, William J. (eds.). *Flavian Rome: Culture, Image, Text*. Leiden, The Netherlands and Boston, MA: Brill, 2003.

Clark, John R. *The Houses of Roman Italy, 100 B.C.–A.D. 250: Ritual, Space, and Decoration*. Berkeley, CA and Oxford, U.K.: University of California Press, 1991.

Conlin, D. and Jacobs, P. *Campus Martius: The Field of Mars in the Life of Ancient Rome*. Cambridge, U.K.: Cambridge University Press, 2014.

D'Ambra, Eve, ed. *Roman Art in Context*. Upper Saddle River, NJ: Prentice Hall, 1994.

D'Ambra, Eve. *Roman Art*, Cambridge, U.K. and New York: Cambridge University Press, 1998.

Davies, Penelope J. E. *Architecture and Politics in Republican Rome*. Cambridge, U.K.: Cambridge University Press, 2018.

Dobbins, John J. and Foss, Pedar W. (eds.). *The World of Pompeii*. London: Routledge, 2007

Fejfer, Jane. *Roman Portraits in Context*. Berlin and New York: Walter De Gruyter 2008.

Flower, Harriet. *Ancestor Masks and Aristocratic Power in Roman Culture*. Oxford, U.K.: Clarendon Press, 1996.

Fullerton, Mark D. *Roman Art and Archaeology*, London and New York: Thames & Hudson, 2019.

Holliday, Peter J. *The Origins of Roman Historical Commemoration in the Visual Arts*. Cambridge, U.K.: Cambridge University Press, 2002.

Kleiner, Diana E. E. *Roman Sculpture*. New Haven, CT: Yale University Press, 1992.

Kleiner, Diana E. E. and Matheson, Susan B. *I, Claudia: Women in Ancient Rome*. Austin, TX: University of Texas Press, 1996.

Kleiner, Diana E. E. and Matheson, Susan B. *I, Claudia II: Women in Roman Art and Society.* Austin, TX: University of Texas Press, 2000.

Kleiner, Fred S. *A History of Roman Art.* Boston, MA: Wadsworth Cengage Learning, 2010.

Leclant, Jean. "Egypt, Land of Africa, in the Greco-Roman World." In David Bindman, Henry Louis Gates Jr., and Karen C. C. Dalton (eds.). *The Image of the Black in Western Art, Volume 1: From the Pharaohs to the Fall of the Roman Empire.* 2nd edn. Cambridge, MA: Harvard University Press, 2010, 275–87.

Ling, Roger. *Roman Painting.* New York: Cambridge University Press, 1991.

Loar, Matthew P., MacDonald, Carolyn, and Peralta, Dan-el Padilla (eds.). *Rome, Empire of Plunder: The Dynamics of Cultural Appropriation.* Cambridge, U.K.: Cambridge University Press, 2017.

Marlowe, Elizabeth. *Shaky Ground: Context, Connoisseurship, and the History of Roman Art.* London, New Delhi, New York, and Sydney: Bloomsbury, 2013.

Packer, James E. *The Forum of Trajan in Rome: A Study of the Monuments.* Berkeley, CA: University of California Press, 1997.

Pollini, John. *From Republic to Empire: Rhetoric, Religion, and Power in the Visual Culture of Ancient Rome.* Norman, OK: University of Oklahoma Press, 2012.

Pollitt, Jerome J. *The Art of Rome, 753 BC–AD 337: Sources and Documents.* Revised edn. Cambridge, U.K.: Cambridge University Press, 1983.

Porter, D. *Ancient Rome: A New History.* 3rd edn. London and New York: Thames & Hudson, 2018.

Sear, Frank. *Roman Architecture.* Ithaca, NY: Cornell University Press, 1989.

Tuck, Steven L. *A History of Roman Art.* Chichester, U.K.: Wiley Blackwell, 2015.

Zanker, Paul. *The Power of Images in the Age of Augustus.* Trans. Alan Shapiro. Ann Arbor, MI: The University of Michigan Press, 1990.

CHAPTER 21: ART OF RISING EMPIRES IN JAPAN AND CHINA (400 BCE–581 CE)

Barnes, Gina. "A Hypothesis for Early Kofun Rulership." *Japan Review* 27 (2014): 3–29.

Hudson, Mark J. "Rice, Bronze, and Chieftains: An Archaeology of Yayoi Ritual." *Japanese Journal of Religious Studies* 19 nos. 2/3 (June–September 1992): 139–89.

Liu, Cary Y., Nylan, Michael, Barbieri-Low, Anthony, et al. *Recarving China's Past: Art, Archaeology, and Architecture of the "Wu Family Shrines."* Princeton, NJ: Princeton University Art Museum; New Haven, CT: Yale University Press, 2005.

Pearson, Richard J. *Ancient Japan.* Washington, D.C.: Sackler Gallery, 1992.

Powers, Martin. *Art and Political Expression in Early China.* New Haven, CT: Yale University Press, 1991.

Tsuji, Nobuo. *History of Art in Japan.* Trans. Nicole Coolidge Rousmaniere. New York: Columbia University Press, 2019.

Whitfield, Roderick, Whitfield, Susan, and Agnew, Neville. *Cave Temples of Mogao at Dunhuang: Art and History on the Silk Road.* Los Angeles, CA: Getty Conservation Institute and the J. Paul Getty Museum, 2000.

Wu, Hung. *The Wu Liang Shrine: The Ideology of Early Chinese Pictorial Art.* Stanford, CA: Stanford University Press, 1992.

Yoshie, Akiko, Tonomura, Hitomi, and Takata, Azumi Ann. "Gendered Interpretations of Female Rule: The Case of Himiko, Ruler of Yamatai." *U.S.-Japan Women's Journal,* no. 44 (2013): 3–23.

CHAPTER 22: ART OF THE LATE ROMAN EMPIRE (193–337 CE)

Bianchi Bandinelli, Ranuccio. *Rome: The Late Empire: Roman Art AD 200–400.* New York: G. Braziller, 1971.

Bianchi Bandinelli, Ranuccio, Caffarelli, Ernesto Vergara, Caputo, Giacomo, and Clerici, Fabrizio. *The Buried City: Excavations at Leptis Magna.* Praeger, 1966.

Coarelli, Filippo. *Rome and Environs: An Archaeological Guide.* Berkeley, CA: University of California Press, 2007.

Kulikowski, M. *The Triumph of Empire: The Roman World from Hadrian to Constantine.* Cambridge, MA: Harvard University Press, 2016.

L'Orange, Hans Peter. *The Roman Empire: Art Forms and Civic Life.* New York: Rizzoli, 1985.

MacCormack, Sabine G. *Art and Ceremony in Late Antiquity.* Berkeley, CA: University of California Press, 1981.

Rees, Roger. *Diocletian and the Tetrarchy.* Edinburgh: Edinburgh University Press, 2004.

Wood, Susan. *Roman Portrait Sculpture, AD 217–260.* Leiden, The Netherlands: Brill, 1986.

Ramage, Nancy H. and Ramage, Andrew. *Roman Art: Romulus to Constantine.* 5th edn. Upper Saddle River, NJ: Pearson, Prentice Hall, 2009.

Zanker, Paul. *Roman Art.* Los Angeles, CA: J. Paul Getty Museum, 2008.

CHAPTER 23: JEWISH AND CHRISTIAN ART IN LATE ANTIQUITY (150–500 CE)

Chi, Jennifer Y. and Heath, Sebastian (eds.). *Edge of Empires: Pagans, Jews, and Christians at Roman Dura-Europos.* Princeton, NJ: Princeton University Press, 2011.

Fine, Steven. *This Holy Place: On the Sanctity of the Synagogue During the Greco-Roman Period.* Notre Dame, IN: University of Notre Dame Press, 1997.

Finney, Paul Corby. *The Invisible God: The Earliest Christians on Art.* Oxford, U.K. and New York: Oxford University Press, 1994.

Jensen, Robin Margaret. *The Cross: History, Art and Controversy.* Cambridge, MA: Harvard University Press, 2017.

Spier, Jeffrey and Kessler, Herbert (eds.). *Picturing the Bible: The Earliest Christian Art.* Exhibition cat. Fort Worth, TX, Kimball Museum of Art, and New Haven, CT: Yale University Press, 2009.

Thomas, Thelma K., ed. *Designing Identity: The Power of Textiles in Late Antiquity.* Princeton, NJ: Princeton University Press, 2016.

CHAPTER 24: THE DEVELOPMENT OF ISLAMIC ART IN NORTH AFRICA, WEST ASIA, AND CENTRAL ASIA (600–1000)

Ballian, Anna. "Country Estates, Material Culture, and the Celebration of Princely Life: Islamic Art and the Secular Domain." In Helen C. Evans, ed. *Byzantium and Islam: Age of Transitions.* New York: The Metropolitan Museum of Art, 2012, 200–8.

Bloom, Jonathan M. *Paper Before Print: The History and Impact of Paper in the Islamic World.* New Haven, CT: Yale University Press, 2001.

Ettinghausen, Richard, Grabar, Oleg, and Jenkins-Madina, Marilyn. *Islamic Art and Architecture, 650–1250.* New Haven, CT: Yale University Press, 2001.

Farhad, Massumeh *et al. The Art of the Qur'an: Treasures from the Museum of Turkish and Islamic Arts.* Washington, D.C.: Arthur M. Sackler Gallery, Smithsonian Institution, 2016.

Frishman, Martin and Khan, Hasan-Uddin. *The Mosque: History, Architectural Development and Regional Diversity.* London and New York: Thames & Hudson, 2002.

Gonnella, Julia. "Three Stucco Panels from Samarra." In Sheila Blair and Jonathan Bloom (eds.). *God Is Beautiful and Loves Beauty: The Object in Islamic Art and Culture.* New Haven, CT and London: Yale University Press, 2013, 79–101.

Grabar, Oleg. *The Formation of Islamic Art.* New Haven, CT: Yale University Press, 1987.

Hillenbrand, Carole. *Introduction to Islam: Beliefs and Practices in Historical Perspective.* London and New York: Thames & Hudson, 2015.

Ruggles, D. Fairchild. *Islamic Art and Visual Culture: An Anthology of Sources.* Malden, MA: Wiley Blackwell, 2011.

CHAPTER 25: ART OF AFRICAN KINGDOMS AND EMPIRES (300–1500)

Connah, Graham. *African Civilizations: An Archaeological Perspective.* 2nd edn. Cambridge, U.K. and New York: Cambridge University Press, 2001.

Drewal, Henry John and Schildkrout, Enid. *Dynasty and Divinity: Ife Art in Ancient Nigeria.* New York: Museum for African Art, 2009.

Garlake, Peter. *Early Art and Architecture of Africa.* Oxford, U.K.: Oxford University Press, 2002.

Heldman, Marilyn with Munro-Hay, Stuart C. *African Zion: The Sacred Art of Ethiopia.* New Haven, CT: Yale University Press, 1993.

Marchand, Trevor H. J. *The Masons of Djenné.* Bloomington, IN: Indiana University Press, 2009.

McNaughton, Patrick R., ed. Special Issue: Protecting Mali's Cultural Heritage, *African Arts* 28, no. 4 (1995).

Olúpònà, Jacob Kehinde. *City of 201 Gods: Ile-Ife in Time, Space and the Imagination.* Berkeley, CA: University of California Press, 2011.

Phillipson, D. W. *Ancient Churches of Ethiopia: Fourth–Fourteenth Centuries.* New Haven, CT: Yale University Press, 2009.

Pikirayi, Innocent. *The Zimbabwe Culture: Origins and Decline of Southern Zambezian States.* Walnut Creek, CA: AltaMira Press, 2001.

CHAPTER 26: MONUMENTAL ART IN SOUTH ASIA AND SOUTHEAST ASIA (700–1400)

Dehejia, Vidya. *Art of the Imperial Cholas.* New York: Columbia University Press, 1990.

Desai, Devangana. *Khajuraho.* New Delhi and New York: Oxford University Press, 2000.

Frédéric, Louis. *Borobudur.* New York: Abbeville Press, 1996.

Jessup, Helen Ibbitson. *Art & Architecture of Cambodia.* World of Art. New York: Thames & Hudson, 2004.

Kaimal, Padma. "Shiva Nataraja: Multiple Meanings of an Icon." In Rebecca Brown and Deborah Hutton (eds.). *A Companion to Asian Art and Architecture.* Malden, MA: Wiley-Blackwell, 2011, 471–85.

Kerlogue, Fiona. *Arts of Southeast Asia.* London and New York: Thames & Hudson, 2004.

Mannikka, Eleanor. *Angkor Wat: Time, Space, and Kingship.* Honolulu, HI: University of Hawai'i Press, 1996.

Maxwell, Thomas S. *Of Gods, Kings, and Men: The Reliefs of Angkor Wat.* Chiang Mai, Thailand: Silkworm Books, 2006.

Miksic, John N. *et al. Borobudur: Majestic, Mysterious, Magnificent.* Yogyakarta, Indonesia: Taman Wisata Candi Borobudur, Prambanan & Ratu Boko, 2010.

CHAPTER 27: THE DISSEMINATION OF BUDDHISM AND EAST ASIAN ART (500–1200)

Harrell, Mark. "Sokkuram: Buddhist Monument and Political Statement in Korea." *World Archaeology* 27 no. 2 Buddhist Archaeology (October 1995): 318–35.

Karetzky, Patricia Eichenbaum. *Early Buddhist Narrative Art: Illustrations of the Life of the Buddha*

from Central Asia to China, Korea, and Japan. Lanham, MD: University Press of America, 2000.

Leidy, Denise. The Art of Buddhism: An Introduction to Its History and Meaning. Boston, MA: Shambhala, 2008.

Lee, Junghee. "The Origins and Development of the Pensive Bodhisattva Images of Asia." Artibus Asiae 53, no. 3/4 (1993): 311–357.

McCallum, Donald F. "The Earliest Buddhist Statues in Japan." Artibus Asiae 61, no. 2 (2001): 149–88.

Stanley-Baker, Richard et al. Reading the Tale of Genji: Its Picture Scrolls, Texts and Romance. Leiden, The Netherlands: Brill, 2009.

Ten Grotenhuis, Elizabeth. Japanese Mandalas: Representations of Sacred Geography. Honolulu, HI: University of Hawai'i Press, 1999.

Walley, Akiko. Constructing the Dharma King: The Hōryūji Shaka Triad and the Birth of the Prince Shōtoku Cult. Leiden, The Netherlands: Brill, 2015.

Yiengpruksawan, Mimi Hall. "The Phoenix Hall at Uji and the Symmetries of Replication." The Art Bulletin 77, no. 4 (December 1995): 647–72.

CHAPTER 28: ART OF THE BYZANTINE EMPIRE (540–1450)

Betancourt, Roland. Sight, Touch, and Imagination in Byzantium. Cambridge, U.K.: Cambridge University Press, 2018.

Evans, Helen, ed. Byzantium: Faith and Power (1261–1557). Exhibition cat. New York: The Metropolitan Museum of Art, 2004.

Evans, Helen C. and Wixom, William D. (eds.). The Glory of Byzantium: Art and Culture of the Middle Byzantine Era, A.D. 843–1261. Exhibition cat. New York: The Metropolitan Museum of Art, 1997.

Maguire, Henry. Art and Eloquence in Byzantium. Princeton, NJ: Princeton University Press, 1981.

Pentcheva, Bissera. The Sensual Icon: Space, Ritual, and the Senses in Byzantium. University Park, PA: Pennsylvania State University Press, 2010.

CHAPTER 29: ART OF EARLY MEDIEVAL EUROPE (600–1250)

Bagnoli, Martina, Klein, Holger A., Griffith Mann, C., and Robinson, James (eds.). Treasures of Heaven: Saints, Relics, and Devotion in Medieval Europe. Exhibition cat. London: British Museum Press, 2011.

Brown, Michelle P. The Lindisfarne Gospels: Society, Spirituality, and the Scribe. Toronto, Canada: University of Toronto, 2003.

Cohen, Adam and Derbes, Anne. "Bernward and Eve at Hildesheim." Gesta 40 (2001): 19–38.

McKitterick, Rosamond, ed. Carolingian Culture: Emulation and Innovation. Cambridge, U.K.: Cambridge University Press, 1994.

Meehan, Bernard. The Book of Kells. London: Thames & Hudson, 2012.

CHAPTER 30: ART OF THE AMERICAS (600–1300)

Carrasco, Davíd, Jones, Lindsay, and Sessions, Scott. Mesoamerica's Classic Heritage: From Teotihuacan to the Aztecs. Boulder, CO: University Press of Colorado, 2002.

Castillo Butters, Luis Jaime. "The Last of the Mochicas: A View from the Jequetepeque Valley." In Joanne Pillsbury, ed. Moche Art and Archaeology in Ancient Peru. National Gallery of Art, Washington D.C. and Yale University Press, 2002, 307–332.

Coe, Michael D. and Houston, Stephen D. The Maya. 9th edn. New York: Thames & Hudson, 2015.

López Austin, Alfredo and Leonardo López Luján. Mexico's Indigenous Past. Norman, OK: Oklahoma University Press, 2007.

Miller, Mary Ellen. The Art of Mesoamerica: From Olmec to Aztec (World of Art). 5th edn. London: Thames & Hudson, 2012.

Stone, Rebecca R. Art of the Andes: From Chavín to Inca. 3rd edn. New York: Thames & Hudson, 2012.

Townsend, Richard F., ed. Hero, Hawk, and Open Hand: American Indian Art of the Ancient Midwest and South. Chicago, IL: Art Institute of Chicago, 2004.

CHAPTER 31: ART DURING THE SONG AND YUAN DYNASTIES OF CHINA (960–1368)

Barnhart, Richard et al. Three Thousand Years of Chinese Painting. New Haven, CT: Yale University Press, 1997.

Bickford, Maggie. "Emperor Huizong and the Aesthetic of Agency." Archives of Asian Art 53 (2002): 71–104.

Foong, Ping. The Auspicious Landscape: On the Authorities of Painting at the Northern Song Court. Harvard East Asian Monographs 372. Cambridge, MA: Harvard University Press, 2015.

Lee, Hui-shu. Empresses, Art, and Agency in Song Dynasty China. Seattle, WA: University of Washington Press, 2010.

Levine, Gregory P. A. "Critical Zen Art History." Journal of Art Historiography 15 (December 2016): 1–30.

Levine, Gregory P. A., Lippit, Yukio, and Japan Society Gallery. Awakenings: Zen Figure Painting in Medieval Japan. New Haven, CT: Yale University Press, 2007.

Murase, Miyeko. "Kuan-Yin as Savior of Men: Illustration of the Twenty-Fifth Chapter of the Lotus Sūtra in Chinese Painting." Artibus Asiae 33, nos. 1/2 (1971): 39–74.

Rio, Aaron. "Shades of Mokkei: Muqi-style Ink Painting in Medieval Kamakura." In Michelle Huang, ed. The Reception of Chinese Art across Cultures. Newcastle-upon-Tyne, U.K.: Cambridge Scholars Publishing, 2014, 2–22.

Watt, James C. Y., ed. The World of Khubilai Khan: Chinese Art in the Yuan Dynasty. New York: The Metropolitan Museum of Art, 2010.

Wyatt, Don. "The Image of the Black in Chinese Art." In D. Bindman et al (eds.). The Image of the Black in African and Asian Art. Cambridge, MA.: The Belknap Press of Harvard University in collaboration with the Hutchins Center for African and African American Research, 2017.

CHAPTER 32: TRANSFORMATIVE ERAS AND ART IN KOREA AND JAPAN (1200–1600)

Burglind, Jungmann. "Sin Sukju's Record on the Painting Collection of Prince Anpyeong and Early Joseon Antiquarianism." Archives of Asian Art 61 (2011): 107–26.

Covaci, Ive and Asia Society Museum. Kamakura: Realism and Spirituality in the Sculpture of Japan. New York: Asia Society Museum, and New Haven, CT: Yale University Press, 2016.

Fister, Patricia. "Commemorating Life and Death: The Memorial Culture Surrounding the Rinzi Zen Nan Mugai Nyodai." In Karen Gerhart, ed. Women, Rites, and Ritual Objects in Premodern Japan. Leiden, The Netherlands: Brill, 2018.

Keene, Donald. Yoshimasa and the Silver Pavilion: The Creation of the Soul of Japan. New York: Columbia University Press, 2006.

Kim, Youngna. "Korea's Search for a Place in Global Art History." The Art Bulletin vol. 98, no 1 (March 2016): 7–13.

Lee, Soyoung and Jeon, Seung-chang. Korean Bucheong Ceramics from Leeum, Samsung Museum of Art. New York: The Metropolitan Museum of Art/ Yale University Press, 2011.

Lippit, Yukio. "Goryeo Buddhist Painting in an Interregional Context." Ars Orientalis 35 (2008): 192–232.

Pitelka, Morgan. "Warriors, Tea, and Art in Premodern Japan." Bulletin of the Detroit Institute of Arts 88.1/4 (2014): 20–33.

Watsky, Andrew Mark. Chikubushima: Deploying the Sacred Arts in Momoyama Japan. Seattle, WA: University of Washington Press, 2004.

CHAPTER 33: THE REGIONALIZATION OF ISLAMIC ART IN NORTH AFRICA, WEST ASIA, AND CENTRAL ASIA (1000–1400)

Berlekamp, Persis. Wonder, Image, and Cosmos in Medieval Islam. New Haven, CT: Yale University Press, 2011.

Blair, Sheila S. Text and Image in Medieval Persian Art. Edinburgh: Edinburgh University Press, 2014.

Blair, Sheila S. and Bloom, Jonathan M. The Art and Architecture of Islam, 1250–1800. The Yale University Press Pelican History of Art Series. New Haven, CT: Yale University Press, 1996.

Flood, Finbarr Barry and Necipoglu, Gulru (eds.). A Companion to Islamic Art and Architecture. 2 vols. Hoboken, NJ: Wiley, 2017.

Gruber, Christiane. The Praiseworthy One: The Prophet Muhammad in Islamic Texts and Images. Bloomington, IN: Indiana University Press, 2018.

Hillenbrand, Robert. Islamic Architecture: Form, Function, and Meaning. New York: Columbia University Press, 2004.

Landau, Amy S., ed. Pearls on a String: Artists, Patrons, and Poets at the Great Islamic Courts. Baltimore, MD: The Walters Art Museum, 2015.

Mackie, Louise W. Symbols of Power: Luxury Textiles from Islamic Lands, 7th–21st Century. New Haven, CT, and London: Yale University Press, in conjunction with the Cleveland Museum of Art, 2015.

Sims, Eleanor. Peerless Images: Persian Painting and Its Sources. New Haven, CT: Yale University Press, 2002.

CHAPTER 34: ART OF THE MEDITERRANEAN WORLD (500–1500)

Anderson, Glaire. The Islamic Villa in Early Medieval Iberia: Architecture and Court Culture in Umayyad Córdoba. Burlington, VT: Ashgate, 2013.

Borsook, Eve. Messages in Mosaic: The Royal Programmes of Norman Sicily, 1130–1187. Oxford, U.K.: Boydell Press, 1998.

Caiger-Smith, Alan. Lustre Pottery: Technique, Tradition and Innovation in Islam and the Western World. London: Faber and Faber, 1985.

Grabar, Oleg. The Alhambra. Cambridge, MA: Harvard University Press, 1978.

Williams, John. The Illustrated Beatus: A Corpus of the Illustrations of the Commentary on the Apocalypse. Five vols. London: Harvey Miller, 1994–2003.

CHAPTER 35: ROMANESQUE ART AND ARCHITECTURE IN EUROPE (1000–1200)

David Bindman, Gates, Jr., Henry Louis, and Dalton, Karen C. C. (eds.). The Image of the Black in Western Art, Vol. II: From the Early Christian Era to the "Age of Discovery", Part 1: From the Demonic Threat to the Incarnation of Sainthood. Cambridge, MA: Harvard University Press, 1979.

Gearhart, Heidi. Theophilus and the Theory and Practice of Medieval Art. University Park, PA: Pennsylvania State University Press, 2017.

Grape, Wolfgang. The Bayeux Tapestry: Monument to a North Triumph. New York: Prestel, 1994.

Hahn, Cynthia. *Strange Beauty: Issues in the Making and Meaning of Reliquaries, 400–circa 1204.* University Park, PA: Pennsylvania State University, 2012.

O'Neill, John P., ed. *Enamels of Limoges 1000–1350.* Exhibition cat. New York: The Metropolitan Museum of Art, 1996.

Seidel, Linda. *Legends in Limestone: Lazarus, Gislebertus, and the Cathedral of Autun.* Chicago, IL: University of Chicago Press, 1999.

Voelkle, William. *The Stavelot Triptych, Mosan Art, and the Legend of the True Cross.* Oxford, U.K.: Oxford University Press, 1980.

CHAPTER 36: GOTHIC ART AND ARCHITECTURE IN EUROPE (1200–1400)

Barnet, Peter, ed. *Images in Ivory: Precious Objects of the Gothic Age.* Exhibition cat. Princeton, NJ: Princeton University Press, 1997.

Caviness, Madeline. "Patron or Matron? A Capetian Bride and a Vade Mecum for Her Marriage Bed." *Speculum* 68 (1993): 333–62.

Drake Boehm, Barbara and Fajt, Jirí (eds.). *Prague: The Crown of Bohemia, 1347–1437.* Exhibition cat. New York: The Metropolitan Museum of Art, 2006.

Hamburger, Jeffrey. *The Visual and the Visionary: Art and Female Spirituality in Late Medieval Germany.* New York: Zone Books, 1998.

Williams, Jane Welch. *Bread, Wine, and Money: The Windows of the Trades at Chartres Cathedral.* Chicago, IL: University of Chicago, 1993.

Wu, Nancy Y., ed. *Ad Quadratum: The Practical Application of Geometry in Medieval Architecture.* London: Routledge, 2002.

CHAPTER 37: ART OF THE LATE MIDDLE AGES IN ITALY (1200–1400)

Belting, Hans. *Bild und Kult—Eine Geschichte des Bildes vor dem Zeitalter der Kunst* (Munich, 1990). Trans. Edmund Jephcott as *Likeness and Presence: A History of the Image before the Era of Art.* Chicago, IL: University of Chicago Press, 1994.

Derbes, Anne. *Picturing the Passion in Late Medieval Italy: Narrative Painting, Franciscan Ideology, and the Levant.* Cambridge, U.K.: Cambridge University Press, 1996.

Derbes, Anne and Sandona, Mark. *The Usurer's Heart: Giotto, Enrico Scrovegni, and the Arena Chapel in Padua.* University Park, PA: Pennsylvania State University Press, 2008.

Flora, Holly. *Cimabue and the Franciscans.* Turnhout, Belgium: Brepols, 2018.

Stubblebine, James H., ed. *Giotto: The Arena Chapel Frescoes.* New York: W. W. Norton and Co., 1969.

Stern, Randolph. *Ambrogio Lorenzetti: The Palazzo Pubblico, Siena.* New York: G. Braziller, 1994.

Sources of Illustrations

All maps by Peter Bull unless otherwise stated. **p. 1** Kobe City Museum/DNPartcom; **pp. 2–3** Metropolitan Museum of Art, New York. Lila Acheson Wallace Gift, 1992, 1992.54. Photo Metropolitan Museum of Art/Art Resource/Scala, Florence; **0.1** Image courtesy Stephen Friedman Gallery and Pearl Lam Galleries. Photo Stephen White & Co. © Yinka Shonibare CBE. All Rights Reserved, DACS/Artimage 2021; **0.2** Courtesy of the artist, Jack Shainman Gallery, New York and Birmingham Museum of Art. Museum purchase with funds provided by Elizabeth (Bibby) Smith, Collectors Circle for Contemporary Art, Jane Comer, Sankofa Society and general acquisition funds. Photo Sean Pathasema. © Kerry James Marshall; **0.3** Ulsan Petroglyph Museum, South Korea; **0.4** cinoby/iStock.com; **0.5** On loan from M. A. Kuiper-Heuvelink, Amsterdam. Photo Rijksmuseum, Amsterdam; **0.6** Hemis/Alamy Stock Photo; **0.7** Photo Trustees of the British Museum, London; **0.8** Metropolitan Museum of Art, New York, The Michael C. Rockefeller Memorial Collection, Gift of Nelson A. Rockefeller, 1969, 1978.412.713. Photo Metropolitan Museum of Art/Art Resource/Scala, Florence; **0.9** Photo Trustees of the British Museum, London; **0.10** xavierarnau/Getty Images; **0.11** Peter Bull; **0.12** Photo courtesy Sher-Gil Archives and PHOTOINK; **0.13** Metropolitan Museum of Art, New York, Purchase, Edward C. Moore Jr. Gift, 1969, 69.135. Photo Metropolitan Museum of Art/Art Resource/Scala, Florence. © The Josef and Anni Albers Foundation/ Artists Rights Society (ARS), New York and DACS, London 2021; **0.14, 0.14 A–C** Kōyasan Reihokan Museum; **0.15, 0.15 A–C** Sylvain Sonnet/Getty Images; **0.16, 0.16a** Photo John Bigelow Taylor/Art Resource/ Scala, Florence. © Succession Picasso/DACS, London 2021; **0.17** © Xu Bing Studio; **p. 32 1** detail of 1.6; **2** detail of 7.11; **3** detail of 2.19; **4** detail of 11.5; **5** detail of 7.5; **6** detail of p. 65; **7** detail of 5.12; **8** detail of 4.3; **9** detail of 9.13; **10** detail of 8.16; **11** detail of 4.11; **12** detail of 11.9; **p. 34** Photo Lionel Guichard © DACS 2021; **1.1** Photo © Pedro Saura. **1.2** Courtesy Maxime Aubert; **1.3** Nature Picture Library/Alamy Stock Photo; **1.4** Photo © J. Clottes/Ministère de la Culture; **1.5** Photo © N. Aujoulat/Centre National de Préhistoire/ Ministère de la Culture; **1.6** Henri Stierlin/Bildarchiv Steffens/Bridgeman Images; **1.7** Courtesy Trust for African Rock Art; **1.8** Photo © Steven David Miller/ naturepl.com; **1.9** Museum Ulm, photo Oleg Kuchar, Ulm; **1.10** Naturhistorisches Museum, Vienna; **1.11** Moravian Museum – Historical Museum – Anthropos Institute; **1.12** Mehmet Çetin/Alamy Stock Photo; **1.13** Photo Göbekli Tepe Project, Deutsches Archäologisches Institut; **1.14** Photo © 2020 Manuel Cohen/Scala, Florence; **1.15** Matt Cardy/Getty Images; **1.16** Bridgeman Images; **1.17, 1.18** Peter Bull; **1.19** funkyfood London – Paul Williams/Alamy Stock Photo; **1.20** Photo Jason Quinlan; **1.21** (top left, top right, bottom right) Erich Lessing/akg-images; **1.21** (bottom left) Photo © 2020 White Images/Scala, Florence; **p. 50** Ariadne Van Zandbergen/Getty Images; **2.1** Courtesy NASA/JPL-Caltech; **2.2** Photo © David Coulson; **2.3, 2.4** Photos © Yves Gauthier; **2.5, 2.6** Photo © David Coulson; **2.7** Photo © András Zboray/

Fliegel Jezerniczky Ltd; **2.8** Fabian von Poser/Getty Images; **2.9** Ariadne Van Zandbergen/Getty Images; **2.10** Iziko Museum/Africa Media Online/akg-images; **2.11** Museum of Fine Arts, Boston, MA/Harvard University – Museum of Fine Arts Expedition/ Bridgeman Images; **2.12** Photo © András Zboray/ Fliegel Jezerniczky Ltd; **2.13** Antonelli Maria Laura/ AGF/UIG via Getty Images; **2.14, 2.15** Photos © Andrea Jemolo; **2.16** Photo © Dirk Bakker 1980; **2.17** Peter Bull; **2.18, 2.19** Photos © Dirk Bakker 1980; **p. 65** Metropolitan Museum of Art, New York, Fletcher Fund, 1940; **3.1** Photo RMN-Grand Palais (Musée du Louvre)/image RMN-GP; **3.2** © artefacts-berlin.de. German Archaeological Institute; **3.3** Peter Bull; **3.4** age fotostock/Alamy Stock Photo; **3.5** Peter Bull; **3.6** bpk, Bildagentur für Kunst, Kultur und Geschichte, Berlin. Photo Olaf M. Tessmer/Scala, Florence; **3.7** Peter Bull; **3.8** Erich Lessing/akg-images; **3.8a** Peter Bull; **3.9** Photo © Dr. Osama Shukir Muhammed Amin; **3.10** bpk, Bildagentur für Kunst, Kultur und Geschichte, Berlin. Photo Olaf M. Tessmer/Scala, Florence; **3.11** Courtesy Oriental Institute of the University of Chicago; **3.12a, b** Photos Trustees of the British Museum, London; **3.13** Courtesy Penn Museum, object no. B17694; **3.14** Peter Bull; **3.15** Interfoto/akg-images; **3.16** Photo RMN-Grand Palais (Musée du Louvre)/Franck Raux; **3.17** Courtesy Penn Museum, object no. B16665; **3.18** Photo Metropolitan Museum of Art, Dist. RMN-Grand Palais/image of the MMA; **3.19** Peter Bull; **p. 81** G. Dagli Orti/DEA/Getty Images; **4.1, 4.1a** Artwork © Joel Paulson; **4.2, 4.2a** Photos Musée du Louvre, Dist. RMN-Grand Palais/ Georges Poncet; **4.3** bpk, Bildagentur für Kunst, Kultur und Geschichte, Berlin. Photo Jürgen Liepe/ Scala, Florence; **4.4** Reproduced by permission of the American Research Center in Egypt, Inc. (ARCE). This project was funded by United States Agency for International Development (USAID). Photo Jason Goodman; **4.5, 4.6** Peter Bull; **4.7** Mark Goddard/ iStock.com; **4.8** De Rocker/Alamy Stock Photo; **4.9** Ministry of Antiquities, Cairo; **4.10** DEA/C.Sappa/ Getty Images; **4.11** Kitti Boonnitrod/Getty Images; **4.12, 4.13** Peter Bull; **4.14** bpk, Bildagentur für Kunst, Kultur und Geschichte, Berlin. Photo Jürgen Liepe/ Scala, Florence; **4.15** Edwin Remsberg/Alamy Stock Photo; **4.16** Museum of Fine Arts, Boston, MA/ Harvard University – Museum of Fine Arts Expedition/ Bridgeman Images; **4.17** www.araldodeluca.com; **4.18** Photo Musée du Louvre, Dist. RMN-Grand Palais/ Christian Decamps; **p. 96 1** Photo Trustees of the British Museum, London; **p. 96 2** Metropolitan Museum of Art/Art Resource/Scala, Florence. Photo Bruce White; **p. 97 3** Metropolitan Museum of Art, Rogers Fund, 1924; **p. 97 4** Photo François Guenet/Art Resource, NY; **p. 98** Oez/iStock.com; **5.1** Photo RMN-Grand Palais (Musée du Louvre)/Franck Raux; **5.2** Peter Bull; **5.3** Photo RMN-Grand Palais (Musée du Louvre)/Franck Raux; **5.4** Photo Trustees of the British Museum, London; **5.5** funkyfood London – Paul Williams/Alamy Stock Photo; **5.6** Gerard Degeorge/ akg-images; **5.7** Ömür Harmanşah; **5.8** G. Dagli Orti/ DEA/De Agostini/Getty Images; **5.9a** Peter Bull; **5.9b** imageBROKER/Alamy Stock Photo; **5.10** Peter Bull;

5.11 Photo Trustees of the British Museum, London; **5.12** Metropolitan Museum of Art, Gift of John D. Rockefeller Jr., 1932. Photo 2020, Metropolitan Museum of Art/Art Resource/Scala, Florence; **5.13** Photo Trustees of the British Museum, London; **5.14** Peter Bull; **5.15** bpk, Bildagentur für Kunst, Kultur und Geschichte, Berlin. Photo Olaf M. Tessmer/Scala, Florence; **5.16** bpk, Bildagentur für Kunst, Kultur und Geschichte, Berlin. Photo Reinhard Saczewski/Scala, Florence; **5.17** Photo Trustees of the British Museum, London; **5.17a** Peter Bull; **5.18** Wojtek Buss/ agefotostock; **5.19** Robbie (Robert) Shaw/Alamy Stock Photo; **5.20** DeAgostini/Getty Images; **p. 115** Kumar Sriskandan/Alamy Stock Photo; **6.1** Peter Bull; **6.2** bpk, Bildagentur für Kunst, Kultur und Geschichte, Berlin. Photo Jürgen Liepe/Scala, Florence; **6.3** François Guénet/akg-images; **6.4** Photo Trustees of the British Museum, London; **6.5** Photo Trustees of the British Museum, London; **6.6** Peter Bull; **6.7** Cultura Creative (RF)/Alamy Stock Photo; **6.8** With permission of the Royal Ontario Museum, ROM; **6.9** www.araldodeluca. com; **6.10** bpk, Bildagentur für Kunst, Kultur und Geschichte, Berlin/Scala, Florence; **6.11, 6.12** bpk, Bildagentur für Kunst, Kultur und Geschichte, Berlin. Photo Jürgen Liepe/Scala, Florence; **6.13** Photo Scala, Florence; **6.14** Oleksandra Vasylenko/Shutterstock. com; **6.15** Guido Vermeulen-Perdaen/Shutterstock. com; **6.16** Peter Bull; **6.17** Peter Phipp/Getty Images; **6.18** Andia/Alamy Stock Photo; **6.19** Photo Trustees of the British Museum, London; **6.20** Photo Musée du Louvre, Dist. RMN-Grand Palais/Christian Decamps; **6.21** Photo Scala, Florence; **p. 132 1** Courtesy Oriental Institute of the University of Chicago; **p. 132 2** Freer Gallery of Art, Smithsonian Institution, Washington, D.C.: Acquired under the guidance of the Carl Whiting Bishop expedition, F1985.35; **p. 133 3** Pablo Caridad/ Alamy Stock Photo; **p. 133 3a** Peter Bull; **p. 134** Pablo Caridad/Alamy Stock Photo; **7.1** Randy Olson/National Geographic Stock; **7.2** Mike Goldwater/Alamy Stock Photo; **7.3** Photo Scala, Florence; **7.4** National Museum of India, New Delhi/Bridgeman Images; **7.5** Photo Trustees of the British Museum, London; **7.6** Photo Luisa Ricciarini/Bridgeman Images; **7.6a** Peter Bull; **7.7** agefotostock/Alamy Stock Photo; **7.8** Photo Trustees of the British Museum, London; **7.9** Erich Lessing/akg-images; **7.10** Marcia and John Friede Collecion, a Promised Gift to the Fine Arts Museum of San Francisco L05.1.111. Photo 2006 John Bigelow Taylor; **7.11** Photo Trustees of the British Museum, London; **7.12** National Gallery of Australia, Canberra, Purchased 1977/Bridgeman Images; **7.13** Stephen Alvarez/National Geographic Stock; **7.14** Courtesy Anthropology Photographic Archive, Department of Anthropology, University of Auckland; **7.15** Courtesy Professor Patrick V. Kirch; **p. 147** imageBROKER/ Alamy Stock Photo; **8.1** Kyonghui University Museum, Seoul; **8.2** Photo Ogawa Tadahiro; **8.3** TNM Image Archives; **8.4** Metropolitan Museum of Art, New York, Gift of Charlotte C. And John C. Weber, 1992, 1992.165.8. Photo Metropolitan Museum of Art/Art Resource/Scala, Florence; **8.5** Metropolitan Museum of Art, New York, Purchase, Friends of Asian Art Gifts, 1986, 1986.112. Photo Metropolitan Museum of Art/Art

Resource/Scala, Florence; 8.6 Martha Avery/Getty Images; 8.7 Granger Historical Picture Archive/Alamy Stock Photo; 8.8 Heritage Image Partnership Ltd/Alamy Stock Photo; 8.8a Peter Bull; 8.9 Granger Historical Picture Archive/Alamy Stock Photo; 8.10 Peter Bull; 8.11 Bridgeman Images; 8.12 Sanxingdui Museum; 8.12a Peter Bull, after Lothar van Falkenhausen; 8.13 National Museum of Korea; 8.14, 8.14a Photos Trustees of the British Museum, London; 8.15, 8.15a With permission of the Royal Ontario Museum. Photos ROM; 8.16 © Asian Art & Archaeology, Inc./Corbis via Getty Images; 8.17 Peter Bull; 8.18 Laurent Lecat/akg-images; p. 161 Luisa Ricciarini/Bridgeman Images; 9.1 Photo © George Stefanou; 9.2 Photo Marie Mauzy/Scala, Florence; 9.3 G. Dagli Orti/DEA/De Agostini/Getty Images; 9.4 Konstantinos Kontos/Photostock; 9.5 Museum of Fine Arts, Boston, Gift of Mrs. W. Scott Fitz. Photo 2021 Museum of Fine Arts, Boston; 9.6 Hackenberg-Photo-Cologne/Alamy Stock Photo; 9.7 Leemage/Universal Images Group/Getty Images; 9.8 Peter Bull; 9.9 Dorling Kindersley: William Donahue; 9.10 Leonid Serebrennikov/Alamy Stock Photo; 9.11 Konstantinos Kontos/Photostock; 9.12 Luisa Ricciarini/Bridgeman Images; 9.13 Konstantinos Kontos/Photostock; 9.14 Photo Metropolitan Museum of Art/Art Resource/Scala, Florence. Photo Bruce Schwarz; 9.15 Photo Marie Mauzy/Scala, Florence; 9.16, 9.16a, 9.17, 9.17a Luisa Ricciarini/Bridgeman Images; 9.18 Peter Bull; 9.19, 9.19a © Manfred Bietak, Nannó Marinatos, Clairy Palyvou. Graphic work M. Negrete Martinez; p. 176 Metropolitan Museum of Art, Rogers Fund, 1914; 10.1 Education Images/Universal Images Group/Getty Images; 10.2 Leemage/Universal Images Group/Getty Images; 10.3, 10.4 Luisa Ricciarini/Bridgeman Images; 10.5 Peter Bull; 10.6 Photo © Ira Block; 10.7 Bildarchiv Monheim GmbH/Alamy Stock Photo; 10.8 Peter Eastland/Alamy Stock Photo; 10.9 imageBROKER/Alamy Stock Photo; 10.10 Peter Bull; 10.11 Courtesy Department of Classics, University of Cincinnati; 10.12 Courtesy Department of Classics, University of Cincinnati. Photo J. Vanderpool; 10.13 Photo RMN-Grand Palais (Musée du Louvre)/Hervé Lewandowski; 10.14 Photo Marie Mauzy/Scala, Florence; 10.15 Peter Bull; 10.16 Metropolitan Museum of Art, Rogers Fund, 1914; 10.17 G. Nimatallah/DEA/Getty Images; 10.18 Peter Bull; 10.19, 10.20 Konstantinos Kontos/Photostock; 10.21 Peter Bull; 10.22 Digital image courtesy of the Getty's Open Content Program; 10.23 Peter Bull; p. 191 Photo 2021 Museum of Fine Arts, Boston; 11.1 Peter Bull; 11.2 Mark Green/Alamy Stock Photo; 11.3 Bildarchiv Steffens/akg-images; 11.3a Peter Bull; 11.4 Metropolitan Museum of Art, New York, Jan Mitchell and Sons Collection, 1999.365. Photo Metropolitan Museum of Art/Art Resource/Scala, Florence; 11.5 Photo 2021 Museum of Fine Arts, Boston; 11.6 Peter Bull; 11.7 Art Institute of Chicago/Art Resource, NY/Scala, Florence; 11.8 Textile Museum, Washington, D.C., N91.26, Acquired by George Hewitt Myers, 1948; 11.9 Martin Bernetti/AFP via Getty Images; 11.10 Museo Larco, Lima, Peru, ML013572; 11.11, 11.12 Frans Lemmens/Alamy Stock Photo; 11.13 Art Institute of Chicago, IL, Kate S. Buckingham Endowment/Bridgeman Images; 11.14 Metropolitan Museum of Art, New York, Gift of Henry G. Marquand, 1882, 82.1.29. Photo Metropolitan Museum of Art/Art Resource/Scala, Florence; 11.15 Aivar Mikko/Alamy Stock Photo; p. 204 1 detail of 12.11; 2 detail of 14.3; 3 detail of p. 270 1; 4 detail of 19.1; 5 see 21.4; 6 detail of 22.3; 7 detail of 16.2; 8 detail of 19.9; 9 detail of 13.13; 10 detail of 21.7; 11 detail of 23.9; 12 detail of 16.9; p. 206 DeAgostini Picture Library/Scala, Florence; 12.1 Ewa Skibinska/Alamy Stock Photo; 12.2 Barna Tanko/Alamy Stock Photo; 12.3 Photo Trustees of the British

Museum, London; 12.4 Peter Bull; 12.5 Jean-Pierre Courau/Gamma-Rapho via Getty Images; 12.6 DeAgostini Picture Library/Scala, Florence; 12.7 Bridgeman Images; 12.8 Danita Delimont/Alamy Stock Photo; 12.9 Jorge Perez de Lara; 12.9a Drawing courtesy George Stuart; 12.10 Proctor Stafford Collection, purchased with funds provided by Mr. and Mrs. Allan C. Balch (M.86.296.122), Los Angeles County Museum of Art; 12.11 aerialarchives.com/Alamy Stock Photo; 12.12 Richard Maschmeyer/Design Pics/Getty Images; 12.13 Diego Grandi/Shutterstock; 12.14 agefotostock; p. 219 1 imageBROKER/Alamy Stock Photo; p. 220 2 Jae C Hong/AP/Shutterstock; p. 220 3 Image courtesy Uşak Museum of Archaeology. Published with the official permissions of the Turkish Ministry of Culture and Tourism and the Uşak Museum of Archaeology; p. 221 Erin Babnik/Alamy Stock Photo; 13.1 charistoone-images/Alamy Stock Photo; 13.2 Peter Bull; 13.3 Ian G Dagnall/Alamy Stock Photo; 13.4, 13.5, 13.6 Peter Bull; 13.7, 13.7a Cynthia Colburn; 13.7b G. Dagli Orti/De Agostini Picture Lib./akg-images; 13.8 Konstantinos Kontos/Photostock; 13.9 Luisa Ricciarini/Bridgeman Images; 13.9a © Liebieghaus Skulpturensammlung, Frankfurt a. M. – Vinzenz Brinkmann – ARTOTHEK; 13.10, 13.11 Photos Marie Mauzy/Scala, Florence; 13.12 Luisa Ricciarini/Bridgeman Images; 13.13 Photo Scala, Florence; 13.14, 13.15 Erin Babnik/Alamy Stock Photo; 13.16 John Hios/jh-Lightbox_Ltd/akg-images; 13.17 G. Dagli Orti/DEA/Getty Images; 13.18, 13.19 Leemage/Corbis/Getty Images; 13.20 Photo Scala, Florence, courtesy of the Ministero Beni e Att. Culturali e del Turismo; p. 238 Alinari Archives, Florence – Reproduced with the permission of Ministero per i Beni e le Attività Culturali/Alinari/Getty Images; 14.1 Peter Connolly/akg-images; 14.2 Peter Bull; 14.3 Photo © David Ball; 14.4, 14.5, 14.6 Peter Bull; 14.7, 14.8, 14.9 Photos Trustees of the British Museum, London; 14.10 Peter Bull; 14.11, 14.12 Photos Trustees of the British Museum, London; 14.13 Adam Eastland/Alamy Stock Photo; 14.14 J. Carlee Adams/Alamy Stock Photo; 14.15 Photo State Hermitage Museum/photo Vladimir Terebenin, Alexander Koksharov; 14.16 Peter Bull; 14.17 Imageplotter/Alamy Stock Photo; 14.18 ZUMA Press, Inc./Alamy Stock Photo; 14.19 Photo Marie Mauzy/Scala, Florence; 14.20 G. Nimatallah/DEA/Getty Images; 14.21 Alinari Archives/Getty Images; 14.22 Photo Marie Mauzy/Scala, Florence; 14.23 National Archaeological Museum, Athens, © Hellenic Ministry of Culture and Sports/Archaeological Receipts Fund; 14.23a Konstantinos Kontos/Photostock; 14.24 Photo RMN-Grand Palais (Musée du Louvre)/Hervé Lewandowski; p. 254 Photo Musée du Louvre, Dist. RMN-Grand Palais/Thierry Ollivier; 15.1 Photo Scala, Florence; 15.2 A. Dagli Orti/DEA/Getty Images; 15.3 Luisa Ricciarini/Bridgeman Images; 15.4 Andrey Khrobostov/Alamy Stock Photo; 15.5 Peter Bull; 15.6 Konstantinos Kontos/Photostock; 15.7 mauritius images GmbH/Alamy Stock Photo; 15.8 Peter Bull; 15.9, 15.10, 15.11 Konstantinos Kontos/Photostock; 15.12 Peter Bull; 15.13 Photo Trustees of the British Museum, London; 15.14 Peter Bull; 15.15 (left) Simon Rawley/Alamy Stock Photo; 15.15 (right) Luisa Ricciarini/Bridgeman Images; 15.16 bpk, Bildagentur für Kunst, Kultur und Geschichte, Berlin/Scala, Florence; 15.17 bpk, Bildagentur für Kunst, Kultur und Geschichte, Berlin. Photo Johannes Laurentius/Scala, Florence; 15.18, 15.19 Photo Musée du Louvre, Dist. RMN-Grand Palais/Thierry Ollivier; 15.20 Eric Vandeville/Gamma-Rapho/Getty Images; 15.21 Photo Scala, Florence; p. 270 1 Musée Guimet, Paris. MNAAG/RMN-Grand Palais; p. 271 2 Photo Scala, Florence; p. 271 3 Guyuan Museum, Ningixia Autonomous Region; p. 271 4 The Shosoin Treasures, Courtesy of the Imperial Household Agency; p. 272

Jon Arnold Images Ltd/Alamy Stock Photo; 16.1 British Library Board, London/Bridgeman Images; 16.2 Jean-Louis Nou/akg-images; 16.3 imageBROKER/Alamy Stock Photo; 16.4 Photo De-nin Lee; 16.5 Dinodia Photos/Alamy Stock Photo; 16.6 Jean-Louis Nou/akg-images; 16.7 The Avery Brundage Collection, Asian Art Museum, San Francisco, B60S597; 16.8 Peter Bull; 16.9 Jean-Louis Nou/akg-images; 16.10 Metropolitan Museum of Art, New York. Gift of Florence and Herbert Irving, 1993, 1993.477.2. Photo Metropolitan Museum of Art/Art Resource/Scala, Florence; 16.11 Peter Bull; 16.12 mdsharma/Shutterstock; 16.13 A-F Art Resource, New York; 16.14 Peter Bull; 16.15 dbimages/Alamy Stock Photo; 16.16 Nikreates/Alamy Stock Photo; 16.17 Peter Bull; 16.18 PA Images/Alamy Stock Photo; 16.19 Newark Museum, New Jersey, 82.183; 16.20 Photo Christophel Fine Art/Universal Images Group via Getty Images; p. 289 DeAgostini/Getty Images; 17.1 Photo Scala, Florence, courtesy of the Ministero Beni e Att. Culturali e del Turismo; 17.2 DeAgostini/Getty Images; 17.3 Peter Bull; 17.4, 17.5 Photos Scala, Florence; 17.6 Peter Bull; 17.7 G. Nimatallah/DEA/Getty Images; 17.8a, 17.8b Peter Bull; 17.9 Pietro Baguzzi/akg-images; 17.10 Krisztian Juhasz/Alamy Stock Photo; 17.11 Peter Bull; 17.12 Photo Scala, Florence, courtesy of the Ministero Beni e Att. Culturali e del Turismo; 17.13 Peter Bull; 17.14 Leemage/Corbis/Getty Images; 17.15 Erich Lessing/akg-images; 17.16 Photo Scala, Florence; 17.17 Photo Scala, Florence – courtesy of the Ministero Beni e Att. Culturali e del Turismo; 17.18 Photo Scala, Florence; 17.19 Leemage/Corbis/Getty Images; p. 303 Agf/Shutterstock; 18.1 Frank Bach/Alamy Stock Photo; 18.2 Peter Bull; 18.3 podorojniy/Shutterstock.com; 18.4 Peter Bull; 18.5 Photo Manuel Cohen/Scala, Florence; 18.6 Peter Bull; 18.7 Bildagentur-online/Universal Images Group/Getty Images; 18.8 Peter Bull; 18.9 L. Romano/DEA/Getty Images; 18.10 Photo Scala, Florence; 18.11 Reproduced by permission of Ministero per i Beni e le Attività Culturali e per il Turismo – Museo Archeologico Nazionale di Napoli, photo Giorgio Albano (Inv. 112222); 18.12 Peter Bull; 18.13 Photo Luciano Romano/Scala, Florence; 18.14 Photo Scala, Florence; 18.14a Photo Scala, Florence, courtesy of the Ministero Beni e Att. Culturali e del Turismo; 18.15 Photo Carole Raddato; 18.16 Peter Bull; 18.17, 18.17a Agf/Shutterstock; 18.18 Metropolitan Museum of Art, Rogers Fund, 1903; 18.19 Photo © J. Paul Getty Trust; 18.20 PRISMA ARCHIVO/Alamy Stock Photo; 18.21 Photo Scala, Florence; 18.22, 18.23 Photo Trustees of the British Museum, London; p. 320 akg-images; 19.1 Photo Scala, Florence; 19.1a Ashmolean Museum/Heritage Images/Getty Images; 19.2 Museo Arqueológico Nacional. Inv. 2737. Photo Enrique Sáenz de San Pedro; 19.3 Andrea Jemolo/Electa/Mondadori Portfolio/Getty Images; 19.4 Photo Luciano Romano/Scala, Florence; 19.5 Photo White Images/Scala, Florence; 19.6 G. Dagli Orti/DEA/Getty Images; 19.7, 19.8 Peter Bull; 19.9 imageBROKER/Alamy Stock Photo; 19.10 KHM-Museumsverband; 19.11 imageBROKER/Alamy Stock Photo; 19.12 Photo Luciano Romano/Scala, Florence; 19.13 Andreas Solaro/AFP/Getty Images; 19.14 Heritage Image Partnership Ltd/Alamy Stock Photo; p. 332 Craig Jack Photographic/Alamy Stock Photo; 20.1 imageBROKER/Alamy Stock Photo; 20.2 Ronald Paras/EyeEm/Getty Images; 20.3 Fabio Mazzarella/Sintesi/Alamy Stock Photo; 20.4 Photo © rafaelbenari/123RF.com; 20.5, 20.6 Newscom/Alamy Stock Photo; 20.7 Photo Scala, Florence, courtesy of the Ministero Beni e Att. Culturali e del Turismo; 20.8a Courtesy Istanbul Archaeological Museum; 20.8b De Agostini Picture Library/Bridgeman Images; 20.9, 20.10 Peter Bull; 20.11 Photo © Calin Stan/123RF.com; 20.11a World History Archive/Alamy Stock Photo; 20.12 Rafal

Cichawa/Alamy Stock Photo; 20.13 Angelo Hornak/Alamy Stock Photo; 20.14 Iain Masterton/Alamy Stock Photo; 20.15a, 20.15b Peter Bull; 20.16 Grzegorz Knec/Alamy Stock Photo; 20.17 Photo Scala, Florence; p. 346 Best View Stock/Alamy Stock Photo; 21.1 TNM Image Archives; 21.2 Fukuoka City Museum, Fukuoka. Agency for Cultural Affairs; 21.3 Photo Kyodo News Stills via Getty Images; 21.4 Peter Bull; 21.5 TNM Image Archives; 21.6 Mawangdui Tomb 1, Changsha, Hunan province, Hunan Provincial Museum; 21.6a, b Peter Bull; 21.7, 21.8 Tomb 1, Mancheng, Hebei Province, Hebei Provincial Museum; 21.9 Princeton University Art Museum/Art Resource, New York/Scala, Florence; 21.10 Photo Werner Forman/Universal Images Group/Getty Images; 21.11, 21.12 Courtesy Palace Museum, Beijing; 21.13 Photo Trustees of the British Museum, London; 21.14 Courtesy Nanjing Museum, Jiangsu; 21.15 Photo Asian Art Museum, San Francisco; 21.16 Robert Harding/Diomedia Images; 21.17 Metropolitan Museum of Art, New York, Fletcher Fund, 1935, 35.146; p. 362 1 Gyeongju National Museum, Korea. National Treasure 191; p. 363 2 Archaeological Museum of Komotini, Greece, 207; p. 363 3 Metropolitan Museum of Art, Michael C. Rockefeller Collection, 1979.206.1245. Photo Metropolitan Museum of Art/Art Resource/Scala, Florence; p. 364 Cris Foto/Shutterstock.com; 22.1 bpk, Bildagentur für Kunst, Kultur und Geschichte, Berlin. Photo Johannes Laurentius/Scala, Florence; 22.2 Peter Bull; 22.3 Guenter Fischer/Getty Images; 22.3a Liquid Light/Alamy Stock Photo; 22.4 Gilles Mermet/akg-images; 22.5 Peter Bull; 22.6 B. O'Kane/Alamy Stock Photo; 22.7 Photo Trustees of the British Museum, London; 22.8 Luisa Ricciarini/Bridgeman Images; 22.9, 22.10 Photo Scala, Florence; 22.11 Luisa Ricciarini/Bridgeman Images; 22.12 Library of Congress, Prints & Photographs Division, Daguerreotypes Collection, Washington, D.C.; 22.13 INTERFOTO/Alamy Stock Photo; 22.14 Peter Bull; 22.15 Adam Eastland/Alamy Stock Photo; p. 377 Giuseppe Schiavinotto/ Mondadori Portfolio/akg-images; 23.1, 23.1a Yale University Art Gallery, Dura-Europos Collection; 23.2 Godong/Bridgeman Images; 23.2a Pascal Deloche/Getty Images; 23.3 Z. Radovan/Bible Land Pictures, Jerusalem/akg-images; 23.4 Peter Bull; 23.5 Yale University Art Gallery, Dura-Europos Collection; 23.5a Peter Bull; 23.6 www.BibleLandPictures.com/Alamy Stock Photo; 23.7 Cleveland Museum of Art, John L. Severance Fund; 23.8 Heritage Image Partnership Ltd/Alamy Stock Photo; 23.9 Giuseppe Schiavinotto/Mondadori Portfolio/akg-images; 23.10 Photo Scala, Florence; 23.11 Photo Trustees of the British Museum, London; 23.12a, 23.12b Peter Bull; 23.13 Andrea Jemolo/akg-images; 23.14 Photo Scala, Florence; 23.15 Peter Bull; 23.16 Photo Scala, Florence/Fondo Edifici di Culto, Min. dell' Interno; 23.17 Photo Andrea Jemolo/Scala, Florence; 23.17a Photo Scala, Florence/Fondo Edifici di Culto – Min. dell' Interno; 23.18 Peter Bull; 23.19 Photo Scala, Florence; 23.20 Photo Andrea Jemolo/Scala, Florence; 23.21 Peter Bull; 23.22 lugris/Alamy Stock Photo; 23.23, 23.24 Photo Scala, Florence; 23.25 Photo Cameraphoto/Scala, Florence; p. 396 1 see 26.7; 2 detail of 30.7; 3 detail of 24.16; 4 detail of 36.7; 5 detail of 27.1; 6 detail of 28.20; 7 detail of 25.16; 8 detail of 29.4; 9 detail of 31.4; 10 see 33.9; 11 detail of p. 592 2; 12 detail of 37.17; p. 398 Thomas Coex/AFP/Getty Images; 24.1 Bandar Aldandani/AFP/Getty Images; 24.2 Peter Bull; 24.3 Ack Guez/AFP/Getty Images; 24.4 DeAgostini/Getty Images; 24.5 Peter Bull; 24.6 Tim Gerard Barker/Getty Images; 24.7 Peter Bull; 24.8 G. Dagli Orti/De Agostini Picture Lib./akg-images; 24.9 Courtesy The Israel Museum, Jerusalem; 24.10 Photo Scala, Florence; 24.11 Gianni Dagli Orti/Shutterstock; 24.12 Cleveland Museum of Art,

Purchase from the J. H. Wade Fund; 24.13 bpk, Bildagentur für Kunst, Kultur und Geschichte, Berlin/Scala, Florence; 24.14 Metropolitan Museum of Art, Harris Brisbane Dick Fund, 1963; 24.15 Metropolitan Museum of Art, Gift of Edwin Binney 3rd and Purchase, Richard S. Perkins Gift, 1977, Photo Metropolitan Museum of Art/Art Resource/Scala, Florence; 24.16 Yoshio Tomii/Getty Images; 24.17 Erich Lessing/akg-images; 24.17a Roland and Sabrina Michaud/akg-images; 24.18 Peter Bull; 24.19 Metropolitan Museum of Art, Purchase, Lila Acheson Wallace Gift, 2004; 24.20 Photo Trustees of the Chester Beatty Library, Dublin; p. 414 Photo Andrea Jemolo; 25.1 John Elk/Getty Images; 25.2 Photo Nigel Pavitt; 25.3 Hauke Dressler/Alamy Stock Photo; 25.4 Danita Delimont Stock Country/AWL Images; 25.5 Sean Sprague/Alamy Stock Photo; 25.6 Image courtesy University of Pretoria Museums; 25.7 Christopher Scott/Alamy Stock Photo; 25.8 Photo Werner Forman/Universal Images Group/Getty Images; 25.9 Denny Allen/Getty Images; 25.10 Ulrich Doering/Alamy Stock Photo; 25.11 Peter Giovannini/imageBROKER/Shutterstock; 25.12 George Steinmetz/National Geographic Images; 25.13 Image courtesy National Museum of African Art, Smithsonian Institution, Washington, D.C. Photo Franko Khoury; 25.14 Image courtesy National Museum, Lagos, Nigeria; 25.15 Jerry L. Thompson/Art Resource, New York; 25.16 Photo Scala, Florence; 25.17 Photo Andrea Jemolo; p. 429 Pictures From History/akg-images; 26.1, 26.1 A–E Photos Deborah Hutton; 26.2 Adel Newman/Shutterstock; 26.3 Peter Bull; 26.4 Photo Deborah Hutton; 26.5 Gnomeandi/Alamy; 26.6 Peter Bull; 26.7 Westend61 RF/Fotofeeling/Diomedia; 26.8 Pjhpix/Shutterstock; 26.9 Philippe Michel/age fotostock/Superstock; 26.10 Photo Deborah Hutton; 26.11 Museum Rietberg, Zurich, RVI 501, Gift of Eduard von der Heydt; 26.12 Alexander Hafemann/Getty; 26.13 Peter Bull; 26.14 Pictures From History/akg-images; 26.15 Rosemary Harris/Alamy; 26.16 Damian Evans/Khmer Archaeology LiDAR Consortium; 26.17 Peter Bull; 26.18 Diomedia Images; 26.19 Photo Deborah Hutton; 26.20 mauritius images GmbH/Alamy; p. 446 Benrido, Inc./Toji, Kyoto; 27.1 National Museum of Korea, Seoul; 27.2 Photo Junro Tomii; 27.3 Peter Bull; 27.4 Peter Bull; 27.5 Iberfoto/Mary Evans; 27.6 Bridgeman Images; 27.7 Granger Historical Picture Archive/Alamy Stock Photo; 27.8 Peter Bull; 27.9 National Museum of China, Beijing; 27.10 agshotime/iStock.com; 27.11 Jon Arnold Images Ltd/Alamy Stock Photo; 27.12 Zhang Peng/LightRocket via Getty Images; 27.13 Manuel Ascanio/Shutterstock; 27.14 Peter Bull; 27.15 Alex Ramsay/Alamy Stock Photo; 27.16 Benrido, Inc./Toji, Kyoto; 27.17 © Byodoin Temple; 27.18 Sean Pavone/Alamy Stock Photo; 27.19 Peter Bull; 27.20 Tokugawa Art Museum Image Archives/DNPartcom; 27.21 Kosanji/Kyoto National Museum; p. 462 1 Photo The Asahi Shimbun via Getty Images; p. 462 2 Peter Bull, McClung Museum, University of Tennessee; p. 462 3 Photo Fred Gerrits (scanning and improvement Professor Gschwind, University of Basel); p. 463 4 Courtesy of Drepung Loseling Monastery, Inc. Photo Brian Moorehead; p. 463 5 Photo Museo Arqueológico Nacional, Madrid; p. 464 Cameraphoto/Scala, Florence; 28.1 Alp S/Alamy Stock Photo; 28.2, 28.3 Peter Bull; 28.4 Stefania Barbier/Alamy Stock Photo; 28.5 Peter Bull; 28.6 Cameraphoto/Scala, Florence; 28.7a, 28.7b Peter Bull; 28.8, 28.9 Cameraphoto/Scala, Florence; 28.10 Photo RMN-Grand Palais (Musée du Louvre)/Les frères Chuzeville; 28.11 Photo Österreichische Nationalbibliothek, Vienna, Cod. Theol. Gr. 31, f.7r; 28.12 By permission of St. Catherine's Monastery, Sinai, Egypt. Photo courtesy Michigan-Princeton-Alexandria Expeditions to Mount Sinai; 28.13 Salvator

Barki/Getty Images; 28.14 Photo State Historical Museum, Moscow, MS. D.129, f.67r; 28.15 Bibliothèque nationale de France, Paris, MS gr. 139, f.1v; 28.16 Paul Ancenay/akg-images; 28.17 Peter Bull; 28.18 Paul Ancenay/akg-images; 28.19 Erich Lessing/akg-images; 28.20 G. Dagli Orti/De Agostini Picture Library/Getty Images; 28.21 Courtesy State Tretyakov Gallery, Moscow; 28.22 Andrea Jemolo/akg-images; 28.23 Erich Lessing/akg-images; 28.24 Ihsan Gercelman/Alamy Stock Photo; p. 480 Photo Morgan Library & Museum/Art Resource, NY/Scala, Florence; 29.1 Photo Trustees of the British Museum, London; 29.2 Board of Trinity College Dublin; 29.3, 29.4 British Library Board, London/Bridgeman Images; 29.5 Board of Trinity College Dublin; 29.6 Pecold/Shutterstock.com; 29.7 Peter Bull; 29.8 Photo © Achim Bednorz; 29.9 Florian Monheim/Bildarchiv Monheim GmbH/akg-images; 29.10 Rodemann/Schütze/akg-images; 29.11 Courtesy Stiftsbibliothek, St Gallen, Cod. Sang. 1092, Plan of Saint Gall (www.e-codices.ch); 29.12 KHM-Museumsverband; 29.13 Médiathèque d'Epernay; 29.14, 29.15 Photo Morgan Library & Museum/Art Resource, NY/Scala, Florence; 29.16 Rodemann/Schütze/akg-images; 29.17 Peter Bull; 29.18 Dommuseum Hildesheim, photo Florian Monheim; 29.19 Peter Bull; 29.20 Azoor Photo/Alamy Stock Photo; 29.20a Erich Lessing/akg-images; 29.21 © Hohe Domkirche Köln, Dombauhütte, Köln, photo Winifried Kralisch; 29.22, 29.22a Domschatz Essen, photo Christian Diehl, Dortmund; 29.23a Alex Ramsay/Alamy Stock Photo; 29.23 Mark Edward Harris/Getty Images; 29.24 John Freeman/Getty Images; 29.25 Peter Bull; 29.26 Dmitry Naumov/Alamy Stock Photo; p. 497 Metropolitan Museum of Art, New York. Gift of H. L. Bache Foundation, 1969, 69.7.10. Photo Metropolitan Museum of Art/Art Resource/Scala, Florence; 30.1, 30.1a Justin Kerr/Mayavase; 30.2 Peabody Museum of Archaeology and Ethnology, Harvard. Gift of the Carnegie Institution of Washington, D.C., PM 28-63-20/17561; 30.3 Photo Jorge Pérez de Lara; 30.4a Chronicle/Alamy Stock Photo; 30.4 National Geographic Images; 30.5 Photo Jorge Pérez de Lara; 30.6 Photo Trustees of the British Museum, London; 30.7 Leonid Andronov/Alamy Stock Photo; 30.8 Gianni Dagli Orti/Shutterstock; 30.9, 30.10 agefotostock/Alamy Stock Photo; 30.11 Photo Trustees of British Museum, London; 30.12 Metropolitan Museum of Art, New York. Gift of H. L. Bache Foundation, 1969, 69.7.10. Photo Metropolitan Museum of Art/Art Resource/Scala, Florence; 30.13 Metropolitan Museum of Art, New York. The Michael C. Rockefeller Memorial Collection, Purchase, Nelson A. Rockefeller Gift, 1968, 1978.412.214. Photo Metropolitan Museum of Art/Art Resource/Scala, Florence; 30.14 Image courtesy Dallas Museum of Art, Texas. The Eugene and Margaret McDermott Art Fund Inc., in honor of Carol Robbin's 40th anniversary with the Dallas Museum of Art; 30.15, 30.16 Ohio Historical Society, Columbus; 30.17 Courtesy of the Cahokia Mounds Historic Site; 30.18 powerofforever/iStock.com; 30.19 Saint Louis Art Museum, Funds given by the Children's Art Festival, 175.1981; 30.20 National Museum of the American Indian, Washington, D.C., William E. Myer Collection, 15/0853; 30.21 Art Institute of Chicago, Hugh L. and Mary T. Adams Fund; p. 513 Metropolitan Museum of Art, New York. Lila Acheson Wallace Gift, 1992, 1992.54. Photo Metropolitan Museum of Art/Art Resource/Scala, Florence; 31.1 Photo Kurokawa Institute of Ancient Cultures, Hyogo; 31.2 a–e Peter Bull; 31.3, 31.4 National Palace Museum, Taipei; 31.5 Courtesy Palace Museum, Beijing; 31.6 National Palace Museum, Taipei; 31.7 Museum of Fine Arts, Boston, Maria Antoinette Evans Fund/Bridgeman Images; 31.8, 31.9, 31.10 National Palace Museum,

Taipei; **31.11** Photo Trustees of the British Museum, London; **31.12** Princeton University Art Museum, New Jersey. Edward L. Elliott Family Collection, Museum purchase, Fowler McCormick, Class of 1912. Photo Bruce M White/Princeton University Art Museum/Art Resource/Scala, Florence; **31.13**, **31.14** National Palace Museum, Taipei; **31.15** Metropolitan Museum of Art, New York. Fletcher Fund, 1928, 28.56; **31.16** Courtesy Daitokuji Temple, Kyoto; **31.17** Metropolitan Museum of Art, New York. Lila Acheson Wallace Gift, 1992, 1992.54. Photo Metropolitan Museum of Art/Art Resource/Scala, Florence; **p. 528 1** bpk, Bildagentur für Kunst, Kultur und Geschichte, Berlin/Scala, Florence; **p. 529 2, 2a** Inner Mongolia Museum of The People's Republic of China, photo Kong Qun; **p. 529 3** Photo State Hermitage Museum/Vladimir Terebeninby/Alexander Koksharov; **p. 530** Sen-Oku Hakukokan Museum, Sumitomo Collection, Kyoto; **32.1** Freer Gallery of Art and Arthur M. Sackler Gallery, Smithsonian Institution, Washington, D.C., Gift of Mason M. Wang, F1984.31; **32.2** Sen-Oku Hakukokan Museum, Sumitomo Collection, Kyoto; **32.3** The Picture Art Collection/Alamy Stock Photo; **32.4** Important Cultural Property of Japan, Tenri Central Library, Tenri University, Nara; **32.5** Art Institute of Chicago, Bequest of Russell Tyson; **32.6** Photo Museum of Fine Arts, Boston. Fenollosa-Weld Collection, 11.4000; **32.7a**, **32.7b** Bijyutsuin Laboratory for Conservation of National Treasures of Japan; **32.8** Kanazawa Bunko, Yokohama; **32.9** Sainen-ji Temple, Aichi; **32.10** Avalon/Photoshot License/Alamy Stock Photo; **32.11** Kobe City Museum/DNPartcom; **32.12** miralex/iStock.com; **32.13** Peter Bull; **32.14** Photo Oyamazaki Town Hall. Courtesy Myōkian Temple, Kyoto Prefecture; **32.15** Peter Bull; **32.16** Photo Hyogo Prefecture Museum of Art; **p. 544** Photo State Hermitage Museum/photo Vladimir Terebenin, Alexander Koksharov; **33.1** Masci Giuseppe/AGF/Universal Images Group/Getty Images; **33.2** Anton Ivanov/Alamy Stock Photo; **33.3** Peter Bull; **33.4** Photo © Michel Schinz; **33.5**, **33.6** B. O'Kane/Alamy Stock Photo; **33.7** Photo State Hermitage Museum/photo Vladimir Terebenin, Alexander Koksharov; **33.8** Bibliothèque nationale de France, Paris, MS Arabe 5847, f.138r; **33.9** Freer Gallery of Art, Smithsonian Institution, Washington, D.C. Purchase – Charles Lang Freer Endowment, F1938.12; **33.10** Metropolitan Museum of Art, Purchase, Harris Brisbane Dick Fund, Joseph Pulitzer Bequest, Louis V. Bell Fund and Fletcher, Pfeiffer and Rogers Funds, 1990; **33.11**, **33.12** Peter Bull; **33.13** Tuul and Bruno Morandi/Alamy Stock Photo; **33.14** With kind permission of the University of Edinburgh/Bridgeman Images; **33.15** Harvard Art Museums/Arthur M. Sackler Museum, Bequest of Abby Aldrich Rockefeller, © President and Fellows of Harvard College; **33.16** Juergen Ritterbach/Getty Images; **33.17** Peter Bull; **33.18** Christoph Lischetzki/Alamy Stock Photo; **33.19** Freer Gallery of Art, Smithsonian Institution, Washington, D.C. Purchase - Charles Lang Freer Endowment, F1957.19; **33.20** Photo © RMN-Grand Palais (Musée du Louvre)/Franck Raux; **p. 560 1** British Library Board, London/Bridgeman Images; **p. 561 2** Metropolitan Museum of Art, New York. Mary Griggs Burke Collection, Gift of the Mary and Jackson Burke Foundation, 2015, 2015.300.231; **p. 561 3** Metropolitan Museum of Art, New York. Rogers Fund, 1965, 65.106.2; **p. 562** KHM-Museumsverband; **34.1** Walters Art Museum, Baltimore, Acquired by Henry Walters, 1930; **34.2** Ken Welsh/agefotostock; **34.3** Peter Bull; **34.4** Peter Eastland/Alamy Stock Photo; **34.5** Photo RMN-Grand Palais (Musée du Louvre)/Hervé Lewandowski; **34.6** akg-images/Album/Oronoz; **34.7** Photo Museu Nacional d'Art de Catalunya, Barcelona 2020; **34.8** Rob Crandall/Alamy Stock Photo; **34.9** Perry van Munster/Alamy Stock Photo; **34.10** Patrimonio Nacional; **34.11** B. O'Kane/Alamy Stock Photo; **34.12** A. Dagli Orti/Scala, Florence; **34.13** Stefano Valeri/Alamy Stock Photo; **34.14** KHM-Museumsverband; **34.15** By permission of St. Catherine's Monastery, Sinai, Egypt. Photograph courtesy of Michigan-Princeton-Alexandria Expeditions to Mount Sinai; **34.16** British Library Board, London/Bridgeman Images; **34.17** B. O'Kane/Alamy Stock Photo; **34.18** DeAgostini Picture Library/Scala, Florence; **34.19** Lucas Vallecillos/Alamy Stock Photo; **p. 578** Bildarchiv Monheim GmbH/Alamy Stock Photo; **35.1** Luisa Ricciarini/Bridgeman Images; **35.2** Bibliothèque nationale de France, Paris, MS nouv. Acq. Lat. 2246, f.79v; **35.3** saiko3p/Shutterstock.com; **35.4** Peter Bull; **35.5** Hemis/Alamy Stock Photo; **35.6** Peter Bull; **35.7** Bildarchiv Monheim/akg-images; **35.8** White Images/Scala, Florence; **35.9** Hemis/Alamy Stock Photo; **35.10** Erich Lessing/akg-images; **35.11** Oronoz/Album/akg-images; **35.12** Metropolitan Museum of Art, Gift of J. Pierpont Morgan, **1916**, Photo Metropolitan Museum of Art/Art Resource/Scala, Florence; **35.13** Photo Trustees of the British Museum, London; **35.14** Angelo Hornak/Alamy Stock Photo; **35.15** Peter Bull; **35.16** With special permission from the City of Bayeux; **35.17**, **35.18** Bildarchiv Monheim/akg-images; **35.19** Kolumba, Cologne, photo Lothar Schnepf; **35.20** Photo Morgan Library & Museum/Art Resource, NY/Scala, Florence; **p. 592** Erich Lessing/akg-images; **36.1** Photo © Pascal Lemaître/Centre des monuments nationaux; **36.2** Peter Bull; **36.3** Photo © Pascal Lemaître/Centre des monuments nationaux; **36.4** Photo © Patrick Müller/Centre des monuments nationaux; **36.5** Peter Bull; **36.6** Sonia Halliday Photographs/Bridgeman Images; **36.7** A. Dagli Orti/Scala, Florence; **36.8** Photo © David Bordes/Centre des monuments nationaux; **36.9**, **36.10** Peter Bull; **36.11** Photo © David Bordes/Centre des monuments nationaux; **36.12** Photo © Pascal Lemaître/Centre des monuments nationaux; **36.13** Bibliothèque nationale de France, Paris, Ms lat.10525, f.7v; **36.14** Metropolitan Museum of Art, New York, The Cloisters Collection, 1954; **36.15** Walters Art Museum, Baltimore, Acquired by Henry Walters, 1923; **36.16** robertharding/Alamy Stock Photo; **36.17** Dean Hoskins/Alamy Stock Photo; **36.18** Julian Elliott Photography/Getty Images; **36.19** Andreas Leachtape/Bildarchiv Monheim/akg-images; **36.20** Mattis Kaminer/Alamy Stock Photo; **36.21** Florian Monheim/Bildarchiv Monheim/akg-images; **36.22** LVR-LandesMuseum Bonn, photo Jürgen Vogel; **36.23** Juan Carlos Muñoz/Alamy Stock Photo; **p. 608**, **37.1**, **37.2**, **37.3**, **37.4**, **37.5**, **37.6** Photos Scala, Florence; **37.7** Photo Scala, Florence, courtesy of the Ministero Beni e Att. Culturali e del Turismo; **37.8** Photo Scala, Florence; **37.9** (pinnacle row) Philadelphia Museum of Art, John G. Johnson Collection, Cat. 88; (top and central rows) Photos Opera Metropolitana Siena/Scala, Florence; (bottom row, from left to right) Photo Opera Metropolitana Siena/Scala, Florence; Frick Collection, New York, Purchased by The Frick Collection, 1927, photo DeAgostini Picture Library/Scala, Florence; Courtesy National Gallery of Art, Washington, D.C., Samuel H. Kress Collection; Photo Opera Metropolitana Siena/Scala, Florence; Museo Thyssen-Bornemisza, Madrid, photo akg-images; Photos The National Gallery, London/Scala, Florence; Photo Kimbell Art Museum, Fort Worth, Texas/Art Resource, NY/Scala, Florence; **37.10**, **37.11** Photos Opera Metropolitana Siena/Scala, Florence; **37.12** Günter Gräfenhain/imageBROKER/agefotostock; **37.13** Photo Scala, Florence; **37.14** Photo Scala, Florence, courtesy of the Ministero Beni e Att. Culturali e del Turismo; **37.15** Cameraphoto Arte Venezia/Bridgeman Images; **37.16** Mauro Magliani/Alinari Archives, Florence/Getty Images; **37.17**, **37.18** Photos Scala, Florence; **37.19** Peter Bull; **37.20** Photo Scala, Florence, courtesy Musei Civici Fiorentini.

Index

S

Sabina, Saint 389
saffron gatherers fresco, Akrotiri *173*, 174
Sahel 423–24
Saint ... (in names of buildings and institutions)
 see St./St-/Ste-)
Saint ... (in names of people) *see next part of name, e.g.*
 Mark, Saint
Saint Francis Altarpiece (Berlinghieri) *614*, 614–15
Sakai, Japan: Daisen Tomb 349, *349*
Saladin 573, 596
Salian dynasty 588–91
Salisbury Cathedral 602–3, *603*
Samanid sultanate 545–46
Samarqand, Uzbekistan 271, 412
Samarra 406–8; Great Mosque of al-Mutawakkil *406*,
 406–7
Samarra Style *407*, 407–8
Samnites 305, 306
San Bartolo, Guatemala: Maya frescoes 212–13, *213*, 216
San Lorenzo, Mexico 207, 208, 211
San Marco (Cathedral of St. Mark), Venice *370*,
 617–18, *618*
San people 55, 56; rock paintings *50*, 56, 56–57
San Vitale, Ravenna *464*, 467–69, *468*, *469*, 485
sancai ceramics *452*, *452*
Sanchi, India: Great Stupa 270, *276*, 276–78, *277*
Sanctuary of Apollo, Delphi *224*, 224–27, *225*
Sanctuary of the moon god Nanna, Ur 79, 79–80
sand mandalas *463*, *463*
Santa Constanza, Rome 390–92, *391*
Santa Maria degli Angeli, Rome *369*, *369*
Santa María la Blanca, Toledo *570*, 570–71
Santa Maria Maggiore, Rome 388, *388*
Santa Maria Novella, Florence 622, *623*
Santa Pudenziana, Rome *377*, 384, *385*
Santa Sabina, Rome 388–90, *389*, *390*
Sant'Apollinare Nuovo, Ravenna 394–95, *395*
Santiago de Compostela, Spain cathedral of 580, *581*
Santo Domingo de Silos, Spain *585*, *585*
Santorini (Thera) 172–74
Sanxingdui, China 155–56
Saqqara, Egypt 86–87; funerary complex of Djoser *87*,
 87–90, *88*, *89*, *90*; mastaba tombs *86*, 86–87, 93, 94,
 94; statue of scribe 95, *95*
sarcophagi: Olmec 211; of Pakal 501, *501*; of Roman
 Christians 384, 386, *386*, 391, *391*; Sarcophagus of
 the Spouses 297–98, *298*; Tomb of Tutankhamun
 125; at Vergina 260
Sargon 77, 78
Sarnath, India 274, *275*, 280
Sasanian Empire 378, 399, 403, 528–29, 556, 599
Sawos culture, New Guinea: *malu* 22, 23
Scandinavia 492–96
scarification 63, 427
schematic depiction 19, 163, 231, 370, 382
Schliemann, Heinrich 178, 179
School of Beauty, School of Culture (Marshall) 16–17,
 17, 20, 21
Scottish manuscript production 481–82, *483*, 483
Scraper, The (Lysippos) 257, *257*
screen painting 517, 531, 540, *540*
screenfold books 213, 499
scrolls *see* handscrolls; hanging scrolls
Scrolls of Frolicking Animals 460, 460–61
sculptural techniques: drillwork 209, 338, *338*, 345;
 molded bricks 110, *110*; stucco modeling 314, *314*;
 terra-cotta 350, *350*; *yosegi zukuri* 457–58; *see also*
 high-relief techniques; low-relief techniques; relief
 sculpture; terra-cotta
sculpture: Adena pipe 509, *509*; Archaic Greek *226*,
 226–30, *227*, *228*, 229, *230*; Buddhist 287, *287*, 449–50,
 450 (*see also* bodhisattvas; buddhas); Classic
 Veracruz 506, *506*; Classical Greek 243, 243–47, *244*,

245, *246*, 248, *249*, 249–51, *250*, *251*; contemporary
16, *16*; crucifixes 492, *492*, *567*, 567–68, 589–90, *590*;
Daedalic style *188*, 188–89, *189*; Djenne Style *425*,
425–26; Early Classical Greek *231*, 231–37, *232*, *233*,
234, *235*, *236*; Etruscan 295, 295–97, 298, *298*; in
Gothic architecture 594, 595–96, *596*, 599, 599–600;
Great Zimbabwe 422, *422*; *haniwa* figures 349–50,
350; Hellenistic *264*, 264–69, *266*, *267*, *268*, *269*;
Indus culture 137, 137–39, *138*; Jain *280*, 280–81; in
Judaism 380; Late Classical Greek 255–57, *256*, *257*;
Nok Style 60, 60–61, *61*; Oceania 143, 143–44, *144*,
145–46, *146*; Olmec 208, 208–10, *209*, 211, 211–12;
prehistoric Europe 40–42, *41*, *42*; prehistoric West
Asia 47, 47–49, *48*; Qin dynasty 147, 158–60, *159*; *see
also* figurines; portrait sculpture; relief sculpture;
rock-cut architecture; statues; votives; woodcarving
sculpture in the round 243, *244*, 264, *264*
Sea Peoples 129, 185
seals *138*, 138–39, *139*; Griffin Warrior sealstone
184, *184*
Seated Boxer (Apollonius) 269, *269*
Seated Buddha, Seokguram Grotto *454*, 454, 456
Second Style painting (Roman) *303*, 314–16, *315*, *316*,
324, *324*, 330
secular medieval art 586, 602, 610–12
Seder 573–74
Sei Shōnagon: *The Pillow Book* 460
Seleucid Empire 262, *262*, 263, 378
self-portraits 25–26, *26*
Seljuq sultanate 473, 546–49, *547*, 573
semicircular vaulting 599
Senusret III 118–19, *119*
Seo Gubang: *Water-Moon Gwaneum Bosal* 530, *532*,
532–33
Seokguram Grotto 454, *454*, 456
Seon Buddhism 514, 537
Sephardic Jews 566, 573–74
Septimius Severus 345, *363*, 365–67, *366*, 368; Arch of
366–68, *367*, *368*
Serdica, Edict of 383
Sergius, Saint 573, *573*
Sesshū Tōyō: *Huike Offering His Arm to Bodhidharma*
538, 538–39
Seven Sages of the Bamboo Grove 358, 358–59
Severan dynasty 365–69
Severe style 231, *232*, 234, *235*
Seville, Spain 568; Giralda 568–69, *569*
shaft graves *178*, 178–179
Shahnama 556
Shailendra dynasty 432, 433
Shaka 450; *see also* Buddha, historical
Shaka Triad (Tori) 450, *450*
Shakyamuni *see* Buddha, historical
Shang dynasty 151–54; and the Nine Cauldrons 353
shell work 462, *462*, 511, *511*
Sher-Gil, Umrao Singh: *Experiment with double
exposure III: self-portrait* 25–26, *26*
Shi'i Islam 401, 410, 554; *see also* Fatimid dynasty
shikhara 282, 435, 436
Shingon Buddhism 457
Shintō 348, 448–49, 462
ship burials: Oseberg 493; Sutton Hoo 481
Shiva 139, 272, 281, *281*, 283, 286, *286*, 288–89, 432;
Khajuraho temple to *435*, 435–37, *436*, *437*; as
Nataraja 438, *438*; Rajarajeshwara Temple to *435*,
437–38, *438*
Shiva cave temple, Elephanta 284–86, *285*, *286*
shogunate *(bakufu)* 535
Shona 415, 420, 422
Shonibare, Yinka: *Cake Man* 16, *16*, 20–21
Shōtoku, Prince 449, 450
shrines: Shintō 462, *462*
Shvetambara Jainism 281
Sicily 262, 290, 563, 571–72; Capella Palatina *571*,
571–72, *572*; mantle of Roger II 562, 572, *572*

Siddhartha Gautama 274, 277–78, 448, 451; *see also*
 Buddha
Siena, Italy 615; cathedral 610, 615–17, 621; Palazzo
 Pubblico 609–12, *610*, *611*
signet rings 184
silk painting 351–52, 515, *530*, 532; *see also* handscrolls;
 hanging scrolls
silk production 157, 528
Silk Road 205, *270*, 270–71, 278, 341, 358, 452; spread of
 paper-making 412
Silla kingdom 348, 349, 362, 447, 454; gold crown
 362, *362*
Sin Sukju *533*, 533–34; *Record on Painting* 534
Sipán, Peru: tomb of Moche lord 200, *201*
Siphnian Treasury, Delphi *225*, 225–27, *226*
Sirmium, Serbia 370
slavery 317, 406, 540, 556
snake goddesses 165, *165*, 168–69, *169*
Sneferu 91
Social Wars (Roman) 302, 305–6
Sogdia 271
soldier emperors, Roman 365, *369*, 369–70
Solomon 415, 467, 597; Temple of 379–80, 467, 563
Solomonic dynasty 418–19
Song Da drum 142, *142*
Song dynasty 397, 420, 514, *514*, 515–21, 524; ceramics
 515, 520, *520*; painting 516, 516–21, *518*, *519*, *520*, *521*,
 525–26, *526*, 538–39
South Africa 55, 56–57; *see also* Mapungubwe
South America 42, 192, *192*, 498, *498*; *see also* Andean
 cultures
South Asia 135, 135–40, 146, 273, 273–86, *430*; animism
 287; Buddhist art 273–81, 283–84; fabrics 19;
 Hellenistic influence 263; Hindu art 281–83, 284–86,
 430–32, 434–39; Islamic art 441–45; Jain art 280–81;
 Silk Road connections 270
Southeast Asia 135, *135*, 140, 140–43, 273, *273*, 286–88,
 430, *430*; Khmer dynasty 439–41; *see also* New
 Guinea
Southern Song dynasty 515, 520–21, 538–39; *Apricot
 Blossoms* (Ma) 520, 520–21; *Knick-knack Peddler* (Li)
 521, *521*; *White-Robed Guanyin, Gibbons, and Crane*
 (Muqi) 525–26, *526*
Southern Tang Kingdom 514–15; *Wintry Groves and
 Layered Banks* (attrib. Dong) 514–15, *515*
Spain: Altamira Cave 38, *39*, 39–40; Granada 574, 575
 (*see also* Alhambra palace complex); La Pasiega
 Cave 36, *36*; Léon 566, 567; Madinat al-Zahra 566,
 568; Santiago de Compostela 580, 581; Santo
 Domingo de Silos 585, *585*; Seville 568–69, *569*;
 Toledo 484, 564, 570–71; *see also* Córdoba; Iberian
 peninsula
Sparta, Greece 229–30, 239
speaking reliquaries 492
Spear Bearer (Polykleitos) 249–50, *250*, 257, 321
Sperlonga, Italy 267
Speyer Cathedral 588–89, *589*
sphinxes 102; Great Sphinx, Giza 92, *93*
spolia 371, 389, 443–44, 564, 569
Square Word Calligraphy 31, *31*
squinches *467*, *475*, 475–76, 575
Sri Lanka 437, 438, 442
St-Denis, abbey of 485, 488, 593–95, *594*, *595*
St. Lawrence mosaic, Ravenna 393, *393*
St-Martin-du-Canigou, France 579, 579, *581*
St. Michael, Abbey of, Hildesheim 489, 489–92, 589
St. Panteleimon, Monastery of, Nerezi 477, *477*
St. Peter's Basilica (Old), Rome *387*, 387–88
St. Peter's Cathedral, Poitiers: *Crucifixion* (stained
 glass) 28–29, *29*
St-Sernin, Toulouse *581*, 581–83, *582*
Stabian Baths, Pompeii *308*, 308–9, *309*
stained glass 28, 29, *29*, 594–95, *595*, 597, 597–98
Standard of Ur, Royal 75, *75*
statues: Buddhist 536, 537, *537* (*see also* bodhisattvas;